NATIONAL GUIDE TO FUNDING IN ARTS AND CULTURE

NATIONAL GUIDE TO FUNDING IN ARTS AND CULTURE

Edited by
Stan Olson, Ruth Kovacs, & Suzanne Haile

Marcellus A. Lloyd, Jr.,
Project Coordinator

The Foundation Center
1990

CONTRIBUTING STAFF

Director of Publications	Bill Bartenbach
Director of Information Systems	Martha David
Director of Research	Loren Renz
Assistant Director of Publications, Reference Publication Coordinator	Marcellus Lloyd, Jr.
Assistant Director of Publications, Production Manager	Rick Schoff
Assistant Director of Information Systems	Melanie Edwards
Information Control Coordinator	Ted Murphy
Assistant Editors	Margaret Mary Feczko Emily Zimmerman Margaret Ziomkowski
Editorial Associates	Martin Allen M. Lara Brock Shiao-Ping Wang Chu Edward DiJoseph Suzanne A. Gould Wendy Guida Gilbert Hennessey Margaret B. Jung Cheryl Loe Zoe Waldron
Editorial Assistants	Louis Au Sonje Berg Sasikanth Doddapaneni Anne Isacowitz Ronald Lee Ruth Montesa Andrea Robinson Alicia Santiago José Santiago Joan Seabourne

CONTENTS

CONTENTS

FOREWORD

This useful publication—*The National Guide to Funding in Arts and Culture*—lists the significant grants made for artistic purposes by American foundations in 1988. There is much to be derived from these pages by grantees, prospective grantees, policymakers and other students of arts funding in this country. One of the facts fortified by the compilation, for instance, is that by any measure, the amount of funding for the arts contributed by corporations and foundations in this country is extremely small.

In 1988, according to *Giving USA*, the arts and the humanities received an estimated $6.82 billion from all private sources. Foundations and corporations contributed less than 20 percent of these funds, while gifts from individuals and bequests accounted for nearly four out of five private dollars. Of an estimated $900 million in arts funding by the more than 6,600 independent, corporate, and community foundations listed in *The Foundation Directory,* over one-fourth, or $250 million, comes from only 35 foundations. And only about half of the grants go directly to artistic enterprise; most funding goes toward cultural purposes and programs of a far more general nature. By any such quantitative measures as these, corporate and foundation funding of the arts is small; it is scarce; it is special.

Yet, the value to the arts of such funding is extremely important. There is something more to measure here than numbers, one comes to think, and of course that is the case. Consider that Ford Foundation funding in 1985, small as it may have been by any quantitative measure, established a national arts stabilization fund to ensure sound finances and planning in significant arts institutions in a half dozen American cities. Consider that the Bush Foundation in Minneapolis, with relatively small dollars, provides through its fellowship programs reasonable income for 15 artists a year, encouraging them to stay in their home city to live and work and generating, in the process, a lively and creative environment for all the city's citizens. Consider that the Pittsburgh Foundation—with a small percentage of its own dollars and a challenge to other funders—has helped to build a magnificent new performance space in its city, increasing audiences, revenues, and attention for the arts by doing so. Consider that Texaco has given the Metropolitan Opera to radio listeners all over the country for 50 years, or that a number of American corporations have enabled WNET to bring Great Performances to American television audiences across the country, or that the Pew Charitable Trusts have made Philadelphia a cultural center for both established and innovating artists. The examples could go on and on, demonstrating that imagination, commitment and a sense of community are contributed by corporations and foundations all out of proportion to their dollars. The point is that these institutions at their best are able to offer ideas as well as funds to meet the needs of artists, and they are often able to address artistic issues and to experiment with answers that cut across needs, factions or fields.

A second, nonquantifiable point to be made about American philanthropy, as with so much else in American life, is its diversity. Funding for the arts in this country comes from a variety of sources, in a mix that is considered marvelous by our friends in other countries and that prevents an official art from developing here. From the distinctively American foundation sector, funding comes in large and small amounts. It is given out of a variety of motives or guidelines, with or without strings attached. The funders may prefer to be strictly anonymous, merely acknowledged, or broadly advertised. Some grants confirm status; others confer it. Some funding programs are accessible only to well-established, well-endowed institutions. Other programs fund only individual artists, or only experimenting artists, or alternative institutions. Some funding is for work of the past and some for work as yet unimagined. In this mix of sources, purposes and aesthetics, all the art the nation makes finds validation. Such diversity reduces our risk of receiving only consensual or traditional or non-controversial art. As long as there is a diversity of patrons, there will be a diversity of sanctions and safeguards for freedom of expression. Here again, corporations and foundations—in their mix and diversity of goals and guidelines—are important far beyond their dollars.

A third significant measure of the importance of foundations is the leadership role that they assume in this society. Grantees make the point very often, insisting that the recognition given by foundations can be as important as dollars in determining their success. At their best, foundation grants can help to promote big or ambitious or far-reaching programs in arts and culture that might not otherwise be feasible. With its leadership nationwide, for instance, AT&T has helped American minority artists achieve performance, exhibition and critical attention that might otherwise elude them. The Ford Foundation's programs often have as their objective the encouragement of experimental work that breaks the boundaries of usual art forms. With support from foundations like the Lila Wallace–Reader's Digest Fund, the Eleanor Naylor Dana Charitable Trust, and the Hewlett Foundation, the Meet-the-Composer organization has helped to transform the musical experience of American orchestras across the country, stimulating them to take contemporary composers into residence and to increase their performance and commissioning of new music. Spurred by the leadership support of foundations, innovative artists and arts organizations, new artistic ideas, imaginative arts administrators and trustees can gather the momentum they need to adapt or grow in ways that are natural and appropriate to changing times and constituencies. The leadership role of American foundations can barely be counted in dollars or

percentages. A more suitable measure would be the influence they are able to exert on behalf of art, or perhaps the ease with which their underwriting makes possible the transfer into the culture of new ideas and programs in the arts.

In the decade of the nineties, corporate and foundation support of arts and culture will be even more important than it has been, and again, numbers are only a small indicator of such change. Art in the nineties promises to be weightier, more grounded in issues, more searching and provocative, more socially aware; the need for bold, self-confident funders, for conscience in funding, will be greater. The increasing internationalization of the world we live in will make corporations and foundations natural partners with artists in increasing cultural understanding and exchange, in achieving the large vision required by problems on a planetary scale. We will surely be looking for leadership in the challenging end of this century from the most creative Americans; corporate managers, foundation executives, artists and intellectuals must supply that leadership, often in coalition. Because the Foundation Center provides the information that is needed for such action in resources like this volume, those of us in the arts and in foundations owe them countless thanks.

Alberta Arthurs
Director for Arts and Humanities
The Rockefeller Foundation

INTRODUCTION
Foundation and Corporate Support for Arts and Culture

In 1988 America's philanthropic foundations and corporations awarded an estimated $10.9 billion in grants and other types of support to nonprofit organizations in the U.S. and abroad. Studies of foundation grantmaking patterns by the Foundation Center indicate that about 15 percent of independent foundation grant dollars benefit arts and cultural programs, while the Conference Board estimates the share of corporate foundation support and direct company giving for the arts at close to 11 percent. Applying these percentages, we can roughly estimate that arts and cultural programs received over $1.4 billion from these two sources in 1988. Although foundations and corporations provide but a small fraction of total private and government support of the arts, they are nonetheless a key funding source for many programs.

This *Guide* is intended as a starting point for grantseekers looking for foundation and corporate support for the visual and performing arts, arts education, museums, film and video, architecture, historic preservation, humanities and classical studies, literature and writing, and public radio and television. It includes 3,358 entries representing various types of grantmakers: 2,168 independent foundations, 129 community foundations, 53 grantmaking operating foundations, 707 company-sponsored foundations, and 301 direct corporate giving programs. In all, the *Guide* covers 924 corporations that support the arts through their foundations, direct giving programs or a combination of both. These foundations and corporations have expressed a substantial interest in arts and culture either as part of their stated purpose or through the actual grants they reported to the Foundation Center in 1988.

The foundations and corporate giving programs listed in this directory do not represent all of the potential private funding sources available to nonprofit groups active in arts and culture, nor does inclusion in the *Guide* imply that grantmakers will consider all programs related to the arts. Some grantmakers support arts and cultural organizations because of their interest in improving the overall quality of life in a specific community. Others may do so because the program relates to another highly specific interest of the grantmaker, such as increasing opportunities for disadvantaged children, providing recreational programs for the elderly or therapy for the mentally ill, or improving the urban environment. Still others are interested in building the capacity of nonprofit institutions by providing specific types of support, such as capital funds or challenge grants.

Grantseekers are therefore urged to read each grantmaker description carefully to determine the nature of their interests and to note any program or geographic restrictions that would prevent the grantmaker from favorably considering their proposal. Readers should also refer to the section of this introduction, "Researching Foundations and Grantseeking from Corporations," for information on identifying other potential private funding sources.

Types of Grantmakers

A foundation is a nonprofit, nongovernmental organization with a principal fund or endowment of its own that maintains or aids charitable, educational, religious, or other activities serving the public good, primarily by making grants to other organizations.

A private **independent foundation** is a grantmaking organization whose funds are generally derived from an individual, family, or group of individuals. It may be operated under the direction of the donor or members of the donor's family or it may have an independent board of directors that manages the foundation's program. Typically, independent foundations have broad charters under which they can operate, but in practice, most limit their giving to a few fields of interest or a specific geographic area.

Community foundations are supported by and operated for a specific community or region. They receive their funds from a variety of donors. In fact, their endowments are frequently composed of a number of different trust funds, some of which bear their donors' names. Their grantmaking activities are administered by a governing body or distribution committee representative of community interests. Although community foundations may support a wide range of activities, their grants are generally restricted to charitable organizations in their own city or region.

Operating foundations are private foundations under the tax laws, but their primary purpose is to operate research, social welfare, cultural, or other charitable programs determined by the donor or governing body. Some grants may be made to organizations outside the foundation, but the majority of the foundation's funds are expended for its own programs. Only those operating foundations that maintain grants programs are listed in this *Guide*.

Corporations contribute through foundations, direct giving programs, or both:

Company-sponsored foundations, also called corporate foundations, are created and funded by business corporations for the purpose of making grants and performing other philanthropic activities. Legally,

they are separate from the sponsoring corporation and are governed by the same federal rules and regulations as are private independent foundations. Company foundations are generally managed by a board of directors that includes corporateofficials but may also include individuals with no corporate affiliation. Their giving programs often focus on communities where the company has operations and on research and education in fields related to company activities.

Foundations may be established to protect a company's level of giving from fluctuations of corporate profits from year to year. An endowed foundation is less susceptible to economic downturns since investment earnings from the endowment or part of the capital itself can be used to augment contributions from the company in periods of reduced profits.

Direct giving or **corporate giving** refers to all other giving of a company, that is, money not turned over to a foundation to administer. Direct giving programs are unregulated and restricted only by the limit of taxable earnings allowable as charitable deductions. In addition to cash contributions, corporate giving includes "in-kind," non-cash, gifts of goods and services. Donations of company products, supplies and equipment—from computers to food—is the most common form of in-kind giving. Other types of support include staff time, technical assistance, and use of office space. Direct giving programs and foundations often share the same staff, although some companies keep these functions administratively separate.

With the exception of community foundations, this *Guide* does not include listings on other types of organizations that use the word "foundation" in their names, but that do not operate as nor are they classified under tax laws as private foundations. These groups are often nonprofit organizations that raise funds from the public to support research or education, operate various institutions, or maintain a host of other charitable activities.

What's Included in Funding Sources?

The Foundation Center examines grantmaker interests in two broad ways: what the funder says it does or will do and what it actually did. The Center's annual publication, *The Foundation Directory*, provides descriptions of the nation's largest foundations—those with assets of $1 million or more or annual giving of at least $100,000. The statements of purpose for each foundation listed in the *Directory* are drawn from the descriptions provided by foundations in their annual reports, information brochures or other publications, responses to our annual questionnaire mailings, and a broad analysis of the foundation's grantmaking program over the last three years. Although some of these statements provide very specific information about the foundation's giving interests, many were

developed to last for substantial time periods and left purposely broad to allow for future shifts in emphasis.

The Center's *Grants Index* database, which records the actual grants of $5,000 and over reported to the Center by approximately 400 to 450 major foundations, provides a more detailed picture of foundation giving interests. Each grant record includes the name and location of the organization receiving the grant, the amount of money awarded, and a brief description of the purpose for which the grant was made. Center staff analyze and index each grant by subject focus, type of recipient organization, type of support provided, and the population group to be served by the program.

The Center's newest publication, *National Directory of Corporate Giving*, provides an additional source of information on corporate grantmakers. The first edition of this *Directory*, published in 1989, profiles 1,551 companies making contributions to nonprofit organizations. It includes listings on 478 direct giving programs and more than 300 corporate foundations not covered in *The Foundation Directory*. The most comprehensive directory on corporate giving available, it includes only corporations that provided information to the Center or for which public documents on giving were available.

In preparing the first edition of the *National Guide to Funding in Arts and Culture*, we drew on these three important tools to identify foundation and corporate grantmakers with a specific interest in arts and culture and those that made contributions for cultural projects as part of a broader giving program. In the twelfth edition of *The Foundation Directory* (1989), we identified 3,121 foundations—nearly half of the 6,615 foundations covered—with a specific interest in the arts. In the *National Directory of Corporate Giving* we identified 144 smaller company-sponsored foundations—those with giving programs less than $100,000 annually—and 301 direct giving programs with a focus on arts and culture. Finally, we turned to *The Foundation Grants Index* where we found that 7,211 grants of $5,000 or more for arts and culture had been reported to the Center in 1988. These grants were made by 359 (89 percent) of the 404 foundations that made up the *Grants Index* sample in that year. These 359 foundations either have a stated interest in the arts or make grants to cultural institutions as part of a broader purpose.

Analysis of Foundation Support for Arts and Culture

The 7,211 arts and culture grants published in the *Foundation Grants Index* and appearing in this *Guide* have a total dollar value of nearly $434 million. Grants supported a wide variety of arts and cultural programs, including visual arts, music, theater and dance, film and video, museums, arts education, architecture,

historic preservation, literature and writing, humanities and classical studies, archaeology, and public radio and television. Grants for journalism and the press, foreign language, linguistics, public and university libraries, reading, or media grants unrelated to arts and culture are not listed in this *Guide*.

A breakdown of grants by primary subject area (Table 1) suggests the range of foundation giving interests represented. The largest share of grant dollars by far ($126.7 million or 29 percent) and the largest number of grants (1,821 or 25 percent) supported general cultural programs or organizations. The visual arts including architecture received the second largest share of funding ($83.3 million or 19 percent).

Table 1. GRANTS FOR THE ARTS AND CULTURE BY PRIMARY SUBJECT*

Subject	Amount	%	No.
Adult or continuing education	$236,120	0.1	3
Anthropology or sociology	10,000	0.0	1
Art or architecture	83,259,070	19.2	986
Business or employment	179,000	0.0	9
Community affairs	1,421,335	0.3	17
Crime or law enforcement	86,249	0.0	5
Culture, general	126,676,015	29.2	1821
Education, general	210,500	0.0	8
Elementary or secondary education	1,614,736	0.4	44
Environment or energy	9,454,101	2.2	56
Equal rights (including legal services)	2,396,802	0.6	28
Health, general	380,000	0.1	4
Higher education	14,731,020	3.4	45
History	23,110,631	5.3	545
Language or literature	5,775,708	1.3	141
Law or legal education	50,000	0.0	3
Life sciences	1,093,055	0.3	18
Media or communications	24,138,528	5.6	368
Medical care	81,220	0.0	6
Medical research	204,965	0.0	3
Mental health	1,350,515	0.3	12
Music	46,491,298	10.7	1237
Physical sciences	495,250	0.1	3
Political science	5,811,430	1.3	62
Public health	3,523,300	0.8	28
Recreation	18,214,042	4.2	182
Religion, general	989,700	0.2	17
Religious education	25,000	0.0	1
Rural development	250,000	0.1	6
Science, general	4,919,839	1.1	33
Social sciences, general	728,050	0.2	5
Technology	254,533	0.1	5
Theater or dance	52,797,698	12.2	1444
Urban development	2,058,055	0.5	28
Vocational education	32,000	0.0	3
Welfare, general	893,126	0.2	34
TOTAL	**$433,942,891**	**100.0**	**7211**

*The statistics in this table do not represent all 3,358 foundations and giving programs with entries in this *Guide*, only the foundations that appear with grants data drawn from the *Foundation Grants Index*, 18th Edition.

Table 2 shows a breakdown of arts and culture grants by type of support. Grants were made for a wide variety of projects, such as construction and renovation, program development, general or operating support, challenge grants, endowments, fellowships and scholarships, and research. By dollar value, the largest share of arts and culture funding was for program development ($159.3 million or 37 percent), followed closely by capital support ($146.7 million or 34 percent). Of the 7,211 grants reported in 1988, 2,103 or 29 percent were for continuing support, that is, the grant was made to an organization that receives yearly support for the same purpose from a foundation. Since a grant may be made for more than one type of support, percentages reflect double counting and do not total 100 percent.

Table 2. GRANTS FOR ARTS AND CULTURE BY TYPE OF SUPPORT*

Type of support	Amount	No.
Capital support	$148,665,031	972
Continuing support	92,559,845	2013
Endowment	39,500,353	154
Fellowships or scholarships	18,578,821	195
General or operating support	66,323,018	1432
Matching or challenge grant	49,332,791	282
Program development	159,345,476	2942
Research	12,258,963	103
Not specified	21,718,071	852

*Grants data drawn from the *Foundation Grants Index*, 18th Edition.

Analysis in Table 3 is by type of organization receiving the grant. Museums and historical societies received the largest share of funding by dollar value ($181.5 million or 42 percent) while performing arts groups received the largest number of grants (2,878 or 40 percent). As with types of support, a recipient may fall into more than one organizations category, such as government agency and school. As a result percentages do not add up to 100 percent.

Table 3. GRANTS FOR ARTS AND CULTURE BY RECIPIENT TYPE*

Recipient Type	Amount	No.
Agency (direct service)	$27,843,398	580
Association or professional society	47,136,713	913
Church or temple	523,855	25
Community fund	10,000	1
Governmental unit	9,461,046	165
Graduate school	3,375,605	61
Hospital or medical care facility	87,254	5
Junior or community college	303,700	17
Library	9,760,157	117
Museum or historical society	181,529,081	1870
Performing arts group	111,019,449	2878
Private university or college	32,819,450	252
Public university or college	8,722,156	162
Research institute	7,254,267	55
School	8,560,158	277
Not specified	43,028,480	651

*Grants data drawn from the *Foundation Grants Index*, 18th Edition.

Table 4. GRANTS FOR ARTS AND CULTURE BY POPULATION GROUP SERVED*

Population Group	Amount	No.
Aged	$1,052,400	58
Alcoholics or drug addicts	120,000	5
Asian Americans	552,500	30
Blacks	7,564,898	176
Children or youth	30,490,058	777
Criminal offenders or ex-offenders	31,249	4
Handicapped	1,122,845	68
Hispanics	2,773,198	91
Men or boys	552,073	26
Minorities	3,083,350	87
Native Americans	3,202,136	28
Women or girls	1,632,470	66
Not specified	385,334,745	5954

*Grants data drawn from the *Foundation Grants Index*, 18th Edition.

As illustrated in Table 4, most grants in arts and culture serve a broad population. Of the 7,211 grants reported in 1988, only 1,257 or 17 percent served a special group of beneficiaries tracked by the *Foundation Grants Index*. Foundations awarded 777 grants to arts and culture projects aimed at children and youth. Together these grants had a dollar value of $30.5 million and represented about 7 percent of total arts and culture dollars. A grant may benefit more than one population group, e.g., handicapped children, therefore percentages reflect double counting.

Table 5. GRANTS FOR ARTS AND CULTURE BY RECIPIENT LOCATION*

Recipient Location	Amount	No.
Alabama	$133,067	8
Alaska	447,200	17
Arizona	567,957	32
Arkansas	131,681	10
Australia	20,000	1
Austria	12,691	2
Bermuda	12,000	1
Brazil	251,934	6
California	36,356,752	835
Canada	367,047	6
China	350,000	2
Colombia	31,000	1
Colorado	6,734,522	121
Connecticut	6,710,516	127
Delaware	1,090,800	14
District of Columbia	22,010,505	364
Egypt	17,500	2
England	1,925,790	26
Florida	3,825,173	104
France	292,020	8
Gambia	60,000	2
Georgia	9,774,548	86
Germany	10,860	1
Hawaii	3,933,923	74
Idaho	110,000	5
Illinois	16,331,756	406
India	340,000	5
Indiana	9,584,645	51
Indonesia	223,000	4
Iowa	459,000	25
Israel	325,000	1
Italy	129,440	4

Table 5. GRANTS FOR ARTS AND CULTURE BY RECIPIENT LOCATION* (continued)

Recipient Location	Amount	No.
Jordan	5,000	1
Kansas	179,000	9
Kentucky	464,000	21
Kenya	96,660	3
Louisiana	386,000	24
Maine	678,095	18
Maryland	1,612,265	25
Massachusetts	15,664,558	282
Michigan	12,180,353	238
Minnesota	14,752,943	350
Mississippi	92,000	7
Missouri	8,667,192	105
Montana	615,000	14
Mozambique	140,000	1
Nebraska	411,000	15
Netherlands	173,986	4
Nevada	145,780	8
New Hampshire	502,324	14
New Jersey	11,273,388	203
New Mexico	499,481	19
New York	85,701,425	1758
Nigeria	11,000	1
North Carolina	3,920,979	80
North Dakota	101,000	12
Ohio	$14,942,228	275
Oklahoma	1,884,088	46
Oregon	6,439,533	106
Pennsylvania	64,413,941	439
Peru	190,000	3
Philippines	26,500	3
Puerto Rico	176,881	2
Rhode Island	753,503	20
Senegal	25,000	1
South Africa	86,000	1
South Carolina	1,300,000	30
South Dakota	70,000	3
South Korea	20,000	1
Spain	25,319	1
Sri Lanka	50,000	1
Sudan	150,000	1
Sweden	15,000	1
Switzerland	131,140	3
Tennessee	2,486,886	41
Texas	48,405,261	385
Thailand	24,000	1
Uganda	15,000	2
Utah	259,500	11
Vermont	377,258	19
Virginia	4,354,349	65
Washington	2,430,699	73
West Germany	80,338	1
West Virginia	231,786	10
Wisconsin	3,647,925	95
Wyoming	87,000	8
TOTAL	**$433,942,891**	**7211**

*Grants data drawn from the *Foundation Grants Index*, 18th Edition.

Three additional tables are provided for analysis. Table 5 shows the breakdown of grants listed in the *Guide* by the state or country in which the recipient organization is located. The 359 *Grants Index* foundations that reported the 7,211 arts and cultural grants and the total dollar amount and number of their grants are listed in Table 6. Finally, we have included a list of the top 15 grants reported in 1988 by highest

dollar value (Table 7). Brief information on the purpose of these large grants can be found in the descriptive entries of the donor foundations. Of the top grants listed, three were made to The Carnegie in Pittsburgh (formerly known as Carnegie Institute), including $11 million, the largest cultural grant of the year, from the Howard Heinz Endowment; $8 million from the Richard King Mellon Foundation; and $5 million from the Hillman Foundation. These three grants supported the institution's Second Century Fund, a major capital campaign.

Table 6. GRANTS FOR ARTS AND CULTURE BY FOUNDATION*

Foundation	Amount	No.
Abell-Hanger Foundation	$328,500	6
Aetna Life & Casualty Foundation, Inc.	377,791	23
Ahmanson Foundation, The	6,367,520	63
Akron Community Foundation	176,360	12
Alden Trust, George I.	587,000	17
Alms Trust, Eleanora C. U.	$163,000	7
Altman Foundation	405,000	14
Amarillo Area Foundation, Inc.	365,332	3
American Express Foundation	981,200	62
Ameritech Foundation	877,500	18
Amoco Foundation, Inc.	1,282,905	47
Andersen Foundation, Hugh J.	180,842	11
ARCO Foundation	1,173,200	97
Arizona Bank Charitable Foundation	77,717	8
Astor Foundation, Vincent, The	420,000	19
AT&T Foundation	3,598,483	207
Atherton Family Foundation	762,500	15
Atkinson Foundation	23,000	3
Atlanta Community Foundation, Inc., Metropolitan	2,845,568	20
Avon Products Foundation, Inc.	52,000	10
Babcock Foundation, Inc., Mary Reynolds	272,900	6
Baton Rouge Area Foundation	10,000	1
Benton Foundation	130,500	8
Biddle Foundation, Mary Duke, The	440,679	14
Bingham Foundation, William, The	100,000	8
Blandin Foundation, The	580,200	17
Boettcher Foundation	1,119,500	15
Booth Ferris Foundation	1,285,000	21
Borg-Warner Foundation, Inc.	367,000	34
Boston Foundation, Inc., The	57,500	3
Boston Globe Foundation, Inc., The	866,470	88
Bothin Foundation, The	47,860	4
Bradley Foundation, Inc., Lynde and Harry, The	1,811,000	18
Bremer Foundation, Otto	50,500	4
Brown Foundation, Inc., The	7,968,730	64
Buffalo Foundation, The	145,046	12
Buhl Foundation, The	1,040,000	3
Burchfield Foundation, Inc., Charles E.	15,000	1
Burden Foundation, Florence V.	25,000	1
Burlington Northern Foundation	2,100,930	108
Bush Foundation, The	3,711,265	30
Bynner Foundation for Poetry, Inc., Witter, The	61,895	7
C. S. Fund	11,500	1
Cabot Corporation Foundation, Inc.	68,580	7
Cafritz Foundation, Morris and Gwendolyn, The	3,886,692	42
Calder Foundation, Louis, The	719,500	31
California Community Foundation	230,650	8
Callaway Foundation, Inc.	289,265	8
Campbell Foundation, J. Bulow	700,000	3
Carnegie Corporation of New York	2,386,500	14
Carter Foundation, Amon G.	3,950,375	17

Table 6. GRANTS FOR ARTS AND CULTURE BY FOUNDATION* (continued)

Foundation	Amount	No.
Cary Charitable Trust, Mary Flagler	5,107,814	55
Castle Foundation, Samuel N. and Mary	430,000	10
Champlin Foundations, The	265,720	10
Chautauqua Region Community Foundation, Inc.	17,500	2
Cheney Foundation, Ben B.	345,360	15
Chicago Community Trust, The	2,254,365	37
Cincinnati Foundation, Greater, The	611,625	30
Clark Foundation, The	757,500	15
Clark Foundation, Edna McConnell, The	18,000	1
Clark Foundation, Inc., Robert Sterling	292,000	15
Cleveland Foundation, The	5,774,929	51
Collins Foundation, The	620,500	25
Colorado Trust, The	1,676,000	1
Columbia Foundation	15,000	3
Columbus Foundation, The	503,000	14
Communities Foundation of Texas, Inc.	3,918,065	41
Connecticut Mutual Life Foundation, Inc., The	100,000	3
Connell Foundation, Michael J.	1,092,800	4
Cooke Foundation, Ltd.	407,600	15
Corning Glass Works Foundation	207,231	20
Council on Library Resources, Inc.	$64,520	5
Cowell Foundation, S. H.	430,425	15
Cowles Charitable Trust, The	75,250	10
Cox Charitable Trust, Jessie B.	429,521	10
Culpeper Foundation, Inc., Charles E.	1,472,220	24
Cummins Engine Foundation	138,131	6
Dade Community Foundation	121,712	10
Dana Foundation, Inc., Charles A., The	475,000	1
Danforth Foundation, The	69,000	2
Davis Foundations, Arthur Vining, The	1,305,000	9
Dayton Foundation, The	74,000	6
Dayton Hudson Foundation	3,632,238	111
DeFrees Family Foundation, Inc.	40,000	4
Denver Foundation, The	233,842	12
Diamond Foundation, Inc., Aaron, The	2,181,000	72
Dodge Foundation, Inc., Cleveland H.	75,000	4
Dodge Foundation, Inc., Geraldine R.	2,367,504	82
Dolfinger-McMahon Foundation	74,990	9
Dow Foundation, Herbert H. and Grace A., The	2,825,400	4
duPont Religious, Charitable and Educational Fund, Jessie Ball	929,750	12
East Bay Community Foundation, The	32,500	6
Eastman Kodak Charitable Trust	1,804,883	29
Educational Foundation of America, The	294,532	10
El Paso Community Foundation	115,000	4
El Pomar Foundation	813,164	12
Erie Community Foundation, The	78,500	5
Evans Foundation, Inc., Lettie Pate	1,135,000	5
Exxon Education Foundation	292,030	11
Fairchild Foundation, Inc., Sherman, The	1,608,000	5
Fels Fund, Samuel S.	181,021	12
Field Foundation of Illinois, Inc., The	397,500	9
Flinn Foundation, The	52,500	2
Ford Foundation, The	14,730,869	123
Ford Foundation, Edward E., The	65,000	2
Ford Fund, S. N. Ford and Ada, The	10,000	1
Ford Motor Company Fund	4,515,650	109
Frear Eleemosynary Trust, Mary D. and Walter F.	25,000	3
Frick Educational Commisison, Henry C.	5,000	1
Frost Foundation, Ltd., The	213,981	19
Frueauff Foundation, Inc., Charles A.	25,000	3
Fry Foundation, Lloyd A.	451,191	31
Fund for the City of New York, Inc.	5,000	1
Gamble and P. W. Skogmo Foundation, B. C., The	69,500	7
Gannett Foundation	1,622,610	146

Table 6. GRANTS FOR ARTS AND CULTURE BY FOUNDATION*
(continued)

Foundation	Amount	No.
Gates Foundation	1,418,750	16
Gebbie Foundation, Inc.	1,112,697	6
Gelco Foundation, The	103,000	3
Gellert Foundation, Carl, The	5,000	1
General Electric Foundation	802,762	23
General Electric Foundation, Inc.	7,500	1
General Mills Foundation	1,080,150	35
General Motors Foundation, Inc.	1,105,867	43
Gerbode Foundation, Wallace Alexander	545,630	29
Gerstacker Foundation, Rollin M., The	45,500	5
Getty Trust, J. Paul	4,950,179	90
Goldman Fund, Richard and Rhoda	68,000	7
Graham Fund, Philip L., The	556,000	19
Grand Rapids Foundation	207,500	10
Grant Foundation, William T.	488,915	6
Green Foundation, Allen P. & Josephine B.	180,500	13
Greenwall Foundation, The	270,394	22
Gregg-Graniteville Foundation, Inc.	5,000	1
Grotto Foundation, Inc.	16,000	3
Gund Foundation, George, The	1,391,454	40
Haas Foundation, Paul and Mary	49,577	4
Haas, Jr. Fund, Evelyn and Walter	82,500	7
Hall Family Foundations	$3,991,789	12
Harris Bank Foundation	62,000	9
Harris Foundation, The	176,300	16
Hartford Courant Foundation, Inc., The	186,150	13
Hartford Foundation for Public Giving	1,679,855	13
Hartford Insurance Group Foundation, Inc., The	232,500	6
Hayden Foundation, Charles	1,023,000	11
Hazen Foundation, Inc., Edward W., The	50,000	4
Hearst Foundation, Inc., The	964,500	49
Hearst Foundation, William Randolph	3,290,000	45
Hechinger Foundation	253,600	14
Heinz Endowment, Howard	13,228,816	18
Heinz Endowment, Vira I.	200,000	10
Herrick Foundation	1,595,000	16
Hewlett Foundation, William and Flora, The	4,447,000	45
Hillman Foundation, Inc., The	5,200,925	8
Hitachi Foundation, The	75,508	2
Hoblitzelle Foundation	2,684,910	4
Houston Endowment, Inc.	1,420,000	15
Hoyt Foundation, Stewart W. & Willma C.	198,075	9
Hudson-Webber Foundation	470,000	11
Hunt Foundation, Roy A., The	245,000	2
Hunter Trust, Inc., A. V.	5,000	1
Hyde and Watson Foundation, The	182,800	12
Independence Foundation	11,000	2
Indianapolis Foundation, The	409,470	11
Irvine Foundation, James, The	4,236,200	38
Irwin-Sweeney-Miller Foundation	635,001	4
Ittleson Foundation, Inc.	91,000	3
J. M. Foundation, The	57,500	3
Janesville Foundation, Inc.	26,500	2
Jennings Foundation, Martha Holden, The	535,575	36
Jerome Foundation	1,353,430	78
Jewett Foundation, George Frederick	134,000	11
Johnson Controls Foundation	429,975	17
Johnson Foundation, Robert Wood, The	150,000	1
Johnson Foundation, Walter S.	210,250	2
Johnson's Wax Fund, Inc., The	106,000	9
Jones Foundation, Daisy Marquis	111,700	6
Jones Foundation, Inc., W. Alton	1,392,220	35
Joyce Foundation, The	1,019,350	41
Kaiser Family Foundation, Henry J., The	27,661	1
Kanawha Valley Foundation, Greater, The	223,786	9
Kansas City Community Foundation and Its Affiliated Trusts, Greater, The	213,000	8
Kantzler Foundation, The	22,500	1

Table 6. GRANTS FOR ARTS AND CULTURE BY FOUNDATION*
(continued)

Foundation	Amount	No.
Kaplan Fund, Inc., J. M., The	2,135,250	79
Keck Foundation, W. M.	1,356,000	7
Kellogg Foundation, W. K.	553,021	14
Kempner Fund, Harris and Eliza	113,000	9
Kettering Family Foundation, The	45,000	5
Kettering Fund, The	1,966,000	9
Kirby Foundation, Inc., F. M.	1,485,500	52
Kleberg Foundation, Robert J. Kleberg, Jr. and Helen C.	145,000	4
Knight Foundation	3,686,490	70
Koret Foundation	370,909	9
Kraft Foundation	1,042,900	43
Kresge Foundation, The	15,320,000	50
Kress Foundation, Samuel H.	2,130,500	33
Kroc Foundation, Joan B.	5,000	1
Levi Strauss Foundation	83,300	8
Lilly Endowment, Inc.	8,011,400	24
Longwood Foundation, Inc.	2,932,800	10
Luce Foundation, Inc., Henry, The	2,498,000	16
Lux Foundation, Miranda	5,000	1
Lyndhurst Foundation	1,722,650	25
Mabee Foundation, Inc., J. E. and L. E., The	1,075,000	5
MacArthur Foundation, J. Roderick	94,702	7
MacArthur Foundation, John D. and Catherine T.	$18,102,148	110
Macy, Jr. Foundation, Josiah	300,000	1
Mailman Family Foundation, Inc., A. L.	10,000	1
Marbrook Foundation	36,000	3
Mardag Foundation	102,000	7
Marin Community Foundation	447,424	20
Maytag Company Foundation, Inc., The	156,500	8
McBeath Foundation, Faye	81,500	3
McCormick Charitable Trust, Robert R.	565,945	32
McCune Foundation	1,045,000	3
McDonnell Douglas Foundation	987,790	23
McDonnell Foundation, James S.	1,285,000	4
McGregor Fund	692,500	18
McInerny Foundation	148,000	8
McKesson Foundation, Inc.	131,500	14
McKnight Foundation, The	15,000	2
Meadows Foundation, Inc.	6,957,724	65
Medtronic Foundation, The	387,900	18
Mellon Foundation, Andrew W., The	24,893,425	55
Mellon Foundation, Richard King	9,323,000	5
Merck Company Foundation, The	203,000	11
Mertz-Gilmore Foundation, Joyce	575,000	46
Metropolitan Life Foundation	610,000	47
Meyer Charitable Trust, Fred	2,215,200	16
Meyer Foundation, Eugene and Agnes E.	227,050	17
Milbank Memorial Fund	20,000	1
Milwaukee Foundation	281,500	27
Minneapolis Foundation, The	62,740	4
Mobil Foundation, Inc.	657,650	56
Monticello College Foundation, The	49,850	5
Morgan Guaranty Trust Company of New York Charitable Trust	1,148,020	96
Mott Foundation, Charles Stewart	775,000	8
Murdock Charitable Trust, M. J.	1,505,000	8
Muskegon County Community Foundation, Inc.	170,132	9
New Hampshire Charitable Fund, The	75,024	8
New Haven Foundation, The	540,995	28
New York Community Trust, The	887,000	43
New York Times Company Foundation, Inc., The	1,472,950	102
Newcombe Foundation, Charlotte W., The	541,000	1
Noble Foundation, Inc., Samuel Roberts, The	1,347,197	10
Nord Family Foundation, The	46,000	3
Norfolk Foundation, The	272,500	4

Table 6. GRANTS FOR ARTS AND CULTURE BY FOUNDATION*
(continued)

Foundation	Amount	No.
Northwest Area Foundation	888,000	19
Oklahoma City Community Foundation, Inc.	93,291	8
Olin Foundation, Inc., F. W.	3,424,300	2
Olin Foundation, Inc., John M.	422,000	7
Olin Foundation, Spencer T. and Ann W.	140,000	4
Onan Family Foundation	33,000	4
Oppenstein Brothers Foundation	58,000	5
Oregon Community Foundation, The	1,921,726	27
Pacific Telesis Foundation	792,870	41
Packard Foundation, David and Lucille, The	2,223,633	70
Parsons Foundation, Ralph M., The	872,182	16
Pasadena Foundation	72,694	10
Peninsula Community Foundation	20,944	4
Penn Foundation, William, The	7,037,987	63
Pew Charitable Trusts, The	21,951,600	129
Pforzheimer Foundation, Inc., Carl and Lily, The	110,000	4
Philadelphia Foundation, The	291,959	28
Phillips Foundation, Ellis L.	51,000	8
Pillsbury Company Foundation, The	641,787	17
Piton Foundation, The	31,000	1
Pittsburgh Foundation, The	157,500	14
PPG Industries Foundation	168,000	11
Primerica Foundation	493,500	22
Procter & Gamble Fund, The	$554,600	21
Prospect Hill Foundation, Inc., The	207,455	11
Prudential Foundation, The	441,000	16
Public Welfare Foundation, Inc.	223,000	6
Quaker Oats Foundation, The	67,000	6
Raskob Foundation for Catholic Activities, Inc.	139,500	5
Retirement Research Foundation, The	5,000	1
Reynolds Charitable Trust, Kate B.	5,000	1
Reynolds Foundation, Inc., Z. Smith	602,500	21
Richardson Foundation, Sid W.	8,259,250	13
Richardson Foundation, Inc., Smith	150,000	2
Rockefeller Brothers Fund	440,000	4
Rockefeller Family Fund, Inc.	45,500	1
Rockefeller Foundation, The	9,693,870	165
Rockefeller Foundation, Winthrop, The	47,000	2
Rockwell International Corporation Trust	1,188,500	59
Rosenberg Foundation	77,287	2
Rubin Foundation, Inc., Samuel	5,000	1
Rubinstein Foundation, Inc., Helena	3,152,000	83
Saint Paul Foundation, The	836,956	16
San Antonio Area Foundation	279,463	12
San Diego Community Foundation	258,281	19
San Francisco Foundation, The	778,800	66
Santa Barbara Foundation	195,239	17
Santa Cruz County Community Foundation, Greater	5,000	1
Sara Lee Foundation	657,500	22
Scaife Foundation, Inc., Sarah	2,050,000	2
Schering-Plough Foundation, Inc.	310,000	10
Scherman Foundation, Inc., The	612,500	39
Schlieder Educational Foundation, Edward G.	75,000	1
Scholl Foundation, Dr.	705,000	26
Schumann Foundation, Florence and John, The	420,000	9
Security Pacific Foundation	586,013	39
Self Foundation,The	32,500	2
Sells Foundation, Carol Buck	197,780	8
Shubert Foundation, Inc., The	3,142,500	174
Siebert Lutheran Foundation, Inc.	5,000	1
Skillman Foundation, The	1,088,000	19
Sloan Foundation, Alfred P.	861,000	4
Smith Charitable Trust, W. W.	55,000	3
Snow Foundation, Inc., John Ben, The	30,000	3

Table 6. GRANTS FOR ARTS AND CULTURE BY FOUNDATION*
(continued)

Foundation	Amount	No.
Snow Memorial Trust, John Ben	278,000	11
Southeast Banking Corporation Foundation	207,500	18
Southeastern Michigan, Community Foundation for	61,000	8
Southwestern Bell Foundation	1,785,813	44
Springs Foundation, Inc.	21,500	2
Starr Foundation, The	852,000	21
State Street Foundation	133,500	17
Steelcase Foundation	478,500	12
Steele Foundation, Harry and Grace, The	2,973,600	23
Steele-Reese Foundation, The	181,000	6
Stern Family Foundation, Alex	40,500	6
Strong Foundation, Hattie M.	15,000	3
Strosacker Foundation, Charles J., The	22,200	1
Stulsaft Foundation, Morris, The	142,500	15
Surdna Foundation, Inc.	1,393,500	34
Tandy Foundation, Anne Burnett and Charles D.	4,181,280	16
Texaco Philanthropic Foundation, Inc.	1,459,900	51
Tinker Foundation, Inc., The	95,000	3
Towsley Foundation, Harry A. and Margaret D., The	165,575	6
Toyota USA Foundation	128,000	4
TRW Foundation	417,000	20
Tucker Charitable Trust, Rose E.	60,000	8
Tuohy Foundation, Alice Tweed	112,700	4
Turrell Fund	66,500	4
United States—Japan Foundation	$328,258	3
UNUM Charitable Foundation	118,461	7
Utica Foundation, Inc.	16,000	3
van Ameringen Foundation, Inc.	90,000	3
Victoria Foundation, Inc.	440,700	17
Vogler Foundation, Inc., Laura B., The	5,000	1
Wallace—Reader's Digest Fund, Inc., DeWitt	2,231,000	54
Wallace—Reader's Digest Fund, Inc., Lila	1,492,500	46
Washington, Inc., Community Foundation of Greater, The	216,640	13
Webster Foundation, Edwin S.	60,000	6
Weingart Foundation	536,260	6
Westinghouse Foundation	646,316	30
Whitaker Foundation, The	278,430	9
Whitehall Foundation, Inc.	9,426	1
Whitehead Foundation, Joseph B.	2,310,000	5
Whitehead Foundation, Inc., Lettie Pate	144,000	5
Wilcox Trust, G. N.	87,000	9
Winston-Salem Foundation, The	91,500	8
Woodruff Foundation, Inc., Robert W.	298,000	7
Woods Charitable Fund, Inc.	251,000	14
Worcester Community Foundation, Inc., Greater	7,500	1
Wortham Foundation, The	6,752,042	24
Xerox Foundation, The	1,413,959	86
Zellerbach Family Fund, The	66,668	6
TOTAL	$433,942,891	7211

*The 359 foundations listed here are those that appear with grants data drawn from the *Foundation Grants Index*, 18th Edition. For a complete list of the 3,057 foundations and 301 corporate giving programs with entries in this *Guide*, consult the Name Index at the back of the volume.

Table 7. TOP 15 RECIPIENTS IN ARTS AND CULTURE BY SINGLE HIGHEST GRANT AMOUNT*

Recipient Name	Donor	Grant Amount
1 Carnegie, The	Howard Heinz Endowment, PA	$11,000,000
2 Carnegie Institute	Richard King Mellon Foundation, PA	8,000,000
3 Fort Worth Art Association	Sid W. Richardson Foundation, TX	5,100,000
4 Carnegie, The	The Hillman Foundation, Inc., PA	5,000,000
5 Childrens Television Workshop	John D. and Catherine T. MacArthur Foundation, IL	5,000,000
6 Lyric Theater of Houston Foundation	The Wortham Foundation, TX	5,000,000
7 Franklin Institute	The Pew Charitable Trusts, PA	4,500,000
8 Films, Incorporated	John D. and Catherine T. MacArthur Foundation, IL	4,500,000
9 Woodrow Wilson National Fellowship Foundation	The Andrew W. Mellon Foundation, NY	4,500,000
10 Indianapolis Museum of Art	Lilly Endowment Inc., IN	3,500,000
11 Southern Methodist University, Meadows School of Arts	Meadows Foundation, Inc., TX	3,500,000
12 Bard College	F. W. Olin Foundation, Inc., NY	$3,393,000
13 Amon Carter Museum	Amon G. Carter Foundation, TX	3,117,075
14 Cleveland Museum of Natural History	The Cleveland Foundation, OH	2,600,000
15 Academy Theater	Metropolitan Atlanta Community Foundation, Inc., GA	2,560,826

*Grants data drawn from the *Foundation Grants Index*, 18th Edition.

The dollar value of the largest grants for arts and cultural projects has jumped. In 1987, the top 15 arts grants reported to the Foundation Center ranged from $1.8 million to $4.5 million and totaled $40 million. In 1988, the top 15 grants ranged from $2.6 million to $11 million and totaled $66 million, an increase of 65 percent. Six of the 15 largest grants in 1988 were valued at 5 million dollars or more.

Loren Renz
Director of Research

Researching Foundations and Grantseeking from Corporations

Researching Foundations

Foundations receive many thousands of worthy requests each year. Most of these requests are declined because there are never enough funds to go around or because the applications clearly fall outside the foundations' fields of interests. Some of the applications denied are poorly prepared and do not reflect a careful analysis of the applicant organization's needs, its credibility, or its capacity to carry out the proposed project. Sometimes the qualifications of staff are not well established. The budget or the means of evaluating the project may not be presented convincingly. The organization may not have asked itself if it is especially suited to make a contribution to the solution of the problem or to provide the service proposed or if others are not already effectively engaged in the same activity.

The first step in researching foundation funding support, then, is to analyze your own program and organization to determine the need you plan to address, the audience you will serve, and the amount and type of support you need. You also need to become familiar with the basic facts about foundations and how they operate. If you are relatively new to the world of foundation funding, we strongly urge you to visit one of the Foundation Center's 175 cooperating libraries across the country. These libraries provide free access to all Foundation Center publications, as well as other materials on funding sources, program planning, and fundraising. For the location of the cooperating library nearest you, call toll-free 1-800-424-9836.

Once you have clearly in mind the amount and type of support you need and the reasons why you are seeking foundation support, this *Guide* can help you to develop an initial list of foundations that might be interested in funding your project. In determining whether or not it is appropriate to approach a particular foundation with a grant request, keep in mind the following questions:

1. Does the foundation's interest in arts and culture include the specific type of service or program you are proposing?

2. Does it seem likely that the foundation will make a grant in your geographic area?

3. Does the amount of money you are requesting fit within the foundation's grant range?

4. Does the foundation have any policy prohibiting grants for the type of support you are requesting?

5. Does the foundation prefer to make grants to cover the full cost of a project or do they favor projects where other foundations or funding sources share the cost?

6. What types of organizations does the foundation tend to support?

7. Does the foundation have specific application deadlines and procedures or does it review proposals continuously?

Some of these questions can be answered from the information provided in the *Guide*, but grantseekers will almost always want to consult a few additional resources before submitting a request for funding. If the foundation issues an annual report, application guidelines, or other printed materials describing its program, it is advisable to obtain copies and study them carefully before preparing your proposal. The foundation's annual information return (Form 990-PF) includes a list of all grants paid by the foundation, as well as basic data about its finances, officers, and giving policies. Copies of these returns are available for free examination at most of the Foundation Center's cooperating libraries described above.

Don't Stop Here

The foundations listed in this *Guide* by no means represent all of the possible foundation funding sources for programs in the field of arts and culture. There are a number of foundations, including the over 250 community foundations across the country, that support a wide variety of programs within a specific community or region. Grantseekers should learn as much as possible about the foundations in their own area, particularly when they are seeking relatively small grants or funds for projects with purely local impact.

You should be sure to check any local or state directories of which the Foundation Center is currently aware. Copies of these directories are almost always available for free use at the local Foundation Center cooperating library.

The Foundation Directory, published by the Foundation Center every year, describes foundations with assets of $1 million or more or annual giving of at least $100,000. The *Directory* is arranged by state and includes a geographic index by state and city to help you identify foundations located or interested in your specific community. The Foundation Center also publishes the *National Data Book of Foundations* annually which provides basic address and financial information on all of the over 27,000 active grantmaking foundations in the United States. The *Data Book* is arranged alphabetically by state, and within states foundations are listed in descending order by annual giving amount.

For those who wish more detailed information on how to identify appropriate foundation funding sources, the Center has also published the basic guidebook, *Foundation Fundamentals*. This guide takes you step-by-stepthrough the research process developed and taught by the Foundation Center and describes how to gather the facts you need to best approach those foundations for funding. All Foundation Center publications are available for free use at Foundation Center libraries.

We hope this *Guide* will help to begin a successful search for funds to support your programs, and we welcome your suggestions and comments for future editions.

Grantseeking from Corporations

The research process for corporate funding is similar to other institutional grantseeking: identifying companies that might be interested in the organization's mission and program, learning as much as possible about those companies, determining the best method of approach, and articulating program objectives so as to be in line with the company's giving rationale. It is different from research on other institutional funders, however, in that it is often more difficult to uncover the needed information, there is great diversity in methods and styles of giving among corporations, and companies are often looking for a quid pro quo for their giving. Corporate philanthropy is often called an oxymoron because many corporations see their giving not as altruism but a responsibility or good business. Soliciting support from corporations, therefore, often requires a shift in perspective from appealing to benevolence to promoting a company's self-interest, which can sometimes be difficult for traditional grantseekers.

Identifying companies to approach is accomplished in several ways: directories such as the *National Directory of Corporate Giving* describe companies with known giving programs. These guides help identify companies' subject interests, geographical giving, or benefits the company hopes to derive that match a nonprofit organization's program goals. Beyond directories on grantmakers, general business directories aid in the search, as do the books and guides listed in the bibliography. The local business community is also accessible through the telephone book and your staff's knowledge of their own community. Staff can suggest names, as should the organization's board and volunteers, who often know or work for the companies that may ultimately provide funds.

After a list of likely prospects is compiled, efforts should continue to locate more information about the company, its primary and secondary business activities, its officers, its giving history, and any details helpful in understanding the company's giving rationale. Understanding why a company gives is essential, as it points to the match between the grantseeker's programmatic goals and the corporation's giving goals. Although determining the specific reasons a company makes contributions can be difficult, it can be accomplished through careful research, including studying the annual reports and materials of other organizations the company has supported and by speaking directly with company officials when possible.

This research usually indicates the best method of approaching a company with a request for support. Companies with formal giving programs may have guidelines and application procedures and require a written proposal, while companies with informal giving programs may better be approached through personal contacts made by board members or volunteers. Once the approach is determined, however, a written or oral presentation should be prepared which articulates how the organization's program fits into the company's giving rationale.

Ultimately, the more known about a company the better the chance of obtaining support. A company should never be approached without some knowledge of its business activities or past giving history because without this knowledge funding chances are jeopardized.

But this does not mean that companies without a record of grantmaking should not be approached. Creative fundraisers have found ways of encouraging companies of all sizes, from small businesses to large corporations, to assist in their activities. Success in acquiring such support, however, was usually the result of good research and good contacts. The job of the corporate fundraiser is to be imaginative and thorough, calling into action all the knowledge, people and ideas available. It means learning where to ask, how to ask, and what to ask for.

How to Use the *National Guide to Funding in Arts and Culture*

In using the *Guide* to identify potential funding sources, be sure to note the limitation statements many foundations have provided to see whether your project falls within the general scope of the foundation's giving program. Some foundations restrict their giving to a particular subject field or geographic area; others are not able to provide certain types of support, such as funds for buildings and equipment or for general operating funds.

ARRANGEMENT

The *Guide* is arranged alphabetically by state, and foundation descriptions are arranged alphabetically by name within the state in which the foundation or giving program maintains its primary offices. Each entry is assigned a sequence number, and references in the indexes which follow the main listings are to entry sequence numbers.

There are 28 basic data elements which could be included in an entry. The completeness of an entry varies widely due to the differences in the size and nature of a foundation's program and the availability of information from the foundation. The specific data elements which could be included are:

1. The full legal **name of the foundation.**
2. The **former name** of the foundation, if the name has changed since the last *Foundation Directory.*
3. **Street address, city, and zip code** of the foundation's principal office. (Entries are arranged alphabetically within state sections.)
4. **Telephone number** supplied by the foundation.
5. Any **additional address** supplied by the foundation for correspondence or grant applications.
6. **Establishment data,** including the legal form (usually a trust or corporation) and the year and state in which the foundation was established.
7. The **donor(s)** or principal contributor(s) to the foundation, including individuals, families, and corporations. If a donor is deceased, the symbol † follows the name.
8. The **year-end date** of the foundation's accounting period for which financial data is supplied.
9. **Assets:** the total value of the foundation's investments at the end of the accounting period. In a few instances, foundations that act as "pass-throughs" for annual corporate or individual gifts report zero assets.
10. **Asset type:** generally, assets are reported at market value (M) or ledger value (L).
11. **Gifts received:** the total amount of new capital received by the foundation in the year of record.
12. **Expenditures:** total disbursements of the foundation, including overhead expenses (salaries; investment, legal, and other professional fees; interest; rent; etc.) and federal excise taxes, as well as the total amount paid for grants, scholarships, matching gifts, and loans.
13. The dollar value and number of **grants paid** during the year, with the largest grant paid (**high**) and smallest grant paid (**low**). When supplied by the foundation, the average range of grant payments is also indicated. Grant figures do not include commitments for future payment or amounts spent for grants to individuals, employee–matching gifts, loans, or foundation-administered programs.
14. The total amount and number of **grants made directly to or on behalf of an individual,** including scholarships, fellowships, awards, or medical payments. When supplied by the foundation, high, low, and average range are also indicated.
15. The dollar amount and number of **employee matching gifts** awarded, generally by company-sponsored foundations.
16. The total dollars expended for **programs administered by the foundation** and the number of foundation-administered programs. These programs can include institutions supported exclusively by the foundation, research programs administered by the foundation and conducted either by foundation staff or at other institutions, etc.
17. The number of **loans** and the total amount loaned to nonprofit organizations by the foundation. These can include program-related investments, emergency loans to help nonprofits that are waiting for grants or other income payments, etc. When supplied by the foundation, high, low, and average range are also indicated.
18. The number of **loans to individuals** and the total amount loaned. When supplied by the foundation, high, low, and average range are also indicated.
19. The monetary value and number of **in-kind gifts**.
20. The **purpose and activities,** in general terms, of the foundation. This statement reflects funding interests as expressed by the foundation or, if no foundation statement is available, an analysis of the actual grants awarded by the foundation during the most recent two-year period for which public records exist.
21. The **types of support** (such as endowment funds, support for buildings and equipment, fellowships, etc.) offered by the foundation.
22. Any stated **limitations** on the foundation's giving program, including geographic preferences, restrictions by subject focus or type of recipient, or

specific types of support the foundation cannot provide.

23. **Publications** or other printed materials distributed by the foundation which describe its activities and giving program. These can include annual or multi-year reports, newsletters, corporate giving reports, informational brochures, grant lists, etc. It is also noted if a foundation will send copies of its IRS information return (Form 990-PF) on request.

24. **Application information,** including the name of the contact person, the preferred form of application, the number of copies of proposals requested, frequency and dates of board meetings, and the general amount of time the foundation requires to notify applicants of the board's decision. Some foundations have also indicated that applications are not accepted or that their funds are currently committed to ongoing projects.

25. The names and titles of **officers, principal administrators, trustees or directors,** and members of other governing bodies. An asterisk following the individual's name indicates an officer who is also a trustee or director.

26. The number of professional and support **staff** employed by the foundation, and an indication of part-time or full-time status of these employees, as reported by the foundation.

27. **Employer Identification Number:** the number assigned to the foundation by the Internal Revenue Service for tax purposes. This number can be useful in ordering microfilm or paper copies of the foundation's annual information return, Form 990-PF.

28. **Recent Arts and Culture Grants** lists grants for arts and culture awarded in 1987–1988. Entries include the name and location of the recipient, the grant amount and year awarded and, where available, text which describes the purpose of the grant.

INDEXES

Five indexes to the descriptive entries are provided at the back of the book.

1. **The Index to Donors, Officers, Trustees** is an alphabetical listing of individuals and corporations that have made substantial contributions to foundations or who serve as officers or members of the governing boards of foundations. Many grantseekers find this index helpful to learn whether current or prospective members of their own governing boards, alumnae of their school, or current contributors are affiliated with any foundation.

2. **The Geographic Index** references foundation entries by the state and city in which the foundation maintains principal offices and includes cross-references to indicate foundations located elsewhere that have made substantial grants to a particular state. Foundations that award grants on a national or regional level are indicated in bold type. The other foundations generally limit their giving to the state or city in which they are located.

3. **The Types of Support Index** indicates entry numbers for foundations that offer specific types of grants and other forms of support, such as building funds or fellowships. Definitions of the terms used to describe the types of support offered are provided at the beginning of the index. Under each type of support term, entry references are arranged by the state in which the foundation is located, and foundations that award grants on a national or regional basis are again indicated in bold type. In using this index, grantseekers should focus on foundations located in their own state which offer the specific types of support needed or, if their project has national impact, on foundations listed in bold type that are located in other states.

4. **The Subject Index** allows users to identify foundations by the broad giving interests expressed in the "Purpose and Activities" section of their descriptive entry. A list of the subject terms is provided at the beginning of the index. Like the Types of Support Index, entry references are arranged under each term by the state in which the foundation is located, and foundations that award grants on a national or regional basis are indicated in bold type. Again, grantseekers should focus on foundations located in their own state that have indicated an interest in their subject field, as well as foundations listed in bold type that are located in other states.

5. **The Index of Foundations and Corporate Giving Programs** is an alphabetical list of all foundations and giving programs appearing in this *Guide*. If a foundation has changed its name since the last edition of *The Foundation Directory*, the former name is also listed.

Glossary

The following list includes important terms used by grantmakers and grantseekers. A number of sources have been consulted in compiling this glossary, including *The Handbook on Private Foundations,* by David F. Freeman (Washington, D.C.: Seven Locks Press, 1981); *The Law of Tax-Exempt Organizations,* 5th Edition, by Bruce R. Hopkins (New York: John Wiley & Sons, 1987); *Corporate Philanthropy: Philosophy, Management, Trends, Future, Background* (Washington, D.C.: Council on Foundations, 1982); and a glossary prepared by Caroline McGilvray, former Director of the Foundation Center San Francisco Office, with the Northern California Foundation

Annual Report: A *voluntary* report issued by a foundation or corporate giving program which provides financial data and descriptions of grantmaking activities. Annual reports vary in format from simple typewritten documents listing the year's grants to detailed publications which provide substantial information about the grantmaking program.

Assets: The amount of capital or principal—money, stocks, bonds, real estate, or other resources of the foundation or corporation.

Beneficiary: In philanthropic terms, the donee or grantee receiving funds from a foundation or corporate giving program is the beneficiary, though society benefits as well. Foundations whose legal terms of establishment restrict their giving to one or more named beneficiaries are not included in this *Guide.*

Bricks and Mortar: An informal term for grants for buildings or construction projects.

Capital Support: Funds provided for endowment purposes, buildings, construction, or equipment and including, for example, grants for "bricks and mortar."

Challenge Grant: A grant award that will be paid only if the donee organization is able to raise additional funds from another source(s). Challenge grants are often used to stimulate giving from other donors. (*See also* **Matching Grant**)

Community Fund: An organized community program which makes annual appeals to the general public for funds which are usually not retained in an endowment but are used for the ongoing operational support of local social and health service agencies. (*See also* **Federated Giving Program**)

Community Foundation: A 501(c)(3) organization which makes grants for charitable purposes in a specific community or region. Funds are usually derived from many donors and held in an endowment independently administered; income earned by the endowment is then used to make grants. Although a few community foundations may be classified by the IRS as private foundations, most are classified as public charities eligible for maximum income tax-deductible contributions from the general public. (*See also* **501(c)(3); Public Charity**)

Company-Sponsored Foundation (also referred to as Corporate Foundation): A private foundation whose grant funds are derived primarily from the contributions of a profit-making business organization. The company-sponsored foundation may maintain close ties with the donor company, but it is an independent organization with its own endowment and is subject to the same rules and regulations as other private foundations. (*See also* **Private Foundation**)

Cooperative Venture: A joint effort between or among two or more grantmakers (including foundations, corporations, and government agencies). Partners may share in funding responsibilities or contribute information and technical resources.

Corporate Giving Program: A grantmaking program established and administered within a profit-making company. Corporate giving programs do not have a separate endowment and their annual grant totals are generally more directly related to current profits. They are not subject to the same reporting requirements as private foundations. Some companies make charitable contributions through both a corporate giving program and a company-sponsored foundation.

Distribution Committee: The board responsible for making grant decisions for community foundations. It is intended to be broadly representative of the community served by the foundation.

Donee: The recipient of a grant. (Also known as the grantee or the beneficiary.)

Donor: The individual or organization which makes a grant or contribution. (Also known as the grantor.)

Employee Matching Gift: A contribution to a charitable organization by a corporate employee which is matched by a similar contribution from the employer. Many corporations have employee matching gift programs in higher education that stimulate their employees to give to the college or university of their choice.

Endowment: Funds intended to be kept permanently and invested to provide income for continued support of an organization.

Expenditure Responsibility: In general, when a private foundation makes a grant to an organization which is

not classified by the IRS as a "public charity," the foundation is required by law to provide some assurance that the funds will be used for the intended charitable purposes. Special reports on such grants must be filed with the IRS. Most grantee organizations are public charities and many foundations do not make "expenditure responsibility" grants.

Family Foundation: An independent private foundation whose funds are derived from members of a single family. Family members often serve as officers or board members of the foundation and have a significant role in grantmaking decisions. (See also **Private Foundation**)

Federated Giving Program: A joint fundraising effort usually administered by a nonprofit "umbrella" organization which in turn distributes contributed funds to several non-profit agencies. United Way and community chests or funds, United Jewish Appeal and other religious appeals, the United Ne"gro College Fund, and joint arts councils are examples of federated giving programs. (See also **Community Fund**)

501(c)(3): The section of the Internal Revenue Code which defines nonprofit, charitable (as broadly defined), tax-exempt organizations. 501(c)(3) organizations are further defined as public charities, private operating foundations, and private non-operating foundations. (See also **Operating Foundation; Private Foundation; Public Charity**)

Form 990-PF: The annual information return that all private foundations must submit to the IRS each year and which is also filed with appropriate state officials. The form requires information on the foundation's assets, income, operating expenses, contributions and grants, paid staff and salaries, program funding areas, grantmaking guidelines and restrictions, and grant application procedures. Foundation Center libraries maintain files of 990-PFs for public inspection.

General Purpose Foundation: An independent private foundation which awards grants in many different fields of interest. (See also **Special Purpose Foundation**)

General Purpose Grant: A grant made to further the general purpose or work of an organization, rather than for a specific purpose or project. (See also **Operating Support Grant**)

Grantee Financial Report: A report detailing how grant funds were used by an organization. Many corporations require this kind of report from grantees. A financial report generally includes a listing of all expenditures from grant funds as well as an overall organizational financial report covering revenue and expenses, assets and liabilities.

Grassroots Fundraising: Efforts to raise money from individuals or groups from the local community on a broad basis. Usually an organization does grassroots fundraising within its own constituency—people who live in the neighborhood served or clients of the agency's services. Grassroots fundraising activities include membership drives, raffles, bake sales, auctions, benefits, dances, and a range of other activities.

Independent Foundation: A grantmaking organization usually classified by the IRS as a private foundation. Independent foundations may also be known as family foundations, general purpose foundations, special purpose foundations, or private non-operating foundations. The Foundation Center defines independent foundations and company-sponsored foundations separately; however, federal law normally classifies both as private, non-operating foundations subject to the same rules and requirements. (See also **Private Foundation**)

In-Kind Contributions: A contribution of equipment, supplies, or other property as distinguished from a monetary grant. Some organizations may also donate space or staff time as an in-kind contribution.

Matching Grant: A grant which is made to match funds provided by another donor. (See also **Challenge Grant; Employee Matching Gift**)

Operating Foundation: A 501(c)(3) organization classified by the IRS as a private foundation whose primary purpose is to conduct research, social welfare, or other programs determined by its governing body or establishment charter. Some grants may be made, but the sum is generally small relative to the funds used for the foundation's own programs. Very few operating foundations are also company sponsored. (See also **501(c)(3)**)

Operating Support Grant: A grant to cover the regular personnel, administrative, and other expenses for an existing program or project. (See also **General Purpose Grant**)

Payout Requirement: The minimum amount that private foundations are required to expend for charitable purposes (includes grants and, within certain limits, the administrative cost of making grants). In general, a private foundation must meet or exceed an annual payout requirement of 5 percent of the average market value of the foundation's assets. Corporate giving programs do not have to meet a payout requirement.

Private Foundation: A nongovernmental, nonprofit organization with funds (usually from a single source, such as an individual, family, or corporation) and program managed by its own trustees or directors which was established to maintain or aid social, educational, religious or other charitable activities serving the common welfare, primarily through the making of grants. "Private foundation" also means an organization that is tax-exempt under Code section 501(c)(3) and is classified by IRS as a private foundation as de-

fined in the Code. The Code definition usually, but not always, identifies a foundation with the characteristics first described. (See also **501(c)(3)**; **Public Charity**)

Program Amount: Funds which are expended to support a particular program. In the *Guide*, this term refers to the total dollars spent to operate programs administered internally by the foundation or the corporate giving program.

Program Officer: A staff member of a foundation who reviews grant proposals and processes applications for the board of trustees. Only a small percentage of foundations have program officers.

Program-Related Investment (PRI): A loan or other investment (as distinguished from a grant) made by a foundation or corporate giving program to another organization (including a business enterprise) for a project related to the grantmaker's stated charitable purpose and interests. Program-related investments are often made from a revolving fund; the foundation or corporation generally expects to receive its money back with interest or some other form of return at less than current market rates, which becomes available for further program-related investments.

Proposal: A written application often with supporting documents submitted to a foundation or corporation in requesting a grant. Preferred procedures and formats vary. Consult published guidelines.

Public Charity: In general, an organization which is tax-exempt under Code section 501(c)(3) and is classified by IRS as a public charity and not a private foundation. Public charities generally derive their funding or support primarily from the general public in carrying out their social, educational, religious, or other charitable activities serving the common welfare. Some public charities engage in grantmaking activities, though most engage in direct service or other tax-exempt activities. Public charities are eligible for maximum income tax-deductible contributions from the public and are not subject to the same rules and restrictions as private foundations. Some are also referred to as "public foundations" or "publicly supported organizations" and may use the term "foundation" in their names. (See also **501(c)(3)**; **Private Foundation**)

Qualifying Distributions: Expenditures of private foundations used to satisfy payout requirement. These can include grants, reasonable administrative expenses, set-asides, loans and program-related investments, and amounts paid to acquire assets used directly in carrying out exempt purposes.

Query Letter: A brief letter outlining an organization's activities and its request for funding sent to a foundation or corporate giving program to determine whether it would be appropriate to submit a full grant proposal. Many grantmakers prefer to be contacted in this way before receiving a full proposal.

RFP: Request For Proposal. When the government issues a new contract or grant program, it sends out RFPs to agencies that might be qualified to participate. The RFP lists project specifications and application procedures. A few foundations occasionally use RFPs in specific fields, but most prefer to consider proposals that are initiated by applicants.

Seed Money: A grant or contribution used to start a new project or organization. Seed grants may cover salaries and other operating expenses of a new project.

Set-Asides: Funds set aside by a foundation for a specific purpose or project which are counted as qualifying distributions toward the foundation's annual payout requirement. Amounts for the project must be paid within five years of the first set-aside.

Special Purpose Foundation: A private foundation which focuses its grantmaking activities in one or a few special areas of interest. For example, a foundation may only award grants in the area of cancer research or child development. (See also **General Purpose Foundation**)

Technical Assistance: Operational or management assistance given to nonprofit organizations. It can include fund-raising assistance, budgeting and financial planning, program planning, legal advice, marketing, and other aids to management. Assistance may be offered directly by a foundation or corporate staff member or in the form of a grant to pay for the services of an outside consultant. (See also **In-Kind Contribution**)

Trustee: A member of a governing board. A foundation's board of trustees meets to review grant proposals and make decisions. Often also referred to as "director" or "board member."

FUNDING IN ARTS AND CULTURE BIBLIOGRAPHY

Compiled by
Margaret Derrickson, Bibliographic Information Service

This selected bibliography is compiled from the Foundation Center's bibliographic database. Many of the items are available for free reference use in the Foundation Center's New York City, Washington, D.C., Cleveland and San Francisco libraries and in many of its cooperating libraries throughout the United States. For further references on such topics as fundraising and proposal development, see *The Literature of the Nonprofit Sector: A Bibliography with Abstracts*. New York: Foundation Center, 1989.

Audio Independents. *Foundation Radio Funding Guide.* San Francisco: Audio Independents, 1982.

Broman, John. *Grantsmanship Resources for the Arts and Humanities.* Reprint. Los Angeles: Grantsmanship Center, 1980.

Brownrigg, W. Grant. *Effective Corporate Fundraising.* New York: American Council for the Arts, 1982.

Business Committee for the Arts. *Directory of Matching Gift Programs for the Arts.* New York: Business Committee for the Arts, 1984.

Center for Arts Information. *Bridge over Troubled Waters: Loan Fund for the Arts.* New York: Center for Arts Information, 1979.

Center for Arts Information. *Corporate Fundraising for the Arts.* New York: Center for Arts Information, 1981.

Center for Arts Information. *New York City Arts Funding Guide.* New York: Center for Arts Information, 1985.

Coe, Linda C. *Funding Sources for Cultural Facilities: Private and Federal Support for Capital Projects.* Salem, Oreg.: Oregon Arts Commission, 1980.

Coleman, William Emmet, David Keller, and Arthur Pfeffer. *A Casebook of Grant Proposals in the Humanities.* New York: Neal-Schuman Publishers, 1982.

Council on Foundations. *We Don't Fund Media.* [Video recording]. Washington: Council on Foundations, 1984.

Csapo, Rita Marika, ed. *The Artists Resource Guide to New England: Galleries, Grants, Services.* Boston: Artists Foundation, 1988.

Cultural Assistance Center. *Partners: A Practical Guide to Corporate Support of the Arts.* New York: Cultural Assistance Center, 1982.

Davis, T.P. "Development: The Fine Art of Funding the Fine Arts." *Black Art* 3 (1979): 40-3.

Directory of Grants in the Humanities. Phoenix, Ariz.: Oryx Press, 1988.

Fandel, Nancy A. *The National Directory of Arts and Education Support by Business Corporations.* 3rd ed. Arts Patronage Series, no. 14. Des Moines, Iowa: Arts Letter, 1988.

Foundation Grants Guide for Schools, Museums and Libraries: Grants with a Slice for Communications Technology Products. Fairfax, Va.: International Communications Industries Association, 1984.

Goldman, Debra, and Laura R. Green. *Sponsors: A Guide for Video and Filmmakers.* New York: Clearinghouse for Arts Information, 1987.

Harnik, Tema Greenleaf. *Wherewithal: A Guide to Resources for Museums and Historical Societies in New York State.* New York: Clearinghouse for Arts Information, 1981.

Hartman, Hedy A. *Fund Raising for Museums: The Essential Book for Staff and Trustees.* 2nd ed. Bellevue, Wash.: Hartman Planning and Development Group, 1987.

Hartman, Hedy A., comp. *Funding Sources and Technical Assistance for Museums and Historical Agencies: A Guide to Public Programs.* Nashville, Tenn.: American Association for State and Local History, 1979.

Hay, John Thomas. *How to Organize a Chamber of Commerce Two Percent Club, to Encourage Increased Private Sector Initiative in Your Community.* Sacramento, Calif.: California Chamber of Commerce, 1982.

Howarth, Shirley Reiff, ed. *International Directory of Corporate Art Collections.* New York: Artnews Associates, 1988.

Jackson, Bruce, and Diane Christian. *Get the Money and Shoot.* Buffalo, N.Y.: Documentary Research, 1986.

Jeffri, Joan. *Artsmoney: Raising It, Saving It, and Earning It.* Minneapolis, Minn.: University of Minnesota Press, 1983.

Kass, Stephen L., Judith M. LaBelle, and David A. Hansell. *Rehabilitating Older and Historic Buildings: Law, Taxation, Strategies.* New York: John Wiley, 1985.

Kass, Stephen L., Judith M. LaBelle, and David A. Hansell. *Rehabilitating Older and Historic Buildings. Supplement.* New York: John Wiley, 1989.

Luehrs, Karen. *Funding Sources and Financial Aid Techniques for Historic Preservation.* Atlanta, Ga.: Georgia Department of Natural Resources, Historic Preservation Section, 1983.

Millsaps, Daniel. *National Directory of Arts Support by Private Foundations.* Vol. 5. Des Moines, Iowa: Arts Letter, 1983.

Murphy, Mary C., and Siu Wai Wong, eds. *Performing Arts Directory.* New York: Dance Magazine, 1988.

Music Industry Directory. 7th ed. Wilmette, Ill.: Marquis Who's Who, 1983.

Musical America: International Directory of the Performing Arts. New York: ABC Leisure Magazines, 1988.

Nass, Elyse. *Queens Arts Manager's Survival Guide: A Directory of Services, Arts Resources, and Publicity Outlets.* Edited by Mark J. Schuyler. Jamaica, N.Y.: Queens Council on the Arts, 1988.

Nichols, Susan K., comp. and ed. *Fund Raising: A Basic Reader.* Resource Report, no. 1. Washington: American Association of Museums, 1987.

Porter, Robert A., ed. *Guide to Corporate Giving in the Arts 4.* New York: American Council for the Arts, 1987.

Porter, Robert A., ed. *United Arts Fundraising.* New York: American Council for the Arts, 1986.

Porter, Robert A., ed. *United Arts Fundraising Manual.* New York: American Council for the Arts, 1980.

Reiss, Alvin H., ed. *The Arts Management Reader.* New York: Marcel Dekker, 1979.

Reiss, Alvin H. *Cash In! Funding and Promoting the Arts.* New York: Theatre Communications Group, 1986.

Reithmaier, Tina M., ed. *A Guide to the Cultural Resources in Illinois.* Springfield, Ill.: Office of the Secretary of State, 1988.

Shepard, David S. *How to Fund Media.* Washington: Council on Foundations, 1984.

Simons, Robin, Peter Lengsfelder, and Lisa Farber Miller. *Nonprofit Piggy Goes to Market: How the Denver Children's Museum Earns $600,000 Annually.* Denver, Colo.: Children's Museum of Denver, 1984.

Stolper, Carolyn L., and Karen Brooks Hopkins. *Successful Fundraising for Arts and Cultural Organizations.* Phoenix, Ariz.: Oryx Press, 1989.

Vinson, Elizabeth A. *For the Soul and the Pocketbook: A Resource Guide for the Arts in Rural and Small Communities.* Washington: National Rural Center, 1981.

Wallen, Denise, and Karen Cantrell. *Funding for Museums, Archives and Special Collections.* Phoenix, Ariz.: Oryx Press, 1988.

White, Virginia P. *Grants for the Arts.* New York: Plenum, 1979.

BIBLIOGRAPHY OF STATE AND LOCAL FOUNDATION DIRECTORIES

Compiled and edited by
Margaret Derrickson and Kevin Kurdylo, Bibliographic Information Service
with assistance from
Oliver Smith and Elizabeth McKenty

Alabama *Alabama Foundation Directory*. Birmingham, Ala.: Birmingham Public Library, 1983. Based primarily on 1982 and 1983 990-PF returns filed with the IRS by 194 foundations. Main section arranged alphabetically by foundation; entries include areas of interest and officers, but no sample grants. Indexes of geographic areas and major areas of interest. Available from Reference Department, Birmingham Public Library, 2020 Park Place, Birmingham, AL 35203.

Alabama Taylor, James H. *Foundation Profiles of the Southeast: Alabama, Arkansas, Louisiana, Mississippi*. Williamsburg, Ky.: James H. Taylor Associates, 1983. Based on 1978 and 1979 990-PF and 990-AR returns filed with the IRS by 212 foundations. Main section arranged by state and alphabetically by foundation name; entries include principal officer, assets, total grants and sample grants. No indexes. Available from James H. Taylor Associates, Inc., 804 Main Street, Williamsburg, KY 40769.

Alabama *See also* **Tennessee:** O'Donnell, Suzanna, et al. *A Guide to Funders in Central Appalachia and the Tennessee Valley*.

Arizona Junior League of Phoenix, comp. *Arizona Foundation Directory*. 2nd ed. Phoenix, Ariz.: Junior League of Phoenix, 1989. Profiles of over 150 private and community foundations are featured in this directory produced by the Junior League of Phoenix in cooperation with the Arizona Chapter of the National Society of Fund Raising Executives. Includes foundations which have assets over $5,000 and which have made at least a total of $500 in grants. Descriptions include name, address, telephone number, source of information, employer identification number, year established, donors, purpose/fields of interest, restrictions, trustees, contact person, application deadline, and preferred form of contact. A presentation of financial data notes the fiscal year, total assets, total grants, number of grants, highest/lowest grants, and selected sample grants of the foundation. The directory also includes a guide for program planning, proposal writing, and budget formulation. Indexed by foundation name. Available from the Junior League of Phoenix, Inc., P.O. Box 10377, Phoenix, AZ 85064.

Arkansas Cronin, Jerry. *1986 Guide to Arkansas Funding Sources*. West Memphis, Ark.: Independent Community

Consultants, 1986. Contains information on 93 private Arkansas foundations, 59 corporate foundations, 33 scholarship sources, 26 church funding sources, and seven neighboring foundations (out-of-state foundations with Arkansas giving interests). Descriptions of the private and neighboring foundations include the name, address, phone number, employer ID number, contact, trustee(s), year end financial information, notes, summary of grantmaking by giving area with sample grants, total dollars granted, number of grants made and grant range. Descriptions for other giving programs include the organization's name, address, phone number, contact person, preferred method of contact, application deadline and notes. Also included is a listing of inactive foundations. Available from Independent Community Consultants, Inc., Research & Evaluation Office, P.O. Box 1673, West Memphis, AR 72301.

Arkansas *See also* **Alabama:** Taylor, James H. *Foundation Profiles of the Southeast: Alabama, Arkansas, Louisiana, Mississippi*.

California Allen, Herb, and Sam Sternberg, eds. *Small Change from Big Bucks: A Report and Recommendations on Bay Area Foundations and Social Change*. San Francisco: Bay Area Committee for Responsive Philanthropy, 1979. Based primarily on 1976 990-AR returns filed with the IRS, CT-2 forms filed with California, annual reports, and interviews with 45 Bay Area foundations. Main section arranged alphabetically by foundation; entries include statement of purpose and contact person, but no sample grants. Also sections on the Bay Area Committee for Responsive Philanthropy, foundations and social change, the study methodology, the committee's findings, and the committee's recommendations. No indexes. Appendixes include Bay Area resources for technical assistance, bibliography, nonprofit organizations in law and fact, and glossary. Available from Bay Area Committee for Responsive Philanthropy, 944 Market St., San Francisco, CA 94102.

California Fanning, Carol. *Guide to California Foundations*. 7th ed. San Francisco: Northern California Grantmakers, 1988. This directory lists more than 800 foundations located in California which award grants totalling $40,000 or more annually. Based primarily on 990-PF returns filed with the IRS or records in the California Attorney General's Office; some additional data supplied by foundations completing questionnaires. Main section

arranged alphabetically by foundation; entries include statement of purpose, sample grants and officers. Also section on applying for grants. Indexes of all foundations by name, subject and county location. Available from Northern California Grantmakers, 116 New Montgomery Street, Suite 742, San Francisco, CA 94105. (415) 777-5761.

California Ford, Gerald, Leslye Louie, and David Miller. *An Examination of Bay Area Corporate Non-Cash Contributions: Programs and policies for the Eighties.* San Francisco: Coro Foundation, 1981. Examines corporate non-cash contributions and selected creative projects. Model programs are described to encourage other companies to broaden their own contributions programs. Provides strategies for nonprofits seeking non-cash contributions, with profiles of 38 corporate contribution programs in the San Francisco Bay Area. Profiles include contact, assets, number of employees, types of non-cash contributions, and program emphasis. Appendix is a cross-reference list of corporate non-cash contribution programs by type. Available from Coro Foundation, 609 S. Grant Street, #810, Los Angeles, CA 90017.

California Logos Associates. *The Directory of the Major California Foundations.* Attleboro, Mass: Logos Associates, 1986. Based on 1983 and 1984 990-PF returns and annual reports for more than 97 foundations. Main section arranged alphabetically by foundation; entries include contact person, activities, categories of giving, board meeting dates, officers and directors, and grants (coded to show type of aid). Subject index. Available from Logos Associates, 7 Park Street, Rm. 212, Attleboro, MA 02703.

California *San Diego County Foundation Directory.* San Diego, Calif.: San Diego Community Foundation, 1989. Based on 990-PF returns filed with the IRS for 67 foundations and 56 corporations. Main sections arranged alphabetically. Entries include contact person, type of support, range of grants, total amount and number of grants, application procedures and directors; no date of financial information indicated. No indexes. Available from San Diego Community Foundation, 525 "B" Street, Suite 410, San Diego, CA 92101. (619) 239-8815.

California Santa Clara County Office of Education. *Corporate Contributions Guide to Santa Clara County.* San Jose, Calif.: Grantsmanship Resource Center, [1989]. Directory of 266 corporations in Santa Clara County (Silicon Valley). Entries vary in completeness; provide address, contact person and phone number, designation for type of office, indication of whether or not the company has a contribution program, preferred program areas, application guidelines, contribution finances, non-cash contributions, and matching gift programs. Indexed by areas of interest. Available from The Nonprofit Development Center, 1762 Technology Drive, Suite 225, San Jose, CA 95110. (408) 452-8181.

Connecticut Burns, Michael E., ed. *Connecticut Foundation Directory.* Hartford, Conn.: D.A.T.A., 1987. Based on 1986 and 1987 990-PF forms filed with the Connecticut Attorney General's Office and completed questionnaires from a December 1987 survey of over 900 foundations. Main section arranged alphabetically by foundation; entries include selected grants list, principal officer, and purpose statement. Index of foundations by city and an alphabetical index. Available from D.A.T.A., Inc., 30 Arbor St. North, Hartford, CT 06106. (203) 786-5225.

Connecticut Burns, Michael E., ed. *Guide to Corporate Giving in Connecticut.* Hartford, Conn.: D.A.T.A., 1986. Features alphabetical and geographic listings of over 850 corporations; specific information for local Connecticut users; names, titles, and roles of charitable giving contacts; foundation information; non-cash giving policies; matching gift policies and priorities; and cash giving policies, procedures and priorities. Available from D.A.T.A. *see above.*

Connecticut Logos Associates, comp. *Directory of the Major Connecticut Foundations.* Attleboro, Mass.: Logos Associates, 1982. Based on 1979 through 1980 990-PF and 990-AR returns, foundation publications and information from the Office of the Attorney General in Hartford. Sixty-one foundations arranged alphabetically; entries include grant range, sample grants, geographic limitations, officers and directors. Index of subjects. Available from Logos Associates, 7 Park St., Rm. 212, Attleboro, MA 02703.

Colorado *Colorado Foundation Directory.* 6th ed. Denver, Colo.: Junior League of Denver, 1988. Information on more than 170 foundations, covering fiscal years from 1984 through 1987; entries include purpose statement/field of interest, sample grants, and contacts. Also includes an excellent guide to program planning and proposal writing. Indexed by areas of foundation interest. Available from Junior League of Denver, Inc., 6300 East Yale Avenue, Denver, CO 80222. (303) 692-0270.

Delaware United Way of Delaware. *Delaware Foundations.* Wilmington, Del.: United Way of Delaware, 1983. Based on 1979 through 1981 990-PF and 990-AR returns filed with the IRS, annual reports, and information supplied by 154 foundations. Main section arranged alphabetically by foundation; entries include statement of purpose and officers, grant analysis, type of recipient; no sample grants. Detailed information on 111 private foundations, a list of 27 operating foundations and a sampling of out-of-state foundations with a pattern of giving in Delaware. Alphabetical index of foundation names and index of all trustees and officers. Available from United Way of Delaware, Inc., 701 Shipley St., Wilmington, DE 19801. (302) 573-2414.

District of Columbia Community Foundation of Greater Washington. *Directory of Foundations of the Greater*

Washington Area. Washington, D.C.: Community Foundation of Greater Washington, 1988. Biennial directory of public and private foundations and trusts as well as some corporate foundations in the greater Washington area. Directory is divided into two sections. Section 1 contains the larger foundations with assets of $1 million or more, or which made grants of $100,000 or more in the reported years, and Section 2 lists the smaller foundations which have below $1 million in assets, or awarded grants of less than $100,000. Section 2 comprises the largest number of foundations. Four indexes include: an alphabetical index of foundations; an alphabetical index of trustees, directors and managers; an index of foundations in order of the size of their assets; and an index grouped by the specific area of interest. Information on each foundation includes: name and address; telephone number; contact person, trustees, directors and managers; areas of interest; application guidelines; financial and grant data (total assets, number of grants, amount of grants, grant range, and the five largest grants). Preceding the directory are helpful statistical tables and lists for distribution of giving by foundation asset size and by amount of grants awarded, largest independent/family foundations by total giving, largest company-sponsored foundations by total giving, community foundations by total giving, fifteen largest grants, foundations not included in the directory, and foundations that do not accept proposals. Also included is a brief adaptation of F. Lee and Barbara L. Jacquette's, "What makes a good proposal?" Available from Community Foundation of Greater Washington, Inc., 1002 Wisconsin Ave., N.W., Washington, DC 20007. (202) 338-8993.

Florida Kruse, J. Carol, ed. *The Complete Guide to Florida Foundations.* 2nd ed. Miami, Fla.: John L. Adams and Co., 1988. Based primarily on information contained in 990-PF returns for over 1,000 foundations. Main section arranged alphabetically by foundation name; entries include officers, assets, total grants amount, range of grant amounts, funding priorities and geographic preferences. Indexed by county and foundation funding priorities. Also includes an index of foundations excluded from the "Guide." Available from John L. Adams & Co. Inc., P.O. Box 561565, Miami, FL 33256-1565.

Florida Logos Associates. *The Directory of the Major Florida Foundations.* Attleboro, Mass.: Logos Associates, 1987. Profiles 107 major Florida foundations that made over $50,000 in grants during 1984. Entries include information on contact person, foundation activities, financial data, officers and directors, geographic range, and grants made. Address, telephone number, contact person and officers are given for 775 foundations making grants of less than $50,000. Includes subject index. Available from Logos Associates, *see above.*

Georgia Taylor, James H. *Foundation Profiles of the Southeast: Georgia.* Williamsburg, Ky.: James H. Taylor Asso-

ciates, 1983. Based on 1975 through 1977 990-PF and 990-AR returns filed with the IRS for 530 foundations. Main section arranged alphabetically by foundation; entries include statement of purpose, sample grants, and principal officer. Indexes of foundation names, cities, and program interests. Available from James H. Taylor Assoc., Inc., 804 Main St., Williamsburg, KY 40769.

Georgia *See also* **Tennessee:** O'Donnell, Suzanna, et al. *A Guide to Funders in Central Appalachia and the Tennessee Valley.* Available from Appalachian Community Fund, 517 Union St., Suite 206, Knoxville, TN 37902.

Hawaii Alu Like. *A Guide to Charitable Trusts and Foundations in the State of Hawaii.* Honolulu, Hawaii: Alu Like, 1984. Part 1 provides sample forms for forming a tax-exempt organization in the state of Hawaii and with the Internal Revenue Service, as well as a reprint of "Program Planning and Proposal Writing" by Norton J. Kiritz. Part 2 provides information on 72 charitable trusts and foundations in Hawaii (detail of information varies), brief information on 16 mainland foundations with sample grants made in Hawaii, profiles for 11 national church funding sources, and a listing of local resource service organizations. Brief bibliography. Indexed by organization. Available from Alu Like, 401 Kamakee St., 3rd fl., Honolulu, HI 96814. (808) 521-9571.

Hawaii Thompson, Susan A., comp. *Foundation Grants in Hawaii, 1970–1980: Grants Awarded by Mainland Foundations to Recipients in the State of Hawaii.* Honolulu, Hawaii: University of Hawaii at Manoa Libraries, 1981. Foundation grants made to recipients in Hawaii, arranged by state. Indexed by recipients and subject categories. Includes addresses for foundations. Selected bibliography. Available from University of Hawaii at Manoa, Libraries, General Reference Dept.

Idaho *Directory of Idaho Foundations.* 4th ed. Caldwell, Idaho: Caldwell Public Library, 1988. Based on 1986 990-PF returns filed with the IRS and questionnaires answered by 100 foundations. Arranged in four sections: 1) active foundations that accept applications, 2) scholarship-granting foundations, 3) foundations that do not accept applications or appear to be inactive and, 4) national and corporate giving in Idaho. Entries vary in completeness, containing information on assets, grants paid, range of grants, sample grants and application information. Alphabetical index. Available from Caldwell Public Library, 1010 Dearborn St., Caldwell, ID 83605-4195. (208) 459-3242.

Ilinois Capriotti, Beatrice J., and Frank J. Capriotti, eds. *Illinois Foundation Directory.* Minneapolis, Minn.: Foundation Data Center. Profiles of approximately 1,900 foundations based on 990-PF and 990-AR returns filed with the IRS and information received from questionnaires. Main section arranged alphabetically by foundation; entries in-

clude financial data, statement and purpose, listing of all grants, officers, and principal contributors. Index section contains a summary report of foundations with special purpose or assets under $200,000; banks/trusts as corporate trustees; donors, trustees and administrators; survey of foundation interests; and foundation guidelines and deadlines. Updated quarterly. Available from Foundation Data Center, 401 Kenmar Circle, Minnetonka, MN 55343. (612) 542-8582.

Illinois Dick, Ellen A. *Chicago's Corporate Foundations: A Directory of Chicago Area and Illinois Corporate Foundations.* Oak Park, Ill.: Ellen Dick, 1988. Entries for 122 corporate foundations provide contact person, phone number, area of giving and limitations, deadlines, total assets, total grants, high/low grant amounts, officers, and the major products or services of the parent corporations. Index of in-kind contributions, areas of giving, and matching gift programs. Available from Ellen Dick, 838 Fair Oaks, Oak Park, IL 60302. (312) 386-9385.

Illinois Donors Forum of Chicago. *The Directory of Illinois Foundations.* Chicago: Donors Forum of Chicago, 1986. Alphabetically-arranged directory provides information on over 400 Illinois foundations and trusts. The directory is arranged into four main sections: foundations, analysis section, subject index, and county index. Foundation listings give: foundation name, telephone number, contact name, donor type, purpose, field of interest, program limitations, geographic limits, contact procedure, information available, funding cycle, application deadlines, paid staff, matching gifts, grants to government funded agencies or programs, total assets, total grants, number of grants, grant range, model grant, officers and directors. The analysis section contains a synthesis of the statistical data collected for the directory. Graphs and charts are included in addition to a breakdown of the 400 foundations by type—family, corporate, community, independent, or operating. The volume contains both county and subject indexes. The "County Index" contains a foundation listing and a compilation of total assets and grants made for each county and city. The "Subject Index" contains foundation listings by broad subject categories. Available from Donors Forum of Chicago, 53 W. Jackson St., Suite 430, Chicago, IL 60604. (314) 431-0260.

Illinois Donors Forum of Chicago. *Members Grants List.* Chicago: Donors Forum of Chicago, 1988. A product of the Donors Forum of Chicago's Philanthropic Database Project, this list represents grants of $500 or more awarded by 54 Donors Forum members to organizations within the Chicago Metropolitan Area. Grantmakers arranged alphabetically; grants are arranged under subject areas showing the name and state of the donee, the specific purpose of the grant within broad subject areas, the type of support, coded descriptions of the beneficiary group, and the amount of the grant. Supplies only the name and address

of the grantmaking organizations. Grants are arranged by donor organization and by recipient organization; index of donor organizations by grant purpose. Appendixes list the 50 largest recipient organizations, percentage of grants by broad subject of grant purpose, percentage of grants by purpose code within the broad subject areas, and percentage of grants by type of support. Available from Donors Forum, *see above.*

Illinois Sheck, Diane, comp. *Members and Library Partners Directory.* Chicago: Donors Forum of Chicago, 1988. Provides data on 145 Donors Forum member foundations and corporate contributions programs. When provided, information includes principal funding areas, total assets (applicable only to foundations), total grants, fiscal year, percentage of grants in greater Chicago and outside Illinois, number of board members, frequency of meetings, names of professional staff, and whether or not guidelines and annual reports are available, or if an employee matching gifts program exists (applicable for corporate contributions programs). Two tables rank the 50 largest Donors Forum foundation members based on total assets and the 50 largest Donors Forum member organizations based on total grants. Available from Donors Forum, *see above.*

Indiana Indiana Donors Alliance. *Directory of Indiana Donors.* Indianapolis, Ind.: Indiana Donors Alliance, 1989. Contains profiles of 475 active grantmaking foundations, trusts, and scholarship programs in Indiana. Arranged alphabetically, each profile includes the donor's name and IRS identification number; the name, address, and telephone number of a contact person; recent financial data (assets, grants paid, number of grants made, and the range of grants); eligibility for grants; program interests, geographic preferences; limitations; and application procedure. The appendix contains graphs showing the number of donors within broad ranges of giving and the amount of grants paid per ranges of giving. The donor profiles are indexed by grants paid (ranked highest to lowest, all foundations having made at least $2,000 in grants), by program interests, and by county. A map shows the numbers of donors by county. Available from Indiana Donors Alliance, 1500 North Delaware Street, Indianapolis, IN 46202. (317) 638-1500.

Indiana Spear, Paula Reading, ed. *Indiana Foundations: A Directory.* Indianapolis, Ind.: Central Research Systems, 1985. Based on 1983 and 1984 990-PF returns filed with the IRS and information supplied by 288 foundations. Main section arranged alphabetically by foundation; entries include officers, areas of interest, sample grants, high and low grants. Indexes of financial criteria, subjects, counties, and officers. Appendixes of restricted foundations, foundations for student assistance only, and foundations without funding. Available from Central Research Systems, 320 N. Meridian, Suite 515, Indianapolis, IN 46204.

Iowa Holm, Diana M. *Iowa Directory of Foundations.* Dubuque, Iowa: Trumpet Associates, 1984. Based primarily on returns filed with the IRS and information supplied by 247 foundations; date of information is 1982 in most cases, no date is given in other entries. Main section arranged alphabetically by foundation; most entries include address, telephone number, Employer Identification Number, total assets, total grants, purpose and activities, officers and trustees, and contact person. Appendix of cancelled foundations. Indexed by city. Available from Trumpet Assoc., Inc., P.O. Box 172, Dubuque, IA 52001. (319) 582-3153.

Kansas Rhodes, James H., ed. *The Directory of Kansas Foundations.* Topeka, Kans.: Topeka Public Library, 1989. More than 300 foundations and trusts are featured in this new edition. Information was gathered from public records, Kansas Attorney General files and questionnaire responses. Each profile notes the grantmaker's name; address; phone number; financial data (assets, total annual gifts, high/low gift, number of gifts, and date of data); board members; funding priority areas, including types of support and sample grants; limitations; application information; and additional information. Contains a bibliography of various materials designed to aid the grantseeker; the front matter of the directory discusses composing a proposal. Indexes are arranged alphabetically by foundation name, city and subject area. Available from Topeka Public Library Foundation Center Collection, 1515 West Tenth Street, Topeka, KS 66604. (913) 233-2040.

Kentucky Dougherty, Nancy C., ed. *A Guide to Kentucky Grantmakers.* Louisville, Ky.: Louisville Foundation, 1982. Based on questionnaires to 101 foundations and their 1981 990-PF and 990-AR IRS returns. Arranged alphabetically by foundation; entries include assets, total grants paid, number of grants, smallest/largest grant, primary area of interest and contact person. No indexes. Available from The Louisville Foundation, Inc., 623 W. Main St., Louisville, KY 40202. (502) 585-4649.

Kentucky Taylor, James H., and John L. Wilson. *Foundation Profiles of the Southeast: Kentucky, Tennessee, Virginia.* Williamsburg, Ky.: James H. Taylor Associates, 1981. Based on 1978 and 1979 990-PF and 990-AR IRS returns for 117 foundations. Main section arranged alphabetically by foundation; entries include assets, total number and amount of grants, sample grants and officers. No indexes. Available from James H. Taylor Associates, Inc., 804 Main St., Williamsburg, KY 40769.

Kentucky *See also* **Tennessee:** O'Donnell, Suzanna, et al. *A Guide to Funders in Central Appalachia and the Tennessee Valley.*

Louisiana Lazaro, Joseph A., comp. *Citizens' Handbook of Private Foundations in New Orleans, Louisiana.* New

Orleans, La.: Greater New Orleans Foundation, 1987. Directory of 112 foundations located and making grants in New Orleans, Louisiana. Data is taken from IRS 990-PF forms filed for 1985. Entries provide information on foundation purpose; contact person; phone number; officers, managers, and trustees; special notations; and financial data (net worth, grant recipients and amounts awarded, and total number and amount of grants awarded). Appendixes include statistics on private philanthropy, resources for grantseekers at the New Orleans Public Library, information reprinted from the Foundation Center, a sample IRS 990-PF form, a listing of private foundations located in the state of Louisiana reprinted from the Foundation Center's "National Data Book," tips on grantsmanship, a foundation prospect worksheet, and a glossary. No indexes. Available from The Greater New Orleans Foundation, 2515 Canal St., Suite 401, New Orleans, LA. (504) 822-4906.

Louisiana *See also* **Alabama:** Taylor, James H. *Foundation Profiles of the Southeast: Alabama, Arkansas, Louisiana, Mississippi.*

Maine Brysh, Janet F., ed. *Maine Corporate Foundation Directory.* Portland, Maine: University of Southern Maine, 1984. Based on information supplied by approximately 75 corporations. Main section arranged alphabetically by corporation; entries include contact person and, for a few corporations, the areas of interest. Alphabetical index. Available from University of Southern Maine, Office of Sponsored Research, 246 Deering Ave., Room 628, Portland, ME 04103. (207) 780-4871.

Maine Burns, Michael E., ed. *Corporate Philanthropy in New England: Maine.* Vol 3. Hartford, Conn.: D.A.T.A., 1987. Entries for over 180 corporate giving programs, providing address, phone number and contact, brief corporate profile, general philanthropic policies, annual cash contributions, and giving priorities and interests. Subject and geographic indexes. Available from D.A.T.A., *see above.*

Maine Office of Sponsored Research. *Directory of Maine Foundations.* 7th ed., rev. Portland, Maine: University of Southern Maine, 1988. Based on information compiled from foundations, the Foundation Center, and primarily 990-PF returns filed with the IRS. Lists over 62 Maine foundations having assets from $799 to $7,024,391. Entries include contact person, number of grants awarded, total amount awarded, and sample grants. Also includes a section with feasibility study to be conducted prior to proposal development and/or fundraising, a self-evaluation, a fundraising intelligence test, and a suggested grant request outline. Entries are arranged alphabetically under cities and towns; indexed alphabetically. Available from University of Southern Maine, Office of Sponsored Research, *see above.*

Maryland Maryland Attorney General's Office. *Annual Index of Foundation Reports and Appendix, 1987.* Baltimore, Md.: Attorney General's Office, 1989. Information on 443 foundations compiled from 1987 IRS 990-PF forms filed with the Maryland Attorney General's office (appendix contains information on 60 foundations which filed after December 1, 1988). The index and appendix are arranged alphabetically; entries give the foundation's name, address, telephone number, employer identification number, fair market value of the foundation, foundation managers and their addresses, purpose of contributions, contact person, contributions given during the fiscal year with the recipient and amount, total contributions given during the fiscal year, and contributions approved for future payment, if any. Available from the Attorney General, 7 North Calvert St., Baltimore, MD 21202. (301) 576-6300.

Massachusetts Associated Grantmakers of Massachusetts. *Massachusetts Grantmakers.* Boston: Associated Grantmakers of Massachusetts, 1990. Published at the request of the Massachusetts Attorney General, this directory contains descriptions of 438 foundations and corporate grantmakers in Massachusetts. Entries indicate type of grantmaking organization, whether support is given to nonprofit organizations and/or individuals, grantmaking philosophy and program emphasis, program interests, geographic focus, financial information, application procedures, trustees, and contact person. A reference chart indexing grantmaking organizations according to program areas and population groups is included. Index to geographic locations and sources of individual support. Foundation Center collections in New England, and those operated by the Foundation Center. Available from Associated Grantmakers of Mass., Inc., 294 Washington St., Suite 840, Boston, MA 02108. (617) 426-2606.

Massachusetts Burns, Michael E., ed. *Guide to Corporate Giving in Massachusetts.* Hartford, Conn.: D.A.T.A., 1983. Based on questionnaires and telephone interviews reaching 737 corporations. Main section arranged alphabetically by city and zip code; entries include product, amount given annually, frequency, area of interest and non-cash contributions. Index of corporations by city. Available from D.A.T.A., *see above.*

Massachusetts Logos Associates, comp. *Directory of the Major Greater Boston Foundations.* Attleboro, Mass.: Logos Associates, 1981. Based on 1975 through 1980 990-PF and 990-AR returns filed with the IRS by 56 Boston area foundations. Main section arranged alphabetically by foundation; entries include statement of purpose, sample grants, and officers. Indexed by fields of interest. Available from Logos, *see above.*

Massachusetts Department of the Attorney General. *Directory of Foundations in Massachusetts.* Boston: Massachusetts Department of the Attorney General, 1977. Arranged in two sections. Part 1 lists 623 foundations which make grants (of $1,000 or more) primarily to organizations. Part 2 lists 411 foundations which make grants (of any amount) primarily to individuals. Entries in both sections provide address, telephone number, officers, trustees, finances (including assets, total expenditures, total grants, largest and smallest grant, and number of grants for the reported year), interests, restrictions and purpose. Part 1 includes appendixes which group foundations by the range of total grants made, by geographic restrictions, and by purposes. Appendixes in Part 2 list foundations which make loans to individuals, which give scholarships to individuals in particular geographic areas, which give scholarships to certain population groups, and which give scholarships according to a particular area of study. Available from Department of the Attorney General, State House, Boston, MA.

Massachusetts Social Service Planning Corporation. *Private Sector Giving, Greater Worcester Area: A Directory and Index.* Worcester, Mass.: Social Service Planning Corp., 1987. 100 foundations arranged alphabetically; entries include financial data, contact person, and a listing of award recipients with the dollar amount each received. Categorical index chart gives access to the foundation entries by their funding interest. Available from The Social Service Planning Corporation.

Michigan Fischer, Jeri L., ed. *The Michigan Foundation Directory.* 6th ed. Grand Haven, Mich.: Council of Michigan Foundations, 1988. Identifies over 543 potential grantmaking sources in Michigan; this includes 475 foundations and 68 corporate giving programs. Divided into five separate parts: 1) largest foundations with assets of $200,000 or grantmaking of $25,000; 2) special purpose foundations (those with a single purpose); 3) foundations with assets less than $200,000 or grantmaking less than $25,000; 4) a listing of foundations by city; and 5) a listing of terminated foundations. Information about the largest foundations, special purpose foundations, and corporate foundations/giving programs in Section 2 includes address, phone number, contact person, donors, purpose and activities, geographic priorities, assets, expenditures, grant amounts, grant ranges, officers and trustees. Also presented is a comparison of the total number of grants and grant amounts made against those made in Michigan. Section 3 contains an in-depth analysis of grantmaking in Michigan. Section 4 provides information on how to research a foundation and compose grant proposals. The directory has indexes by subject, trustees, and foundation name. Available from Michigan League for Human Services, 300 N., Washington Square, Suite 401, Lansing, MI 48933. (517) 487-5436.

Michigan Logos Associates, comp. *The Directory of the Major Michigan Foundations.* 2nd ed. Attleboro, Mass.:

Logos Associates, 1989. Based on IRS financial data and most current annual reports, profiles in this directory offer in-depth information for over 350 corporate and private foundations in Michigan. Excellent descriptions of foundation activities, program interests and past grants in addition to address, contact person, trustees, application information and financial assets. Divided into sections for "Foundations Making Grants of $400,000 or More," "Major Michigan Corporations," "Foundations Making Grants From $101,000 to $399,999," and "Foundations Making Grants From $50,000 to $100,000." Indexed by foundation name, geographical location, and support interest. Available from Logos, *see above*.

Minnesota Capriotti, Beatrice J., and Frank J. Capriotti, eds. *Minnesota Foundation Directory.* Minneapolis, Minn.: Foundation Data Center, 1985. Profiles on approximately 700 foundations based on 990-PF and 990-AR returns filed with the IRS plus returned questionnaires. Main section arranged alphabetically by foundation; entries include financial data, statement and purpose, listing of all grants, officers, and principal contributors. Index section contains a summary report of foundations with special purpose or assets under $200,000; banks/trusts as corporate trustees; donors, trustees and administrators; survey of foundation interests; and foundation guidelines and deadlines.

Minnesota Minnesota Council on Foundations. *Guide to Minnesota Foundations and Corporate Giving Programs.* Minneapolis, Minn.: University of Minnesota Press, 1989. Based primarily on 1987 and 1988 IRS 990-PF returns and a survey of over 600 grantmakers. Main section arranged alphabetically by foundation name; entries include program interests, officers and directors, assets, total grants, number of grants, range, and sample grants. Some entries include geographic orientation, types of organizations funded and types of support. Appendixes of inactive foundations, foundations with designated recipients, foundations making grants only outside of Minnesota and foundations not accepting applications. Also section on funding research in Minnesota. Indexed by foundation name, types of organizations funded, and grantmakers by size (according to grants paid). Available from Minnesota Council on Foundations, 425 Peavey Bldg., 730 Second Ave. So., Minneapolis, MN 55402. (612) 338-1989.

Minnesota Minnesota Council of Nonprofits. *Minnesota Foundations Sourcebook.* Minneapolis, Minn.: Minnesota Council of Nonprofits, 1989. Using data from "Minnesota Philanthropic Support for the Disadvantaged," profiles in this directory provide name, address, telephone number, contact person and deadlines for the 60 largest Minnesota foundations and corporate giving programs. For some grantmakers additional information is provided, including percentage of total giving granted to benefit the disadvantaged, geographic distribution, grantee types, percentage between general support and project-related grants, a list

of sample grants, the average percentage of the dollar amount requested that was actually granted, and a ratio of the methods of contact with staff (phone conversations, meetings, site visits). Arranged alphabetically, no indexes. Available from Minnesota Council of Nonprofits, 2700 University Ave. W., #250, St. Paul, MN 55514. (612) 642-1904.

Mississippi *See* **Tennessee:** O'Donnell, Suzanna, et al. *A Guide to Funders in Central Appalachia and the Tennessee Valley.*

Mississippi *See also* **Alabama:** Taylor, James H. *Foundation Profiles of the Southeast: Alabama, Arkansas, Louisiana, Mississippi.*

Missouri Clearinghouse for Midcontinent Foundations, comp. *The Directory of Greater Kansas City Foundations.* Kansas City, Mo.: Clearinghouse for Midcontinent Foundations, 1986. Directory provides detailed profiles on 281 foundations and trusts in the eight-county Greater Kansas City (Missouri) metropolitan area. These foundations have estimated market assets of $610.5 million and estimated annual contributions of $37 million. The foundation listings, arranged alphabetically by foundation name, are indexed by broad fields of interest. The foundation profile contains the foundation name, address, telephone number, contact person, officers and directors, administrators, assets, fiscal year date, recipient information, range, limitations, purpose, and other information. Indexes included in the directory are "Top Twenty Grantmaking Foundations," based on assets; "Top Twenty Grantmaking Foundations," based on charitable payout; "Foundations with Designated Recipients"; and "Foundations Making Grants in (specific subject areas such as arts, health, etc.)." Available from The Clearinghouse for Midcontinent Foundations, P.O. Box 22680, Kansas City, MO 64113. (816) 276-1176.

Missouri Swift, Wilda H., comp. and ed. *The Directory of Missouri Foundations.* 2nd ed. St. Louis, Mo.: Swift Associates, 1988. Based on 1986 and 1987 990-PF returns and questionnaires of 919 foundations. Included are sections on foundations making grants to organizations (large foundations, community foundations, and small foundations), foundations giving assistance to individuals (financial assistance to students and assistance to individuals in need), foundations with designated recipients, foundations which contribute scholarship funds to educational institutions, and inactive, operating, relocated and terminated foundations. Entries include address, telephone number, contact person, assets, total grants amount, low and high grant amounts and funding priorities. The directory includes alphabetical indexes by city and by foundation name. Available from Swift Associates, P.O. Box 28033, St. Louis, MO 63119.

Montana McRae, Kendall, and Kim Pederson, eds. *The*

Montana and Wyoming Foundation Directory. 4th ed. Billings, Mont.: Grants Assistance Center, 1986. Based on 990-PF returns filed with the IRS, the "National Data Book," and information supplied by 65 foundations in Montana and twenty in Wyoming. Main section arranged alphabetically by foundation; entries include areas of interest, geographic preference, application process and contact person; no sample grants. Indexes of foundation names and areas of interest. Available from Eastern Montana College Library, 1500 North 30th, Billings, MT 59101. (406) 657-1666.

Nebraska *Nebraska Foundation Directory.* Omaha, Nebr.: Junior League of Omaha, 1985. Based on mostly 1982 and 1983 990-PF returns filed with the IRS by approximately 200 foundations. Main section arranged alphabetically by foundation; entries include statement of purpose and officers. No sample grants or indexes. Available from Junior League of Omaha, 808 South 74th Plaza, Omaha, NE 68114.

Nevada Honsa, Vlasta, comp. *Nevada Foundation Directory.* 2nd ed. Las Vegas, Nev.: Las Vegas–Clark County Library District, 1989. Based on 1987 and 1988 990-PF returns filed with the IRS and questionnaires completed by foundations and corporations. Main section arranged alphabetically by foundation or corporation name; entries include contact person, financial data, funding interests and sample grants. Section on inactive and defunct Nevada foundations. Section on 42 national foundations that fund Nevada projects. Indexed by fields of interest, geographic location and name. Available from Las Vegas–Clark County Library District, 1401 E. Flamingo Road, Las Vegas, NV 89119. (702) 733-7810.

New Hampshire Burns, Michael E., ed. *Corporate Philanthropy in New England: New Hampshire 1987–1988.* New Haven, Conn.: DATA, 1987. Based on questionnaires answered by 275 corporations. Main section arranged alphabetically by corporation; entries include contact person, products, and giving interests. Subject index and list of corporations by city. Available from DATA, Inc., 30 Astor St. North, Hartford, CT 06106. (203) 786-5225.

New Hampshire Office of the Attorney General. *Directory of Charitable Funds in New Hampshire.* 4th ed. Concord, N.H.: New Hampshire Office of the Attorney General, 1988. Based on records in the New Hampshire Attorney General's Office, and updated annually; published in June. 233 foundations arranged alphabetically; entries include statement of purpose, officers and assets; no sample grants. Indexes of geographical areas when restricted, and of purposes when not geographically restricted. Grants for scholarships also included. Available from Division of Charitable Trusts, Office of the Attorney General, State House Annex, 23 Capitol St., Concord, NH 03301. (603) 271-3591.

New Jersey Littman, Wendy P., ed. *The Mitchell Guide to Foundations, Corporations, and Their Managers: New Jersey.* Belle Mead, N.J.: Littman Associates, 1988. Based primarily on 990-PF returns filed with the IRS from 1984 through 1987 and, in some cases, information supplied by 196 foundations; data for the 558 companies on the corporation list compiled from basic business references. The funder profiles are arranged alphabetically by foundation name; entries include sample grants and foundation managers, restrictions and program priorities. The corporate section is a list which includes address, telephone, and contact person. Contains indexes by county for both foundations and corporations. Available from The Mitchell Guide, P.O. Box 613, Belle Mead, NJ 08502.

New Jersey Logos Associates. *The Directory of the Major New Jersey Foundations.* Attleboro, Mass.: Logos Associates, 1988. Based on IRS financial data, annual reports and other public materials, offers profiles on approximately 110 foundations, all of which have given away a minimum of $50,000 in the year of record, have distributed the bulk of this within the state of New Jersey, and are a source of funding to the general nonprofit institutions in New Jersey. Arranged alphabetically by foundation; entries include address, telephone number, contact, foundation activities, total assets and grants, information relevant to corporate foundations, officers and directors, and sample grants. Subject index. Available from Logos Associates, 7 Park St., Room 212, Attleboro, MA 02803.

New Mexico Murrell, William G., and William M. Miller. *New Mexico Private Foundation Directory.* Tijeras, NM: New Moon Consultants, 1982. Thirty-five foundations and 17 corporations. Entries include contact person, program purpose, areas of interest, financial data, application procedure, meeting times and publications. Also sections on proposal writing, private and corporate grantsmanship, library support and other information services, and bibliography. No indexes. Available from New Moon Consultants, P.O. Box 532, Tijeras, NM 87059.

New York Mitchell, Rowland L., Jr., ed. *The Mitchell Guide to Foundations, Corporations and Their Managers: Central New York, Including Binghamton, Corning, Elmira, Geneva, Ithaca, Oswego, Syracuse, Utica.* 2nd ed. Scarsdale, N.Y.: Rowland Mitchell Jr., 1987. Based on 990-PF returns filed with the IRS. Main sections arranged alphabetically by foundations which made grants totalling more than $5,000 or had assets of $100,000 or more and by corporations with net earnings of at least $10 million. Entries for over 90 foundations provide names of managers, financial data and sample grants. Entries for over 100 corporations provide address, phone number, names and titles of one or two executive officers, and the company's business focus. Alphabetical indexes of foundation and company names, as well as an index to managers. Available from Rowland L. Mitchell, Jr., Box 172, Scarsdale, NY

10583. (914) 723-7770.

New York Mitchell, Rowland L., Jr., ed. *The Mitchell Guide to Foundations, Corporations and Their Managers: Long Island, Including Nassau and Suffolk Counties.* 2nd ed. Scarsdale, N.Y.: Rowland Mitchell Jr., 1987. Based on 990-PF returns filed with the IRS. Main sections arranged alphabetically by foundations which made grants totalling more than $5,000 or had assets of $100,000 or more and by corporations with net earnings of at least $10 million. Entries for 180 foundations provide names of managers, financial data and sample grants. Entries for 130 corporations provide address, phone number, the names and titles of one or two executive officers and the company's business focus. Alphabetical indexes of foundation and corporation names, as well as an index to managers. Available from Rowland L. Mitchell, *see above.*

New York Mitchell, Rowland L., Jr., ed. *The Mitchell Guide to Foundations, Corporations and Their Managers: Upper Hudson Valley Including Capital Area, Glens Falls, Newburgh, Plattsburgh, Poughkeepsie, Schenectady.* 2nd ed. Scarsdale, N.Y.: Rowland Mitchell Jr., 1987. Based on 990-PF returns filed with the IRS. Main sections arranged alphabetically by foundations which made grants totalling more than $5,000 or had assets of $100,000 or more and by corporations with net earnings of at least $10 million. Entries for over 60 foundations provide names of managers, financial data and sample grants. Entries for over 40 corporations provide address, phone number, the names and titles of one or two executive officers and the company's business focus. Alphabetical indexes of foundation and corporation names, as well as an index to managers. Available from Rowland L. Mitchell, *see above.*

New York Mitchell, Rowland L., Jr., ed. *The Mitchell Guide to Foundations, Corporations and Their Managers: Westchester, Including Putnam, Rockland and Orange Counties.* 2nd ed. Scarsdale, N.Y.: Rowland Mitchell Jr., 1987. Based on 990-PF returns filed with the IRS. Main sections arranged alphabetically by foundations which made grants totalling more than $5,000 or had assets of $100,000 or more and by corporations with net earnings of at least $10 million. Entries for 214 foundations provide names of managers, financial data and sample grants. Entries for 75 corporations provide address, phone number, the names and titles of one or two executive officers and the company's business focus. Alphabetical indexes of foundation and corporation names, as well as an index to managers. Available from Rowland L. Mitchell, *see above.*

New York Mitchell, Rowland L., Jr., ed. *The Mitchell Guide to Foundations, Corporations and Their Managers: Western New York, Including Buffalo, Jamestown, Niagara Falls, Rochester.* 2nd ed. Scarsdale, N.Y.: Rowland Mitchell Jr., 1987. Based on 990-PF returns filed with the IRS. Main sections arranged alphabetically by foundations which

made grants totalling more than $5,000 or had assets of $100,000 or more and by corporations with net earnings of at least $10 million. Entries for over 130 foundations provide names of managers, financial data and sample grants. Entries for 90 corporations provide address, phone number, the names and titles of one or two executive officers and the company's business focus. Alphabetical indexes of foundation and corporation names, as well as an index to managers. Available from Rowland L. Mitchell, *see above.*

New York National Center for Charitable Statistics. *Yearbook of New York State Charitable Organizations: Fund-Raising and Expense Information As Reported by Charitable, Civic, Health, Fraternal, and Other Organizations.* Washington, D.C.: Independent Sector, 1987. Directory lists the charities registered with the New York State Department of State, Office of Charities Registration as either raising or intending to raise contributions of at least $10,000 annually. The directory is arranged in three parts: an alphabetical master list, a cross-reference guide by type of organization, and a county cross-reference. The master list contains organization name and address; New York State registration number; a classification code which identifies the general organization type; date of information; and dollar amounts for direct public support, total support and revenue, payments to affiliates, program expense, management and general expense, fundraising and total expenses. Available from Independent Sector, National Center for Charitable Statistics, 1828 L Street, N.W., Suite 1200, Washington, DC 20036. (202) 223-8100.

New York Olson, Stan, and Natividad S.H. del Pilar, eds. *New York State Foundations: A Comprehensive Directory.* New York: Foundation Center, 1988. Comprehensive directory of over 4,500 independent, company-sponsored, and community foundations which are currently active in New York State and which have awarded grants of one dollar or more in the latest fiscal year. Arranged alphabetically by New York counties (including the five boroughs of New York City). A separate section includes 97 out-of-state foundations with funding interests in New York State. Each foundation entry includes information on address; telephone numbers; principal donor(s); assets; gifts received; expenditures, including dollar value and number of grants paid (with largest and smallest grant paid indicated); fields of interest; types of support; geographic preference; limitations; publications; application information; names of officers, principal administrators, trustees or directors; Employer Identification Number (useful in ordering copies of the foundation's 990-PF); and a listing of sample grants, when available, to indicate the foundation's giving pattern. Indexed by donors, officers, and trustees; geographic location; types of support; broad giving interests; and foundation name. Available from the Foundation Center, 79 Fifth Avenue, Dept. LC, New York, NY 10003. (800) 424-9836.

North Carolina Shirley, Anita Gunn, ed. *Grantseeking in North Carolina: A Guide to Foundation and Corporate Giving.* Raleigh, N.C.: North Carolina Center for Public Policy Research, 1985. Based on 1981 through 1983 990-PF returns filed with the IRS and questionnaires answered by 589 foundations. Main sections arranged by type of foundation; entries include financial data, trustees, sample grants, limitations and application procedures. Alphabetical index of foundations and corporations; indexes by county, funding interest and index of officers, directors and trustees. Appendixes on proposal writing and corporate fundraising. Available from North Carolina Center for Public Policy Research, P.O. Box 430, Raleigh, NC 27602.

North Carolina Shirley, Anita Gunn, ed. *North Carolina Giving: The Directory of the State's Foundations.* Raleigh, N.C.: Capital Consortium, 1990. Descriptions of 707 private and community foundations with combined assets of $2.8 billion and annual contributions in excess of $169 million. Indexes. Capitol Consortium, P.O. Box 2918, Raleigh, NC 27602. (919) 833-4553.

North Carolina *See also* **Tennessee**: O'Donnell, Suzanna, et al. *A Guide to Funders in Central Appalachia and the Tennessee Valley.*

Ohio Ohio. Attorney General's Office. *Charitable Foundations Directory of Ohio.* 8th ed. Columbus, Ohio: Attorney General's Office, 1987. Directory compiled from the registration forms and annual reports of the 1,800 grantmaking charitable organizations in Ohio which represent $3.4 billion in assets and $262 million in grants. The basic information in the directory includes name of foundation, address, contact person, and telephone number; restrictions; purpose (designated with a purpose code); total assets; year of latest Attorney General's report; total grants awarded for latest year; and the Ohio Attorney General's trust number. The directory contains both a purpose (subject area) and a county index. Available from Office of the Attorney General, Charitable Foundations Section, 30 East Broad St., 15th fl., Columbus, OH 43266-0410.

Ohio *The Source: A Directory of Cincinnati Foundations.* Cincinnati, Ohio: Junior League of Cincinnati, 1985. Based primarily on 1982 and 1983 990-PF returns filed with the IRS and questionnaires answered by 259 foundations. Main section arranged alphabetically by foundation; entries may include financial data, sample grants, area of interest, officers and trustees, and application information. Indexed by areas of interest. Available from Junior League of Cincinnati, Regency Square, Apt. 6-F, 2334 Dana Avenue, Cincinnati, OH 45208.

Oklahoma Streich, Mary Deane, comp. and ed. *The Directory of Oklahoma Foundations.* Oklahoma City, Okla.: Foundation Research Project, 1988. Based on information from the latest IRS 990 forms on file at the Okla-

homa Medical Research Foundation, directory provides basic information on over 240 Oklahoma foundations. Includes funding emphasis, geographic area, restrictions, financial data (assets, income, total grants and total pledges), information on the application process and the name, address and phone number of the contact person. Indexed by foundation name, city location, areas of funding interest, and trustees. Available from Foundation Research Project, P.O. Box 1146, Oklahoma City, OK 73101-1146.

Oregon McPherson, Craig, comp. *The Guide to Oregon Foundations.* Portland, Oreg.: United Way of Columbia-Willamette, 1987. Based on 990-PF and 990-AR forms filed with the Oregon Attorney General's Charitable Trust Division and information supplied by over 350 foundations. Main section arranged alphabetically by foundation within five subdivisions: general purpose foundations, special purpose foundations, student aid or scholarship funds, service clubs, and national or regional foundations with an active interest in Oregon. Entries include statement of purpose, financial data, sample grants, officers, and contact person. Appendixes include foundations ranked by asset size, by grants awarded, and by geographic focus; index of foundation names with Attorney General index numbers. Available from United Way of the Columbia-Willamette, 718 West Burnside, Portland, OR 97209. (503) 228-9131.

Pennsylvania Kletzien, S. Damon, ed. *The Corporate Funding Guide of Greater Philadelphia.* Philadelphia: Greater Philadelphia Cultural Alliance, 1984. Contains full profiles of the charitable giving activities of 69 selected corporations and banks in the Philadelphia area. Entries provide information on business activities, number of employees, sales, profit, top officers, type of charitable support, application guidelines, and contact person. Section 2 provides a summary listing (address, contact person, telephone number) of 73 other corporations and banks in greater Philadelphia with charitable giving programs. Appendixes contain listings of the names of major advertising agencies, commercial banks, savings and loan associations, brokerage firms, CPA firms, insurance companies, law firms, and real estate agencies in greater Philadelphia; a ranking by sales volume of the 100 largest firms in the Philadelphia area; and an annotated bibliography of 33 publications on corporate giving and researching corporations. Available from Greater Philadelphia Cultural Alliance, 1718 Locust St., Philadelphia, PA 19103. (215) 735-0570.

Pennsylvania Kletzien, S. Damon *Directory of Pennsylvania Foundations,* 3rd ed. Springfield, Pa.: Triad-vocates Associated, 1986. Based primarily on 1984 990-PF returns filed with the IRS and information supplied by the more than 2,300 foundations listed in the directory. Organized in five geographical regions. Full profile entries for about 975 foundations with assets exceeding $75,000 or awarding grants totalling $5,000 or more on a discretionary basis; entries include a statement on geographical em-

phasis of giving, a descending listing of all grants down to $250, listing of major interest codes, application guidelines and/or statement on giving policy when available, and a list of directors, trustees, and donors. Other foundations not meeting above criteria listed by name, address and status code only. Appendix article on broadening the foundation search. Indexes of officers, directors, trustees and donors; major giving interests; and foundation names. Available from Triadvocates Associated, P.O. Box 336, Springfield, PA 19064. (215) 544-6927.

Pennsylvania Kletzien, S. Damon, comp. *Directory of Pennsylvania Foundations.* Supplement. 3rd ed. Springfield, Pa.: Triadvocates Associated, 1988. This supplement to the third edition contains information on Pennsylvania foundations which filed 990-PF's for the first time since the third edition was published in July 1986. The supplement is alphabetically arranged within geographic regions. Full profiles for 216 foundations with assets exceeding $75,000 or which award grants totalling at least $5,000; all other foundation entries provide only name, address, and status code. Indexed by foundation name; officers, directors, and trustees; and major interests. Available from Triadvocates Press, P.O. Box 336, Springfield, PA 19064. (215) 544-6927.

Rhode Island Burns, Michael E., ed. *Corporate Philanthropy in New England: Rhode Island.* Hartford, Conn.: D.A.T.A., 1989. Based on questionnaires and telephone interviews with over 250 corporations. Main section arranged alphabetically; entries include product, plant location, giving interests and non-cash giving, where available. Subject and index of corporations by city. Available from D.A.T.A., Inc., 30 Arbor St. North, Hartford, CT 06106. (203) 786-5225.

Rhode Island Council for Community Services. *Directory of Grant-Making Foundations in Rhode Island.* Providence, R.I.: Council for Community Services, 1983. Based on 1980 and 1981 990-PF and 990-AR returns filed with the IRS, information from the Rhode Island Attorney General's Office and information provided by the 91 foundations listed. Main section arranged alphabetically by foundation; entries include officers and trustees, assets, total dollar amount of grants and total number of grants, statement of purpose, geographic restrictions, application information and sample grants. Includes "Introduction to Foundations"; indexes of foundations by total dollar amount of grants made, foundations by location and by area of interest. Available from The Council for Community Services, 229 Waterman St., Providence, RI 02906.

South Carolina Williams, Guynell, ed. *South Carolina Foundation Directory.* 3rd ed. Columbia, S.C.: South Carolina State Library, 1987. Based on 1984 through 1986 990-PF returns filed with the IRS by 196 foundations. Main section arranged alphabetically by foundation; entries

include areas of interest, principal officer, assets, total grants, number of grants, range and geographic limitations. Indexed alphabetically by foundation name, location, and program interest. Available from South Carolina State Library, 1500 Senate St., P.O. Box 11469, Columbia, SC 29211. (803) 734-8666.

South Dakota South Dakota State Library, comp. *The South Dakota Grant Directory.* Pierre, S. Dak.: South Dakota State Library, 1989. Directory produced by the South Dakota State Library contains information on over 300 grantmaking institutions in South Dakota, including foundations, state government programs, corporate giving programs, and South Dakota scholarships. Also lists major foundations located outside the state which have shown an interest in South Dakota, and non-grantmaking foundations. Descriptions of grantmakers include name, address, and purpose statements, along with information on finances, application requirements, and eligibility/limitations. Indexed by subject and name; appendixes contain definitions of foundation types and an annotated bibliography of materials relating to foundations, student funding, grant research and proposal writing. Available from South Dakota State Library, 800 Governors Drive, Pierre, SD 57501-2294. (800) 592-1841 (SD only), (605) 773-3131.

Tennessee Memphis Bureau of Intergovernmental Management. *The Tennessee Directory of Foundations and Corporate Philanthropy.* 3rd ed. Memphis, Tenn.: City of Memphis. Bureau of Intergovernmental Management, 1985. Profiles of 58 foundations and 21 corporations and corporate foundations, based primarily on 990-PF returns filed with the IRS and questionnaires. Two main sections arranged alphabetically by foundation and alphabetically by corporation; entries include contact person, contact procedure, fields of interest, geographic limitations, financial data, officers and trustees, and sample grants. Indexes of foundations and corporations by name, fields of interest, and geographic area of giving. Appendixes of foundations giving less than $10,000 a year, and major corporations in Tennessee which employ more than 300 persons. Available from City of Memphis, Bureau of Intergovernmental Management, 125 North Mid-America Mall, Room 508, Memphis, TN 38103. (901) 528-2809.

Tennessee O'Donnell, Suzanna, and Kim Klein, eds. *A Guide to Funders in Central Appalachia and the Tennessee Valley.* Knoxville, Tenn.: Appalachian Community Fund, 1988. Funded by the Mary Reynolds Babcock Foundation, this guide lists nearly 500 funders which give grants in the geographical region that includes northern Alabama, northern Georgia, eastern Kentucky, western North Carolina, southeastern Virginia, and the entire states of Mississippi, Tennessee, and West Virginia. The directory begins with a section on "How to Write a Grant Proposal" which includes a sample proposal and a companion

cassette tape. The audiotape "How to Write a Proposal" was produced by the Carpetbag Theatre. From the several thousand foundations operating in the region, the compilers included those which met the criteria of: 1) annual grantmaking of $25,000 or assets of $500,000, and 2) a willingness to consider proposals from organizations or groups not previously funded. (Businesses and corporations are not listed unless they have their own foundation.) In addition to these foundations, religious organizations as well as foundations outside Appalachia which make grants and revolving loan funds in the region are listed in Sections 3, 4, and 5. The guide is indexed alphabetically, by interest areas, and by funders grouped within interest areas. Also included is a bibliography and a listing of the Foundation Center research collections within the region. Available from Appalachia Community Fund, 517 Union Street, Suite 206, Knoxville, TN 37902.

Texas Herfurth, Sharon, and Karen Fagg, eds. *Directory of Dallas County Foundations.* Dallas, Tex.: Dallas Public Library, 1984. Based on 1982 and 1983 990-PF returns and information provided by the Funding Information Library and the Foundation Center on 268 foundations. Main section arranged alphabetically by foundation; entries include contact person, interests, total assets, total amount and number of grants, and officers. Appendix of Dallas foundations ranked by assets; index of foundations by giving interests and index of trustees and officers. Available from Urban Information Center, Dallas Public Library, 1515 Young St., Dallas, TX 75201. (214) 670-1487.

Texas Logos Associates. *The Directory of the Major Texas Foundations.* Attleboro, Mass.: Logos Associates, 1986. Full profiles for 73 major foundations making grants above $400,000 in Texas, with address, telephone number, contact, foundation activities, categories of giving, financial data, application procedures, grant range and geographic area (some grants made out of state), and sample grants. Partial profiles for 33 additional foundations making under $400,000 in grants, listing address, financial data, number and/or amount of grants made; some entries have sample grants. Name, address and telephone numbers for 34 major Texas foundations granting $200,000 to $399,000. Includes subject index. Available from Logos Associates, 7 Park St., Room 212, Attleboro, MA 02703.

Texas Blackwell, Dorothy and Catherine Rhodes. *Directory of Tarrant County Foundations.* 4th ed. Fort Worth, Tex.: Texas Christian University, 1989. Based on 990-PF forms filed with the IRS and foundation questionnaires. Main section arranged alphabetically by foundation; entries include financial data, officers and trustees, types of support and application information. Indexes of foundations, trustees and officers, types of support and fields of interest. Appendixes of foundations by asset amount and foundations by total grants, excluded and terminated foundations, and subject index. Available from Funding Information

Center, Texas Christian University, Mary Couts Burnett Library, P.O. Box 32904, Fort Worth, TX 76129. (817) 921-7664.

Texas Webb, Missy, ed. *Directory of Texas Foundations.* 10th ed. San Antonio, Tex.: Funding Information Center of Texas, 1989. A total of 1,510 private foundations, corporate giving programs, government agencies and public charities are profiled. Directory is divided into 895 large foundations and 615 small foundations (with assets of less than $300,000 and grantmaking activity of less than $15,000). Entry information includes foundation name, emphasis (giving area), population group, restrictions, tax year of financial data, assets, total grants, grant range, application process, trustees, and contact person. Includes sections with top 100 Texas foundations in descending order by assets and by grants, excluded and terminated foundations, and a 1987 grant distribution of Texas foundations. Indexed by areas of giving, city, trustees and officers, and foundation name. Available from Funding Information Center of Texas, Inc., 507 Brooklyn, San Antonio, TX 78215. (512) 227-4333.

Texas Webb, Missy, ed. *Directory of Texas Foundations.* Supplement. 10th ed. San Antonio, Tex.: Funding Information Center of Texas, 1989. Provides updated financial information on foundations listed in the *Directory of Texas Foundations,* 10th ed. Includes 80 foundations not previously profiled and updates on previously profiled foundations. Tables; indexes. Available from Funding Information Center of Texas, Inc., *see above.*

Utah Jacobsen, Lynn Madera. *A Directory of Foundations in Utah.* Salt Lake City, Utah: University of Utah Press, 1985. Based on 1980 through 1982 990-PF returns filed with the IRS by 189 foundations in Utah, with additional information supplied by questionnaire. Main section arranged alphabetically by foundation name; entries include officers and directors, financial data, area of interest, types of support, grant analysis and sample grants. Alphabetical index of foundations as well as index by area of interest and index of officers, directors, and advisors. Available from University of Utah Press, 101 University Services Bldg., Salt Lake City, UT 84112. (800) 444-8638, Ext. 6771.

Vermont Burns, Michael E., ed. *Corporate Philanthropy in New England: Vermont.* Vol. 4. Hartford, Conn.: D.A.T.A., 1987. Entries for over 125 corporate giving programs, providing address, phone number and contact, brief corporate profile and general philanthropic policies, annual cash contributions, and giving priorities. Subject and geographic indexes. Available from D.A.T.A., Inc., 30 Arbor St. North, Hartford, CT 06106. (203) 786-5225.

Virginia *See* **Tennessee:** O'Donnell, Suzanna, et al. *A Guide to Funders in Central Appalachia and the*

Tennessee Valley.

Washington Washington (State). Office of Attorney General. *Charitable Trust Directory.* Olympia, Wash.: Attorney General of Washington, 1987. Based on the 1987 records in the files of the Attorney General of Washington. Includes information on over 400 charitable organizations and trusts reporting to the Attorney General under the Washington Charitable Trust Act. Divided into two main sections: "Grantmakers" and "Grantseekers." Grantmaker entries may include statement of purpose, officers, sample grants, and financial data. Alphabetical index of all organizations appearing in the directory, and another of grantmakers only, divided into purpose categories. Available from Attorney General of Washington, 7th floor, Highways–Licenses Building, Olympia, WA 98504-8071.

West Virginia *West Virginia Foundation Directory.* 2nd ed. Charleston, W. Va.: Kanawha County Public Library, 1987. Divided into two sections, the first half of the directory consists of 62 profiles derived from survey data and 990-PF financial data. Each profile gives the foundation's name, address, contact person, date established, and information on the foundation's giving interest, restrictions, and application procedures; lists trustees, when available, and provides a chronological list of assets and grants in dollars. The second half of the directory consists of 42 foundations which did not return their surveys; provides each foundation's name, address, and contact person, if given in the tax form, and includes the assets and grants in dollars. Final section contains updates on over 100 foundations. Index by foundation name only. Available from Kanawha County Public Library, 123 Capitol Street, Charleston, WV 25301.

West Virginia *See also* **Tennessee**: O'Donnell, Suzanna, et al. *A Guide to Funders in Central Appalachia and the Tennessee Valley.*

Wisconsin Hopwood, Susan H., ed. *Foundations in Wisconsin: A Directory.* Milwaukee, Wis.: Marquette University Memorial Library, 1988. Contains information on 713 active grantmaking foundations. Entries include name of foundation, address, officers and directors, assets, grants paid, range, purpose, sample grants, and interests. (Lists the 50 largest foundations by grantmaking amount.) Also listed are over 250 unprofiled grantmakers which are rated as inactive, operating, restricted, or terminated foundations. Directory includes an area of interest index, Wisconsin county index of foundations, and an officer index. Available from Marquette University Memorial Library, 1415 West Wisconsin Avenue, Milwaukee, WI 53233.

Wyoming Darcy, Kathy, ed. *Wyoming Foundations Directory.* 3rd ed. Cheyenne, Wyoming: Laramie County Community College, 1985. Based on 990-PF and 990-AR returns filed with the IRS and a survey of more than 70 foundations listed in the directory. Main section arranged alphabetically by foundation; entries include statement of purpose and contact person when available. Also sections on foundations based out-of-state that award grants in Wyoming and a list of foundations awarding educational loans and scholarships. Index of foundations. Available from Laramie County Community College, 1400 East College Drive, Cheyenne, WY 82007. (307) 634-5853, Ext. 206.

Wyoming *See also* **Montana**: McRae, Kendall, et al. *The Montana and Wyoming Foundation Directory.*

THE FOUNDATION CENTER COOPERATING COLLECTIONS NETWORK
Free Funding Information Centers

The Foundation Center is an independent national service organization established by foundations to provide an authoritative source of information on private philanthropic giving. The New York, Washington, DC, Cleveland and San Francisco reference collections operated by the Foundation Center offer a wide variety of services and comprehensive collections of information on foundations and grants. Cooperating Collections are libraries, community foundations and other nonprofit agencies that provide a core collection of Foundation Center publications and a variety of supplementary materials and services in areas useful to grantseekers. The core collection consists of:

Foundation Directory	Foundation Grants to Individuals	National Directory of Corporate Giving
Foundation Fundamentals	Literature of the Nonprofit Sector	Source Book Profiles
Foundation Grants Index	National Data Book of Foundations	

Many of the network members have sets of private foundation information returns (IRS 990-PF) for their state or region which are available for public use. A complete set of U.S. foundation returns can be found at the New York and Washington, DC offices of the Foundation Center. The Cleveland and San Francisco offices contain IRS 990-PF returns for the midwestern and western states, respectively. Those Cooperating Collections marked with a bullet (●) have sets of private foundation information returns for their state or region.

Because the collections vary in their hours, materials and services, IT IS RECOMMENDED THAT YOU CALL EACH COLLECTION IN ADVANCE. To check on new locations or more current information, call 1-800-424-9836.

Reference Collections Operated by the Foundation Center

The Foundation Center
8th Floor
79 Fifth Avenue
New York, NY 10003
212-620-4230

The Foundation Center
Room 312
312 Sutter Street
San Francisco, CA 94108
415-397-0902

The Foundation Center
1001 Connecticut Avenue, NW
Washington, DC 20036
202-331-1400

The Foundation Center
Kent H. Smith Library
1442 Hanna Building
Cleveland, OH 44115
216-861-1933

ALABAMA

● Birmingham Public Library
Government Documents
2100 Park Place
Birmingham 35203
205-226-3600

Huntsville Public Library
915 Monroe St.
Huntsville 35801
205-532-5940

University of South Alabama
Library Reference Dept.
Mobile 36688
205-460-7025

● Auburn University at
Montgomery Library
I-85 @ Taylor Rd.
Montgomery 36193-0401
205-271-9649

ALASKA

● University of Alaska
Anchorage Library
3211 Providence Drive
Anchorage 99508
907-786-1848

Juneau Public Library
292 Marine Way
Juneau 99801
907-586-5249

ARIZONA

● Phoenix Public Library
Business & Sciences Dept.
12 East McDowell Road
Phoenix 85257
602-262-4636

● Tucson Public Library
200 South Sixth Avenue
Tucson 85726-7470
602-791-4393

ARKANSAS

● Westark Community College
Library
5210 Grand Avenue
Fort Smith 72913
501-785-7000

● Central Arkansas Library System
Reference Services
700 Louisiana Street
Little Rock 72201
501-370-5950

CALIFORNIA

● Peninsula Community
Foundation
1204 Burlingame Avenue
Burlingame 94011-0627
415-342-2505

● Orange County Community
Developmental Council
1695 W. MacArthur Blvd.
Costa Mesa 92626
714-540-9293

● California Community Foundation
Funding Information Center
3580 Wilshire Blvd., Suite 1660
Los Angeles 90010
213-413-4042

● Community Foundation for
Monterey County
420 Pacific Street
Monterey 93942
408-375-9712

Riverside Public Library
3581 7th Street
Riverside 92501
714-782-5201

California State Library
Reference Services, Rm. 301
914 Capitol Mall
Sacramento 95814
916-322-4570

● San Diego Community
Foundation
525 "B" Street, Suite 410
San Diego 92101
619-239-8815

● Nonprofit Development
1762 Technology Dr., Suite 225
San Jose 95110
408-452-8181

California Community
Foundation
Volunteer Center of Orange
County
1000 E. Santa Ana Blvd.
Santa Ana, CA 92701
714-953-1655

● Santa Barbara Public Library
40 East Anapamu
Santa Barbara 93101-1603
805-962-7653

Santa Monica Public Library
1343 Sixth Street
Santa Monica 90401-1603
213-458-8859

COLORADO

Pikes Peak Library District
20 North Cascade Avenue
Colorado Springs 80901
719-473-2080

● Denver Public Library
Sociology Division
1357 Broadway
Denver 80203
303-571-2190

CONNECTICUT

Danbury Public Library
170 Main Street
Danbury 06810
203-797-4527

● Hartford Public Library
Reference Department
500 Main Street
Hartford 06103
203-293-6000

D.A.T.A.
25 Science Park
Suite 502
New Haven 06511
203-786-5225

DELAWARE

● University of Delaware
Hugh Morris Library
Newark 19717-5267
302-451-2965

FLORIDA

Volusia County Library Center
City Island
Daytona Beach 32014-4484
904-255-3765

Nova University
Einstein Library—Foundation
Resource Collection
3301 College Avenue
Fort Lauderdale 33314
305-475-7497

Indian River Community College
Learning Resources Center
3209 Virginia Avenue
Fort Pierce 34981-5599
407-468-4757

● Jacksonville Public Libraries
Business, Science & Documents
122 North Ocean Street
Jacksonville 32206
904-630-2665

● Miami–Dade Public Library
Humanities Department
101 W. Flagler St.
Miami 33130
305-375-2665

● Orlando Public Library
Orange County Library System
101 E. Central Blvd.
Orlando 32801
407-425-4694

Selby Public Library
1001 Boulevard of the Arts
Sarasota 34236
813-951-5501

● Leon County Public Library
Funding Resource Center
1940 North Monroe Street
Tallahassee 32303
904-487-2665

Palm Beach County Community
Foundation
324 Datura Street, Suite 340
West Palm Beach 33401
407-659-6800

GEORGIA

● Atlanta–Fulton Public Library
Foundation Collection—Ivan
Allen Department
1 Margaret Mitchell Square
Atlanta 30303-1089
404-730-1900

HAWAII

● Hawaii Community Foundation
Hawaii Resource Room
212 Merchant Street
Suite 330
Honolulu 96813
808-599-5767

University of Hawaii
Thomas Hale Hamilton Library
2550 The Mall
Honolulu 96822
808-948-7214

IDAHO

● Boise Public Library
715 S. Capitol Blvd.
Boise 83702
208-384-4024

● Caldwell Public Library
1010 Dearborn Street
Caldwell 83605
208-459-3242

ILLINOIS

Belleville Public Library
121 East Washington Street
Belleville 62220
618-234-0441

● Donors Forum of Chicago
53 W. Jackson Blvd., Rm. 430
Chicago 60604
312-431-0265

● Evanston Public Library
1703 Orrington Avenue
Evanston 60201
312-866-0305

● Sangamon State University
Library
Shepherd Road
Springfield 62794-9243
217-786-6633

INDIANA

● Allen County Public Library
900 Webster Street
Fort Wayne 46802
219-424-7241

Indiana University Northwest
Library
3400 Broadway
Gary 46408
219-980-6582

● Indianapolis–Marion County
Public Library
40 East St. Clair Street
Indianapolis 46206
317-269-1733

IOWA

● Cedar Rapids Public Library
Funding Information Center
500 First Street, SE
Cedar Rapids 52401
319-398-5145

Southwestern Community
College
Learning Resource Center
1501 W. Townline Rd.
Creston 50801
515-782-7081, ext. 262

● Public Library of Des Moines
100 Locust Street
Des Moines 50308
515-283-4152

KANSAS

● Topeka Public Library
1515 West Tenth Street
Topeka 66604
913-233-2040

● Wichita Public Library
223 South Main
Wichita 67202
316-262-0611

KENTUCKY

Western Kentucky University
Helm-Cravens Library
Bowling Green 42101
502-745-6122

● Louisville Free Public Library
Fourth and York Streets
Louisville 40203
502-561-8617

LOUISIANA

● East Baton Rouge Parish Library
Centroplex Branch
120 St. Louis Street
Baton Rouge 70802
504-389-4960

● New Orleans Public Library
Business and Science Division
219 Loyola Avenue
New Orleans 70140
504-596-2580

● Shreve Memorial Library
424 Texas Street
Shreveport 71120-1523
318-226-5894

MAINE

● University of Southern Maine
Office of Sponsored Research
246 Deering Ave., Rm. 628
Portland 04103
207-780-4871

MARYLAND

● Enoch Pratt Free Library
Social Science and History
Department
400 Cathedral Street
Baltimore 21201
301-396-5320

MASSACHUSETTS

● Associated Grantmakers of
Massachusetts
294 Washington Street
Suite 840
Boston 02108
617-426-2608

● Boston Public Library
666 Boylston St.
Boston 02117
617-536-5400

● Western Massachusetts Funding
Resource Center
Campaign for Human
Development
73 Chestnut Street
Springfield 01103
413-732-3175

● Worcester Public Library
Grants Resource Center
Salem Square
Worcester 01608
508-799-1655

MICHIGAN

● Alpena County Library
211 North First Avenue
Alpena 49707
517-356-6188

University of Michigan–Ann
Arbor
209 Hatcher Graduate Library
Ann Arbor 48109-1205
313-764-1149

● Henry Ford Centennial Library
16301 Michigan Avenue
Dearborn 48126
313-943-2330

● Wayne State University
Purdy-Kresge Library
5265 Cass Avenue
Detroit 48202
313-577-6424

● Michigan State University
Libraries
Reference Library
East Lansing 48824-1048
517-353-8818

● Farmington Community Library
32737 West 12 Mile Road
Farmington Hills 48018
313-553-0300

● University of Michigan–Flint
Library
Reference Department
Flint 48502-2186
313-762-3408

● Grand Rapids Public Library
Business Dept.
60 Library Plaza NE
Grand Rapids 49503-3093
616-456-3600

● Michigan Technological
University Library
Highway U.S. 41
Houghton 49931
906-487-2507

● Sault Ste. Marie Area
Public Schools
Office of Compensatory
Education
460 W. Spruce St.
Sault Ste. Marie 49783-1874
906-635-6619

MINNESOTA

● Duluth Public Library
520 W. Superior Street
Duluth 55802
218-723-3802

Southwest State University
Library
Marshall 56258
507-537-7278

● Minneapolis Public Library
Sociology Department
300 Nicollet Mall
Minneapolis 55401
612-372-6555

Rochester Public Library
11 First Street, SE
Rochester 55902-3743
507-285-8002

St. Paul Public Library
90 West Fourth Street
Saint Paul 55102
612-292-6307

MISSISSIPPI

Jackson/Hinds Library System
300 North State Street
Jackson 39201
601-968-5803

MISSOURI

● Clearinghouse for Midcontinent
Foundations
Univ. of Missouri
Law School, Suite 1-300
52nd Street and Oak
Kansas City 64113-0680
816-276-1176

● Kansas City Public Library
311 East 12th Street
Kansas City 64106
816-221-9650

● Metropolitan Association for
Philanthropy, Inc.
5585 Pershing Avenue
Suite 150
St. Louis 63112
314-361-3900

- Springfield–Greene County
 Library
 397 East Central Street
 Springfield 65801
 417-866-4636

MONTANA

- Eastern Montana College Library
 1500 N. 30th Street
 Billings 59101-0298
 406-657-1662

- Montana State Library
 Reference Department
 1515 E. 6th Avenue
 Helena 59620
 406-444-3004

NEBRASKA

- University of Nebraska
 106 Love Library
 14th & R Streets
 Lincoln 68588-0410
 402-472-2848

- W. Dale Clark Library
 Social Sciences Department
 215 South 15th Street
 Omaha 68102
 402-444-4826

NEVADA

- Las Vegas–Clark County Library
 District
 1401 East Flamingo Road
 Las Vegas 89119-6160
 702-733-7810

- Washoe County Library
 301 South Center Street
 Reno 89501
 702-785-4012

NEW HAMPSHIRE

- New Hampshire Charitable Fund
 One South Street
 Concord 03302-1335
 603-225-6641

NEW JERSEY

Cumberland County Library
800 E. Commerce Street
Bridgeton 08302-2295
609-453-2210

The Support Center
17 Academy Street, Suite 1101
Newark 07102
201-643-5774

County College of Morris
Masten Learning Resource
 Center
Route 10 and Center Grove Rd.
Randolph 07869
201-361-5000 ext. 470

- New Jersey State Library
 Governmental Reference
 185 West State Street
 Trenton 08625-0520
 609-292-6220

NEW MEXICO

Albuquerque Community
 Foundation
6400 Uptown Boulevard N.E.
Suite 500-W
Albuquerque 87105
505-883-6240

- New Mexico State Library
 325 Don Gaspar Street
 Santa Fe 87503
 505-827-3827

NEW YORK

- New York State Library
 Cultural Education Center
 Humanities Section
 Empire State Plaza
 Albany 12230
 518-473-4636

- Suffolk Cooperative Library
 System
 627 North Sunrise Service Road
 Bellport 11713
 516-286-1600

New York Public Library
Bronx Reference Center
2556 Bainbridge Avenue
Bronx 10458
212-220-6575

Brooklyn in Touch
One Hanson Place
Room 2504
Brooklyn 11243
718-230-3200

- Buffalo and Erie County Public
 Library
 Lafayette Square
 Buffalo 14202
 716-858-7103

Huntington Public Library
338 Main Street
Huntington 11743
516-427-5165

Queens Borough Public Library
89-11 Merrick Boulevard
Jamaica 11432
718-990-0700

- Levittown Public Library
 One Bluegrass Lane
 Levittown 11756
 516-731-5720

SUNY/College at Old Westbury
 Library
223 Store Hill Road
Old Westbury 11568
516-876-3156

- Plattsburgh Public Library
 15 Oak Street
 Plattsburgh 12901
 518-563-0921

Adriance Memorial Library
93 Market Street
Poughkeepsie 12601
914-485-3445

- Rochester Public Library
 Business Division
 115 South Avenue
 Rochester 14604
 716-428-7328

Staten Island Council on the Arts
One Edgewater Plaza, Rm. 311
Staten Island 10305
718-447-4485

- Onondaga County Public Library
 at the Galleries
 447 S. Salina Street
 Syracuse 13202-2494
 315-448-4636

- White Plains Public Library
 100 Martine Avenue
 White Plains 10601
 914-682-4480

NORTH CAROLINA

- Asheville-Buncomb Technical
 Community College
 Learning Resources Center
 340 Victoria Rd.
 Asheville 28802
 704-254-1921 x300

- The Duke Endowment
 200 S. Tryon Street, Ste. 1100
 Charlotte 28202
 704-376-0291

Durham County Library
300 N. Roxboro Street
Durham 27702
919-560-0100

- North Carolina State Library
 109 East Jones Street
 Raleigh 27611
 919-733-3270

- The Winston-Salem Foundation
 229 First Union Bank Building
 Winston-Salem 27101
 919-725-2382

NORTH DAKOTA

- North Dakota State University
 The Library
 Fargo 58105
 701-237-8886

OHIO

Stark County District Library
715 Market Avenue North
Canton 44702-1080
216-452-0665

- Public Library of Cincinnati and
 Hamilton County
 Education Department
 800 Vine Street
 Cincinnati 45202-2071
 513-369-6940

Columbus Metropolitan Library
96 S. Grant Avenue
Columbus 43215
614-645-2590

- Dayton and Montgomery County
 Public Library
 Grants Information Center
 215 E. Third Street
 Dayton 45402-2103
 513-227-9500 ext. 211

- Toledo–Lucas County Public
 Library
 Social Science Department
 325 Michigan Street
 Toledo 43623
 419-259-5245

Ohio University–Zanesville
Community Education and
 Development
1425 Newark Road
Zanesville 43701
614-453-0762

OKLAHOMA

- Oklahoma City University Library
 2501 North Blackwelder
 Oklahoma City 73106
 405-521-5072

- Tulsa City–County Library System
 400 Civic Center
 Tulsa 74103
 918-596-7944

OREGON

- Pacific Non-Profit Network
 Grantsmanship Resource Library
 33 N. Central, Ste. 211
 Medford 97501
 503-779-6044

- Multnomah County Library
 Government Documents Room
 801 S.W. Tenth Avenue
 Portland 97205-2597
 503-223-7201

Oregon State Library
State Library Building
Salem 97310
503-378-4274

PENNSYLVANIA

Northampton Community College
Learning Resources Center
3835 Green Pond Road
Bethlehem 18017
215-861-5360

- Erie County Public Library
 3 South Perry Square
 Erie 16501
 814-451-6927

- Dauphin County Library System
 101 Walnut Street
 Harrisburg 17101
 717-234-4961

Lancaster County Public Library
125 North Duke Street
Lancaster 17602
717-394-2651

- The Free Library of Philadelphia
 Logan Square
 Philadelphia 19103
 215-686-5423

- University of Pittsburgh
 Hillman Library
 Pittsburgh 15260
 412-648-7722

Economic Development Council
 of Northeastern Pennsylvania
1151 Oak Street
Pittston 18640
717-655-5581

RHODE ISLAND

- Providence Public Library
 Reference Department
 150 Empire Street
 Providence 02903
 401-521-7722

SOUTH CAROLINA

- Charleston County Library
 404 King Street
 Charleston 29403
 803-723-1645

- South Carolina State Library
 Reference Department
 1500 Senate Street
 Columbia 29211
 803-734-8666

SOUTH DAKOTA

- South Dakota State Library
 800 Governors Drive
 Pierre 57501-2294
 605-773-5070
 800-592-1841 (SD residents)

 Sioux Falls Area Foundation
 141 N. Main Ave., Suite 500
 Sioux Falls 57102-1134
 605-336-7055

TENNESSEE

- Knoxville–Knox County Public
 Library
 500 West Church Avenue
 Knoxville 37902
 615-544-5750

- Memphis & Shelby County
 Public Library
 1850 Peabody Avenue
 Memphis 38104
 901-725-8877

- Public Library of Nashville and
 Davidson County
 8th Ave. N. and Union St.
 Nashville 37211
 615-259-6256

TEXAS

- Community Foundation of Abilene
 Funding Information Library
 708 NCNB Bldg.
 402 Cypress
 Abilene 79601
 915-676-3883

 Amarillo Area Foundation
 70 1st National Place I
 800 S. Fillmore
 Amarillo 79101
 806-376-4521

Hogg Foundation for Mental Health
University of Texas
Austin 78713
512-471-5041

- Corpus Christi State University
 Library
 6300 Ocean Drive
 Corpus Christi 78412
 512-994-2608

- Dallas Public Library
 Grants Information Service
 1515 Young Street
 Dallas 75201
 214-670-1487

- Pan American University
 Learning Resource Center
 1201 W. University Drive
 Edinburg 78539
 512-381-3304

- El Paso Community Foundation
 1616 Texas Commerce Building
 El Paso 79901
 915-533-4020

- Texas Christian University Library
 Funding Information Center
 Ft. Worth 76129
 817-921-7664

- Houston Public Library
 Bibliographic Information Center
 500 McKinney Avenue
 Houston 77002
 713-236-1313

- Lubbock Area Foundation
 502 Texas Commerce Bank
 Building
 Lubbock 79401
 806-762-8061

- Funding Information Center
 507 Brooklyn
 San Antonio 78215
 512-227-4333

UTAH

- Salt Lake City Public Library
 Business and Science Dept.
 209 East Fifth South
 Salt Lake City 84111
 801-363-5733

VERMONT

- Vermont Dept. of Libraries
 Reference Services
 109 State Street
 Montpelier 05602
 802-828-3268

VIRGINIA

- Hampton Public Library
 Grants Resources Collection
 4207 Victoria Blvd.
 Hampton 23669
 804-727-1154

- Richmond Public Library
 Business, Science, & Technology
 101 East Franklin Street
 Richmond 23219
 804-780-8223

- Roanoke City Public Library
 System
 Central Library
 706 S. Jefferson Street
 Roanoke 24014
 703-981-2477

WASHINGTON

- Seattle Public Library
 1000 Fourth Avenue
 Seattle 98104
 206-386-4620

- Spokane Public Library
 Funding Information Center
 West 906 Main Avenue
 Spokane 99201
 509-838-3364

WEST VIRGINIA

- Kanawha County Public Library
 123 Capital Street
 Charleston 25304
 304-343-4646

WISCONSIN

- University of Wisconsin–Madison
 Memorial Library
 728 State Street
 Madison 53706
 608-262-3242

- Marquette University
 Memorial Library
 1415 West Wisconsin Avenue
 Milwaukee 53233
 414-288-1515

WYOMING

- Laramie County Community
 College Library
 1400 East College Drive
 Cheyenne 82007-3299
 307-778-1205

AUSTRALIA

ANZ Executors & Trustees Co.
Ltd.
91 William St., 7th floor
Melbourne VIC 3000
03-648-5764

CANADA

Canadian Centre for Philanthropy
74 Victoria Street, Suite 920
Toronto, Ontario M5C 2A5
416-368-1138

ENGLAND

Charities Aid Foundation
18 Doughty Street
London WC1N 2PL
01-831-7798

JAPAN

Foundation Center Library
of Japan
Elements Shinjuku Bldg. 3F
2-1-14 Shinjuku, Shinjuku-ku
Tokyo 160
03-350-1857

MEXICO

Biblioteca Benjamin Franklin
American Embassy, USICA
Londres 16
Mexico City 6, D.F. 06600
905-211-0042

PUERTO RICO

University of Puerto Rico
Ponce Technological College
Library
Box 7186
Ponce 00732
809-844-4150

Universidad Del Sagrado
Corazon
M.M.T. Guevarra Library
Correo Calle Loiza
Santurce 00914
809-728-1515 ext. 357

U.S. VIRGIN ISLANDS

University of the Virgin Islands
Paiewonsky Library
Charlotte Amalie
St. Thomas 00802
809-828-3261

THE FOUNDATION CENTER AFFILIATES PROGRAM

As participants in the Cooperating Collections Network, affiliates are libraries or nonprofit agencies that provide fundraising information or other funding-related technical assistance in their communities. Affiliates agree to provide free public access to a basic collection of Foundation Center publications during a regular schedule of hours, offering free funding research guidance to all visitors. Many also provide a variety of special services for local nonprofit organizations using staff or volunteers to prepare special materials, organize workshops, or conduct library orientations.

The Foundation Center welcomes inquiries from agencies interested in providing this type of public information service. If you are interested in establishing a funding information library for the use of nonprofit agencies in your area or in learning more about the program, we would like to hear from you. For more information, please write to: Anne J. Borland, The Foundation Center, 79 Fifth Avenue, New York, NY 10003.

DESCRIPTIVE DIRECTORY

DESCRIPTIVE DIRECTORY

ALABAMA

1
The Greater Birmingham Foundation
P.O. Box 131027
Birmingham 35213 (205) 933-0753

Community foundation established in 1959 in
AL by resolution and declaration of trust.
Financial data (yr. ended 12/31/85): Assets,
$14,016,523 (M); gifts received, $785,727;
expenditures, $972,609 for 78 grants.
Purpose and activities: To promote the health,
welfare, cultural, educational, and social needs
of the Birmingham area only.
Limitations: Giving limited to the Birmingham,
AL, area. No support for religiously oriented
agencies. No grants to individuals, or for
endowment funds or operating budgets.
Publications: Annual report.
Application information:
 Initial approach: Letter
 Board meeting date(s): Quarterly
 Write: Mrs. William C. McDonald, Jr., Exec.
 Dir.
Officer: Mrs. William C. McDonald, Jr., Exec.
Dir.
Distribution Committee: William M. Spencer
III, Chair.; Houston Blount, Donald Brabston,
Frank Dominick, Marvin Engel, A. Gerow
Hodges, Crawford Johnson III, Richard Russell,
James Simpson.
Trustees: AmSouth Bank, N.A., Central Bank of
the South, Colonial Bank, First Alabama Bank
of Birmingham, South Trust Bank of Alabama.
Employer Identification Number: 636019864

2
The Blount Foundation, Inc.
c/o Blount, Inc.
4520 Exec. Park Dr.
Montgomery 36116 (205) 244-4000

Incorporated in 1970 in AL.
Donor(s): Blount, Inc.
Financial data (yr. ended 2/29/88): Assets,
$112,646 (M); gifts received, $505,000;
expenditures, $668,821, including $576,565
for 164 grants (high: $100,000; low: $25) and
$90,870 for 486 employee matching gifts.
Purpose and activities: Giving for culture and
the arts, higher and secondary education,

including an employee matching gift program,
civic affairs, and health care.
Types of support: General purposes, building
funds, equipment, endowment funds,
scholarship funds, matching funds, research,
publications, employee matching gifts.
Limitations: No support for certain religious or
sectarian groups, governmental or quasi-
governmental agencies. No grants to
individuals, or for demonstration projects,
conferences, seminars, or courtesy advertising;
no loans; no in-kind grants.
Publications: Informational brochure (including
application guidelines).
Application information:
 Initial approach: 2- or 3-page letter
 Copies of proposal: 1
 Deadline(s): None
 Board meeting date(s): As needed
 Final notification: 12 weeks after board
 meets
 Write: D. Joseph McInnes, Pres.
Officers: D. Joseph McInnes,* Pres.; W.
Houston Blount,* V.P.; Louis A. Griffin, Secy.
Directors:* Winton M. Blount.
Number of staff: 1 full-time professional; 1 full-
time support.
Employer Identification Number: 636050260

3
Central Bank Foundation
P.O. Box 10566
Birmingham 35296

Established in l981 in AL.
Donor(s): Central Bank of the South.
Financial data (yr. ended 12/31/87): Assets,
$0 (M); gifts received, $200,352; expenditures,
$206,928, including $204,935 for 121 grants
(high: $25,000; low: $25).
Purpose and activities: Giving primarily for
community funds, business and business
education, health, social service and youth
agencies, education, civic affairs, and arts and
cultural programs.
Types of support: General purposes, annual
campaigns, building funds, employee-related
scholarships.
Limitations: Giving primarily in AL. No
support for religious organizations. No grants
to individuals.
Application information:
 Copies of proposal: 1
 Deadline(s): None
Officers: Terence C. Brannon, Pres.; Jerry W.
Powell, Secy.; Michael A. Bean, Treas.
Trustee: Harry B. Brock, Jr., Chair.
Employer Identification Number: 630823545

4
The Comer Foundation
P.O. Box 302
Sylacauga 35150 (205) 249-2962

Incorporated in 1945 in AL.
Donor(s): Avondale Mills, Comer-Avondale
Mills, Inc., Cowikee Mills.
Financial data (yr. ended 12/31/87): Assets,
$8,297,712 (M); expenditures, $558,137,
including $457,677 for 56 grants (high:
$58,710; low: $100).
Purpose and activities: Emphasis on higher
education, health, recreation, community
funds, and cultural programs.
Limitations: Giving primarily in AL.
Application information:
 Initial approach: Letter
 Deadline(s): None
 Write: R. Larry Edmunds, Secy.-Treas.
Officers: Richard J. Comer,* Chair.; William T.
King,* Vice-Chair.; R. Larry Edmunds, Secy.-
Treas.
Trustees:* Jane S. Crockard, Herbert C.
Ryding, Jr., W. Bew White, Jr.
Number of staff: 1 full-time professional.
Employer Identification Number: 636004424

5
The Daniel Foundation of Alabama
200 Office Park Dr., Suite 100
Birmingham 35223 (205) 879-0902

Established in 1978 in AL as partial successor
to the Daniel Foundation.
Donor(s): Charles W. Daniel,† R. Hugh
Daniel.†
Financial data (yr. ended 12/31/87): Assets,
$19,120,099 (M); expenditures, $1,458,248,
including $1,326,840 for 26 grants (high:
$270,340; low: $500; average: $5,000-
$50,000).
Purpose and activities: Emphasis on health
and higher education; support also for cultural
programs, social service and youth agencies,
and civic affairs.
Limitations: Giving primarily in the
southeastern states, especially AL.
Application information:
 Initial approach: Letter
 Deadline(s): None
 Board meeting date(s): Apr. and Oct.
 Final notification: Varies
 Write: S. Garry Smith, Secy.-Treas.

Officers: M.C. Daniel, Chair.; Harry B. Brock, Jr., Pres.; Charles W. Daniel, V.P.; S. Garry Smith, Secy.-Treas.
Number of staff: 1 part-time professional.
Employer Identification Number: 630736444

6
Durr-Fillauer Medical Foundation
P.O. Box 951
Montgomery 36192

Established in 1982 in AL.
Donor(s): Durr-Fillauer Medical, Inc.
Financial data (yr. ended 12/31/87): Assets, $17,556 (M); gifts received, $135,000; expenditures, $135,195, including $134,218 for 51 grants (high: $25,000; low: $100) and $315 for 4 employee matching gifts.
Purpose and activities: Support primarily for higher education, culture, and community funds.
Types of support: Scholarship funds, fellowships, building funds.
Trustees: John W. Durr, Charles T. Gross, Richard L. Klein.
Employer Identification Number: 630847294

7
William P. Engel Foundation
P.O. Box 187
Birmingham 35201 (205) 323-8081

Established in 1972 in AL.
Financial data (yr. ended 12/31/86): Assets, $1,402,940 (M); expenditures, $90,508, including $79,050 for 39 grants (high: $32,000; low: $50).
Purpose and activities: Emphasis on Jewish welfare funds; support also for cultural programs, health, and education.
Limitations: Giving primarily in AL.
Application information:
 Deadline(s): None
 Write: Marvin R. Engel, Trustee
Trustees: Marvin R. Engel, Ruth S. Engel, Robert D. Reich, Jr.
Employer Identification Number: 237182007

8
Estes H. & Florence Parker Hargis Charitable Foundation
317 20th St. North
P.O. Box 370404
Birmingham 35237 (205) 251-2881

Established in 1966 in AL as Estes Hargis Charitable Foundation, merged with Florence Parker Hargis Charitable Foundation in 1980.
Donor(s): Estes H. Hargis,† Florence Parker Hargis,† Florence Parker Hargis.†
Financial data (yr. ended 6/30/88): Assets, $2,674,204 (M); expenditures, $414,302, including $395,374 for 7 grants (high: $376,074; low: $300).
Purpose and activities: Giving for youth services, Protestant religion, and for the maintenance of a museum and garden area.
Types of support: Endowment funds.
Limitations: Giving primarily in AL and TN.
Application information:
 Copies of proposal: 1

Deadline(s): May 1
Board meeting date(s): Jan., May, Aug., and Nov.
Final notification: June 30
Write: Gerald D. Colvin, Jr., Chair.
Trustees: Gerald D. Colvin, Jr., Chair.; Melvin Bailey, George Crawford, Rosemary Morse, Florence Wade.
Number of staff: None.
Employer Identification Number: 636062967

9
Caroline P. and Charles W. Ireland Foundation
(Formerly C Foundation)
c/o AmSouth Bank, N.A.
P.O. Box 11426
Birmingham 35202 (205) 326-5396

Established in 1977 in AL.
Financial data (yr. ended 12/31/87): Assets, $1,286,047 (M); expenditures, $42,326, including $34,500 for grants.
Purpose and activities: Giving primarily for higher education and cultural programs.
Limitations: No grants to individuals.
Application information:
 Initial approach: Letter
 Deadline(s): None
 Write: Kathryn W. Miree
Officers: Mrs. Charles Ireland, Pres.; George Stevens, Bew White, Cynthia Wilson.
Agent: AmSouth Bank, N.A.
Employer Identification Number: 636106086

10
Kinder-Care Learning Centers, Inc. Corporate Giving Program
4505 Executive Park Dr.
P.O. Box 2151
Montgomery 36197 (205) 277-5090

Purpose and activities: In 1988, Kinder-Care Learning Centers made a $1 million grant to the Muscular Dystrophy Association, a regular recipient of aid from the company. Support is also given to arts, including museums and theater, and through employee volunteerism to community programs. The main emphasis is the welfare of children.
Limitations: Giving primarily in headquarters city and areas where there is a Kinder-Care center.
Application information:
 Initial approach: Letter

11
Linn-Henley Charitable Trust
c/o Central Bank of the South, Trust Dept.
P.O. Box 10566
Birmingham 35296 (205) 558-6717

Trust established in 1965 in AL.
Donor(s): Walter E. Henley.†
Financial data (yr. ended 3/31/88): Assets, $5,680,095 (M); expenditures, $324,110, including $249,350 for 28 grants (high: $50,000; low: $250).
Purpose and activities: Emphasis on cultural programs and higher education.

Limitations: Giving limited to Jefferson County, AL.
Application information:
 Initial approach: Letter
 Deadline(s): None
 Write: Mitzie Hall
Trustees: John C. Henley III, Central Bank of the South.
Employer Identification Number: 636051833

12
The Mobile Community Foundation
100 St. Joseph St., Suite 416
Mobile 36602 (205) 438-5591

Community foundation incorporated in 1976 in AL.
Financial data (yr. ended 9/30/88): Assets, $9,968,580 (M); gifts received, $949,907; expenditures, $239,910, including $167,418 for 256 grants (high: $14,000; low: $100; average: $1,000).
Purpose and activities: Giving in the fields of health and human services, education, civic affairs, culture, and the arts.
Types of support: Capital campaigns, endowment funds, general purposes, operating budgets, scholarship funds, special projects.
Limitations: Giving primarily in the Mobile, AL, metropolitan area.
Publications: Annual report, informational brochure (including application guidelines), newsletter, 990-PF.
Application information: Application form required.
 Initial approach: Letter
 Copies of proposal: 8
 Deadline(s): Oct. 1
 Board meeting date(s): Quarterly
 Write: Thomas H. Davis, Jr., Exec. Dir.
Officers and Directors:* A.F. Delchamps, Jr.,* Pres.; G. Porter Brock, Jr., V.P.; Robert J. Williams,* V.P.; Jane F. Bledsoe, Secy.; Robert J. Blackwell,* Treas.; Thomas H. Davis, Jr., Exec. Dir.; and 12 additional directors.
Number of staff: 1 full-time professional; 1 full-time support.
Employer Identification Number: 630695166

13
Randa, Inc.
P.O. Box 511
Montgomery 36134

Trust established in 1948 in AL.
Donor(s): Adolf Weil, Jr., Robert S. Weil.
Financial data (yr. ended 12/31/86): Assets, $2,372,986 (M); expenditures, $160,205, including $154,750 for 28 grants (high: $50,000; low: $100).
Purpose and activities: Giving primarily for higher education, and community funds; support also for cultural programs.
Application information: Contributes only to pre-selected organizations. Applications not accepted.
Trustee: First Alabama Bank.
Directors: M.J. Rothschild, Adolf Weil, Jr., Robert S. Weil.
Employer Identification Number: 636048966

14

Barbara Ingalls Shook Foundation
P.O. Box 7332A
Mountain Brook 35253 (205) 870-0299

Established in 1980.
Financial data (yr. ended 8/31/88): Assets,
$4,446,492 (M); expenditures, $333,749,
including $144,924 for 57 grants (high:
$50,200; low: $27).
Purpose and activities: Emphasis on hospitals
and medical research; support also for higher
education and cultural programs.
Limitations: Giving primarily in AL and CO.
Application information:
 Initial approach: Proposal
 Deadline(s): None
 Final notification: Within 6 months
 Write: Barbara Ingalls Shook, Chair.
Officers and Trustees: William Bew White,
Barbara Ingalls Shook, Chair. and Treas.; Robert
P. Shook, Pres. and Secy.; Ellen Gregg Shook.
Employer Identification Number: 630792812

15

M. W. Smith, Jr. Foundation
c/o AmSouth Bank, N.A.
P.O. Drawer 1628
Mobile 36629 (205) 438-8260

Trust established in 1960 in AL.
Donor(s): M.W. Smith, Jr.†
Financial data (yr. ended 12/31/88): Assets,
$1,780,033 (M); expenditures, $35,917,
including $17,456 for 5 grants (high: $10,000;
low: $1,000).
Purpose and activities: Emphasis on
education, cultural organizations, and youth
activities.
Types of support: Operating budgets, general
purposes, continuing support, annual
campaigns, seed money, emergency funds,
deficit financing, building funds, equipment,
land acquisition, endowment funds, special
projects, research, publications, conferences
and seminars, scholarship funds, matching
funds.
Limitations: Giving primarily in southwest AL.
No grants to individuals; no loans.
Application information:
 Initial approach: Letter
 Copies of proposal: 1
 Deadline(s): None
 Board meeting date(s): May and Nov.
 Final notification: 1 month
 Write: Kenneth E. Niemeyer
Distribution Committee: Maida S. Pearson,
Chair.; Mary M. Riser, Secy.; Louis M. Finlay,
Jr., Sybil H. Lebherz, John H. Martin.
Trustee: AmSouth Bank, N.A.
Number of staff: None.
Employer Identification Number: 636018078

16

The Sonat Foundation, Inc.
1900 Fifth Ave., N.
P.O. Box 2563
Birmingham 35202 (205) 325-7460

Established in 1982 in AL.
Donor(s): Sonat, Inc.

Financial data (yr. ended 12/31/87): Assets,
$3,932,070 (M); gifts received, $3,000,000;
expenditures, $916,227, including $695,110
for grants (high: $200,000; low: $1,000;
average: $5,000), $67,000 for 36 grants to
individuals and $134,609 for 278 employee
matching gifts.
Purpose and activities: Giving mainly for
higher education, including employee-related
scholarships, and community funds; some
support also for social service and youth
agencies, and cultural programs.
Types of support: Matching funds, employee-
related scholarships, general purposes,
operating budgets, building funds, research,
employee matching gifts, annual campaigns,
capital campaigns, emergency funds,
endowment funds, land acquisition, renovation
projects, program-related investments, seed
money, special projects, technical assistance,
lectureships, professorships.
Limitations: No grants to individuals (except
for employee-related scholarships).
Publications: Application guidelines.
Application information: Application form
required.
 Initial approach: Letter
 Copies of proposal: 1
 Deadline(s): None
 Board meeting date(s): As necessary
 Final notification: Normally within 2 weeks
 Write: Darlene Sanders, Secy.
Officers and Directors: J. Robert Doody,
Pres.; Beverley Krannich, V.P.; Sarrah W.
Rankin, V.P.; William A. Smith, V.P.; Darlene
Sanders, Secy.; John Musgrave, Treas.
Number of staff: 1 full-time professional.
Employer Identification Number: 630830299

17

**Charles W. & Minnie Temerson
 Foundation Trust**
P.O. Box 2554
Birmingham 35202-2554

Financial data (yr. ended 12/31/87): Assets,
$640,018 (M); expenditures, $138,307,
including $129,360 for 9 grants (high: $30,000;
low: $1,172).
Purpose and activities: Support primarily for
Jewish giving and education, support also for
cultural organizations, including a public library.
Trustee: SouthTrust Bank of Alabama, N.A.
Employer Identification Number: 636069899

18

Susan Mott Webb Charitable Trust
c/o AmSouth Bank, N.A.
P.O. Box 11426
Birmingham 35202 (205) 326-5423

Established in 1978 in AL.
Donor(s): Susan Mott Webb.†
Financial data (yr. ended 12/31/87): Assets,
$7,707,641 (M); expenditures, $546,930,
including $498,600 for grants (high: $125,000;
low: $2,500).
Purpose and activities: Emphasis on a
university, health services, and cultural
programs; support also for religion and civic
affairs.

Types of support: Building funds, equipment,
special projects.
Limitations: Giving primarily in the greater
Birmingham, AL, area. No grants to
individuals, or for scholarships or fellowships;
no loans.
Application information:
 Initial approach: Letter or proposal
 Copies of proposal: 6
 Deadline(s): May 15
 Board meeting date(s): June and Dec.
 Final notification: 2 months
 Write: Kathryn W. Miree, V.P. and Trust
 Officer, AmSouth Bank, N.A.
Trustees: Stewart Dansby, Suzanne Dansby,
Charles B. Webb, Jr., William Bew White, Jr.,
AmSouth Bank, N.A.
Number of staff: None.
Employer Identification Number: 636112593

19

Diane Wendland 1962 Charitable Trust
c/o First Alabama Bank of Montgomery, Trust
Dept.
P.O. Box 511
Montgomery 36134

Established in 1962 in AL.
Financial data (yr. ended 12/31/86): Assets,
$1,583,859 (M); expenditures, $116,838,
including $101,725 for 51 grants (high:
$13,000; low: $100).
Purpose and activities: Giving primarily for
civic affairs, social service and youth agencies,
education, with emphasis on higher education,
and cultural programs.
Limitations: Giving primarily in AL, with
emphasis on Autauga County.
Trustee: First Alabama Bank.
Advisory Committee: Milton Wendland, Mrs.
Milton Wendland.
Employer Identification Number: 636019220

ALASKA

20

Atwood Foundation, Inc.
P.O. Box 40
Anchorage 99510

Foundation established in 1965 in AK.
Donor(s): Robert B. Atwood, Anchorage Times
Publishing Co.
Financial data (yr. ended 12/31/86): Assets,
$2,902,732 (M); gifts received, $20,000;
expenditures, $188,167, including $176,000
for 7 grants (high: $50,000; low: $2,000).
Purpose and activities: Support largely for
educational, cultural, and civic affairs
organizations.
Limitations: Giving primarily in AK.
Officer and Trustee: Robert B. Atwood, Pres.
Employer Identification Number: 926002571

21
CIRI Foundation

P.O. Box 9-3330
Anchorage 99509
Application address: Scholarship Program, CIRI Foundation, P.O. Box 93330, Anchorage, AK 99509-3330; Tel.: (907) 274-8638

Established in 1982 in AK.
Donor(s): Cook Inlet Region, Inc.
Financial data (yr. ended 12/31/87): Assets, $1,238,281 (M); gifts received, $309,710; expenditures, $295,977, including $3,000 for 3 grants of $1,000 each and $135,686 for 192 grants to individuals.
Purpose and activities: Educational support for enrollees of Cook Inlet Region.
Types of support: Student aid, grants to individuals, internships.
Publications: Informational brochure (including application guidelines).
Application information: Applicant must be an enrollee, or child or spouse of an enrollee, of Cook Inlet Region. Application form required.
 Deadline(s): July 1 and Dec. 15 for scholarships; Mar. 31, June 30, Sept. 30, and Dec. 31 for grants, fellowships and internships
 Board meeting date(s): Quarterly
 Final notification: Within 2 weeks of board meeting
 Write: Lydia L Hays, Exec. Dir.
Officers and Directors: Margaret Sagerser-Brown, Chair.; John Monfor, Pres.; Roy M. Huhndorf, Secy.-Treas.; Esther Combs, Britton E. Crosly, William English, Bart Garber, Jeff Gonnason, Carol Gore, David Heatwole, Don Karabelnikoff, Frank Klett, Janie Leask, Monroe Price, Edward Rasmuson.
Number of staff: 1 full-time professional; 1 full-time support.
Employer Identification Number: 920087914

22
Sealaska Corporate Contributions Program

One Sealaska Plaza, Suite 400
Juneau 99801-1276 (907) 586-1512

Financial data (yr. ended 3/31/89): $100,000 for grants (high: $20,000; low: $50).
Purpose and activities: Primary interests are Alaska natives, youth sports, programs for low-income families, and organizations that benefit the company's 16,000 Alaskan native shareholders; grants for alcohol abuse, culture, conservation, and hospices.
Types of support: Annual campaigns, building funds, endowment funds, general purposes, publications, scholarship funds, employee-related scholarships, seed money.
Limitations: Giving primarily in AK; some support for national programs which benefit the shareholders.
Application information:
 Initial approach: Letter
 Deadline(s): 3 to 4 weeks before due date
 Board meeting date(s): Twice a month
 Final notification: Letter of determination
 Write: Maxine H. Richert, Corp. Secy.

ARIZONA

23
A.P.S. Foundation, Inc.

P.O. Box 53999, Station 1520
Phoenix 85072-3999

Established in 1981 in AZ.
Donor(s): Arizona Public Service Co.
Financial data (yr. ended 12/31/87): Assets, $7,624,937 (M); gifts received, $2,000,000; expenditures, $557,907, including $544,591 for 162 grants (high: $25,400; low: $25).
Purpose and activities: Grants for education, culture, hospitals, and youth.
Types of support: Operating budgets, matching funds.
Application information: Applications not accepted.
Officers: Keith L. Turley, Pres.; O. Mark De Michele, V.P.; Jaron B. Norgerg, Jr., V.P.; Nancy C. Loftin, Secy.; William J. Post, Treas.
Director: Shirley A. Richard.
Employer Identification Number: 953735903

24
Arizona Bank Charitable Foundation

c/o Security Pacific Bank Arizona
P.O. Box 2511
Phoenix 85002 (602) 262-2832

Established in 1977.
Donor(s): The Arizona Bank.
Financial data (yr. ended 12/31/87): Assets, $606,065 (M); expenditures, $606,065, including $586,077 for grants and $19,988 for 130 employee matching gifts.
Purpose and activities: Emphasis on social services, mainly through the United Way, capital fund drives for hospitals and other medical facilities, education, including scholarship programs for qualified and needy students, culture, and civic organizations, especially those concerned with the environment, civic planning, law and order, improving government, and preserving the free enterprise system.
Types of support: Employee matching gifts.
Limitations: Giving primarily in AZ. No support for religious denominations and church affiliate schools, fraternal organizations whose programs mainly benefit their own memebers, or organizations eligible for the United Way, but who refuse membership.
Application information:
 Initial approach: Letter
 Write: Jose A. Ronstadt, Chair.
Officer and Trustees: Jose A. Ronstadt, Chair.; Leon O. Chase, Secy.-Treas.; Robert L. Matthews, James E. Neihart, William S. Thomas, Jr.
Employer Identification Number: 860337807
Recent arts and culture grants:
Arizona Arts Stabilization Committee, Phoenix, AZ, $8,333. 1987.
Arizona Historical Society, Tucson, AZ, $8,333. 1987.
Heard Museum, Phoenix, AZ, $6,000. 1987.

Museum of Northern Arizona, Flagstaff, AZ, $19,717. 1987.
Phoenix Art Museum, Phoenix, AZ, $10,000. 1987.
Phoenix Performing Arts Center, Phoenix, AZ, $7,000. 1987.
Phoenix Symphony, Phoenix, AZ, $10,000. 1987.
Phoenix Zoo, Phoenix, AZ, $8,334. 1987.

25
Arizona Community Foundation

4350 East Camelback Rd., Suite 216C
Phoenix 85018 (602) 952-9954

Community foundation incorporated in 1978 in AZ.
Donor(s): L. Dilatush, R. Kieckhefer, Bert A. Getz, Newton Rosenzweig, G.R. Herberger.
Financial data (yr. ended 3/31/88): Assets, $19,174,267 (L); gifts received, $5,863,654; expenditures, $1,714,283, including $1,039,789 for 270 grants (high: $175,000; low: $100; average: $1,000-$10,000).
Purpose and activities: Support for children's mental health, youth agencies, health agencies, organizations for the handicapped, and other human services programs, community-based economic development, performing arts, and cultural programs.
Types of support: Seed money, emergency funds, equipment, technical assistance, special projects, operating budgets, continuing support, building funds, matching funds, scholarship funds, special projects, general purposes.
Limitations: Giving primarily in AZ. No grants to individuals, or for deficit financing, endowment funds, employee matching gifts, consulting services, or publications; low priority on capital grants.
Publications: Annual report, program policy statement, application guidelines, newsletter, financial statement, informational brochure.
Application information: Application form required.
 Initial approach: Letter or proposal
 Copies of proposal: 6
 Deadline(s): Feb. 1, Oct. 1, and June 1
 Board meeting date(s): Semiannually
 Final notification: 60 days
 Write: Stephen D. Mittenthal, Pres.
Officers and Directors: Bert A. Getz, Chair.; Stephen D. Mittenthal, Pres. and Exec. Dir.; Joan C. Nastro, Secy.; James D. Bruner, Treas.; and 21 other directors.
Number of staff: 4 full-time professional; 1 part-time professional; 1 full-time support.
Employer Identification Number: 860348306

26
Herbert Cummings Charitable Trust

6900 East Camelback Rd., No. 700
Scottsdale 85251-2431 (602) 990-0880

Established in 1984 in AZ.
Donor(s): Herbert K. Cummings.
Financial data (yr. ended 12/31/87): Assets, $1,036,654 (M); gifts received, $54,638; expenditures, $32,752, including $29,492 for 153 grants (high: $5,000; low: $10).
Purpose and activities: Giving primarily for cultural organizations and institutions, health

related research and services, and Jewish concerns; support also for child welfare and the aged.
Types of support: Annual campaigns, endowment funds, matching funds, research.
Limitations: Giving primarily in AZ.
Application information: Applications not accepted.
Deadline(s): None
Write: Herbert K. Cummings, Trustee
Trustees: Diane M. Cummings, Herbert K. Cummings, James K. Cummings.
Employer Identification Number: 866148404

27
DeGrazia Art & Cultural Foundation, Inc.
c/o Jennifer Potter
6300 North Swan Rd.
Tucson 85718 (602) 299-9191

Established in 1977 in AZ.
Financial data (yr. ended 6/30/87): Assets, $14,662,448 (M); expenditures, $494,833, including $95,535 for 13 grants (high: $25,000; low: $100).
Purpose and activities: Support for displaying the art works and artifacts of De Grazia to promote the appreciation of art and other cultural interests, to perpetuate and maintain for the benefit of the public the artistic works of De Grazia, and to provide a dignified cultural center for their display.
Types of support: General purposes.
Limitations: Giving primarily in AZ.
Application information:
Initial approach: Letter or proposal
Deadline(s): The end of each calendar quarter
Officers and Directors: Marion DeGrazia, Pres.; Harold Griere, Treas.; Frank De Grazia.
Employer Identification Number: 860339837

28
First Interstate Bank of Arizona, N.A. Charitable Foundation
P.O. Box 29743
Phoenix 85038-9743 (602) 229-4520

Established in 1976 in AZ.
Donor(s): First Interstate Bank of Arizona.
Financial data (yr. ended 12/31/87): Assets, $6,701,032 (M); gifts received, $2,002,041; expenditures, $1,087,046, including $1,062,853 for 262 grants (high: $189,180; low: $50; average: $500-$10,000).
Purpose and activities: Support for community funds and higher education, community development, hospitals, social service agencies, cultural programs, and youth agencies.
Types of support: Annual campaigns, building funds, continuing support, emergency funds, equipment, general purposes, land acquisition, research, scholarship funds, seed money, capital campaigns, renovation projects, operating budgets, special projects.
Limitations: Giving limited to AZ-based organizations or national organizations which fund programs in AZ. No support for solely religious purposes. No grants to individuals, or for endowment funds or travel; no loans.
Publications: Application guidelines.

Application information: Application form required.
Initial approach: Letter
Copies of proposal: 1
Deadline(s): Submit proposals Jan. through June and Sept. and Oct.
Board meeting date(s): Twice a month
Final notification: 2 months
Write: Mark A. Dinunzio, Chair., Corp. Contribs. Comm.
Trustees: Mark A. Dinunzio, Chair.; William T. Rauch, Dianne E. Stephens.
Number of staff: 2 part-time professional.
Employer Identification Number: 510204372

29
The Flinn Foundation
3300 North Central Ave., Suite 2300
Phoenix 85012 (602) 274-9000

Trust established in 1965 in AZ.
Donor(s): Mrs. Irene Flinn,† Robert S. Flinn, M.D.†
Financial data (yr. ended 12/31/88): Assets, $110,159,738 (M); expenditures, $5,603,742, including $4,699,446 for 98 grants (high: $135,314; low: $2,000; average: $20,000-$100,000).
Purpose and activities: The foundation concentrates its grantmaking in three broad areas: 1.the health and medical-care field including programs for health-care professionals, programs for the elderly and chronically ill, health programs for children, programs to increase access to services, and programs in health policy and analysis; 2.the education of youth in AZ including programs for gifted and talented students, and programs for promising disadvantaged students; 3.the cultural arts including programs to enhance artistic achievement and programs to strengthen the financial and management capabilities of AZ's principal arts organizations.
Types of support: Special projects, research, seed money, student aid, lectureships.
Limitations: Giving primarily in AZ and NM. No grants to individuals; or for matching gifts, emergency funds, land acquisitions, renovation projects, annual campaigns, capital or endowment funds, operating or deficit costs, or film projects; no support for equipment, publications, or workshops and conferences that are not an integral part of a larger project.
Publications: Program policy statement, application guidelines, multi-year report, grants list, newsletter, occasional report.
Application information:
Initial approach: Letter or telephone
Copies of proposal: 2
Deadline(s): None
Board meeting date(s): 6 times a year
Final notification: Within 12 weeks
Officers: Donald K. Buffmire, M.D., Chair. and Pres.; David R. Frazer, V.P. and Treas.; Jay S. Ruffner, Secy.
Directors: John W. Murphy, Exec. Dir.; Robert A. Brooks, M.D., David J. Gullen, M.D., Merlin W. Kampfer, M.D., Edward V. O'Malley, Jr., A.J. Pfister.
Number of staff: 4 full-time professional; 1 part-time professional; 3 full-time support.
Employer Identification Number: 860421476
Recent arts and culture grants:

Arizona Commission on the Arts, Phoenix, AZ, $45,000. Toward technical assistance program for developing visual and performing arts organizations. 5/24/88.
Community Programs in the Arts and Sciences (COMPAS), Phoenix, AZ, $7,500. Toward one-time support of matching contributions program for Phoenix area cultural organizations. 1/26/88.

30
Globe Foundation
3634 Civic Center Plaza
Scottsdale 85251 (602) 947-7888

Established in 1958 in IL.
Donor(s): Bert A. Getz.
Financial data (yr. ended 12/31/86): Assets, $7,995,166 (M); gifts received, $152,833; expenditures, $513,382, including $511,007 for 40 grants (high: $137,969; low: $100).
Purpose and activities: Giving primarily for publicly supported organizations and institutions, with emphasis on youth, education, and cultural organizations.
Limitations: Giving limited to AZ and IL. No support for privately supported groups. No grants to individuals, or for general operating expenses.
Application information: New applicants limited to $5,000. Application form required.
Deadline(s): Applications accepted only in Sept.
Final notification: Oct.
Write: C.L. Lux, V.P.
Officers and Directors: George F. Getz, Jr., Pres.; C.L. Lux, V.P. and Treas.; Bert A. Getz, Secy.; James W. Ashley, Lynn Getz Polite.
Employer Identification Number: 366054050

31
Margaret T. Morris Foundation
P.O. Box 592
Prescott 86302 (602) 445-4010

Established in 1967.
Donor(s): Margaret T. Morris.†
Financial data (yr. ended 12/31/87): Assets, $18,447,767 (M); expenditures, $941,015, including $895,344 for 46 grants (high: $150,000; low: $1,000).
Purpose and activities: Support for cultural programs, education, with emphasis on higher education, youth and child welfare, a community foundation, population control, and social services, primarily those benefitting the handicapped.
Types of support: Land acquisition, general purposes, building funds, scholarship funds, deficit financing, endowment funds, operating budgets.
Limitations: Giving primarily in AZ. No support for religious organizations or their agencies. No grants to individuals; no loans.
Publications: 990-PF.
Application information:
Initial approach: Proposal
Deadline(s): Submit proposal preferably in May through Nov.
Board meeting date(s): Aug. and Dec.
Final notification: After board meetings

Write: Eugene P. Polk, Trustee
Trustees: Richard L. Menschel, Eugene P. Polk.
Number of staff: None.
Employer Identification Number: 866057798

32
Phelps Dodge Foundation
2600 North Central Ave.
Phoenix 85004-3014 (602) 234-8100

Incorporated in 1953 in NY.
Donor(s): Phelps Dodge Corp., and subsidiaries.
Financial data (yr. ended 12/31/87): Assets,
$11,418,432 (M); expenditures, $956,013,
including $623,259 for grants (high: $25,000)
and $208,897 for employee matching gifts.
Purpose and activities: Emphasis on higher
education, community funds, health and
welfare, civic activities, and cultural programs.
Types of support: Continuing support, annual
campaigns, endowment funds, employee
matching gifts, scholarship funds, fellowships.
Limitations: Giving primarily in areas of
operations of Phelps Dodge Corp. and its
subsidiaries. No grants to individuals, or for
operating budgets, seed money, emergency
funds, deficit financing, research, special
projects, publications, or conferences; no loans.
Application information:
 Initial approach: Letter or proposal
 Copies of proposal: 1
 Deadline(s): Oct. to Nov.; budgeting process
 occurs in Dec.
 Board meeting date(s): Apr.
 Final notification: 3 to 4 months
 Write: William C. Tubman, Pres.
Officers: William C. Tubman, Pres.; Frank W.
Longto, V.P. and Treas.; Mary K. Sterling, Secy.
Directors: Cleveland E. Dodge, Jr., G. Robert
Durham, George B. Munroe, Edward L. Palmer,
John P. Schroeder.
Number of staff: 2 part-time professional; 1
part-time support.
Employer Identification Number: 136077350

33
Raymond Educational Foundation, Inc.
P.O. Box 1423
Flagstaff 86002 (602) 774-8081

Incorporated in 1951 in AZ.
Donor(s): R.O. Raymond.†
Financial data (yr. ended 4/30/88): Assets,
$2,053,827 (M); expenditures, $148,531,
including $116,900 for 9 grants (high: $87,900;
low: $1,500).
Purpose and activities: Grants limited to
institutions within Coconino County, Arizona,
principally for scholarship funds; some support
for cultural programs and health services.
Types of support: Scholarship funds.
Limitations: Giving limited to Coconino
County, AZ.
Publications: Program policy statement.
Application information:
 Initial approach: Proposal not exceeding 2
 pages
 Copies of proposal: 9
 Deadline(s): Mar. 31
 Board meeting date(s): As required
 Write: Henry L. Giclas, Pres.

Officers: Henry L. Giclas,* Pres.; John Stilley,*
Exec. V.P. and Treas.; Catherine Adel,* V.P.;
Charles B. Wilson, Secy.
Directors:* Valeen T. Avery, Eldon Bills, Platt
C. Cline, Wilfred Killip, Joyce Leamon, Ralph
Wheeler.
Number of staff: None.
Employer Identification Number: 866050920

34
Talley Industries Foundation, Inc.
2800 North 44th St.
Phoenix 85008-1592 (602) 957-7711

Financial data (yr. ended 12/31/87): Assets,
$516,859 (M); gifts received, $0; expenditures,
$90,535, including $89,086 for 13 grants (high:
$20,000; low: $1,000).
Purpose and activities: Support for health
associations, arts and culture, and education.
Types of support: Building funds, research.
Limitations: Giving primarily in AZ.
Application information:
 Initial approach: Typed proposal
 Deadline(s): None
 Write: Bill Bonnell, Dir. of Human Resources
Officers: William H. Mallender,* Pres.; Daniel
P. Mullen, V.P. and Treas.; Mark S.
Dickerson,* Secy.
Directors:* Jack C. Crim.
Employer Identification Number: 066090371

35
Tucson Community Foundation
6842 East Tanque Verde
Tucson 85715 (602) 772-1707

Established in 1980 in Tucson, AZ.
Financial data (yr. ended 7/31/88): Assets,
$4,686,489 (M); gifts received, $1,631,603;
expenditures, $935,283, including $746,639
for 100 grants (high: $15,000; low: $200;
average: $2,500), $60,000 for 35 grants to
individuals and $5,000 for 2 in-kind gifts.
Purpose and activities: Giving primarily for
arts and culture, social services, youth,
education, health, and the environment.
Types of support: General purposes,
equipment, renovation projects, student aid,
conferences and seminars, matching funds,
seed money, special projects, technical
assistance.
Limitations: Giving primarily in the Tucson,
AZ, metropolitan area. No support for
sectarian organizations. No grants to
individuals (except scholarships and art
fellowships).
Publications: Annual report, application
guidelines, financial statement, informational
brochure.
Application information: Application form
required.
 Initial approach: Telephone call to obtain
 application guidelines
 Copies of proposal: 20
 Deadline(s): Feb. and Aug.
 Board meeting date(s): Monthly
 Write: Donna L. Grant, Exec. Dir.
Officers and Trustees: Sidney Brinckerhoff,
Pres.; Elizabeth T. Alexander, V.P.; John Even,
V.P.; Nancy Kinerk, Secy.; Jerry Shull, Treas.;
and 24 other trustees.

Staff: Donna L. Grant, Exec. Dir.
Number of staff: 1 full-time professional; 1
part-time professional; 1 full-time support; 2
part-time support.
Employer Identification Number: 942844781

36
Valley Bank Charitable Foundation, Inc.
P.O. Box 71, B633
Phoenix 85001 (602) 221-4613

Incorporated in 1978 in AZ.
Donor(s): Valley National Bank of Arizona.
Financial data (yr. ended 12/31/87): Assets,
$2,233,646 (M); expenditures, $1,493,613,
including $1,483,151 for 162 grants (high:
$285,937; low: $200; average: $1,000-
$10,000).
Purpose and activities: Emphasis on
community funds, cultural programs, including
museums and the performing arts, higher
education, social services, youth agencies, and
hospitals.
Types of support: Annual campaigns, capital
campaigns, operating budgets, seed money.
Limitations: Giving limited to AZ. No support
for religious organizations. No grants to
individuals, or for research.
Publications: Informational brochure (including
application guidelines).
Application information: Application form
required.
 Initial approach: Letter
 Copies of proposal: 1
 Deadline(s): None
 Board meeting date(s): Quarterly
 Final notification: Following board meetings
 Write: Neil H. Christensen, Secy.-Treas.
Officers and Directors: Leonard W. Huck,
Pres.; Howard C. McCrady, V.P.; Neil H.
Christensen, Secy.-Treas.; Timothy Creedon, J.
Robert White.
Number of staff: 1 full-time professional; 2 full-
time support.
Employer Identification Number: 953330232

37
Western Savings and Loan Corporate
Giving Program
6001 North 24th St.
Phoenix 85016 (602) 468-5500

Financial data (yr. ended 12/31/88): Total
giving, $500,000, including $475,000 for
grants and $25,000 for 150 in-kind gifts.
Purpose and activities: Supports arts, culture,
health, welfare, education, and civic affairs
programs.
Types of support: General purposes, capital
campaigns, annual campaigns.
Limitations: Giving primarily in AZ, particularly
Maricopa County area.
Application information: Must have request in
writing.
 Copies of proposal: 1
 Deadline(s): On-going
 Board meeting date(s): As needed
 Write: Sandy Rolland, Public Relations
Administrators: Pat Connor, P.R. Coordinator;
John Meadows, Dir., Marketing; Sandy Rolland,
P.R. Mgr.
Number of staff: 1 full-time professional; 1 full-
time support.

38
Edna Rider Whiteman Foundation
Empire Southwest
P.O. Box 2985
Phoenix 85062 (602) 898-4400
Application address: 1725 South Country Club,
Phoenix, AZ 85062

Established in 1961 in AZ.
Donor(s): C.O. Whiteman.†
Financial data (yr. ended 7/31/88): Assets,
$1,843,207 (M); gifts received, $36,609;
expenditures, $170,638, including $146,065
for 140 grants (high: $10,000; low: $25;
average: $1,000-$1,500).
Purpose and activities: Grants for health and
social services, arts and culture, youth and
education, and civic affairs.
Types of support: Annual campaigns, building
funds, capital campaigns, conferences and
seminars, continuing support, emergency funds,
employee matching gifts, equipment, general
purposes, land acquisition, lectureships,
matching funds, operating budgets,
publications, renovation projects, research,
seed money, special projects, endowment
funds, employee-related scholarships.
Limitations: Giving primarily in the Phoenix,
AZ, metropolitan area. No support for religious
organizations, athletic organizations, fraternal
organizations, or organizations that are largely
tax-supported. No grants to individuals.
Publications: Informational brochure (including
application guidelines).
Application information:
 Initial approach: Letter of request with
 proposal
 Copies of proposal: 1
 Deadline(s): 1 month prior to board meetings
 Board meeting date(s): 2nd Wed. in Sept.,
 Dec., Mar., and June
 Final notification: Following board meeting
 Write: John G. Hough, Treas.
Officers: Jack W. Whiteman, Pres.; E.R.
Strahm, Secy.; John G. Hough, Treas.
Directors: Lynne Denton, Louise Kleinz, Jeffrey
Whiteman.
Number of staff: 1 part-time professional.
Employer Identification Number: 866052816

ARKANSAS

39
Arkansas Community Foundation, Inc.
604 East Sixth St.
Little Rock 72202 (501) 372-1116

Established in 1976 in AR.
Financial data (yr. ended 7/31/88): Assets,
$5,588,210 (M); gifts received, $2,095,440;
expenditures, $1,062,334 for 189 grants (high:
$61,690; low: $100; average: $1,000-$5,000).
Purpose and activities: Grants for social
services, cultural programs, health, community
development, the environment, and
scholarships.

Types of support: Scholarship funds, general
purposes, research, seed money, special
projects, student loans, student aid.
Limitations: Giving primarily in AR.
Publications: Annual report (including
application guidelines), financial statement,
newsletter, informational brochure, grants list.
Application information: Application form
required.
 Initial approach: Letter or telephone
 Copies of proposal: 7
 Deadline(s): Jan. 1, Apr. 1, July 1, Sept. 1,
 and Oct. 1
 Board meeting date(s): Mar., June, Sept., and
 Dec.
 Write: Martha Ann Jones, Exec. Dir., Bonnie
 Nickol, Prog. Dir., or Becky Bien, Admin.
Officers and Trustees: Don Munro, Pres.;
William Dunklin, 1st V.P.; William Fisher, 2nd
V.P.; Betty Lile, Secy.; Bronson Van Wyck,
Treas.; Martha Ann Jones, Exec. Dir.; Bum
Atkins, Curtis Bradbury, Peggy Clark, Thedford
Collins, Herman Davenport, Michael Gibson,
JaNelle Hembree, Carter Hunt, Kent Ingram,
Malcolm McNair, Julia Peck Mobley, John
Rush, Charles Scharlau, Betty Sloan, Sam
Sowell, Larry Wallace, Charles West.
Number of staff: 4 full-time professional; 1 full-
time support.
Employer Identification Number: 521055743

40
Arkla Corporate Giving Program
400 E. Capitol Ave.
P.O. Box 751
Little Rock 72203 (501) 377-4610

Purpose and activities: Support for a wide
variety of programs, including health services,
mental health, AIDS, child welfare, drug abuse,
rural development, leadership development,
volunteerism, media and communications,
literacy, libraries, education including
secondary education, and the performing and
fine arts.
Types of support: Annual campaigns, building
funds, conferences and seminars, deficit
financing, employee matching gifts, equipment.
Limitations: Giving primarily in major
operating areas; states served include AR, CA,
KS, TX, OK and MS. No grants to individuals.
Publications: Corporate report, informational
brochure.
Application information:
 Initial approach: Letter of inquiry; include
 constituency
 Copies of proposal: 1
 Deadline(s): None
 Write: James L. Rutherford, III, Sr. V.P. for
 Little Rock, AR, area, or Hugh H.
 McCastlain for Shreveport, LA, area
Administrators: James L. Rutherford III, Sr.
V.P.; Hugh H. McCastlain, Exec. V.P.

41
M. M. Cohn Company Foundation
P.O. Box 911
Little Rock 72203-0911

Financial data (yr. ended 1/31/88): Assets,
$4,614 (M); expenditures, $35,505, including

$35,491 for 23 grants (high: $11,700; low:
$25).
Purpose and activities: Support for medical
research and assistance, arts, social services,
wildlife, and civic affairs.
Application information: Contributes only to
preselected organizations. Applications not
accepted.
Officers: H. Donald Pfeifer, Secy.-Treas.; A.
Dan Phillips, Pres.
Employer Identification Number: 716052676

42
First Commercial Bank Corporate
Giving Program
Capital and Broadway
Little Rock 72201 (501) 371-7284

Financial data (yr. ended 12/31/86):
$160,000 for grants.
Purpose and activities: Giving primarily for
community funds and development, arts and
culture, education, and health and welfare;
giving includes in-kind services and technical
assistance.
Types of support: In-kind gifts, general
purposes, operating budgets, special projects.
Limitations: Giving limited to AR.
Publications: Informational brochure (including
application guidelines).
Application information:
 Initial approach: Proposal with budget
 Final notification: 3 weeks
 Write: Charles Stewart, Sr. V.P.
Number of staff: None.

43
Murphy Foundation of Louisiana
200 North Jefferson, Suite 400
El Dorado 71730
Application address: 200 Peach St., El Dorado,
AR 71730; Tel.: (501) 862-6411

Established in 1958 in LA.
Donor(s): Bertie M. Deming, John W. Deming,
C.H. Murphy, Jr.
Financial data (yr. ended 4/30/87): Assets,
$1,730,000 (M); gifts received, $17,000;
expenditures, $59,374, including $56,000 for 4
grants (high: $30,000; low: $1,000).
Purpose and activities: Grants primarily for
higher education and culture.
Limitations: Giving primarily in northern LA.
Application information:
 Initial approach: Letter
 Deadline(s): None
 Write: Lucy A. Ring, Secy.-Treas.
Officers: Johnie W. Murphy,* Pres.; Bertie M.
Deming,* V.P.; Lucy A. Ring, Secy.-Treas.
Directors:* John W. Deming, C.H. Murphy, Jr.
Employer Identification Number: 726018262

44
William C. & Theodosia Murphy Nolan
Foundation
200 North Jefferson, Suite 308
El Dorado 71730

Established in 1962 in AR.
Donor(s): Theodosia Murphy Nolan, William
C. Nolan.

Financial data (yr. ended 2/28/87): Assets, $1,320,325 (M); expenditures, $69,958, including $69,267 for 19 grants (high: $19,475; low: $100).
Purpose and activities: Grants primarily for education, medical research, culture, and historic preservation.
Types of support: Building funds, operating budgets, general purposes, research, scholarship funds.
Officers: Theodosia Murphy Nolan, Pres.; William C. Nolan, V.P.; William C. Nolan, Jr., Secy.-Treas.
Director: Robert C. Nolan.
Employer Identification Number: 716049791

45
Overstreet Short Mountain Foundation
1500 South Albert Pike, Unit 29
Fort Smith 72903-3053

Established in 1982 in AR.
Financial data (yr. ended 5/31/88): Assets, $595,693 (M); expenditures, $243,844, including $229,984 for 4 grants (high: $199,789; low: $205).
Purpose and activities: Support primarily for an agricultural museum; support also for a Presbyterian church.
Application information: Contributes only to pre-selected organizations. Applications not accepted.
Officers: Maudress E. Overstreet, Chair.; Carl E. Hefner, Vice-Chair.; R.C. Taylor, Secy.
Employer Identification Number: 710564702

46
Rebsamen Fund
P.O. Box 3198
Little Rock 72203

Incorporated in 1944 in AR.
Donor(s): Rebsamen Cos., Inc.
Financial data (yr. ended 11/30/88): Assets, $1,118,354 (M); gifts received, $105,930; expenditures, $131,359, including $126,130 for 86 grants (high: $28,000; low: $50).
Purpose and activities: Emphasis on higher education, community funds, health services, civic affairs and recreation, cultural programs, and religion.
Limitations: Giving primarily in AR.
Application information:
 Deadline(s): None
Officers and Directors: Kenneth Pat Wilson, Pres.; H. Maurice Mitchell, V.P.; Sam C. Sowell, V.P.; Patricia Lavender, Secy.-Treas.
Employer Identification Number: 716053911

47
The Donald W. Reynolds Foundation, Inc.
920 Rogers Ave.
Fort Smith 72901
Application address: P.O. Box 1359, Fort Smith, AR 72902; Tel.: (501) 785-7810

Incorporated in 1954 in NV.
Donor(s): Donald W. Reynolds, Southwestern Publishing Co., Southwestern Operating Co., and others.

Financial data (yr. ended 6/30/88): Assets, $12,661,693 (M); gifts received, $6,000,000; expenditures, $399,874, including $355,099 for 88 grants (high: $20,000; low: $100).
Purpose and activities: Grants largely for higher education, community funds, cultural programs, health, social service and youth agencies, civic affairs and community development.
Types of support: Matching funds, scholarship funds.
Limitations: Giving primarily in areas served by Donney Media Group in AR, CA, CO, HI, MO, NM, NV, OK, TX, and WA.
Publications: Application guidelines.
Application information:
 Initial approach: Proposal
 Deadline(s): June 15, Sept. 15, Dec. 15, and Mar. 15
 Board meeting date(s): Quarterly
Officers and Directors: Donald W. Reynolds, Pres.; Fred W. Smith, Exec. V.P.; E.H. Patterson, Treas.; Don R. Buris, Bob G. Bush, Robert S. Howard, George O. Kleier, Ross Pendergraft, Don E. Pray.
Employer Identification Number: 716053383

48
The Winthrop Rockefeller Foundation
308 East Eighth St.
Little Rock 72202 (501) 376-6854

Incorporated in 1956 in AR as Rockwin Fund, Inc.; renamed in 1974.
Donor(s): Winthrop Rockefeller.†
Financial data (yr. ended 12/31/88): Assets, $41,227,377 (M); gifts received, $690,000; expenditures, $4,188,292, including $3,044,494 for 389 grants (high: $1,000,000; low: $70; average: $10,000-$40,000) and $273,703 for loans.
Purpose and activities: Emphasis on economic development and education; support for local projects which (a) improve the delivery of services or administrative capacity of institutions; (b) increase the participation of people in the decision-making process; or (c) achieve more productive development and use of human, physical, and fiscal resources. The foundation will fund innovative demonstration projects which improve people's living standards and the institutions which serve the community; projects which have economic development potential; and community-based projects concerned with organizational planning and fundraising.
Types of support: Special projects, seed money, conferences and seminars, matching funds, technical assistance, consulting services, program-related investments, publications.
Limitations: Giving primarily in AR, or projects that benefit AR. No grants to individuals, or for capital expenditures, endowments, building funds, equipment, annual fund drives, deficit financing, general support, emergency funds, most types of research, trips by community organizations, scholarships, or fellowships.
Publications: Annual report (including application guidelines), occasional report.
Application information: Application form required.
 Initial approach: Telephone or letter
 Copies of proposal: 2

 Deadline(s): Submit proposal preferably by June 1 or Dec. 1
 Board meeting date(s): On the 1st weekend in Mar., June, Sept., and Dec.; new projects considered only in Mar. or Sept.
 Final notification: 2 weeks after board meeting dates
 Write: Mahlon Martin, Pres.
Officers: Mahlon Martin, Pres.; Teresa Hudson, Controller.
Directors: John L. Ward, Chair.; Leslie Lilly, Vice-Chair.; James D. Bernstein, Ernest G. Green, Joe Hatcher, Cora D. McHenry, Robert D. Pugh, Andree Layton Roaf, Winthrop Paul Rockefeller, Thomas B. Shropshire, Martin D. Strange.
Number of staff: 5 full-time professional; 2 full-time support; 1 part-time support.
Employer Identification Number: 710285871
Recent arts and culture grants:
Arkansas Endowment for the Humanities, Little Rock, AR, $10,000. To develop plans for Arkansas-based global studies institute for secondary teachers in mid-America. The institute will focus on western hemisphere, and use agriculture as unifying theme. 9/12/87.
Historic Preservation Alliance, Historic Tourism Action Plan, Little Rock, AR, $37,000. To develop action plan that would allow state tourism industry to make use of historic sites to increase number of visitors to local communities and have positive impact on local economy. 9/10/88.

49
Tyson Foundation, Inc.
P.O. Drawer E
Springdale 72764 (501) 756-4513

Established in 1970 in AR.
Financial data (yr. ended 12/31/87): Assets, $5,581,262 (M); gifts received, $23,500; expenditures, $284,352, including $126,111 for 39 grants (high: $35,000; low: $51) and $122,273 for 137 grants to individuals.
Purpose and activities: Grants for community projects, education, social services, and culture.
Types of support: Student aid.
Limitations: Giving limited to the mid-South area.
Application information: Application form required.
 Deadline(s): None
 Write: Cheryl J. Tyson, Trustee
Trustees: James B. Blair, Harry C. Erwin, Joe F. Starr, Cheryl L. Tyson, John H. Tyson.
Employer Identification Number: 237087948

CALIFORNIA

50
ABC Foundation
P.O. Box 3809
San Francisco 94119-3809

Donor(s): Nonie B. Ramsay.
Financial data (yr. ended 12/31/87): Assets,
$1,682,222 (M); expenditures, $89,887,
including $86,000 for 14 grants (high: $20,000;
low: $500).
Purpose and activities: Giving primarily for
education, cultural programs, and general
charities.
Limitations: Giving limited to CA. No grants
to individuals.
Application information: Contributes only to
pre-selected organizations. Applications not
accepted.
Officers: Nonie B. Ramsay,* Pres.; Elizabeth
H. Bechtel,* V.P.; A. Barlow Perguson, Secy.;
Charles J. Spevak, Treas.; Theodore J.
VanBebber, Treas.
Directors:* S.D. Bechtel, Jr.
Employer Identification Number: 942415607

51
The Aerospace Corporate Contributions Program
2350 East El Segundo Blvd., M.S. MI-448
El Segundo 90245 (213) 336-6515
Special address for applications: P.O. Box
92957, Los Angeles, CA 90278

Financial data (yr. ended 09/30/89): Total
giving, $384,000, including $101,000 for
grants and $283,000 for employee matching
gifts.
Purpose and activities: Supports education
including public colleges; and federated
campaigns including the United Way; also
supports human services, including alcohol
rehabilitation, child welfare and health care;
also culture, including music, museums, and
performing arts. Matching gifts used for
education only.
Types of support: General purposes, annual
campaigns, employee matching gifts.
Limitations: Giving primarily in communities
where company employees live and work,
in Greater Los Angeles, CA, area.
Publications: Informational brochure.
Application information:
 Write: Janet M. Antrim, Coord., Community
 Support
Administrators: Janet M. Antrim, Coord.,
Community Support; David C. Cone, Dir.,
Public Affairs.
Number of staff: 1 full-time professional.

52
The Ahmanson Foundation
9215 Wilshire Blvd.
Beverly Hills 90210 (213) 278-0770
Incorporated in 1952 in CA.
Donor(s): Howard F. Ahmanson,† Dorothy G.
Sullivan,† William H. Ahmanson, Robert H.
Ahmanson.
Financial data (yr. ended 10/31/88): Assets,
$386,636,000 (M); expenditures, $16,010,543,
including $13,794,543 for 381 grants (high:
$1,352,403; low: $200; average: $1,000-
$500,000).
Purpose and activities: Emphasis on
education, the arts and humanities, medicine
and health, and a broad range of social welfare
programs, including youth organizations.
Types of support: Building funds, equipment,
land acquisition, endowment funds, matching
funds, scholarship funds, special projects,
renovation projects, capital campaigns.
Limitations: Giving primarily in southern CA,
with emphasis on the Los Angeles area. No
grants to individuals, or for continuing support,
annual campaigns, deficit financing,
professorships, internships, fellowships, or
exchange programs; no loans.
Publications: Program policy statement,
application guidelines, grants list.
Application information:
 Initial approach: Proposal or letter
 Copies of proposal: 1
 Deadline(s): None
 Board meeting date(s): 3 to 4 times annually
 Final notification: 30 to 60 days
 Write: Lee E. Walcott, V.P. and Managing
 Dir.
Officers: Robert H. Ahmanson,* Pres.; William
H. Ahmanson,* V.P.; Lee E. Walcott, V.P.;
Karen A. Hoffman, Secy.; Donald B. Stark,
Treas.
Trustees:* Howard F. Ahmanson, Jr., Daniel
N. Belin, Robert M. DeKruif, Robert F. Erburu,
Franklin D. Murphy, M.D.
Number of staff: 8 full-time professional.
Employer Identification Number: 956089998
Recent arts and culture grants:
Aman Folk Ensemble, Los Angeles, CA, $7,745.
 Toward new series of community service
 programs to be presented in collaboration
 with Los Angeles County Public Library.
 1987.
American Council for the Arts, NYC, NY,
 $25,000. Toward support for Arts Education
 program. 1987.
American Friends of the Israel Museum, NYC,
 NY, $5,000. For general support. 1987.
Antelope Valley Cultural Foundation, Apple
 Valley, CA, $10,000. Toward establishment
 of performing arts theater. 1987.
Arrowhead Arts Association, Blue Jay, CA,
 $7,500. For Third Annual Music Festival.
 1987.
California Institute of the Arts, Valencia, CA,
 $250,000. For scholarship support during
 academic 1986-87 and 1987-88. 1987.
California Institute of the Arts, Valencia, CA,
 $15,000. For purchase of van and for Inter-
 and Intra-School projects during academic
 1986-87 and 1987-88. 1987.
California Museum Foundation, Los Angeles,
 CA, $1,000,000. Toward retirement of
 building debt, program development and

installation and maintenance of new exhibits.
 1987.
Center Theater Group of Los Angeles, Los
 Angeles, CA, $25,000. For matching grant
 for general support. 1987.
Center Theater Group of Los Angeles, Los
 Angeles, CA, $5,000. Toward support of
 Ahmanson Theater and Mark Taper Forum
 through Brighton Beach Memoirs benefit.
 1987.
Charles W. Bowers Museum Corporation, Santa
 Ana, CA, $5,000. For expansion, acquisition
 and development. 1987.
Community School of Performing Arts, Los
 Angeles, CA, $45,000. Toward endowment
 to create scholarship fund for gifted
 artist/student. 1987.
Community Television of Southern California,
 Los Angeles, CA, $50,000. To renew partial
 underwriting of NOVA series for 1987
 season. 1987.
Community Television of Southern California,
 Los Angeles, CA, $50,000. Toward renewal
 of partial underwriting of NOVA series for
 1988 season. 1987.
Craft and Folk Art Museum Incorporating the
 Egg and the Eye, Los Angeles, CA, $90,000.
 Toward endowment and furnishings for new
 building. 1987.
Craft and Folk Art Museum Incorporating the
 Egg and the Eye, Los Angeles, CA, $5,000.
 For general support. 1987.
Douglas County Historical Society, Omaha, NE,
 $25,000. Toward support of archival, exhibit
 and program development of society's
 collections. 1987.
Fresno Metropolitan Museum of Art, History
 and Science, Fresno, CA, $10,000. Toward
 Science Section. 1987.
Friends of the Junior Arts Center, Los Angeles,
 CA, $6,275. Toward publication of results of
 major study of visitors to 28 regional
 museums conducted by Museum Educators
 of Southern California. 1987.
Grand People Tour Company, Los Angeles, CA,
 $16,000. Toward upgrading electrical system
 and plumbing for new facility housing
 performing arts auditorium for seniors. 1987.
Harvard University, President and Fellows of
 Harvard College, Cambridge, MA, $50,000.
 Toward preservation fund for Villa I Tatti.
 1987.
Historic Churches Preservation Fund, NYC, NY,
 $25,000. For general support for
 Westminister Abbey restoration program.
 1987.
Japanese American Cultural and Community
 Center, Los Angeles, CA, $20,000. To assist
 in book purchases and related costs for
 expansion of Franklin D. Murphy Library.
 1987.
Kansas University Endowment Association,
 University of Kansas, Lawrence, KS,
 $25,000. To acquisition fund for Art History
 Library. 1987.
Lincoln Theater Foundation, DC, $30,000. For
 restoration of Lincoln Theater. 1987.
Living Desert Reserve, Palm Desert, CA,
 $10,000. For general support. 1987.
Los Angeles Arts High School Center
 Foundation, Los Angeles, CA, $15,000.
 Toward second year funding of Community
 Outreach Program. 1987.

Los Angeles Chamber Orchestra Society, Pasadena, CA, $5,000. For general support. 1987.

Los Angeles Childrens Museum, Los Angeles, CA, $20,000. Toward redesign and renovation of T.V. Studio Exhibit. 1987.

Los Angeles County Museum of Natural History Foundation, Los Angeles, CA, $25,000. Toward construction of Museum's Great Bird Hall. 1987.

Los Angeles Educational Partnership, Los Angeles, CA, $125,000. For continuing support for Humanities Program. 1987.

Los Angeles Police Band Association, Sherman Oaks, CA, $7,500. Toward purchase of band uniforms. 1987.

Los Angeles Theater Works, Venice, CA, $10,000. Toward multi-disciplinary arts curriculum to promote students' development of positive self-concepts, discipline, creativity and effective relationships. 1987.

Mission San Juan Capistrano, San Juan Capistrano, CA, $10,000. Toward completion of exhibition environment documenting Mexican Rancho Period. 1987.

Museum Associates, Los Angeles, CA, $1,250,000. Toward acquisition of Jan Steen's painting, Samson and Delilah. 1987.

Museum Associates, Los Angeles, CA, $725,000. Toward purchase of altar piece painting entitled, Holy Family with Saint Francis in a Landscape, by Vasari. 1987.

Museum Associates, Los Angeles, CA, $69,500. Toward acquisition of Madonna drawing by Tanzio da Varallo. 1987.

Museum Associates, Los Angeles, CA, $50,000. For general support. 1987.

Museum Associates, Los Angeles, CA, $25,000. Toward decorative art purchases. 1987.

Museum Associates, Los Angeles, CA, $20,000. Toward acquisition of Babylonian sculpture, the Seated Baboon. 1987.

Museum Associates, Los Angeles, CA, $5,000. For general support. 1987.

Museum of Contemporary Art, Los Angeles, CA, $25,000. For general support. 1987.

Music Center Foundation, Los Angeles, CA, $30,000. For general support for Music Center Unified Fund. 1987.

Napili Kai Foundation, Lahaina, HI, $25,000. For general support. 1987.

National Cowboy Hall of Fame and Western Heritage Center, Oklahoma City, OK, $10,000. For general support. 1987.

National Symphony Orchestra Association of Washington, D.C., DC, $10,000. For general support. 1987.

Odyssey Theater Foundation, Los Angeles, CA, $5,000. For general support for this equity waiver theater complex. 1987.

Otis Art Institute of Parsons School of Design, Los Angeles, CA, $1,000,000. Toward capital campaign to expand campus facilities. 1987.

Performing Tree, Los Angeles, CA, $14,000. Toward Model Program of arts education at four underserved schools in Los Angeles. 1987.

Plaza de la Raza, Los Angeles, CA, $29,000. Toward cost of long range planning program. 1987.

Prospect Hill Cemetery Historical Site Development Foundation, Omaha, NE, $25,000. Toward general equipment and property taxes. 1987.

Roman Catholic Archbishop of Los Angeles, Los Angeles, CA, $20,000. For Cathedral of Saint Vibiana--for execution and installation of tapestries at Japanese American Cultural Center, in connection with Pope John Paul's 1987 visit. 1987.

Santa Barbara Symphony Orchestra Association, Santa Barbara, CA, $25,000. For two-to-one challenge grant toward debt retirement. 1987.

South Coast Repertory, Costa Mesa, CA, $100,000. Toward capital campaign to initiate new play development program. 1987.

Triton Museum of Art, Santa Clara, CA, $5,000. For general support. 1987.

United States Catholic Conference, DC, $5,000. Toward relocation to new studio and office space for Saint Joseph Ballet Company. 1987.

University of California, Berkeley, CA, $500,000. For UCLA Museum of Cultural History for construction of facilities. 1987.

University of California, Berkeley, CA, $200,000. For UC Riverside toward completion of Eighteenth Century Short Title Catalogue of computerized listings of English and American publications. 1987.

University of California at Los Angeles Foundation, Center for Medieval and Renaissance Studies, Los Angeles, CA, $20,000. For general support for Center for Medieval and Renaissance Studies. 1987.

University of California at Los Angeles Foundation, Franklin D. Murphy Sculpture, Los Angeles, CA, $25,000. In support of Conservation program for Sculpture Garden. 1987.

University of Southern California, K U S C-FM, Los Angeles, CA, $10,000. Toward purchase and equipping of new mobile production vehicle. 1987.

Whittier College, Whittier, CA, $100,000. Toward construction of new Performing Arts Center. 1987.

World Monuments Fund, NYC, NY, $10,000. For general support. 1987.

53
The Albertson Foundation
c/o Robert Sutton
12839 Marlboro St.
Los Angeles 90049-3720 (213) 386-1196

Incorporated in 1964 in CA.
Donor(s): Hazel H. Albertson.†
Financial data (yr. ended 12/31/86): Assets, $0 (M); expenditures, $1,324,807, including $1,311,850 for 2 grants (high: $1,310,850; low: $1,000; average: $5,000-$10,000).
Purpose and activities: Emphasis on private secondary education, cultural institutions, hospitals, and youth activities.
Types of support: Continuing support, annual campaigns, building funds, equipment, research.
Limitations: Giving primarily in southern CA. No grants to individuals, or for operating budgets, seed money, emergency funds, deficit financing, endowment funds, matching gifts,

scholarships, fellowships, special projects, publications, or conferences; no loans.
Application information:
 Initial approach: Letter
 Copies of proposal: 3
 Deadline(s): Submit proposal preferably in Sept. or Oct.; deadline Oct. 31
 Board meeting date(s): Nov.
 Final notification: 4 weeks
 Write: Robert F. O'Neill, Pres.
Officers: Robert F. O'Neill, Pres.; Kay S. Onderdonk, V.P. and Secy.; Jean A. Peck, V.P. and Treas.
Number of staff: 1 part-time professional; 1 part-time support.
Employer Identification Number: 956100378

54
Allequash Foundation
234 East Colorado Blvd., Rm. 225
Pasadena 91101-2206

Established in 1961 in CA.
Donor(s): Alexander P. Hixon, Midland Investment Co.
Financial data (yr. ended 12/31/86): Assets, $660,135 (M); gifts received, $738,858; expenditures, $260,683, including $259,765 for 61 grants (high: $33,525; low: $20).
Purpose and activities: Grants for higher and secondary education, social services, culture, and a nature conservancy program.
Application information: Contributes only to pre-selected organizations. Applications not accepted.
Directors: Adelaide F. Hixon, Alexander P. Hixon.
Employer Identification Number: 956050003

55
American Medical International Contributions Program
414 North Camden Dr.
Beverly Hills 90210 (213) 205-6016

Financial data (yr. ended 08/31/88): Total giving, $750,000, including $600,000 for grants and $150,000 for employee matching gifts.
Purpose and activities: Support for community development, education, civic affairs and arts, medical education, business education, the disadvantaged, literacy, social services, youth, and public policy organizations. Support also for medical care for the indigent; includes in-kind giving.
Types of support: Equipment, general purposes, continuing support, employee matching gifts, in-kind gifts.
Limitations: Giving primarily in major operating areas.
Publications: Corporate report.
Application information: Include proof of 501(c)(3) status, purpose and budget of project.
 Copies of proposal: 1
 Deadline(s): Committee meets quarterly
 Final notification: Within 3 months
 Write: Diane Marquis-Sebie, Mgr., Corp. Contribs.
Number of staff: 1 part-time professional.

56
American President Companies Foundation

1800 Harrison St., 21st Fl.
Oakland 94612-3429 (415) 272-8369

Established in 1984 in CA.
Donor(s): American President Cos., Ltd.
Financial data (yr. ended 12/31/87): Assets, $1,005,328 (M); gifts received, $500,000; expenditures, $448,662, including $448,189 for 138 grants (high: $142,100).
Purpose and activities: Giving to health, educational, civic, and cultural programs.
Types of support: General purposes.
Limitations: Giving primarily in the City of Oakland, the San Francisco Bay Area, CA, and company and subsidiary operating locations; support also for national programs. No support for religious, veterans', labor, or fraternal organizations.
Application information: Applications must be submitted in writing using forms provided for this purpose or by means of other documentation acceptable to the Foundation.
 Initial approach: Letter
 Deadline(s): None
 Write: Michael T. Maher, V.P.
Officers and Directors:* W.B. Seaton,* Pres.; John E. Flynn,* V.P. and C.F.O.; Richard L. Tavrow,* V.P., Secy., and General Counsel; Joji Hayashi,* V.P.; Michael T. Maher, V.P.; Derek Foote, Treas.; William J. Stuebgen, Cont.
Employer Identification Number: 942955262

57
Apple Computer Corporate Giving Program

20525 Mariani Ave., MS:38J
Cupertino 95014 (408) 974-2974

Financial data (yr. ended 12/31/87): $3,400,000 for grants.
Purpose and activities: Apple donates equipment, including basic software, computers, printers, modems, and disk drives, initial training, technical support, access to on-line systems, and opportunities to network to nonprofit organizations. Grants are awarded within 3 fields of interest: 1) citizen action-includes direct services involving health, human services, environmental protection, the elderly, substance abuse, and economic development; 2) arts and culture-includes the use of computers by performing and visual arts groups, and arts councils for information management or direct artistic applications; and 3) the disabled-involves use of computer systems by agencies serving the disabled and by the disabled themselves. Support also for research and development-involves medical, scientific, and social scientific research and skills development, including innovative community based training programs that enhance educational and vocational opportunities for the disabled, disadvantaged, or those at-risk. Apple Education Grants help teachers improve the outlook of at-risk students by enabling educators to develop technology-based curricula. Apple also makes some cash contributions, mainly by matching employee gifts. In addition employees use a weekly

payroll deduction to make contributions, and participate in employee volunteer programs.
Types of support: In-kind gifts.
Limitations: No support for political or religious uses. No grants to individuals.
Publications: Corporate giving report, informational brochure, application guidelines, newsletter.
Application information: Application form required.
 Initial approach: Letter; ask for application-guidelines
 Final notification: 8-10 weeks after complete application is submitted
 Write: Fred Silverman, Mgr., Corp. Grants

58
Applied Materials Corporate Philanthropy Program

M.S. 0918
P.O. Box 58039
Santa Clara 95054 (408) 729-5555
Application address: 3050 Bowers Ave., Santa Clara, CA 95054

Financial data (yr. ended 10/31/89): Total giving, $2,050,000, including $50,000 for grants (high: $5,000; low: $25) and $2,000,000 for 4 in-kind gifts.
Purpose and activities: Supports the arts, leadership development, business education, mathematics, youth, minorities, and women.
Types of support: Annual campaigns, consulting services, employee matching gifts, equipment, fellowships, program-related investments, special projects, in-kind gifts.
Limitations: Giving primarily in Santa Clara, CA. No grants for general operating costs; support for specific programs only.
Publications: Corporate report, informational brochure (including application guidelines).
Application information:
 Initial approach: Letter
 Copies of proposal: 6
 Deadline(s): Quarterly
 Write: Tom Hayes, Corp. Relations Mgr.
Number of staff: 1 full-time professional; 1 full-time support.

59
ARCO Foundation

515 South Flower St.
Los Angeles 9007i (213) 486-3342

Incorporated in 1963 in NY.
Donor(s): Atlantic Richfield Co.
Financial data (yr. ended 12/31/88): Assets, $3,270,037 (M); gifts received, $19,724,125; expenditures, $14,091,746, including $12,213,497 for 1,539 grants (high: $103,495; low: $500; average: $2,500-$25,000) and $1,878,249 for 11,125 employee matching gifts.
Purpose and activities: Giving primarily to programs that address the underlying causes of educational, social, and cultural disparity in American life. Early involvement in "root-cause" issues allows the foundation to test innovative models, build leadership and leverage its investments to generate the greatest return to ARCO and the society. Support largely for higher and pre-collegiate education,

including minority retention programs in business and science and engineering; community programs, especially for low income groups, including job creation and job training programs, community economic development, neighborhood revitalization, and youth agencies; aging programs; access to the humanities and the arts; public information organizations; and environmental programs.
Types of support: Operating budgets, seed money, equipment, land acquisition, matching funds, employee matching gifts, employee-related scholarships, special projects, technical assistance.
Limitations: Giving primarily in areas of company operations, especially Anchorage, AK, Dallas, TX, and Los Angeles, CA. No support for sectarian religious organizations, professional associations, specialized health organizations, or military or veterans' organizations. No grants to individuals, or for professional schools of art, academic art programs, performances at colleges or universities, university art museums, campus performance halls, individual high school or college performing groups, endowment funds, annual campaigns, deficit financing, hospital or university operating funds, research, publications, building programs (except for economic revitalization in a deteriorating urban neighborhood), or conferences; no loans.
Publications: Annual report (including application guidelines), application guidelines.
Application information:
 Initial approach: Proposal limited to 2 pages
 Copies of proposal: 1
 Deadline(s): None
 Board meeting date(s): June and Dec.
 Final notification: 4 to 6 months
 Write: Eugene R. Wilson, Pres.
Officers: Eugene R. Wilson,* Pres.; L. Marlene Bailey-Whiteside, Secy.; M.C. Recchuite, Treas.
Directors:* Lodwrick M. Cook, Chair.; Ronald J. Arnault, K.R. Dickerson, S.J. Giovanisci, J.S. Middleton, J.S. Morrison, Robert E. Wycoff.
Number of staff: 6 full-time professional; 4 part-time support.
Employer Identification Number: 953222292
Recent arts and culture grants:
Academy of Natural Sciences of Philadelphia, Philadelphia, PA, $30,000. For study on toxic pollution in the river system. 1987.
Acting Company, NYC, NY, $11,000. For national touring ensemble to ARCO key cities. 1987.
Alaska Arts Southeast, Sitka, AK, $7,200. For summer fine arts camp. 1987.
Alaska Light Opera Theater, Anchorage, AK, $10,000. For operating support. 1987.
Alaska Public Radio Network, Anchorage, AK, $5,000. For operating support. 1987.
Alaska Repertory Theater, Anchorage, AK, $6,000. For student matinees. 1987.
American Ballet Theater, NYC, NY, $7,500. For ticket distribution for inner-city youth in Los Angeles. 1987.
American Craft Council, NYC, NY, $5,000. For operating support. 1987.
American Youth Symphony, Los Angeles, CA, $5,000. For community outreach program. 1987.
Anchorage Arts Council, Anchorage, AK, $7,500. For Ushering in the Arts volunteer program. 1987.

Anchorage Concert Association, Anchorage, AK, $12,500. For operating support. 1987.

Anchorage Opera, Anchorage, AK, $10,000. For operating support. 1987.

Anchorage Symphony Orchestra, Anchorage, AK, $10,000. For operating support. 1987.

Archaeological Conservancy, Santa Fe, NM, $10,000. To preserve Borax Lake archaeological site. 1987.

Armand Bayou Nature Center, Houston, TX, $10,000. For environmental education program for youth. 1987.

Arts Resources and Technical Services, Los Angeles, CA, $5,000. For management assistance program. 1987.

Asia Society, NYC, NY, $10,000. For publication of FOCUS magazine for students. 1987.

Bilingual Foundation of the Arts, Los Angeles, CA, $5,000. For senior citizen and student outreach programs. 1987.

Cabrillo Marine Museum Volunteers, San Pedro, CA, $6,000. For educational programs for youth. 1987.

California Museum Foundation, Los Angeles, CA, $10,000. For Museum of Science and Industry. 1987.

Casa de Amigos, Midland, TX, $5,000. For performing arts series for children. 1987.

Center for United States-China Arts Exchange, NYC, NY, $5,000. For operating support. 1987.

Central City Opera House Association, Denver, CO, $5,000. For Apprentice Studio Arts Program. 1987.

Chamber Music America, NYC, NY, $9,000. For Naumburg Competition for Young Singers: 10th Anniversary Conference in Los Angeles. 1987.

Council for Basic Education, DC, $7,500. For fellowships for humanities teachers from Philadelphia public schools. 1987.

Dallas Childrens Theater, Dallas, TX, $10,000. For operating support. 1987.

Dallas Institute of Humanities and Culture, Dallas, TX, $15,000. For teachers academy program. 1987.

Dallas Museum of Natural History Association, Dallas, TX, $25,000. For Cenozoic Hall. 1987.

Dallas Opera, Dallas, TX, $20,000. For community outreach program. 1987.

Dallas Society for the Classical Guitar, Dallas, TX, $5,000. For Guitar-in-the-Community program. 1987.

Dallas Symphony Association, Dallas, TX, $38,000. For elementary school outreach program. 1987.

Dallas Theater Center, Dallas, TX, $20,000. For youth outreach program. 1987.

Dance Theater of Harlem, NYC, NY, $28,500. For Arts Exposure Week in Los Angeles. 1987.

Denver Center for the Performing Arts, Denver, CO, $10,000. For operating support. 1987.

Denver Symphony Association, Denver, CO, $10,000. For concert series for inner-city schools. 1987.

Earthwatch Expeditions, Pacific Palisades, CA, $8,000. For scholarships for MESA students in California. 1987.

Fairbanks Symphony Association, Fairbanks, AK, $8,000. For operating support. 1987.

Fords Theater, DC, $10,000. For operating support. 1987.

Franklin Institute, Philadelphia, PA, $50,000. For science-kit program for public elementary school teachers. 1987.

Grand People Tour Company, Los Angeles, CA, $5,000. For programs for low-income seniors. 1987.

Hebrew Union College, Los Angeles, CA, $30,000. For From Ashes to the Rainbow exhibit in Washington, DC. 1987.

Houston Grand Opera, Houston, TX, $10,000. For youth outreach program. 1987.

Houston Symphony Society, Houston, TX, $10,000. For youth outreach program. 1987.

Imaginarium, Anchorage, AK, $23,500. For science center for children. 1987.

Independence Community College, Independence, KS, $13,000. For William Inge Festival. 1987.

Japanese American Cultural and Community Center, Los Angeles, CA, $5,000. For theater project. 1987.

Joffrey Ballet, Los Angeles, CA, $15,000. For community outreach program. 1987.

John F. Kennedy Center for the Performing Arts, DC, $30,000. For outreach program for seniors and low-income youth. 1987.

Juneau Arts and Humanities, Juneau, AK, $7,500. For Byrd and Brass jazz and chamber music concert. 1987.

K E R A-TV Public Communications Foundation for North Texas, Dallas, TX, $6,000. For challenge fund for on-air development campaign. 1987.

Long Beach Symphony Association, Long Beach, CA, $10,000. For community outreach program. 1987.

Los Angeles Actors Theater, Los Angeles, CA, $15,000. For operating support. 1987.

Los Angeles Chamber Orchestra Society, Los Angeles, CA, $15,000. For community outreach program. 1987.

Los Angeles County Museum of Natural History Foundation, Los Angeles, CA, $5,000. For Magnificent Voyagers exhibit. 1987.

Los Angeles Pops Orchestra, Los Angeles, CA, $10,000. For operating support. 1987.

Lyric Opera of Dallas, Dallas, TX, $5,000. For outreach to new audiences. 1987.

Mann Music Center, Philadelphia, PA, $5,000. For summer program. 1987.

Midland Community Theater, Midland, TX, $10,000. For operating support. 1987.

Midland-Odessa Symphony and Chorale, Midland, TX, $10,000. For operating support. 1987.

Museum of African American Art, Los Angeles, CA, $5,000. For catalog of permanent collection. 1987.

Museum of African-American Life and Culture, Dallas, TX, $15,000. For audience development. 1987.

Museum of Art of the American West, Houston, TX, $5,000. For operating support. 1987.

Museum of Contemporary Art, Los Angeles, CA, $10,000. For community outreach program. 1987.

Music Center Unified Fund, Los Angeles, CA, $75,000. For support for member performing arts groups. 1987.

National Museum of American Jewish History, Philadelphia, PA, $8,000. For Peopling of Philadelphia project. 1987.

National Symphony Orchestra, DC, $15,000. For Young People's Concert. 1987.

National Trust for Historic Preservation, DC, $5,000. For operating support. 1987.

Nature Conservancy, Fairfax, VA, $5,000. For Wild California exhibit on Stearns Wharf. 1987.

New Freedom Theater, Philadelphia, PA, $5,000. For performing arts workshops and drama for minority students. 1987.

Northwood Institute, Dallas, TX, $10,000. For training program in arts for Dallas elementary school teachers. 1987.

Oklahoma Arts Institute, Oklahoma City, OK, $5,000. For summer program for high school students. 1987.

Pacific Science Center, Seattle, WA, $20,000. For dinosaur exhibit in Anchorage. 1987.

Pacificulture Foundation, Pacific Asia Museum, Pasadena, CA, $10,000. For community outreach program. 1987.

Pennsylvania Academy of the Fine Arts, Philadelphia, PA, $25,000. For membership development program. 1987.

Pennsylvania Ballet, Philadelphia, PA, $10,000. For Nutcracker production. 1987.

Pennsylvania Opera Theater, Philadelphia, PA, $5,000. For matinee outreach program. 1987.

Performing Tree, Los Angeles, CA, $5,000. For arts programs in the schools. 1987.

Perseverance Theater, Douglas, AK, $15,000. For Coyote Builds North America production. 1987.

Philadelphia Alliance for Teaching Humanities in the Schools, Philadelphia, PA, $50,000. For mini-grant program and student excellence awards. 1987.

Philadelphia Drama Guild, Philadelphia, PA, $10,000. For outreach program. 1987.

Philadelphia Festival Theater for New Plays, Philadelphia, PA, $10,000. For operating support. 1987.

Philadelphia Museum of Art, Philadelphia, PA, $10,000. For operating support. 1987.

Phoenix Symphony Association, Phoenix, AZ, $5,000. For operating support. 1987.

Please Touch Museum, Philadelphia, PA, $10,000. For youth outreach. 1987.

Santa Barbara Museum of Art, Santa Barbara, CA, $5,000. For Family Days outreach program. 1987.

Santa Barbara Museum of Natural History, Santa Barbara, CA, $5,000. For animated dinosaurs exhibit. 1987.

Santa Fe Chamber Music Festival, Santa Fe, NM, $5,000. For Music of the Americas Concert Series. 1987.

Settlement Music School of Philadelphia, Philadelphia, PA, $10,000. For minority enrichment program. 1987.

South Coast Repertory, Costa Mesa, CA, $5,000. For community outreach program. 1987.

Theater Three, Dallas, TX, $12,000. For community outreach program. 1987.

University of California, Los Angeles, CA, $5,000. For humanities project for teachers. 1987.

University of Pennsylvania, Annenberg Center, Philadelphia, PA, $10,000. For International Theater Festival for Children. 1987.

University of Southern California, Los Angeles, CA, $15,000. For KUSC Public Radio. 1987.

Walnut Street Theater, Philadelphia, PA, $5,000. For operating support. 1987.

Washington Opera, DC, $5,000. For community outreach programs. 1987.

Woodland Park Zoological Society, Seattle, WA, $25,000. For Alaska-Taiga exhibit. 1987.

Wyoming Heritage Foundation, Cody, WY, $6,500. For partnership program with local communities. 1987.

60
Argyros Foundation
950 South Coast Dr., Suite 200
Costa Mesa 92626 (714) 241-5000

Established in 1979 in CA.
Donor(s): The Argyros Charitable Trusts.
Financial data (yr. ended 7/31/87): Assets, $6,466,952 (M); gifts received, $1,053,304; expenditures, $560,286, including $541,607 for 54 grants (high: $184,000; low: $12).
Purpose and activities: Giving for culture, education, religious giving, social services, recreation, and health services.
Types of support: General purposes.
Application information:
Initial approach: Proposal
Deadline(s): June 1
Write: Chuck Packard, Trustee
Officers and Trustees: Julie Argyros, Pres.; George L. Argyros, Secy.; Carol Campbell, Exec. Dir.; Warren Finley, Chuck Packard, G.T. Smith.
Employer Identification Number: 953421867

61
Philip D. Armour Foundation
505 Sa some St., Suite 900
San Francisco 94111

Established in 1949 in CA.
Financial data (yr. ended 12/31/87): Assets, $1,081,648 (M); expenditures, $80,505, including $70,000 for 25 grants (high: $13,500; low: $500).
Purpose and activities: Giving primarily to theater groups; also supports a wide range of charitable organizations.
Officers: John St. John, Pres. and Treas.; Julia H. Armour, V.P.; Gillian McDonald, V.P.; Donald E. Scholtz, V.P.; Laura Williams, Secy.
Employer Identification Number: 362407161

62
Atkinson Foundation
Ten West Orange Ave.
South San Francisco 94080 (415) 876-1559

Incorporated in 1939 in CA.
Donor(s): George H. Atkinson,† Mildred M. Atkinson,† and others.
Financial data (yr. ended 12/31/88): Assets, $15,246,419 (M); expenditures, $874,449, including $755,440 for 139 grants (high: $50,000; low: $500; average: $3,000-$10,000).
Purpose and activities: Broad purposes are to help people reach their highest potential in their spiritual and economic life and to reach self-sufficiency; giving primarily for social

services, education, the United Methodist Church and other church activities, and international development and relief.
Types of support: Seed money, operating budgets, emergency funds, building funds, scholarship funds, continuing support, equipment, general purposes, technical assistance.
Limitations: Giving primarily in San Mateo County, CA, for schools, colleges, and other organizations; United Methodist churches and church activities in northern CA; and international grantmaking for technical assistance, relief, and population issues. No support for doctoral study, or elementary schools. No grants to individuals, or for research or fundraising events; no loans.
Publications: Annual report (including application guidelines), informational brochure (including application guidelines), application guidelines.
Application information:
Initial approach: Telephone, proposal, or letter
Copies of proposal: 1
Deadline(s): None
Board meeting date(s): Feb. or Mar., May or June, Sept., and Dec.
Final notification: 3 months
Write: Norma Arlen, Admin.
Officers and Directors: Duane E. Atkinson, Pres.; Ray N. Atkinson, V.P.; Thomas J. Henderson, V.P.; Donald K. Grant, Treas.; Lavina M. Atkinson, Elizabeth H. Curtis, James C. Ingwersen, Robert D. Langford, Lawrence A. Wright.
Number of staff: 1 full-time professional; 1 part-time professional.
Employer Identification Number: 946075613
Recent arts and culture grants:
Art-Rise, San Bruno, CA, $5,000. For start-up renovations at El Rancho school for Art-Rise, community based theater and arts group. 1987.
K Q E D, San Francisco, CA, $8,000. For cost of printing instructional TV brochures and one half the cost of primers for teachers. 1987.
San Mateo Performing Arts Center, San Mateo, CA, $10,000. Toward construction costs at San Mateo Performing Arts Center. 1987.

63
Autry Foundation
5858 Sunset Blvd.
P.O. Box 710
Los Angeles 90078 (213) 460-5676

Established in 1974 in CA.
Donor(s): Gene Autry.
Financial data (yr. ended 12/31/87): Assets, $54,552,027 (M); gifts received, $484,904; expenditures, $16,224,687, including $16,056,172 for 50 grants (high: $15,370,000; low: $30).
Purpose and activities: Giving primarily for cultural, educational, medical, and youth-related programs.
Limitations: Giving limited to Los Angeles, CA, area and Riverside and Orange counties, CA. No grants to individuals.
Application information:
Initial approach: Letter

Deadline(s): None
Write: Maxine Hansen, Secy.
Officers: Gene Autry,* Pres.; Jacqueline Autry, V.P.; Maxine Hansen, Secy.; Stanley Schneider,* Treas.
Directors:* Clyde Tritt.
Employer Identification Number: 237433359

64
The R. C. Baker Foundation
P.O. Box 6150
Orange 92613-6150

Trust established in 1952 in CA.
Donor(s): R.C. Baker, Sr.†
Financial data (yr. ended 12/31/87): Assets, $16,362,750 (M); gifts received, $163,250; expenditures, $1,074,892, including $945,650 for 190 grants (high: $100,000; low: $100; average: $100-$100,000).
Purpose and activities: Emphasis on higher education, including scholarships administered by selected colleges and universities; some support for hospitals and health agencies, cultural programs, and social service and youth agencies.
Types of support: Emergency funds, deficit financing, building funds, equipment, research, operating budgets, scholarship funds, fellowships, exchange programs, general purposes, continuing support, annual campaigns, capital campaigns, renovation projects, special projects.
Limitations: No grants to individuals, or for endowment funds; no loans.
Application information:
Initial approach: Cover letter with proposal
Copies of proposal: 1
Deadline(s): Submit proposal preferably in Apr. or Sept.; deadline May 1 and Oct. 1
Board meeting date(s): June and Nov.
Write: Frank L. Scott, Chair.
Officer and Trustees: Frank L. Scott, Chair.; George M. Anderson, K. Dale, J. Shelton, R. Turner, Robert N. Waters, Security Pacific National Bank.
Number of staff: 3
Employer Identification Number: 951742283

65
BankAmerica Foundation
Bank of America Center
Dept. 3246, P.O. Box 37000
San Francisco 94137 (415) 953-3175

Incorporated in 1968 in CA.
Donor(s): BankAmerica Corp., and subsidiaries.
Financial data (yr. ended 12/31/86): Assets, $2,300,000 (M); gifts received, $1,895,000; expenditures, $5,475,000, including $4,102,776 for 113 grants (high: $1,400,000; low: $600; average: $1,000-$15,000), $312,510 for 368 grants to individuals and $1,059,714 for 4,900 employee matching gifts.
Purpose and activities: To fund private, nonprofit, tax-exempt organizations providing services to communities locally, nationally, and internationally in areas where the company operates. Support both through grants and loans in 5 major funding areas: health, human resources, community and economic development, education, and culture and the

arts; support also for special programs developed by the foundation to use its resources most effectively.

Types of support: Annual campaigns, building funds, special projects, scholarship funds, employee-related scholarships, matching funds, general purposes, continuing support, capital campaigns, emergency funds.

Limitations: Giving limited to areas of major company operations, including communities in CA, metropolitan areas nationwide, and foreign countries. No support for religious organizations for sectarian purposes, organizations where funding would primarily benefit membership, or government-funded programs. No grants to individuals, or for fundraising events, memorial campaigns, or endowment funds. Generally no grants for research, conferences or seminars, publications, or operating support.

Publications: Program policy statement, application guidelines, 990-PF.

Application information: The employee matching gift program has been discontinued.

Initial approach: Letter
Copies of proposal: 1
Deadline(s): For capital/major campaigns, July 31; all others, none
Board meeting date(s): Annually and as necessary
Final notification: Varies
Write: Caroline O. Boitano, V.P. and Asst. Dir.

Officers: James P. Miscoll,* Chair.; Donald A. Mullane,* Pres. and C.E.O.; Caroline O. Boitano, V.P. and Asst. Dir.; John S. Stephan,* V.P.; James S. Wagele, V.P.; Michael Anderson, Treas.; Judy Granucci, Financial Officer.

Trustees:* Robert N. Beck, Robert W. Frick, Richard Rosenberg.

Number of staff: 1 full-time professional; 1 full-time support.

Employer Identification Number: 941670382

66

The William C. Bannerman Foundation

1405 North San Fernando Blvd., Suite 201
Burbank 91504-4150

Established in 1958 in CA.

Financial data (yr. ended 4/30/88): Assets, $3,226,599 (M); expenditures, $204,750, including $134,750 for 33 grants (high: $35,000; low: $1,000).

Purpose and activities: Support primarily for an art museum and a medical center; support also for social sevices and for health associations.

Application information:

Initial approach: Letter
Deadline(s): Feb. 28

Officers: E.T. Ponchick, Pres.; W.F. Pongle, Treas.

Employer Identification Number: 956061353

67

The Donald R. Barker Foundation

P.O. Box 936
Rancho Mirage 92270 (619) 321-2345

Established in 1977 in OR.

Donor(s): Donald R. Barker.

Financial data (yr. ended 11/30/88): Assets, $3,925,901 (M); expenditures, $229,407, including $190,440 for 24 grants (high: $75,000; low: $1,000).

Purpose and activities: Giving largely to higher education, the handicapped, and hospitals; support also for youth and health agencies, cultural programs, and high school athletic programs.

Types of support: Operating budgets, scholarship funds, building funds, equipment, special projects.

Limitations: Giving primarily in CA and OR. No support for sectarian religious purposes, or for agencies that rely on federal or tax dollars for their principal support. No grants to individuals, or for endowment funds, conferences, or operational deficits.

Publications: Application guidelines.

Application information: Application form required.

Initial approach: Letter
Copies of proposal: 1
Deadline(s): Mar. 1 and Aug. 1
Board meeting date(s): May and Oct.
Final notification: Promptly after decision

Trustees: John R. Lamb, Coeta Barker McGowan, J.R. McGowan, Joseph A. Moore.

Employer Identification Number: 930698411

68

Bechtel Foundation

50 Beale St.
San Francisco 94105 (415) 768-5974

Incorporated in 1953 in CA.

Donor(s): Bechtel Power Corp.

Financial data (yr. ended 12/31/87): Assets, $19,091,730 (M); expenditures, $1,736,538, including $1,325,788 for 179 grants (high: $377,000; low: $100; average: $1,000-$20,000) and $164,699 for employee matching gifts.

Purpose and activities: Grants for higher education and community funds, and to organizations related to some aspect of the engineering business and construction. Support also for cultural programs, public interest, health organizations, and social services.

Types of support: Employee matching gifts.

Limitations: No support for religious organizations. No grants to individuals, or for endowment funds or special projects.

Application information: Applications not accepted.

Board meeting date(s): Annually
Write: K.M. Bandarrae, Asst. Secy.

Officers: Alden P. Yates,* Chair.; R.P. Bechtel,* Vice-Chair.; C.W. Hull,* Vice-Chair.; John Neerhout, Jr.,* Vice-Chair.; J.W. Weiser,* Pres.; D.M. Slavich,* Sr. V.P.; T.G. Flynn, V.P.; A.R. Escola, Secy.; J.C. Stromberg, Treas.

Directors:* Stephen D. Bechtel, Jr.

Number of staff: 1 full-time professional; 1 part-time professional; 1 full-time support; 1 part-time support.

Employer Identification Number: 946078120

69

S. D. Bechtel, Jr. Foundation

50 Beale St.
San Francisco 94105 (415) 768-7620
Mailing address: P.O. Box 3809, San Francisco, CA 94119

Incorporated in 1957 in CA.

Donor(s): S.D. Bechtel, Jr., Mrs. S.D. Bechtel, Jr.

Financial data (yr. ended 12/31/86): Assets, $16,577,521 (M); gifts received, $10,168,575; expenditures, $35,777, including $24,500 for 15 grants (high: $5,000; low: $500).

Purpose and activities: Grants restricted to institutions in which the directors have personal involvement, primarily educational institutions and cultural programs.

Limitations: Giving primarily in the San Francisco Bay Area, CA. No grants to individuals.

Application information: Contributes only to pre-selected organizations. Applications not accepted.

Board meeting date(s): As required
Write: Charles J. Spevak, V.P.

Officers and Directors:* S.D. Bechtel, Jr.,* Pres.; A. Barlow Ferguson,* V.P. and Secy.; Charles J. Spevak, V.P. and Treas.; Elizabeth Hogan Bechtel,* V.P.; Thomas G. Flynn, V.P.

Employer Identification Number: 946066138

70

Legler Benbough Foundation

2550 Fifth Ave., Suite 132
San Diego 92103-6622 (619) 235-8099

Established in 1985 in CA.

Donor(s): Legler Benbough.

Financial data (yr. ended 12/31/87): Assets, $4,148,540 (M); expenditures, $155,708, including $140,850 for 13 grants (high: $70,000; low: $100).

Purpose and activities: Support primarily for cancer research, museums, and the arts. Some support for community development.

Types of support: General purposes.

Limitations: Giving primarily in the San Diego, CA, area.

Application information:

Initial approach: Letter
Write: Legler Benbough, Pres.

Officers: Legler Benbough, Pres.; Winifred Demming, V.P.; Peter K. Ellsworth, Secy.; Thomas Cisco, Treas.

Employer Identification Number: 330105049

71

H. N. and Frances C. Berger Foundation

P.O. Box 3064
Arcadia 91006

Incorporated in 1961 in CA.

Donor(s): Frances C. Berger, H.N. Berger.

Financial data (yr. ended 12/31/86): Assets, $11,190,107 (M); gifts received, $170,805; expenditures, $363,603, including $338,162 for 43 grants (high: $102,025; low: $50).

Purpose and activities: Emphasis on higher education, cultural programs, public health organizations, and hospitals. Committed to long-term support of present donees.

Limitations: Giving primarily in CA. No grants to individuals.
Application information:
Initial approach: Letter
Deadline(s): None
Board meeting date(s): Semiannually and as required
Write: H.N. Berger, Pres.
Officers and Directors: H.N. Berger, Pres.; John N. Berger, V.P.; Frances C. Berger, Secy.; Robert M. Barton, Harry F. Booth, Jr.
Employer Identification Number: 956048939

72
The Lowell Berry Foundation
One Kaiser Plaza, Suite 995
Oakland 94612 (415) 452-0433

Incorporated in 1950 in CA.
Donor(s): Lowell W. Berry,† Farm Service Co., The Best Fertilizer Co. of Texas.
Financial data (yr. ended 12/31/88): Assets, $15,070,810 (M); expenditures, $1,376,605, including $1,176,095 for 212 grants (high: $386,000; low: $100; average: $500-$25,000).
Purpose and activities: Support for evangelical Christian religious programs non-religious grants are focused on social services. Grants also for education, youth agencies, health associations, and cultural programs.
Types of support: Annual campaigns, conferences and seminars, continuing support, emergency funds, endowment funds, general purposes, lectureships, operating budgets, professorships, research, scholarship funds, special projects.
Limitations: Giving primarily in Contra Costa and northern Alameda counties, CA. No grants to individuals, or for building or capital funds, equipment, seed money, or land acquisition.
Publications: Application guidelines, program policy statement.
Application information:
Initial approach: Letter
Copies of proposal: 1
Deadline(s): None
Board meeting date(s): Bimonthly
Final notification: 1 to 2 months for religious grants; 2 to 4 months for secular grants
Write: Susan L. Shira, Admin.; John C. Branagh, Pres. (for religious grants); Barbara Berry Corneille, Dir. (for secular grants)
Officers and Directors: John C. Branagh, Pres.; Herbert Funk, V.P.; Barbara Berry Corneille, Secy.; Robert Wiley, Treas.; Patricia Berry Felix, William Stoddard, Eugene Wilson.
Number of staff: 1 full-time professional.
Employer Identification Number: 946108391

73
The Stanley & Lynn Beyer Charitable Foundation, Inc.
132 South Rodeo Dr.
Beverly Hills 90212

Established in 1978 in CA.
Donor(s): Stanley Beyer, Lynn Beyer.
Financial data (yr. ended 11/30/87): Assets, $89,995 (M); gifts received, $200,000; expenditures, $113,228, including $112,730 for grants (high: $35,000).

Purpose and activities: Support primarily for Jewish organizations and music.
Officers: Stanley Beyer, Pres.; Lynn Beyer, V.P.; Robert Beyer, Secy.-Treas.
Employer Identification Number: 953314425

74
Bing Fund
9700 West Pico Blvd.
Los Angeles 90035 (213) 277-5711

Trust established in 1958 in CA.
Donor(s): Mrs. Anna Bing Arnold, Peter S. Bing.
Financial data (yr. ended 2/28/87): Assets, $3,684,282 (M); gifts received, $153,783; expenditures, $136,603, including $131,500 for 10 grants (high: $75,000; low: $500).
Purpose and activities: Giving for higher education and cultural programs.
Types of support: General purposes.
Limitations: Giving primarily in CA. No grants to individuals.
Application information:
Initial approach: Letter
Copies of proposal: 1
Deadline(s): None
Board meeting date(s): Quarterly
Write: Peter S. Bing, Trustee
Trustees: Anna H. Bing, Peter S. Bing, Robert D. Burch.
Employer Identification Number: 956031105

75
Sam & Rie Bloomfield Foundation, Inc.
P.O. Box 686
200 Dinsmore Dr.
Fortuna 95540

Established in 1958 in KS.
Donor(s): Sam Bloomfield,† Rie Bloomfield.
Financial data (yr. ended 11/30/87): Assets, $6,836,966 (M); expenditures, $98,943, including $64,500 for 8 grants (high: $26,700; low: $200).
Purpose and activities: Giving primarily for Jewish temple support and higher education; some support also for hospitals and cultural organizations.
Limitations: No grants to individuals.
Application information:
Write: Paul Mahan, Trustee
Officers and Trustees: Rie Bloomfield, Pres.; Vernon McKay, Secy.; Paul D. Mahan, Treas.
Employer Identification Number: 956074613

76
The Bothin Foundation
873 Sutter St., Suite B
San Francisco 94109 (415) 771-4300

Incorporated in 1917 in CA.
Donor(s): Henry E. Bothin,† Ellen Chabot Bothin,† Genevieve Bothin de Limur.†
Financial data (yr. ended 12/31/87): Assets, $16,088,895 (M); expenditures, $950,926, including $588,203 for 100 grants (high: $50,000; low: $100).
Purpose and activities: Giving for youth and cultural programs for youth, community activities, health, the handicapped, social

services, minorities, the aged, and the environment.
Types of support: Building funds, equipment, matching funds, technical assistance.
Limitations: Giving primarily in CA, with emphasis on San Francisco, Marin, Sonoma, and San Mateo counties. No support for religious organizations, or educational institutions (except those directly aiding the developmentally disabled), or for production or distribution of films or other documentary presentations. No grants to individuals, or for general operating funds, endowment funds, scholarships, fellowships, or conferences; no loans.
Publications: Biennial report (including application guidelines).
Application information:
Initial approach: Letter containing a brief and comprehensive outline of the project
Copies of proposal: 1
Deadline(s): 8 weeks prior to meeting
Board meeting date(s): Early to mid Feb., June, and Oct.
Final notification: 2 to 3 months
Write: Lyman H. Casey, Exec. Dir.
Officers: Genevieve di San Faustino,* Pres.; Edmona Lyman Mansell,* V.P.; Frances L. Joyce, Secy.; Lyman H. Casey,* Treas. and Exec. Dir.
Directors:* William W. Budge, A. Michael Casey, William F. Geisler, Benjamin J. Henley, Jr., Stephanie P. MacColl, Rhoda W. Schultz.
Number of staff: 1 full-time professional; 1 full-time support.
Employer Identification Number: 941196182
Recent arts and culture grants:
California Academy of Sciences, San Francisco, CA, $7,860. Toward repair of Seahorse Railing around Swamp Aquarium. 1987.
Fort Mason Center, San Francisco, CA, $25,000. Toward conversion of Pier 3 into Festival Pavilion. 1987.
Friends of Photography, San Francisco, CA, $10,000. Toward establishment of Ansel Adams Center at Fort Mason. 1987.
Make A Circus/Feedback Productions, San Francisco, CA, $5,000. For matching funds for new truck. 1987.

77
Braun Foundation
400 South Hope St.
Los Angeles 90071-2899 (818) 577-7000

Incorporated in 1953 in CA.
Donor(s): Members of the Braun family.
Financial data (yr. ended 12/31/86): Assets, $1,216,718 (M); gifts received, $1,514,867; expenditures, $1,644,879, including $1,623,700 for 63 grants (high: $900,000; low: $500; average: $2,500-$21,000).
Purpose and activities: Contributions to hospitals, medical research, elementary and secondary schools, higher education, youth agencies, museums, cultural programs, and social services, including support programs for the handicapped.
Limitations: Giving primarily in CA.
Application information:
Deadline(s): None
Board meeting date(s): Oct. or Nov.
Final notification: Varies

Write: Donald R. Spuehler
Officers and Directors: Henry A. Braun, Pres.; C. Allan Braun, John G. Braun.
Number of staff: None.
Employer Identification Number: 956016820

78
The Mervyn L. Brenner Foundation, Inc.
Three Embarcadero Center, 21st Fl.
San Francisco 94111 (415) 951-7508

Incorporated in 1961 in CA.
Donor(s): Mervyn L. Brenner.†
Financial data (yr. ended 8/31/88): Assets, $2,589,142 (M); expenditures, $147,000, including $126,600 for 60 grants (high: $10,000; low: $150).
Purpose and activities: Emphasis on health and hospitals, including medical research, social services and youth agencies, including Jewish welfare funds, cultural organizations, higher education and the field of accounting.
Types of support: Annual campaigns, operating budgets.
Limitations: Giving primarily in CA. No grants to individuals.
Application information: Funds fully committed.
Initial approach: Proposal
Deadline(s): None
Write: John R. Gentry, Pres.
Officers and Directors: John R. Gentry, Pres.; William D. Crawford, V.P.; Marvin T. Tepperman, V.P.; Marc H. Monheimer, Secy.; John T. Seigle, Treas.
Number of staff: None.
Employer Identification Number: 946088679

79
Robert and Alice Bridges Foundation
Two Embarcadero Center, No. 2140
San Francisco 94111 (415) 392-6320

Foundation established in 1957 in CA.
Donor(s): Robert L. Bridges.
Financial data (yr. ended 12/31/86): Assets, $1,783,894 (M); expenditures, $130,984, including $119,920 for 78 grants (high: $15,000; low: $15).
Purpose and activities: Support largely for higher education; grants also for youth agencies, hospitals and health associations, and the performing arts.
Types of support: Capital campaigns, continuing support, general purposes.
Limitations: Giving primarily in the San Francisco Bay Area, CA. No grants to individuals for education or for any other purpose.
Publications: Annual report.
Application information: Contributes only to pre-selected organizations. Applications not accepted.
Deadline(s): None
Write: Robert L. Bridges, Pres.
Officers: Robert L. Bridges, Pres.; Alice M. Bridges, V.P.; David M. Bridges, V.P.; James R. Bridges, V.P.; Linda Bridges Ingham, V.P.; Michael L. Mellor, Secy.
Employer Identification Number: 946066355

80
Eli Broad Family Foundation
11601 Wilshire Blvd., 12th Fl.
Los Angeles 90025

Established in 1980 in CA.
Donor(s): Eli Broad.
Financial data (yr. ended 6/30/88): Assets, $13,464,723 (M); gifts received, $1,510,613; expenditures, $332,964, including $89,300 for 15 grants (high: $36,000; low: $150; average: $150-$36,000).
Purpose and activities: Support primarily for organizations which support the exhibition of contemporary American art.
Types of support: General purposes.
Limitations: Giving primarily in CA.
Application information: Contributes only to pre-selected organizations. Applications not accepted.
Officers: Eli Broad, Pres.; Sharon McQueen, Secy.; Edythe L. Broad, Treas.
Number of staff: 2 part-time professional; 3 full-time support; 1 part-time support.
Employer Identification Number: 953537237

81
Dana & Albert R. Broccoli Charitable Foundation
2121 Avenue of the Stars, Suite 1240
Los Angeles 90067

Established in 1980 in CA.
Donor(s): Albert R. Broccoli, Dana Broccoli.
Financial data (yr. ended 12/31/87): Assets, $2,625,249 (M); gifts received, $500,000; expenditures, $48,630, including $44,000 for 6 grants (high: $20,000; low: $1,000).
Purpose and activities: Support for higher education, hospitals and health associations, cultural programs, and youth and family services.
Types of support: General purposes.
Application information: Contributes only to pre-selected organizations. Applications not accepted.
Officers: Albert R. Broccoli, Pres.; Dana Broccoli, V.P.; Michael Wilson, C.F.O.
Employer Identification Number: 953502889

82
Brotman Foundation of California
c/o Robert D. Hartford
433 North Camden Dr., No. 600
Beverly Hills 90210 (213) 271-2910

Established in 1964.
Financial data (yr. ended 12/31/86): Assets, $7,697,240 (M); expenditures, $416,206, including $272,780 for 31 grants (high: $75,000; low: $100).
Purpose and activities: Giving mainly for children and health; some support for arts and education.
Limitations: Giving primarily in CA.
Application information:
Initial approach: Letter
Deadline(s): None
Officers and Directors: Michael B. Sherman, Pres.; Lowell Marks, Secy.; Robert D. Hartford, Treas.; Toni Wald.
Employer Identification Number: 956094639

83
Buchalter, Nemer, Fields, Chrystie & Younger Charitable Foundation
700 South Flower St., Suite 700
Los Angeles 90017 (213) 626-6700

Trust established in 1965 in CA.
Donor(s): Buchalter, Nemer, Fields, Chrystie & Younger.
Financial data (yr. ended 12/31/87): Assets, $304,435 (M); gifts received, $88,250; expenditures, $146,501, including $138,735 for 93 grants (high: $17,750; low: $25).
Purpose and activities: Emphasis on Jewish welfare funds, hospitals, and educational and cultural programs.
Limitations: Giving primarily in CA. No grants to individuals, or for endowment funds, research, scholarships, or fellowships; no loans.
Application information:
Initial approach: Letter, telephone, or full proposal
Copies of proposal: 1
Deadline(s): Submit proposal preferably in Nov. or Dec.; deadline Dec. 31
Board meeting date(s): As required
Trustees: Irwin R. Buchalter, Arthur Chinski, Murray M. Fields, Terrance Nunan, Philip J. Wolman.
Employer Identification Number: 956112980

84
C & H Charitable Trust
1390 Willow Pass Rd., Suite 700
Concord 94520

Donor(s): Hawaiiian Commercial & Sugar, Hamakua Sugar Co.
Financial data (yr. ended 12/31/87): Assets, $45,782 (M); gifts received, $110,000; expenditures, $145,402, including $145,283 for 29 grants (high: $78,000; low: $350).
Purpose and activities: Support for health and welfare, education, culture and art, and for civic organizations.
Types of support: Employee matching gifts.
Application information:
Write: Sheri Tillison, Exec. Secy.
Officers: John B. Bunker,* Chair.; William H. Stewart,* Pres.; Virginia M. d'Almeida, Secy.-Treas.
Trustees:* James M. Burt, Gary A. Nelson, Harold R. Somerset.
Employer Identification Number: 237410587

85
C.S. Fund
469 Bohemian Hwy.
Freestone 95472 (707) 829-5444

Established in 1981 in CA as "pass through" fund for annual gifts of donors.
Donor(s): Maryanne Mott, Herman E. Warsh.
Financial data (yr. ended 10/31/88): Assets, $691,200 (M); gifts received, $1,200,000; expenditures, $1,390,451, including $906,000 for grants and $219,766 for 3 foundation-administered programs.
Purpose and activities: Giving for programs with national or international impact, in the areas of peace, especially alternative security; toxics, especially source reduction; protection

of dissent and diversity, and preservation of genetic diversity.

Types of support: Special projects, research, general purposes, matching funds, publications, conferences and seminars, continuing support, operating budgets, technical assistance.

Limitations: No grants for endowment funds, capital ventures, emergency requests, or video or film production.

Publications: Annual report (including application guidelines), informational brochure (including application guidelines), financial statement, grants list.

Application information:
Initial approach: Proposal
Copies of proposal: 1
Deadline(s): Jan. 15, May 15, and Sept. 15, or the next Monday if deadline falls on a weekend
Final notification: Approximately 12 weeks after deadline

Officers and Directors: Maryanne Mott, Pres.; Martin Teitel, V.P.; Herman E. Warsh, Secy.-Treas.; Shan Thomas, 2nd Secy.-Treas.

Number of staff: 4 full-time professional; 4 full-time support.

Employer Identification Number: 953607882

Recent arts and culture grants:
Desert Botanic Gardens, Phoenix, AZ, $11,500. For Endangered Plants of Hybrid Origin Project which examines endangered species protection laws with respect to naturally hybridized plant species. 1987.

86
California Community Foundation

3580 Wilshire Blvd., Suite 1660
Los Angeles 90010 (213) 413-4042
Orange County office: 13252 Garden Grove Blvd., Suite 195, Garden Grove, CA 92643; Tel: (714) 750-7794

Community foundation established in 1915 in CA by bank resolution.

Financial data (yr. ended 6/30/88): Assets, $74,406,692 (M); gifts received, $9,446,217; expenditures, $8,699,763, including $6,661,881 for 403 grants (high: $250,000; low: $500; average: $5,000-$25,000) and $525,890 for 1 loan to an individual.

Purpose and activities: Support for arts, humanities, education, the environment, health, human services, the handicapped, public affairs, and community development.

Types of support: Matching funds, technical assistance, emergency funds, program-related investments, seed money, special projects.

Limitations: Giving limited to Los Angeles, Orange, Riverside, San Bernadino, and Ventura counties, CA. No support for sectarian purposes. No grants to individuals, or for building funds, annual campaigns, equipment, endowment funds, operating budgets, scholarships, fellowships, films, conferences, dinners, or special events; no loans.

Publications: Annual report, application guidelines, informational brochure, newsletter.

Application information: Application form required.
Initial approach: Proposal
Copies of proposal: 1
Deadline(s): None
Board meeting date(s): Quarterly

Final notification: 3 months after board meets
Write: Jack Shakely, Pres.

Officer: Jack Shakely, Pres.

Board of Governors: Stephen D. Gavin, Chair.; Caroline L. Ahmanson, Bruce C. Corwin, John Gavin, Walter B. Gerken, Philip M. Hawley, Robert Hurwitz, Ignacio E. Lozano, Jr., Sister Marie Madeleine, S.C.L., Paul A. Miller, Bruce Ramer, Daniel H. Ridder, Ann Shaw, William French Smith, Esther Wachtell, Peggy Fouke Wortz.

Trustees: Security Pacific National Bank, City National Bank, First Interstate Bank, Trust Services of America, Wells Fargo Bank, N.A.

Number of staff: 7 full-time professional; 1 part-time professional; 8 full-time support.

Employer Identification Number: 956013179

Recent arts and culture grants:
Japanese American National Museum, Los Angeles, CA, $24,000. To produce capital campaign materials for this new experiential museum. 12/87.

K C E T Community Television of Southern California, Los Angeles, CA, $150,000. To underwrite development and production of 12-part, three-year Los Angeles History Project. 12/87.

Long Beach Museum of Art Foundation, Long Beach, CA, $5,000. For challenge grant to partially support creation of membership development materials and direct mail test program. 12/87.

Long Beach Opera, Long Beach, CA, $6,000. For management audit and strategic planning. 9/87.

Long Beach Symphony, Long Beach, CA, $8,000. Toward new marketing director. 6/87.

Los Angeles Center for Photographic Studies, Los Angeles, CA, $12,150. To develop joint promotional materials for coalition of local artist-run organizations. 9/87.

Music Center of Los Angeles County, Education Division, Los Angeles, CA, $15,000. To expand interdisciplinary Music Center on Tour program and bring arts programs to neighboring cities in collaboration with League of California Cities. 6/87.

Public Corporation for the Arts, Long Beach, CA, $10,500. To match California Arts Council grant for second phase of financial management program for member nonprofit organizations. 9/87.

87
California Tamarack Foundation

1100 Larkspur Landing Circle, Suite 294
Larkspur 94939

Established in 1977 in CA.

Donor(s): Ann M. Hatch, Hatch Charitable Lead Annuity Trust.

Financial data (yr. ended 8/31/87): Assets, $11,439 (M); gifts received, $142,200; expenditures, $135,972, including $133,200 for 32 grants (high: $35,000; low: $200).

Purpose and activities: Giving primarily for a welfare organization and social services with emphasis on child welfare and youth development; support for cultural organizations with emphasis on the visual arts and films.

Types of support: Operating budgets, scholarship funds, publications, general purposes.

Application information:
Initial approach: Letter
Deadline(s): None
Write: Ann M. Hatch, Director

Directors: James Augustino, Kathleen Baxter-Stern, Squeak Cornwatch, Ann M. Hatch.

Employer Identification Number: 942747078

88
The Callison Foundation

c/o Feeney, Sparks & Rudy
44 Montgomery St., Suite 900
San Francisco 94104 (415) 362-2981

Established in 1965 in CA.

Donor(s): Fred W. Callison.

Financial data (yr. ended 12/31/86): Assets, $4,522,472 (M); expenditures, $295,207, including $222,300 for 26 grants (high: $22,500; low: $4,500).

Purpose and activities: Emphasis on Roman Catholic religious organizations, youth agencies, social welfare, cultural programs, hospitals, aid to the handicapped, and higher education.

Types of support: General purposes.

Limitations: Giving primarily in San Francisco, CA. No grants to individuals.

Application information:
Initial approach: Proposal
Deadline(s): None
Write: Dorothy J. Sola, Secy.

Officers and Directors: Ward Ingersoll, Pres.; Chester MacPhee, V.P.; Dorothy J. Sola, Secy.; Peter O'Hara, C.F.O.; Thomas E. Feeney, Frances M. Smith.

Employer Identification Number: 946127962

89
John W. Carson Foundation, Inc.

c/o Ernst & Whinney
2029 Century Park East, Suite 2200
Los Angeles 90067

Established in 1981 in CA.

Donor(s): John W. Carson.

Financial data (yr. ended 11/30/86): Assets, $1,329,954 (M); gifts received, $545,575; expenditures, $154,737, including $123,400 for 33 grants (high: $50,000; low: $250).

Purpose and activities: Giving primarily for child welfare programs; some support also for medical research and cultural programs.

Limitations: No grants to individuals.

Application information: Contributes only to pre-selected organizations. Applications not accepted.
Write: John W. Carson, Pres.

Officers: John W. Carson, Chair. and Pres.; Henry I. Buskin, V.P. and C.F.O.

Employer Identification Number: 953714138

90
Carter Hawley Hale Stores Corporate Giving Program

550 South Flower St.
Los Angeles 90071 (213) 620-0150

Purpose and activities: Support for health, welfare, including youth organizations and community funds, education, including business schools, culture, including performing and visual arts organizations, and civic affairs. The policy is to support existing organizations which are working to improve social and economic conditions. Principal emphasis is on special projects, but occasional operating support is awarded.

Types of support: Operating budgets, special projects.

Limitations: Giving primarily in areas where operations exist; some regional and national giving. No support for political, labor, fraternal, sectarian, social or other groups that serve the special interests of their constituency. No grants for souvenir programs, commemorative journals or fund raising events.

Application information: Local requests apply to executive offices of nearest subsidiary; educational requests or requests national or regional in scope, apply to Carter Hawley Hale.

Initial approach: Letter
Deadline(s): None
Write: Jeanette McElwee, Dir., Community Affairs

91
Carver Foundation
c/o Anne Martensen
655 Montgomery St., Suite 1730
San Francisco 94111

Established in 1982 in CA.
Donor(s): Carver Grandchildren's Trust, Carver Greatgrandchildren's Trust.
Financial data (yr. ended 5/31/87): Assets, $79,528 (M); gifts received, $222,338; expenditures, $257,667, including $255,050 for 54 grants (high: $50,000; low: $150).
Purpose and activities: Giving primarily for the arts.
Application information: Contributes only to pre-selected organizations. Applications not accepted.
Officers and Directors: Ann D. Gralnek, Pres.; Anne Martensen, Secy.-Treas.; Philae C. Dominick, Pauline C. Duxbury.
Employer Identification Number: 942825557

92
Cedars-Sinai Medical Center Section D Fund
8700 Beverly Blvd.
Los Angeles 90048

Established in 1984 in CA.
Donor(s): Mark Goodson.
Financial data (yr. ended 12/31/87): Assets, $3,320,353 (M); expenditures, $701,120, including $666,700 for 47 grants (high: $200,000; low: $500).
Purpose and activities: Grants to Jewish organizations and welfare funds, hospitals and health associations, education and film associations.
Limitations: Giving primarily in New York, NY, and Los Angeles, CA. No grants to individuals.
Application information: Contributes only to pre-selected organizations. Applications not accepted.
Trustee: Cedars-Sinai Medical Center.
Employer Identification Number: 953918393

93
Hugh Stuart Center Charitable Trust
52 North Third St., Suite 400
San Jose 95115-0024 (408) 293-0463

Trust established in 1977 in CA.
Donor(s): Hugh Stuart Center.†
Financial data (yr. ended 12/31/86): Assets, $4,870,974 (M); expenditures, $467,558, including $411,023 for 76 grants (high: $70,525; low: $25).
Purpose and activities: Support largely for higher and secondary education, hospitals, and cultural programs.
Limitations: Giving primarily in San Jose, CA.
Application information: Contributes only to pre-selected organizations. Applications not accepted.
Trustees: Arthur K. Lund, Louis O'Neal.
Employer Identification Number: 942455308

94
Chevron Corporate Giving Program
575 Market St.
P.O. Box 7753
San Francisco 94120-7753 (415) 894-4193
Arts Support: R.C. Wooten, Corporate Advertising and Arts Liaison, 575 Market St., P.O. Box 7753, San Francisco, CA 94120-7753

Financial data (yr. ended 12/31/87): Total giving, $30,212,790, including $20,800,790 for 6,738 grants (high: $7,208,000; low: $20), $1,405,000 for 6,616 employee matching gifts and $8,007,000 for 45 in-kind gifts.
Purpose and activities: Contributions are intended to strengthen the economic vitality of communities where company operations exist to ensure continued success, through support for programs involving the environment, education, health and social services, the arts, and international relations. Giving is through the Chevron Companies and through eight Chevron Donor Designated Funds, administered through community foundations; support generally for operating expenses and special projects.
Types of support: General purposes, employee matching gifts, research, scholarship funds, continuing support, program-related investments, in-kind gifts.
Limitations: Giving primarily in AL, AZ, AK, AR, CA, CO, CT, DC, FL, GA, HI, LA, MD, NJ, NM, MS, MT, NM, NV, OR, OK, PA, TX, UT and in more than 80 countries.
Publications: Corporate giving report, application guidelines.
Application information: Application should contain a brief description of purpose, objectives, programs and accomplishments; 501 (c)(3) status letter; board list; contributor's list; form 990.
Initial approach: One or two-page letter
Copies of proposal: 1
Final notification: 6-8 weeks
Write: J.W. Rhodes, Jr., Mgr., Corp. Contribs.
Number of staff: 6 full-time professional; 3 full-time support.

95
The Christensen Fund
780 Welch Rd., Suite 100
Palo Alto 94304

Incorporated in 1957 in CA.
Donor(s): Allen D. Christensen, Carmen M. Christensen.
Financial data (yr. ended 11/30/87): Assets, $41,882,600 (M); gifts received, $25,830,525; expenditures, $2,293,341, including $964,606 for 21 grants (high: $390,962; low: $100; average: $500-$15,000).
Purpose and activities: A private operating foundation to display art objects in museums and support higher educational institutions, including Oxford University in England; very limited grants.
Limitations: No loans.
Application information: Contributes only to pre-selected organizations. Applications not accepted.
Officers: Allen D. Christensen,* Pres.; C. Diane Christensen,* V.P.; Carmen M. Christensen,* V.P.; William R. Benevento,* Secy.
Directors:* Karen K. Christensen Calvin, Rosemary Pratt.
Employer Identification Number: 946055879

96
Clorox Company Corporate Giving Program
1221 Broadway
Oakland 94612 (415) 271-7000

Financial data (yr. ended 12/31/88): $649,296 for grants.
Purpose and activities: Support for youth, education, employment training, social welfare, community funds, culture, civic affairs, health, and economic development; in addition, employees donate their time to charities, through the Clorox Employee Volunteer program. Programs reflect combined foundation and corporate giving.
Limitations: Giving primarily in general operating areas in CA, FL, IL, KY, MO, NY, WA, and WI.
Application information:
Write: J.J. Calderini, V.P., Human Resources

97
The Clorox Company Foundation
1221 Broadway
Oakland 94612 (415) 271-7747
Mailing address: P.O. Box 24305, Oakland, CA 94623

Incorporated in 1980 in CA.
Donor(s): Clorox Co.
Financial data (yr. ended 6/30/88): Assets, $2,056,242 (M); gifts received, $1,500,000; expenditures, $1,309,881, including $1,243,275 for 428 grants (high: $90,000; low: $25; average: $1,000-$10,000) and $44,484 for 110 employee matching gifts.
Purpose and activities: Giving primarily for youth, education, social welfare, civic affairs, arts and culture, and health; some support also for economic development and employment training; and emergency product donations.

Types of support: Building funds, operating budgets, general purposes, employee matching gifts, capital campaigns, matching funds, employee-related scholarships, special projects, technical assistance, scholarship funds.
Limitations: Giving primarily in Oakland, CA, and other areas of company operations. No support for sectarian religious purposes, or for veterans', fraternal, or labor organizations. No grants to individuals, or for goodwill advertising.
Publications: Corporate giving report (including application guidelines), program policy statement, application guidelines.
Application information: Application form required.
 Initial approach: Letter requesting application
 Copies of proposal: 1
 Deadline(s): By 15th of month prior to board meetings
 Board meeting date(s): 3rd Fridays of July, Sept.-Nov., Jan., Mar., and May
 Final notification: Varies
 Write: Carmella Johnson, Contribs. Admin.
Officers: Patricia J. Marino,* Pres.; David L. Goodman,* V.P.; Elizabeth A. Harvey, Secy.; Priscilla Thilmony,* Treas.
Trustees:* Jack J. Calderini, Rita A. Glazer, Roderic A. Lorimer, Ignacio R. Martinez, Patrick M. Meehan, Richard C. Soublet.
Number of staff: 1 full-time professional; 1 part-time professional; 1 full-time support.
Employer Identification Number: 942674980

98
The Colburn Collection
6311 Romaine St., No. 7111
Los Angeles 90038

Established in 1986 in CA.
Financial data (yr. ended 12/31/87): Assets, $6,678,430 (M); gifts received, $0; expenditures, $480,822, including $414,757 for 1 grant.
Purpose and activities: Support for instruction in the performing arts, including music. Musical instruments loaned to students of music unitl they can afford to purchase their own.
Types of support: Endowment funds.
Application information:
 Initial approach: Letter
 Deadline(s): None
 Write: Frances K. Rosen, Mgr.
Officers: Richard W. Colburn,* Pres.; Frances K. Rosen, Mgr. and Secy.; Carol Colburn Aogel, Richard D. Colburn.
Directors:* Keith W. Colburn.
Employer Identification Number: 954021014

99
The Tara and Richard Colburn Fund
1516 Pontius Ave.
Los Angeles 90025

Established in 1985 in CA.
Donor(s): Richard D. Colburn, Consolidated Electrical Distributors, U.S. Rentals, Inc.
Financial data (yr. ended 12/31/87): Assets, $1,523,768 (M); gifts received, $1,085,000; expenditures, $577,036, including $576,750 for 26 grants (high: $250,000; low: $100).
Purpose and activities: Giving primarily for music and education.

Application information:
 Deadline(s): None
 Write: Bernard E. Lyons, Dir.
Directors: Richard D. Colburn, Tara G. Colburn, Bernard E. Lyons.
Employer Identification Number: 954018318

100
Columbia Foundation
1160 Battery St., Suite 400
San Francisco 94111 (415) 986-5179

Incorporated in 1940 in CA.
Donor(s): Madeleine H. Russell, Christine H. Russell.
Financial data (yr. ended 5/31/88): Assets, $28,631,776 (M); gifts received, $100,164; expenditures, $1,069,855, including $935,491 for 162 grants (high: $125,000; low: $600; average: $1,000-$20,000).
Purpose and activities: Current focus is on projects that address critical issues and offer promise of significant positive impact in the following areas: preservation of the natural environment; enhancement of urban community life and culture; the interdependence of nations and understanding among people from different cultures; reversal of the arms race worldwide; and protection of basic human rights. The foundation focuses its program primarily on projects that seek common ground between the San Francisco community and the shared global concerns facing an interdependent world.
Types of support: Seed money, special projects, research, publications, conferences and seminars.
Limitations: Giving primarily in northern CA, with emphasis on the San Francisco Bay Area. No support for private foundations, or institutions supported by federated campaigns or heavily subsidized by government funds, or for projects in medicine or religion. No grants to individuals, or for building or endowment funds, scholarships, fellowships, or operating budgets.
Publications: Application guidelines, program policy statement, grants list, multi-year report (including application guidelines).
Application information:
 Initial approach: Letter
 Copies of proposal: 1
 Deadline(s): None
 Board meeting date(s): 4 times per year
 Final notification: 2 to 3 months
 Write: Susan Clark Silk, Exec. Dir.
Officers and Directors:* Madeleine H. Russell,* Pres.; Charles P. Russell,* V.P.; Alice Russell-Shapiro,* Secy.; Christine H. Russell,* Treas.; Susan Clark Silk, Exec. Dir.
Number of staff: 1 full-time professional; 1 full-time support.
Employer Identification Number: 941196186
Recent arts and culture grants:
American Inroads, San Francisco, CA, $5,000. For San Francisco New Performance Festival. 6/87.
Film Arts Foundation, San Francisco, CA, $5,000. For script development for Slow Boat to Moscow, film which will tell story of black Americans who settled in Soviet Union during 1930's. 7/87.

Jewish Community Museum, San Francisco, CA, $5,000. For major exhibit of works of Marc Chagall entitled, I and the Village: A Centennial Tribute to Marc Chagall. 9/87.

101
Computer Sciences Corporate Giving Program
2100 East Grand Ave.
El Segundo 90245 (213) 615-0311

Financial data (yr. ended 4/1/88): $82,000 for grants.
Purpose and activities: Company primarily supports health and welfare organizations. Also supports education, civic affairs and the arts.
Types of support: General purposes, building funds.
Limitations: Giving primarily in major operating areas in CA, MA, MI, and VA.
Application information: 501 (c)(3) status letter; description of the organization and project.
 Initial approach: Letter of inquiry
 Deadline(s): Applications accepted throughout the year
 Final notification: 4-6 weeks
 Write: Dorothy A. Horton, Sr. Staff Admin., Corp. Communications

102
Michael J. Connell Foundation
201 South Lake Ave., Suite 303
Pasadena 91101 (213) 681-8085

Incorporated in 1931 in CA.
Donor(s): Michael J. Connell.†
Financial data (yr. ended 6/30/88): Assets, $9,436,378 (M); expenditures, $797,586, including $635,000 for 21 grants (high: $100,000; average: $15,000-$50,000).
Purpose and activities: Giving generally restricted to programs initiated by the foundation in social, cultural, educational, and medical fields.
Types of support: Internships, fellowships, special projects.
Limitations: Giving primarily in southern CA, with emphasis on Los Angeles. No grants to individuals, or for building funds; no loans.
Publications: Financial statement.
Application information:
 Initial approach: Letter
 Copies of proposal: 1
 Deadline(s): None
 Board meeting date(s): Quarterly
 Final notification: 3 months
 Write: Michael J. Connell, Pres.
Officers: Michael J. Connell,* Pres.; Richard A. Wilson,* V.P.; Kay M. Staub, Secy.
Directors:* Mary C. Bayless, John Connell.
Number of staff: 1 full-time professional; 1 part-time professional.
Employer Identification Number: 956000904
Recent arts and culture grants:
Friends of the Junior Arts Center, Los Angeles, CA, $32,800. To support two programs - Sunday Open Sunday and International Child Art Collection. 1987.

Grand Peoples Company, Los Angeles, CA, $10,000. For programs to enrich lives of senior citizens in Los Angeles area. 1987.

Huntington Library, Art Gallery and Botanical Garden, San Marino, CA, $50,000. For fellowships for Library scholars. 1987.

Los Angeles Philharmonic Association, Los Angeles, CA, $1,000,000. Toward Philharmonic Orchestra's endowment fund, specifically to endow Principal Concert Master's Chair, to be known as Marjorie Connell Wilson Chair in perpetuity. 1987.

103
Cook Brothers Educational Fund
13005 Salinas Rd.
Atascadero 93422

Established about 1980 in CA.
Donor(s): Howard F. Cook.†
Financial data (yr. ended 12/31/87): Assets, $7,083,303 (M); expenditures, $265,290, including $91,551 for 6 grants (high: $64,000; low: $1,000).
Purpose and activities: Support for social service agencies, cultural programs, and higher education.
Application information: Contributes only to pre-selected organizations.
Officers and Trustees: Susan V. Cook, Pres.; Kathleen M. Cook, Secy.; Frank C. Cook, William H. Cook.
Employer Identification Number: 237306457

104
James S. Copley Foundation
7776 Ivanhoe Ave.
P.O. Box 1530
La Jolla 92038-1530 (619) 454-0411

Incorporated in 1953 in CA.
Donor(s): The Copley Press, Inc.
Financial data (yr. ended 12/31/88): Assets, $17,040,780 (M); gifts received, $17,203; expenditures, $1,599,997, including $1,538,271 for 187 grants (high: $357,000; low: $100; average: $500-$10,000) and $32,972 for 137 employee matching gifts.
Purpose and activities: Support for higher and secondary education, including an employee matching gift program, cultural programs, a community fund, and social services.
Types of support: Annual campaigns, emergency funds, building funds, equipment, land acquisition, scholarship funds, employee matching gifts.
Limitations: Giving primarily in circulation areas of company newspapers: San Diego, Torrance, San Pedro, and Santa Monica in CA; and Aurora, Elgin, Wheaton, Joliet, Springfield, Lincoln, and Waukegan in IL. No support for religious, fraternal, or athletic organizations, local chapters of national organizations, or public elementary or secondary schools. No grants to individuals, or for endowment funds, research, publications, conferences, unrestricted purposes, operating budgets, or large campaigns; no loans.
Publications: Application guidelines, program policy statement.
Application information:
 Initial approach: Letter

Copies of proposal: 1
Deadline(s): None
Board meeting date(s): Feb. and as required
Final notification: 2 to 3 weeks
Write: Anita A. Baumgardner, Secy.
Officers and Directors: Helen K. Copley, Chair.; David C. Copley, Pres.; Alex De Bakcsy, V.P.; Hubert L. Kaltenbach, V.P.; Anita A. Baumgardner, Secy.; Charles F. Patrick, Treas.
Number of staff: None.
Employer Identification Number: 956051770

105
Dorothy and Sherril C. Corwin Foundation
8727 West Third St.
Los Angeles 90048

Established in 1958 in CA.
Donor(s): Sherrill C. Corwin, Dorothy Corwin, Metropolitan Theatres Corp.
Financial data (yr. ended 12/31/86): Assets, $541,346 (M); expenditures, $117,856, including $117,119 for 65 grants (high: $37,780; low: $50).
Purpose and activities: Giving primarily for Jewish welfare, social services, medical research, cultural programs, and temple support.
Application information: Contributes only to pre-selected organizations. Applications not accepted.
Trustees: Martin Appel, Bruce C. Corwin, Dorothy Corwin, Bonnie Fuller.
Employer Identification Number: 956061525

106
S. H. Cowell Foundation
260 California, Suite 501
San Francisco 94111 (415) 397-0285

Trust established in 1955 in CA.
Donor(s): S.H. Cowell.†
Financial data (yr. ended 9/30/87): Assets, $104,000,000 (M); expenditures, $6,314,794, including $4,979,005 for 122 grants (high: $300,000; low: $1,200; average: $30,000-$50,000).
Purpose and activities: Support for programs aiding the handicapped, educational programs, community organizations, family planning projects, youth agencies, including training and employment programs, cultural programs, social rehabilitation services, and a new program for quality child care with emphasis on low-income single parent families.
Types of support: Seed money, building funds, equipment, land acquisition, matching funds, renovation projects, capital campaigns.
Limitations: Giving limited to northern CA. No support for hospitals or sectarian religious purposes. No grants to individuals, or for operating budgets, media programs, continuing support, annual campaigns, routine program administration, workshops, symposia, deficit financing, fellowships, special projects, medical research or treatment, publications, or conferences; no loans.
Publications: Annual report (including application guidelines), grants list.
Application information: The foundation has terminated the Minority Scholarship Program.

Initial approach: Letter
Copies of proposal: 1
Deadline(s): May 15 for colleges and universities, Apr. 1 for small arts organizations
Board meeting date(s): Monthly
Final notification: 4 to 5 months
Write: Stephanie Wolf, Exec. Dir.
Officers: Max Thelen, Jr.,* Pres.; William P. Murray, Jr.,* V.P.; George A. Hopiak, Secy.-Treas.; Stephanie Wolf, Exec. Dir.
Trustees:* J.D. Erickson, Wells Fargo Bank, N.A.
Number of staff: 4 full-time professional; 1 part-time professional; 2 full-time support.
Employer Identification Number: 941392803
Recent arts and culture grants:
California College of Arts and Crafts, Oakland, CA, $100,000. Toward construction of new gallery. 1987.
Cinnabar Arts Corporation, Petaluma, CA, $7,810. For renovations and lighting equipment at community theater. 1987.
Creativity Explored, San Francisco, CA, $40,000. For renovation and related costs to move into larger facility providing art therapy and expression for disabled clients. 1987.
Fairfield-Suisun Arts Council, Fairfield, CA, $15,000. For purchase of technical equipment at community arts center. 1987.
Fine Arts in Recreation, Sacramento, CA, $15,000. For purchase of technical equipment for Coloma Community Center. 1987.
Fort Mason Foundation, San Francisco, CA, $136,765. Toward completion of Cowell Theater on Pier 2 at Fort Mason Center. 1987.
La Raza Bookstore/Galeria Posada, Sacramento, CA, $6,710. For purchase of sound equipment and chairs for arts center. 1987.
Luther Burbank Memorial Foundation, Santa Rosa, CA, $15,000. For purchase of technical equipment at Luther Burbank Center for the Arts. 1987.
Matrix: Workshop of Women Artists, Sacramento, CA, $6,700. For purchase of technical equipment for gallery and arts center. 1987.
Napa County Arts Council, Napa, CA, $15,000. For establishment of equipment bank for local small arts organizations. 1987.
Old Lodi Union High School Site Foundation, Lodi, CA, $15,000. For purchase of lighting equipment at Hutchins Street Square arts center. 1987.
Sierra-Curtis Neighborhood Association, Sacramento, CA, $15,000. For purchase of technical equipment and renovations at Sierra 2 Center for the Arts and the Community. 1987.
Solano Arts Alliance, Suisun City, CA, $14,840. For establishment of equipment bank for local small arts organizations. 1987.
Sonoma Community Center, Sonoma, CA, $15,000. For purchase of lights and draperies at Andrews Hall. 1987.
Stockton Civic Theater, Stockton, CA, $12,600. For purchase of sound and lighting equipment. 1987.

107
Douglas S. Cramer Foundation
4605 Lankersham Blvd., Suite 714
North Hollywood 91602 (213) 877-7031

Established in 1987 in CA.
Financial data (yr. ended 4/30/88): Assets, $3,686,717 (M); gifts received, $823,000; expenditures, $136,796, including $33,750 for 5 grants (high: $25,000; low: $250).
Purpose and activities: A private operating foundation; support primarily for a fine arts museum; support also for outside arts organizations.
Types of support: Special projects.
Application information: Contributes only to pre-selected charitable organizations. Applications not accepted.
Write: Paula Kendall-Waxman, Curator
Officers and Directors:* Douglas S. Cramer,* Pres. and Treas.; Douglas S. Cramer, Jr.,* V.P.; Craig W. Johnson,* V.P.; Diana Weatherhill, Secy.
Number of staff: 2
Employer Identification Number: 956358014

108
Damien Foundation
235 Montgomery St., Suite 1010
San Francisco 94104 (415) 421-7555

Established in 1979 in DE.
Donor(s): Kristina Tara Fondaras Charitable Lead Trust.
Financial data (yr. ended 12/31/87): Assets, $404,229 (M); gifts received, $250,715; expenditures, $282,172, including $221,023 for 5 grants (high: $40,000; low: $5,000; average: $5,000).
Purpose and activities: Giving for innovative contemporary art education, transformative psychology, ecology, and human awareness.
Types of support: General purposes, special projects.
Limitations: Giving limited to the San Francisco Bay Area, CA, and England.
Application information:
Initial approach: Letter and proposal
Copies of proposal: 1
Deadline(s): None
Write: Sheila Weintraub, Asst. Secy.
Officers and Director:* Tara Lamont,* Pres.; Thomas Silk, Secy.-Treas.
Number of staff: 2
Employer Identification Number: 133006359

109
Davies Charitable Trust
c/o Bank of California
P.O. Box 45000
San Francisco 94145 (415) 765-0400

Trust established in 1974 in CA.
Donor(s): Ralph K. Davies.†
Financial data (yr. ended 9/30/87): Assets, $3,652,437 (M); expenditures, $203,951, including $182,500 for 48 grants (high: $16,500; low: $500).
Purpose and activities: Emphasis on the cultural programs, including performing arts, and higher and secondary education.
Limitations: Giving primarily in CA and HI.

Application information:
Initial approach: Written request
Deadline(s): None
Write: Donald D. Crawford
Trustees: Alicia C. Davies, Maryon Davies Lewis, The Bank of California, N.A.
Employer Identification Number: 237417287

110
Willametta K. Day Foundation
400 South Hope St., Rm. 500
Los Angeles 90071 (213) 683-4285
Mailing address: P.O. Box 71289, Los Angeles, CA 90071

Trust established in 1954 in CA.
Donor(s): Willametta K. Day.†
Financial data (yr. ended 12/31/87): Assets, $4,479,819 (M); expenditures, $307,476, including $252,925 for 33 grants (high: $10,000; low: $1,000; average: $1,500-$2,500).
Purpose and activities: Grants for higher and secondary education, hospitals, religion, and cultural programs.
Types of support: General purposes.
Limitations: Giving primarily in CA. No grants to individuals.
Publications: 990-PF, financial statement.
Application information:
Initial approach: Letter
Copies of proposal: 1
Deadline(s): Apr. and Nov.
Board meeting date(s): Semiannually
Write: Alvin R. Albe, Jr., C.F.O.
Officers: Maynard J. Toll,* Chair.; Jerry W. Carlton,* V.P.; Alvin R. Albe, Jr., C.F.O. and Secy.-Treas.
Trustees:* Howard M. Day, Robert A. Day, Jr., Tammis M. Day, Theodore J. Day.
Employer Identification Number: 956092476

111
Cecil B. DeMille Trust
223 West Alameda, Suite 101
Burbank 91502 (213) 660-3244

Trust established in 1952 in CA.
Financial data (yr. ended 12/31/86): Assets, $2,507,201 (M); expenditures, $262,421, including $132,542 for 29 grants (high: $50,000; low: $50).
Purpose and activities: Emphasis on social services, education, cultural programs, and child welfare.
Limitations: Giving primarily in CA.
Application information:
Initial approach: Letter or proposal
Deadline(s): None
Write: Lydia A. Magat
Director: Joseph W. Harper, Jr.
Trustees: Peter DeMille Calvin, Cecilia DeMille Presley.
Employer Identification Number: 951882931

112
The Rene & Veronica DiRosa Foundation
5200 Sonoma Hwy.
Napa 94558

Established in 1983 in CA.
Financial data (yr. ended 12/31/87): Assets, $3,068,788 (M); gifts received, $105,000; expenditures, $140,433, including $60,872 for 123 grants (high: $5,500; low: $6).
Purpose and activities: Giving primarily to environmental organizations, arts programs and education.
Application information:
Deadline(s): None
Officers: Rene di Rosa, Pres.; Veronica di Rosa, V.P.; Maude Connor, C.F.O.
Employer Identification Number: 942856000

113
Disney Foundation
500 South Buena Vista St.
Burbank 91521 (818) 840-1000

Incorporated in 1951 in CA.
Donor(s): Walt Disney Productions, and its associated companies.
Financial data (yr. ended 9/30/87): Assets, $191,250 (M); gifts received, $725,650; expenditures, $608,833, including $440,487 for 80 grants (high: $100,000; low: $100; average: $1,000-$20,000) and $158,685 for 50 grants to individuals.
Purpose and activities: Emphasis on youth and child welfare agencies, health, higher education, cultural programs, and community funds; scholarships for the children of employees.
Types of support: Annual campaigns, continuing support, operating budgets, special projects, scholarship funds, employee-related scholarships, general purposes, capital campaigns.
Limitations: Giving primarily in areas where the company's businesses are located, including central FL, and Los Angeles and Orange County, CA. No grants to individuals (except for scholarships to children of company employees) or for endowment funds.
Publications: Application guidelines.
Application information:
Initial approach: Letter, proposal, or telephone
Copies of proposal: 1
Deadline(s): Oct. 1 for scholarships
Board meeting date(s): Annually between Jan. and May
Final notification: 20 to 30 days
Write: Doris A. Smith, Secy.
Officers: Michael D. Eisner,* Pres.; Roy E. Disney,* V.P.; Jack B. Lindquist,* V.P.; Doris A. Smith, Secy.; Frank G. Wells, Treas.
Number of staff: None.
Employer Identification Number: 956037079

114
The Lillian B. Disney Foundation
P.O. Box 2039
Burbank 91507-2039

Established in 1974 in CA.
Donor(s): Lillian D. Truyens.
Financial data (yr. ended 12/31/86): Assets, $19,444,850 (M); gifts received, $49,977; expenditures, $62,859, including $59,989 for 4 grants (high: $25,000; low: $5,000).
Purpose and activities: Support for cultural programs, civic affairs and youth.
Types of support: General purposes.
Limitations: Giving primarily in CA.
Officers: Lillian B. Disney, Pres.; Sharon D. Lund, V.P.; Diane D. Miller, V.P.; Roy W. McClean, Secy.-Treas.
Employer Identification Number: 237425637

115
Douglas Charitable Foundation
141 El Camino Dr.
Beverly Hills 90212

Established in 1964 in CA.
Donor(s): Kirk Douglas, Anne Douglas.
Financial data (yr. ended 12/31/87): Assets, $3,260,929 (M); gifts received, $1,246,724; expenditures, $128,995, including $104,460 for 67 grants (high: $26,000; low: $70).
Purpose and activities: Giving for Jewish welfare, social services, and the arts.
Managers: Anne Douglas, Kirk Douglas, Karl Samuelian, John T. Trotter, Jack Valenti.
Employer Identification Number: 956096827

116
Dr. Seuss Foundation
7301 Encelia Dr.
La Jolla 92037 (619) 454-7384

Incorporated in 1958 in CA.
Donor(s): Theodor S. Geisel.
Financial data (yr. ended 12/31/86): Assets, $1,851,470 (M); expenditures, $233,039, including $182,675 for 92 grants (high: $50,000; low: $50).
Purpose and activities: Support for mental health, hospitals, higher education, youth agencies, cultural programs, and the arts.
Limitations: Giving primarily in CA. No grants to individuals.
Application information:
 Deadline(s): None
 Write: Theodor Geisel, Pres.
Officers and Directors: Theodor S. Geisel, Pres.; R.L. Bernstein, V.P.; Audrey Geisel, V.P.; Karl Zobell, Secy.; Jeanne Jones, Edward Lathem, James Youngblood.
Employer Identification Number: 956029752

117
Dreyer's Charitable Foundation
5929 College Ave.
Oakland 94618

Donor(s): Dreyer's Grand Ice Cream, Inc.
Financial data (yr. ended 12/26/87): Assets, $141,615 (M); gifts received, $153,000; expenditures, $161,735, including $5,438 for 48 grants (high: $500; low: $5).

Purpose and activities: Dreyer's Charitable Foundation gives through a bus program (available to schools and other non-profit organizations for field trips and cultural activities) and a grants program. The grants are given to a variety of non-profit educational, cultural, and community organizations.
Limitations: No support for political organizations. No grants to individuals.
Application information:
 Deadline(s): None
 Write: Linda Bryant
Officer: Diane McIntyre, Pres.
Directors: Kenneth James Duggan, Margaret Ann Gable.
Employer Identification Number: 943006987

118
Ducommun & Gross Foundation
237 Strada Corta Rd.
Los Angeles 90077-3726

Established in 1968 in CA.
Financial data (yr. ended 12/31/87): Assets, $1,427,975 (M); expenditures, $110,513, including $100,000 for 13 grants (high: $35,000; low: $1,000).
Purpose and activities: Support primarily for higher education and the arts, including art museums.
Application information:
 Initial approach: Letter
 Deadline(s): None
 Write: Charles E. Ducommun, Pres.
Officers: Charles E. Ducommun, Pres.; Virginia D. Ward, V.P.; Frederick A. Richmond, Secy.
Employer Identification Number: 956210834

119
The Durfee Foundation
11444 West Olympic Blvd., Suite 1015
Los Angeles 90064 (213) 312-9543

Incorporated in 1960 in CA.
Donor(s): Ray Stanton Avery, Dorothy Durfee Avery.†
Financial data (yr. ended 12/31/88): Assets, $12,200,406 (M); gifts received, $15,000; expenditures, $743,066, including $575,085 for 38 grants (high: $89,250; low: $1,000).
Purpose and activities: Support for cultural programs and education. Biannual cash awards of up to $25,000 are made to individuals who have enhanced human dignity through the law.
Types of support: Special projects.
Limitations: Giving primarily in CA. No grants for endowment funds or operating budgets.
Publications: Occasional report, multi-year report.
Application information: Submit grant application at request of foundation only; foundation solicits proposals in areas of interest.
 Copies of proposal: 1
 Deadline(s): None
 Write: Robert S. Macfarlane, Jr., Managing Dir.
Officers and Trustees: Ray Stanton Avery, Chair.; Russell D. Avery, Pres.; Judith A. Newkirk, V.P.; Dennis S. Avery, Secy.-Treas.;

Robert S. Macfarlane, Jr., Managing Dir.; Caroline Newkirk, Michael Newkirk.
Number of staff: 1 part-time professional; 1 part-time support.
Employer Identification Number: 952223738

120
The East Bay Community Foundation
6230 Claremont Ave.
Oakland 94618 (415) 658-5441

Community foundation established in 1928 in CA by resolution and declaration of trust; revised in 1972.
Financial data (yr. ended 12/31/86): Assets, $6,800,000 (M); gifts received, $934,873; expenditures, $554,698, including $413,630 for 70 grants.
Purpose and activities: Grants for community welfare, youth, the aged, women's programs, health care, arts and culture, and educational programs.
Limitations: Giving limited to Alameda and Contra Costa counties, CA. No support for sectarian religious causes, or educational or hospital foundations. No grants to individuals, or for building and endowment funds, equipment, annual fund drives, salaries, scholarships, deficit financing, matching gifts, travel, or conferences; no loans.
Publications: Annual report, program policy statement, application guidelines.
Application information:
 Initial approach: Letter or proposal
 Copies of proposal: 1
 Deadline(s): Jan. 1, May 1, and Sept. 1
 Board meeting date(s): Feb., June, and Oct.
 Write: Sandra L. Pyer, Exec. Dir.
Officers: Sandra L. Pyer, Exec. Dir.; Virginia H. Hooper, Secy.-Treas.
Governing Board: Lois De Domenico, Chair.; David L. Cutter, Vice-Chair.; Hon Chew, Penny Deleray, Barbara C. Donald, Salvatore V. Giuffre, Margaret Stuart Graupner, Ed Heafey, Jr., Lucile Lansing-Levin, Gregory L. McCoy, Neil W. McDaniel, Linda C. Roodhouse, Donald H. Sledge, Y. Charles Soda.
Trustees: First Interstate Bank, Wells Fargo Bank, N.A.
Number of staff: 1 full-time professional; 1 part-time professional; 1 full-time support.
Employer Identification Number: 946070996
Recent arts and culture grants:
Berkeley Repertory Theater, Berkeley, CA, $5,000. To produce twentieth anniversary report. 1987.
Berkeley Symphony Orchestra, Berkeley, CA, $5,000. To expand 1987-88 season. 1987.
Lawrence Hall of Science, Berkeley, CA, $5,000. For general support. 1987.
Oakland Ballet Association, Oakland, CA, $7,500. To support Premiere Fund for Ballet's Anniversary Campaign. 1987.
Oakland Ballet Association, Oakland, CA, $5,000. For support of work-in-progress, Nicholas and Concepcion. 1987.
Oakland Youth Orchestra, Oakland, CA, $5,000. For general support. 1987.

121
Lucius & Eva Eastman Fund, Inc.
24120 Summit Woods Dr.
Los Gatos 95030

Established in 1946 in CA.
Financial data (yr. ended 12/31/88): Assets, $1,149,964 (M); expenditures, $71,135, including $55,375 for 43 grants (high: $2,500; low: $500).
Purpose and activities: Support for law and justice, including civil and human rights, social services, women, and cultural programs, especially the fine arts.
Application information:
Deadline(s): None
Board meeting date(s): Quarterly
Write: Lucius R. Eastman, Jr., Pres.
Officer: Lucius R. Eastman, Jr., Pres.
Number of staff: None.
Employer Identification Number: 131958483

122
Eldorado Foundation
15 Sixth Ave.
San Francisco 94118 (415) 221-0734

Established in 1964 in CA.
Financial data (yr. ended 12/31/87): Assets, $1,299,933 (M); expenditures, $95,235, including $89,000 for 30 grants (high: $15,000; low: $500).
Purpose and activities: Giving primarily for cultural programs and conservation; support also for social services, hospitals, education, and religion.
Application information:
Initial approach: Letter
Deadline(s): Apr. 1
Write: Ava Jean Pischel, Secy.
Officers and Directors: Helen D. Van Blair, Pres.; Jack F. Dohrmann, V.P.; Ava Jean Pischel, Secy.-Treas.; Henry K. Evers, Peggy Merrifield.
Number of staff: None.
Employer Identification Number: 946100642

123
Isadore and Sunny Familian Family Foundation
906 Loma Vista Dr.
Beverly Hills 90210 (213) 272-0191

Incorporated in 1947 in CA.
Donor(s): The Familian family and others.
Financial data (yr. ended 12/31/87): Assets, $1,200,542 (M); gifts received, $380,082; expenditures, $144,976, including $122,321 for 75 grants (high: $64,345; low: $18).
Purpose and activities: Support for Jewish welfare funds and religious organizations, higher education, and cultural programs.
Limitations: Giving primarily in CA.
Application information: Contributes only to pre-selected organizations. Applications not accepted.
Write: Isadore Familian, Pres.
Officers and Director: Isadore Familian, Pres. and Treas.; Sondra Smalley, Secy.; Marvin Smalley.
Employer Identification Number: 956027950

124
Zalec Familian Foundation
P.O. Box 5149
Compton 90224

Established in 1958 in CA.
Donor(s): Zalec Familian,† and others.
Financial data (yr. ended 3/31/87): Assets, $1,388,742 (M); expenditures, $66,946, including $62,000 for 15 grants (high: $10,000; low: $1,000).
Purpose and activities: Emphasis on higher education, social services, and cultural programs.
Types of support: General purposes.
Limitations: Giving primarily in CA.
Application information: Budget for grants considered late in the calendar year.
Initial approach: Proposal
Write: Robert J. Cannon, Asst. Secy.
Officers: Lilian Levinson, Pres.; Albert T. Galen, V.P.; Albert Levinson, Secy.-Treas.
Employer Identification Number: 956099164

125
Feintech Family Foundation
321 South Beverly Dr., Suite K
Beverly Hills 90212 (213) 879-3262

Established in 1950 in CA.
Donor(s): Irving Feintech.
Financial data (yr. ended 9/30/87): Assets, $1,926,379 (M); gifts received, $277,350; expenditures, $109,555, including $62,245 for 29 grants (high: $16,000; low: $45).
Purpose and activities: Support primarily for Jewish welfare and concerns, including giving to Jewish universities; support also for the arts and health service organizations.
Limitations: Giving primarily in CA and IL.
Application information:
Initial approach: Letter or proposal
Deadline(s): None
Write: Norman Feintech, Pres. or Irving Feintech, V.P.
Officers and Director: Norman Feintech, Pres.; Irving Feintech, V.P.; Celia Littenberg.
Employer Identification Number: 956072287

126
Lorser Feitelson and Helen Lundeberg Feitelson Arts Foundation
8307 West Third St.
Los Angeles 90048 (213) 655-3245

Established in 1979.
Donor(s): Lorser Feitelson.
Financial data (yr. ended 11/30/86): Assets, $1,012,602 (M); expenditures, $433,870, including $415,900 for 3 grants (high: $253,400; low: $6,500).
Purpose and activities: Grants and loans in form of art works by Lorser Feitelson, to major universities with prominent art museums and art history departments and to municipal art museums; also individual grants based on need to artists living in southern CA.
Types of support: Grants to individuals.
Limitations: Giving primarily in CA.
Application information:
Initial approach: Letter
Deadline(s): None

Officers and Directors: Helen L. Feitelson, Pres.; Josine Ianco-Starrels, Secy.; Monroe Price, Treas.
Employer Identification Number: 953451355

127
Fireman's Fund Foundation
(Formerly Fireman's Fund Insurance Company Foundation)
777 San Marin Dr.
P.O. Box 777
Novato 94998 (415) 899-2757

Incorporated in 1953 in CA.
Donor(s): Fireman's Fund Insurance Co., and subsidiaries.
Financial data (yr. ended 12/31/87): Assets, $147,397 (M); gifts received, $1,567,913; expenditures, $1,457,820, including $1,102,496 for 223 grants (high: $225,000; low: $50; average: $100-$5,000) and $342,739 for 766 employee matching gifts.
Purpose and activities: Giving primarily to assist higher education, human service agencies, youth groups, and civic and cultural activities; grants also for United Way campaigns nationwide in cities where principal company offices are located.
Types of support: Operating budgets, annual campaigns, equipment, technical assistance, continuing support, employee matching gifts, matching funds.
Limitations: Giving primarily in the counties of San Francisco, Marin, and Sonoma, CA. No support for religious or national organizations, or other grantmaking bodies. No grants to individuals, or for travel, benefit events, or operating expenses of organizations that receive federated-campaign support; no loans.
Publications: Annual report (including application guidelines).
Application information:
Initial approach: Letter
Copies of proposal: 1
Deadline(s): None
Board meeting date(s): Jan.; distribution committee meets once a month
Final notification: 6 weeks
Write: Mary K. Anderson, Secy. and Dir.
Officers: William M. McCormick,* Chair.; Donald H. McComber,* Pres.; Mary K. Anderson,* Secy.; Robert Marto, Treas.
Directors:* Francis W. Benedict, Lawrence E. Wiesen.
Number of staff: 1 full-time professional; 1 part-time support.
Employer Identification Number: 946078025

128
First Interstate Bank of California Foundation
1055 Wilshire Blvd., B9-75
Los Angeles 90017 (213) 580-6658
Additional tel.: (213) 580-6666

Established in 1978 in CA.
Donor(s): First Interstate Bank of California.
Financial data (yr. ended 12/31/88): Assets, $19,154,000 (M); expenditures, $2,496,988, including $2,432,000 for 300 grants (high: $680,853; low: $500; average: $1,000-

$25,000) and $139,916 for 536 employee matching gifts.

Purpose and activities: Giving primarily for community funds, education, the performing arts and cultural programs, hospitals, urban and civic affairs, and social service and youth agencies; employee-related scholarships made through the Citizens' Scholarship Foundation of America.

Types of support: Building funds, land acquisition, endowment funds, matching funds, technical assistance, scholarship funds, employee-related scholarships, special projects, publications, employee matching gifts, annual campaigns, operating budgets, continuing support, capital campaigns.

Limitations: Giving limited to CA. No support for religious organizations for religious purposes, agencies supported by the United Way, or private foundations. No grants to individuals, or for research, conferences, or equipment for hospitals; no loans.

Publications: Informational brochure (including application guidelines).

Application information: Application form required.

 Initial approach: Letter, telephone, or proposal
 Copies of proposal: 1
 Deadline(s): Capital campaigns July 1; for other programs, none
 Board meeting date(s): Quarterly
 Final notification: 6 weeks to 3 months after board meeting
 Write: Ruth Jones-Saxey, Secy.

Officers: William E.B. Siart,* Chair.; Gary S. Gertz,* C.F.O.; Ruth Jones-Saxey, Secy.-Treas.

Directors:* Richard L. Barkhurst, John F. Futcher, John Popovich.

Number of staff: 2 full-time professional.

Employer Identification Number: 953288932

129
First Nationwide Bank Corporate Giving Program
700 Market St.
San Francisco 94102 (415) 772-1475

Financial data (yr. ended 01/31/88): $305,000 for 220 grants (high: $20,000; low: $150; average: $200-$2,000).

Purpose and activities: Supports community, social, and health services, public and civic affairs, community development, business, crime and law enforcement programs, minorities, women, youth, education, cultural organizations and the arts.

Types of support: Capital campaigns, emergency funds, operating budgets, scholarship funds, technical assistance.

Limitations: Giving primarily in major operating areas.

Publications: Corporate giving report, application guidelines.

Application information: Include description of the organization and project, audited financial statement, list of board members and contributors, geographical areas and populations served and evidence of tax exemption.

 Copies of proposal: 1
 Board meeting date(s): Bi-monthly

 Final notification: soon after each board meeting
 Write: Stephen L. Johnson, Sr. V.P. and Dir., Public Affairs

Administrators: Stephen L. Johnson, Gerri Romero.

Number of staff: 1 full-time professional.

130
Fleishhacker Foundation
The Alcoa Bldg.
One Maritime Plaza, Suite 830
San Francisco 94111 (415) 788-2909

Incorporated in 1947 in CA.

Donor(s): Mortimer Fleishhacker, Sr.†

Financial data (yr. ended 4/30/88): Assets, $6,827,866 (M); expenditures, $368,980, including $216,500 for 30 grants (high: $25,000; low: $1,000; average: $5,000-$10,000) and $60,000 for 8 grants to individuals.

Purpose and activities: The foundation operates the Eureka Fellowships program for individual artists to spend uninterrupted time pursuing creative work; grants also to literary and performing arts organizations. Support for pre-collegiate education.

Types of support: Operating budgets, special projects, fellowships, general purposes, grants to individuals, publications, seed money.

Limitations: Giving limited to northern CA. No grants for annual campaigns, deficit financing, or matching gifts; no loans.

Publications: Application guidelines, program policy statement, grants list.

Application information: Fellowship seekers should contact the foundation for detailed application information.

 Initial approach: Letter
 Copies of proposal: 1
 Deadline(s): Announced in Mar. of each year for fellowships
 Board meeting date(s): Quarterly
 Final notification: 2 to 5 months
 Write: Sarah Lutman, Exec. Dir.

Officers: Delia F. Ehrlich,* Pres.; Leon Sloss,* V.P.; David Fleishhacker,* Secy.; Mortimer Fleishhacker III,* Treas.; Sarah Lutman, Exec. Dir.

Directors:* John Stephen Ehrlich, Jr., Lois Gordon, Laurie Sloss.

Number of staff: 1 part-time professional; 1 part-time support.

Employer Identification Number: 946051048

131
Willis & Jane Fletcher Foundation
530 Broadway, Suite 1048
San Diego 92101 (619) 239-0481

Established in 1969 in CA.

Financial data (yr. ended 12/31/88): Assets, $1,459,490 (M); expenditures, $84,398, including $72,826 for 61 grants (high: $19,000; low: $40; average: $1,000-$19,000).

Purpose and activities: Support primarily for youth activities, social services, and education; some support for cultural programs, and conservation and wildlife.

Types of support: Annual campaigns, building funds, endowment funds, equipment, matching funds, seed money.

Limitations: Giving limited to San Diego County, CA. No grants for capital funds other than gifts to the United Way.

Publications: Application guidelines.

Application information: Application form required.

 Initial approach: Telephone call or letter
 Copies of proposal: 1
 Deadline(s): June and Oct.
 Board meeting date(s): July and Nov.
 Final notification: Aug. and Dec.
 Write: Willis H. Fletcher, Pres. or Mary V. Todal, Asst. Secy.

Officers: Willis H. Fletcher, Pres.; Jane C. Fletcher, V.P.; Susan Randerson, Secy.; Mary Harker, Treas.

Number of staff: 1 part-time support.

Employer Identification Number: 952624912

132
Flintridge Foundation
1100 El Centro St., Suite 103
South Pasadena 91030 (818) 799-4178

Established in 1984 in CA.

Donor(s): Francis Loring Moseley,† Louisa Moseley.†

Financial data (yr. ended 12/31/87): Assets, $15,200,300 (M); gifts received, $1,239,492; expenditures, $936,846, including $679,300 for 17 grants (high: $250,000; low: $1,000; average: $30,000).

Purpose and activities: Support for medical and scientific research, conservation, cultural programs, particularly those involving theatre, painting, and sculpture, and social service agencies, with emphasis on combined teenage pregnancy and AIDS education, peer counseling program for seniors, and afterschool latchkey program.

Types of support: Fellowships, matching funds, professorships, research, seed money, special projects.

Limitations: Giving primarily in CA, OR, and WA. No support for religious groups. No grants for endowment funds, annual campaigns, capital funds, deficit financing, or building funds.

Publications: Annual report (including application guidelines), application guidelines.

Application information: Most grants foundation-initiated.

 Initial approach: Letter
 Board meeting date(s): Feb., May, Aug., and Nov.
 Write: Jaylene L. Moseley, Managing Dir.

Officers: Susan A. Addison, Pres.; Alexander Moseley, Secy.

Directors: Joshua D. Addison, Michael Addison, Ann A. Morris, Brook B. Morris, Peter Moseley, Joany Mosher, Joan Tanner.

Number of staff: None.

Employer Identification Number: 953926331

133
The Fluor Foundation
3333 Michelson Dr.
Irvine 92730 (714) 975-6797

Incorporated in 1952 in CA.
Donor(s): Fluor Corp.
Financial data (yr. ended 10/31/87): Assets, $2,759,835 (M); expenditures, $508,663, including $505,853 for 308 grants (high: $100,152; low: $10; average: $100-$40,000).
Purpose and activities: Support for higher education, culture and the arts, public and civic affairs, and health and welfare organizations, especially the United Way; scholarships for children of company employees are administered by an independent scholarship corporation.
Types of support: Annual campaigns, building funds, continuing support, emergency funds, employee matching gifts, operating budgets, seed money, technical assistance, employee-related scholarships, general purposes.
Limitations: Giving primarily in areas where the corporation has permanent offices, with some emphasis on CA, TX, IL, and SC. No support for medical research, guilds, and sports organizations. No grants to individuals (except for employee-related scholarships).
Publications: Program policy statement, application guidelines.
Application information:
 Initial approach: Letter
 Copies of proposal: 1
 Deadline(s): None
 Board meeting date(s): Dec. and June
 Final notification: 2 months
 Write: Suzanne H. Esber, Dir., Comm. Affairs
Officers: J.R. Fluor II,* Pres.; L.N. Fisher, Secy.; V.L. Prechtl, Treas.
Trustees:* David S. Tappan, Jr., Chair.; H.K. Coble, Robert L. Guyett, V.L. Kontny, L.G. McCraw, E.J. Parente, N.A. Peterson.
Number of staff: 1 full-time professional; 1 full-time support.
Employer Identification Number: 510196032

134
The Foothills Foundation
P.O. Box 3809
San Francisco 94119-3809

Established in 1977 in CA.
Donor(s): Gary Hogan Bechtel.
Financial data (yr. ended 12/31/87): Assets, $2,752,759 (M); gifts received, $200,000; expenditures, $199,718, including $196,000 for 4 grants (high: $152,500; low: $5,000).
Purpose and activities: Support for hospitals and health associations, higher and secondary education, social service and child welfare agencies, cultural programs, and religion.
Types of support: Endowment funds, capital campaigns, annual campaigns.
Application information: Contributes only to pre-selected organizations. Applications not accepted.
Officers and Directors:* Gary Hogan Bechtel,* Pres.; Carolyn M. Bechtel,* V.P.; Elizabeth Hogan Bechtel,* V.P.; George T. Argyris,* Secy.; Theodore J. VanBebber,* Treas.
Investment Manager: S.D. Bechtel, Jr.
Employer Identification Number: 942412392

135
Fox Foundation
c/o Union Bank
P.O. Box 109
San Diego 92112

Established in 1955 in CA.
Financial data (yr. ended 3/31/87): Assets, $1,652,913 (M); expenditures, $82,867, including $62,150 for 55 grants (high: $5,000; low: $250).
Purpose and activities: Emphasis on culture, youth activities, hospitals and health agencies, and social services.
Limitations: Giving limited to San Diego County, CA.
Application information:
 Deadline(s): None
Trustee: California First Bank.
Employer Identification Number: 956010288

136
Lawrence L. Frank Foundation
2950 Los Feliz Blvd., Suite 204
Los Angeles 90039

Established in 1959 in CA.
Donor(s): Richard N. Frank.
Financial data (yr. ended 11/30/87): Assets, $137,929 (M); gifts received, $218,307; expenditures, $145,179, including $144,099 for 93 grants (high: $77,050; low: $25).
Purpose and activities: Giving primarily for higher and secondary education; support also for social service agencies, including community funds, youth, and Jewish welfare funds, and cultural programs.
Limitations: No grants for scholarships, fellowships, or prizes; no loans.
Officers and Directors: Richard N. Frank, Pres.; Susan S. Rosenberg, V.P. and Secy.; Arthur Wynne, V.P. and Treas.; Richard R. Frank, V.P.; Stuart Kadison.
Employer Identification Number: 956034851

137
Fresno Regional Foundation
1515 Van Ness Ave.
Fresno 93721 (209) 233-2016

Community foundation established as a Trust in 1966 in CA.
Financial data (yr. ended 12/31/87): Assets, $981,447 (M); gifts received, $387,536; expenditures, $254,601, including $211,736 for grants.
Purpose and activities: Interests include health, the arts, alleviation of social problems, education, senior citizens, character building, conservation and beautification, religious institutions, conservation of human and natural resources, and local historical programs.
Types of support: Continuing support, equipment, program-related investments, seed money.
Limitations: Giving primarily in the central San Joaquin Valley, CA, area, especially Fresno. No grants to individuals, or for building or endowment funds, operating budgets, or research; no loans.
Publications: Annual report, program policy statement, application guidelines.

Application information: Application form required.
 Initial approach: Letter or telephone
 Deadline(s): Dec. 1 to Jan. 31
 Board meeting date(s): Mar.
 Final notification: Apr.
 Write: Robert S. Miner, Exec. Dir.
Officer: Robert S. Miner, Exec. Dir.
Governors: Paul S. Asperger, Larry Balakian, Shirley Brinker, Robert E. Duncan, Virginia Meux, Chris Rogers, Malcolm Stewart, Gerald Tahajian, O. James Woodward III.
Trustee Banks: First Interstate Bank, Lloyds Bank California, Wells Fargo Bank, N.A.
Number of staff: 1 part-time professional; 1 part-time support.
Employer Identification Number: 946140207

138
Friedman Family Foundation
1160 Battery St., Suite 400
San Francisco 94111 (415) 986-7570

Established in 1964 in CA.
Donor(s): Phyllis K. Friedman, Howard Friedman.
Financial data (yr. ended 2/28/87): Assets, $2,115,831 (M); expenditures, $154,826, including $130,850 for 41 grants (high: $5,000; low: $100).
Purpose and activities: Support primarily for social services and education; some support for culture, Jewish welfare, and women.
Application information:
 Deadline(s): None
 Write: Phyllis K. Friedman, Pres.
Officers and Directors: Phyllis K. Friedman, Pres. and Treas.; Howard A. Friedman, V.P.; William K. Coblentz, Secy.
Employer Identification Number: 946109692

139
The Friend Family Foundation
585 Mission St.
San Francisco 94105 (415) 546-0696

Donor(s): Donald A. Friend, Eugene L. Friend, Robert B. Friend.
Financial data (yr. ended 6/30/87): Assets, $341,972 (M); gifts received, $200,000; expenditures, $139,916, including $138,978 for 82 grants (high: $85,000; low: $20).
Purpose and activities: Grants primarily for Jewish giving, including Jewish welfare funds; support also for cultural programs.
Application information:
 Deadline(s): None
 Write: Eugene L. Friend, Pres.
Officers and Directors: Eugene L. Friend, Pres. and Treas.; Robert B. Friend, V.P.; Donald A. Friend, Secy.
Employer Identification Number: 946163916

140
Furth Foundation
201 Sansome St., No. 1000
San Francisco 94104 (415) 433-2070

Established in 1969 in CA.
Financial data (yr. ended 12/31/86): Assets, $1,567,305 (M); gifts received, $200,000;

expenditures, $221,152, including $216,569 for 123 grants (high: $52,140; low: $24).

Purpose and activities: Giving primarily for social services and education; some support for public affairs and culture.

Limitations: No grants to individuals.

Application information:

Deadline(s): None

Write: Frederick Furth, Pres.

Officers and Directors: Frederick Furth, Pres.; Donna Furth, V.P.; Alison Darby Furth, Peggy Furth.

Employer Identification Number: 237062014

141
Gamble Foundation

P.O. Box 2655
San Francisco 94126

Established in 1968 in CA.

Financial data (yr. ended 12/31/87): Assets, $1,305,378 (M); gifts received, $12,000; expenditures, $74,781, including $69,800 for 40 grants (high: $11,000; low: $50).

Purpose and activities: Support primarily for a land trust and for environmental conservation organizations; support also for community funds, a hospital, a symphony association and a fine arts museum.

Application information:

Initial approach: Letter

Deadline(s): None

Officers: Launce E. Gamble, Pres.; George F. Gamble, V.P. and Secy.-Treas.; Mary S. Gamble, V.P.

Employer Identification Number: 941680503

142
The Gap Foundation

900 Cherry Ave.
San Bruno 94066 (415) 952-4400

Established in 1977 in CA.

Donor(s): The Gap, Inc.

Financial data (yr. ended 6/30/87): Assets, $211,920 (M); gifts received, $407,000; expenditures, $263,174, including $242,217 for 86 grants and $20,808 for 111 employee matching gifts.

Purpose and activities: Support for higher and other education, civic and public affairs, cultural programs, and health and welfare, including youth organizations.

Types of support: Employee matching gifts, capital campaigns, general purposes, operating budgets.

Limitations: Giving primarily in San Francisco and San Mateo, CA.

Application information:

Initial approach: Letter

Deadline(s): None

Write: Sherry Reson, Mgr.

Officers: Donald G. Fisher, Pres.; Alan E. Zimtbaum, Sr. V.P.; Dexter C. Tight, Secy.

Number of staff: 1 part-time professional.

Employer Identification Number: 942474426

143
John Jewett & H. Chandler Garland Foundation

P.O. Box 550
Pasadena 91102-0550

Trust established in 1959 in CA.

Donor(s): Members of the Garland family.

Financial data (yr. ended 12/31/86): Assets, $162,927 (M); gifts received, $1,025,269; expenditures, $1,305,660, including $1,261,500 for 50 grants (high: $480,000; low: $1,000; average: $5,000-$20,000).

Purpose and activities: Emphasis on cultural and historical programs, secondary and higher education, social services, especially for the elderly, youth agencies, hospitals, and health services.

Limitations: Giving primarily in CA, with emphasis on Los Angeles.

Application information:

Initial approach: Letter

Deadline(s): None

Board meeting date(s): 3 times per year

Final notification: After each meeting

Trustees: G.E. Morrow, Mgr.; Gwendolyn Garland Babcock, Louise Grant Garland.

Number of staff: None.

Employer Identification Number: 956023587

144
The Carl Gellert Foundation

2222 19th Ave.
San Francisco 94116 (415) 566-4420

Incorporated in 1958 in CA.

Donor(s): Carl Gellert,† Atlas Realty Co., Pacific Coast Construction Co., Gertrude E. Gellert.†

Financial data (yr. ended 11/30/88): Assets, $7,046,615 (M); expenditures, $701,838, including $637,300 for 117 grants (high: $100,000; low: $500; average: $1,000-$10,000).

Purpose and activities: Support for the aged and hospitals; grants also for Roman Catholic church support, higher and secondary education, including scholarship funds, and to community development programs and social service agencies.

Types of support: Operating budgets, continuing support, annual campaigns, deficit financing, building funds, equipment, endowment funds, scholarship funds, research, publications, special projects, renovation projects, capital campaigns, general purposes.

Limitations: Giving primarily in the San Francisco Bay Area, CA. No grants to individuals, or for seed money, emergency funds, land acquisition, matching gifts, or conferences; no loans.

Publications: 990-PF, program policy statement, application guidelines.

Application information:

Initial approach: Proposal

Copies of proposal: 5

Deadline(s): Submit proposal preferably in Aug. and Sept.; deadline Oct. 1st

Board meeting date(s): Apr. and Nov.

Final notification: Nov. 30, for recipients only

Write: Peter J. Brusati, Secy.

Officers and Directors: Fred R. Bahrt, Pres.; Robert L. Pauly, V.P.; Peter J. Brusati, Secy.; Marie Simpson, Treas.; Celia Berta Gellert.

Number of staff: None.

Employer Identification Number: 946062858

Recent arts and culture grants:

Feedback Productions, San Francisco, CA, $5,000. For Make A Circus Project Clown Therapy Program. 1987.

145
The Fred Gellert Foundation

1655 Southgate Ave., Suite 203
Daly City 94015 (415) 991-1855

Established in 1958 in CA.

Donor(s): Fred Gellert, Sr.†

Financial data (yr. ended 11/30/88): Assets, $9,193,113 (M); expenditures, $666,694, including $599,976 for 96 grants (high: $100,000; low: $300; average: $1,000-$5,000).

Purpose and activities: Grants for cultural programs, hospitals, health care programs, programs for the disabled, social service agencies, and education, including ophthalmology education.

Types of support: Operating budgets, continuing support, building funds, equipment, research, special projects, general purposes.

Limitations: Giving primarily in San Francisco and San Mateo counties, CA. No grants to individuals, or for annual campaigns; no loans.

Publications: Application guidelines, financial statement.

Application information:

Initial approach: Letter

Copies of proposal: 5

Deadline(s): Submit proposal preferably in May through Aug.; deadline Sept. 15

Board meeting date(s): Nov.

Final notification: 1st week in Dec.

Write: Fred Gellert, Jr., Chair.

Officers and Directors: Fred Gellert, Jr., Chair.; John D. Howard, Secy.-Treas.; Annette Gellert, Joan Sargen, Marche H. Yoshioka.

Number of staff: 1 part-time professional.

Employer Identification Number: 946062859

146
Wallace Alexander Gerbode Foundation

470 Columbus Ave., Suite 209
San Francisco 94133 (415) 391-0911

Incorporated in 1953 in CA.

Donor(s): Members of the Gerbode family.

Financial data (yr. ended 12/31/88): Assets, $40,961,000 (M); expenditures, $2,500,000, including $1,938,439 for 150 grants (high: $150,000; low: $475; average: $5,000-$25,000) and $1,250,000 for 3 loans.

Purpose and activities: Support for innovative, positive programs in the arts, education, environment, health, and urban affairs.

Types of support: Consulting services, technical assistance, program-related investments, loans, special projects.

Limitations: Giving primarily to programs directly affecting residents of Alameda, Contra Costa, Marin, San Francisco, and San Mateo counties in CA, and HI; on occasion and as a second priority grants will be made in other northern CA communities. No support for

religious purposes. No grants to individuals, or for general or continuing support, direct services, operating budgets, capital or endowment funds, fundraising or annual campaigns, emergency funds, matching gifts, scholarships, fellowships, publications, deficit financing, building funds, equipment or materials, land acquisition, or renovation projects.

Publications: Grants list, annual report (including application guidelines).

Application information:
Initial approach: Letter
Copies of proposal: 1
Deadline(s): None
Board meeting date(s): 6 times a year
Final notification: 2 to 3 months
Write: Thomas C. Layton, Exec. Dir.

Officers and Directors: Maryanna G. Shaw, Pres.; Frank A. Gerbode, M.D., V.P.; Joan Richardson, Secy.; Charles M. Stockholm, Treas.; Thomas C. Layton, Exec. Dir.

Number of staff: 1 full-time professional; 1 full-time support.

Employer Identification Number: 946065226

Recent arts and culture grants:

California Poets in the Schools, San Francisco, CA, $10,000. For second year support of Leadership Training Project. 8/19/87.

Catticus Corporation, Emeryville, CA, $25,000. For film documentary, The Judge Who Changed America, on life and times of Earl Warren. 12/11/87.

Central City Hospitality House, San Francisco, CA, $30,000. For development of arts program. 12/11/87.

Childrens Book Press, Bookends Project, San Francisco, CA, $10,000. To support project which will seek to develop multi-cultural educational materials for middle school teachers and students. 6/10/88.

Circuit Network, San Francisco, CA, $10,000. For support of efforts to expand management services to include additional performing arts groups. 8/19/87.

Circuit Network, San Francisco, CA, $5,000. For support of efforts to expand management services for performing arts groups. 10/5/88.

Civil Rights Project, Boston, MA, $25,000. For costs in developing production of television history of American Depression years 1929-41. 12/11/87.

East Bay Negro Historical Society, Oakland, CA, $25,000. For documentary film project, Visions Toward Tomorrow: The History of the East Bay Afro-American Community. 3/8/88.

Eureka Theater Company, San Francisco, CA, $25,000. For Theater Production Award in support of 1988 production of Angels in America. 8/19/87.

Exploratorium, San Francisco, CA, $20,000. To help establish program for solicitation of major individual gifts. 3/8/88.

Film Arts Foundation, San Francisco, CA, $25,000. For development of consultation services for Northern California independent film and video artists to help with exhibition and distribution strategies appropriate for their works. 3/8/88.

Film Arts Foundation, San Francisco, CA, $5,000. For film project, The Color of Honor, documentary on role of Japanese-American soldiers in WWII. 11/25/87.

Film Arts Foundation, Forbidden City, USA, San Francisco, CA, $5,000. For support of production of Forbidden City, USA. 10/5/88.

Hawaii Nature Center, Honolulu, HI, $5,810. For expansion of weekend programs. 3/24/88.

Headlands Arts Center, Sausalito, CA, $7,500. For support of organizational development. 7/24/87.

Intersection Art Center, San Francisco, CA, $19,320. For Small Press Traffic Project's organizational development. 3/8/88.

Magic Theater, San Francisco, CA, $25,000. For Theater Production Award in support of 1988 production of Pledging My Love. 8/19/87.

Musical Traditions, Berkeley, CA, $25,000. For Theater Production Award in support of 1988 production of The Detective Piece. 8/9/87.

National Asian American Telecommunications Association, San Francisco, CA, $10,000. For work to develop educational programming around broadcast of PBS documentary, Who Killed Vincent Chin. 3/25/88.

Oakland Ensemble Theater, Oakland, CA, $25,000. For Theater Production Award in support of 1988 production of Ain't No On Use Going Home. 8/19/87.

Oakland Museum Association, Oakland, CA, $18,000. For long-range planning effort. 3/8/88.

People Speaking, San Anselmo, CA, $15,000. To support organizational development. 6/10/88.

Performing Arts Services, San Francisco, CA, $50,000. For support of development of Accolades for the Arts, monthly newspaper of performing and visual arts in San Francisco. 8/19/87.

San Francisco Art Institute, San Francisco, CA, $30,000. For renewed support of development of Bay Area Consortium for the Visual Arts. 8/19/87.

San Francisco State University Foundation, San Francisco, CA, $25,000. For Theater in Education Program organizational development. 3/8/88.

San Francisco Study Center, San Francisco, CA, $10,000. For project working with Misha Berson to develop and publish history of performing arts in San Francisco Bay area. 2/12/88.

Soon 3, San Francisco, CA, $25,000. For Theater Production Award in support of 1988 production of Synthetic Solitudes. 8/19/87.

Theater Bay Area, San Francisco, CA, $10,000. For support of Non-Traditional Casting Project. 11/16/87.

Theater Rhinoceros, San Francisco, CA, $25,000. For Theater Production Award in support of 1988 production of In the Summer When It's Hot and Sticky. 8/19/87.

147
The Ann and Gordon Getty Foundation
50 California St., Suite 3315
San Francisco 94111 (415) 788-5844

Established in 1986 in CA.
Donor(s): Gordon P. Getty.

Financial data (yr. ended 12/31/87): Assets, $7,233,935 (M); gifts received, $7,289,581; expenditures, $8,664,977, including $8,648,323 for 237 grants (high: $1,000,000; low: $100).

Purpose and activities: Support primarily for symphonies, operas, and educational institutions.

Types of support: General purposes.

Limitations: Giving primarily in the San Francisco Bay Area, CA.

Application information: Contributes only to pre-selected organizations. Applications not accepted.
Board meeting date(s): Annually
Final notification: Mar. 15
Write: Larry Chazen, Dir.

Officers: Gordon P. Getty, Pres.; George E. Stephens, Jr., Secy.

Number of staff: None.

Employer Identification Number: 954078340

148
J. Paul Getty Trust
401 Wilshire Blvd., Suite 1000
Santa Monica 90401-1455 (213) 393-4244

Operating trust established in 1953 in CA as J. Paul Getty Museum.

Donor(s): J. Paul Getty.†

Financial data (yr. ended 6/30/88): Assets, $3,982,184,662 (M); gifts received, $13,950; qualifying distributions, $149,143,432, including $11,553,597 for 107 grants (high: $1,500,000; low: $100; average: $10,000-$50,000), $1,030,078 for 56 grants to individuals and $136,771,341 for foundation-administered programs.

Purpose and activities: A private operating foundation. In addition to the Getty Grant Program, there are seven operating entities in the visual arts and related humanities: the J. Paul Getty Museum (a public museum), the Getty Center for the History of Art and the Humanities, the Getty Center for Education in the Arts, the Getty Conservation Institute, the Getty Art History Information Program, the Museum Management Institute, and the Program for Art on Film (a joint venture with the Metropolitan Museum of Art). Through the Getty Grant Program, begun in October 1984, support is available for scholarship in the history of art and the humanities (senior research grants, postdoctoral fellowships, centers for advanced research in art history, archival projects, reference tools, and art historical publications); documentation and interpretation of art museum collections; art conservation training, libraries, surveys, treatment, and publications; architectural conservation and related national and international service organizations.

Types of support: Special projects, fellowships, publications, matching funds, research.

Limitations: No grants to individuals (except senior research grants and postdoctoral fellowships). No support for operating or endowment purposes, construction or maintenance of buildings, or acquisition of works of art.

Publications: Informational brochure, multi-year report, newsletter, grants list, application guidelines.
Application information: Application form available for publication grant requests, architectural conservation grants, postdoctoral fellowships, and senior research grants.
 Initial approach: Letter
 Copies of proposal: 3
 Deadline(s): For publications grants, 6 months before book goes into production; Nov. 10 for senior research grants and postdoctoral fellowships; for architectural conservation grants, request specific deadline from Grants Program; otherwise, no deadline
 Board meeting date(s): As necessary
 Final notification: 6 months
 Write: The Getty Grant Program
Officers: Harold M. Williams,* Pres. and C.E.O.; Joseph J. Kearns, V.P. and Treas.
Trustees:* Jon B. Lovelace, Chair.; Harold E. Berg, Norris Bramlett, Kenneth N. Dayton, John T. Fey, Gordon P. Getty, Vartan Gregorian, Herbert L. Lucas, Jr., Franklin D. Murphy, Stuart T. Peeler, Rocco C. Siciliano, Jennifer Jones Simon, J. Patrick Whaley, Otto Wittmann.
Employer Identification Number: 951790021
Recent arts and culture grants:
American Association for State and Local History, Nashville, TN, $13,900. For conservation publication. 1987.
American Philological Association, NYC, NY, $8,500. For publication on Early Greek Sculpture. 1987.
American Research Center in Egypt, NYC, NY, $12,000. For publication on Greek Pottery from Naukratis. 1987.
American School of Classical Studies at Athens, Princeton, NJ, $10,000. For publication of Isthmia, Excavations. 1987.
Amsterdam Municipal Archives, Amsterdam, Netherlands, $59,244. For Dutch Inventories 1710-1800. 1987.
Architectural History Foundation, NYC, NY, $10,000. For publication on Bourges Cathedral. 1987.
Arts Council of Great Britain, London, England, $26,480. For publication of Le Courbusier 1887-1965. 1987.
Ashmolean Museum, Oxford, England, $100,147. For Pisarro Archives. 1987.
Ashmolean Museum, Oxford, England, $71,206. To catalogue Byzantine collection. 1987.
Association of Art Historians, Brighton, England, $31,075. For British Artists' Papers Registry. 1987.
British Archaeological Trust, muse, Hertforshire, England, $17,050. For conservation publication. 1987.
British Architectural Library, London, England, $5,704. For support for imprints catalogue. 1987.
Burlington Magazine Publications, London, England, $115,000. For publication of Burlington Magazine. 1987.
California Institute of the Arts, Valencia, CA, $9,000. For charitable activities. 1987.
Chinese Culture Foundation of San Francisco, San Francisco, CA, $25,000. For publication of Stories from China's Past. 1987.

Council of American Overseas Research Centers, DC, $30,000. For basic operating budget. 1987.
Dumbarton Oaks Research Library and Collection, DC, $16,205. For publication of Corpus des Mosaiques de Tunisie. 1987.
Eugene Public School District, Eugene, OR, $49,771. For implementation of discipline-based art education program. 1987.
Fine Arts Museums of San Francisco Foundation, San Francisco, CA, $60,000. For publication of The New Painting. 1987.
Florida State University, Tallahassee, FL, $20,000. For discipline-based art education planning. 1987.
Fundacio Joan Miro, Barcelona, Spain, $25,319. For conservation survey. 1987.
Gemeentelijk Museum het Princessehof, Netherlands, $58,000. To catalogue Asian ceramics collection. 1987.
Hamilton Kerr Institute, Cambridge, England, $42,321. For conservation internships. 1987.
Harvard University, DC, $15,000. For publication of The Fortifications of Armenian Cilicia. 1987.
Harvard University, Cambridge, MA, $127,500. For library acquisitions at Villa I Tatti in Florence, Italy. 1987.
Harvard University, Cambridge, MA, $22,000. For publication of the Florence, Italy, I Tatti Studies. 1987.
Harvard University, Cambridge, MA, $10,000. For Art Books in Series. 1987.
Harwood Foundation of the University of New Mexico, Taos, NM, $12,500. For staffing, as part of scholarly cataloguing awards. 1987.
Hirschhorn Museum and Sculpture Garden, DC, $24,725. For audio-visual orientation program, as part of education awards. 1987.
Independent School District No. 281, Minneapolis, MN, $84,615. For discipline-based art education planning. 1987.
Intermuseum Conservation Association, Oberlin, OH, $49,500. For conservation internships. 1987.
International Center for Medieval Studies, NYC, NY, $6,660. For publication of Gesta. 1987.
International Committee for Conservation (ICC), Rome, Italy, $14,190. For conservation survey meeting to survey conservation needs in Chile. 1987.
International Committee for Conservation (ICC), Rome, Italy, $13,250. For conservation of house in Pompeii. 1987.
International Council of Museums, France, $5,000. For general support. 1987.
Kunsthistorisches Museum, Vienna, Austria, $5,691. To catalogue ecclesiastical material. 1987.
Kutztown University Foundation, Kutztown, PA, $20,000. For discipline-based art education planning. 1987.
Lawrence University, Appleton, WI, $17,500. For conservation of La Vera Pohl collection. 1987.
Los Angeles County Museum of Art, Los Angeles, CA, $10,125. For charitable activities. 1987.
Massachusetts Institute of Technology Press, Cambridge, MA, $20,000. For October publication. 1987.
Minneapolis Society of Fine Arts, Minneapolis, MN, $30,000. For charitable activities. 1987.

Minnesota School & Resource, Saint Paul, MN, $20,000. For discipline-based art education planning. 1987.
Museum Associates, Los Angeles, CA, $50,000. For interpretation of permanent collection, as part of education awards. 1987.
Museum Boymans-van Beuningen, Rottersdam, Netherlands, $36,742. For publication of Drawings by Rembrandt and His School. 1987.
Museum of Contemporary Art, Los Angeles, CA, $29,550. For charitable activities. 1987.
Museum of Modern Art, NYC, NY, $50,000. For publication on Paul Klee. 1987.
Music Center Unified Fund, Los Angeles, CA, $30,500. For charitable activities. 1987.
National Art Education Association, Reston, VA, $15,855. For meeting for museum educators. 1987.
Nebraska Department of Education, Lincoln, NE, $20,000. For discipline-based art education planning. 1987.
North Carolina Museum of Art Foundation, Raleigh, NC, $20,000. For publication on Sir David Wilkie. 1987.
North Texas State University, Denton, TX, $20,000. For discipline-based art education planning. 1987.
Northeast Document Conservation Center, Andover, MA, $117,000. For conservation internship program. 1987.
Northwestern University, Evanston, IL, $8,000. For publication on Salome and Judas in the Cave of Sex. 1987.
Ohio State University Research Foundation, Columbus, OH, $20,000. For discipline-based art education planning. 1987.
Pennsylvania Academy of the Fine Arts, Philadelphia, PA, $23,600. For conservation of C. Bregler Eakins collection. 1987.
Philadelphia Museum of Art, Philadelphia, PA, $65,700. For conservation interships. 1987.
Philadelphia Museum of Art, Philadelphia, PA, $40,000. For Dutch paintings cataloque. 1987.
Portland Public Schools, Portland, OR, $50,136. For implementation of discipline-based art education program. 1987.
Princeton University Press, Princeton, NJ, $13,000. For publication of Artemisia Gentileschi. 1987.
Princeton University Press, Princeton, NJ, $7,000. For publication of Painting as an Art. 1987.
Provo City Schools, Provo, UT, $47,000. For implementation of discipline-based art education program. 1987.
Reunion des Musees Nationaux, Paris, France, $32,620. For Sculptures en Cire (publication), as part of conservation awards. 1987.
Rhode Island School of Design, Providence, RI, $20,000. For discipline-based art education planning. 1987.
Royal Academy of Arts, London, England, $50,000. For paintings conservation. 1987.
Royal Ontario Museum, Toronto, Canada, $9,691. For publication of Excavation at Altun Ha. 1987.
Smithsonian Institution, DC, $175,000. For archives of American Art. 1987.
Southern Methodist University, Dallas, TX, $7,700. For conservation survey. 1987.
Southwest Museum, Los Angeles, CA, $1,000,000. For capital development. 1987.

Stadtische Kunsthalle Mannheim, Mannheim, West Germany, $80,338. To catalogue nineteenth century drawings. 1987.

State University College at Buffalo, Buffalo, NY, $105,750. For conservation internship. 1987.

Studio Museum in Harlem, NYC, NY, $150,000. For archives of Black American Art. 1987.

Tufts University, Medford, MA, $200,000. For Corpus Vitrearum. 1987.

University of California, Wight Art Gallery, Los Angeles, CA, $40,000. For publication of Foirades/Fizzles: Jasper Johns. 1987.

University of Delaware, Winterthur, Newark, DE, $84,000. For conservation internship at Winterthur, the museum at du Pont's former mansion. 1987.

University of Oklahoma, Norman, OK, $9,600. For publication of False Faces of the Iroquois. 1987.

University of Pennsylvania Press, Philadelphia, PA, $26,000. For publication of Harry Chapman Mercer and the Moravian Pottery, Tile Works. 1987.

University of Tennessee, Chattanooga, TN, $20,000. For discipline-based art education planning. 1987.

University of Washington, Seattle, WA, $10,000. For publication of The Remaking of Istanbul. 1987.

University of Washington Press, Seattle, WA, $23,000. For publication of The Paintings of C.C. Wang. 1987.

University of Washington Press, Seattle, WA, $17,000. For publication of Symmetries of Culture. 1987.

Victoria and Albert Museum, London, England, $76,005. To catalogue Twentieth Century Women's Dress. 1987.

Victoria and Albert Museum, London, England, $13,555. To catalogue photographs of Lady Hawarden. 1987.

Warburg Institute, London, England, $10,747. For library acquisitions. 1987.

Woodrow Wilson National Fellowship Foundation, Princeton, NJ, $607,782. For art history fellowship program. 1987.

World Monuments Fund, NYC, NY, $100,000. For Mexican Mural program. 1987.

World Monuments Fund, NYC, NY, $17,300. For collegiate church restoration. 1987.

World Monuments Fund, NYC, NY, $5,000. For charitable activities. 1987.

Yale University Press, New Haven, CT, $33,780. For publication of Irish Cistercian Abbeys. 1987.

Yale University Press, New Haven, CT, $26,190. For publication of Cubism and Its Enemies. 1987.

Zentrainstitut/Kunstgeschichte, Munchen, Germany, $10,860. For cataloging library accessions. 1987.

149
The William G. Gilmore Foundation
120 Montgomery St., Suite 1880
San Francisco 94104 (415) 546-1400

Incorporated in 1953 in CA.
Donor(s): William G. Gilmore,† Mrs. William G. Gilmore.†
Financial data (yr. ended 12/31/87): Assets, $10,890,000 (M); expenditures, $715,000,

including $607,000 for 127 grants (high: $25,000; low: $200; average: $500-$5,000).
Purpose and activities: Grants largely for community-based organizations.
Types of support: Annual campaigns, continuing support, emergency funds, general purposes, operating budgets, scholarship funds.
Limitations: Giving primarily in northern CA, OR, and WA. No grants to individuals.
Application information:
Initial approach: Letter of intent
Copies of proposal: 1
Deadline(s): May 1 and Nov. 1
Board meeting date(s): June and Dec.
Final notification: 2 months
Write: Faye Wilson, Secy.
Officers and Trustees:* Robert C. Harris,* Pres.; Lee Emerson,* V.P., and Treas.; William R. Mackey,* V.P.; Faye Wilson, Secy.; Thomas B. Boklund, V. Neil Fulton.
Number of staff: 1 part-time support.
Employer Identification Number: 946079493

150
Richard and Rhoda Goldman Fund
1090 Sansome St.
San Francisco 94111 (415) 788-1090

Incorporated in 1951 in CA.
Donor(s): Rhoda H. Goldman, Richard N. Goldman.
Financial data (yr. ended 10/31/88): Assets, $5,922,708 (M); gifts received, $1,500,000; expenditures, $708,549, including $554,493 for 73 grants (high: $50,000; low: $200; average: $7,500-$25,000).
Purpose and activities: Giving with emphasis on the elderly, the environment, and civic affair.
Types of support: Seed money, special projects.
Limitations: Giving primarily in the San Francisco Bay Area, CA. No grants to individuals, or for deficit budgets, building or endowment funds, general fundraising campaigns, conferences, research, scholarships, fellowships, or matching gifts; no loans.
Publications: Annual report.
Application information:
Initial approach: Letter or telephone
Deadline(s): None
Board meeting date(s): Jan., Apr., July, and Oct.
Write: Duane Silverstein, Exec. Dir.
Officers: Richard N. Goldman, Pres.; Richard W. Goldman, V.P.; Rhoda H. Goldman, Secy.-Treas.; Duane Silverstein, Exec. Dir.
Number of staff: 1 full-time professional; 1 full-time support.
Employer Identification Number: 946064502
Recent arts and culture grants:
Amnesty International, San Francisco, CA, $10,000. For global concert tour to publicize Universal Declaration of Human Rights. 1987.
Bay Area Discovery Museum, Kentfield, CA, $10,000. For membership campaign challenge grant. 1987.
Civil Rights Project, Boston, MA, $15,000. For Eyes on the Prize Civil Rights Series, Part II. 1987.
Northern California Grantmakers, San Francisco, CA, $5,000. For Arts Loan Fund. 1987.

San Francisco Museum of Modern Art, San Francisco, CA, $10,000. For general support. 1987.
Stern Grove Festival Association, San Francisco, CA, $10,000. For fiftieth anniversary summer concert series. 1987.
University Art Museum, Berkeley, CA, $8,000. For general support. 1987.

151
Goldsmith Family Foundation
400 North Roxbury Dr.
Beverly Hills 90210

Established in 1980 in CA.
Donor(s): Mrs. Bram Goldsmith, Bram Goldsmith.
Financial data (yr. ended 9/30/88): Assets, $2,150,063 (M); gifts received, $816,400; expenditures, $433,363, including $424,380 for 17 grants (high: $155,000; low: $75).
Purpose and activities: Support for higher education, Jewish giving, and cultural programs.
Types of support: Annual campaigns, building funds, continuing support, endowment funds.
Limitations: Giving primarily in the southern, CA, area.
Application information: Contributes only to pre-selected organizations. Applications not accepted.
Officers: Bram Goldsmith, Pres.; Elaine Goldsmith, V.P. and Secy.-Treas.
Directors: Bruce L. Goldsmith, Russell Goldsmith.
Employer Identification Number: 953545880

152
The Samuel Goldwyn Foundation
10203 Santa Monica Blvd., Suite 500
Los Angeles 90067 (213) 552-2255

Established in 1947 in CA.
Donor(s): Samuel Goldwyn,† Frances H. Goldwyn.†
Financial data (yr. ended 12/31/86): Assets, $17,818,793 (M); expenditures, $1,694,697, including $580,518 for 41 grants (high: $400,822; low: $248; average: $1,000-$10,000).
Purpose and activities: To promote community-related activities; grants primarily for a library, higher education, cultural programs, youth, medical research, and innovative social service programs.
Types of support: Annual campaigns, seed money, scholarship funds, operating budgets, research, equipment, special projects.
Limitations: Giving limited to the Los Angeles, CA, metropolitan area. No grants to individuals, or for building funds.
Application information:
Initial approach: Proposal
Deadline(s): None
Board meeting date(s): Quarterly
Final notification: 60 to 90 days
Write: Priscilla J. Mick, Exec. Secy.
Officers and Directors: Samuel Goldwyn, Jr., Pres.; Peggy E. Goldwyn, V.P.; Priscilla J. Mick, Exec. Secy.; Meyer Gottlieb, Treas.; Francis Goldwyn, John Goldwyn, George Slaff.
Number of staff: 1 full-time professional.
Employer Identification Number: 956006859

153
I. H. and Anna Grancell Foundation
1469 Carla Ridge
Beverly Hills 90210 (213) 272-7091

Incorporated in 1957 in CA.
Donor(s): Anna Grancell, Anna Grancell Charitable Trust.
Financial data (yr. ended 7/31/87): Assets, $1,253,495 (M); expenditures, $440,037, including $430,952 for 13 grants (high: $133,861; low: $270).
Purpose and activities: Giving for hospitals, temple support, higher education, and cultural programs.
Limitations: Giving primarily in CA.
Application information:
 Initial approach: Letter
 Deadline(s): None
 Write: Sherman Grancell, Treas.
Officers: Paul Grancell, Pres.; Morton Bauman, Secy.; Sherman Grancell, Treas.
Employer Identification Number: 956027429

154
Great American Corporate Giving Program
600 B St., Suite 800
San Diego 92101 (619) 231-6242

Purpose and activities: Support for community health care, education and arts; includes in-kind giving.
Types of support: Special projects, special projects, in-kind gifts.
Limitations: Giving generally limited to Northern and Southern CA.
Application information:
 Initial approach: Narrative letter
 Deadline(s): Applications accepted throughout the year
 Final notification: 2-3 weeks
 Write: Karen Miller, Community Relations Officer

155
Miriam and Peter Haas Fund
Levi Plaza, LS/7, 1155 Battery St., 7th Fl.
San Francisco 94111 (415) 544-7623

Incorporated in 1953 in CA.
Donor(s): Peter E. Haas.
Financial data (yr. ended 8/31/86): Assets, $5,847,860 (M); expenditures, $317,884, including $272,668 for 136 grants (high: $41,800; low: $25; average: $250-$1,000).
Purpose and activities: Giving primarily for higher education; support also for community funds and cultural programs.
Types of support: Operating budgets, continuing support, deficit financing, building funds, equipment, special projects.
Limitations: Giving primarily in northern CA. No grants to individuals, or for annual campaigns, seed money, emergency funds, land acquisition, matching gifts, scholarships, fellowships, research, demonstration projects, publications, or conferences; no loans.
Application information:
 Copies of proposal: 1
 Deadline(s): None
 Board meeting date(s): As required

Final notification: 1 month
 Write: Peter E. Haas, V.P.
Officers: Miriam L. Haas, Pres.; Peter E. Haas, V.P.; Willard L. Ellis, Secy.-Treas.
Number of staff: None.
Employer Identification Number: 946064551

156
Walter and Elise Haas Fund
1160 Battery St., Suite 400
San Francisco 94111 (415) 398-4474

Incorporated in 1952 in CA.
Donor(s): Walter A. Haas,† Elise S. Haas.
Financial data (yr. ended 12/31/88): Assets, $58,425,000 (M); expenditures, $3,493,600, including $3,218,846 for 150 grants (high: $800,000; low: $500; average: $1,000-$25,000).
Purpose and activities: Support for projects which demonstrate an ability to have a wide impact within their respective fields through enhancing public education and access to information, serving a central organizing role, addressing public policy, demonstrating creative approaches toward meeting human needs, supporting the work of a major institution in the field, or extending the arts and humanities into the community.
Types of support: Operating budgets, continuing support, seed money, emergency funds, building funds, equipment, endowment funds, matching funds, scholarship funds, professorships, fellowships, special projects, capital campaigns, land acquisition.
Limitations: Giving primarily in the San Francisco Bay Area, CA. No grants to individuals, or for deficit financing.
Publications: Multi-year report, program policy statement, application guidelines.
Application information: Application form required.
 Initial approach: Letter
 Copies of proposal: 1
 Deadline(s): None
 Board meeting date(s): As required
 Final notification: 2 to 4 months
 Write: Bruce R. Sievers, Exec. Dir.
Officers and Directors:* Rhoda H. Goldman,* Pres.; Elise S. Haas,* V.P.; Peter E. Haas,* V.P.; Walter A. Haas, Jr.,* V.P.; Bruce R. Sievers, Exec. Dir. and Secy.-Treas.
Number of staff: 2 full-time professional; 1 full-time support; 1 part-time support.
Employer Identification Number: 946068564

157
Evelyn and Walter Haas, Jr. Fund
1160 Battery St., Suite 400
San Francisco 94111 (415) 544-6575

Incorporated in 1953 in CA.
Donor(s): Walter A. Haas, Jr., Evelyn D. Haas.
Financial data (yr. ended 12/31/87): Assets, $24,674,511 (M); expenditures, $1,604,851, including $1,311,285 for 166 grants (high: $150,000; low: $25; average: $5,000-$25,000).
Purpose and activities: Giving primarily for alternatives to institutional care for the elderly, selected programs serving the hungry and homeless, corporate social responsibility and business ethics, and community development.

Types of support: Seed money, special projects, technical assistance, general purposes.
Limitations: Giving primarily in San Francisco and Alameda counties, CA. No support for private foundations or religious organizations. No grants to individuals, or for deficit financing, workshops, conferences, publications, capital campaigns, films, or research.
Publications: Annual report (including application guidelines).
Application information: Grants in the areas of arts and education are initiated by the trustees.
 Initial approach: Letter
 Copies of proposal: 1
 Deadline(s): None
 Board meeting date(s): 3 times a year
 Final notification: Within 90 days
 Write: Melissa Bannett, Exec. Dir.
Officers and Trustees: Walter A. Haas, Jr., Pres.; Evelyn D. Haas, V.P.; Walter J. Haas, Secy.-Treas.
Advisory Trustees: Dyke Brown, Elizabeth Haas Eisenhardt, James C. Gaither, Robert D. Haas, Cecil F. Poole.
Number of staff: 1 full-time professional; 1 full-time support; 1 part-time support.
Employer Identification Number: 946068932
Recent arts and culture grants:
California Academy of Sciences, San Francisco, CA, $5,000. 1987.
Exploratorium, San Francisco, CA, $7,500. For Explainer Program which trains teenage docents. 1987.
National Gallery of Art, DC, $5,000. 1987.
San Francisco Museum of Modern Art, San Francisco, CA, $25,000. For accessions fund. 1987.
San Francisco Museum of Modern Art, San Francisco, CA, $25,000. For 50th Anniversary. 1987.
San Francisco Museum of Modern Art, San Francisco, CA, $10,000. For trustees dues. 1987.
San Francisco Museum of Modern Art, San Francisco, CA, $5,000. For annual dues. 1987.

158
Ernest W. and Jean E. Hahn Foundation
P.O. Box 2009
Rancho Santa Fe 92067 (619) 756-2453

Established in 1981 in CA.
Donor(s): Ernest W. Hahn, Jean E. Hahn.
Financial data (yr. ended 12/31/87): Assets, $176,874 (M); expenditures, $1,306,313, including $1,296,463 for 106 grants (high: $100,500; low: $100).
Purpose and activities: Giving for social services, youth agencies, hospitals and health services, the arts, and conservation.
Limitations: Giving primarily in CA.
Application information:
 Initial approach: Letter
 Deadline(s): None
 Write: Ernest W. Hahn, Pres.
Officers: Ernest W. Hahn, Pres.; Jean E. Hahn, V.P.; Anna M. Renn, Secy.
Employer Identification Number: 953643330

159
Florence P. Hamilton Foundation
100 South Los Robles, Suite 470
Pasadena 91101-2453

Established about 1969 in CA.
Donor(s): Florence P. Hamilton, William H.
Peterson Trust.
Financial data (yr. ended 12/31/86): Assets,
$1,824,904 (M); gifts received, $150,000;
expenditures, $29,498, including $7,500 for 1
grant.
Purpose and activities: Support for cultural
programs, social services, and hospitals.
Application information: Contributes only to
pre-selected organizations. Applications not
accepted.
Officers and Trustees: Barry H. Herlihy,
Treas.; Florence P. Hamilton, Mgr.; Robert A.
Hamilton, F. George Herlihy.
Employer Identification Number: 956235131

160
The Luke B. Hancock Foundation
360 Bryant St.
Palo Alto 94301 (415) 321-5536

Incorporated in 1948 in NV.
Donor(s): Luke B. Hancock.†
Financial data (yr. ended 4/30/88): Assets,
$18,899,069 (M); expenditures, $1,100,938,
including $877,216 for 85 grants (high:
$50,000; low: $500; average: $1,000-$30,000).
Purpose and activities: Giving primarily for
job training and employment for youth.
Special project grants include: consortium with
other foundations in areas where there is
unmet need; some support for technical
assistance, emergency funding, music and the
arts in education. During l988, primary focus
on youth employment.
Types of support: Operating budgets,
continuing support, seed money, emergency
funds, matching funds, consulting services,
technical assistance, conferences and seminars.
Limitations: Giving limited to CA, particularly
the six counties of the San Francisco Bay Area.
No support for films. No grants to individuals,
or for deficit financing, capital or building
funds, acquisitions, endowment funds,
scholarships, fellowships, personal research, or
publications.
Publications: Annual report (including
application guidelines).
Application information:
 Initial approach: Letter
 Copies of proposal: 1
 Deadline(s): None
 Board meeting date(s): Feb., July, and Oct.
 Final notification: 3 to 4 months
 Write: Joan H. Wylie, Exec. Dir.
Officers and Directors: Marsha A. Adams,
Chair.; Jane Hancock, Pres.; Noble Hancock,
V.P.; Janice H. Pettit, Secy.; Tom Hancock,
Treas.; Joan H. Wylie, Exec. Dir.; Courtney J.
Catron, Linda Catron, Carol E. Hancock,
Denise J. Hancock, James Hancock, Lorraine A.
Hancock, Marian L. Hancock, Mark Hancock,
Wesley Hancock, William Hancock, Susan
Hillstrom-Masi, Joseph L. Masi.
Number of staff: 1 full-time professional; 1
part-time support.
Employer Identification Number: 886002013

161
Fred Hayman Family Foundation
c/o Financial Services & Seminars
10951 West Pico Blvd., Suite 201
Los Angeles 90064 (213) 477-0429

Established in 1985 in CA.
Donor(s): Fred J. Hayman.
Financial data (yr. ended 12/31/87): Assets,
$976,153 (M); expenditures, $140,304,
including $122,150 for 11 grants (high:
$50,000; low: $150).
Purpose and activities: Grants for music,
Jewish giving, and general social services.
Limitations: Giving primarily in CA.
Application information: Foundation prefers
to initiate grants.
 Write: Libbie Agran, Fdn. Mgr.
Officers and Directors: Fred J. Hayman,
Chair. and Pres.; Irene Fuhrman, C.F.O.;
Kathryn Franzen, Secy.; Libbie Agran, Fdn.
Mgr.; Leo Ziffren.
Employer Identification Number: 953996817

162
The Held Foundation
10866 Wilshire Blvd., No. 800
Los Angeles 90024-4303

Established in 1985 in CA.
Donor(s): Harold Held, Louise Held.
Financial data (yr. ended 12/31/87): Assets,
$242,076 (M); gifts received, $167,000;
expenditures, $158,965, including $158,524
for 31 grants (high: $73,865; low: $45).
Purpose and activities: Giving primarily for
Jewish concerns and the arts.
Application information: Contributes only to
pre-selected organizations. Applications not
accepted.
Trustees: Harold Held, Louise Held.
Employer Identification Number: 954016569

163
Helms Foundation, Inc.
25765 Quilla Rd.
P.O. Box 55827
Valencia 91355 (805) 253-3485

Incorporated in 1946 in CA.
Donor(s): The Helms family, Helms Bakeries.
Financial data (yr. ended 6/30/87): Assets,
$4,050,715 (M); expenditures, $356,893,
including $309,168 for 79 grants (high:
$31,500; low: $175).
Purpose and activities: Support primarily for
higher and other education, including
scholarship funds, and religious education;
support also for health agencies and hospitals,
cultural organizations, and youth and social
service agencies.
Application information:
 Deadline(s): None
 Write: William D. Manuel, Asst. Secy.
Officers and Trustees: Peggy Helms Hurtig,
Pres.; Elizabeth Helms Adams, V.P. and Secy.-
Treas.; John B. Gostovich, Frank J. Kanne, Jr.
Employer Identification Number: 956091335

164
Hester Family Foundation
1105 Quail St.
Newport Beach 92660 (714) 883-1560

Established in 1976 in CA.
Donor(s): Charles W. Hester, Nora Hester.
Financial data (yr. ended 12/31/87): Assets,
$999,766 (M); gifts received, $30,000;
expenditures, $115,136, including $108,517
for 35 grants (high: $10,000; low: $100).
Purpose and activities: Support for hospitals
and health associations, cultural programs,
education, social service and youth agencies.
Application information:
 Write: Charles W. Hester, Pres.
Officers: Charles W. Hester, Pres.; Nora
Hester, V.P. and Secy.-Treas.
Directors: Marilyn Gianulias, Janet Hamilton,
Charlene Immell.
Employer Identification Number: 510189743

165
The William and Flora Hewlett
Foundation
525 Middlefield Rd., Suite 200
Menlo Park 94025 (415) 329-1070

Incorporated in 1966 in CA.
Donor(s): Flora Lamson Hewlett,† William R.
Hewlett.
Financial data (yr. ended 12/31/88): Assets,
$622,042,000 (M); expenditures, $36,176,526,
including $31,925,422 for 222 grants (high:
$750,000; low: $2,000; average: $10,000-
$500,000) and $40,807 for 75 employee
matching gifts.
Purpose and activities: Emphasis on conflict
resolution, the environment, performing arts,
education, especially at the college-university
level, population, and regional grants program.
Types of support: General purposes, operating
budgets, continuing support, seed money,
emergency funds, land acquisition, special
projects, matching funds, employee matching
gifts, endowment funds.
Limitations: Giving limited to the San
Francisco Bay Area, CA, for regional grants
program; performing arts limited to the area in
part. No support for medicine and health-
related projects, law, criminal justice, and
related fields, juvenile delinquency, drug and
alcohol addiction, problems of the elderly and
the handicapped, or television or radio
projects. No grants to individuals, or for
building funds, basic research, equipment,
scholarships, or fellowships; no loans.
Publications: Annual report, program policy
statement, application guidelines, informational
brochure.
Application information:
 Initial approach: Letter
 Copies of proposal: 1
 Deadline(s): Jan. 1, music; Apr. 1, theater;
 July 1, dance, film, and video service
 organizations; no deadlines for other
 programs
 Board meeting date(s): Jan., Apr., July, and
 Oct.
 Final notification: 1 to 2 months
 Write: Roger W. Heyns, Pres.

Officers: Roger W. Heyns,* Pres.; Marianne Pallotti, V.P. and Corp. Secy.; William F. Nichols, Treas.

Directors:* William R. Hewlett, Chair.; Walter B. Hewlett, Vice-Chair.; Robert M. Brown, Robert Erburu, Eleanor H. Gimon, Arjay Miller, Lyle M. Nelson, William D. Ruckelshaus.

Number of staff: 9 full-time professional; 2 part-time professional; 5 full-time support.

Employer Identification Number: 941655673

Recent arts and culture grants:

Archives for the Performing Arts, San Francisco, CA, $50,000. For general support. 7/15/88.

Bay Area Womens Philharmonic, San Francisco, CA, $25,000. For general support. 7/15/88.

Bay Chamber Symphony Orchestra, San Mateo, CA, $10,000. For general support. 7/15/88.

Brooklyn Academy of Music, Brooklyn, NY, $180,000. For general support of Next Wave Festival. 7/15/88.

Cabrillo Music Festival, Aptos, CA, $75,000. For general support and cash reserve. 7/15/88.

Carmel Bach Festival, Carmel, CA, $100,000. For general support and endowment fund. 7/15/88.

Childrens Discovery Museum, San Jose, CA, $250,000. For capital campaign. 3/15/88.

City Celebration, Great Hall Project, San Francisco, CA, $25,000. For general support. 7/15/88.

Columbia University, Center for United States-China Arts Exchange, NYC, NY, $150,000. For general support of exchange program. 11/3/87.

Dance Through Time, Kentfield, CA, $150,000. For artistic support and for joint marketing and development project. 11/3/87.

Dell Arte, San Francisco New Vaudeville Festival, Blue Lake, CA, $20,000. For general support. 7/15/88.

Exploratorium, San Francisco, CA, $500,000. Toward planning efforts for capital campaign. 3/15/88.

Fine Arts Museums of San Francisco, San Francisco, CA, $250,000. For general support. 7/15/88.

Foundation for Art in Cinema, San Francisco Cinematheque, San Francisco, CA, $20,000. For support of evaluation and planning activities. 1/13/88.

Fremont-Newark Philharmonic, Fremont, CA, $75,000. For general support and endowment fund. 7/15/88.

Historical Society of Pennsylvania, Philadelphia, PA, $100,000. For general support. 9/14/88.

Lines A Dance Company, San Francisco, CA, $24,500. For general support. 7/15/88.

Magic Theater, San Francisco, CA, $80,000. For general support. 9/14/88.

Marin Civic Ballet, San Rafael, CA, $25,000. For general support. 1/13/88.

Musical Traditions, Paul Dresher Ensemble, Berkeley, CA, $20,000. For general support. 7/15/88.

National Japanese American Historical Society, San Francisco, CA, $25,000. For exhibit on Japanese American internment. 7/15/88.

National Public Radio, DC, $150,000. For general support. 7/15/88.

New Contra Costa Symphony, Orlinda, CA, $10,000. For general support. 7/15/88.

New Langton Arts, San Francisco, CA, $25,000. For general support. 7/15/88.

Nightfire Theater, Sausalito, CA, $105,000. For general support. 9/14/88.

Old First Center for the Arts, Old First Concerts, San Francisco, CA, $25,000. For general support and to help establish cash reserve. 7/15/88.

Opera America, DC, $60,000. For Opera for the 80s and Beyond program. 9/14/88.

Oregon Shakespearean Festival, Ashland, OR, $165,000. For general support to be matched for endowment. 9/14/88.

Peninsula Ballet Theater, San Mateo, CA, $40,000. For artistic salaries for 1987-88 season. 11/3/87.

Pickle Family Circus, San Francisco, CA, $120,000. For general support. 9/14/88.

Playwrights Unlimited, Mill Valley, CA, $25,000. For Bay Area Playwrights Festival XI. 7/15/88.

Rova Saxaphone Quartet, San Francisco, CA, $22,500. For general support. 1/13/88.

San Francisco Ballet, San Francisco, CA, $250,000. For Scholarship Program and Apprentice and Student Dancer Program. 11/3/87.

San Francisco Bay Area Dance Coalition, San Francisco, CA, $150,000. For general support and for regranting program for individual dance artists. 11/3/87.

San Francisco Contemporary Music Players, San Francisco, CA, $90,000. For general support. 7/15/88.

San Francisco Performances, San Francisco, CA, $120,000. For general support and endowment fund. 7/15/88.

San Jose Symphony Orchestra, San Jose, CA, $350,000. For general support. 7/15/88.

Santa Cruz County Symphony Association, Aptos, CA, $30,000. For general support. 7/15/88.

Sew Productions, Lorraine Hansberry Theater, San Francisco, CA, $25,000. For general support. 7/15/88.

Soon 3 Theater, San Francisco, CA, $40,000. For general support. 9/14/88.

Theater Artaud, San Francisco, CA, $105,000. For general support. 9/14/88.

Theater Bay Area, San Francisco, CA, $60,000. For general support. 9/14/88.

Theaterworks, Palo Alto, CA, $105,000. For general support. 9/14/88.

Valley Institute of Theater Arts, Saratoga, CA, $120,000. For general support. 9/14/88.

Virginia Historical Society, Richmond, VA, $100,000. For general support. 9/14/88.

166
Hewlett-Packard Company Foundation

3000 Hanover St., 20AH
Palo Alto 94304 (415) 857-3053
Mailing address: P.O. Box 10301, Palo Alto, CA 94303-0890

Established in 1979.

Donor(s): Hewlett-Packard Co.

Financial data (yr. ended 10/31/88): Assets, $1,580,000 (M); expenditures, $613,000 for 17 grants.

Purpose and activities: National giving for causes related to higher education in science, engineering, medicine and business; international giving in countries where Hewlett-Packard has subsidiaries. Support for community service, health and cultural agencies in locations where the company has major facilities.

Limitations: No grants to individuals; or for conferences, seminars, meetings, or workshops.

Publications: Informational brochure (including application guidelines).

Application information:

Write: Roderick Carlson, Exec. Dir.

Directors: Jack Brigham III, Dean O. Morton, John A. Young.

Officers: Roderick Carlson, Exec. Dir.; Craig Nordlund, Secy.; Robert P. Wayman, F.O.

Employer Identification Number: 942618409

167
Hewlett-Packard Company
Philanthropic Grants

3000 Hanover St.
Palo Alto 94304 (415) 857-3053
Application address: P.O. Box 10301, Palo Alto, CA 94303-0890

Financial data (yr. ended 10/31/88): Total giving, $50,400,000, including $3,700,000 for grants, $3,900,000 for employee matching gifts and $42,800,000 for in-kind gifts.

Purpose and activities: The company seeks to be an economic, intellectual, cultural, and social asset in the technical and geographical areas in which it functions. The University Grants Program is the largest and contributes Hewlett-Packard equipment to teaching laboratories nationally for engineering, science, medicine, and business. The HP Community College Equipment Program serves institutions in areas of company facilities. The National Contributions Program, which is run at the headquarters in Palo Alto, contributes equipment and cash to national organizations in the areas of mathematics and science literacy, health and human services, affirmative actions, and arts and culture. Contributions Committees in locations where Hewlett-Packard has major facilities make contributions to support local human services, education, and arts and culture. Employee matching gift programs include the Product-Gift Program and Funds-Matching Program.

Types of support: General purposes, equipment, special projects, employee matching gifts, in-kind gifts.

Limitations: Giving primarily in major operating locations in CA, CO, ID, MA, NJ, OR, PA, UT, WA IL, and MD, and to national organizations; grants outside the U.S., in Europe and Latin America; equipment grants only in countries where Hewlett-Packard installation, repair, and maintenance is available. No support for sectarian puposes. No grants to individuals; or for conferences, seminars, meetings, workshops, fundraising events, or annual memberships.

Publications: Corporate giving report (including application guidelines).

Application information: For University Equipment Grants, a proposal including description of institution, department, and

faculty member(s) making the request, and need, use, and impact of equipment requested; Community College Equipment Grants applicant should indicate how proposal will promote training that meets the needs of local industry, increase the school's minority population, establish or maintain the school's relationship with local HP operations, and how the equipment requested will be supported. National Grants applicants should include organization description, financial statement, budget, staff list.

Initial approach: University equipment requests are through HP sponsor; national grants through National Contribs. Mgr. in Palo Alto; community grants through nearest company facility; international requests to the HP subsidiary in the country of origin
Copies of proposal: 2
Deadline(s): July 1 for college and university equipment program which is annual
Board meeting date(s): Annually for university grants; other committees meet quarterly
Final notification: 2-4 weeks after committee meetings for non-university grants; early Jan. for university grants
Write: Rod Carlson, Dir. of Corp. Grants
Contributions Committee: Roderick Carlson, Dir. of Corporate Grants; Tony Napolitan, Jr., Univ. Grants Mgr.; Nancy Thomas, National Contribs. Mgr.

168
Hexcel Foundation
P.O. Box 2312
Dublin 94568 (415) 828-4200
Additional address: 650 California St., San Francisco, CA 95108

Donor(s): Hexcel Corp.
Financial data (yr. ended 6/30/88): Assets, $257,444 (M); gifts received, $200,000; expenditures, $24,125, including $24,125 for 18 grants (high: $2,500; low: $125).
Purpose and activities: Support in the areas of capital fund drives; civic and community improvement projects, including economic groups, planning and urban development organizations, job training and youth activities, and environmental, wildlife and natural resources preservation groups; cultural activities, including the performing and visual arts, libraries, public media and humanities groups in key operating cities or those which are nationally significant; education, in the form of direct financial aid to higher education; and health and welfare, including local and national health agencies, hospitals, mental health, drug abuse rehabilitation centers, and the disabled. Special consideration is given to organizations in which company employees are involved.
Types of support: General purposes, capital campaigns, scholarship funds.
Limitations: Giving limited to San Francisco, Dublin, Pleasanton, Livermore, City of Industry, Chatsworth and San Diego, CA; Reno, NV; Lancaster, OH; Pottsville, PA; Casa Grande, AZ; Graham and Seguin, TX; and Zeeland, MI. No support for religious organizations or groups which affect only a small segment of the community. No grants to individuals.

Application information:
Initial approach: Letter
Deadline(s): None
Write: Karel Kramer Marriott, Mgr., Corp. Communications
Officers: Robert L. Witt, Pres.; John F. O'Flaherty, Secy.; D. Thomas Divird, Treas.
Employer Identification Number: 942972860

169
The Edward E. Hills Fund
c/o Pillsbury, Madison and Sutro
225 Bush St., Rm. 1900
San Francisco 94104

Incorporated in 1953 in CA.
Donor(s): Edward E. Hills.†
Financial data (yr. ended 12/31/87): Assets, $8,576,162 (M); expenditures, $646,713, including $575,000 for 8 grants (high: $100,000: low: $10,000).
Purpose and activities: Grants primarily to the performing arts, a museum, and higher and secondary educational institutions.
Limitations: Giving primarily in CA.
Application information:
Deadline(s): None
Officers: Reuben W. Hills III, Pres.; John B. Bates,* Secy.-Treas.
Directors:* Edmond S. Gillette, Jr.
Employer Identification Number: 946062537

170
Hoag Foundation
2029 Century Park East, Suite 4392
Los Angeles 90067 (213) 683-6500

Incorporated in 1940 in CA.
Donor(s): George Grant Hoag,† Grace E. Hoag, George Grant Hoag II.
Financial data (yr. ended 12/31/87): Assets, $29,190,947 (M); expenditures, $1,488,679, including $1,145,000 for 9 grants (high: $1,000,000; low: $5,000).
Purpose and activities: Emphasis on medical research and health; support also for youth and cultural programs.
Limitations: Giving primarily in Orange County, CA. No support for government agencies, tax-supported projects, or sectarian or religious organizations for the benefit of their own members. No grants to individuals, or for deficit financing, or normal operating expenses.
Application information: Application form required.
Initial approach: Letter not exceeding 2 pages
Deadline(s): Feb. 15 and Sept. 15
Board meeting date(s): Mar. and Oct.
Final notification: Following meeting at which proposal is acted upon
Write: W. Dickerson Milliken, Secy.
Officers and Directors: John Macnab, Pres.; George Grant Hoag II, V.P.; W. Dickerson Milliken, Secy.; Del V. Werderman, Treas.; John Curci, Patty Hoag, Gwyn Parry, Melinda Hoag Smith.
Employer Identification Number: 956006885

171
K. H. Hofmann Foundation
P.O. Box 907
Concord 94522 (415) 687-1826

Established in 1963 in CA.
Donor(s): Alta Mortgage Co., Hofmann Co., Ken, Inc., New Discovery, Inc., Kenneth H. Hoffmann.
Financial data (yr. ended 7/31/88): Assets, $6,168,396 (M); gifts received, $1,924,436; expenditures, $1,662,164, including $1,527,010 for 100 grants (high: $1,000,000; low: $100).
Purpose and activities: Support for 1)acquisition, preservation,and conservation of wildlife lands specifically the wetland marshlands that are sanctuaries to waterfowl and related wildlife; 2)education of the community to its needs to preserve wildlife without undermining related sports and recreation; 3)local educational institutions that demonstrate a profound need to challenge and improve the hearts and minds of its students; 4)local cultural organizations, especially those which demonstrate a desire to establish and create long lasting cultural programs and facilities; 5)to a limited degree, local organizations which address the general citizens' welfare. Some support for local medical and health agencies, as well as nationally recognized medical research agencies.
Types of support: Building funds, research, scholarship funds, special projects.
Limitations: Giving primarily in northern CA, with a concentration on Bay Area organizations; limited support for national organizations. No grants for general purposes, capital funding, routine operating expenses, or repayment of indebtedness.
Publications: Annual report (including application guidelines).
Application information:
Initial approach: Inquiry letter of no more than 3 pages; attach proof of IRS status
Copies of proposal: 1
Deadline(s): None
Board meeting date(s): Quarterly
Final notification: 3-4 months
Write: Nick Rossi
Officers: Kenneth H. Hofmann, Pres.; Lisa Ann Hofmann-Affinito, V.P.; Albert T. Shaw, Secy.; Vita Lori Hofmann-Daskalos, Treas.
Number of staff: 4
Employer Identification Number: 946108897

172
Glen Holden Foundation
11365 West Olympic Blvd., Suite 444 W
Los Angeles 90064

Established in 1980 in CA.
Donor(s): Glen A. Holden, Sr.
Financial data (yr. ended 11/30/88): Assets, $455,514 (M); gifts received, $8,200; expenditures, $314,747, including $312,673 for 26 grants (high: $105,000; low: $20).
Purpose and activities: Support for human services, higher education, and cultural programs.

Officers: Glen A. Holden, Sr., Chair.; Gloria A. Holden, Pres.; Georgianne Holden-Stone, V.P. and Secy.; Glen A. Holden, Jr., V.P. and Treas.; Geannie Holden-Sheller, V.P.
Employer Identification Number: 953450000

173
William Knox Holt Foundation
505 Sansome St., Suite 1001
San Francisco 94111 (415) 981-3455

Established in 1967.
Donor(s): William Knox Holt.†
Financial data (yr. ended 12/31/87): Assets, $8,012,265 (M); expenditures, $736,141, including $630,783 for grants (high: $232,283; low: $5,000; average: $5,000).
Purpose and activities: Giving primarily for higher and secondary education in the field of science; some support also for museums.
Types of support: Building funds, matching funds, research, special projects, scholarship funds, fellowships.
Limitations: Giving primarily in northern CA and southern TX. No grants for general support, operating budgets, continuing support, annual campaigns, emergency funds, deficit financing, equipment, land acquisition, or endowment funds; no loans.
Application information:
 Initial approach: Letter
 Copies of proposal: 1
 Deadline(s): Submit proposal in Jan. or Feb.; deadline Feb. 15
 Board meeting date(s): Quarterly
 Final notification: 3 months
 Write: Stephen W. Veitch, Secy.
Officer and Directors: Roberta Atherton, Stephen W. Veitch, Secy.; Stevenson Atherton, George M. Malti.
Employer Identification Number: 746084245

174
The Homeland Foundation
412 North Pacific Coast Hwy., Suite 345
Laguna Beach 92651-1381 (714) 494-5480

Established in 1986 in CA.
Donor(s): The NISA Trust.
Financial data (yr. ended 12/31/87): Assets, $4,674,297 (M); gifts received, $2,895,516; expenditures, $99,598, including $73,500 for 12 grants (high: $15,000; low: $1,000).
Purpose and activities: Giving to preserve individual rights to have a safe place to live, and to organizations that work to preserve the earths natural resources; support also for wildlife and crafts museums.
Limitations: No grants to individuals.
Application information:
 Initial approach: Letter or proposal
 Deadline(s): Mar. 1, June 1, Sept. 1, and Dec. 1
 Board meeting date(s): Quarterly
 Write: Sandra Lund Gavin
Officers: John E. Earhart, Pres.; Anne Earhart, Secy.; Oliver Crary, Treas.
Trustees: Kate Raftery.
Number of staff: 1 full-time professional.
Employer Identification Number: 956301027

175
The Humboldt Area Foundation
P.O. Box 632
Eureka 95502 (707) 442-2993

Community foundation established in 1972 in CA by declaration of trust.
Donor(s): Vera P. Vietor,† Lynn A. Vietor,† and others.
Financial data (yr. ended 12/31/87): Assets, $8,400,000 (L); gifts received, $802,000; expenditures, $460,000, including $393,020 for 94 grants (high: $18,000; low: $100) and $9,300 for 12 grants to individuals.
Purpose and activities: Grants for cultural programs, health, recreation, public safety, education, and human service programs.
Types of support: Special projects, equipment, building funds, continuing support, matching funds, renovation projects, student aid.
Limitations: Giving limited to Humboldt County and Del Norte County, CA. No grants to individuals (except from donor-designated funds); generally no grants for endowment funds, unspecified emergency purposes, deficit financing, or operating budgets.
Publications: Annual report, application guidelines, informational brochure (including application guidelines).
Application information: Application form required.
 Initial approach: Letter or telephone
 Copies of proposal: 8
 Deadline(s): Feb. 1, May 1, Aug. 1, and Nov. 1
 Board meeting date(s): Monthly; applications reviewed quarterly in Jan., Apr., July, and Oct.
 Write: Ellen A. Dusick, Exec. Dir.
Officer: Ellen A. Dusick, Exec. Dir.
Governors: M. Dale Stanhope, Chair.; John R. Selvage, Vice-Chair.; Dolores Vellutini, Secy.; Don Albright, Sam B. Merryman, Jr., Edward L. Nilson, Willis J. Tyson.
Trustees: First Interstate Bank, Security Pacific Bank, Wells Fargo Bank, N.A.
Number of staff: 1 full-time professional; 2 part-time support.
Employer Identification Number: 237310660

176
Jaquelin Hume Foundation
550 Kearny St., Suite 1000
San Francisco 94108 (415) 421-6615

Established in 1962 in CA.
Donor(s): Jaquelin H. Hume, Caroline H. Hume.
Financial data (yr. ended 12/31/87): Assets, $2,228,275 (M); gifts received, $320,506; expenditures, $57,426, including $53,700 for 41 grants (high: $10,000; low: $100).
Purpose and activities: Support primarily for education, cultural programs, public interest, and civic affairs.
Types of support: Annual campaigns, conferences and seminars, general purposes, operating budgets, special projects.
Limitations: Giving primarily in the San Francisco Bay, CA, area.
Application information:
 Initial approach: Letter
 Deadline(s): None

Write: Mr. Jaquelin H. Hume, Pres.
Officers and Trustees: Jaquelin H. Hume, Pres.; Caroline H. Hume, Sr. V.P.; George H. Hume, 1st V.P. and Secy.; William J. Hume, 2nd V.P. and Treas.; Edward A. Landry, Walter H. Sullivan, Jr.
Number of staff: None.
Employer Identification Number: 946080099

177
Dora Donner Ide Foundation
c/o Chickering & Gregory
Two Embarcadero Center, Suite 740
San Francisco 94111

Established in 1982 in CA.
Donor(s): Dora Donner Ide.
Financial data (yr. ended 06/30/86): Assets, $3,218 (M); gifts received, $562,119; expenditures, $563,222, including $550,000 for 5 grants (high: $250,000; low: $10,000).
Purpose and activities: Support for higher education and cultural programs.
Application information:
 Initial approach: Letter
 Deadline(s): None
 Write: Dora Donner Ide, Pres.
Officers and Directors: Dora Donner Ide, Pres.; C. Kenneth Baxter, V.P.; Darrell E. Williams, Secy.-Treas.
Employer Identification Number: 942838673

178
Audrey & Sydney Irmas Charitable Foundation
13500 Paxton St.
Pacoima 91331

Established in 1986 in CA.
Financial data (yr. ended 12/31/87): Assets, $2,800,469 (M); gifts received, $2,275,000; expenditures, $232,680, including $230,490 for 26 grants (high: $115,000; low: $100).
Purpose and activities: Support primarily for a charitable foundation; support also for housing, the arts, and Jewish welfare.
Types of support: General purposes.
Limitations: Giving primarily in Los Angeles, CA.
Application information:
 Initial approach: Letter
 Deadline(s): None
 Write: Sydney Irmas, Mgr.
Employer Identification Number: 954030813

179
The James Irvine Foundation
One Market Plaza
Spear Tower, Suite 1715
San Francisco 94105 (415) 777-2244
Southern CA office: 450 Newport Center Dr., Suite 545, Newport Beach, CA 92660; Tel.: (714) 644-1362

Incorporated in 1937 in CA.
Donor(s): James Irvine.†
Financial data (yr. ended 12/31/88): Assets, $458,000,000 (M); expenditures, $20,857,982, including $19,440,661 for grants (high: $2,000,000; low: $5,000; average: $25,000-$750,000).

Purpose and activities: Grants for private higher education, health, youth services, community services, and cultural projects.
Types of support: Seed money, equipment, matching funds, special projects, capital campaigns, renovation projects, technical assistance.
Limitations: Giving limited to CA. No support for primary or secondary schools, agencies receiving substantial government support, films, or sectarian religious activities. No grants to individuals, or for operating budgets, continuing support, annual campaigns, deficit financing, endowment funds, research, scholarships, publications, or conferences; no loans.
Publications: Annual report (including application guidelines), informational brochure.
Application information:
 Initial approach: Letter and/or proposal
 Copies of proposal: 1
 Deadline(s): Proposals from institutions of higher education are reviewed separately in mid-summer; no other deadlines
 Board meeting date(s): Mar., June, Sept., Oct., and Dec.
 Final notification: Three to six months
 Write: Luz A. Vega, Dir. of Grants Prog.
Officers: Dennis A. Collins, Pres.; Larry R. Fies, Treas. and Corp. Secy.
Directors: Myron Du Bain, Chair.; Samuel H. Armacost, Edward W. Carter, Virginia B. Duncan, Camilla C. Frost, Walter B. Gerken, Roger W. Heyns, Donn B. Miller, Forrest N. Shumway, Kathryn L. Wheeler, Edward Zapanta, M.D.
Number of staff: 9 full-time professional; 1 part-time professional; 6 full-time support; 1 part-time support.
Employer Identification Number: 941236937
Recent arts and culture grants:
Alliance for Childrens Arts, Palm Springs, CA, $7,000. To underwrite student tickets for opera productions. 11/87.
Aman Folk Ensemble, Los Angeles, CA, $25,000. For creation of three new dance suites. 4/88.
American Conservatory Theater, San Francisco, CA, $215,000. For capital stabilization campaign. 12/8/87.
Berkeley Repertory Theater, Berkeley, CA, $150,000. For Artistic Initiative. 5/26/88.
Berkeley Shakespeare Festival, Berkeley, CA, $40,000. To extend touring program for two weeks in 1988. 10/13/87.
Berkeley Symphony Orchestra, Berkeley, CA, $25,000. For administrative assistant to Executive Director. 6/20/88.
Business Volunteers for the Arts/San Francisco, San Francisco, CA, $100,000. For program strengthening and expansion. 12/8/87.
California International Arts Foundation, Los Angeles, CA, $40,000. For salary of fundraising coordinator. 2/88.
California School of Mechanical Arts, San Francisco, CA, $30,000. Toward Aim High, academic and cultural enrichment program for economically disadvantaged youth. 12/21/87.
Columbia University, NYC, NY, $20,000. Toward California part of nationwide Information on Artists Project, study of artists' work/financial/social service needs. 4/20/88.

Dance Gallery, Los Angeles, CA, $100,000. Toward construction. 12/87.
Eureka Theater Company, San Francisco, CA, $5,000. For planning phase of Audience Development and Stabilization Project. 2/24/88.
Gaslamp Theater Company, San Diego, CA, $30,000. For salary of subscription manager. 2/88.
Khadra International Folk Ballet, San Francisco, CA, $25,000. Toward Development Director's salary. 12/8/87.
La Jolla Museum of Contemporary Art, La Jolla, CA, $40,000. To complete Phase II of museum's computerization project. 12/87.
Long Beach Symphony Association, Long Beach, CA, $100,000. To expand cash reserves. 5/88.
Los Angeles Chamber Orchestra Society, Los Angeles, CA, $125,000. To expand cash reserves. 5/88.
Margaret Jenkins Dance Company, San Francisco, CA, $50,000. For artistic advancement. 12/8/87.
Montalvo Center for the Arts, Saratoga, CA, $35,000. Toward completion of renovations and improvements to Garden Theater. 10/13/87.
Music Academy of the West, Santa Barbara, CA, $75,000. For salary of development director. 5/88.
Musical Traditions, Berkeley, CA, $33,000. Toward salary of administrative director. 6/20/88.
Nature Conservancy, San Francisco, CA, $10,000. Toward new photographic survey by Tupper Ansel Blake entitled, The Borderlands: A Natural History of the Mexican-American Boundary. 4/20/88.
Opera Pacific, Irvine, CA, $150,000. To develop unrestricted gifts program. 12/87.
Otis Art Institute of Parsons School of Design, Los Angeles, CA, $400,000. Toward facilities expansion. 12/87.
Pacific Chorale, Santa Ana, CA, $35,000. Toward salary of full-time development director and cost of development audit. 12/87.
Performing Arts Services, San Francisco, CA, $75,000. To support Phase I purchase of computer hardware to automate services and to provide Phase II seed monies for operating Embarcadero Center ticket booth. 12/8/87.
Philharmonia Baroque Orchestra of the West, Berkeley, CA, $50,000. For marketing and fundraising director. 12/8/87.
San Diego Opera Association, San Diego, CA, $150,000. For matching grant to formalize annual fund program. 5/88.
San Diego Theater Foundation, San Diego, CA, $50,000. Toward construction of ticket booth ARTS-TIX, and cost of first year of operation. 12/87.
San Francisco Ballet Association, San Francisco, CA, $500,000. To increase staff and development. 12/8/87.
San Francisco Chanticleer, San Francisco, CA, $50,000. To support administrative improvements in marketing and development. 12/8/87.
San Francisco Girls Chorus, San Francisco, CA, $15,000. For scholarship aid to underrepresented minority girls in East Bay program. 4/20/88.

San Francisco Opera Association, San Francisco, CA, $500,000. For challenge grant to get new donors and increased giving levels. 12/8/87.
San Francisco Symphony Association, San Francisco, CA, $500,000. For matching grant to enhance artistic quality. 5/26/88.
Shakespeare - San Francisco, San Francisco, CA, $35,000. To expand season two weeks, build sets and create costumes at ACT shop, and hire administrative assistant. 4/20/88.
Theaterworks, Palo Alto, CA, $29,500. For marketing director and computer equipment. 10/13/87.
Ukiah Players Theater, Ukiah, CA, $16,700. To complete Phase II construction of Ukiah Players Theater Playhouse. 2/4/88.
Whittier College, Whittier, CA, $400,000. Toward construction cost of Center for Performing Arts. 9/87.

180
The William G. Irwin Charity Foundation
711 Russ Bldg.
235 Montgomery St.
San Francisco 94104 (415) 362-6954

Trust established in 1919 in CA.
Donor(s): Fannie M. Irwin,† Helene Irwin Fagan.†
Financial data (yr. ended 12/31/86): Assets, $45,089,029 (M); expenditures, $1,835,134, including $1,465,068 for 30 grants (high: $150,000; low: $7,500; average: $50,000-$150,000).
Purpose and activities: To apply its net income to charitable uses, including medical research and other scientific uses designed to promote or improve the physical condition of mankind; support also for hospitals, cultural programs, education, and social service agencies.
Types of support: Building funds, equipment, general purposes, land acquisition, research.
Limitations: Giving limited to HI and CA.
Application information:
 Initial approach: Letter or proposal
 Deadline(s): Approximately 3 weeks prior to board meeting
 Board meeting date(s): Approximately every 2 months
 Write: Michael R. Gorman, Exec. Dir.
Officers: Jane Fagan Olds,* Pres.; Atherton Phleger,* V.P.; Michael R. Gorman, Exec. Dir.
Trustees:* Fred R. Grant, Merl McHenry, William Lee Olds, Jr.
Number of staff: 2 full-time professional.
Employer Identification Number: 946069873

181
J. W. and Ida M. Jameson Foundation
P.O. Box 397
Sierra Madre 91024 (818) 355-6973

Incorporated in 1955 in CA.
Donor(s): J.W. Jameson Corp., Ida M. Jameson.†
Financial data (yr. ended 6/30/87): Assets, $520,773 (M); gifts received, $580,000; expenditures, $593,192, including $580,500 for 71 grants (high: $40,000; low: $1,000).

Purpose and activities: Emphasis on higher education, including theological seminaries; hospitals and medical research; cultural programs; and youth agencies; grants also for Protestant church support.
Types of support: Research, general purposes, scholarship funds.
Limitations: Giving primarily in CA.
Application information:
Deadline(s): None
Write: William M. Croxton, V.P.
Officers and Directors: William M. Croxton, V.P. and Treas.; Pauline Vetrovec, Secy.; Bill B. Betz, Fred L. Leydorf.
Employer Identification Number: 956031465

182
Elizabeth Bixby Janeway Foundation
2029 Century Park East, Suite 400
Los Angeles 90067

Established in 1966 in CA.
Donor(s): Elizabeth Bixby Janeway.
Financial data (yr. ended 9/30/87): Assets, $2,837,271 (M); expenditures, $94,707, including $82,000 for 13 grants (high: $25,000; low: $1,000).
Purpose and activities: Grants primarily for social services, including child welfare, health services, and culture.
Application information:
Deadline(s): None
Write: Robert D. Burch, Secy.
Officers and Directors: Elizabeth Bixby Janeway, Pres.; Preston B. Hotchkis, V.P.; Freeman Gates, 2nd V.P.; Robert D. Burch, Secy.; R.M. Faletti, Treas.
Employer Identification Number: 952466561

183
George Frederick Jewett Foundation
One Maritime Plaza
The Alcoa Bldg., Suite 990
San Francisco 94111 (415) 421-1351

Trust established in 1957 in MA.
Donor(s): George Frederick Jewett.†
Financial data (yr. ended 12/31/87): Assets, $16,019,040 (M); expenditures, $1,086,305, including $901,686 for 135 grants (high: $40,000; low: $500; average: $1,000-$15,000).
Purpose and activities: To carry on the charitable interests of the donor to stimulate, encourage, and support activities of established, voluntary, nonprofit organizations which are of importance to human welfare. Interests include social welfare; arts and humanities, including the performing arts; conservation of natural resources; higher education; population planning; health care and medical research and services; religion and religious training; and public affairs.
Types of support: General purposes, building funds, equipment, land acquisition, research, matching funds, special projects, operating budgets, seed money, technical assistance.
Limitations: Giving primarily in the Pacific Northwest, with emphasis on northern ID and eastern WA, particularly Spokane, and in San Francisco, CA. No grants to individuals, or for scholarships or fellowships; no loans. No emergency grants, except for disaster relief.

Publications: Annual report (including application guidelines).
Application information:
Initial approach: Letter
Copies of proposal: 1
Deadline(s): Nov. 1
Board meeting date(s): Mar., June, Sept., and Dec. (for annual distributions)
Final notification: Annually, at the end of the year
Write: Theresa Mullen, Prog. Dir.
Officers and Trustees: George Frederick Jewett, Jr., Chair.; Mary Jewett Gaiser, Secy.; Margaret Jewett Greer, William Hershey Greer, Jr., Lucille McIntyre Jewett.
Number of staff: 1 full-time professional; 1 part-time support.
Employer Identification Number: 046013832
Recent arts and culture grants:
American Festival Ballet, Moscow, ID, $10,000. For general operating support. 1987.
Eastern Washington State Historical Society, Spokane, WA, $10,000. For salary support for educational coordinator. 1987.
Festival at Sandpoint, Sandpoint, ID, $10,000. For general support. 1987.
K P B X-FM Spokane Public Radio, Spokane, WA, $10,000. Toward station's locally produced programs. 1987.
Margaret Jenkins Dance Company, San Francisco, CA, $7,000. Toward Bay Area Season at Herbst Theater in San Francisco. 1987.
Mystic Seaport Museum, Mystic, CT, $10,000. For third and final payment on commitment to assist Museum in acquisition of Stanley Rosenfeld Collection of sailing photographs. 1987.
Oregon Shakespearean Festival Association, Ashland, OR, $10,000. For Festival's 1987 Season. 1987.
San Francisco Public Library, Friends of the, San Francisco, CA, $12,000. To support City Guides project, program of historical and architectural walks in San Francisco's neighborhoods. 1987.
Spokane Ballet, Spokane, WA, $10,000. For general operating support for company's 1987-88 season. 1987.
Spokane Symphony Society, Spokane, WA, $40,000. For endowment campaign. 1987.
Spokane Symphony Society, Spokane, WA, $5,000. For annual giving campaign. 1987.

184
Walter S. Johnson Foundation
525 Middlefield Rd., Suite 110
Menlo Park 94025 (415) 326-0485

Established in 1968 in CA.
Donor(s): Walter S. Johnson.†
Financial data (yr. ended 12/31/88): Assets, $44,894,000 (M); expenditures, $2,405,283, including $2,131,619 for 25 grants (high: $186,710; low: $8,000; average: $30,000-$60,000) and $130,000 for loans.
Purpose and activities: Giving primarily for public schools and social service agencies concerned with the quality of public education and the social family experiences of children between kindergarten and twelfth grade.

Types of support: Operating budgets, seed money, special projects, research, technical assistance, general purposes.
Limitations: Giving primarily in Alameda, Contra Costa, San Francisco, San Mateo, and Santa Clara counties in CA, and in Washoe County, NV. No support for religious organizations for sectarian purposes, or for private schools. No grants to individuals, or for continuing support, annual campaigns, deficit financing, memorial funds, capital or endowment funds, matching gifts, scholarships, fellowships, publications, or conferences; no loans.
Publications: Annual report, informational brochure (including application guidelines), grants list.
Application information:
Initial approach: Telephone or letter
Copies of proposal: 4
Deadline(s): Submit proposal 12 weeks before board meeting
Board meeting date(s): Mar., May, July, and Nov.
Final notification: 1 to 4 months
Write: Deborah Wood, Prog. Officer
Officers: Gloria Eddie,* Pres.; Charles P. Eddie,* V.P.; Sandra Bruckner,* Secy.; Elio L. Martin, Treas.; Donna Terman, Exec. Dir.
Trustees:* Gloria Jeneal Eddie, Christopher Johnson, Mary Lanigar, Hathily J. Winston.
Number of staff: 3 part-time professional; 1 full-time support.
Employer Identification Number: 237003595
Recent arts and culture grants:
Exploratorium, San Francisco, CA, $20,000. For evaluation of teacher training program. 1987.
University of California, Lawrence Hall of Science, Berkeley, CA, $190,250. For chemistry curriculum for middle schools. 1987.

185
The Fletcher Jones Foundation
(Formerly The Jones Foundation)
One Wilshire Bldg., Suite 1210
624 South Grand Ave.
Los Angeles 90017 (213) 689-9292

Established in 1969 in CA.
Donor(s): Fletcher Jones.†
Financial data (yr. ended 12/31/87): Assets, $73,112,267 (M); expenditures, $3,561,341, including $3,316,000 for 59 grants (high: $800,000; low: $2,500; average: $5,000-$100,000).
Purpose and activities: Support primarily for private higher educational institutions; grants also for cultural programs, social services, and health.
Types of support: Seed money, building funds, equipment, professorships, special projects, endowment funds, scholarship funds, renovation projects.
Limitations: Giving primarily in CA. No support for secondary schools. No grants to individuals or for operating funds, deficit financing, conferences, travel exhibits, surveys, or projects supported by government agencies.
Publications: Annual report (including application guidelines).
Application information:

Initial approach: Letter
Deadline(s): One month prior to board
meetings
Board meeting date(s): Mar., May, Sept.,
and Nov.
Final notification: 3 to 6 months
Write: Harvey L. Price, Exec. Dir.
Officers: John P. Pollock,* Pres.; Houston
Flournoy,* V.P.; Jess C. Wilson, Jr.,* V.P.; Jack
Pettker, Secy.; Harvey L. Price, Treas. and
Exec. Dir.
Trustees:* Dean S. Butler, Robert F. Erburu,
Chauncey J. Medberry III, Rudy J. Munzer,
Donald E. Nickelson, Dickinson C. Ross.
Number of staff: 1 part-time professional; 1
part-time support.
Employer Identification Number: 237030155

186
Felix & Helen Juda Foundation
3440 Torrance Blvd., Suite 102
Torrance 90503-5802

Established in 1951 in CA.
Donor(s): Felix M. Juda, Helen Juda.
Financial data (yr. ended 11/30/87): Assets,
$878,291 (M); expenditures, $131,217,
including $118,645 for 25 grants (high:
$32,350).
Purpose and activities: Emphasis on cultural
programs, social services, and higher
education; some support for hospitals.
Types of support: General purposes.
Trustees: Felix M. Juda, Helen Juda, Tom Juda,
Patsy Palmer.
Employer Identification Number: 956048035

187
The Henry J. Kaiser Family Foundation
Quadras
2400 Sand Hill Rd.
Menlo Park 94025 (415) 854-9400

Trust established in 1948 in CA.
Donor(s): Bess F. Kaiser,† Henry J. Kaiser,†
Henry J. Kaiser, Jr.,† and others.
Financial data (yr. ended 12/31/87): Assets,
$354,413,428 (M); expenditures, $18,118,653,
including $11,786,136 for 173 grants (high:
$3,302,650; low: $1,750; average: $155,476)
and $93,878 for 50 employee matching gifts.
Purpose and activities: Major share of
resources devoted to programs in health and
medicine.
Types of support: Special projects, research,
seed money, fellowships, professorships,
scholarship funds, conferences and seminars,
publications, matching funds, technical
assistance.
Limitations: Giving limited to the San
Francisco Bay Area, CA, for the Community
Grants Program only; other grants nationwide.
No grants to individuals, or for construction,
equipment, or capital funds.
Publications: Annual report, informational
brochure (including application guidelines).
Application information: For Community
Health Promotion Grants Program, contact
foundation for brochure.
Initial approach: Letter
Copies of proposal: 3
Deadline(s): None

Board meeting date(s): Mar., July, and Nov.
Final notification: 3 to 6 months
Write: Karen P. Sparks, Proposal and Grants
Mgr.
Officers: Alvin R. Tarlov, M.D.,* Pres.; Hugh
C. Burroughs, V.P.; Lawrence W. Green, V.P.;
Barbara H. Kehrer, V.P.; Sol Levine, V.P.;
Bruce W. Madding, V.P.
Trustees:* Edgar F. Kaiser, Jr., Chair.; Joseph
A. Califano, Jr., Hale Champion, Richard P.
Cooley, Douglas A. Fraser, Barbara C. Jordan,
Henry M. Kaiser, Kim J. Kaiser, Edwin H.
Morgens, Joan E. Morgenthau, M.D.
Number of staff: 18 full-time professional; 12
full-time support; 3 part-time support.
Employer Identification Number: 946064808
Recent arts and culture grants:
University of California, Bancroft Library,
Berkeley, CA, $27,661. For Henry J. Kaiser
and Edgar F. Kaiser Archives. 10/2/87.

188
Danny Kaye and Sylvia Fine Kaye
Foundation
c/o Manny Flekman & Co.
9171 Wilshire Blvd., No. 530
Beverly Hills 90210

Established in 1983 in CA.
Donor(s): Danny Kaye,† Sylvia Fine Kaye.
Financial data (yr. ended 12/31/87): Assets,
$834,212 (M); expenditures, $521,541,
including $501,800 for 5 grants (high:
$500,000; low: $100).
Purpose and activities: Giving primarily for
culture, with emphasis on the performing arts.
Limitations: Giving primarily in CA and NY.
Application information: Contributes only to
pre-selected organizations. Applications not
accepted.
Officer and Directors: Sylvia Fine Kaye, Pres.;
Dena Kaye.
Employer Identification Number: 953864096

189
W. M. Keck Foundation
555 South Flower St., Suite 3230
Los Angeles 90071 (213) 680-3833

Established in 1954 and incorporated in 1959
in DE; sole beneficiary of W.M. Keck Trust.
Donor(s): William M. Keck.†
Financial data (yr. ended 12/31/88): Assets,
$679,896,348 (M); expenditures, $37,350,435,
including $34,015,500 for 69 grants (high:
$7,640,000; low: $25,000; average: $50,000-
$500,000).
Purpose and activities: To strengthen studies
and programs in educational institutions of
higher learning in the areas of earth science,
engineering, general science, medical education
and research, and liberal arts. Eligible
institutions in these fields are accredited
colleges and universities, medical schools, and
major independent medical research
institutions. Some consideration, limited to
southern CA, given to organizations and
institutions in health care and hospitals, arts
and culture, civic and community services, and
primary and secondary education.
Types of support: Building funds, seed money,
equipment, special projects, research,

renovation projects, fellowships, scholarship
funds, endowment funds.
Limitations: Giving primarily in southern CA in
all categories except higher education, and
medical research. No support for conduit
organizations. No grants to individuals, or for
routine expenses, general endowments, deficit
reduction, fundraising events, dinners, mass
mailings, conferences, seminars, publications,
films, or public policy research.
Publications: Annual report (including
application guidelines), informational brochure
(including application guidelines).
Application information: Foundation selects
applicant institutions to submit a complete
proposal.
Initial approach: Letter
Copies of proposal: 1
Deadline(s): Mar. 15 and Sept. 15 for
complete proposal; initial letters accepted
year-round
Board meeting date(s): June and Dec.
Final notification: June and Dec.
Write: Sandra A. Glass for sciences,
engineering, and liberal arts, Joan DuBois
for medical research, medical education,
and Southern California program
(arts/culture; civic/community affairs;
health care/hospitals; pre-collegiate
education)
Officers: Howard B. Keck,* Chair., Pres., and
C.E.O.; Gregory R. Ryan, V.P. and Secy.;
Robert A. Day, Jr.,* V.P.; Walter B. Gerken,*
V.P.; W.M. Keck II,* V.P.; Julian O. von
Kalinowski,* V.P.; Dorothy A. Harris, Treas.
Directors:* Norman Barker, Jr., Marsh A.
Cooper, Naurice G. Cummings, Howard M.
Day, Tammis M. Day, Theodore J. Day, Bob
Rawls Dorsey, Thomas P. Ford, Howard B.
Keck, Jr., Erin A. Kjorliev, John E. Kolb, Max R.
Lents, James Paul Lower, Simon Ramo, Arthur
M. Smith, Jr., David A. Thomas, Kerry C.
Vaughan, C. William Verity, Jr., Thomas R.
Wilcox.
Number of staff: 3 full-time professional; 8 full-
time support.
Employer Identification Number: 956092354
Recent arts and culture grants:
Community School of Performing Arts, Los
Angeles, CA, $40,000. To fully fund existing,
single W. M. Keck Scholarship. 1987.
Huntington Library, Art Gallery and Botanical
Garden, San Marino, CA, $350,000. For
endowment of Keck fellowships at
Huntington for graduate/post-doctoral
scholars in history, literature and arts. 1987.
K C E T Community Television of Southern
California, Los Angeles, CA, $250,000. To
continue to underwrite and broadcast
Sesame Street. 1987.
Los Angeles Chamber Orchestra, Los Angeles,
CA, $50,000. To underwrite prior grantee's 3-
concert matinee series for youth and senior
citizens at Wiltern Theater. 1987.
Los Angeles Philharmonic Association, Los
Angeles, CA, $375,000. Toward continued
support for education activities including
Symphony for Youth, High School Night at
Music Center and Open House at
Hollywood Bowl. 1987.
Museum of Contemporary Art, Los Angeles,
CA, $250,000. Toward endowment and
general support for education programs,

including national model, Contemporary Art Start program. 1987.

Southwest Museum, Los Angeles, CA, $41,000. Toward funds to help match endowment for staff positions; pilot video display program; and computer-related planning funds. 1987.

190
William M. Keck, Jr. Foundation
555 South Flower St., Suite 3230
Los Angeles 90071 (213) 680-3833

Incorporated in 1958 in DE.
Donor(s): William M. Keck, Jr.
Financial data (yr. ended 12/31/86): Assets, $11,895,233 (M); gifts received, $175,000; expenditures, $858,946, including $700,000 for 16 grants (high: $135,000; low: $5,000).
Purpose and activities: Emphasis on higher and secondary education, hospitals, cultural programs and church support.
Application information: Contributes only to pre-selected organizations. Applications not accepted.
Officers and Directors: William M. Keck II, Pres.; Marie E. Keck, V.P.; Mark Kessel, Secy.; Arthur Logan, Treas.
Employer Identification Number: 136097874

191
The Tom and Valley Knudsen Foundation
900 Wilshire Blvd., No. 1424
Los Angeles 90017 (213) 614-1940

Incorporated in 1951 in CA.
Donor(s): Th. R. Knudsen,† Valley M. Knudsen.†
Financial data (yr. ended 12/31/88): Assets, $3,893,725 (M); gifts received, $109,898; expenditures, $742,609, including $666,500 for 30 grants (high: $100,000; low: $1,000; average: $5,000).
Purpose and activities: Emphasis on private higher educational institutions; grants also for cultural institutions.
Types of support: General purposes, annual campaigns.
Limitations: Giving limited to southern CA. No grants to individuals, or for matching gifts, capital or endowment funds, scholarships, fellowships, research, or special projects; no loans.
Publications: Program policy statement, application guidelines.
Application information:
 Initial approach: Proposal
 Copies of proposal: 1
 Deadline(s): Mar. 1 and Sept. 1
 Board meeting date(s): Apr. and Oct.
 Final notification: 2 months
 Write: Helen B. McGrath, Exec. V.P.
Officers and Directors: J.R. Vaughan, Pres.; Helen B. McGrath, Exec. V.P., Secy., and Treas.; Christian Castenskiold, William W. Escherich, Gene Knudsen Hoffman, Doris Holtz, Peter O'Malley, Robert E. Osborne, Harold Skou.
Number of staff: None.
Employer Identification Number: 956031188

192
Komes Foundation
1801 Van Ness Ave., Suite 300
San Francisco 94109 (415) 441-6462

Established in 1965 in CA.
Donor(s): Jerome W. Komes, Flora Komes.
Financial data (yr. ended 12/31/87): Assets, $2,098,185 (M); expenditures, $179,776, including $153,797 for 71 grants (high: $25,000; low: $250; average: $2,050).
Purpose and activities: Emphasis on hospitals and health agencies, higher education, cultural programs, youth agencies, and Christian welfare organizations.
Types of support: Building funds, capital campaigns, continuing support, endowment funds, general purposes, operating budgets, program-related investments, research, seed money, annual campaigns, scholarship funds.
Limitations: Giving primarily in northern CA. No support for literary publications. No grants to individuals, or for budget deficits, or conferences or travel.
Publications: Annual report (including application guidelines), occasional report, informational brochure (including application guidelines).
Application information:
 Initial approach: Letter
 Deadline(s): None
Officers: Jerome W. Komes, Pres.; Flora Komes, V.P.; Michael L. Mellor, Secy.
Employer Identification Number: 941611406

193
Koret Foundation
33 New Montgomery St., Suite 1090
San Francisco 94105 (415) 882-7740

Foundation established in 1966 in CA.
Donor(s): Joseph Koret,† Stephanie Koret.†
Financial data (yr. ended 12/31/88): Assets, $157,346,174 (M); gifts received, $415,625; expenditures, $7,827,653 for 235 grants (high: $500,000; low: $1,000) and $20,817 for 1 in-kind gift.
Purpose and activities: To promote the well-being of the general and Jewish communities of the San Francisco Bay Area and to assist the people of Israel through special projects.
Types of support: Operating budgets, continuing support, special projects, building funds, general purposes, consulting services, renovation projects, seed money.
Limitations: Giving limited to the Bay Area counties of San Francisco, Alameda, Contra Costa, Marin, Santa Clara, and San Mateo, CA, and Israel. No support for veterans', fraternal, military, religious, or sectarian organizations whose principal activity is for the benefit of their own membership. No grants to individuals, general fundraising campaigns, endowment funds, equipment funds, deficit financing, or emergency funds; no loans.
Publications: Program policy statement, application guidelines, annual report (including application guidelines).
Application information: Application form required.
 Initial approach: Letter of inquiry
 Copies of proposal: 2
 Deadline(s): None

 Board meeting date(s): Quarterly
 Final notification: 4 months
 Write: Rosemary Peterson, Grants Admin.
Officers: Eugene L. Friend,* Pres.; Jack R. Curley, Treas.; Stephen Mark Dobbs, C.E.O. and Exec. Dir.
Directors: Susan Koret, Chair.; Richard Blum, William K. Coblentz, Richard L. Greene, Stanley Herzstein, Bernard A. Osher, Melvin M. Swig, Thaddeus N. Taube.
Number of staff: 7 full-time professional; 5 full-time support.
Employer Identification Number: 941624987
Recent arts and culture grants:
American Conservatory Theater Foundation, San Francisco, CA, $25,000. To support largest theater company in San Francisco Bay Area. 1987.
American Friends of Beth Hatefutsoth, NYC, NY, $40,000. For Museum's special exhibition, In the Footsteps of Columbus: Jews in America 1654-1880. 1987.
American Himalayan Foundation, San Francisco, CA, $50,000. To provide education and health care for peoples of Himalayan region and to promote cultural preservation and conservation in area. 1987.
California College of Arts and Crafts, Oakland, CA, $44,889. For Summer Youth Program, which seeks to offer disadvantaged high school students from Oakland Unified School District introduction to professional arts education and careers within arts. 1987.
Jewish Community Museum, San Francisco, CA, $25,000. For Museum's special exhibition, I and the Village: A Centennial Tribute to Marc Chagall. 1987.
Jewish Community Museum, San Francisco, CA, $25,000. For feasibility study, which will explore possibility of merger between Jewish Community Museum in San Francisco and Judah L. Magnes Memorial Museum in Berkeley. 1987.
Judah L. Magnes Memorial Museum, Berkeley, CA, $50,000. For challenge/outright grant for Museum's capital fundraising campaign. 1987.
K Q E D, San Francisco, CA, $11,020. For annual auction to raise support for Station's general operations. 1987.
Stanford University, Stanford, CA, $100,000. To assist Stanford University Libraries with preservation and conservation of Taube-Baron Collection on Jewish History and Culture. 1987.

194
Joan B. Kroc Foundation
8939 Villa La Jolla Dr., Suite 201
La Jolla 92037 (619) 453-3737

Established in 1984 in CA.
Donor(s): Joan B. Kroc.
Financial data (yr. ended 12/31/88): Assets, $13,657,140 (M); expenditures, $12,056,570, including $11,935,101 for 31 grants (high: $6,000,000; low: $100; average: $1,000-$1,000,000).
Purpose and activities: To initiate and sustain programs and activities that help people to accept and overcome conditions that may undermine individual worth and family love.

The foundation no longer supports programs in chemical dependence.

Types of support: Operating budgets, continuing support, seed money, building funds, equipment, land acquisition, consulting services, technical assistance, research, conferences and seminars, special projects, endowment funds, general purposes.

Limitations: Giving primarily in the San Diego, CA, area for programs serving a particular community; giving also for national programs. No support for religious events or programs in chemical dependence; generally does not fund traditional medical research. No grants to individuals, or for annual campaigns, fundraising, deficit financing, renovation projects, program-related investments, scholarships, or fellowships; no loans.

Publications: Annual report.

Application information: Most programs initiated by the foundation; applications not encouraged. Applications not accepted.

Deadline(s): None

Board meeting date(s): Annually

Write: Elizabeth E. Benes, General Counsel

Officers and Directors: Joan B. Kroc, Pres. and Secy.; Beverly Greek.

Number of staff: None.

Employer Identification Number: 330001724

Recent arts and culture grants:

Tender Loving Zoo, San Diego, CA, $5,000. For therapy program. 1987.

195

L.L.W.W. Foundation

1260 Huntington Dr., Suite 204

South Pasadena 91030-4561 (213) 259-0484

Established in 1980 in CA.

Donor(s): Laura Lee Whittier Woods.

Financial data (yr. ended 12/31/87): Assets, $9,086,677 (M); gifts received, $187,968; expenditures, $634,915, including $530,015 for 61 grants (high: $100,000; low: $50).

Purpose and activities: Emphasis on the arts, including museums; giving also for education and social services.

Limitations: Giving primarily in southern CA.

Application information: Contributes only to pre-selected organizations. Applications not accepted.

Write: Linda J. Blinkenberg, Secy.

Officers: Laura Lee Whittier Woods, Pres.; Arlo G. Sorensen, V.P.; Linda J. Blinkenberg, Secy.; Robert D. Sellers, C.F.O.

Employer Identification Number: 953464689

196

Lakeside Foundation

50 Fremont St., Suite 3825

San Francisco 94105 (415) 768-6022

Incorporated in 1953 in CA.

Donor(s): S.D. Bechtel, Mrs. S.D. Bechtel, S.D. Bechtel, Jr., Mrs. Paul L. Davies, Jr., Bechtel Corp.

Financial data (yr. ended 12/31/86): Assets, $6,520,167 (M); gifts received, $78,765; expenditures, $238,702, including $211,100 for 63 grants (high: $77,500; low: $250).

Purpose and activities: Emphasis on health care, higher education, including international

studies, and cultural programs; support also for religious, scientific, and literary purposes, a community fund, and youth agencies.

Types of support: General purposes, operating budgets, continuing support, building funds.

Limitations: Giving primarily in the San Francisco Bay Area, CA. No grants to individuals, or for endowment funds, scholarships, fellowships, or matching gifts; no loans.

Application information: Contributes only to pre-selected organizations. Applications not accepted.

Board meeting date(s): Annually, usually in the spring

Write: Barbara B. Davies, Pres.

Officers: Barbara B. Davies,* Pres.; D.A. Ruhl, V.P. and Treas.; Laura P. Bechtel,* V.P.; Marlies A. Carver, Secy.

Directors:* S.D. Bechtel, Paul L. Davies, Jr., Paul Lewis Davies III, A. Barlow Ferguson, Laura Davies Mateo.

Number of staff: None.

Employer Identification Number: 946066229

197

Lannan Foundation

5401 McConnell Ave.

Los Angeles 90066 (213) 301-7683

Established in 1960 in IL.

Donor(s): J. Patrick Lannan.†

Financial data (yr. ended 12/31/87): Assets, $108,210,017 (M); expenditures, $5,121,986, including $2,716,629 for 42 grants (high: $1,500,000; low: $1,000) and $1,144,586 for foundation-administered programs.

Purpose and activities: A private foundation with grant programs to support the visual and literary arts. The visual arts program has developed 4 programs: grants for varied programs and activites in contemporary art, exhibition and interpretation of the Lannan Foundation collection, and fostering serious scholarship and criticism in contemporary art. The foundation also operates a public gallery. The literary arts program fosters the creation of prose and poetry through grants and projects designed to recognize excellence in English language literature, to widen the audience for serious literature and to stimulate more effective production, marketing, and distribution of small press books, journals, and audio and videotapes featuring important contemporary literary work, and to encourage and stimulate networking among organizations that have demonstrated a commitment to literature. The foundation makes a limited number of grants to miscellaneous charitable causes.

Limitations: No grants to individuals.

Publications: Program policy statement.

Application information: Contributes only to pre-selected organizations for its charitable giving program; literary arts program is by invitation only; 5 copies of proposal needed for visual arts program.

Initial approach: For visual arts program, telephone or letter

Deadline(s): For visual arts, Feb. 1, May 1, and Oct. 1; none for literary arts

Officers: J. Patrick Lannan, Jr., Pres.; Sharon Ferrill,* 1st V.P.; John R. Lannan, V.P. and

Treas.; Barbara A. Dalderis, V.P., Finance and Administration; Frank Lawler,* Secy.; Bonnie R. Clearwater, Exec. Dir., Art Progs.

Directors:* Colleen Dillon, Tsheng S. Feng, John J. Lannan, Lawrence Lannan, Jr., Michael J. Lannan, Patricia Lawler, Mary M. Plauche.

Employer Identification Number: 366062451

198

The Norman Lear Foundation

1800 Century Park East, Suite 200

Los Angeles 90067 (213) 553-3636

Established in 1986 in CA.

Donor(s): Norman Lear.

Financial data (yr. ended 11/30/87): Assets, $1,096,625 (M); gifts received, $1,030,764; expenditures, $222,558, including $196,600 for 36 grants (high: $25,000; low: $100).

Purpose and activities: Giving primarily to promote health; support also for the arts, citizenship and public policy, business education, Jewish welfare, women, and conservation.

Application information:

Deadline(s): None

Write: Betsy Kenny

Officers: Norman Lear, Pres.; Paul Schaeffer, V.P.; Stuart Tobisman, Secy.; Warren Spector, Treas.

Employer Identification Number: 954036197

199

The Ledler Foundation

1800 West Magnolia Blvd.

P.O. Box 828

Burbank 91503

Established in 1966 in CA.

Donor(s): Lawrence E. Deutsch,† Lloyd E. Rigler, Adolph's, Ltd., Adolph's Food Products Manufacturing Co.

Financial data (yr. ended 12/31/86): Assets, $4,992,971 (M); expenditures, $1,020,228, including $736,668 for 47 grants (high: $284,500).

Purpose and activities: Grants mainly for cultural programs in the performing arts.

Limitations: No grants to individuals.

Application information:

Initial approach: Letter

Deadline(s): None

Board meeting date(s): As necessary

Final notification: Varies

Write: Audre Estrin, Asst. Treas.

Officers and Director:* Lloyd E. Rigler,* Pres.; Simon Miller, V.P.; Donald Rigler, Secy.

Number of staff: None.

Employer Identification Number: 956155653

200

The LEF Foundation

1095 Lodi Ln.

St. Helena 94574 (707) 963-9591

Established in 1985 in CA.

Donor(s): Lyda Ebert Trust.

Financial data (yr. ended 6/30/88): Assets, $6,504,112 (M); expenditures, $465,737, including $385,645 for 40 grants (high: $44,000; low: $500; average: $5,000-$15,000).

Purpose and activities: Support for intersection of art and environment.
Types of support: Land acquisition, general purposes, publications, seed money, special projects.
Limitations: Giving primarily in northern CA and New England and proactive in other states.
Publications: Application guidelines, 990-PF, grants list.
Application information:
 Initial approach: Letter or telephone
 Copies of proposal: 7
 Deadline(s): Mar. 1 and Sept. 1
 Board meeting date(s): Varies
 Write: Marina Drummer, Exec. Dir.
Officers: Marion E. Greene, Pres.; Dean Kuth, V.P.; Lyda Ebert Kuth, Secy. and C.F.O.
Director: Lyda G. Ebert.
Number of staff: 1 full-time professional; 1 part-time support.
Employer Identification Number: 680070194

201
Levi Stauss & Company Corporate Giving Program
1155 Battery St.
P.O. Box 7215
San Francisco 94111 (415) 544-7224

Financial data (yr. ended 12/31/88): $1,105,263 for grants.
Purpose and activities: Grants for job creation and training, economic development, equal opportunity, leadership development, for youth to help them complete their education and prepare for the workforce and for health and welfare, education, arts and culture, and civic affairs; also gives internationally.
Application information:
 Initial approach: Write or call nearest plant to find out whom to write to. Contacts vary, depending on location and whether grant is local or statewide. For National, Regional, and International grants, write to above address
 Write: Martha Montag Brown, Mgr. of Contribs. and contact for National, Regional, and International grants

202
Levi Strauss Foundation
1155 Battery St.
P.O. Box 7215
San Francisco 94111 (415) 544-7248

Incorporated in 1941 in CA.
Donor(s): Levi Strauss & Co.
Financial data (yr. ended 12/31/88): Assets, $21,503,343 (M); gifts received, $3,800,000; expenditures, $4,960,310, including $2,936,000 for 258 grants (high: $79,600; low: $100) and $100,810 for 886 employee matching gifts.
Purpose and activities: To improve human services through direct grants and encouragement of employee volunteer activities. Focus is on enhancing the economic opportunities of the disadvantaged through job training and job creation. Support also for international economic development.
Types of support: Matching funds, continuing support, seed money, equipment, exchange

programs, employee-related scholarships, employee matching gifts, technical assistance, general purposes, special projects, operating budgets.
Limitations: Giving generally limited to areas of company operations in AR, CA, GA, KY, MS, TN, NV, NM, TX, and VA, and abroad. No support for sectarian or religious purposes. No grants to individuals, or for tickets for banquets, or courtesy advertising; research, conferences, films, videos, or publications are considered only if they are a small part of a larger effort being supported.
Publications: Corporate giving report (including application guidelines), grants list, informational brochure.
Application information: Application forms required for scholarships for children of company employees; all other types of scholarships discontinued.
 Initial approach: Letter
 Copies of proposal: 1
 Deadline(s): None
 Board meeting date(s): Mar., June, Sept., and Dec.
 Final notification: 2 to 3 months
 Write: Martha Montag Brown, Dir. of Contribs.
Officers: Peter E. Haas,* Pres.; Walter A. Haas, Jr.,* V.P.; Martha Montag Brown, Secy. and Dir. Contribs.; Joseph Maurer, Treas.
Directors:* Frances K. Geballe, Rhoda H. Goldman, Robert D. Haas, George B. James, Madeleine Haas Russell, Thomas W. Tusher.
Number of staff: 13 part-time professional; 6 part-time support.
Employer Identification Number: 946064702
Recent arts and culture grants:
ETCOM, El Paso, TX, $36,800. 1987.
K Q E D, San Francisco, CA, $5,000. 1987.
Laotian Handcraft Project, Berkeley, CA, $7,500. 1987.
Northern California Grantmakers, Arts Loan Fund, San Francisco, CA, $5,000. 1987.
San Francisco Museum of Modern Art, San Francisco, CA, $5,000. 1987.
San Francisco Opera Association, San Francisco, CA, $5,000. 1987.
San Francisco Symphony Association, San Francisco, CA, $5,000. 1987.
Stern Grove Festival Association, San Francisco, CA, $14,000. 1987.

203
Achille Levy Foundation
c/o Bank of A. Levy
P.O. Box 2575
Ventura 93002 (805) 487-6541

Established in 1969 in CA.
Donor(s): Bank of A. Levy.
Financial data (yr. ended 11/30/88): Assets, $818 (M); gifts received, $305,500; expenditures, $305,500, including $284,250 for 183 grants (high: $45,000; low: $25) and $21,250 for 17 grants to individuals.
Purpose and activities: Support for higher and secondary education, including scholarships for seniors from high schools near the Bank of A. Levy branch stores, community funds, social services, culture and the arts, health associations, and youth.

Types of support: Operating budgets, annual campaigns, emergency funds, building funds, equipment, employee matching gifts, scholarship funds, employee-related scholarships.
Limitations: Giving limited to Ventura County, CA, near branch offices. No grants for continuing support, seed money, deficit financing, land acquisition, endowment funds, special projects, research, publications, or conferences; no loans; no scholarships to bank employees or children of bank employees.
Application information: Final selections of scholarship recipients are made by the principals or counselors of the various high schools, along with three officers of the bank. Application form required.
 Initial approach: Letter
 Copies of proposal: 1
 Write: Robert L. Mobley, Vice-Chair.
Officers and Directors: A.A. Milligan, Chair.; Robert L. Mobley, Vice-Chair.; James F. Koenig, Secy.-Treas.; Walter H. Hoffman.
Number of staff: None.
Employer Identification Number: 956264755

204
Mabelle McLeod Lewis Memorial Fund
P.O. Box 3730
Stanford 94305

Trust established in 1968 in CA.
Donor(s): Donald McLeod Lewis.†
Financial data (yr. ended 3/31/87): Assets, $2,574,775 (M); expenditures, $160,431, including $101,750 for 12 grants to individuals (high: $10,900; low: $3,000).
Purpose and activities: Direct grants to scholars in the humanities affiliated with northern CA universities and colleges to bring about the completion of a scholarly dissertation; presently limited to advanced doctoral candidates.
Types of support: Research, fellowships.
Limitations: Giving limited to northern CA. No grants for publication of dissertations.
Publications: Application guidelines, program policy statement.
Application information: Application form required.
 Initial approach: Letter
 Copies of proposal: 2
 Deadline(s): Submit application preferably in Nov. or Dec.; deadline Jan. 15
 Board meeting date(s): Feb. or Mar.
 Final notification: Mid-March
 Write: Ms. Shirleyann Shyne, Exec. Secy.
Officer: Shirleyann Shyne, Exec. Secy.
Nominating Committee: William M. Chace, Chair.
Number of staff: 1
Employer Identification Number: 237079585

205
Edmund Wattis Littlefield Foundation
550 California St.
San Francisco 94104-1006

Established in 1958 in CA.
Donor(s): Edmund W. Littlefield.
Financial data (yr. ended 12/31/87): Assets, $1,290,285 (M); gifts received, $620,571;

expenditures, $592,916, including $589,321 for 43 grants (high: $283,140; low: $100).
Purpose and activities: Support primarily for education, with emphasis on higher education, and for youth, cultural, and social service organizations.
Application information: Contributes only to pre-selected organizations. Applications not accepted.
Officers: Edmund W. Littlefield, Pres. and Treas.; Jeannik M. Littlefield, V.P.; Harry R. Horrow, Secy.
Employer Identification Number: 946074780

206
Foundation of the Litton Industries
360 North Crescent Dr.
Beverly Hills 90210 (213) 859-5423

Incorporated in 1954 in CA.
Donor(s): Litton Industries, Inc., and its subsidiaries.
Financial data (yr. ended 4/30/88): Assets, $26,901,034 (M); gifts received, $954,549; expenditures, $1,343,521, including $1,195,000 for 38 grants (high: $300,000; low: $1,000; average: $1,000-$10,000) and $90,046 for employee matching gifts.
Purpose and activities: Grants largely for higher education, including scholarship funds, and community funds; support also for cultural activities; limited employee matching gifts.
Types of support: Operating budgets, continuing support, seed money, endowment funds, employee matching gifts, scholarship funds.
Limitations: No grants to individuals, or for deficit financing, capital funds, equipment, land acquisition, renovation projects, special projects, publications, dinners, or conferences; no loans.
Application information:
Initial approach: Letter
Copies of proposal: 1
Deadline(s): None
Board meeting date(s): As required
Write: Clarence L. Price, Pres.
Officers: Clarence L. Price,* Pres.; John L. Child, V.P.; Janice F. Homer,* V.P.; Mabel B. Herring, Secy.; Cynthia M. Stec, Treas.
Directors:* Norma E. Nelson.
Number of staff: None.
Employer Identification Number: 956095343

207
The Ralph B. Lloyd Foundation
12400 Wilshire Blvd., Suite 1180
Los Angeles 90025 (213) 207-9479

Incorporated in 1939 in CA.
Donor(s): Ralph B. Lloyd.†
Financial data (yr. ended 12/31/86): Assets, $4,429,532 (M); expenditures, $510,601, including $481,150 for 80 grants (high: $50,000; low: $100).
Purpose and activities: Support for higher and secondary education, cultural organizations, community funds, Protestant church support, and youth agencies.
Types of support: Building funds, operating budgets, equipment, special projects.

Limitations: Giving primarily in CA, with some support in OR. No grants to individuals.
Application information: Grants only to pre-selected charitable organizations. Applications not accepted.
Officers and Trustees: Eleanor Lloyd Dees, Pres.; Ida Hull Lloyd Crotty, V.P.; Theresa Von Hagen Bucher, Secy.-Treas.
Employer Identification Number: 956048100

208
Louis R. Lurie Foundation
555 California St., Suite 5100
San Francisco 94104 (415) 392-2470

Incorporated in 1948 in CA.
Donor(s): Louis R. Lurie,† Robert A. Lurie, George S. Lurie.†
Financial data (yr. ended 12/31/87): Assets, $13,287,053 (M); gifts received, $353,534; expenditures, $1,247,824, including $1,134,000 for 77 grants (high: $175,000; low: $1,000; average: $5,000-$25,000).
Purpose and activities: Giving primarily for higher and secondary education, Jewish welfare agencies, community services, hospitals and health agencies, and cultural programs.
Types of support: General purposes, matching funds, scholarship funds, special projects, operating budgets.
Limitations: Giving limited to the San Francisco Bay Area, CA, and the Chicago, IL, metropolitan area. No grants to individuals, or for building funds; no loans.
Publications: Application guidelines.
Application information:
Initial approach: Telephone call, followed by letter
Copies of proposal: 1
Deadline(s): Applicants should contact foundation for deadlines
Board meeting date(s): Twice a year, and as needed
Final notification: After board meeting
Write: Robert A. Lurie, Pres.
Officers: Robert A. Lurie,* Pres.; H. Michael Kurzman,* V.P.; Eugene L. Valla,* V.P. and Controller; Charles F. Jonas, Secy.
Directors:* A.R. Zipf.
Number of staff: None.
Employer Identification Number: 946065488

209
Miranda Lux Foundation
57 Post St., Suite 604
San Francisco 94104 (415) 981-2966

Incorporated in 1908 in CA.
Donor(s): Miranda W. Lux.†
Financial data (yr. ended 6/30/87): Assets, $3,911,702 (M); expenditures, $159,741, including $127,857 for 13 grants (high: $47,383; low: $500).
Purpose and activities: Support to promising proposals for preschool through junior college programs in the fields of prevocational and vocational education and training.
Types of support: Operating budgets, continuing support, seed money, equipment, matching funds, scholarship funds, special projects, fellowships, internships.

Limitations: Giving limited to San Francisco, CA. No grants to individuals, or for annual campaigns, emergency funds, deficit financing, building or endowment funds, land acquisition, renovations, research, publications, or conferences; no loans.
Publications: Annual report, application guidelines, informational brochure, program policy statement.
Application information:
Initial approach: Letter or telephone
Copies of proposal: 6
Deadline(s): Submit proposal 3 weeks prior to board meeting; no set deadline
Board meeting date(s): Jan., Mar., June, Sept., and Nov.
Final notification: 1 week after board meeting
Write: Lawrence I. Kramer, Jr., Exec. Dir.
Officers: Benson B. Roe, M.D., Pres.; David Wisnom, Jr., V.P.; Philip F. Spalding, Secy.-Treas.; Lawrence I. Kramer, Jr., Exec. Dir.
Trustees: Edmond S. Gillette, Jr., Diana Potter Wolfensperger.
Number of staff: 1 part-time professional.
Employer Identification Number: 941170404
Recent arts and culture grants:
San Francisco Conservatory of Music, San Francisco, CA, $5,000. For Preparatory Division Scholarship Fund. 1987.

210
Bertha Russ Lytel Foundation
P.O. Box 893
Ferndale 95536 (707) 786-4682

Established in 1974 in CA.
Donor(s): Bertha Russ Lytel,† L.D. O'Rourke.†
Financial data (yr. ended 9/30/88): Assets, $10,322,416 (M); expenditures, $551,963, including $502,294 for 44 grants (high: $80,000; low: $100; average: $100-$80,000).
Purpose and activities: Giving primarily to social service agencies for the aged and handicapped, civic and cultural programs, and agricultural and nursing scholarship funds.
Types of support: Operating budgets, seed money, building funds, equipment, scholarship funds, continuing support, matching funds.
Limitations: Giving limited to Humboldt County, CA. No grants to individuals, or for annual campaigns, emergency or endowment funds, deficit financing, land acquisition, renovations, research, demonstration projects, or publications; no loans.
Publications: Application guidelines, 990-PF.
Application information: Application form required.
Initial approach: Letter
Copies of proposal: 8
Deadline(s): 1st Thursday of each month
Board meeting date(s): Monthly
Final notification: 30 to 60 days
Write: George Hindley, Mgr.
Officers and Directors: Charles M. Lawrence,* Pres.; Carl Carlson, Jr.,* V.P.; James K. Morrison,* Secy.; Doris Nairne,* Treas.; George Hindley, Mgr.
Directors:* Gerald Becker, Clarence Crane, Jr., Jack Russ.
Number of staff: 1 part-time professional.
Employer Identification Number: 942271250

211
M.E.G. Foundation

7855 Ivanhoe Ave., Suite 420
La Jolla 92037 (619) 454-3237

Established in 1974 in CA.
Donor(s): Lindavista, S.A., Members of the Gildred family.
Financial data (yr. ended 5/31/87): Assets, $11,093,353 (M); expenditures, $668,409, including $514,000 for 14 grants (high: $120,000; low: $3,000).
Purpose and activities: Emphasis on medical research and hospitals, including buildings and equipment; support also for higher education, social welfare, and cultural programs.
Types of support: Annual campaigns, seed money, building funds, equipment, research, general purposes, matching funds, continuing support, special projects.
Limitations: Giving primarily in San Diego County, CA. No grants to individuals, or for endowment funds or operating budgets.
Application information: Applications for grants presently not invited.
 Initial approach: Proposal
 Copies of proposal: 1
 Deadline(s): None
 Board meeting date(s): Oct. and Apr.
 Final notification: Up to 7 months
 Write: William P. Shannahan, V.P.
Officers: Stuart C. Gildred,* Pres.; William P. Shannahan, V.P. and Secy.
Directors:* Ferdinand T. Fletcher, Helen C. Gildred, Lynne E. Gildred.
Number of staff: 1
Employer Identification Number: 237364942

212
Marin Community Foundation

1100 Larkspur Landing Circle, Suite 365
Larkspur 94939 (415) 461-3333

Incorporated in 1986 in CA; the Buck Foundation Trust, its original donor, was established in 1973 and administered by the San Francisco Foundation through 1986.
Donor(s): Leonard and Beryl Buck.†
Financial data (yr. ended 6/30/88): Assets, $424,000,000 (M); gifts received, $42,602; expenditures, $24,008,000, including $22,313,753 for 350 grants (high: $550,000; low: $750; average: $50,000) and $75,000 for loans.
Purpose and activities: The Marin Community Foundation was established in July 1986 as a nonprofit public benefit corporation to engage in, conduct, and promote charitable, religious, educational scientific, artistic, and philanthropic activities primarily in Marin County, CA. on Jan. 1, 1987, administration of the Buck Trust, created in accordance with the 1973 will of Beryl Buck and valued at approximately $447,000,000, was transferred from the Foundation. To realize its purposes, the Foundation will seek advice and guidance from the community; work as a partner with organizations and individuals; and, encourage the participation of volunteers. Grantmaking for the fiscal year 1987/88 was approximately $22.3 million. As part of the settlement agreement, three major projects, located in Marin County, but intended to be of national

and international importance, were selected by the Court. During the fiscal year 1987/88 these three projects received approximately $6,356,882 from the Buck Trust.
Types of support: Continuing support, emergency funds, equipment, land acquisition, loans, matching funds, operating budgets, program-related investments, renovation projects, seed money, special projects, technical assistance.
Limitations: Giving limited to Marin County, CA. No grants to individuals, or for planning initiatives, or generally for capital projects (except those meeting criteria specified in the funding guidelines).
Publications: Annual report, application guidelines, program policy statement.
Application information: Application form required.
 Initial approach: Request for funding policies and application guidelines
 Copies of proposal: 2
 Deadline(s): None
 Board meeting date(s): Monthly, Jan. through Dec.
 Final notification: 3 months
 Write: Intake Coordinator
Officers: Douglas X. Patino, Pres. and C.E.O.; Barbara B. Lawson, V.P. Finance and Admin.; Lynn Clifford Michals, Secy. and Asst. to Pres.
Trustees: Gary R. Spratling, Chair.; Rev. Douglas Huneke, Vice-Chair.; Peter Arrigoni, Rita Granados, Leland Hamilton, Shirley Thornton, John L. Ziegler, M.D.
Number of staff: 11 full-time professional; 1 part-time professional; 8 full-time support.
Employer Identification Number: 943007979
Recent arts and culture grants:
Baulines Craftsmans Guild, Bolinas, CA, $13,125. For activities of Guild, which is dedicated to promoting excellence in craftsmanship and public appreciation for crafts professions. 1/7/88.
Bay Area Discovery Museum, Kentfield, CA, $20,000. To extend support for new children's museum and educational center. 3/30/88.
Blue Monday Foundation, San Rafael, CA, $23,700. For annual Marin County Blues Festival, which is held in conjunction with Marin County Fair. 1/7/88.
Bread and Roses, Mill Valley, CA, $10,500. For provision of performing arts and services for institutionalized people. 1/7/88.
California State Prison at San Quentin, San Quentin, CA, $11,249. For Artist-in-Residence Program for inmates on condemned row in San Quentin. 2/18/88.
Dance Through Time, Kentfield, CA, $20,000. To extend support for performance of historical social dance. 12/3/87.
Film Institute of Northern California, Mill Valley, CA, $11,600. To extend support for eleventh Annual Mill Valley Film Festival. 3/30/88.
Headlands Arts Center, Sausalito, CA, $65,000. To extend support of Center's programs of artists in residency, symposia, and fine and performing arts presentations. 12/3/87.
Inter-Arts of Marin, San Anselmo, CA, $6,250. To extend support for public arts program and curriculum development. 3/30/88.
Marin Arts Council, Artists Grants Program, San Rafael, CA, $85,000. To extend support for

grants to artists in areas of playwriting; choreography; music composition; film and video; and non-traditional media; and to test and implement changes in regranting process. 11/19/87.
Marin Community Playhouse, San Anselmo, CA, $20,000. To extend support to provide rehearsal and performance space and services to performing and community groups. 12/3/87.
Marin Music Fest, Mill Valley, CA, $15,000. To extend support for annual summer series of chamber music concerts. 3/30/88.
Marin Opera Company, Larkspur, CA, $27,000. To extend support for company's opera productions and in-school programs. 11/5/87.
Novato Music Association, Novato, CA, $10,000. To extend support to volunteer organization for bringing musical and dance programs to elementary schools, and for presentations of Northbay Lyric Opera. 11/19/87.
San Anselmo Organ Festival, San Anselmo, CA, $22,500. For annual organ festival including lectures, demonstrations and evening recitals; and National Improvisation Competition, only one of its kind in US. 1/7/88.
San Domenico School, San Anselmo, CA, $7,000. To continue support for Virtuoso Music Program which serves young artists with exceptional talent in music. 3/3/88.
Theater Artists of Marin, Larkspur, CA, $22,500. To extend support for productions, staged readings, and programming for seniors. 12/3/87.
West Marin Community Chorus and Orchestra, Bolinas, CA, $5,000. For members of West Marin community to participate in choral, orchestral and musical theater productions in West Marin. 1/7/88.
Winifred Baker Chorale, San Rafael, CA, $5,000. To extend support for presentation of chorale concerts in Marin County. 12/3/87.
Youth in Arts, San Rafael, CA, $47.000. To extend support for model arts program serving children and youth by providing professional theater experiences in public schools. 11/5/87.

213
MCA Foundation, Ltd.

100 Universal City Plaza
Universal City 91608 (818) 777-1208

Incorporated in 1956 in CA.
Donor(s): MCA, Inc.
Financial data (yr. ended 12/31/87): Assets, $11,131,442 (M); expenditures, $920,815, including $867,500 for 81 grants (high: $100,000; low: $1,000).
Purpose and activities: Grants largely for health and welfare, cultural programs including film and telvision, higher education, child and youth agencies, and medical research.
Application information: Proposal of not more than three pages.
 Write: Helen D. Yatsko, Coord., Corp. Contribs.
Officers and Directors:* Sidney J. Sheinberg,* Pres.; Thomas Wertheimer,* V.P.; Michael Samuel, Secy.; Ruth S. Cogan,* Treas.
Employer Identification Number: 136096061

214
The Atholl McBean Foundation
c/o Price Waterhouse
555 California St., Suite 3800
San Francisco 94104

Incorporated in 1955 in CA.
Donor(s): Atholl McBean.†
Financial data (yr. ended 12/31/86): Assets,
$3,585,209 (M); gifts received, $266,317;
expenditures, $434,328, including $388,000
for 19 grants (high: $50,000; low: $1,000).
Purpose and activities: Emphasis on hospitals,
higher and secondary education, and cultural
organizations.
Limitations: Giving primarily in CA. No grants
to individuals, or for endowment funds,
research, scholarships, or fellowships; no loans.
Application information:
 Initial approach: Letter
 Copies of proposal: 1
 Deadline(s): None
 Board meeting date(s): Dec. and as required
 Write: Peter McBean, Pres.
Officers and Directors: Peter McBean, Pres.;
George T. Cronin, V.P.; Clark Nelson, Secy.-
Treas.; R. Gwen Follis, Judith McBean Hunt,
Edith McBean.
Employer Identification Number: 946062239

215
McKesson Foundation, Inc.
One Post St.
San Francisco 94104 (415) 983-8673

Incorporated in 1943 in FL.
Donor(s): McKesson Corp.
Financial data (yr. ended 3/31/88): Assets,
$11,800,000 (M); expenditures, $1,850,000,
including $1,750,000 for 220 grants (high:
$50,000; low: $1,500; average: $5,000-
$25,000) and $100,000 for 330 employee
matching gifts.
Purpose and activities: Giving primarily to
programs for junior high school students, and
for emergency services such as food and
shelter; limited support for other educational,
civic, cultural, and human service programs.
Types of support: Continuing support,
emergency funds, employee matching gifts,
matching funds, operating budgets, seed
money, employee-related scholarships,
equipment.
Limitations: Giving primarily in the Bay Area
of San Francisco, CA, and in other cities where
the company has a major presence. No
support for religious organizations or political
groups. No grants to individuals, or for
endowment funds, advertising, or capital fund
drives; no loans.
Publications: Annual report, application
guidelines.
Application information:
 Initial approach: Letter
 Copies of proposal: 1
 Deadline(s): Submit initial letter preferably
 between Apr. and Oct.; submit full
 proposal upon request
 Board meeting date(s): Bimonthly beginning
 in Apr.
 Final notification: 60 to 90 days
 Write: Marcia M. Argyris, Pres.

Officers: Marcia M. Argyris, Pres.; Douglas
Thompson,* V.P.; Dena J. Goldberg, Secy.;
Garrett A. Scholz,* Treas.
Trustees:* James S. Cohune, Thomas W. Field,
Jr., Kenneth Hicken, Hayes Johnson, James I.
Johnston, Marvin L. Krasnansky, Rex Malson,
Ivan D. Meyerson, Roy Miner, John Robinson,
Susan Weir.
Number of staff: 1 full-time professional; 1
part-time professional; 1 full-time support; 1
part-time support.
Employer Identification Number: 596144455
Recent arts and culture grants:
City Celebration, San Francisco, CA, $10,000.
 For weekly summer senior citizen concert
 series in Golden Gate Park. 1987.
Feedback Productions, Tale Spinners and Make-
 A-Circus, San Francisco, CA, $5,000. To
 support theater group that presents plays on
 such senior issues as forced retirement,
 shared housing and crimes in lives of elderly
 people, and to support arts group which
 serves as fundraising resource to community
 agencies. 1987.
Fine Arts Museums of San Francisco, San
 Francisco, CA, $5,000. For general operating
 support for M.H. de Young Memorial
 Museum and California Palace of the Legion
 of Honor. 1987.
John F. Kennedy Center for the Performing
 Arts, DC, $5,000. For general operating
 support. 1987.
Los Angeles Theater Works, Venice, CA,
 $10,000. To develop and implement
 curriculum which serves in rehabilitation of
 teenagers under authority of Juvenile Court
 of Los Angeles. 1987.
Marin Civic Ballet, San Rafael, CA, $7,500. To
 help renovate facility of this dance training
 school. 1987.
Oakland Ballet Company and Guild, Oakland,
 CA, $5,000. For general operating support.
 1987.
Pasadena Art Workshops, Pasadena, CA,
 $9,000. To fund Arroyo Seca Explorations
 project which introduces inner-city children
 to art and writing in wilderness environment.
 1987.
San Francisco Ballet, San Francisco, CA,
 $15,000. To support dance movement
 classes in schools, public libraries, Head Start
 sites and facilities for handicapped. 1987.
San Francisco Opera, San Francisco, CA,
 $10,000. For general operating support.
 1987.
San Francisco School Volunteers, San
 Francisco, CA, $5,000. To support
 Think/Write program. 1987.
San Francisco Symphony, San Francisco, CA,
 $15,000. To sponsor senior citizen discount
 series. 1987.
San Francisco Zoological Society, San
 Francisco, CA, $20,000. To complete pledge
 for construction of Primate Discovery Center.
 1987.
Young Audiences of the Bay Area, San
 Francisco, CA, $10,000. To sponsor year-
 long series of cultural programs at California
 Academy of Sciences in San Francisco for
 school children and their families. 1987.

216
Giles W. and Elise G. Mead Foundation
P.O. Box 1298
South Pasadena 91030-1298 (818) 799-0502

Incorporated in 1961 in CA.
Donor(s): Elise G. Mead.†
Financial data (yr. ended 10/31/88): Assets,
$9,705,267 (M); expenditures, $623,688,
including $434,270 for 17 grants (high:
$125,000; low: $500; average: $1,000-
$10,000).
Purpose and activities: Giving for the arts,
education, natural and medical sciences, and
other activities likely to enhance civilization.
Types of support: Seed money, land
acquisition, endowment funds, research,
scholarship funds, matching funds, equipment.
Limitations: Giving primarily in southern CA.
No grants to individuals, or for general
operating expenses; no loans.
Publications: Application guidelines.
Application information:
 Initial approach: Letter
 Copies of proposal: 10
 Deadline(s): None
 Board meeting date(s): Jan., June, and Oct.
 Final notification: 2 months
 Write: Myrna L. Patrick, V.P.
Officers and Directors: Giles W. Mead, Jr.,
Pres. and C.E.O.; Daniel E. McArthur, V.P.;
Myrna L. Patrick, V.P.; George C. Silzer, Jr.,
V.P.; Calder M. Mackay, Secy.-Treas.; Parry
Mead Ahmad, Stafford R. Grady, Katherine
Cone Keck, Richard N. Mackay, Jane W. Mead.
Number of staff: 1 full-time professional.
Employer Identification Number: 956040921

217
Mericos Foundation
1260 Huntington Dr., Suite 204
South Pasadena 91030 (213) 259-0484

Established in 1980 in CA.
Donor(s): Donald W. Whittier Charitable Trust.
Financial data (yr. ended 12/31/87): Assets,
$7,921,801 (M); gifts received, $2,778,120;
expenditures, $1,869,681, including
$1,679,875 for 28 grants (high: $300,000; low:
$375; average: $10,000-$50,000).
Purpose and activities: Primarily local giving
for cultural programs, the aged, and medical
research.
Limitations: Giving primarily in CA.
Application information: Grants generally
initiated by foundation.
 Deadline(s): None
 Write: Linda J. Blinkenberg, Secy.
Officers: Joanne W. Blokker, Pres.; Steven A.
Anderson, V.P.; Linda J. Blinkenberg, Secy.;
Arlo G. Sorensen, Treas.
Number of staff: 1
Employer Identification Number: 953500491

218
Mervyn's Corporate Giving Program
25001 Industrial Blvd.
Hayward 94545 (415) 786-7492
Contacts: Region I-North CA, CO, MI, NV,
OR, UT, WA - Rita Sklar; Region II-South CA,
AZ, FL, GA, LA, NM, OK, TX - Kathy Blackhurn

Financial data (yr. ended 1/31/89): $1,728,095 for grants (high: $165,000; low: $500).

Purpose and activities: Primary interest is in serving the needs of families and children. Funding areas include: 1) United Way; 2) child care, primarily for increasing the quality of family child care services (funds are not available for local child care centers or individual family day homes). In 1988, Mervyn's and the Dayton Hudson Foundation launched a $3.7 million child care initiative, known as "Family to Family", to develop training for family child care providers and support the development of national standards. Six communities will be selected to send in proposals; 3) the arts, through programs which specifically address the needs of families and children, such as educational outreach programs and programs that build family audiences. Priority is given to full-time arts organizations, which pay their artistic personnel. In smaller communities, consideration may be given to part-time or volunteer organizations. Through Mervyn's Volunteer Program for employees, up to 50 awards are granted annually to non-profit organizations.

Types of support: General purposes, special projects.

Limitations: Giving primarily in major operating areas in AZ, CA, CO, GA, NV, NM, OK, OR, TX, UT, WA, ID, LA, and MI. No support for religious organizations for sectarian purposes, educational institutions, health-related organizations and services, emergency services, physically disabled or mental health services, or advocacy or research groups. No grants to individuals, or for endowment funds, trips or tours, operating expenses of organizations receiving United Way support, tickets, tables or advertising for benefit purposes, conferences, or video/film production.

Publications: Informational brochure (including application guidelines).

Application information: Specific amount requested and intended use; description of the organization's purposes and objectives; list of project objectives, including what methods will be used to evaluate the impact of programs or services offered; names and qualifications of the persons who will administer the grant; most recent tax-exempt status letter; list of organization's officers and directors and their primary affiliations; audited financial report; organizational budget and a sample donor list showing corporate and foundation contributors and amounts given during the past twelve months.

 Initial approach: Letter of inquiry; no more than 2 typewritten pages
 Copies of proposal: 1
 Deadline(s): Apr. 1 to Sept. 30 each year
 Board meeting date(s): As needed
 Final notification: 60-90 days
 Write: Sandra Salyer, V.P., Public Affairs, Judy Belk, Mgr., Public Affairs, or Kathy Blackburn, Mgr., Community Relations

Administrators: Sandra Salyen, V.P., Public Affairs; Judy Belk, Public Affairs Mgr.; Kathy Blackburn, Mgr., Community Relations.

Number of staff: 3 full-time professional; 1 full-time support.

219
Metropolitan Theatres Foundation
8727 West Third St.
Los Angeles 90048

Established in 1980 in CA.
Donor(s): Metropolitan Theatres Corp.
Financial data (yr. ended 4/30/87): Assets, $186 (M); gifts received, $98,460; expenditures, $100,806, including $100,682 for 85 grants (high: $11,405; low: $50).
Purpose and activities: Support for civic programs, education, health and welfare agencies, Jewish organizations, cultural programs, Hispanic and youth organizations.
Application information: Contributes only to pre-selected organizations. Applications not accepted.
Officers: Bruce C. Corwin, Pres. and Treas.; Irving Fuller, V.P. and Secy.
Employer Identification Number: 953520828

220
The Millard Foundation
P.O. Box 10408
Oakland 94610
Mailing address: P.O. Box 549 CHRB, Saipan, CNMI 94650

Established in 1982 in CA.
Donor(s): William H. Millard, ComputerLand Corp.
Financial data (yr. ended 12/31/86): Assets, $592,514 (M); expenditures, $161,067, including $152,601 for 24 grants (high: $51,000; low: $100).
Purpose and activities: Giving primarily for health and social services, international affairs, and the arts.
Limitations: Giving primarily in CA and the Commonwealth of the Northern Mariana Islands.
Application information: Contributes only to pre-selected organizations. Applications not accepted.
Officers: Michael A. Judith,* Pres.; Alton G. Burkhalter, Secy.
Directors: Elizabeth A. Judith, Michael W. Wichman.
Employer Identification Number: 942894847

221
Community Foundation for Monterey County
P.O. Box 1384
Monterey 93942 (408) 375-9712
Additional tel.: (408) 758-4492

Community foundation incorporated in 1945 in CA.
Financial data (yr. ended 12/31/88): Assets, $7,500,000 (M); gifts received, $1,200,000; expenditures, $580,000, including $400,000 for grants and $3,200 for grants to individuals.
Purpose and activities: Giving primarily for social services, education, the environment, the arts, health, and other charitable purposes.
Types of support: Operating budgets, continuing support, seed money, emergency funds, building funds, equipment, land acquisition, matching funds, special projects, research, consulting services, technical

assistance, program-related investments, capital campaigns, renovation projects, general purposes.
Limitations: Giving primarily in Monterey County, CA. No grants to individuals (except for limited scholarships from restricted funds), or for annual campaigns, deficit financing, general endowments, employee matching gifts, or publications.
Publications: Annual report (including application guidelines), 990-PF, application guidelines, informational brochure, newsletter.
Application information:
 Initial approach: Telephone or letter
 Copies of proposal: 1
 Deadline(s): Mar. 15, June 15, Sept. 15, and Dec. 15
 Board meeting date(s): 3rd Tuesday of every month
 Final notification: 1 day after each quarterly meeting
 Write: Todd Lueders, Exec. Dir.
Director: Todd Lueders, Exec. Dir.
Board of Governors: Kenneth Ehrman, Pres.; Roberta Bialer, V.P.
Number of staff: 3 full-time professional.
Employer Identification Number: 941615897

222
Montgomery Street Foundation
(Formerly Crown Zellerbach Foundation)
235 Montgomery St., Suite 1107
San Francisco 94104 (415) 398-0600

Incorporated in 1952 in CA and originally funded by Crown Zellerbach Corp.; later became a totally separate entity from the corporation.
Financial data (yr. ended 12/31/87): Assets, $20,680,000 (M); expenditures, $1,387,965, including $1,113,000 for 204 grants (high: $75,000; low: $1,500; average: $5,000-$10,000).
Purpose and activities: Grants made selectively to qualified organizations, primarily in the fields of higher education, international understanding, community funds, community welfare, cultural institutions, youth, health, rehabilitation, and related areas.
Types of support: General purposes, annual campaigns, operating budgets, capital campaigns.
Limitations: Giving primarily in CA; limited grants awarded nationally. No grants to individuals; no loans.
Application information:
 Initial approach: Concise letter request
 Copies of proposal: 1
 Deadline(s): Reviewed on ongoing basis
 Board meeting date(s): As required
 Final notification: Usually within 3 months
 Write: Carol K. Elliott, Secy.-Treas.
Officers: Charles E. Stine,* Pres.; Carol K. Elliott, Secy.-Treas.
Directors:* C.S. Cullenbine, C.R. Dahl, R.W. Roth, Richard G. Shephard.
Number of staff: 2 full-time professional.
Employer Identification Number: 941270335

223
Samuel B. Mosher Foundation
3278 Loma Riviera Dr.
San Diego 92110 (714) 226-6122

Incorporated in 1951 in CA.
Donor(s): Samuel B. Mosher,† Goodwin J. Pelissero, Deborah S. Pelissero.
Financial data (yr. ended 8/31/88): Assets, $4,820,707 (M); expenditures, $221,238, including $203,200 for 14 grants (high: $67,500; low: $200; average: $10,000-$15,000).
Purpose and activities: Grants mainly for educational purposes; some support for agencies or organizations benefiting youth and cultural organizations.
Types of support: Building funds, general purposes, operating budgets, program-related investments, scholarship funds.
Limitations: Giving primarily in AZ and CA. No grants to individuals, or for endowment funds, scholarships, fellowships, or matching gifts.
Application information:
 Initial approach: Proposal
 Copies of proposal: 1
 Deadline(s): None
 Board meeting date(s): Monthly
 Final notification: None
 Write: Robert R. Fredrickson, Secy.
Officers and Trustees: Margaret C. Mosher, Pres.; Robert R. Fredrickson, Secy.; Marjorie Chelini, Marilyn I. Fredrickson, Laverne Gates, Lester Maitlan.
Number of staff: None.
Employer Identification Number: 956037266

224
Muller Foundation
(Formerly Frank Muller, Sr. Foundation)
7080 Hollywood Blvd., Suite 318
Hollywood 90028 (213) 463-8176

Established in 1965 in CA.
Donor(s): Frank Muller.
Financial data (yr. ended 7/31/88): Assets, $6,086,560 (M); expenditures, $402,303, including $274,620 for 221 grants (high: $25,000; low: $100).
Purpose and activities: Emphasis on higher and secondary education, social service agencies, Roman Catholic church support, hospitals, and cultural programs.
Limitations: Giving primarily in CA. No grants to individuals.
Application information:
 Initial approach: Letter
 Deadline(s): None
 Write: Walter Muller, Treas.
Officers and Directors: R.A. Vilmure, Pres.; Mary M. Thompson, V.P.; Walter Muller, Secy.; John Muller, Treas.; James Muller, Tim Muller.
Employer Identification Number: 956121774

225
David H. Murdock Foundation
10900 Wilshire Blvd., Suite 1600
Los Angeles 90024

Established in 1978 in CA.
Donor(s): Murdock Investment Corp.
Financial data (yr. ended 6/30/87): Assets, $14,026 (M); gifts received, $475,000; expenditures, $569,861, including $569,261 for 22 grants (high: $202,000; low: $250).
Purpose and activities: Support for cultural programs, with emphasis on ballet, and youth.
Application information: Contributes only to pre-selected organizations. Applications not accepted.
Officers: David H. Murdock, Pres.; Lilymae Penton, Secy.; William J. Scully, Treas.
Employer Identification Number: 953367891

226
Murdy Foundation
335 Centennial Way
Tustin 92680

Established in 1958.
Donor(s): John A. Murdy, Jr., Norma Murdy Trust B.
Financial data (yr. ended 12/31/87): Assets, $3,251,418 (M); expenditures, $162,035, including $141,555 for 13 grants (high: $41,175; low: $250).
Purpose and activities: Giving primarily for higher education and Protestant church support; support also for cultural programs, social agencies, and conservation.
Limitations: Giving primarily in CA.
Application information: Contributes only to pre-selected charitable organizations. Applications not accepted.
Officers: George E. Trotter, Jr., Pres.; John A. Murdy III, V.P.; Maxine Trotter, Secy.-Treas.
Employer Identification Number: 956082270

227
Lluella Morey Murphey Foundation
c/o Nossaman, Gunther, et al.
445 South Figueroa St., 31st Fl.
Los Angeles 90071

Established in 1967.
Donor(s): Lluella Morey Murphey.†
Financial data (yr. ended 11/30/86): Assets, $2,836,794 (M); expenditures, $206,535, including $139,912 for 36 grants (high: $25,000; low: $1,000; average: $1,000-$5,000).
Purpose and activities: Support for higher and secondary education, youth programs, health, and cultural programs.
Types of support: General purposes, building funds, equipment, matching funds.
Limitations: Giving primarily in CA.
Application information:
 Initial approach: Proposal
 Deadline(s): None
 Write: Harold S. Voegelin, Trustee
Trustees: Alfred B. Hastings, Jr., James A. Schlinger, Harold S. Voegelin.
Employer Identification Number: 956152669

228
The Peter & Mary Muth Foundation
335 Centennial Way
Tustin 92680-3786

Established in 1984 in CA.
Financial data (yr. ended 12/31/87): Assets, $2,135,088 (M); gifts received, $800,000; expenditures, $246,696, including $243,000 for 11 grants (high: $75,000; low: $1,000).
Purpose and activities: Support primarily for a hospital, a museum, secondary education, historic preservation, and a speech and hearing center; support also for various charitable organizations.
Types of support: General purposes.
Application information: Contributes only to pre-selected organizations.
Officers: Verlyn N. Jensen, Pres.; Joseph P. McCormick, V.P.; Robert Pralle, V.P.; Richard J. Muth, Secy.; Marvin E. Helsley, Treas.
Employer Identification Number: 330016627

229
The E. Nakamichi Foundation
515 South Figueroa St., Suite 320
Los Angeles 90071 (213) 683-1608

Incorporated in 1982 in CA.
Donor(s): E. Nakamichi.†
Financial data (yr. ended 12/31/86): Assets, $22,772,618 (M); gifts received, $583,599; expenditures, $1,901,249, including $1,202,510 for 11 grants (high: $200,000; low: $50,000).
Purpose and activities: Emphasis on the musical arts (primarily baroque and classical); supports musical performances, television and radio broadcasts, public concert series, and occasional lecture series.
Types of support: Special projects.
Limitations: No grants to individuals, or for capital campaigns, endowments, deficit financing, building funds, or equipment.
Publications: Grants list, occasional report, informational brochure (including application guidelines), program policy statement.
Application information:
 Initial approach: Letter
 Deadline(s): None
 Board meeting date(s): 3 times annually, generally Mar., June, and Oct.
 Final notification: 1 week following board meeting
 Write: Les Mitchnick, V.P. and Exec. Dir.
Officers: Yas Yamazaki,* Pres.; Les Mitchnick, V.P., Secy., and Exec. Dir.; Ray Privette,* Treas.
Directors:* Niro Nakamichi, Chair.; Francis W. Costello, Edward Y. Kakita, Takeshi Nakamichi, Shunji Shinoda, Ted T. Tanaka, Koichi Yamasaki.
Number of staff: 1 full-time professional; 1 full-time support.
Employer Identification Number: 953847716

230
National Metal and Steel Foundation
22010 Wilmington Ave., Suite 102
Carson 90745 (213) 833-5281

Financial data (yr. ended 2/29/88): Assets, $825,205 (M); gifts received, $25,000;

expenditures, $45,450, including $44,350 for 64 grants (high: $2,500; low: $100).
Purpose and activities: Support for social services and youth, arts and culture, and Jewish giving.
Application information:
Deadline(s): None
Officers: Joseph S. Schapiro, Pres.; Harry Faversham, V.P.; Douglas Schapiro, Secy.; Frank Pimentel, Treas.
Employer Identification Number: 237424802

231
National Pro-Am Youth Fund
(Formerly Bing Crosby Youth Fund, Inc.)
490 Calla Principal
Monterey 93940 (408) 375-3151
Mailing address: P.O. Box 112, Monterey, CA 93942

Established in 1963 in CA.
Donor(s): Bing Crosby.†
Financial data (yr. ended 6/30/87): Assets, $573,378 (M); gifts received, $605,526; expenditures, $522,482, including $507,446 for 125 grants (high: $50,000; low: $300).
Purpose and activities: Giving primarily for youth agencies, social services, higher and secondary education; support also for health services and cultural organizations.
Types of support: Building funds, equipment, scholarship funds, consulting services.
Limitations: Giving primarily in Monterey and Santa Cruz counties, CA. No grants to individuals.
Application information:
Initial approach: Letter
Deadline(s): None
Write: Carmel Martin, Jr., Secy.
Officers: Ted Durein, Pres.; Carmel C. Martin, Jr., Secy.; John Burns, Treas.
Trustees: Marsha Searle Brown, Peter J. Coniglio, Leon E. Edner, Warner Keeley, Frank Thacker, Murray C. Vout.
Employer Identification Number: 946050251

232
New Roads Foundation
c/o Gelfand, Rennert & Feldman
1880 Century Park East, No. 900
Los Angeles 90067

Donor(s): Neil Diamond.
Financial data (yr. ended 12/31/86): Assets, $1,167,788 (M); gifts received, $125,000; expenditures, $101,748, including $99,650 for 34 grants (high: $50,000; low: $50).
Purpose and activities: Grants for social services, Jewish organizations and welfare funds, and for secondary education; some support for music.
Trustees: David Braun, Neil Diamond, Marshall M. Gelfand.
Employer Identification Number: 136327069

233
Andrew Norman Foundation
10960 Wilshire Blvd., Suite 820
Los Angeles 90024 (213) 478-1213

Incorporated in 1958 in CA.
Donor(s): Andrew Norman.†
Financial data (yr. ended 6/30/88): Assets, $6,258,630 (M); expenditures, $354,298, including $193,350 for 24 grants (high: $60,000; low: $200; average: $5,000-$25,000).
Purpose and activities: Emphasis on seed money for the environment, medical education, justice and the legal system, and the arts and humanities.
Types of support: Seed money, special projects.
Limitations: Giving primarily in CA, with emphasis on the Los Angeles area. No grants to individuals, or for endowment funds, scholarships, or fellowships.
Application information: Contributes only to pre-selected organizations. Applications not accepted.
Board meeting date(s): May and as required
Write: Dan Olincy, Secy.
Officers and Trustees: Virginia G. Olincy, Pres.; Bernice G. Kranson, V.P.; Dan Olincy, Secy.-Treas.
Number of staff: None.
Employer Identification Number: 953433781

234
The Kenneth T. and Eileen L. Norris Foundation
11 Golden Shore, Suite 440
Long Beach 90802 (213) 435-8444

Trust established in 1963 in CA.
Donor(s): Kenneth T. Norris,† Eileen L. Norris.
Financial data (yr. ended 11/30/88): Assets, $74,000,000 (M); expenditures, $3,651,490 for 123 grants (high: $1,000,000; low: $1,000; average: $5,000-$20,000).
Purpose and activities: Emphasis on hospitals, health agencies, higher education, medical research, cultural institutions, and social services.
Types of support: Building funds, equipment, research, scholarship funds, continuing support, endowment funds, professorships, seed money, matching funds, special projects, general purposes.
Limitations: Giving primarily in Los Angeles County, CA. No grants to individuals; no loans.
Application information:
Initial approach: Letter
Copies of proposal: 1
Deadline(s): None
Board meeting date(s): As required
Write: Kenneth T. Norris, Jr., Exec. Dir.
Officer and Trustees: Kenneth T. Norris, Jr., Exec. Dir.; Ronald R. Barnes, William G. Corey, George Gordon, Harlyne J. Norris.
Number of staff: 1 part-time professional; 4 part-time support.
Employer Identification Number: 956080374

235
Northrop Corporate Contributions Program
1840 Century Park East
Los Angeles 90067 (213) 553-6262

Purpose and activities: Company has adopted a new contributions policy called Concentrated Giving in order to help organizations located in major operating areas accomplish their goals. Fields of interest include health, welfare, education, business, cultural and civic affairs.
Types of support: Building funds, capital campaigns, equipment, general purposes, operating budgets, special projects.
Limitations: Giving primarily in company headquarters and major operating locations.
Application information: Brief history of organization, amount and purpose of grant, scope of benefits of organizations (i.e., local, national, or international), and an operating budget and source of funding.
Initial approach: Letter and Proposal
Deadline(s): Nov. 1
Final notification: Mar. 1
Write: Rogg Collins, Dir.

236
Oak Industries Corporate Giving Program
16510 Via Esprillo
San Diego 92127 (619) 485-9300

Purpose and activities: Supports arts institutes and education including higher education. At this time support is minimal; no formal giving program is in place.
Limitations: Giving limited to major operating areas.
Application information: Applications not accepted.
Write: E.L. McNeely, Chair.
Number of staff: None.

237
Occidental Petroleum Charitable Foundation, Inc.
10889 Wilshire Blvd.
Los Angeles 90024 (213) 208-8800

Incorporated in 1959 in NY.
Donor(s): Occidental Petroleum Corp.
Financial data (yr. ended 12/31/87): Assets, $1,649,160 (M); gifts received, $1,500,000; expenditures, $1,207,963, including $1,010,797 for 33 grants (high: $100,000; low: $500; average: $5,000-$50,000) and $191,951 for 667 employee matching gifts.
Purpose and activities: Grants primarily for cultural programs and for higher education, including an employee matching gift program, hospitals, and a few national organizations for social betterment on a national basis.
Types of support: Employee matching gifts, scholarship funds, general purposes, building funds, equipment, capital campaigns.
Limitations: No grants to individuals.
Publications: Application guidelines.
Application information:
Initial approach: Proposal of no more than 4 pages
Copies of proposal: 1

Deadline(s): Proposals accepted between
Sept. 1 and Nov. 1
Board meeting date(s): Mar., June, Sept., and
Dec.
Write: Evelyn S. Wong, Asst. Secy.-Treas.
Officers: Arthur Groman, Pres.; Maurie A.
Moss, V.P.; Paul C. Hebner, Secy.-Treas.
Directors: Armand Hammer, Richard Jacobs,
Ray R. Irani, Rosemary Tomich.
Employer Identification Number: 166052784

238
Orleton Trust Fund
1777 Borel Place, Rm. 306
San Mateo 94402
Additional office: c/o Mrs. Anne Johnston
Greene, Co-Trustee, 1101 Runnymede Rd.,
Dayton, OH 45419

Trust established in 1944 in OH.
Donor(s): Miss Mary E. Johnston.†
Financial data (yr. ended 12/31/86): Assets,
$7,375,252 (M); expenditures, $659,179,
including $618,476 for 109 grants (high:
$25,000; low: $100; average: $500-$5,000).
Purpose and activities: Support for secondary
and higher education, cultural programs, youth
and social service agencies, and community
funds; grants also for Protestant churches and
religious associations, health associations, and
ecology and population control groups.
Limitations: Giving primarily in Dayton, OH,
and San Mateo County, CA. No grants to
individuals.
Application information:
Initial approach: Letter
Board meeting date(s): As required
Write: Mrs. Jean Sawyer Weaver, Co-Trustee
Trustees: Anne Johnston Greene, Jean Sawyer
Weaver.
Employer Identification Number: 316024543

239
**Samuel and Helen Oschin Foundation,
Inc.**
P.O. Box 48289
Los Angeles 90048

Established in 1980 in CA.
Donor(s): Samuel Oschin, Helen Oschin.†
Financial data (yr. ended 9/30/86): Assets,
$4,365,991 (M); gifts received, $3,716;
expenditures, $152,851, including $141,274
for 21 grants (high: $32,000; low: $125).
Purpose and activities: Support primarily for
Jewish welfare organizations, higher education,
and cultural programs.
Limitations: Giving primarily in CA, particularly
Los Angeles.
Application information: Contributes only to
pre-selected organizations. Applications not
accepted.
Officers: Samuel Oschin, Pres.; William
Glikbarg, V.P.; Irving Oschin, Secy.-Treas.
Directors: Barbara Oschin, Michael Oschin.
Employer Identification Number: 953560088

240
Bernard Osher Foundation
220 San Bruno Ave.
San Francisco 94103-5090

Established in 1977 in CA.
Donor(s): Bernard A. Osher.
Financial data (yr. ended 12/31/88): Assets,
$38,808,530 (M); expenditures, $1,361,778,
including $1,291,290 for 105 grants (high:
$300,000; low: $130).
Purpose and activities: Giving primarily for
the arts and humanities, including the fine and
performing arts; education, especially higher
education; and social services, with emphasis
on youth and drug abuse; support also for
Jewish organizations, including Jewish welfare
funds.
Types of support: General purposes, special
projects.
Limitations: Giving primarily in San Francisco,
Alameda, Contra Costa, Marin, and San Mateo
counties, CA. No grants to individuals.
Publications: Informational brochure.
Application information:
Initial approach: Letter
Copies of proposal: 1
Deadline(s): None
Board meeting date(s): Six times per year
Write: Patricia Tracy-Nagle, Exec. Admin.
Officers: Barbra Sachs-Osher, Pres.; Patricia
Tracy-Nagle, Exec. Admin.
Directors: Frederick Balderston, Reeder
Butterfield, Judith E. Ciani, Dr. Stephen Mark
Dobbs, Robert Friend, Bernard A. Osher.
Number of staff: 1 full-time professional.
Employer Identification Number: 942506257

241
Seniel and Dorothy Ostrow Foundation
c/o S. Sanford Ezralow & Co.
9171 Wilshire Blvd., Suite 441
Beverly Hills 90210

Trust established in 1961 in CA.
Donor(s): Seniel Ostrow.†
Financial data (yr. ended 7/31/87): Assets,
$925,597 (M); expenditures, $129,194,
including $115,212 for 84 grants (high:
$50,000; low: $25).
Purpose and activities: Giving primarily for
social welfare, civil rights, higher education,
cultural programs, and civic and public affairs.
Application information:
Initial approach: Letter
Deadline(s): None
Write: Laurie Ostrow and Lucille Ostrow
Trustees: Laurie Ostrow, Lucille Ostrow.
Employer Identification Number: 956029169

242
Ottenstein Family Foundation, Inc.
225 Stevens, Suite 210A
Solana Beach 92075

Established in 1960 in MD and DC.
Donor(s): Members of the Ottenstein family.
Financial data (yr. ended 4/30/88): Assets,
$1,784,316 (M); gifts received, $2,000;
expenditures, $136,043, including $113,850
for 31 grants (high: $65,500; low: $50).

Purpose and activities: Giving primarily for
Jewish welfare and temple support; support
also for cultural programs, social services,
health, and education.
Limitations: Giving primarily in CA, particularly
San Diego.
Directors: Leonard Glass, Adam S. Ottenstein,
Paul F. Ottenstein, S.G. Ottenstein, V.H.
Ottenstein.
Employer Identification Number: 526036064

243
Pacific Mutual Charitable Foundation
700 Newport Center Dr.
Newport Beach 92660 (714) 640-3014

Established in 1984 in CA.
Donor(s): Pacific Mutual Life Insurance Co.
Financial data (yr. ended 12/31/88): Assets,
$5,544,750 (M); gifts received, $10,513;
expenditures, $530,218, including $499,513
for 105 grants (high: $201,385; low: $100;
average: $500-$2,000) and $87,143 for 111 in-
kind gifts.
Purpose and activities: Grants for health and
human services, education, arts and culture,
and civic and community services; special
emphasis on AIDS education and support
programs.
Types of support: Capital campaigns, special
projects.
Limitations: Giving primarily in areas of
company operations. No support for
professional associations, veterans', labor, or
fraternal organizations, athletic or social clubs,
or sectarian religious groups, except for
programs which are available to everyone. No
grants to individuals, or for operating expenses
of organizations which receive United Way
funding, except under special circumstances.
Publications: Corporate giving report
(including application guidelines).
Application information:
Initial approach: Proposal
Deadline(s): Sept. 15
Board meeting date(s): Dec.
Final notification: After Jan. 1
Write: Robert G. Haskell, Pres.
Officers: Harry G. Bubb,* Chair.; Robert G.
Haskell,* Pres.; Patricia A. Kosky, V.P.; Audrey
L. Milfs, Secy.; Harold T. Joanning, C.F.O.
Directors:* Walter B. Gerken, Thomas C.
Sutton, Joseph A. Thomas.
Number of staff: 1 full-time professional; 1 full-
time support.
Employer Identification Number: 953433806

244
Pacific Telesis Foundation
Pacific Telesis Center
130 Kearney St., Rm. 3351
San Francisco 94105 (415) 394-3693

Established in 1984 in CA.
Donor(s): Pacific Telesis Group.
Financial data (yr. ended 12/31/88): Assets,
$58,340,384 (M); gifts received, $27,000,000;
expenditures, $6,506,295, including
$5,822,470 for 341 grants (high: $100,000;
low: $500; average: $2,000-$50,000) and
$94,528 for 637 employee matching gifts.

Purpose and activities: Support primarily for higher education, culture, community funds, community and civic affairs, and health and social services.

Types of support: Publications, special projects, fellowships, scholarship funds, conferences and seminars, seed money, employee matching gifts, matching funds, technical assistance.

Limitations: Giving primarily in CA, NV, and other select states where Pacific Telesis Group has business interests. No support for religious organizations for religious purposes, organizations receiving operating support from the United Way, medical clinics, or individual primary or secondary schools or school districts. No grants to individuals, or for general operating purposes, medical research, capital projects or endowments, or goodwill advertising; no loans.

Publications: 990-PF, grants list, application guidelines, annual report.

Application information:
 Initial approach: Letter
 Copies of proposal: 1
 Deadline(s): None
 Board meeting date(s): Quarterly
 Final notification: 2 months
 Write: Thomas S. Donahoe, Pres.

Officers and Directors: Sam E. Ginn, Chair.; Arthur C. Latno, Jr., Vice-Chair.; Thomas S. Donahoe, Pres.; Jere A. Jacobs, V.P.; Richard W. Odgers, Secy.; Lydell L. Christensen, Treas.; Richard K. Van Allen.

Number of staff: 10 part-time professional; 3 part-time support.

Employer Identification Number: 942950832

Recent arts and culture grants:

Accolades for the Arts, San Francisco, CA, $5,000. To underwrite publication of monthly newspaper covering arts in San Francisco Bay Area. 1987.

Affiliate Artists, NYC, NY, $21,000. To underwrite three-week residency of selected solo performers in Orange County and Los Angeles. 1987.

Association of Science Technology Centers, DC, $25,000. For U.S. traveling exhibition entitled In Touch: Children Look at Communications, images from quadrennial worldwide art contest sponsored by International Telecommunications Union. 1987.

Business Committee for the Arts, NYC, NY, $10,000. For 1987 and 1988 programs of this national organization, which promotes business-arts partnerships. 1987.

California Academy of Sciences, San Francisco, CA, $19,870. To underwrite this natural history museum's Science in Action Program for 12 months as well as series of supplemental slide/video productions. 1987.

California Theater Ensemble, Altadena, CA, $7,500. To partially fund feasibility study for this recently established professional theater group in Contra Costa County. 1987.

City Celebration, San Francisco, CA, $35,000. To underwrite open auditions for 1987 San Francisco Ethnic Dance Festival as well as documentary film on festival: And Still We Dance. 1987.

Deaf Communications Foundation, Hollywood, CA, $7,500. To underwrite California college tour of The Glass Menagerie, performed in both American Sign Language and voice. 1987.

East Bay Zoological Society, Oakland, CA, $7,500. To underwrite special fundraising concert for Oakland Zoo. 1987.

Exploratorium, San Francisco, CA, $5,000. For Explainer program, which trains high school students to work as docents in this San Francisco museum of science, art, and human perception. 1987.

Fine Arts Museums of San Francisco, San Francisco, CA, $100,000. To underwrite exhibition, Ansel Adams: Classic Images, at M.H. de Young Memorial Museum in 1987. 1987.

Fine Arts Museums of San Francisco, San Francisco, CA, $7,500. For 1987 programs of M.H. de Young Memorial Museum, Palace of the Legion of Honor and Museum Auxiliary. 1987.

Friends of Photography, Carmel, CA, $25,000. To underwrite national direct mail membership drive. 1987.

High Museum of Art, Atlanta, GA, $16,500. To underwrite promotional programs to enhance exhibition, Ansel Adams: Classic Images, at Museum in 1987-1988. 1987.

Humboldt State University, Eureka, CA, $10,000. To co-sponsor new work by Bella Lewitzky Dance Company in two-week residency at University. 1987.

Interlochen Center for the Arts, Interlochen, MI, $7,500. For scholarships awarded to students from California to attend Interlochen Arts Academy. 1987.

K P O O, San Francisco, CA, $5,000. To underwrite intern program of California's only minority controlled public broadcasting station. 1987.

K Q E D, San Francisco, CA, $9,000. To support this public television station's 1987 programming and special broadcast, Ansel Adams: Photographer. 1987.

Lorraine Hansberry Theater, San Francisco, CA, $15,000. To underwrite 1988 opening gala to celebrate this black theater company's move into permanent home in San Francisco. 1987.

Los Angeles County Museum of Art, Los Angeles, CA, $50,000. For exclusive sponsorship of Museum's 1988 Ansel Adams exhibition. 1987.

Marin Symphony, San Rafael, CA, $5,000. For Symphony's Instrumental Music Program for Schools. 1987.

Music Center of Los Angeles County, Los Angeles, CA, $25,000. For 1988 Music Center on Tour program bringing professional performing arts to schools in eight Southern California counties. 1987.

Music Center of Los Angeles County, Los Angeles, CA, $25,000. For 1987 programs of resident companies of Music Center. 1987.

Nevada Opera Association, Reno, NV, $20,000. For two children's matinee performances of The Nutcracker, performed by Nevada Opera in Reno. 1987.

Oakland Ballet Association, Oakland, CA, $5,000. For 1987 student matinee series. 1987.

Performing Tree, Los Angeles, CA, $6,000. For attendance of 10 teachers from Los Angeles inner-city schools at 1988 Arts Retreat as well as NEA Challenge Grant campaign. 1987.

Sacramento Ballet, Sacramento, CA, $10,000. To help sponsor opening performances of American Tour of Les Ballet de Monte Carlo in Sacramento in 1987. 1987.

Sacramento Symphony Association, Sacramento, CA, $25,000. To co-sponsor Symphony's 75th Anniversary Season. 1987.

San Diego Performances, San Diego, CA, $20,000. To underwrite 1988 special matinee of performance by Dance Theater of Harlem for 2,200 inner-city children. 1987.

San Diego Zoological Society, San Diego, CA, $7,500. To underwrite opening of zoo's Giant Panda exhibition on loan from People's Republic of China. 1987.

San Francisco Arts Commission, San Francisco, CA, $5,000. To underwrite family weekend art event in Golden Gate Park as part of 1987 Arts Commission Festival. 1987.

San Francisco Ballet Association, San Francisco, CA, $7,500. To sponsor senior citizen's matinee of The Nutcracker during San Diego residency in 1987. 1987.

San Francisco Museum of Modern Art, San Francisco, CA, $50,000. To sponsor Museum's Free Tuesday admission program for one year, enabling seniors and others on fixed incomes to enjoy museum during daytime. 1987.

San Francisco Opera Association, San Francisco, CA, $50,000. To sponsor Opera's 1987-88 Royal Family of Opera Series. 1987.

San Francisco Symphony, San Francisco, CA, $100,000. To sponsor Symphony's 1987 Holiday Concert Series. 1987.

Smithsonian Institution, DC, $5,000. To underwrite reception for opening of National Museum of American History exhibition: A More Perfect Union: Japanese Americans and the U.S. Constitution. 1987.

South Coast Repertory Theater, Costa Mesa, CA, $10,000. To underwrite marketing and communication efforts for 1987 Hispanic Playwright Project at this Orange County theater company. 1987.

Stern Grove Festival Association, San Francisco, CA, $8,000. To underwrite 50th Anniversary Birthday Party, a free performing arts gala in San Francisco's Stern Grove in 1987. 1987.

Theater Bay Area, San Francisco, CA, $5,000. To underwrite outreach brochure to inform Bay Area parents, educators and children of youth theater events. 1987.

University of California, Lawrence Hall of Science, Berkeley, CA, $10,000. For Industry Initiatives for Science and Math Education at Lawrence Hall of Science. 1987.

University of California, Lawrence Hall of Science, Berkeley, CA, $5,000. For Chemical Education for Public Understanding Program. 1987.

245

The David and Lucile Packard Foundation

300 Second St., Suite 200
Los Altos 94022 (415) 948-7658

Incorporated in 1964 in CA.

Donor(s): David Packard, Lucile Packard.†

Financial data (yr. ended 12/31/88): Assets, $149,981,918 (M); gifts received, $12,216,011; expenditures, $10,733,594 for 317 grants (high: $2,900,000; low: $600; average: $5,000-$10,000) and $1,000,000 for loans.

Purpose and activities: Support for the performing arts, education, youth, homeless children, management assistance, handicapped, and child welfare; national and international giving in areas of conservation, ancient studies, film preservation, and population issues.

Types of support: General purposes, building funds, equipment, land acquisition, research, internships, matching funds, program-related investments, consulting services, technical assistance, loans, operating budgets, capital campaigns, seed money, renovation projects, fellowships, special projects.

Limitations: Giving primarily in the San Francisco and Monterey Bay, CA, areas; some giving also in the Pueblo area of CO. No grants to individuals; generally no grants for endowment funds.

Publications: Annual report (including application guidelines), grants list, newsletter.

Application information:
Initial approach: Proposal
Copies of proposal: 1
Deadline(s): Jan. 1, Apr. 1, July 1, and Oct. 1
Board meeting date(s): Mar., June, Sept., and Dec.
Final notification: Directly after board meetings
Write: Colburn S. Wilbur, Exec. Dir.

Officers: David Packard,* Chair.; Susan Packard Orr,* Vice-Chair.; David Woodley Packard,* Vice-Chair.; Barbara P. Wright, Secy.; Edwin E. Van Bronkhorst, Treas.; Colburn S. Wilbur, Exec. Dir.

Trustees:* Nancy Packard Burnett, Robin Chandler Duke, Robert Glaser, M.D., Julie E. Packard, Frank Roberts.

Number of staff: 6 full-time professional; 2 part-time professional; 7 full-time support; 3 part-time support.

Employer Identification Number: 942278431

Recent arts and culture grants:

Alum Rock Union Elementary School District, San Jose, CA, $10,000. For Music-in-the-Schools program. 1987.

American Film Institute, Los Angeles, CA, $50,000. Toward supporting research on AFI Catalog of Feature films, 1931-1940. 1987.

American Philological Association, NYC, NY, $12,500. For support of Thesaurus Linguae Latinae fellowship. 1987.

Art Museum of Santa Cruz County, Santa Cruz, CA, $19,000. To support salary of director of development. 1987.

Bay Chamber Symphony Orchestra, San Mateo, CA, $10,000. For audience development efforts. 1987.

Berryessa Union School District, San Jose, CA, $7,370. For Music-in-the-Schools program. 1987.

Cabrillo Music Festival, Aptos, CA, $10,000. To partially support salary of executive director. 1987.

California Academy of Sciences, San Francisco, CA, $42,000. For third year of Science in Action Radio Program and Learning Series. 1987.

California Confederation of the Arts, Sacramento, CA, $10,000. To support statewide membership campaign. 1987.

Cambrian School District, San Jose, CA, $8,333. For Music-in-the-Schools program. 1987.

Campbell Union School District, Campbell, CA, $6,172. For Music-in-the-Schools program. 1987.

Childrens Hospital at Stanford, Palo Alto, CA, $19,534. To underwrite expenses of Fred Astaire Film Festival benefiting Children's Hospital at Stanford. 1987.

Childrens Theater of Palo Alto, Friends of the, Palo Alto, CA, $16,000. To finance fundraising effort of Golden Anniversary campaign. 1987.

Colorado Outdoor Performing Arts Association, Pueblo, CO, $10,000. For operating expenses. 1987.

Community School of Music and Arts, Mountain View, CA, $15,000. For Music-in-the-Schools program. 1987.

Cornell University, Department of Classics, Ithaca, NY, $104,333. For continued support for computerization of Attic inscriptions. 1987.

Cultural Council of Santa Cruz County, Aptos, CA, $25,000. For Spectra Artistically Gifted and Talented Education Program. 1987.

Cultural Council of Santa Cruz County, Aptos, CA, $15,000. For salary support of associate director position. 1987.

Cupertino Union School District, Cupertino, CA, $7,400. For Music-in-the-Schools program. 1987.

Duke University, Department of Classical Studies, Durham, NC, $70,500. For support for Duke Data Bank of Documentary Greek Papyri. 1987.

Evergreen School District, San Jose, CA, $6,993. For Music-in-the-Schools program. 1987.

Exploratorium, San Francisco, CA, $30,000. For development of educational program services and for general fund support. 1987.

Foothill DeAnza Community College Foundation, Los Altos Hills, CA, $18,300. For marketing expenses of 1987 Performing Arts Alliance Festival. 1987.

Franklin-McKinley School District, San Jose, CA, $7,875. For Music-in-the-Schools program. 1987.

Gilroy Unified School District, Gilroy, CA, $8,488. For Music-in-the-Schools program. 1987.

Grovemont Community Theater, Monterey, CA, $15,000. To assist with administrative salaries. 1987.

Hidden Valley Music Seminars, Carmel Valley, CA, $25,000. For general support and management assistance. 1987.

Institute for Advanced Study, School of Historical Studies, Princeton, NJ, $55,811. For computerizing Greek inscriptions of Asia Minor. 1987.

K T S C-TV, Pueblo, CO, $25,000. For new transmitter. 1987.

Los Altos Elementary School District, Los Altos, CA, $8,333. For Music-in-the-Schools program. 1987.

Los Gatos - Saratoga Joint Union School District, Los Gatos, CA, $70,000. For Music-in-the-Schools program. 1987.

Milpitas Unified School District, Milpitas, CA, $9,300. For Music-in-the-Schools program. 1987.

Monterey Bay Aquarium, Monterey, CA, $20,137. For pilot project to demonstrate utility of video laser disks to scientists in discipline of sponge systematics. 1987.

Monterey County Symphony Association, Carmel, CA, $15,000. For support of audience development and for in-school performances. 1987.

Monterey Peninsula Unified School District, Monterey, CA, $90,000. For Music-in-the-Schools program. 1987.

Moreland School District, San Jose, CA, $8,213. For Music-in-the-Schools program. 1987.

Mount Pleasant Elementary School District, San Jose, CA, $5,200. For Music-in-the-Schools program. 1987.

Mountain View School District, Mountain View, CA, $8,333. For Music-in-the-Schools program. 1987.

Mountain View-Los Altos Union High School District, Mountain View, CA, $300,000. For Music-in-the-Schools program. 1987.

Nature Center of Pueblo, Pueblo, CO, $12,500. Toward development of promotional campaign. 1987.

Nature Center of Pueblo, Pueblo, CO, $12,500. For challenge grant for capital projects in Pueblo on River Trails and new Pueblo Arboretum and Birds of Prey Park. 1987.

Oak Grove School District, San Jose, CA, $7,232. For Music-in-the-Schools program. 1987.

Ohio State University, Department of History, Columbus, OH, $9,750. To support publication of Isthmia excavations carried out between 1967-78. 1987.

Opera San Jose, San Jose, CA, $24,000. To support first-time hire of production manager. 1987.

Palo Alto Unified School District, Palo Alto, CA, $10,190. For Music-in-the-Schools program. 1987.

Peninsula Ballet Theater, San Mateo, CA, $15,000. For support of managing director's salary. 1987.

Pueblo School District No. 60, Pueblo, CO, $8,750. For support to expand existing Dance in the Schools Program. 1987.

San Francisco Symphony, San Francisco, CA, $20,000. For general operating support for Symphony's Youth Orchestra in 1986/87 season. 1987.

San Jose Repertory Company, San Jose, CA, $50,000. For matching grant to stimulate increased giving by individuals. 1987.

San Jose Repertory Company, San Jose, CA, $25,000. To assist them in hiring fund development consultant to help board eliminate deficit and begin development of capital campaign. 1987.

San Jose Unified School District, San Jose, CA, $36,383. For Music-in-the-Schools program. 1987.

San Mateo Union High School District, San Mateo, CA, $55,000. For Music-in-the-Schools program. 1987.

Santa Clara Unified School District, Santa Clara, CA, $6,542. For Music-in-the-Schools program. 1987.

Santa Cruz County Symphony Association, Aptos, CA, $17,500. For audience outreach and artistic development efforts. 1987.

Schola Cantorum, Palo Alto, CA, $12,000. For audience development and general operating expenses. 1987.

Sequoia Union High School District, Redwood City, CA, $90,000. For Music-in-the-Schools program. 1987.

Spreckles Union School District, Spreckles, CA, $24,141. For Music-in-the-Schools program. 1987.

Sunnyvale Elementary School District, Sunnyvale, CA, $8,000. For Music-in-the-Schools program. 1987.

Theaterworks, Palo Alto, CA, $15,000. For matching grant to stimulate new or increased individual contributions. 1987.

Union School District, San Jose, CA, $8,080. For Music-in-the-Schools program. 1987.

University of California, Irvine, CA, $120,120. For support of Thesaurus Linguae Graecae. 1987.

University of California, Pacific Film Archive, Berkeley, CA, $15,000. For continuing support of Archival Film Program. 1987.

University of California, UCLA Film & Radio Archive, Los Angeles, CA, $247,190. For UCLA Film and Television Archive's newsreel film preservation project. 1987.

University of California at Santa Cruz Foundation, Santa Cruz, CA, $16,100. For audience and fund development for Shakespeare Santa Cruz. 1987.

University of Illinois, Department of History, Chicago, IL, $10,000. For support of research on Dionysiaic inscriptions. 1987.

University of Michigan, Department of Classical Studies, Ann Arbor, MI, $59,000. For scholarly editing of machine-readable texts of documentary papyri. 1987.

Valley Institute of Theater Arts, Saratoga, CA, $23,500. To assist with marketing and audience development. 1987.

Wolf Trap Institute for Early Learning through the Arts, Vienna, VA, $15,130. For continuation of Performing Arts Training and Child Development Program in child care centers in San Jose area. 1987.

Yale University, Department of Classics, New Haven, CT, $24,900. To support work of scholar who is compiling canon of Latin authors and texts. 1987.

Zohar Dance Company, Palo Alto, CA, $30,000. To support IndepenDANCE Program. 1987.

246
The Parker Foundation
1200 Prospect St., Suite 575
La Jolla 92037 (619) 456-3038

Trust established in 1971 in CA; incorporated in 1975.
Donor(s): Gerald T. Parker,† Inez Grant Parker.†
Financial data (yr. ended 9/30/88): Assets, $12,082,908 (M); expenditures, $790,920, including $708,434 for 62 grants (high: $100,000; low: $500; average: $5,000-$15,000) and $5,000 for 1 loan.
Purpose and activities: Equal emphasis on cultural programs, health and welfare, including

medical support and research, adult services, and youth agencies; grants also for education and community activities. Giving largely in the form of partial seed money and matching or challenge grants; generally no support that would make an organization dependent on the foundation.
Types of support: Seed money, matching funds, operating budgets, annual campaigns, emergency funds, building funds, equipment, land acquisition, research, program-related investments, continuing support, special projects, publications, general purposes, renovation projects.
Limitations: Giving limited to San Diego County, CA. No support for sectarian religious purposes. No grants to individuals, or for endowment funds, scholarships, or fellowships; no loans.
Publications: Annual report, informational brochure (including application guidelines).
Application information:
 Initial approach: Letter
 Copies of proposal: 6
 Deadline(s): None
 Board meeting date(s): Monthly
 Final notification: 2 months
 Write: Judi Di Benedetto, Asst. Secy.
Officers and Directors: Kenneth R. Rearwin, Pres.; V. DeWitt Shuck, V.P.; William E. Beamer, Secy.-Treas.; John F. Borchers, Roy M. Drew, Judy McDonald.
Number of staff: None.
Employer Identification Number: 510141231

247
The Ralph M. Parsons Foundation
1055 Wilshire Blvd., Suite 1701
Los Angeles 90017 (213) 482-3185

Incorporated in 1961 in CA.
Donor(s): Ralph M. Parsons.†
Financial data (yr. ended 12/31/88): Assets, $142,044,082 (M); expenditures, $7,713,799, including $6,020,765 for 111 grants (high: $465,819; low: $1,000; average: $10,000-$75,000).
Purpose and activities: Giving for higher and secondary education, with emphasis on engineering, technology, law, science and medicine; and for social impact areas, including assistance to children, women, families and seniors; grants also for cultural and civic projects, and health services for disadvantaged populations.
Types of support: Seed money, equipment, matching funds, special projects, internships, renovation projects, research, scholarship funds, fellowships, operating budgets.
Limitations: Giving limited to Los Angeles County, CA, with the exception of some grants for higher education. No support for sectarian religious or fraternal purposes, or for programs for which substantial support from government or other sources is readily available. No grants to individuals, or for continuing support, annual campaigns, emergency, or endowment funds, land acquisition, workshops, exhibits, surveys, or conferences.
Publications: Annual report.
Application information:
 Initial approach: Letter
 Copies of proposal: 1

 Deadline(s): None
 Board meeting date(s): Bimonthly beginning in Jan.
 Final notification: 4 months
 Write: Christine Sisley, Exec. Dir.
Officers: Joseph G. Hurley,* Pres.; Leroy B. Houghton,* V.P. and C.F.O.; Everett B. Laybourne,* V.P.; Christine Sisley, Secy. and Exec. Dir.
Directors:* Ira J. Blanco, Albert A. Dorskind, Robert F. Erburu, Alex Haley, Edgar R. Jackson.
Number of staff: 3 full-time professional; 3 full-time support.
Employer Identification Number: 956085895
Recent arts and culture grants:
Art Center College of Design, Pasadena, CA, $100,000. To re-capitalize Ralph M. Parsons Student Revolving Loan Fund. 1987.

Arts, Inc., Los Angeles, CA, $6,250. Toward new part-time Arts Loan Fund manager position, matching California Arts Council grant. 1987.

Assistance League of Southern California, Los Angeles, CA, $68,700. Toward one-time capital improvements to Theater for Children's Playhouse, including disabled access. 1987.

Bethune Ballet, Los Angeles, CA, $10,000. Toward Dance Outreach Program, which provides creative movement and dance classes for disabled children. 1987.

Bilingual Foundation of the Arts, Los Angeles, CA, $15,000. For purchase of improved lighting and sound systems for main stage theater in Lincoln Heights. 1987.

California Chamber Symphony Society, Los Angeles, CA, $10,000. To underwrite concerts for youth presented at public schools throughout Los Angeles. 1987.

Dance Gallery, Los Angeles, CA, $250,000. Toward construction of dance complex at California Plaza. 1987.

K U S C-FM, Los Angeles, CA, $25,000. Toward purchase of new mobile production vehicle. 1987.

Kidspace, A Participatory Museum, Pasadena, CA, $20,232. For seed funding to hire full-time education director for this participatory children's museum. 1987.

Los Angeles Childrens Museum, Los Angeles, CA, $15,000. To underwrite admission to museum for children in school groups from low income and disadvantaged backgrounds. 1987.

Los Angeles County High School for the Arts Foundation, Los Angeles, CA, $25,000. For seed funding to establish guest artist program in theater department. 1987.

Music Center of Los Angeles County, Los Angeles, CA, $250,000. For general support of Quarter Century Fund. 1987.

Natural History Museum of Los Angeles County Foundation, Los Angeles, CA, $25,000. Toward support of School Tours Program. 1987.

Nucleus, Beverly Hills, CA, $15,000. To underwrite 20 presentations of motivational theater program for local high school students. 1987.

Pasadena Art Workshops, Pasadena, CA, $12,000. To expand Outreach Through Art, innovative project designed to serve low income and disabled children. 1987.

Southwest Museum, Los Angeles, CA, $25,000. Toward underwriting of U.S. premier of internationally acclaimed special exhibition of Northwest Coast Indian art, The Legacy. 1987.

248
Pasadena Area Residential Aid A Corporation
P.O. Box 984
Pasadena 91102 (213) 681-1331

Foundation established in 1948 in CA.
Financial data (yr. ended 7/31/87): Assets, $2,437,261 (M); gifts received, $3,522,645; expenditures, $2,423,048, including $2,374,503 for 913 grants (high: $331,794; low: $20).
Purpose and activities: Grants largely for higher education, cultural programs, Christian church support and social services; also for youth agencies, hospitals and community funds.
Application information: Contributions initiated by donor/members only. Applications not accepted.
 Board meeting date(s): Annually
 Write: Linda M. Moore, Asst. Secy.
Officers and Directors:* Joseph D. Messler,* Pres.; Robert R. Huffman,* V.P.; Thomas S. Jones III,* Secy.; James N. Gamble,* Treas.; Kathy L. Golden, Thayer S. Holbrook, George D. Jagels,* Mary W. Johnson,* Linda M. Moore, Robert F. Niven,* Lee G. Paul,* Philip V. Swan.*
Number of staff: 1 part-time professional.
Employer Identification Number: 952048774

249
Pasadena Foundation
16 North Marengo Ave., Suite 219
Pasadena 91101 (818) 796-2097

Community foundation established in 1953 in CA by resolution and declaration of trust.
Donor(s): Louis A. Webb,† Marion L. Webb,† Helen B. Lockett,† Dorothy I. Stewart,† Rebecca R. Anthony,† Lucille Crumb.†
Financial data (yr. ended 12/31/87): Assets, $3,111,299 (M); gifts received, $215,891; expenditures, $356,988, including $276,338 for 275 grants (high: $15,000; low: $100; average: $3,000-$7,000).
Purpose and activities: Grants for capital improvements to established local agencies, with emphasis on child welfare, youth agencies, and senior citizen welfare.
Types of support: Building funds, equipment, matching funds, renovation projects.
Limitations: Giving limited to the Pasadena, CA, area. No grants to individuals, or for operating budgets, continuing support, annual campaigns, emergency funds, seed money, deficit financing, land acquisition, endowment funds, research, special projects, publications, conferences, scholarships, or fellowships; no loans.
Publications: Annual report, application guidelines, informational brochure.
Application information: Application form required.
 Initial approach: Letter
 Copies of proposal: 1

Deadline(s): Submit proposal preferably from Jan. to June; deadline July
Board meeting date(s): Apr. and Dec.
Final notification: After Dec. meeting
Write: Josephine L. Stephen, Exec. Dir.
Advisory Board: Kyhl S. Smeby, Chair.; Albert C. Lowe, Vice-Chair.; Josephine L. Stephen, Exec. Dir. and Secy.; James B. Boyle, Jr., Fred H. Felberg, James M. King, Sr., Joel V. Sheldon, Jack H. Wall, David A. Werbelow, Marjorie Wyatt.
Trustees: Security Pacific National Bank, Bank of America, Citizens Commercial Trust and Savings Bank, Interstate Bank.
Number of staff: 1 part-time professional.
Employer Identification Number: 956047660
Recent arts and culture grants:
Huntington Library, Art Gallery and Botanical Garden, San Marino, CA, $7,700. For slide show equipment. 1987.
Kidspace, A Participatory Museum, Pasadena, CA, $5,418. For computer system. 1987.
Music Center Unified Fund, Los Angeles, CA, $6,000. 1987.
Norton Simon Museum, Pasadena, CA, $6,055. For computer. 1987.
Pacific Asia Museum, Pasadena, CA, $6,500. For computer software. 1987.
Pasadena Art Workshops, Pasadena, CA, $10,485. For building pre-school area. 1987.
Pasadena Playhouse, Pasadena, CA, $10,300. For sprinkler system. 1987.
Pasadena Symphony Association, Pasadena, CA, $8,000. 1987.
Pasadena Symphony Association, Pasadena, CA, $6,896. For computer. 1987.
Southwest Museum, Los Angeles, CA, $5,340. For audio-visual equipment. 1987.

250
Norman and Mary Pattiz Foundation
c/o Westwood One
9540 Washington Blvd.
Culver City 90232

Established in 1985 in CA.
Donor(s): Norman Pattiz, Mary Pattiz.
Financial data (yr. ended 12/31/88): Assets, $100,917 (M); gifts received, $340,000; expenditures, $238,720, including $238,200 for 10 grants (high: $100,000; low: $200).
Purpose and activities: Support for hospitals, music education, youth and Jewish welfare.
Directors: Mary Pattiz, Norman Pattiz.
Employer Identification Number: 954019729

251
Edwin W. Pauley Foundation
10900 Wilshire Blvd., Suite 521
Los Angeles 90024

Trust established in 1962 in CA.
Donor(s): Edwin W. Pauley, Barbara Pauley Pagen.
Financial data (yr. ended 11/30/87): Assets, $1,695,721 (M); expenditures, $89,748, including $84,500 for 12 grants (high: $43,200; low: $1,000).
Purpose and activities: Grants principally for construction programs for cultural and civic organizations, and educational institutions.

Types of support: Building funds, annual campaigns, continuing support, general purposes.
Limitations: Giving primarily in CA.
Application information:
 Write: William R. Pagen and Barbara Pauley Pagen, Trustees
Trustees: Barbara Pauley Pagen, William R. Pagen.
Employer Identification Number: 956039872

252
The PCS Foundation
2180 Sand Hill Rd., Suite 300
Menlo Park 94025 (415) 845-9080

Established in 1977 in CA.
Donor(s): Members of the Moldaw family.
Financial data (yr. ended 11/30/87): Assets, $90 (M); gifts received, $511,007; expenditures, $230,590, including $230,590 for 41 grants (high: $63,100; low: $30).
Purpose and activities: Support primarily for Jewish welfare and other social service agencies; grants also for medical research and health associations.
Limitations: Giving primarily in CA, particularly San Francisco and Stanford.
Application information:
 Deadline(s): None
 Write: Susan J. Moldaw
Officers: Stuart Moldaw, Pres.; Phyllis Moldaw, V.P. and Treas.
Employer Identification Number: 942450734

253
Peat Marwick-Los Angeles Foundation
(Formerly Peat Marwick Mitchell-Los Angeles Foundation)
725 South Figueroa St.
Los Angeles 90017 (213) 972-4000

Financial data (yr. ended 6/30/87): Assets, $2,134 (M); gifts received, $61,101; expenditures, $66,538, including $66,500 for 13 grants (high: $10,000; low: $1,000).
Purpose and activities: Support for museums, music, literacy, health associations, and YMCA.
Application information:
 Initial approach: Letter
Trustees: M.J. DeWald, R.E. Buce, L.H. Howe, M.J. Moy, R.J. Rehm, S. Yellen.
Employer Identification Number: 956230342

254
Charles Pelletier & Ray Precourt Memorial Foundation
c/o William T. Barden
P.O. Box 368
Los Alamitos 90720-0368

Established in 1967 in CA.
Financial data (yr. ended 9/30/86): Assets, $1,028,115 (M); expenditures, $148,155, including $141,000 for 22 grants (high: $25,000; low: $2,000).
Purpose and activities: Grants for social service and youth agencies, cultural programs, higher education, and hospitals.
Types of support: General purposes.
Limitations: Giving primarily in southern CA.

Application information: Contributes only to pre-selected organizations. Applications not accepted.
Officers: Leonard J. Pelletier, Chair.; Donalda Pelletier, Pres.; Kurt Shepard, V.P.; Renee P. Shepard, V.P.; Ben J. Little, Secy.-Treas.
Employer Identification Number: 952499281

255
Peninsula Community Foundation
1204 Burlingame Ave.
P.O. Box 627
Burlingame 94011-0627 (415) 342-2477

Community foundation established as a trust in 1964 in CA; incorporated about 1982.
Financial data (yr. ended 12/31/87): Assets, $14,289,223 (M); gifts received, $1,889,818; expenditures, $1,694,035, including $1,359,203 for 407 grants (high: $33,000; low: $175; average: $5,000-$20,000) and $25,000 for grants to individuals.
Purpose and activities: To support local cultural, educational, social service, and health programs; interests include youth, environment, elderly, disabled, civic concerns, and recreation; provides counseling services for local fund seekers.
Types of support: Operating budgets, continuing support, seed money, emergency funds, equipment, matching funds, consulting services, technical assistance, internships, scholarship funds, special projects, research, publications, conferences and seminars, general purposes, lectureships, student aid.
Limitations: Giving limited to San Mateo County and northern Santa Clara County, CA. No grants for endowment funds.
Publications: Annual report, application guidelines, informational brochure, newsletter, grants list.
Application information:
 Initial approach: Letter
 Copies of proposal: 1
 Deadline(s): None
 Board meeting date(s): Distribution committee meets in Feb., May., Aug., and Nov.
 Final notification: 3 months
 Write: Bill Somerville, Exec. Dir.
Officer: Bill Somerville, Exec. Dir.
Directors: T. Jack Foster, Chair.; Marjorie Bolton, Vice-Chair.; Morgan A. Gunst, Jr., Bruce Hinchliffe, Albert J. Horn, Thomas M. Jenkins, Charles B. Johnson, Ernest A. Mitchell, John P. Renshaw, William Wilson III, Rosemary Young.
Trustee Banks: The Bank of California, N.A., Borel Bank and Trust Co., Burlingame Bank and Trust Company, First Interstate Bank of California, The Hibernia Bank, Lloyds Bank California, Pacific Union Bank & Trust Co., University National Bank and Trust Co., Wells Fargo Bank, N.A.
Number of staff: 2 full-time professional; 2 full-time support; 1 part-time support.
Employer Identification Number: 942746687
Recent arts and culture grants:
Kulintang Arts Ensemble, San Francisco, CA, $5,000. For dance performances by Filipino company in San Mateo County. 11/24/87.

Performing Arts Workshop, San Francisco, CA, $5,000. Toward Artists in Schools Program in San Mateo County. 11/24/87.
San Mateo County Historical Association, San Mateo, CA, $5,000. Toward cost of county-wide survey of historic buildings. 2/24/88.
San Mateo Performing Arts Center, San Mateo, CA, $5,944. To purchase portable dance floor. 2/24/88.

256
Leon S. Peters Foundation, Inc.
4712 North Van Ness Blvd.
Fresno 93704 (209) 227-5901

Established in 1959 in CA.
Donor(s): Leon S. Peters.†
Financial data (yr. ended 11/30/87): Assets, $8,805,727 (M); gifts received, $60,989; expenditures, $434,700, including $434,700 for 54 grants (high: $50,000; low: $100; average: $5,000).
Purpose and activities: Giving for community funds, cultural programs, higher education, youth agencies, museums, and hospitals.
Types of support: Scholarship funds.
Limitations: Giving primarily in Fresno, CA. No grants to individuals.
Application information: Applications not accepted.
 Initial approach: Letter
 Copies of proposal: 1
 Board meeting date(s): Feb., May, Aug., and Nov.
Officers and Directors: Alice Peters, Pres. and Treas.; Pete P. Peters, V.P. and Secy.; Craig Apregan, George Apregan, Darell Peters, Ronald Peters.
Number of staff: None.
Employer Identification Number: 946064669

257
Plantronics Corporate Giving Program
337 Encinal St.
P.O. Box 1802
Santa Cruz 95061 (408) 458-4490

Financial data (yr. ended 6/30/88): Total giving, $100,000, including $16,000 for 30 grants (high: $3,500; low: $50), $16,000 for employee matching gifts and $68,000 for 4 in-kind gifts.
Purpose and activities: Support for the elderly, arts and culture, cancer, catholic welfare, community funds, the disadvantaged, higher, secondary and minority education, the handicapped, health services, including cancer and heart disease programs, employment, humanities, hunger, marine sciences, minorities, social services, vocational education, and youth. Support includes in-kind giving.
Types of support: Employee matching gifts, in-kind gifts.
Limitations: Giving primarily in areas of company operations.
Publications: Annual report.
Application information:
 Initial approach: Write and enclose budget information
 Copies of proposal: 1
 Deadline(s): None
 Write: Robert D. Lee, V.P., Human Resources

258
Plitt Southern Theatres, Inc. Employees Fund
1801 Century Park East, Suite 1225
Los Angeles 90067

Established in 1945 in TX.
Donor(s): Plitt Southern Theatres.
Financial data (yr. ended 12/31/87): Assets, $7,263,749 (M); expenditures, $618,601, including $298,500 for 31 grants (high: $75,000; low: $500) and $215,212 for 81 grants to individuals.
Purpose and activities: Giving for medical research and hospitals, the arts, higher education, youth, and mental health; also supports an employee welfare fund.
Types of support: Grants to individuals, loans.
Application information: Grants are awarded at the discretion of the trustees. Applications not accepted.
 Write: Joe S. Jackson, Pres.
Officers and Trustees: Joe S. Jackson, Pres.; W.R. Curtis, V.P. and Secy.-Treas.; Roy H. Aaron, Raymond C. Fox, Henry G. Plitt.
Employer Identification Number: 756037855

259
Michael H. & Natalie F. Podell Foundation
1199 Howard Ave., Suite 301
Burlingame 94010-4250 (415) 579-7900

Established in 1963 in CA.
Financial data (yr. ended 2/29/88): Assets, $1,110,050 (M); expenditures, $45,204, including $39,265 for 23 grants (high: $10,000; low: $25).
Purpose and activities: Support for Jewish organizations, higher education and the arts.
Application information:
 Deadline(s): None
 Write: Michael H. Podell, Secy.
Officers: Natalie F. Podell, Pres.; Michael H. Podell, Secy.-Treas.
Employer Identification Number: 946096039

260
The R & R Foundation
1911 Spruce St.
South Pasadena 91030

Trust established in 1967 in CA.
Donor(s): Charles H. Reeves, Richard J. Riordan, Ralph Richley,† and others.
Financial data (yr. ended 2/28/87): Assets, $131,305 (M); gifts received, $25,326; expenditures, $326,959, including $321,499 for 167 grants (high: $120,000; low: $25).
Purpose and activities: Grants largely for higher education, social and health agencies, including population control, church support and religious associations, and cultural programs.
Limitations: No grants to individuals.
Application information: Contributes only to pre-selected organizations; grants decided by donors and not through applications. Applications not accepted.

Officers and Trustees: Richard J. Riordan, Chair.; Charles H. Reeves, Pres.; Paul T. Guinn, William E. Gunther, Jr.
Number of staff: None.
Employer Identification Number: 956192664

261
R.P. Foundation, Inc.
4438 Ingraham Blvd.
San Diego 92109

Incorporated in 1966 in CA.
Donor(s): Robert O. Peterson.
Financial data (yr. ended 11/30/87): Assets, $2,115,186 (M); expenditures, $190,784, including $173,600 for 8 grants.
Purpose and activities: Emphasis on cultural programs, including an historic preservation organization; support also for an oceanographic research institute and education.
Limitations: Giving primarily in CA and NY.
Application information:
Initial approach: 1-page letter
Deadline(s): None
Write: Robert O. Peterson, C.E.O.
Officers and Trustees: Robert O. Peterson, C.E.O.; Maureen F. O'Connor, C.F.O.; John J. McCloskey, Secy.
Employer Identification Number: 952536736

262
The Roberts Foundation
873 Sutter St., Suite B
San Francisco 94109 (415) 771-4300

Established in 1985 in CA.
Donor(s): George R. Roberts.
Financial data (yr. ended 12/31/87): Assets, $4,577,931 (M); gifts received, $3,321,579; expenditures, $1,547,201, including $1,475,000 for 15 grants (high: $500,000; low: $5,000).
Purpose and activities: Giving primarily for youth, conservation and environmental issues; wildlife preservation, health care, the elderly, hispanics, public broadcasting and education; special emphasis on the learning disabled and for innovative programs with an impact on the homeless.
Limitations: Giving limited to CA. No support for medical research, endowment funds, annual or year-end appeals, or for religious organizations. No grants to individuals.
Application information:
Initial approach: Letter
Deadline(s): 60 days prior to a meeting
Board meeting date(s): Feb., June, and Oct.
Write: Lyman H. Casey, Dir.
Officers: Leanne B. Roberts,* Pres.; George R. Roberts, V.P. and Secy.; John P. McLoughlin, V.P.; Lyman H. Casey, Dir.
Employer Identification Number: 942967074

263
Rosenberg Foundation
210 Post St.
San Francisco 94108-5172 (415) 421-6105

Incorporated in 1935 in CA.
Donor(s): Max L. Rosenberg,† Charlotte S. Mack.†

Financial data (yr. ended 12/31/88): Assets, $29,135,983 (M); gifts received, $100; expenditures, $1,875,336, including $1,523,970 for grants (average: $15,000-$50,000).
Purpose and activities: New and innovative programs benefiting children and youth. Priority given to 1) children and their families in poverty in rural and urban areas of CA: activities which reduce dependency, promote self-help, create access to the economic mainstream, or which address the causes of poverty among children and families; and 2) the changing population of CA: activities which promote the full social, economic, and cultural integration of immigrants and other minorities into a pluralistic society.
Types of support: Special projects, research, loans.
Limitations: Giving limited to CA, except for national grants related to the promotion of philanthropy. No grants to individuals, or for endowment, building, or capital funds, operating expenses of established agencies, scholarships, fellowships, continuing support, annual campaigns, emergency funds, deficit financing, matching funds, land acquisition, renovation projects, or conferences and seminars; generally no grants for equipment, films, or publications (except when a necessary part of larger project).
Publications: Multi-year report, program policy statement (including application guidelines).
Application information:
Initial approach: Letter
Copies of proposal: 1
Deadline(s): None
Board meeting date(s): 6 times a year
Final notification: 2 to 3 months
Write: Kirke Wilson, Exec. Dir.
Officers: Cruz Reynoso,* Pres.; Phyllis Cook,* V.P.; Kirke Wilson, Exec. Dir. and Secy.; S. Donley Ritchey,* Treas.
Directors:* Herma Hill Kay, Benton W. Dial, Leslie L. Luttgens, Mary S. Metz, Peter F. Sloss, Norvel L. Smith.
Number of staff: 2 full-time professional.
Employer Identification Number: 941186182
Recent arts and culture grants:
California Historical Society, San Francisco, CA, $22,287. To support the Promised Land. 10/29/87.
Radio Bilingue, Fresno, CA, $55,000. For Noticiero Latino Project. 6/30/87.

264
Roth Family Foundation
12021 Wilshire Blvd., Suite 505
Los Angeles 90025

Established in 1966 in CA.
Donor(s): Louis Roth and Co.
Financial data (yr. ended 10/31/88): Assets, $6,150,000 (M); expenditures, $306,620, including $242,775 for grants.
Purpose and activities: Emphasis on cultural, educational programs, and general charitable giving.
Limitations: Giving primarily in CA. No grants to individuals.
Application information: Grants limited to established charities; unsolicited grants are rarely funded.

Initial approach: Brief proposal letter
Write: Sukey Garcetti, Exec. Dir.
Officers and Directors: Michael Roth, Pres.; Gilbert Garcetti, V.P.; Patricia Roth, V.P.; Susan Roth, V.P.; Sukey Garcetti, Secy.-Treas. and Exec. Dir.; Richard Miller.
Number of staff: 1 part-time professional.
Employer Identification Number: 237008897

265
David Claude Ryan Foundation
P.O. Box 6409
San Diego 92106 (619) 291-7311

Established in 1959 in CA.
Donor(s): Jerome D. Ryan, Gladys B. Ryan.
Financial data (yr. ended 12/31/86): Assets, $2,593,764 (M); gifts received, $210,702; expenditures, $180,668, including $173,600 for 43 grants (high: $55,000; low: $500).
Purpose and activities: Giving primarily for Christian religious organizations, social service and youth agencies, education, and cultural programs.
Types of support: Continuing support.
Limitations: Giving primarily in CA, with emphasis on San Diego. No grants to individuals.
Application information:
Initial approach: Letter
Deadline(s): None
Write: Jerome D. Ryan, Pres.
Officers: Jerome D. Ryan, Pres.; Gladys B. Ryan, V.P. and Secy.-Treas.; Stephen M. Ryan, V.P.
Employer Identification Number: 956051140

266
Sacramento Regional Foundation
1900 Point West Way, Suite 128
Sacramento 95815-4704 (916) 927-2241

Incorporated in 1983 in CA.
Financial data (yr. ended 12/31/88): Assets, $2,810,463 (M); gifts received, $664,522; expenditures, $713,602, including $592,242 for 139 grants (high: $50,300; low: $10) and $4,633 for 5 grants to individuals.
Purpose and activities: Support primarily for education, the arts, conservation, health, and community development.
Types of support: Student aid, conferences and seminars, consulting services, emergency funds, equipment, publications, renovation projects, seed money, technical assistance, scholarship funds.
Limitations: Giving limited to organizations within or those offering services to Sacramento, Yolo, Placer, and El Dorado counties, CA. No grants to individuals (except scholarships), or for annual campaigns, endowments, building funds, continuing support, deficit financing, employee matching gifts, foundation-managed projects, research, land acquisitions; no loans.
Publications: Annual report (including application guidelines), financial statement.
Application information:
Initial approach: Letter
Copies of proposal: 1
Deadline(s): Jan. 6
Board meeting date(s): Mar. 15, June 15, Sept. 21, and Jan. 18

Write: David F. Hess, Exec. Dir.
Officers: F. Frederick Brown, Pres.; Merrily Wong, V.P.; Jean Runyon Graham, Secy.; A. Alan Post, Treas.; David F. Hess, Exec. Dir.
Number of staff: 1 full-time professional; 1 full-time support.
Employer Identification Number: 942891517

267
San Diego Community Foundation
525 B St., Suite 410
San Diego 92101 (619) 239-8815

Established in 1975 in CA.
Financial data (yr. ended 6/30/88): Assets, $29,802,029 (M); gifts received, $1,002,192; expenditures, $2,019,509, including $1,307,082 for 243 grants (high: $126,000; low: $100; average: $2,900).
Purpose and activities: Giving to religious organizations, social service agencies, cultural activities, education, civic affairs, and recreational activities.
Types of support: Seed money, matching funds, building funds, equipment, general purposes, special projects, publications, renovation projects, technical assistance.
Limitations: Giving limited to San Diego County, CA. No support for political or religious organizations. No grants to individuals, or for operating support, annual or capital fund campaigns, or endowment funds, research, conferences, travel, or to underwrite fundraising events and performances; no loans.
Publications: Annual report, informational brochure (including application guidelines).
Application information: Application form required.
 Initial approach: Telephone or letter
 Copies of proposal: 1
 Deadline(s): Quarterly; call for details
 Board meeting date(s): Bimonthly beginning in Feb.
 Final notification: 3 months
 Write: Helen Monroe, Exec. Dir., or Pamela Hall, Asst. Dir.
Officers and Board of Governors: Ronald E. Hahn, Pres.; Philip Del Cumpo, V.P., Distribs.; Frank H. Ault, V.P., Finance; R. Page Jones, V.P., Marketing; Hope Logan, Secy.; Maurice T. Watson, Treas.; and 15 additional governors.
Number of staff: 3 full-time professional; 3 full-time support.
Employer Identification Number: 952942582
Recent arts and culture grants:
International Aerospace Hall of Fame, San Diego, CA, $6,000. For education outreach program. 1987.
La Jolla Museum of Contemporary Art, La Jolla, CA, $20,000. For general support. 1987.
La Jolla Museum of Contemporary Art, La Jolla, CA, $11,000. For general support. 1987.
La Jolla Museum of Contemporary Art, La Jolla, CA, $10,000. To underwrite Smorgon Collection. 1987.
La Jolla Playhouse, La Jolla, CA, $15,000. For general support. 1987.
La Jolla Playhouse, La Jolla, CA, $10,000. For general support. 1987.
Old Globe Theater, San Diego, CA, $20,000. For general support. 1987.
Reuben H. Fleet Space Theater and Science Center, San Diego, CA, $17,500. For

Environmental Impact Report for facility expansion. 1987.
Reuben H. Fleet Space Theater and Science Center, San Diego, CA, $5,000. For support. 1987.
San Diego Historical Society, San Diego, CA, $15,000. For final payment for Archives' Photographic Division. 1987.
San Diego Museum of Art, San Diego, CA, $56,281. For endowment fund. 1987.
San Diego Museum of Art, San Diego, CA, $10,000. To underwrite Dr. Seuss show. 1987.
San Diego Museum of Man, San Diego, CA, $15,000. For final payment for stairway and elevator project. 1987.
San Diego Museum of Natural History, San Diego, CA, $5,000. For endowment fund. 1987.
San Diego Opera Association, San Diego, CA, $12,500. For general support. 1987.
San Diego Opera Association, San Diego, CA, $5,000. For general support. 1987.
San Diego, City of, San Diego, CA, $10,000. For Spreckels Organ renovation in Balboa Park. 1987.
Zoological Society of San Diego, San Diego, CA, $10,000. For general support. 1987.
Zoological Society of San Diego, San Diego, CA, $5,000. For general support. 1987.

268
The San Francisco Foundation
685 Market St., Suite 910
San Francisco 94105-9716 (415) 543-0223

Community foundation established in 1948 in CA by resolution and declaration of trust.
Financial data (yr. ended 6/30/88): Assets, $164,144,398 (M); gifts received, $5,413,451; expenditures, $13,085,907, including $9,732,596 for grants (high: $500,000; low: $100; average: $20,000) and $327,592 for loans.
Purpose and activities: Grants principally in five categories: the arts and humanities, community health, education, environment, and urban affairs. Technical assistance grants also made, primarily to current recipients. On Jan. 1, 1987, the foundation transferred the entire Buck Trust, which is limited to use for charitable purposes in Marin County, CA, to a new and independent foundation, the Marin Community Foundation. The foundation continues to serve five counties of the Bay Area, and in the 12 months ending June 30, 1988, paid out nearly $10 million (excluding Buck Trust funds) in grants to nonprofit agencies.
Types of support: Operating budgets, seed money, loans, technical assistance, special projects.
Limitations: Giving limited to the Bay Area, CA counties of Alameda, Contra Costa, Marin, San Francisco, and San Mateo. No support for religious purposes. No grants to individuals, or for annual campaigns, general fundraising campaigns, emergency or endowment funds, deficit financing, matching gifts, scholarships (except when so designated by donor), or fellowships.

Publications: Annual report, newsletter, application guidelines, program policy statement, informational brochure.
Application information: Application form required.
 Initial approach: Letter of intent (not exceeding 3 pages)
 Copies of proposal: 1
 Deadline(s): Letters reviewed continuously; proposal deadlines available upon request
 Board meeting date(s): Monthly except Aug.; applications are reviewed 4-6 times each year
 Final notification: 3 to 4 months
 Write: Robert M. Fisher, Dir.
Director: Robert M. Fisher.
Board of Trustees: Peter E. Haas, Chair.; Leonard E. Kingsley, Vice-Chair. and Treas.; Lucille S. Abrahamson, Peter H. Behr, John F. Kilmartin, Joan F. Lane, Mary Lee Widener.
Number of staff: 10 full-time professional; 8 full-time support.
Employer Identification Number: 941101547
Recent arts and culture grants:
American Indian Contemporary Arts, San Francisco, CA, $10,000. To support basic administrative, technical and exhibition expenses. 12/2/87.
Archives for the Performing Arts, San Francisco, CA, $15,000. To support stabilization of key administrative and archival positions. 6/20/88.
Asian American Dance Collective, San Francisco, CA, $10,000. To increase time allocated to positions of artistic director and general manager to advance efforts to build audiences and technical excellence. 6/20/88.
Asian Art Foundation of San Francisco, San Francisco, CA, $20,000. To conduct feasibility analysis of conversion of San Francisco's Main Public Library building into facility for Asian Art Museum. 5/11/88.
Bay Area Consortium for the Visual Arts, San Francisco, CA, $5,000. To support expansion of services to artists and visual arts organizations, increase membership and improve fundraising capability. 3/23/88.
Bay Area Multi-Cultural Arts Initiatives, San Francisco, CA, $10,000. For contingency fund to support Minority Arts Initiatives. 6/1/88.
Bay Area Womens Philharmonic, San Francisco, CA, $5,000. To assist with formation of Women Composers National Resource Center to promote wider dissemination of orchestral music composed by women. 3/23/88.
Benjamin Franklin Middle School, San Francisco, CA, $5,000. To support band program and public concerts. 10/12/87.
Benjamin Franklin Middle School, San Francisco, CA, $5,000. For instrument purchase, maintenance and overhead; transportation; purchase of music and supplies; and costs for next year's scrapbook. 7/29/88.
Berkeley Unified School District, Berkeley, CA, $9,000. To support program of integrating music and songs into social studies history curriculum. 9/23/87.
Black Repertory Group, Berkeley, CA, $15,000. To support new administrative position related to moving to newly constructed facility. 1/11/88.

Blackside, Civil Rights Project, Boston, MA, $25,000. To contribute production of Eyes on the Prize, Part 2, eight part television documentary on civil rights movement of mid '60s to early '80s. 7/18/88.

Capp Street Project, San Francisco, CA, $5,000. To support organizational and programming objectives for artist-in-residence program. 9/14/87.

Central City Hospitality House, San Francisco, CA, $7,500. To support position of Exhibitions/Sales Coordinator to promote development of arts programs serving Tenderloin neighborhood. 6/20/88.

Childrens Book Press, San Francisco, CA, $15,000. For Bookends, language arts project in selected San Francisco middle schools using bilingual, multi-cultural literature for children. 6/1/88.

Childrens Television Resource and Education Center, San Francisco, CA, $16,050. To produce, print and distribute Getting Along, social skills curriculum for grades K-4 and to generate income to support development and testing of preschool and middle school version of curriculum. 7/27/88.

Choreographics, Berkeley, CA, $5,000. To support creation of new choreography and performances in East Bay, Marin and Peninsula. 6/8/88.

Cine Accion, San Francisco, CA, $6,500. For expanded programming and staff hours in support of contemporary Latino film and video. 4/4/88.

City Celebration, San Francisco, CA, $5,000. To increase donations from individuals through direct mail campaign. 9/14/87.

Cultural Odyssey, San Francisco, CA, $5,000. To support key administrative, artistic and production personnel during course of implementation of new multiple year plan for agency that specializes in works by black artists. 7/25/88.

Dancers Stage Company, San Francisco, CA, $5,000. To support new administrative positions in keeping with development plan for professional chamber ballet company. 6/20/88.

Dimensions Dance Theater, Oakland, CA, $20,000. To provide partial compensation to one principal dancer and three corps dancers to advance production quality for dance company featuring traditional African and contemporary Afro-American dance. 6/1/88.

East Bay Center for the Performing Arts, Richmond, CA, $6,000. To support new marketing position to build earned revenues generated by performing arts tuition and concerts. 8/18/88.

East Bay Negro Historical Society, Oakland, CA, $5,000. Toward curator-librarian for organization that collects, preserves and disseminates information related to Afro-American presence in Bay Area. 8/16/88.

Ellen Webb Dance Company, Oakland, CA, $5,000. To provide partial salary support for two new administrative positions--management/marketing director and booking--to build audiences and fundraising capacity for small dance company. 8/18/88.

Exploratorium, San Francisco, CA, $7,500. For assistance in preparing and conducting two-day meeting to plan for agency's future. 11/24/87.

Eye Gallery, San Francisco, CA, $5,000. To support new staffing related to move to larger facility for gallery specializing in socially significant photography. 8/16/88.

Footwork/Dancers Group, San Francisco, CA, $5,000. To support staff stabilization and expanded programming consistent with three-year organizational plan. 1/19/88.

Foundation for Art in Cinema, San Francisco, CA, $15,000. To support additional evening of programming each week, expanded membership, increased staff hours and artists' honoraria for contemporary film exhibition organization. 4/27/88.

Galeria de la Raza/Studio 24, San Francisco, CA, $12,500. To support new part-time curatorial and management positions for program of visual arts exhibitions featuring Latino artists. 7/29/88.

George Coates Performance Works, San Francisco, CA, $25,000. To add new General Manager position to bolster planning and financial controls consistent with recent management study. 12/16/87.

Great Hall Project, San Francisco, CA, $5,000. To formulate architectural, fundraising and organizational plans for performing arts hall with prospective seating capacity of 760. 6/8/88.

Headlands Center for the Arts, Sausalito, CA, $10,000. To complete design and fabrication of furnishings for two main rooms to support greater utilization by artists and public. 7/29/88.

Intersection for the Arts, San Francisco, CA, $20,000. To support new development position and fees for artists at this Mission District facility presenting variety of literary, performing and visual arts programs. 3/23/88.

Japanese American Library, San Francisco, CA, $5,000. To promote understanding of Japanese-Americans and Japan through diverse collection of library materials. 10/6/87.

Jazz In Flight, San Francisco, CA, $5,000. To support extension of concert series featuring Bay Area jazz musicians and composers. 8/18/88.

Joe Goode Performance Group, San Francisco, CA, $5,000. To support increased time for artistic and managerial personnel to advance efforts to build audiences, expand board and stabilize financial base. 7/29/88.

John F. Kennedy University, Orinda, CA, $5,000. To support formulation of integrated organizational plan and specific consultation related to computer systems for program of technical services and graduate training in museum management. 6/1/88.

Koncepts Cultural Gallery, Oakland, CA, $7,500. To build audiences in new facility and strengthen board and staff capacity. 4/4/88.

Kulintang Arts Ensemble, San Francisco, CA, $7,500. To pay salary and fringe benefits of full-time general manager for dance and music ensemble that promotes artistic traditions of Filipino people. 7/27/88.

Lines Dance Company, San Francisco, CA, $5,000. To increase compensation for dancers and to augment rehearsal times, thereby improving production quality and stability of dance corps. 7/29/88.

Lorraine Hansberry Theater, San Francisco, CA, $30,000. To support two administrative positions needed to move to larger facility and advance into second year of three year plan. 10/12/87.

Lorraine Hansberry Theater, San Francisco, CA, $5,000. To engage consultant to assist with market research and business planning related to new permanent theater space. 12/16/87.

Make A Circus/Feedback Productions, San Francisco, CA, $10,000. To provide Bay Area audiences with circus performances and circus skills in variety of settings for diverse populations, including developmentally handicapped, low-income youth and elderly. 8/16/88.

Mission Economic and Cultural Association, San Francisco, CA, $16,000. To assist with organizational audit and to develop business plan and board of directors training program. 8/18/88.

Mixed Bag Productions, San Francisco, CA, $5,000. To support development of new choreography by four artists associated with Mixed Bag. 11/18/87.

New Langton Arts, San Francisco, CA, $10,000. To provide honoraria for artists and changes in pattern of administrative staffing. 1/13/88.

Nightfire, Sausalito, CA, $5,000. To support production of new work and consolidation of management and governance resources corresponding to smaller scale of operation. 1/14/88.

Oakland Ballet Company and Guild, Oakland, CA, $35,000. To support increased work weeks for Company dancers and increased compensation for apprentice dancers, thereby adding new choreography to repertoire, expanding touring and improving dance. 6/7/88.

Oakland Ballet Company and Guild, Oakland, CA, $6,000. To conduct market survey and develop marketing plan. 12/16/87.

Oakland Ensemble Theater, Oakland, CA, $25,000. To support elements of Theater's three-year plan. 12/16/87.

Oakland Museum Association, Oakland, CA, $20,000. To formulate comprehensive plan covering governance, programming, funding and space. 1/11/88.

Poetry Flash, Berkeley, CA, $5,000. To support staff development and expand circulation. 2/18/88.

Richmond Art Center, Richmond, CA, $15,000. To expand position of curator to full time and augment staffing for outreach and fundraising for program of visual arts exhibitions featuring Bay Area artists. 6/8/88.

San Francisco Art Institute, San Francisco, CA, $10,000. To conduct analysis of prospects for major fundraising campaign to restore Institute's physical plant and augment endowment. 6/9/88.

San Francisco Ballet Association, San Francisco, CA, $45,000. To support staff positions related to new data processing systems for managing donations and ticket sales. 5/16/88.

San Francisco Ballet Association, San Francisco, CA, $10,000. To stimulate matching gifts on more than three to one ratio to underwrite costs of employing executive search firm to

complete Ballet's transition to new president. 7/27/88.

San Francisco Crafts and Folk Art Museum, San Francisco, CA, $10,000. To support expanded work hours for administrative staff position and upgraded capacity for exhibit design. 1/27/88.

San Francisco Museum of Modern Art, San Francisco, CA, $41,250. To support major revisions in accounting systems and formulation of job evaluation and performance review system in preparation for prospective move to larger facility and operating budget. 6/7/88.

San Francisco New Vaudeville Festival, San Francisco, CA, $7,500. To bolster fundraising capability and support public programming. 3/23/88.

San Francisco Opera, San Francisco, CA, $30,000. To underwrite portion of total cost of completing multiple-year institutional plan. 7/18/88.

San Francisco Shakespeare Festival, San Francisco, CA, $8,000. To increase number of compensated actors and expand hours for position of executive director, thereby advancing quality and audiences for free Shakespeare presentations. 6/20/88.

Southern Exposure Gallery, San Francisco, CA, $5,000. To support reorganization of board and staff functions, and artists' honoraria for gallery featuring local visual artists. 6/20/88.

Theater Artaud, San Francisco, CA, $15,000. To increase paid hours for technical staff for theater providing flexible 300 seat hall for presentation of contemporary works of music, drama, dance and new genres of performance. 8/24/88.

Threepenny Review, Berkeley, CA, $15,000. To support subscription campaign, lecture series and key staff positions for literary quarterly. 7/25/88.

ZYZZYVA, San Francisco, CA, $10,000. To advance sales and board development for West Coast literary magazine. 7/25/88.

269
Santa Barbara Foundation
15 East Carrillo St.
Santa Barbara 93101 (805) 963-1873

Community foundation incorporated in 1928 in CA.

Financial data (yr. ended 12/31/87): Assets, $31,535,569 (M); gifts received, $1,752,892; expenditures, $2,216,264, including $1,362,453 for 132 grants (high: $51,500; low: $794; average: $7,000-$15,000) and $493,251 for 282 loans to individuals.

Purpose and activities: Giving for social services, youth, health services, cultural activities, education, and student aid loans for Santa Barbara County secondary school graduates.

Types of support: Building funds, equipment, land acquisition, matching funds, student loans, renovation projects, publications, technical assistance.

Limitations: Giving limited to Santa Barbara County, CA. No grants to individuals (except for student loans for Santa Barbara County secondary school graduates), or for operating budgets, annual campaigns, seed money, deficit

financing, endowment funds, scholarships, fellowships, research, publications, or conferences.

Publications: Annual report, application guidelines, newsletter, informational brochure.

Application information: The foundation considers 30 applications per quarter. Application form required.

Initial approach: Letter
Copies of proposal: 1
Deadline(s): None
Board meeting date(s): Monthly except July; decisions on grant requests made in Mar., June, Sept. and Dec.
Final notification: 2 months
Write: Edward R. Spaulding, Exec. Dir.

Officers and Trustees: Patricia Dow, Pres.; B. Paul Blasingame, V.P.; Barbara K. Merritt, V.P.; P. Paul Riparetti, M.D., V.P.; Valencia Nelson, Secy.; Warren E. Fenzi, Treas.; Fritz Amacher, Spaulding Birss, William L. Coulson, Edwin F. Froelich, James J. Giusto, Mrs. Robert Grogan, John Howland, Charles H. Jarvis, Marshall A. Rose, Michael Towbes, Mrs. Howard Vesey.

Fund Managers: Capital Research & Management Co., Crocker National Bank, Security Pacific Investment Mgrs.

Number of staff: 1 full-time professional; 1 part-time professional; 2 full-time support; 1 part-time support.

Employer Identification Number: 951866094

Recent arts and culture grants:

Arts Outreach, Santa Barbara, CA, $5,500. To purchase copier and produce catalogue. 1987.

Childrens Creative Project, Santa Barbara, CA, $7,000. For Italian Street Painting Festival. 1987.

Community Arts Music Association, Santa Barbara, CA, $10,000. To purchase orchestra chairs. 1987.

Goleta Valley Historical Society, Goleta, CA, $10,000. To reroof Stow House. 1987.

Lobero Theater Foundation, Santa Barbara, CA, $10,000. To provide noise control. 1987.

Music Academy of the West, Santa Barbara, CA, $6,750. To install doors and lighting system. 1987.

Santa Barbara Botanic Garden, Santa Barbara, CA, $19,332. To improve sewage treatment facilities. 1987.

Santa Barbara Historical Society, Santa Barbara, CA, $10,000. To purchase computer system. 1987.

Santa Barbara Museum of Art, Santa Barbara, CA, $17,557. For unrestricted support. 1987.

Santa Barbara Symphony Orchestra Association, Santa Barbara, CA, $20,000. For program support. 1987.

Santa Barbara Trust for Historic Preservation, Santa Barbara, CA, $10,000. To fund archaeological excavation. 1987.

Santa Maria Civic Theater, Santa Monica, CA, $8,000. To make roof repairs and fund publicity campaign. 1987.

Santa Maria Symphony Society, Santa Monica, CA, $5,000. For program support. 1987.

Santa Ynez Valley Historical Society, Santa Ynez, CA, $6,100. To purchase display cases. 1987.

Solvang Theaterfest, Solvang, CA, $15,000. For facility repairs. 1987.

Solvang Theaterfest, Solvang, CA, $5,000. For facility improvements. 1987.

Vietnam Veterans Living Memorial Committee, Santa Barbara, CA, $30,000. To build and landscape walkway through memorial. 1987.

270
Community Foundation of Santa Clara County
960 West Hedding, No. 220
San Jose 95126-1215 (408) 241-2666

Community foundation established in 1954 in CA.

Financial data (yr. ended 12/31/88): Assets, $8,000,000 (M); gifts received, $2,956,000; expenditures, $2,659,652, including $2,412,129 for 300 grants (high: $700,000; low: $500; average: $2,500-$15,000).

Purpose and activities: Giving primarily for education (including awards in literature), social services, the arts, health, the environment, and urban affairs.

Types of support: Seed money, emergency funds, matching funds, consulting services, technical assistance, fellowships.

Limitations: Giving primarily in Santa Clara County, CA. No support for religious organizations for sectarian purposes. No grants for deficit financing, or building funds.

Publications: Annual report (including application guidelines), newsletter, 990-PF, financial statement, informational brochure.

Application information: Application form required.

Initial approach: Telephone
Copies of proposal: 6
Deadline(s): 12 weeks prior to board meetings
Board meeting date(s): Varies
Final notification: Within 2 weeks of meetings
Write: Peter Hero, Exec. Dir.

Directors: William F. Scandling, Chair.; Peter Hero, Exec. Dir.; Phillip Boyce, Leonard Ely, Marti Erickson, John Freidenrich, Robert Joss, Tom Killefer, Sandra Kurtzig, David W. Mitchell, M. Kenneth Oshman, Ernest Renzel, Jr., Tom Rimerman, James Rosse, Barbara Doyle Roupe, Sven Simonsen, Mrs. C. Barron Swenson, Ray L. Wilbur.

Number of staff: 3 full-time professional; 1 part-time professional.

Employer Identification Number: 770066922

271
Greater Santa Cruz County Community Foundation
820 Bay Ave., Suite 204
Capitola 95010 (408) 662-8290

Community foundation incorporated in 1982 in CA.

Financial data (yr. ended 12/31/88): Assets, $2,787,687 (M); gifts received, $1,277,211; expenditures, $285,608, including $178,826 for 148 grants.

Purpose and activities: Giving for social services, health, education, cultural programs, the environment, conservation, and community development programs.

Types of support: General purposes, seed money, operating budgets, emergency funds, equipment, special projects, conferences and

seminars, technical assistance, consulting services, matching funds, building funds, continuing support.
Limitations: Giving limited to Santa Cruz County, CA. No grants to individuals, or for continuing support, annual campaigns, deficit financing, building funds, land acquisition, student loans, fellowships, or research.
Publications: Multi-year report, grants list, newsletter, program policy statement, application guidelines, annual report.
Application information:
 Initial approach: In person, telephone, or letter
 Copies of proposal: 15
 Deadline(s): Mar. 31 and Sept. 30
 Board meeting date(s): 4th Monday of every other month
 Final notification: Within 60 days of each deadline
 Write: Grace Jepsen, Exec. Dir.
Officers and Directors: William F. Locke-Paddon, Pres.; Alan Simpkins, V.P.; Gloria Hihn Welsh, Secy.; Donald Starr, Treas.; and 23 other directors.
Number of staff: 1 full-time professional; 1 full-time support.
Employer Identification Number: 942808039
Recent arts and culture grants:
Art Museum of Santa Cruz County, Santa Cruz, CA, $5,000. For seed grant to initiate art rental program. 1987.

272
The Vidal Sassoon Foundation
c/o Parks, Palmer, Turner & Yemenidjian
1990 South Bundy Dr., Suite 600
Los Angeles 90025

Established in 1979.
Donor(s): Vidal Sassoon.
Financial data (yr. ended 12/31/86): Assets, $9,419 (M); gifts received, $143,450; expenditures, $148,395, including $145,360 for 34 grants (high: $25,000; low: $50).
Purpose and activities: Support for Jewish organizations and cultural programs, and youth and social service agencies.
Application information: Contributes only to pre-selected organizations. Applications not accepted.
Officers: Vidal Sassoon, Pres.; George Shaw, V.P. and Secy.; Brian Adams, V.P. and Treas.; Linda Turner, V.P.
Employer Identification Number: 953401086

273
Charles M. Schulz Foundation
One Snoopy Place
Santa Rosa 95401

Established in 1982 in CA.
Donor(s): Charles M. Schulz, Jean F. Schulz, Charles M. and Jean F. Schulz Trust.
Financial data (yr. ended 12/31/87): Assets, $1,040,288 (M); gifts received, $1,034,078; expenditures, $270,791, including $269,200 for 9 grants (high: $100,000; low: $1,000).
Purpose and activities: Grants primarily for culture and social services.
Types of support: General purposes.

Limitations: Giving primarily in Sonoma County, CA.
Officers: Craig Schulz,* Pres.; Edwin C. Anderson, Jr., Secy.; Ronald A. Nelson, C.F.O.
Directors:* Meredith Hodges, Charles M. Schulz, Jr., Jill Schulz.
Employer Identification Number: 942715935

274
Virginia Steele Scott Foundation
1151 Oxford Rd.
San Marino 91108 (818) 405-2152

Established in 1974.
Donor(s): Virginia Steele Scott,† Grace C. Steele.†
Financial data (yr. ended 6/30/88): Assets, $4,426,922 (M); expenditures, $417,382, including $234,170 for grants.
Purpose and activities: Giving of works of art to a local art museum, and other fine arts organizations.
Limitations: Giving primarily in Pasadena, CA.
Application information:
 Write: Sandra S. Bradner
Officers: Charles Newton,* Pres.; Henry Tanner, V.P.
Directors:* Blake R. Nevius, Robert R. Wark.
Employer Identification Number: 237365076

275
The Seaver Institute
800 West Sixth St., Suite 1410
Los Angeles 90017 (213) 688-7550

Incorporated in 1955 in CA.
Donor(s): Frank R. Seaver.†
Financial data (yr. ended 6/30/86): Assets, $31,444,632 (M); expenditures, $1,636,726, including $1,324,659 for 83 grants (high: $150,000; low: $450; average: $1,000-$75,000).
Purpose and activities: Emphasis on education, health, the arts, and the community.
Types of support: Matching funds, special projects, research.
Limitations: Giving primarily in CA, MA, and MN. No grants to individuals, or for operating budgets, continuing support, annual campaigns, emergency or endowment funds, scholarships, fellowships, deficit financing, capital or building funds, equipment, land acquisition, publications, or conferences; no loans.
Publications: Informational brochure (including application guidelines).
Application information:
 Initial approach: Telephone
 Deadline(s): None
 Board meeting date(s): Dec. and June
 Final notification: 3 to 6 months
 Write: Richard Call, Pres.
Officers and Directors: Blanche Ebert Seaver, Chair.; Richard Seaver, Vice-Chair.; Richard Call, Pres.; John F. Hall, V.P. and Treas.; Christopher Seaver, Secy.; Richard A. Archer, Camron Cooper, Myron E. Harpole, Raymond Jallow, Victoria Seaver.
Number of staff: 2 full-time professional; 3 part-time professional.
Employer Identification Number: 956054764

276
Security Pacific Corporate Giving Program
333 South Hope St.
Los Angeles 90071 (213) 613-6688

Purpose and activities: Support for business-related organizations and other professional organizations and community affairs.
Application information: Grants generated internally. Applications not accepted.
 Write: Carol E. Taufer, Fdn. Pres.

277
Security Pacific Foundation
333 South Hope St.
Los Angeles 90071 (213) 345-6688
Grant application address: P.O. Box 2097, Terminal Annex, Los Angeles, CA 90051

Incorporated in 1977 in CA.
Donor(s): Security Pacific Corp.
Financial data (yr. ended 12/31/88): Assets, $6,720,754 (M); expenditures, $5,054,509, including $4,579,425 for 625 grants (high: $1,050,650; low: $100; average: $500-$2,500) and $428,523 for 1,982 employee matching gifts.
Purpose and activities: Support for charitable efforts including higher education, community programs, arts and cultural programs, social services, youth agencies, and civic affairs.
Types of support: Annual campaigns, building funds, continuing support, employee matching gifts, operating budgets, employee-related scholarships, general purposes, capital campaigns.
Limitations: Giving primarily in CA. No support for national agencies, legal defense funds, veterans', military, fraternal, or professional organizations, or churches or religious groups. No grants to individuals (except for employee-related scholarships), or for seed money, emergency funds, deficit financing, land acquisition, equipment, endowments, matching or challenge grants, operational grants for hospitals or health associations, scholarships, fellowships, special projects, research, media projects, or advertising in charitable publications; no loans.
Publications: Annual report, informational brochure, program policy statement, application guidelines.
Application information:
 Initial approach: Letter or proposal
 Copies of proposal: 1
 Deadline(s): July 15 for capital grant requests; none for operating grants
 Board meeting date(s): Aug. for capital grants, and Nov.
 Final notification: 4 to 6 weeks; Sept. for capital grants
 Write: Mrs. Carol E. Taufer, Pres.
Officers: Carol E. Taufer,* Pres. and C.E.O.; Richard J. Flamson III,* V.P.; Joseph A. Irwin,* V.P.; John F. Kooken,* V.P.; George F. Moody,* V.P.; Richard A. Warner,* V.P.; Howard B. Stevens, Secy.; Kenneth C. Sherman, Treas.
Directors:* Carl E. Hartnack, Chair.; John Mangels, Robert Philipp, Robert H. Smith, Stephen J. Yoder.
Number of staff: 4 full-time professional.

Employer Identification Number: 953195084
Recent arts and culture grants:

Arts Resources and Technical Services, Los Angeles, CA, $5,000. For operating support. 1987.

Bob Hope Cultural Center, Palm Springs, CA, $25,000. For capital support. 1987.

Business Committee for the Arts, NYC, NY, $5,000. For operating support. 1987.

California Museum of Science and Industry, Hall of Finance, Los Angeles, CA, $32,500. For capital support. 1987.

California Performing Arts Center for Children, San Diego, CA, $5,000. For capital support. 1987.

Combined Arts and Education Council of San Diego County (COMBO), San Diego, CA, $15,000. For operating support. 1987.

Desert Opera Theater, Palm Dale, CA, $5,000. For capital support. 1987.

Fort Mason Center, San Francisco, CA, $10,000. For capital support. 1987.

Greater Los Angeles Zoo Association, Los Angeles, CA, $20,000. For capital support. 1987.

Huntington Library, Art Gallery and Botanical Garden, San Marino, CA, $6,000. For operating support. 1987.

John F. Kennedy Center for the Performing Arts, DC, $5,000. For operating support. 1987.

K C E T Community Television of Southern California, Los Angeles, CA, $15,000. For operating support. 1987.

K O C E-TV, Huntington Beach, CA, $5,000. For operating support. 1987.

K U S C-FM, Los Angeles, CA, $5,000. For operating support. 1987.

K V I E Central California Education Television Station, Sacramento, CA, $8,000. For capital support. 1987.

Laguna Moulton Community Playhouse, Laguna Beach, CA, $5,000. For capital support. 1987.

Los Angeles Childrens Museum, Los Angeles, CA, $7,013. For operating support. 1987.

Los Angeles Contemporary Exhibitions (LACE), Los Angeles, CA, $5,000. For capital support. 1987.

Los Angeles County Museum of Art, Los Angeles, CA, $15,000. For operating support. 1987.

Los Angeles County Museum of Natural History, Los Angeles, CA, $30,000. For capital support. 1987.

Los Angeles County Museum of Natural History, Los Angeles, CA, $5,000. For operating support. 1987.

Los Angeles Museum of Contemporary Art, Los Angeles, CA, $25,000. For operating support. 1987.

Los Angeles Music Center, Unified Fund, Los Angeles, CA, $73,000. For operating support. 1987.

Los Angeles Pops Orchestra, Santa Monica, CA, $5,000. For operating support. 1987.

Los Angeles Theater Center, Los Angeles, CA, $50,000. For capital support. 1987.

Luther Burbank Center for the Arts, Santa Rosa, CA, $5,000. For capital support. 1987.

March Field Museum, March Air Force Base, March, CA, $10,000. For capital support. 1987.

Mission Inn Foundation, Riverside, CA, $5,000. For operating support. 1987.

Orange County Performing Arts Center, Costa Mesa, CA, $87,500. For capital support. 1987.

Orange County Performing Arts Center, Costa Mesa, CA, $20,000. For operating support. 1987.

Pacific Southwest Railway Museum Association, La Mesa, CA, $5,000. For capital support. 1987.

Paradise Auditorium/Community Center, Paradise, CA, $5,000. For capital support. 1987.

Riverside Art Center and Museum, Riverside, CA, $5,000. For capital support. 1987.

Sacramento Symphony Association, Sacramento, CA, $5,000. For operating support. 1987.

San Diego Historical Society, Museum of San Diego History, San Diego, CA, $12,000. For capital support. 1987.

San Diego Museum of Art, San Diego, CA, $5,000. For operating support. 1987.

South Coast Repertory, Costa Mesa, CA, $6,000. For operating support. 1987.

South Coast Repertory Theater, Costa Mesa, CA, $9,000. For capital support. 1987.

University of California, California Museum of Photography, Riverside, CA, $20,000. For capital support. 1987.

278
Charles See Foundation
2222 Ave. of the Stars, Suite 2505
Los Angeles 90067 (213) 879-1182

Incorporated in 1960 in CA.
Donor(s): Charles B. See.
Financial data (yr. ended 12/31/87): Assets, $1,698,597 (M); expenditures, $103,894, including $77,000 for 43 grants (high: $13,000; low: $200).
Purpose and activities: Emphasis on mental health, education, hospitals, church support, conservation, cultural programs, and international affairs.
Limitations: Giving primarily in CA. No grants to individuals.
Application information:
 Initial approach: Letter
 Deadline(s): Nov. 14
 Board meeting date(s): Around Dec. 1
 Write: Betty Ann Pettite, Admin.
Officers: Charles B. See, Pres.; C.H. Baumhefner, V.P.; Betty Ann Pettite, Secy.-Treas. and Admin.
Directors: Harry A. See, Alta B. Underwood.
Employer Identification Number: 956038358

279
J. W. Sefton Foundation
P.O. Box 1871
San Diego 92112

Incorporated in 1945 in CA.
Donor(s): J.W. Sefton, Jr.†
Financial data (yr. ended 12/31/86): Assets, $3,353,047 (M); expenditures, $161,478, including $104,945 for 16 grants (high: $20,000; low: $69).

Purpose and activities: Giving for community development, including grants for the police, museums, and a historical society.
Limitations: Giving primarily in San Diego, CA.
Application information:
 Write: Thomas W. Sefton, Pres.
Officers and Trustees: Thomas W. Sefton, Pres.; Donna K. Sefton, V.P.; Gordon T. Frost, Secy.; Gordon E. McNary, Treas.
Employer Identification Number: 951513384

280
Sequoia Trust Fund
555 California St., 36th Fl.
San Francisco 94104 (415) 393-8552

Established in 1944 in CA.
Financial data (yr. ended 9/30/88): Assets, $1,363,349 (M); gifts received, $1,225; expenditures, $83,842, including $26,500 for 7 grants (high: $10,000; low: $1,000) and $31,400 for 4 grants to individuals.
Purpose and activities: Support for arts, social service organizations, and aid to needy individuals.
Types of support: Grants to individuals.
Limitations: Giving limited to the San Francisco Bay, CA, area.
Application information:
 Initial approach: Letter
 Write: Walter M. Baird, Secy.
Officer and Trustees: Walter M. Baird, Secy.; Roy A. Folger, W. Parmer Fuller III, Raymond W. Hackett, Patrick O'Nelveny.
Employer Identification Number: 946065506

281
The Setzer Foundation
2555 Third St., Suite 200
Sacramento 95818

Trust established in 1965 in CA.
Donor(s): Members of the Setzer family.
Financial data (yr. ended 3/31/87): Assets, $4,101,702 (M); expenditures, $143,009, including $81,995 for 158 grants (high: $3,000; low: $20).
Purpose and activities: Emphasis on higher education, cultural programs, youth and social service agencies, and hospitals.
Limitations: Giving primarily in CA.
Application information: Contributes only to pre-selected organizations. Applications not accepted.
Trustees: G. Cal Setzer, Hardie C. Setzer, Mark Setzer.
Employer Identification Number: 946115578

282
Shaklee Corporate Giving Program
c/o Shaklee Corp.
444 Market St.
San Francisco 94111 (415) 954-2007

Purpose and activities: Supports programs and projects in the areas of health promotion, nutrition, physical fitness and the arts, and a smaller proportion for welfare, civic activities and education; provides college scholarships to eligible children of sales leaders and employees through the National Merit Scholarship Corp.;

also has an employee volunteer program and a matching gifts program, which matches employees' contributions on a two-for-one basis.

Types of support: General purposes, matching funds, scholarship funds, in-kind gifts.

Limitations: Giving primarily in major operating locations. No support for religious or sectarian institutions, or fraternal, veterans and labor groups. No grants to individuals, or for capital or building funds, research, conferences, seminars, and fund-raising events, or recipients of United Way funds.

Application information: If a preliminary evaluation meets with policy and priorities, the organization will be asked to complete a formal application.

Initial approach: Letter of inquiry, not longer than two pages including description of organization and project, amount requested, and constituency served
Deadline(s): None
Write: Karin Topping, Public Relations Dir.

283
The Shea Foundation
655 Brea Canyon Rd.
Walnut 91789

Incorporated in 1960 in CA.
Donor(s): Members of the Shea family.
Financial data (yr. ended 11/30/86): Assets, $2,877,208 (M); expenditures, $150,813, including $125,000 for 41 grants (high: $15,000; low: $500).
Purpose and activities: Emphasis on Roman Catholic church support and religious associations; support also for education, the handicapped, museums, hospitals, and theater.
Types of support: Scholarship funds.
Limitations: Giving primarily in CA.
Application information:
Initial approach: Proposal
Copies of proposal: 1
Deadline(s): None
Board meeting date(s): Apr.
Write: Rudy Magallanes
Officers: John F. Shea,* Pres.; Patricia Ann Shea Meek, V.P.; Michael L. Mellor,* Secy.-Treas.
Trustees:* Robert L. Bridges.
Employer Identification Number: 956027824

284
Walter H. and Phyllis J. Shorenstein Foundation
One California St.
San Francisco 94111

Established in 1965 in CA.
Financial data (yr. ended 12/31/87): Assets, $95,463 (M); gifts received, $211,500; expenditures, $157,748, including $157,096 for 13 grants (high: $100,000; low: $500).
Purpose and activities: Giving primarily for cultural programs; support also for Jewish giving and education, with emphasis on medical education.
Officers: Walter H. Shorenstein, Pres.; Phyllis J. Shorenstein, V.P.; Iona Blampied, Secy.; Douglas W. Shorenstein, Treas.
Employer Identification Number: 946113160

285
Sierra Pacific Foundation
P.O. Box 1189
Arcarta 95521 (707) 443-3111

Donor(s): Sierra Pacific Industries.
Financial data (yr. ended 6/30/88): Assets, $1,554,577 (M); gifts received, $180; expenditures, $140,126, including $78,323 for 62 grants (high: $10,000; low: $10) and $58,763 for 50 grants to individuals.
Purpose and activities: Support for higher and secondary education; recreational activities for youth; parks; culture, including museums, the arts, and libraries; civic affairs, including citizen's associations and public media; wildlife and environmental preservation; social services, including women's shelters and child welfare; and health, including hospitals and an eye bank; scholarships are restricted to dependent children of Sierra Pacific Industries employees.
Types of support: Employee-related scholarships.
Application information: Application form required.
Initial approach: Letter
Board meeting date(s): Mar. 30
Write: H.L. Smith, V.P.
Officers: Ida Emmerson, Pres.; Richard L. Smith, V.P.; Carolyn I. Dietz, Treas.
Employer Identification Number: 942574178

286
The Norton Simon Foundation
411 West Colorado Blvd.
Pasadena 91105 (818) 449-6840

Incorporated in 1952 in CA.
Donor(s): Norton Simon, and family members.
Financial data (yr. ended 12/31/87): Assets, $284,901,358 (M); gifts received, $348,887; expenditures, $5,871,165, including $5,655,256 for 1 foundation-administered program.
Purpose and activities: A private operating foundation of which the principal activity is the purchase of works of art and their loan to major public museums for exhibition; grants generally restricted to programs initiated by the foundation in the arts, education, and health.
Types of support: Annual campaigns.
Limitations: Giving primarily in the Los Angeles, CA, area. No grants to individuals, or for building or endowment funds, research, scholarships, fellowships, or matching gifts; no loans.
Application information: Grants generally initiated by the foundation. Applications not accepted.
Board meeting date(s): As required
Write: Walter W. Timoshuk, V.P.
Officers and Trustees: Jennifer Jones Simon, Chair.; Norton Simon, Pres.; Walter W. Timoshuk, V.P. and Treas.; David J. Mahoney, Donald E. Simon, Eric Simon, Billy Wilder, Harold M. Williams.
Number of staff: None.
Employer Identification Number: 956035908

287
Norton Simon Philanthropic Foundation - New York
411 West Colorado Blvd.
Pasadena 91105 (818) 449-6840

Incorporated in 1957 in NY.
Donor(s): Norton Simon, Norton Simon, Inc., and its subsidiaries and predecessors, and members of the family.
Financial data (yr. ended 12/31/87): Assets, $553,049 (M); expenditures, $351,507, including $344,744 for 1 grant.
Purpose and activities: Giving generally for arts, culture, education, and health.
Types of support: Annual campaigns.
Limitations: Giving primarily in the Los Angeles, CA, area. No grants to individuals, or for building or endowment funds, research, scholarships, fellowships, or matching gifts; no loans.
Application information: Grants largely initiated by the foundation. Applications not accepted.
Board meeting date(s): As required
Write: Walter W. Timoshuk, V.P.
Officers and Directors: Norton Simon, Pres.; Jennifer Jones Simon, Exec. V.P.; Walter W. Timoshuk, V.P., Secy., and Treas.
Number of staff: None.
Employer Identification Number: 136161697

288
L. J. Skaggs and Mary C. Skaggs Foundation
1221 Broadway, 21st Fl.
Oakland 94612-1837 (415) 451-3300

Incorporated in 1967 in CA.
Donor(s): L. J. Skaggs,† Mary C. Skaggs.
Financial data (yr. ended 12/31/87): Assets, $12,171,662 (M); gifts received, $880,000; expenditures, $3,765,288, including $2,797,011 for 308 grants (high: $250,000; low: $250).
Purpose and activities: Giving for the performing arts, specifically theatre and "world performance" projects of historic interest, folklore and folk life, and special projects; giving also for social and community concerns with some emphasis on child advocacy and women's projects. Some foreign grants to Pacific Rim countries in areas of interest, particularly historic preservation, health and hunger programs at the village level, women's rights, and a literature program.
Types of support: Seed money, special projects, matching funds, technical assistance, general purposes, continuing support, conferences and seminars, equipment.
Limitations: Giving primarily in northern CA for social and community concerns. No support for higher education, residence home programs, halfway houses, or sectarian religious purposes. No grants to individuals, or for capital funds, annual fund drives, budget deficits, scholarships, or fellowships; no loans.
Publications: Annual report (including application guidelines), informational brochure (including application guidelines), grants list.
Application information:
Initial approach: Letter
Copies of proposal: 1

Deadline(s): June 1 for letter of intent, Sept. 1 for invited proposal
Board meeting date(s): Nov.
Final notification: 2 to 3 weeks after board meeting
Write: Philip M. Jelley, Secy., or David G. Knight, Prog. Dir. and Office Mgr.
Officers and Directors: Mary C. Skaggs, Pres.; Peter H. Forsham, M.D., V.P.; Catherine L. O'Brien, V.P.; Philip M. Jelley, Secy. and Fdn. Mgr.; Donald D. Crawford, Treas.; Jillian Steiner Sandrock.
Number of staff: 4 full-time professional.
Employer Identification Number: 946174113

289
Lon V. Smith Foundation
9440 Santa Monica Blvd., Suite 303
Beverly Hills 90210-4201

Established in 1952 in CA.
Financial data (yr. ended 12/31/87): Assets, $16,559,823 (M); expenditures, $728,648, including $579,550 for 73 grants (high: $100,000; low: $100).
Purpose and activities: Support primarily for higher education, health and medical organizations, social services and museums.
Types of support: General purposes.
Limitations: Giving primarily in Southern CA.
Application information: Contributes only to pre-selected organizations. Applications not accepted.
Officers: W. Layton Stanton, Pres.; Marguerite B. Smith, V.P.; Marguerite M. Murphy, Secy.-Treas.
Employer Identification Number: 956045384

290
Smith-Welsh Foundation
760 North La Cienega Blvd.
Los Angeles 90069-5279

Established in 1985 in CA.
Donor(s): Omer Smith Marital Trust.
Financial data (yr. ended 12/31/87): Assets, $1,821,786 (M); gifts received, $788,830; expenditures, $32,674, including $15,250 for 15 grants (high: $2,500; low: $250).
Purpose and activities: Giving for health services, social services, and arts organizations.
Application information: Applications not accepted.
Officers: Nancy S. Welsh, C.E.O.; James E. Welsh, C.F.O. and Secy.
Employer Identification Number: 953958030

291
Southern Pacific Corporate Contributions Program
One Market Plaza
San Francisco 94105 (415) 541-1853

Purpose and activities: Supports all levels of educational programs, cultural institutions, minority programs, youth services, United Way, music, science, theater, international and environmental issues, and job development.

Limitations: Giving primarily in headquarters city and major operating locations.
Application information:
Write: Gerald Pera, Community Relations Rep.

292
Caryll M. and Norman F. Sprague, Jr. Foundation
3600 Wilshire Blvd., Suite 2110
Los Angeles 90010 (213) 387-7311

Trust established in 1957 in CA.
Donor(s): Caryll M. Sprague, Norman F. Sprague, Jr., M.D.
Financial data (yr. ended 12/31/87): Assets, $3,458,261 (M); expenditures, $192,567, including $174,350 for 32 grants (high: $93,750; low: $250).
Purpose and activities: Emphasis on higher education including medical education, hospitals, secondary education, and museums.
Limitations: Giving primarily in CA. No grants to individuals.
Application information:
Initial approach: Letter or telephone
Board meeting date(s): Annually and as required
Write: Norman F. Sprague, Jr., M.D., Trustee
Trustees: Cynthia S. Connolly, Caryll S. Mingst, Charles T. Munger, Norman F. Sprague, Jr., M.D., Norman F. Sprague III, M.D.
Employer Identification Number: 956021187

293
C. J. Stafford & Dot Stafford Memorial Trust
c/o San Diego Trust & Savings Bank
P.O. Box X-1013
San Diego 92112 (619) 238-4874

Established in 1984 in CA.
Donor(s): C.J. Stafford,† Dot Stafford.†
Financial data (yr. ended 4/30/87): Assets, $1,395,982 (M); expenditures, $219,896, including $182,140 for 27 grants (high: $40,000; low: $1,000; average: $500-$30,000).
Purpose and activities: Giving primarily for hospitals, youth agencies, community funds and health associations, and social services; support also for education, museums, music, performing arts, and religion.
Types of support: Building funds, continuing support, emergency funds, equipment, general purposes, matching funds, operating budgets, renovation projects, special projects, capital campaigns.
Limitations: Giving limited to San Diego County, CA.
Publications: 990-PF, application guidelines.
Application information:
Initial approach: Letter
Copies of proposal: 6
Deadline(s): Apr. 1
Board meeting date(s): Quarterly - varies
Write: John Harwell, Asst. V.P., San Diego Trust & Savings Bank
Trustee: San Diego Trust & Savings Bank.
Number of staff: 1 full-time professional; 4 part-time professional; 1 full-time support.
Employer Identification Number: 330085374

294
The Stans Foundation
350 West Colorado Blvd.
Pasadena 91105 (818) 795-5947

Incorporated in 1945 in IL.
Donor(s): Maurice H. Stans, Kathleen C. Stans.†
Financial data (yr. ended 12/31/87): Assets, $3,500,000 (M); expenditures, $221,275, including $221,000 for 170 grants (high: $50,000; low: $25; average: $1,000-$50,000).
Purpose and activities: Emphasis on a restoration project, an historical society, and a museum; grants also for public service organizations, research, higher education, and church support.
Types of support: General purposes, continuing support, annual campaigns, building funds, equipment, research, conferences and seminars, operating budgets, program-related investments.
Limitations: No grants to individuals, or for operating budgets, endowment funds, scholarships, fellowships, or matching gifts; no loans.
Publications: 990-PF.
Application information: Funds fully committed for next 5 years. Applications not accepted.
Write: Maurice H. Stans, Chair.
Officers: Maurice H. Stans,* Chair. and Treas.; Steven H. Stans,* Pres.; Mary C. Elia, Secy.
Directors:* Maureen Stans Helmick, Walter Helmick, Terrell Stans Manley, William Manley, Diane Stans, Susan Stans, Theodore M. Stans.
Number of staff: None.
Employer Identification Number: 366008663

295
The Stark Foundation
c/o Rochelle Edwards, Burbank Studios
Columbia Plaza, W.
Burbank 91505 (818) 954-2506

Established in 1982 in CA.
Financial data (yr. ended 11/30/87): Assets, $52,675 (M); gifts received, $3,498; expenditures, $207,791, including $207,050 for 35 grants (high: $80,000; low: $100).
Purpose and activities: Giving primarily for medical care and research, higher education with an emphasis on film studies, Jewish organizations, and secondary education.
Application information:
Initial approach: Letter
Deadline(s): None
Officers: Ray Stark, Chair.; Frances Stark, Pres.; Gerald Lipsky, V.P. and Treas.; Herbert A. Allen, V.P.
Employer Identification Number: 953767859

296
John and Beverly Stauffer Foundation
P.O. Box 2246
Los Angeles 90028 (213) 381-3933

Incorporated in 1954 in CA.
Donor(s): John Stauffer,† Beverly Stauffer.†
Financial data (yr. ended 12/31/87): Assets, $3,281,783 (M); expenditures, $155,999, including $129,841 for 37 grants (high: $27,200; low: $45; average: $1,000-$5,000).

Purpose and activities: Support for higher and secondary education; hospitals and medical research, including cancer research; social service and child welfare agencies, including projects for the homeless, alcoholism, and drug abuse; cultural programs; and Christian religious associations.

Types of support: Continuing support, annual campaigns, building funds, equipment, scholarship funds, general purposes.

Limitations: Giving primarily in the southern CA, area. No grants to individuals, or for endowment funds or operating budgets.

Application information:

 Initial approach: Letter

 Copies of proposal: 1

 Deadline(s): None

 Board meeting date(s): 4 times a year

 Write: Jack R. Sheridan, Pres.

Officers and Directors: Jack R. Sheridan, Pres.; Felix W. Robertson, V.P.; Mary Ann Frankenhoff, Secy.; Thomas C. Towse, Treas.; Leslie Sheridan Bartleson, Louise Camp, Brooke Sheridan Carnes, Craig Flanaghan, Harriette Hughes, Katherine Stauffer Sheridan.

Employer Identification Number: 952241406

297
Marshall Steel, Sr. Foundation
P.O. Box 915
Pebble Beach 93953 (408) 624-7341

Trust established in 1957 in CA.

Donor(s): Members of the Steel family and family-related businesses.

Financial data (yr. ended 12/31/86): Assets, $5,130,000 (M); expenditures, $250,269, including $220,800 for 56 grants (high: $30,000; low: $500).

Purpose and activities: Giving for higher education and science studies, cultural programs and museums, hospitals, social service agencies, and conservation.

Limitations: Giving primarily in CA; no grants outside the U.S. No support for religious purposes. No grants to individuals, or for publications or film making.

Application information:

 Initial approach: Letter stating objectives, scope of project, and evidence of local support

 Copies of proposal: 1

 Deadline(s): None

 Board meeting date(s): Usually Oct. and Dec.

 Write: Marshall Steel, Jr.

Trustees: Alison Steel, Eric Steel, Gordon Steel, Jane Steel, Lauri Steel, Marshall Steel, Jr.

Number of staff: None.

Employer Identification Number: 946080053

298
The Harry and Grace Steele Foundation
441 Old Newport Blvd., Suite 301
Newport Beach 92663 (714) 631-9158

Incorporated in 1953 in CA.

Donor(s): Grace C. Steele.†

Financial data (yr. ended 10/31/88): Assets, $47,201,490 (M); expenditures, $4,235,572, including $4,024,014 for 55 grants (high: $390,219; low: $1,000; average: $5,000-$250,000).

Purpose and activities: Emphasis on higher and secondary education, including scholarship funds, the fine arts, population control, hospitals and clinics, and youth agencies.

Types of support: Building funds, endowment funds, scholarship funds, matching funds, continuing support, general purposes, special projects, equipment.

Limitations: Giving primarily in Orange County, CA. No support for tax-supported organizations or private foundations. No grants to individuals; no loans.

Publications: Annual report, program policy statement, application guidelines.

Application information:

 Initial approach: Letter, followed by proposal

 Copies of proposal: 1

 Deadline(s): None

 Board meeting date(s): Quarterly

 Final notification: 6 months

 Write: Marie F. Kowert, Asst. Secy.

Officers and Trustees: Audrey Steele Burnand, Pres.; Richard Steele, V.P. and Treas.; Alphonse A. Burnand III, Secy.; Elizabeth R. Steele, Barbara Steele Williams, Nick B. Williams.

Number of staff: 1 part-time support.

Employer Identification Number: 956035879

Recent arts and culture grants:

Chosin Few Fund, Hull, MA, $10,000. For International Korean War Memorial at Los Angeles, CA. 4/13/88.

K O C E-TV, Huntington Beach, CA, $269,588. For support of programs in arts and humanities and instructional programs for young people from preschool through college years. 7.87.

Laguna Beach Museum of Art, Laguna Beach, CA, $150,000. Toward matching grant for Home Coming Campaign. 1/86.

Laguna Beach Museum of Art, Laguna Beach, CA, $100,000. For capital improvements. 9/88.

Laguna Moulton Community Playhouse, Laguna Beach, CA, $126,877. Toward matching challenge grant. 1/86.

Music Center of Los Angeles County, Los Angeles, CA, $5,000. For continuing general support. 1/88.

Natural History Museum Foundation, Los Angeles, CA, $271,075. Toward completing matching pledge for Great Bird Hall. 1/86.

Natural History Museum Foundation, Los Angeles, CA, $50,000. For continuing support for Ralph Schreiber Hall of Birds. 4/88.

Newport Aquatic Center, Newport Beach, CA, $106,650. For building fund. 7/87.

Newport Aquatic Center, Newport Beach, CA, $25,000. For continuing general support. 4/13/88.

Newport Harbor Art Museum, Newport Beach, CA, $250,000. For 25th Anniversary Fund. 1/87.

Opera Pacific, Irvine, CA, $27,500. Toward educational purposes. 7/87.

Opera Pacific, Irvine, CA, $27,500. For final payment toward training program. 1/88.

Orange County Chamber Orchestra, Yorba Linda, CA, $5,000. For general support. 9/88.

Orange County Performing Arts Center, Costa Mesa, CA, $363,411. For underwriting opera and musical theater for opening season. 10/86.

Pasadena Symphony Association, Pasadena, CA, $10,000. For continuing support. 7/87.

Planned Parenthood Association of San Diego County, San Diego, CA, $10,000. Toward operating expenses for New Image Teen Theater. 10/86.

South Coast Repertory Theater, Costa Mesa, CA, $100,000. For continuing support. 10/85.

South Coast Repertory Theater, Costa Mesa, CA, $100,000. For payment for capital improvements. 10/87.

Statue of Liberty-Ellis Island Foundation, NYC, NY, $340,031. For continued support of restoration. 1/86.

Statue of Liberty-Ellis Island Foundation, NYC, NY, $325,968. For final payment for restoration. 10/87.

University of the South, Sewanee, TN, $150,000. For continued support for Chair in English. 3/85.

University of the South, Sewanee, TN, $150,000. For payment for Chair in English. 1/88.

299
Jules and Doris Stein Foundation
(Formerly Doris Jones Stein Foundation)
P.O. Box 30
Beverly Hills 90213 (213) 276-2101

Established in 1981 in CA.

Donor(s): Doris Jones Stein Family Trust.

Financial data (yr. ended 12/31/88): Assets, $35,713,517 (M); expenditures, $4,700,632, including $4,504,958 for 288 grants (high: $1,500,000; low: $250; average: $5,000-$20,000).

Purpose and activities: Support for medical research, education, fine arts and social welfare.

Types of support: General purposes, building funds, continuing support, endowment funds, equipment, matching funds, research, special projects, capital campaigns, fellowships, operating budgets.

Limitations: Giving primarily in the metropolitan areas of Los Angeles, Kansas City, and New York City. No support for political advocacy groups. No grants to individuals.

Publications: Application guidelines, newsletter.

Application information: Application form required.

 Initial approach: Letter

 Deadline(s): None

 Board meeting date(s): Varies

 Write: Linda L. Valliant

Officers and Directors: Lew R. Wasserman, Chair.; Gerald H. Oppenheimer, Pres.; Gil Shiva, V.P.; Jean Stein, V.P.; Linda L. Valliant, Secy.; Stephen P. Petty, C.F.O.; Hamilton G. Oppenheimer.

Number of staff: 1 full-time professional; 2 part-time professional; 2 part-time support.

Employer Identification Number: 953708961

300
Sidney Stern Memorial Trust
P.O. Box 893
Pacific Palisades 90272
Additional address: c/o Susan Boling, Asst. V.P. & Trust Officer, Wells Fargo Bank, P.O.

Box 54410, Los Angeles, CA 90054; Tel.: (213) 253-3154

Trust established in 1974 in CA.
Donor(s): S. Sidney Stern.†
Financial data (yr. ended 8/31/87): Assets, $18,368,257 (M); expenditures, $1,188,290, including $1,041,845 for 168 grants (high: $100,500; low: $500; average: $1,000-$15,000).
Purpose and activities: Giving primarily for higher education, social service agencies, including aid to the handicapped; youth and child welfare agencies, health associations, and cultural programs.
Types of support: Operating budgets, annual campaigns, seed money, emergency funds, deficit financing, building funds, equipment, land acquisition, endowment funds, matching funds, scholarship funds, special projects, research.
Limitations: Giving primarily in CA; all funds must be used within the U.S. No grants to individuals, or for continuing support, publications, or conferences; no loans.
Publications: Program policy statement, application guidelines.
Application information:
 Initial approach: Letter or proposal
 Copies of proposal: 1
 Deadline(s): None
 Board meeting date(s): Monthly, except Aug.
 Final notification: 3 months
 Write: Marvin Hoffenberg, Chair.
Board of Advisors: Marvin Hoffenberg, Chair.; Ira E. Bilson, Secy.; Peter H. Hoffenberg, Edith Lessler, Howard O. Wilson.
Number of staff: None.
Employer Identification Number: 956495222

301
Laura May Stewart Trust
c/o Laura May Distrib. Comm.
P.O. Box 574
Banning 92220

Trust established in 1975 in CA.
Donor(s): Laura May Stewart.†
Financial data (yr. ended 5/31/87): Assets, $1,402,387 (M); expenditures, $77,481, including $58,977 for 17 grants (high: $10,000; low: $100).
Purpose and activities: Emphasis on civic affairs and cultural programs.
Limitations: Giving limited to the Banning-Beaumont, CA, area.
Application information:
 Initial approach: Letter
 Deadline(s): None
 Write: Edith Hensell
Trustee: Wells Fargo Private Banking Group.
Employer Identification Number: 956527634

302
The Morris Stulsaft Foundation
100 Bush St., Rm. 500
San Francisco 94104 (415) 986-7117

Incorporated in 1953 in CA; sole beneficiary of feeder trust created in 1965; assets reflect value of assets of testamentary trust.

Donor(s): The Morris Stulsaft Testamentary Trust.
Financial data (yr. ended 12/31/87): Assets, $18,133,457 (M); gifts received, $1,050,563; expenditures, $1,172,490, including $1,021,210 for 118 grants (high: $50,000; low: $1,000; average: $8,654).
Purpose and activities: "To aid and assist needy and deserving children"; giving for youth programs, including recreational, health, educational, cultural, and social service programs.
Types of support: Operating budgets, building funds, equipment, matching funds, renovation projects, research, special projects.
Limitations: Giving limited to the San Francisco Bay Area, CA: Alameda, Contra Costa, Marin, San Francisco, Santa Clara, and San Mateo counties. No support for sectarian religious projects, or ongoing support for private schools. No grants to individuals, or for emergency funding, annual campaigns, workshops, or conferences.
Publications: Biennial report (including application guidelines).
Application information: Application form required.
 Initial approach: Letter or call requesting application form
 Copies of proposal: 1
 Deadline(s): 7 months prior to meetings
 Board meeting date(s): Jan., Mar., May, July, Sept., and Nov.
 Final notification: Approximately 7 months
 Write: Joan Nelson Dills, Admin.
Officers and Directors: J. Boatner Chamberlain, Pres.; Mrs. William S. Corvin, V.P.; Raymond A. Marks, Secy.-Treas.; Roy L. Bouque, Mrs. Robert S. Corvin, Andrew C. Gaither, Loral Good-Swan, Isadore Pivnick, Yori Wada.
Number of staff: 2 full-time professional.
Employer Identification Number: 946064379
Recent arts and culture grants:
Diablo Youth Symphony Orchestra, Walnut Creek, CA, $5,000. Toward purchase of percussion intruments. 1987.
Exploratorium, San Francisco, CA, $5,000. To train, equip and employ high school youth as Exploratorium Explainers. 1987.
Fine Arts Museums of San Francisco, San Francisco, CA, $25,000. For Museum Ambassador Program to train students to present museum programs to schools. 1987.
Hayward Area Forum of the Arts/Sun Gallery, Hayward, CA, $5,000. Toward educational programming as Art Enrichment for school children and teachers. 1987.
Jewish Community Museum, San Francisco, CA, $5,000. Toward use of museum as learning laboratory for school children and seniors. 1987.
K Q E D, San Francisco, CA, $50,000. For Instructional Television training for high school teachers in five Bay Area counties. 1987.
Performing Arts Workshop, San Francisco, CA, $5,000. To serve special education students through Artist-in-Schools program. 1987.
San Francisco Ballet Association, San Francisco, CA, $5,000. To support Student Sampler Program and provide scholarships. 1987.

San Francisco Conservatory of Music, San Francisco, CA, $5,000. To provide subsidies for musically talented students. 1987.
San Francisco State University Foundation, San Francisco, CA, $7,500. To provide Theater-In-Education Social Studies project for San Francisco Unified School District high schools. 1987.
San Francisco Symphony, San Francisco, CA, $5,000. To train talented young musicians in Youth Orchestra. 1987.
San Jose State University Foundation, San Jose, CA, $5,000. To support lecture/demonstrations by San Jose music students for public schools. 1987.
Triton Museum of Art, Santa Clara, CA, $5,000. Toward visual arts education project for school teachers and students through ARTREACH. 1987.
University of California, Berkeley, CA, $5,000. To subsidize low income musically gifted students in training for professional careers. 1987.
Young Audiences of the Bay Area, San Francisco, CA, $5,000. To increase communication skills for disadvantaged and limited English speaking through performing arts education. 1987.

303
Dorothy Grannis Sullivan Foundation
9215 Wilshire Blvd.
Beverly Hills 90210 (213) 278-0770

Financial data (yr. ended 12/31/87): Assets, $1,424,999 (M); expenditures, $95,554, including $83,000 for 19 grants (high: $15,000; low: $1,000).
Purpose and activities: Support for health organizations and hospitals, and cultural organizations.
Application information:
 Initial approach: Letter or proposal
 Deadline(s): None
 Write: William H. Ahmanson, Pres.
Officers and Trustees: William H. Ahmanson, Pres.; Joseph Ball, V.P.
Employer Identification Number: 237010674

304
Swig Foundation
c/o The Swig Foundations
Fairmont Hotel
San Francisco 94106 (415) 772-5275

Established in 1957 in CA.
Donor(s): Benjamin H. Swig,† members of the Swig family.
Financial data (yr. ended 12/31/86): Assets, $14,861,620 (M); expenditures, $222,246, including $190,326 for 56 grants (high: $25,000; low: $100; average: $1,000-$65,000).
Purpose and activities: Grants for arts and culture, education, community welfare, medical care, and projects in Israel.
Limitations: Giving primarily in the San Francisco Bay Area, CA. No grants to individuals, or for conferences, seminars, or workshops.
Application information:
 Initial approach: Letter
 Deadline(s): None

Board meeting date(s): Apr., Aug., and Dec.
Final notification: Immediately following
 board meeting
Write: Louis Stein, Dir.
Trustees: Richard S. Dinner, Melvin M. Swig,
Richard L. Swig.
Administrator: Louis Stein, Dir.
Number of staff: 1
Employer Identification Number: 946065205

305
Syntex Corporate Contributions
Program
3401 Hillview Ave., A6-164A
Palo Alto 94304 (415) 855-6111

Financial data (yr. ended 7/31/88): Total
giving, $2,752,336, including $2,555,853 for
grants (high: $150,000; low: $1,000; average:
$2,500-$10,000), $121,935 for employee
matching gifts and $74,548 for in-kind gifts.
Purpose and activities: Supports education
with an emphasis on health, AIDS, medicine,
science, community affairs in operating areas,
health services, environment, the handicapped,
and the arts.
Types of support: In-kind gifts, special
projects, scholarship funds, fellowships, capital
campaigns, continuing support, employee
matching gifts, employee-related scholarships.
Limitations: Giving primarily in Santa Clara
County in CA. No support for religious,
political, veterans' or fraternal organizations,
tax supported organizations, or United Way
recipients. No grants to individuals.
Publications: Application guidelines.
Application information: Include description
of the organization and project; detailed budget
and contributors list; board members' list;
501(c)(3) status letter and list of Syntex
employee connections, if any.
 Initial approach: Letter of inquiry
 Copies of proposal: 1
 Deadline(s): None
 Board meeting date(s): Quarterly
 Write: Frank Koch, Dir., Corp. Contribs.
Number of staff: 1 full-time professional; 1 full-
time support.

306
Henri & Tomoye Takahashi Foundation
200 Rhode Island St.
San Francisco 94103

Established in 1985 in CA.
Financial data (yr. ended 12/31/87): Assets,
$1,086,891 (M); gifts received, $325,000;
expenditures, $27,561, including $22,700 for 8
grants (high: $5,000; low: $1,200).
Purpose and activities: Supports Japanese
cultural programs and Japanese American cross-
cultural projects.
Officers and Directors: Henri Takahashi,
Pres.; Martha Suzuki, Secy.; Tomaye Takahashi,
Treas.
Employer Identification Number: 942977890

307
The Tang Foundation
c/o Leslie W. Tang
944 Market St., Suite 610
San Francisco 94102-4010

Established in 1984 in CA.
Financial data (yr. ended 10/31/87): Assets,
$3,899,208 (M); gifts received, $1,500,000;
expenditures, $211,882, including $191,750
for 6 grants (high: $80,000; low: $250).
Purpose and activities: Support primarily for
museums and for higher education.
Application information:
 Deadline(s): None
Officers and Directors:* Jack C.C. Tang,*
Pres; Madeline H. Tang, V.P.; Martin Y. Tang,
V.P.; Leslie W. Tang, Secy. and C.F.O.
Employer Identification Number: 942963249

308
The Thornton Foundation
523 West Sixth St., Suite 636
Los Angeles 90014 (213) 629-3867

Incorporated in 1958 in CA.
Donor(s): Charles B. Thornton,† Flora L.
Thornton.
Financial data (yr. ended 12/31/87): Assets,
$6,000,000 (M); gifts received, $90,000;
expenditures, $99,000, including $90,000 for
10 grants (high: $50,000; low: $100).
Purpose and activities: Emphasis on higher
and secondary education and cultural programs.
Types of support: Operating budgets,
continuing support, annual campaigns, building
funds, endowment funds, research.
Limitations: Giving primarily in CA. No grants
to individuals, or for seed money, emergency
funds, deficit financing, equipment, land
acquisition, demonstration projects,
publications, conferences, scholarships, or
fellowships; no loans.
Application information:
 Initial approach: Letter
 Deadline(s): None
 Board meeting date(s): As required
 Final notification: 1 month
 Write: Charles B. Thornton, Jr., Pres.
Officers and Trustees:* Charles B. Thornton,
Jr.,* Pres.; William Laney Thornton,* V.P.;
Robert E. Novell, Secy.
Number of staff: 2 part-time professional; 2
part-time support.
Employer Identification Number: 956037178

309
Flora L. Thornton Foundation
c/o Edward A. Landry
4444 Lakeside Dr., Suite 300
Burbank 91505

Established in 1983 in CA.
Donor(s): Flora L. Thornton.
Financial data (yr. ended 11/30/88): Assets,
$3,941,470 (M); expenditures, $295,230,
including $287,870 for 28 grants (high:
$100,000; low: $200).
Purpose and activities: Grants primarily for
culture, with emphasis on music, and for
secondary and higher education; some support
for a foundation.

Application information:
 Deadline(s): None
 Write: Flora L. Thornton, Trustee
Trustees: Edward A. Landry, Glen P.
McDaniel, Flora L. Thornton, William L.
Thornton.
Employer Identification Number: 953855595

310
John M. & Sally B. Thornton Foundation
2125 Evergreen St.
San Diego 92106

Established in 1982 in CA.
Financial data (yr. ended 9/30/88): Assets,
$2,429,874 (M); gifts received, $241,600;
expenditures, $444,296, including $432,684
for 66 grants (high: $190,000; low: $10).
Purpose and activities: Giving primarily for
cultural programs, education, and health
services; support also for a community
foundation.
Types of support: Operating budgets.
Application information: Contributes only to
pre-selected organizations. Applications not
accepted.
Officers and Directors: Sally B. Thornton,
Pres.; John M. Thornton, Secy.; Mark B.
Thornton, Steven B. Thornton.
Employer Identification Number: 953800986

311
Ticor Foundation
P.O. Box 92790
Los Angeles 90009 (213) 852-6311

Incorporated in 1952 in CA.
Donor(s): Ticor, and its subsidiaries.
Financial data (yr. ended 12/31/87): Assets,
$2,752,723 (M); expenditures, $221,788,
including $196,000 for 40 grants (high:
$40,000; low: $500) and $25,788 for
employee matching gifts.
Purpose and activities: Emphasis on
community funds, private higher education,
cultural programs, hospitals, youth agencies,
and social services.
Types of support: General purposes,
continuing support, annual campaigns, building
funds, employee matching gifts.
Limitations: Giving primarily in CA and the
Pacific Northwest. No support for secondary
education. No grants to individuals, or for
endowment funds, research, operating grants to
organizations receiving money from community
funds, scholarships, or fellowships; no loans.
Application information:
 Initial approach: Proposal
 Copies of proposal: 1
 Deadline(s): Submit proposal preferably in
 June or Dec.; no set deadline
 Board meeting date(s): Feb. and Nov.
 Final notification: 3 months
 Write: Virginia Veracka, Exec. Dir.
Officers: Winston V. Morrow,* Chair. and
Pres.; G.L. Ippel,* V.P.; Virginia Veracka, V.P.,
Secy.-Treas., and Exec. Dir.
Trustees:* Ernest J. Loebbecke, William T.
Seitz, Leonard T. Wood.
Number of staff: 1
Employer Identification Number: 956030995

312
The Times Mirror Foundation
Times Mirror Sq.
Los Angeles 90053 (213) 237-3945

Incorporated in 1962 in CA.
Donor(s): The Times Mirror Co.
Financial data (yr. ended 12/31/87): Assets,
$10,209,714 (M); gifts received, $6,000,000;
expenditures, $5,708,700, including
$5,700,844 for 143 grants (high: $600,000;
low: $1,500; average: $5,000-$200,000).
Purpose and activities: Giving largely for
higher education, including liberal arts, business
and communications programs, and arts and
culture; support also for health, community
service, and civic organizations.
Types of support: Operating budgets, annual
campaigns, seed money, building funds,
endowment funds, program-related
investments, scholarship funds, continuing
support, capital campaigns, equipment, general
purposes, renovation projects, special projects.
Limitations: Giving primarily in communities
served by the company's subsidiaries, with
emphasis on southern CA. No support for
religious organizations. No grants to
individuals, or for publications, conferences, or
films; no loans.
Publications: Corporate giving report
(including application guidelines).
Application information:
 Initial approach: 2-3 page letter
 Copies of proposal: 1
 Deadline(s): May 1 and Oct. 15
 Board meeting date(s): June and Dec.
 Final notification: June 30 or Jan. 15
 Write: Cassandra Malry, Treas.
Officers: Robert F. Erburu,* Chair.; Charles R.
Redmond,* Pres.; Donald S. Kellerman,* V.P.;
Stephen C. Meier, Secy.; Cassandra Malry,
Treas.
Directors:* Tom Johnson, David Laventhol,
Phillip L. Williams, Donald F. Wright.
Number of staff: 1 full-time professional; 1 full-
time support.
Employer Identification Number: 956079651

313
Timken-Sturgis Foundation
401 B St., Suite 1700
San Diego 92101 (619) 699-2782

Incorporated in 1949 in CA.
Donor(s): The Timken family, Valerie T.
Whitney.†
Financial data (yr. ended 11/30/87): Assets,
$1,387,040 (M); expenditures, $105,459,
including $90,100 for 29 grants (high: $15,000;
low: $100).
Purpose and activities: Giving for education,
medical research, and health services; support
also for cultural programs.
Types of support: Research, professorships.
Limitations: Giving primarily in southern CA
and NV. No grants to individuals, or for
general support, capital or endowment funds,
or matching gifts; no loans.
Application information:
 Initial approach: Letter
 Copies of proposal: 1
 Deadline(s): None
 Board meeting date(s): As required

 Final notification: 1 month
 Write: Kenneth G. Coveney, Secy.
Officers and Trustees: George R. Sturgis,
Pres.; Judy Price Sturgis, V.P.; William T.
Sturgis, V.P.; Kenneth G. Coveney, Secy.;
Joannie Barrancotto, Treas.
Number of staff: None.
Employer Identification Number: 956048871

314
Toyota Motor Sales, U.S.A.
Contributions Fund, Inc.
19001 South Western Ave.
Torrance 90501 (213) 618-4726

Donor(s): Toyota Motor Sales U.S.A., Inc.
Financial data (yr. ended 6/30/87): $95,000
for 3 grants (high: $50,000; low: $2,000).
Purpose and activities: Giving for health
services, youth, education, and cultural
programs.
Limitations: No support for religious groups, or
military, political, or lobbying organizations.
No grants to individuals.
Application information:
 Initial approach: Proposal
 Deadline(s): None
 Write: Kurt Von Zumwalt
Officers: Yukiyasu Togo, Pres.; Yale Gieszl, Sr.
V.P.; Yoshio Ishizaka, V.P.; Takao Kawamura,
V.P.; Akira Kisaki, Secy.-Treas.; Robert
McCurry.
Employer Identification Number: 953255038

315
Toyota USA Foundation
19001 South Western Ave.
Torrance 90509 (213) 618-6766

Established in 1987 in CA.
Financial data (yr. ended 6/30/88): Assets,
$10,424,452 (M); gifts received, $3,000,000;
expenditures, $283,334, including $264,000
for 10 grants (high: $52,000; low: $5,000).
Purpose and activities: Support for health and
community services, for the aged, minorities,
and youth, education programs promoting
literacy, aiding minorities, early childhood and
post-secondary levels of study, and cultural
programs.
Types of support: Special projects.
Limitations: No support for religious, fraternal,
veterans', or labor groups; or military, political,
or lobbying organizations. No grants to
individuals, or for trips, tours, seminars,
advertising, deficit reduction, or fundraising
dinners.
Publications: Informational brochure,
application guidelines.
Application information:
 Deadline(s): Feb. 15, May 15, Aug. 15, and
 Nov. 15
 Write: Kimberly Byron
Officers: Yukiyasu Togo, Pres.; Yale Gieszl,
V.P. and Secy.; Yoshio Ishizaka, V.P.; Takao
Kawamura, V.P.; Shiro Maruta, Treas.; Robert
B. McCurry.
Recent arts and culture grants:
Fine Arts Museums of San Francisco, San
 Francisco, CA, $25,000. To fund two
 exhibitions of Japanese art: Modern Japanese

prints and Images of Men in Japanese Prints.
 4/19/88.
Grove Theater, Garden City, CA, $25,000. To
 fund company's 1988 Shakespeare festival.
 4/19/88.
K R M A-Channel 6 TV, Denver, CO, $26,000.
 To produce television documentary, On
 Challenged Wings, for broadcast in Denver
 and syndication to other Public Broadcasting
 Service stations. Documentary will feature
 handicapped people who have taken on
 challenge of expanding their lives through
 high risk adventure and recreation. 4/19/88.
Los Angeles Chamber Orchestra, Pasadena,
 CA, $52,000. To underwrite taping of
 Orchestra's 1988 season and broadcast on
 KUSC-FM Radio and American Public Radio
 network. 4/19/88.

316
Transamerica Life Insurance Companies
Giving Program
1150 South Olive St., T-2900
Los Angeles 90015 (213) 742-3600

Purpose and activities: Support for wellness
and health, youth, civic affairs, housing,
hunger, homelessness, the elderly, education,
minority groups, the arts, and the difficult to
employ. Priority is given to programs that have
not traditionally received assistance from large
charitable campaigns. Provides in-kind services
seasonally, depending on availability.
Transamerica Life Companies do adhere to an
annual budget, but will accept properly
documented requests throughout the year.
Depending on the size and nature of the
request, assistance may not be available during
a current funding cycle. A file of all requests is
maintained and some programs are funded on
a rotating basis.
Types of support: In-kind gifts.
Limitations: Giving primarily in Los Angeles,
CA. No support for religious organizations,
except secular programs that are open to the
whole community; for-profit organizations;
fraternal, labor, or veterans' organizations, or
athletic, social, or country clubs; organizations
that are United Way recipients; organizations
whose activities are not in the best interest of
Transamerica Life Insurance Companies, their
employees, policy holders, or business
communities. No grants to individuals.
Publications: Informational brochure,
application guidelines.
Application information: Include project
description, amount requested, complete
budget including a statement of fundraising
expenses, list of major donors, most recent
audited financial statement, list of board
members and officers, and brief review of past
TLC grants. A site visit may be requested.
 Initial approach: Letter and proposal
 Deadline(s): None
 Final notification: As promptly as possible
 Write: Gillian Nash

317
Transition Foundation
One Wilshire Bldg., Suite 1600
Los Angeles 90017 (213) 629-0349

Established in 1968 in CA.
Donor(s): Frances B. McAllister.
Financial data (yr. ended 12/31/86): Assets, $5,111 (M); gifts received, $298,265; expenditures, $300,378, including $300,000 for 1 grant.
Purpose and activities: Giving primarily for a horticulture institute and biological research; support also for the arts and museums.
Limitations: Giving limited to Coconino County, AZ. No grants to individuals.
Application information:
 Initial approach: Brief proposal with copy of IRS exemption and financial statements
 Deadline(s): None
 Write: John S. Warren, Secy.
Officers and Directors: Frances B. McAllister, Pres.; John S. Warren, Secy.-Treas.; Katherine Chase, Otto Franz, Rayma Sharber.
Employer Identification Number: 952563618

318
Trefethen Foundation
c/o John Crncich & Co.
300 Lake Side Dr., No. 1086
Oakland 94612

Established in 1980 in CA.
Donor(s): Catherine M. Trefethen, E.E. Trefethen, Jr.
Financial data (yr. ended 12/31/87): Assets, $172,900 (M); gifts received, $86,156; expenditures, $193,277, including $189,400 for 48 grants (high: $50,000; low: $100).
Purpose and activities: Support primarily for higher education.
Types of support: Annual campaigns, building funds.
Limitations: Giving primarily in CA.
Application information: Contributes only to pre-selected organizations. Applications not accepted.
Officers: E.E. Trefethen, Jr., Pres.; Catherine M. Trefethen, V.P. and Secy.; John V. Trefethen, V.P. and C.F.O.; Carla J. Saunders, V.P.
Employer Identification Number: 942739938

319
Alice Tweed Tuohy Foundation
1006 Santa Barbara St.
Santa Barbara 93101 (805) 963-0675
Mailing address: P.O. Box 2578, Santa Barbara, CA 93120

Incorporated in 1956 in CA.
Donor(s): Alice Tweed Tuohy.†
Financial data (yr. ended 6/30/88): Assets, $11,219,719 (M); expenditures, $731,026, including $524,899 for 45 grants (high: $103,750; low: $500; average: $1,000-$10,000).
Purpose and activities: Grants for higher education, art as related to higher education, hospital care, patient rehabilitation, and youth programs; substantial support also for the art

program at the Duluth campus of the University of Minnesota.
Types of support: Seed money, matching funds, building funds, equipment, land acquisition, scholarship funds, renovation projects.
Limitations: Giving limited to the Santa Barbara, CA, area. No support for private foundations. No grants to individuals, or for operating budgets, national campaigns, research, unrestricted purposes, and rarely for endowment funds; no loans.
Publications: Annual report (including application guidelines).
Application information:
 Initial approach: Letter
 Copies of proposal: 5
 Deadline(s): Submit proposal between July 1 and Sept. 15; proposals received after deadline may be deferred for a year
 Board meeting date(s): Apr. or May, and Nov.
 Final notification: 2 to 3 months
 Write: Harris W. Seed, Pres.
Officers and Directors: Harris W. Seed, Pres.; Eleanor Van Cott, Exec. V.P. and Secy.-Treas.; Lorenzo Dall'Armi, Jr., John R. Mackall, Paul W. Hartloff, Jr.
Number of staff: 2 part-time professional.
Employer Identification Number: 956036471
Recent arts and culture grants:
Lobero Theater Foundation, Santa Barbara, CA, $10,000. Toward renovation of patio area for general improvement of landmark building and as income generator for rehearsals, cast parties and receptions. 1987.
Santa Barbara Trust for Historic Preservation, Santa Barbara, CA, $10,200. For development of Presidio Archive Research Center in adobe dwelling behind Canedo Adobe. 1987.
University of California at Santa Barbara Foundation, Santa Barbara, CA, $10,000. For continuing support of new University Art Museum building which is under construction. 1987.
University of Minnesota Foundation, Duluth, MN, $82,500. For benefit of Tweed Museum of Art and Department of Art at Duluth Campus for art scholarships. 1987.

320
U. S. Leasing Corporate Giving Program
733 Front St., M/S 12
San Francisco 94111 (415) 627-9710

Financial data (yr. ended 12/31/88): Total giving, $462,457, including $422,457 for 100 grants (high: $7,500; low: $500; average: $1,000-$5,000) and $40,000 for employee matching gifts.
Purpose and activities: Supports a wide range of social services, legal services, civic and public affairs, AIDS programs, community development, arts and culture, employment, and elementary education where employees have made a regular volunteer commitment.
Types of support: Matching funds, general purposes, publications, employee matching gifts, operating budgets, special projects.
Limitations: Giving primarily in the San Francisco Bay area, CA. No support for political, religious or sectarian activities.

Application information: Provide name of employee and nature of volunteer commitment, description of organization and clients served, project budget, board member list and major donor list, 501(C)(3) status letter, and a recently audited financial statement.
 Initial approach: Letter and proposal
 Copies of proposal: 1
 Deadline(s): None
 Board meeting date(s): 6 times a year
 Final notification: Notice of denial sent
 Write: Sherry Reson, Contribs. Mgr.
Number of staff: 1 part-time professional.

321
UCLA Foundation Charitable Fund
405 Hilgard Ave.
Los Angeles 90024

Established in 1977 in CA.
Donor(s): James A. Collins, Hoyt S. Pardee, William A. Rutter, Jerome H. Snyder, David L. Abell.
Financial data (yr. ended 6/30/87): Assets, $474,531 (M); gifts received, $193,438; expenditures, $250,311, including $248,412 for 17 grants (high: $82,892; low: $594).
Purpose and activities: Support for higher education, particularly UCLA, cultural programs, youth organizations, and social services.
Types of support: General purposes.
Limitations: Giving primarily in CA.
Publications: 990-PF.
Application information: Contributes only to pre-selected organizations. Applications not accepted.
Officers and Directors:* William Finestone,* Chair.; Bertrand I. Ginsberg,* Pres.; Richard P. Carlsberg,* V.P.; Eugene S. Rosenfeld,* V.P.; Roger A. Meyer, Secy.; Jo Ann Hankin,* C.F.O.
Employer Identification Number: 953169709

322
UCLA Foundation Charitable Fund III
405 Hilgard Ave.
Los Angeles 90024

Established in 1985 in CA.
Donor(s): Albert B. Glickman, Mrs. Albert B. Glickman.
Financial data (yr. ended 6/30/87): Assets, $1,135,038 (M); expenditures, $181,070, including $174,516 for 14 grants (high: $100,000; low: $1,000).
Purpose and activities: Support primarily for education and culture.
Types of support: General purposes.
Limitations: Giving primarily in CA.
Publications: 990-PF.
Application information: Contributes only to pre-selected organizations. Applications not accepted.
Officers and Directors:* William Finestone,* Chair.; Bertrand I. Ginsberg,* Pres.; Richard P. Carlsberg,* V.P.; Eugene S. Rosenfeld,* V.P.; Roger A. Meyer, Secy.; Jo Ann Hankin,* C.F.O.
Employer Identification Number: 953975787

323
Union Bank Foundation
P.O. Box 3100
Los Angeles 90051 (213) 236-5826

Trust established in 1953 in CA.
Donor(s): Union Bank.
Financial data (yr. ended 12/31/86): Assets, $23,611 (M); gifts received, $450,000; expenditures, $550,838, including $529,644 for 114 grants (high: $230,000; low: $10) and $21,092 for 109 employee matching gifts.
Purpose and activities: Emphasis on community funds, higher education, hospitals, cultural programs, social services, and youth.
Types of support: General purposes, operating budgets, continuing support, annual campaigns, emergency funds, building funds, equipment, employee matching gifts.
Limitations: Giving primarily in CA, particularly in areas of company operations. No grants to individuals, or for endowment funds, scholarships, fellowships, or research; no loans.
Application information:
 Initial approach: Proposal
 Copies of proposal: 1
 Deadline(s): Submit proposal preferably in Jan.; no set deadline
 Board meeting date(s): Monthly
 Final notification: 3 months
Trustee: Union Bank.
Number of staff: 3
Employer Identification Number: 956023551

324
Unocal Foundation
1201 West Fifth St.
Los Angeles 90017 (213) 977-6172
Mailing address for applications: P.O. Box 7600, Los Angeles, CA 90051

Incorporated in 1962 in CA.
Donor(s): Unocal Corp.
Financial data (yr. ended 1/31/88): Assets, $5,481,295 (M); expenditures, $3,054,932, including $2,702,942 for 263 grants (high: $100,000; low: $500; average: $1,000-$20,000) and $325,143 for 1,670 employee matching gifts.
Purpose and activities: Giving primarily for higher education and various national organizations, including those concerned with energy.
Types of support: Annual campaigns, continuing support, employee matching gifts, fellowships, research, scholarship funds, employee-related scholarships, equipment.
Limitations: Giving primarily in areas of parent company operations in CA, IL, and TX. No support for veterans', fraternal, sectarian, social, religious, athletic, choral, band, or similar groups; trade or business associations; political or lobbying organizations; state agencies and departments; or elementary or secondary education. No grants to individuals, or for general purposes, capital funds for education, endowment funds, courtesy advertising, conferences, supplemental operating support to recipients of United Funds, or for trips or tours; no loans.
Publications: Annual report.
Application information: Application form required for employee-related scholarships.

Initial approach: Letter
Copies of proposal: 1
Deadline(s): Sept. 15
Board meeting date(s): As required
Final notification: 6 to 8 weeks
Write: R.P. Van Zandt, V.P.
Officers: Fred L. Hartley,* Pres.; R.P. Van Zandt,* V.P.; R.O. Hedley,* Secy.; E.H. Powell, Treas.
Trustees:* William H. Doheny, Richard J. Stegmeier.
Number of staff: 1 full-time professional; 1 full-time support; 2 part-time support.
Employer Identification Number: 956071812

325
The Upjohn California Fund
P.O. Box 169
Carmel Valley 93924 (408) 659-4662

Incorporated in 1955 in CA.
Financial data (yr. ended 10/31/86): Assets, $1,973,378 (M); expenditures, $165,841, including $134,800 for 61 grants (high: $20,000; low: $500; average: $1,000-$2,500).
Purpose and activities: Support for hospitals and medical research, education, including secondary schools, civic and cultural affairs, child welfare, and youth.
Limitations: Giving primarily in northern CA. No grants to individuals.
Application information:
 Initial approach: Letter, followed by proposal
 Copies of proposal: 1
 Deadline(s): None
 Board meeting date(s): Mar., June, Sept., and Dec.
 Write: Eugene C. Wheary, Pres.
Officers and Directors: Eugene C. Wheary, Pres.; Ronald Larson, V.P.; John W. Broad, Secy.; Edwin W. Macrae, C.E.O.
Employer Identification Number: 946065219

326
Ernst D. van Loben Sels-Eleanor Slate van Loben Sels Charitable Foundation
235 Montgomery St., No. 1635
San Francisco 94104 (415) 983-1093

Incorporated in 1964 in CA.
Donor(s): Ernst D. van Loben Sels.†
Financial data (yr. ended 12/31/88): Assets, $8,678,274 (M); expenditures, $428,750 for 67 grants (high: $60,000; low: $500; average: $1,000-$20,000).
Purpose and activities: Priority given to nonrecurring grants in support of projects which will test potentially useful innovations in the areas of education, health, welfare, humanities, and the environment.
Types of support: Seed money, emergency funds, matching funds, special projects, research, publications, conferences and seminars, loans.
Limitations: Giving limited to northern CA. No support for national organizations unless for a specific local project, or to projects requiring medical, scientific, or other technical knowledge for evaluation. No grants to individuals, or for operating budgets, continuing support, deficit financing, capital or endowment funds, scholarships, or fellowships.

Publications: Annual report, program policy statement, application guidelines.
Application information:
 Initial approach: Proposal, letter, or telephone
 Copies of proposal: 3
 Deadline(s): None
 Board meeting date(s): About every 6 weeks
 Final notification: 3 to 4 weeks
 Write: Claude H. Hogan, Pres.
Officers and Directors: Claude H. Hogan, Pres.; Edward A. Nathan, V.P.; Toni Rembe, Secy.-Treas.
Number of staff: None.
Employer Identification Number: 946109309

327
Varian Associates Corporate Giving Program
611 Hansen Way
Palo Alto 94303 (415) 493-4000

Financial data (yr. ended 12/31/88): $750,000 for grants (high: $50,000; low: $500).
Purpose and activities: Support for education in engineering, science, business, and medicine. Areas of principal activity are equipment grants, engineering and science faculty development, science and engineering-oriented Affirmative Action and student fellowship programs, and university high technology centers. Grants also to science, math, and business education programs at the secondary level; employee matching gift program for higher education. Grants generally are confined to United Way in communities where Varian has major operations; employee's contributions to such United Way contributions are matched. Interest in initiatives that involve public/private partnerships; grants have been made in such fields as environmental improvement, transportation services, and housing; grants also made occasionally to selected arts and cultural programs with emphasis on local programs which either build creative bridges between the sciences and the humanities, or promote audience development.
Types of support: Annual campaigns, building funds, capital campaigns, matching funds, employee-related scholarships, scholarship funds, seed money, special projects.
Limitations: Giving primarily in communities where there are manufacturing operations or where a large number of employees live; limited amount of national giving in fields of communications, engineering, medicine, science, and technology. No support for fraternal or religious groups or disease-related organizations. No grants to individuals, or for research projects; advertising campaigns; conferences, seminars and meetings; film or other creative productions. Employee matching gifts limited to higher education and United Way.
Publications: Informational brochure (including application guidelines).
Application information:
 Initial approach: Written proposal
 Copies of proposal: 1
 Deadline(s): End of Aug. for consideration in the upcoming year
 Board meeting date(s): Fall
 Final notification: Within 4 weeks
 Write: Derrel De Passe, Dir., Govt. Affairs

328
The Elizabeth Firth Wade Endowment Fund

114 East De la Guerra St., No. 7
Santa Barbara 93101 (805) 963-8822

Trust established in 1961 in CA; incorporated in 1979.
Donor(s): Elizabeth Firth Wade.†
Financial data (yr. ended 1/31/87): Assets, $2,872,153 (M); expenditures, $209,388, including $120,500 for 19 grants (high: $25,000; low: $500).
Purpose and activities: Support for youth agencies, the handicapped, education, and cultural programs.
Application information:
Initial approach: Letter
Deadline(s): None
Write: Patricia M. Brouard, Secy.-Treas.
Officers and Directors: Arthur R. Gaudi, Pres.; Steven M. Anders, V.P.; Patricia M. Brouard, Secy.-Treas.
Employer Identification Number: 953610694

329
T. B. Walker Foundation

P.O. Box 330112
San Francisco 94133

Incorporated in 1925 in MN; reincorporated partially in 1976 in CA.
Donor(s): T.B. Walker,† Gilbert M. Walker.†
Financial data (yr. ended 9/30/88): Assets, $5,142,422 (M); expenditures, $320,841, including $276,000 for 66 grants (high: $37,000; low: $1,000).
Purpose and activities: Interests primarily in the arts and other cultural and educational programs, with some support for population control, and youth and social agencies.
Types of support: Continuing support, annual campaigns, research, special projects.
Limitations: Giving limited to CA. No grants to individuals.
Application information: Contributes only to pre-selected organizations. Applications not accepted.
Officers and Trustees: John C. Walker, Pres.; Harriet W. Henderson, 2nd V.P.; Colleen Marsh, Secy.; Brooks Walker, Jr., Treas.; Ann M. Hatch, Wellington S. Henderson, Jr., R. Lance Walker, S. Adrian Walker, Jean W. Yeates, Jeffrey L. Yeates.
Number of staff: None.
Employer Identification Number: 521078287

330
Warren Family Foundation

P.O. Box 915
Rancho Santa Fe 92067

Established in 1977 in CA.
Donor(s): Frank R. Warren, Joanne C. Warren.
Financial data (yr. ended 6/30/87): Assets, $1,106,400 (M); gifts received, $150,750; expenditures, $100,676, including $93,261 for 87 grants (high: $13,300; low: $20).
Purpose and activities: Emphasis on cultural programs and the performing arts, health and social service agencies, and education.
Limitations: Giving primarily in CA.

Officer: Joanne C. Warren, Pres.
Directors: Richard K. Colbourne, Frank R. Warren.
Employer Identification Number: 953201177

331
Wasserman Foundation

10920 Wilshire Blvd., Suite 1200
Los Angeles 90024-6514

Incorporated in 1956 in CA.
Donor(s): Lew R. Wasserman, Edith Wasserman.
Financial data (yr. ended 12/31/87): Assets, $18,026,844 (M); expenditures, $1,248,394, including $1,228,072 for grants (high: $1,008,047).
Purpose and activities: Emphasis on hospitals and medical research, Jewish welfare funds, higher education, public policy groups, and the performing arts.
Types of support: Capital campaigns, endowment funds, research, scholarship funds.
Limitations: Giving primarily in CA.
Application information: Contributes only to pre-selected organizations. Applications not accepted.
Write: William J. Bird, V.P.
Officers and Directors: Lew R. Wasserman, Pres.; Edith Wasserman, V.P., C.F.O. and Secy.; William J. Bird, V.P.; Sidney Jay Sheinberg, V.P.; Allen E. Susman, V.P.; Thomas Wertheimer, V.P.; Carol Ann Leif, Lynne Wasserman.
Employer Identification Number: 956038762

332
Weingart Foundation

1200 Wilshire Blvd., Suite 305
Los Angeles 90017-1984 (213) 482-4343
Mailing address: P.O. Box 17982, Los Angeles, CA 90017-0982

Incorporated in 1951 in CA.
Donor(s): Ben Weingart,† Stella Weingart.†
Financial data (yr. ended 6/30/88): Assets, $377,131,937 (M); gifts received, $890,000; expenditures, $18,504,246, including $13,721,520 for 144 grants (high: $1,300,000; low: $500; average: $10,000-$250,000) and $3,500,000 for loans.
Purpose and activities: Support for community services, health and medicine, higher education, including a student loan program, and public policy, with emphasis on programs for children and youth.
Types of support: Seed money, building funds, equipment, matching funds, special projects, research, renovation projects, capital campaigns, research.
Limitations: Giving limited to southern CA. No support for environmental, refugee, or religious programs, international concerns, or federated fundraising groups. No grants to individuals, or for endowment funds, normal operating expenses, annual campaigns, emergency funds, deficit financing, land acquisition, scholarships, fellowships, seminars, conferences, publications, workshops, travel, or surveys.
Publications: Annual report, application guidelines.

Application information: Student loan program limited to 14 private colleges and universities in southern CA. Application form required.
Initial approach: Letter
Copies of proposal: 12
Deadline(s): None
Board meeting date(s): Bimonthly, except July and Aug.
Final notification: 3 to 4 months
Write: Charles W. Jacobson, Pres.
Officers: Charles W. Jacobson, Pres.; Ann Van Dormolen, V.P. and Treas.; Laurence A. Wolfe, V.P.
Directors: Harry J. Volk, Chair.; John T. Gurash, William J. McGill, Sol Price, Dennis Stanfill.
Number of staff: 3 full-time professional; 7 full-time support.
Employer Identification Number: 956054814
Recent arts and culture grants:
Bernice P. Bishop Museum, Honolulu, HI, $100,000. To renovate and upgrade planetarium's facilities and equipment. 1987.
California Institute of Technology, Pasadena, CA, $34,260. For final installment of five-year grant for special educational programs in humanities and microsciences. 1987.
California Museum Foundation, Los Angeles, CA, $302,000. Toward development of prototype chemistry exhibit. 1987.
Performing Arts Council of the Music Center, Los Angeles, CA, $50,000. To support special music and arts programs for school children. 1987.
Saint Margaret of Scotland Episcopal School, Southgate, CA, $25,000. Toward construction of new gymnasium, fine arts building and preschool teaching center. 1987.
Southwest Museum, Los Angeles, CA, $25,000. Toward creation of computerized catalog system. 1987.

333
The Frederick R. Weisman Art Foundation

(Formerly The Frederick R. Weisman Collection)
10350 Santa Monica Blvd., Suite 160
Los Angeles 90025 (213) 556-2235

Established in 1982 in CA.
Donor(s): Frederick R. Weisman, Frederick Weisman Co.
Financial data (yr. ended 1/31/89): Assets, $12,321,951 (M); gifts received, $2,606,309; expenditures, $1,176,178, including $110,072 for 18 grants (high: $32,950; low: $70) and $600,000 for 4 foundation-administered programs.
Purpose and activities: Support towards the improvement of the public's understanding of contemporary visual art.
Publications: Occasional report.
Application information: Applications not accepted.
Initial approach: Letter
Deadline(s): None
Write: Mitchell L. Reinschreiber, C.F.O. and Exec. V.P., or Charles E. Castle, Admin.
Officers and Trustees: Frederick R. Weisman, Pres.; Mitchell L. Reinschreiber, C.F.O. and Exec. V.P.; Henry T. Hopkins, Exec. V.P.; Lee Larssen Romaniello, Secy.; Billie Milam, Judith

Pisar, Edward Ruscha, Marcia S. Weisman, Milton Wexler.
Number of staff: 4 full-time professional; 1 full-time support; 1 part-time support.
Employer Identification Number: 953767861

334
The David & Sylvia Weisz Foundation
1933 Broadway, Rm. 244
Los Angeles 90007

Established in 1980 in CA.
Financial data (yr. ended 10/31/88): Assets, $6,894,841 (M); expenditures, $1,054,825, including $665,250 for 82 grants (high: $200,000; low: $100).
Purpose and activities: Support primarily for Jewish welfare, cultural organizations, and social services; some support also for health services and hospitals.
Types of support: General purposes.
Officers and Directors: Sylvia Weisz, Pres.; Richard Miller, Secy.-Treas.; Donald Bean, Jay Grodin, Louis Leviton.
Employer Identification Number: 953551424

335
Wells Family Charitable Foundation
712 North Palm Dr.
Beverly Hills 90210 (213) 274-2884

Established in 1985 in CA.
Financial data (yr. ended 12/31/87): Assets, $887,203 (M); expenditures, $126,436, including $116,867 for 58 grants (high: $26,000; low: $50).
Purpose and activities: Giving primarily for the arts; support also for health associations.
Application information:
 Initial approach: Letter
 Deadline(s): None
 Write: Frank G. Wells, V.P.
Officers: Luanne Wells, Pres.; Frank G. Wells, V.P. and Secy.-Treas.
Employer Identification Number: 953982216

336
Wells Fargo Foundation
420 Montgomery St., MAC 0101-111
San Francisco 94163 (415) 396-3568

Established in 1978 in San Francisco.
Donor(s): Wells Fargo Bank, N.A.
Financial data (yr. ended 12/31/87): Assets, $2,711,767 (M); gifts received, $1,445,268; expenditures, $5,789,580, including $4,773,021 for 823 grants (high: $1,500,000; low: $500; average: $1,000-$25,000).
Purpose and activities: Support for art and cultural programs, education, civic affairs organizations, social service agencies, and community funds.
Types of support: Special projects, renovation projects.
Limitations: Giving primarily in CA. No support for government agencies, United Way-supported agencies, hospitals, national health organizations, organizations with multiple chapters, religious activities, political purposes, or secondary schools. No grants to individuals, or for videotapes, films, advertising,

publications, endowments, research, conferences, or general operating budgets.
Publications: Corporate giving report, informational brochure.
Application information:
 Initial approach: Telephone or letter
 Copies of proposal: 1
 Deadline(s): 1 month prior to board meeting
 Board meeting date(s): Quarterly
 Final notification: Varies
 Write: Elisa Arevalo Boone, V.P.
Officers: Ronald E. Eadie,* Pres.; Elisa Arevalo Boone, V.P.
Directors:* Regina Chun, Michael J. Dasher, Terri Dial, Stephen A. Enna, Michael Gillfillan, Lois L. Rice.
Number of staff: 2 full-time professional; 3 full-time support.
Employer Identification Number: 942549743

337
The Whitelight Foundation
c/o Ernst & Whinney
1875 Century Park East, Suite 2200
Los Angeles 90067 (213) 553-2800

Established in 1980.
Donor(s): Betty Freeman.
Financial data (yr. ended 12/31/87): Assets, $133,383 (M); gifts received, $143,485; expenditures, $226,446, including $199,550 for 52 grants (high: $36,500; low: $250) and $12,000 for 1 grant to an individual.
Purpose and activities: Giving primarily for music, performing arts and fine arts organizations, and for social service agencies; grants also to established classical musicians in publishing new compositions, copying scores, and performing new compositions in grants generally not exceeding $7,000.
Types of support: Grants to individuals.
Limitations: Giving primarily in southern CA.
Application information: Individuals submit brief resume and outline of project, including budget.
 Initial approach: Letter
 Deadline(s): None
 Write: Betty Freeman, Trustee
Trustee: Betty Freeman.
Employer Identification Number: 953513930

338
Brayton Wilbur Foundation
320 California St., Suite 200
San Francisco 94104 (415) 772-4006

Incorporated in 1947 in CA.
Donor(s): Wilbur-Ellis Co., Connell Bros. Co., Ltd.
Financial data (yr. ended 12/31/87): Assets, $2,960,940 (M); gifts received, $50,000; expenditures, $205,121, including $181,425 for 53 grants (high: $35,000; low: $250; average: $1,000-$5,000).
Purpose and activities: Emphasis on the arts and on higher and secondary education; grants also for hospitals and church support.
Types of support: Annual campaigns, building funds, capital campaigns, continuing support, endowment funds.
Limitations: Giving primarily in San Francisco, CA. No grants to individuals.

Application information: Contributes only to preselected organizations. Applications not accepted.
 Write: Brayton Wilbur, Jr., Pres.
Officers and Directors: Brayton Wilbur, Jr., Pres.; Carter P. Thacher, V.P.; Herbert B. Tully, Secy.-Treas.
Employer Identification Number: 946088667

339
Marguerite Eyer Wilbur Foundation
P.O. Box B-B
Santa Barbara 93102 (805) 962-0011

Established in 1975 in CA.
Donor(s): Marguerite Eyer Wilbur.†
Financial data (yr. ended 6/30/87): Assets, $2,719,467 (M); expenditures, $245,189, including $100,971 for grants (high: $25,000; low: $500; average: $1,000-$6,000) and $82,500 for 17 grants to individuals.
Purpose and activities: Resident fellowships are provided to writers of promise, to live and work in Mecosta, MI, with preference given to writers in the areas of history, religion, or philosophy. Grants to individuals are provided to those who have demonstrated unique accomplishments or promise in humane literature, particularly in history, religion and philosophy and are personally known to one of the trustees.
Types of support: Operating budgets, annual campaigns, seed money, exchange programs, special projects, research, publications, conferences and seminars, fellowships, grants to individuals.
Limitations: No support for music or fine arts projects. No grants for continuing support, deficit financing, building or endowment funds, or land acquisition; no loans.
Publications: Program policy statement, application guidelines.
Application information:
 Initial approach: Proposal
 Copies of proposal: 1
 Deadline(s): Sept. 1 through Dec. 31
 Board meeting date(s): Feb.
 Final notification: Mar.
 Write: Gary R. Ricks, C.E.O.
Officers and Trustees: Russell Kirk, Pres.; William Longstreth, V.P.; F. Joseph Frawley, Secy.; Gary R. Ricks, C.E.O.
Number of staff: 1 full-time professional; 1 full-time support.
Employer Identification Number: 510168214

340
The Wilsey Foundation
P.O. Box 3532
San Francisco 94119

Established in 1964 in CA.
Donor(s): Alfred S. Wilsey, Wilsey Foods, Inc., Wilsey Bennett Co.
Financial data (yr. ended 3/31/88): Assets, $782,991 (M); gifts received, $250,000; expenditures, $153,962, including $150,450 for 84 grants (high: $25,000; low: $100).
Purpose and activities: Grants primarily for secondary and higher education, and to museums.

Limitations: Giving primarily in the San Francisco Bay Area, CA.
Application information:
Initial approach: Letter
Deadline(s): None
Officers: Alfred S. Wilsey, Pres.; Diane B. Wilsey, V.P.; Michael W. Wilsey, V.P.; Alfred S. Wilsey, Jr., Secy.; Jerome P. Solari, Treas.
Employer Identification Number: 946098720

341
The Peg Yorkin Foundation
(Formerly The Yorkin Foundation)
2176 Century Hill
Los Angeles 90067

Established in 1979 in CA.
Donor(s): Peg Yorkin.
Financial data (yr. ended 11/30/88): Assets, $44,124 (M); gifts received, $85,360; expenditures, $189,953, including $182,595 for 189 grants (high: $35,000; low: $100; average: $1,442).
Purpose and activities: Giving for arts and cultural programs, health, Jewish welfare, and a genetics foundation.
Types of support: Operating budgets, annual campaigns, seed money, emergency funds, special projects, research, conferences and seminars, continuing support, general purposes.
Limitations: Giving primarily in Los Angeles, CA. No grants to individuals, or for capital or endowment funds, deficit financing, scholarships, fellowships, or matching gifts; no loans.
Application information:
Initial approach: Letter
Copies of proposal: 1
Deadline(s): None
Board meeting date(s): Mar.
Final notification: 2 months
Write: Peg Yorkin, Pres.
Officers and Directors: Peg Yorkin, Pres.; Nicole Yorkin, Secy.; David Yorkin.
Number of staff: None.
Employer Identification Number: 953454331

342
Youth Development Foundation
3355 Via Lido, Suite 235
Newport Beach 92663-3917 (714) 675-6856

Established in 1953 in CA.
Financial data (yr. ended 11/30/88): Assets, $1,460,678 (M); expenditures, $72,086 for 37 grants (high: $10,000; low: $50).
Purpose and activities: Support primarily for education, child development, the performing arts, the environment, and animal welfare.
Types of support: General purposes, scholarship funds, special projects.
Limitations: Giving primarily in CA.
Application information: Application form required.
Initial approach: Letter
Copies of proposal: 2
Deadline(s): Feb.
Board meeting date(s): Mar.
Write: Frand R. Randall, Trustee
Trustees: Frank R. Randall, Joan P. Randall, Paul S. Randall.
Number of staff: 1 part-time support.
Employer Identification Number: 956087465

343
Virginia Zanuck Charitable Foundation
c/o Loeb & Loeb
10100 Santa Monica Blvd., No. 2200
Los Angeles 90067 (213) 282-2061

Established in 1983 in CA.
Donor(s): Richard Zanuck Charitable Trust, Virginia Zanuck Charitable Trust.
Financial data (yr. ended 8/31/87): Assets, $23,261 (M); gifts received, $191,220; expenditures, $176,572, including $175,160 for 43 grants (high: $66,250; low: $150).
Purpose and activities: Support primarily for higher education, museums, and film-related activities; some support for child welfare, the visually impaired, and health associations.
Limitations: Giving primarily in Los Angeles, CA.
Application information:
Deadline(s): None
Write: Andrew M. Katzenstein
Officers and Directors: Daryln Zanuck, Chair.; Richard Zanuck, Pres.; Sybil Brand, V.P. and C.F.O.; Lilli Zanuck, Secy.
Employer Identification Number: 953882409

344
The Zellerbach Family Fund
120 Montgomery St., Suite 2125
San Francisco 94104 (415) 421-2629

Incorporated in 1956 in CA.
Donor(s): Jennie B. Zellerbach.†
Financial data (yr. ended 12/31/87): Assets, $30,331,891 (M); expenditures, $1,983,122, including $1,317,864 for 182 grants (high: $67,370; low: $500; average: $5,000-$35,000).
Purpose and activities: Support for direct-service projects in the arts, health, mental health, and social and child welfare.
Types of support: Continuing support, technical assistance, special projects.
Limitations: Giving primarily in the San Francisco Bay Area, CA. No grants to individuals, or for capital or endowment funds, research, scholarships, or fellowships; no loans.
Publications: Annual report (including application guidelines).
Application information: Applications rarely granted; foundation develops most of its own grant proposals. The foundation is currently committed to projects underway and does not expect to make grants to new programs over the next few years. Community arts groups will continue to be funded.
Initial approach: Telephone or proposal
Copies of proposal: 1
Deadline(s): Submit full art proposal in 8 copies, preferably 2 weeks prior to board meeting
Board meeting date(s): Quarterly
Final notification: 1 week after board meeting for art applications
Write: Edward A. Nathan, Exec. Dir.
Officers: William J. Zellerbach,* Pres.; Louis J. Saroni II,* V.P. and Treas.; Robert E. Sinton,* V.P.; P.S. Ehrlich, Jr.,* Secy.; Edward A. Nathan,* Exec. Dir.
Directors:* Stewart E. Adams, Zachary Coney, Jeanette Dunckel, Lucy Ann Geiselman, George B. James,* Verneice Thompson, John W. Zellerbach.

Number of staff: 1 full-time professional; 2 part-time professional; 2 full-time support.
Employer Identification Number: 946069482
Recent arts and culture grants:
Fine Arts Museums of San Francisco, San Francisco, CA, $10,000. For general support. 1987.
ODC, San Francisco, CA, $5,000. For general support. 1987.
San Francisco Ballet, San Francisco, CA, $10,000. For general support. 1987.
San Francisco Opera, San Francisco, CA, $10,000. For general support. 1987.
San Francisco Symphony, San Francisco, CA, $26,668. For Special Endowment Fund challenge grant and operating expenses. 1987.
Western Public Radio, San Francisco, CA, $5,000. To produce demonstration radio program based on Word Weaving to be submitted for national competition. 1987.

345
Zoline Foundation
624 North Canon Dr.
Beverly Hills 90210

Established in 1954 in CA.
Donor(s): Janice K. Zoline, Joseph T. Zoline.
Financial data (yr. ended 11/30/88): Assets, $1,336,047 (M); expenditures, $83,745, including $80,075 for 50 grants (high: $20,000; low: $25; average: $25-$20,000).
Purpose and activities: Giving primarily for higher education, health associations, and social services.
Officers: Joseph T. Zoline,* Pres. and Treas.; Janice K. Zoline, Secy.-Treas.
Directors:* James L. Zacharias.
Employer Identification Number: 366083529

COLORADO

346
The Anschutz Family Foundation
2400 Anaconda Tower
555 17th St.
Denver 80202 (303) 293-2338

Established in 1979 in CO.
Donor(s): Fred B. Anschutz, Antelope Land and Livestock Co., Inc., Medicine Bow Ranch Co., Sue Anschutz Hegwill.
Financial data (yr. ended 11/30/88): Assets, $6,549,863 (M); gifts received, $200,000; expenditures, $781,195, including $606,900 for 140 grants (high: $55,000; low: $100; average: $5,000-$10,000).
Purpose and activities: Grants for the direct provision of human services, especially for children, the elderly, and the poor, including health services; support also for cultural programs, public policy, and urban development organizations.

Types of support: Special projects, operating budgets, continuing support, annual campaigns, seed money, emergency funds, technical assistance, publications, conferences and seminars.
Limitations: Giving primarily in CO, especially Denver. No support for programs of research organizations. No grants to individuals, or for capital or building funds, deficit financing, endowment funds, scholarships, or fellowships.
Publications: 990-PF, application guidelines.
Application information:
 Initial approach: Letter
 Copies of proposal: 1
 Deadline(s): Submit proposal before Mar. 1 and Sept. 1
 Board meeting date(s): Nov.
 Final notification: By Nov. 30
 Write: Sue Anschutz Rodgers, Pres.
Officers and Directors: Sue Anschutz Rodgers, Pres. and Exec. Dir.; Nancy P. Anschutz, V.P.; Philip F. Anschutz, V.P.; Hugh C. Braly, Secy.-Treas.; Fred B. Anschutz, Melinda A. Couzens, Melissa A. Rodgers, Susan E. Rodgers.
Number of staff: 1 full-time professional; 1 full-time support.
Employer Identification Number: 742132676

347
The Anschutz Foundation
2400 Anaconda Tower
555 17th St.
Denver 80202 (303) 293-2338

Established in 1984 in CO.
Donor(s): Philip F. Anschutz, The Anschutz Corp.
Financial data (yr. ended 11/30/87): Assets, $1,638,944 (M); gifts received, $13,230; expenditures, $519,441, including $393,523 for 50 grants (high: $122,848; low: $200).
Purpose and activities: General purposes; national giving with emphasis on social and cultural organizations which work in areas larger than local communities; support for public policy and traditional family values.
Types of support: General purposes, operating budgets, publications, conferences and seminars.
Limitations: No support for programs within educational or research institutions, or for cultural or arts organizations. No grants to individuals, or for capital campaigns or continuing support.
Publications: 990-PF, application guidelines.
Application information:
 Initial approach: Letter of no more than 2 pages
 Deadline(s): Sept. 1 and Mar. 1
 Board meeting date(s): Semiannually, May and Nov.
 Final notification: By Nov. 30 and by May 30
 Write: Sue Anschutz Rodgers, Pres.
Officers and Directors: Philip F. Anschutz, Chair.; Sue Anschutz Rodgers, Pres. and Exec. Dir.; Nancy P. Anschutz, V.P.; Hugh C. Braly, Secy.-Treas.; Fred B. Anschutz, James A. Applegate.
Number of staff: 1
Employer Identification Number: 742316617

348
Apache Corporation Giving Program
1700 Lincoln St., Suite 1900
Denver 80203-4519 (303) 837-5095

Purpose and activities: Supports arts and culture, education, health, social services, community development, and civic and urban programs; includes in-kind giving.
Types of support: In-kind gifts, building funds, special projects, employee matching gifts, operating budgets, special projects.
Limitations: Giving primarily in major operating locations in Denver, CO, Tulsa, OK, Houston, TX, and WY.
Publications: Application guidelines.
Application information:
 Write: Bruce Thomson, Community Relations Coord.

349
E. L. and Oma Bacon Foundation, Inc.
(Formerly E. L. Bacon Foundation, Inc.)
355 Main St.
Grand Junction 81501
Application address: P.O. Box 908, Grand Junction, CO 81502

Established in 1978 in CO.
Donor(s): E.L. Bacon,† Oma Bacon.†
Financial data (yr. ended 8/31/88): Assets, $2,050,045 (M); expenditures, $70,105, including $62,270 for 13 grants (high: $20,000; low: $100; average: $2,000-$10,000).
Purpose and activities: Support for health and social services, religion, culture, and community development.
Types of support: General purposes.
Limitations: Giving primarily in CO.
Publications: Application guidelines.
Application information:
 Initial approach: Letter requesting application guidelines
 Deadline(s): None
 Board meeting date(s): Meets on an on-call basis
 Write: Herbert L. Bacon, Pres.
Officers: Herbert L. Bacon, Pres.; Patrick A. Gormley, V.P.; Laura May Bacon, Secy.
Number of staff: None.
Employer Identification Number: 840772667

350
Boettcher Foundation
1670 Broadway, Suite 3301
Denver 80202 (303) 831-1937

Incorporated in 1937 in CO.
Donor(s): C.K. Boettcher,† Mrs. C.K. Boettcher,† Charles Boettcher,† Fannie Boettcher,† Ruth Boettcher Humphreys.†
Financial data (yr. ended 12/31/88): Assets, $92,442,850 (M); expenditures, $5,515,532, including $4,886,198 for grants.
Purpose and activities: Grants to educational institutions with emphasis on scholarships and fellowships, community and social services; hospitals and health; and civic and cultural programs.
Types of support: Scholarship funds, operating budgets, seed money, building funds, equipment, land acquisition, matching funds,

general purposes, annual campaigns, capital campaigns, renovation projects.
Limitations: Giving limited to CO. No grants to individuals, or for endowment funds.
Publications: Annual report, application guidelines.
Application information:
 Initial approach: Letter
 Copies of proposal: 1
 Deadline(s): None
 Board meeting date(s): Monthly
 Final notification: 2 to 3 months
 Write: William A. Douglas, Pres.
Officers: Hover T. Lentz,* Chair.; Claudia B. Merthan,* Vice-Chair.; William A. Douglas, Pres. and Exec. Dir.; John C. Mitchell II,* Secy.; George M. Wilfley,* Treas.
Trustees:* Mrs. Charles Boettcher II, E. Atwill Gilman, A. Barry Hirschfeld, Edward Lehman, Harry T. Lewis, Jr.
Number of staff: 2 full-time professional; 2 full-time support.
Employer Identification Number: 840404274
Recent arts and culture grants:
Artreach, Denver, CO, $7,000. Toward acquisition of needed equipment. 1987.
Central City Opera House Association, Denver, CO, $30,000. For operations. 1987.
Del Norte Neighborhood Development Corporation, Denver, CO, $12,500. Toward historic rental rehabilitation. 1987.
Denver Art Museum, Denver, CO, $250,000. Toward permanent endowment. 1987.
Denver Botanic Gardens, Denver, CO, $250,000. Toward permanent endowment. 1987.
Denver Museum of Natural History, Denver, CO, $100,000. Toward creation of new food facility. 1987.
Denver Symphony Orchestra, Denver, CO, $250,000. For permanent endowment. 1987.
Denver Symphony Orchestra, Denver, CO, $100,000. For 1987 Annual Maintenance Campaign. 1987.
Eden Theatrical Workshop, Denver, CO, $5,000. To support Plays for Living, Teenage Pregnancy Program. 1987.
Huerfano County Historical Society, La Veta, CO, $15,000. Toward museum project and restoration program. 1987.
Lyons Historical Society, Lyons, CO, $5,000. Toward fire protection system for Lyons Redstone Museum. 1987.
Manitou Springs Council for the Arts and Humanities, Manitou Springs, CO, $10,000. For start-up phase of Business of Art Center. 1987.
Northern Colorado Foundation for the Arts, Greeley, CO, $50,000. Toward construction of Greeley Civic Auditorium. 1987.
Opera Colorado, Denver, CO, $30,000. For operations. 1987.
Otero Museum Association, La Junta, CO, $5,000. Toward restoration and renovation program. 1987.

351
Bonfils-Stanton Foundation
1601 Arapahoe St., Suite 5
Denver 80202 (303) 825-3774

Established in 1968 in CO.
Donor(s): Charles E. Stanton.†

Financial data (yr. ended 6/30/88): Assets, $6,666,055 (M); expenditures, $470,350, including $305,505 for 16 grants (high: $50,000; low: $1,000).

Purpose and activities: Multi-purpose giving. The foundation acknowledges the importance of major categories of philanthropy: Education, Scientific, Health, Civic and Cultural, and Community and Human Services.

Types of support: Capital campaigns, equipment, fellowships, general purposes, land acquisition, lectureships, program-related investments, renovation projects, research, scholarship funds, special projects, technical assistance.

Limitations: Giving limited to CO. No support for religious organizations.

Publications: Annual report (including application guidelines), informational brochure.

Application information:
Initial approach: Proposal
Copies of proposal: 6
Deadline(s): Jan. 1, Apr. 1, July 1, and Oct. 1
Board meeting date(s): Apr., July, Sept., and Nov.
Write: William L. Funk, Exec. Dir.

Officers and Trustees: Robert E. Stanton, Pres. and Treas.; Benjamin F. Stapleton, V.P.; Eileen Greenawalt, Secy.; William L. Funk, Exec. Dir.; Louis J. Duman, Flaminia Odescalchi Kelly, Johnston R. Livingston.

Number of staff: 1 full-time professional; 2 full-time support.

Employer Identification Number: 846029014

352
Temple Hoyne Buell Foundation
2700 East Hampden Ave.
Englewood 80110 (303) 761-1717

Incorporated in 1962 in CO.
Donor(s): Temple Hoyne Buell.
Financial data (yr. ended 6/30/88): Assets, $27,837,600 (M); expenditures, $964,319, including $731,250 for 12 grants (high: $250,000; low: $100; average: $1,000-$100,000).

Purpose and activities: Giving primarily for higher education, including architecture, and for charitable organizations.

Types of support: Operating budgets, continuing support, annual campaigns, seed money, building funds, equipment, land acquisition, endowment funds, professorships, scholarship funds.

Limitations: Giving primarily in CO, with emphasis on Denver. No grants to individuals; no loans.

Publications: 990-PF.

Application information:
Initial approach: Letter
Deadline(s): None
Board meeting date(s): Quarterly
Final notification: 3 to 4 months

Officers and Trustees: Temple Hoyne Buell, Chair.; Jack Kent, Pres.; Jerome Lindberg, V.P.; Alexander M. Groos, Secy.-Treas.; Harold E. Williamson, Exec. Dir.; George Cannon, Thomas J. Curnes.

Number of staff: 1 full-time professional; 1 part-time support.

Employer Identification Number: 846037604

353
Ralph L. & Florence R. Burgess Trust
c/o First Interstate Bank of Denver, N.A.
P.O. Box 5825, Terminal Annex
Denver 80217

Established in 1985 in CO.
Financial data (yr. ended 1/31/88): Assets, $1,606,107 (M); gifts received, $2; expenditures, $104,100, including $88,000 for 5 grants (high: $24,000; low: $1,000).

Purpose and activities: Giving primarily for the arts, especially the performing arts.

Limitations: Giving primarily in Denver, CO.

Application information:
Initial approach: Letter
Deadline(s): None

Trustee: First Interstate Bank of Denver, N.A.

Employer Identification Number: 742383505

354
Franklin L. Burns Foundation
1625 Broadway Penthouse Dome Tower
Denver 80202-4717 (303) 629-1899

Established in 1951 in CO.
Financial data (yr. ended 12/31/87): Assets, $700,068 (M); expenditures, $136,039, including $125,086 for 32 grants (high: $82,100; low: $61).

Purpose and activities: Support primarily for youth organizations and services, cultural organizations, colleges and universities and community funds.

Limitations: Giving primarily in Denver, CO.

Application information:
Deadline(s): None
Write: L.E. Canterbury, Secy.

Officers: L.E. Canterbury, Secy. and Mgr.

Employer Identification Number: 846022631

355
Fay S. Carter Foundation
1875 Deer Valley Rd.
Boulder 80303-5227

Established in 1964 in CO.
Donor(s): Fay S. Carter.
Financial data (yr. ended 11/30/86): Assets, $2,786,218 (M); expenditures, $173,208, including $118,050 for 31 grants (high: $32,500; low: $100; average: $100-$25,000).

Purpose and activities: Giving for higher education and cultural programs.

Limitations: Giving primarily in CO.

Application information:
Write: Fay S. Carter, Pres.

Officers: Fay S. Carter,* Pres.; Sydney N. Freidman, Secy.-Treas.

Directors:* Judy Drake, Susan Hedling.

Employer Identification Number: 846041358

356
The Colorado Trust
One Civic Center Plaza
1560 Broadway, Suite 875
Denver 80202-9697 (303) 837-1200

Established in 1985 in CO.
Donor(s): Presbyterian/St. Lukes Health Care Corp.

Financial data (yr. ended 12/31/87): Assets, $141,494,160 (M); expenditures, $11,633,129, including $9,839,649 for 124 grants (high: $2,000,000; low: $250).

Purpose and activities: Support for institutions and organizations that improve the well-being of the people of CO, with special emphasis on health through six programs: Rural Health Care Initiative, Health Promotion, Indigent Health Policy, Children's Issues, Elderly Issues, and Indian Health; grants also for projects not based in CO that have the potential of broader societal benefit such as health policy research.

Types of support: Equipment, operating budgets, conferences and seminars, special projects.

Limitations: Giving primarily in CO. No support for religious organizations for religious purposes, private foundations, or direct subsidization of care to the medically indigent. No grants to individuals, or for endowments, deficit financing or debt retirement, building funds, real estate acquisition, medical research, fundraising drives and events, testimonial dinners, or advertising.

Publications: Annual report, application guidelines, newsletter.

Application information:
Initial approach: Letter and proposal
Copies of proposal: 3
Deadline(s): None
Board meeting date(s): Monthly
Final notification: Funding decisions announced on even numbered months throughout the year
Write: Judith Anderson, Grants Admin.

Officers: William F. Beattie,* Chair.; Donald W. Fink, M.D.,* Vice-Chair.; Bruce M. Rockwell, Pres. and Exec. Dir.; Rev. Kathryn Cone,* Secy.; Robert G. Boucher,* Treas.

Trustees:* W.R. Alexander, Donald G. Butterfield, M.D., A. Gordon Rippey, James G. Urban, M.D., Richard F. Walker.

Number of staff: 9

Employer Identification Number: 840994055

Recent arts and culture grants:
Denver Museum of Natural History, Denver, CO, $1,676,000. To help build Hall of Life, an innovative health education exhibit at Museum. 1987.

357
Adolph Coors Corporate Contributions Program
MAIL NH410
Golden 80401 (303) 277-3397

Financial data (yr. ended 12/31/87): $3,000,000 for 900 grants (average: $100-$1,000).

Purpose and activities: Supports special interest groups (including Native Americans, women, and minorities), religious organizations, community sports, military programs, and volunteerism. Funding focuses on the arts and humanities, education, health, and civic organizations with emphasis on reducing substance abuse. Support is given in the form of general and project grants and in-kind gifts. Product donations are made on the basis of individual applications; products must be used in compliance with all applicable laws and regulations. Gifts and souvenir items,

equipment, in-kind services such as printing and staff expertise also donated.
Types of support: In-kind gifts, general purposes, equipment, special projects.
Limitations: Giving primarily in Denver; exceptions made only in very special circumstances when national organizations play a key role in Coors market area. No grants to individuals; or for telethons, walkathons, or travel; no monetary assistance for third party fundraisers or sales promotions; for these events gifts limited to items bearing the Coors logo; no loans of company vehicles.
Publications: Corporate giving report (including application guidelines), newsletter.
Application information: Include complete name of the organization with address, telephone number and contact name; complete description of the organization including goals and purpose. Also include 501(c)(3), budget, and board of directors.
 Initial approach: Letter
 Copies of proposal: 1
 Deadline(s): 60 days in advance of needed funds
 Write: Mary Anne Fleet, Asst. Mgr., Community Affairs
Administrator: Mary Anne Fleet, Asst. Mgr.
Number of staff: 2 full-time professional; 2 full-time support.

358
The Denver Foundation
455 Sherman St., Suite 220
Denver 80203 (303) 778-7587

Community foundation established in 1925 in CO by resolution and declaration of trust.
Financial data (yr. ended 12/31/88): Assets, $19,847,351 (M); gifts received, $889,319; expenditures, $1,508,873, including $1,049,300 for 105 grants (high: $196,000; low: $144; average: $15,000-$20,000).
Purpose and activities: To "assist, encourage and promote the well-being of mankind, and primarily the inhabitants of Metropolitan Denver." Grants primarily for education, health and hospitals, social services, and cultural programs.
Types of support: Seed money, renovation projects, technical assistance, special projects, matching funds, scholarship funds.
Limitations: Giving limited to Adams, Denver, Douglas, Jefferson, Arapahoe, and Boulder counties, CO. No support for sectarian programs, or projects supported largely by public funds. No grants to individuals or for debt liquidation, endowment funds, research, publications, films, travel, or conferences; no loans.
Publications: Annual report, application guidelines, program policy statement.
Application information:
 Initial approach: Letter
 Copies of proposal: 1
 Deadline(s): Dec. 31, Mar. 31, June 30, and Aug. 31
 Board meeting date(s): Mar., June, Sept., and Nov.
 Final notification: Within 3 months
 Write: Robert E. Lee, Exec. Dir.
Officer: Robert E. Lee, Exec. Dir.

Distribution Committee: Robert S. Slosky, Chair.; Virginia Rockwell, Vice-Chair.; C. Howard Kast, Treas.; Mary Lee Anderson, Donald K. Bain, Sidney Friedman, William H. Hornby, John H. McLagan, Darlene Silver, Bernard Valdez.
Trustee Banks: Central Bank of Denver, Colorado National Bank of Denver, Colorado State Bank, First Bank of Westland, First Interstate Bank of Denver, First Trust Corp., Guaranty Bank & Trust, Jefferson Bank and Trust, United Bank of Denver.
Number of staff: 3 full-time professional; 1 part-time professional; 1 full-time support.
Employer Identification Number: 846048381
Recent arts and culture grants:
Art Students League of Denver, Denver, CO, $9,430. For purchase of studio equipment. 1987.
Artreach, Denver, CO, $10,750. To support Community Events Program. 1987.
Central City Opera House Association, Denver, CO, $25,000. To support Apprentice/Studio Artist Program. 1987.
Changing Scene Theater, Denver, CO, $7,437. For equipment purchase and repairs. 1987.
Colorado Ballet Company, Denver, CO, $15,000. For debt retirement incentive grant. 1987.
Denver Center for the Performing Arts, Denver, CO, $15,000. For support of Youth Conservatory Project. 1987.
Denver Chamber Orchestra, Denver, CO, $21,000. To establish operations cash flow fund. 1987.
Denver Firefighters Museum, Denver, CO, $5,375. For acquisition and display of horsedrawn steamer. 1987.
Denver Museum of Natural History, Denver, CO, $45,000. For acquisition and display of Tyrannosaurus Rex Reproduction. 1987.
Denver Museum of Natural History, Denver, CO, $39,000. For acquisition and display of Tyrannosaurus Rex. 1987.
Denver Museum of Natural History, Denver, CO, $15,850. For acquisition and exhibition of Tyrannosaurus Rex. 1987.
K C F R Public Radio, Denver, CO, $25,000. To underwrite Pinchas Zuckerman concert. 1987.

359
John G. Duncan Trust
c/o First Interstate Bank of Denver
P.O. Box 5825 TA
Denver 80217 (303) 293-5324

Trust established in 1955 in CO.
Donor(s): John G. Duncan.†
Financial data (yr. ended 12/31/86): Assets, $2,838,100 (M); expenditures, $190,457, including $168,750 for 28 grants (high: $10,000; low: $3,250).
Purpose and activities: Support for hospitals, higher and secondary education, youth agencies, cultural programs, and a community fund.
Types of support: Annual campaigns, building funds, equipment, research, operating budgets, continuing support, seed money, emergency funds, special projects.

Limitations: Giving limited to CO. No grants to individuals, or for endowment funds, scholarships, or fellowships; no loans.
Publications: Application guidelines.
Application information:
 Initial approach: Letter or proposal
 Copies of proposal: 1
 Deadline(s): None
 Board meeting date(s): Dec.
 Final notification: Dec. 31
 Write: Yvonne Baca, V.P.
Trustee: First Interstate Bank of Denver.
Number of staff: None.
Employer Identification Number: 846016555

360
El Pomar Foundation
Ten Lake Circle Dr.
P.O. Box 158
Colorado Springs 80906 (303) 633-7733

Incorporated in 1937 in CO.
Donor(s): Spencer Penrose,† Mrs. Spencer Penrose.†
Financial data (yr. ended 12/31/88): Assets, $220,000,000 (M); expenditures, $13,267,000, including $12,748,742 for 122 grants (high: $2,350,000; low: $500).
Purpose and activities: Grants only to nonprofit organizations for public, educational, arts and humanities, health, and welfare purposes; municipalities may request funds for specific projects.
Types of support: Operating budgets, continuing support, emergency funds, building funds, equipment, land acquisition, scholarship funds, special projects, general purposes.
Limitations: Giving limited to CO. No support for organizations that distibute funds to other grantees. No grants to individuals, or for annual campaigns, travel, film or other media projects, conferences, deficit financing, endowment funds, research, matching gifts, seed money, or publications; no loans.
Publications: Annual report (including application guidelines), application guidelines, grants list.
Application information:
 Initial approach: Letter
 Copies of proposal: 1
 Deadline(s): None
 Board meeting date(s): 7 to 9 times a year
 Final notification: 90 days
 Write: William J. Hybl, Pres.
Officers: Russell T. Tutt,* Chair. and C.E.O.; William J. Hybl,* Pres.; R. Thayer Tutt, Jr.,* Exec. V.P., C.F.O., and Treas.; Ben S. Wendelken,* V.P.; Robert Hilbert, Secy.; Jerry Roblewsky, Secy.
Trustees:* Karl E. Eitel, William B. Tutt, William Thayer Tutt.
Number of staff: 4 full-time professional; 3 part-time professional; 6 full-time support; 2 part-time support.
Employer Identification Number: 846002373
Recent arts and culture grants:
Central City Opera House Association, Denver, CO, $12,500. For operations and Penrose Scholarships. 1987.
Cheyenne Mountain Museum and Zoological Society, Colorado Springs, CO, $250,000. For general operating support. 1987.

Cheyenne Mountain Museum and Zoological Society, Colorado Springs, CO, $32,064. For office remodeling. 1987.

Colorado Endowment for the Humanities, Denver, CO, $33,400. To establish Colorado Arts Stabilization Project. 1987.

Colorado Springs Symphony Orchestra Association, Colorado Springs, CO, $60,000. For operating support. 1987.

Denver Botanic Gardens, Denver, CO, $100,000. For general operating support. 1987.

Denver Museum of Natural History, Denver, CO, $100,000. For renovation project. 1987.

K T S C-TV, Pueblo, CO, $15,000. For purchase of equipment for microwave link. 1987.

Manitou Springs Council for the Arts and Humanities, Manitou Springs, CO, $170,000. For Business Arts Center. 1987.

Prorodeo Hall of Champions and Museum of the American Cowboy, Colorado Springs, CO, $30,000. For purchase of bronze statue. 1987.

Pueblo Zoological Society, Pueblo, CO, $5,000. For construction and renovation projects. 1987.

University of Colorado, Colorado Springs, CO, $5,200. For Shakespeare in the Park program. 1987.

361
Harmes C. Fishback Foundation Trust
Eight Village Rd.
Englewood 80110 (303) 789-1753

Trust established in 1972 in CO.
Donor(s): Harmes C. Fishback.†
Financial data (yr. ended 12/31/87): Assets, $1,739,249 (M); expenditures, $93,058, including $76,300 for 34 grants (high: $10,000; low: $250).
Purpose and activities: Emphasis on higher education, hospitals, medical research, cultural programs, and youth agencies.
Types of support: Capital campaigns, continuing support, endowment funds, program-related investments, scholarship funds.
Limitations: Giving primarily in Denver, CO. No grants to individuals.
Application information:
 Initial approach: Letter
 Deadline(s): None
 Board meeting date(s): Quarterly
 Write: Katharine H. Stapleton, Trustee
Trustee: Katharine H. Stapleton.
Employer Identification Number: 846094542

362
Forest Oil Corporate Contributions Program
1500 Colorado National Building
950 17th Street
Denver 80202 (303) 592-2400

Purpose and activities: While the foundation gives for specific predetermined educational and medical research, the corporate giving program concentrates on causes in areas of company operations. Support for the sciences, including biochemistry, biological and social sciences, child development and welfare, drug abuse and rehabilitation, health, including hospitals and hospices, the fine arts, libraries and museums, higher and secondary education, and hunger relief.
Types of support: Annual campaigns, capital campaigns, continuing support, endowment funds, fellowships, general purposes, operating budgets, renovation projects, research, scholarship funds.
Limitations: Giving primarily in TX, PA, CO, LA, and OK.
Publications: Corporate report, program policy statement.
Application information:
 Copies of proposal: 1
 Deadline(s): Sept.
 Board meeting date(s): Mid-Feb., early May, mid. Aug., and mid. Oct.
 Final notification: Within 2 months of receipt
 Write: Leslie D. Young, Contribs. Comm.
Number of staff: 7 full-time professional.

363
The Frost Foundation, Ltd.
Cherry Creek Plaza II, Suite 205
650 South Cherry St.
Denver 80222 (303) 388-1687

Incorporated in 1959 in LA.†
Donor(s): Virginia C. Frost.†
Financial data (yr. ended 12/31/88): Assets, $19,837,394 (M); expenditures, $1,279,015, including $1,279,015 for 79 grants (high: $170,000; low: $250; average: $5,000-$15,000).
Purpose and activities: Giving primarily for education, including medical education and business administration; grants also for cultural programs, health associations and hospitals, social service and youth organizations, and denominational giving.
Types of support: Seed money, equipment, endowment funds, matching funds, professorships, internships, scholarship funds, fellowships, special projects, research, publications, conferences and seminars, consulting services, technical assistance.
Limitations: Giving primarily in the Southwest, including AR, CO, LA, NM, TX, AZ, and OK. No grants to individuals, or for operating expenses or building funds; no loans.
Publications: Annual report (including application guidelines).
Application information:
 Initial approach: Telephone or letter
 Copies of proposal: 4
 Deadline(s): Dec. 1 and July 1
 Board meeting date(s): Feb. and Sept.
 Final notification: 7 to 10 days
 Write: Theodore R. Kauss, Exec. Dir.
Officers: Edwin F. Whited,* Pres.; Theodore R. Kauss, V.P. and Exec. Dir.; Claude G. Rives III,* V.P.; Mitchell R. Woodard, Treas.
Directors:* Dallas P. Dickinson, J. Luther Jordan, Jr., John A. LeVan, John W. Loftus, Mary Amelia Douglas Whited.
Number of staff: 1 full-time professional; 1 part-time professional; 1 full-time support.
Employer Identification Number: 720520342
Recent arts and culture grants:
American Rose Foundation, Shreveport, LA, $50,000. To endowment fund to support Project 80's - for maintenance, research, educational and public awareness programs of American Rose Center. 1987.

Artreach, Denver, CO, $5,000. To support pilot program in arts appreciation directed to children, and youth groups, primarily disadvantaged and minority youth. 1987.

Arvada Center for the Arts and Humanities, Arvada, CO, $10,000. To support audience development and outreach efforts for center's nationally recognized Deaf Access Program. 1987.

Black American West Museum, Denver, CO, $7,500. To partially fund proposed research center for museum. 1987.

Childrens Museum of Denver, Denver, CO, $5,000. To meet needs of expanded program. 1987.

Colorado Endowment for the Humanities, Denver, CO, $12,000. To support establishment of humanities resource center to address long-standing needs such as need to create cost-efficient packageable programs for statewide use and need to create and acquire reusable programming sources. 1987.

Colorado Historical Society, Denver, CO, $9,000. Toward development of Georgetown Loop Historic Mining Park as national historic site to tell story of mining and its impact on Colorado and West. 1987.

Crow Canyon Center for Southwestern Archaeology, Denver, CO, $5,000. To support establishment of Archeological Science Center that will bring public, especially teenage students, into direct contact with Early Civilizations of American West. 1987.

Denver Museum of Natural History, Denver, CO, $25,000. Toward production of 45-minute Planetarium production, Stars of the Pharaohs. 1987.

Louisiana Endowment for the Humanities, New Orleans, LA, $5,000. To purchase computer equipment and software to improve management of extensive programs and to help become fiscally self-sufficient. 1987.

Louisiana State University, Shreveport, LA, $18,000. To assist public radio station KDAQ and for underwriting its support. 1987.

Museum of Broadcast Communications, Chicago, IL, $5,000. To underwrite portion of Museum's programming of Children's Television, specifically to enable staff to create and develop first programs in area. 1987.

National Repertory Orchestra, Evergreen, CO, $10,000. To help obtain services of major conductors, guest artists and talented musicians. 1987.

North Arkansas Symphony Society, Fayetteville, AR, $5,000. To establish endowment for North Arkansas Symphony Orchestra. 1987.

Paramount Theater for the Performing Arts, Austin, TX, $10,000. Toward production costs of The Foreigner. 1987.

Red River Revel Arts Festival, Shreveport, LA, $15,000. To support expansion of education performance component and introduction of hospital residency activities with annual arts festival. 1987.

Southwest Ballet, Albuquerque, NM, $7,481. To support proposed lecture/demonstration dance program for Albuquerque public elementary schools. 1987.

Utah Opera Company, Salt Lake City, UT, $5,000. To co-sponsor two performances. 1987.

W L A E - TV, New Orleans, LA, $5,000. To assist in sponsorship of two-day Media Ethics Seminar in New Orleans in spring of 1988. 1987.

364
Gates Foundation
3200 Cherry Creek South Dr., Suite 630
Denver 80209-3247 (303) 722-1881

Incorporated in 1946 in CO.
Donor(s): Charles Gates,† Hazel Gates,† John Gates.†
Financial data (yr. ended 12/31/88): Assets, $90,800,000 (M); expenditures, $4,628,000, including $3,911,887 for grants (high: $650,000).
Purpose and activities: To promote the health, welfare, and broad education of mankind whether by means of research, grants, publications, the foundation's own agencies and activities, or through cooperation with agencies and institutions already in existence; grants primarily for education, youth services, including leadership development; public policy, historic preservation, humanities and cultural affairs, health care, including cost reduction; and human services.
Types of support: Continuing support, building funds, capital campaigns, endowment funds, matching funds, program-related investments, renovation projects, seed money, special projects, equipment, fellowships, general purposes, land acquisition, publications, technical assistance.
Limitations: Giving limited to CO, especially the Denver area, except for foundation-initiated grants. No support for private foundations. No grants to individuals, or for operating budgets, annual campaigns, emergency funds, deficit financing, purchase of tickets for fundraising dinners, parties, balls, or other social fundraising events, research, or scholarships; no loans.
Publications: Annual report, informational brochure (including application guidelines), program policy statement, grants list.
Application information:
Initial approach: Telephone
Copies of proposal: 1
Deadline(s): Jan. 15, Apr. 15, July 15, and Oct. 15
Board meeting date(s): Apr. 1, June 15, Oct. 1, Dec. 15
Final notification: 2 weeks following meetings
Write: F. Charles Froelicher, Exec. Dir.
Officers: Charles C. Gates,* Pres.; Brown W. Cannon, Jr.,* V.P.; F. Charles Froelicher, Secy. and Exec. Dir.; T.J. Gibson, Treas.; Christina H. Turissini, Comptroller.
Trustees: George B. Beardsley, William W. Grant III, Robert K. Timothy, Diane Gates Wallach, Michael Wilfley.
Number of staff: 3 full-time professional; 2 full-time support.
Employer Identification Number: 840474837
Recent arts and culture grants:
Arvada Center for the Arts and Humanities, Arvada, CO, $12,750. To modify sound and acoustics systems in Center's theater. 1987.

Central City Opera House Association, Denver, CO, $10,000. For general operating support. 1987.
Colorado Amateur Sports Corporation, Colorado Springs, CO, $200,000. Toward construction of Olympic Hall of Fame. 1987.
Colorado Contemporary Dance, Denver, CO, $5,000. To fund two master classes for Denver high school students by Dance Theater of Harlem. 1987.
Colorado Historical Society, Denver, CO, $56,000. To repair and renovate Governor's Mansion. 1987.
Colorado Historical Society, Denver, CO, $50,000. Toward restoration, repair and renovation of Byers/Evans house. 1987.
Council for Public Television, Channel 6, K R M A Channel 6, Denver, CO, $35,000. To fund cost of 1987-88 MacNeil/Lehrer Report. 1987.
Denver Museum of Natural History, Hall of Life, Denver, CO, $750,000. To plan and endow Hall of Life, dedicated to eliminating ten leading causes of premature death, 80 percent of which are caused by inappropriate lifestyles. 1987.
Denver Symphony Association, Denver, CO, $200,000. For challenge grant for endowment. 1987.
Denver Symphony Association, Denver, CO, $25,000. For general operating support. 1987.
Foothills Art Center, Golden, CO, $5,000. Toward reduction of mortgage. 1987.
Germinal Stage, Denver, CO, $30,000. Toward purchase and renovation of new theater building. 1987.
Northern Colorado Foundation for the Arts, Greeley, CO, $20,000. Toward construction and equipping of new Civic Auditorium. 1987.
Opera Colorado, Denver, CO, $10,000. For general operating support. 1987.
Otero Museum Association, La Junta, CO, $5,000. For materials for volunteer craftsmen to repair, restore, and renovate five museum buildings. 1987.
Urban Design Forum, Denver, CO, $5,000. For development of Denver metropolitan area map which will focus on high-quality community amenities such as parks, trails, museums, and zoo. 1987.

365
Hewit Family Foundation
621 17th St., Suite 2555
Denver 80293

Established in 1985 in CO.
Donor(s): Members of the Hewit family.
Financial data (yr. ended 11/30/87): Assets, $1,258,011 (M); gifts received, $250,000; expenditures, $53,023, including $50,000 for 4 grants (high: $20,000; low: $10,000).
Purpose and activities: First year of grantmaking 1986-87; support primarily for health, social services, a natural history museum and a zoo.
Application information:
Initial approach: Letter
Write: William D. Hewit, Pres.

Officers: William D. Hewit, Pres. and Treas.; Betty Ruth Hewit, V.P. and Secy.; Christie F. Hewit, V.P.; William E. Hewit, V.P.
Employer Identification Number: 742397040

366
Hill Foundation
c/o Kutak, Rock & Campbell, 2400 Arco Tower
707 17th St.
Denver 80202 (303) 297-2400
Additional address: First Interstate Bank of Denver, Terminal Annex, Box 5825, Denver, CO 80217

Trust established in 1955 in CO.
Donor(s): Virginia W. Hill.†
Financial data (yr. ended 4/30/87): Assets, $7,352,837 (M); expenditures, $1,047,246, including $760,100 for 63 grants (high: $45,000; low: $250; average: $10,000-$30,000).
Purpose and activities: Grants largely for health care for the medically indigent, higher education, services for the elderly, and cultural programs; support also for social service agencies.
Types of support: Scholarship funds, equipment, matching funds, special projects.
Limitations: Giving primarily in CO and WY. No grants to individuals, or for capital improvements other than equipment acquisition for health care and related purposes.
Publications: Program policy statement, application guidelines.
Application information: Beginning with 1988, grants only to qualified charitable organizations from which the foundation will have first requested a proposal or which have been selected by the foundation to carry out one of its specific objectives. Applications not accepted.
Write: John R. Moran, Jr., Trustee
Trustees: Francis W. Collopy, John R. Moran, Jr., First Interstate Bank of Denver.
Number of staff: None.
Employer Identification Number: 846081879

367
Mabel Y. Hughes Charitable Trust
c/o The First Interstate Bank of Denver
P.O. Box 5825 TA
Denver 80217 (303) 293-5324

Trust established in 1969 in CO.
Donor(s): Mabel Y. Hughes**Financial data** (yr. ended 8/31/88): Assets, $6,475,828 (M); expenditures, $416,934, including $345,246 for 38 grants (high: $40,000; low: $246).
Purpose and activities: Emphasis on hospitals, education, museums, and community funds.
Types of support: Operating budgets, continuing support, annual campaigns, seed money, emergency funds, building funds, equipment, endowment funds, research, special projects.
Limitations: Giving limited to CO, with emphasis on the Denver area. No grants to individuals, or for deficit financing, scholarships, or fellowships; no loans.
Publications: Application guidelines, 990-PF.
Application information:
Initial approach: Letter

Copies of proposal: 1
Deadline(s): None
Board meeting date(s): Dec.
Write: Yvonne J. Baca, V.P., The First
 Interstate Bank of Denver
Trustees: Eugene H. Adams, The First Interstate
Bank of Denver.
Number of staff: None.
Employer Identification Number: 846070398

368
The Humphreys Foundation
555 17th St., Suite 2900
Denver 80202-3929 (303) 295-8065

Established in 1922 in CO.
Financial data (yr. ended 12/31/87): Assets,
$1,131,077 (M); expenditures, $73,967,
including $59,700 for 32 grants (high: $7,500;
low: $200).
Purpose and activities: Support for
educational institutions, social services,
including an organization involved in family
planning, cultural and health organizations, and
museums.
Types of support: Operating budgets, general
purposes.
Limitations: Giving primarily in CO.
Application information:
 Initial approach: Letter
 Copies of proposal: 1
 Deadline(s): Oct. 1
 Board meeting date(s): Semi-annually
 Write: Janet Stork
Officers and Directors: Stephen H. Hart,
Pres.; Claude M. Maer, Jr., V.P.; Karen
Sweeney, Secy.-Treas.
Number of staff: 1
Employer Identification Number: 846021274

369
A. V. Hunter Trust, Inc.
633 Seventeenth St., Suite 1780
Denver 80202 (303) 292-2048

Trust established in 1927; incorporated in 1937
in CO.
Donor(s): A.V. Hunter.†
Financial data (yr. ended 12/31/88): Assets,
$21,720,682 (M); expenditures, $972,788,
including $571,007 for 68 grants (high:
$35,000; low: $1,000; average: $3,000-
$15,000) and $39,178 for grants to individuals.
Purpose and activities: Distributions to give
aid, comfort, support, or assistance to children
or aged persons or indigent adults, crippled,
maimed or needy, through charitable
organizations rendering such aid to persons in
the categories named; no direct grants to
individuals.
Types of support: General purposes, operating
budgets.
Limitations: Giving limited to CO, with
emphasis on Denver. No support for tax-
supported institutions. No grants for
scholarships, capital improvements, or
acquisitions; no loans.
Publications: Informational brochure,
application guidelines.
Application information: Application form
required for grants to individuals.
 Initial approach: Letter

Copies of proposal: 1
Deadline(s): Mar. 1, July 1 and Oct. 1
Board meeting date(s): Apr., Aug., and Nov.
 and as required
Final notification: Within 20 days after
 meeting
Write: Sharon Holt, Secy.
Officers: G.C. Gibson,* Chair.; W.R.
Alexander,* V.P.; Sharon Holt, Secy.; Allan B.
Adams,* Treas.
Trustees:* Mary Anstine, William K. Coors.
Number of staff: 1 full-time professional.
Employer Identification Number: 840461332
Recent arts and culture grants:
Artreach, Denver, CO, $5,000. For Artists'
 Program for special needs population. 1987.

370
The JFM Foundation
P.O. Box 5083
Denver 80217 (303) 832-3131

Established in 1980 in CO.
Donor(s): Frederick R. Mayer.
Financial data (yr. ended 11/30/88): Assets,
$0 (M); expenditures, $385,816, including
$385,816 for 32 grants (high: $50,000; low:
$300).
Purpose and activities: Support for innovative
approaches towards emerging social issues, and
towards community service projects focused
upon children and youth, and the educational,
transportation, and legal systems; grants for the
cultural areas of the visual arts, nautical
archaeology, and Isthmanian Pre-Columbian art
and archaeology.
Types of support: Matching funds, special
projects, seed money.
Limitations: Giving limited to CO for
community projects and social issues; cultural
programs having national or international
significance are considered. No support for
medical or health related fields or religious
organizations for religious purposes. No grants
to individuals, or for endowments, deficit
financing, fundraising, or basic research.
Publications: Application guidelines.
Application information:
 Initial approach: Letter, and concept paper
 of no more than 2 pages
 Copies of proposal: 3
 Deadline(s): None
 Write: Loretta Roulier or Gloria Higgins
Officers: Frederick R. Mayer, Pres.; Jan Perry
Mayer, V.P. and Secy.-Treas.
Directors: Anthony R. Mayer, Frederick
M. Mayer.
Employer Identification Number: 840833163

371
Helen K. and Arthur E. Johnson
Foundation
1700 Broadway, Rm. 2302
Denver 80290 (303) 861-4127

Incorporated in 1948 in CO.
Donor(s): Arthur E. Johnson,† Mrs. Helen K.
Johnson.†
Financial data (yr. ended 12/31/87): Assets,
$62,690,721 (M); expenditures, $3,311,070,
including $2,176,064 for 90 grants (high:

$500,000; low: $100; average: $5,000-
$30,000).
Purpose and activities: "To solve human
problems and enrich the quality of human
life." Emphasis on operational and capital
support for community and social services,
education, youth, health, and civic and cultural
affairs.
Types of support: Operating budgets, building
funds, general purposes, equipment,
scholarship funds, continuing support, annual
campaigns, seed money, land acquisition,
research, technical assistance, matching funds,
special projects, renovation projects, capital
campaigns.
Limitations: Giving limited to CO. No grants
to individuals, or for endowment funds,
conferences, or purchase of blocks of tickets;
no loans.
Publications: Annual report (including
application guidelines).
Application information:
 Initial approach: Letter or proposal
 Copies of proposal: 1
 Deadline(s): Jan. 1, Apr. 1, July 1, and Sept. 1
 Board meeting date(s): Apr., July, Oct., and
 Dec.
 Final notification: 2 weeks after board
 meeting
 Write: Stan Kamprath, Exec. Dir.
Officers: Mrs. James R. Hartley,* Pres.; David
R. Murphy,* V.P. and Treas.; Stan Kamprath,
V.P. and Exec. Dir.; Gerald R. Hillyard, Jr.,*
Secy.
Trustees:* Lynn H. Campion, Thomas B.
Campion, Ralph W. Collins, William H. Kistler,
Roger D. Knight, Jr., J. Churchill Owen.
Number of staff: 1 full-time professional; 1 full-
time support; 2 part-time support.
Employer Identification Number: 846020702

372
Margulf Foundation Inc.
616 East Hyman Ave., Suite 2-D
Aspen 81611

Established in 1977 in NY and DE.
Donor(s): Martin Flug, James Flug, Robert Flug.
Financial data (yr. ended 11/30/87): Assets,
$2,659,637 (M); gifts received, $251,000;
expenditures, $136,743, including $132,000
for 6 grants (high: $50,000; low: $1,000).
Purpose and activities: Grants for education,
social services, and culture; support also for
Jewish welfare.
Types of support: General purposes.
Application information: Contributes only to
pre-selected organizations. Applications not
accepted.
Officer and Directors: Martin Flug, Pres.;
Patricia Ann Flug, Ernest Rubenstein.
Employer Identification Number: 132927245

373
The McCoy Foundation
5040 Lyda Ln.
Colorado Springs 80904

Established in 1979.
Donor(s): Arthur H. McCoy.
Financial data (yr. ended 11/30/86): Assets,
$1,945,971 (M); expenditures, $169,249,

including $154,810 for 12 grants (high: $75,000; low: $500; average: $5,000-$20,000).
Purpose and activities: Grants for cultural programs, including music, and for hospitals and a university.
Officers: Arthur H. McCoy, Pres. and Treas.; Barbara M. Gartner, V.P.; Craig W. McCoy, V.P.; Virginia G. McCoy, Secy.
Employer Identification Number: 840802889

374
The McHugh Family Foundation
650 South Cherry St., Suite 1225
Denver 80222 (303) 321-2111

Established in 1980.
Donor(s): Jerome P. McHugh, Kindermac Partnership.
Financial data (yr. ended 11/30/87): Assets, $1,211,230 (M); expenditures, $329,679, including $329,679 for 44 grants (high: $250,000; low: $100).
Purpose and activities: Giving primarily for education, including higher education, and for social services and cultural programs.
Limitations: Giving primarily in Denver, CO. No grants to individuals.
Application information:
 Initial approach: Proposal
 Deadline(s): None
 Write: Jerome P. McHugh, Pres.
Officers and Directors: Jerome P. McHugh, Pres.; Anabel C. McHugh, V.P.; Paul D. Holleman, Secy.; Jerome P. McHugh, Jr., Treas.; Erin McHugh Gogolak.
Employer Identification Number: 742131272

375
Monfort Charitable Foundation
804 7th St.
Greeley 80632
Application address: 825 North County Line Rd., Berthoud, CO 80513; Tel.: (303) 352-9469

Established in 1970.
Financial data (yr. ended 12/31/86): Assets, $4,296,847 (M); expenditures, $187,444, including $165,284 for 23 grants (high: $45,000; low: $70).
Purpose and activities: Giving primarily to community funds and cultural programs.
Limitations: Giving limited to CO, KS, and NE. No grants to individuals.
Publications: 990-PF.
Application information:
 Deadline(s): None
 Write: Kaye C. Montera, Secy.-Treas.
Officers: Kenneth W. Monfort, Pres.; Kyle Futo, V.P.; Kaye C. Montera, Secy.-Treas.
Number of staff: None.
Employer Identification Number: 237068253

376
Pauline A. and George R. Morrison Charitable Trust
1801 York St.
Denver 80206

Established in 1980 in CO.
Donor(s): George R. Morrison.

Financial data (yr. ended 11/30/87): Assets, $7,133,882 (M); expenditures, $873,881, including $734,397 for 4 grants (high: $700,000; low: $8,397).
Purpose and activities: Support primarily for a natural history museum; support also for parks and recreation.
Types of support: Building funds.
Limitations: Giving primarily in CO. No grants for general operating costs.
Application information:
 Initial approach: Proposal
 Deadline(s): None
 Board meeting date(s): Monthly
 Write: Jerry I. Maine, Chair
Trustees: Jerry I. Maine, Chair.; Robert W. Findlay, L. Douglas Hoyt, Robert D. Ibbotson.
Employer Identification Number: 846166335

377
The Aksel Nielsen Foundation
Three Melody Ln.
Parker 80134-8631

Established in 1956 in CO.
Financial data (yr. ended 12/31/86): Assets, $1,409,314 (M); gifts received, $1,500; expenditures, $47,394, including $40,650 for 20 grants (high: $12,000; low: $250).
Purpose and activities: Support primarily for cultural programs, museums, and general charitable giving.
Application information:
 Initial approach: Letter
 Deadline(s): None
 Write: Virginia N. Muse, V.P.
Officers and Trustees: Fred L. Klein, Pres.; Virginia N. Muse, V.P.; Jack M. Muse, Secy.-Treas.; Judith M. Pemstein.
Employer Identification Number: 846025711

378
Martin J. and Mary Anne O'Fallon Trust
2800 South University Blvd., Rm. 61
Denver 80210

Trust established in 1951 in CO.
Donor(s): Martin J. O'Fallon.†
Financial data (yr. ended 12/31/87): Assets, $2,133,122 (M); expenditures, $146,485, including $120,000 for 27 grants (high: $25,000; low: $100; average: $2,000-$5,000).
Purpose and activities: Grants to established organizations and agencies to assist cultural programs, health, social, and educational services.
Types of support: Building funds, equipment, special projects, capital campaigns, seed money, technical assistance.
Limitations: Giving limited to CO; priority always given to Denver. No grants to individuals, or for endowment funds, research, scholarships, travel, fellowships, annual campaigns, or operating support; no loans.
Publications: Annual report (including application guidelines).
Application information: Grant applications from agencies outside CO not accepted. Application form required.
 Initial approach: Letter
 Copies of proposal: 1

 Deadline(s): Submit proposal preferably between May and Aug.
 Board meeting date(s): Feb., Apr., Aug., and Nov., and monthly for other trust business
 Final notification: Dec.
 Write: Alfred O'Meara, Jr., Trustee
Trustees: Margaret H. Carey, Alfred O'Meara, Jr., Brian O'Meara, Patrick E. Purcell.
Number of staff: 1 part-time professional.
Employer Identification Number: 840415830

379
The Piton Foundation
Kittredge Bldg.
511 16th St., Suite 700
Denver 80202 (303) 825-6246

Incorporated in 1976 in CO.
Donor(s): Samuel Gary.
Financial data (yr. ended 11/30/87): Assets, $4,084,033 (M); gifts received, $968,464; expenditures, $2,966,270, including $1,065,859 for 54 grants (high: $63,000; low: $1,000; average: $5,000-$40,000) and $620,243 for loans.
Purpose and activities: To encourage personal effort toward self-realization, to promote the development of strong cooperative relationships between the public and private sectors with emphasis on local involvement, and to improve conditions and opportunities for persons inadequately served by the institutions of society. Almost exclusively local giving, especially for children, youth, families, and community development, especially housing and economic development; support to individual volunteer agencies to encourage improved management and service effectiveness; some giving also for civic, conservation, cultural, educational and health programs.
Types of support: Operating budgets, seed money, emergency funds, consulting services, technical assistance, program-related investments, student aid, renovation projects.
Limitations: Giving primarily in CO, with emphasis on the Denver metropolitan area. No grants for basic research, long-range support, debt reduction, building or endowment funds, media projects, or matching gifts.
Publications: Annual report (including application guidelines), program policy statement.
Application information:
 Initial approach: Letter
 Copies of proposal: 1
 Deadline(s): Jan. 15, Apr. 15, July 15, and Oct. 15 for Community Development Project; none for Grant Program
 Board meeting date(s): As required
 Final notification: Approximately 4 months for Grant Program; Mar. 1, June 1, Sept. 1, and Dec. 1 for Community Development Project
 Write: Phyllis Buchele for Grant Program; Judy Kaufmann or Joe McKeon for Community Development Project
Officers and Directors: Samuel Gary, Chair. and Pres.; James E. Bye, Kathryn Gary, Nancy Gary, Ronald W. Williams.
Number of staff: 6 full-time professional; 4 full-time support; 1 part-time support.
Employer Identification Number: 840719486

Recent arts and culture grants:
Denver Indian Center Development
Corporation, Denver, CO, $31,000. For
market study on Cultural Trade Center; for
test marketing Ute Mountain Pottery in
metropolitan Denver area; and for general
operating support. 1987.

380
Schlessman Foundation, Inc.
1500 Grant St., Suite 400
Denver 80203 (303) 861-8081

Incorporated in 1957 in CO.
Donor(s): Greeley Gas Co.
Financial data (yr. ended 3/31/88): Assets,
$18,000,000 (M); gifts received, $80,000;
expenditures, $875,270, including $875,210
for 60 grants (high: $18,750; low: $500;
average: $1,000-$10,000).
Purpose and activities: Support for higher
education, including theological education,
cultural programs, and youth agencies.
Types of support: General purposes.
Limitations: Giving primarily in CO. No grants
to individuals.
Application information: Funds largely
committed.
 Initial approach: Letter
 Copies of proposal: 1
 Deadline(s): None
 Board meeting date(s): Mar., June, Sept., and
 Dec.
 Write: Lee E. Schlessman, Pres.
Officers: Lee E. Schlessman, Pres.; Susan M.
Duncan, V.P. and Secy.
Number of staff: 1 part-time support.
Employer Identification Number: 846030309

381
The Schramm Foundation
8528 West 10th Ave.
Lakewood 80215

Established in 1956.
Financial data (yr. ended 6/30/87): Assets,
$3,676,407 (M); expenditures, $163,385,
including $139,418 for 47 grants (high:
$20,000; low: $250).
Purpose and activities: Giving for hospitals,
education, youth activities, social services, and
cultural programs.
Types of support: Equipment, general
purposes, scholarship funds, operating budgets.
Limitations: Giving primarily in Denver, CO
and the surrounding area.
Application information:
 Initial approach: Letter
 Deadline(s): Aug. 15
 Write: Lesley E. Kring, Pres.
Officers: Lesley E. Kring, Pres.; Arnold Tietze,
V.P.; Gary S. Kring, Secy.; Joe Heit, Treas.
Employer Identification Number: 846032196

382
Sterne-Elder Memorial Trust
1700 Broadway
Denver 80274-0081

Trust established in 1977 in CO.
Donor(s): Charles S. Sterne.

Financial data (yr. ended 3/31/88): Assets,
$3,971,993 (M); expenditures, $306,916,
including $271,250 for 52 grants (high:
$50,000; low: $100).
Purpose and activities: Emphasis on the
performing arts, health organizations, and social
services.
Limitations: Giving primarily in CO.
Director: Dorothy Elder Sterne.
Trustee: United Bank of Denver, N.A.
Employer Identification Number: 846143172

383
Stuart-James Foundation
8055 East Tuffs Ave. Pkwy., Suite 1200
Denver 80237 (303) 796-8488

Established in 1985 in CO.
Financial data (yr. ended 11/30/87): Assets,
$532,077 (M); gifts received, $302,500;
expenditures, $514,230, including $503,561
for 46 grants (high: $75,000; low: $100).
Purpose and activities: Giving primarily for
higher education, hospitals and medical
research, and the arts.
Application information:
 Initial approach: Letter
 Deadline(s): None
 Write: James Padgett or Stuart Graff
Officers: Stuart Graff, Pres.; C. James Padgett,
Secy.
Employer Identification Number: 742401272

384
The Bal F. and Hilda N. Swan
Foundation
c/o The First Interstate Bank of Denver
P.O. Box 5825, Terminal Annex
Denver 80217

Established in 1976.
Donor(s): Bal F. Swan.†
Financial data (yr. ended 12/31/86): Assets,
$1,879,180 (M); expenditures, $293,170,
including $275,500 for 27 grants (high:
$25,000; low: $1,000).
Purpose and activities: Giving for aid to the
handicapped, medical research, child welfare,
cultural programs, social agencies, and higher
education.
Limitations: Giving primarily in CO.
Application information:
 Initial approach: Letter
 Deadline(s): None
 Write: Francis Collopy
Trustees: Anthony F. Zarlengo, The First
Interstate Bank of Denver.
Employer Identification Number: 742108775

385
The Ruth and Vernon Taylor Foundation
1670 Denver Club Bldg.
Denver 80202 (303) 893-5284

Trust established in 1950 in TX.
Donor(s): Members of the Taylor family.
Financial data (yr. ended 6/30/87): Assets,
$27,153,465 (M); expenditures, $1,762,248,
including $1,612,380 for 175 grants (high:
$175,000; low: $100; average: $2,000-
$15,000).

Purpose and activities: Support for higher and
secondary education, cultural programs, social
service and youth agencies, ecology and
conservation, and hospitals and medical
research.
Types of support: Research, endowment
funds, building funds, general purposes.
Limitations: Giving primarily in TX, CO, WY,
MT, IL, and the Mid-Atlantic states. No grants
to individuals.
Application information:
 Initial approach: Proposal
 Copies of proposal: 1
 Deadline(s): Apr. 30
 Board meeting date(s): May and Aug.
 Final notification: 30 days
 Write: Miss Friday A. Green, Trustee
Trustees: Ruth Taylor Campbell, Friday A.
Green, Sara Taylor Swift, Vernon Taylor, Jr.
Number of staff: None.
Employer Identification Number: 846021788

386
The Thatcher Foundation
P.O. Box 1401
Pueblo 81002
Scholarship application address: Charlene
Burkhard, The Thatcher Foundation, Minnequa
Bank of Pueblo, Pueblo, CO 81004; Tel.: (303)
544-3565

Established in 1924 in CO.
Financial data (yr. ended 12/31/86): Assets,
$3,090,589 (M); gifts received, $18,740;
expenditures, $224,214, including $182,712
for 42 grants (high: $35,000; low: $100) and
$24,850 for 18 grants to individuals.
Purpose and activities: Giving for higher
education, including undergraduate
scholarships and a chair in music, a community
fund, cultural programs, youth agencies, and
health.
Types of support: Student aid.
Limitations: Giving limited to Pueblo County,
CO.
Application information: Applications not
accepted except for scholarships; contributes
only to pre-selected organizations.
Applications not accepted.
 Deadline(s): Prior to beginning of school year
 in which assistance is requested
Officers and Trustees: Mahlon T. White,
Pres.; Helen T. White, V.P.; Lester Ward, Jr.,
Secy.-Treas.; Adrian Comer, Elizabeth Ensign.
Employer Identification Number: 840581724

387
True North Foundation
2190 West Drake, No. 361
Fort Collins 80526

Established in 1986 in CO.
Financial data (yr. ended 12/31/87): Assets,
$6,420,103 (M); expenditures, $310,888,
including $227,793 for 27 grants (high:
$41,000; low: $500).
Purpose and activities: Support for
conservation of wildlife and wilderness areas,
cultural institutions, family planning services,
and community programs for the aged and
hungry.

Types of support: Equipment, scholarship funds, general purposes, building funds.
Limitations: Giving primarily in CA and OR.
Officer and Directors: Kerry K. Hoffman, Pres.; L. Jane Gallup, Kathryn F. Stephens.
Employer Identification Number: 742421528

388
US WEST Corporate Giving Program
7800 East Orchard Rd.
Englewood 80111 (303) 793-6578

Purpose and activities: Supports social services, education, arts and culture programs. Types of support include capital campaigns, operating funds, scholarships, seed money and special project funding.
Types of support: Capital campaigns, operating budgets, scholarship funds, seed money, special projects.
Limitations: Giving primarily in company's operating areas in AZ, CO, IA, ID, MN, MT, ND, NE, NM, OR, SD, UT, WA, and WY.
Application information: Include complete budget, IRS letter, board list, donor list and audited statement.
 Initial approach: Letter
 Deadline(s): N; applications accepted on an ongoing basis
 Write: Larry Nash, Dir., U.S. West Foundation

389
US WEST Foundation
(Formerly Mountain Bell Foundation)
7800 East Orchard Rd., Suite 300
Englewood 80111 (303) 793-6661
Application address: Local US WEST Public Relations Office or Community Relations Team

Established in 1985 in CO.
Donor(s): Mountain Bell.
Financial data (yr. ended 12/31/87): Assets, $2,797,503 (M); gifts received, $6,673,523; expenditures, $6,013,446, including $5,893,391 for 2,218 grants (high: $193,750; low: $50; average: $500-$10,000) and $98,281 for 830 employee matching gifts.
Purpose and activities: Giving primarily for human services, education, health, arts and culture, civic and community development, and economic development; employee matching gifts for higher education, human services, and the arts.
Types of support: Operating budgets, general purposes, employee matching gifts, special projects, continuing support.
Limitations: Giving limited to the states served by the US WEST calling areas, including AZ, CO, IA, ID, MN, MT, ND, NE, NM, OR, UT, WA, and WY. No support for international organizations, political or religious organizations, or school bands or choral groups. No grants to individuals, or for endowment funds, deficit financing, scholarships, athletic funds, or goodwill advertising.
Publications: Corporate giving report (including application guidelines).
Application information:
 Initial approach: Proposal
 Deadline(s): None

Board meeting date(s): Feb., May, Aug., and Nov.
Final notification: Most funds disbursed during 4th quarter each year
Write: L.J. Nash, Dir. Administration
Officers: Jack A. MacAllister, Pres.; Larry DeMuth, Secy.; Howard P. Doerr, Treas.
Number of staff: 7 full-time professional; 1 full-time support.
Employer Identification Number: 840978668

390
Eleanore Mullen Weckbaugh Foundation
13064 Parkview Dr.
Aurora 80011 (303) 367-1545
Application address: P.O. Box 31678, Aurora, CO 80041

Established in 1975.
Donor(s): Eleanore Mullen Weckbaugh.†
Financial data (yr. ended 3/31/88): Assets, $5,609,044 (M); expenditures, $430,515, including $384,825 for 52 grants (high: $30,000; low: $1,000).
Purpose and activities: Emphasis on Roman Catholic church support and welfare funds; grants also for higher and secondary education, the performing arts, health agencies, and a social agency.
Types of support: General purposes.
Limitations: Giving primarily in CO. No grants to individuals.
Publications: 990-PF.
Application information:
 Initial approach: Letter
 Copies of proposal: 1
 Deadline(s): None
 Board meeting date(s): Mar., June, Sept., and Dec.
 Write: Edward J. Limes, Pres.
Officers: Edward J. Limes,* Pres. and Treas.; Jean Guyton, Secy.
Trustees:* S.P. Guyton, Michael Polakovic, Teresa Polakovic.
Number of staff: 1 full-time professional.
Employer Identification Number: 237437761

CONNECTICUT

391
Aetna Life & Casualty Foundation, Inc.
151 Farmington Ave.
Hartford 06156 (203) 273-3340

Incorporated in 1972 in CT.
Donor(s): Aetna Life and Casualty Co.
Financial data (yr. ended 12/31/88): Assets, $32,641,934 (M); gifts received, $20,000,000; expenditures, $7,531,496, including $7,668,643 for 488 grants (high: $1,087,000; low: $300) and $783,998 for employee matching gifts.
Purpose and activities: To help preserve a viable society by supporting programs and

organizations that can have a real impact on solving social problems and by providing support that will stimulate other donors. Priority areas for giving are problems of urban public education, minority higher education, improving minority youth employment opportunities, urban neighborhood revitalization, and reform of the civil justice system; also support for the arts and social services, with an emphasis on AIDS. The foundation encourages employee participation in community affairs through support for regional grants and FOCUS, foundation initiatives that serve the headquarters city, Hartford, CT, and cities where Aetna has major field office operations, several international initiatives in countries where the company operates, Dollars-for-Doers, and matching gifts for higher education.
Types of support: Operating budgets, continuing support, seed money, emergency funds, matching funds, employee matching gifts, technical assistance.
Limitations: Giving limited to organizations in the U.S. No support for religious organizations for religious purposes, or private secondary schools. No grants to individuals, or for endowment funds, medical research, capital or building funds or renovation projects or annual operating funds for colleges, universities, social service agencies, secondary schools, museums, hospitals, or other such institutions; no grants for computer hardware; no loans.
Publications: Corporate giving report, application guidelines, program policy statement.
Application information: Application form required for Focus grants.
 Initial approach: Letter with proposal summary
 Copies of proposal: 1
 Deadline(s): None
 Board meeting date(s): Feb., May, July, and Nov.
 Final notification: 2 months
 Write: Marge Mlodzinski, Prog. Officer
Officers: Ronald E. Compton,* Pres.; Sanford Cloud, Jr., V.P. and Exec. Dir.; Stephen B. Middlebrook, V.P.; Frederick W. Kingsley, Treas.
Directors:* William H. Donaldson, Chair.; Arthur R. Ashe, Jr., Donald G. Conrad, Marian W. Edelman, Barbara Hackman Franklin, Edward K. Hamilton, James T. Lynn.
Number of staff: 10 full-time professional; 6 full-time support.
Employer Identification Number: 237241940
Recent arts and culture grants:
Affiliate Artists, NYC, NY, $22,750. 1987.
Affiliate Artists, NYC, NY, $19,500. 1987.
Arts and Science Council, Charlotte/Mecklenburg Chapter, Charlotte, NC, $5,000. 1987.
Charlotte Opera Association, Charlotte, NC, $8,500. 1987.
Charlotte Shakespeare Company, Charlotte, NC, $7,000. 1987.
Childrens Theater of Charlotte, Charlotte, NC, $10,000. 1987.
College of Art and Design, Detroit, MI, $5,000. 1987.
Connecticut Humanities Council, Hartford, CT, $11,000. For Mark Twain Memorial. 1987.

Detroit Community Music School, Detroit, MI, $7,000. 1987.

Grand Rapids Symphony Society, Grand Rapids, MI, $5,000. 1987.

Greater Hartford Arts Council, Hartford, CT, $165,000. For annual support. 1987.

Library Theater, DC, $6,951. 1987.

Louisiana State University, Baton Rouge, LA, $6,000. For grant shared with Agricultural and Mechanical College and KDAQ Public Broadcasting. 1987.

Middletown Foundation for the Arts, Middletown, CT, $6,340. 1987.

Music Center of Los Angeles County, Los Angeles, CA, $7,500. 1987.

New Jersey Youth Symphony, Summit, NJ, $5,000. 1987.

Niagara Council of the Arts, Niagara Falls, NY, $5,000. 1987.

Philbrook Art Center, Tulsa, OK, $7,500. 1987.

Pittsburgh Public Theater Corporation, Pittsburgh, PA, $5,000. 1987.

Repertory Theater of Saint Louis, Saint Louis, MO, $7,250. 1987.

Science Museum of Connecticut, West Hartford, CT, $6,500. For Pre-Engineering program. 1987.

Walnut Creek Regional Arts Center, Walnut Creek, CA, $35,000. 1987.

Young Audiences, Denver, CO, $14,000. 1987.

392
AMAX Foundation, Inc.
Amax Center
Greenwich 06836 (203) 629-6901

Incorporated in 1955 in NY.
Donor(s): AMAX, Inc.
Financial data (yr. ended 12/31/87): Assets, $2,753,101 (M); expenditures, $767,416, including $639,101 for 328 grants (high: $25,000; low: $250; average: $500-$2,000), $65,850 for 37 grants to individuals and $37,876 for 124 employee matching gifts.
Purpose and activities: Grants for higher education, largely in the fields related to mining, metallurgy, geology, geophysics, and geochemistry; employee matching gift program and Amax Earth Sciences Scholarships for children of employees only; and for health and welfare, especially United Way campaigns; cultural programs, and civic and public affairs.
Types of support: Building funds, continuing support, employee matching gifts, fellowships, general purposes, professorships, research, scholarship funds, employee-related scholarships, matching funds.
Limitations: Giving primarily in areas of company operations. No support for political, fraternal, religious, or sectarian organizations, primary or secondary education, creative arts groups, sports or athletic events, nursing homes, organizations supported by the United Way (unless permission has been granted by the United Way), or governmental or quasi-governmental agencies. No grants to individuals (except company-employee scholarships), or for memorial funds, goodwill advertisements in yearbooks or souvenir programs, charity dinners or special performance events; no support for endowment funds; no loans.

Publications: Application guidelines, program policy statement, informational brochure.
Application information:
Initial approach: Letter
Copies of proposal: 1
Deadline(s): Submit proposal by Mar. 15 for civic and charitable projects and from July 1 to Sept. 1 for educational projects
Board meeting date(s): May and Oct. and as required
Final notification: 60 days
Write: Sonja B. Michaud, Pres.
Officers: Sonja B. Michaud,* Pres.; Malcolm B. Bayliss,* V.P.; Raymond J. Cooke,* Secy.; Dennis Arrouet, Treas.
Directors:* Helen M. Feeney, Charles Toder.
Number of staff: 1 full-time professional; 1 full-time support.
Employer Identification Number: 136111368

393
The Anthony Trust Association
c/o The Chase Coggins Memorial Scholarship
5471 Yale Station
New Haven 06520

Established in 1941 in CT.
Financial data (yr. ended 6/30/88): Assets, $1,928,291 (M); expenditures, $123,812, including $2,000 for 2 grants to individuals.
Purpose and activities: A private operating foundation; support to individuals for wilderness exploration and travel or for artistic or educational intent.
Types of support: Student aid.
Limitations: Giving primarily in CT.
Application information:
Initial approach: Letter
Deadline(s): Mar. 29
Officers: Richard G. Bell, Secy.; Charles Roraback, Treas.
Trustees: Augustus G. Kellogg, Carter Weisman, and 10 additional trustees.
Employer Identification Number: 060245162

394
Bank of Boston Connecticut Corporate Giving Program
81 West Main St.
Waterbury 06720 (203) 574-7473

Financial data (yr. ended 12/31/87): Total giving, $372,783, including $311,894 for grants and $60,889 for in-kind gifts.
Purpose and activities: Support for education, employment, and training, higher education, health and human services, culture and the arts, social services, civic and community affairs, memberships, benefits, and program ads; also provides in-kind contributions of personnel, products, and facilities. In addition, the Bank matches employee pledges to United Way branches.
Types of support: In-kind gifts.
Limitations: Giving limited to CT.
Application information:
Initial approach: Letter
Write: Jill Murray, V.P. and Mgr., Community Affairs

395
The Bannow-Larson Foundation, Inc.
1976 Post Rd.
Fairfield 06430-5720

Established in 1966 in CT.
Financial data (yr. ended 7/31/87): Assets, $1,115,059 (M); expenditures, $47,801, including $29,400 for 10 grants (high: $10,000; low: $300).
Purpose and activities: Support primarily for a medical center foundation; support also for cultural programs and a community foundation.
Application information: Contributes only to pre-selected organizations. Applications not accepted.
Officers and Directors: Gilbert R. Larson, Pres.; Dorothy B. Larson, Secy.; Denise L. Lovegrove.
Employer Identification Number: 066084233

396
J. Walton Bissell Foundation
CityPlace, 25th Fl.
Hartford 06103

Trust established in 1952 in CT.
Donor(s): J. Walton Bissell.†
Financial data (yr. ended 12/31/87): Assets, $10,118,483 (M); expenditures, $620,004, including $527,500 for 68 grants (high: $50,000; low: $500).
Purpose and activities: Giving for higher and secondary education, including scholarship funds, hospitals, youth agencies, care of the aged, Protestant church support, and historic preservation.
Types of support: Scholarship funds.
Limitations: Giving primarily in CT, MA, VT, and NH. No grants to individuals; no loans.
Application information:
Initial approach: Letter
Deadline(s): None
Write: J.D. Anthony, Jr.
Officer and Trustees: D.M. Rockwell, Secy.; J.D. Anthony, Jr., P.R. Reynolds, L. Steiner.
Employer Identification Number: 066035614

397
Bodenwein Public Benevolent Foundation
c/o Connecticut National Bank
250 Captain's Walk
New London 06320 (203) 447-6133

Established in 1939 in CT.
Donor(s): The Day Trust.
Financial data (yr. ended 12/31/87): Assets, $315,600 (M); gifts received, $241,320; expenditures, $274,153, including $258,496 for 58 grants (high: $22,000; low: $100).
Purpose and activities: Giving to social service and health agencies, cultural programs, youth agencies, and civic groups.
Types of support: Building funds, capital campaigns, conferences and seminars, consulting services, equipment, matching funds, publications, renovation projects, research, scholarship funds, seed money, special projects.
Limitations: Giving limited to Lyme, Old Lyme, East Lyme, Waterford, New London, Montville,

Groton, Ledyard, Stonington, North Stonington, and Salem CT.
Publications: Informational brochure (including application guidelines).
Application information: Application form required.

 Initial approach: Telephone
 Copies of proposal: 1
 Deadline(s): May 15 and Nov. 15
 Board meeting date(s): Jan. and July
 Final notification: 8 to 12 weeks
 Write: Mildred E. Devine, V.P., Connecticut National Bank

Trustee: Connecticut National Bank.
Number of staff: None.
Employer Identification Number: 066030548

398
The Bridgeport Area Foundation, Inc.
446 University Ave.
Bridgeport 06604 (203) 334-7511

Community foundation incorporated in 1967 in CT.
Financial data (yr. ended 12/31/88): Assets, $7,050,840 (M); gifts received, $954,036; expenditures, $658,027, including $520,539 for 163 grants (high: $15,000; low: $250; average: $3,000-$5,000).
Purpose and activities: Grants to organizations and for projects that benefit named local communities.
Types of support: Continuing support, annual campaigns, seed money, emergency funds, building funds, equipment, consulting services, technical assistance, conferences and seminars, special projects, general purposes, renovation projects, scholarship funds.
Limitations: Giving primarily in Bridgeport, Easton, Fairfield, Milford, Monroe, Shelton, Stratford, Trumbull, and Westport, CT. No grants to individuals, or for operating budgets, deficit financing; no loans.
Publications: Annual report (including application guidelines), newsletter, application guidelines, financial statement, informational brochure (including application guidelines).
Application information: Application form required.

 Initial approach: Letter
 Copies of proposal: 2
 Deadline(s): Feb. 15, May 15, and Sept. 15
 Board meeting date(s): Apr. and Oct.; distribution committee meets in Mar., June, and Oct.
 Final notification: Nov.
 Write: Richard O. Dietrich, Pres. AND C.E.O.

Officers and Directors: George F. Taylor, Chair.; Robert W. Huebner, Vice-Chair.; Richard O. Dietrich, Pres. and C.E.O.; Peter Wilkinson, Secy.; Henry L. Katz, Treas.; Robert J. Ashkins, John P. Bassett, Mrs. Gerald C. Baum, Edward F. Bodine, Frank G. Elliott, Jr., M.D., Richard F. Freeman, Norwick R.G. Goodspeed, Mrs. Gilbert R. Larson, John Marshall Lee, Carmen L. Lopez, Newman Marsilius, Jr., L. Scott Melville, Cecil S. Semple, Richard I. Steiber, Robert S. Tellalian, Philip Trager, William S. Warner, Mrs. Edward Wasserman, Ernest A. Wiehl, Jr., Austin K. Wolf.
Distribution Committee:* Ronald D. Williams, Chair.; Mrs. Leete P. Doty, Assoc. Chair.; Mrs. Henry B. duPont III, William L.

Hawkins, Geraldine W. Johnson, Robert C. Lindquist, Carmen L. Lopez, James E. Marbury, Ronald B. Noren, James F. Tomchik.
Trustees: Citytrust, Connecticut Bank & Trust Co., N.A., Connecticut National Bank, Lafayette Bank & Trust Co., Peoples Bank.
Number of staff: 1 full-time professional; 2 part-time professional; 3 full-time support.
Employer Identification Number: 066103832

399
Fred R. & Hazel W. Carstensen Memorial Foundation, Inc.
c/o Tellalian & Tellalian
211 State St.
Bridgeport 06604

Established in 1982 in CT.
Financial data (yr. ended 6/30/87): Assets, $2,052,522 (M); expenditures, $140,841, including $89,000 for 22 grants (high: $15,000; low: $1,000).
Purpose and activities: Support for churches and church-related activities, cultural programs, including a local symphony, hospitals and health organizations, and a YMCA; some support for education.
Limitations: Giving primarily in CT.
Application information:

 Deadline(s): None
 Write: Aram H. Tellalian, Jr., Chair.

Officers and Trustees: Aram H. Tellalian, Jr., Chair. and Pres.; Leo C. O'Loughlin, V.P. and Treas.; Robert S. Tellalian, Secy.
Employer Identification Number: 061078756

400
Champion International Corporate Contributions Program
One Champion Plaza
Stamford 06921 (203) 358-7000

Financial data (yr. ended 12/31/87): $4,200,000 for grants (high: $750,000; low: $500; average: $2,500-$5,000).
Purpose and activities: Support for higher, elementary, secondary, business, technical, engineering, and minority education. Also supports the United Way, natural resources and the environment, hospital building funds, volunteerism, human services, drug counseling, visual and graphic arts, and national organizations.
Types of support: Building funds, capital campaigns, employee matching gifts, general purposes, special projects.
Limitations: Giving primarily in areas of company operations. No support for political candidates or organizations, or religious, veterans' or fraternal organizations unless funds donated are used to benefit the general public. No grants to individuals, or for endowments.
Publications: Informational brochure (including application guidelines).
Application information:

 Initial approach: Request "Guidelines for Giving" for proper procedure
 Copies of proposal: 1
 Deadline(s): None
 Write: Maris Vanasse, Dir., Corp. Contribs. and Community Relations

Number of staff: 3 full-time professional; 2 full-time support.

401
Chesebrough-Pond's Corporate Giving Program
33 Benedict Place
P.O. Box 6000
Greenwich 06836 (203) 661-2000

Purpose and activities: Supports education, health, welfare, the arts, civic affairs, and an AIDS program.
Types of support: Building funds, capital campaigns, employee matching gifts, fellowships, general purposes, operating budgets, special projects, scholarship funds, research.
Limitations: Giving primarily in operating locations: Merced, CA; Greenwich, Linton, and Fairfield County, CT; Owensboro, KY; Jefferson City, MO; and Rochester, NY. No support for political or religious groups, current United Way recipients, or government-supported agencies. No grants to individuals, or for endowments or seed money; very few fellowships given.
Publications: Informational brochure.
Application information: Proposal including organization description and activities, amount of request, and geographic area served. Application form required.

 Initial approach: Letter
 Copies of proposal: 1
 Deadline(s): None
 Board meeting date(s): 4-5 times yearly
 Final notification: Within 1-3 1/2 months
 Write: Janet Hooper, Mgr., Corp. Social Responsibility

Number of staff: 1 full-time professional; 1 full-time support.

402
Clabir Corporation Foundation
485 West Putnam Ave.
Greenwich 06830-6073
Application address: P.O. Box 4545, Greenwich, CT 06830

Established in 1977 in CT.
Donor(s): Clabir Corp.
Financial data (yr. ended 12/31/87): Assets, $608,986 (M); gifts received, $95,000; expenditures, $454,373, including $444,285 for 39 grants (high: $300,000; low: $250).
Purpose and activities: Support for museums, youth and child welfare, and health.
Application information:

 Initial approach: Proposal
 Deadline(s): Apr. 30 and Oct. 31
 Board meeting date(s): May and Nov.
 Write: Henry D. Clarke, Jr., Trustee

Trustees: Donna L. Clarke, Henry D. Clarke, Jr., Robert H. Clarke, Wilmot L. Harris, Jr.
Employer Identification Number: 060972125

403
Henry D. Clarke, Jr. Foundation
Greenwich Office Park Four
Greenwich 06830

Established in 1977 in CT.
Donor(s): Henry D. Clarke, Jr.
Financial data (yr. ended 11/30/87): Assets, $723,713 (M); gifts received, $150,370;

expenditures, $299,923, including $296,050 for 42 grants (high: $81,000; low: $100).
Purpose and activities: Support for higher education, social services and cultural institutions.
Officers and Trustees: Wilmot L. Harris, Jr., Secy.; Donna L. Clarke, Treas.; Henry D. Clarke, Jr., Robert H. Clarke.
Employer Identification Number: 060972127

404
Combustion Engineering Corporate Giving Program
900 Long Ridge Road
P.O. Box 9308
Stamford 06904 (203) 328-7646

Financial data (yr. ended 12/31/88): Total giving, $415,082, including $167,500 for grants (average: $1,000-$40,000) and $246,588 for 994 employee matching gifts.
Purpose and activities: Supports the arts and higher education, health organizations including hospitals, hospices, and national disease associations, community funds, conservation, ecology, engineering, science and technology, and programs to benefit minorities and women.
Types of support: Endowment funds, scholarship funds, capital campaigns, employee matching gifts, fellowships, operating budgets, research, special projects.
Limitations: Giving primarily in headquarters state and national operating locations. No grants to individuals, or for tax-supported, political, fraternal, or veterans' organizations.
Publications: Corporate report.
Application information:
 Initial approach: Query letter
 Deadline(s): Best time to apply is between Aug. and Oct.
 Final notification: Within 2 weeks
 Write: William J. Connolly, Contribs. and Community Affairs; Dorothy D. Arnette, Educational Contribs.; Dr. Jack Sanderson, Science and Technology Contribs.

405
Connecticut Mutual Life Corporate Giving Program
140 Garden St.
Hartford 06154 (203) 727-6500

Financial data (yr. ended 12/31/88): Total giving, $1,535,000, including $1,500,000 for loans and $35,000 for 29 in-kind gifts.
Purpose and activities: Most giving is through the foundation. The Community Relations Program supports local events such as benefits which the company considers to be of importance in the community, donations of surplus equipment, and use of facilities. Through the Social Investments Program, the company supports community improvement, particularly housing development through high-risk, low interest loans.
Types of support: Program-related investments, loans, in-kind gifts.
Limitations: Giving primarily in Hartford, CT, and surrounding area.
Application information:
 Initial approach: Brief letter
 Deadline(s): None

Write: Astrida R. Olds, Corp. Responsibility Officer
Number of staff: 2 full-time professional; 1 part-time professional; 1 full-time support.

406
The Connecticut Mutual Life Foundation, Inc.
140 Garden St.
Hartford 06154 (203) 727-6621

Established in 1976.
Donor(s): Connecticut Mutual Life Insurance Co.
Financial data (yr. ended 12/31/87): Assets, $9,355,320 (M); expenditures, $1,212,803, including $914,336 for 87 grants (high: $206,141; average: $3,000-$6,000) and $206,141 for employee matching gifts.
Purpose and activities: Giving largely for education, particularly higher education, equal opportunity and employment programs, a community fund, social services, including housing, civic affairs, health agencies, and cultural programs.
Types of support: Operating budgets, continuing support, seed money, matching funds, employee matching gifts, technical assistance, program-related investments, scholarship funds, special projects, capital campaigns, internships, loans.
Limitations: Giving primarily in the Hartford, CT, area. No support for sectarian groups, political organizations, or federated drives outside the local area. No grants to individuals, or for endowment funds, deficit financing, emergency funds, publications, land acquisition, scholarships, fellowships, capital fund drives outside the local area, or goodwill advertising.
Publications: Corporate giving report, informational brochure (including application guidelines).
Application information:
 Initial approach: Letter or proposal
 Copies of proposal: 1
 Deadline(s): None
 Board meeting date(s): Mar. and Nov.
 Final notification: 3 months
 Write: Astrida R. Olds, Asst. V.P.
Officers: Donald W. Davis,* Pres.; Robert R. Googins,* V.P.; Katharine K. Miller, Secy.; William J. Sullivan, Treas.
Directors:* Constance Clayton, William Ellis, Denis Mullane, S. Caesar Raboy.
Number of staff: 2 full-time professional; 1 part-time professional; 1 full-time support; 1 part-time support.
Employer Identification Number: 510192500
Recent arts and culture grants:
AIDS Project/Hartford, Benefit-Theater Works, Hartford, CT, $25,000. For production of As Is. 1987.
Bushnell Fund for the First Century, Hartford, CT, $15,000. For capital campaign contribution. 1987.
Greater Hartford Arts Council, Hartford, CT, $60,000. For federated arts fund drive. 1987.

407
Nancy Sayles Day Foundation
c/o Union Trust Co.
P.O. Box 1297
Stamford 06904

Trust established in 1964 in CT.
Donor(s): Mrs. Nancy Sayles Day,† Mrs. Lee Day Gillespie.
Financial data (yr. ended 9/30/87): Assets, $8,103,185 (L); gifts received, $200,156; expenditures, $320,743, including $286,520 for 33 grants (high: $35,000; low: $1,000).
Purpose and activities: Support for music, the arts, higher and secondary education, and youth agencies.
Types of support: Continuing support, general purposes, operating budgets.
Limitations: Giving primarily in MA. No grants to individuals, or for building or endowment funds, research, or matching gifts; no loans.
Publications: 990-PF.
Application information:
 Initial approach: Letter
 Copies of proposal: 1
 Write: John R. Disbrow, V.P., Union Trust Co.
Trustees: Leonard W. Cronkhite, Jr., M.D., Mrs. Lee Day Gillespie, Union Trust Co.
Employer Identification Number: 066071254

408
Marie G. Dennett Foundation
c/o Badger, Fisher, Cohen & Barnett
49 West Putnam Ave., P.O. Box 1189
Greenwich 06836

Incorporated in 1956 in IL.
Donor(s): Marie G. Dennett,† Priscilla D. Ramsey.
Financial data (yr. ended 8/31/87): Assets, $3,018,006 (M); expenditures, $273,831, including $266,650 for 33 grants (high: $88,200; low: $150).
Purpose and activities: Giving primarily for hospitals, education, conservation, cultural programs and health agencies.
Application information:
 Initial approach: Brief proposal
 Deadline(s): Sept. 30
 Write: Donat C. Marchand
Officers and Trustees: Priscilla D. Ramsey, Pres.; Lyle B. Ramsey, V.P.; Everett Fisher, Secy. and Treas.; Peter H. Blair, James D. Farley.
Number of staff: None.
Employer Identification Number: 061060970

409
Dexter Corporation Foundation, Inc.
One Elm St.
Windsor Locks 06096 (203) 627-9051

Established in 1976.
Donor(s): The Dexter Corp.
Financial data (yr. ended 12/31/87): Assets, $11,793 (M); gifts received, $450,000; expenditures, $509,204, including $434,623 for grants and $74,081 for employee matching gifts.
Purpose and activities: Grants largely for higher education, including employee matching

gifts, and for community funds, public policy organizations, business and professional organizations, health and youth agencies, and cultural and historic programs.

Types of support: Employee matching gifts, annual campaigns, capital campaigns, scholarship funds.

Limitations: Giving primarily in areas of business operations.

Publications: Application guidelines.

Application information:
Initial approach: Letter
Deadline(s): None
Write: David L. Coffin, Chair.

Officers and Directors: David L. Coffin, Chair.; Worth Loomis, Pres.; Robert E. McGill III, Secy.; James F. Calvert, Walter J. Connolly, Jr., Donald W. Davis, William P. Frankenhoff, John H. Page, Donald R. Roon, Peter L. Scott, George M. Whitesides.

Employer Identification Number: 061013754

410
The Dibner Fund, Inc.
c/o Burndy Library
Richards Ave.
Norwalk 06852 (203) 852-6203

Incorporated in 1957 in CT.

Donor(s): Barbara Dibner, Bern Dibner, David Dibner.

Financial data (yr. ended 12/31/87): Assets, $10,862,463 (M); expenditures, $1,195,121, including $1,159,360 for 33 grants (high: $591,500; low: $100; average: $500-$50,000).

Purpose and activities: Support largely for history of science institutions and projects; support also for higher education and cultural programs.

Limitations: No grants to individuals, or generally for building or endowment funds, scholarships, fellowships, and matching gifts; no loans.

Application information:
Initial approach: Letter
Deadline(s): None
Board meeting date(s): May

Officers and Trustees: David Dibner, Pres.; Frances K. Dibner, V.P.; George M. Szabad, Secy.-Treas.

Number of staff: None.

Employer Identification Number: 066038482

411
The Educational Foundation of America
35 Church Ln.
Westport 06880
Grant application office: 23161 Ventura Blvd., Suite 201, Woodland Hills, CA 91364; Tel.: (818) 999-0921

Trust established in 1959 in NY.

Donor(s): Richard P. Ettinger,† Elsie Ettinger,† Richard P. Ettinger, Jr., Elaine P. Hapgood, Paul R. Andrews,† Virgil P. Ettinger,† Barbara P. Ettinger, John G. Powers.

Financial data (yr. ended 12/31/88): Assets, $91,322,263 (M); gifts received, $69,566; expenditures, $4,815,011, including $4,117,207 for 78 grants (high: $206,000; low: $1,500; average: $10,000-$50,000).

Purpose and activities: Grants largely for higher education, including education for American Indians, medical education, and medical research; grants also for population control, children's education, and research in gerontology.

Types of support: General purposes, operating budgets, continuing support, seed money, professorships, internships, scholarship funds, matching funds, special projects, research, publications, fellowships.

Limitations: No grants to individuals, or for capital or endowment funds; no loans.

Publications: Annual report.

Application information:
Initial approach: Letter
Copies of proposal: 1
Deadline(s): None
Board meeting date(s): Feb., May, Aug., and Nov.
Final notification: 2 to 3 months
Write: Richard W. Hansen, Exec. Dir.

Officer: Richard W. Hansen, Exec. Dir.

Trustees: Elaine P. Hapgood, Chair.; Lynn P. Babicka, Barbara P. Ettinger, Richard P. Ettinger, Jr., Cyrus S. Hapgood, Frederic Rocco Landesman, Erica Pifer, John P. Powers.

Number of staff: 2 full-time professional; 4 part-time support.

Employer Identification Number: 136147947

Recent arts and culture grants:

Brooklyn Academy of Music, Brooklyn, NY, $25,000. For production of Swing--Le Grand Hotel, musical presentation made up predominantly of young people, dealing with critical issues, such as poverty, homelessness, broken homes. 8/11/87.

Dartmouth College, Hood Museum of Art, Hanover, NH, $27,500. For art education program for children in New Hampshire and Vermont. 8/16/88.

Dartmouth College, Hopkins Center for the Creative Arts, Hanover, NH, $10,000. For teacher training program which will benefit rural elementary and secondary school educators by expanding and enhancing their arts education skills. 8/16/88.

Foundation of the Dramatists Guild, NYC, NY, $27,482. For Young Playwrights Festival Education Program, which identifies and produces talented playwrights under age of nineteen. 3/1/88.

Manhattan Theater Club, NYC, NY, $25,000. For program for internships: Theater Administration Practicums. Program will provide intensive practical experience to students interested in non-profit theater management, while supplementing staff with qualified individuals. 11/17/87.

National Dance Institute, NYC, NY, $50,000. For work with nonprofessional public school students to encourage understanding and appreciation of the arts that will make these youngsters more informed audience for the future. 3/1/88.

New York City Ballet, NYC, NY, $25,000. For Dancer Training Program. 8/9/87.

New York Public Library, NYC, NY, $25,000. For videotaping several theater productions for Library's Theater on Film and Tape Archive. 8/16/88.

Society of the Third Street Music School Settlement, NYC, NY, $24,750. For

computer system to aid fund-raising. 8/16/88.

Spaulding Youth Center, Tilton, NH, $54,800. For expansion of artist residency program for emotionally disturbed boys and for establishment of creative arts program for students in Spaulding's Autistic Unit. 8/16/88.

412
The Ensign-Bickford Foundation, Inc.
Ten Mill Pond Ln.
Simsbury 06070 (203) 658-4411

Incorporated in 1952 in CT.

Donor(s): Ensign-Bickford Industries, Inc.

Financial data (yr. ended 12/31/87): Assets, $271,467 (M); gifts received, $447,000; expenditures, $264,851, including $105,451 for 142 grants (high: $15,000; low: $50), $29,000 for 33 grants to individuals, $79,570 for 462 employee matching gifts and $45,125 for 1 foundation-administered program.

Purpose and activities: Grants for welfare, education, and cultural programs; support also for employee-related scholarships, a summer job program for children of company employees, and for employee matching gifts.

Types of support: Continuing support, annual campaigns, seed money, building funds, equipment, land acquisition, special projects, scholarship funds, internships, research, publications, conferences and seminars, employee-related scholarships, employee matching gifts.

Limitations: Giving primarily in areas of company operations, particularly in the Simsbury and Avon, CT, area. No grants to individuals (except for employee-related scholarships), or for general endowment funds, operating budgets, emergency funds, or deficit financing; no loans.

Application information:
Initial approach: Letter
Deadline(s): None
Board meeting date(s): Approximately every two months
Final notification: 3 months
Write: Linda M. Walsh, Secy.

Officers: Robert E. Darling, Pres.; Thornton B. Morris, V.P.; Linda M. Walsh, Secy.; Jeffrey J. Nelb, Treas.

Directors: David C. Balbon, Austin D. Barney II, John E. Ellsworth, Arnold O. Freas, Sandra Ginnis, Frank S. Wilson.

Number of staff: 1 part-time professional.

Employer Identification Number: 066041097

413
The Ensworth Charitable Foundation
c/o Connecticut National Bank
777 Main St. - MSN 218
Hartford 06115 (203) 728-2274

Trust established in 1948 in CT.

Donor(s): Antoinette L. Ensworth.†

Financial data (yr. ended 5/31/86): Assets, $8,619,661 (M); expenditures, $486,924, including $430,525 for 103 grants (high: $25,000; low: $500).

Purpose and activities: Emphasis on health and welfare programs, youth activities,

enjoyment of the natural environment, religion, arts, and education.

Types of support: Continuing support, seed money, emergency funds, matching funds, conferences and seminars.

Limitations: Giving limited to Hartford, CT and vicinity. No grants to individuals, or for operating budgets, annual campaigns, deficit financing, building or endowment funds, equipment and materials, land acquisition, renovation projects, scholarships, fellowships, research, or publications; no loans.

Publications: 990-PF, program policy statement, application guidelines.

Application information: Application form required.

Initial approach: Letter or full proposal
Copies of proposal: 5
Deadline(s): 18th of month preceding board meetings
Board meeting date(s): Feb., May, Aug., and Nov.
Final notification: 1 month
Write: Maxine R. Dean, Community Action Officer

Advisory Committee: William Brown, Jr., Yasha Escalera, Johanna Murphy.

Trustee: Connecticut National Bank.

Number of staff: 1 full-time professional.

Employer Identification Number: 066026018

414

The Sherman Fairchild Foundation, Inc.
71 Arch St.
Greenwich 06830 (203) 661-9360

Incorporated in 1955 in NY.

Donor(s): May Fairchild,† Sherman Fairchild.†

Financial data (yr. ended 12/31/87): Assets, $179,725,061 (M); gifts received, $5,036; expenditures, $13,868,626, including $11,135,372 for 39 grants (high: $1,004,213; low: $11,200; average: $100,000-$800,000).

Purpose and activities: Emphasis on higher education and fine arts and cultural institutions; some support for medical research and social welfare.

Application information:

Initial approach: Proposal
Deadline(s): None
Write: Patricia A. Lydon, V.P.

Officers: Walter Burke,* Pres. and Treas.; Patricia A. Lydon, V.P.; Richard C. Pugh,* Secy.

Directors:* Walter F. Burke III, William Elfers, Lee P. Gagliardi, Robert P. Henderson, Bonnie Himmelman, Paul D. Paganucci, Agnar Pytte.

Number of staff: 1 full-time support; 1 part-time support.

Employer Identification Number: 131951698

Recent arts and culture grants:

Art Center College of Design, Pasadena, CA, $200,000. For endowment. 1987.

Brooklyn Museum, Brooklyn, NY, $275,000. For expansion and renovation of Museum. 1987.

Metropolitan Museum of Art, NYC, NY, $333,000. For endowment. 1987.

Museum of Fine Arts, Boston, MA, $500,000. For renovation of Evans Wing. 1987.

New York University, Institute of Fine Arts, NYC, NY, $300,000. For endowment of faculty chair. 1987.

415

Fairfield County Cooperative Foundation
Five Landmark Sq.
Stamford 06901 (203) 323-7410

Incorporated in 1982 in CT.

Financial data (yr. ended 12/31/88): Assets, $1,369,428 (M); gifts received, $112,697; expenditures, $1,169,016, including $1,074,651 for 70 grants (high: $20,000; low: $1,000).

Purpose and activities: Grants for health and social services, arts and culture, education, environment, and government and urban affairs.

Types of support: Scholarship funds, seed money, special projects, conferences and seminars, matching funds, research, consulting services, emergency funds, internships, publications, technical assistance.

Limitations: Giving primarily in Fairfield County, CT. No grants to individuals; low priority given to requests for endowments, capital projects, building funds, continuing support, deficit financing, general operating support, fellowships, or annual giving; no loans.

Publications: Grants list, informational brochure, program policy statement, application guidelines.

Application information:

Initial approach: Proposal
Copies of proposal: 1
Board meeting date(s): Feb., Apr., June, Aug., Oct., and Dec.
Write: Betsy Rich, Exec. Dir.

Officer: Betsy Rich, Exec. Dir.

Distribution Committee: Dana Ackerly, Chair.; Kaye E. Barker, Nancy C. Brown, George Carroll, Jr., Karl H. Epple, Edward E. Harrison, Harold Howe, Jr., Sydney C. Kweskin, Violet Manon.

Number of staff: 1 full-time professional; 1 part-time professional; 1 part-time support.

Employer Identification Number: 061083896

416

General Electric Foundation
3135 Easton Tpke.
Fairfield 06431 (203) 373-3216

Trust established in 1952 in NY.

Donor(s): General Electric Co.

Financial data (yr. ended 12/31/88): Assets, $32,380,000 (M); gifts received, $9,145,000; expenditures, $17,970,000, including $15,476,304 for 767 grants (high: $550,000; low: $100; average: $5,000-$100,000) and $3,101,895 for 19,977 employee matching gifts.

Purpose and activities: Institutional grants primarily in support of education, with emphasis on strengthening specific areas of work in undergraduate education; graduate-level research and teaching; support for disciplinary fields, including the physical sciences, engineering, computer science, mathematics, industrial management, and business administration; support for minority group education programs, with emphasis on engineering and business; matches educational contributions of employees. Support also for community funds in communities where the company has a significant presence, selected

public schools, arts and cultural centers, public issues research and analysis, equal opportunity, international understanding, and other special grants. Grants are directed toward specific programs authorized by the trustees and most are approved in advance of each calendar year.

Types of support: Annual campaigns, continuing support, employee matching gifts, fellowships, general purposes, publications, research, scholarship funds, seed money, special projects.

Limitations: Giving limited to the U.S. and its possessions; grants to community funds limited to areas where the company has a significant presence. No support for religious or sectarian groups. No grants to individuals, or for capital or endowment funds, scholarships, or equipment donations; no loans.

Publications: Annual report (including application guidelines).

Application information: Ability to respond to unsolicited requests is extremely limited.

Initial approach: Proposal
Copies of proposal: 1
Deadline(s): None
Board meeting date(s): As required
Final notification: Varies
Write: Paul M. Ostergard, Pres.

Officers: Paul M. Ostergard,* Pres.; Michael J. Cosgrove, Treas.; Jane L. Polin, Compt.

Trustees:* Dennis D. Dammerman, Chair.; James P. Baughman, Frank P. Doyle, Benjamin W. Heineman, Joyce Hergenhan, Jack O. Peiffer.

Number of staff: 6 full-time professional; 4 full-time support.

Employer Identification Number: 146015766

Recent arts and culture grants:

Affiliate Artists, NYC, NY, $140,000. 1987.

Arts Center and Theater of Schenectady, Schenectady, NY, $22,385. To match employee gifts under the More Gifts...More Givers Program. 1987.

Buffalo Bill Memorial Association, Cody, WY, $5,000. 1987.

Concert Artists Guild, NYC, NY, $70,000. 1987.

Cooper Union for the Advancement of Science and Art, NYC, NY, $5,000. 1987.

Coordinating Council of Literary Magazines, NYC, NY, $95,000. 1987.

Edison Institute, Dearborn, MI, $75,000. 1987.

Foundation for Hospital Art, Atlanta, GA, $10,500. 1987.

Friends of the Burnet Park Zoo, Burnet, TX, $10,000. 1987.

John F. Kennedy Center for the Performing Arts, DC, $35,000. 1987.

Lincoln Center for the Performing Arts, NYC, NY, $10,000. 1987.

Manhattan College, Bronx, NY, $44,000. 1987.

Milwaukee Repertory Theater, Milwaukee, WI, $50,000. 1987.

Museum of Modern Art, NYC, NY, $15,000. 1987.

National Corporate Fund for Dance, NYC, NY, $65,000. 1987.

National Corporate Theater Fund, NYC, NY, $25,000. 1987.

New York Zoological Society, Bronx, NY, $5,000. 1987.

Philharmonic-Symphony Society of New York, NYC, NY, $20,000. 1987.

Schenectady County Historical Society, Schenectady, NY, $14,195. To match

employee gifts under the More Gifts...More Givers Program. 1987.

Schenectady Museum Association, Schenectady, NY, $7,382. To match employee gifts under the More Gifts...More Givers Program. 1987.

School of American Ballet, NYC, NY, $5,000. 1987.

Stamford Center for the Arts, Stamford, CT, $25,000. 1987.

Young Audiences, NYC, NY, $49,300. 1987.

417
General Electric Foundation, Inc.
3135 Easton Turnpike
Fairfield 06431 (203) 373-3216

Established in 1985 in CT.
Donor(s): General Electric Co.
Financial data (yr. ended 12/31/88): Assets, $1,427,000 (M); expenditures, $703,000, including $618,235 for 24 grants (high: $100,000; low: $2,500; average: $5,000-$50,000).
Purpose and activities: Giving primarily to innovative organizations that will play a significant role internationally in advancing charitable, scientific, literary, or educational programs.
Types of support: Special projects, research, employee matching gifts.
Limitations: Giving limited to foreign or domestic organizations whose funds will be spent outside the U.S. and its possessions. No support for religious or sectarian groups. No grants to individuals, or for capital or endowment funds, scholarships, or equipment donations; no loans.
Publications: Annual report (including application guidelines).
Application information: Ability to respond to unsolicited proposals is extremely limited.
Initial approach: Proposal
Copies of proposal: 1
Deadline(s): None
Board meeting date(s): As required
Final notification: Varies
Write: Paul M. Ostergard, Pres.
Officers: Paul M. Ostergard, Pres.; Michael J. Cosgrove, Treas.; Jane L. Polin, Comptroller.
Directors: Dennis D. Dammerman, Chair.; James P. Baughman, Frank P. Doyle, Benjamin W. Heineman, Joyce Hergenhan, Jack O. Peiffer.
Number of staff: 4 full-time professional; 1 full-time support.
Employer Identification Number: 222621967
Recent arts and culture grants:
Institute of Cultural Affairs, Egypt, $7,500. 1987.

418
Herbert Gilman Family Charitable Foundation
2418 Main St.
Rocky Hill 06067

Established in 1964 in CT.
Financial data (yr. ended 1/31/87): Assets, $1,722,357 (M); expenditures, $178,287, including $178,036 for 32 grants (high: $75,130; low: $12).

Purpose and activities: Support for higher education, health organizations, and the performing arts; some support for Jewish welfare organizations.
Types of support: General purposes.
Application information: Contributes only to pre-selected organizations. Applications not accepted.
Trustees: Morris Crosky, Evelyn Gilman, Herbert Gilman.
Employer Identification Number: 066071321

419
Great Northern Nekoosa Foundation, Inc.
P.O. Box 5120
Norwalk 06856-5120 (203) 845-9000

Incorporated in 1974 in CT.
Donor(s): Great Northern Nekoosa Corp.
Financial data (yr. ended 12/31/88): Assets, $241,000 (M); expenditures, $759,747, including $758,484 for 142 grants (high: $80,800; low: $100; average: $5,000).
Purpose and activities: Giving primarily for hospitals, higher education, and youth agencies; support also for the arts, and civic organizations.
Types of support: Annual campaigns, building funds, capital campaigns, continuing support, general purposes, research, scholarship funds, special projects.
Limitations: Giving primarily in ME, WI, GA, and MS. No support for religious or political organizations.
Application information:
Copies of proposal: 1
Deadline(s): None
Write: Shirley Leopold, Secy.
Officers: William R. Laidig, Pres.; James G. Crump, V.P.; William Laimbeer, V.P.; Victor F. Mattson, V.P.; Arnold M. Nemirow, V.P.; Ronald J. Rakowski, V.P.; Raymond H. Taylor, V.P.; Francis G. Walker, V.P.; Shirley Leopold, Secy.; Douglas C. Wright, Treas.
Number of staff: 1 part-time support.
Employer Identification Number: 237424336

420
Maurice Greenberg Family Foundation, Inc.
c/o Coleco Industries
80 Darling Dr.
Avon 06001-4236

Established in 1963 in CT.
Financial data (yr. ended 12/31/87): Assets, $576,246 (M); expenditures, $111,798, including $108,550 for 8 grants (high: $100,000; low: $1,000).
Purpose and activities: Giving primarily for Jewish welfare and the arts.
Application information: Contributes primarily to pre-selected organizations.
Officers: Arnold C. Greenberg, V.P.; Leonard E. Greenberg, V.P.
Employer Identification Number: 066066013

421
GTE Foundation
One Stamford Forum
Stamford 06904 (203) 965-3620

Trust established in 1952 in NY as the Sylvania Foundation; renamed in 1960 as General Telephone & Electronics Foundation; renamed again in 1982.
Donor(s): GTE Corp., and subsidiaries.
Financial data (yr. ended 12/31/88): Assets, $18,100,000 (M); gifts received, $18,100,000; expenditures, $19,100,000, including $15,518,191 for 1,080 grants (high: $2,300,000), $2,481,809 for 5,000 employee matching gifts and $1,100,000 for in-kind gifts.
Purpose and activities: Emphasis on higher education in mathematics, science, and technology, and retention of minority students; sponsors an employee-related scholarship program through the College Scholarship Service; support also for community funds, the performing arts and social service agencies.
Types of support: Emergency funds, scholarship funds, fellowships, employee matching gifts, continuing support, employee-related scholarships, lectureships, operating budgets, special projects, program-related investments.
Limitations: Giving limited to areas of company operations and national organizations deemed to be of broad benefit to GTE companies, employees, shareholders, or customers. No grants to individuals (except for scholarships to the children of GTE employees), or for research; no loans.
Publications: Annual report, application guidelines.
Application information:
Initial approach: Letter or proposal
Copies of proposal: 2
Deadline(s): Fall
Board meeting date(s): Feb., May, Aug., Dec., and as required
Final notification: After Dec. 15
Write: Maureen Gorman, Dir., Corporate Social Responsibility
Officer: Maureen Gorman, Secy. and Dir., Corporate Social Responsibility.
Trustees: James L. Johnson, Chair.; Bruce Carswell, Charles R. Lee, Edward Schmults, Nicholas Trivisonno.
Number of staff: 3 full-time professional; 5 full-time support; 2 part-time support.
Employer Identification Number: 136046680

422
Ellen Knowles Harcourt Foundation, Inc.
c/o George Verenes
12 Aspetuck Ave.
New Milford 06776 (203) 355-2631
Application address: c/o Paul B. Altermatt, Pres., 51 Main St., New Milford, CT 06776

Established in 1982 in CT.
Donor(s): Ellen Knowles Harcourt.†
Financial data (yr. ended 12/31/87): Assets, $1,442,101 (M); gifts received, $6,653; expenditures, $70,166, including $51,146 for grants.
Purpose and activities: Support primarily for higher education and music programs.

Limitations: Giving primarily in the New Milford, CT, area.
Application information:
 Initial approach: Letter
 Deadline(s): None
Officers and Directors: Paul B. Altermatt, Pres.; R. McFarland Tilley, Secy.; George Verenes, Treas.; Adelle F. Ghisalbert, Alice McCallister, Leandro Pasqual.
Employer Identification Number: 061068025

423
The Hartford Courant Foundation, Inc.
285 Broad St.
Hartford 06115 (203) 241-6472

Established in 1950 in CT as a corporate foundation; restructured in 1980 as a private, independent foundation.
Donor(s): The Hartford Courant Co.
Financial data (yr. ended 12/31/88): Assets, $9,600,000 (M); expenditures, $622,823, including $527,814 for 86 grants (high: $62,000; low: $1,700; average: $4,000-$10,000) and $36,800 for 39 grants to individuals.
Purpose and activities: Giving primarily for arts and cultural programs, education, health and social service agencies, emerging community needs, and the advancement of journalism; support also for secondary school scholarship aid for Hispanic students.
Types of support: Land acquisition, scholarship funds, building funds, capital campaigns, equipment, general purposes, operating budgets, renovation projects, seed money, special projects, student aid, technical assistance, matching funds, publications, scholarship funds.
Limitations: Giving primarily in the central CT, area. No support for religious organizations (for sectarian purposes), veterans, fraternal, professional, or business associations, political groups, or private schools. No grants to individuals (except secondary school scholarships) or for continuing support, endowment or emergency funds, conferences, performances, or other short-term, one-time events; no loans.
Publications: Annual report, application guidelines, informational brochure.
Application information: Application form required.
 Initial approach: Telephone
 Copies of proposal: 1
 Deadline(s): Dec. 15, Mar. 15, June 15, and Sept. 15
 Board meeting date(s): Feb., May, Sept., and Nov.
 Final notification: 3 months
 Write: Alexandrina M. Sergio, Exec. Dir.
Officers: Linda J. Kelly,* Pres.; Millard H. Pryor, Jr.,* V.P.; Alexandrina M. Sergio, Secy. and Exec. Dir.; Richard H. King, Treas.
Trustees:* William O. Bailey, Michael Davies, Elliot F. Gerson, Alberto Ibarguen, Raymond A. Jansen, Jr., Linda J. Kelly, David Laventhol, Hartzel L. Lebed, Worth Loomis, Martha S. Newman, Donald F. Wright.
Number of staff: 1 full-time professional.
Employer Identification Number: 060759107
Recent arts and culture grants:

Amistad Foundation, Hartford, CT, $15,000. For initial installment of grant to purchase Simpson Collection of artifacts and artworks relating to black experience in America. 1987.
Ancient Burying Ground Association, Hartford, CT, $9,000. For replication of grave stones of Ebenezer and Elizabeth Watson. 1987.
Bushnell Memorial Hall, Hartford, CT, $15,000. For final installment of grant toward renovation of concert hall. 1987.
Connecticut Public Television, Hartford, CT, $9,400. For underwriting of MacNeil-Lehrer Newshour on Thursday evenings for one-half year. 1987.
Farmington Valley Arts Center, Farmington, CT, $5,000. Toward purchase and renovation of facilities. 1987.
Farmington Village Green and Library Association, Farmington, CT, $6,000. For challenge grant to match individual donations toward restoration of Stanley Whitman House. 1987.
Greater Hartford Arts Council, Hartford, CT, $57,000. For challenge to be matched by new or increased gifts from small businesses and for support of member arts organizations. 1987.
Greater Hartford Arts Council, Hartford, CT, $41,500. For final installment for establishment of Hartford Courant Arts Center. 1987.
Hartford Architecture Conservancy, Hartford, CT, $5,750. For specialized real estate financial planning computer program. 1987.
Hartt School of Music, Hartford, CT, $5,000. For activities associated with Menuhin residency. 1987.
La Casa de Puerto Rico, Hartford, CT, $5,000. Toward creation and installation of bronze relief of Dr. Ramon Emeterio Bentances over entrance to Hartford's Betances School. 1987.
Simsbury Light Opera Company, Simsbury, CT, $5,000. Toward construction of rehearsal and storage building. 1987.
Windham Textile and History Museum, Windham, CT, $7,500. Toward first year operating expenses. 1987.

424
Hartford Fire Insurance Corporate Giving Program
Hartford Plaza
Hartford 06115 (203) 547-4972

Purpose and activities: Giving in five major areas: Education and Equal Opportunity, Health and Human Services, Urban and Civic Affairs, Arts and Culture, and Mature Americans. Emphasis is on agencies which help people help themselves, show initiative in their fundraising efforts, and are managed effectively and prudently. In addition to cash grants, the company gives non-monetary support in four major areas for nonprofits: access to corporate facilities, in-kind printing, donation of corporate surplus, and through an organization of employee volunteers, "The Hartford Insurance People - helping people" or H.I.P. through which employees volunteer their time to charities. The Community Service Fund provides grants to civic projects to which staff

members contribute money and time. In 1987, the Hartford developed a unique model home called the Hartford House to demonstrate how subtle home improvements can compensate for the changes people experience as they age.
Types of support: In-kind gifts.
Application information:
 Write: Sandra A. Sharr, Dir., Corp. Contribs.

425
Hartford Foundation for Public Giving
85 Gillett St.
Hartford 06105 (203) 548-1888

Community foundation established in 1925 in CT by resolution and declaration of trust.
Financial data (yr. ended 9/30/88): Assets, $125,894,523 (M); gifts received, $2,462,245; expenditures, $6,778,550, including $6,064,544 for 230 grants (high: $287,000; low: $416; average: $45,000-$55,000), $1,000 for 1 employee matching gift and $100,000 for loans.
Purpose and activities: Giving for demonstration programs and capital purposes, with emphasis on community advancement, educational institutions, youth groups, hospitals, social services, including the aging, and cultural and civic endeavors.
Types of support: Seed money, emergency funds, building funds, equipment, land acquisition, matching funds, scholarship funds, loans, special projects, renovation projects, technical assistance, capital campaigns.
Limitations: Giving limited to the greater Hartford, CT, area. No support for sectarian purposes or tax-supported agencies. No grants to individuals, or for operating budgets, continuing support, annual campaigns, deficit financing, endowment funds, research, publications or conferences.
Publications: Annual report, application guidelines, program policy statement, newsletter, informational brochure.
Application information: Application form required.
 Initial approach: Telephone
 Copies of proposal: 3
 Deadline(s): Educ., schol. & youth, Jan. 30; Family, children, & early childhood, Mar. 30; Health care, July 30; Housing, neighborhood devel., employ. & training, Oct. 30; Arts & culture, Dec. 30; Sum. prog. & camperships, Feb. 15; and general grants, May 30 & Sept. 30
 Board meeting date(s): Monthly except Aug.
 Final notification: 60 to 90 days
 Write: R. Malcolm Salter, Dir.
Distribution Committee: Frederick G. Adams, Chair.; James F. English, Jr., Vice-Chair.; R. Malcolm Salter, Secy. and Dir.; Brewster P. Perkins, Treas.; Maria Borrero, Alan E. Green, George Levine, Jon O. Newman, Sue Ann Shay, Judith S. Wawro, Wilson Wilde.
Trustees: Connecticut Bank & Trust Co., N.A., Connecticut National Bank, United Bank & Trust Co., Society for Savings.
Number of staff: 6 full-time professional; 2 part-time professional; 5 full-time support.
Employer Identification Number: 060699252
Recent arts and culture grants:

Ancient Burying Ground Association, Hartford, CT, $80,000. For restoration and repair of burying ground established in 1640. 4/88.

Artists Collective, Hartford, CT, $300,000. Toward constructing and furnishing new arts center in Upper Albany neighborhood. 9/88.

Company One of Connecticut, Hartford, CT, $50,000. For lunch time theater series, Play with Your Food, to enrich Hartford as arts community. 2/88.

Connecticut Classical Guitar Society, Hartford, CT, $30,000. To partially fund executive director and establish outreach program of concerts at Greater Hartford Area Schools, hospitals, and recreation centers. 5/88.

Connecticut Opera Association, Hartford, CT, $105,000. For second and third year funding of audience development program to be done by expanding subscriber maintenance program, creating programs which have broader appeal, expanding student oriented performances, expanding tele-marketing campaign, and encouraging greater involvement of community in performances. 3/88.

Core Orchestra, Hartford, CT, $150,000. Toward funding 21 member Core to provide musical performances for Hartford community. 9/88.

Hartford Stage Company, Hartford, CT, $265,000. To cover costs of capital and endowment campaign. 5/88.

Hill-Stead Museum, Farmington, CT, $175,000. To upgrade fire protection and security system. 4/88.

School of the Hartford Ballet, Hartford, CT, $150,000. For dance program for city youth. 9/88.

Shelter for Women, Hartford, CT, $62,185. To complete restoration of historic John Davenport Cheney family mansion to provide housing for troubled adolescent girls. 6/88.

Symphony Society of Greater Hartford, Hartford, CT, $87,670. To supplement costs of community concerts, pre-concert talks and newsletters and to establish audience development program. 11/87.

Wadsworth Atheneum, Hartford, CT, $150,000. Toward enhancing and expanding museum's public education programs. 5/88.

West Hartford Art League, West Hartford, CT, $75,000. To renovate Buena Vista Club House for year-round use as gallery and classroom. 4/88.

426
The Hartford Insurance Group Foundation, Inc.
Hartford Plaza
Hartford 06115 (203) 547-4972
Additional tel.: (203) 547-5816

Incorporated in 1966 in CT.
Donor(s): Hartford Fire Insurance Co., and affiliates.
Financial data (yr. ended 12/31/87): Assets, $257,482 (M); gifts received, $2,200,000; expenditures, $2,268,145, including $1,931,988 for 324 grants (high: $180,130; low: $25; average: $2,000-$10,000) and $329,350 for 1,261 employee matching gifts.

Purpose and activities: Giving primarily for higher education (including employee-related scholarships through the National Merit Scholarship Corporation and employee matching gifts program), job training, community funds, health, urban and civic affairs, arts and culture, the elderly; also has a community service fund that supports the efforts of its employees in community programs.
Types of support: Scholarship funds, employee matching gifts, employee-related scholarships, building funds, annual campaigns, special projects.
Limitations: Giving primarily in the Hartford, CT, area, and in communities where the company has a regional office. No support for political or religious purposes, disease-specific health organizations, student group trips or parades, United Way member agencies, public educational organizations (except for matching gifts program), or national fund drives or research programs not having a clear relationship to overall interests of the company and only on an exceptional basis. No grants to individuals, or for endowment funds, conferences, travel, testimonial or fundraising dinners, membership in business, professional and trade associations, courtesy advertising, or capital fund drives outside the greater Hartford area.
Publications: Corporate giving report (including application guidelines), informational brochure.
Application information: Application form required.
 Initial approach: Letter
 Copies of proposal: 1
 Deadline(s): None
 Board meeting date(s): Quarterly
 Write: Sandra A. Sharr, Dir., Community Affairs
Officers: Donald R. Frahm,* Pres.; Robert C. Fischer, Secy.; Michael O'Halloran, Secy.; J. Richard Garrett, Treas.
Directors:* Michael S. Wilder.
Number of staff: 1 full-time professional; 1 part-time support.
Employer Identification Number: 066079761
Recent arts and culture grants:
Connecticut Educational Telecommunications Corporation, Hartford, CT, $25,000. 1987.
Connecticut Opera Association, Hartford, CT, $72,500. 1987.
Greater Hartford Arts Council, Hartford, CT, $95,000. 1987.
Hartford Ballet, Hartford, CT, $5,000. 1987.
Horace Bushnell Memorial Hall, Hartford, CT, $25,000. 1987.
New York Center for Visual History, NYC, NY, $10,000. For final support for production of documentary on life and work of poet Wallace Stevens to be broadcast nationally on PBS. 1987.

427
Hartford Steam Boiler Inspection and Insurance Company Giving Program
One State St.
Hartford 06102 (203) 722-1866

Financial data (yr. ended 12/31/88): Total giving, $425,000, including $360,000 for grants and $65,000 for employee matching gifts.

Purpose and activities: Supports civic programs, housing, community arts, dance, fine arts institutes, general arts, general education, music, private colleges, public broadcasting, and theatre.
Types of support: Employee matching gifts.
Limitations: Giving primarily in Greater Hartford, CT, area.
Application information: Include project description, project budget, financial report, board list, and major donor list.
 Initial approach: Letter
 Final notification: Rejections will be notified
 Write: Grace Martin, Dir., Public Relations

428
The Howard and Bush Foundation, Inc.
P.O. Box 12670
Hartford 06112 (203) 525-5585
Application address for organizations in Troy, NY, area: Ms. Jean Bolgatz, 127 Elmgrove Ave., Troy, NY 12180; Tel.: (518) 274-2501

Incorporated in 1961 in CT.
Donor(s): Edith Mason Howard,† Julia Howard Bush.†
Financial data (yr. ended 12/31/87): Assets, $8,035,787 (M); gifts received, $1,080; expenditures, $939,430, including $863,391 for 61 grants (high: $52,830; low: $4,500; average: $5,000-$25,000).
Purpose and activities: Emphasis on social service and youth agencies, cultural programs, education, civic and urban affairs, and health agencies.
Types of support: Special projects, building funds, equipment, matching funds.
Limitations: Giving primarily in the Hartford, CT, and Troy, NY, areas. No support for government or largely tax-supported agencies, or to colleges, schools, or churches not connected with the founders. No grants to individuals, or for endowment funds, operating budgets, reserve or revolving funds, or deficit financing.
Publications: Annual report, application guidelines.
Application information: Application form required.
 Initial approach: Letter
 Copies of proposal: 1
 Deadline(s): Submit proposal well before 1st of month of board meeting
 Board meeting date(s): Feb., June, and Oct.
 Final notification: Within 10 days after board meeting
 Write: Bertina Williams, Exec. Dir., The Coordinating Council for Foundations, Inc.
Officers and Trustees: Sara H. Catlin, Pres.; Thomas S. Melvin, V.P.; James Lyons, Secy.; Connecticut Bank & Trust Co., N.A., Treas.; Bertina Williams, Exec. Dir.; Jean Bolgatz, James Lyon, George W. McIsaac, Margaret Mochan, Ned Paitison, Robert A. Stierer, David Tarmelee.
Number of staff: 1 full-time professional; 1 part-time support.
Employer Identification Number: 066059063

429
The ITT Rayonier Foundation
1177 Summer St.
Stamford 06904 (203) 348-7000

Incorporated in 1952 in NY.
Donor(s): ITT Rayonier, Inc.
Financial data (yr. ended 12/31/88): Assets,
$2,540,000 (M); gifts received, $292,000;
expenditures, $353,000, including $283,000
for 85 grants (high: $20,000; low: $25;
average: $1,000-$3,000), $52,000 for 45
grants to individuals and $50,000 for 5 in-kind
gifts.
Purpose and activities: Created as a medium
to meet civic responsibilities in the areas of
company operations and to educational
institutions related to ITT Rayonier recruitment
or to forest industry specializations. Grants to
educational associations for scholarships; to
hospitals for buildings and equipment; and to
health agencies and community funds;
scholarships to individuals residing in areas of
company operations in Nassau County, FL;
Wayne County, GA; and Clallam, Mason, and
Grays Harbor counties, WA.
Types of support: Scholarship funds,
employee-related scholarships, building funds,
equipment, operating budgets, continuing
support, annual campaigns, seed money,
emergency funds, deficit financing, land
acquisition, endowment funds, special projects,
matching funds, general purposes, capital
campaigns, employee matching gifts.
Limitations: Giving primarily in areas of
company operations in FL, GA, and WA. No
loans.
Application information:
 Initial approach: Letter or full proposal
 Copies of proposal: 1
 Deadline(s): Nov. 30
 Board meeting date(s): Feb.
 Final notification: 1 month
 Write: Jerome D. Gregoire, V.P.
Officers: R.M. Gross,* Chair. and Pres.;
Jerome D. Gregoire,* V.P.; C.W. Peacock,*
V.P.; J.B. Canning, Secy.; Gerald J. Pollack,
Compt.
Directors:* W.S. Berry, W.L. Nutter.
Number of staff: None.
Employer Identification Number: 136064462

430
The Cyrus W. & Amy F. Jones & Bessie D. Phelps Foundation, Inc.
c/o Tellalian & Tellalian
211 State St.
Bridgeport 06604

Incorporated in CT.
Donor(s): Amy F. Jones.†
Financial data (yr. ended 9/30/87): Assets,
$2,102,379 (M); expenditures, $138,835,
including $90,000 for 19 grants (high: $10,000;
low: $1,000).
Purpose and activities: Giving largely for
higher education, cultural programs, religion,
and science.
Types of support: Operating budgets.
Limitations: Giving primarily in CT.
Application information:
 Initial approach: Letter
 Deadline(s): None

Write: Aram H. Tellalian, Jr., Pres.
Officers and Trustees: Aram H. Tellalian, Jr.,
Chair., Pres., and Treas.; Alexander R. Nestor,
V.P.; Robert S. Tellalian, Secy.
Employer Identification Number: 060943204

431
Kohn-Joseloff Fund, Inc.
(Formerly Morris Joseloff Foundation, Inc.)
125 La Salle Rd., Rm. 200
West Hartford 06107 (203) 521-7010

Incorporated in 1936 in CT.
Donor(s): Lillian L. Joseloff,† Moris Joseloff
Foundation Trust.
Financial data (yr. ended 12/31/87): Assets,
$6,434,461 (M); expenditures, $1,408,733,
including $1,327,133 for 71 grants (high:
$1,000,800; low: $28).
Purpose and activities: Giving primarily for
Jewish welfare funds, higher and secondary
education, and cultural programs.
Limitations: Giving primarily in CT.
Application information: Applications not
accepted.
 Deadline(s): None
 Write: Bernard L. Kohn, Pres.
Officers and Directors: Bernhard L. Kohn, Sr.,
Pres.; Joan J. Kohn, V.P. and Secy.-Treas.;
Bernhard L. Kohn, Jr., V.P.; Kathryn K. Rieger,
V.P.
Employer Identification Number: 136062846

432
The Koopman Fund, Inc.
17 Brookside Blvd.
West Hartford 06107 (203) 232-6406

Incorporated in 1963 in CT.
Donor(s): Richard Koopman,† Georgette
Koopman.
Financial data (yr. ended 12/31/88): Assets,
$6,766,452 (M); expenditures, $449,017,
including $376,651 for 167 grants (high:
$176,825; low: $20).
Purpose and activities: Giving primarily for
higher and secondary education, welfare funds,
museums, and health organizations.
Types of support: Annual campaigns, building
funds, capital campaigns, continuing support,
emergency funds, endowment funds,
equipment, general purposes, matching funds,
publications, scholarship funds.
Limitations: Giving primarily in CT. No grants
to individuals.
Application information:
 Initial approach: Telephone
 Copies of proposal: 1
 Deadline(s): None
 Board meeting date(s): As required
 Write: Georgette Koopman, Pres.
Officers and Trustees: Georgette Koopman,
Pres.; Beatrice Koopman, Dorothy Koopman,
George Koopman, Rena Koopman, Richard
Koopman, Jr., Dorothy A. Schiro.
Number of staff: 1
Employer Identification Number: 066050431

433
John & Evelyn Kossak Foundation, Inc.
68 Cross Hwy.
Westport 06880-2147 (203) 259-8779

Established in 1969 in CT.
Financial data (yr. ended 12/31/87): Assets,
$1,267,790 (M); gifts received, $150,000;
expenditures, $70,618, including $69,150 for
40 grants (high: $25,000; low: $25).
Purpose and activities: Support primarily for
higher education, health organizations, and an
art museum.
Application information:
 Write: Evelyn K. Kossak, Pres.
Officers: Evelyn K. Kossak, Pres.; Jeffrey
Kossack, V.P.; Steven M. Kossak, Treas.
Employer Identification Number: 237045906

434
Ethel & Abe Lapides Foundation, Inc.
261 Bradley St., P.O. Box 1694
New Haven 06510

Financial data (yr. ended 11/30/86): Assets,
$1,437,471 (M); expenditures, $114,897,
including $93,500 for 65 grants (high: $5,000;
low: $500).
Purpose and activities: Grants for education,
the arts, health agencies and hospitals, and the
humanities.
Limitations: Giving primarily in CT.
Application information:
 Initial approach: Proposal
 Deadline(s): None
 Write: Jack Evans, V.P.
Officers: Burton Chizzick, Pres.; Jack Evans,
V.P.; Richard Feldman, Secy.; Fred J. Criscuolo,
Treas.
Employer Identification Number: 066068567

435
Albert A. List Foundation, Inc.
207 Byram Shore Rd.
Greenwich 06830
Application address: 888 Seventh Ave., New
York, NY 10019; Tel.: (212) 582-7235

Incorporated in 1953 in CT.
Donor(s): Albert A. List,† Vera G. List.
Financial data (yr. ended 6/30/87): Assets,
$13,288,052 (M); expenditures, $892,753,
including $816,167 for 18 grants (high:
$250,000; low: $2,000; average: $2,000-
$60,000).
Purpose and activities: Grants largely for
Jewish welfare funds, hospitals, and higher
education; giving also for the aged and cultural
programs.
Limitations: Giving primarily in NY and CT.
No grants to individuals.
Application information:
 Initial approach: Letter
 Deadline(s): None
 Board meeting date(s): Oct. and Apr.
 Final notification: Varies
 Write: Vera G. List, Pres.
Officers: Vera G. List,* Pres.; JoAnn List
Levinson,* Treas.
Directors:* Viki List, Olga List Mack, Carol List
Schwartz.
Number of staff: None.
Employer Identification Number: 510188408

436
Loctite Corporate Contributions Program
Hartford Square North
10 Columbus Blvd.
Hartford 06106 (203) 520-5000

Purpose and activities: Supports health, community arts, dance, economic education, fine arts institutes, general education, science and technology, engineering, and private colleges. Types of support include funding for equipment.
Types of support: General purposes, employee-related scholarships.
Limitations: Giving primarily in headquarters city and major operating areas.
Application information: Include description of the project, budget of project, board member list and major donor list.
 Initial approach: Proposal or letter
 Final notification: All requests will be
 answered
 Write: Bruce A. Vakiener, V.P.

437
George A. and Grace L. Long Foundation
c/o Connecticut National Bank
777 Main St.
Hartford 06115 (203) 728-2274

Trust established in 1960 in CT.
Donor(s): George A. Long, Grace L. Long.†
Financial data (yr. ended 12/31/87): Assets, $4,823,849 (M); expenditures, $154,030, including $97,531 for grants.
Purpose and activities: Emphasis on cultural programs, education, hospitals, social services, and community funds.
Types of support: Scholarship funds, special projects, building funds.
Limitations: Giving primarily in the greater Hartford, CT, area. No grants to individuals, or for operating budgets or endowment funds; no loans.
Application information: Application form required.
 Initial approach: Letter
 Copies of proposal: 3
 Deadline(s): Mar. 15 and Sept. 15
 Board meeting date(s): Apr. and Oct.
 Write: Maxine L. Dean, Comm. Action
 Officer, Connecticut National Bank
Trustees: J. Harold Williams, Connecticut National Bank.
Employer Identification Number: 066030953

438
Albert & Helen Meserve Memorial Fund
Union Trust Co.
P.O. Box 404
New Haven 06502 (203) 773-5832
Additional address: Betsy Rich, Exec. Dir., Fairfield County Cooperative Foundation, Three Landmark Square, Stamford, CT 06904

Established in 1983 in CT; grant program administered through the Fairfield County Cooperative Foundation.
Donor(s): Albert W. Meserve,† Helen C. Meserve.†

Financial data (yr. ended 8/31/88): Assets, $2,739,722 (M); expenditures, $148,461, including $90,851 for 30 grants (high: $10,000; low: $750).
Purpose and activities: Support primarily for the arts, education, the environment, health services, social services, and urban development.
Types of support: Conferences and seminars, consulting services, matching funds, scholarship funds, seed money, special projects, technical assistance.
Limitations: Giving primarily in Bethel, Bridgewater, Brookfield, Danbury, New Fairfield, New Milford, Newton, Redding, Ridgefield, and Sherman, CT. No support for religious or sectarian organizations, political activities, or groups desiring to benefit their own membership. No grants to individuals, or for endowment or general fund drives, operating budgets of United Way agencies, or deficit financing.
Publications: Application guidelines, informational brochure, grants list.
Application information:
 Initial approach: Proposal
 Copies of proposal: 1
 Deadline(s): Oct. 15 and Mar. 15
 Write: Eileen M. Wilhem, Sr. Trust Officer
Distribution Committee: Karl H. Epple, Chair.; Gino Arconti, Karl H. Epple, Rabbi Jerome R. Malino, Clarice Osiecki.
Number of staff: 1 part-time professional; 1 part-time support.
Employer Identification Number: 066254956

439
The New Haven Foundation
One State St.
New Haven 06515 (203) 777-2386

Community foundation established in 1928 in CT by Resolution and Declaration of Trust.
Financial data (yr. ended 12/31/88): Assets, $80,120,096 (M); gifts received, $1,921,626; expenditures, $4,768,851, including $3,949,947 for grants.
Purpose and activities: Emphasis on social service and youth agencies, hospitals and health agencies, educational institutions, community funds, and the arts.
Types of support: Operating budgets, continuing support, seed money, emergency funds, building funds, equipment, matching funds, consulting services, technical assistance, special projects, loans, scholarship funds, endowment funds.
Limitations: Giving primarily in greater New Haven, CT, and the lower Naugatuck River Valley. No grants to individuals, or for annual campaigns, deficit financing, endowment funds, research, scholarships, or fellowships, or generally for capital projects.
Publications: Annual report, application guidelines, newsletter.
Application information: Application form required.
 Initial approach: Telephone or letter
 Copies of proposal: 14
 Deadline(s): Jan., Apr., Aug., and Oct.
 Board meeting date(s): Mar., June, Oct., and
 Dec.
 Final notification: Within 1 week of decision

 Write: Helmer N. Ekstrom, Dir.
Distribution Committee: Lawrence M. Liebman, Chair.; Terry R. Chatfield, Vice-Chair.; Richard G. Bell, Richard H. Bowerman, Anne Calabrezi, Donald W. Celotto, Jr., Marcella T. Glazer, Theodore F. Hogan, Jr., Agnes W. Timpson.
Trustees: Bank of Boston Connecticut, Connecticut Bank & Trust Co., N.A., Connecticut National Bank, New Haven Savings Bank, Peoples Bank, Union Trust Co.
Number of staff: 10 full-time professional; 2 part-time professional; 6 full-time support; 1 part-time support.
Employer Identification Number: 066032106
Recent arts and culture grants:
Alliance Theater, New Haven, CT, $21,000. For matching support for hiring of additional staff in effort to increase community access to performances and to broaden financial base. 1987.
Arts Council of Greater New Haven, New Haven, CT, $45,000. For partially matching support to promote artistic and cultural life of New Haven by providing information, education, and support services for artists, arts groups, and general public. 1987.
Arts Council of Greater New Haven, Computer Consortium, New Haven, CT, $10,500. To broaden community arts programming by providing computer training and customized software to assist in business management of participating arts organizations. 1987.
Artspace, New Haven, CT, $15,000. For matching support to enhance elderly, student and minority attendance at performing and visual arts shows. 1987.
Barbara Feldman and Dancers, New Haven, CT, $15,000. For matching support to increase program's access to minority students and senior citizens and to develop touring potential in New Haven region and other Connecticut areas. 1987.
Brass Ring, New Haven, CT, $10,000. For matching support to expand brass chamber music programs for senior citizens and young adults. 1987.
City Spirit Artists, New Haven, CT, $38,150. For partially matching support to continue providing community access to arts and to develop long-range plan for fund-raising and public relations. 1987.
City Spirit Artists, New Haven, CT, $32,750. For matching support to promote community arts projects aimed at senior citizens and youths at risk while increasing public awareness of New Haven's parks through summer concert series. 1987.
Connecticut Chamber Orchestra, Hamden, CT, $15,000. For matching support to facilitate hiring of new staff in order to increase community access through block ticket sales. 1987.
Cultural Arts Council of East Haven, East Haven, CT, $7,800. For matching support to augment delivery of services in East Haven and attract new council members. 1987.
Dixwell Childrens Creative Arts Center, New Haven, CT, $10,000. For matching support to expose neighborhood children between ages of 5 and 15 to dance, drama, visual arts, and music. 1987.
Edgerton Garden Center, Hamden, CT, $10,000. To preserve original architectural

design and continued community use and enjoyment through restoration of portions of Edgerton Park. 1987.

Eli Whitney Museum, Meriden, CT, $25,000. For matching support to launch fund-raising drive to strengthen development capability and become more visible to local community. 1987.

Ensemble Center for the Performing Arts, Ensemble Theater, New Haven, CT, $18,000. For matching support to implement subscription campaign for senior citizens and students. 1987.

Neighborhood Music School, New Haven, CT, $17,730. For matching support to broaden development efforts toward audience expansion to include adult and public school children. 1987.

Neighborhood Music School, New Haven, CT, $7,000. For partially matching support to offer high quality music instruction to children in the Hill area of New Haven who otherwise could not afford it. 1987.

New Haven Artists Theater, New Haven, CT, $12,500. For matching support to create Director of Development position to try new fund-raising approaches and attract audiences to untraditional theater. 1987.

New Haven Board of Education, Community Arts Resources Project, New Haven, CT, $74,325. To expose students in grades K-6 to arts by working with community artists both in school and in community programs. 1987.

New Haven Chorale, New Haven, CT, $9,950. For matching support to sustain operating expenses and modify the subscription program to include senior citizens and churches. 1987.

New Haven Preservation Trust, New Haven, CT, $8,000. To offer residents of New Haven neighborhoods public, cultural, architectural and social history education through walking tours and slide lectures. 1987.

New Haven Symphony Orchestra, New Haven, CT, $10,800. To provide free tickets to orchestra concerts for elderly and visually handicapped. 1987.

New Haven Symphony Orchestra, Symphony on Wheels, New Haven, CT, $17,000. For matching support to enable small ensembles of orchestra to travel to businesses and community organizations. 1987.

Old Derby Historical Society, Derby, CT, $15,000. For partially matching support to teach local history to fifth grade students through hands-on experience of living life of a child of 1762, and to provide other community programs. 1987.

Orchestra of New England, New Haven, CT, $21,000. For partially matching support to allow for continuation of programs. 1987.

Performance Studio, New Haven, CT, $21,990. For matching support to implement Shakespeare on the Green program as model for developing long-range marketing plan for studio's auxiliary programs. 1987.

Shoreline Alliance for the Arts, New Haven, CT, $23,000. For matching support to promote involvement of students and parents in community-based and school programs. 1987.

Shubert Performing Arts Center, New Haven, CT, $20,000. To expand community participation and enjoyment through creation of Director of Audience Development position. 1987.

Sumumi Dance Theater Company, New Haven, CT, $9,500. For matching support to promote organization outside Greater New Haven by creating marketing tools which would develop new engagements with schools and theaters. 1987.

440
The Frank Loomis Palmer Fund
c/o Connecticut National Bank
250 Captain's Walk
New London 06320 (203) 447-6133

Trust established in 1936 in CT.
Donor(s): Virginia Palmer.†
Financial data (yr. ended 7/31/88): Assets, $11,388,165 (M); expenditures, $505,671, including $431,505 for 54 grants (high: $26,000; low: $350).
Purpose and activities: Grants to encourage new projects and to provide seed money, with emphasis on child welfare and family services, youth agencies, and higher and secondary education; support also for civic groups, cultural programs, social services, churches, and hospitals.
Types of support: Seed money, special projects, capital campaigns, conferences and seminars, consulting services, equipment, matching funds, publications, research, scholarship funds, renovation projects.
Limitations: Giving limited to New London, CT. No grants to individuals, or for endowment funds.
Publications: Informational brochure (including application guidelines).
Application information: Application form required.
 Initial approach: Telephone
 Copies of proposal: 1
 Deadline(s): May 15 and Nov. 15
 Board meeting date(s): Jan. and July
 Final notification: 8 to 12 weeks
 Write: Mildred E. Devine, V.P., Connecticut National Bank
Trustee: Connecticut National Bank.
Number of staff: None.
Employer Identification Number: 066026043

441
Panwy Foundation, Inc.
Greenwich Office Park
P.O. Box 1800
Greenwich 06836 (203) 661-6616

Trust established in 1943 in NY; incorporated in 1951 in NJ; reincorporated in 1988 in CT.
Donor(s): Olga Resseguier, Henry W. Wyman, Maria Wyman, Ralph M. Wyman, Ruth L. Russell, Pantasote, Inc., and others.
Financial data (yr. ended 12/31/87): Assets, $582,493 (M); gifts received, $188,634; expenditures, $255,507, including $255,507 for 250 grants (high: $33,000; low: $25).
Purpose and activities: Emphasis on cultural activities, church support, higher and secondary education, and hospitals.

Types of support: Operating budgets, continuing support, annual campaigns, seed money, emergency funds, endowment funds, building funds, research, equipment, conferences and seminars, scholarship funds, capital campaigns, general purposes, loans, renovation projects.
Limitations: No grants for matching gifts.
Application information:
 Initial approach: Letter
 Copies of proposal: 1
 Deadline(s): None
 Board meeting date(s): As required
 Final notification: 1 month
 Write: Ralph M. Wyman, Pres.
Officers and Trustees: Henry W. Wyman, Chair.; Ralph M. Wyman, Pres.; Harry A. Russell, V.P.; Virginia A.W. Meyer, Secy.-Treas.
Number of staff: None.
Employer Identification Number: 136130759

442
The Pequot Community Foundation, Inc.
302 Captain's Walk, Rm. 211
P.O. Box 769
New London 06320 (203) 442-3572

Established in 1982 in CT.
Financial data (yr. ended 12/31/88): Assets, $1,814,771 (L); gifts received, $296,450; expenditures, $182,858, including $138,522 for grants.
Purpose and activities: To promote learning, to advance scientific research, to provide care for the needy, sick, aged, or helpless, to secure the care of children, to encourage historical, literary, and artistic endeavors, and to otherwise contribute to the general welfare.
Types of support: Seed money, emergency funds, equipment, renovation projects, scholarship funds, fellowships, conferences and seminars, publications, general purposes, special projects, student aid.
Limitations: Giving limited to southeastern CT, including East Lyme, Groton, Ledyard, Lyme, Montville, New London, North Stonington, Old Lyme, Salem, Stonington, and Waterford. No support for sectarian or religious programs. No grants to individuals (except for scholarships awarded by nomination only) or for endowment, memorial, or building funds, operating expenses, deficit financing, annual campaigns, or land acquisition; no loans.
Publications: Annual report, application guidelines, informational brochure (including application guidelines), financial statement, grants list, newsletter.
Application information: Application form required.
 Initial approach: Letter
 Copies of proposal: 2
 Deadline(s): 2nd Monday in Jan.
 Board meeting date(s): Nov.
 Final notification: Grants are distributed in Mar.
 Write: Thomas T. Wetmore III, Exec. Dir.
Officers and Trustees:* Stephen Percy,* Pres.; Richard Creviston,* V.P.; Rita Hendel,* Secy.; John O. Zimmerman,* Treas.; Thomas T.

Wetmore III, Exec. Dir.; and 35 additional trustees.
Number of staff: 1 part-time professional; 1 part-time support.
Employer Identification Number: 061080097

443
Pitney Bowes Corporate Contributions Program

World Headquarters
Stamford 06926-0700 (203) 351-7751

Financial data (yr. ended 12/31/86): $1,756,000 for grants.
Purpose and activities: Supports programs concerning education, human services, health, the United Way, community services and culture.
Types of support: Operating budgets, capital campaigns, employee matching gifts.
Limitations: Giving primarily in company operating areas of CT, NE, NY, and OH. No support for tax-supported institutions or individuals. Generally does not give company products or equipment. Does not purchase tickets or advertising space. No scholarships are given.
Publications: Application guidelines.
Application information: Include description of organization, amount requested, total amount needed, purpose for which funds are sought, recently audited financial statement, proof of tax-exempt status and list of donors.
 Initial approach: Query letter; no telephone solicitations accepted
 Deadline(s): Applications preferred in the first 6 months of the year
 Write: Mary M. McCaskey, Secy., Corp. Contribs. Comm.

444
Evelyn W. Preston Trust

c/o Connecticut Bank & Trust Co., N.A.
Hartford 06115 (203) 244-5000

Trust established in 1978 in CT.
Donor(s): Mary Yale Bettis,† Evelyn Preston.†
Financial data (yr. ended 12/31/87): Assets, $2,082,562 (M); expenditures, $141,109, including $105,780 for 40 grants (high: $12,500; low: $50) and $18,385 for 14 grants to individuals.
Purpose and activities: Grants for free band and orchestral concerts in the city of Hartford from June through September.
Types of support: General purposes, grants to individuals.
Limitations: Giving limited to Hartford, CT.
Publications: Application guidelines.
Application information: Application form required.
 Final notification: 2 months
Trustee: Connecticut Bank & Trust Co., N.A.
Number of staff: None.
Employer Identification Number: 060747389

445
Primerica Foundation

American Lane
P.O. Box 3610
Greenwich 06830-3610 (203) 552-2148

Incorporated in 1960 in NY.
Donor(s): Primerica Corp.
Financial data (yr. ended 12/31/87): Assets, $0 (M); gifts received, $3,700,000; expenditures, $4,299,284, including $3,532,943 for 378 grants (high: $280,000; low: $200; average: $1,000-$50,000) and $167,941 for 486 employee matching gifts.
Purpose and activities: The foundation is undergoing a review of its grantmaking activities.
Types of support: Operating budgets, seed money, emergency funds, employee matching gifts, scholarship funds, employee-related scholarships, fellowships, special projects, continuing support, program-related investments.
Limitations: Giving primarily to national organizations, with some emphasis on areas of company operations. No support for strictly recreational, sectarian, or denominational organizations. Usually no grants to veterans' or fraternal organizations for their own benefit. No grants to individuals, or for building or endowment funds, continuing support, courtesy advertising, annual campaigns, deficit financing, land acquisition, or special events; no loans. Generally, no grants for capital drives.
Publications: Annual report, program policy statement, application guidelines.
Application information:
 Initial approach: Letter or proposal
 Copies of proposal: 1
 Deadline(s): None
 Board meeting date(s): Every 8 to 10 weeks
 Final notification: 2 months
Officers and Directors: William S. Woodside, Pres.; Kenneth A. Yarnell, Jr., V.P. and Treas.; Peter Goldberg, V.P.; Gerald Tsai, Jr., V.P.; John T. Andrews, Jr., Secy.; Robert B. Bogart, David A. Frank, JoAnn H. Heisen, John G. Polk, Walter A. Scott.
Number of staff: 4 full-time professional; 2 full-time support.
Employer Identification Number: 136161154
Recent arts and culture grants:
American Federation of Arts, NYC, NY, $5,000. 1987.
American Museum of Natural History, NYC, NY, $5,000. 1987.
Asia Society, NYC, NY, $33,000. 1987.
Business Arts Fund, Houston, TX, $5,000. 1987.
Business Committee for the Arts, NYC, NY, $5,000. 1987.
China Institute in America, NYC, NY, $5,000. 1987.
Goodspeed Opera House, East Haddam, CT, $5,000. 1987.
Historic Hudson Valley, Tarrytown, NY, $7,500. 1987.
Houston Symphony Society, Houston, TX, $10,000. 1987.
Japan Society, NYC, NY, $5,000. 1987.
John F. Kennedy Center for the Performing Arts, DC, $7,500. 1987.
Lincoln Center for the Performing Arts, NYC, NY, $20,000. 1987.

Long Wharf Theater, New Haven, CT, $6,000. 1987.
National Corporate Fund for Dance, NYC, NY, $10,000. 1987.
National Corporate Theater Fund, NYC, NY, $5,000. 1987.
National Public Radio, DC, $25,000. For in-depth reports on selected education issues and coverage of education events and issues on daily radio news magazines, Morning Edition and All Things Considered. 1987.
New Canaan Historical Society, New Canaan, CT, $7,500. 1987.
New York School for Circus Arts, NYC, NY, $25,000. 1987.
Smithsonian Institution, DC, $10,000. 1987.
W G B H Educational Foundation, Boston, MA, $7,000. 1987.
W N E T Channel 13, NYC, NY, $5,000. 1987.
Whitney Museum of American Art, NYC, NY, $280,000. 1987.

446
The Rich Foundation, Inc.

One Landmark Sq.
Stamford 06901 (203) 359-2900

Established in 1984 in CT.
Donor(s): F.D. Rich Co., Inc., Members of the Rich family.
Financial data (yr. ended 6/30/87): Assets, $848,304 (M); gifts received, $1,643,480; expenditures, $159,041, including $157,450 for 45 grants (high: $25,000; low: $200).
Purpose and activities: Support for educational and cultural institutions, health services and programs, and social service organizations.
Limitations: Giving primarily in lower Fairfield County, CT.
Application information: Applicants are urged to consult with the foundation staff in the development of their proposals.
 Initial approach: Proposal
 Deadline(s): Aug. 15
 Board meeting date(s): Sept. for budgets commencing Oct. 1 and ending Sept. 30 of the following calendar year; Mar. for supplementary budgets requests
Officers: Joseph F. Fahy, Jr., Pres.; Richard G. Bell, Secy.; Harold Spelke, Treas.
Employer Identification Number: 222544173

447
Edward C. & Ann T. Roberts Foundation, Inc.

c/o Connecticut Bank & Trust Co.
P.O. Box 3334
Hartford 06103 (203) 233-0228

Established in 1964 in CT.
Financial data (yr. ended 12/31/87): Assets, $1,268,851 (M); expenditures, $88,570, including $58,909 for grants (high: $7,500; low: $317).
Purpose and activities: Giving primarily for visual and performing arts.
Limitations: Giving limited to the greater Hartford, CT, area.
Application information:
 Initial approach: Letter

Deadline(s): 1st of each month of each calendar quarter
Write: Rosalie B. Lee, Exec. Dir.
Officers: Ann T. Roberts,* Pres.; John H. Riege,* Secy.; John T. Small, Jr.,* Treas.
Directors:* Rosalie Lee, Exec. Dir.; Marshall W. Davenson, William W. Graulty, Donald Harris, Mrs. Christopher Larson.
Employer Identification Number: 066067995

448
Charles Nelson Robinson Fund
c/o Connecticut Bank & Trust Co., N.A.
One Constitution Plaza
Hartford 06115 (203) 244-5586

Trust established in 1928 in CT.
Donor(s): Charles Nelson Robinson.†
Financial data (yr. ended 6/30/87): Assets, $2,111,453 (M); expenditures, $96,650, including $80,807 for 30 grants (high: $5,000; low: $300).
Purpose and activities: To aid "organized charities having a principal office in the City of Hartford"; support for social service agencies, including aid for the aged and youth, secondary education, and cultural programs.
Limitations: Giving primarily in Hartford, CT. No grants to individuals, or for endowment funds.
Publications: Application guidelines.
Application information: Application form required.
Initial approach: Letter or telephone
Copies of proposal: 5
Deadline(s): Jan. 15, May 15, and Sept. 15
Board meeting date(s): Feb., June, and Oct.
Write: Barbara L. Campbell, Asst. Treas.
Trustee: Connecticut Bank & Trust Co., N.A.
Employer Identification Number: 066029468

449
The Richard and Hinda Rosenthal Foundation
High Ridge Park
Stamford 06905 (203) 322-9900

Trust established in 1948 in NY.
Donor(s): Richard L. Rosenthal, and family, associates, and associated interests.
Financial data (yr. ended 12/31/88): Assets, $9,800,000 (M); gifts received, $14,625; expenditures, $340,000, including $320,000 for 200 grants (high: $46,000; low: $500).
Purpose and activities: To encourage achievement and excellence in the arts, social sciences, medical and scientific research, and clinical medicine. Conceived and annually sponsors the Rosenthal Awards for Fiction and for Painting through the American Academy and National Institute of Arts and Letters; also conceived and sponsors five national awards in clinical medicine through the American College of Physicians, American Heart Association, American Association for Cancer Research, and others. Has sponsored similar "discovery" awards in film.
Types of support: Research, special projects, annual campaigns, capital campaigns, general purposes.
Limitations: No grants to individuals.
Publications: Program policy statement.

Application information:
Initial approach: Letter
Copies of proposal: 1
Deadline(s): Oct. 31
Board meeting date(s): Quarterly and as required
Write: Hinda Gould Rosenthal, Pres.
Officers and Trustees: Richard L. Rosenthal, Chair.; Hinda Gould Rosenthal, Pres.; Richard L. Rosenthal, Jr., V.P.; Jamie G.R. Wolf, V.P.
Number of staff: 3 part-time support.
Employer Identification Number: 136104817

450
Schiro Fund, Inc.
25 Brookside Blvd.
West Hartford 06107 (203) 232-5854

Incorporated in 1963 in CT.
Donor(s): Bernard W. Schiro, Beatrice Fox Auerbach.†
Financial data (yr. ended 12/31/87): Assets, $5,156,990 (M); expenditures, $336,159, including $246,188 for 203 grants (high: $100,000; low: $10).
Purpose and activities: Emphasis on Jewish welfare funds, higher education, social services, and cultural organizations.
Types of support: General purposes.
Limitations: Giving primarily in CT.
Application information:
Deadline(s): None
Write: Bernard Schiro, Pres., and Dorothy A. Schiro, Secy.
Officers and Trustees: Bernard Schiro, Pres.; Dorothy A. Schiro, Secy.-Treas.; Georgette A. Koopman.
Employer Identification Number: 066056977

451
The Alix W. Stanley Charitable Foundation, Inc.
235 Main St.
New Britain 06051 (203) 224-6478
Mailing address: P.O. Box 2140, New Britain, CT 06050

Incorporated in 1943 in CT.
Donor(s): Alix W. Stanley.†
Financial data (yr. ended 12/31/88): Assets, $9,100,000 (M); expenditures, $602,000, including $549,875 for 31 grants (high: $100,000; low: $200).
Purpose and activities: Emphasis on cultural programs, community funds, family and youth agencies, and hospitals.
Types of support: Continuing support, annual campaigns, building funds, capital campaigns, emergency funds, seed money.
Limitations: Giving primarily to organizations benefiting the citizens of New Britain, CT, and surrounding areas. No grants to individuals; no loans.
Application information:
Initial approach: Proposal
Board meeting date(s): Mar., June, Sept., and Dec.
Write: James R. Lemeris, Trust Officer, Connecticut National Bank
Officers: William E. Attwood, Pres.; Timothy Grace, Secy.; Connecticut National Bank,

Treas.; Marie S. Gustin, Susan Rathgeber, John W. Shumaker.
Trustees: Donald W. Davis, Catherine Rogers, Rev. James A. Simpson, Talcott Stanley.
Employer Identification Number: 060724195

452
The Travelers Companies Foundation
One Tower Sq.
Hartford 06183-1060 (203) 277-2307
Additional tel.: (203) 277-6080

Established about 1984 in CT.
Donor(s): The Travelers Corp., and subsidiaries.
Financial data (yr. ended 12/31/88): Assets, $3,667,221 (M); gifts received, $5,015,888; expenditures, $4,535,120, including $4,043,883 for 171 grants (high: $835,000; low: $500; average: $500-$25,000) and $491,237 for 4,229 employee matching gifts.
Purpose and activities: Support primarily for programs that benefit older Americans, and for youth education, and civil justice reform. Grants also for civic affairs, community development, health and social services, arts and culture, and higher education; support for capital campaigns on a local level only.
Types of support: General purposes, operating budgets, special projects, research, fellowships, technical assistance, capital campaigns, employee matching gifts, seed money.
Limitations: Giving primarily in areas of company operations; giving for capital projects limited to the greater Hartford, CT, area; grants for youth education limited to programs within Hartford, CT, schools. No support for political, fraternal, athletic, social, or veterans' organizations; religious sectarian activities; or for business, professional, or trade associations. No grants to individuals, or for mass mail appeals or testimonial dinners.
Publications: Annual report, informational brochure.
Application information:
Initial approach: Proposal
Copies of proposal: 1
Deadline(s): None
Board meeting date(s): Quarterly
Final notification: Usually within 60 days
Write: Georgina Lucas, Pres. or Janet C. French, Exec. Dir.
Officers: F. Peter Libassi,* Chair.; Georgina I. Lucas, Pres.; Michael S. Smiley, Secy.; John Berthoud,* Treas.; Janet C. French, Exec. Dir.
Directors:* Elliot F. Gerson, Brooks Joslin.
Number of staff: 5 part-time professional; 1 full-time support; 3 part-time support.
Employer Identification Number: 222535386

453
The United Illuminating Company
c/o Corporate Social Responsibility
80 Temple St. (1-45)
New Haven 06506-0901 (203) 787-7711

Financial data (yr. ended 12/31/88): $150,000 for grants.
Purpose and activities: "In 1985 the officers of our company recognized that United Illuminating has an obligation to participate in the establishment and maintenance of a healthy physical and social environment in its service

territory; that good citizenship is good business and essential to the future health and profitability of the company; that changes in operating conditions or corporate priorities do not diminish---in fact may increase---the company's need to maintain good relationships with the diverse public it serves. In 1986 the program was established." Support for the arts, education, energy, the environment, and housing; provides in-kind support.

Types of support: Conferences and seminars, consulting services, special projects, technical assistance, in-kind gifts.

Limitations: Giving primarily in the CT towns served by the company: New Haven, West Haven, Orange, Woodbridge, Hampden, North Haven, North Branford, East Haven, Bridgeport, Stratford, Trumbull, Easton, Fairfield, Milford, Derby, Ansonia, and Shelton.

Application information: Application form required.

 Initial approach: Send request in letter form

 Copies of proposal: 1

 Write: Albert Harary, V.P., Mgt. Services

Administrator: Barbara C. Wareck, Corp. Social Responsibility Specialist.

Number of staff: 2 part-time professional; 1 part-time support.

454
United Technologies Corporate Contributions Program

United Technologies Bldg.
Hartford 06101 (203) 728-7943

Financial data (yr. ended 12/31/88): Total giving, $12,402,354, including $10,822,960 for grants (high: $300,000; low: $1,000; average: $5,000-$20,000) and $1,579,394 for employee matching gifts.

Purpose and activities: Supports education, including higher education, engineering, health, human services, culture and civic affairs. Types of support include employee matching gifts for education and culture, special project funding and research/study funding.

Types of support: Capital campaigns, employee matching gifts, matching funds, special projects, research, scholarship funds.

Limitations: Giving primarily in company operating areas which include all states except ID, ND, SD, UT, and WY.

Publications: Informational brochure.

Application information: Include 501(c)(3), organization description, project description, board list and donor list, expected results of activity.

 Initial approach: Letter

 Copies of proposal: 1

 Deadline(s): Applications preferred in Aug.

 Board meeting date(s): Jan.

 Write: Richard Creighton Cole, Mgr., Corp. Contribs. and Community Affairs

Director: Gordon Bowman.

Number of staff: 3 full-time professional.

455
R. T. Vanderbilt Trust

30 Winfield St.
Norwalk 06855 (203) 853-1400

Trust established in 1951 in CT.

Financial data (yr. ended 12/31/86): Assets, $6,095,924 (M); expenditures, $266,952, including $231,292 for 101 grants (high: $56,000; low: $100).

Purpose and activities: Emphasis on education and conservation; support also for hospitals, cultural programs, and historic preservation.

Types of support: Building funds, endowment funds, operating budgets, special projects.

Limitations: Giving primarily in CT and NY. No grants to individuals.

Application information:

 Initial approach: Proposal

 Copies of proposal: 1

 Deadline(s): Submit proposal preferably in Nov.

 Board meeting date(s): Apr., June, Sept., and Dec.

 Write: Hugh B. Vanderbilt, Chair.

Trustees: Hugh B. Vanderbilt, Chair.; Robert T. Vanderbilt, Jr.

Number of staff: 2 part-time support.

Employer Identification Number: 066040981

456
Hilla Von Rebay Foundation

c/o Cummings & Lockwood
10 Stamford Forum
Stamford 06904
Application address: P.O. Box 120, Stamford, CT 06904

Established in 1967 in CT.

Financial data (yr. ended 12/31/87): Assets, $2,863,719 (M); expenditures, $90,709, including $31,028 for 2 grants (high: $26,028; low: $5,000).

Purpose and activities: Support limited to promotion of non-objective painting, particularly to exhibition of the Rebay Collection, and to a nature sanctuary in Westport, CT.

Application information:

 Initial approach: Letter or brief proposal

 Deadline(s): None

 Write: Francis P. Schiaroli

Trustees: Lawrence J. McGrath, Jr., Connecticut Bank & Trust Co., N.A.

Employer Identification Number: 237112973

457
The Waterbury Foundation

P.O. Box 252
Waterbury 06720 (203) 753-1315

Community foundation incorporated in 1923 by special Act of the CT Legislature.

Donor(s): Katherine Pomeroy,† Edith Chase.†

Financial data (yr. ended 12/31/88): Assets, $6,350,000 (M); gifts received, $627,123; expenditures, $517,342, including $389,890 for 51 grants (high: $120,000; low: $197).

Purpose and activities: Grants largely for social services, health care, education, including scholarship funds, youth agencies, community funds, and the arts, with emphasis

on providing seed money and venture capital for new projects.

Types of support: Seed money, emergency funds, building funds, equipment, land acquisition, matching funds, research, special projects, publications, conferences and seminars, capital campaigns, consulting services, renovation projects, scholarship funds, technical assistance.

Limitations: Giving limited to the greater Waterbury, CT, area. No support for sectarian or religious purposes. No grants for deficit financing, continuing support, annual campaigns, endowment funds; no loans.

Publications: Annual report (including application guidelines), program policy statement, newsletter, informational brochure, application guidelines.

Application information: Application form required.

 Initial approach: Telephone or letter

 Copies of proposal: 23

 Deadline(s): 7 weeks prior to board meetings

 Board meeting date(s): Mar., June, and Nov.; Grants Committee meets twice, 6 weeks and 1 week prior to each board meeting

 Final notification: 7 weeks

 Write: Mrs. Ingrid Manning, Admin.

Officers: Christopher A. Brooks,* Pres.; Patricia B. Sweet,* V.P.; Robert N. Davie, M.D., V.P., Development; N. Patricia Yarborough,* Secy.; Sean T. Egan,* Treas.

Trustees:* Carol B. Andrews, Dirck Barhydt, Lillian Brown, John F. Burbank, Jaci Carroll, Ralph DiPalma, Robert W. Garthwait, Sr., Margaret Rosita Kenney, Robert J. Narkis, Pasquale Palumbo, Scott Peterson, James C. Smith.

Trustee Bank: Bank of Boston Connecticut.

Number of staff: 1 full-time professional; 1 full-time support.

Employer Identification Number: 066038074

458
Julia A. Whitney Foundation

c/o Thomas P. Whitney, Dir.
Roxbury Rd., Box 277
Washington 06793

Established in 1965 in NY.

Financial data (yr. ended 12/31/86): Assets, $1,778,665 (M); expenditures, $94,791, including $86,400 for 10 grants (high: $35,000; low: $1,000).

Purpose and activities: Grants primarily to foster appreciation and preservation of Russian language, literature, and art, including support for a library of Russian literature; support also for higher education.

Application information: Contributes only to pre-selected organizations. Applications not accepted.

Directors: Harrison E. Salisbury, Marguerite C. Whitney, Thomas P. Whitney.

Employer Identification Number: 136192314

459

Wiremold Foundation, Inc.

60 Woodlawn St.
West Hartford 06110 (203) 233-6251

Established in 1967 in CT.
Donor(s): The Wiremold Co.
Financial data (yr. ended 12/31/87): Assets, $768,051 (M); gifts received, $72,000; expenditures, $157,560, including $150,725 for 86 grants (high: $49,700; low: $25) and $5,620 for 23 employee matching gifts.
Purpose and activities: Giving primarily for education and cultural activities; support also for social services.
Types of support: Employee matching gifts.
Application information:
 Write: John Davis Murphy, Pres.
Officers: John Davis Murphy, Pres.; Robert H. Murphy, V.P.; Joan L. Johnson, Secy.; Warren C. Packard, Treas.
Employer Identification Number: 066089445

460

Xerox Corporate Contributions Program

P.O. Box 1600
Stamford 06904 (203) 968-3306

Financial data (yr. ended 12/31/87): $3,000,000 for grants.
Purpose and activities: Supports civic affairs, arts and humanities, the handicapped, law and justice, urban affairs, health, youth, education, employment training, international development, women's affairs, and the United Way. Types of support include volunteer recruitment, employee volunteer programs, use of company facilities and donations of the company's primary goods or services.
Types of support: Exchange programs, research.
Publications: Informational brochure.
Application information: Include project description and budget, a financial report, an IRS 501(c)(3) status letter, and major donor list.
 Initial approach: Letter
 Final notification: If turned down, company will send a rejection notice
 Write: Robert H. Gudger, Mgr. of Corp. Responsibilities and V.P., The Xerox Foundation

461

The Xerox Foundation

P.O. Box 1600
Stamford 06904 (203) 329-8700

Incorporated in 1978 in DE as successor to Xerox Fund.
Donor(s): Xerox Corp.
Financial data (yr. ended 12/31/87): Assets, $3,181,626 (M); gifts received, $12,000,000; expenditures, $11,988,661, including $10,773,896 for 8 grants (high: $1,202,250; low: $1,000; average: $2,000-$20,000) and $1,200,000 for employee matching gifts.
Purpose and activities: Broad commitment in support of higher education to prepare qualified men and women for careers in business, government, and education; advance knowledge in science and technology; commitment also to enhance learning

opportunities for minorities and the disadvantaged. Also operates employee matching gift program. Support additionally for social, civic, and cultural organizations including United Ways, providing broad-based programs and services in cities where Xerox employees live and work; organizations that foster debate on major national public policy issues; and worldwide, for leadership efforts around major social problems, education, employability, and student exchange.
Types of support: General purposes, operating budgets, annual campaigns, seed money, emergency funds, research, conferences and seminars, scholarship funds, fellowships, professorships, internships, employee-related scholarships, exchange programs, employee matching gifts, program-related investments, consulting services, publications.
Limitations: Giving primarily in areas of company operations. No support for community colleges, organizations supported by United Way, religious organizations, or governmental agencies. No grants to individuals, or for capital or endowment funds; no donations of machines or related services; no loans.
Publications: Application guidelines.
Application information:
 Initial approach: Brief proposal
 Copies of proposal: 1
 Deadline(s): None
 Board meeting date(s): Usually in Dec. and as required
 Final notification: 3 months
 Write: Robert H. Gudger, V.P.
Officers: Robert J. Kammerer, Pres.; Robert H. Gudger, V.P.; Martin S. Wagner, Secy.; Allan Z. Senter, Treas.
Trustees: Paul A. Allaire, David T. Kearns, Stuart B. Ross.
Number of staff: 2 full-time professional; 3 full-time support.
Employer Identification Number: 060996443
Recent arts and culture grants:
Acting Company, NYC, NY, $5,000. 1987.
Affiliate Artists, NYC, NY, $35,000. 1987.
Affiliate Artists, NYC, NY, $12,500. 1987.
Aldrich Museum of Contemporary Art, Ridgefield, CT, $5,000. 1987.
American Academy of Arts and Sciences, Cambridge, MA, $25,000. 1987.
American Council for the Arts, NYC, NY, $7,500. 1987.
American Place Theater, NYC, NY, $10,000. 1987.
American Symphony Orchestra League, DC, $5,000. 1987.
Arts for Greater Rochester, Rochester, NY, $7,500. 1987.
Bay Area Video Coalition, San Francisco, CA, $5,000. 1987.
Bilingual Foundation of the Arts, Los Angeles, CA, $15,000. 1987.
Bucket Dance Theater, Rochester, NY, $7,500. 1987.
Business Committee for the Arts, NYC, NY, $5,000. 1987.
Carnegie Hall, NYC, NY, $25,000. 1987.
Carnegie Hall Society, NYC, NY, $7,500. 1987.
Center for Peace Through Culture of Texas, San Antonio, TX, $5,000. 1987.
Community Arts Fund, Columbus, OH, $5,000. 1987.

Community Youth Sports and Arts Foundation, Los Angeles, CA, $12,500. 1987.
Computer Museum, Boston, MA, $10,000. 1987.
Connecticut Public Broadcasting, Hartford, CT, $5,000. 1987.
Dallas Museum of Art, Dallas, TX, $5,000. 1987.
Dixwell Childrens Creative Arts Center, New Haven, CT, $10,000. 1987.
Experiment in International Living, Brattleboro, VT, $5,000. 1987.
Exploratorium, San Francisco, CA, $7,500. 1987.
Fords Theater Society, DC, $5,000. 1987.
Genesee Valley Arts Foundation, Geva Theater, Rochester, NY, $10,000. 1987.
GeVa Theater, Rochester, NY, $12,000. 1987.
Goodspeed Opera House, East Haddam, CT, $5,000. 1987.
Guadalupe Cultural Arts Center, San Antonio, TX, $5,000. 1987.
Harlem School of the Arts, NYC, NY, $7,000. 1987.
Hartford Courant Center for the Arts, Hartford, CT, $10,000. 1987.
Hartman Regional Theater, Stamford, CT, $8,500. 1987.
Interlochen Center for the Arts, Interlochen, MI, $5,000. 1987.
International Museum of Photography at George Eastman House, Rochester, NY, $100,000. 1987.
Islamic Cultural Center of New York, Harrison, NY, $10,000. 1987.
Japan Society, NYC, NY, $20,000. 1987.
Japan Society, NYC, NY, $10,000. 1987.
John F. Kennedy Center for the Performing Arts, DC, $25,000. 1987.
John F. Kennedy Center for the Performing Arts, DC, $25,000. 1987.
Library of Congress, Council of Scholars, DC, $5,000. 1987.
Lincoln Center for the Performing Arts, NYC, NY, $30,000. 1987.
Long Wharf Theater, New Haven, CT, $15,000. 1987.
Los Angeles Chamber Orchestra, Los Angeles, CA, $5,000. 1987.
Maritime Center, South Norwalk, CT, $20,000. 1987.
Memorial Art Gallery of the University of Rochester, Rochester, NY, $24,000. 1987.
Metropolitan Museum of Art, NYC, NY, $30,000. 1987.
Museum of American Folk Art, NYC, NY, $25,000. 1987.
Museum of American Theater, New Haven, CT, $5,000. 1987.
Museum of Flight, Seattle, WA, $6,000. 1987.
Museum of Holography, NYC, NY, $5,000. 1987.
Music Center Unified Fund, Los Angeles, CA, $15,000. 1987.
Mystic Seaport Museum, Mystic, CT, $6,500. 1987.
National Corporate Fund for Dance, NYC, NY, $12,500. 1987.
National Corporate Theater Fund, NYC, NY, $10,000. 1987.
National Museum of American History, DC, $100,000. 1987.
National Public Radio, DC, $5,000. 1987.

National Symphony Orchestra, DC, $5,000.
1987.
National Theater of the Deaf, Chester, CT,
$20,000. 1987.
New England Foundation for the Arts,
Cambridge, MA, $5,000. 1987.
New York Zoological Society, Bronx, NY,
$11,000. 1987.
Orange County Pacific Symphony, Fullerton,
CA, $5,000. 1987.
Plaza de la Raza, Los Angeles, CA, $5,000.
1987.
Plimoth Plantation, Plymouth, MA, $10,000.
1987.
Poets and Writers, NYC, NY, $5,000. 1987.
Rochester Area Educational Television/Channel
21, Rochester, NY, $20,000. 1987.
Rochester Museum and Science Center,
Rochester, NY, $75,000. 1987.
Rochester Museum and Science Center,
Rochester, NY, $20,000. 1987.
Rochester Philharmonic Orchestra, Rochester,
NY, $100,000. 1987.
Rochester Philharmonic Orchestra, Rochester,
NY, $8,959. 1987.
Sci-Tech Center at Liberty State Park, Morris
Plains, NJ, $50,000. 1987.
Shakespeare and Company, Boston
Shakespeare Company, Lenox, MA, $25,000.
1987.
Shubert Performing Arts Center, New Haven,
CT, $5,000. 1987.
Smithsonian Institution, DC, $40,000. 1987.
Stamford Chamber Orchestra, Stamford, CT,
$5,000. 1987.
Stamford Symphony Orchestra, Stamford, CT,
$5,000. 1987.
Statue of Liberty-Ellis Island Foundation, NYC,
NY, $100,000. 1987.
Strong Museum, Rochester, NY, $5,000. 1987.
Studio Museum in Harlem, NYC, NY, $15,000.
1987.
Studio Theater, DC, $5,000. 1987.
Syracuse Symphony Orchestra, Syracuse, NY,
$5,000. 1987.
Theater Communications Group, NYC, NY,
$5,000. 1987.
Volunteers in Asia, Stanford, CA, $5,000. 1987.
Western States Arts Foundation, Santa Fe, NM,
$15,000. 1987.
Young Audiences, NYC, NY, $5,000. 1987.
Youngstown Symphony Society, Youngstown,
OH, $5,000. 1987.
Youth for Understanding, DC, $10,000. 1987.

DELAWARE

462
Jack and Mimi Leviton Amsterdam Foundation
c/o Thomas Sweeney
One Rodney Square, P.O. Box 551
Wilmington 19899 (302) 658-6541

Established in 1977 in DE.

Donor(s): Jack Amsterdam.
Financial data (yr. ended 12/31/87): Assets,
$1,682,693 (M); gifts received, $37,500;
expenditures, $54,628, including $47,700 for
13 grants (high: $10,000; low: $200).
Purpose and activities: Giving for medical
research, higher education, Jewish
organizations in the U.S. and Israel, and the
performing arts.
Types of support: Research.
Application information: Contributes only to
pre-selected organizations. Applications not
accepted.
Officers: Jack Amsterdam, Pres.; Dasha L.
Epstein, V.P.
Employer Identification Number: 510220854

463
Beneficial Foundation, Inc.
1100 Carr Rd.
P.O. Box 911
Wilmington 19899 (302) 798-0800

Incorporated in 1951 in DE.
Donor(s): Beneficial Corp., and its subsidiaries,
Beneficial New Jersey.
Financial data (yr. ended 12/31/87): Assets,
$4,805,617 (M); gifts received, $350,000;
expenditures, $628,375, including $383,500
for 38 grants (high: $100,000; low: $1,000;
average: $1,000-$10,000) and $208,941 for
700 grants to individuals.
Purpose and activities: Grants primarily to
educational institutions, hospitals, and for
medical research; also a scholarship program
for children of employees of Beneficial
Corporation or of the Beneficial Finance
System. Support also for cultural programs.
Types of support: Employee-related
scholarships, research, continuing support,
annual campaigns, seed money, building funds,
equipment, special projects.
Limitations: Giving primarily in DE, FL, NJ, and
NY. No grants for endowment funds; no loans.
Application information: Application form
required for scholarship applicants.
 Initial approach: Proposal
 Copies of proposal: 1
 Deadline(s): None
 Board meeting date(s): Usually in May and
 Dec.
 Write: John O. Williams, V.P.
Officers: Robert A. Tucker,* Pres.; Finn M.W.
Caspersen,* V.P. and Secy.; Kenneth J. Kircher,
Treas.
Directors: * Freda R. Caspersen, John O.
Williams.
Number of staff: 2 part-time support.
Employer Identification Number: 516011637

464
Stephen and Mary Birch Foundation, Inc.
501 Silverside Rd., Suite 73
Wilmington 19809

Incorporated in 1938 in DE.
Donor(s): Stephen Birch.†
Financial data (yr. ended 12/31/87): Assets,
$58,911,374 (M); expenditures, $5,635,818,
including $189,300 for 8 grants (high:
$149,000,500; low: $37,500).

Purpose and activities: Emphasis on health
agencies, hospitals, youth agencies, cultural
programs, social services, civic organizations,
and the blind.
Application information:
 Initial approach: Letter
 Copies of proposal: 1
 Deadline(s): None
 Board meeting date(s): Quarterly
 Write: Elfriede Looze
Officers: Patrick J. Patek, Pres.; Christopher
Patek, V.P.; Rose B. Patek, Secy-Treas.
Employer Identification Number: 221713022

465
Edward E. and Lillian H. Bishop Foundation
c/o Wilmington Trust Co.
Rodney Square North
Wilmington 19890

Trust established in 1953 in DE.
Donor(s): Lillian H. Bishop.
Financial data (yr. ended 12/31/87): Assets,
$2,265,705 (M); gifts received, $0;
expenditures, $143,261, including $133,000
for 39 grants (high: $25,000; low: $100).
Purpose and activities: Emphasis on a
museum and planetarium; some support for
cultural programs, welfare funds, and care of
animals.
Types of support: General purposes.
Limitations: Giving primarily in Manatee
County, FL.
Application information:
 Deadline(s): None
Trustees: Mary E. Parker, Richard W. Pratt,
William D. Sugg, Willett Wentzel, P. Woodrow
Young, Wilmington Trust Co.
Employer Identification Number: 516017762

466
Chichester duPont Foundation, Inc.
3120 Kennett Pike
Wilmington 19807-3045 (302) 658-5244

Incorporated in 1946 in DE.
Donor(s): Lydia Chichester duPont,† Mary
Chichester duPont Clark,† A. Felix duPont, Jr.,
Alice du Pont Mills.
Financial data (yr. ended 12/31/86): Assets,
$19,823,423 (M); expenditures, $876,466,
including $819,000 for 25 grants (high:
$185,000; low: $2,000; average: $15,000-
$50,000).
Purpose and activities: Emphasis on child
welfare, including support for a camp for
handicapped children, education, health,
cultural programs, and religion; some support
for conservation.
Types of support: Operating budgets, building
funds.
Limitations: Giving primarily in the DE, MD,
and PA, areas. No grants to individuals.
Application information:
 Deadline(s): Oct. 1
 Board meeting date(s): Dec.
 Final notification: 2 weeks after meeting
 Write: Gregory F. Fields, Secy.
Officers: Alice du Pont Mills, Pres.; Gregory F.
Fields, Secy.; A. Felix duPont, Jr., Treas.

Trustees: Allaire C. duPont, Caroline J. duPont, Christopher T. duPont, Mary Mills Abel Smith, Phyllis Mills Wyeth.
Number of staff: None.
Employer Identification Number: 516011641

467
The Columbia Gas System Corporate Contributions Program
20 Montchanin Rd.
Wilmington 19807 (302) 429-5261

Financial data (yr. ended 12/31/88): Total giving, $1,100,000, including $987,000 for grants and $113,000 for employee matching gifts.
Purpose and activities: Supports primarily social welfare, health and hospitals, cultural and civic affairs, conservation, education, and economic education. Types of support include matching gifts and employee volunteer/loan programs.
Types of support: Matching funds, research, building funds, capital campaigns, general purposes, operating budgets, special projects, endowment funds, employee matching gifts.
Limitations: Giving primarily in Wilmington, DE, Columbus and Toledo, OH, KY, MD, NJ, NY, PA, TX, and VA. No support for political, labor, veterans', or strictly sectarian/denominational religious organizations. No grants to organizations eligible for but not participating in United Way support. No grants to individuals; or for operating expenses of United Way agencies; or for courtesy advertising.
Publications: Informational brochure (including application guidelines).
Application information:
 Initial approach: Letter
 Copies of proposal: 1
 Final notification: 8-10 weeks
 Write: Bruce V. Quayle, V.P., Corp. Communications

468
The Common Wealth Trust
c/o Bank of Delaware
222 Delaware Ave.
Wilmington 19899

Established in 1978.
Donor(s): Ralph W. Hayes.†
Financial data (yr. ended 12/31/87): Assets, $6,079,572 (M); expenditures, $285,807, including $171,832 for 5 grants (high: $155,831; low: $1,000) and $23,900 for 21 grants to individuals.
Purpose and activities: Support for a historical society and educational purposes; also gives distinguished service awards to prominent individuals in literature, the dramatic arts, and communications.
Types of support: Grants to individuals.
Limitations: Giving primarily in DE.
Trustee: Bank of Delaware.
Employer Identification Number: 510232187

469
Copeland Andelot Foundation, Inc.
1100 DuPont Bldg.
Wilmington 19898

Incorporated in 1953 in DE.
Donor(s): Lammot du Pont Copeland.
Financial data (yr. ended 12/31/86): Assets, $1,094,743 (M); gifts received, $195,000; expenditures, $16,056.
Purpose and activities: Emphasis on hospitals, cultural institutions, community funds, education, and conservation.
Limitations: Giving limited to Wilmington, DE and its 50-mile radius.
Application information:
 Initial approach: Proposal
 Copies of proposal: 5
 Deadline(s): None
 Write: Blaine T. Phillips, Pres.
Officers: Blaine T. Phillips, Pres.; Gerret van S. Copeland, V.P.; Hugh R. Sharp, Jr., Secy.-Treas.
Employer Identification Number: 516001265

470
Crystal Trust
1088 DuPont Bldg.
Wilmington 19898 (302) 774-8421

Trust established in 1947 in DE.
Donor(s): Irenee du Pont.†
Financial data (yr. ended 12/31/88): Assets, $45,200,000 (M); expenditures, $2,350,000, including $2,247,000 for 47 grants (high: $200,000; low: $4,000; average: $5,000-$50,000).
Purpose and activities: Giving mainly for higher and secondary education and social services; support also for cultural programs and youth agencies.
Types of support: Seed money, building funds, equipment, land acquisition, program-related investments, renovation projects, capital campaigns.
Limitations: Giving primarily in DE, especially Wilmington. No grants to individuals, or for endowment funds, research, scholarships, fellowships, or matching gifts; no loans.
Publications: Application guidelines, program policy statement.
Application information:
 Initial approach: Proposal
 Copies of proposal: 1
 Deadline(s): Oct. 1
 Board meeting date(s): Nov.
 Final notification: Dec. 15
 Write: Burt C. Pratt, Dir.
Director: Burt C. Pratt.
Trustees: Irenee du Pont, Jr., David Greenewalt, Eleanor S. Maroney.
Number of staff: 1 part-time professional; 1 part-time support.
Employer Identification Number: 516015063

471
Delmarva Power and Light Corporate Giving Program
P.O. Box 231
Wilmington 19899 (302) 429-3410

Financial data (yr. ended 12/31/88): Total giving, $292,698, including $137,698 for

grants and $155,000 for 1 company-administered program.
Purpose and activities: Support for culture, business, business education, computer sciences, economics, community development, crime and law enforcement, leadership development, employment, minorities, the handicapped, rural development, science and technology, media and communications, and volunteerism.
Types of support: Annual campaigns, building funds, capital campaigns, conferences and seminars, general purposes, operating budgets, research, scholarship funds.
Limitations: Giving primarily in service territory of corporation.
Publications: Informational brochure (including application guidelines).
Application information: Application form required.
 Board meeting date(s): July and as necessary
 Final notification: Within 30 days of application
 Write: Richard H. Evans, V.P., Corp. Communications

472
Du Pont Corporate Contributions Program
External Affairs Dept., Du Pont and Co.
8065 Du Pont Building
Wilmington 19898 (302) 774-1000

Purpose and activities: The company is committed to improving the quality of life in general, and, in particular, to enhancing the vitality of the communities in which it operates. "Corporate giving is one means of demonstrating these commitments and is considered essential to the long-term prosperity of the company." This includes programs which address special company interests or areas of expertise; organizations that provide resources and information upon which the company depends; nonprofit organizations whose functions are important to the company and society; programs which contribute to the well-being of employees as well as their community and volunteer efforts. Focus on: education, health and human services, enviornment and ecology, and civic and community activities.
Types of support: Capital campaigns, fellowships, general purposes, research, special projects, scholarship funds.
Limitations: Giving primarily in areas of company operations. No support for sectarian religious groups, fraternal organizations, or veterans' groups. No grants to individuals.
Publications: Application guidelines.
Application information: National organizations or programs in Wilmington, DE, write to headquarters; other projects should be addressed to nearest company site; most education grants are initiated by Du Pont, but applications are accepted.
 Initial approach: Letter
 Board meeting date(s): Annually
 Write: Peter C. Morrow, Mgr., Contribs. and Community Affairs

473
Ederic Foundation, Inc.
A-102 Greenville Center
3801 Kennett Pike
Wilmington 19807

Incorporated in 1958 in DE.
Donor(s): John E. Riegel, Natalie R.
Weymouth, Richard E. Riegel, Jr., Mrs. G.
Burton Pearson, Jr.
Financial data (yr. ended 12/31/87): Assets,
$265 (M); gifts received, $2,855; expenditures,
$329,820, including $329,805 for 94 grants
(high: $38,000; low: $50).
Purpose and activities: Giving for private
elementary and secondary schools, hospitals
and health care, community funds, cultural
institutions, and higher education; grants also
for youth agencies and conservation.
Limitations: Giving primarily in DE.
Application information:
 Initial approach: Letter
 Deadline(s): None
 Write: Harry S. Short, Secy.
Officers: Mrs. G. Burton Pearson, Jr.,* Pres.;
Harry S. Short, Secy.-Treas.
Trustees:* Robert C. McCoy, John E. Riegel,
Richard E. Riegel, Jr., Philip B. Weymouth, Jr.
Employer Identification Number: 516017927

474
Fair Play Foundation
350 Delaware Trust Bldg.
Wilmington 19801 (302) 658-6771

Established about 1983 in DE.
Financial data (yr. ended 12/31/86): Assets,
$5,998,385 (M); expenditures, $394,303,
including $311,500 for 11 grants (high:
$64,000; low: $7,500).
Purpose and activities: Grants for culture,
including museums, historical preservation, and
education.
Types of support: Renovation projects,
equipment.
Limitations: Giving primarily in DE.
Application information:
 Initial approach: Letter
 Deadline(s): None
 Write: Blaine T. Phillips, Pres.
Officers and Trustees: Blaine T. Phillips, Pres.;
James F. Burnett, V.P.; L.E. Grimes, Treas.;
George P. Bissell, George P. Edmonds, D.P.
Ross, Jr.
Employer Identification Number: 516017779

475
ICI Americas Corporate Giving Program
Public Affairs Dept.
Concord Pike and New Murphy Rd.
Wilmington 19897 (302) 575-3000

Financial data (yr. ended 12/27/87): Total
giving, $2,100,000, including $2,038,100 for
grants and $61,900 for employee matching gifts.
Purpose and activities: Support for the arts,
including music, theater, fine and performing
arts; welfare, including programs for the aged,
the handicapped, women, youth, and children;
health associations and services for AIDS,
alcoholism, cancer, drug abuse, mental health,
and heart disease; legal services; medical

education, sciences, and research; libraries,
hospitals and hospital building funds, education
and educational research; urban affairs and
urban development; and media and
communications.
Types of support: Annual campaigns, building
funds, capital campaigns, continuing support,
emergency funds, employee matching gifts,
equipment, matching funds, operating budgets,
renovation projects, research, employee-related
scholarships, special projects.
Publications: Financial statement, informational
brochure.
Application information:
 Initial approach: Written request
 Copies of proposal: 1
 Write: William C. Adams
Administrator: William C. Adams, Chair.,
Corp. Contribs. Comm.

476
Atwater Kent Foundation, Inc.
101 Springer Bldg.
3411 Silverside Rd.
Wilmington 19810 (302) 478-4383

Established in 1919 in DE.
Financial data (yr. ended 12/31/87): Assets,
$1,423,521 (M); expenditures, $71,572,
including $61,100 for 73 grants (high: $15,000;
low: $100; average: $100-$5,000).
Purpose and activities: Emphasis on museums
and historic preservation, higher education, and
hospitals.
Limitations: Giving primarily in the
metropolitan Philadelphia, PA, area, but will
consider grants to organizations in other areas.
No grants to individuals, or to pass-through
organizations.
Application information:
 Initial approach: Proposal
 Deadline(s): None
 Board meeting date(s): Periodically
 Write: Hope P. Kent, Pres.
Officers: Hope P. Kent,* Pres. and Treas.;
Elizabeth K. Van Alen,* V.P.; James R. Weaver,
Secy.
Trustees:* A. Atwater Kent III.
Employer Identification Number: 510081303

477
Kent-Lucas Foundation, Inc.
101 Springer Bldg.
3411 Silverside Rd.
Wilmington 19810 (302) 478-4383
Mailing address: P.O. Box 7048, Wilmington,
DE 19803

Incorporated in 1968 in DE.
Donor(s): Atwater Kent Foundation, Inc.
Financial data (yr. ended 12/31/87): Assets,
$2,355,196 (M); expenditures, $152,765,
including $140,187 for 93 grants (high:
$30,337; low: $25).
Purpose and activities: Grants largely for
cultural programs, including historic
preservation, hospitals, education, and church
support; support also for public information
organizations.
Types of support: General purposes, operating
budgets, continuing support, building funds.

Limitations: Giving primarily in the
Philadelphia, PA, metropolitan area, ME, and
FL. No grants to individuals or for endowment
funds.
Publications: Application guidelines.
Application information:
 Initial approach: Letter
 Copies of proposal: 1
 Deadline(s): None
 Board meeting date(s): As required
 Final notification: 1 to 3 months
 Write: Elizabeth K. Van Alen, Pres.
Officers: Elizabeth K. Van Alen,* Pres. and
Treas.; William L. Van Alen,* V.P.; James R.
Weaver, Secy.
Number of staff: 4
Employer Identification Number: 237010084

478
The Kingsley Foundation
c/o Wilmington Trust Co.
Rodney Square North
Wilmington 19890

Established in 1961 in CT.
Donor(s): F.G. Kingsley, Ora K. Smith.
Financial data (yr. ended 12/31/87): Assets,
$3,527,484 (M); gifts received, $118,521;
expenditures, $176,329, including $169,938
for 48 grants (high: $90,000; low: $100).
Purpose and activities: Support primarily for
health, medical education, social services, and
cultural programs.
Application information: Grants are made to
charitable organizations as selected by the
advisers. Applications not accepted.
Trustees: L. Heagney, Ora Rimes Kingsley,
Minot K. Milliken, Roger Milliken, Ora K. Smith.
Employer Identification Number: 066037966

479
**Morris & Lillie Leibowitz Charitable
 Trust**
c/o Bank of Delaware
300 Delaware Ave.
Wilmington 19899

Established in 1968 in DE.
Financial data (yr. ended 12/31/87): Assets,
$1,070,063 (M); expenditures, $56,436,
including $49,016 for 13 grants (high: $15,000;
low: $1,000).
Purpose and activities: Support primarily for
the family wing of a congregation and a Jewish
community center; support also for medical
research, higher education, and cultural
institutions.
Limitations: Giving primarily in DE.
Application information:
 Initial approach: Letter
 Deadline(s): None
Trustee: Bank of Delaware.
Employer Identification Number: 516024643

480
Longwood Foundation, Inc.
1004 Wilmington Trust Center
Wilmington 19801 (302) 654-2477

Incorporated in 1937 in DE.
Donor(s): Pierre S. du Pont.†

Financial data (yr. ended 9/30/88): Assets, $254,370,604 (M); expenditures, $16,234,443, including $15,114,320 for 80 grants (high: $2,025,000; low: $1,250; average: $10,000-$250,000).

Purpose and activities: Primary obligation is the support, operation, and development of Longwood Gardens, which is open to the public; limited grants generally to educational institutions, to local hospitals for construction purposes, and to social service and youth agencies, and cultural programs.

Types of support: Annual campaigns, operating budgets, building funds, equipment, land acquisition, endowment funds, research.

Limitations: Giving limited to DE, and Greater Wilmington; some giving in PA. No grants to individuals, or for special projects.

Application information:
Initial approach: Letter
Copies of proposal: 1
Deadline(s): Submit proposal by Apr. 15 or Oct. 1
Board meeting date(s): May and Oct.
Final notification: At time of next board meeting
Write: Endsley P. Fairman, Exec. Secy.

Officers and Trustees: H. Rodney Sharp III, Pres.; Edward B. du Pont, V.P.; Irenee du Pont May, Secy.; Henry H. Silliman, Jr., Treas.; Gerret van S. Copeland, David L. Craven.

Number of staff: 4 full-time professional.

Employer Identification Number: 510066734

Recent arts and culture grants:
Brandywine Conservancy, Chadds Ford, PA, $45,000. For project expenses. 1987.
Delaware Art Museum, Wilmington, DE, $333,000. For capital campaign. 1987.
Eleutherian Mills-Hagley Foundation, Wilmington, DE, $250,000. To maintain Crowninshield property. 1987.
Eleutherian Mills-Hagley Foundation, Wilmington, DE, $100,000. For major improvements. 1987.
Eleutherian Mills-Hagley Foundation, Wilmington, DE, $19,000. For nonprofit conference trip. 1987.
Greenbank Mill Associates, Wilmington, DE, $50,000. For Mill restoration. 1987.
Longwood Fire Company, Kennett Square, PA, $22,500. For Marine band performances. 1987.
Longwood Gardens, Kennett Square, PA, $1,900,000. For project expenditures. 1987.
Longwood Gardens, Kennett Square, PA, $186,000. For graduate program. 1987.
Wilmington Garden Center, Wilmington, DE, $27,300. For operating expenses. 1987.

481
The Lovett Foundation, Inc.
82 Governor Printz Blvd.
Claymont 19703 (302) 798-6604

Incorporated in 1952 in DE.
Donor(s): Walter L. Morgan.
Financial data (yr. ended 11/30/87): Assets, $2,573,964 (M); gifts received, $542,212; expenditures, $192,058, including $171,945 for 78 grants (high: $25,000; low: $100).
Purpose and activities: Emphasis on church support, hospitals, cultural programs, and civic

affairs; grants also for education and social agencies.

Limitations: Giving primarily in the Wilmington, DE, and Philadelphia, PA, areas. No grants to individuals.

Application information:
Initial approach: Letter
Deadline(s): Submit proposal prior to Mar. 15; no set deadline
Board meeting date(s): Quarterly
Write: Michael J. Robinson III, V.P.

Officers: Walter L. Morgan,* Pres.; Michael J. Robinson III,* V.P.; Leanor H. Silver, Secy.

Trustees:* Andrew B. Young.

Employer Identification Number: 236253918

482
The Marmot Foundation
1004 Wilmington Trust Center
Wilmington 19801 (302) 654-2477

Established in 1968 in DE.
Donor(s): Margaret F. du Pont Trust.
Financial data (yr. ended 12/31/87): Assets, $15,727,000 (M); expenditures, $883,000, including $816,000 for 68 grants (high: $65,000; low: $2,000).

Purpose and activities: Support for hospitals, health, higher and secondary education, community funds, cultural programs, youth agencies, and social services.

Types of support: Emergency funds, building funds, equipment, research, special projects, matching funds, continuing support, capital campaigns.

Limitations: Giving primarily in DE and FL. No support for religious organizations. No grants to individuals, or for operating budgets or scholarships; no loans.

Application information:
Initial approach: Letter
Copies of proposal: 1
Deadline(s): Submit proposal preferably in Apr. and Oct.
Board meeting date(s): May and Nov.
Final notification: 2 weeks after board meeting
Write: Endsley P. Fairman, Secy. (for DE organizations); Willis H. du Pont, Chair. (for FL organizations)

Officers and Trustees: Willis H. du Pont, Chair.; Endsley P. Fairman, Secy.; Lammot Joseph du Pont, Miren deA. du Pont, George S. Harrington.

Number of staff: 2

Employer Identification Number: 516022487

483
Esther S. Marshall Charitable Trust
Box 72
Yorklyn 19736-0072 (302) 239-6379

Established in 1980 in DE.
Financial data (yr. ended 11/30/87): Assets, $792,658 (M); expenditures, $148,535, including $120,000 for 4 grants (high: $50,000; low: $10,000).
Purpose and activities: Support for educational institutions and historic museums.
Types of support: Operating budgets.
Limitations: Giving primarily in DE.
Application information:

Deadline(s): None
Write: Thomas C. Marshall, Jr., Trustee
Trustees: Walter W. Anderson, Lindsey Greenplate, Thomas C. Marshall, Jr.
Employer Identification Number: 510256407

484
Presto Foundation
P.O. Box 2105
Wilmington 19899
Application address: 3925 North Hastings Way, Eau Claire, WI 54703

Incorporated in 1952 in WI.
Donor(s): National Presto Industries, Inc.
Financial data (yr. ended 5/31/87): Assets, $12,917,770 (M); expenditures, $613,936, including $507,045 for 135 grants (high: $100,000; low: $25) and $49,015 for 14 grants to individuals.

Purpose and activities: Giving for higher education, including scholarships for employees' children, educational television, local community funds, health, and social service agencies.

Types of support: Employee-related scholarships.

Limitations: Giving primarily in northwestern WI; Eau Claire and Chippewa County preferred.

Application information:
Initial approach: Letter
Deadline(s): None
Write: Harriet Rose

Officers and Trustees: Melvin S. Cohen, Chair. and Pres.; R.J. Alexy, V.P.; Walter Gold, V.P.; William A. Nelson, V.P.; Maryjo R. Cohen, Secy.-Treas.; Eileen Phillips Cohen, Donald Dickson, Kenneth Hansen, Richard Myhers.

Employer Identification Number: 396045769

485
Raskob Foundation for Catholic Activities, Inc.
P.O. Box 4019
Wilmington 19807 (302) 655-4440

Incorporated in 1945 in DE.
Donor(s): John J. Raskob.†
Financial data (yr. ended 12/31/87): Assets, $67,996,951 (M); expenditures, $3,827,053, including $2,923,226 for 526 grants (high: $250,000; low: $50; average: $5,000-$10,000).

Purpose and activities: To support Roman Catholic church organizations and activities worldwide, providing funds to official Catholic organizations for education, training, social services, health and emergency relief. In order to qualify for consideration for large building or renovation projects, construction must be underway, a signed construction contract must exist, and 50 percent of the total funds needed must already be committed.

Types of support: Operating budgets, seed money, emergency funds, building funds, equipment, land acquisition, matching funds, conferences and seminars, program-related investments, renovation projects, special projects.

Limitations: No grants to individuals, or for continuing support, annual campaigns, deficit financing (except missions), endowment funds,

tuition, scholarships, fellowships, individual research, building projects prior to the start or after the completion of construction, after-the-fact requests, or computer projects lacking 50% of total cost.

Publications: Biennial report (including application guidelines), application guidelines.
Application information: Application form required.

Initial approach: Letter
Deadline(s): Applications accepted for spring meeting from Dec. 15 to Feb. 15, for fall meeting from June 15 to Aug. 15
Board meeting date(s): Spring and fall
Final notification: 6 months
Write: Gerard S. Garey, Pres.

Officers and Trustees: Anthony W. Raskob, Chair.; Gerard S. Garey, Pres.; Peter S. Robinson, V.P.; Kathleen D. Smith, Secy.; William F. Raskob III, Treas.; Ann R. Borden, Patsy R. Bremer, John J. Harmon, Eileen D. McGrory, Jacob T. Raskob, Charles R. Robinson, Susan Y. Stanton.
Number of staff: 2 full-time professional; 2 full-time support; 1 part-time support.
Employer Identification Number: 510070060
Recent arts and culture grants:
Catholic Church Rauris, Salzburg, Austria, $7,000. To replace pews in historic church. 1987.
Hispanic Telecommunications Network, Saint Paul, MN, $15,000. For production costs of Nuestra Familia. 1987.
Paulist Productions, Pacific Palisades, CA, $100,000. For film on Archbishop Oscar A. Romero. 1987.
Radio Veritas, Manila, Philippines, $10,000. For construction of radio transmitter. 1987.
Saint Augustine School of the Arts, Bronx, NY, $7,500. For operating expenses. 1987.

486
The Bernard Lee Schwartz Foundation, Inc.
P.O. Box 7138
2625 Concord Pike
Wilmington 19803

Incorporated in 1951 in NY.
Donor(s): Bernard L. Schwartz.†
Financial data (yr. ended 9/30/87): Assets, $10,906,453 (M); gifts received, $489,569; expenditures, $336,507, including $325,526 for 22 grants (high: $200,000; low: $100; average: $250-$20,000).
Purpose and activities: Support largely for higher education, cultural programs, and medical tax-exempt institutions, including hospitals and research facilities.
Types of support: Continuing support, building funds, equipment, endowment funds, internships, fellowships, research.
Limitations: No grants to individuals, or for annual campaigns, seed money, emergency funds, deficit financing, renovation projects, land acquisition, demonstration projects, publications, or conferences; no loans.
Publications: 990-PF.
Application information:
Initial approach: Letter
Deadline(s): Submit proposal between Jan. and July 31; deadline July 31
Board meeting date(s): Dec. and as required

Final notification: 1 month for positive response
Write: Mrs. Rosalyn R. Schwartz, Pres.
Officers and Directors: Rosalyn R. Schwartz, Pres.; Donald N. Ravitch, V.P.; Tilda R. Orr, Secy.; Michael L. Schwartz, Treas.; Eric A. Schwartz.
Number of staff: None.
Employer Identification Number: 136096198

487
Wilmington Trust Company Foundation
c/o Wilmington Trust Co.
Wilmington 19890

Established in 1966 in DE.
Donor(s): Wilmington Trust Co.
Financial data (yr. ended 12/31/87): Assets, $146,912 (M); gifts received, $272,109; expenditures, $325,553, including $324,821 for 74 grants (high: $140,000; low: $100).
Purpose and activities: Grants for community funds, health and social services, culture, and community development.
Types of support: General purposes.
Application information: Contributes only to preselected organizations. Applications not accepted.
Trustees: John S. Garrett, Jr., Bernard J. Taylor II.
Agents: Beryl Barmore, Wilmington Trust Co.
Employer Identification Number: 516021540

DISTRICT OF COLUMBIA

488
The Alvord Foundation
918 16th St., N.W., No. 200
Washington 20006 (202) 393-2266

Trust established in 1937 in DC.
Donor(s): Ellsworth C. Alvord.†
Financial data (yr. ended 12/31/87): Assets, $1,897,716 (M); expenditures, $318,408, including $92,100 for 39 grants (high: $19,250; low: $250).
Purpose and activities: Grants primarily for higher and secondary education, performing arts, and hospitals.
Limitations: Giving primarily in DC. No grants to individuals.
Publications: 990-PF.
Application information:
Initial approach: Letter
Deadline(s): None
Write: Robert W. Alvord, V.P.
Officers and Trustees: Ellsworth C. Alvord, Jr., Pres.; Robert W. Alvord, V.P.; John H. Doyle, Secy.-Treas.
Employer Identification Number: 526037194

489
The Appleby Foundation
c/o Crestar Bank, N.A., Trust Div.
1445 New York Ave., N.W.
Washington 20005 (202) 879-6341

Trust established in 1958 in DC.
Donor(s): Scott B. Appleby.†
Financial data (yr. ended 12/31/87): Assets, $6,383,883 (M); expenditures, $352,508, including $274,114 for 41 grants (high: $37,114; low: $1,000).
Purpose and activities: Grants primarily for higher education; giving also for youth agencies, music, Protestant church support, cultural programs, and hospitals.
Types of support: Scholarship funds, general purposes.
Limitations: Giving primarily in Washington, DC, FL, and GA.
Application information:
Initial approach: Letter
Deadline(s): None
Write: Virginia M. Herrin, V.P., Crestar Bank, N.A.
Trustees: F. Jordan Colby, Sarah P. Williams, Crestar Bank, N.A.
Number of staff: 1
Employer Identification Number: 526026971

490
Scott B. and Annie P. Appleby Trust
c/o Crestar Bank, N.A.
1445 New York Ave., N.W.
Washington 20005 (202) 879-6341

Trust established in 1948 in DC.
Financial data (yr. ended 12/31/86): Assets, $2,717,137 (M); expenditures, $87,076, including $61,500 for 13 grants (high: $25,000; low: $500).
Purpose and activities: Emphasis on higher education for the handicapped, primarily in GA; some grants for cultural programs and child welfare in FL.
Limitations: Giving primarily in GA and FL. No grants to individuals.
Application information:
Initial approach: Proposal
Copies of proposal: 1
Deadline(s): Submit proposal preferably in May; deadline June 1
Board meeting date(s): July or Aug.
Write: Virginia M. Herrin, V.P., Crestar Bank, N.A.
Trustees: F. Jordan Colby, Sarah P. Williams, Crestar Bank, N.A.
Employer Identification Number: 526033671

491
Benton Foundation
1776 K St., N.W., Suite 605
Washington 20006 (202) 429-7350

Incorporated in 1948 in NY.
Donor(s): William Benton,† Helen Benton.†
Financial data (yr. ended 12/31/88): Assets, $11,500,000 (M); expenditures, $846,008, including $445,875 for 50 grants (high: $50,000; low: $500; average: $10,000-$25,000) and $66,300 for 3 foundation-administered programs.

Purpose and activities: Limited number of grants for communications research and education, and media projects.
Types of support: Matching funds, research, special projects, publications, conferences and seminars, consulting services, technical assistance.
Limitations: No grants to individuals, or for general purposes, capital funds, or scholarships; no loans.
Publications: Multi-year report, informational brochure (including application guidelines), grants list.
Application information:
Initial approach: Letter
Copies of proposal: 1
Deadline(s): Submit proposal preferably in Dec. or Apr.
Board meeting date(s): Mar., July, and Nov.
Final notification: About 3 weeks after board meetings
Write: Larry Kirkman, Exec. Dir.
Officers and Directors: Charles Benton, Pres. and Chair.; Adrianne Benton, Secy.; Leonard Schrager, Treas. and General Counsel; John Brademas, Dick Clark, Roy Fisher, Richard Neustadt, Michael Pertschuk, Gene Pokorny, Dorothy Ridings, Carolyn Sachs.
Number of staff: 2 full-time professional; 2 full-time support.
Employer Identification Number: 136075750
Recent arts and culture grants:
American Film Institute, Los Angeles, CA, $15,000. For matching grant for study of prospects for home video distribution of independent film and video, which will identify strategies for facilitating entry of independent films and videotapes into home market. 1987.
Center for New Television, Chicago, IL, $10,000. For matching grant toward series of three cable television programs. Incorporating short documentaries, live panel presentations, and audience interaction, series will promote public debate about solutions to regional problems. 1987.
CIStems (Cultural Information Service), NYC, NY, $5,000. For preparation and distribution of teacher's/viewer's guide to ABC News Congressbridge broadcasts, series of three live videoconferences linking Members of Congress and representatives of U.S.S.R. government. 1987.
Citizen Exchange Council, NYC, NY, $15,000. For conference and handbook about U.S.-Soviet spacebridges. In 1987 producers, distributors, funders, researchers, and government officials involved in international satellite videoconferences met to develop strategies for improving quality and effectiveness of this new medium. Handbook will include proceedings of this and earlier conference and reference guide to field for newcomers, broadcasters, and funders. 1987.
Foundation for Independent Video and Film, NYC, NY, $30,000. For three media projects: two for projects that contribute to world peace, and third for project that enhances public understanding of role of communications in society. 1987.
Foundation for Independent Video and Film, NYC, NY, $23,000. To administer two grants in 1987 for media projects that further public understanding of prospects for world peace.

Grant also enabled FIVF to publicize its Donor-Advised Film and Video Fund, grantmaking program created to support high-quality independent film and video projects dealing with social, political, and environmental issues. 1987.
Foundation for Independent Video and Film, NYC, NY, $7,500. For public education project on role of independent production in public broadcasting. This outreach effort will produce and disseminate materials about public broadcasting policy and funding and their impact on independent production. 1987.
National Public Radio, DC, $25,000. For second year of two-year commitment for coverage of communications and information technologies and issues on NPR's news programs. 1987.

492
Diane & Norman Bernstein Foundation
2025 Eye St., N.W., Suite 400
Washington 20006-5099 (202) 331-7500

Established in 1965 in DC.
Financial data (yr. ended 9/30/88): Assets, $1,600,000 (M); gifts received, $300,000; expenditures, $75,000, including $75,000 for 1 grant (high: $25,000; low: $5,000).
Purpose and activities: Grants primarily to cultural institutions; support also for education, conservation, Jewish welfare, health, AIDS and the performing arts.
Types of support: General purposes.
Application information: Contributes only to pre-selected organizations. Applications not accepted.
Deadline(s): None
Board meeting date(s): Aug.
Final notification: By Sept. 30
Write: Diane and Norman Bernstein, Directors
Directors: Celia Ellen Bernstein, Diane Bernstein, Marianne Bernstein, Norman Bernstein, James Connell.
Number of staff: 1 part-time professional.
Employer Identification Number: 526047356

493
The Morris and Gwendolyn Cafritz Foundation
1825 K St., N.W., 14th Fl.
Washington 20006 (202) 223-3100

Incorporated in 1948 in DC.
Donor(s): Morris Cafritz,† Gwendolyn D. Cafritz.†
Financial data (yr. ended 4/30/88): Assets, $171,324,866 (M); gifts received, $20,000; expenditures, $7,329,631 for 118 grants (high: $2,500,000; low: $2,000; average: $10,000-$50,000).
Purpose and activities: Giving only for programs of direct assistance, with emphasis on community service, cultural programs, education, and health.
Types of support: Operating budgets, continuing support, annual campaigns, seed money, matching funds, scholarship funds, exchange programs.

Limitations: Giving limited to Washington, DC. No grants to individuals, or for emergency funds, deficit financing, capital, endowment, or building funds, research, demonstration projects, or conferences; no loans.
Publications: Annual report, application guidelines.
Application information:
Initial approach: Proposal
Copies of proposal: 1
Deadline(s): July 1, Nov. 1, and Mar. 1
Board meeting date(s): May, Oct., and Jan.
Write: Martin Atlas, Pres.
Officers: Martin Atlas,* Pres. and Treas.; Roger A. Clark, Secy.
Directors:* Calvin Cafritz, William P. Rogers.
Number of staff: 1 part-time professional; 2 part-time support.
Employer Identification Number: 526036989
Recent arts and culture grants:
Amherst College, Amherst, MA, $25,000. For general support of Folger Consort's 1986-87 season of concerts in DC. 1987.
Art Barn Association, DC, $15,000. To continue program of free art education classes for DC school children during summer of 1987 at Art Barn Gallery. 1987.
Cathedral Choral Society of Washington, D.C., DC, $10,000. For general support of 1987-88 season. 1987.
Chamber Music-Washington, DC, $15,000. To underwrite Music at Noon 1987 spring series of concerts at Western Presbyterian Church. 1987.
Choral Arts Society of Washington, DC, $20,000. To support Mozart-Hindemith concert at Kennedy Center. 1987.
Corcoran Gallery of Art, DC, $125,000. To support We the People, outreach program. 1987.
Cultural Alliance of Greater Washington, DC, $15,000. To support Business Volunteers for the Arts program. 1987.
D.C. Wheel Productions, DC, $10,000. For general support of The Dance Place. 1987.
Dumbarton Concert Series, DC, $10,000. To match grant from The April Trust to support Live Music Now, outreach program for people in institutions. 1987.
Fords Theater Society, DC, $100,000. For general support of 1986-87 season's Productions Fund. 1987.
Georgetown Day School, DC, $150,000. To furnish and equip performing arts complex in new high school building. 1987.
Greater Washington Educational Telecommunications Association, DC, $60,000. To underwrite two television programs in series More Lively Arts featuring music ensembles performing at locations in DC. 1987.
Greater Washington Educational Telecommunications Association, DC, $11,500. To underwrite WETA Wednesday Night, series of 52 weekly concerts on WETA-FM Radio. 1987.
Hispanic Institute for the Performing Arts, DC, $7,500. For general support of educational programs. 1987.
John F. Kennedy Center for the Performing Arts, DC, $250,000. To help support visits of foreign ballet companies during 1987. 1987.

Joy Zinoman Studio, DC, $25,000. To support Growth Challenge Program of Studio Theater and Acting Conservatory. 1987.

Library of Congress, DC, $252,341. To underwrite Washingtoniana II, A Guide to the Architecture, Design and Engineering Collections of Washington, DC Metropolitan Area. 1987.

Museum One, DC, $8,300. To help develop Creating for Life, series of workshops at Saint Elizabeth's Hospital combining visual arts, dance and music. 1987.

National Captioning Institute, Falls Church, VA, $25,000. To support closed captioning of It's Academic on WRC-TV so that hearing impaired viewers can read what other viewers hear. 1987.

National Choral Foundation, DC, $20,000. To support performance by Paul Hill Chorale of Verdi's Requiem at Kennedy Center. 1987.

National Gallery of Art, DC, $1,200,000. For additional funds to purchase a work of art. 1987.

National Symphony Orchestra Association of Washington, D.C., DC, $250,000. For challenge grant to fiscal 1987 annual fund. 1987.

New Arts Theater Company, DC, $9,000. To support production of three plays in spring of 1987. 1987.

PEN American Center, NYC, NY, $25,000. To support PEN/Faulkner Foundation Award for Fiction program. 1987.

Phillips Collection, DC, $100,000. To support The Pastoral Landscape, joint exhibition with National Gallery of Art. 1987.

Phillips Collection, DC, $50,000. For challenge grant. 1987.

Protestant Episcopal Cathedral Foundation of the District of Columbia, DC, $50,000. For challenge grant to continue cultural arts program at Washington Cathedral during fiscal 1987. 1987.

Selma M. Levine School of Music, DC, $40,000. To support student and faculty enrichment programs and the library and to set up special fund for community outreach programs in recognition of School's Tenth Anniversary. 1987.

Shakespeare Theater at the Folger, DC, $100,000. To support production of four classical plays during 1986-87 season. 1987.

Smithsonian Institution, DC, $97,115. To produce orientation film for Information Center. 1987.

Smithsonian Institution, DC, $82,000. To purchase portrait of Benjamin Franklin, attributed to Joseph-Siffrein Duplisses, for National Portrait Gallery. 1987.

Smithsonian Institution, DC, $21,436. To continue Exploring the Smithsonian, multiple-visit program for teachers and students from DC junior high schools. 1987.

Source Theater Company, DC, $10,000. For general support of 1986-87 season. 1987.

Summer Opera Theater Company, DC, $10,000. For general support of 1987 season. 1987.

Textile Museum, DC, $30,000. To help open Museum on Sundays and to support annual Open House Celebration of Textiles. 1987.

Washington Ballet, DC, $100,000. For challenge grant to support 1986-87 season. 1987.

Washington Drama Society, DC, $175,000. For general support of Arena Stage's 1986-87 season. 1987.

Washington Episcopal Day School, DC, $25,000. To help establish arts program in new school. 1987.

Washington Opera, DC, $300,000. For challenge grant to support 1986-87 season and to prepare for move from Terrace Theater to Eisenhower Theater for 1987-88 season at Kennedy Center. 1987.

Washington Performing Arts Society, DC, $30,000. For general support of 1986-87 season. 1987.

Washington Project for the Arts (WPA), DC, $20,000. To support artists-in-residence program. 1987.

Woolly Mammoth Theater Company, DC, $7,500. For general support of 1986-87 season. 1987.

494
The Manny and Ruth Cohen Foundation, Inc.
2920 Albemarle St., N.W.
Washington 20008 (202) 244-8884

Established in 1986 in CT.
Donor(s): Ruth Cohen.
Financial data (yr. ended 12/31/87): Assets, $1,522,071 (M); gifts received, $1,496,048; expenditures, $117,383, including $117,383 for 8 grants (high: $29,258; low: $4,935).
Purpose and activities: Support primarily for performing arts and religion.
Application information:
 Deadline(s): None
 Write: Ruth Cohen, Pres.
Officers: Ruth Cohen, Pres.; Alvin Morgenstein, V.P.; Melvin Morgenstein, Secy.-Treas.
Employer Identification Number: 592744621

495
Council on Library Resources, Inc.
1785 Massachusetts Ave., N.W.
Washington 20036 (202) 483-7474

Incorporated in 1956 in DC.
Donor(s): National Endowment for the Humanities, and private foundations.
Financial data (yr. ended 6/30/87): Assets, $8,552,741 (M); gifts received, $1,303,136; expenditures, $1,407,391, including $653,973 for 54 grants (high: $160,000; low: $300; average: $1,500-$25,000) and $11,347 for 3 grants to individuals.
Purpose and activities: A private operating foundation; grants limited to programs that show promise of helping to provide solutions to problems that affect libraries in general, and academic and research libraries in particular. The council operates programs of its own to serve the same general purpose.
Types of support: Special projects, research, conferences and seminars, grants to individuals.
Limitations: No grants for building construction or improvement, indirect costs, purchase of collections or equipment, normal staffing or operational costs, or programs useful only to the institutions in which they take place.

Publications: Annual report (including application guidelines), newsletter, informational brochure (including application guidelines).
Application information:
 Initial approach: Letter
 Copies of proposal: 1
 Deadline(s): None for general grant applications; deadlines for competitive programs are stated with their announcement
 Board meeting date(s): Apr. and Nov.
 Write: Warren J. Haas, Pres.
Officers: Warren J. Haas,* Pres.; Deanna B. Marcum, V.P.; Mary Agnes Thompson, Secy.-Treas.
Directors:* Maximilian W. Kempner, Chair.; Charles D. Churchwell, Vice-Chair.; Page Ackerman, William O. Baker, Patricia Battin, Laura Bornholdt, Harvey Brooks, James S. Coles, Samuel DuBois Cook, Martin M. Cummings, Ruth M. Davis, Billy E. Frye, Caryl P. Haskins, William N. Hubbard, Jr., Elizabeth T. Kennan, Herman Liebaers, Howard R. Swearer, Robert Vosper, Frederick H. Wagman, Thomas H. Wright.
Number of staff: 8 full-time professional; 1 part-time professional; 4 full-time support.
Employer Identification Number: 530232831
Recent arts and culture grants:
American Antiquarian Society, Worcester, MA, $30,000. For completion of North American Imprints Program. 1987.

American Historical Association, DC, $6,780. For planning meeting for new Guide to Historical Literature. 1987.

Columbia University, NYC, NY, $7,630. For bibliography on impact of information revolution on scholarship in humanities and social sciences. 1987.

Library of Congress, DC, $15,110. For completion of series of training videotapes on library preservation. 1987.

Library of Congress, DC, $5,000. For symposium on incunabula in American libraries. 1987.

496
The Dimick Foundation
c/o Crestar Bank, N.A.
15th and New York Ave., N.W.
Washington 20005 (202) 879-6345

Established in 1957 in DC.
Donor(s): John Dimick.†
Financial data (yr. ended 12/31/87): Assets, $3,571,061 (L); expenditures, $381,855, including $331,000 for 44 grants (high: $10,000; low: $1,000).
Purpose and activities: Emphasis on cultural programs, especially music, and on higher education and social services.
Limitations: Giving primarily in Washington, DC. No grants for student loans.
Application information:
 Initial approach: Letter
 Deadline(s): None
 Write: Joseph R. Riley, John M. Lynham, Jr. or Nancy Cree, Trustees
Trustees: Nancy Cree, John M. Lynham, Joseph R. Riley, Crestar Bank, N.A.
Employer Identification Number: 526038149

497
Fannie Mae Foundation
(Formerly Federal National Mortgage
Association Foundation)
3900 Wisconsin Ave., N.W.
Washington 20016 (202) 752-4927

Established in 1979 in DC.
Donor(s): Fannie Mae Association.
Financial data (yr. ended 12/31/87): Assets,
$1,452,879 (M); gifts received, $1,000,000;
expenditures, $870,002, including $800,838
for 203 grants (high: $50,000; low: $100;
average: $500-$5,000) and $66,504 for 418
employee matching gifts.
Purpose and activities: Support primarily
awarded for housing and community
development programs, cultural and artistic
programs, and health and social concerns.
Types of support: Annual campaigns, building
funds, conferences and seminars, employee
matching gifts, endowment funds, equipment,
general purposes, matching funds, operating
budgets, renovation projects, research, seed
money, special projects, technical assistance.
Limitations: Giving primarily in the
Washington, DC, metropolitan area and areas
where corporation maintains regional offices in
Philadelphia, PA; Atlanta, GA; Chicago, IL;
Dallas, TX; and Los Angeles, CA. No support
for organizations whose fundraising costs are in
excess of 20 percent of their contributed
support; generally, no support for organizations
that benefit from United Way support or for
churches and sectarian organizations, though
contributions to religious group-sponsored,
nondenominational activities are considered.
No grants to support charitable activities
undertaken outside of the U.S. No grants to
individuals; generally no grants to institutions of
higher learning or secondary education for
general or scholarship support.
Publications: Informational brochure (including
application guidelines), grants list.
Application information:
 Initial approach: Proposal
 Copies of proposal: 1
 Deadline(s): None
 Board meeting date(s): Periodically
 throughout year
 Write: Harriet M. Ivey, Exec. Dir.
Officers and Directors: David O. Maxwell,
Chair.; Roger E. Birk, Pres.; Bruce C. McMillen,
V.P. and Treas.; Douglas M. Bibby, V.P.;
Michael A. Smilow, V.P.; Caryl S. Bernstein,
Secy.; Stuart A. McFarland, Treas.; Harriet M.
Ivey, Exec. Dir.; Henry C. Cashen II, Carla A.
Hills, Samuel J. Simmons, Mallory Walker.
Number of staff: 2 part-time professional; 1
part-time support.
Employer Identification Number: 521172718

498
First American Bankshares Corporate
 Contributions Program
15th and H St., N.W.
Washington 20005 (202) 383-1462

Financial data (yr. ended 12/31/88):
$900,000 for 350 grants (high: $45,000; low:
$100).
Purpose and activities: Primarily supports the
fine arts and education, including higher

education, hospitals, building funds for
hospitals, mental health, and child welfare.
Types of support: Annual campaigns, building
funds, capital campaigns, continuing support,
operating budgets.
Limitations: Giving primarily in communities
within service areas.
Publications: Application guidelines.
Application information: Send letter to
Marketing Dir. of FA affiliate in community or
to FA Contributions Prog. Admin. Application
form required.
 Copies of proposal: 1
 Deadline(s): None
 Board meeting date(s): Quarterly
 Write: Carol S. Gimmel, Asst. V.P. and Prog.
 Admin.
Administrator: Carol S. Gimmel, Prog. Admin.

499
The Folger Fund
2800 Woodley Rd., N.W.
Washington 20008 (202) 667-2991

Incorporated in 1955 in DC.
Donor(s): Eugenia B. Dulin,† Kathrine Dulin
Folger, and others.
Financial data (yr. ended 8/31/88): Assets,
$12,674,214 (M); gifts received, $220,813;
expenditures, $668,149, including $638,633
for 103 grants (high: $249,546; low: $25).
Purpose and activities: Giving primarily for
the arts and museums, historic preservation,
education, health and welfare, and church
support.
Types of support: General purposes, building
funds, capital campaigns.
Limitations: Giving primarily in Washington,
DC, Knox County, TN, and Palm Beach
County, FL. No grants to individuals.
Publications: Annual report.
Application information: Future funds
currently committed.
 Initial approach: Proposal
 Deadline(s): None
 Board meeting date(s): Sept.
 Final notification: Usually within 3 months
 Write: Kathrine Dulin Folger, Pres.
Officers: Kathrine Dulin Folger, Pres. and
Treas.; Lee Merritt Folger, V.P. and Secy.
Trustee: John Dulin Folger.
Employer Identification Number: 520794388

500
GEICO Philanthropic Foundation
c/o GEICO Corp.
GEICO Plaza
Washington 20076 (301) 986-2807

Established in 1980 in Washington, DC.
Donor(s): Criterion Insurance Co., Government
Employees Insurance Co., Government
Employees Insurance Co.
Financial data (yr. ended 12/31/87): Assets,
$1,603,314 (M); gifts received, $967,492;
expenditures, $872,878, including $857,118
for 239 grants (high: $125,292; low: $17).
Purpose and activities: Grants for higher
education, a community fund, health agencies,
hospitals, cultural programs, child welfare, and
youth and social service agencies.
Application information:

Initial approach: Letter
Deadline(s): None
Write: Noel A. Chandonnet, V.P.
Officers: Donald K. Smith,* Pres.; John M.
O'Connor, Secy.; Charles G. Schara, Treas.
Directors:* Louis A. Simpson, Chair.; Noel A.
Chandonnet, John J. Krieger, Eugene J. Meyung,
William B. Snyder, W. Alvon Sparks, Jr.,
Edward H. Utley.
Employer Identification Number: 521202740

501
Melvin and Estelle Gelman Foundation
2120 L St., N.W., Suite 800
Washington 20037

Established in 1963 in DC.
Donor(s): Melvin Gelman,† Towers, Inc.
Financial data (yr. ended 11/30/87): Assets,
$862,074 (M); gifts received, $680,000;
expenditures, $371,224, including $368,556
for 187 grants (high: $4,000; low: $10).
Purpose and activities: Support primarily for
Jewish welfare, cultural organizations and the
arts, and medical research.
Limitations: Giving primarily in DC.
Officers: Estelle S. Gelman, Pres. and Treas.;
Elise G. Lefkowitz, V.P.; Elaine G. Miller, V.P.;
Martin Goldstein, Secy.
Employer Identification Number: 526042344

502
Aaron & Cecile Goldman Foundation
1725 K St., N.W., Suite 907
Washington 20006

Established in 1962 in DC.
Donor(s): Aaron Goldman, Cecile Goldman.
Financial data (yr. ended 9/30/86): Assets,
$1,910,774 (M); gifts received, $108,276;
expenditures, $61,484, including $58,173 for
65 grants (high: $15,000; low: $100).
Purpose and activities: Giving primarily for
Jewish welfare, cultural activities, and
education.
Application information:
 Deadline(s): None
 Write: Aaron Goldman, Trustee
Trustees: Aaron Goldman, Cecile Goldman.
Employer Identification Number: 526037949

503
The Philip L. Graham Fund
c/o The Washington Post Co.
1150 Fifteenth St., N.W.
Washington 20071 (202) 334-6640

Trust established in 1963 in DC.
Donor(s): Katharine Graham, Frederick S.
Beebe,† The Washington Post Co., Newsweek,
Inc., Post-Newsweek Stations.
Financial data (yr. ended 12/31/87): Assets,
$54,064,144 (M); expenditures, $2,450,581,
including $2,386,700 for 102 grants (high:
$100,000; low: $2,500; average: $10,000-
$35,000).
Purpose and activities: Support for raising
standards of excellence in journalism. Grants
also for arts and culture, social welfare, with an
emphasis on youth agencies, and civic and
community affairs.

Types of support: Seed money, building funds, equipment, endowment funds, matching funds, renovation projects, capital campaigns, special projects.
Limitations: Giving primarily in metropolitan Washington, DC. No support for national or international organizations, or for religious organizations for religious purposes. No grants to individuals, or for research, annual campaigns, operating expenses, conferences, publications, tickets, films, or courtesy advertising; no loans.
Publications: Application guidelines, program policy statement, grants list.
Application information:
 Initial approach: Letter, telephone or proposal
 Copies of proposal: 1
 Deadline(s): Apr. 1, Aug. 1, and Nov. 1
 Board meeting date(s): Spring, summer and fall
 Final notification: 6 months
 Write: Mary M. Bellor, Secy.
Officers: Mary M. Bellor, Secy. and Exec. Dir.; Martin Cohen,* Treas.
Trustees: Donald E. Graham, Katharine Graham, Vincent E. Reed, John W. Sweeterman.
Number of staff: 1 part-time professional; 1 part-time support.
Employer Identification Number: 526051781
Recent arts and culture grants:
Art in the Stations, Detroit, MI, $25,000. To help fund permanent art installations of People Mover, elevated transit system in Detroit's central business district. 1987.
Asia Society, DC, $10,000. For interim support while society undertakes to increase membership and corporate underwriting. 1987.
D.C. Wheel Productions, Dance Place, DC, $20,000. Toward renovation of Dance Place's new performance space in Northeast Washington. 1987.
District Curators, DC, $10,000. To help meet terms of National Endowment for the Arts Advancement Program challenge grant awarded to developing small arts organizations. 1987.
Family Respite Center, Falls Church, VA, $5,000. To underwrite costs of art therapy program for victims of Alzheimer's and related diseases. 1987.
Horizons Theater, DC, $9,000. To help underwrite 1987-88 season, marking Horizon's eleventh year of operations. 1987.
Jacksonville Symphony Orchestra, Jacksonville, FL, $12,000. Toward expansion program that will increase size of orchestra. 1987.
John F. Kennedy Center for the Performing Arts, DC, $30,000. Toward capital campaign to help protect Kennedy Center from vagaries of annual fund raising and to permit more flexibility in acquisition and development of programs. 1987.
Meridian House International, DC, $100,000. Toward Campaign for Crescent Place, which will enable Meridian House to expand space for educational and cultural programs. 1987.
Miami City Ballet, Miami, FL, $10,000. Toward inaugural year expenses of ballet company performing in Broward, Palm Beach and Dade Counties. 1987.
Museum of Broadcasting, NYC, NY, $100,000. To support museum's campaign for construction of new building. 1987.

Prince Georges County Arts Council, Riverdale, MD, $10,000. To subsidize salary of development officer for Arts Council. 1987.
Source Theater Company, DC, $25,000. Toward capital improvements for theater's main performance space, Warehouse Rep. 1987.
United States Holocaust Memorial Museum, DC, $20,000. Toward campaign to build and equip museum and provide for research and education programs. 1987.
W E T A Greater Washington Educational Television Association, DC, $100,000. Toward establishing revolving program fund for development of television and radio productions devoted to culture and arts. 1987.
Washington Opera, DC, $20,000. Toward acquisition of computer system to streamline such tasks as subscription fulfillment, fund raising, accounting and box office processing. 1987.
Washington Performing Arts Society, DC, $10,000. Toward costs associated with City Dance Festival, forum to promote recognition of diverse local dance groups and troupes. 1987.
Washington Project for the Arts (WPA), DC, $25,000. Toward costs associated with expense of making temporary quarters usable as exhibition space while permanent facility is being renovated. 1987.
Woolly Mammoth Theater Company, DC, $15,000. To support theater's longer-range plan for growth, including performance space of its own, and to provide additional grant in 1988 if it can be matched on two-to-one basis with new or increased contributions. 1987.

504
Hill-Snowdon Foundation
1607 New Hampshire Ave., N.W.
Washington 20009

Donor(s): Arthur B. Hill.†
Financial data (yr. ended 12/31/86): Assets, $1,788,998 (M); expenditures, $61,169, including $60,000 for 15 grants (high: $10,000; low: $200).
Purpose and activities: Giving for secondary education, the performing arts, including theatre, community funds, environmental organizations, and organizations for the blind.
Application information: Contributes only to pre-selected organizations. Applications not accepted.
 Write: Richard W. Snowdon, Dir.
Directors: Edward W. Snowdon, Edward W. Snowdon, Jr., Lee Hill Snowdon, Marguerite H. Snowdon, Richard W. Snowdon.
Employer Identification Number: 226081122

505
The Hitachi Foundation
1509 22nd St., N.W.
Washington 20037 (202) 457-0588

Established in 1985 in DC.
Donor(s): Hitachi, Ltd.
Financial data (yr. ended 3/31/88): Assets, $21,985,820 (M); gifts received, $7,727,800;

expenditures, $1,636,197, including $707,095 for 48 grants (high: $50,000; low: $1,500; average: $28,000) and $30,000 for loans.
Purpose and activities: Giving in 4 areas: community and economic development - emphasizing leadership skills for individuals and community groups, volunteerism, and help for businesses; arts and cross-cultural understanding - increasing understanding between Japan and the U.S., making the arts accessible to all segments of society, and encouraging the use of arts to improve education; education - improving the quality of teaching and learning at all levels, particularly in middle and secondary schools; and technology and human resource development - enhancing and evaluating the social and economic effects of rapidly changing technology, including its dysfunctional aspects, making it accessible to all segments of society, and the use of new technology in education. The foundation makes awards to individuals for exemplary service to the community.
Types of support: General purposes, program-related investments, seed money, special projects, technical assistance.
Limitations: No support for sectarian or denominational religious organizations, health programs, or social organizations. No grants to individuals (except for Yoshiyama Awards for community service), or for fund-raising events, building funds, publications, conferences and seminars, endowments, advertising, capital campaigns, or research.
Publications: Annual report (including application guidelines), program policy statement, application guidelines, newsletter.
Application information:
 Initial approach: Letter of no more than 3 pages; if project is of interest, a more detailed proposal will be invited
 Deadline(s): Feb. 1, June 1, and Oct. 1
 Board meeting date(s): Mar., July, and Oct. to review proposal
 Write: Felicia B. Lynch, V.P., Progs.
Officers: Delwin A. Roy,* Pres.; Felicia B. Lynch, V.P., Programs; Soji Teramura, Secy.; Robyn L. James, Treas.
Directors: Percy A. Pierre, Katsushige Mita, Honorary Chair.; Elliot Lee Richardson, Chair.; Patricia Albjerg Graham, Joseph E. Kasputys, S. Dillon Ripley.
Number of staff: 4 full-time professional; 2 part-time professional; 1 full-time support; 1 part-time support.
Employer Identification Number: 521428862
Recent arts and culture grants:
Arena Stage, DC, $45,508. For audience development and educational outreach in conjuction with Tadashi Suzuki's The Tale of Lear, collaborative production of Milwaukee Repertory Theater, Berkeley Repertory Theater Company, StageWest, and Arena Stage. 2/88.
Japan Society, NYC, NY, $30,000. To support series of 15 film modules about Japanese society for use in colleges and universities. 2/88.

506
The Kiplinger Foundation, Inc.
1729 H St., N.W.
Washington 20006 (202) 887-6537

Incorporated in 1948 in MD.
Donor(s): Willard M. Kiplinger.†
Financial data (yr. ended 12/31/87): Assets,
$14,672,841 (M); gifts received, $400,000;
expenditures, $1,173,968, including $998,776
for 92 grants (high: $160,000; low: $1,000;
average: $1,000-$10,000) and $46,867 for 74
employee matching gifts.
Purpose and activities: Support primarily for
higher education, including journalism
programs; grants also for cultural groups, a
community fund, social service and youth
agencies, and civic affairs groups.
Types of support: Operating budgets,
continuing support, annual campaigns, building
funds, endowment funds, capital campaigns,
matching funds, special projects, employee
matching gifts.
Limitations: Giving primarily in the greater
Washington, DC, area. No grants to
individuals, or for seed money, emergency
funds, deficit financing, equipment and
materials, land acquisition, renovation projects,
publications, conferences, scholarships or
fellowships.
Application information: Application form
required for matching gift program.
 Initial approach: Letter
 Copies of proposal: 1
 Deadline(s): None
 Board meeting date(s): 4 or 5 times a year
 Final notification: 3 to 6 months
 Write: Frances Turgeon, Secy.
Officers and Trustees: Austin H. Kiplinger,
Pres.; Frances Turgeon, Secy.; James O. Mayo,
Treas.; Knight A. Kiplinger, Todd L. Kiplinger.
Number of staff: 1 part-time support.
Employer Identification Number: 520792570

507
Marpat Foundation, Inc.
c/o Miller & Chevalier
655 15th St., NW
Washington 20005

Incorporated in 1985 in MD.
Donor(s): Marvin Breckinridge Patterson.
Financial data (yr. ended 12/31/87): Assets,
$8,719,300 (M); gifts received, $733,484;
expenditures, $433,503, including $350,000
for 10 grants (high: $75,000; low: $5,000).
Purpose and activities: "It is anticipated that
grants will be made primarily to established
charitable organizations whose activities are
personally known to the directors."
Limitations: No grants to individuals, or for
endowment funds.
Application information:
 Initial approach: Proposal
 Copies of proposal: 6
 Deadline(s): Oct. 1
 Board meeting date(s): Nov.
 Final notification: After Dec. 15
Officers and Directors: Marvin Breckinridge
Patterson, Pres.; Charles T. Akre, V.P.; Joan F.
Koven, Secy.-Treas.; Isabella B. Dubow, Mrs.
John Farr Simons.
Employer Identification Number: 521358159

508
Marriott Corporate Giving Program
Marriott Drive
Washington 20058 (301) 380-7430

Purpose and activities: Supports four primary
areas: education, with an emphasis on higher
education; health and human services, with
most giving through United Way; and civic
programs and cultural institutes and the arts,
mostly in the Washington, D.C., area.
Types of support: Building funds, capital
campaigns, equipment, general purposes,
operating budgets, annual campaigns,
continuing support.
Limitations: Giving primarily in Marriott
operating communities (all 50 states) and the
Washington, D.C., headquarters area. No
support for sports groups, or for religious,
fraternal, or veterans' organizations. No grants
to individuals.
Publications: Application guidelines.
Application information:
 Initial approach: Letter
 Copies of proposal: 1
 Deadline(s): Applications preferred in Oct.
 but accepted anytime. Apply at least 4 to
 6 weeks before funding is needed
 Final notification: 1 month
 Write: Judi A. Hadfield, Dir., Corp. Relations
 Services
Number of staff: 1 full-time professional; 1 full-
time support.

509
**Thomas and Frances McGregor
Foundation**
c/o Robert Philipson & Co.
2000 L St., N.W., Suite 609
Washington 20036

Incorporated in 1961 in DC.
Donor(s): Thomas W. McGregor, McGregor
Printing Corp.
Financial data (yr. ended 2/29/88): Assets,
$3,763,802 (M); expenditures, $215,670,
including $202,570 for 59 grants (high:
$25,000; low: $20).
Purpose and activities: Emphasis on higher
and secondary education, hospitals and health
agencies, cultural programs, and support for
religious organizations.
Limitations: Giving primarily in DC.
Application information:
 Write: Victor Krakower, Mgr.
Manager: Victor Krakower.
Employer Identification Number: 526041498

510
Eugene and Agnes E. Meyer Foundation
1400 Sixteenth St., N.W., Suite 360
Washington 20036 (202) 483-8294

Incorporated in 1944 in NY.
Donor(s): Eugene Meyer,† Agnes E. Meyer.†
Financial data (yr. ended 12/31/88): Assets,
$48,212,394 (M); expenditures, $2,128,521,
including $1,948,157 for 116 grants (high:
$100,000; low: $250; average: $10,000-
$25,000).
Purpose and activities: To assist in the
development of community services and

facilities; grants principally for welfare,
education, health and mental health, the arts
and humanities, and law and justice, preferably
to provide new or improved services rather
than to support existing programs.
Types of support: Seed money, matching
funds, special projects, technical assistance.
Limitations: Giving limited to the metropolitan
Washington, DC area, including VA and MD.
No support for sectarian purposes, or for
programs that are national or international in
scope. No grants to individuals, or for
continuing support, annual campaigns, deficit
financing, building or endowment funds,
equipment, land acquisition, renovations,
scholarships, fellowships, research,
publications, or conferences; no loans.
Publications: Annual report (including
application guidelines).
Application information:
 Initial approach: Letter or proposal
 Copies of proposal: 3
 Deadline(s): Apr. 1, Aug. 1, and Dec. 1
 Board meeting date(s): Applications
 considered only at Feb., June, and Oct.
 meetings; board meets also in Apr. and
 Dec.
 Final notification: 1 month after meetings
 Write: Julie L. Rogers, Exec. Dir.
Officers and Directors: Mallory Walker,
Chair.; Delano E. Lewis, Vice-Chair.; Newman
T. Halvorson, Jr., Secy.-Treas.; Lucy M. Cohen,
Theodore C. Lutz, Harry C. McPherson, Peter
F. O'Malley, Pearl Rosser, M.D., David W.
Rutstein, Carrie Thornhill.
Staff: Julie L. Rogers, Exec. Dir.; Irene S. Lee,
Prog. Officer.
Number of staff: 2 full-time professional; 1 full-
time support; 2 part-time support.
Employer Identification Number: 530241716
Recent arts and culture grants:
African American Museums Association, DC,
 $10,000. For production costs of educational
 and cultural documentary, Freedom Bags, for
 use in ninth and eleventh grade curriculum of
 D.C. public schools. 2/88.
Columbia Historical Society, DC, $15,000. For
 membership development and outreach
 activities. 2/88.
Cultural Alliance of Greater Washington, DC,
 $15,000. For second year support for
 Business Volunteers for the Arts. 2/88.
Dance Exchange, DC, $10,000. For support for
 Financial Administrator. 2/88.
Dance Place, DC, $10,000. For New Works
 Project/NEA challenge grant. 2/88.
Durrin Films, DC, $10,000. For production
 costs of film version of Til Death Do Us Part
 by Everyday Theater Youth Ensemble. 2/88.
Friends of D.C. Youth Orchestra Program, DC,
 $10,000. For support for symphony
 performance training for minority youth.
 2/88.
Greater Washington Educational
 Telecommunications Association, DC,
 $20,000. For education and promotion
 related to AIDS movie, Changing the Rules.
 10/87.
National Building Museum, DC, $10,000. For
 continued development of Learning Center
 educational activities. 2/88.
Public Productions of Virginia, Arlington, VA,
 $7,050. For in-service training for

D.C. public school teachers on historical storytelling. 2/88.

Shakespeare Theater at the Folger, DC, $15,000. For support for minority actors training program. 10/87.

Studio Theater, DC, $20,000. For Phase II of campaign for new theater. 2/88.

Washington DC International Film Festival, DC, $5,000. For support of Emerging African Cinema series and community programs in second annual film festival program. 10/87.

Washington Performing Arts Society, DC, $15,000. For support of City Dance, three day festival of area professional dance companies. 10/87.

Washington Project for the Arts (WPA), DC, $20,000. For support of artistic programming initiatives addressing issues of culture, community, and racial identity. 2/88.

Woolly Mammoth Theater Company, DC, $15,000. For support for theater's new home. 2/88.

Young Audiences, DC, $20,000. For development activities to broaden and diversify base funding. 10/87.

511
National Home Library Foundation

1333 New Hampshire Ave., N.W., Suite 600
Washington 20036 (202) 293-3860

Incorporated in 1932 in DC.
Donor(s): Sherman F. Mittell.†
Financial data (yr. ended 12/31/87): Assets, $1,082,823 (M); expenditures, $170,311, including $127,500 for 19 grants (high: $25,000; low: $2,000; average: $3,000-$10,000).
Purpose and activities: To assist in the distribution of books, pamphlets, and documents to libraries and to community groups with limited access to sources of specific areas of information; to encourage new techniques in the operation of libraries of printed and audio-visual materials and to aid in the wider dissemination of information by use of these techniques; and to encourage projects involving radio and television and other technological improvements in the transmission of information relating primarily to literary and cultural topics.
Limitations: No grants to individuals, or for building or endowment funds, operating budgets, scholarships, fellowships, or matching gifts; no loans.
Publications: Biennial report (including application guidelines).
Application information:
 Initial approach: Proposal
 Copies of proposal: 1
 Deadline(s): Submit application 3 weeks prior to board meetings
 Board meeting date(s): Mar., June, Sept., and Dec.
 Final notification: 3 months
 Write: Leonard H. Marks, Pres.
Officers and Directors: Leonard H. Marks, Pres.; Charles G. Dobbins, V.P. and Exec. Dir.; Alice B. Popkin, V.P.; Michael R. Gardner, Secy.-Treas.; Meredith A. Brokaw, Bernard M.W. Knox, Ann Bradford Mathias, Lynda J. Robb.
Number of staff: 1 part-time professional.
Employer Identification Number: 526051013

512
The Marjorie Merriweather Post Foundation

P.O. Box 96202
Washington 20090-6202

Established in 1956.
Donor(s): Marjorie Merriweather Post.†
Financial data (yr. ended 12/31/88): Assets, $3,304,229 (L); expenditures, $168,006, including $143,500 for 62 grants (high: $10,000; low: $500).
Purpose and activities: Grants primarily for higher and secondary education, cultural programs, international affairs, religious organizations, and social service and health agencies.
Limitations: No grants to individuals.
Application information:
 Initial approach: Proposal
 Write: Lois J. Shortell, Secy.
Officers and Trustees: John A. Logan, Jr., Chair.; Spottswood P. Dudley, Vice-Chair.; Lois J. Shortell, Secy.; Leonard L. Silverstein, Treas.; Nina Craig, Henry A. Dudley, Jr., George B. Hertzog, Godfrey T. McHugh.
Number of staff: None.
Employer Identification Number: 526054705

513
Marjorie Merriweather Post Foundation of D.C.

4155 Linnean Ave., N.W.
Washington 20008 (202) 686-8500

Established in 1967 in DC.
Donor(s): Marjorie Merriweather Post.†
Financial data (yr. ended 12/31/87): Assets, $66,689,794 (M); expenditures, $3,185,571, including $1,377,500 for 87 grants (average: $5,000-$10,000).
Purpose and activities: The foundation was formed to perpetuate Hillwood Museum; when an excess of funds is available, grants are utilized for other charitable purposes, including social services, education, hospitals and health associations, and cultural programs.
Types of support: Building funds, capital campaigns, conferences and seminars, continuing support, general purposes, special projects, renovation projects, research, loans, matching funds, operating budgets.
Limitations: Giving primarily in VA and DC. No grants to individuals.
Publications: Financial statement, application guidelines.
Application information: One half of funds currently committed for operation of Hillwood Museum.
 Copies of proposal: 1
 Deadline(s): Oct. 1
 Board meeting date(s): Dec. and as required
 Final notification: Spring
 Write: Raymond P. Hunter, Secy.
Officers and Directors: Adelaide C. Riggs, Pres.; E. Brevoort MacNeille, V.P.; Nadeenia H. Robertson, V.P.; Raymond P. Hunter, Secy.-Treas.; Ross Barzelay, Antal de Beckessy, Rodion Cantacuzene, David P. Close, Albert G. Perkins, Stanley Rumbough, Douglas R. Smith, Philip L. Smith.
Number of staff: 1 full-time support.
Employer Identification Number: 526080752

514
Public Welfare Foundation, Inc.

2600 Virginia Ave., N.W., Rm. 505
Washington 20037-1977 (202) 965-1800

Incorporated in 1947 in TX; reincorporated in 1951 in DE.
Donor(s): Charles Edward Marsh,† and others.
Financial data (yr. ended 10/31/88): Assets, $224,480,000 (M); expenditures, $11,615,100, including $10,543,100 for 310 grants (high: $150,000; low: $3,300; average: $34,000).
Purpose and activities: Grants primarily to grass roots organizations in the U.S. and abroad, with emphasis on the environment, population, the elderly, youth underclass, and criminal justice; support also for community services, health, and education. Programs must serve low-income populations, with preference to short-term needs.
Types of support: Matching funds, operating budgets, seed money, special projects.
Limitations: No support for religious purposes. No grants to individuals, or for building funds, capital improvements, endowments, scholarships, graduate work, foreign study, conferences, seminars, publications, films, research, workshops, technical assistance, consulting services, annual campaigns, emergency funds, or deficit financing; no loans.
Publications: Annual report (including application guidelines).
Application information:
 Initial approach: Proposal with summary sheet
 Copies of proposal: 1
 Deadline(s): None
 Board meeting date(s): Mar., June, Sept., and Dec.
 Final notification: 3 months
 Write: C. Glenn Ihrig, Exec. Dir.
Officers and Directors: Donald T. Warner, Chair.; C. Glenn Ihrig,* Pres. and Exec. Dir.; Thomas J. Scanlon,* V.P.; Linda J. Leamon, Secy.; Veronica T. Keating,* Treas.; C. Davis Haines, Antoinette M. Haskell, Robert H. Haskell, Robert R. Nathan, Myrtis H. Powell, Thomas W. Scoville, Murat W. Williams.
Number of staff: 7 full-time professional; 3 full-time support.
Employer Identification Number: 540597601
Recent arts and culture grants:
Arena Stage, DC, $15,000. To expand project which uses improvisational theater techniques to reach at-risk children in public schools. 5/1/88.
Dance Theater of Harlem, NYC, NY, $50,000. For continued support to allow low-income students opportunity to develop in performing arts. 9/1/88.
National Public Radio, DC, $80,000. To expand coverage of AIDS epidemic. 9/1/88.
Teatro Nuestro, San Francisco, CA, $25,000. For 30-city tour of California to provide information about alternative educational programs and pesticide awareness to migrant/seasonal farmworkers through bilingual theater. 9/1/88.
W E T A Greater Washington Educational Television Association, DC, $23,000. For production of discussion guide to accompany film, AIDS: Changing the Rules. 10/31/87.

W N E T Channel 13, NYC, NY, $30,000. For documentary, Who Lives, Who Dies, film which addresses issue of health care rationing and disenfranchisement of poor. 1/15/88.

515
Silverstein Family Foundation
1776 K St. N.W.
Washington 20006-2301

Established in 1965 in DC.
Donor(s): Leonard L. Silverstein.
Financial data (yr. ended 11/30/87): Assets, $545,566 (M); gifts received, $235,475; expenditures, $154,237, including $150,750 for 23 grants (high: $25,000; low: $250).
Purpose and activities: Suport for performing arts, music, and cultural institutions.
Limitations: No grants to individuals.
Application information: Contributes only to pre-selected organizations. Applications not accepted.
Officers and Directors: Elaine W. Silverstein, Pres.; Leonard L. Silverstein, V.P.; Morris B. Hariton, Secy.-Treas.
Employer Identification Number: 520845731

516
David S. Stone Foundation, Inc.
1140 Connecticut Ave. N.W., Suite 703
Washington 20036 (202) 785-1111

Established in 1978 in DC.
Financial data (yr. ended 12/31/87): Assets, $2,247,761 (M); expenditures, $218,428, including $195,000 for 6 grants (high: $50,000; low: $5,000).
Purpose and activities: Giving primarily for education, the arts, and Jewish organizations, including community centers and group homes.
Limitations: Giving primarily in Washinton, DC, Toledo, OH, and Boca Raton, FL.
Application information: Application form required.
Initial approach: Letter
Copies of proposal: 4
Deadline(s): None
Board meeting date(s): Varies
Write: Shelton Binstock, Pres.
Officers and Directors: Shelton M. Binstock, Pres.; Irving Adler, V.P.; David A. Katz, V.P.; Ralph Cohen, Secy.-Treas.
Number of staff: None.
Employer Identification Number: 521120708

517
Hattie M. Strong Foundation
Cafritz Bldg., Suite 409
1625 I St., N.W.
Washington 20006 (202) 331-1619

Incorporated in 1928 in DC.
Donor(s): Hattie M. Strong.†
Financial data (yr. ended 8/31/88): Assets, $14,940,965 (M); gifts received, $1,795; expenditures, $810,511, including $270,735 for 39 grants (high: $32,000; low: $1,000; average: $5,000-$10,000) and $500,900 for 232 loans to individuals.

Purpose and activities: Non-interest-bearing loans to students who are within one year of their degree in college or graduate school and to students from the metropolitan Washington, DC, area who are enrolled in vocational schools in the Washington area. Maximum loan to vocational school applicants is $2,000; maximum loan to college students is $2,500. Grants program focused primarily on educational programs for the disadvantaged.
Types of support: Student loans.
Limitations: Giving primarily in the Washington, DC, area. No grants to individuals (except for loans), or for building or endowment funds, research, scholarships, or fellowships.
Publications: Annual report.
Application information: Application form required for students.
Initial approach: Letter or telephone
Copies of proposal: 1
Deadline(s): Feb. 1, May. 1, Aug. 1, and Nov. 1 for organizations; Mar. 31 for student aid
Board meeting date(s): Mar., June, Sept., and Dec.
Final notification: Within 1 week
Write: Thelma L. Eichman, Secy.
Officers: Henry Strong,* Chair. and Pres.; Trowbridge Strong, V.P.; Thelma L. Eichman, Secy.; Barbara B. Cantrell, Treas.
Directors: Olive W. Covington, Charles H. Fleischer, Richard S.T. Marsh, John A. Nevius, Vincent E. Reed, C. Peter Strong, Trowbridge Strong, Bennetta B. Washington.
Number of staff: 2 full-time professional; 3 full-time support; 1 part-time support.
Employer Identification Number: 530237223
Recent arts and culture grants:
Ellington Fund, DC, $5,000. To upgrade library at Duke Ellington High School of the Arts. 1987.
Folger Shakespeare Library, DC, $5,000. For workshops for junior high teachers providing new approaches to teaching and learning Shakespeare. 1987.
Washington Performing Arts Society, DC, $5,000. For workshops in public schools enabling students to have better understanding of music and dance. 1987.

518
The Community Foundation of Greater Washington, Inc.
1002 Wisconsin Ave., N.W.
Washington 20007 (202) 338-8993

Community Foundation incorporated in 1973 in DC.
Financial data (yr. ended 12/31/87): Assets, $9,253,063 (M); gifts received, $5,846,589; expenditures, $3,811,307, including $1,915,918 for 200 grants (high: $140,850; low: $100; average: $1,000-$10,000), $1,173,457 for 6 foundation-administered programs and $62,000 for loans.
Purpose and activities: Through its programs and unrestricted funds, the foundation works to establish new coalitions for delivery of public services, develop public-private partnerships of shared resources to meet public needs, catalyze efforts leading to social change, and promote self-help grassroot efforts and increase

use of volunteers. Areas of interest include health care for the homeless, substance abuse, community development, newcomers, and youth in philanthropy.
Types of support: Seed money, emergency funds, technical assistance, program-related investments, loans, special projects, research, publications, conferences and seminars.
Limitations: Giving limited to the metropolitan Washington, DC, area. No support for religious purposes. No grants to individuals, or for annual campaigns, endowment funds, continuing support, equipment, land acquisition, renovation projects, scholarships, fellowships, operating budgets, or matching gifts.
Publications: Annual report (including application guidelines), informational brochure.
Application information:
Initial approach: Letter
Copies of proposal: 1
Deadline(s): May and Oct.
Board meeting date(s): Mar., June, and Nov.
Final notification: Up to 6 months
Write: Deborah S. McKown, Dir. of Finance
Officers and Directors: Richard Snowdon, Chair.; John W. Hechinger, Jr., Vice-Chair.; Jack Pollock, Vice-Chair.; Lawrence S. Stinchcomb, Pres.; Jim Adler, Treas.; Stephen J. Slade, Secy.; and 22 additional directors.
Number of staff: 7 full-time professional; 4 full-time support.
Employer Identification Number: 237343119
Recent arts and culture grants:
Arena Stage, DC, $20,000. 1987.
Arena Stage, DC, $8,000. 1987.
Capital Childrens Museum, DC, $20,000. 1987.
Fire Museum of Maryland, Lutherville, MD, $50,000. 1987.
Folger Shakespeare Theater, DC, $5,000. 1987.
International Red Cross Museum, Geneva, Switzerland, $61,140. 1987.
National Archives, DC, $5,000. 1987.
National Faculty of Humanities, Arts and Sciences, Parker, SC, $12,500. 1987.
National Symphony Orchestra, DC, $15,000. 1987.
National Symphony Orchestra, DC, $5,000. 1987.
Washington Project for the Arts (WPA), DC, $5,000. 1987.
Washington Project for the Arts (WPA), DC, $5,000. 1987.
Young Audiences, DC, $5,000. 1987.

519
Washington Bancorporation Foundation
The National Bank of Washington
4340 Connecticut Ave., N.W.
Washington 20008 (202) 364-6938

Financial data (yr. ended 12/31/87): Assets, $3,753 (M); gifts received, $89,792; expenditures, $87,662, including $82,220 for 25 grants (high: $5,000; low: $500).
Purpose and activities: Emphasis is on programs benefiting the local community through cultural, civic, educational, and welfare programs in the Washington, DC community.
Types of support: Technical assistance, matching funds, general purposes, operating budgets, capital campaigns.

Limitations: Giving limited to the Washington, DC, metropolitan area.
Application information:
Initial approach: Letter
Deadline(s): None
Write: Patricia N. Matthews, Pres.
Officers: Patricia Matthews, Pres.; William D. Wooten, Secy.; Phyllis Willey, Treas.
Directors: Luther H. Hodges, Jr., Philipp J. Walter, Jr., William White.
Employer Identification Number: 521485726

520
The Washington Post Company Giving Program
1150 15th St., N.W.
Washington 20071 (202) 334-6640

Purpose and activities: Supports civic and public concerns, educational institutions and programs, community services, public policy, welfare, cultural institutes, arts, and national and international journalism. Provides in-kind donations of goods and services.
Types of support: Employee matching gifts, matching funds, general purposes, operating budgets, annual campaigns, special projects, building funds, capital campaigns, in-kind gifts.
Limitations: Giving primarily in Hartford, CT; Washington, DC; Jacksonville, FL; Detroit, MI; New York, NY; and Everett, WA.
Application information: Narrative/letter, budget proposal, 501(c)(3), audited financial statement, board member list and major donor list.
Initial approach: Initial contact by letter
Deadline(s): Applications accepted throughout the year
Final notification: 8 weeks after submission of complete application
Write: Mary M. Bellor, Corp. Affairs Mgr.
Number of staff: 1 part-time professional; 1 part-time support.

521
Weir Foundation Trust
c/o American Security and Trust Co.
730 15th St., N.W.
Washington 20013

Trust established in 1953 in DC.
Donor(s): Davis Weir.†
Financial data (yr. ended 12/31/87): Assets, $2,100,000 (M); expenditures, $90,000, including $87,000 for 65 grants (high: $10,000; low: $500; average: $1,000-$2,000).
Purpose and activities: Giving for higher education, arts and cultural programs, Protestant church support, and social services.
Types of support: Annual campaigns, building funds, capital campaigns, continuing support, endowment funds, equipment, general purposes, operating budgets, renovation projects, special projects.
Limitations: Giving primarily in DC, MD, and VA. No grants to individuals.
Publications: 990-PF.
Application information: Applications not accepted.
Write: Charles D. Weir, Trustee
Trustee: Charles D. Weir.
Employer Identification Number: 526029328

522
The Westport Fund
1815 Randolph St., N.W.
Washington 20011

Established in 1943.
Donor(s): Milton McGreevy,† and others.
Financial data (yr. ended 12/31/87): Assets, $2,512,789 (M); expenditures, $171,055, including $148,650 for 82 grants (high: $25,500; low: $100).
Purpose and activities: Giving primarily to cultural organizations, social services, and education, especially higher education.
Types of support: Annual campaigns, building funds, capital campaigns, continuing support, endowment funds, equipment, general purposes, lectureships, operating budgets, publications, research, scholarship funds.
Limitations: Giving primarily in Kansas City, MO. No grants to individuals, or for consulting services, deficit financing, exchange programs, internships, matching funds, land acquisition, renovation projects, seed money, or technical assistance; no loans.
Application information: Applications not accepted.
Officers: Gail McGreevy Harmon, Pres.; Jean McGreevy Green, V.P. and Secy.; Thomas J. McGreevy, V.P.; Ann McGreevy Heller, Treas.
Director: Barbara James McGreevy.
Number of staff: None.
Employer Identification Number: 446007971

523
Abe Wouk Foundation, Inc.
3255 N St., N.W.
Washington 20007

Established in 1954.
Donor(s): Betty Sarah Wouk, Herman Wouk.
Financial data (yr. ended 12/31/87): Assets, $1,168,416 (M); gifts received, $2,895; expenditures, $153,196, including $148,550 for 69 grants (high: $15,000; low: $100).
Purpose and activities: Grants primarily for higher education, the arts, conservation, and Jewish welfare funds and temple support.
Limitations: Giving primarily in CA, NY, and DC.
Application information:
Deadline(s): None
Write: Herman Wouk, Pres.
Officers: Herman Wouk,* Pres.; Joseph Wouk, V.P.; Nathaniel Wouk, V.P.; Suzanne Stein, Secy.; Betty Sarah Wouk,* Treas.
Trustees:* Charles Rembar.
Employer Identification Number: 136155699

524
Martin Andersen and Gracia Andersen Foundation, Inc.
1717 Edgewater Dr.
Orlando 32804

Established in 1953 in FL.
Financial data (yr. ended 10/31/88): Assets, $1,213,493 (M); expenditures, $23,142, including $11,100 for 27 grants (high: $1,000; low: $25).
Purpose and activities: Grants for health services, education, culture, social services, youth programs, and religious support.
Officers: Gracia B. Andersen, Pres.; Graham Barr, V.P.; A.S. Johnson, Secy.-Treas.
Directors: Robert van Roijen, Richard F. Trismen.
Employer Identification Number: 596166589

525
Arison Foundation, Inc.
3915 Biscayne Blvd., 4th Fl.
Miami 33137-3720

Incorporated in 1981 in FL.
Donor(s): Carnival Cruise Lines, Inc., Festivale Maritime, Inc., Intercon Overseas, Inc.
Financial data (yr. ended 6/30/87): Assets, $4,394 (M); gifts received, $1,358,000; expenditures, $1,357,688, including $1,357,594 for 45 grants (high: $589,444; low: $100; average: $100-$10,000).
Purpose and activities: Emphasis on arts and cultural programs; support also for Jewish welfare funds.
Limitations: Giving primarily in FL.
Officers: Shari Arison, Pres.; Robert B. Sturges, V.P.
Trustee: Marilyn Arison.
Employer Identification Number: 592128429

526
Barnett Charities, Inc.
100 Laura St.
Jacksonville 32202 (904) 791-5407
Mailing address: P.O. Box 40789, Jacksonville, FL 32203-5407

Established in 1983 in FL as Barnett Foundation, Inc.; re-incorporated with current name in 1987.
Donor(s): Barnett Banks Trust Co., N.A.
Financial data (yr. ended 12/31/88): Assets, $286,705 (M); gifts received, $625,307; expenditures, $644,500, including $644,500 for 10 grants (high: $200,000; low: $5,000).
Purpose and activities: Support for culture and the arts, education, fitness, and health and human services.
Types of support: Consulting services, endowment funds, scholarship funds.
Limitations: Giving limited to FL and GA.
Publications: Annual report, grants list.

Application information: Programs which have statewide impact or are beyond the scope of the local banks' markets are submitted to Barnett Charities by the local Barnett Banks. Application form required.

Initial approach: Letter or telephone
Copies of proposal: 1
Deadline(s): None
Board meeting date(s): Weekly on Monday
Final notification: Within 2 weeks of meeting
Write: Beth A. Bollinger, Admin.

Officers: Allen L. Lastinger, Pres.; Jeffrey K. Graf, Secy.

Trustees:* Albert D. Ernest, Earl B. Hadlow, Stephen A. Hansel, Hinton Nobles, Charles E. Rice.

Employer Identification Number: 592761362

527

Cordelia Lee Beattie Foundation Trust
P.O. Box 267
Sarasota 34230 (813) 951-7242

Trust established in 1975 in FL.
Donor(s): Cordelia Lee Beattie.†
Financial data (yr. ended 10/31/88): Assets, $1,860,799 (M); expenditures, $96,370, including $89,891 for 14 grants (high: $26,750; low: $1,400).
Purpose and activities: Giving for the arts, with emphasis on music.
Types of support: Building funds, equipment, land acquisition, matching funds, scholarship funds, publications.
Limitations: Giving limited to Sarasota County, FL. No grants to individuals, or for general support, endowment funds, special projects, research, or conferences; no loans.
Publications: Application guidelines.
Application information:

Initial approach: Letter
Copies of proposal: 3
Deadline(s): Submit proposal from Aug. through Jan.
Board meeting date(s): Quarterly
Final notification: 4 to 6 months
Write: Robert E. Perkins, Admin. Agent

Trustees: Mrs. Deane Carroll Allyn, Eric Bjorlund, Robert A. Kimbrough, Southeast Bank, N.A.
Number of staff: 1 part-time professional.
Employer Identification Number: 596540711

528

The Frank Stanley Beveridge Foundation, Inc.
1515 Ringling Blvd., Suite 340
P.O. Box 4097
Sarasota 34230-4097 (813) 955-7575

Trust established in 1947 in MA; incorporated in 1956.
Donor(s): Frank Stanley Beveridge.†
Financial data (yr. ended 12/31/87): Assets, $30,852,632 (M); expenditures, $2,782,232, including $2,470,571 for 91 grants (high: $900,000; low: $250; average: $1,000-$30,000).
Purpose and activities: A portion of the income designated for maintenance of a local park established by the donor in Westfield, MA; the balance for general local giving, with emphasis on higher and secondary education, social service and youth agencies, community development, culture, and health.
Types of support: Capital campaigns, seed money, general purposes, equipment, building funds, land acquisition, renovation projects, scholarship funds, matching funds, endowment funds, continuing support, special projects, technical assistance.
Limitations: Giving primarily in Western MA, and Hillsborough and Sarasota counties in FL. No support for tax-supported organizations. No grants to individuals, or for operating funds, scholarships or fellowships; no loans.
Publications: Informational brochure (including application guidelines), application guidelines.
Application information: Application form required.

Initial approach: Letter
Copies of proposal: 2
Deadline(s): None
Board meeting date(s): Feb., June, and Oct.
Final notification: 2 weeks after meeting date
Write: Philip Caswell, Pres.

Officers: Philip Caswell,* Pres.; David F. Woods,* Secy.; Carole S. Lenhart, Treas.
Directors:* John Beveridge Caswell, Pamela Everets, John G. Gallup, Joseph Beveridge Palmer, Homer G. Perkins, Evelyn Beveridge Russell, J. Thomas Touchton.
Number of staff: 1 full-time professional; 1 part-time professional; 2 part-time support.
Employer Identification Number: 046032164

529

Broward Community Foundation, Inc.
2601 East Oakland Park Blvd., Suite 202
Fort Lauderdale 33306 (305) 563-4483

Incorporated in 1984 in FL.
Financial data (yr. ended 6/30/88): Assets, $995,578 (M); gifts received, $444,117; expenditures, $169,338, including $146,891 for 42 grants (high: $12,500; low: $100).
Purpose and activities: Support for social services, the arts, education, health organizations and the environment.
Types of support: Equipment, matching funds, seed money.
Limitations: Giving primarily in Broward County, FL. No grants to individuals; no support for annual campaigns, building funds, consulting services, continuing support, deficit financing, employee matching gifts, emergency funds, land acquisition, operating budgets; no loans.
Publications: Annual report, newsletter, informational brochure (including application guidelines).
Application information:

Initial approach: Letter
Copies of proposal: 1
Deadline(s): Sept.
Board meeting date(s): Nov.
Final notification: Nov.
Write: Elizabeth C. Deinhardt, Exec. Dir.

Officers and Directors: Walter E. Howard, Pres.; Thomas P. O'Donnell, V.P.; Marsha O. Levy, Secy.; John B. Deinhardt, Treas.; Elizabeth C. Deinhardt, Exec. Dir.; James J. Blosser, Leonard L. Farber, William Gundlach, Stewart R. Kester, Sr., Leonard Robbins, George E. Sullivan.
Number of staff: 1 full-time professional; 1 part-time support.
Employer Identification Number: 592477112

530

Edyth Bush Charitable Foundation, Inc.
199 East Welbourne Ave.
P.O. Box 1967
Winter Park 32790-1967 (407) 647-4322

Originally incorporated in 1966 in MN; reincorporated in 1973 in FL.
Donor(s): Edyth Bush.†
Financial data (yr. ended 8/31/88): Assets, $45,548,432 (M); expenditures, $3,350,676, including $2,345,162 for 54 grants (high: $200,000; low: $3,500; average: $20,000-$75,000), $214,436 for 2 foundation-administered programs and $1,261,099 for loans.
Purpose and activities: Support for charitable, educational, and health service organizations, with emphasis on human services and health; higher education; the elderly; youth services; the handicapped; and demonstrated nationally-recognized quality arts or cultural programs. Provides limited number of program-related investment loans for construction, land purchase, emergency or similar purposes to organizations otherwise qualified to receive grants. Active programs directly managed and/or financed for able learner education, and for management/volunteer development of nonprofits.
Types of support: Seed money, emergency funds, building funds, equipment, land acquisition, loans, conferences and seminars, matching funds, consulting services, technical assistance, program-related investments, renovation projects, capital campaigns, continuing support.
Limitations: Giving primarily within a 100-mile radius of Winter Park, FL; also AZ and CA if supported by one or more family member directors (normally less than 10% of grants). No support for alcohol or drug abuse projects or organizations, church, denominational, sacramental, or religious facilities or functions; primarily (50% or more) tax-supported institutions; advocacy organizations; foreign organizations; or generally for cultural programs. No grants to individuals, or for scholarships or individual research projects, endowments, fellowships, travel, routine operating expenses, annual campaigns (unless for local United Way), or deficit financing.
Publications: 990-PF, program policy statement, application guidelines, financial statement, grants list, 990-PF (including application guidelines).
Application information: Outline required for applications; see Policy Statement before applying.

Initial approach: Telephone, letter of inquiry, or proposal
Copies of proposal: 2
Deadline(s): Sept. 1 or Jan. 1; May 30 if funds are available for a July meeting
Board meeting date(s): Usually in Oct., Mar., July, and as required

Final notification: 2 weeks after board
 meetings
 Write: H. Clifford Lee, Pres.
Officers: Charlotte H. Forward,* Chair.;
Frances M. Woodard,* Vice-Chair.; H. Clifford
Lee,* Pres. and C.E.O.; Herbert W. Holm,*
V.P.-Finance and Treas.; David R. Roberts,* Sr.
V.P.; Alice J. Rettig, Corp. Secy.; Harold A.
Ward III,* General Counsel; Betty Condon,
Controller.
Directors:* Mary Gretchen Belloff, Guy
D. Colado, Hugh F. McKean, Jerrold S.
Trumbower, Milton P. Woodard.
Number of staff: 1 full-time professional; 3
part-time professional; 4 full-time support.
Employer Identification Number: 237318041

531
CenTrust Foundation
101 East Flagler St.
Miami 33131

Financial data (yr. ended 4/30/88): Assets,
$1,888 (M); gifts received, $544,000;
expenditures, $576,127, including $576,000
for 32 grants (high: $51,500; low: $500).
Purpose and activities: Support for higher
education, civic affairs, and the arts.
Application information: Applications not
accepted.
Trustees: Angel Cortina, Jr., Catherine H.
Fahringer, Richard H. Judy, Peter K. Moser,
David L. Paul.
Employer Identification Number: 592693270

532
Robert Lee Chastain and Thomas M.
Chastain Charitable Foundation
c/o First Union National Bank of Florida
Drawer G, P.O. Box 190
West Palm Beach 33402

Trust established in 1966 in FL.
Donor(s): Robert Lee Chastain.†
Financial data (yr. ended 12/31/86): Assets,
$2,869,697 (M); expenditures, $165,438,
including $148,500 for 7 grants (high:
$125,000; low: $1,000).
Purpose and activities: Grants policy confined
to community and publicly-managed agencies
with emphasis given to public higher education,
programs in the humanities and sciences, and
environmental resource management projects
offering benefits to the general population. A
few trustee-initiated contributions may exceed
these limits.
Limitations: Giving primarily in the Palm
Beach and Martin County, FL, area. No
support for church-related groups or national
charities. No grants to individuals, or for
building or endowment funds or appeals in
mass circulation.
Application information:
 Initial approach: Proposal with cover letter
 Copies of proposal: 2
 Board meeting date(s): Quarterly
 Write: Thomas M. Chastain, Trustee
Trustees: Thomas M. Chastain, Harry Johnston
II, First Union National Bank of Florida.
Employer Identification Number: 596171294

533
The Francis and Miranda Childress
Foundation, Inc.
218 West Adams St., Suite 201
Jacksonville 32202

Established in 1963 in FL.
Donor(s): Francis B. Childress.†
Financial data (yr. ended 12/31/86): Assets,
$2,554,213 (M); gifts received, $7,160;
expenditures, $225,666, including $197,000
for 19 grants (high: $50,000; low: $1,000).
Purpose and activities: Emphasis on higher
and secondary education, Protestant church
support, youth agencies, cultural programs, and
hospitals.
Limitations: Giving primarily in FL.
Officers and Trustees:* Miranda Y.
Childress,* Pres.; Francis Childress Lee,* V.P.;
Augusta L. Owens, Secy.; Lewis S. Lee,* Treas.
Employer Identification Number: 591051733

534
The Raymond E. and Ellen F. Crane
Foundation
P.O. Box 25427
Tamarac 33320

Trust established in 1949 in PA.
Donor(s): Raymond E. Crane,† Ellen F. Crane.†
Financial data (yr. ended 12/31/87): Assets,
$3,083,848 (M); expenditures, $184,780,
including $155,000 for 71 grants (high: $5,000;
low: $500).
Purpose and activities: Giving for higher
education and community funds; grants also for
cultural programs, secondary education, health,
and Protestant church support.
Limitations: Giving primarily in the
southeastern states.
Application information: Contributes only to
pre-selected organizations. Applications not
accepted.
Officer and Trustees: George A. Owen, Mgr.;
Alpo F. Crane, David J. Crane, Jr., Robert F.
Crane, Jr., S.R. Crane.
Employer Identification Number: 596139265

535
Dade Community Foundation
(Formerly Dade Foundation)
200 South Biscayne Blvd., Suite 4970
Miami 33131-2343 (305) 371-2711

Community foundation established in 1967 in
FL.
Financial data (yr. ended 12/31/87): Assets,
$11,171,533 (M); gifts received, $3,532,447;
expenditures, $1,551,311, including
$1,086,490 for 211 grants (high: $103,000;
low: $45).
Purpose and activities: Support for projects
which provide an innovative response to a
recognized community need but which do not
duplicate other efforts; help an organization
build internal stability; promise to affect a
broad segment of the residents of Dade
County; and exert a leverage or multiplier
effect in addressing community problems to be
solved. Areas of support include health, social
services, civic affairs, education, and arts and
culture.

Types of support: Building funds, equipment,
land acquisition, seed money, emergency
funds, research, general purposes, matching
funds, publications, scholarship funds, special
projects, technical assistance.
Limitations: Giving limited to Dade County,
FL. No grants to individuals, or for continuing
support, scholarships, fellowships, or
conferences.
Publications: Annual report, application
guidelines, informational brochure (including
application guidelines), newsletter.
Application information:
 Initial approach: Letter
 Copies of proposal: 1
 Deadline(s): Submit proposal preferably in
 Nov.; deadline Dec. 1
 Board meeting date(s): Feb., May, Sept., and
 Nov.
 Final notification: 1st quarter of the year
 Write: Ruth Shack, Pres.
Officers: Ruth Shack, Pres.; Frank Scruggs,*
Secy.; John Porta,* Treas.
Governors:* Sherrill Hudson, Chair.; James A.
Batten, Vice-Chair.; and 17 other governors.
Trustee Banks: Barnett Banks Trust Co., N.A.,
Bessemer Trust Co. of Florida, Florida National
Bank of Miami, NCNB National Bank of
Florida, Northern Trust Bank of Florida,
Southeast Bank, N.A., SunBank Miami, N.A.,
Trust Company of the South.
Number of staff: 1 full-time professional; 1 full-
time support; 1 part-time support.
Employer Identification Number: 596183655
Recent arts and culture grants:
Bakehouse Art Complex, Miami, FL, $5,000.
 1987.
Center for the Fine Arts, Miami, FL, $32,500.
 1987.
Coconut Grove Playhouse, Miami, FL, $5,000.
 1987.
Fairchild Tropical Garden, Miami, FL, $25,000.
 1987.
Greater Miami Opera Association, Miami, FL,
 $22,500. 1987.
Inner City Touring Dance Company, Liberty
 City, FL, $5,000. 1987.
Miami City Ballet, Miami, FL, $11,000. 1987.
Museum of Modern Art, International Council,
 NYC, NY, $5,000. 1987.
Palm Beach Festival, West Palm Beach, FL,
 $5,000. 1987.
W L R N, Friends of, Miami, FL, $5,712. 1987.

536
The Leonard and Sophie Davis
Foundation, Inc.
601 Clearwater Park Rd.
West Palm Beach 33401

Incorporated in 1961 in NY.
Donor(s): Leonard Davis, Sophie Davis.
Financial data (yr. ended 12/31/86): Assets,
$17,033,572 (M); gifts received, $2,681,583;
expenditures, $2,043,686, including
$1,956,500 for 78 grants (high: $400,000; low:
$50; average: $1,000-$25,000).
Purpose and activities: Grants primarily for
Jewish charitable, religious, and educational
organizations, and for higher education;
support also for the arts, community services,
and health agencies and hospitals; limited
giving to public interest groups.

Limitations: Giving primarily in Palm Beach County, FL, and New York, NY. No grants to individuals.
Application information:
Deadline(s): None
Board meeting date(s): As required
Final notification: Varies
Write: Marilyn Hoadley, Pres.
Officers: Marilyn Hoadley, Pres.; Sophie Davis, V.P. and Secy.; Leonard Davis, V.P.
Number of staff: None.
Employer Identification Number: 136062579

537
The Arthur Vining Davis Foundations
645 Riverside Ave., Suite 520
Jacksonville 32204 (904) 359-0670

Three trusts established: in 1952 and 1965 in PA; in 1965 in FL.
Donor(s): Arthur Vining Davis.†
Financial data (yr. ended 12/31/88): Assets, $98,365,000 (M); expenditures, $5,027,000, including $4,626,000 for 64 grants (high: $500,000; low: $1,000; average: $75,000-$125,000).
Purpose and activities: Support largely for private higher education, hospices, medicine, public television, and graduate theological education.
Types of support: Building funds, continuing support, endowment funds, equipment, fellowships, internships, land acquisition, matching funds, professorships, research, scholarship funds, capital campaigns, general purposes, lectureships, operating budgets, publications, renovation projects, special projects, technical assistance.
Limitations: Giving primarily in U.S. and its possessions and territories. No support for community chests, institutions primarily supported by government funds, and projects incurring obligations extending over many years. No grants to individuals; no loans.
Publications: Annual report, informational brochure.
Application information:
Initial approach: Letter
Copies of proposal: 1
Deadline(s): None
Board meeting date(s): Spring, fall, and winter
Final notification: 10 to 15 months for approvals; 8 months for rejections
Write: Max Morris, Exec. Dir.
Officer: Max Morris, Exec. Dir.
Trustees: Nathanael V. Davis, Chair.; Holbrook R. Davis, J.H. Dow Davis, Joel P. Davis, Atwood Dunwody, Rev. Davis Given, Dorothy Davis Kee, Mrs. John L. Kee, Jr., W.R. Wright, Mellon Bank, N.A., Southeast Bank of Miami.
Number of staff: 2 full-time professional; 4 part-time professional; 3 full-time support.
Employer Identification Number: 256018909
Recent arts and culture grants:
College of Wooster, Wooster, OH, $75,000. To help equip new music center. 10/23/87.
Fairfield University, Fairfield, CT, $75,000. To help equip new performing and visual arts center. 9/23/88.
Hampden-Sydney College, Hampden-Sydney, VA, $100,000. To help modernize historic classroom building. 10/23/87.

Marquette University, Milwaukee, WI, $75,000. To improve humanities teaching resources. 9/23/88.
Muhlenberg College, Allentown, PA, $75,000. To help fund modernization of historic campus building. 10/23/87.
W E T A Greater Washington Educational Television Association, DC, $350,000. To provide final production funding for five-episode educational television series entitled The Civil War. 10/23/87.
W G B H Educational Foundation, Boston, MA, $275,000. For final production of series entitled Columbus and the Age of Discovery. 5/20/88.
W G B H Educational Foundation, Boston, MA, $250,000. For final production funding for, Long Ago and Far Away, major children's series for national viewing on public television. 2/5/88.
W G B H Educational Foundation, Florentine Films, Boston, MA, $30,000. To fund completion of first film of series on American wilderness areas. 9/23/88.

538
George Delacorte Fund
11556 Turtle Beach Rd.
North Palm Beach 33408

Established about 1977 in NY.
Donor(s): George T. Delacorte, Jr., and others.
Financial data (yr. ended 12/31/87): Assets, $4,548,090 (M); gifts received, $794,103; expenditures, $670,913, including $575,850 for 38 grants (high: $550,000; low: $50) and $54,561 for foundation-administered programs.
Purpose and activities: Grants for cultural programs, youth, religious organizations, education, and health; program support annually to maintain and build public monuments in New York City.
Limitations: Giving primarily in FL and the New York City, NY, area.
Application information: Contributes only to pre-selected organizations. Applications not accepted.
Officers: George T. Delacorte, Jr., Pres.; Valerie Delacorte, V.P. and Treas.; Albert P. Delacorte, Secy.
Employer Identification Number: 510202382

539
Elizabeth Ordway Dunn Foundation, Inc.
P.O. Box 016309
Miami 33101-6309 (305) 374-0100
Application address: c/o Ann Fowler Wallace, Grants Management Associates, 100 Franklin St., Boston, MA 02110; Tel.: (617) 357-1500; c/o Becky Roper Matkov, 11320 Southwest 74th Court, Miami, FL 33156; Tel.: (305) 253-2713

Incorporated in 1983 in FL.
Donor(s): Elizabeth Ordway Dunn Charitable Lead Trust.
Financial data (yr. ended 12/31/87): Assets, $837,229 (M); gifts received, $661,772; expenditures, $634,212, including $561,200 for 20 grants (high: $75,000; low: $4,000).

Purpose and activities: Giving for conservation and environmental concerns; some support for historic preservation.
Types of support: Special projects.
Limitations: Giving primarily in FL. No support for sectarian religious activities. No grants to individuals, or for capital purposes, operating budgets, endowments, or deficit financing.
Publications: Informational brochure (including application guidelines), multi-year report.
Application information: Applicants are urged to submit concept papers to either of the application addresses; if the paper is reviewed favorably, a full proposal will be requested.
Initial approach: Proposal
Copies of proposal: 3
Deadline(s): Mar. 15 and Sept. 15
Board meeting date(s): May and Nov.
Write: Ann Fowler Wallace or Becky Roper Matkov
Officers and Directors: Robert W. Jensen, Pres.; Lynn F. Lummus, V.P. and Secy.; E. Rodman Titcomb, Jr., V.P. and Treas.
Number of staff: 2 part-time professional; 1 part-time support.
Employer Identification Number: 592393843

540
The Dunspaugh-Dalton Foundation, Inc.
9040 Sunset Dr., Suite 30
Miami 33173 (305) 596-6951

Incorporated in 1963 in FL.
Donor(s): Ann V. Dalton.†
Financial data (yr. ended 12/31/87): Assets, $21,751,033 (M); expenditures, $1,131,733, including $749,200 for 82 grants (high: $50,000; low: $300; average: $5,000-$20,000).
Purpose and activities: Grants largely for education, particularly higher education; social service and youth agencies; health organizations and hospitals; cultural programs; and civic groups.
Types of support: General purposes.
Limitations: Giving primarily in Dade County, FL, and Monterey, CA; some giving also in NC. No grants to individuals; no loans.
Publications: 990-PF.
Application information:
Initial approach: Letter
Copies of proposal: 1
Deadline(s): None
Board meeting date(s): Monthly
Write: William A. Lane, Jr., Pres.
Officers and Trustees: William A. Lane, Jr., Pres.; Sarah L. Bonner, V.P.; Thomas H. Wakefield, Secy.-Treas.
Number of staff: 3 part-time professional; 2 part-time support.
Employer Identification Number: 591055300

541
Jessie Ball duPont Religious, Charitable and Educational Fund
Florida National Bank Tower
225 Water St., Suite 1200
Jacksonville 32202-4424 (904) 353-0890

Trust established in 1976 in FL.
Donor(s): Jessie Ball duPont.†

Financial data (yr. ended 10/31/88): Assets, $122,283,073 (M); expenditures, $6,194,459, including $4,913,928 for 77 grants (high: $307,461; low: $1,000; average: $5,000-$100,000) and $535,000 for 7 loans.

Purpose and activities: Grants limited to those institutions to which the donor contributed personally during the five-year period ending December 31, 1964. Among the 350 institutions eligible to receive funds are higher and secondary education institutions, cultural and historic preservation programs, social service organizations, hospitals, health agencies, churches and church-related organizations, and youth agencies.

Types of support: Seed money, equipment, special projects, research, publications, professorships, scholarship funds, exchange programs, matching funds, general purposes, endowment funds, internships, technical assistance.

Limitations: Giving primarily in the South, especially FL, DE, and VA. No support for organizations other than those awarded gifts by the donor from 1960-1964. No grants to individuals, or, generally, for capital campaigns.

Publications: Annual report, application guidelines, informational brochure, grants list.

Application information: Applicant must submit proof with initial application that a contribution was received from the donor between 1960 and 1964. Application form required.

Initial approach: Brief proposal
Copies of proposal: 1
Deadline(s): None
Board meeting date(s): Bimonthly beginning in Jan.
Final notification: Approximately 3 to 4 months
Write: George Penick, Exec. Dir.

Officers: George Penick, Exec. Dir.; Jo Ann P. Bennett, Exec. Secy.; Ronald V. Gallo, Prog. Officer.

Trustees:* George C. Bedell, Jean W. Ludlow, Mary K. Phillips, Florida National Bank.

Number of staff: 2 full-time professional; 2 full-time support.

Employer Identification Number: 596368632

Recent arts and culture grants:

American School of Classical Studies at Athens, NYC, NY, $12,000. For institutional memberships in southern colleges and universities. The American School provides professional network in this country and opportunity for research and archeological exploration abroad to scholars of classical Greek history, art and literature. 1987.

Association for the Preservation of Virginia Antiquities, Richmond, VA, $51,000. For the development of a computerized management system of the extensive collections of period furniture to improve the educational and interpretive programs at two of the sites, the Mary Ball Washington House and the Rising Sun Tavern. 1987.

Bethune-Cookman College, Facility Development Endowment Program, Daytona Beach, FL, $250,000. To partially match Mellon Foundation grant for humanities endowment fund that includes professional development opportunities and campus seminars. 1987.

Delaware Symphony Association, Wilmington, DE, $50,000. For Portugal Tour. 1987.

General Douglas MacArthur Foundation, Norfolk, VA, $39,244. For preservation of the papers of General MacArthur. 1987.

Longwood College, Farmville, VA, $243,570. For Virginia Writing Program for high school students and teachers from throughout Virginia, grant provides phased-down support for writer-in-residence and matching endowment to ensure continuation program. 1987.

Northern Neck of Virginia Historical Society, Montross, VA, $50,000. For Justice Joseph W. Chinn Community Center. 1987.

Northern Neck of Virginia Historical Society, Montross, VA, $10,000. For Jessie Ball duPont Fellowships. 1987.

Randolph-Macon College, Ashland, VA, $108,000. For Peer Response Educational Preparation (PREP) Program, to prepare college freshmen to better express themselves through writing and class discussion, and to decrease the first-year drop-out rate. 1987.

Robert E. Lee Memorial Association, Stratford, VA, $85,000. For Stratford-Monticello Seminar Fellows Program. 1987.

Rollins College, Winter Park, FL, $25,000. For Ethics of Change Seminar in which national panel will explore the tensions between the arts and humanities and the challenge of technology in a 1988 seminar. 1987.

University of Florida, Gainesville, FL, $5,936. For grant shared with newly-formed Marjorie Kinnan Rawlings Society to sponsor jointly conference on the fifieth anniversary of the publication of Pulitzer Prize-winning The Yearling. 1987.

542

Jack Eckerd Corporation Foundation

P.O. Box 4689
Clearwater 34618 (813) 397-7461

Established in 1973 in FL.

Donor(s): Jack Eckerd Corp.

Financial data (yr. ended 7/30/88): Assets, $1,246,305 (M); expenditures, $577,219, including $528,281 for 348 grants (high: $10,000; low: $250) and $43,944 for 210 employee matching gifts.

Purpose and activities: Support for higher education, including pharmacy scholarships, health organizations, hospitals, hospices, ophthalmology, community funds, culture, and economics.

Types of support: Operating budgets, continuing support, annual campaigns, emergency funds, building funds, employee matching gifts, scholarship funds, program-related investments, special projects, capital campaigns.

Limitations: Giving primarily in areas with company locations, in AL, DE, FL, GA, LA, MS, NJ, NC, OK, SC, TN, TX, and VA. No grants to individuals, or for endowment funds, deficit financing, equipment, land acquisition, renovation projects, special projects, research, publications, or conferences; no loans.

Publications: Annual report.

Application information:

Initial approach: Letter

Copies of proposal: 1
Deadline(s): None
Board meeting date(s): Quarterly
Final notification: 4 to 6 months
Write: Michael Zagorac, Jr., Chair.

Trustees: Michael Zagorac, Jr., Chair.; Harry W. Lambert, Ronald D. Peterson, James M. Santo.

Number of staff: 1 full-time professional; 1 part-time professional.

Employer Identification Number: 237322099

543

Florida Charities Foundation

Rollins College
Winter Park 32789

Established in 1959 in FL.

Financial data (yr. ended 7/31/88): Assets, $1,133,553 (M); gifts received, $50,000; expenditures, $38,481, including $26,685 for 39 grants (high: $10,000; low: $20).

Purpose and activities: Giving primarily for the arts and medical facilities.

Limitations: Giving primarily in central FL.

Application information:

Initial approach: Letter
Deadline(s): None
Write: John Tiedke

Trustee: SunBank, N.A.

Employer Identification Number: 596125203

544

Florida Progress Foundation

260 First Ave. South
St. Petersburg 33701-4306 (813) 895-1700

Donor(s): Florida Power Corp., Progress Financial Services.

Financial data (yr. ended 12/31/87): Assets, $447,715 (M); gifts received, $100,000; expenditures, $15,984, including $11,000 for 4 grants (high: $5,000; low: $500).

Purpose and activities: Support for education and the arts.

Application information: Contributes only to preselected organizations. Applications not accepted.

Deadline(s): None

Officer: C.W. McKee, Jr., Chair.

Employer Identification Number: 592589629

545

A. Friends' Foundation Trust

9100 Hubbard Place
Orlando 32819 (305) 843-5316

Established in 1959 in FL as the Hubbard Foundation; merged in 1985 with A. Friends' Fund, Inc., into A. Friends' Foundation Trust.

Donor(s): Frank M. Hubbard, A Friends' Fund, Inc.

Financial data (yr. ended 12/31/88): Assets, $5,191,802 (M); gifts received, $1,596,275; expenditures, $205,143, including $184,000 for 68 grants (high: $25,000; low: $1,000; average: $2,750).

Purpose and activities: Support for private higher education, civic affairs, the arts, youth activities, religion, and health.

Types of support: Annual campaigns, building funds, capital campaigns, conferences and seminars, continuing support, emergency funds, equipment, general purposes, land acquisition, matching funds, operating budgets, renovation projects, special projects.
Limitations: Giving principally in central FL. No grants to individuals, or for endowment funds.
Publications: 990-PF, grants list.
Application information: Emergency funding available at all times.
 Initial approach: Letter
 Copies of proposal: 1
 Deadline(s): Sept.
 Board meeting date(s): Varies
 Final notification: Oct.
 Write: Frank M. Hubbard, Chair.
Officer: Frank M. Hubbard, Chair.
Trustee: SunBank, N.A.
Board Members: L. Evans Hubbard, Ruth C.H. Miller.
Number of staff: None.
Employer Identification Number: 596125247

546
Elizabeth Morse Genius Foundation
P.O. Box 40
Winter Park 32790

Established in 1959.
Donor(s): Jeannette G. McKean.
Financial data (yr. ended 12/31/88): Assets, $7,961,000 (M); expenditures, $437,745, including $367,500 for 30 grants (high: $342,000; low: $25).
Purpose and activities: Support for education, social services, museums and other cultural programs, health services, and wildlife protection.
Types of support: Operating budgets.
Application information: Contributes only to pre-selected organizations; funds fully committed. Applications not accepted.
 Write: Herbert W. Holm, Treas.
Officers: Jeannette G. McKean, Pres.; Hugh F. McKean, V.P.; Herbert W. Holm, Secy.-Treas.
Number of staff: 1 part-time professional.
Employer Identification Number: 136115217

547
Elesabeth Ingalls Gillett Foundation
c/o E. Hamilton & Co.
1551 Forum Place, Suite 200A
West Palm Beach 33401

Established in 1980 in PA.
Donor(s): The Ingalls Foundation, Robert Ingalls Testamentary Trust.
Financial data (yr. ended 12/31/86): Assets, $5,444,788 (M); expenditures, $288,620, including $124,500 for 15 grants (high: $50,000; low: $50).
Purpose and activities: Grants largely for hospitals, social services, historic preservation, cultural programs, and higher education.
Limitations: Giving primarily in FL.
Officers: Elesabeth I. Gillett,* Chair., Pres., and V.P.; F. Warrington Gillett, Jr., Secy.-Treas.
Directors:* Charles H. Norris, Jr.
Employer Identification Number: 232142065

548
Harris Foundation
1025 W. NASA Blvd.
Melbourne 32919 (305) 727-9378

Incorporated in 1952 in OH.
Donor(s): Harris Corp.
Financial data (yr. ended 6/30/88): Assets, $92,697 (M); gifts received, $200,000; expenditures, $240,385, including $11,000 for 3 grants (high: $15,000; low: $1,000) and $225,824 for employee matching gifts.
Purpose and activities: Support for higher education, including an employee matching gifts program, community funds, cultural programs, youth agencies, and hospitals.
Types of support: General purposes, operating budgets, continuing support, annual campaigns, building funds, research, professorships, scholarship funds, fellowships, employee matching gifts.
Limitations: Giving limited to areas of company operations. No grants to individuals, or for endowment funds; no loans.
Application information:
 Initial approach: Proposal
 Copies of proposal: 1
 Deadline(s): None
 Write: O.W. Hudson, Secy.
Officers and Trustees: John T. Hartley, Pres.; R.E. Sullivan, V.P.; O.W. Hudson, Secy.; Bryan R. Roub, Treas.; G.I. Meisel.
Number of staff: None.
Employer Identification Number: 346520425

549
Holmes Foundation, Inc.
3111 Cardinal Dr., Suite B
Vero Beach 32963 (407) 231-6900

Incorporated in 1935 in NY.
Donor(s): Carl Holmes,† Mrs. Christian R. Holmes,† Jay Holmes.†
Financial data (yr. ended 12/31/87): Assets, $2,125,689 (M); expenditures, $109,983, including $73,500 for 18 grants (high: $20,000; low: $1,000).
Purpose and activities: Emphasis on arts, hospitals, and education.
Types of support: General purposes, special projects.
Application information:
 Initial approach: Proposal
 Copies of proposal: 1
 Deadline(s): Mar. 15 and Sept. 15
 Board meeting date(s): Apr. and Nov.
 Write: Michael O'Haire, Secy.
Officers: Jacqueline M. Holmes,* Pres.; John Peter Holmes,* V.P.; Michael O'Haire,* Secy.; Richard B. Candler, Treas.
Directors:* Christian R. Holmes, Alvin Ruml.
Employer Identification Number: 131946867

550
Isaly Dairy Charitable Trust
c/o H. William Isaly, The Isaly Klondike Co.
5400 118th Ave. North
Clearwater 33520

Financial data (yr. ended 12/31/87): Assets, $123,957 (M); expenditures, $6,583, including $5,300 for 14 grants (high: $1,000; low: $100).

Purpose and activities: Support for social services and youth, education, health and hospitals, civic affairs, arts and culture, and science.
Limitations: No grants to individuals.
Application information:
 Initial approach: Letter
Trustee: Pittsburgh National Bank.
Employer Identification Number: 256024887

551
George W. Jenkins Foundation, Inc.
P.O. Box 407
Lakeland 33802 (813) 688-1188

Incorporated in 1967 in FL.
Donor(s): George W. Jenkins.
Financial data (yr. ended 12/31/87): Assets, $10,933,069 (M); expenditures, $372,590, including $342,214 for 95 grants (high: $50,000; low: $200).
Purpose and activities: Emphasis on youth agencies, the handicapped, health, cultural programs, community funds, higher education, and social service agencies.
Types of support: Building funds, operating budgets, special projects.
Limitations: Giving limited to FL. No grants to individuals.
Application information:
 Initial approach: Proposal
 Copies of proposal: 1
 Deadline(s): None
 Board meeting date(s): Monthly
 Final notification: 2 weeks after first Monday of the month
 Write: Barbara Hart Hall, Pres.
Officers and Directors: George W. Jenkins, Chair.; Barbara Hart Hall, Pres.; Charles H. Jenkins, Sr., V.P.; John A. Turner, Secy.-Treas.; Jere W. Annis, Carol Jenkins Barnett, Clayton Hollis, Mark C. Hollis, Charles H. Jenkins, Jr., Howard Jenkins.
Number of staff: None.
Employer Identification Number: 596194119

552
The Edward & Lucille Kimmel Foundation, Inc.
625 North Flagler Dr.
West Palm Beach 33401-4024

Established in 1983 in FL.
Financial data (yr. ended 12/31/87): Assets, $1,044,716 (M); gifts received, $140,453; expenditures, $43,113, including $32,000 for 4 grants (high: $10,000; low: $6,000).
Purpose and activities: Support for the arts, health, education, and Jewish giving.
Limitations: Giving primarily in West Palm Beach, FL, and New York, NY.
Application information:
 Initial approach: Letter
 Deadline(s): None
 Write: Edward A. Kimmel, Pres.
Officer and Trustees: Edward A. Kimmel, Pres.; Joan K. Eigen, Alan Kimmel, Lucille Kimmel.
Employer Identification Number: 592380662

553
Koger Foundation
P.O. Box 4520
Jacksonville 32207 (904) 396-4811

Established in 1977 in FL.
Donor(s): Koger Properties, Inc., The Koger Co.
Financial data (yr. ended 12/31/87): Assets, $576,116 (M); gifts received, $120,000; expenditures, $565,418, including $502,839 for 92 grants (high: $308,725; low: $35).
Purpose and activities: Support primarily for cultural programs and education.
Limitations: Giving primarily in areas of company operations, including: FL, GA, SC, NC, VA, TN, AR, OK, TX and AL.
Application information: Application form required.
 Initial approach: Letter
 Copies of proposal: 1
 Deadline(s): None
 Board meeting date(s): Quarterly
 Write: Celeste K. Hampton, Trustee
Trustees: Celeste K. Hampton, Nancy T. Koger, Pamela K. Moore.
Number of staff: None.
Employer Identification Number: 591757872

554
Leidesdorf Foundation, Inc.
203 South Lake Trail
Palm Beach 33480

Incorporated in 1949 in NY.
Donor(s): Samuel D. Leidesdorf.†
Financial data (yr. ended 12/31/86): Assets, $365,458 (M); expenditures, $396,266, including $373,047 for 44 grants (high: $281,122; low: $100).
Purpose and activities: Grants for hospitals, health and cancer research, higher education, schools, cultural programs, and social services, particularly Jewish-affiliated agencies and temple support.
Limitations: Giving primarily in Palm Beach, FL, and in New York, NY.
Application information:
 Deadline(s): None
 Write: Arthur D. Leidesdorf, Chair.
Officers: Arthur D. Leidesdorf, Chair.; Tova D. Leidesdorf, V.P., Secy., and Treas.
Employer Identification Number: 136075584

555
The Charles N. & Eleanor Knight Leigh Foundation, Inc.
c/o Sullivan, Admire & Sullivan
2511 Ponce de Leon Blvd., Suite 320
Coral Gables 33134-6084

Established in 1985 in FL.
Donor(s): Eleanor Knight Leigh.†
Financial data (yr. ended 4/30/87): Assets, $1,288,597 (M); gifts received, $1,200,000; expenditures, $13,750, including $8,000 for 3 grants (high: $3,500; low: $1,500).
Purpose and activities: Emphasis on youth organizations; support also for a museum of science and technology.
Limitations: Giving primarily in FL.
Application information:
 Initial approach: Proposal

Deadline(s): None
 Write: Jack G. Admire, Pres.
Officers: Jack G. Admire, Pres.; Marilyn West, V.P.; John C. Sullivan, Jr., Secy.-Treas.
Director: Ruth C. Admire.
Employer Identification Number: 592562596

556
The Joe and Emily Lowe Foundation, Inc.
249 Royal Palm Way
Palm Beach 33480 (407) 655-7001

Incorporated in 1949 in NY.
Donor(s): Joe Lowe,† Emily Lowe.†
Financial data (yr. ended 12/31/87): Assets, $16,336,000 (M); expenditures, $1,818,486, including $1,573,407 for 400 grants (high: $100,000; low: $100; average: $1,000-$10,000).
Purpose and activities: Emphasis on Jewish welfare funds and social and religious groups, the arts, museums, higher education, including medical education, hospitals, health services, and medical research; support also for social services, including aid to the handicapped, underprivileged children's organizations, and women's projects.
Types of support: General purposes, building funds, equipment, endowment funds, matching funds, continuing support.
Limitations: Giving primarily in the New York, NY, metropolitan area, including NJ, and in FL, including Palm Beach. No grants to individuals, or for scholarships, fellowships, or prizes; no loans.
Application information:
 Initial approach: Letter or brief proposal
 Copies of proposal: 1
 Deadline(s): None
 Board meeting date(s): Feb. and May or June
 Final notification: 1 to 3 months
Officers and Trustees: Bernard Stern, Pres. and Treas.; David Fogelson, V.P. and Secy.; Helen G. Hauben, V.P.
Number of staff: 1 full-time professional.
Employer Identification Number: 136121361

557
Chesley G. Magruder Foundation, Inc.
P.O. Box 199
Orlando 32802 (305) 648-2840

Established in 1979 in FL.
Donor(s): Chesley G. Magruder Trust.
Financial data (yr. ended 6/30/87): Assets, $9,480,498 (M); gifts received, $981,943; expenditures, $503,599, including $461,604 for 56 grants (high: $25,000; low: $550).
Purpose and activities: Giving primarily for higher and other education, youth and social services agencies, church support, and cultural programs.
Types of support: General purposes.
Limitations: Giving primarily in FL. No grants to individuals.
Application information:
 Deadline(s): None
 Write: Board of Trustees

Officers and Trustees: Allen K. Holcomb, Pres.; G. Brock Magruder, V.P.; Ernest M. Kelly, Jr., Secy.-Treas.; Leon Handley, Robert N. Blackford.
Employer Identification Number: 591920736

558
Metal Industries Foundation, Inc.
1310 North Hercules Ave.
Clearwater 34625 (813) 441-2651

Donor(s): Metal Industries, Inc.
Financial data (yr. ended 10/31/88): Assets, $1,626,024 (M); gifts received, $200,000; expenditures, $85,685, including $77,473 for 40 grants (high: $25,000; low: $50).
Purpose and activities: Support primarily for youth organizations, community development, the arts, Christian churches, and mental health.
Application information: Application form required.
 Deadline(s): None
 Write: J.L. Fasenmyer
Officers and Trustees: James T. Walker, Jr., Pres.; James T. Walker, V.P.; Jay K. Poppleton.
Employer Identification Number: 237098483

559
The Baron de Hirsch Meyer Foundation
407 Lincoln Rd., Suite 6F
Miami Beach 33139 (305) 538-2531

Incorporated in 1940 in FL.
Donor(s): Baron de Hirsch Meyer.†
Financial data (yr. ended 12/31/87): Assets, $2,758,750 (M); expenditures, $242,644, including $181,175 for 34 grants (high: $50,000; low: $40).
Purpose and activities: Support for religious welfare, with emphasis on Jewish welfare funds, hospitals, medical agencies, child welfare, and the performing arts.
Types of support: Building funds.
Limitations: Giving primarily in FL. No grants to individuals.
Application information:
 Initial approach: Proposal or letter
 Copies of proposal: 1
 Board meeting date(s): Feb.
Officers and Directors: Polly de Hirsch Meyer, Pres. and Treas.; Marie Williams, V.P.; Leo Rose, Jr., Secy.
Employer Identification Number: 596129646

560
Miller Family Foundation, Inc.
700 Northwest 107th St., Fourth Fl.
Miami 33172

Established in 1984 in FL.
Donor(s): Leonard Miller, Susan Miller.
Financial data (yr. ended 11/30/86): Assets, $492,722 (M); gifts received, $742,950; expenditures, $464,508, including $464,378 for 21 grants (high: $115,000; low: $250).
Purpose and activities: Support for education, Jewish organizations, community funds, and the arts.
Limitations: Giving primarily in Miami, FL.

Application information: Contributes only to pre-selected organizations. Applications not accepted.

Directors: Jeffrey Miller, Leonard Miller, Stuart Miller, Susan Miller, Vicki Miller, Leslie Saiontz, Steven Saiontz.

Employer Identification Number: 592474323

561
National Vulcanized Fibre Company Community Services Trust Fund

6917 Collins Ave.
Miami Beach 33141

Trust established in 1956 in DE.
Donor(s): National Vulcanized Fibre Co.
Financial data (yr. ended 12/31/86): Assets, $1,593,562 (M); expenditures, $122,396, including $106,224 for 31 grants (high: $76,500; low: $100).
Purpose and activities: Giving for higher education, cultural programs, and child welfare.
Limitations: Giving primarily in DE.
Trustees: Jack Coppersmith, Steven Posner, Victor Posner.
Employer Identification Number: 516021550

562
The Orlando Sentinel Foundation, Inc.

(Formerly Sentinel Communications Charities, Inc.)
c/o Sentinel Communications Co.
633 North Orange Ave.
Orlando 32801 (407) 420-5591

Established in 1969 in FL.
Donor(s): Sentinel Communications Co.
Financial data (yr. ended 12/31/87): Assets, $142,479 (M); gifts received, $450,730; expenditures, $382,620, including $382,545 for 99 grants (high: $95,000; low: $25).
Purpose and activities: A company-sponsored foundation created exclusively for charitable, religious, educational and scientific purposes, including, for such purposes, the making of distributions to organizations that qualify.
Types of support: Building funds, capital campaigns, endowment funds, matching funds, renovation projects, special projects.
Limitations: Giving limited to the six-county area of east central FL. No grants to individuals.
Publications: Program policy statement, application guidelines.
Application information: Application form required.
 Initial approach: Letter
 Copies of proposal: 1
 Deadline(s): Mar. 1, June 1, Sept. 1, and Dec. 1
 Board meeting date(s): Quarterly
 Write: Nancy F. Peed, Community Relations Coord.
Officers and Directors: Harold R. Lifvendahl, Pres.; John L. Blexrud, V.P.; L. John Haile, V.P.; Nancy F. Peed, Secy.; Richard E. Darden, Treas.
Number of staff: 1 part-time professional.
Employer Identification Number: 237063917

563
Palm Beach County Community Foundation

324 Datura St., Suite 340
West Palm Beach 33401-9938 (407) 659-6800

Incorporated in 1972 in FL.
Financial data (yr. ended 6/30/88): Assets, $3,542,686 (L); gifts received, $796,818; expenditures, $613,361, including $296,805 for 92 grants (high: $31,000; low: $25) and $18,500 for 6 grants to individuals.
Purpose and activities: Support for education, the arts, health, social services, and the conservation and preservation of historical and cultural resources.
Types of support: Seed money, student aid, conferences and seminars, emergency funds, equipment, matching funds, special projects, technical assistance.
Limitations: Giving primarily in Palm Beach County, FL, and surrounding regions. No grants to individuals (except scholarships), or for operating funds, building campaigns, endowments, or annual campaigns.
Publications: Annual report, informational brochure (including application guidelines).
Application information:
 Initial approach: Telephone call followed by proposal
 Copies of proposal: 1
 Deadline(s): Apr. 1 and Oct. 1
 Board meeting date(s): May and Nov.
 Final notification: June and Dec.
Officers and Directors:* Dwight L. Allison, Jr.,* Pres.; John B. Dodge,* 1st V.P.; William E. Benjamin II,* 2nd V.P.; Ruth Lewis Farkas,* Secy.; R. Michael Strickland,* Treas.; Shannon G. Sadler, Exec. Dir.; and 19 other directors.
Number of staff: 3 full-time professional; 1 full-time support; 6 part-time support.
Employer Identification Number: 237181875

564
The Paulucci Family Foundation

250 International Pkwy.
Heathrow 32746

Incorporated in 1966 in MN.
Donor(s): Jeno F. Paulucci.
Financial data (yr. ended 12/31/86): Assets, $2,025,896 (M); expenditures, $185,494, including $154,086 for 22 grants (high: $35,000; low: $50).
Purpose and activities: Emphasis on higher education, medical research, and support of Italian-American cultural and charitable activities.
Limitations: Giving primarily in MN and FL. No grants to individuals.
Application information:
 Initial approach: Letter
 Copies of proposal: 1
 Board meeting date(s): Annually
Officers and Directors: Jeno F. Paulucci, Pres.; Lois M. Paulucci, V.P.; Michael J. Paulucci, V.P. and Treas.; Gina J. Paulucci, Cynthia Paulucci Soderstrom.
Employer Identification Number: 416054004

565
Dr. M. Lee Pearce Foundation

9405 Northwest 41st St.
Miami 33178 (305) 477-0222

Established in 1984 in FL.
Donor(s): M. Lee Pearce.
Financial data (yr. ended 12/31/87): Assets, $5,172,377 (M); expenditures, $131,413, including $126,625 for 8 grants (high: $100,000; low: $1,000).
Purpose and activities: Giving for social services, education, and cultural activities; grant to a medical research organization.
Limitations: Giving primarily in FL, with emphasis on Miami.
Application information: Contributes only to pre-selected organizations. Applications not accepted.
 Write: A.B. Wiener, Secy.-Treas.
Officers and Directors: M. Lee Pearce, Pres.; Robert L. Achor, V.P.; Modesto M. Moro, V.P.; A.B. Wiener, Secy.-Treas.; Marc H. Bivins, Seymour H. Chalif, Arnold Hantman, Nora Lodge Pearce.
Employer Identification Number: 592424272

566
Albin Polasek Foundation, Inc.

P.O. Box 880
Winter Park 32790

Established in 1963 in FL.
Financial data (yr. ended 12/31/87): Assets, $1,030,395 (M); expenditures, $73,786, including $24,000 for 6 grants.
Purpose and activities: Support for educational and arts organizations.
Officers: Webber B. Haines, Pres.; Emily Polasek, V.P.; Kenneth Wacker,* Secy.; John Dem. Haines,* Treas.
Directors:* Roman Hruska.
Employer Identification Number: 591102353

567
The Revere Foundation, Inc.

621 Northwest S3, Suite 240
Boca Raton 33487 (407) 241-3911

Donor(s): Revere Copper and Brass.
Financial data (yr. ended 12/31/88): Assets, $141,597 (M); expenditures, $198,344, including $195,000 for 2 grants (high: $100,000; low: $95,000).
Purpose and activities: Grants for a library and historic preservation.
Application information: Applications not accepted.
 Write: Richard Olson, Asst. Treas., Revere Copper and Brass
Employer Identification Number: 136098441

568
River Branch Foundation

1514 Nira St.
Jacksonville 32207 (904) 396-5831

Trust established in 1963 in NJ.
Donor(s): J. Seward Johnson 1951 and 1961 Charitable Trusts, The Atlantic Foundation.
Financial data (yr. ended 12/31/86): Assets, $4,345,930 (M); expenditures, $243,758,

including $193,500 for 22 grants (high: $50,000; low: $500).

Purpose and activities: Giving for youth agencies, education, the arts, and cultural programs.

Limitations: Giving primarily in the Jacksonville, FL, area. No grants to individuals.

Application information:

Write: Walter L. Woolfe, Trustee

Trustees: A.M. Foote, Jr., Nathan J. Travassos, Walter L. Woolfe.

Employer Identification Number: 226054887

569
Roberts Charitable Trust

P.O. Box 40200
Jacksonville 32203-0200 (904) 798-1887

Financial data (yr. ended 8/31/88): Assets, $1,055,115 (M); expenditures, $42,364, including $25,088 for 26 grants (high: $2,100; low: $85; average: $500-$1,000).

Purpose and activities: Support for educational and cultural institutions, social service organizations; and community organizations.

Limitations: Giving primarily in FL.

Application information:

Write: c/o Barnett Banks Trust Co., N.A.

Trustees: T.S. Robert III, Garnet Ashby, Barnett Banks Trust Co., N.A.

Employer Identification Number: 596559688

570
The Roberts Foundation

520 Harbor Point Rd.
Longboat Key 33548

Established in 1954 in FL.

Donor(s): F.L. Roberts & Co., Inc.

Financial data (yr. ended 9/30/87): Assets, $143,788 (M); gifts received, $21,500; expenditures, $171,263, including $171,129 for 36 grants (high: $80,000; low: $50).

Purpose and activities: Support primarily for Jewish welfare and temples; support also for the arts and for higher education.

Trustee: Abbott S. Roberts.

Employer Identification Number: 046112106

571
The Ryder System Charitable Foundation, Inc.

c/o Ryder System, Inc.
3600 Northwest 82nd Ave.
Miami 33166 (305) 593-3642

Established in 1984 in FL.

Donor(s): Ryder System, Inc.

Financial data (yr. ended 12/31/87): Assets, $914,000 (M); gifts received, $1,680,000; expenditures, $1,518,529, including $1,489,922 for 308 grants (high: $150,000; low: $25; average: $1,000-$30,000).

Purpose and activities: Grants for health and human services, educational, cultural, civic and literary organizations that operate in communities having significant concentrations of Ryder personnel; giving also for the advancement of minorities and disadvantaged groups.

Types of support: Employee matching gifts, annual campaigns, operating budgets, scholarship funds.

Limitations: Giving primarily in areas of company operations.

Publications: Corporate giving report.

Application information:

Initial approach: Letter
Copies of proposal: 1
Deadline(s): 1st half of the calendar year
Board meeting date(s): Annually and as needed
Final notification: Within 4 months
Write: Office of Corp. Progs.

Officers and Directors: M. Anthony Burns, Chair. and Pres.; Edwin A. Huston, V.P.; David R. Parker, V.P.; James M. Herron, Secy.; Wendell R. Beard, Donald W. Estes, Robert G. Lambert, Gail M. McDonald.

Number of staff: 1 full-time professional; 1 full-time support.

Employer Identification Number: 592462315

572
The Saunders Foundation

c/o First Florida Bank, Trust Dept.
P.O. Box 1810
Tampa 33601 (813) 224-1535

Established in 1970 in FL.

Donor(s): William N. Saunders,† Ruby Lee Saunders.†

Financial data (yr. ended 12/31/87): Assets, $9,262,389 (M); expenditures, $579,093, including $391,347 for 24 grants.

Purpose and activities: Support for higher education and youth agencies.

Types of support: Scholarship funds, matching funds.

Limitations: Giving primarily in western FL. No support for travel projects or to organizations which promote sports or athletic competition. No grants for fellowships or operating funds.

Publications: Application guidelines.

Application information: Application form required.

Copies of proposal: 2
Deadline(s): None
Board meeting date(s): 1st Wednesday of each month
Write: James M. Kelly, V.P.

Officers and Directors: Herbert G. McKay, Pres.; James M. Kelly, V.P. and Treas.; Michael G. Emmanuel, Secy.; Solon F. O'Neal, Jr.

Number of staff: None.

Employer Identification Number: 596152326

573
Schultz Foundation, Inc.

c/o Schultz Bldg.
P.O. Box 1200
Jacksonville 32201

Established in 1964 in FL.

Financial data (yr. ended 12/31/87): Assets, $2,064,467 (M); expenditures, $175,727, including $154,696 for 53 grants (high: $25,100; low: $15).

Purpose and activities: Support primarily for community funds, cultural organizations, educational institutions, and wildlife.

Limitations: Giving primarily in Jacksonville, FL. No grants to individuals.

Application information: Contributes only to pre-selected organizations. Applications not accepted.

Officers: Clifford G. Schultz II,* Pres.; Frederick H. Schultz,* V.P.; John F. Reilly, Secy.-Treas.

Trustees:* Catherine Kelly, Frederick H. Schultz, Jr., John R. Schultz, Nancy Schultz.

Employer Identification Number: 591055869

574
William G. Selby and Marie Selby Foundation

Southeast Bank
P.O. Box 267
Sarasota 34230 (813) 951-7241

Trust established in 1955 in FL.

Donor(s): William G. Selby,† Marie M. Selby.†

Financial data (yr. ended 5/31/88): Assets, $36,333,861 (M); expenditures, $1,421,803, including $1,104,600 for 47 grants (high: $100,000; low: $1,000; average: $10,000-$40,000).

Purpose and activities: Emphasis on scholarships and capital grants for giving directly to Florida colleges and universities; local giving also for the aged, hospitals, social service and youth agencies, and cultural programs.

Types of support: Building funds, equipment, land acquisition, matching funds, scholarship funds, renovation projects.

Limitations: Giving limited to FL, with emphasis on the Sarasota area. No grants to individuals, or for general purposes, continuing support, annual campaigns, deficit financing, seed money, emergency funds, operating budgets, endowment funds, special projects, research, publications, or conferences; no loans.

Publications: Informational brochure, program policy statement, application guidelines.

Application information: Application form required.

Initial approach: Letter
Copies of proposal: 3
Deadline(s): Submit proposal preferably in July and Dec.; deadlines Aug. 1 and Feb. 1
Board meeting date(s): June, Sept., Dec., and Mar.
Final notification: 2 to 6 months
Write: Robert E. Perkins, Exec. Dir.

Trustee: Southeast Banks Trust Co.

Administrative Committee: Jerome A. Jannopoulo, Chair.; Robert E. Perkins, Exec. Dir.; John Davidson, Anthony DeDeyn, Wendel Kent, Jeffrey Reynolds, Charles E. Stottlemyer.

Number of staff: 1 full-time professional; 1 part-time support.

Employer Identification Number: 596121242

575
Carl and Ruth Shapiro Foundation

Two North Breakers Row
Palm Beach 33480

Established originally in MA as Carl Shapiro Foundation.

Financial data (yr. ended 12/31/86): Assets, $1,931,521 (M); expenditures, $487,344,

including $476,370 for 38 grants (high: $143,000; low: $50).

Purpose and activities: Grants primarily for Jewish welfare funds, higher education, hospitals, art organizations, and museums.

Application information: Contributes only to pre-selected organizations. Applications not accepted.

Officers: Carl Shapiro, Pres.; Ruth Shapiro, Secy.

Employer Identification Number: 046135027

576
John & Catherine Shuler Charitable Trust
c/o Northern Trust Bank Florida/Sarasota
1515 Ringling Blvd.
Sarasota 33577

Established in 1958 in IA.

Financial data (yr. ended 12/31/86): Assets, $430,265 (M); gifts received, $0; expenditures, $233,820, including $230,992 for 12 grants (high: $71,664; low: $500).

Purpose and activities: Support primarily for cultural organizations, animal welfare, and a church.

Limitations: Giving primarily in Des Moines, IA and Sarasota, FL.

Application information:
Deadline(s): None
Trustees: Ann Schuler Blair, Jean Shuler Rawson.

Employer Identification Number: 426076704

577
Southeast Banking Corporation Foundation
One Southeast Financial Center, 22nd Fl.
Miami 33131 (305) 375-7295

Established in 1980.

Donor(s): Southeast Banking Corp., and its affiliates.

Financial data (yr. ended 12/31/88): Assets, $1,030,000 (M); expenditures, $1,454,550 for 182 grants (high: $385,000; low: $300; average: $1,500-$35,000).

Purpose and activities: Giving primarily for health and welfare, including the United Way, cultural programs, and education.

Types of support: Operating budgets, annual campaigns, seed money, publications, conferences and seminars, scholarship funds, consulting services, technical assistance, general purposes, special projects.

Limitations: Giving primarily in FL. No grants to individuals. Generally no support for capital or endowment funds.

Publications: Annual report (including application guidelines).

Application information:
Initial approach: Telephone, letter, or proposal
Copies of proposal: 3
Deadline(s): None
Board meeting date(s): Quarterly and as required
Final notification: 6 to 8 weeks
Write: Robin Reiter, Exec. Dir.
Officer: Robin Reiter, V.P., Corp. Comm. Involvement and Exec. Dir., Fdn.

Trustees: David Aucamp, Rip DuPont, Bill Klich, Tom Woolsey.

Number of staff: 1 full-time professional; 2 full-time support.

Employer Identification Number: 591172753

Recent arts and culture grants:
Brevard Art Center and Museum, Melbourne, FL, $5,000. 1987.
Center Florida Civic Theater, Orlando, FL, $5,000. 1987.
Coconut Grove Playhouse, Miami, FL, $25,000. 1987.
Florida History Associates, Tallahassee, FL, $15,000. 1987.
Florida Orchestra, Tampa, FL, $22,500. 1987.
Florida Trust for Historic Preservation, Bonnet House, Tallahassee, FL, $5,000. 1987.
Greater Miami Opera Association, Miami, FL, $25,000. 1987.
Historical Association of Southern Florida, Miami, FL, $10,000. 1987.
Jacksonville Symphony Association, Jacksonville, FL, $15,000. 1987.
Mary Luft and Company, Miami, FL, $5,000. 1987.
Miami City Ballet, Miami, FL, $15,000. 1987.
Museum of Art, Fort Lauderdale, FL, $15,000. 1987.
Orlando Museum of Art, Orlando, FL, $5,000. 1987.
Orlando Science Center, Orlando, FL, $5,000. 1987.
Palm Beach County Center for the Arts, West Palm Beach, FL, $13,500. 1987.
Performing Arts Center and Theater, Clearwater, FL, $5,000. 1987.
Philharmonic Orchestra of Florida, Fort Lauderdale, FL, $10,000. 1987.
Polk Museum of Art, Lakeland, FL, $6,500. 1987.

578
The George B. Storer Foundation, Inc.
P.O. Box 1207
Islamorada 33036 (305) 664-8805

Incorporated in 1955 in FL.

Financial data (yr. ended 12/31/86): Assets, $41,321,309 (M); gifts received, $20,865; expenditures, $1,848,194, including $1,389,677 for 54 grants (high: $300,000; low: $1,000; average: $1,000-$50,000).

Purpose and activities: Grants for higher education, social services, particularly for the blind, youth organizations, conservation, hospitals, and cultural programs.

Types of support: Research, general purposes, building funds, matching funds, endowment funds.

Limitations: Giving primarily in FL. No grants for scholarships or fellowships; no loans.

Application information:
Initial approach: Letter
Copies of proposal: 1
Deadline(s): Nov. 30
Board meeting date(s): Dec.
Write: Peter Storer, Pres.
Officers and Directors: Peter Storer, Pres. and Treas.; William Michaels, V.P.; James P. Storer, Secy.

Employer Identification Number: 596136392

579
Tampa Cable Television Trust
P.O. Box 320265
Tampa 33679 (813) 875-9461

Established in 1982.

Donor(s): Tampa Cable Television.

Financial data (yr. ended 12/31/86): Assets, $282,069 (M); expenditures, $281,408, including $257,300 for 37 grants (high: $20,000; low: $1,000).

Purpose and activities: Giving for higher education, youth and social service agencies, and cultural programs; strong preference for matching funds.

Types of support: Matching funds.

Limitations: Giving limited to the Tampa, FL, community. No support for organizations which limit services to members of any one religious group. No grants to individuals, or for start-up funds, deficit financing, or fundraising events.

Application information: Application form required.
Deadline(s): Varies each year
Write: Homer Tillery, Chair.
Trustees: Homer Tillery, Chair.; T. Terrell Sessums, Secy.; Laura Blain, Nick Capitano, Robert L. Cromwell, Joseph Garcia, Malinda E. Gray, Robert D. Heide, Rev. Laurence Higgins, Richard S. Hodes, J. Leonard Levy, A. Leon Lowry, Robert Morrison, J. Benton Stewart, Gilbert E. Turner, Donald L. Whittemore, Jr., Sandra H. Wilson.

Employer Identification Number: 592273947

580
Tampa Electric Company Contributions Program
Corporate Communications
P.O. Box 111
Tampa 33601 (813) 228-4111

Financial data (yr. ended 12/31/88): Total giving, $940,048, including $898,085 for grants, $4,500 for 7 employee matching gifts and $37,463 for 26 in-kind gifts.

Purpose and activities: Interests include early childhood, elementary, higher, and business education, the arts and culture, including fine and performing arts, crime and law enforcement, accounting, community development, community funds, medical research, health, including health associations and health services, programs for drug rehabilitation, race relations, the disadvantaged, women, and youth.

Types of support: Annual campaigns, building funds, capital campaigns, continuing support, employee matching gifts, operating budgets, matching funds.

Limitations: Giving primarily in Hillsborough County, FL; generally no support for national organizations unless local community is affected.

Application information: Application form required.
Initial approach: Mail to Contribs. Admin.
Copies of proposal: 1
Final notification: 3 weeks
Write: Hugh L. Culbreath, Chair., Pres. and C.E.O.
Number of staff: 3 part-time professional.

581
George G. Tapper Foundation Trust
P.O. Box 280
Port St. Joe 32456 (904) 227-1111
Aditional tel.: 902 227-1112

Established in 1986 in FL.
Financial data (yr. ended 12/31/88): Assets, $1,154,746 (M); gifts received, $91,437; expenditures, $60,487, including $58,000 for 13 grants (high: $10,000; low: $500).
Purpose and activities: Support for higher education, health, civic affairs, community development, family services, and culture.
Types of support: Scholarship funds, general purposes.
Limitations: Giving primarily in the gulf and Bay County areas of northwest FL.
Application information: Application form required.
 Initial approach: Letter
 Copies of proposal: 1
 Deadline(s): None
 Board meeting date(s): Feb.
 Write: Amelia G. Tapper, Mgr.
Trustees: David C. Gaskin, Robert McSpadden, Amelia G. Tapper, Patricia M. Tapper.
Number of staff: None.
Employer Identification Number: 592639039

582
C. Herman Terry Foundation
1301 Gulf Life Dr., Suite 2216
Jacksonville 32207

Established in 1982 in FL.
Donor(s): C. Herman Terry.
Financial data (yr. ended 12/31/86): Assets, $2,110,459 (M); expenditures, $412,525, including $396,727 for 14 grants (high: $303,000; low: $100).
Purpose and activities: Grants for youth, culture, and religious giving; substantial support for an education foundation.
Trustees: Kenneth A. Barnebey, Hugh T. Nelson, C. Herman Terry, Mary Virginia Terry, James H. Winston.
Employer Identification Number: 592241642

583
The Thoresen Foundation
2881 La Concha Dr.
Clearwater 34622

Trust established in 1952 in IL.
Donor(s): William E. Thoresen, Catherine E. Thoresen.
Financial data (yr. ended 2/29/88): Assets, $4,014,202 (M); gifts received, $75,000; expenditures, $203,221, including $198,525 for grants.
Purpose and activities: Emphasis on higher education; grants also for hospitals, social service agencies, museums, and cultural programs.
Limitations: Giving primarily in FL and IL. No grants to individuals, or for scholarships.
Application information:
 Initial approach: Letter
 Board meeting date(s): As required
 Write: George V. Berger, Trustee

Trustees: George V. Berger, Katherine Culver, Catherine E. Thoresen, William E. Thoresen.
Number of staff: None.
Employer Identification Number: 366102493

584
The Wahlstrom Foundation, Inc.
2855 Ocean Dr., Suite D-4
Vero Beach 32963 (407) 231-0373
Mailing address: P.O. Box 3276, Vero Beach, FL 32964

Incorporated in 1956 in CT.
Donor(s): Magnus Wahlstrom.†
Financial data (yr. ended 12/31/88): Assets, $4,753,694 (M); gifts received, $20,000; expenditures, $223,220 for 20 grants (high: $63,014; low: $500; average: $5,000).
Purpose and activities: Emphasis on aid to the handicapped, higher education, hospitals, youth agencies, religion, the arts and humanities, the underprivileged, and community priorities.
Types of support: Continuing support, seed money, building funds, equipment, research, special projects, matching funds, capital campaigns, endowment funds, scholarship funds.
Limitations: Giving primarily in the greater Bridgeport, CT, area, and Indian River County, FL. No grants to individuals, or for fellowships, or operating budgets; no loans.
Publications: Application guidelines.
Application information: Application form required.
 Initial approach: Letter
 Copies of proposal: 1
 Deadline(s): May 1 and Oct. 1
 Board meeting date(s): June and Nov.
 Final notification: 3 to 6 months
 Write: Eleonora W. McCabe, Pres.
Officers and Directors: Eleonora W. McCabe, Pres. and Treas.; Lois J. Hughes, V.P. and Secy.; Bruce R. Johnson, V.P.
Number of staff: 1 part-time support.
Employer Identification Number: 066053378

585
The I. Waldbaum Family Foundation, Inc.
16519 Ironwood Dr.
Delray Beach 33445

Incorporated in 1961 in NY.
Donor(s): Bernice Waldbaum, Ira Waldbaum, Waldbaum, Inc.
Financial data (yr. ended 12/31/86): Assets, $7,556,435 (M); gifts received, $100,000; expenditures, $238,342, including $93,155 for 59 grants (high: $50,000; low: $5).
Purpose and activities: Giving chiefly to Jewish welfare funds, including temple support, and to cultural programs.
Limitations: Giving primarily in the New York metropolitan area.
Application information:
 Initial approach: Proposal
 Write: Lawrence J. Waldman
Officers and Directors: Ira Waldbaum, Pres.; Bernice Waldbaum, Treas.; Randie Malinsky, Julia Waldbaum.
Employer Identification Number: 136145916

586
Jim Walter Corporation Foundation
1500 North Dale Mabry Hwy.
P.O. Box 31601
Tampa 33631-3601 (813) 871-4168

Established in 1966 in FL.
Donor(s): Jim Walter Corp., and subsidiaries.
Financial data (yr. ended 8/31/88): Assets, $6,298,211 (M); gifts received, $479,328; expenditures, $385,541, including $344,123 for grants.
Purpose and activities: Giving for community funds; support also for higher education, youth and social service agencies, hospitals, and the arts.
Limitations: Giving primarily in the state of FL.
Application information:
 Write: W.K. Baker, Trustee
Trustees: W.K. Baker, Joe B. Cordell, J.W. Kynes.
Employer Identification Number: 596205802

587
The Ware Foundation
147 Alhambra Circle, Suite 215
Coral Gables 33134

Trust established in 1950 in PA.
Donor(s): John H. Ware, Jr.†
Financial data (yr. ended 12/31/86): Assets, $19,300,960 (M); expenditures, $815,100, including $790,000 for 87 grants (high: $75,000; low: $1,000; average: $5,000-$15,000).
Purpose and activities: Giving primarily for Christian schools and higher education; support also for hospitals, historic preservation groups, youth agencies, and Christian organizations.
Limitations: Giving primarily in FL and other southern states. No support for private foundations. No grants to individuals.
Application information:
 Initial approach: Letter or proposal; no telephone inquiries
 Deadline(s): None
 Final notification: Positive responses only
Trustees: Rhoda C. Ware, Chair.; Martha W. Odom, Vice-Chair.; Rhoda W. Cobb, Nancy W. Pascal.
Number of staff: None.
Employer Identification Number: 237286585

588
Lillian S. Wells Foundation, Inc.
600 Sagamore Rd.
Fort Lauderdale 33301 (305) 462-8639
Application address: P.O. Box 14338, Fort Lauderdale, FL 33301

Donor(s): Barbara S. Wells; Preston A. Wells, Jr.
Financial data (yr. ended 12/31/86): Assets, $4,583,624 (M); expenditures, $156,740, including $153,000 for 7 grants (high: $60,000; low: $3,000).
Purpose and activities: Support for medical research, and art education and appreciation.
Limitations: Giving limited to Chicago, IL; Ft. Lauderdale, FL; and Garden County, NE.
Application information:
 Write: Barbara S. Wells, Pres.

Officers: Barbara S. Wells, Pres.; Preston A. Wells, Jr., V.P.; Mary B. Moulding, Secy.; Joseph E. Malecek, Treas.
Employer Identification Number: 237433827

589
Dr. Herbert A. Wertheim Foundation, Inc.
4470 Southwest 74th Ave.
Miami 33155

Established in 1977 in FL.
Donor(s): Herbert A. Wertheim.
Financial data (yr. ended 9/30/87): Assets, $3,202,613 (M); gifts received, $1,000,000; expenditures, $109,260, including $102,934 for 23 grants (high: $40,000; low: $15).
Purpose and activities: Support primarily for the fine arts and medical research.
Types of support: Research.
Application information:
 Initial approach: Letter
 Deadline(s): None
Officers and Directors: Herbert A. Wertheim, Pres.; Nicole J. Wertheim, Treas.
Employer Identification Number: 591778605

590
Whitehall Foundation, Inc.
249 Royal Palm Way, Suite 202
Palm Beach 33480 (407) 655-4474
Application address: P.O. Box 3225, Palm Beach, FL 33480; FAX: (407) 659-4978

Incorporated in 1937 in NJ.
Donor(s): George M. Moffett,† and others.
Financial data (yr. ended 9/30/88): Assets, $36,079,047 (M); expenditures, $2,426,839, including $1,877,297 for 70 grants (high: $48,944; low: $4,369; average: $10,000-$40,000) and $54,458 for 6 grants to individuals.
Purpose and activities: Support for scholarly research in the life sciences, with emphasis on behavioral neuroscience, and invertebrate neurophysiology; innovative and imaginative projects preferred. Research grants are paid to sponsoring institutions, rather than directly to individuals. Grants-in-aid are paid to assistant and/or senior professors; research grants are available to Ph.D.'s with established labs. Employee-related scholarships are awarded only through CPC International.
Types of support: Research, seed money, technical assistance, special projects, equipment, publications, employee-related scholarships.
Limitations: No support for investigators who already have, or expect to receive, substantial support from other quarters. No grants for the purchase of major items of permanent equipment; travel, unless to unique field areas essential to the research; salary support; living expenses while working at home; travel to conferences or for consultation; or secretarial services.
Publications: Informational brochure (including application guidelines), grants list.
Application information: Applicant must have Ph.D. before applying. Application form required.
 Initial approach: Letter

Copies of proposal: 2
Deadline(s): Mar. l, Sept. l, and Dec. 1 for research grants; Jan. 1, June 1, and Oct. 1 for grants-in-aid
Board meeting date(s): Nov., but votes by mail in Mar., June, and Dec.
Final notification: 4 months
Write: Laurel T. Baker, Secy.
Officers and Trustees: George M. Moffett II, Pres. and Treas.; J. Wright Rumbough, Jr., V.P.; Laurel T. Baker, Secy.; Warren S. Adams II, Kenneth S. Beall, Jr., Helen M. Brooks, Van Vetchen Burger, James A. Moffett, Peter G. Neff.
Number of staff: 2 part-time professional.
Employer Identification Number: 135637595
Recent arts and culture grants:
University of Colorado Museum, Boulder, CO, $9,426. For study, Mesozoic Eggshell of Western Interior. 1987.

591
Hugh & Mary Wilson Foundation, Inc.
1950 Landings Blvd., Suite 105
Sarasota 34231 (813) 954-2155
Application address: 240 North Washington Blvd., Suite 460, Sarasota, FL 34236

Established in 1984 in FL.†
Donor(s): Hugh H. Wilson,† Mary P. Wilson.†
Financial data (yr. ended 12/31/88): Assets, $4,522,673 (M); expenditures, $296,655, including $187,000 for 8 grants (high: $100,000; low: $1,500; average: $1,500-$100,000).
Purpose and activities: Support for education, health, performing arts and social issues.
Types of support: Building funds, capital campaigns, conferences and seminars, scholarship funds.
Limitations: Giving limited to the Manatee-Sarasota, FL, area and the Lewisburg-Danville, PA area. No grants for operating expenses.
Publications: Informational brochure (including application guidelines).
Application information:
 Initial approach: Letter or telephone
 Copies of proposal: 2
 Deadline(s): None
 Board meeting date(s): Mar., June, and Sept.
 Final notification: Oct.
 Write: John R. Wood, Pres.
Officers and Directors: John R. Wood, Pres.; Harry Klinger, V.P.; Sadie L. Wood, Secy.; George Fraley, Treas.; Susan Wood.
Number of staff: 3
Employer Identification Number: 592243926

592
Wiseheart Foundation, Inc.
2840 S.W. Third Ave.
Miami 33129

Incorporated in 1953 in FL.
Donor(s): Malcolm B. Wiseheart,† Dorothy A. Wiseheart.†
Financial data (yr. ended 12/31/86): Assets, $2,522,399 (M); expenditures, $84,808, including $80,790 for 63 grants (high: $11,000; low: $50).
Purpose and activities: Emphasis on secondary and higher education, Protestant

church support and cultural programs, including a local community television foundation.
Limitations: Giving primarily in FL. No grants to individuals, or for building or endowment funds, or operating budgets.
Application information:
 Initial approach: Proposal
 Copies of proposal: 2
 Board meeting date(s): Quarterly
 Write: Malcolm B. Wiseheart, Jr., Pres.
Officers and Directors: Malcolm B. Wiseheart, Jr., Pres.; Elizabeth W. Joyce, V.P.; Marilyn W. Little, Carolyn W. Milne.
Employer Identification Number: 590992871

593
Loulyfran Wolfson Foundation, Inc.
2399 North East 2nd Ave.
Miami 33137-4807

Established in 1967 in FL.
Financial data (yr. ended 12/31/87): Assets, $699,755 (M); gifts received, $200,000; expenditures, $144,883, including $141,500 for 8 grants (high: $100,000; low: $1,500).
Purpose and activities: Support primarily for higher education, medical research and cultural institutions.
Limitations: Giving primarily in Miami, FL.
Officers and Trustees:* Lynn R. Wolfson,* Pres.; J. Bruce Irving, Secy.; Linda Wolfson, Treas.; Louis Wolfson III.
Employer Identification Number: 596196403

594
Yablick Charities, Inc.
c/o Jefferson National Bank of Miami
301-41st St.
Miami Beach 33140

Incorporated in 1960 in NJ.
Donor(s): Herman Yablick.†
Financial data (yr. ended 12/31/86): Assets, $1,175,459 (M); expenditures, $195,518, including $110,678 for 95 grants (high: $13,516; low: $18).
Purpose and activities: Grants largely for higher education, hospitals, and cultural programs.
Limitations: Giving primarily in FL and Israel.
Application information:
 Deadline(s): Sept. 30
 Write: Jarrold F. Goodman, Pres.
Officers: Jerrold F. Goodman, Pres.; Jane Goodman, V.P.; Ruth Cohen, V.P.
Employer Identification Number: 591411171

595
Zeitz Foundation, Inc.
The Meadows
5657 Pipers Waite
Sarasota 34235 (813) 377-7419

Established in 1943 in FL.
Financial data (yr. ended 6/30/88): Assets, $1,031,019 (M); expenditures, $64,038, including $50,388 for 103 grants (high: $10,000; low: $10).
Purpose and activities: Support primarily for Jewish organizations; support also for higher

education, health services and cultural institutions.

Application information:

Initial approach: Letter

Deadline(s): June

Write: Robert Z. Rosenthal, V.P.

Officers: Williard Zeitz, Pres.; Wilbur Levin, V.P. and Secy.; Robert Z. Rosenthal, V.P. and Treas.

Director: Daniel Ross.

Employer Identification Number: 116037021

GEORGIA

596
Allen Foundation, Inc.

Box 1712

Atlanta 30301　　　　　　(404) 521-0800

Established in 1956 in GA.

Donor(s): Ivan Allen Co.

Financial data (yr. ended 2/28/87): Assets, $762,446 (M); gifts received, $158,427; expenditures, $199,442, including $196,381 for 56 grants (high: $35,450; low: $250).

Purpose and activities: Support for education, health services, and cultural programs; scholarship support for dependents of company employees.

Types of support: Employee-related scholarships.

Limitations: Giving primarily in the South, with emphasis on GA.

Application information: Application form required.

Deadline(s): June 30

Write: R.E. Herndon, Secy.-Treas.

Officers and Trustees: Ivan Allen, Jr., Pres.; Ivan Allen III, V.P.; R.E. Herndon, Secy.-Treas.

Employer Identification Number: 586037237

597
Anncox Foundation, Inc.

c/o Cox Enterprises, Inc.

P.O. Box 105720

Atlanta 30302

Incorporated in 1960 in GA.

Donor(s): Anne Cox Chambers.

Financial data (yr. ended 12/31/86): Assets, $4,151 (M); gifts received, $239,862; expenditures, $237,754, including $237,720 for 12 grants (high: $71,000; low: $2,000).

Purpose and activities: Emphasis on educational associations, museums, animal care programs, and cultural programs.

Limitations: Giving primarily in GA.

Officers and Directors: Anne Cox Chambers, Pres. and Treas.; James Cox Chambers, V.P. and Secy.

Employer Identification Number: 586033966

598
Arnold Fund

1200 C & S National Bank Bldg.

35 Broad St.

Atlanta 30335　　　　　　(404) 586-1500

Established in 1952 in GA.

Donor(s): Florence Arnold.

Financial data (yr. ended 12/31/87): Assets, $2,932,666 (M); expenditures, $140,365, including $115,900 for 11 grants (high: $31,400; low: $1,000).

Purpose and activities: Funds primarily for education; some support for music.

Limitations: Giving primarily in GA.

Application information:

Initial approach: Letter

Deadline(s): None

Write: Arthur Howell, Exec. Dir.

Officer: Arthur Howell, Exec. Dir.

Trustees: Miriam A. Newman, Frank Turner.

Employer Identification Number: 586032079

599
Metropolitan Atlanta Community Foundation, Inc.

The Hurt Bldg., Suite 449

Atlanta 30303　　　　　　(404) 688-5525

Community foundation incorporated in 1977 as successor to Metropolitan Foundation of Atlanta established in 1951 in GA by bank resolution and declaration of trust.

Financial data (yr. ended 6/30/87): Assets, $68,019,271 (M); gifts received, $8,883,508; expenditures, $11,009,389, including $10,223,081 for grants (high: $1,000,000; low: $50; average: $3,000-$5,000).

Purpose and activities: Organized for the permanent administration of funds placed in trust by various donors for charitable purposes. Grants, unless designated by the donor, are confined to the metropolitan area of Atlanta, with emphasis on social services, arts and culture, education, health, and civic purposes.

Types of support: Seed money, emergency funds, building funds, equipment, land acquisition, technical assistance, program-related investments, special projects, publications, capital campaigns, matching funds, renovation projects.

Limitations: Giving limited to the metropolitan area of Atlanta, GA, and surrounding regions. No support for religious organizations (except through donor-advised funds). No grants to individuals, or for endowment funds, continuing support, annual campaigns, deficit financing, research, films, conferences, scholarships, or fellowships; generally no grants for operating budgets or for loans.

Publications: Annual report, program policy statement, application guidelines.

Application information: Application form required.

Initial approach: Letter or telephone

Copies of proposal: 1

Deadline(s): June 1, Sept. 1, Dec. 1, and Mar. 1

Board meeting date(s): July, Oct., Jan., and Apr.

Final notification: 6 weeks

Write: Alicia Philipp, Exec. Dir.

Officers: L.L. Gellerstedt, Jr.,* Pres.; Alicia Philipp, Exec. Dir.

Directors:* Arthur C. Baxter, Howard Ector, Susie Elson, Alston Glenn, Victor A. Gregory, J. Robin Harris, George Lanier, D. Lurton Massee, Jr., William McClatchey, M.D., Enoch Prow, Felker W. Ward, Jr.

Trustees: The Bank of the South, Citizens & Southern National Bank, First American Bank, The First National Bank of Atlanta, Trust Co. Bank.

Number of staff: 3 full-time professional; 1 full-time support; 1 part-time support.

Employer Identification Number: 581344646

Recent arts and culture grants:

Academy Theater, Atlanta, GA, $2,560,826. 1987.

Academy Theater, Atlanta, GA, $18,567. To assist in move to new facility, production of public relations materials and for existing programs. 1987.

Atlanta Ballet, Atlanta, GA, $24,500. 1987.

Atlanta Botanical Garden, Atlanta, GA, $6,600. 1987.

Atlanta Historical Society, Atlanta, GA, $33,948. 1987.

Atlanta Preservation Center, Atlanta, GA, $10,000. To assist in development of Atlanta preservation plan. 1987.

Atlanta Symphony Orchestra, Atlanta, GA, $52,950. 1987.

Center for Puppetry Arts, Atlanta, GA, $5,000. To assist in purchasing Center's facility and for facility improvements. 1987.

Center for Puppetry Arts, Atlanta, GA, $5,000. 1987.

Forward Arts Foundation, Atlanta, GA, $17,000. 1987.

Friends of Zoo Atlanta, Atlanta, GA, $7,785. 1987.

Friends of Zoo Atlanta, Atlanta, GA, $5,000. Toward Zoo Atlanta. 1987.

Georgia Artists International Exhibition Fund, Atlanta, GA, $7,769. 1987.

Georgia Trust for Historic Preservation, Atlanta, GA, $8,600. 1987.

Georgia Trust for Historic Preservation, Atlanta, GA, $5,000. Toward study on potential of Margaret Mitchell Museum in Atlanta. 1987.

High Museum of Art, Atlanta, GA, $7,330. 1987.

Image Film/Video, Atlanta, GA, $5,000. 1987.

New Group/Georgia Artists Fund, Atlanta, GA, $9,693. For expenses. 1987.

Quilan Arts, Atlanta, GA, $50,000. 1987.

Southeastern Academy of Theater and Music, Atlanta, GA, $5,000. 1987.

600
Atlanta Foundation

c/o The First National Bank of Atlanta

P.O. Box 4148, MC 705

Atlanta 30383　　　　　　(404) 332-6677

Community foundation established in 1921 in GA by bank resolution and declaration of trust.

Financial data (yr. ended 12/31/87): Assets, $6,415,855 (M); gifts received, $64,165; expenditures, $442,224, including $397,815 for 61 grants (high: $40,315; low: $1,000; average: $5,000).

Purpose and activities: Assistance to charitable and educational institutions for

promoting education and scientific research and improving local living conditions. Grants chiefly for community funds, hospitals, education, including higher education, cultural programs, and youth agencies.

Types of support: Research, general purposes, seed money, emergency funds, building funds, equipment, land acquisition, endowment funds, renovation projects, special projects.

Limitations: Giving limited to Fulton and De Kalb counties, GA. No grants to individuals, or for scholarships, or fellowships; no loans.

Application information:
Initial approach: Letter
Copies of proposal: 1
Deadline(s): Dec. 1
Board meeting date(s): Jan.
Final notification: 1 week
Write: Beverly Blake, Secy.

Officers and Distribution Committee: McChesney H. Jeffries, Chair.; Beverly Blake, Secy.; Thomas E. Boland, Shirley C. Franklin, Edward C. Harris, D. Raymond Riddle.

Trustee: The First National Bank of Atlanta.

Number of staff: None.

Employer Identification Number: 586026879

601
Atlanta Journal and Constitution Corporate Giving Program
72 Marietta St., N.W.
Atlanta 30303 (404) 526-5091

Purpose and activities: Emphasis on culture and the arts, education, literacy, social services, civic affairs, and minorities.

Types of support: Annual campaigns, capital campaigns, continuing support, endowment funds, special projects.

Limitations: Giving primarily in metropolitan Atlanta, GA, area.

Application information:
Initial approach: Letter of inquiry
Copies of proposal: 1
Write: Alexis Scott Reeves, V.P., Comm. Affairs

602
BellSouth Corporate Giving Program
1155 Peachtree St., N.E., Room 15H09
Atlanta 30367-6000 (404) 249-2397

Purpose and activities: Supports civic, minority, health, youth, and urban programs and education, including private colleges and teacher recruitment. Also gives to fine arts institutes, economic development, and the United Way.

Types of support: Conferences and seminars, employee matching gifts, general purposes, professorships, program-related investments, employee-related scholarships.

Limitations: No support for political organizations or campaigns, veterans', or fraternal organizations, labor unions, denominational or sectarian religious groups, national or international organizations with limited relationships to corporate priorities.

Application information: Include description of organization and funding request, financial reports, budget information, 501(c)(3) status,

financial practices and fund-raising strategies and activities.
Initial approach: Letter of inquiry
Copies of proposal: 1
Write: Patricia L. Willis, Exec. Dir., Bellsouth Foundation

603
Bradley-Turner Foundation
P.O. Box 140
Columbus 31902 (404) 571-6040

Incorporated in 1943 in GA as W.C. and Sarah H. Bradley Foundation; in 1982 absorbed the D.A. and Elizabeth Turner Foundation, Inc., also of GA.

Donor(s): W.C. Bradley,† D.A. Turner, Elizabeth B. Turner.†

Financial data (yr. ended 12/31/87): Assets, $37,031,428 (M); gifts received, $282,940; expenditures, $2,484,534, including $2,310,516 for 33 grants (high: $1,250,000; low: $400; average: $2,000-$65,000).

Purpose and activities: Giving primarily for higher education, religious associations, a community fund, youth and social service agencies; support also for cultural and health-related programs.

Limitations: Giving primarily in GA, with emphasis on Columbus. No grants to individuals.

Application information:
Initial approach: Letter
Copies of proposal: 2
Deadline(s): None
Board meeting date(s): Quarterly
Final notification: Varies
Write: Stephen T. Butler, Chair.

Officers and Trustees: Stephen T. Butler, Chair.; Lovick P. Corn, Vice-Chair.; R. Neal Gregory, Exec. Secy.; William B. Turner, Treas.; Clarence C. Butler, M.D., Sarah T. Butler, Elizabeth T. Corn, Elizabeth C. Ogie, Sue T. Turner, William B. Turner, Jr.

Number of staff: None.

Employer Identification Number: 586032142

604
Callaway Foundation, Inc.
209 Broome St.
P.O. Box 790
LaGrange 30241 (404) 884-7348

Incorporated in 1943 in GA.

Donor(s): Textile Benefit Association, Callaway Mills, Callaway Institute, Inc.

Financial data (yr. ended 9/30/88): Assets, $136,251,210 (M); expenditures, $6,623,013, including $6,024,098 for 73 grants (high: $1,133,800; low: $200; average: $1,000-$100,000).

Purpose and activities: Giving for education, including buildings and equipment, elementary and secondary schools, libraries, hospitals, community funds, care for the aged, and church support.

Types of support: Continuing support, annual campaigns, general purposes, building funds, equipment, land acquisition, matching funds.

Limitations: Giving primarily in GA, with emphasis on the city of LaGrange and Troup County. No grants to individuals, or for

endowment funds, operating expenses, deficit financing, scholarships, or fellowships; no loans.

Publications: Annual report (including application guidelines).

Application information:
Initial approach: Letter
Copies of proposal: 1
Deadline(s): End of month preceding board meetings
Board meeting date(s): Jan., Apr., July, and Oct.
Final notification: 2 months
Write: J.T. Gresham, Pres.

Officers: J.T. Gresham, Pres., General Mgr., and Treas.; Charles D. Hudson,* V.P.; C.L. Pitts, Secy.

Trustees:* Mark Clayton Callaway, Ida Callaway Hudson, James R. Lewis, Fred L. Turner.

Number of staff: 2 part-time professional; 3 part-time support.

Employer Identification Number: 580566147

Recent arts and culture grants:

Chattahoochee Valley Art Association, La Grange, GA, $23,000. For operations. 1987.

Chattahoochee Valley Art Association, La Grange, GA, $5,000. For Purchase Award Program. 1987.

Columbus Museum, Columbus, GA, $100,000. For construction and rehabilitation project. 1987.

La Grange College, La Grange, GA, $5,000. For Art Purchase Award Program. 1987.

Troup County Historical Society, La Grange, GA, $27,500. Toward operations. 1987.

Troup County Historical Society, La Grange, GA, $17,810. For heating and air conditioning system improvements. 1987.

Troup County Historical Society, La Grange, GA, $10,955. For Archival Program for local government records. 1987.

Zoological Society of Atlanta, Atlanta, GA, $100,000. For Zoo Revitalization Project. 1987.

605
J. Bulow Campbell Foundation
1401 Trust Company Tower
25 Park Place, N.E.
Atlanta 30303 (404) 658-9066

Trust established in 1940 in GA.

Donor(s): J. Bulow Campbell.†

Financial data (yr. ended 12/31/87): Assets, $89,130,308 (M); expenditures, $5,922,458, including $5,417,257 for grants (high: $750,000; low: $55,000; average: $100,000-$200,000).

Purpose and activities: Broad purposes "including but not limited to privately-supported education, human welfare, youth development, the arts, church-related agencies and agencies of the Presbyterian Church (not congregations) operating within the Foundation's giving area. Concern for improving quality of spiritual and intellectual life, with priority to private agencies undertaking work of regional importance, preferably projects of permanent nature or for capital funds. Gives anonymously and requests no publicity."

Types of support: Building funds, endowment funds, equipment, land acquisition, matching funds, renovation projects, capital campaigns.
Limitations: Giving primarily in GA; very limited giving in AL, FL, NC, SC, and TN. No support for local church congregations. No grants to individuals, or for research, scholarships, fellowships, special projects, operating budgets, or recurring items; no loans.
Publications: Informational brochure (including application guidelines).
Application information: Submit 1-page proposal, 3 copies of tax information.
　Initial approach: Letter or telephone
　Copies of proposal: 1
　Deadline(s): Jan. 15, Apr. 15, July 15, and Oct. 15
　Board meeting date(s): Jan., Apr., July, and Oct.
　Final notification: Within 1 week after board meets
　Write: John W. Stephenson, Exec. Dir.
Officer: John W. Stephenson, Exec. Dir.
Trustees: William A. Parker, Jr., Chair.; Richard W. Courts II, Vice-Chair.; John B. Ellis, Langdon S. Flowers, Mark P. Pentecost, Jr., M.D., Rev. J. Davidson Philips, Lawrence B. Teague.
Number of staff: 1 full-time professional; 1 full-time support.
Employer Identification Number: 580566149
Recent arts and culture grants:
Atlanta Botanical Garden, Atlanta, GA, $500,000. For endowment. 7/25/88.
Joel Chandler Harris Association, Wrens Nest, Atlanta, GA, $100,000. For major renovation of facilities. 4/25/88.
Thomasville Cultural Center, Thomasville, GA, $100,000. For major renovation of facilities. 4/25/88.

606
Thalia & Michael C. Carlos Foundation, Inc.

One National Dr., S.W.
Atlanta 30336

Established in 1980 in GA.
Donor(s): National Distributing Co., Inc., Bay Distributors, Inc., NDC Distributors, Inc., and others.
Financial data (yr. ended 12/31/87): Assets, $244,457 (M); gifts received, $762,550; expenditures, $345,149, including $330,480 for 15 grants (high: $122,730; low: $100).
Purpose and activities: Support primarily for cultural programs, churches, and higher education.
Officers: Michael C. Carlos, Pres. and Treas.; Thalia Carlos, Secy.
Employer Identification Number: 581410420

607
CB&T Charitable Trust

(also known as Columbus Bank & Trust Company Charitable Trust)
P.O. Box 120
Columbus 31902　　　　　(404) 649-2242

Established in 1969.
Donor(s): Columbus Bank and Trust Co.
Financial data (yr. ended 12/31/87): Assets, $156,752 (M); gifts received, $403,150; expenditures, $399,351, including $398,836 for 45 grants (high: $75,000; low: $25).
Purpose and activities: Emphasis on youth agencies and education, including higher education, museums, health associations, a community fund, and a library.
Limitations: Giving primarily in the Columbus, GA, area.
Application information:
　Write: Clifford J. Swift, III, V.P., CB&T Charitable Trust
Manager: Clifford J. Swift III, V.P. and Trust Officer.
Trustees: James H. Blanchard, William B. Turner, James D. Yancey.
Employer Identification Number: 237024198

608
The Chatham Foundation

P.O. Box 339
Savannah 31402

Trust established in 1953 in GA.
Donor(s): Savannah Foods & Industries, Inc.
Financial data (yr. ended 11/30/88): Assets, $4,826,978 (M); expenditures, $247,328, including $223,417 for 35 grants (high: $45,000; low: $200).
Purpose and activities: Support primarily for community funds, higher education, and cultural programs.
Limitations: Giving primarily in Savannah, GA.
Application information: Contributes only to pre-selected organizations. Applications not accepted.
Trustees: Walter C. Scott, John E. Simpson, William W. Sprague, Jr., W.R. Steinhauer.
Corporate Trustee: The C & S National Bank.
Employer Identification Number: 586033047

609
The Chatham Valley Foundation, Inc.

1100 Citizens and Southern National Bank Bldg.
Atlanta 30335　　　　　(404) 572-6605

Incorporated in 1962 in GA.
Donor(s): A.J. Weinberg,† Elliott Goldstein, W.B. Schwartz, Arthur Jay Schwartz, Robert C. Schwartz.
Financial data (yr. ended 7/31/88): Assets, $8,570,151 (M); gifts received, $38,250; expenditures, $518,263, including $449,914 for 208 grants (high: $80,000; low: $25).
Purpose and activities: Giving for a local Jewish welfare federation and other Jewish organizations, and broad support for local charitable, educational, cultural and civic activities.
Types of support: Annual campaigns, building funds, capital campaigns.
Limitations: Giving primarily in the metropolitan Atlanta, GA, area.
Application information:
　Board meeting date(s): Semiannually
　Write: Elliott Goldstein, Secy.
Officers and Trustees: W.B. Schwartz, Jr., Chair.; Harriet Goldstein, Vice-Chair.; Sonia Schwartz, Vice-Chair.; Elliott Goldstein, Secy.-Treas.; Lillian Friedlander, Arthur Jay Schwartz.
Number of staff: 1 part-time support.
Employer Identification Number: 586039344

610
The Citizens and Southern Fund

c/o Citizens & Southern National Bank
P.O. Box 4899
Atlanta 30302-4899　　　　(404) 581-2496

Trust established in 1956 in GA.
Donor(s): Citizens & Southern National Bank.
Financial data (yr. ended 12/31/87): Assets, $1,000,000 (M); expenditures, $1,500,000, including $1,300,000 for 90 grants and $50,000 for employee matching gifts.
Purpose and activities: Support for education, civic affairs, and art and culture; health and welfare supported through the United Way.
Types of support: Employee matching gifts, annual campaigns, building funds, capital campaigns, seed money.
Limitations: Giving limited to GA, particularly in communities in which the bank operates. No grants to individuals, or for endowment funds.
Publications: Program policy statement, application guidelines.
Application information:
　Initial approach: Letter
　Copies of proposal: 1
　Deadline(s): Sept.
　Board meeting date(s): Quarterly
　Final notification: Within 3 months
　Write: Kirby Thompson, Secy.
Officers and Distribution Committee: Enoch J. Prow, Managing Trustee; Kirby Thompson, Secy.-Treas.; Willard A. Alexander, Bennett A. Brown, Hugh M. Chapman, Henry A. Collingsworth, James D. Dixon, John W. McIntyre.
Number of staff: 2 full-time professional.
Employer Identification Number: 586025583

611
The Coca-Cola Foundation

One Coca-Cola Plaza
Atlanta 30313　　　　　(404) 676-2568

Established in 1984 in GA.
Donor(s): Coca-Cola Co.
Financial data (yr. ended 12/31/87): Assets, $8,172,658 (M); gifts received, $5,628,464; expenditures, $3,673,126, including $3,666,464 for 157 grants (high: $371,031; low: $200; average: $2,500-$50,000) and $500,000 for 1 loan.
Purpose and activities: Emphasis on education, arts and cultural programs, health and wellness, civic and community affairs, and social services, including community funds.
Types of support: Annual campaigns, scholarship funds, continuing support, operating budgets, program-related investments, special projects.
Limitations: Giving primarily in Atlanta, GA, Houston, TX, New York, NY, and Los Angeles, CA. No support for religious organizations or religious endeavors, political or veterans' organizations, hospitals, local chapters of national organizations, or legislative or lobbying efforts. No grants to individuals, or for workshops, travel costs, conferences or seminars, building or endowment funds, operating budgets, charitable dinners, or fundraising events and related advertising

publications, equipment, or land acquisition; generally, no loans.
Publications: Annual report, application guidelines, informational brochure (including application guidelines).
Application information:
Initial approach: Proposal
Deadline(s): None
Board meeting date(s): Feb., May, July, and Nov.
Final notification: 90 to 120 days
Write: Donald R. Greene, Pres.
Officers and Directors: Carl Ware, Chair.; Donald R. Greene, Pres.; Joseph W. Jones, Secy.; Jack L. Stahl, Treas.; William W. Allison, Michelle Beale, Lawrence Coward, Bruce Kirkman.
Number of staff: 7
Employer Identification Number: 581574705

612
Community Welfare Association of Colquitt County
P.O. Box 460
Moultrie 31776

Established in 1937 in GA.
Donor(s): Lottie T. Vereen,† W.C. Vereen Trust.
Financial data (yr. ended 12/31/86): Assets, $1,956,534 (M); expenditures, $99,731, including $88,669 for 71 grants (high: $15,000; low: $25) and $3,333 for 4 grants to individuals.
Purpose and activities: Grants for education, particularly higher education, including scholarships to individuals, social service and youth programs, culture, and denominational giving.
Types of support: Student aid.
Trustees: T.J. Vereen, W.C. Vereen, Jr., W.J. Vereen.
Employer Identification Number: 586032259

613
Contel Corporate Giving Program
245 Perimeter Center Pkwy.
P.O. BOx 105194
Atlanta 30348 (404) 391-8267
Additional tel: (404) 391-8287

Financial data (yr. ended 12/31/88): Total giving, $1,850,000, including $1,610,000 for 3,500 grants (high: $10,000; low: $25; average: $5,000-$10,000), $105,000 for 125 grants to individuals and $135,000 for 157 in-kind gifts.
Purpose and activities: Supports health, education, and social services including the United Way and programs for children and youth. Also supports cultural and arts programs and civic, community, and urban affairs.
Types of support: Employee matching gifts, annual campaigns, building funds, capital campaigns, continuing support, equipment, general purposes, operating budgets, matching funds, employee-related scholarships, seed money, special projects.
Limitations: Giving primarily in rural communities in company-operating areas in 1800 communities in 30 states, and in Atlanta, GA (corporate headquarters) and Washington, D.C. No support for religious organizations

whose programs benefit only their own members, or to fraternal, political, or veterans' organizations. No grants to individuals.
Publications: Informational brochure.
Application information: Include organization description, project description including goals and objectives and budget, list of other corporate support, audited financial report and 501(c)(3).
Initial approach: Full proposal
Copies of proposal: 1
Deadline(s): None
Board meeting date(s): As needed (at least quarterly)
Write: Dixie Purvis, Dir., Community Affairs
Number of staff: 1 full-time professional; 3 part-time professional; 4 full-time support.

614
Cox Enterprises Corporate Giving Program
1400 Lake Hearn Dr.
P.O. Box 105357
Atlanta 30348 (404) 843-5123

Purpose and activities: Supports education including private colleges, civic affairs, media and journalism programs, minority and youth programs, arts and culture, and social science and health programs. Also supports the United Way. Types of support include scholarships.
Types of support: Scholarship funds, operating budgets.
Limitations: Giving primarily in the metropolitan Atlanta, GA, area.
Application information:
Initial approach: Letter of inquiry
Write: Lynda J. Stewart, Dir., Communications

615
The James M. Cox Foundation of Georgia, Inc.
c/o Cox Newspapers
P.O. Box 105720
Atlanta 30348 (404) 843-7912

Incorporated in 1957 in GA.
Donor(s): Atlanta Newspapers, Inc., Cox Enterprises, Inc.
Financial data (yr. ended 12/31/88): Assets, $5,749,026 (M); gifts received, $700,000; expenditures, $655,082, including $642,000 for 37 grants (high: $150,000; low: $2,000).
Purpose and activities: Giving primarily for higher education, hospitals, and the arts.
Types of support: Building funds, capital campaigns, continuing support, endowment funds, renovation projects, research, special projects.
Limitations: Giving limited to areas of company operations. No grants to individuals.
Application information: Applicant should have support of local corporate office for grant requested.
Initial approach: Proposal
Copies of proposal: 1
Deadline(s): None
Board meeting date(s): Quarterly
Write: Leigh Ann Korns
Officers and Trustees:* Barbara Cox Anthony,* Chair.; Anne Cox Chambers,* Pres.;

James A. Hatcher, Secy.; John G. Boyette, Treas.; Carl R. Gross, James C. Kennedy.
Number of staff: 1
Employer Identification Number: 586032469

616
The Davis Foundation, Inc.
One National Dr.
Atlanta 30336

Established in 1960.
Donor(s): Raleigh Linen Service, Inc., National Distributing Co., Inc., and subsidiaries, Truck Rental Co., Alfred M. Davis, ADP Rental Co., Servitex, Inc.
Financial data (yr. ended 7/31/88): Assets, $111,368 (M); gifts received, $475,000; expenditures, $822,049, including $819,970 for 24 grants (high: $401,000; low: $95).
Purpose and activities: Grants primarily for Jewish welfare funds and temple support in the Atlanta area and for higher education; support also for cultural programs and health services.
Limitations: Giving primarily in Atlanta, GA.
Application information:
Initial approach: Proposal
Deadline(s): None
Write: Alfred A. Davis, Pres.
Officers: Alfred A. Davis, Pres.; Jay M. Davis, V.P.
Employer Identification Number: 586035088

617
The Florence C. and Harry L. English Memorial Fund
P.O. Box 4418, MC 041
Atlanta 30302 (404) 588-8246

Established in 1964 in GA.
Donor(s): Florence Cruft English.†
Financial data (yr. ended 12/31/87): Assets, $6,718,271 (M); gifts received, $493,550; expenditures, $373,073, including $327,528 for 99 grants (high: $75,000; low: $3,333; average: $3,000-$5,000).
Purpose and activities: Grants only for education, health, general welfare, and culture, with emphasis on assisting the aged and chronically ill, the blind, and those persons generally designated as the "underprivileged."
Types of support: Renovation projects, equipment, special projects.
Limitations: Giving limited to the metropolitan Atlanta, GA, area, including Fulton and DeKalb counties. No support for veterans' or political organizations, or organizations which have not been operating without a deficit for at least a year. No grants to individuals; no loans.
Publications: Program policy statement, application guidelines.
Application information: Application form required.
Initial approach: Telephone or letter
Copies of proposal: 1
Deadline(s): 1st of month preceding month in which board meeting will be held
Board meeting date(s): Jan., Apr., July, and Oct.
Write: Victor A. Gregory, Secy.
Distribution Committee: Robert Strickland, Chair.; Victor A. Gregory, Secy.; Jesse S. Hall, L.P. Humann.

Trustee: Trust Co. Bank.
Number of staff: 1 full-time professional; 1 full-time support.
Employer Identification Number: 586045781

618

Equifax Foundation
c/o Equifax Inc.
1600 Peachtree St., N.W.
Atlanta 30309 (404) 885-8000
Mailing address: P.O. Box 4081, Atlanta, GA 30302

Trust established in 1978 in GA.
Donor(s): Equifax, Inc.
Financial data (yr. ended 12/31/87): Assets, $15,740 (L); gifts received, $595,000; expenditures, $591,000, including $591,000 for 84 grants (high: $205,000; low: $200; average: $500-$5,000).
Purpose and activities: Giving primarily for higher education, a community fund, and an arts alliance; support also for health and welfare organizations.
Types of support: Operating budgets, continuing support, annual campaigns, seed money, emergency funds, building funds, land acquisition, endowment funds, scholarship funds, special projects, research, conferences and seminars, renovation projects, capital campaigns, general purposes.
Limitations: Giving primarily in GA. No grants to individuals, or for deficit financing, fellowships, publications, matching gifts, or travel.
Application information:
 Initial approach: Proposal
 Copies of proposal: 1
 Deadline(s): None
 Board meeting date(s): Approximately every other month
 Final notification: 30 days
 Write: Nancy Golonka Rozier, Staff V.P., Corp. Public Affairs
Trustees: William N. Aitken, W. Lee Burge, Robert Strickland.
Number of staff: 2 part-time professional.
Employer Identification Number: 581296807

619

Lettie Pate Evans Foundation, Inc.
1400 Peachtree Center Tower
230 Peachtree St., N.W., Suite 1400
Atlanta 30303 (404) 522-6755

Incorporated in 1945 in GA.
Donor(s): Lettie Pate Evans,† Robert W. Woodruff.†
Financial data (yr. ended 12/31/88): Assets, $59,748,665 (M); expenditures, $3,105,074, including $3,014,000 for 21 grants (high: $1,000,000; low: $10,000; average: $15,000-$250,000).
Purpose and activities: Grants primarily for higher education; support also for educational institutions and social services. Preference is given to one-time capital projects of established private charitable organizations.
Types of support: Building funds, equipment, land acquisition, seed money, renovation projects, capital campaigns.

Limitations: Giving primarily in the Atlanta, GA, area. No grants to individuals, or generally for operating expenses, research, scholarships, fellowships, or matching gifts; no loans.
Publications: Application guidelines.
Application information:
 Initial approach: Letter of inquiry followed by proposal
 Copies of proposal: 1
 Deadline(s): First of Feb. and Sept.
 Board meeting date(s): Apr. and Nov.
 Final notification: 30 days after board meeting
 Write: Charles H. McTier, Pres.
Officers: Charles H. McTier, Pres.; P. Russell Hardin, Secy.
Trustees: J.W. Jones, Chair.; Hughes Spalding, Jr., Vice-Chair.; Roberto C. Goizueta, James M. Sibley, James B. Williams.
Number of staff: 7
Employer Identification Number: 586004644
Recent arts and culture grants:
Atlanta Landmarks, Fox Theater Building, Atlanta, GA, $50,000. Toward completion of campaign to Fix the Fox Theater. 1987.
Georgia Trust for Historic Preservation, Atlanta, GA, $100,000. Toward renovation of Rhodes Hall, one of Georgia's finest examples of Romanesque architecture which houses agency's headquarters. 1987.
Holy Innocents Episcopal School, Atlanta, GA, $100,000. Toward constructing Fine Arts Center at school serving students from pre-school to eighth grade. 1987.
Lightfoot Films, Atlanta, GA, $20,000. Toward producing documentary film, Ralph McGill and His Times, to be used for public and classroom educational purposes. 1987.
Robert W. Woodruff Arts Center, Atlanta, GA, $865,000. Toward Memorial Arts Building renovations. 1987.

620

Exposition Foundation, Inc.
2970 Peachtree Rd., Suite 820
Atlanta 30305

Incorporated in 1950 in GA.
Financial data (yr. ended 8/31/87): Assets, $2,568,599 (M); expenditures, $124,087, including $108,468 for 40 grants (high: $20,000; low: $500).
Purpose and activities: Giving primarily for cultural programs, including a museum; support also for education.
Types of support: Annual campaigns, building funds, capital campaigns, equipment.
Limitations: Giving primarily in GA.
Officers and Trustees: Frances F. Cocke, Pres.; Jane C. Black, V.P.; C.T. Slade, Secy.-Treas.
Employer Identification Number: 586043273

621

First Atlanta Foundation, Inc.
c/o The First National Bank of Atlanta
P.O. Box 4148, MC 540
Atlanta 30302 (404) 332-5000

Incorporated in 1976.
Donor(s): First Atlanta Corp.

Financial data (yr. ended 12/31/88): Assets, $4,726,225 (M); gifts received, $902,134; expenditures, $793,997, including $708,246 for 153 grants (high: $100,000; low: $50) and $66,986 for 550 employee matching gifts.
Purpose and activities: Emphasis on higher education, community funds, arts and cultural programs, and youth agencies.
Types of support: Employee matching gifts.
Limitations: Giving primarily in the Atlanta, GA, area.
Officer and Directors: Thomas Boland,* Pres.; Arthur Baxter, Secy.-Treas.; George Atkins, D. Raymond Riddle.
Employer Identification Number: 581274979

622

The Lawrence & Alfred Fox Foundation, Inc.
3100 Equitable Bldg.
Atlanta 30303

Financial data (yr. ended 12/31/87): Assets, $1,141,900 (M); gifts received, $0; expenditures, $93,729, including $83,550 for 45 grants (high: $25,000; low: $100).
Purpose and activities: Support primarily for Jewish welfare; support also for museums and the arts, and for higher education.
Limitations: Giving primarily in GA.
Trustees: Ann Abrams, Edward M. Abrams, Louis Regenstein, Alene Uhry.
Number of staff: None.
Employer Identification Number: 586033168

623

John and Mary Franklin Foundation, Inc.
c/o Bank South, N.A.
P.O. Box 4956
Atlanta 30302 (404) 529-4614

Incorporated in 1955 in GA.
Donor(s): John Franklin, Mary O. Franklin.†
Financial data (yr. ended 12/31/86): Assets, $14,956,433 (M); expenditures, $885,918, including $794,300 for 104 grants (high: $65,000; low: $50).
Purpose and activities: Giving for higher and secondary education, youth agencies, hospitals, and cultural programs.
Types of support: General purposes, scholarship funds, building funds.
Limitations: Giving primarily in GA, with emphasis on the metropolitan Atlanta area; special types of grants awarded to institutions in adjoining states.
Publications: Annual report.
Application information:
 Initial approach: Letter
 Board meeting date(s): Jan. and July, and as needed
 Write: Robert B. Rountree, Treas.
Officers and Trustees: W. Kelly Mosley, Chair.; Virlyn B. Moore, Jr., Secy.; Robert B. Rountree, Treas.; George T. Duncan, Frank M. Malone, Marilu H. McCarty, L. Edmund Rast, Alexander W. Smith, Jr., William M. Suttles, Walter O. Walker.
Employer Identification Number: 586036131

624
Philip and Irene Toll Gage Foundation
P.O. Box 4446
Atlanta 30302 (404) 897-3222

Established in 1985 in GA.
Donor(s): Betty G. Holland.
Financial data (yr. ended 11/30/87): Assets, $3,652,337 (M); gifts received, $1,000; expenditures, $190,656, including $161,141 for 28 grants (high: $33,333; low: $100).
Purpose and activities: Support for education, culture, and hospitals and health services; grants also for religious giving.
Types of support: Annual campaigns, general purposes.
Limitations: Giving primarily in Atlanta, GA. No grants for endowment programs.
Publications: 990-PF.
Application information:
 Initial approach: Proposal
 Copies of proposal: 1
 Deadline(s): Submit proposals preferably in Aug. and Sept.; deadline is Oct. 15
 Board meeting date(s): Nov.
 Final notification: Within 1 week of annual meeting
 Write: Larry B. Hooks, Sr. V.P., Citizens & Southern Trust Co.
Officers: Betty G. Holland, Chair.; William J. Holland, Vice-Chair.; Larry B. Hooks, Secy.
Trustee: Citizens & Southern Trust Co.
Employer Identification Number: 581727394

625
Georgia Power Company Corporate Giving Program
333 Piedmont Ave.
Atlanta 30302 (404) 526-6784

Financial data (yr. ended 12/31/88): $687,815 for 1,433 grants (high: $10,000; low: $10).
Purpose and activities: Interests include health and health related fields, conservation, dance, drug abuse, education, museums, performing arts, fine arts, race relations, wildlife, social services, family services, historic preservation, literacy, medical education and research, mental health, and minorities.
Limitations: Giving primarily in the state of GA.
Publications: Informational brochure (including application guidelines).
Application information: Tax determination letter required.
 Initial approach: Letter
 Copies of proposal: 1
 Deadline(s): None
 Board meeting date(s): First week of each month
 Final notification: After board review
 Write: Judy Anderson, Corp. Secy.
Administrator: Risa Hammonds, Coord., Investor Relations.
Number of staff: 2 part-time professional; 1 part-time support.

626
Georgia Power Foundation, Inc.
333 Piedmont Ave., 20th Fl.
Atlanta 30308 (404) 526-6784

Established in 1986, in GA.
Financial data (yr. ended 12/31/88): Assets, $12,480,000 (M); expenditures, $2,156,358, including $2,122,949 for 226 grants (high: $652,832; low: $500; average: $1,000-$100,000).
Purpose and activities: Interests include the aged, AIDS, cancer, community development, race relations, education, family services, health, the homeless, rehabilitation, human rights, leadership development, legal services, libraries, medical research, museums, performing arts, theater, historic preservation, and fine arts.
Types of support: Annual campaigns, building funds, capital campaigns, conferences and seminars, endowment funds, equipment, operating budgets, renovation projects, research, scholarship funds, seed money, special projects, deficit financing.
Limitations: Giving primarily in GA. No grants for for private foundations.
Publications: Informational brochure (including application guidelines), 990-PF.
Application information: Tax determination letter must be included with requests.
 Initial approach: Letter with proposal
 Copies of proposal: 1
 Deadline(s): None
 Board meeting date(s): First week of each month
 Final notification: After board review
 Write: Judy M. Anderson, Exec. Dir.
Officers and Directors: Warren Y. Jobe, Pres.; Judy M. Anderson, Secy.-Treas. and Exec. Dir.; Fred W. Dement, Jr., Carl L. Donaldson, Dwight H. Evans, James W. George, Gene R. Hodges, Ross C. Kist III, Charles W. Whitney.
Number of staff: 2 part-time professional; 1 full-time support; 1 part-time support.
Employer Identification Number: 581709417

627
Georgia-Pacific Corporate Giving Program
133 Peachtree Street, N.E.
Atlanta 30303 (404) 521-5228

Purpose and activities: Supports cultural institutes, economic and job development, federated campaigns, environmental issues, general education and programs for minorities and youth.
Limitations: Giving primarily in headquarters city and major operating locations.
Application information:
 Write: Wayne I. Tamblyn, Pres.

628
Lenora and Alfred Glancy Foundation, Inc.
One Atlantic Center, Suite 4200
1201 West Peachtree St.
Atlanta 30309-3424 (404) 881-7000

Incorporated in 1954 in GA.
Donor(s): Alfred R. Glancy, Sr.†

Financial data (yr. ended 12/31/88): Assets, $4,669,978 (M); expenditures, $243,142, including $200,500 for 47 grants (high: $30,000; low: $500; average: $500-$30,000).
Purpose and activities: Support for higher and secondary education; grants also for hospitals, medical research, cultural programs, and community funds.
Types of support: Operating budgets, continuing support, annual campaigns, seed money, emergency funds, deficit financing, building funds, equipment, land acquisition, endowment funds, general purposes, capital campaigns, conferences and seminars, publications, renovation projects, research, special projects.
Limitations: Giving primarily in Atlanta, GA, and MI. No grants to individuals, or for scholarships or fellowships; no loans.
Publications: Application guidelines, 990-PF.
Application information:
 Initial approach: Letter or proposal
 Copies of proposal: 1
 Deadline(s): Submit proposal before end of Oct.; deadline Nov. 1
 Board meeting date(s): Nov. or Dec.
 Write: Benjamin T. White, Asst. Secy.
Officers and Directors: Gerry Hull, Chair.; A.R. Glancy III, Vice-Chair.; Christopher Brandon, Treas.
Number of staff: None.
Employer Identification Number: 586041425

629
W. B. Haley Foundation
c/o First State Bank and Trust Co.
333 Broad Ave., P.O. Box 8
Albany 31703 (912) 883-4800
Application address: 1612 Orchard Dr., Albany, GA 31707

Established in 1973 in GA.
Donor(s): W.B. Haley, Jr.†
Financial data (yr. ended 2/29/88): Assets, $2,056,157 (M); expenditures, $115,816, including $96,087 for 13 grants (high: $69,000; low: $500).
Purpose and activities: Emphasis on an art museum; giving also for social services.
Limitations: Giving primarily in Albany, GA.
Application information:
 Deadline(s): None
 Write: Eloise Haley, Pres.
Officers: Eloise Haley, Pres.; Stuart Watson, Secy.
Directors: Virginia Holman, Emily Jean H. McAfee, Joseph B. Powell, Jr., Harry Willson.
Trustee: First State Bank and Trust Co.
Employer Identification Number: 586113405

630
Walter Clay Hill and Family Foundation
c/o Trust Company Bank
P.O. Box 4655
Atlanta 30302

Trust established in 1967 in GA.
Donor(s): Rebecca Travers Hill.†
Financial data (yr. ended 8/31/88): Assets, $2,615,217 (M); expenditures, $291,331, including $264,833 for 24 grants (high: $60,000; low: $1,000).

Purpose and activities: Grants for the arts, museums, conservation, and Protestant church support; support also for higher education and an historical association.

Types of support: General purposes, operating budgets, continuing support, annual campaigns, seed money, emergency funds, deficit financing, building funds, equipment, land acquisition, endowment funds, special projects.

Limitations: Giving primarily in the Southeast, particularly in the Atlanta, GA, area. No grants to individuals, or for research, publications, conferences, scholarships and fellowships, or matching gifts; no loans.

Publications: Application guidelines.

Application information:
Initial approach: Proposal
Copies of proposal: 1
Deadline(s): Submit proposal preferably from Jan. through June; no set deadline
Board meeting date(s): July or Oct.
Final notification: Immediately after annual meeting if decision is positive
Write: Mary Simmons, Trust Officer, Trust Co. Bank.

Trustees: Laura Hill Boland, Walter Clay Hill, Trust Co. Bank.

Number of staff: None.

Employer Identification Number: 586065956

631
Hollis Foundation, Inc.
P.O. Box 2707
Columbus 31902-2707

Established in 1960 in GA.

Financial data (yr. ended 12/31/87): Assets, $1,526,507 (M); expenditures, $58,955, including $57,750 for 34 grants (high: $10,000; low: $100).

Purpose and activities: Support for education, cultural institutions and general charitable giving.

Officers: Howell Hollis, Pres.; Mary H. Clark, V.P.; Howell Hollis III, Secy.; Dale H. Clark, Treas.

Employer Identification Number: 580870013

632
The Howell Fund, Inc.
c/o Trust Co. Bank
P.O. Box 4655
Atlanta 30302

Incorporated in 1951 in GA.

Donor(s): Margaret Carr Levings.

Financial data (yr. ended 12/31/86): Assets, $1,467,963 (M); expenditures, $65,785, including $56,500 for 23 grants (high: $6,000; low: $665).

Purpose and activities: Giving primarily for education, cultural programs, and health associations.

Types of support: Operating budgets.

Limitations: Giving limited to Atlanta, GA.

Application information:
Initial approach: Letter
Deadline(s): Oct. 15
Write: Dameron Black, III, Secy.

Trustee: Trust Co. Bank.

Officer and Directors: Dameron Black III, Secy.-Treas.; Clark Howell III, W. Barrett Howell, Margaret Carr Levings, Ray B. Wilhoit.

Employer Identification Number: 586026027

633
A. and M. L. Illges Memorial Foundation, Inc.
1224 Peacock Ave.
P.O. Box 103
Columbus 31902 (404) 323-5342

Incorporated in 1947 in GA.

Financial data (yr. ended 9/30/88): Assets, $2,953,318 (M); gifts received, $0; expenditures, $144,620, including $110,100 for 45 grants (high: $10,000; low: $100).

Purpose and activities: Emphasis on higher education, including scholarship funds, hospitals, church support, and cultural programs.

Types of support: Operating budgets, endowment funds.

Limitations: Giving primarily in GA.

Application information:
Deadline(s): None
Write: Howell Hollis, Pres.

Officers and Directors: Howell Hollis, Pres. and Treas.; J. Barnett Woodruff, V.P.; John P. Illges III, Secy.; Arthur I. Chenoweth, B.M. Chenoweth, Jr., Martha H. Heinz, A. Illges, Jr.

Employer Identification Number: 586033958

634
Mills Bee Lane Memorial Foundation, Inc.
c/o Citizens and Southern National Bank
P.O. Box 9626
Savannah 31402
Additional mailing address: P.O. Box 2364, Savannah, GA 31402

Incorporated in 1947 in GA.

Donor(s): Members of the Lane family.

Financial data (yr. ended 12/31/86): Assets, $8,399,272 (M); expenditures, $501,684, including $484,577 for 66 grants (high: $100,000).

Purpose and activities: Emphasis on higher and secondary education and cultural programs.

Types of support: Seed money, building funds, equipment, land acquisition, professorships, internships, scholarship funds, exchange programs, fellowships, matching funds, endowment funds.

Limitations: Giving primarily in the Savannah, GA, area. No grants to individuals, or for operating budgets; no loans.

Publications: Application guidelines.

Application information: Application form required.
Initial approach: Letter
Copies of proposal: 1
Deadline(s): Submit proposal in 3 month period prior to each board meeting; deadlines May 15 and Nov. 15
Board meeting date(s): June and Dec.
Final notification: 2 weeks after board meetings

Officers and Trustees: Hugh C. Lane, Jr., Chair.; Mills Lane Morrison, Secy.; Howard Jackson Morrison, Jr., Treas.

Number of staff: None.

Employer Identification Number: 586033043

635
The Ray M. and Mary Elizabeth Lee Foundation, Inc.
c/o Citizens & Southern Trust Co.
P.O. Box 4446
Atlanta 30302-4899 (404) 897-3222

Incorporated in 1966 in GA.

Donor(s): Ray M. Lee,† Mary Elizabeth Lee.†

Financial data (yr. ended 9/30/88): Assets, $7,121,459 (M); expenditures, $603,214, including $360,000 for 59 grants (high: $40,000; low: $1,000; average: $6,000).

Purpose and activities: Giving for educational institutions, health agencies, hospitals, Protestant church support, and the arts.

Types of support: Annual campaigns, building funds, capital campaigns, conferences and seminars, consulting services, continuing support, deficit financing, emergency funds, equipment, exchange programs, fellowships, general purposes, internships, land acquisition, lectureships, matching funds, operating budgets, professorships, program-related investments, publications, renovation projects, research, scholarship funds, seed money, special projects, technical assistance.

Limitations: Giving primarily in GA and the southeast. No grants to individuals.

Publications: 990-PF, financial statement, grants list.

Application information:
Initial approach: Proposal
Copies of proposal: 1
Deadline(s): Jan. 31, Apr. 30, July 31, Oct. 31
Board meeting date(s): As required
Final notification: Following board meeting
Write: Larry B. Hooks, Admin. Mgr.

Officers and Trustees: William B. Stark, Pres. and Treas.; Donald D. Smith, Secy.; Ronald W. Gann.

Number of staff: None.

Employer Identification Number: 586049441

636
Livingston Foundation, Inc.
55 Park Place, Suite 400
Atlanta 30335 (404) 577-5100
Application address: c/o Arnall, Golden & Gregory, Fulton Federal Bldg., 10th Fl., Atlanta, GA 30335

Incorporated in 1964 in GA.

Donor(s): Roy N. Livingston,† Mrs. Leslie Livingston Kellar,† Bess B. Livingston.†

Financial data (yr. ended 9/30/87): Assets, $7,340,242 (M); gifts received, $6,756; expenditures, $602,717, including $515,930 for 19 grants (high: $143,500; low: $1,000).

Purpose and activities: Emphasis on cultural organizations.

Types of support: Operating budgets, continuing support, annual campaigns.

Limitations: Giving primarily in the Atlanta, GA area. No grants to individuals, or for endowment funds, scholarships and fellowships, or matching gifts; no loans.

Application information:
Initial approach: Letter
Copies of proposal: 1
Deadline(s): None
Board meeting date(s): Quarterly

Final notification: 4 months
 Write: Ben W. Brannon, Pres.
Officers and Trustees: Ben W. Brannon, Pres.;
Sol I. Golden, Secy.; Ellis Arnall, Milton
Brannon, Jonathan Golden, C.E. Gregory III.
Number of staff: 1
Employer Identification Number: 586044858

637
Gay and Erskine Love Foundation Inc.
4335 Wendell Dr., S.W.
Atlanta 30378

Established in 1976 in GA.
Donor(s): Printpack, Inc.
Financial data (yr. ended 12/31/87): Assets,
$4,126,382 (M); gifts received, $396,122;
expenditures, $214,863, including $161,000
for 33 grants (high: $25,000; low: $500).
Purpose and activities: Giving primarily for
education, especially higher education, and
social service and youth agencies; support also
for community funds, and cultural programs.
Application information: Contributes only to
pre-selected organizations. Applications not
accepted.
Officers: Dennis M. Love, Pres.; Gay M. Love,
V.P.; R. Michael Hembree, Secy.-Treas.
Director: L. Neil Williams, Jr.
Employer Identification Number: 510198585

638
Lubo Fund, Inc.
3910 Randall Mill Rd., N.W.
Atlanta 30327

Incorporated in 1958 in GA.
Donor(s): Members of the Bunnen family.
Financial data (yr. ended 12/31/86): Assets,
$1,750,000 (M); expenditures, $93,000,
including $93,000 for 83 grants (high: $20,000;
low: $2,500; average: $50-$5,000) and
$20,000 for loans.
Purpose and activities: Giving for cultural
programs, including the performing and visual
arts; support also for education.
Types of support: General purposes, special
projects, publications, matching funds, annual
campaigns, continuing support, seed money,
emergency funds.
Limitations: Giving primarily in GA, with
emphasis on Atlanta. No grants to individuals,
or for land acquisition, renovation projects,
endowment funds, scholarships, fellowships,
research, or conferences; no loans.
Application information:
 Initial approach: Letter or proposal
 Copies of proposal: 1
 Deadline(s): None
 Board meeting date(s): July
 Final notification: 1 to 3 months
 Write: Lucinda W. Bunnen, Pres.
Officers: Lucinda W. Bunnen, Pres.; Robert L.
Bunnen, V.P. and Secy.; Robert L. Bunnen, Jr.,
Treas.
Number of staff: None.
Employer Identification Number: 586043631

639
Jeannette & Lafayette Montgomery Foundation, Inc.
480 East Paces Ferry Rd., N.E.
Atlanta 30305

Established in 1955 in GA.
Donor(s): Montgomery Foundation, Inc.
Financial data (yr. ended 12/31/87): Assets,
$1,575,674 (M); expenditures, $343,076,
including $325,889 for 50 grants (high:
$35,000; low: $100).
Purpose and activities: Giving primarily to
higher and secondary education, cultural
programs including historic preservation, social
service and youth agencies, and hospitals and
health associations.
Officers: Arthur L. Montgomery, Pres.; George
A. Montgomery, Exec. V.P.
Employer Identification Number: 586033520

640
James Starr Moore Memorial Foundation, Inc.
526 East Paces Ferry Rd., N.E.
Atlanta 30305 (404) 262-7134

Incorporated in 1953 in GA.
Financial data (yr. ended 12/31/88): Assets,
$7,896,759 (M); expenditures, $384,463,
including $240,400 for 66 grants (high:
$30,000; low: $100).
Purpose and activities: Emphasis on cultural
programs, higher education, Protestant church
support, hospitals, and health agencies.
Limitations: Giving primarily in GA. No grants
to individuals.
Application information: Applications not
accepted.
 Initial approach: Letter
 Write: James M. Henson, Treas.
Officers: James M. Henson, Secy.-Treas.
Trustees: Sara Giles Moore, Chair.; Monroe F.
Swilley, Jr., Vice-Chair.; Morton S. Hodgson,
Jr., Starr Moore.
Employer Identification Number: 586033190

641
Katherine John Murphy Foundation
P.O. Box 4655
Atlanta 30302 (404) 588-7356

Trust established in 1954 in GA.
Donor(s): Katherine M. Riley.
Financial data (yr. ended 12/31/87): Assets,
$4,385,995 (M); gifts received, $2,040,048;
expenditures, $310,461, including $282,600
for 23 grants (high: $100,000; low: $1,000).
Purpose and activities: Emphasis on hospitals,
cultural programs, health agencies, higher
education, youth agencies, and child welfare.
Types of support: Annual campaigns, building
funds, capital campaigns, equipment, general
purposes, renovation projects, continuing
support, operating budgets, seed money,
special projects.
Limitations: Giving primarily in Atlanta, GA.
No grants to individuals, or for research,
scholarships, fellowships, or matching gifts; no
loans.
Application information:
 Initial approach: Letter

Copies of proposal: 1
 Deadline(s): Mar. 31 and Sept. 30
 Board meeting date(s): Apr. and Oct. and as
 required
 Write: Brenda Rambeau, V.P., Trust Co. Bank
Managers: Dameron Black, A.D. Boylston, Jr.,
Martin Gatins.
Trustee: Trust Co. Bank.
Employer Identification Number: 586026045

642
National Service Foundation
1180 Peachtree St., N.E.
Atlanta 30309

Established about 1969.
Financial data (yr. ended 8/31/88): Assets,
$2,073 (M); expenditures, $225,551, including
$225,139 for 112 grants (high: $59,500; low:
$25).
Purpose and activities: Support for culture,
education, community funds, and health; some
support for social services and Jewish
organizations.
Limitations: Giving primarily in GA.
Application information: Contributes only to
preselected organizations. Applications not
accepted.
Trustees: Robert H. Creviston, Mgr.; Henry R.
Dressel, Jr., Sidney Kirschner, David Levy,
Erwin Zaban.
Employer Identification Number: 586051102

643
Oxford Foundation, Inc.
222 Piedmont Ave., N.E.
Atlanta 30308

Established in 1963 in GA.
Donor(s): Sartain Lanier.
Financial data (yr. ended 12/31/87): Assets,
$2,050,592 (M); gifts received, $20,071;
expenditures, $43,281, including $33,773 for
28 grants (high: $8,000; low: $25).
Purpose and activities: Support for
educational institutions and health and cultural
organizations.
Types of support: Operating budgets.
Limitations: Giving primarily in Atlanta, GA.
Application information:
 Write: Sartain Lanier, Chair.
Officers: Sartain Lanier, Chair. and Treas.; J.
Hicks Lanier, Vice Chair. and Secy.
Trustee: Mrs. George C. Blount.
Employer Identification Number: 586045056

644
Oxford Industries Foundation, Inc.
222 Piedmont Ave., N.E.
Atlanta 30308-3391

Financial data (yr. ended 12/31/86): Assets,
$876,631 (M); expenditures, $94,291,
including $93,334 for 73 grants (high: $13,500;
low: $25).
Purpose and activities: Support for health
associations, culture and the arts, youth and
welfare, higher education, and community and
social services.
Types of support: Operating budgets, general
purposes.

Application information:
Deadline(s): None
Write: Exec. Dir.
Officers and Trustees: J. Hicks Lanier, Chair. and Pres.; Jonathan M. Fee, Secy.; R. William Lee.
Employer Identification Number: 581209452

645
Piggly Wiggly Southern Foundation, Inc.
P.O. Box 569
Vidalia 30474

Donor(s): Piggly Wiggly Southern, Inc.
Financial data (yr. ended 6/30/87): Assets, $3,597 (M); gifts received, $54,110; expenditures, $52,215, including $52,215 for 86 grants (high: $9,000; low: $50).
Purpose and activities: Support for higher education and educational associations, cultural and civic programs, and welfare and social services.
Types of support: Capital campaigns, general purposes.
Application information:
Initial approach: Proposal
Deadline(s): None
Officers: James A. Bolonda, Chair.; Dent L. Temples, Secy.; Fisher L. Barfoot, Treas.
Employer Identification Number: 586035162

646
Pine Mountain Benevolent Foundation, Inc.
P. O. Box 2301
Columbus 31902

Incorporated in 1959 in GA.
Donor(s): Ida Cason Callaway Foundation.
Financial data (yr. ended 6/30/86): Assets, $1,460,967 (M); expenditures, $196,622, including $169,150 for 24 grants (high: $5,000; low: $100) and $3,150 for 4 grants to individuals.
Purpose and activities: Support for education and culture; some support for social services and assistance to worthy and needy individuals.
Types of support: Grants to individuals.
Limitations: Giving primarily in GA.
Directors: Cason J. Callaway, Jr., Cason J. Callaway III, Kenneth H. Callaway, Nancy H. Callaway, Virginia H. Callaway.
Employer Identification Number: 586033162

647
James Hyde Porter Testamentary Trust
c/o Trust Co. Bank of Middle Georgia
606 Cherry St., P.O. Box 4248
Macon 31208 (912) 741-2265

Trust established in 1949 in GA.
Donor(s): James Hyde Porter.†
Financial data (yr. ended 12/31/88): Assets, $5,995,177 (M); expenditures, $297,000, including $290,000 for 24 grants (high: $65,000; low: $1,000).
Purpose and activities: Emphasis on social services, civic affairs, cultural programs, higher education, and health agencies.
Types of support: Building funds, renovation projects, seed money.

Limitations: Giving limited to Bibb and Newton counties, GA. No grants to individuals, or for endowment funds, research programs, scholarships, or fellowships; no loans.
Publications: 990-PF, application guidelines.
Application information: Application form required.
Initial approach: Telephone
Copies of proposal: 7
Deadline(s): Submit proposal preferably in Mar.; deadline Apr. 20
Board meeting date(s): June
Write: Deanna D. Neely, Trust Officer, Trust Co. Bank of Middle Georgia
Managers: Rodney Browne, Emory Greene, Rabbi Jay Heyman, Kathy Kalish, Lee Robinson, Donald G. Stephenson.
Trustee: Trust Co. Bank of Middle Georgia, N.A.
Employer Identification Number: 586034882

648
The Rich Foundation, Inc.
P.O. Box 4539
Atlanta 30302 (404) 586-2488

Incorporated in 1942 in GA.
Donor(s): Rich's, Inc., and members of the Rich family.
Financial data (yr. ended 1/31/88): Assets, $16,774,003 (M); expenditures, $1,363,917, including $1,156,200 for 39 grants (high: $539,200; low: $1,000; average: $1,000-$30,000).
Purpose and activities: Giving primarily for a community fund, cultural programs, higher and secondary education, including private schools, social service and youth agencies, and hospitals.
Types of support: Annual campaigns, building funds, consulting services, continuing support, equipment, operating budgets, technical assistance, employee-related scholarships, research.
Limitations: Giving limited to Atlanta, GA, area. No grants to individuals, or for matching gifts; no loans.
Publications: Application guidelines.
Application information: Application form required.
Initial approach: Letter
Copies of proposal: 1
Deadline(s): Submit proposal 1 month prior to meetings
Board meeting date(s): Feb., May, Sept., and Nov.
Final notification: 2 weeks
Write: Anne Poland Berg, Grant Consultant
Officers and Trustees: Joel Goldberg, Pres.; Thomas J. Asher, V.P.; Michael P. Rich, Secy.-Treas.; Joseph F. Asher, David S. Baker, Harold Brockey, Joseph K. Heyman.
Number of staff: None.
Employer Identification Number: 586038037

649
Russell Charitable Trust
P.O. Box 1064
Decatur 30031 (404) 636-0367

Established in 1960 in ME.
Donor(s): H.M. Russell.

Financial data (yr. ended 7/31/87): Assets, $1,219,263 (M); gifts received, $5,623; expenditures, $303,082, including $272,600 for 14 grants (high: $200,000; low: $500).
Purpose and activities: Grants primarily to religious related institutions in higher education, specifically colleges and seminaries, medicine, media communications, and institutions serving youth and the elderly.
Types of support: Capital campaigns, endowment funds, general purposes, seed money.
Application information:
Deadline(s): None
Board meeting date(s): Quarterly
Final notification: Grants are made at the beginning of each calendar quarter
Write: Ernest J. Arnold, Trustee
Trustees: Ernest J. Arnold, Francis P. Arnold, Judy A. Moore.
Employer Identification Number: 016009882

650
Savannah Electric and Power Corporate Giving Program
600 Bay St. E.
P.O. Box 968
Savannah 31402 (912) 232-7171

Financial data (yr. ended 12/31/88): $118,230 for grants.
Purpose and activities: Interests include adult, higher, and business education, culture, historic preservation, conservation, wildlife, Jewish giving, child welfare, the homeless, race relations, and youth.
Types of support: Annual campaigns, building funds, capital campaigns, general purposes, operating budgets.
Limitations: Giving primarily in service area in GA.
Application information:
Write: E. Olin Yeale, Sr. V.P.

651
Simon Schwob Foundation, Inc.
P.O. Box 1014
Columbus 31902 (404) 327-4582

Incorporated in 1949 in GA.
Donor(s): Schwob Manufacturing Co., Schwob Realty Co., Schwob Co. of Florida.
Financial data (yr. ended 12/31/86): Assets, $2,871,626 (M); expenditures, $195,669, including $130,905 for 18 grants (high: $44,500; low: $100).
Purpose and activities: Giving for higher education, Jewish welfare funds, music, and community funds.
Limitations: Giving primarily in GA.
Application information:
Initial approach: Letter
Copies of proposal: 1
Deadline(s): None
Board meeting date(s): Semiannually
Officers and Trustees: Henry Schwob, Pres.; Joyce Schwob, V.P.; Hannah Harrison, Secy.-Treas.; Jane Beth Schwob, Simone Schwob.
Employer Identification Number: 586038932

652
Ships of the Sea, Inc.
501 East River St.
Savannah 31401

Established in 1965 in GA.
Financial data (yr. ended 12/31/87): Assets, $2,814,638 (M); gifts received, $2,550; expenditures, $340,226, including $149,429 for 2 grants (high: $146,929; low: $2,500).
Purpose and activities: Support for a historical museum.
Types of support: Renovation projects.
Limitations: Giving primarily in Savannah, GA.
Officers: Mills B. Lane, Chair. and Treas.; Anne W. Lane, Vice Chair.; Gladys B. Dodd, Secy.
Employer Identification Number: 580959654

653
The South Atlantic Foundation, Inc.
428 Bull St.
Savannah 31401 (912) 238-3288

Established in 1953 in GA.
Financial data (yr. ended 12/31/87): Assets, $1,300,000 (M); gifts received, $77,863; expenditures, $159,903, including $128,388 for 26 grants.
Purpose and activities: Support primarily for social services, welfare organizations, religious giving, health organizations, medical research, education and cultural programs.
Types of support: Annual campaigns, building funds, conferences and seminars, emergency funds, employee-related scholarships, equipment, endowment funds, land acquisition, operating budgets, professorships, program-related investments, publications, renovation projects, seed money.
Limitations: Giving primarily in GA, SC, and FL. No grants to individuals, or for continuing support, deficit financing, foundation managed projects, matching or challenge grants, program-related investments, operating support, or endowment funds.
Application information: Application form required.
 Initial approach: Telephone
 Deadline(s): Mar. 15 and Sept. 15
 Board meeting date(s): May and Nov.
 Write: William W. Byram, Jr., Dir.
Director: William W. Byram, Jr.
Number of staff: 1 full-time professional; 1 full-time support.
Employer Identification Number: 586033468

654
Kate and Elwyn Tomlinson Foundation, Inc.
3000 Habersham Rd., N.W.
Atlanta 30305

Incorporated in 1949 in GA.
Financial data (yr. ended 12/31/86): Assets, $2,270,303 (M); expenditures, $314,775, including $97,750 for 42 grants (high: $7,000; low: $400).
Purpose and activities: Emphasis on higher and secondary education, arts and culture, hospitals, health agencies, and a community fund.

Limitations: Giving primarily in GA.
Officers: Kathryn Bridges, Chair.; Mark P. Tomlinson, Vice-Chair.
Employer Identification Number: 580634727

655
Trust Company of Georgia Foundation
c/o Trust Co. Bank, Atlanta
P.O. Box 4418; MC 041
Atlanta 30302 (404) 588-8246

Trust established in 1959 in GA.
Donor(s): Trust Co. Bank.
Financial data (yr. ended 12/31/88): Assets, $7,710,363 (M); gifts received, $998,550; expenditures, $996,696, including $775,961 for grants (average: $3,000-$5,000) and $183,875 for employee matching gifts.
Purpose and activities: Emphasis on local community welfare, including a community fund; support also for youth agencies, secondary schools, cultural groups, and health services.
Types of support: Building funds, renovation projects, special projects, employee matching gifts, capital campaigns.
Limitations: Giving primarily in metropolitan Atlanta, GA (Fulton and DeKalb counties). No support for churches or political organizations. No grants to individuals, or for scholarships, fellowships, maintenance, or debt service; no loans.
Publications: Application guidelines, program policy statement.
Application information: Application form required.
 Initial approach: Letter or telephone
 Copies of proposal: 1
 Deadline(s): 1st of month preceding month of board meeting
 Board meeting date(s): Jan., Apr., July, and Oct.
 Final notification: By letter
 Write: Victor A. Gregory, Secy.
Distribution Committee: Robert Strickland, Chair.; Victor A. Gregory, Secy.; Jesse S. Hall, L.P. Humann, Wade T. Mitchell, John W. Spiegel, James B. Williams.
Trustee: Trust Co. Bank.
Number of staff: 1 full-time professional; 1 full-time support.
Employer Identification Number: 586026063

656
Gertrude and William C. Wardlaw Fund, Inc.
c/o Trust Co. Bank
P.O. Box 4655
Atlanta 30302
Application address: c/o Gertrude & W.C. Wardlaw Fund, Inc., P.O. Box 4655, Atlanta, GA 30302

Trust established in 1936 in GA; incorporated in 1951.
Donor(s): Gertrude Wardlaw, William C. Wardlaw, Jr.†
Financial data (yr. ended 12/31/87): Assets, $3,776,884 (M); expenditures, $189,108, including $165,400 for 46 grants (high: $17,500; low: $1,000).

Purpose and activities: Emphasis on higher education, youth agencies, cultural programs, a community fund and a hospital.
Types of support: Operating budgets.
Limitations: Giving primarily in Atlanta, GA.
Application information:
 Initial approach: Letter
 Deadline(s): None
Directors: Victor A. Gregory, A. Pickney Straughn, Ednabelle Raine Wardlaw, William C. Wardlaw III.
Trustee: Trust Co. Bank.
Employer Identification Number: 586026065

657
West Foundation
1491 Piedmont Ave., N.E.
Atlanta 30309

Financial data (yr. ended 12/31/86): Assets, $4,724,121 (M); expenditures, $121,001, including $55,863 for 18 grants (high: $10,000; low: $250).
Purpose and activities: Support for health organizations, cultural programs, and Protestant churches.
Officers and Directors: Charles B. West, Pres.; Charles B. West, Jr., V.P.; Elizabeth D. West, V.P.; G. Vincent West, V.P.; Marian T. West, V.P.; Marjorie E. West, V.P.; Mark C. West, V.P.; Robert Wynne, V.P.; Marjorie West Wynne, Secy.
Employer Identification Number: 586073270

658
Joseph B. Whitehead Foundation
1400 Peachtree Center Tower
230 Peachtree St., N.W.
Atlanta 30303 (404) 522-6755

Incorporated in 1937 in GA.
Donor(s): Joseph B. Whitehead, Jr.†
Financial data (yr. ended 12/31/88): Assets, $206,458,305 (M); expenditures, $10,175,587, including $9,920,000 for 47 grants (high: $2,500,000; low: $5,000; average: $15,000-$550,000).
Purpose and activities: Giving primarily for child care and youth programs, education, health, cultural programs, the arts, care of the aged, and civic affairs. Preference is given to one-time capital projects of established private charitable organizations.
Types of support: Seed money, building funds, equipment, land acquisition, special projects, capital campaigns.
Limitations: Giving limited to metropolitan Atlanta, GA. No grants to individuals, or for endowment funds, research, scholarships, fellowships, or matching gifts; no loans; generally no support for operating expenses.
Publications: Application guidelines, informational brochure (including application guidelines), program policy statement.
Application information:
 Initial approach: Letter
 Copies of proposal: 1
 Deadline(s): First of Feb. and Sept.
 Board meeting date(s): Apr. and Nov.
 Final notification: 30 days after board meeting
 Write: Charles H. McTier, Pres.

Officers: Charles H. McTier, Pres.; P. Russell
Hardin, Secy.
Trustees: J.W. Jones, Chair.; James M. Sibley,
Vice-Chair.; Roberto C. Goizueta.
Number of staff: 7
Employer Identification Number: 586001954
Recent arts and culture grants:
Atlanta Zoological Society, Atlanta Zoological
Park, Atlanta, GA, $1,000,000. Toward
revitalization plan for Zoo Atlanta. 1987.
Boys Clubs of Metro Atlanta, Atlanta, GA,
$10,000. Toward costs of hosting in Atlanta
participants in 1987 international youth
educational/cultural program. 1987.
Collections of Life and Heritage, Atlanta, GA,
$200,000. To purchase and renovate
building for black history museum and
cultural center. 1987.
Science and Technology Museum of Atlanta,
Atlanta, GA, $1,000,000. Toward
establishing science and technology museum
at Atlanta Civic Center Exhibition Hall. 1987.
Southeastern Academy of Theater and Music,
Academy Theater, Atlanta, GA, $100,000.
To offset extraordinary expenses involved in
move of Academy Theater to its new
location and to assist with operating
expenses of new facility beyond its normal
budget. 1987.

659
Lettie Pate Whitehead Foundation, Inc.
1400 Peachtree Center Tower
230 Peachtree St., N.W.
Atlanta 30303 (404) 522-6755

Incorporated in 1946 in GA.
Donor(s): Conkey Pate Whitehead.†
Financial data (yr. ended 12/31/88): Assets,
$153,305,082 (M); expenditures, $7,806,321,
including $7,500,000 for 191 grants (high:
$225,000; low: $6,000; average: $20,000-
$65,000).
Purpose and activities: Grants to institutions
for scholarships for the education of poor
Christian girls and institutional grants for
assistance to poor aged Christian women.
Types of support: Scholarship funds.
Limitations: Giving limited to AL, FL, GA, LA,
MS, NC, SC, TN, and VA. No grants to
individuals, or for building or endowment
funds, or matching gifts; no loans.
Publications: Application guidelines,
informational brochure.
Application information:
 Initial approach: Letter
 Copies of proposal: 1
 Deadline(s): Sept. 1
 Board meeting date(s): Apr. and Nov.
 Final notification: Within 1 year
 Write: Charles H. McTier, Pres.
Officers: Charles H. McTier, Pres.; P. Russell
Hardin, Secy.
Trustees: Hughes Spalding, Jr., Chair.; Herbert
A. Claiborne, Jr., M.D., Vice-Chair.; Lyons Gray.
Number of staff: 7
Employer Identification Number: 586012629
Recent arts and culture grants:
Atlanta College of Art, Atlanta, GA, $30,000.
For general scholarship support. 1987.
North Carolina School of the Arts Foundation,
Winston-Salem, NC, $45,000. For general
scholarship support. 1987.

Richmond Ballet, Richmond, VA, $20,000. For
general scholarship support. 1987.
Theater Virginia, Richmond, VA, $24,000. For
fellowships in theater arts. 1987.
Virginia Museum Foundation, Richmond, VA,
$25,000. For fellowships in fine arts. 1987.

660
**Marguerite N. & Thomas L. Williams,
Jr. Foundation, Inc.**
P.O. Box 378
Thomasville 31799

Established in 1980 in GA.
Donor(s): Diane W. Parker, Marguerite N.
Williams, Thomas L. Williams III, Bennie G.
Williams.†
Financial data (yr. ended 11/30/87): Assets,
$4,265,609 (M); gifts received, $75,087;
expenditures, $249,362, including $219,600
for 50 grants (high: $15,000; low: $100).
Purpose and activities: Support for cultural
activities and education; some support for
social services and health.
Officers and Directors: Marguerite N.
Williams, Pres.; Diane W. Parker, Secy.;
Bernard Lanigan, Jr., Treas.; Joseph E. Beverly,
Frederick E. Cooper, Thomas H. Vann, Jr.,
Thomas L. Williams III.
Employer Identification Number: 581414850

661
Robert W. Woodruff Foundation, Inc.
(Formerly Trebor Foundation, Inc.)
1400 Peachtree Center Tower
230 Peachtree St., N.W.
Atlanta 30303 (404) 522-6755

Incorporated in 1937 in DE.
Donor(s): Robert W. Woodruff,† The Acmaro
Securities Corp., and others.
Financial data (yr. ended 12/31/87): Assets,
$66,213,222 (M); expenditures, $3,089,930,
including $2,975,820 for 25 grants (high:
$1,500,000; low: $5,000; average: $25,000-
$200,000).
Purpose and activities: Interests include
expansion and improvement of health and
educational facilities, youth and child welfare
programs, care of the aged, and cultural and
civic affairs.
Types of support: Building funds, renovation
projects, land acquisition, equipment, general
purposes, seed money, scholarship funds,
capital campaigns.
Limitations: Giving primarily in Atlanta, GA.
No grants to individuals, or for endowment
funds, operating budgets, research, special
projects, publications, conferences and
seminars, or operating budgets; no loans.
Publications: Application guidelines.
Application information:
 Initial approach: Letter
 Copies of proposal: 1
 Deadline(s): End of Feb. and Sept.
 Board meeting date(s): Apr. and Nov.
 Final notification: Within 1 year
 Write: Charles H. McTier, Pres.
Officers: Charles H. McTier, Pres.; P. Russell
Hardin, Secy.

Trustees: Joseph W. Jones, Chair.; James M.
Sibley, Vice-Chair.; Ivan Allen, Jr., A.D.
Boylston, Jr., James B. Williams.
Number of staff: 7
Employer Identification Number: 581695425
Recent arts and culture grants:
Atlanta Landmarks, Fox Theater Building,
Atlanta, GA, $100,000. Toward completion
of funds campaign to Fix the Fox Theater.
1987.
King-Tisdell Cottage Foundation, Savannah,
GA, $10,000. Toward purchase, restoration
and expansion of historic museum and
center for black heritage activities. 1987.
Morgan County Foundation, Madison, GA,
$25,000. Toward renovation and building
addition to expand exhibit and performance
space of Madison-Morgan Cultural Center.
1987.
Robert W. Woodruff Arts Center, Atlanta, GA,
$50,000. Toward extraordinary expenses
connected with hosting 38th Annual
Conference of Council on Foundations to be
held in Atlanta. 1987.
Scholars Press, Decatur, GA, $50,000. Toward
upgrading computer system for international
communications program serving scholars
and students in religious, classical and related
disciplines. 1987.
Thomasville Cultural Center, Thomasville, GA,
$38,000. Toward Phase II costs of restoring
former East Side School for use as
community meeting and cultural center.
1987.
Waycross Area Community Theater, Waycross,
GA, $25,000. Toward replacement of
heating and air-conditioning systems of
restored Ritz Theater now used for
community arts functions. 1987.

662
**The David, Helen, and Marian
Woodward Fund-Atlanta**
(also known as Marian W. Ottley Trust-Atlanta)
c/o The First National Bank of Atlanta
P.O. Box 4148 MC705
Atlanta 30383 (404) 332-6677

Trust established in 1975 in GA.
Donor(s): Marian W. Ottley.†
Financial data (yr. ended 5/31/88): Assets,
$21,519,562 (M); expenditures, $1,004,737,
including $890,000 for 39 grants (high:
$150,000; low: $1,285; average: $15,000).
Purpose and activities: Emphasis on higher
and secondary education; support also for
health associations, social service and youth
agencies, cultural programs, a community fund,
and churches.
Types of support: Building funds, emergency
funds, endowment funds, equipment, operating
budgets, special projects.
Limitations: Giving primarily in Atlanta, GA.
No grants to individuals.
Application information:
 Initial approach: Letter
 Copies of proposal: 1
 Deadline(s): 30 days prior to board meetings
 Board meeting date(s): June and Dec.
 Final notification: 10 days after meeting
 Write: Beverly Blake, V.P.

Distribution Committee: Edward D. Smith, Chair.; William D. Ellis, Jr., Robert L. Foreman, Jr., Joseph H. Hilsman, Horace Sibley.
Trustee: The First National Bank of Atlanta.
Number of staff: None.
Employer Identification Number: 586222004

663
The Vasser Woolley Foundation, Inc.
c/o Alston & Bird, One Atlantic Ctr.
1201 West Peachtree St., Suite 4200
Atlanta 30309-3424 (404) 881-7000

Incorporated in 1961 in GA.
Donor(s): Vasser Woolley.†
Financial data (yr. ended 12/31/88): Assets, $4,967,193 (M); expenditures, $235,246, including $196,667 for 14 grants (high: $25,000; low: $7,500; average: $7,500-$25,000).
Purpose and activities: Emphasis on higher education; support also for the arts, youth agencies, community funds, crime prevention, and aid to the handicapped.
Types of support: Seed money, emergency funds, building funds, equipment, land acquisition, general purposes, professorships, scholarship funds, matching funds.
Limitations: Giving primarily in the metropolitan Atlanta, GA, area. No grants to individuals, or for operating budgets, continuing support, annual campaigns, deficit financing, special projects, research, publications, or conferences; no loans.
Publications: Informational brochure, 990-PF, program policy statement, application guidelines.
Application information:
 Initial approach: Letter
 Copies of proposal: 1
 Board meeting date(s): Jan., Apr., July, and Oct.
 Final notification: 3 months
 Write: L. Neil Williams, Jr., Chair.
Officers and Trustees: L. Neil Williams, Jr., Chair.; Benjamin T. White, Secy. - Treas.; R. Neal Batson, Alex P. Gaines, G. Conley Ingram, John R. Seydel, Paul V. Seydel.
Number of staff: None.
Employer Identification Number: 586034197

664
Zaban Foundation Inc.
335 Green Glen Way
Atlanta 30327

Established in 1960 in GA.
Donor(s): Erwin Zaban.
Financial data (yr. ended 6/30/87): Assets, $3,605,906 (M); gifts received, $102,000; expenditures, $88,497, including $87,000 for 10 grants (high: $25,000; low: $1,000).
Purpose and activities: Support primarily for Jewish welfare organizations; some support for culture and social services.
Limitations: Giving primarily in Atlanta, GA.
Application information: Contributes only to pre-selected organizations. Applications not accepted.
Officers: Erwin Zaban, Pres. and Treas.; Marshall Dinerman, Secy.
Employer Identification Number: 586034590

HAWAII

665
Atherton Family Foundation
c/o Hawaiian Trust Co., Ltd.
111 South King St.
Honolulu 96813 (808) 599-5767
Mailing address: c/o Hawaiian Trust Co., Ltd., P.O. Box 3170, Honolulu, HI 96802

Incorporated in 1975 in HI as successor to Juliette M. Atherton Trust established in 1915; F. C. Atherton Trust merged into the Foundation in 1976.
Donor(s): Juliette M. Atherton,† Frank C. Atherton.†
Financial data (yr. ended 12/31/87): Assets, $40,226,475 (M); expenditures, $2,572,218, including $2,114,600 for 136 grants (high: $105,000; low: $500; average: $2,500-$25,000) and $64,645 for 36 grants to individuals.
Purpose and activities: Concerned with education, social welfare, culture and the arts, religion, health, and the environment. Scholarships for the education of Protestant ministers for postgraduate education; Protestant ministers' children for undergraduate study, and for graduate theological education at a Protestant seminary.
Types of support: Operating budgets, building funds, student aid, annual campaigns, consulting services, continuing support, endowment funds, equipment, matching funds, publications, renovation projects, research, seed money, special projects.
Limitations: Giving limited to HI; student aid for HI residents only. No support for private foundations or for organizations engaged in fundraising for the purpose of distributing grants to recipients of their own choosing. No grants for operating support.
Publications: Annual report, program policy statement, application guidelines.
Application information: Application forms required for students.
 Initial approach: Telephone or proposal
 Copies of proposal: 6
 Deadline(s): 1st day of month preceding board meeting for organizations; Mar. 1 for scholarships
 Board meeting date(s): 3rd Wednesday of Feb., Apr., June, Aug., Oct., and Dec.
 Final notification: 1 to 2 months
 Write: Jane R. Smith, Secy.
Officers and Directors:* Alexander S. Atherton,* Pres.; Judith Dawson, V.P.; Robert R. Midkiff,* V.P.; James F. Morgan, Jr.,* V.P.; Joan H. Rohlfing,* V.P.; Jane R. Smith, Secy.; Hawaiian Trust Co., Ltd., Treas.
Number of staff: 6
Employer Identification Number: 510175971
Recent arts and culture grants:
Bernice P. Bishop Museum, Honolulu, HI, $100,000. For capital endowment. 1987.
Friends of Father Damien, Honolulu, HI, $7,500. For Saint Philomena's Kalaupapa Church restoration project. 1987.

Hawaii Army Museum Society, Honolulu, HI, $10,000. For interpretive exhibit preparation. 1987.
Hawaii Imin Centennial Corporation, Honolulu, HI, $25,000. For International Conference Center. 1987.
Hawaii Maritime Center, Honolulu, HI, $30,000. For Aloha Tower area renovation. 1987.
Hawaii Opera Theater, Honolulu, HI, $40,000. For capital fund drive. 1987.
Hawaii Preparatory Academy, Kamuela, HI, $105,000. For arts center and swimming pool. 1987.
Hawaii Public Radio, Honolulu, HI, $150,000. To match individual donor gifts. 1987.
Hawaii Public Radio, Honolulu, HI, $70,000. For site purchase and program expansion. 1987.
Hawaii Theater Center, Honolulu, HI, $50,000. For acquisition of land and theater building. 1987.
Honolulu Academy of Arts, Honolulu, HI, $60,000. For Linekoma Arts Education Center. 1987.
Honolulu Symphony Society, Honolulu, HI, $50,000. For endowment trust fund. 1987.
Kawaiahao Church Endowment Trust, Honolulu, HI, $50,000. For endowment for church preservation. 1987.
Pacific Aerospace Museum, Honolulu, HI, $10,000. For historical aviation museum. 1987.
Pacific Tropical Botanical Garden, Lawai, HI, $5,000. For Lawai Valley road improvement. 1987.

666
Bancorp Hawaii Charitable Foundation
c/o Controllers Dept.
P.O. Box 2900
Honolulu 96846

Established in 1981 in HI.
Donor(s): Bank of Hawaii.
Financial data (yr. ended 12/31/87): Assets, $1,747,616 (M); expenditures, $73,043, including $70,000 for 6 grants (high: $20,000; low: $5,000).
Purpose and activities: Giving primarily to museums, education, and a church.
Types of support: General purposes, endowment funds, building funds.
Limitations: Giving limited to HI.
Application information: Contributes only to preselected organizations. Applications not accepted.
Officers and Directors:* Frank J. Manaut,* Pres.; H. Howard Stephenson,* V.P. and Treas.; Richard J. Dahl, V.P.; Ruth E. Miyashiro, Secy.; and 20 additional directors.
Employer Identification Number: 990210467

667
C. Brewer Charitable Foundation
827 Fort St.
Honolulu 96813 (808) 536-4461

Established in 1980 in HI.
Donor(s): C. Brewer and Co., Ltd.
Financial data (yr. ended 12/31/87): Assets, $539,232 (M); expenditures, $220,282,

including $214,682 for 93 grants (high: $70,000; low: $50; average: $500-$5,000) and $4,285 for 34 employee matching gifts.
Purpose and activities: Giving for community funds, social services, including youth agencies, education, and the arts.
Types of support: General purposes, equipment, emergency funds, building funds, employee matching gifts, renovation projects, scholarship funds.
Limitations: Giving primarily in HI.
Application information:
Initial approach: Letter
Copies of proposal: 1
Deadline(s): None
Write: Donald E. James, Treas.
Officers: James G. Higgins, Pres.; James S. Andrasick, V.P.; J. Alan Kugle, V.P.; Donald E. James, Secy.-Treas.
Number of staff: None.
Employer Identification Number: 990203743

668
James & Abigail Campbell Foundation
828 Fort St. Mall., Suite 500
Honolulu 96813 (808) 536-1961

Established in 1980 in HI.
Donor(s): James C. Shingle, Seymour Shingle.
Financial data (yr. ended 12/31/87): Assets, $1,199,713 (M); gifts received, $89,025; expenditures, $66,067, including $48,100 for 14 grants (high: $10,000; low: $600).
Purpose and activities: Local giving in education, cultural programs, historic preservation, health organizations, recreation, and family services.
Types of support: Scholarship funds, building funds, equipment.
Limitations: Giving limited to HI. No grants to individuals.
Application information:
Initial approach: Letter
Deadline(s): None
Board meeting date(s): Monthly
Final notification: 60 days
Write: Gail Chew, Mgr., Community Affairs
Officers: Wade H. McVay, Pres.; Fred Trotter, V.P.; Paul R. Cassidy, Secy.; Herbert C. Cornuelle, Treas.
Employer Identification Number: 990203078

669
Harold K. L. Castle Foundation
629 Kailua Rd., Rm. 210
Kailua 96734 (808) 262-9413

Incorporated in 1962 in HI.
Donor(s): Harold K.L. Castle,† Mrs. Harold K.L. Castle.†
Financial data (yr. ended 12/31/86): Assets, $47,720,417 (M); expenditures, $712,732, including $184,715 for 9 grants (high: $35,000; low: $4,715; average: $25,000-$100,000).
Purpose and activities: Emphasis on education; support also for youth agencies, hospitals, cultural programs, and marine research.
Types of support: Annual campaigns, seed money, emergency funds, building funds, equipment, research, general purposes, continuing support, capital campaigns.

Limitations: Giving primarily in HI. No grants to individuals.
Application information:
Initial approach: Letter
Copies of proposal: 1
Deadline(s): Submit proposal preferably in Jan. or Feb.; deadline Mar. 31
Board meeting date(s): Apr.
Final notification: May
Write: David D. Thoma, V.P.
Officers: James C. Castle,* Pres.; David D. Thoma, V.P. and Treas.; James C. Castle, Jr., V.P.; Carol Conrad, Secy.
Directors:* Virginia C. Baldwin-Dubois, James C. McIntosh, Peter E. Russell.
Number of staff: 1
Employer Identification Number: 996005445

670
Samuel N. and Mary Castle Foundation
c/o Hawaii Community Fdn.
212 Merchant St., Suite 330
Honolulu 96813 (808) 599-5767

Incorporated in 1925 in HI; Founded as Mary Castle Fund in 1898.
Donor(s): Mary Castle.†
Financial data (yr. ended 12/31/87): Assets, $17,903,839 (M); expenditures, $1,369,399, including $1,198,650 for 89 grants (high: $150,000; low: $500; average: $3,000-$25,000).
Purpose and activities: Emphasis on higher and secondary education, cultural programs, human service organizations, community funds, and denominational giving; support also for health associations and hospitals and environmental groups; special fund for early childhood education programs. Most grants for direct service activities or capital projects.
Types of support: Special projects, building funds, operating budgets, equipment, seed money, land acquisition, renovation projects, general purposes, capital campaigns.
Limitations: Giving limited to HI. No grants to individuals, or for continuing support, endowment funds, or scholarships; generally no support for research; no loans.
Publications: Annual report, program policy statement, application guidelines.
Application information:
Initial approach: Telephone or proposal
Copies of proposal: 7
Deadline(s): 1st day of month preceding meetings; Nov. 1 for capital projects over $25,000
Board meeting date(s): 2nd Thursday in Mar., June, Sept., and Dec.
Final notification: 2 or 3 months
Write: Jane R. Smith, Grants Admin.
Officers: W. Donald Castle,* Pres.; James C. Castle,* V.P.; Mark J. O'Donnell, Secy.; Hawaiian Trust Co., Ltd., Managing Agent; Hawaii Community Fdn., Grants Admin.
Trustees:* William E. Aull, Zadoc W. Brown, Alfred L. Castle, Robert R. Midkiff.
Number of staff: 9
Employer Identification Number: 996003321
Recent arts and culture grants:
Arizona Memorial Museum Association, Friends of Father Damien, Honolulu, HI, $10,000. To assist with preservation of church. 1987.

Bernice P. Bishop Museum, Honolulu, HI, $150,000. For capital campaign. 1987.
Contemporary Arts Center of Hawaii, Honolulu, HI, $60,000. For capital campaign. 1987.
Hawaii Army Museum Society, Honolulu, HI, $5,000. For capital improvement project. 1987.
Hawaii Imin Centennial Corporation, Honolulu, HI, $20,000. For international conference facilities. 1987.
Hawaii Mission Childrens Society, Honolulu, HI, $50,000. For capital and endowment campaign. 1987.
Hawaii Theater Center, Honolulu, HI, $50,000. For theater renovation/land purchase. 1987.
Honolulu Academy of Arts, Honolulu, HI, $50,000. For Linekona renovations. 1987.
Honolulu Symphony Society, Honolulu, HI, $15,000. For operating support. 1987.
K H P R-Hawaii Public Radio, Honolulu, HI, $20,000. For purchase of site/equipment. 1987.

671
Cooke Foundation, Ltd.
c/o Hawaii Community Foundation
212 Merchant St., Suite 330
Honolulu 96813 (808) 599-5767

Trust established in 1920 in HI; incorporated in 1971.
Donor(s): Anna C. Cooke.†
Financial data (yr. ended 6/30/88): Assets, $13,447,570 (M); expenditures, $1,189,214, including $1,087,800 for 78 grants (high: $200,000; low: $500; average: $2,500-$25,000).
Purpose and activities: Giving primarily for culture and the arts, education, social services, including programs for youth and the elderly, the humanities, health, and the environment.
Types of support: Special projects, annual campaigns, equipment, research, publications, conferences and seminars, matching funds, operating budgets, renovation projects, seed money.
Limitations: Giving limited to HI or to organizations serving the people of HI. No support for churches or religious organizations, unless the trustees' "missionary forebears" were involved with them. No grants to individuals, or for scholarships or fellowships; no loans.
Publications: Program policy statement, application guidelines, annual report (including application guidelines).
Application information:
Initial approach: Telephone or proposal
Copies of proposal: 7
Deadline(s): 1st week of month preceding each board meeting
Board meeting date(s): 4th Wednesday in Jan., Apr., July, and Oct.
Final notification: 2 weeks after board meeting
Write: Jane R. Smith, Asst. Secy.
Officers: Richard A. Cooke, Jr.,* Pres.; Charles C. Spalding,* 1st V.P.; Samuel A. Cooke,* 2nd V.P.; Dora C. Derby,* Secy.; Hawaiian Trust Co., Ltd., Treas.
Trustees:* Betty P. Dunford, Catherine C. Summers.

Number of staff: 9
Employer Identification Number: 237120804
Recent arts and culture grants:
Bernice P. Bishop Museum, Honolulu, HI, $25,000. For capital construction campaign. 1987.
Bernice P. Bishop Museum, Honolulu, HI, $20,000. For Preservation of Malacological Collection. 1987.
Central Union Church, Honolulu, HI, $20,000. For church restoration. 1987.
Daughters of Hawaii, Honolulu, HI, $7,600. For reprinting of Amos Starr Cooke and Juliette Montague Cooke biography. 1987.
East-West Center, Honolulu, HI, $5,000. For Sixth Annual International Film Festival. 1987.
Hawaii Imin Centennial Corporation, Honolulu, HI, $25,000. For International Conference Center. 1987.
Hawaii Mission Childrens Society, Honolulu, HI, $50,000. For capital endowment. 1987.
Hawaii Opera Theater, Honolulu, HI, $5,000. For operating support. 1987.
Hawaii Preparatory Academy, Kamuela, HI, $70,000. For New Arts Center. 1987.
Honolulu Academy of Arts, Honolulu, HI, $50,000. For operating support. 1987.
Honolulu Symphony Society, Honolulu, HI, $50,000. For endowment support. 1987.
Honolulu Symphony Society, Honolulu, HI, $15,000. For sustaining fund. 1987.
Kawaiahao Church, Honolulu, HI, $25,000. For endowment trust for church restoration. 1987.
Pacific Tropical Botanical Garden, Lawai, HI, $15,000. For Water Management and Irrigation Project. 1987.
Saint Louis High School, Honolulu, HI, $25,000. For fine arts complex campaign. 1987.

672
The Davies Foundation
841 Bishop St.
P.O. Box 3020
Honolulu 96802

Established in 1964.
Financial data (yr. ended 6/30/87): Assets, $1,040,904 (M); gifts received, $97,802; expenditures, $105,378, including $98,950 for 45 grants (high: $29,000; low: $25).
Purpose and activities: Support primarily for higher and secondary education, and a community fund; some support also for cultural programs, youth agencies, and health.
Limitations: Giving primarily in HI.
Officers: D.A. Heenan, Pres.; M.J. Jaskot, V.P.; M. Kitagawa, Secy.; R.W. Rex, Treas.
Employer Identification Number: 996009108

673
First Hawaiian Foundation
165 South King St.
Honolulu 96813 (808) 525-8144

Established in 1975 in HI.
Donor(s): First Hawaiian Bank, and affiliated companies.
Financial data (yr. ended 12/31/88): Assets, $5,993,472 (M); gifts received, $1,808,004; expenditures, $741,137, including $733,536

for 50 grants (high: $127,031; low: $177; average: $500-$100,000).
Purpose and activities: Support for social services, education, cultural programs, health services, a church, and a community fund.
Types of support: General purposes, operating budgets, renovation projects, building funds, land acquisition, equipment.
Limitations: Giving primarily in HI.
Application information:
 Initial approach: Letter
 Deadline(s): None
 Board meeting date(s): Minimum once every 2 months
 Write: Herbert E. Wolff, Secy.
Officers and Directors: John D. Bellinger, Pres.; Philip H. Ching, V.P.; Walter A. Dods, Jr., V.P.; John A. Hoag, V.P.; Donald G. Horner, V.P.; Hugh Pingree, V.P.; Herbert E. Wolff, Secy.; Howard H. Karr, Treas.
Employer Identification Number: 237437822

674
Mary D. and Walter F. Frear Eleemosynary Trust
c/o Bishop Trust Co., Ltd.
140 South King St.
Honolulu 96813 (808) 523-2111
Mailing address: P.O. Box 2390, Honolulu, HI 96804-2390

Trust established in 1936 in HI.
Donor(s): Mary D. Frear,† Walter F. Frear.†
Financial data (yr. ended 12/31/87): Assets, $7,276,831 (M); expenditures, $516,463, including $46,196 for 126 grants (high: $15,000; low: $420).
Purpose and activities: Support for health and social welfare, youth development, education, and music.
Types of support: Operating budgets, seed money, building funds, equipment, matching funds, scholarship funds, special projects, conferences and seminars, capital campaigns.
Limitations: Giving primarily in HI. No grants to individuals, or for endowment funds, reserve funds, travel, deficit financing, or publications; no loans.
Publications: Annual report (including application guidelines).
Application information:
 Initial approach: Proposal
 Copies of proposal: 4
 Deadline(s): Jan. 15, Apr. 15, July 15, and Oct. 15
 Board meeting date(s): Distribution committee meets in Mar., June, Sept., and Dec.
 Final notification: 2 to 3 months
 Write: Mrs. Lois C. Loomis, V.P. and Corp. Secy., Bishop Trust Co., Ltd.
Distribution Committee: Sharon McPhee, Chair.; Edwin L. Carter, Howard Hamamoto.
Trustee: Bishop Trust Co., Ltd.
Number of staff: 1 part-time professional; 1 part-time support.
Employer Identification Number: 996002270
Recent arts and culture grants:
Hawaii Imin Centennial Corporation, Honolulu, HI, $5,000. For final pledge payment for conference center at Jefferson Hall. 1987.

Hawaii Preparatory Academy, Kamuela, HI, $10,000. For capital fund drive for arts complex and pool. 1987.
Honolulu Academy of Arts, Honolulu, HI, $10,000. For capital fund drive. 1987.

675
The Hawaii Community Foundation
(Formerly The Hawaiian Foundation)
212 Merchant St., Suite 330
Honolulu 96813 (808) 599-5767

Community foundation established in 1916 in HI by trust resolution; incorporated in 1987; reorganizied in 1988.
Financial data (yr. ended 12/31/87): Assets, $11,101,622 (M); gifts received, $2,338,594; expenditures, $1,070,877, including $819,907 for 95 grants (high: $200,000; low: $85).
Purpose and activities: To assist charitable, religious, and educational institutions by the distribution of funds, many of which have been restricted for specific purposes and in some instances for specific institutions. General fund priorities are problems of youth, families in crisis, rural area special projects, environmental concerns, cultural and historic preservation, and community-based economic development; also provided: one-time only welfare assistance to needy adults or children and partial tuition support for learning disabled children.
Types of support: Operating budgets, seed money, equipment, technical assistance, scholarship funds, student aid, research, special projects, publications, grants to individuals.
Limitations: Giving limited to HI. No grants for building or endowment funds; no loans.
Publications: Program policy statement, application guidelines, informational brochure, annual report.
Application information: Application forms required for grants to individuals only.
 Initial approach: Proposal
 Copies of proposal: 8
 Deadline(s): 1st day of month preceding board meeting
 Board meeting date(s): Jan. and July
 Final notification: Feb. and Aug.
Officers and Board: Jane R. Smith, C.E.O; James F. Gary, Pres.; Samuel A. Cooke, V.P.; Douglas Philpotts, Secy.; Robert R. Midkiff, Treas.; and 17 additional board members.
Trustees: Hawaiian Trust Co., Ltd., Bishop Trust Co.
Number of staff: 4 full-time professional; 3 full-time support; 2 part-time support.
Employer Identification Number: 990261283

676
Hawaiian Electric Industries Charitable Foundation
P.O. Box 730
Honolulu 96808 (808) 543-7356

Established in 1984 in HI.
Donor(s): Hawaiian Electric Industries, Inc.
Financial data (yr. ended 12/31/88): Assets, $3,986,124 (M); gifts received, $2,612,626; expenditures, $634,182, including $611,485 for 186 grants (high: $20,000; low: $300; average: $300-$20,000), $10,000 for 10 grants

to individuals and $8,085 for 72 employee matching gifts.

Purpose and activities: Support for arts and culture, education, health and hospitals, social services and welfare, community development, the disadvantaged, and ecology.

Types of support: Employee matching gifts, capital campaigns, building funds, emergency funds, renovation projects, scholarship funds, conferences and seminars, matching funds, professorships, research.

Limitations: Giving primarily in HI. No support for political, religious, veterans', or fraternal organizations. No grants for operating budgets or maintenance activities.

Publications: Annual report (including application guidelines).

Application information:
 Initial approach: Letter, with project data
 Deadline(s): Dec. 1 and June 1
 Board meeting date(s): Feb. and Aug.
 Write: Ted Souza

Officers and Directors: C. Dudley Pratt, Jr., Pres.; George T. Iwahiro, V.P.; Wayne Minami, V.P.; Paul A. Oyer, Treas.; Edwin L. Carter, John D. Field, Diane Plotts.

Number of staff: 1 part-time professional; 1 part-time support.

Employer Identification Number: 990230697

677
McInerny Foundation
c/o Bishop Trust Co., Ltd.
140 South King St.
Honolulu 96813 (808) 523-2111
Mailing address: P.O. Box 2390, Honolulu, HI 96804

Trust established in 1937 in HI.

Donor(s): William H. McInerny,† James D. McInerny,† Ella McInerny.†

Financial data (yr. ended 9/30/87): Assets, $21,983,284 (M); expenditures, $1,739,670, including $1,294,380 for 134 grants (high: $65,000; low: $500; average: $25,000-$100,000).

Purpose and activities: Emphasis on education, youth and social services, health and rehabilitation, culture and the arts.

Types of support: Operating budgets, continuing support, seed money, building funds, equipment, matching funds, scholarship funds, special projects.

Limitations: Giving limited to HI. No support for religious institutions. No grants to individuals, or for endowment funds, deficit financing, or research; no loans.

Publications: Annual report (including application guidelines).

Application information: Application form required for capital or scholarship funds.
 Initial approach: Proposal
 Copies of proposal: 7
 Deadline(s): Jan. 15 for scholarships; July 15 for capital fund drives; none for others
 Board meeting date(s): Distribution committee generally meets monthly
 Final notification: 2 months
 Write: Mrs. Lois C. Loomis, V.P. and Corp. Secy., Bishop Trust Co., Ltd.

Distribution Committee: Edwin L. Carter, Chair.; Henry B. Clark, Jr., Vice-Chair.; Thomas K. Hitch.

Trustee: Bishop Trust Co., Ltd.

Number of staff: 2

Employer Identification Number: 996002356

Recent arts and culture grants:

Bernice P. Bishop Museum, Honolulu, HI, $36,000. For capital fund drive. 1987.

Hawaii Imin Centennial Corporation, Honolulu, HI, $20,000. For building fund drive. 1987.

Hawaii Nature Center, Honolulu, HI, $5,000. For program support. 1987.

Hawaii Opera Theater, Honolulu, HI, $25,000. For capital fund drive. 1987.

Hawaii Public Broadcasting Authority, Honolulu, HI, $21,500. To co-underwrite The MacNeil/Lehrer Newshour. 1987.

Honolulu Symphony Society, Honolulu, HI, $30,000. For operations. 1987.

Honolulu Theater for Youth, Honolulu, HI, $5,500. For program support. 1987.

San Francisco Ballet Association, San Francisco, CA, $5,000. For performances in Hawaii. 1987.

678
O. L. Moore Foundation
c/o Hawaiian Trust Company, Ltd.
P.O. Box 3170
Honolulu 96802

Established in 1959 in IL.

Donor(s): O.L. Moore.†

Financial data (yr. ended 12/31/87): Assets, $1,381,419 (M); expenditures, $89,608, including $77,500 for 24 grants (high: $12,000; low: $500).

Purpose and activities: Support for higher education, health associations and services, cultural programs, and Protestant religious organizations.

Types of support: Continuing support.

Limitations: Giving primarily in HI and KY.

Application information: Contributes only to pre-selected regular donees. Applications not accepted.
 Write: J. Edward Moore, Pres.

Officers and Directors: J. Edward Moore, Pres.; William E. Moore, V.P.; Dorothy D. Moore, Secy.-Treas.; Crane C. Hauser, Charles M. Hoge, Dee Anne Mahuna, Howard E. Trent, Jr.

Employer Identification Number: 366101149

679
PRI Foundation
Bishop Trust Co.
P.O. Box 2390
Honolulu 96804
Application address: PRI Foundation, P.O. Box 3379, Honolulu, HI 96842

Established in 1986 in HI.

Financial data (yr. ended 12/31/87): Assets, $166,330 (M); gifts received, $783,797; expenditures, $626,358, including $622,416 for grants.

Purpose and activities: Support for culture and the arts, education, health, religion, social welfare, and youth services.

Types of support: Equipment, renovation projects, capital campaigns.

Limitations: Giving primarily in HI and other areas of company operations. No support for

sports. No grants to individuals or for operating support to Aloha United Way-supported organizations, educational institutions for scholarships, or subsidization of travel l.

Application information: Include with application brief description of the organization and purpose; summary of proposed activity, including the need or problem, how activity is to be carried out; population to be served, plan for evaluating effectiveness; financial data of the organization or budget for special projects; list of Board; 501(c)(3) letter. For newly-established organizations unfamiliar to the Trustees of the Foundation, a letter from the Better Business Bureau may be requested.
 Initial approach: Proposal
 Deadline(s): None
 Board meeting date(s): Quarterly

Trustee: Bishop Trust Co.

Employer Identification Number: 990248628

680
G. N. Wilcox Trust
c/o Bishop Trust Co., Ltd.
140 South King St.
Honolulu 96813 (808) 523-2111
Mailing address: P.O. Box 2390, Honolulu, HI 96804

Trust established in 1916 in HI.

Donor(s): George N. Wilcox.†

Financial data (yr. ended 12/31/87): Assets, $11,170,873 (M); expenditures, $839,397, including $653,615 for 131 grants (high: $20,000; low: $420; average: $1,000-$10,000).

Purpose and activities: Support for education and social service agencies, including child welfare; grants also for arts and culture, care of the sick, health agencies, the aged, community funds, delinquency and crime prevention, family services, and Protestant church support.

Types of support: Seed money, building funds, equipment, matching funds, scholarship funds, general purposes, continuing support, capital campaigns, special projects.

Limitations: Giving limited to HI, particularly the island of Kauai. No support for government agencies or organizations substantially supported by government funds. No grants to individuals, or for endowment funds (except endowments for scholarships), reserve funds, research, publications, deficit financing, or travel; no direct student aid or scholarships; no loans.

Publications: Annual report (including application guidelines).

Application information: Scholarship requests considered at Mar. meeting; capital requests considered at Dec. meeting.
 Initial approach: Telephone or proposal
 Copies of proposal: 5
 Deadline(s): Jan. 15, Apr. 15, July 15, and Oct. 15
 Board meeting date(s): Mar., June, Sept., and Dec.
 Final notification: 2 months
 Write: Mrs. Lois C. Loomis, V.P. and Corp. Secy., Bishop Trust Co., Ltd.

Committee on Beneficiaries: Aletha Kaohl, Edwin L. Carter, Chair.; Gale Fisher Carswell.

Trustee: Bishop Trust Co., Ltd.

Number of staff: 1 part-time professional; 1 part-time support.
Employer Identification Number: 996002445
Recent arts and culture grants:

Arizona Memorial Museum Association, Honolulu, HI, $5,000. For restoration of St. Philomena Church on Molokai. 1987.

Contemporary Arts Center of Hawaii, Honolulu, HI, $10,000. For payment for capital fund drive. 1987.

Hawaii Imin Centennial Corporation, Honolulu, HI, $5,000. For final pledge payment for conference center at Jefferson Hall. 1987.

Hawaii Public Radio, Honolulu, HI, $10,000. For pledge payment for capital fund drive. 1987.

Honolulu Academy of Arts, Honolulu, HI, $10,000. For payment for capital fund drive. 1987.

Honolulu Symphony Society, Honolulu, HI, $20,000. For payment for Bridge to Future Campaign. 1987.

Kauai Museum Association, Lihue, HI, $10,000. For structural repairs of A.S. Wilcox Memorial Building. 1987.

Lyman House Memorial Museum, Hilo, HI, $7,000. For operational support. 1987.

Saint Louis Education Foundation, Honolulu, HI, $10,000. For final pledge payment for Fine Arts Complex. 1987.

IDAHO

681
The Leland D. Beckman Foundation
c/o Holden, Kidwell, Hahn & Crapo
P.O. Box 50130
Idaho Falls 83402-0129 (208) 523-0620

Established in 1965 in ID.
Financial data (yr. ended 12/31/87): Assets, $2,094,307 (M); gifts received, $1,530,367; expenditures, $47,528, including $31,250 for 12 grants (high: $8,000; low: $750).
Purpose and activities: Support primarily for a child development workshop, elementary, secondary and vocational technical educational institutions, and the arts.
Types of support: Equipment, operating budgets.
Limitations: Giving primarily in Idaho Falls, ID.
Application information:
Initial approach: Letter
Deadline(s): None
Write: Stephen E. Martin
Trustees: William S. Holden, Stephen E. Martin.
Employer Identification Number: 826009504

682
Boise Cascade Corporate Giving Program
One Jefferson Sq.
Boise 83728 (208) 384-7673

Financial data (yr. ended 12/31/86): $2,800,000 for grants.
Purpose and activities: Support for 1)Health and Human Services-United Way, hospitals, health and wellness promotion, programs to reduce health care costs, youth, senior citizens, emergency services; 2)Education-institutions conducting research in pulp and paper science, wood products manufacturing and forest management, or other fields related to the business, institutions that are sources for recruiting employees, school districts or communities where company operates, and affirmative action programs; 3)Public Issues and Economic Education-emphasis on business and teacher education and programs involving volunteers from the business sector; 4) Civic and Environmental-civic improvement, sports, recreation, parks, zoos, urban development, law and enforcement, housing and conservation, efforts supporting multiple forest management; 5) Culture-local and regional arts, museums, libraries, and public broadcasting; 6) Affirmative action-to improve the educational and employment opportunities for minorities, women, the disabled, and Vietnam era veterans in the private sector, housing rehabilitation, and social and recreational activities. In addition, the company donates products, services, inventory, equipment, and land, and employee volunteers donate their time to charities.
Types of support: Capital campaigns, fellowships, general purposes, operating budgets, research, scholarship funds, special projects, employee matching gifts, in-kind gifts.
Limitations: Giving primarily in areas of company operations. No support for private foundations or for international, fraternal, social, labor, veterans, or religious organizations. No grants for political, sensitive, or controversial projects, or for projects perceived to be harmful to the company or those posing a possible conflict of interest; generally no support for local or regional chapters of national health organizations. No grants to individuals, or for courtesy ads, deficit financing, testimonials, school trips, or tours; no operating funds for United Way recipients.
Publications: Corporate giving report.
Application information: National organizations, programs that address company issues, organizations in Boise, and institutions where the company recruits employees write to headquarters, other organizations write to nearest plant. Application form required.
Initial approach: Letter
Write: Vicki M. Wheeler, Contribs. Mgr.
Vicki M. Wheeler, Contributions Mgr.; Jean Miller, Bobbi Youmans.

683
Idaho First National Bank Corporate Giving Program
Communications Department 1-5011
P.O. Box 8247
Boise 83733

Purpose and activities: Giving for: 1)Health and Welfare-emphasis on ensuring the availability of adequate health care and human services and to promote the development of new, workable responses to health and welfare needs; support for alternatives to costly

institutional care and the development of cost-efficient modes of patient care; includes assistance to federated drives, hospitals, youth agencies, and senior citizens. Requests for operating funds, and for capital funds under special circumstances, accepted only from local health and welfare agencies which do not derive their primary funding from federated drives to which the Bank separately contributes. Exceptions may be made in special circumstances. Capital grants to hospitals and outpatient facilities only if such investments have been approved by the appropriate health planning agency. Capital grants are limited to five percent of the project's budget. 2)Education-to assure the availability of highly skilled, educated people from which to draw employees, to encourage continuing research and development in academic specialties relevant to the bank, and to promote standards of educational excellence; includes assistance to private secondary schools, public and private higher education institutions, adult education, and other education-related organizations including those which seek to increase public knowledge of economics. 3)Culture-to encourage high standards of excellence and provide a pool of creative resources in the visual and performing arts for the enrichment of our employees, customers and the public; includes orchestras, museums, educational television, theaters, opera and dance companies, cultural centers, and libraries. 4)Civic and Community Needs-to support programs dealing with the quality of government and administration, justice and law enforcement, voter registration and education, good citizenship, civil rights, and equal opportunity; extends to supporting organizations which provide a sufficient level of community services, adequate housing and neighborhood improvement, environment maintenance, energy conservation and research, and workable solutions to community problems.
Types of support: Matching funds, continuing support, operating budgets, capital campaigns.
Limitations: Giving limited to ID. No support for fraternal, service,or veterans' organizations, or for churches and religious groups, beauty or talent contests, political organizations, benefit advertising, grant-making private foundations, or athletic teams. No grants to individuals; no operating support for organizations funded through United Way; no support for trips, tours, or telethons.
Publications: Informational brochure (including application guidelines).
Application information: Application form required.
Initial approach: Letter
Write: Robert J. Lane, Pres. and C.O.O.

684
Morrison-Knudsen Corporate Giving Program
P.O. Box 73
Boise 83707 (208) 345-5000

Financial data (yr. ended 12/31/87): Total giving, $392,652, including $326,706 for grants (high: $75,000; low: $500; average:

$1,000-$5,000), $43,333 for employee matching gifts and $22,613 for in-kind gifts.
Purpose and activities: Giving primarily for higher education and programs that focus on energy resources and drug abuse; support also for theater, dance, and fine arts.
Types of support: Capital campaigns, special projects, technical assistance, employee matching gifts, in-kind gifts.
Limitations: Giving primarily in areas of company operations.
Publications: Informational brochure (including application guidelines).
Application information: Application form required.
Initial approach: Letter
Copies of proposal: 1
Deadline(s): Oct.1
Final notification: 6-8 weeks
Write: Vickie Sherman, Mgr., Community Relations
Number of staff: 1 full-time professional.

685
Claude R. and Ethel B. Whittenberger Foundation
P.O. Box 1073
Caldwell 83605 (208) 459-0091

Established in 1970 in ID.
Donor(s): Ethel B. Whittenberger.†
Financial data (yr. ended 12/31/87): Assets, $2,979,127 (M); expenditures, $222,466, including $180,000 for 33 grants (high: $34,600; low: $1,000).
Purpose and activities: Giving for higher and secondary education; support also for hospitals, cultural programs, and local public libraries.
Types of support: Continuing support, emergency funds, building funds, equipment, fellowships, publications, conferences and seminars.
Limitations: Giving limited to ID. No grants to individuals, or for endowment funds.
Publications: Program policy statement, application guidelines.
Application information: Application form required.
Initial approach: Letter
Copies of proposal: 5
Deadline(s): None
Board meeting date(s): Apr., July, Sept., and Nov.
Write: William J. Rankin, Chair.
Officers and Managers: William J. Rankin, Chair.; Joe Miller, Secy.; Margaret Gigray, Treas.; Robert A. Johnson, D. Whitman Jones.
Employer Identification Number: 237092604

ILLINOIS

686
Lester S. Abelson Foundation
One North La Salle St., Suite 1315
Chicago 60602

Established in 1966 in IL.
Donor(s): Lester S. Abelson,† and members of the Abelson family.
Financial data (yr. ended 12/31/87): Assets, $1,548,182 (M); gifts received, $105,003; expenditures, $29,983, including $16,735 for 43 grants (high: $2,000; low: $25).
Purpose and activities: Support primarily for the fine and performing arts and other cultural programs.
Application information: Contributes only to pre-selected organizations. Applications not accepted.
Officers: Hope A. Abelson, Pres.; Katherine A. Abelson, V.P.; Stuart R. Abelson, Secy.-Treas.
Employer Identification Number: 366153888

687
ACP Foundation
30 Bridlewood Rd.
Northbrook 60062-4702 (312) 272-3034

Established in 1951 in IL.
Financial data (yr. ended 12/31/87): Assets, $1,094,749 (M); expenditures, $72,037, including $67,654 for grants.
Purpose and activities: Giving primarily for social services and higher education; support also for the fine arts and theaters.
Application information:
Write: A.C. Buehler, Jr.
Officers and Directors: A.C. Buehler, Jr., Pres.; Carl Buehler, V.P.; Pat Buehler, Secy.; A.C. Buehler III, Treas.
Employer Identification Number: 366046903

688
Allen-Heath Memorial Foundation
8500 Sears Tower
233 South Wacker Dr.
Chicago 60606 (312) 876-2100

Incorporated in 1947 in CA.
Donor(s): Harriet A. Heath,† John E.S. Heath.†
Financial data (yr. ended 12/31/86): Assets, $2,711,822 (M); expenditures, $153,939, including $130,000 for 18 grants (high: $33,000; low: $1,000).
Purpose and activities: Grants to a limited number of educational institutions, hospitals, museums, air safety organizations, and other charitable institutions.
Limitations: No support for religious or foreign organizations. No grants to individuals; no loans.
Publications: Application guidelines, annual report.
Application information: Contributes only to pre-selected organizations. Applications not accepted.

Board meeting date(s): Nov.
Write: Susan M. Powers, Secy.
Officers and Directors: Charles K. Heath, Pres.; Ruth R. Hooper, V.P.; Susan M. Powers, Secy.
Number of staff: None.
Employer Identification Number: 363056910

689
The Allstate Foundation
Allstate Plaza, F-3
Northbrook 60062 (312) 291-5502

Incorporated in 1952 in IL.
Donor(s): Allstate Insurance Co.
Financial data (yr. ended 12/31/88): Assets, $14,956,279 (M); gifts received, $10,000,000; expenditures, $8,336,986, including $8,057,528 for 1,797 grants (high: $300,000; low: $25; average: $5,000-$25,000), $200,000 for 200 grants to individuals and $279,458 for 1,864 employee matching gifts.
Purpose and activities: To assist deserving organizations serving the fields of education, including colleges and universities, cultural pursuits, urban and civic affairs, safety, and health and welfare, including youth agencies and community funds. Particular interest in organizations dedicated to principles of self-help and self-motivation.
Limitations: No support for fraternal or religious organizations. No grants to individuals; or for annual campaigns, deficit financing, building, capital, endowment funds, fund raising events, conferences, films, videotapes or audio productions, or travel funds; no loans.
Publications: Informational brochure (including application guidelines), program policy statement.
Application information:
Initial approach: Proposal
Copies of proposal: 1
Deadline(s): None
Board meeting date(s): Mar., June, Sept., and Dec.
Final notification: 30 to 90 days
Write: Wilfredo Ramos, Exec. Dir., or Allen Goldhamer, Mgr., or Cathy Presti, Admin. Asst.
Officers and Trustees:* Wayne E. Hedien,* Pres.; Robert W. Pike, V.P. and Secy.; Myron J. Resnick,* V.P. and Treas.; Wayne E. Hedien,* V.P.; John K. O'Loughlin,* V.P.; Lawrence H. Williford, V.P.; Wilfredo Ramos, Exec. Dir.
Number of staff: 2 full-time professional; 1 full-time support.
Employer Identification Number: 366116535

690
Alsdorf Foundation
301 Woodley Rd.
Winnetka 60093 (312) 501-3335

Incorporated in 1944 in IL.
Donor(s): James W. Alsdorf.
Financial data (yr. ended 12/31/87): Assets, $2,050,618 (M); expenditures, $148,971, including $135,589 for 54 grants (high: $90,245; low: $20).
Purpose and activities: Grants largely for the fine arts and higher education.

Limitations: Giving primarily in Chicago, IL. No grants to individuals, or for scholarships, fellowships, or prizes; no loans.
Application information:
 Initial approach: Proposal
 Copies of proposal: 1
 Board meeting date(s): Dec. and as required
 Write: James W. Alsdorf, Pres.
Officers and Directors: James W. Alsdorf, Pres. and Treas.; Marilynn B. Alsdorf, V.P. and Secy.; Mary Fujishama.
Employer Identification Number: 366065388

691
Alton Foundation
Box 1078
Alton 62002 (618) 462-3953

Established in 1947 in IL.
Financial data (yr. ended 12/31/87): Assets, $2,115,507 (M); gifts received, $120,481; expenditures, $366,130, including $348,875 for grants.
Purpose and activities: Grants awarded for culture, social services, education, women, and youth; some support also for organizations that benefit the handicapped.
Limitations: Giving limited to Madison County, IL, and adjoining counties.
Application information: Application form required.
 Initial approach: Letter
 Copies of proposal: 1
 Deadline(s): None
 Write: R.S. Minsker, Secy.
Officers: Carlos Byassee, Chair.; R.S. Minsker, Vice-Chair. and Secy.
Employer Identification Number: 376045370

692
American National Bank and Trust Company of Chicago Foundation
33 North LaSalle St.
Chicago 60690 (312) 661-6115

Trust established in 1955 in IL.
Donor(s): American National Bank & Trust Co. of Chicago.
Financial data (yr. ended 12/31/87): Assets, $3,037,731 (M); gifts received, $1,073,535; expenditures, $717,898, including $658,581 for grants (high: $265,000; low: $100; average: $2,500) and $7,736 for employee matching gifts.
Purpose and activities: Emphasis on hospitals, the arts, elementary and higher education; support also for community organizations, youth agencies, and urban affairs.
Types of support: Employee matching gifts, operating budgets, general purposes, continuing support, annual campaigns, building funds, special projects, capital campaigns.
Limitations: Giving limited to the six-county Chicago, IL, metropolitan area. No support for religious organizations serving only one group. No grants to individuals, or for conferences or seminars, land acquisition, endowment funds, fellowships, lectureships, professorships, or scholarships; no loans.
Publications: Application guidelines, program policy statement.
Application information:

Initial approach: Letter; no telephone calls
Copies of proposal: 1
Board meeting date(s): Bimonthly
Final notification: 3 months
Write: Catherine Brown, Administrative Dir.
Trustees: Ronald J. Grayheck, Timothy P. Moen, John F. Reuss, Henry S. Roberts, Robert F. Schnoes, Michael E. Tobin.
Number of staff: 1 full-time professional; 1 part-time support.
Employer Identification Number: 366052269

693
Ameritech Foundation
30 South Wacker Dr., 34th Fl.
Chicago 60606 (312) 750-5223

Established in 1984 in IL.
Donor(s): American Information Technologies.
Financial data (yr. ended 12/31/88): Assets, $54,828,685 (M); gifts received, $10,000,000; expenditures, $3,505,858, including $3,222,776 for 78 grants (high: $163,525; low: $2,000; average: $2,000-$50,000) and $125,182 for 233 employee matching gifts.
Purpose and activities: Grants largely to multi-state organizations for economic revitalization, education, and culture in the Great Lakes region. Support also for research and programs designed to determine ways communications can contribute to the betterment of society, and selected public policy issues which are relevant to the telecommunications industry, health and human services and to national organizations which address the foundation's stated interests.
Types of support: Employee matching gifts, special projects, conferences and seminars, research.
Limitations: Giving primarily in IL, WI, IN, MI, and OH. No support for religious organizations for sectarian purposes, national or international organizations with limited relationships to local company operations, local chapters of national organizations, veterans' or military organizations, discriminating organizations, political groups, athletics, or health organizations concentrating on research and treatment in one area of human disease. No grants to individuals, or for start-up funds, or advertising.
Publications: Annual report (including application guidelines).
Application information:
 Initial approach: Letter
 Copies of proposal: 1
 Deadline(s): None
 Board meeting date(s): Mar., June, Sept., and Dec.
 Final notification: 3 months
 Write: Michael E. Kuhlin, Dir.
Officers: John A. Koten,* Pres.; Carl G. Koch,* C.F.O.; Michael E. Kuhlin, Secy.; Robert Kolbe, Treas.
Directors:* James F. Bere, Harry Kalajian, Martha Thornton, William L. Weiss.
Number of staff: 1 full-time professional; 1 part-time support.
Employer Identification Number: 363350561
Recent arts and culture grants:
American Council for the Arts, NYC, NY, $5,000. To promote communications and improve management of arts. 1987.

American Symphony Orchestra League, DC, $28,000. For national conference in Chicago, and for general operating support. 1987.
Arts Midwest, Minneapolis, MN, $5,000. For midwestern arts programs. 1987.
Business Committee for the Arts, NYC, NY, $5,000. For programs to encourage new and increased contributions to arts. 1987.
Chicago Historical Society, Chicago, IL, $50,000. For William Wordsworth and the Age of English Romanticism exhibition. 1987.
Chicago Symphony Orchestra, Chicago, IL, $100,000. To underwrite Symphony's Carnegie Hall tours. 1987.
Chicago Symphony Orchestra, Chicago, IL, $10,000. For Symphony's Annual Fund. 1987.
Cleveland Ballet, Cleveland, OH, $50,000. For Ballet's first Chicago tour. 1987.
Field Museum of Natural History, Chicago, IL, $37,500. For final payment of pledge to Museum's Time Future from Time Past campaign. 1987.
Interlochen Center for the Arts, Interlochen, MI, $15,000. For Chicago Symphony Orchestra's performance at Interlochen. 1987.
Interlochen Center for the Arts, Interlochen, MI, $10,000. For Interlochen Orchestra's performance at Kennedy Center. 1987.
John G. Shedd Aquarium, Chicago, IL, $42,000. To Oceanarium campaign. 1987.
Kennedy Center for the Performing Arts, DC, $50,000. For Ameritech/Terrace Concerts Series. 1987.
Lyric Opera of Chicago, Chicago, IL, $90,000. For final payment of pledge to underwrite I Capuleti ei Montecchi. 1987.
Lyric Opera of Chicago, Chicago, IL, $10,000. For Lyric Opera Center for American Artists. 1987.
Museum of Science and Industry, Chicago, IL, $10,000. For Museum's Annual Fund. 1987.
W E T A Greater Washington Educational Television Association, DC, $350,000. For second-year funding of grant to underwrite The Congress, film documentary to air on public television in 1989. 1987.
Washington Performing Arts Society, DC, $10,000. For Chicago Symphony Orchestra at Kennedy Center. 1987.

694
Amoco Foundation, Inc.
200 East Randolph Dr.
Chicago 60601 (312) 856-6306

Incorporated in 1952 in IN.
Donor(s): Amoco Corp.
Financial data (yr. ended 12/31/87): Assets, $62,696,271 (M); expenditures, $19,879,631, including $18,657,933 for 1,600 grants (high: $1,475,000; low: $200) and $1,221,648 for 3,137 employee matching gifts.
Purpose and activities: Grants awarded for higher and precollege education, primarily in science and engineering, and for community organizations, urban programs, and energy conservation, with emphasis on new initiatives; support also for independent public interest research, a limited program in culture and art, a volunteer program, and an employee educational gift matching program. Limited

contributions to foreign charitable and educational institutions.

Types of support: Operating budgets, continuing support, annual campaigns, seed money, emergency funds, building funds, equipment, scholarship funds, fellowships, special projects, general purposes, capital campaigns, employee matching gifts.

Limitations: Giving primarily in areas of company representation to assist communities. No support for primary or secondary schools; religious, fraternal, social, and athletic organizations; or generally for organizations already receiving operating support through the United Way. No grants to individuals, or for endowment funds, research, publications, or conferences; no loans.

Publications: Annual report (including application guidelines).

Application information:
 Initial approach: Letter or proposal
 Copies of proposal: 1
 Deadline(s): Sept. 1
 Board meeting date(s): Mar., June, Sept., and Dec.; contributions committee meets monthly
 Final notification: 4 to 6 weeks
 Write: Bob L. Arganbright, Exec. Dir.

Officers: Richard M. Morrow,* Chair.; H. Laurance Fuller,* Pres.; Bob L. Arganbright, Secy. and Exec. Dir.; J.S. Ruey, Treas.

Directors:* R. Wayne Anderson, John H. Bryan, Jr., James W. Cozad, Rady A. Johnson, Richard H. Leet, Walter E. Massey, Walter R. Peirson, Arthur E. Rasmussen.

Number of staff: 5 full-time professional; 5 full-time support.

Employer Identification Number: 366046879

Recent arts and culture grants:

American Museum of Natural History, NYC, NY, $5,000. 1987.

American Research Center in Egypt, Princeton, NJ, $5,000. 1987.

Art Institute of Chicago, Chicago, IL, $60,000. For capital support. 1987.

Art Institute of Chicago, Chicago, IL, $30,000. 1987.

Art Institute of Chicago, Chicago, IL, $5,000. 1987.

Audubon Zoo, New Orleans, LA, $15,000. 1987.

Broken Arrow Community Playhouse, Broken Arrow, OK, $5,000. 1987.

Business Arts Fund, Houston, TX, $5,000. 1987.

Charleston Museum, Charleston, SC, $8,000. 1987.

Chicago Historical Society, Chicago, IL, $5,000. 1987.

Chicago International Theater Festival, Chicago, IL, $20,000. 1987.

Chicago Symphony Orchestra, Chicago, IL, $460,905. For public radio syndication. 1987.

Chicago Symphony Orchestra, Chicago, IL, $32,000. 1987.

Chicago Theater Group, Goodman Theater, Chicago, IL, $7,500. 1987.

Chicago Zoological Society, Brookfield Zoo, Brookfield, IL, $20,000. 1987.

Classical Youth Symphony Orchestra, Chicago, IL, $5,000. 1987.

Denver Museum of Natural History, Denver, CO, $10,000. 1987.

DuSable Museum of African American History, Chicago, IL, $10,000. 1987.

DuSable Museum of African American History, Chicago, IL, $8,000. 1987.

Ebony Talent Associates Creative Arts Foundation, Chicago, IL, $8,000. 1987.

Ebony Talent Associates Creative Arts Foundation, Chicago, IL, $8,000. 1987.

Evanston Art Center, Evanston, IL, $15,000. 1987.

Field Museum of Natural History, Chicago, IL, $100,000. 1987.

Fort Abraham Lincoln Foundation, Bismarck, ND, $10,000. 1987.

Houston Museum of Natural Science, Houston, TX, $5,000. 1987.

Institute of Cultural Affairs, Egypt, $10,000. 1987.

Iowa Historical Museum Foundation, Des Moines, IA, $10,000. 1987.

Kennedy Center for the Performing Arts, DC, $10,000. 1987.

Lincoln Park Zoological Society, Chicago, IL, $20,000. 1987.

Louisiana Nature and Science Center, New Orleans, LA, $25,000. For environmental conservation. 1987.

Louisiana Nature and Science Center, New Orleans, LA, $5,000. 1987.

Lyric Opera of Chicago, Chicago, IL, $50,000. For capital support. 1987.

Lyric Opera of Chicago, Chicago, IL, $30,000. 1987.

Metropolitan Opera, NYC, NY, $10,000. 1987.

Mexican Fine Arts Center Museum, Chicago, IL, $5,000. 1987.

Museum of Flight, Seattle, WA, $10,000. 1987.

Museum of Science and Industry, Chicago, IL, $100,000. 1987.

Music of the Baroque, Chicago, IL, $10,000. 1987.

National Institute of Building Sciences, DC, $12,500. 1987.

Nederlands Dans Theater, Netherlands, $20,000. 1987.

Newberry Library, Chicago, IL, $5,000. 1987.

Ravinia Festival Association, Highland Park, IL, $10,000. 1987.

Santa Fe Chamber Music Festival, Santa Fe, NM, $25,000. 1987.

Shedd Aquarium, Chicago, IL, $10,000. 1987.

Urban Gateways, Chicago, IL, $18,000. 1987.

Walters Art Gallery, Baltimore, MD, $20,000. 1987.

Zoological Society of Houston, Houston, TX, $5,000. 1987.

695

Amsted Industries Foundation
205 North Michigan Ave., 44th Floor
Chicago 60601 (312) 645-1700

Trust established in 1953 in IL.

Donor(s): Amsted Industries, Inc.

Financial data (yr. ended 9/30/88): Assets, $4,274,071 (M); expenditures, $420,419, including $400,055 for 224 grants (high: $32,650; low: $200).

Purpose and activities: Grants largely for community funds and higher education; support also for civic affairs, youth agencies, and cultural activities.

Types of support: Operating budgets, employee matching gifts, building funds, continuing support.

Limitations: Giving limited to areas of company operations: main emphasis on Chicago, IL; support also in KS, AL, MO, MD, IN, NE, DE, VA, CA, PA, DE, CT and Washington, DC. No support for political or religious organizations, or veterans' groups. No grants to individuals, or for endowment funds, scholarships, fellowships, or courtesy advertising; no loans.

Application information:
 Initial approach: Letter
 Deadline(s): May 1
 Board meeting date(s): As required
 Final notification: 45 days
 Write: Jerry W. Gura, Dir., Public Affairs

Trustees: Arthur W. Goetschel, Mgr.; O.J. Sopranos, G.K. Walter, Robert H. Wellington.

Number of staff: 1 part-time professional; 1 part-time support.

Employer Identification Number: 366050609

696

Arthur Andersen Foundation
P.O. Box 6
Barrington 60010 (312) 381-8134

Incorporated in 1953 in IL.

Donor(s): Arthur A. Andersen.†

Financial data (yr. ended 10/31/88): Assets, $2,306,992 (M); gifts received, $4,000; expenditures, $302,518, including $251,500 for 10 grants (high: $100,000; low: $2,000).

Purpose and activities: Grants largely for higher and secondary education, hospitals and medical research, and music and arts.

Application information:
 Deadline(s): None
 Write: Arthur Andersen, III, Pres.

Officers: Arthur E. Andersen III, Pres.; Joan N. Andersen, V.P. and Treas.; John E. Hicks, Secy.

Employer Identification Number: 510175922

697

The Andreas Foundation
c/o Archer-Daniels-Midland Co.
P.O. Box 1470
Decatur 62525 (217) 424-5200

Incorporated in 1945 in IA.

Donor(s): Dwayne O. Andreas, Lowell W. Andreas, Glenn A. Andreas, and others.

Financial data (yr. ended 11/30/87): Assets, $2,355,290 (M); gifts received, $1,500; expenditures, $710,113, including $702,131 for 93 grants (high: $200,000; low: $50; average: $500-$5,000).

Purpose and activities: Giving primarily for higher and secondary education, civil rights and economic opportunities for minority groups, and cultural programs; some support for hospitals, public policy research, churches, and youth agencies.

Types of support: Continuing support.

Limitations: No grants to individuals.

Application information: Contributes only to pre-selected organizations. Applications not accepted.
 Board meeting date(s): As required
 Write: Dwayne O. Andreas, Pres.

Officers and Trustees: Dwayne O. Andreas, Pres.; Lowell W. Andreas, Exec. V.P. and Treas.; Michael D. Andreas, V.P. and Secy.;

Dorothy Inez Andreas, Terry Lynn Bevis, Sandra Andreas McMurtrie.
Number of staff: None.
Employer Identification Number: 416017057

698
Edward F. Anixter Family Foundation
1040 North Lake Shore Dr.
Chicago 60611

Established in 1983 in IL.
Donor(s): Edward Anixter.
Financial data (yr. ended 1/31/88): Assets, $84,109 (M); gifts received, $50,000; expenditures, $129,805, including $129,160 for 63 grants (high: $37,084; low: $25).
Purpose and activities: Giving primarily for Jewish organizations, museums, hospitals, and medical research.
Application information:
 Initial approach: Letter
 Deadline(s): None
 Write: Edward F. Anixter, Pres.
Officers: Edward Anixter, Pres.; Edith Anixter, V.P.; Jack Ehrlich, Secy.
Employer Identification Number: 363297335

699
William and Nancy Anixter Family Foundation
630 Winnetka Mews
Winnetka 60093

Established in 1986 in IL.
Donor(s): William R. Anixter.
Financial data (yr. ended 12/31/87): Assets, $1,110,842 (M); expenditures, $161,573, including $157,538 for 17 grants (high: $50,000; low: $60).
Purpose and activities: Support for the aged, higher education, health associations, and cultural organizations.
Limitations: Giving primarily in IL and NM.
Application information: Contributes only to pre-selected organizations. Applications not accepted.
Officers and Directors: William R. Anixter, Pres. and Treas.; Nancy A. Anixter, V.P. and Secy.; Gregory Anixter.
Employer Identification Number: 363482640

700
Arthur I. Appleton Foundation
1701 West Wellington Ave.
Chicago 60657-4095

Established in 1951 in IL.
Financial data (yr. ended 12/31/87): Assets, $1,067,444 (M); gifts received, $750; expenditures, $36,944, including $35,375 for 30 grants (high: $16,000; low: $50).
Purpose and activities: Giving primarily for a cultural center and higher education.
Trustee: Arthur I. Appleton.
Employer Identification Number: 366062190

701
Archer-Daniels-Midland Foundation
P.O. Box 1470
Decatur 62525 (217) 424-5200

Incorporated in 1953 in MN.
Donor(s): Archer-Daniels-Midland Co.
Financial data (yr. ended 6/30/88): Assets, $3,106,807 (M); expenditures, $2,458,805, including $2,387,527 for 467 grants (high: $100,000; low: $25; average: $1,000-$10,000).
Purpose and activities: Grants largely for higher education; support also for minority group development, cultural activities, hospitals, youth agencies, community funds, public policy organizations, and for the prevention of cruelty to animals or children.
Application information:
 Initial approach: Letter
 Deadline(s): None
 Board meeting date(s): As needed
 Final notification: Upon acceptance; no
 notification of negative decision
 Write: Richard E. Burket, Mgr.
Officers: Lowell W. Andreas, Pres.; Roy L. Erickson, Secy.; Donald P. Poboisk, Treas.; Richard E. Burket, Mgr.
Employer Identification Number: 416023126

702
Atwood Foundation
c/o LBD Trust Co.
P.O. Box 5564
Rockford 61125 (815) 398-0907

Incorporated in 1949 in IL.
Donor(s): Atwood Enterprises, Inc., members of the Atwood family.
Financial data (yr. ended 12/31/88): Assets, $1,796,054 (M); expenditures, $36,555 for 35 grants (high: $10,000; low: $100; average: $100-$10,000).
Purpose and activities: Emphasis on education, hospitals, a community fund, arts and cultural programs, and youth and health agencies.
Types of support: Special projects, capital campaigns.
Limitations: Giving primarily in Rockford, IL. No grants to individuals.
Application information:
 Initial approach: Letter
 Copies of proposal: 1
 Deadline(s): None
 Write: Bruce T. Atwood, Co-Trustee
Trustees: Bruce T. Atwood, Diane P. Atwood, Seth G. Atwood, Seth L. Atwood, L.B.D. Trust Co.
Number of staff: None.
Employer Identification Number: 366108602

703
The Aurora Foundation
111 West Downer Place, Suite 312
Aurora 60506-5136 (312) 896-7800

Community foundation incorporated in 1948 in IL.
Financial data (yr. ended 9/30/88): Assets, $7,060,509 (M); gifts received, $350,316; expenditures, $693,636, including $373,527

for 69 grants and $140,717 for grants to individuals.
Purpose and activities: Grants for scholarships and student loans, colleges and hospitals, youth activities, and community services.
Types of support: Student aid, student loans, matching funds, building funds, equipment, capital campaigns, seed money.
Limitations: Giving limited to the Aurora, IL, area. No grants for operating budgets, research, annual campaigns, or continuing support.
Publications: Annual report, application guidelines, newsletter.
Application information: Application form required.
 Initial approach: Telephone
 Copies of proposal: 11
 Deadline(s): Feb., May, and Sept.
 Board meeting date(s): May and Nov.;
 executive committee meets as required
 Write: Sharon Stredde, Exec. Dir.
Officers and Directors: John H. McEachern, Jr., Pres.; Donald A. Schindlbeck, V.P.; Thomas S. Alexander, Treas.; Sharon Stredde, Exec. Dir.; and 24 additional directors.
Number of staff: 1 full-time professional; 1 full-time support.
Employer Identification Number: 366086742

704
Axia Incorporated Giving Program
122 West 22nd St.
Oak Brook 60521 (312) 571-3350

Financial data (yr. ended 12/31/88): Total giving, $45,000, including $40,660 for grants and $4,340 for employee matching gifts.
Purpose and activities: Supports arts and culture, health and welfare, education, and civic programs. Community service programs also receive some support. Arts support includes museums, public television and radio, symphonies and chamber orchestras.
Types of support: Employee matching gifts, employee-related scholarships.
Limitations: Giving primarily in home office area and plant locations.
Publications: Informational brochure.
Application information: 501(c)(3) status letter required.
 Initial approach: Letter describing project
 Copies of proposal: 1
 Deadline(s): End of calender year
 Write: Dennis W. Sheehan, Chair., Pres., and
 C.E.O.
Number of staff: 3

705
Barber-Colman Charitable Contribution Program
P.O. Box 7040
555 Colman Center Dr.
Rockford 61125 (815) 397-7400

Financial data (yr. ended 12/31/88): Total giving, $160,000, including $140,000 for 19 grants (high: $50,000; low: $500; average: $3,000-$5,000) and $20,000 for employee matching gifts.
Purpose and activities: Support for the arts, community development, economics,

unemployment, health services, including hospices, higher and secondary education, and science and technology.

Types of support: Building funds, capital campaigns, equipment, seed money, technical assistance, employee matching gifts.

Limitations: Giving primarily in communities where company has manufacturing facilities employing 100 or more, mainly IL. No grants to individuals, or for deficit financing, research, scholarships or fellowships; no loans.

Publications: Application guidelines, program policy statement.

Application information: Application form required.

Initial approach: Letter
Copies of proposal: 1
Deadline(s): May 15 and Nov.15
Board meeting date(s): Usually June and Dec.
Final notification: Within 10 weeks after meeting
Write: Robert M. Hammes, Secy.

Administrator: Robert M. Hammes, Secy.

Number of staff: 1 part-time professional; 2 part-time support.

706

M. R. Bauer Foundation

208 South LaSalle St., Suite 1750
Chicago 60604 (312) 372-1947

Established in 1955 in IL.

Donor(s): M.R. Bauer,† Evelyn M. Bauer.†

Financial data (yr. ended 12/31/86): Assets, $38,582,424 (M); expenditures, $1,827,548, including $1,600,000 for 115 grants (high: $150,000; low: $500; average: $2,000-$20,000).

Purpose and activities: Grants primarily for higher education, including medical and legal education, hospitals, cultural programs, and social service and youth agencies.

Types of support: General purposes, operating budgets, professorships, research.

Limitations: Giving primarily in CA and IL. No grants to individuals.

Application information: Contributes only to pre-selected organizations. Applications not accepted.

Board meeting date(s): Irregularly
Write: Kent Lawrence, Treas.

Officers and Directors: A. Charles Lawrence, Pres.; James H. Ackerman, V.P. and Secy.; Loraine E. Ackerman, V.P.; Kent Lawrence, Treas.; Lee James Ackerman, James J. Lawrence.

Number of staff: None.

Employer Identification Number: 366052129

707

The Baxter Foundation

(Formerly The Baxter Travenol Foundation)
One Baxter Pkwy.
Deerfield 60015 (312) 948-4605

Established in 1982 in IL.

Donor(s): American Hospital Supply Corp., Baxter Travenol Laboratories, Inc.

Financial data (yr. ended 12/31/88): Assets, $12,989,097 (M); expenditures, $3,061,989, including $2,520,591 for 204 grants (high: $333,330; low: $100) and $289,583 for 1,249 employee matching gifts.

Purpose and activities: Supports health care organizations which address a broad national or regional need. Emphasis on research and advocacy efforts that have a broad effect on increasing access to health care services and that provide resources to help hospital managers and medical personnel become more effective. Prize programs include the Foster G. McGraw Prize, the Baxter Health Services Research Award, the Baxter International Faculty Fellowships, the Baxter Fellowships for Innovation in Health Care Management, and the Baxter Foundation Episteme award. Matching gift program for hospitals and education. Scholarships for the children of company employees are paid through the Citizen's Scholarship Foundation of America. The Dollars for Doers program supports organizations in which Baxter employees are active volunteers.

Types of support: Scholarship funds, fellowships, employee matching gifts, operating budgets, employee-related scholarships, special projects.

Limitations: Giving nationally for health care organizations which address a broad national or regional need. No support for religious organizations, disease-specific organizations, or educational institutions except where grant supports a health care goal. No grants to individuals, or for dinners and special fundraising events.

Publications: Annual report, application guidelines.

Application information:

Initial approach: Letter
Copies of proposal: 1
Deadline(s): One month before meetings
Board meeting date(s): Jan., Apr., July, Oct., and Dec.
Write: Barbara A. Eychaner, Exec. Dir.

Officers and Directors: Wilbur H. Gantz, Chair.; G. Marshall Abbey, Pres.; Roger F. Lewis, V.P.; William B. Graham, Wilfred J. Lucas, Barbara Young Morris, Robert A. Patterson, Robert J. Simmons.

Number of staff: 2 full-time professional.

Employer Identification Number: 363159396

708

The Beatrice Foundation

Two North LaSalle St.
Chicago 60602 (312) 558-3758

Incorporated in 1953 in IL as the Esmark, Inc. Foundation.

Donor(s): Esmark, Inc., Beatrice Companies, Inc.

Financial data (yr. ended 12/31/86): Assets, $15,689,740 (M); gifts received, $4,750,000; expenditures, $2,442,806, including $2,371,372 for 820 grants (high: $430,834; low: $25; average: $100-$5,000).

Purpose and activities: Giving in two major categories: a nonprofit management program to encourage excellence in nonprofit organizations and a community priorities program to strengthen communities, with special attention to disadvantaged populations. This program also includes support for a community fund, an employee matching gift program for higher education, public media, and performing arts,

and scholarships for dependents of company employees.

Types of support: Consulting services, conferences and seminars, equipment, general purposes, operating budgets, capital campaigns, employee matching gifts, employee-related scholarships, research.

Limitations: Giving primarily in the Chicago, IL, metropolitan area. No support for United Way campaigns (other than in Chicago), national health organizations, or for political, veterans', or sectarian organizations, or organizations that have discriminatory policies. No grants to individuals, or for advertising or fundraising events.

Publications: Annual report, informational brochure (including application guidelines).

Application information: Contact foundation for new guidelines.

Initial approach: Letter
Deadline(s): Feb. 1, May 1, Aug. 1, and Nov. 1
Board meeting date(s): Mar., June, Sept., and Dec.
Write: Linda Robbins, Fdn. Admin.

Officers and Directors: Lizabeth Sode, Pres.; William P. Carmichael, V.P.; Susan Maloney Meyer, Secy.; Gregg A. Ostrander, Treas.; Lynda Robbins, Admin.; Barbara Stockton, Matching Gifts Admin.; William Chambers, Floyd W. (Bud) Glisson.

Number of staff: 2 part-time professional; 2 part-time support.

Employer Identification Number: 366050467

709

Bell & Howell Foundation

5215 Old Orchard Rd.
Skokie 60077 (312) 470-7100

Incorporated in 1951 in IL.

Donor(s): Bell & Howell Co.

Financial data (yr. ended 12/31/87): Assets, $14,419 (M); gifts received, $490,000; expenditures, $479,411, including $432,730 for 93 grants (high: $130,000; low: $135) and $46,591 for employee matching gifts.

Purpose and activities: Support for community funds and education; support also for human services, cultural programs, youth agencies, and social services; scholarships for dependents of employees administered by the National Merit Scholarship Corp.

Types of support: Employee matching gifts, operating budgets, employee-related scholarships.

Limitations: Giving primarily in local plant areas. No support for fraternal, veterans', or labor organizations. No grants to individuals, or for building or endowment funds, research, scholarships, fellowships, or special projects; no loans.

Publications: Application guidelines.

Application information: Application form required for scholarships.

Initial approach: Proposal
Copies of proposal: 1
Deadline(s): Before Jan. of student's junior year for scholarships
Board meeting date(s): Mar.
Final notification: Mar. of senior year for scholarships

Write: Lois Robinson, Pres., or M.J. Winfield, Scholarship Prog. Dir.
Officers: Lois Robinson,* Pres.; M.D. Phillips, Secy.; Deeon Zadrozny, Treas.
Directors:* Donald N. Frey, J.B. Kambanis, Gerlad E. Schultz.
Number of staff: 1 part-time professional; 1 part-time support.
Employer Identification Number: 366095749

710
Beloit Foundation, Inc.
11722 Main St.
Roscoe 61073 (815) 623-6600

Incorporated in 1959 in WI.
Donor(s): Elbert H. Neese.†
Financial data (yr. ended 12/31/87): Assets, $11,993,490 (M); gifts received, $24,063; expenditures, $1,402,851, including $1,196,342 for 30 grants (high: $500,000; low: $500; average: $500-$500,000).
Purpose and activities: Giving only to local community organizations for special projects, and new program development; support for education, with emphasis on a local college, social service and youth agencies, health, recreation, the arts, and a community fund.
Types of support: Building funds, matching funds, seed money, special projects, capital campaigns, equipment, renovation projects.
Limitations: Giving limited to local stateline area, including Beloit, WI, and South Beloit, Rockton, and Roscoe, IL. No grants to individuals, or for endowment funds, research, direct scholarships, or fellowships; or for nationally organized fundraising campaigns.
Application information: Application form required.
 Initial approach: Letter
 Copies of proposal: 1
 Deadline(s): Submit proposal in Dec. or June; no set deadline
 Board meeting date(s): Feb. and Aug.
 Final notification: 3 months
 Write: Gary G. Grabowski, Exec. Dir.
Officers: Elbert H. Neese,* Pres.; V.K. Hauser, Secy.; Gary G. Grabowski,* Exec. Dir. and Treas.
Directors:* Harry C. Moore, Alonzo A. Neese, Jr., Gordon C. Neese, Laura Neese-Malik, Jane Petit-Moore.
Number of staff: 1 part-time professional; 1 part-time support.
Employer Identification Number: 396068763

711
Bere Foundation, Inc.
641 South Elm St.
Hinsdale 60521

Established in 1983 in IL.
Donor(s): James F. Bere.
Financial data (yr. ended 12/31/87): Assets, $4,136,899 (M); gifts received, $286,455; expenditures, $120,157, including $103,700 for 16 grants (high: $31,000; low: $250).
Purpose and activities: Support primarily for churches and religious groups; some support for cultural programs.
Types of support: General purposes.

Limitations: Giving primarily in the greater Chicago, IL, area.
Application information: Contributes only to pre-selected organizations. Applications not accepted.
 Write: James F. Bere, Pres.
Officers and Directors: James F. Bere, Pres.; David L. Bere, V.P.; James F. Bere, Jr., V.P.; Robert P. Bere, V.P.; Becky B. Sigfusson, V.P.; Lynn B. Stine, V.P.; Barbara Van Dellen Bere, Secy.-Treas.
Employer Identification Number: 363272779

712
Albert E. Berger Foundation, Inc.
c/o Miles Berger
180 North LaSalle St.
Chicago 60601

Established in 1957 in IL.
Donor(s): Members of the Berger family, Berger Investment Co.
Financial data (yr. ended 12/31/87): Assets, $3,299,319 (M); gifts received, $125,000; expenditures, $410,267, including $163,774 for 109 grants (high: $59,210; low: $10).
Purpose and activities: Giving primarily for Jewish welfare and for cultural organizations; some support for health and social services.
Officers: Miles Berger, Pres.; Robert Berger, Secy.-Treas.
Directors: Ronald Berger, Dorothy Berger Epstein.
Employer Identification Number: 366080617

713
The Bersted Foundation
c/o Continental Illinois National Bank & Trust Co. of Chicago
30 North LaSalle St.
Chicago 60697 (312) 828-8026

Established in 1972 in IL.
Donor(s): Alfred Bersted.†
Financial data (yr. ended 12/31/87): Assets, $8,921,505 (M); expenditures, $415,969, including $336,500 for 19 grants (high: $50,000; low: $2,000).
Purpose and activities: Emphasis on community welfare and family service agencies, aid to the handicapped, conservation, cultural programs, youth agencies, and health care.
Types of support: Building funds, technical assistance, general purposes, operating budgets.
Limitations: Giving limited to Kane, DuPage, DeKalb, and McHenry counties, IL. No support for religious houses of worship or degree-conferring institutions of higher learning. No grants to individuals.
Publications: Multi-year report.
Application information:
 Initial approach: Letter
 Copies of proposal: 2
 Deadline(s): None
 Board meeting date(s): Generally in Feb., May, Aug., and Nov.
 Write: A.W. Murray
Trustee: Continental Illinois National Bank & Trust Co. of Chicago.
Employer Identification Number: 366493609

714
Grace A. Bersted Foundation
Continental Illinois Bank & Trust Co. of Chicago, Sixth Fl.
30 North LaSalle
Chicago 60697 (312) 828-1785

Established in 1986 in IL.
Donor(s): Grace A. Bersted.†
Financial data (yr. ended 12/31/87): Assets, $3,699,113 (M); expenditures, $134,355, including $105,000 for 8 grants (high: $25,000; low: $10,000).
Purpose and activities: Support for youth organizations, social services, wilderness conservation and culture.
Limitations: Giving limited to DuPage, Kane, Lake and McHenry Counties, IL.
Application information:
 Initial approach: Proposal
 Deadline(s): None
 Write: M.C. Ryan
Trustee: Continental Illinois National Bank & Trust Co. of Chicago.
Employer Identification Number: 366841348

715
William Blair and Company Foundation
135 South LaSalle St.
Chicago 60603 (312) 236-1600

Established in 1980 in IL.
Donor(s): William Blair & Co.
Financial data (yr. ended 8/31/88): Assets, $1,089,690 (M); gifts received, $325,000; expenditures, $166,790, including $165,990 for 108 grants (high: $5,000; low: $200; average: $500-$2,000).
Purpose and activities: Giving primarily for cultural programs, hospitals and health associations including cancer research, higher education, social services and youth agencies, civic and public affairs, and Jewish giving.
Types of support: Annual campaigns, building funds, capital campaigns, continuing support, endowment funds, fellowships, general purposes, internships, operating budgets.
Limitations: Giving primarily in the metropolitan Chicago, IL, area; the grantee should have significant, but not necessarily exclusive impact on the Chicago metropolitan area.
Application information:
 Initial approach: Letter
 Copies of proposal: 1
 Deadline(s): None
 Write: Stephen Campbell, Treas.
Officers: Edgar D. Jannotta, Pres.; E. David Coolidge III, V.P.; James M. McMullan, V.P.; Gregory N. Thomas, Secy.; Stephen Campbell, Treas.
Number of staff: None.
Employer Identification Number: 363092291

716
Harry and Maribel G. Blum Foundation
919 North Michigan Ave., Suite 2800
Chicago 60611

Established in 1967 in IL.
Donor(s): Harry Blum.†

Financial data (yr. ended 12/31/87): Assets, $11,429,516 (M); expenditures, $649,111, including $568,550 for 16 grants (high: $310,000; low: $500).
Purpose and activities: Grants primarily for hospitals and health agencies, higher education, temple support, social services, an art institute, and Jewish welfare funds.
Types of support: General purposes.
Limitations: No grants to individuals.
Application information:
 Initial approach: Letter or proposal
 Deadline(s): None
 Board meeting date(s): As required
Officers and Directors: H. Jonathan Kovler, Pres.; H.H. Bregar, Secy.; Peter Kovler.
Employer Identification Number: 366152744

717
Blum-Kovler Foundation
500 North Michigan Ave.
Chicago 60611 (312) 828-9777

Incorporated in 1953 in IL.
Donor(s): Harry Blum,† Everett Kovler.
Financial data (yr. ended 12/31/87): Assets, $25,878,500 (M); expenditures, $1,660,430, including $1,360,850 for 148 grants (high: $310,000; low: $100; average: $500-$5,000).
Purpose and activities: Emphasis on social services, including Jewish welfare funds; higher education; hospitals, health services, and medical research; and cultural programs; support also for youth and child welfare agencies, and public interest and civic affairs groups.
Types of support: General purposes.
Limitations: Giving primarily in the Chicago, IL, area.
Application information:
 Initial approach: Written request
 Deadline(s): None
 Board meeting date(s): As required
 Final notification: Varies
 Write: H. Jonathan Kovler, Treas.
Officers and Directors: Everett Kovler, Pres.; H.H. Bregar, Secy.; H. Jonathan Kovler, Treas.; Peter Kovler.
Number of staff: 1 full-time support.
Employer Identification Number: 362476143

718
Charles H. and Bertha L. Boothroyd Foundation
135 South LaSalle St., Rm. 1254
Chicago 60603 (312) 346-3833

Incorporated in 1958 in IL.
Donor(s): Mary T. Palzkill.†
Financial data (yr. ended 6/30/88): Assets, $2,960,165 (M); gifts received, $75,000; expenditures, $158,244, including $121,500 for 19 grants (high: $25,000; low: $1,000).
Purpose and activities: Grants for medical school scholarship funds for research on Parkinson's disease and for hospitals, higher education, social services, and cultural institutions.
Limitations: Giving primarily in IL.
Application information:
 Initial approach: Letter
 Deadline(s): None

 Write: Bruce E. Brown, Pres.
Officers and Trustees: Bruce E. Brown, Pres.; Donald C. Gancer, V.P.; Lorraine Marcus, Secy.
Employer Identification Number: 366047045

719
Borg-Warner Foundation, Inc.
200 South Michigan Ave.
Chicago 60604 (312) 322-8659

Incorporated in 1953 in IL.
Donor(s): Borg-Warner Corp., and its divisions and subsidiaries.
Financial data (yr. ended 12/31/88): Assets, $6,232,702 (M); expenditures, $1,767,226, including $1,295,455 for 149 grants (high: $200,000; low: $500; average: $2,500-$10,000) and $204,445 for employee matching gifts.
Purpose and activities: Support for community funds, for educational institutions, for culture, neighborhood revitalization, social welfare, health agencies, and civic affairs.
Types of support: General purposes, building funds, equipment, land acquisition, endowment funds, matching funds, professorships, special projects, publications, continuing support, employee matching gifts, seed money, scholarship funds, operating budgets, renovation projects, capital campaigns.
Limitations: Giving primarily in the Chicago, IL, area. No support for sectarian institutions for religious purposes, foreign-based organizations, or medical or academic research. No grants to individuals, or for testimonial dinners, fundraising events, or advertising.
Publications: Annual report, informational brochure (including application guidelines), application guidelines.
Application information:
 Initial approach: Proposal preferably no longer than 10 pages for general purposes; RFP details requirements for education
 Copies of proposal: 1
 Deadline(s): None
 Board meeting date(s): Quarterly
 Write: Ellen J. Benjamin, Dir., Corp. Contribs.
Directors: James F. Bere, Chair. and Pres.; John D. O'Brien, V.P.; Neal F. Farrell, V.P. and Secy.; Donald C. Trausch, V.P. and Treas.
Number of staff: 1 full-time professional; 1 full-time support.
Employer Identification Number: 366051857
Recent arts and culture grants:
Adler Planetarium, Chicago, IL, $5,000. 1987.
Art Institute of Chicago, Chicago, IL, $10,000. 1987.
Baliwick Theater, Chicago, IL, $5,000. 1987.
Black Ensemble Theater, Chicago, IL, $5,000. 1987.
Body Politic Theater, Chicago, IL, $10,000. 1987.
Brookfield Zoo, Chicago, IL, $15,000. 1987.
Chamber Music Chicago, Chicago, IL, $6,000. 1987.
Chicago Architecture Foundation, Chicago, IL, $5,000. 1987.
Chicago City Ballet, Chicago, IL, $10,000. 1987.
Chicago Dance Arts Coalition, Chicago, IL, $6,000. 1987.

Chicago Opera Theater, Chicago, IL, $5,000. 1987.
Chicago Symphony Orchestra, Chicago, IL, $65,000. 1987.
Chicago Theater Company, Chicago, IL, $5,000. 1987.
Express-Ways Childrens Museum, Chicago, IL, $8,000. 1987.
Field Museum of Natural History, Chicago, IL, $10,000. 1987.
Goodman Theater, Chicago, IL, $12,500. 1987.
Illinois State Historical Society, Springfield, IL, $15,500. 1987.
Joseph Holmes Dance Theater, Chicago, IL, $5,000. 1987.
Lyric Opera of Chicago, Chicago, IL, $20,000. 1987.
Mexican Fine Arts Center Museum, Chicago, IL, $5,000. 1987.
MoMing Dance and Arts Center, Chicago, IL, $6,000. 1987.
Museum of Contemporary Art, Chicago, IL, $25,000. 1987.
Museum of Science and Industry, Chicago, IL, $10,000. 1987.
New Music Chicago, Chicago, IL, $10,000. 1987.
North Lakeside Cultural Center, Chicago, IL, $10,000. 1987.
Performance Community, Chicago, IL, $12,500. 1987.
Schwab Rehabilitation Center, Chicago, IL, $8,000. 1987.
Steppenwolf Theater, Chicago, IL, $5,000. 1987.
Terra Nova Films, Chicago, IL, $10,000. 1987.
Urban Gateways, Chicago, IL, $5,000. 1987.
Victory Gardens Theater, Chicago, IL, $10,000. 1987.
W B E Z, Chicago, IL, $10,000. 1987.
W T T W Chicago Public Television, Chicago, IL, $5,000. 1987.
Wisdom Bridge Theater, Chicago, IL, $12,500. 1987.

720
Brand Companies Charitable Foundation
1420 Renaissance Dr.
Park Ridge 60068

Donor(s): Brand Insulations, Inc.
Financial data (yr. ended 12/31/87): Assets, $486,959 (M); gifts received, $103,601; expenditures, $87,775, including $87,100 for 54 grants (high: $10,000; low: $200).
Purpose and activities: Support for civic affairs, health, culture, religion, higher education, social services, and community funds.
Application information:
 Initial approach: Letter
 Deadline(s): None
Officers: Eugene L. Barnett, Chair. and Secy.; Malcolm Smith, Pres. and Secy.
Director: Marc Neuerman.
Employer Identification Number: 363255889

721
The Buchanan Family Foundation
222 East Wisconsin Ave.
Lake Forest 60045

Established in 1967 in IL.
Donor(s): D.W. Buchanan, Sr.,† D.W. Buchanan, Jr.
Financial data (yr. ended 12/31/87): Assets, $32,442,868 (M); expenditures, $2,144,542, including $2,080,000 for 51 grants (high: $100,000; low: $5,000; average: $5,000-$100,000).
Purpose and activities: Emphasis on cultural programs, hospitals and health associations, education, social service agencies, community funds, and environmental associations.
Limitations: Giving primarily in Chicago, IL.
Application information:
 Board meeting date(s): Fall
 Write: Huntington Eldridge, Jr., Treas.
Officers: Kenneth H. Buchanan,* Pres.; G.M. Walsh, V.P. and Secy.; Huntington Eldridge, Jr., Treas.
Directors:* Kent Chandler, Jr.
Number of staff: None.
Employer Identification Number: 366160998

722
Carlin Fund
8000 Sears Tower
Chicago 60606

Incorporated in 1954 in IL.
Donor(s): Leo J. Carlin, Celia Carlin.
Financial data (yr. ended 12/31/87): Assets, $1,346,587 (M); expenditures, $75,531, including $66,850 for 75 grants (high: $12,000; low: $200).
Purpose and activities: Giving for higher education, medical research, Jewish welfare funds, temple support, the arts, public policy, and civic affairs.
Limitations: No grants to individuals.
Application information: Applications not accepted.
Officers and Directors: Jerome E. Carlin, Pres.; Chester M. Epstein, V.P.; David Epstein, Secy.; Nicholas Carlin, Treas.
Employer Identification Number: 366057155

723
Carson Pirie Scott Foundation
36 South Wabash St.
Chicago 60603 (312) 641-8055

Incorporated in 1959 in IL.
Donor(s): Carson Pirie Scott & Co., Carson International, Inc.
Financial data (yr. ended 12/31/87): Assets, $202,168 (M); gifts received, $340,000; expenditures, $390,637, including $379,115 for 104 grants (high: $185,000; low: $100) and $11,477 for 79 employee matching gifts.
Purpose and activities: Emphasis on community funds; support also for education, the arts, health services, community development, and civic affairs; contributions in proportion to size of company operations.
Types of support: Continuing support, building funds, scholarship funds, equipment.

Limitations: Giving primarily in Chicago, IL, and communities with company operations. No grants to individuals, or for endowment funds, research, or matching gifts; no loans.
Publications: Program policy statement, application guidelines.
Application information:
 Initial approach: Letter
 Copies of proposal: 1
 Deadline(s): None
 Board meeting date(s): Feb., May, and Sept.
 Final notification: 2 to 3 weeks after meetings
Officers: Peter S. Willmott,* Pres.; Daniel M. Fort, V.P. and Secy.; Charles T. Reice,* V.P. and Treas.
Directors:* Dennis S. Bookshester, Robert P. Bryant, Carroll E. Ebert, Kurt Gasser, Donald J. Gralen, Robert D. Jones, Dean B. McKinney, Robert S. Ruwitch.
Employer Identification Number: 366112629

724
Cartwright Foundation
c/o L. Russell Cartwright
1 Prudential Plaza, Suite 3800, 130 East Randolph
Chicago 60601

Established in 1964 in IL.
Donor(s): Levering R. Cartwright.†
Financial data (yr. ended 12/31/87): Assets, $1,269,628 (M); gifts received, $27,000; expenditures, $82,806, including $60,000 for 17 grants (high: $12,500; low: $125).
Purpose and activities: Support primarily for culture, hospitals, and education.
Application information: Contributes only to pre-selected organizations. Applications not accepted.
Trustees: Cameron Avery, Abigail Cartwright, Janet W. Cartwright, L. Russell Cartwright, Joan M. Hall.
Employer Identification Number: 366101710

725
Carus Corporate Contributions Program
315 Fifth Avenue
Peru 61354 (815) 223-1500

Financial data (yr. ended 12/31/88): $10,000 for in-kind gifts.
Purpose and activities: Giving for adult, higher, secondary, elementary and early childhood education, business, community development, the arts, chemistry, science, mathematics, media and communications, and public affairs. The corporation provides facilities and services to nonprofit organizations as a form of in-kind giving.
Types of support: Annual campaigns, conferences and seminars, continuing support, general purposes, internships, lectureships, publications, seed money, special projects, in-kind gifts.
Limitations: Giving primarily in IL, but with exceptions.
Application information: Grant applications not generally invited or accepted; mostly generated internally.
 Board meeting date(s): Quarterly
 Write: Robert J. Willmot, Dir., Corp. Communications
Number of staff: 1 part-time support.

726
Caterpillar Corporate Giving Program
100 N.E. Adams St.
Peoria 61629-1480

Financial data (yr. ended 12/31/88): $382,554 for grants.
Purpose and activities: Support overwhelmingly for civic affairs on the local, state, and national level, for trade and public policy organizations, and for international development; smaller grants for education, health and welfare, and culture.
Types of support: Special projects, capital campaigns, operating budgets.
Limitations: Giving primarily in areas of company operations; support also for national organizations. No support for fraternal organizations, political activities or religious organizations whose services are limited to one sectarian group. No grants to individuals, or for tickets or advertising for fundraising benefits, general operations or ongoing programs of agencies funded by United Way.
Publications: Informational brochure (including application guidelines).
Application information:
 Initial approach: Letter
 Deadline(s): None
 Write: Edward W. Siebert, Mgr., Corp. Support Programs

727
Caterpillar Foundation
100 N.E. Adams St.
Peoria 61629-1480

Established in 1952 in IL.
Donor(s): Caterpillar, Inc.
Financial data (yr. ended 12/31/87): Assets, $302,994 (M); gifts received, $3,617,000; expenditures, $3,549,462, including $3,122,716 for grants and $419,466 for employee matching gifts.
Purpose and activities: Giving primarily to community funds, higher education, and a youth agency; employee matching gift support for cultural and educational institutions.
Types of support: Employee matching gifts, operating budgets, special projects, capital campaigns.
Limitations: Giving primarily in areas of company operations. No support for fraternal organizations, religious organizations whose services are limited to one sectarian group, or political activities. No grants to individuals, or for general operations or ongoing programs of agencies funded by the United Way, or tickets or advertising for fundraising benefits.
Publications: Corporate giving report.
Application information:
 Initial approach: Letter or proposal
 Deadline(s): None
 Board meeting date(s): Dec. 1
 Write: Edward W. Siebert, Mgr.
Officers and Directors:* Peter P. Donis,* Pres.; E.J. Schlegel,* Exec. V.P.; Edward W. Siebert, V.P. and Mgr.; B. DeHaan,* V.P.; H.W. Holling, V.P.; L.A. Kuchan, V.P.; R.R. Thornton, Secy.; A.C. Greer, Treas.
Employer Identification Number: 376022314

728
Community Foundation of Champaign County

c/o Bank of Illinois in Champaign
100 West University Ave., P.O. Box 826
Champaign 61820 (217) 351-6607

Incorporated in 1972 in IL.
Financial data (yr. ended 3/31/88): Assets, $1,419,380 (M); gifts received, $659,150; expenditures, $83,434, including $69,938 for 40 grants and $300 for 2 grants to individuals.
Purpose and activities: Support for health programs, education, social services, the arts, civic affairs, and the humanities.
Types of support: Student aid, annual campaigns, building funds, consulting services, continuing support, equipment, program-related investments, publications, renovation projects.
Limitations: Giving primarily in Champaign, IL.
Publications: Annual report.
Application information: Application form required.
 Copies of proposal: 1
 Deadline(s): Feb. 1
 Board meeting date(s): Feb. 15
 Final notification: Mar. 1
 Write: Albert D. Mulliken, Exec. Secy.
Officers: Arthur H. Perkins, Pres.; Donald G. Armstrong, V.P.; Marilyn Thies, Secy.; Martin E. Verdick, Treas.
Number of staff: 1 part-time support.
Employer Identification Number: 237176723

729
Frances Chapin Foundation

105 Old Mill Rd.
Barrington 60010

Incorporated in 1966 in NJ.
Donor(s): Frances C. Crook.†
Financial data (yr. ended 3/31/87): Assets, $3,138,097 (M); expenditures, $123,411, including $110,500 for 11 grants (high: $35,000; low: $2,500).
Purpose and activities: Emphasis on hospitals, social services, youth, secondary education, and cultural programs.
Limitations: Giving primarily in Barrington, IL.
Application information: Contributes only to pre-selected organizations.
Officer and Director: Thomas O. Maxfield III, Pres.
Employer Identification Number: 226087456

730
Chapman and Cutler Charitable Trust

111 West Monroe
Chicago 60603

Financial data (yr. ended 12/31/87): Assets, $2,714 (M); gifts received, $121,168; expenditures, $119,845, including $119,845 for 50 grants (high: $71,985; low: $25).
Purpose and activities: Giving primarily for a community fund; support also for legal services, cultural programs, and youth.
Application information: Contributes only to pre-selected organizations. Applications not accepted.
Trustees: Edwin S. Brown, Richard H. Goss, David G. Williams.
Employer Identification Number: 363125206

731
Chicago Board of Trade Foundation

141 West Jackson Blvd.
Chicago 60604 (312) 435-3457

Financial data (yr. ended 6/30/87): Assets, $370,861 (M); gifts received, $600; expenditures, $27,338, including $24,000 for 35 grants (high: $2,000; low: $500).
Purpose and activities: Support for education, including a school for the blind and higher education; and civic affairs with emphasis on youth and child development, including science, arts, wildlife, community funds, health services, and museums.
Limitations: Giving primarily in Chicago, IL.
Application information:
 Initial approach: Letter
Officers and Directors: Karsten Mahlman, Chair.; Thomas R. Donovan, Pres.; George Sladoje, V.P. and Secy.; Glen M. Johnson, Treas.; Patrick Arbor, Francis X. O'Donnell, Keith Rudman, Erwin Smith.
Employer Identification Number: 363348469

732
The Chicago Community Trust

222 North LaSalle St., Suite 1400
Chicago 60601 (312) 372-3356

Community foundation established in 1915 in IL by bank resolution and declaration of trust.
Financial data (yr. ended 9/30/88): Assets, $269,457,800 (M); gifts received, $11,631,441; expenditures, $25,569,465, including $22,004,515 for 531 grants (high: $1,000,000; low: $100; average: $10,000-$50,000) and $532,600 for 3 loans.
Purpose and activities: Established "for such charitable purposes as will...best make for the mental, moral, intellectual and physical improvement, assistance and relief of the inhabitants of the County of Cook, State of Illinois." Grants for both general operating support and specific programs and projects in the areas of health and social services, youth agencies, education, particularly higher education, and cultural and civic affairs; awards fellowships to individuals in leadership positions in local community service organizations.
Types of support: Operating budgets, continuing support, emergency funds, building funds, equipment, land acquisition, loans, research, special projects, renovation projects, capital campaigns, general purposes, technical assistance.
Limitations: Giving primarily in Cook County, IL. No support for religious purposes or government agencies. No grants to individuals, (except for the Community Service Fellowship Program), or for annual campaigns, deficit financing, endowment funds, publications, conferences, or scholarships; no support for the purchase of computer hardware; no general operating support for agencies or institutions whose program activities substantially duplicate those already undertaken by others.
Publications: Annual report, informational brochure, program policy statement, application guidelines, newsletter.
Application information: Application form required for fellowship program.
 Initial approach: Proposal

Copies of proposal: 2
Deadline(s): June 30 for fellowship program; other applications accepted throughout the year
Board meeting date(s): Jan., Mar., June, and Sept.
Final notification: 90 days after board meeting
Write: Ms. Trinita Logue, Asst. Dir., Admin. (grants to organizations and Community Service Fellowship Program)
Officer: Bruce L. Newman, Exec. Dir.
Executive Committee: James F. Bere, Chair.; Franklin A. Cole, Vice-Chair.; Mrs. Philip D. Block III, James J. Brice, J. Ira Harris, Margaret D. Hartigan, Edgar D. Jannotta, Margaret P. MacKimm, Cordell Reed, Mrs. Patrick G. Ryan, Mrs. Gordon H. Smith, Rev. Dr. Kenneth B. Smith, Arthur R. Velasquez.
Trustees: American National Bank & Trust Co. of Chicago, Boulevard Bank National Assn., Chicago Title and Trust Co., Continental Illinois National Bank & Trust Co. of Chicago, First National Bank of Chicago, Harris Trust & Savings Bank, Heritage Pullman Bank, LaSalle National Bank, Northern Trust Company.
Number of staff: 14 full-time professional; 1 part-time professional; 8 full-time support; 2 part-time support.
Employer Identification Number: 362167000
Recent arts and culture grants:
Adler Planetarium, Chicago, IL, $300,000. For matching grant for Campaign for Chicago's Brightest Star. 9/87.
Adler Planetarium, Chicago, IL, $100,000. For support of Campaign for Chicago's Brightest Star. 9/87.
Art Institute of Chicago, Chicago, IL, $126,704. For maintenance, cleaning, conservation, restoration, and reinstallation of Thorne Miniature Rooms Collection. 6/88.
Art Institute of Chicago, Chicago, IL, $32,842. For maintenance of Thorne Miniature Rooms Collection. 6/88.
Art Institute of Chicago, Chicago, IL, $20,000. For maintenance of Thorne Miniature Room Collection. 9/87.
Art Resources in Teaching, Chicago, IL, $25,000. To support expansion of visual arts program in Chicago public schools. 1/88.
Business Volunteers for the Arts/Chicago, Chicago, IL, $30,000. For salary support for additional staff position. 1/88.
Chicago City Ballet, Chicago, IL, $23,905. To support costs of salary and severance expense of administrative and production staff, insurance, and employee-related out-of-pocket expenses. 1/88.
Chicago International Theater, Chicago, IL, $50,000. To support professional development program for local artists. 9/87.
Chicago Maritime Society, Chicago, IL, $10,000. For general operating support. 3/88.
Chicago Opera Theater, Chicago, IL, $105,000. For general operating support. 1/88.
Chicago Repertory Dance Ensemble, Chicago, IL, $20,000. For general operating support. 3/88.
Chicago, City of, Department of Cultural Affairs, Chicago, IL, $15,000. Toward cost of consultant to evaluate grant programs of Chicago Office of Fine Arts. 6/88.
City Musick, Chicago, IL, $20,000. For general operating support. 3/88.

Express-Ways Childrens Museum, Chicago, IL, $48,600. For salary support of exhibit developer, travel expenses, and exhibit development expenses. 1/88.

Frank Lloyd Wright Home and Studio Foundation, Oak Park, IL, $10,000. For salary support of education director. 9/87.

Friends of the Illinois and Michigan Canal National Heritage Corridor, Illinois and Michigan Canal National Heritage Corridor Civic Center Authority, Joliet, IL, $15,000. For matching grant for general operating support. 6/88.

Hubbard Street Dance Company, Chicago, IL, $75,000. For general operating support. 3/88.

Hubbard Street Dance Company, Chicago, IL, $50,000. For matching grant in support of major gifts campaign. 3/88.

Illinois Arts Alliance, Chicago, IL, $10,000. To support commission of study on economic impact of arts in Illinois. 1/88.

Joseph Holmes Dance Theater, Chicago, IL, $50,000. For general operating support. 1/88.

Landmarks Preservation Council of Illinois, Chicago, IL, $150,000. To purchase and rehabilitate Reliance Building in downtown Chicago and to create cooperative office facility for not-for-profit charitable agencies serving greater Chicago area. 3/88.

Mexican Fine Arts Center Museum, Chicago, IL, $150,000. To support renovation of Harrison Park facility. 1/88.

Mexican Fine Arts Center Museum, Chicago, IL, $105,000. For salary support of project director and business manager, and for general support. 1/88.

Museum of Broadcast Communications, Chicago, IL, $100,000. For general operating support. 6/88.

Music Center of the North Shore, Winnetka, IL, $15,000. To partially support hiring facilitator to assist in strategic planning. 1/88.

Music of the Baroque, Chicago, IL, $73,000. Toward costs of professional search, staff salaries, and public relations and development consulting. 9/87.

Newberry Library, Chicago, IL, $250,000. For general operating support. 3/88.

North Lakeside Cultural Center, Chicago, IL, $25,000. For matching grant for general operating support in 1988 and 1989. 1/88.

Northlight Theater, Evanston, IL, $40,000. For matching grant to support increased salaries for artists. 3/88.

Old Town School of Folk Music, Chicago, IL, $20,000. Toward costs of equipment and furnishings. 9/87.

Orchestra of Illinois, Chicago, IL, $50,000. For marketing expenses and salary support of marketing director. 1/88.

Randolph Street Gallery, Chicago, IL, $28,650. For salary support of administrative assistant. 1/88.

Remains Theater, Chicago, IL, $45,000. For general operating support. 1/88.

Steppenwolf Theater Company, Chicago, IL, $25,000. To partially support planning of flexible theater space, to obtain cost estimates of building such space, and to test design for city code requirements. 1/88.

Suzuki-Orff School for Young Musicians, Chicago, IL, $5,664. To support scholarships for young children studying violin,

violoncello, or piano, made from fund restricted to this purpose. 1/88.

Wisdom Bridge Theater, Chicago, IL, $35,000. For general operating support. 1/88.

733
Chicago Sun-Times Charity Trust
401 North Wabash Ave., Rm. 356
Chicago 60611 (312) 321-2218

Trust established in 1936 in IL as the Times Charity Fund.

Donor(s): Racing Industry Charitable Foundation, Inc.

Financial data (yr. ended 9/30/88): Assets, $277,635 (M); gifts received, $207,541; expenditures, $228,264, including $12,500 for 2 grants (high: $7,500; low: $5,000).

Purpose and activities: Giving primarily for higher education, social services, hospitals, and health services; support also for youth agencies, civic affairs, and cultural organizations.

Types of support: Special projects, general purposes, operating budgets.

Limitations: Giving limited to the Chicago, IL, area. No support for religious organizations for sectarian purposes, primary or secondary schools, or political activities. No grants to individuals, or for medical research, scholarships, fellowships, films, publications, or conferences.

Publications: Application guidelines.

Application information:
Initial approach: Proposal
Deadline(s): None
Write: Sandra Simmons, Exec. Dir.

Officers: Charles T. Price,* Pres.; Sandra L. Simmons,* Secy. and Exec. Dir.; Donald P. Piazza, Treas.

Trustees:* James Meyers.

Employer Identification Number: 366059459

734
Chicago Title and Trust Company Foundation
111 West Washington St.
Chicago 60602 (312) 630-2911

Trust established in 1951 in IL.

Donor(s): Chicago Title and Trust Co.

Financial data (yr. ended 12/31/87): Assets, $938,300 (M); gifts received, $614,134; expenditures, $332,394, including $311,736 for 268 grants (high: $88,000; low: $25).

Purpose and activities: Emphasis on community funds, social services, higher education, health, hospitals, and culture; also support for community improvement, public policy and economic understanding, and development.

Types of support: Continuing support, employee matching gifts, special projects.

Limitations: Giving primarily in Chicago, IL. No support for United Way member agencies. No grants to individuals, or for operating budgets, annual campaigns, seed money, emergency funds, deficit financing, building funds, equipment, land acquisition, research, scholarships, fellowships, publications, or conferences; no loans.

Publications: Program policy statement, application guidelines.

Application information: Application form required.
Initial approach: Letter
Copies of proposal: 1
Deadline(s): Feb. 1 for culture, May 1 for education, and Aug. 1 for health
Board meeting date(s): Jan., Apr., July, and Oct.
Final notification: 60 days
Write: Carolyn I. Smith

Trustees: Alvin Behnke, Stuart Bilton, William Halvorsen, M. Leanne Lachman, Alvin Long, Alan Prince, Richard P. Toft, Lannette Zimmerman.

Number of staff: 2 part-time professional; 1 full-time support.

Employer Identification Number: 366036809

735
Chicago Tribune Foundation
435 North Michigan Ave.
Chicago 60611 (312) 222-4300

Incorporated in 1958 in IL.

Donor(s): Chicago Tribune Co.

Financial data (yr. ended 12/31/88): Expenditures, $1,036,485, including $963,199 for grants (high: $50,000; low: $100; average: $5,000) and $72,518 for 325 employee matching gifts.

Purpose and activities: Support for social services through the United Way, journalism, higher education and education programs for minorities, civic affairs, and cultural programs, including museums; giving also includes an employee matching gift program.

Types of support: General purposes.

Limitations: Giving primarily in the metropolitan Chicago, IL, area. No grants to individuals, or for building or endowment funds, fundraising functions, free advertising, or fellowships; no loans.

Publications: Corporate giving report, informational brochure (including application guidelines).

Application information: Applications not solicited for social services and employee matching gifts program.
Initial approach: Letter
Copies of proposal: 1
Deadline(s): Varies depending on program; see guidelines for exact deadlines
Board meeting date(s): Aug.
Final notification: After appropriate board meeting
Write: Nicholas Goodban, Exec. V.P.

Officers: John W. Madigan,* Pres.; J. Nicholas Goodban,* Exec. V.P. and Exec. Dir.; Robert B. Holzkamp,* V.P.; Stanley J. Gradowski, Secy.; Thomas Schneider, Treas.

Directors:* James D. Squires.

Number of staff: 4 full-time professional; 2 full-time support; 1 part-time support.

Employer Identification Number: 366050792

736
Chicago White Metal Charitable Foundation

Rte. 83 & Fairway Dr.
Bensenville 60106-9806 (312) 595-4424

Financial data (yr. ended 10/31/88): Assets, $58,257 (M); gifts received, $7,500; expenditures, $17,957, including $10,811 for 29 grants (high: $4,358; low: $15) and $7,000 for grants to individuals.
Purpose and activities: Support for health, civic affairs, arts and culture, social services, youth, and community funds; scholarships for employees' children.
Types of support: Employee-related scholarships.
Application information:
 Initial approach: Letter
 Deadline(s): None
Manager: Walter Trieber, Jr.
Selection Committee: James E. Murphy, Charles A. Stern, John R. Waters.
Employer Identification Number: 366069669

737
CLARCOR Foundation

(Formerly Clark Foundation)
2323 Sixth St.
P.O. Box 7007
Rockford 61125 (815) 962-8867

Trust established in 1954 in IL.
Donor(s): Clarcor.
Financial data (yr. ended 12/31/88): Assets, $7,292,833 (M); gifts received, $200,000; expenditures, $724,660, including $607,050 for 74 grants (high: $204,000; low: $100) and $8,025 for 34 employee matching gifts.
Purpose and activities: Emphasis on hospitals, youth agencies, higher education, culture, and community funds.
Types of support: Employee matching gifts, continuing support, annual campaigns, emergency funds, building funds, equipment, capital campaigns, operating budgets, renovation projects.
Limitations: Giving primarily in areas of company operations in CA, IL, IN, MD, MI, NE, and PA. No grants to individuals, or for endowment funds, research, scholarships, or fellowships; no loans.
Publications: Program policy statement, application guidelines.
Application information: Application form required.
 Initial approach: Letter
 Copies of proposal: 1
 Deadline(s): None
 Board meeting date(s): Jan., Apr., July, and Oct.
 Write: W.F. Knese, Chair.
Officers and Trustees: William F. Knese, Chair.; B.J. Peterson, Secy.; Marshall C. Arne, Lawrence E. Gloyd, T.P. Harnois, J.S. Waddell.
Number of staff: None.
Employer Identification Number: 366032573

738
CNW Philanthropic Committee

One North Western Center, 7-N.
Chicago 60606 (312) 633-4310

Financial data (yr. ended 12/31/88): $332,000 for grants.
Purpose and activities: The company supports annual campaigns for the United Way, arts, child welfare, civic affairs, and programs for the disadvantaged.
Types of support: General purposes, employee-related scholarships.
Limitations: Giving primarily in communities located on C&NW's rail lines which are located in IL, MI, WI, IA, MN, SD, NE, WY, and MO.
Publications: Corporate report, application guidelines.
Application information:
 Initial approach: Requests must be in writing
 Deadline(s): None
 Board meeting date(s): No set dates; requests usually screened once every 30 days by a committee consisting of two Sr. V.P.'s and one V.P.
 Write: Michael W. Payette, Secy., Philanthropic Donation Comm.
Administrators: J.W. Colon, Sr. V.P. Public Affairs, Acquisitions & Planning; A.W. Peters, Sr. V.P.; R.L. Wilson, V.P., Human Resources.
Number of staff: 1 part-time professional; 1 part-time support.

739
The Robert & Terri Cohn Family Foundation

100 South Wacker Dr., Rm. 1222
Chicago 60606

Established in 1982 in IL.
Financial data (yr. ended 1/31/88): Assets, $1,108,189 (M); gifts received, $106,000; expenditures, $36,661, including $32,940 for 44 grants (high: $2,000; low: $100).
Purpose and activities: Support primarily for Jewish welfare; support also for hospitals, cultural and health organizations.
Application information:
 Deadline(s): None
Officers and Directors: Robert H. Cohn, Pres.; Andrew Cohn, V.P.; Jamie Cohn, V.P.; Jonathan Cohn, V.P.; Lawrence Cohn, V.P.; Terri H. Cohn, Treas.
Employer Identification Number: 363192296

740
Earle M. & Virginia M. Combs Foundation

141 West Jackson Blvd.
Chicago 60604 (312) 922-3900

Established in 1967 in IL.
Donor(s): Earle M. Combs III, Virginia M. Combs.
Financial data (yr. ended 12/31/87): Assets, $2,026,232 (M); gifts received, $111,881; expenditures, $106,498, including $96,300 for 19 grants (high: $31,000; low: $500).
Purpose and activities: Giving primarily for religious purposes and to youth organizations; some support for higher education and culture.
Types of support: General purposes.

Application information: Contributes only to pre-selected organizations. Applications not accepted.
Officers: Earle M. Combs III, Pres.; Virginia M. Combs, Secy.
Directors: Earle M. Combs IV, B.F. Etters, Donald F. Miller.
Employer Identification Number: 366168454

741
Richard H. Cooper Foundation

611 Enterprise Dr.
Oak Brook 60521

Established in 1969 in IL.
Financial data (yr. ended 12/31/87): Assets, $658,375 (M); gifts received, $94,500; expenditures, $139,538, including $139,244 for 30 grants (high: $25,000; low: $10).
Purpose and activities: Support primarily for youth and community organizations, for the arts and museums.
Officers: Richard H. Cooper,* Pres.-Treas.; Lana S. Cooper,* Secy.
Directors: * Jean Frandsen.
Employer Identification Number: 237024516

742
Arie and Ida Crown Memorial

300 West Washington St.
Chicago 60606 (312) 236-6300

Incorporated in 1947 in IL.
Donor(s): Members of the Crown family.
Financial data (yr. ended 12/31/86): Assets, $71,233,275 (M); expenditures, $3,429,005, including $3,429,005 for 275 grants (high: $250,000; low: $100; average: $100-$25,000).
Purpose and activities: Broad mandate with focus on "opportunity building"; emphasis on Jewish issues, education, arts and culture, health care, community development, youth agencies, inner city welfare, and assistance to the aged and the handicapped.
Types of support: Continuing support, annual campaigns, equipment, land acquisition, endowment funds, matching funds, professorships, research, special projects, consulting services, general purposes, operating budgets, renovation projects, seed money, technical assistance.
Limitations: Giving primarily in the metropolitan Chicago, IL, area or to national organizations with local programs. No grants to individuals; the foundation does not provide consulting services or technical assistance; no loans.
Application information:
 Initial approach: Letter of inquiry (1 page)
 Deadline(s): Jan. 30 and June 30
 Board meeting date(s): Spring and fall
 Write: Susan Crown, Pres.
Officers and Directors: Susan Crown, Pres.; Lester Crown, V.P. and Treas.; Arie Steven Crown, James Schine Crown, Charles Goodman, Barbara N. Manilow, Byron S. Miller.
Number of staff: 1 full-time professional; 1 full-time support.
Employer Identification Number: 366076088

743
D and R Fund
8000 Sears Tower
Chicago 60606

Incorporated in 1951 in IL.
Donor(s): Samuel R. Rosenthal, Marie-Louise Rosenthal, Carolyn S. Dreyfus,† Alice L. Dreyfus.†
Financial data (yr. ended 12/31/86): Assets, $7,076,700 (M); gifts received, $14,902; expenditures, $862,283, including $833,960 for 63 grants (high: $635,600; low: $50; average: $100-$10,000).
Purpose and activities: Grants largely for higher education, hospitals, libraries, and cultural institutions, particularly for conservation purposes.
Limitations: No grants to individuals, or for building or endowment funds or operating budgets.
Application information: Contributes only to pre-selected organizations. Applications not accepted.
 Board meeting date(s): As necessary
 Write: Samuel R. Rosenthal, Pres.
Officers and Directors: Samuel R. Rosenthal, Pres.; Marie-Louise Rosenthal, V.P. and Secy.; Louise R. Glasser, V.P. and Treas.; James J. Glasser, Babette H. Rosenthal, Daniel R. Swet, Anthony G. Zulfer, Jr.
Number of staff: None.
Employer Identification Number: 366057159

744
The Danielson Foundation
410 North Michigan Ave., Rm. 590
Chicago 60611-4252

Established in 1964 in IL.
Financial data (yr. ended 11/30/87): Assets, $893,803 (M); gifts received, $100,000; expenditures, $159,499, including $154,920 for 60 grants (high: $27,000; low: $580).
Purpose and activities: Support primarily for cultural and educational organizations; support also for health and civic associations, hospitals, churches and for higher education.
Limitations: Giving primarily in CA and FL.
Application information:
 Deadline(s): None
Officers and Directors: Richard E. Danielson, Jr., Pres.; Molly Danielson, V.P. and Secy.; Charles E. Schroeder, V.P. and Treas.
Employer Identification Number: 362540494

745
James Deering Danielson Foundation
410 North Michigan Ave., Rm. 590
Chicago 60611

Established in 1969 in IL.
Donor(s): Deering Foundation.
Financial data (yr. ended 12/31/87): Assets, $790,614 (M); gifts received, $110,000; expenditures, $104,995, including $100,000 for 17 grants (high: $16,000; low: $1,000).
Purpose and activities: Support for higher and other education, religious organizations, particularly Presbyterian churches, and cultural programs.
Types of support: General purposes.

Application information: Contributes only to pre-selected organizations. Applications not accepted.
Officers and Directors: James Deering Danielson, Pres.; Charles E. Schroeder, V.P. and Treas.; Beverly Danielson, Secy.
Employer Identification Number: 237042530

746
The Davee Foundation
180 East Pearson St., No. 6503
Chicago 60611 (312) 664-4128

Established in 1964 in IL.
Donor(s): Ken M. Davee.
Financial data (yr. ended 12/31/86): Assets, $8,969,521 (M); expenditures, $317,166, including $316,504 for 42 grants (high: $25,000; low: $35).
Purpose and activities: Emphasis on the arts, hospitals, and higher education; support also for civil rights organizations.
Types of support: General purposes.
Limitations: Giving primarily in IL.
Application information:
 Initial approach: Letter
 Deadline(s): None
 Write: Ken M. Davee, Pres.
Officers: Ken M. Davee, Pres.
Director: J.W. Dugdale.
Employer Identification Number: 366124598

747
John Deere Foundation
John Deere Rd.
Moline 61265 (309) 765-4137

Incorporated in 1948 in IL.
Donor(s): Deere & Co.
Financial data (yr. ended 10/31/88): Assets, $3,000,070 (M); gifts received, $240,000; expenditures, $2,136,598, including $1,978,435 for 168 grants (high: $488,000; low: $150; average: $1,000-$5,000) and $158,163 for 1 foundation-administered program.
Purpose and activities: Grants largely for community funds, higher education, agriculture, youth agencies, health services, and cultural programs.
Types of support: Annual campaigns, seed money, building funds, scholarship funds, fellowships, operating budgets, general purposes, continuing support.
Limitations: Giving limited to areas where company employees live and work: IA, IL, and WI. No grants to individuals, or for endowment funds; no loans.
Publications: Corporate giving report (including application guidelines).
Application information:
 Initial approach: Letter or telephone
 Copies of proposal: 1
 Deadline(s): None
 Board meeting date(s): As required, usually quarterly
 Final notification: 30 days after board review
 Write: Donald R. Margenthaler, Pres.
Officers: Joseph W. England, Chair.; Donald R. Margenthaler, Pres.; Hans W. Becherer, V.P.;

Robert A. Hanson, V.P.; Sonja Sterling, Secy.; Michael S. Plunkett, Treas.
Number of staff: 1 full-time professional; 1 full-time support.
Employer Identification Number: 366051024

748
Deering Foundation
410 North Michigan Ave., Rm. 590
Chicago 60611

Incorporated in 1956 in IL.
Donor(s): Barbara D. Danielson, Richard E. Danielson, Jr., Marion D. Campbell, Miami Corp.
Financial data (yr. ended 11/30/86): Assets, $6,733,197 (M); expenditures, $469,951, including $455,000 for 16 grants (high: $100,000; low: $5,000).
Purpose and activities: Giving for other foundations, and for hospitals, education, conservation, and museums.
Types of support: General purposes.
Limitations: Giving primarily in IL and MA.
Officers and Directors: Marion D. Campbell, Pres.; James Deering Danielson, V.P.; Richard E. Danielson, Jr., V.P.; Charles E. Schroeder, Secy.-Treas.
Employer Identification Number: 366051876

749
Edwin F. Deicke Foundation
P.O. Box 734
Wheaton 60189

Trust established in 1956 in IL.
Donor(s): Edwin F. Deicke, Suburban Casualty Co., Pioneer Insurance Co.
Financial data (yr. ended 12/31/87): Assets, $1,559,232 (M); expenditures, $240,780, including $221,400 for 24 grants (high: $50,000; low: $100).
Purpose and activities: Support primarily for a performing arts center and an historical museum; support also for youth organizations and higher education.
Limitations: Giving primarily in IL and FL.
Application information:
 Initial approach: Letter
 Deadline(s): None
 Write: Mrs. Edwin F. Deicke, Chair.
Trustees: Mrs. Edwin F. Deicke, Chair.; James D. Anderson, Robert Covert, Lois L. Deicke, Lois D. Martin.
Employer Identification Number: 366053612

750
DeSoto Foundation
P.O. Box 5030
1700 South Mt. Prospect Rd.
Des Plaines 60017 (312) 391-9112

Incorporated in 1963 in IL.
Donor(s): DeSoto, Inc.
Financial data (yr. ended 12/31/87): Assets, $707,519 (M); gifts received, $250,000; expenditures, $295,279, including $283,620 for 123 grants (high: $34,945; low: $100) and $10,781 for 58 employee matching gifts.
Purpose and activities: Emphasis on community funds, higher education, youth

agencies, crime and law enforcement, health agencies, mental health programs, hospitals, and cultural programs.
Types of support: Employee matching gifts.
Limitations: Giving primarily in IL.
Application information:
 Initial approach: Letter
 Copies of proposal: 1
 Deadline(s): Before board meetings
 Board meeting date(s): Mar., Aug., and Nov.
 Final notification: After meetings
 Write: J. Barreiro, V.P.
Officers: R.R. Missar,* Pres.; J. Barreiro,* V.P.; Nicholas A. Vittore, Secy.-Treas.
Director:* W.L. Lamey, Jr.
Number of staff: 4 part-time professional; 2 part-time support.
Employer Identification Number: 366097563

751
Dick Family Foundation
249 Market Square
Box 312
Lake Forest 60045

Financial data (yr. ended 12/31/86): Assets, $2,094,160 (M); expenditures, $79,278, including $62,900 for 38 grants (high: $12,000; low: $200).
Purpose and activities: Support for hospitals, higher and other education, and arts and culture.
Limitations: Giving primarily in IL.
Officers: Edison Dick, Pres.; Albert B. Dick III, V.P.; John H. Dick, Secy.-Treas.
Director: Letitia Ellis.
Employer Identification Number: 366057056

752
F.B. Doane Foundation
115 South LaSalle, Suite 3400
Chicago 60603-3903

Established in 1959 in IL.
Financial data (yr. ended 12/31/88): Assets, $1,141,105 (M); expenditures, $68,576, including $42,265 for 11 grants (high: $12,000; low: $1,000).
Purpose and activities: Giving to a high school for awards to the highest achieving students and a college for awards to students in the art department; support also for other colleges and for art museums.
Limitations: Giving primarily in Bandera, TX.
Application information: Contributes only to pre-selected organizations. Applications not accepted.
Officers: T.P. Healy, Secy.; S.D. Turk, Pres.; M.D. Calvert, V.P.; R.W. Calvert, V.P. and Treas.
Employer Identification Number: 746040766

753
R. R. Donnelley & Sons Corporate Giving Program
2223 South Martin Luther King Drive
Chicago 60616 (312) 326-8102

Financial data (yr. ended 12/31/88): Total giving, $2,016,642, including $1,608,140 for 400 grants (high: $75,000; low: $500),

$65,000 for 32 grants to individuals and $343,502 for 1,500 employee matching gifts.
Purpose and activities: Supports education, including higher and secondary education, literacy, and libraries, culture, including performing arts and historic preservation, public policy, conservation and the environment, and health and welfare, including community funds, the handicapped and drug abuse programs; support also for employeee-related scholarships. Grants range from $500-$2,500 for general operating funds and from $10,000-$50,000 for capital funds.
Types of support: General purposes, capital campaigns, special projects, employee matching gifts, operating budgets, employee-related scholarships.
Limitations: Giving primarily in communities with corporate manufacturing operations and employees, particularly Chicago. No support for religious or fraternal organizations. No grants to individuals, except for employee-related scholarships.
Publications: Application guidelines.
Application information: Include description of organization, its activities, and its clients; a clear statement of what is desired from R.R. Donnelley and an explanation of what is planned to be accomplished; 501(c)(3) status; list of board members; and an audited financial statement.
 Initial approach: Proposal
 Copies of proposal: 1
 Deadline(s): None
 Board meeting date(s): Mar., May, July, Sept., and Nov. or Dec.
 Final notitfia: 2-3 weeks after meeting
 Write: Susan M. Levy, Mgr., Community Relations
Contributions Committee Members: Charles C. Haffner III, Vice-Chair. (Chair, Contribs.); James C. Ratcliffe, V.P., Corp. Relations (Secy., Contribs.); Gaylord Donnelley, James R. Donnelley, Group V.P., Corp. Dev.; Carl K. Doty, Exec. V.P., Operations; Frank R. Jarc, Exec. V.P., Finance.
Number of staff: 1 full-time professional; 1 part-time support.

754
Elliott and Ann Donnelley Foundation
1121 Ringwood Rd.
Lake Forest 60045

Incorporated in 1954 in IL.
Donor(s): Elliott Donnelley.†
Financial data (yr. ended 12/31/87): Assets, $2,766,217 (M); expenditures, $202,627, including $200,275 for 67 grants (high: $81,000; low: $25; average: $500-$2,000).
Purpose and activities: Giving for hospitals and education; support also for cultural programs and youth agencies.
Types of support: Continuing support.
Limitations: Giving primarily in IL. No grants to individuals.
Application information: Applications not accepted.
 Board meeting date(s): As required
 Write: Ann S. Hardy, Pres.
Officers and Director:* Ann S. Hardy,* Pres. and Treas.; Robert Wood Tullis, Secy.
Number of staff: None.
Employer Identification Number: 366066894

755
Gaylord and Dorothy Donnelley Foundation
350 East 22nd St.
Chicago 60616 (312) 326-7255

Incorporated in 1952 in IL.
Donor(s): Gaylord Donnelley, Dorothy Ranney Donnelley.
Financial data (yr. ended 12/31/88): Assets, $6,640,000 (M); gifts received, $645,000; expenditures, $815,842, including $742,895 for 158 grants (high: $76,095; low: $500; average: $1,000-$2,000).
Purpose and activities: Support for education, including higher education, culture, conservation, museums, including wildlife, animal health and welfare, and general welfare institutions.
Types of support: General purposes, operating budgets, special projects.
Limitations: Giving primarily in the Chicago, IL, area, the Midwest, and SC. No grants to individuals, or for emergency funds, pledges, benefits, conferences, meetings, or matching gifts; no loans.
Publications: Application guidelines.
Application information:
 Initial approach: Letter and/or 1-page summary of purpose of organization and reason for grant request together with more descriptive letter if desired; list of directors; budget, financial statement, a copy of IRS Letter of Determination certifying 501 (c)(3) status
 Copies of proposal: 1
 Deadline(s): None
 Board meeting date(s): Spring and fall
 Write: Mrs. Jane Rishel, Pres.
Officers and Directors: Larry D. Berning, Gaylord Donnelley, Chair.; Jane Rishel, Pres. and Treas.; Dorothy Ranney Donnelley, V.P.; Elliott R. Donnelley, V.P.; Laura Donnelley, V.P.; Strachan Donnelley, V.P.; Middleton Miller, Secy.; Robert T. Carter, Robert W. Carton, M.D., C. Bouton McDougal.
Number of staff: 1 full-time professional.
Employer Identification Number: 366108460

756
The Duchossois Foundation
c/o Lois May
845 Larch Ave.
Elmhurst 60126 (312) 279-3600

Established in 1984 in IL.
Donor(s): Duchossois Industries, Inc.
Financial data (yr. ended 12/31/88): Assets, $1,307,632 (M); expenditures, $629,409, including $610,750 for 46 grants (high: $250,000; low: $150).
Purpose and activities: Support for health programs, community and social services, cultural programs, and elementary education.
Types of support: General purposes, capital campaigns.
Limitations: Giving primarily in the metropolitan Chicago, IL, area.
Publications: Application guidelines.
Application information: Guidelines available upon request.
 Initial approach: Letter
 Deadline(s): None

Board meeting date(s): Every 6 weeks
Write: Kimberly Duchossois Lenczuk, Secy.
Officers and Directors: Richard L.
Duchossois, Pres.; Craig J. Duchossois, V.P.; R.
Bruce Duchossois, V.P.; Kimberly Duchossois
Lenczuk, Secy.; Lois B. May, Treas.
Number of staff: 1 part-time professional.
Employer Identification Number: 363327987

757
William F. Farley Foundation
233 South Wacker Dr., Suite 6300
Chicago 60606 (312) 993-1827

Established about 1979 in IL.
Financial data (yr. ended 4/30/87): Assets,
$38,769 (M); gifts received, $342,940;
expenditures, $337,941, including $337,910
for 223 grants (high: $30,000; low: $25).
Purpose and activities: Grants primarily to
community funds and for secondary and higher
education; support also for civic and cultural
organizations and social service agencies.
Application information:
Initial approach: Letter or proposal
Deadline(s): None
Write: Diane Gold, Mgr., Communications
Officer and Directors: William F. Farley,
Pres.; Barbara Farley, John F. Farley, Barbara F.
Mooney, Maureen Thornton.
Employer Identification Number: 362977029

758
The Field Foundation of Illinois, Inc.
135 South LaSalle St.
Chicago 60603 (312) 263-3211

Incorporated in 1960 in IL.
Donor(s): Marshall Field IV.†
Financial data (yr. ended 4/30/87): Assets,
$29,304,536 (M); expenditures, $1,943,736,
including $1,645,108 for 56 grants (high:
$250,000; low: $1,000; average: $10,000-
$20,000).
Purpose and activities: Giving in the fields of
health, community welfare, education, cultural
activities, conservation, and urban affairs;
grants focused on youth agencies, race
relations, and the aged.
Types of support: Building funds, emergency
funds, equipment, special projects, land
acquisition.
Limitations: Giving primarily in the Chicago,
IL, area. No support for member agencies of
community funds, national health agencies,
neighborhood health clinics, small cultural
groups, private schools, or for religious
purposes. No grants to individuals, or for
endowment funds, continuing operating
support, medical research, conferences,
operating support of day care centers,
fundraising events, advertising, scholarships, or
fellowships; no loans.
Publications: Annual report (including
application guidelines).
Application information:
Initial approach: Proposal
Copies of proposal: 1
Deadline(s): None
Board meeting date(s): 3 times a year
Write: Handy L. Lindsey, Jr., Exec. Dir.

Officers: Leland Webber,* Chair.; Gary H.
Kline, Secy.; Handy L. Lindsey, Jr., Exec. Dir.
and Treas.
Directors:* Marshall Field, Hanna H. Gray,
Philip Wayne Hummer, Arthur F. Quern,
George A. Ranney, Jr., Arthur E. Rasmussen.
Number of staff: 1 full-time professional; 1 full-
time support.
Employer Identification Number: 366059408
Recent arts and culture grants:
Art Institute of Chicago, Chicago, IL, $70,000.
 Toward cost of replacing glass roof of
 Allerton Building and East Wing of Art
 Institute of Chicago. 1987.
Art Resources in Teaching, Chicago, IL,
 $7,500. For Field Trip Program. 1987.
Chicago Botanic Garden, Glencoe, IL, $50,000.
 For construction of James Brown IV Waterfall
 Garden. 1987.
Chicago Historical Society, Chicago, IL,
 $20,000. For needed renovation of
 Education Department. 1987.
Chicago Zoological Society, Brookfield Zoo,
 Brookfield, IL, $45,000. For establishment of
 Children's Discovery Point in Aquatic Bird
 House. 1987.
Field Museum of Natural History, Chicago, IL,
 $60,000. For renovation of Hall of Plant Life.
 1987.
Lincoln Park Zoological Society, Chicago, IL,
 $40,000. For construction of Visitor
 Observation Area in Primate House. 1987.
Museum of Science and Industry, Chicago, IL,
 $55,000. For construction of Spaceport
 entrance to Crown Space Center. 1987.
Orchestral Association, Chicago, IL, $50,000.
 To internationally renowned Chicago
 Symphony Orchestra for purchase of nine
 bass viols and cases which orchestra
 members will use while on tour. 1987.

759
The Firestone Trust Fund
205 North Michigan Ave., Suite 3800
Chicago 60601-5965 (312) 819-8548

Trust established in 1952 in OH.
Donor(s): The Firestone Tire & Rubber Co.
Financial data (yr. ended 10/31/88): Assets,
$12,000,000 (M); expenditures, $6,125,616,
including $6,125,616 for 530 grants (high:
$3,000,000; low: $50; average: $1,000-
$35,000).
Purpose and activities: Support for higher
education, including employee matching gifts;
community funds, health, and welfare; also
supports civic and community affairs, culture,
and the arts.
Types of support: Continuing support, annual
campaigns, seed money, emergency funds,
building funds, endowment funds, matching
funds, employee matching gifts, research,
special projects.
Limitations: Giving primarily in areas of
company operations in AR, IL, IA, IN, LA, NC,
OH, OK, TX, and VA. No grants to
individuals, or for operating budgets, deficit
financing, equipment, land acquisition,
fellowships, publications, or conferences; no
loans.
Publications: Application guidelines.
Application information:
Initial approach: Letter

Copies of proposal: 1
Deadline(s): Submit proposal preferably by
 July; no set deadline
Board meeting date(s): As required
Final notification: 3 to 4 weeks
Write: Bob Troyer, Secy.
Firestone Trust Fund Committee: J. Robert
Anderson, Chair.; Bob Troyer, Secy.
Trustee: AmeriTrust Co.
Directors: Michael J. Connor, Donald L.
Groninger.
Number of staff: 1 full-time support.
Employer Identification Number: 346505181

760
The First National Bank of Chicago
Corporate Giving Program
One First National Plaza
Chicago 606700356 (312) 732-6948

Financial data (yr. ended 12/31/87): Total
giving, $3,016,879, including $2,255,879 for
319 grants (high: $885,000; low: $25) and
$761,000 for in-kind gifts.
Purpose and activities: Support for the arts
and culture, dance, performing arts, theater,
business education, civic affairs, community
development, community funds, crime and law
enforcement, ecology, education, education
building funds, higher education, the
environment, housing, libraries, minorities,
museums, music, race relations, and urban
development.
Types of support: Annual campaigns, building
funds, capital campaigns, endowment funds,
fellowships, matching funds.
Limitations: Giving primarily in the Chicago,
IL, metropolitan area.
Application information:
Initial approach: Letter
Copies of proposal: 1
Deadline(s): None
Board meeting date(s): Mar., June, Sep., and
 Dec.
Final notification: 3 months
Write: Diane M. Smith, V.P.
Number of staff: 2 full-time professional; 2 full-
time support.

761
First National Bank of Chicago
Foundation
One First National Plaza
Chicago 60670 (312) 732-6948

Incorporated in 1961 in IL.
Donor(s): First National Bank of Chicago.
Financial data (yr. ended 12/31/87): Assets,
$893,768 (M); gifts received, $270,000;
expenditures, $702,634, including $81,000 for
23 grants (high: $6,500; low: $1,000) and
$339,629 for employee matching gifts.
Purpose and activities: Giving to organizations
in social welfare, education, community
development, culture and the arts, and civic
affairs; support also for a local United
Way/Crusade of Mercy.
Types of support: Operating budgets,
continuing support, annual campaigns, building
funds, equipment, endowment funds, matching
funds, scholarship funds, fellowships, employee
matching gifts, capital campaigns.

Limitations: Giving limited to the metropolitan Chicago, IL, area. No support for fraternal or religious organizations, preschool, elementary, or secondary education, public agencies, or United Way/Crusade of Mercy-supported agencies. No grants to individuals, or for emergency funds, deficit financing, land acquisition, research, publications, conferences, or multi-year operating pledges; no loans.
Publications: Informational brochure (including application guidelines).
Application information:
Initial approach: Letter
Copies of proposal: 1
Deadline(s): None
Board meeting date(s): Mar., June, Sept., and Dec.
Final notification: 3 months
Write: David J. Paulus, Pres.
Officers and Directors:* David J. Paulus,* Pres.; Clark Burrus,* V.P.; Lawrence E. Fox,* V.P.; A.D. Frazier, Jr.,* V.P.; Emile S. Godfrey, Jr., V.P.; William S. Lear,* V.P.; William J. McDonough,* V.P.; Leo F. Mullin,* V.P.; Diane M. Smith,* V.P.; Barry F. Sullivan,* V.P.; Richard L. Thomas,* V.P.; David J. Vitale,* V.P.; Ilona M. Berry, Secy.
Number of staff: 2 full-time professional; 2 full-time support.
Employer Identification Number: 366033828

762
Florsheim Shoe Foundation, Inc.
130 South Canal St.
Chicago 60606-3999

Financial data (yr. ended 12/31/87): Assets, $58,292 (M); gifts received, $60,000; expenditures, $82,795, including $82,572 for 77 grants (high: $64,047; low: $25).
Purpose and activities: Support for United Way, culture, civic affairs, health, including single-disease associations, social services, including the Salvation Army, and youth.
Officers: Ronald J. Mueller, Pres.; James J. Tunney, V.P.; L.R. Solomon, Secy.
Employer Identification Number: 366108530

763
FMC Foundation
200 East Randolph Dr.
Chicago 60601 (312) 861-6135

Incorporated in 1953 in CA.
Donor(s): FMC Corp.
Financial data (yr. ended 11/30/88): Assets, $775,635 (M); gifts received, $1,091,274; expenditures, $1,643,672, including $1,428,280 for 213 grants (high: $87,000; low: $1,000; average: $2,000-$15,000) and $215,392 for 1,441 employee matching gifts.
Purpose and activities: Giving primarily for higher education and community improvement funds; grants also for public issues, economic education, urban affairs, health and welfare, cultural institutions, civic affairs groups, and youth agencies.
Types of support: Building funds, continuing support, employee matching gifts, scholarship funds, special projects, general purposes, employee-related scholarships, capital campaigns, equipment.

Limitations: Giving primarily in areas in which corporate facilities are located. No support for educational institutions below the college or university level, or state or regional associations of independent colleges, national health agencies, or United Way supported organizations. No grants to individuals, or for endowment funds or hospital operating expenses; no loans.
Publications: Program policy statement, application guidelines, annual report (including application guidelines).
Application information:
Initial approach: Letter
Copies of proposal: 1
Deadline(s): None
Board meeting date(s): Quarterly
Final notification: 6 weeks
Write: Catherine Johnston, Exec. Dir.
Officers: William R. Jenkins,* Pres.; W. Glenn Bush, V.P.; William Kirby, V.P.; James A. McClung,* V.P.; Daniel N. Schuchardt, Secy.-Treas.
Directors:* Robert H. Malott, Raymond C. Tower.
Number of staff: 1 full-time professional; 1 part-time support.
Employer Identification Number: 946063032

764
Foote, Cone & Belding Foundation
101 East Erie
Chicago 60611 (312) 751-7000

Incorporated in 1947 in IL.
Donor(s): Foote, Cone & Belding Communications, Inc., and subsidiaries.
Financial data (yr. ended 12/31/87): Assets, $100,510 (M); expenditures, $250,999, including $250,975 for 50 grants (high: $50,000; low: $100).
Purpose and activities: Emphasis on higher education, community funds, cultural programs, and youth agencies.
Application information:
Initial approach: Letter
Deadline(s): None
Write: Gregory Blaine, Sr. V.P.
Officers and Directors: Willard R. Wirth, Jr., Pres.; Gregory Blaine, Sr. V.P.; David Ofner, V.P.; Thomas F. Randolph, V.P.; Charles H. Gunderson, Jr., Secy.-Treas.
Employer Identification Number: 366116701

765
The Forest Fund
Route 1, Box 32, St. Mary's Rd.
Libertyville 60048 (312) 362-2994

Incorporated in 1956 in IL.
Donor(s): Marion M. Lloyd.
Financial data (yr. ended 12/31/86): Assets, $2,402,374 (M); expenditures, $131,633, including $127,465 for 155 grants (high: $5,500; low: $100).
Purpose and activities: Grants primarily for education, health services, and cultural programs.
Limitations: No grants to individuals, or for endowment funds, scholarships, or fellowships; no loans.
Application information:

Initial approach: Proposal
Copies of proposal: 1
Deadline(s): None
Write: Mrs. Glen A. Lloyd
Officers and Directors: Marion M. Lloyd, Pres. and Treas.; Louise A. Baker, Secy.; Marianne S. Harper.
Employer Identification Number: 366047859

766
Frankel Foundation
c/o Harris Trust and Savings Bank
111 West Monroe St.
Chicago 60603
Application address: P.O. Box 755, Chicago, IL 60603

Established in 1959 in IL.
Donor(s): Gerald Frankel,† Gustav Frankel,† Julius N. Frankel.†
Financial data (yr. ended 10/31/88): Assets, $23,867,327 (M); gifts received, $2,072,309; expenditures, $1,864,106, including $1,655,500 for 37 grants (high: $530,000; low: $3,000).
Purpose and activities: Giving primarily for higher education, hospitals, arts and culture, and social services.
Limitations: Giving primarily in IL. No grants to individuals.
Application information:
Initial approach: Letter
Deadline(s): None
Board meeting date(s): 4 or 5 times a year
Final notification: Immediately following meetings
Write: Ellen A. Bechtold
Trustees: Nelson O. Cornelius, John L. Georgas, Harris Trust & Savings Bank.
Number of staff: None.
Employer Identification Number: 366765844

767
Lloyd A. Fry Foundation
135 South LaSalle St., Suite 1910
Chicago 60603 (312) 580-0310

Established in 1959 in IL.
Donor(s): Lloyd A. Fry.†
Financial data (yr. ended 6/30/88): Assets, $57,602,404 (M); expenditures, $2,784,594, including $2,179,000 for 138 grants (high: $125,000; low: $1,000).
Purpose and activities: Emphasis on education, civic affairs, cultural programs, health, and social services.
Types of support: Special projects, seed money, equipment, matching funds, research, publications, conferences and seminars, internships, scholarship funds.
Limitations: Giving primarily in the Chicago, IL, area. No support for governmental bodies or tax-supported educational institutions for services that fall within their responsibilities, or for fund-raising benefits. No grants to individuals, or for continuing support, annual campaigns, emergency funds, general operating budgets, deficit financing, building funds, land acquisition, renovation projects, endowment funds, or employee matching gifts; no loans.
Publications: Application guidelines, annual report (including application guidelines).

Application information:
Initial approach: Letter
Copies of proposal: 1
Deadline(s): None
Board meeting date(s): May, Aug., Nov., and Feb.
Final notification: 3 months
Write: Ben Rothblatt, Exec. Dir.
Officers and Directors:* Edmund A. Stephan,* Chair.; Roger E. Anderson,* Vice-Chair.; Lloyd A. Fry, Jr.,* Pres.; M. James Termondt,* V.P. and Treas.; Howard M. McCue III,* Secy.; Ben Rothblatt,* Exec. Dir.
Number of staff: 1 full-time professional; 1 part-time professional; 1 full-time support.
Employer Identification Number: 366108775
Recent arts and culture grants:
Art Resources in Teaching, Chicago, IL, $8,000. For visual arts workshops in Chicago public elementary schools. 1987.
Chamber Music Chicago, Chicago, IL, $10,000. To establish Early Talent Recognition Program in nine Chicago public high schools. 1987.
Chicago Access Corporation, Chicago, IL, $9,000. For fist payment of two-year grant for start-up costs for public access educational channel on cable television. 1987.
Chicago Historical Society, Chicago, IL, $25,191. For conservation of photographs and other library materials. 1987.
Chicago Music Alliance, Chicago, IL, $5,000. For education and marketing assistance for member organizations. 1987.
Chicago String Ensemble, Chicago, IL, $5,000. For concerts in elementary and junior high schools. 1987.
Chicago Theater Foundation, Chicago, IL, $7,500. For outreach program for Chicago public schools. 1987.
Columbia College, Chicago, IL, $30,000. For computerized reference system and union catalogue in library of Center for Black Music Research. 1987.
Court Theater, Chicago, IL, $10,000. For High School Matinee Program. 1987.
Duke University, Fayetteville, NC, $11,000. Toward preparation of index and guide to collected papers of Jane Addams. 1987.
ETA Creative Arts Foundation, Chicago, IL, $5,000. For educational and training programs for children and adults. 1987.
Facets Multimedia, Chicago, IL, $7,500. For 1987 Chicago International Festival of Children's Films. 1987.
Field Museum of Natural History, Chicago, IL, $100,000. For second payment of three-year grant for development of new programs and exhibits in field of anthropology. 1987.
Free Street Theater, Chicago, IL, $10,000. For workshops in theater, dance and music for residents of Cabrini-Bree housing complex. 1987.
Goodman Theater, Chicago, IL, $15,000. For subscription series for Chicago public high school students. Grant shared with Chicago Theater Group. 1987.
Hubbard Street Dance Company, Chicago, IL, $5,000. For special performances for children, senior citizens and handicapped persons. 1987.

Illinois Philharmonic Orchestra, Park Forest, IL, $8,000. For concerts and instruction in south suburban schools. 1987.
Imagination Theater, Chicago, IL, $5,000. For school performances of plays directed at prevention of sexual abuse. 1987.
International Music Foundation, Chicago, IL, $5,000. For performances and instruction in Chicago public schools. 1987.
Joseph Holmes Dance Theater, Chicago, IL, $10,000. For Chance to Dance Program for Chicago high school students. 1987.
Lill Street Gallery, Chicago, IL, $5,000. For expansion of educational programs in schools and hospitals. 1987.
Lyric Opera of Chicago, Chicago, IL, $30,000. For first payment of two-year grant for performances and educational programs for elementary and high school students. 1987.
Merit Music Program, Chicago, IL, $5,000. For instrumental music instruction in Chicago public elementary schools. 1987.
Museum of Contemporary Art, Chicago, IL, $15,000. For school outreach activities. 1987.
Northlight Theater, Evanston, IL, $10,000. For high school matinee program. 1987.
Ravinia Festival, Highland Park, IL, $7,500. For 1987 Young People's Programs. 1987.
Steppenwolf Theater Company, Chicago, IL, $10,000. For special productions for high school students. 1987.
Suzuki-Orff School for Young Musicians, Chicago, IL, $5,000. For instrumental music instruction for low-income students. 1987.
Victory Gardens Theater, Chicago, IL, $10,000. For performances in Chicago area high schools. 1987.
W T T W Chicago Public Television, Chicago, IL, $52,500. For production and broadcast of documentary on Chicago's Hispanics. 1987.
Young Audiences of Chicago, Skokie, IL, $10,000. For arts performances and workshops in Chicago public elementary schools. 1987.

768
GATX Corporate Contributions Program
120 South Riverside Plaza
Chicago 60606-3998 (312) 621-6221

Financial data (yr. ended 12/31/88): Total giving, $500,000, including $310,000 for 120 grants (high: $10,000; low: $1,000; average: $3,000), $40,000 for 60 employee matching gifts and $150,000 for in-kind gifts.
Purpose and activities: Supports civic affairs, community development, law and justice, culture and art, health and hospitals, drug rehabilitation, social services, education and United Way programs. Type of support includes in-kind donations.
Types of support: Employee matching gifts, matching funds, general purposes, operating budgets, scholarship funds, special projects, in-kind gifts.
Limitations: Giving primarily in Chicago and major operating locations. No support for political, religious or fraternal organizations. No grants to individuals, or for trips or tours, advertising, tickets for benefit purposes or capital campaigns.
Publications: Grants list, newsletter.

Application information: Include proposal with member list, audited financial statement, budget, annual report, donor list, history of organization and 501(c)(3).
Initial approach: Letter
Copies of proposal: 1
Deadline(s): 15th day of the month preceding a board meeting
Board meeting date(s): Quarterly in Feb., May, Aug. and Nov.
Write: Christiane S. Wilczura, Corp. Admin.
Number of staff: 1 full-time professional.

769
Generations Fund
c/o Felt Products Mfg. Co.
7450 North McCormick Blvd.
Skokie 60076 (312) 674-7700

Established in 1977 in IL.
Donor(s): Felt Products Manufacturing Co., Fel-Pro Incorporated.
Financial data (yr. ended 12/31/87): Assets, $1,053,514 (M); gifts received, $210,000; expenditures, $96,593, including $95,751 for 37 grants (high: $25,000; low: $50).
Purpose and activities: Support for Jewish organizations, social services, and youth agencies, and cultural programs.
Types of support: General purposes.
Application information:
Initial approach: Letter
Deadline(s): None
Write: Robert Morris, V.P.
Officers: Clara Morris, Pres.; Robert Morris, V.P.
Employer Identification Number: 362946589

770
Geraldi-Norton Memorial Corporation
One First National Plaza, Suite 3148
Chicago 60603

Incorporated in 1952 in IL.
Donor(s): Grace Geraldi Norton.†
Financial data (yr. ended 12/31/87): Assets, $2,524,696 (M); expenditures, $181,562, including $143,275 for 91 grants (high: $15,000; low: $200).
Purpose and activities: Support for higher education, hospitals, cultural programs, and youth agencies.
Limitations: Giving primarily in the Chicago, IL, area. No grants to individuals.
Application information:
Initial approach: Letter
Deadline(s): None
Write: Roger P. Eklund, Pres.
Officers and Directors: Roger P. Eklund, Pres. and Treas.; Dariel P. Eklund, V.P.; Dariel Ann Eklund, V.P.; Sally S. Eklund, Secy.
Employer Identification Number: 366069997

771
The Max and Lottie Gerber Foundation, Inc.
4656 West Touhy Ave.
Chicago 60646

Incorporated in 1942 in IL.

Donor(s): Globe Valve Corp., Kokomo Sanitary Pottery Corp.
Financial data (yr. ended 9/30/87): Assets, $448,426 (M); gifts received, $350,000; expenditures, $358,685, including $358,117 for 60 grants (high: $289,812; low: $75).
Purpose and activities: Giving to Jewish welfare funds and educational organizations; support also for cultural programs.
Limitations: Giving primarily in IL.
Officers: Harriet G. Lewis, Pres.; Robert C. Luker, Secy.; Ila J. Lewis, Treas.
Employer Identification Number: 366091012

772
Emma & Oscar Getz Foundation
30 North LaSalle St., Suite 3210
Chicago 60602

Established in 1966 in IL.
Donor(s): Oscar Getz,† Emma Getz.
Financial data (yr. ended 12/31/87): Assets, $2,921,397 (M); gifts received, $55,028; expenditures, $273,436, including $273,436 for 36 grants (high: $150,000; low: $300).
Purpose and activities: Grants primarily for higher education in the U.S. and Israel, film and theatre, and Jewish organizations, including welfare funds.
Limitations: No grants to individuals.
Application information: Contributes only to pre-selected organizations. Applications not accepted.
Officers: Emma Getz,* Pres.; William Getz,* V.P. and Secy.; Ralph P. Silver, Treas.
Directors:* Byron S. Miller.
Employer Identification Number: 366150787

773
Gibbet Hill Foundation
410 North Michigan Ave., Rm. 590
Chicago 60611

Established in 1976 in IL.
Donor(s): Deering Foundation, Miami Corp.
Financial data (yr. ended 12/31/87): Assets, $801,029 (M); gifts received, $100,000; qualifying distributions, $148,455, including $100,000 for 20 grants (high: $15,000; low: $2,000).
Purpose and activities: Support for higher and other education, museums, a public library, and conservation groups.
Types of support: General purposes.
Limitations: No grants to individuals; no grants, scholarships, fellowships; no loans.
Application information: Contributes only to pre-selected organizations determined by foundation's board of directors.
Officers and Directors: Marion D. Campbell, Pres.; Charles E. Schroeder, Secy.-Treas.; Richard Strachan, Stephen M. Strachan.
Employer Identification Number: 510189357

774
Morris and Rose Goldman Foundation
845 North Michigan Ave.
Chicago 60611 (312) 337-6435

Established in 1965.
Donor(s): Morris Goldman, Rose Goldman.

Financial data (yr. ended 12/31/87): Assets, $2,234,179 (M); gifts received, $746,502; expenditures, $302,598, including $284,143 for 128 grants (high: $167,675; low: $15).
Purpose and activities: Giving primarily to Jewish welfare funds, cultural organizations, and social services.
Application information:
 Initial approach: Proposal
 Deadline(s): None
 Write: Rose Goldman, V.P.
Officers: Morris Goldman, Pres.; Rose Goldman, V.P.; Shirley Warshaver, Secy.
Directors: Barbara Pine, Shirley Schnachenberg.
Employer Identification Number: 362615047

775
Graham Foundation for Advanced Studies in the Fine Arts
Four West Burton Place
Chicago 60610 (312) 787-4071

Incorporated in 1935 in IL.
Donor(s): Ernest R. Graham.†
Financial data (yr. ended 12/31/87): Assets, $16,365,409 (M); expenditures, $889,431, including $358,967 for 57 grants (high: $16,667; low: $500) and $297,870 for 61 grants to individuals.
Purpose and activities: Grants for advanced research in contemporary architecture, design, and the study of urban planning, principally to Americans working within the U.S. who have demonstrated mature, creative talent and have specific work objectives. Fellows are selected by the trustees on the recommendation of the Director and special advisors. Some support for exhibitions, publications, lectures, and architectural and urban studies.
Types of support: Research, publications, conferences and seminars, fellowships, grants to individuals, special projects, lectureships.
Limitations: No grants for building or endowment funds, scholarships, or matching gifts; no loans.
Publications: Annual report (including application guidelines), application guidelines.
Application information:
 Initial approach: Letter or proposal
 Copies of proposal: 1
 Deadline(s): June 1 and Dec. 1
 Board meeting date(s): July and Jan.
 Final notification: 1 to 4 months
 Write: Carter H. Manny, Jr., Exec. Dir.
Officers: Carter H. Manny, Jr., Exec. Dir.
Number of staff: 2 full-time professional; 1 part-time support.
Employer Identification Number: 362356089

776
The Grainger Foundation Inc.
5500 West Howard St.
Skokie 60077 (312) 982-9000

Incorporated in 1967 in IL as successor to the Grainger Charitable Trust established in 1949.
Donor(s): W.W. Grainger,† Hally W. Grainger,† David W. Grainger.
Financial data (yr. ended 12/31/88): Assets, $56,536,398 (M); expenditures, $5,965,709, including $5,829,188 for 33 grants (high: $2,032,188; low: $1,000).

Purpose and activities: Emphasis on endowments, capital funds, and special program funds for higher education (colleges & universities), cultural and historical institutions (art, symphony, and museums), hospitals, and human services organizations.
Types of support: Continuing support, building funds, equipment, endowment funds, professorships, research, general purposes, renovation projects, special projects, operating budgets.
Limitations: Giving primarily in the Chicago, IL, area. No grants to individuals, or for general operating budgets, seed money, emergency funds, deficit financing, special projects, publications, conferences, scholarships, fellowships, or matching gifts; no loans.
Publications: 990-PF.
Application information: The foundation contributes only to pre-selected charitable organizations as determined by its directors and officers. For this reason, and due to staffing constraints, grant requests received from organizations other than those first contacted by The Grainger Foundation cannot be reviewed or acknowledged.
 Board meeting date(s): Periodically
 Final notification: Favorable decisions only
 Write: Lee J. Flory, V.P.
Officers and Directors: David W. Grainger, Pres. and Treas.; Lee J. Flory, V.P. and Secy.; Juli P. Grainger, V.P.; John S. Chapman.
Number of staff: None.
Employer Identification Number: 366192971

777
The H.B.B. Foundation
35 East Wacker Dr., Suite 2332
Chicago 60601

Established in 1964 in IL.
Financial data (yr. ended 12/31/87): Assets, $1,513,071 (M); expenditures, $110,502, including $93,000 for 33 grants (high: $25,000; low: $500).
Purpose and activities: Grants to hospitals, scientific organizations and museums, orchestras, and for higher education.
Application information: Contributes only to pre-selected organizations. Applications not accepted.
Officers and Directors: Elizabeth B. Tieken, Pres.; Theodore D. Tieken, Jr., V.P. and Secy.; Mark Stephenitch, Treas.
Employer Identification Number: 366104969

778
Haffner Foundation
2223 South Martin Luther King Dr.
Chicago 60616 (312) 326-8042

Incorporated in 1952 in IL.
Donor(s): Charles C. Haffner, Jr.,† Mrs. Charles C. Haffner, Jr.,† Charles C. Haffner III.
Financial data (yr. ended 12/31/88): Assets, $1,812,000 (M); expenditures, $119,500, including $114,000 for 47 grants (high: $12,000; low: $5,000; average: $1,000-$5,000).
Purpose and activities: To contribute to religious, charitable, and educational

organizations of whose activities the foundation's officers have personal knowledge. Support largely for higher and secondary education, hospitals, social service agencies, cultural activities, and health agencies.

Types of support: Operating budgets, continuing support, annual campaigns, seed money, emergency funds, building funds, equipment, endowment funds, capital campaigns, general purposes, land acquisition, renovation projects.

Limitations: Giving primarily in IL, MA, and WA. No grants to individuals, or for scholarships, fellowships, or matching gifts; no loans.

Application information: Applications not accepted.

Board meeting date(s): May

Write: Charles C. Haffner III, Pres.

Officers and Directors: Charles C. Haffner III, Pres. and Treas.; Clarissa H. Chandler, V.P. and Secy.; Phoebe H. Andrew, Frances H. Colburn.

Number of staff: None.

Employer Identification Number: 366064770

779
Hales Charitable Fund, Inc.

120 West Madison St., Suite 14E
Chicago 60602 (312) 641-7016
Additional address: 550 Frontage Road, Suite 3086, Northfield, IL 60093

Incorporated in 1939 in IL.

Donor(s): G. Willard Hales,† Burton W. Hales,† William M. Hales.

Financial data (yr. ended 12/31/86): Assets, $5,783,214 (M); gifts received, $27,810; expenditures, $347,725, including $326,510 for 46 grants (high: $200,000; low: $100).

Purpose and activities: Emphasis on higher education, Protestant church organizations, hospitals and health agencies; support also for cultural programs and social agencies.

Types of support: Operating budgets, continuing support, annual campaigns, emergency funds, building funds, endowment funds, scholarship funds, professorships, research.

Limitations: Giving primarily in IL. No grants to individuals, or for seed money, deficit financing, equipment, land acquisition, renovations, matching gifts, demonstration projects, publications, or conferences; no loans.

Application information: Applications not accepted.

Board meeting date(s): Annually and as required

Write: William M. Hales, Jr., Pres.

Officers and Directors: William M. Hales, Pres.; Burton W. Hales, Jr., Secy.-Treas.; Marion J. Hales, Mary C. Hales.

Number of staff: None.

Employer Identification Number: 366060632

780
Armand Hammer Foundation

135 South LaSalle St., Suite 1000
Chicago 60603 (312) 580-1225

Established in 1968 in CA.

Donor(s): Armand Hammer.

Financial data (yr. ended 12/31/87): Assets, $23,771,555 (M); gifts received, $9,762,000; expenditures, $2,183,224, including $2,054,136 for 62 grants (high: $935,000; low: $15; average: $500-$25,000).

Purpose and activities: Giving primarily for higher education, art museums and galleries, and medical research; support also for the state of Israel.

Limitations: No grants to individuals.

Application information:

Initial approach: Letter

Copies of proposal: 2

Deadline(s): None

Board meeting date(s): Annually and as required

Write: David J. Creagan, Jr.

Directors: Arthur Groman, Armand Hammer.

Number of staff: None.

Employer Identification Number: 237010813

781
Philip S. Harper Foundation

c/o Harper-Wyman Co.
930 North York Rd., Suite 204
Hinsdale 60521

Incorporated in 1953 in IL.

Donor(s): Philip S. Harper, Harper-Wyman Co.

Financial data (yr. ended 11/30/88): Assets, $4,710,435 (M); expenditures, $259,236, including $185,900 for 124 grants (high: $9,000; low: $250).

Purpose and activities: Support for higher education, child welfare, health agencies and medical research, cultural programs, including public broadcasting, social welfare, including youth agencies, and Protestant churches.

Officers: Philip S. Harper, Jr., Pres.; Lamar Harper Williams, V.P.; Charles C. Lamar, Secy.-Treas.

Employer Identification Number: 366049875

782
Harris Bank Foundation

111 West Monroe St.
P.O. Box 755
Chicago 60690 (312) 461-6660

Incorporated in 1953 in IL.

Donor(s): Harris Trust & Savings Bank.

Financial data (yr. ended 12/31/87): Assets, $610,332 (M); gifts received, $500,000; expenditures, $1,032,548, including $911,435 for 144 grants (high: $315,500; low: $150; average: $2,000-$5,000), $22,000 for 16 grants to individuals and $98,613 for 756 employee matching gifts.

Purpose and activities: Emphasis on a community fund and higher education, including an employee matching gifts program; support also for cultural activities, neighborhood redevelopment, and social services.

Types of support: Operating budgets, continuing support, annual campaigns, seed money, building funds, equipment, matching funds, technical assistance, scholarship funds, special projects, employee-related scholarships, employee matching gifts, renovation projects.

Limitations: Giving limited to the Chicago, IL, metropolitan area, except for matching gifts

program. No support for sectarian or religious organizations, fraternal organizations, or political activities. No grants to individuals (except for employee-related scholarships for dependents of Harris Bank employees), or for emergency or endowment funds, deficit financing, land acquisition, capital grants for higher education, research, publications, conferences, testimonials, advertisements, or raffle tickets; no loans.

Publications: Annual report (including application guidelines), program policy statement.

Application information:

Initial approach: Letter

Copies of proposal: 1

Deadline(s): First week of month board meets

Board meeting date(s): Jan., Mar., June, Aug., Oct., and Dec.

Final notification: 2 weeks after board meetings

Write: H. Kris Ronnow, Secy.-Treas.

Officers : John L. Stephens,* Pres.; Philip A. Delaney,* V.P.; H. Kris Ronnow, Secy.-Treas.

Directors:* Joan M. Baratta, Melody L. Camp, Cecil R. Coleman, Donald S. Hunt, Max M. Jacobson, Bruce Osborne, Edward J. Williams.

Number of staff: 2 part-time professional; 1 part-time support.

Employer Identification Number: 366033888

Recent arts and culture grants:

Art Institute of Chicago, Chicago, IL, $6,000. For operating expenses. 1987.

Chicago Historical Society, Chicago, IL, $5,000. For operating expenses. 1987.

Chicago Symphony Orchestra, Chicago, IL, $10,000. For operating expenses. 1987.

Chicago Zoological Society, Brookfield, IL, $5,000. For operating expenses. 1987.

Field Museum of Natural History, Chicago, IL, $10,500. For operating expenses. 1987.

Lincoln Park Zoological Society, Chicago, IL, $5,500. For operating expenses. 1987.

Lyric Opera of Chicago, Chicago, IL, $10,000. For operating expenses. 1987.

Museum of Science and Industry, Chicago, IL, $5,000. For operating expenses. 1987.

Shedd Aquarium, Chicago, IL, $5,000. For operating expenses. 1987.

783
Harris Bankcorp Corporate Giving Program

111 West Monroe St.
P.O. Box 755
Chicago 60690 (312) 461-6660

Purpose and activities: Supports general and higher education, culture and the arts, social services and health and civic programs. Also supports United Way/Crusade of Mercy. Types of support include a matching gifts program for culture and arts, higher education, education-related programs, social service and business related programs and funding for special projects, and a scholarship program for employees' children. Total giving for the foundation, Harris Bankcorp and its subsidiaries amounted to $2,228,702 in 1988. Programs reflect combined foundation and corporate giving.

Types of support: Special projects, employee matching gifts, employee-related scholarships.

Limitations: Giving primarily in metropolitan Chicago, IL, for the parent company; Harris Bank affiliates give in their local communities. No support for political activities, sectarian or religious organizations or fraternal organizations. No grants to individuals, or for testimonial drives or advertisements.
Publications: Informational brochure.
Application information: Include proposal with budget, potential funding sources, background information on the organization, 501(c)(3) and current audited financial statement.
 Initial approach: Letter
 Copies of proposal: 1
 Deadline(s): One month prior to bimonthly meetings
 Board meeting date(s): Bimonthly
 Final notification: Following Board meeting
 Write: Diana Nelson, V.P., Public Affairs
Number of staff: 2 full-time professional; 1 full-time support.

784
Harris Family Foundation
333 Skokie Blvd.
Northbrook 60062 (312) 498-1260

Incorporated in 1957 in IL.
Donor(s): Neison Harris, and family.
Financial data (yr. ended 2/28/87): Assets, $5,962,465 (M); gifts received, $49,250; expenditures, $621,910, including $604,561 for 133 grants (high: $250,000; low: $25).
Purpose and activities: Emphasis on medical research and health services, Jewish welfare funds, cultural programs, higher and secondary education, community funds, and social service agencies.
Types of support: General purposes, building funds.
Limitations: Giving primarily in the Chicago, IL, area. No grants to individuals.
Application information:
 Initial approach: Letter
 Copies of proposal: 1
 Deadline(s): Submit proposal preferably in May; no set deadline
 Board meeting date(s): May and Nov.
 Final notification: 30 days
 Write: Neison Harris, Pres.
Officers and Directors: Neison Harris, Pres. and Treas.; Bette D. Harris, V.P. and Secy.; Sidney Barrows, Katherine Harris, King W. Harris, Toni H. Paul.
Number of staff: None.
Employer Identification Number: 366054378

785
The Harris Foundation
Two North LaSalle St., Suite 605
Chicago 60602-3703 (312) 621-0566

Incorporated in 1945 in MN.
Donor(s): Members of the Harris family and others.
Financial data (yr. ended 12/31/87): Assets, $17,117,161 (M); gifts received, $125,000; expenditures, $1,830,496, including $1,745,217 for 360 grants (high: $200,000; low: $50; average: $250-$25,000).

Purpose and activities: Interests include demonstration and research programs in prevention of family dysfunction: prevention of teenage pregnancy and infant mortality and morbidity; infant mental health and early childhood development; Jewish charities; the arts and educational television.
Types of support: Annual campaigns, seed money, equipment, special projects, research, publications, conferences and seminars, general purposes, operating budgets, scholarship funds.
Limitations: No grants to individuals, or for continuing support, emergency or endowment funds, deficit financing, land acquisition, renovations, scholarships, or fellowships; no loans.
Application information:
 Initial approach: Letter
 Copies of proposal: 1
 Deadline(s): None
 Board meeting date(s): Semiannually
 Write: Ruth K. Belzer, Exec. Dir.
Officers and Trustees: Irving B. Harris, Chair.; William W. Harris, Vice-Chair.; Benno F. Wolff, Secy.; Sidney Barrows, Roxanne Harris Frank, Joan W. Harris, Neison Harris, Daniel Meyer, Virginia Harris Polsky.
Staff: Ruth K. Belzer, Exec. Dir.
Number of staff: 1 full-time professional; 1 full-time support.
Employer Identification Number: 366055115
Recent arts and culture grants:
Alternative Media Information Center, NYC, NY, $10,500. For support of American Documentary project. 1987.
Art Institute of Chicago, Chicago, IL, $5,000. To support Sustaining Fellows Program. 1987.
Central Educational Network Association, American Children's Television Festival, Des Plaines, IL, $7,600. To support intern position. 1987.
Central Educational Network Association, American Children's Television Festival, Des Plaines, IL, $5,000. For general operating support. 1987.
Chicago Opera Theater, Chicago, IL, $25,500. For general operating support. 1987.
Minnesota Orchestral Association, Minneapolis, MN, $7,000. For 1986-87 Guaranty Fund and for general operating support. 1987.
Museum of Contemporary Art, Chicago, IL, $5,300. For general operating support. 1987.
Music Associates of Aspen, Aspen, CO, $5,650. For general operating support. 1987.
National Public Radio, DC, $25,000. For general operating support. 1987.
Northwestern Memorial Hospital, Chicago, IL, $5,000. To support Medical Program for Performing Artists. 1987.
Orchestral Association, Chicago Symphony Orchestra, Chicago, IL, $14,500. For general operating support. 1987.
Ordway Music Theater, Saint Paul, MN, $5,500. For general operating support. 1987.
Public Television Playhouse, NYC, NY, $39,500. For general operating support. 1987.
Ravinia Festival Association, Highland Park, IL, $5,250. To support Young Artists Institute. 1987.
W G B H Educational Foundation, Boston, MA, $5,000. Toward teacher's guide for second DeGrassi Junior High series. 1987.

W T T W Chicago Public Television Association, Chicago, IL, $5,000. For general operating support. 1987.

786
Hartmarx Charitable Foundation
101 North Wacker Dr.
Chicago 60606 (312) 372-6300

Incorporated in 1966 in IL.
Donor(s): Hartmarx Corp.
Financial data (yr. ended 11/30/88): Assets, $734,116 (M); expenditures, $747,150 for 347 grants (high: $75,000; low: $50) and $23,479 for 72 employee matching gifts.
Purpose and activities: Grants primarily for community funds, higher education, and cultural, civic and health programs.
Types of support: Employee matching gifts, annual campaigns, building funds, capital campaigns, endowment funds, general purposes, operating budgets, professorships, scholarship funds.
Limitations: Giving primarily in GA, IL, IN, MI, NY, OR, and WA. No grants to individuals.
Application information:
 Initial approach: Letter
 Copies of proposal: 1
 Deadline(s): None
 Board meeting date(s): Dec., Mar., June, and Sept.
 Write: Kay C. Nalbach, Pres.
Officers: Kay C. Nalbach, Pres.; Wayne H. Ahlberg, V.P.; Jerome Dorf, V.P.; Cary M. Stein, Secy.; J.R. Meinert, Treas.
Employer Identification Number: 366152745

787
Walter E. Heller Foundation
c/o Continental Illinois National Bank and Trust Co. of Chicago
30 North LaSalle St., 6th Floor
Chicago 60693 (312) 828-1785

Incorporated in 1955 in IL.
Donor(s): Walter E. Heller,† Whico, Inc.
Financial data (yr. ended 12/31/86): Assets, $3,284,224 (M); expenditures, $491,611, including $465,927 for 69 grants (high: $89,650; low: $10).
Purpose and activities: Emphasis on cultural programs, particularly museums and the performing arts; support also for higher education and health organizations.
Limitations: Giving primarily in Chicago, IL.
Application information:
 Initial approach: Letter
 Deadline(s): None
 Write: M.C. Ryan
Officer and Directors: Alyce H. DeCosta, Pres.; Edwin J. DeCosta, M.D., Addis E. Hull, Albert E. Jenner, Jr., M. James Termondt.
Employer Identification Number: 366058986

788
The Dave Hokin Foundation
875 North Michigan Ave., Rm. 3707
Chicago 60611

Incorporated in 1951 in IL.

Financial data (yr. ended 10/31/86): Assets, $428,773 (M); gifts received, $350,000; expenditures, $195,047, including $193,541 for 124 grants (high: $83,275; low: $15).
Purpose and activities: Grants for medical research, hospitals, higher education, cultural organizations, and Jewish welfare funds.
Officers: Myron Hokin, Pres.; Carl K. Heyman, Treas.
Employer Identification Number: 366079161

789
The H. Earl Hoover Foundation
1801 Green Bay Rd.
P.O. Box 330
Glencoe 60022 (312) 835-3350

Trust established in 1947 in IL.
Donor(s): H. Earl Hoover.
Financial data (yr. ended 12/31/86): Assets, $2,673,836 (M); expenditures, $180,118, including $163,850 for 64 grants (high: $20,000; low: $50).
Purpose and activities: Giving for youth agencies, hospitals, social and welfare agencies, cultural organizations, and Protestant church support.
Limitations: Giving primarily in IL.
Application information:
 Initial approach: Letter
 Deadline(s): None
Trustees: Robert L. Foote, Miriam W. Hoover, Michael A. Leppen.
Employer Identification Number: 366063814

790
Susan Cook House Educational Trust
Marine Bank of Springfield, Trust Dept.
One Old Capital Plaza East
Springfield 62701 (217) 525-9600

Trust established in 1969 in IL.
Financial data (yr. ended 11/30/87): Assets, $1,723,679 (M); expenditures, $141,603, including $96,000 for 12 grants (high: $20,000; low: $1,000) and $14,500 for 20 grants to individuals.
Purpose and activities: Emphasis on higher and secondary education, including a scholarship program; support also for the arts and a social agency.
Types of support: Student aid.
Limitations: Giving limited to Sangamon County, IL.
Application information:
 Initial approach: Letter
 Deadline(s): None
Trustee: Marine Bank of Springfield.
Number of staff: None.
Employer Identification Number: 376087675

791
Hyatt Foundation
200 West Madison, 38th Fl.
Chicago 60606 (312) 750-8400

Established in 1978 in IL.
Donor(s): Pritzker Foundation.
Financial data (yr. ended 7/31/87): Assets, $830 (M); gifts received, $403,000;

expenditures, $413,650, including $105,920 for 1 grant to an individual.
Purpose and activities: Annual award made to an individual for "significant contribution to humanity through architecture."
Types of support: Grants to individuals.
Application information: No posthumous awards are given. Applications not accepted.
 Write: Simon Zunamon
Officers: Jay A. Pritzker, Pres.; Marian Pritzker, V.P.; Allen M. Turner, V.P.; Thomas J. Pritzker, Secy.; Nicholas J. Pritzker, Treas.
Number of staff: 1 full-time professional; 1 part-time support.
Employer Identification Number: 362981565

792
Illinois Bell Corporate Giving Program
HQ 190
225 West Randolph Street
Chicago 60606 (312) 726-4691

Financial data (yr. ended 12/31/88): Total giving, $4,795,000, including $4,155,279 for 1,500 grants (high: $100,000; low: $750; average: $1,500-$5,000) and $639,721 for 3,127 employee matching gifts.
Purpose and activities: Supports arts, humanities, civic and public affairs, health programs, and the United Way. Types of support include in-kind donations of products and used furniture.
Types of support: Building funds, capital campaigns, employee matching gifts, general purposes, operating budgets, special projects, in-kind gifts.
Limitations: Giving primarily in the Chicago area. No support for political, religious or veterans' organizations; or ideological movements. No grants to individuals, or for endowment funds, hospital operating funds, trips or tours, or goodwill advertising.
Publications: Informational brochure.
Application information: Include organization history, beneficiaries of the program, contributor list, financial reports and 501(c)(3).
 Initial approach: Letter
 Copies of proposal: 1
 Deadline(s): None
 Board meeting date(s): Bimonthly
 Write: Jack Gardner, Mgr., Corp. Contribs.
Number of staff: 1 full-time professional; 2 full-time support.

793
IMC Foundation
2315 Sanders Rd.
Northbrook 60062 (312) 564-8600

Incorporated in 1967 in IL.
Donor(s): International Minerals & Chemical Corp.
Financial data (yr. ended 6/30/88): Assets, $818,745 (M); expenditures, $175,157, including $174,500 for 31 grants (high: $54,000; low: $500; average: $1,000-$5,000).
Purpose and activities: Support for social services, including family services, child welfare and development, and youth groups; the United Way; elementary and higher education; and the arts and humanities.

Types of support: Annual campaigns, continuing support, operating budgets, program-related investments, special projects.
Limitations: Giving primarily in the Chicago, IL, area. No support for religious organizations. No grants to individuals, or for building or endowment funds, scholarships, fellowships, or matching gifts; no loans.
Publications: Annual report, corporate giving report, informational brochure (including application guidelines), financial statement, grants list.
Application information: Application form required.
 Initial approach: Proposal with application form
 Copies of proposal: 1
 Deadline(s): End of Jan., Apr., July, and Oct.
 Board meeting date(s): Feb., May, Aug., and Nov.
 Final notification: End of Mar., June, Sept., and Dec.
 Write: Colleen D. Keast, Exec. Dir.
Officers: George D. Kennedy,* Pres.; Elizabeth M. Higashi, V.P.; A. Jacqueline Dout, Treas.; Kenneth J. Burns, Secy.
Directors:* Colleen D. Keast, Exec. Dir.; Raymond F. Bentele, M. Blakemon Ingle, Billie B. Turner.
Number of staff: None.
Employer Identification Number: 366162015

794
The Ingersoll Foundation, Inc.
934 North Main St.
Rockford 61103 (815) 964-3242

Trust established in 1948 in IL; incorporated in 1983.
Donor(s): The Ingersoll Milling Machine Co.
Financial data (yr. ended 9/30/88): Assets, $236,466 (M); gifts received, $47,403; expenditures, $178,293, including $44,150 for 29 grants (high: $18,000; low: $50; average: $500-$5,000) and $30,000 for 2 grants to individuals.
Purpose and activities: Support for local organizations whose activities include direct involvement in character education and/or citizenship education; grants also to organizations outside the Rockford area that have a national impact, and for the two annual Ingersoll Prizes, which include the T.S. Eliot Award for Creative Writing and the Richard M. Weaver award for Scholarly Letters.
Types of support: Operating budgets, continuing support, annual campaigns, seed money, special projects, publications, conferences and seminars, grants to individuals.
Limitations: Giving primarily in the Rockford, IL, area. No grants to individuals (except Ingersoll Prizes recipients), or for emergency or deficit financing, matching gifts, scholarships, fellowships, or research; no loans.
Publications: Application guidelines, program policy statement.
Application information:
 Initial approach: Letter or telephone
 Copies of proposal: 1
 Deadline(s): Submit proposal in Sept. or Feb.; no set deadline
 Board meeting date(s): Spring and annual meeting in Sept.

Final notification: 3 weeks after the Sept.
board meeting; 3 months for requests
submitted between Sept. and Apr. 1
Write: Dr. John A. Howard, Pres.
Officer and Directors: Clayton R. Gaylord,
Chair.; John A. Howard,* Pres.; Edson I.
Gaylord, Robert M. Gaylord, Jr.
Number of staff: None.
Employer Identification Number: 363211777

795
Interlake Foundation

701 Harger Rd.
Oak Brook 60521 (312) 572-6600

Incorporated in 1951 in IL.
Donor(s): The Interlake Corp.
Financial data (yr. ended 12/31/87): Assets,
$2,724,000 (M); gifts received, $243,000;
expenditures, $555,000, including $445,000
for 164 grants and $52,000 for 195 employee
matching gifts.
Purpose and activities: Emphasis on
community funds and higher education;
support also for youth agencies and cultural
programs. The foundation is the main vehicle
for giving; a direct corporate contributions
program handles requests for fundraisers and
other local activities.
Types of support: Employee matching gifts,
capital campaigns, continuing support, general
purposes, matching funds, research.
Limitations: Giving primarily in Chicago, IL,
San Diego, CA, NJ, and CT. No grants to
individuals.
Application information:
Initial approach: Letter
Copies of proposal: 1
Deadline(s): Sept. to Dec. is preferred time
for applying
Board meeting date(s): Quarterly
Final notification: 3 months
Write: Raymond T. Anderson, Treas.
Officers: Frederick C. Langenberg,* Pres.;
Edward D. Hopkins,* V.P.; I.R. MacLeod,
Secy.; Raymond T. Anderson, Treas.
Directors:* Edward J. Williams.
Employer Identification Number: 362590617

796
International Minerals & Chemical Community Partnership

2315 Sanders Rd.
Northbrook 60062 (312) 564-8600

Financial data (yr. ended 6/30/88): Total
giving, $1,138,000, including $904,778 for 179
grants (high: $70,000; low: $500; average:
$3,000-$5,000) and $233,222 for employee
matching gifts.
Purpose and activities: IMC headquarters and
subsidiaries support a variety of programs,
including all levels of education, family and
children's services, aid to the homeless,
hunger, international studies, volunteerism,
youth, arts and culture, community services,
environmental and disaster relief, and the
United Way; IMC has plans to broaden
community involvement to include a formal
employee volunteer program and in-kind
resource donations.

Types of support: Annual campaigns,
continuing support, employee matching gifts,
internships, operating budgets, program-related
investments, scholarship funds, employee-
related scholarships, special projects, in-kind
gifts.
Limitations: Giving primarily in Chicago, IL, St.
Louis, MO, and Terre Haute, IN. No support
for fraternal or religious organizations. No
grants to individuals, or for
building/endowment funds, or fellowships.
Publications: Corporate giving report,
application guidelines, financial statement.
Application information: Application form
required.
Initial approach: Write for application form
and guidelines
Copies of proposal: 1
Deadline(s): Quarterly: last day in July, Oct.,
Jan., and Apr.
Board meeting date(s): Mid-month of Aug.,
Nov., Feb., and May
Final notification: Quarterly: Sept., Dec.,
Mar., and June
Write: Coleen D. Keast, Mgr., Public Affairs
and Exec. Dir., IMC Foundation
Number of staff: 1 full-time professional; 1 full-
time support.

797
The Joyce Foundation

135 South LaSalle St., Suite 4010
Chicago 60603 (312) 782-2464

Incorporated in 1948 in IL.
Donor(s): Beatrice Joyce Kean.†
Financial data (yr. ended 12/31/88): Assets,
$288,677,963 (M); expenditures, $13,333,260,
including $12,313,161 for 421 grants (high:
$150,000; low: $500; average: $5,000-
$50,000), $3,370 for employee matching gifts
and $50,000 for loans.
Purpose and activities: Support for 1)
conservation: soil conservation, groundwater
protection, reducing atmospheric pollutants,
protecting and enhancing the basic qualities of
the Great Lakes; 2) culture: encouraging artistic
excellence and cultural diversity in the Chicago
metropolitan area with special attention given
to organizations in early stages of development
that have already shown achievement or
exceptional promise; 3) economic
development: strengthening the economic
vitality of the Midwest and expanding
opportunities for low-income individuals to
fully participate in the economy through
projects that work directly with individuals
such as training, business development, or
testing innovative business structures; 4)
education: improving the educational
opportunities offered to low-income students in
primary, secondary and collegiate institutions
by improving the performance of public
schools and a limited number of independent
and parochial schools that serve low-income
students and increasing their access to higher
education; emphasis also on strengthening the
independent liberal arts colleges; 5)
government: encouraging greater citizen
participation in the electoral process,
strengthening public understanding of and
participation in state and local budget making
processes; 6) health: preventing first births

among adolescents, with priority given to
efforts for high-risk youth in urban areas that
have the potential for replication; and
heightening public awareness of the need for
primary prevention.
Types of support: Operating budgets,
continuing support, seed money, emergency
funds, matching funds, consulting services,
technical assistance, program-related
investments, scholarship funds, loans, special
projects, publications, conferences and
seminars, employee matching gifts, general
purposes.
Limitations: Giving primarily in the midwestern
states, including IL, IN, IA, MI, MN, OH, WI;
limited number of conservation grants made in
ND, SD, KS, MO, and NE. No grants to
individuals, or for endowment or building
funds, annual campaigns, deficit financing,
research, or land acquisition.
Publications: Annual report, informational
brochure (including application guidelines),
financial statement, program policy statement.
Application information: Program policy and
grant proposal guidelines reviewed annually in
Dec.; completion of questionnaire is required
prior to proposal submission in field of higher
education; requests should be sent to
foundation in Oct. for higher education
questionnaire.
Initial approach: Letter
Copies of proposal: 1
Deadline(s): Dec. 15 (for Apr. meeting -
Education, Economic Development); Apr.
15 (for Aug. meeting - Health and
Conservation); Aug. 15 (for Dec. meeting -
Culture and Government)
Board meeting date(s): Apr. or May, Aug. or
Sept., and twice in Dec.
Final notification: 3 weeks following meeting
Write: Craig Kennedy, Pres.
Officers: Craig Kennedy,* Pres.; Cushman B.
Bissell, Jr.,* V.P., Finance, and Secy.-Treas.;
Linda K. Schelinski, V.P., Administration.
Directors:* John T. Anderson, Co-Chair.;
Raymond Wearing, Vice-Chair.; Lewis H.
Butler, Charles U. Daly, Richard K. Donahue,
Marion T. Hall, Jessica T. Mathews.
Number of staff: 10 full-time professional; 3
full-time support.
Employer Identification Number: 366079185
Recent arts and culture grants:
Academy, The, Chicago, IL, $30,000. For
expansion of development efforts. 12/8/87.
Art Resources in Teaching, Chicago, IL,
$25,000. For general support. 12/8/87.
Boitsov Classical Ballet Council, Chicago, IL,
$20,000. For general support. 12/8/87.
Boulevard Arts Center, Chicago, IL, $10,000.
For arts education workshops for teachers.
12/8/87.
Carroll College, Waukesha, WI, $27,750. For
Milwaukee Area Writing Project. 5/5/88.
Center for New Television, Chicago, IL,
$35,000. For general support. 12/8/87.
Chicago Chamber Musicians, Chicago, IL,
$10,000. For general support. 12/8/87.
Chicago Childrens Choir, Chicago, IL, $12,000.
For development activities. 12/8/87.
Chicago Dramatists Workshop, Chicago, IL,
$10,000. For general support. 12/8/87.
Chicago Opera Theater, Chicago, IL, $30,000.
For regional touring program. 12/8/87.

Chicago Sinfonietta, River Forest, IL, $20,000. For general support. 12/8/87.

Chicago String Ensemble, Chicago, IL, $10,000. For general support. 5/5/88.

Chicago Theater Company, Chicago, IL, $20,000. For general support. 12/8/87.

Chicago Theater Group, Chicago, IL, $40,000. For outreach to Chicago public schools. 12/8/87.

Childs Play Touring Theater, Chicago, IL, $10,000. For writing program in Chicago public schools. 12/8/87.

City Lit Theater Company, Chicago, IL, $45,000. For general support. 12/8/87.

City Musick, Chicago, IL, $20,000. For general support. 12/8/87.

Corporation for Cultural Reinvestment, Chicago, IL, $20,000. For arts incubator project. 12/8/87.

Ebony Talent Associates Creative Arts Foundation, Chicago, IL, $30,000. For general support. 12/8/87.

Express-Ways Childrens Museum, Chicago, IL, $25,000. For outreach program. 12/8/87.

Field Museum of Natural History, Chicago, IL, $125,000. For educational programming. 12/8/87.

Field Museum of Natural History, Chicago, IL, $25,000. For Chicago Seminars on the Future project. 5/5/88.

Jazz Institute of Chicago, Chicago, IL, $17,000. For outreach program in Chicago public high schools. 12/8/87.

Kuumba Theater, Chicago, IL, $25,000. For administrative support. 12/8/87.

Lifeline Productions, Chicago, IL, $10,000. For administrative support. 12/8/87.

Merit Music Program, Chicago, IL, $25,000. For music education program for low-income students. 12/8/87.

Mexican Fine Arts Center Museum, Chicago, IL, $27,600. For administrative support. 12/8/87.

Millan Theater Company, Chicago, IL, $20,000. For marketing program. 12/8/87.

Mordine and Company, Chicago, IL, $20,000. For educational outreach program to inner-city minorities. 12/8/87.

Muntu Dance Theater, Chicago, IL, $15,000. For general support. 12/8/87.

National Public Radio, DC, $100,000. For Midwest news coverage. 5/5/88.

Next Theater Company, Evanston, IL, $10,000. For administrative support. 12/8/87.

Northwestern University, Triquarterly, Evanston, IL, $10,000. For library subscription project of literary publication. 12/8/87.

Park Forest Orchestra Association, Park Forest, IL, $15,000. For artists-in-the-school program for minority students. 12/8/87.

Peace Museum, Chicago, IL, $20,000. For institutional development. 12/8/87.

Pegasus Players, Chicago, IL, $20,000. For general support. 12/8/87.

Peoples Music School, Chicago, IL, $15,000. For music education program for low-income students. 12/8/87.

Suzuki-Orff School for Young Musicians, Chicago, IL, $10,000. For scholarship program. 5/5/88.

Victory Gardens Theater, Chicago, IL, $25,000. For outreach program. 12/8/87.

Waterloo Community Playhouse, Waterloo, IA, $20,000. For outreach program to public schools. 12/8/87.

Youth Symphony Orchestra of Greater Chicago, Chicago, IL, $15,000. For general support. 12/8/87.

798
Mayer and Morris Kaplan Foundation

191 Waukegan Rd.
Northfield 60093 (312) 441-6630

Incorporated in 1957 in IL.
Donor(s): Alice B. Kaplan, Sealy Mattress Co. of Illinois, Burton B. Kaplan.
Financial data (yr. ended 10/30/87): Assets, $9,664,757 (M); gifts received, $5,523,960; expenditures, $247,571, including $199,884 for grants.
Purpose and activities: Support primarily for Jewish welfare funds, community funds, higher education, and cultural programs.
Types of support: Operating budgets, continuing support, annual campaigns, endowment funds, employee matching gifts, scholarship funds, professorships, internships, employee-related scholarships, exchange programs, fellowships.
Limitations: Giving primarily in the Chicago, IL, area. No grants to individuals, or for seed money, emergency funds, deficit financing, building funds, equipment or materials, land acquisition, general endowments, matching grants, research, demonstration projects, publications, or conferences and seminars.
Application information: Contributes only to pre-selected organizations. Applications not accepted.
 Write: Sharon Osterberg
Officers: Morris A. Kaplan, Pres.; Burton B. Kaplan, Treas.
Number of staff: None.
Employer Identification Number: 366099675

799
A. T. Kearney & Company Foundation

222 South Riverside Plaza
Chicago 60606

Financial data (yr. ended 12/31/87): Assets, $60,493 (M); gifts received, $12; expenditures, $54,402, including $54,302 for 31 grants (high: $30,000; low: $25).
Purpose and activities: Support for United Way; health, including several single-disease associations; culture, including the fine and performing arts, music, and museums; religion, including missionary programs and interfaith councils; civic affairs; and animal welfare.
Limitations: Giving primarily in IL and OH.
Application information:
 Deadline(s): None
 Write: James Lagges, Trustee
Officer: Lester K. Kloss, Mgr.
Trustees: James Lagges, Robert Sabath.
Employer Identification Number: 362597511

800
Keebler Company Foundation

One Hollow Tree Ln.
Elmhurst 60126 (312) 833-2900
Application address: 677 Larch Ave., Elmhurst, IL 60126

Established in 1968 in IL.
Donor(s): Keebler Co.
Financial data (yr. ended 12/31/87): Assets, $45,394 (M); gifts received, $392,000; expenditures, $360,104, including $359,987 for 239 grants (high: $34,186; low: $10).
Purpose and activities: Emphasis on community funds; support also for minority programs and employee matching gifts for higher education; health and human services, education, and culture and the arts.
Types of support: Employee matching gifts.
Limitations: Giving primarily in areas where the company has major operations including IL, PA, CO, TX, MI, NC, MN, and IN. No grants to individuals, or for endowment funds, research programs, scholarships, or fellowships; no loans.
Application information:
 Initial approach: Letter
 Deadline(s): None
 Write: A.G. Bland, Treas.
Officers: Thomas M. Garvin,* Pres.; J.J. Kelly,* V.P. and Secy.; A.G. Bland, Treas.
Directors:* C. Allen Gerber.
Employer Identification Number: 362658310

801
Kemper Corporate Giving Program, F-6

Route 22
Long Grove 60049 (312) 540-2846
Additional tel.: (312) 540-2512

Purpose and activities: Supports health and welfare, youth, civic, cultural and education programs. Types of support include employee matching gifts for health, welfare and education, equipment funds, and in-kind donations in the form of employee volunteers.
Types of support: Employee matching gifts, equipment, general purposes, operating budgets, special projects, in-kind gifts.
Limitations: Giving primarily in headquarters city and major operating areas nationwide including CA, IL, IA, KS, NJ, NY, OH, and WI. No grants to individuals.
Application information: Include description of organization and project, budget, 501(c)(3) and statement of project's relevance to the company.
 Initial approach: Letter
 Copies of proposal: 1
 Deadline(s): None
 Board meeting date(s): Committee meets monthly
 Final notification: 6 weeks
 Write: John H. Barcroft, Exec. Dir. (education only); C.W. Mewhardt (all other requests)
Administrators: A.J. Baltz, Chair., Corp. Controller; C.F. Johann, V.P., Corp. Relations; A.E. Catania, Dir. of Corp. Human Resources.
Number of staff: None.

802

Kemper Educational and Charitable Fund
35 East Wacker Dr., Suite 1880
Chicago 60601 (312) 580-1024

Incorporated in 1961 in IL.
Donor(s): James S. Kemper.†
Financial data (yr. ended 9/30/88): Assets, $7,836,710 (M); gifts received, $3,362; expenditures, $398,677, including $367,000 for 26 grants (high: $50,000; low: $2,000; average: $5,000).
Purpose and activities: Giving primarily for higher and secondary education; support also for cultural programs and health.
Types of support: Continuing support, equipment, scholarship funds, research.
Limitations: Giving primarily in metropolitan Chicago, IL, area, and states adjoining Illinois. No grants to individuals, or for building or endowment funds; no loans.
Publications: Application guidelines.
Application information: Contributes only to pre-selected organizations. Applications not accepted.
 Copies of proposal: 1
 Deadline(s): None
 Board meeting date(s): Annually and as required
 Write: Virginia J. Heitz, Secy.
Officers: Gertrude Z. Kemper,* Chair.; Peter Van Cleave,* Vice-Chair.; Dale Park, Jr.,* Pres.; Mildred K. Terrill,* V.P.; Virginia J. Heitz, Secy.-Treas.
Trustees:* Margaret M. Archambault, Leslie N. Christensen, Frank D. Stout, John Van Cleave.
Number of staff: 1 part-time professional; 1 part-time support.
Employer Identification Number: 366054499

803

Herman & Gertrude Klafter Foundation
c/o Barry D. Elman
222 North LaSalle, Suite 1900
Chicago 60601

Financial data (yr. ended 12/31/87): Assets, $1,121,404 (M); expenditures, $90,217, including $62,058 for 24 grants (high: $25,000; low: $500).
Purpose and activities: Support primarily for Jewish welfare and cultural programs.
Application information: Contributes only to pre-selected organizations. Applications not accepted.
Trustees: Barry D. Elman, Marvin S. Fenchel.
Employer Identification Number: 363154088

804

Kraft Foundation
(Formerly Dart and Kraft Foundation)
Kraft Court
Glenview 60025 (312) 998-2419

Established in 1983 in IL.
Donor(s): Kraft, Inc.
Financial data (yr. ended 12/26/87): Assets, $52,916,275 (M); expenditures, $8,979,664, including $8,887,757 for grants (high: $817,264; average: $25,000-$50,000).

Purpose and activities: Support primarily for innovative "self-help" programs, with emphasis on nutrition and physical fitness, education, and economic and community development; grants also for public policy and cultural programs. Special focus on the needs of minorities, women, and persons with disabilities.
Types of support: Building funds, endowment funds, research, scholarship funds, fellowships, professorships, general purposes, employee matching gifts.
Limitations: Giving to organizations having national impact or which benefit communities where company employees live and work. No support for organizations with a limited constituency, such as fraternal or veterans' groups, and organizations which restrict their services to members of one religious group. No grants to individuals, or for travel, tuition, and registration fees, membership dues, or goodwill advertising for benefit purposes; no loans.
Publications: Application guidelines.
Application information: The foundation requests that applicants do not call or visit.
 Initial approach: Proposal
 Deadline(s): None
 Board meeting date(s): Quarterly
 Final notification: 1 to 2 months
 Write: Ronald J. Coman, Admin. Dir.
Officers: Margaret P. MacKimm,* Pres.; Gary P. Coughlan,* V.P. and Treas.; William W. Crawford,* V.P.; Thomas J. McHugh, V.P.; Kenneth S. Kirsner, Secy.; Ronald J. Coman, Admin. Dir.
Directors:* Lowell Hoffman, Robert McVicker, John J. Tucker, Joel D. Weiner.
Number of staff: None.
Employer Identification Number: 363222729
Recent arts and culture grants:
Affiliate Artists, NYC, NY, $5,000. 1987.
American Advertising Museum, Portland, OR, $10,000. 1987.
Art Institute of Chicago, Chicago, IL, $30,000. 1987.
Business Committee for the Arts, NYC, NY, $5,000. 1987.
Chicago Academy of Sciences, Chicago, IL, $15,000. 1987.
Chicago City Ballet, Chicago, IL, $20,000. 1987.
Chicago Symphony Orchestra, Chicago, IL, $66,000. 1987.
Colonial Williamsburg Foundation, Williamsburg, VA, $7,500. 1987.
DuSable Museum of African American History, Chicago, IL, $5,000. 1987.
Entertainment Action Team, Chicago, IL, $5,000. For Ending Hunger in Chicago. 1987.
Field Museum of Natural History, Chicago, IL, $25,000. 1987.
Field Museum of Natural History, Chicago, IL, $7,500. 1987.
Free Street Theater, Chicago, IL, $5,000. 1987.
Goodman Theater, Chicago, IL, $22,500. 1987.
International Theater Festival, Chicago, IL, $12,500. 1987.
Japan Society, NYC, NY, $5,000. 1987.
John F. Kennedy Center for the Performing Arts, DC, $7,500. 1987.
John G. Shedd Aquarium, Chicago, IL, $59,000. 1987.
Krakowiak Polish Dancers of Boston, Boston, MA, $5,000. 1987.

Lincoln Center for the Performing Arts, NYC, NY, $10,000. 1987.
Los Angeles County Museum of Natural History, Los Angeles, CA, $5,000. 1987.
Lyric Opera of Chicago, Chicago, IL, $142,500. 1987.
Mexican Fine Arts Center Museum, Chicago, IL, $10,000. 1987.
Museum of Broadcast Communications, Chicago, IL, $200,000. 1987.
Museum of Contemporary Art, Chicago, IL, $7,500. 1987.
Museum of Science and Industry, Chicago, IL, $25,000. For Black Activity Program. 1987.
Museum of Science and Industry, Chicago, IL, $15,000. 1987.
Music Center of the North Shore, Winnetka, IL, $8,000. 1987.
Music of the Baroque, Chicago, IL, $20,000. 1987.
National Captioning Institute, Falls Church, VA, $10,000. 1987.
National Football Foundation and Hall of Fame, Larchmont, NY, $5,000. 1987.
National Museum of Women in the Arts, DC, $5,000. 1987.
Newberry Library, Chicago, IL, $6,000. 1987.
Norman Rockwell Museum at Stockbridge, Stockbridge, MA, $100,000. 1987.
Northlight Theater, Chicago, IL, $8,000. 1987.
Orange County Performing Arts Center, Costa Mesa, CA, $20,000. 1987.
Ravinia Festival Association, Highland Park, IL, $10,000. 1987.
Richard Nixon Presidential Archives Foundation, Morristown, NJ, $25,000. 1987.
Smithsonian Institution, DC, $20,000. 1987.
Wisdom Bridge Theater, Chicago, IL, $5,000. 1987.
Wolf Trap Foundation for the Performing Arts, Vienna, VA, $5,000. 1987.
Youth for Understanding, DC, $13,400. 1987.
Zoological Society of Milwaukee County, Milwaukee, WI, $50,000. 1987.

805

The Francis L. Lederer Foundation
c/o Leo H. Arnstein
7500 Sears Tower
Chicago 60606

Established in 1966 in IL.
Financial data (yr. ended 12/31/86): Assets, $2,378,930 (M); expenditures, $144,839, including $122,000 for 22 grants (high: $20,000; low: $500).
Purpose and activities: Emphasis on higher and secondary education, medical education and research, Jewish welfare funds, and the arts.
Limitations: Giving primarily in IL.
Officers and Directors: Francis L. Lederer II, Pres. and Treas.; Adrienne Lederer, V.P.; Leo H. Arnstein, Secy.
Employer Identification Number: 362594937

806

Otto W. Lehmann Foundation
3240 North Lake Shore Dr., Apt. 7A
Chicago 60657 (312) 929-9851
Mailing address: P.O. Box 11194, Chicago, IL 60611

Incorporated in 1967 in IL.
Donor(s): Otto W. Lehmann.†
Financial data (yr. ended 7/31/88): Assets, $2,062,459 (M); expenditures, $171,694, including $148,385 for 69 grants (high: $8,000; low: $100).
Purpose and activities: Emphasis on youth agencies and child welfare, including aid for the handicapped, higher education, health agencies, social agencies, rehabilitation, and cultural organizations.
Limitations: Giving limited to the Chicago, IL, area.
Application information:
 Initial approach: Letter
 Deadline(s): July 31
 Write: Richard J. Peterson, Managing Trustee
Trustees: Richard J. Peterson, Managing Trustee; David W. Peterson, James F. Elworth, Lucille S. Peterson.
Employer Identification Number: 366160836

807
Leslie Fund, Inc.
One Northfield Plaza
Northfield 60093 (312) 441-2613

Incorporated in 1956 in IL.
Donor(s): Members of the Leslie family.
Financial data (yr. ended 3/31/88): Assets, $2,949,007 (M); expenditures, $236,886, including $209,275 for 73 grants (high: $50,000; low: $50).
Purpose and activities: Emphasis on cultural programs, aid to the handicapped, education, youth agencies, conservation and social welfare agencies, and hospitals.
Limitations: Giving primarily in IL. No grants to individuals.
Application information:
 Initial approach: Letter
 Copies of proposal: 1
 Deadline(s): None
 Board meeting date(s): Jan., Apr., July, and Oct.
 Write: John H. Leslie, Pres.
Officers: John H. Leslie,* Pres.; Virginia A. Leslie, V.P.; Barbara Laskin, Secy.-Treas.
Directors:* James W. Leslie, Vicki Leslie, Robert W. Wright.
Number of staff: 1 part-time support.
Employer Identification Number: 366055800

808
Chas and Ruth Levy Foundation
1200 North Branch St.
Chicago 60622

Incorporated in 1959 in IL.
Donor(s): Charles Levy, Charles Levy Circulating Co., and several other Levy companies.
Financial data (yr. ended 6/30/88): Assets, $3,297,371 (M); gifts received, $207,250; expenditures, $279,785, including $235,718 for 56 grants (high: $125,000; low: $50).
Purpose and activities: Emphasis on Jewish welfare funds, higher education, and performing arts.
Limitations: Giving primarily in IL.

Application information: Contributes only to pre-selected organizations. Applications not accepted.
Officers and Directors: Charles Levy, Pres. and Treas.; Barbara Kipper, V.P.; Ruth Levy, Donald Lubin, Ralph Schneider.
Employer Identification Number: 366032324

809
Marguerite Listeman Foundation
c/o Northern Trust Company
50 South LaSalle St.
Chicago 60675 (312) 630-6000

Trust established in 1958 in WI.
Donor(s): Kurt Listeman.†
Financial data (yr. ended 12/31/86): Assets, $1,370,526 (M); expenditures, $103,208, including $90,300 for 13 grants (high: $30,000; low: $600).
Purpose and activities: Grants primarily for community development, including support for buildings and equipment for parks and recreation areas and cultural facilities.
Types of support: Building funds, equipment.
Limitations: Giving limited to the Clark County-Neillsville, WI, area. No grants to individuals.
Application information: Contributions only to pre-selected organizations. Applications not accepted.
Officer and Advisors: Mike Krultz, Jr., Secy.; Bruce Beilfuss, Bradley Larsen, James Musil, Heron Van Gorden, Fred Wall.
Trustee: Northern Trust Company.
Employer Identification Number: 366028439

810
Michael Littner Charitable Foundation Trust
180 North Michigan Ave.
Chicago 60601

Established in 1981 in IL.
Financial data (yr. ended 12/31/87): Assets, $326,777 (M); gifts received, $0; expenditures, $135,960, including $127,137 for 14 grants (high: $25,000; low: $250).
Purpose and activities: Support for dance companies, theatre companies and productions, and a mental health institute.
Limitations: Giving primarily in Chicago, IL. No grants to individuals.
Application information:
 Deadline(s): None
 Write: Ner Littner, M.D., Trustee
Trustee: Ner Littner, M.D.
Employer Identification Number: 363235601

811
Joseph Lizzadro Family Foundation
2215 York Rd., Suite 304
Oak Brook 60521

Incorporated in 1957 in IL.
Donor(s): Members of the Lizzadro family and others.
Financial data (yr. ended 12/31/86): Assets, $3,855,833 (M); expenditures, $134,624, including $119,750 for 7 grants (high: $115,000; low: $200; average: $1,000).

Purpose and activities: Grants primarily for cultural organizations, hospitals, and health agencies.
Limitations: Giving limited to Oak Brook, IL. No grants to individuals, or for endowment funds.
Application information:
 Initial approach: Letter
 Copies of proposal: 1
 Deadline(s): Submit proposal in Nov.; deadline Nov. 30
 Board meeting date(s): Mar. and Dec.
 Write: John S. Lizzadro, Treas.
Officers and Directors: Mary Lizzadro, Pres.; Joseph Lizzadro, Jr., V.P.; Angela Anderson, Secy.; John S. Lizzadro, Treas.; Bonita Hay, Frank C. Lizzadro, Theresa McPherson, Diane Nicholas.
Employer Identification Number: 366047939

812
J. Roderick MacArthur Foundation
9333 North Milwaukee Ave.
Niles 60648 (312) 966-0143

Established in 1976 in IL.
Donor(s): J. Roderick MacArthur,† Bradford Exchange AG, Solange D. MacArthur, Bradford Exchange, Ltd.
Financial data (yr. ended 1/31/89): Assets, $25,499,279 (M); gifts received, $519,983; expenditures, $3,939,177, including $3,536,821 for 115 grants (high: $300,000; low: $2,000; average: $2,000-$20,000).
Purpose and activities: The foundation seeks to "aid those who are inequitably or unjustly treated by established institutions" by "protecting and encouraging freedom of expression, human rights, civil liberties, and social justice; and by eliminating political, economic, social, religious, and cultural oppression."
Types of support: Seed money, publications, special projects.
Limitations: No support for ongoing social services, government programs, religious, church-based activities, university or other educational programs, or economic development or training programs. No grants to individuals, or for capital projects, endowments, development campaigns, statues or memorials, annual campaigns, conferences, continuing support, deficit financing, land acquisition, endowments, matching gifts, consulting services, technical assistance, scholarships, internships, fellowships, seminars or benefits; no pass through grants, no support for grassroots organizing or demonstrations; no loans.
Publications: Financial statement, grants list, informational brochure (including application guidelines).
Application information:
 Initial approach: Letter
 Copies of proposal: 1
 Deadline(s): None
 Board meeting date(s): Approximately every 2 months
 Final notification: 1 to 2 months
 Write: Lance E. Lindblom, Pres.
Officers and Directors:* Solange D. MacArthur,* Chair.; Gregoire C. MacArthur,*

Vice-Chair.; Lance E. Lindblom, Pres.; John R. MacArthur,* Secy.-Treas.
Number of staff: 4 full-time professional.
Employer Identification Number: 510214450
Recent arts and culture grants:
Film Arts Foundation, San Francisco, CA, $20,000. To complete video documentary investigating gun battle between American Sioux Indians and FBI agents on Pine Ridge Reservation of South Dakota in 1975 and constitutional and other legal issues. 1988.
Film Arts Foundation, San Francisco, CA, $7,500. For documentary film, Fenix Rising, concerning radiation contamination caused by dismantled cobalt 60 cancer treatment machine, as illustration of U.S. policy concerning export of radioactive waste. 1988.
Film Arts Foundation, San Francisco, CA, $7,202. To support completion costs of documentary film project, Legacy of the Hollywood Blacklist. 1988.
Film News Now Foundation, NYC, NY, $20,000. For post-production expenses of video documentary, Adopted Son: The Death of Vincent Chin, which focuses on slaying in Detroit of Chinese-American in 1982 during auto industry recession. 1988.
National Public Radio, DC, $5,000. For on-site research and production of series on Afghanistan and Pakistan, focusing on human rights, social, economic and political conditions. 1988.
New York Foundation for the Arts, NYC, NY, $20,000. For development and production of bilingual video documentary about 1964 Cuban political trial of Marcos Rodriguez, examining use of revolutionary tribunals in Cuba and their impact on human rights. 1988.
PEN American Center, NYC, NY, $15,000. For Freedom to Write Committee's White Paper on Domestic Censorship project, which will document and analyze state of censorship in U.S.. 1988.

813
John D. and Catherine T. MacArthur Foundation
140 South Dearborn St.
Chicago 60603 (312) 726-8000

Incorporated in 1970 in IL.
Donor(s): John D. MacArthur.†
Financial data (yr. ended 12/31/88): Assets, $2,837,000,000 (M); expenditures, $120,900,000, including $103,600,000 for grants and $45,200,000 for loans.
Purpose and activities: Six major initiatives currently authorized: MacArthur Fellows Program, for highly talented individuals in any field of endeavor who are chosen in a foundation-initiated effort (no applications are accepted for this program); the Health Program, for research in mental health and the psychological and behavioral aspects of health and rehabilitation (including designated programs in parasitology and aging); the Special Grants Program for support of cultural and community development in the Chicago metropolitan area (including the Program for Neighborhood Initiatives); the International Peace and Security Program, for support of initiatives which promote and strengthen

international security; the World Environment and Resources Program, for support of conservation programs which protect the earth's biological diversity and work to protect tropical ecology; and the Education Program, to focus on the promotion of literacy. Although the foundation has also made grants in such areas as population and mass communications, no formal programs or guidelines have been established to date.
Types of support: Matching funds, general purposes, operating budgets, special projects, research, fellowships.
Limitations: No support for churches or religious programs, political activities or campaigns, or other foundations or institutions. No grants for capital or endowment funds, equipment purchases, plant construction, conferences, publications, media productions, debt retirement, development campaigns, fundraising appeals, scholarships, or fellowships (other than those sponsored by the foundation); no loans.
Publications: Annual report, program policy statement, application guidelines, informational brochure.
Application information: Direct applications for Fellows Program not accepted. Grants increasingly initiated by the board.
 Initial approach: Letter
 Copies of proposal: 1
 Deadline(s): None
 Board meeting date(s): Monthly, except Aug.
 Final notification: Varies
 Write: James M. Furman, Exec. V.P.
Officers: Adele Simmons,* Pres.; James M. Furman,* Exec. V.P.; Lawrence L. Landry, V.P. - Finance; William Bevan, V.P. and Dir. of Health Prog.; Lawrence G. Martin, V.P.; Nancy B. Ewing, Secy.; Philip M. Grace, Treas.; James T. Griffin, General Counsel.
Directors:* William T. Kirby, Chair.; Robert P. Ewing, Murray Gell-Mann, Alan M. Hallene, Paul Harvey, Shirley Mount Hufstedler, Margaret E. Mahoney, Elizabeth Jane McCormack, Jonas Salk, M.D., Jerome B. Wiesner.
Number of staff: 65
Employer Identification Number: 237093598
Recent arts and culture grants:
ACSN-The Learning Channel, DC, $200,000. For continued production support. 1987.
American Academy of Arts and Sciences, Cambridge, MA, $180,000. To support special issue of Daedalus, examining range of issues produced by AIDS epidemic. 1987.
American Museum of the Moving Image, Astoria, NY, $15,000. To support direct mail membership solicitation. 1987.
American Public Radio, Saint Paul, MN, $500,000. To support Program Fund. 1987.
Appalshop, Whitesburg, KY, $15,000. To support fund raising campaign to underwrite media productions. 1987.
Art Institute of Chicago, Film Center, Chicago, IL, $15,000. To upgrade The Film Center Gazette. 1987.
Asian Cinevision, NYC, NY, $15,000. To support annual giving campaign, hiring consultant, travel expenses, and annual report. 1987.
Auditorium Theater Council, Chicago, IL, $100,000. To revitalize management and board of Auditorium Theater, historic and

architecturally significant performing arts facility. 1987.
Bay Area Video Coalition, San Francisco, CA, $30,000. To support upgrading of Coalition's Betacam video equipment. 1987.
Bernice P. Bishop Museum, Honolulu, HI, $765,513. For environmental education in Hawaiian schools. 1987.
Bernice P. Bishop Museum, Honolulu, HI, $45,100. For Museum's database on Hawaiian insects and for research workshop on Hawaiian invertebrates. 1987.
Black Filmmaker Foundation, NYC, NY, $15,000. To support expansion of staff and establishment of print fund. 1987.
Black Theater Alliance of Chicago, Chicago, IL, $10,000. To support Midwest Regional Open Dialogue Conference. 1987.
Boitsov Classical Ballet, Chicago, IL, $25,000. For renewed support of promotional and consulting services. 1987.
Boston Film Video Foundation, Boston, MA, $30,000. To support funding for marketing and new ventures. 1987.
Boulevard Arts Center, Chicago, IL, $30,000. To support general operations and for Body Language Dance Company. 1987.
Boulevard Arts Center, Chicago, IL, $5,500. For technical assistance. 1987.
Boy Scouts of America, Thatcher Woods Area Council, Oak Park, IL, $10,000. To support Explosonic Rockers Theatrical Troupe. 1987.
Carnegie Museum of Art, Pittsburgh, PA, $15,000. To support acquisition of word processing, computer, and used 35mm equipment. 1987.
Center for Contemporary Arts of Santa Fe, Santa Fe, NM, $7,500. To support creation of full programming potential, including international cinema. 1987.
Center for New Television, Chicago, IL, $30,000. To support purchase of new equipment and to market Center's facilities. 1987.
Central and East European Publishing Project, England, $100,000. Toward publication, translation, and dissemination of current writings by Central and East European authors. 1987.
Chamber Music Chicago, Chicago, IL, $20,000. To support general operations. 1987.
Chatham House Foundation, DC, $40,000. Toward microform preservation of Toynbee Press Cuttings Collection. 1987.
Chicago Academy for the Arts, Chicago, IL, $30,000. For renewed support of general operations. 1987.
Chicago Artists Coalition, Chicago, IL, $10,000. To support general operations. 1987.
Chicago Center for Ceramic Arts, Chicago, IL, $10,000. To support general operations. 1987.
Chicago City Ballet, Chicago, IL, $25,000. Toward costs incurred by search for new artistic director and for related board education activities. 1987.
Chicago Filmmakers, Chicago, IL, $15,000. To support purchase of audio recording and lighting equipment. 1987.
Chicago Music Alliance, Chicago, IL, $10,000. To support general operations. 1987.
Chicago New Art Association, Chicago, IL, $10,000. For publication, New Art Examiner,

reader survey and for public lectures and panel discussions. 1987.

Chicago Opera Theater, Chicago, IL, $15,000. To complete installation of computer system. 1987.

Chicago String Ensemble, Chicago, IL, $20,000. For renewed support of general operations. 1987.

Chicago Theater Company, Chicago, IL, $60,000. For support of general operations. 1987.

Childrens Television Workshop, NYC, NY, $5,000,000. To support research and development in educational television. 1987.

City Lit Theater Company, Chicago, IL, $30,000. For support of general operations. 1987.

City Musick, Chicago, IL, $40,000. To support general operations and Mozart Series. 1987.

Community Film Workshop of Chicago, Chicago, IL, $15,000. To support training program, utilizing market development, advertising, and outreach, to benefit women, minorities, high school students, working adults, and media professionals. 1987.

Concertante di Chicago, Chicago, IL, $5,000. To support general operations. 1987.

Corporation for Cultural Reinvestment, Chicago, IL, $20,000. To support office assistance center for small non-profit arts organizations. 1987.

Corporation for Public Broadcasting, DC, $25,000. For printing and additional viewers' guides for television series, Voices and Visions. 1987.

David Puszh Dance Company, Chicago, IL, $10,000. For renewed support of general operations. 1987.

Downtown Community Television Center, NYC, NY, $30,000. To support rehabilitation of Center's landmark firehouse home. 1987.

Educational Broadcasting Corporation, W N E T Channel 13, NYC, NY, $171,172. To support Zipporah Films production of Missile, documentary film on Minuteman missile crew training. 1987.

Electronic Arts Intermix, NYC, NY, $15,000. To support replacement and upgrading of technical equipment for video-tape distribution service and post-production facility. 1987.

Facets Multimedia, Chicago, IL, $30,000. To support establishment of children's media network and for release of children's films. 1987.

Field Museum of Natural History, Chicago, IL, $22,000. To support Museum's entomological expedition to Zona Protectora. 1987.

Film Arts Foundation, San Francisco, CA, $15,000. To support endowment. 1987.

Film Forum, Los Angeles, CA, $7,500. To support funding and publicizing its relocation. 1987.

Film in the Cities, Saint Paul, MN, $30,000. To support stabilization of general operations budget, expansion of earned income, and advancement of organization. 1987.

Film/Video Arts, NYC, NY, $30,000. To support upgrading and expanding of equipment systems. 1987.

Films, Incorporated, Chicago, IL, $4,500,000. To support Video Classics Library, an effort

designed to place timeless PBS series in public libraries nationwide. 1987.

Foundation for Independent Video and Film, NYC, NY, $15,000. To support national directory of independent producers. 1987.

Free Street Theater, Chicago, IL, $40,000. To support Cabrini-Green Residency Program. 1987.

Global Village Video Resource Center, NYC, NY, $15,000. To support Stage II development and organizational advancement for documentary Center. 1987.

Grant Park Concerts Society, Chicago, IL, $100,000. For support of general operations. 1987.

Guadalupe Cultural Arts Center, San Antonio, TX, $7,500. To support marketing plan for exhibition programs and development of cultural arts center; grant made as part of Foundation's media awards. 1987.

Haleakala, The Kitchen, NYC, NY, $15,000. To support Media and the Humanities, series of video installations and exhibitions. 1987.

Illinois Arts Alliance, Chicago, IL, $10,000. For planning, development, and implementation of IAA's Business and Civic Advisory Committee Forums. 1987.

Illinois Humanities Council, Chicago, IL, $250,000. To support Inventing Illinois, five-year program highlighting people, economy, leaders, history, and future role of Illinois. 1987.

Image Film/Video, Atlanta, GA, $15,000. To support building and equipping screening room. 1987.

Immediate Theater Company, Chicago, IL, $10,000. To support general operations. 1987.

Institute of Contemporary Art, Boston, MA, $15,000. To develop and apply marketing plan to expand Institute's audience and increase income for its media arts program. 1987.

Intermedia Arts Minnesota, Minneapolis, MN, $15,000. To support continuation of Production Awards. 1987.

International House of Philadelphia, Philadelphia, PA, $15,000. To support exhibition activities. 1987.

K T C A Twin Cities Public Television, Saint Paul, MN, $100,000. To support series, Alive From Off Center, showcasing new dance, music, theater, performance, and media art. 1987.

Kidsnet, DC, $150,000. For support, partially challenge, to refine and expand services and establish client base. Kidsnet provides qualitative information on children's television and relates the way educators can use this information in their curriculum. 1987.

Lawyers for the Creative Arts, Chicago, IL, $10,000. To support general operations. 1987.

Long Beach Museum of Art Foundation, Long Beach, CA, $15,000. To expand workshop program, accommodate video exhibitions, and improve efficiency and quality of video design and printing. 1987.

Loxahatchee Historical Society, Jupiter, FL, $20,000. To support general operations. 1987.

Mexican Fine Arts Center Museum, Chicago, IL, $65,000. To support general operations

and for renovation of museum's building. 1987.

Minnesota Film Center, Minneapolis, MN, $7,500. To support funding for desk-top publishing. 1987.

Morikami Museum, Delray Beach, FL, $7,000. For donation of Japanese temple urns. 1987.

Moving Image, NYC, NY, $30,000. To support purchase of office equipment, display ads, and for upgrading of Film Forum cinema. 1987.

Museum of Modern Art, NYC, NY, $30,000. To support Between Two Worlds, exhibition program on Yiddish cinema. 1987.

Music of the Baroque, Chicago, IL, $25,000. To support presentation of Bach's Christmas Oratorio at Lincoln Center, New York. 1987.

Music/Theater Workshop, Chicago, IL, $10,000. To support general operations. 1987.

National Alliance of Media Arts Centers, Staten Island, NY, $50,000. For projects to strengthen Media Arts Centers throughout U.S.. 1987.

National Learning Center, DC, $30,000. To provide experimental learning components in artist's experimental TV studio and lab. 1987.

National Public Radio, DC, $200,000. For special coverage of 1988 election. 1987.

Nine One One Contemporary Arts Center, Seattle, WA, $7,500. To support stabilization and expansion of video editing suite for artists and producers. 1987.

Northwest Film and Video Center, Portland, OR, $30,000. To support acquisition of video field production system for use by artists, students, and Center. 1987.

Northwest Media Project, Portland, OR, $7,500. To support 1987 Film and Video Distribution Project. 1987.

Northwestern University, Chicago, IL, $10,000. To support publication of TriQuarterly. 1987.

Palm Beach County Center for the Arts, West Palm Beach, FL, $1,000,000. For challenge grant toward construction and development of multi-purpose performing arts facility. 1987.

Pittsburgh Filmmakers, Pittsburgh, PA, $30,000. To support acquisition of camera and editing systems. 1987.

Public Television Playhouse, NYC, NY, $200,000. To support series, P.O.V., showcasing best independently produced documentaries of past years. 1987.

Randolph Street Gallery, Chicago, IL, $10,000. To support general operations. 1987.

Ruiz Belvis Cultural Center, Chicago, IL, $31,000. To support general operations. Grant shared with Latin American Development Services Corporation. 1987.

Science Museum of Minnesota, Saint Paul, MN, $57,000. For planning Omnimax film on tropical ecology. 1987.

Second Presbyterian Church, Chicago, IL, $25,000. For capital repairs to church, national historic landmark. 1987.

Smithsonian Institution, DC, $542,363. To support Tropical Rainforests: a Disappearing Treasure, multi-media exhibition opening in Washington, DC, and traveling to twelve cities. 1987.

Sojourner Productions, DC, $7,500. To support Black Film Institute. 1987.

South Carolina Arts Commission, Columbia, SC, $15,000. To support acquisition of Betacam video camcorder for Media Arts Center. 1987.

Southwest Alternate Media, Houston, TX, $15,000. To support Independent Feature Film Institute Program. 1987.

Syracuse University, Syracuse, NY, $10,500. To bind collections of Harper's Magazine from 1850 through 1980. 1987.

Textile Arts Center, Chicago, IL, $5,000. To support general operations. 1987.

Three Arts Club of Chicago, Chicago, IL, $40,000. To support development of alumnae organization. 1987.

Tides Foundation, San Francisco, CA, $25,000. For Film and Theater Diplomacy, in partial support of first American film festival in Soviet Union. 1987.

University of California, Berkeley, CA, $30,000. To support Pacific Film Archives. 1987.

University of California, Los Angeles, CA, $30,000. To support UCLA Film and Television archive project, and planning and creation of News and Public Affairs Center. 1987.

University of Colorado, Boulder, CO, $30,000. To support Rocky Mountain Film Center. 1987.

Utah Media Center, Salt Lake City, UT, $7,500. To support employment of half-time marketing specialist. 1987.

Visual Studies Workshop, Rochester, NY, $15,000. To support promotional campaign to expand organizational membership of AFTERIMAGE, and to provide support for writers. 1987.

W G B H Educational Foundation, Boston, MA, $400,000. To fund television documentary series on global environment, State of the World. 1987.

W G B H Educational Foundation, Boston, MA, $200,000. Toward production of The Other Americas. 1987.

W N E T Channel 13, NYC, NY, $750,000. For support of production and broadcast of nine-part public television series, The Mind, and related promotion and education activities. 1987.

W Q E D Metropolitan Pittsburgh Public Broadcasting, Pittsburgh, PA, $850,000. To support eight-part public television series, Man and Nature. 1987.

Walker Art Center, Minneapolis, MN, $15,000. To support installation of new shelving and storage systems; grant made as part of Foundation's media awards. 1987.

Whitney Museum of American Art, NYC, NY, $15,000. To support Program Notes Project; grant made as part of Foundation's media awards. 1987.

814
Nathan Manilow Foundation
754 North Milwaukee Ave.
Chicago 60622 (312) 829-3655

Incorporated in 1955 in IL.
Donor(s): Nathan Manilow,† Lewis Manilow.
Financial data (yr. ended 5/31/88): Assets, $4,642,778 (M); expenditures, $326,101, including $241,169 for 43 grants (high: $50,000; low: $250).

Purpose and activities: Emphasis on Jewish welfare funds, culture, and education; grants also for temple support and child welfare.
Limitations: Giving primarily in IL.
Application information:
Initial approach: Letter
Deadline(s): None
Write: Lewis Manilow, Pres.
Officers: Lewis Manilow, Pres. and Treas.; Susan Manilow, Secy.
Director: Norman Altman.
Employer Identification Number: 366079220

815
Marquette Charitable Organization
2141 South Jefferson St.
Chicago 60616

Incorporated in 1923 in IL.
Financial data (yr. ended 12/31/86): Assets, $8,805,581 (M); expenditures, $742,221, including $674,638 for 108 grants (high: $147,661; low: $100).
Purpose and activities: Emphasis on secondary and higher education, and cultural programs, including historic preservation; support also for Christian religious organizations, health agencies, youth and child welfare, and public policy organizations.
Application information:
Deadline(s): None
Write: Betty Basile, Secy.
Officers: Henry Regnery,* Pres.; William H. Regnery II,* V.P.; Betty Basile, Secy.-Treas.
Directors:* David R. Meyers.
Employer Identification Number: 366055852

816
Mason Charitable Foundation
One First National Plaza, Suite 5000
Chicago 60603

Established in 1980 in IL.
Donor(s): Marian Tyler.
Financial data (yr. ended 1/31/88): Assets, $1,891,088 (M); expenditures, $140,295, including $102,250 for 4 grants (high: $50,000; low: $10,000).
Purpose and activities: Grants primarily for public television and social services; some support for an aquarium.
Application information: Contributes only to pre-selected organizations. Applications not accepted.
Trustees: Katheryn Cowles Douglass, Kingman Scott Douglass, Louise J. Douglass, Robert Dun Douglass, Timothy P. Douglass.
Employer Identification Number: 363101263

817
Material Service Foundation
222 North LaSalle
Chicago 60601

Established about 1952 in IL; incorporated in 1960 in IL.
Donor(s): Material Service Corp., and various subsidiaries of General Dynamics Corp.
Financial data (yr. ended 12/31/88): Assets, $224,123 (M); gifts received, $341,500;

expenditures, $307,060 for 126 grants (high: $98,250; low: $25; average: $1,000-$2,000).
Purpose and activities: Giving primarily for community funds; grants also for community development, youth agencies, education, health agencies, and cultural activities.
Types of support: Annual campaigns, building funds, capital campaigns, continuing support, operating budgets, seed money, special projects.
Limitations: Giving primarily in IL, with emphasis on Chicago. No grants to individuals.
Publications: Grants list, financial statement.
Application information:
Initial approach: Letter
Board meeting date(s): As required
Write: Louis J. Levy, Admin.
Manager: Lester Crown.
Employer Identification Number: 366062106

818
Oscar G. and Elsa S. Mayer Charitable Trust
c/o Hugo J. Melvoin
115 South LaSalle St., Rm. 2500
Chicago 60603 (312) 332-3682
Additional application address: c/o Imojean E. Onsrud, One South Pinckney St., Suite 312, Madison, WI 53703; Tel.: (608) 256-3682

Trust established in 1965 in IL.
Donor(s): Oscar G. Mayer, Sr.,† Elsa S. Mayer.†
Financial data (yr. ended 12/31/86): Assets, $9,655,844 (M); expenditures, $645,051, including $545,000 for 37 grants (high: $50,000; low: $5,000; average: $5,000-$25,000).
Purpose and activities: Grants limited to charitable institutions in which the donors did or their descendants do actively participate, including higher education, hospitals, music, and museums.
Types of support: General purposes.
Limitations: Giving primarily in the Chicago, IL, metropolitan area and in WI. No grants to individuals.
Application information:
Initial approach: Letter
Copies of proposal: 1
Deadline(s): None
Board meeting date(s): As required
Final notification: 2 weeks
Write: Oscar G. Mayer, Managing Trustee
Trustees: Oscar G. Mayer, Managing Trustee; Allan C. Mayer, Harold F. Mayer, Harold M. Mayer.
Number of staff: 1 part-time professional; 1 part-time support.
Employer Identification Number: 366134354

819
Robert R. McCormick Charitable Trust
435 North Michigan Ave., Suite 770
Chicago 60611 (312) 222-3510

Trust established in 1955 in IL.
Donor(s): Robert R. McCormick.†
Financial data (yr. ended 12/31/87): Assets, $544,412,157 (M); expenditures, $18,830,563, including $16,246,546 for 158 grants (high: $8,650,000; low: $400).

Purpose and activities: Largest contributions for private higher education, health care, arts and culture, and youth and human services.
Types of support: Building funds, equipment, renovation projects, capital campaigns, continuing support, operating budgets, technical assistance.
Limitations: Giving primarily in the Chicago, IL, metropolitan area. No support for primary or secondary education. No grants to individuals, or for seed money; no loans; no gifts to the same institution for more than 3 successive years.
Publications: Annual report, application guidelines.
Application information:
 Initial approach: Letter
 Deadline(s): Submit proposal preferably in Jan., Apr., July, and Oct.; deadlines Feb. 1, May 1, Aug. 1, and Nov. 1
 Board meeting date(s): Mar., June, Sept., and Dec.
 Final notification: 3 months
 Write: Claude A. Smith, Dir. of Philanthropy
Officers and Trustees: Charles T. Brumback, Chair.; Neal Creighton, Pres. and C.E.O.; Claude A. Smith, Exec. V.P. and Dir. of Philanthropy; Stanton R. Cook, Robert M. Hunt, Clayton Kirkpatrick, John W. Madigan.
Number of staff: 4 full-time professional; 2 full-time support.
Employer Identification Number: 366046974
Recent arts and culture grants:
American Conservatory of Music, Chicago, IL, $50,000. Toward moving school to its new quarters. 1987.
Art Resources in Teaching, Chicago, IL, $5,000. To support program of teaching art in public schools. 1987.
Auditorium Theater Council, Chicago, IL, $20,000. Toward theatre refurbishing. 1987.
Boulevard Arts Center, Chicago, IL, $9,500. To purchase video equipment for use in dance and drama classes. 1987.
Business Volunteers for the Arts/Chicago, Chicago, IL, $18,000. To provide management assistance to ethnic and neighborhood-based arts organizations. 1987.
Chicago Academy for the Arts, Chicago, IL, $5,000. For general operating support. 1987.
Chicago City Ballet, Chicago, IL, $100,000. For general operating support. 1987.
Chicago Horticultural Society, Botanic Garden, Glencoe, IL, $20,000. To support new gardens. 1987.
Chicago International Theater Festival, Chicago, IL, $30,000. To support festival. 1987.
Chicago Opera Theater, Chicago, IL, $15,000. For general program support, particularly its youth outreach activities. 1987.
Chicago Repertory Dance Ensemble, Chicago, IL, $5,000. For general operating support. 1987.
Chicago String Ensemble, Chicago, IL, $5,000. For general operating support. 1987.
Chicago Winds, Evanston, IL, $6,675. To support recital workshops for handicapped students. 1987.
Chicago Youth Symphony Orchestra, Chicago, IL, $5,000. For general operating support. 1987.
Classical Symphony Orchestra, Chicago, IL, $5,000. To support free concerts. 1987.

Court Theater, Chicago, IL, $5,000. To help fund high school matinee program. 1987.
DuSable Museum of African American History, Chicago, IL, $15,000. For staff training and enhancement of educational and membership programs. 1987.
ETA Creative Arts Foundation, Chicago, IL, $5,000. For general operating support of performing arts program. 1987.
Fort Sheridan Centennial Fund, Fort Sheridan, IL, $27,500. Toward construction of memorial to Lt. Gen. Philip Sheridan. 1987.
Free Street Theater, Chicago, IL, $20,000. To support Cabrini-Green residency project. 1987.
Grant Park Concerts Society, Chicago, IL, $10,000. Toward equipment to improve facility's sound system. 1987.
Hubbard Street Dance Company, Chicago, IL, $7,500. For general operating support. 1987.
Imagination Theater, Chicago, IL, $5,000. For general operating support. 1987.
MoMing Dance and Arts Center, Chicago, IL, $12,000. For challenge grant to develop membership. 1987.
Museum of Contemporary Art, Chicago, IL, $20,000. Toward publication of catalogues. 1987.
Museum of Science and Industry, Chicago, IL, $64,770. To maintain Newspapers in America exhibit. 1987.
National Society of the Colonial Dames of America in the State of Illinois, Chicago, IL, $10,000. Toward restoring H.B. Clarke House, oldest in Chicago. 1987.
Organic Theater Company, Chicago, IL, $17,500. Toward building improvements. 1987.
Ragdale Foundation, Lake Forest, IL, $10,000. For general program support for artists' center. 1987.
Ravinia Festival Association, Highland Park, IL, $25,000. For building program of its new Institute for Young Artists. 1987.
Steppenwolf Theater, Chicago, IL, $5,000. For general operating support. 1987.
Urban Gateways, Chicago, IL, $7,500. To support cultural enrichment program for public school students in disadvantaged neighborhoods. 1987.

820
Brooks & Hope B. McCormick Foundation
410 North Michigan Ave., Rm. 590
Chicago 60611

Established in 1967 in IL.
Donor(s): Brooks McCormick, Hope B. McCormick.
Financial data (yr. ended 12/31/86): Assets, $963,988 (M); gifts received, $318,800; expenditures, $486,135, including $482,037 for 46 grants (high: $85,000; low: $500).
Purpose and activities: Giving for civic, cultural, educational, and health programs; support also for religion and social services.
Types of support: General purposes.
Limitations: No grants to individuals.
Application information: Grants made at the discretion of the board. Applications not accepted.
 Write: Brooks McCormick, Chair.

Officers and Directors: Hilary Hunt, Brooks McCormick, Chair.; Hope B. McCormick, Pres.; Charles E. Schroder, V.P. and Secy.; Martha McCormick Hunt, V.P. and Treas.
Employer Identification Number: 366156922

821
Chauncey and Marion Deering McCormick Foundation
410 North Michigan Ave., Rm. 590
Chicago 60611 (312) 644-6720

Incorporated in 1957 in IL.
Donor(s): Brooks McCormick, Brooks McCormick Trust, Charles Deering McCormick Trust, Roger McCormick Trust.
Financial data (yr. ended 7/31/87): Assets, $14,545,306 (M); expenditures, $764,470, including $600,000 for 23 grants (high: $240,000; low: $1,000).
Purpose and activities: Emphasis on higher and secondary education, hospitals, and cultural institutions, including an art museum; support also for conservation and child welfare.
Types of support: General purposes.
Limitations: Giving primarily in Chicago, IL. No grants to individuals.
Officers and Directors: Charles Deering McCormick, Pres.; Brooks McCormick, V.P.; Charles E. Schroeder, Secy.-Treas.; James McCormick.
Employer Identification Number: 366054815

822
Robert R. McCormick Foundation
435 North Michigan Ave., Suite 770
Chicago 60611 (312) 222-3512

Incorporated in 1953 in IL.
Donor(s): Robert R. McCormick,† Robert R. McCormick Charitable Trust.
Financial data (yr. ended 12/31/87): Assets, $4,889 (M); gifts received, $673,815; expenditures, $675,800, including $663,815 for 142 grants (high: $15,000; low: $1,000).
Purpose and activities: Emphasis on youth, social services, health agencies, music, and cultural programs.
Types of support: Operating budgets, continuing support, annual campaigns, emergency funds, general purposes.
Limitations: Giving limited to the Chicago, IL, metropolitan area. No support for primary or secondary education. No grants to individuals, or for building or endowment funds, research, scholarships, fellowships, or matching gifts; no loans.
Publications: Annual report, application guidelines.
Application information:
 Initial approach: Letter
 Copies of proposal: 1
 Deadline(s): Feb. 1, May 1, Aug. 1, or Nov. 1
 Board meeting date(s): Mar., June, Sept., and Dec.
 Write: Claude A. Smith, Exec. V.P.
Officers and Trustees: John W. Madigan, Chair.; Neal Creighton, Pres. and C.E.O.; Claude A. Smith, Exec. V.P.; Charles T.

Brumback, Stanton R. Cook, Robert M. Hunt, Clayton Kirkpatrick.
Number of staff: 1 part-time professional; 1 full-time support; 1 part-time support.
Employer Identification Number: 366046973

823
Roger McCormick Foundation
410 North Michigan Ave., Rm. 590
Chicago 60611

Established in 1967 in IL.
Financial data (yr. ended 12/31/87): Assets, $991,721 (M); gifts received, $65,000; expenditures, $130,537, including $125,163 for 18 grants (high: $50,163; low: $2,000).
Purpose and activities: Giving primarily for hospitals, medical research, and museums.
Application information: Contributes only to pre-selected organizations. Applications not accepted.
Officers and Directors: Charlotte McCormick Collins, Pres.; Charles E. Schroeder, Secy.-Treas.; Amy Blair Collins.
Employer Identification Number: 366158862

824
McDonald's Contributions Department
McDonald's Plaza
Oak Brook 60521 (312) 887-3200

Financial data (yr. ended 12/31/88): $1,000,000 for grants.
Purpose and activities: Supports national programs improving young people's educational, recreational, health, safety, employment, and cultural opportunities, including minority development; in Chicago, McDonald's headquarters city, the contributions department helps children through special projects in the areas of health, education, recreation, and training programs for the disadvantaged and the disabled, and an employee matching gift program. In addition, McDonald's franchises worldwide are involved in a wide range of charitable and community relations projects, including overseeing fundraisers, events for children, and product donations at disaster sites.
Types of support: Matching funds, seed money, special projects, in-kind gifts.
Limitations: Giving primarily in operating locations, through restaurants, and nationally through the corporation. No support for fraternal, veterans', religious, political, or sectarian programs; intermediary funding organizations; or the United Way outside of Chicago area. No grants to individuals, or for capital funds, general operating purposes, endowments, scholarship funds, loans, investment funds, advertising, unspecified funds for specific elementary or secondary schools, multi-year grants, or research.
Publications: Corporate giving report, informational brochure.
Application information: Include organization description, annual operating budget, project budget, board list, donor list, 3-4 page project proposal and 501(c)(3).
 Initial approach: Full proposal (submit only one proposal per year)
 Copies of proposal: 1

Deadline(s): None
Board meeting date(s): Review on an on-going basis
Final notification: Within 3 months
Write: Betsy Davis, Supervisor, Contribs.

825
McGraw Foundation
3436 North Kennicott Dr.
Arlington Heights 60004 (312) 870-8014
Mailing address: P.O. Box 307 B, Wheeling, IL 60090

Incorporated in 1948 in IL.
Donor(s): Alfred Bersted,† Carol Jean Root, Maxine Elrod,† Donald S. Elrod, Max McGraw,† Richard F. McGraw,† McGraw-Edison Co., and others.
Financial data (yr. ended 12/31/86): Assets, $14,210,765 (M); expenditures, $1,217,167, including $989,213 for 87 grants (high: $110,139; low: $1,500; average: $5,000-$25,000).
Purpose and activities: Giving primarily for higher education, health, civic affairs, social services, science, culture, and the environment.
Types of support: Operating budgets, annual campaigns, building funds, equipment, research, matching funds, seed money, continuing support.
Limitations: Giving primarily in the Chicago, IL, area, and in adjoining states. No grants to individuals.
Publications: Program policy statement, application guidelines.
Application information:
 Initial approach: Letter
 Copies of proposal: 1
 Deadline(s): Submit proposal between Dec. 1 and Feb. 1
 Board meeting date(s): June; grant committee meets annually in Mar.
 Final notification: 30 days to 1 year
 Write: James F. Quilter, V.P.
Officers and Directors: Scott M. Elrod, Pres.; James F. Quilter, V.P., Secy.-Treas., and Exec. Dir.; William W. Mauritz, V.P.; J. Bradley Davis, Dennis W. Fitzgerald, Raymond H. Giesecke, Jerry D. Jones, Catherine B. Nelson, Bernard B. Rinella, Leah K. Robson.
Number of staff: 1 full-time professional; 1 part-time support.
Employer Identification Number: 362490000

826
MidCon Corporate Giving Program
701 E. 22nd St.
Lombard 60148 (312) 691-3000

Purpose and activities: Supports higher education, culture, health, social services, child welfare, law and justice, libraries, museums, and programs for minorities. Types of support include employee matching gifts for higher education.
Types of support: Employee matching gifts.
Application information:
 Initial approach: Written proposal
 Deadline(s): None
 Board meeting date(s): Proposals are continuously reviewed
 Write: James D. Tansor, Corp. Contribs.
Number of staff: 1

827
Adah K. Millard Charitable Trust
c/o Northern Trust Company
62 Green Bay Rd.
Winnetka 60093 (312) 446-6300

Trust established in 1976 in IL.
Donor(s): Adah K. Millard.†
Financial data (yr. ended 12/31/88): Assets, $4,275,072 (M); expenditures, $237,146, including $231,867 for 18 grants (high: $53,000; low: $1,500; average: $20,000).
Purpose and activities: Emphasis on youth agencies, social welfare groups, and cultural programs.
Types of support: General purposes, continuing support, seed money, building funds, equipment, renovation projects, special projects.
Limitations: Giving limited to Omaha and Douglas counties, NE. No grants to individuals, or for endowment funds, scholarships, or fellowships; generally no grants for operating budgets; no loans.
Publications: Application guidelines.
Application information: Request application form. Application form required.
 Copies of proposal: 6
 Deadline(s): Apr. 1 and Oct. 1
 Board meeting date(s): Apr. and Nov.
 Write: John C. Goodall, Jr., V.P.
Trustee: Northern Trust Company.
Number of staff: None.
Employer Identification Number: 366629069

828
Miner-Weisz Charitable Foundation
c/o Northern Trust Company
50 South LaSalle St.
Chicago 60675 (312) 630-6000

Established in 1966 in IL.
Financial data (yr. ended 12/31/87): Assets, $789,956 (M); expenditures, $171,665, including $157,500 for 16 grants (high: $45,000; low: $500).
Purpose and activities: Support primarily for an art institute and for educational foundations; support also for a symphony orchestra, an opera company, and a hospital.
Limitations: Giving primarily in IL.
Application information:
 Deadline(s): None
 Write: Winifred Date
Trustees: Max E. Meyer, Northern Trust Company.
Employer Identification Number: 366149589

829
Bernard & Marjorie Mitchell Family Foundation
c/o Victoria Kohn Trustee
875 North Michigan Ave., Suite 3412
Chicago 60611

Donor(s): Bernard A. Mitchell Trust.
Financial data (yr. ended 10/31/87): Assets, $2,480,305 (M); gifts received, $2,050,000; expenditures, $80,873, including $70,650 for 18 grants (high: $30,000; low: $100).

Purpose and activities: Support primarily for Jewish welfare; support also for the arts and an art museum, and medical research.
Limitations: Giving primarily in Chicago, IL.
Application information: Contributes only to pre-selected organizations. Applications not accepted.
Trustees: Victoria C. Kohn, Lee H. Mitchell, Marjorie I. Mitchell.
Employer Identification Number: 237007014

830
Molner Foundation
c/o Morton John Barnard
11 South LaSalle St., Suite 1100
Chicago 60603-1207

Established in 1980 in IL.
Financial data (yr. ended 12/31/87): Assets, $1,048,191 (M); expenditures, $96,064, including $86,000 for 54 grants (high: $20,000; low: $250).
Purpose and activities: Support primarily for social services and cultural programs.
Application information:
 Deadline(s): None
Trustee: Foss, Schuman, Drake & Barnard.
Employer Identification Number: 366702256

831
Montgomery Ward Foundation
Montgomery Ward Plaza, 8A
Chicago 60671 (312) 467-7663

Established in 1968 in IL.
Donor(s): Montgomery Ward & Co., Inc.
Financial data (yr. ended 12/31/86): Assets, $73,417 (M); gifts received, $345,544; expenditures, $470,587, including $154,585 for 53 grants.
Purpose and activities: Giving currently limited to United Way, arts and cultural programs, and civic and welfare programs in the immediate corporate headquarters' neighborhood; support also for employee matching gifts to higher education, cultural institutions, and public television and radio.
Types of support: Employee matching gifts, emergency funds, continuing support, general purposes.
Limitations: Giving limited to Chicago, IL. No support for health-related programs. No grants to individuals, or for building or endowment funds.
Publications: Program policy statement.
Application information:
 Initial approach: Letter or telephone
 Copies of proposal: 1
 Deadline(s): Submit proposal preferably between Jan. and May; deadline Sept.
 Board meeting date(s): Mar., June, Sept., and Dec.
 Final notification: Up to 7 months
 Write: Charles A. Holland, Jr., Secy.
Officers and Directors: R. Kasenter, Pres.; Bernard Andrews, V.P.; Jack Daynard, V.P.; Spencer Heine, V.P.; Charles A. Holland, Jr., Secy.
Number of staff: 1 full-time professional.
Employer Identification Number: 362670108

832
The Monticello College Foundation
The Evergreens
Godfrey 62035 (618) 466-7911

Incorporated in 1843 in IL as Monticello College; reorganized as a foundation in 1971.
Financial data (yr. ended 6/30/88): Assets, $5,317,274 (M); gifts received, $7,233; expenditures, $305,606, including $256,780 for 18 grants (high: $110,000; low: $1,000).
Purpose and activities: Support for programs that assist advancing education for women.
Types of support: Scholarship funds, special projects, fellowships, internships.
Limitations: No support for social service agencies, foreign schools, or foreign-based American schools. No grants to individuals, or for capital funds, operating expenses, endowed chairs, conferences and seminars, or exchange students.
Publications: Annual report (including application guidelines).
Application information:
 Initial approach: Proposal
 Copies of proposal: 15
 Deadline(s): Submit proposal preferably in July or Feb.; deadline 8 weeks before board meeting
 Board meeting date(s): Third week of Sept. and Apr.
 Final notification: 2 weeks after board meeting
 Write: Winifred G. Delano, Exec. Dir.
Officers: Mrs. Vaughan Morrill,* Secy.; Karl K. Hoagland, Jr.,* Treas.; Winifred G. Delano, Exec. Dir.
Trustees:* Harry N. Schweppe, Jr., Chair.; Mrs. William J. Barnard, Vice-Chair.; Mrs. Glenn L. Allen, Jr., Robert R. Anschuetz, M.D., Mrs. Robert R. Anschuetz, Mrs. Stephen L. Biermann, Mrs. Paul Jones, Mrs. Leland F. Kreid, Nancy C. McCaig, M.D., M. Ryrie Milnor, Alice M. Norton, Mrs. John C. Pritzlaff, Jr., Henry N. Schweppe III.
Number of staff: 1 part-time professional.
Employer Identification Number: 370681538
Recent arts and culture grants:
Illinois State Museum Society, Springfield, IL, $9,600. For Monticello College Foundation Internship for Women in Museum Education. 1987.
Interlochen Center for the Arts, Interlochen, MI, $10,000. For endowed scholarship fund for scholarships to enable exceptionally talented and needy young women to pursue pre-professional training in performing, visual and literary art at Interlochen Arts Academy. 1987.
National Association for Regional Ballet, NYC, NY, $9,250. For ten women to attend 1987 Craft of Choreography Conferences sponsored by National Association of Regional Ballet. 1987.
Newberry Library, Chicago, IL, $9,500. For fellowship for women for post-doctoral research at Newberry Library. 1987.
Saint Louis Conservatory and Schools for the Arts (CASA), Saint Louis, MO, $11,500. For scholarship assistance to women students in collegiate program at St. Louis Conservatory for academic year 1986-87. 1987.

833
Morton Thiokol Foundation
110 North Wacker Dr.
Chicago 60606

Established in 1984 in IL.
Donor(s): Morton Thiokol, Inc.
Financial data (yr. ended 6/30/88): Assets, $334,839 (M); gifts received, $300,000; expenditures, $348,615, including $348,390 for 77 grants (high: $108,140; low: $500).
Purpose and activities: Support primarily for health and social services, education, civic affairs, and cultural programs.
Application information: Contributes only to preselected organizations. Applications not accepted.
Officers and Directors:* Charles S. Locke,* Pres.; Hugh C. Marx,* V.P.; P. Michael Phelps, Secy.
Employer Identification Number: 363282328

834
Motorola Foundation
1303 East Algonquin Rd.
Schaumburg 60196 (312) 576-6200

Incorporated in 1953 in IL.
Donor(s): Motorola, Inc.
Financial data (yr. ended 12/31/88): Assets, $3,995,519 (M); gifts received, $2,500,000; expenditures, $2,430,053, including $2,099,414 for 327 grants (high: $267,180; low: $200; average: $1,000-$5,000) and $326,152 for 591 employee matching gifts.
Purpose and activities: Giving for higher and other education, including an employee matching gift program, united funds, and hospitals; support also for cultural programs, social services, and youth agencies.
Types of support: Operating budgets, seed money, building funds, scholarship funds, employee matching gifts, fellowships, general purposes, continuing support.
Limitations: Giving primarily in communities where the company has major facilities, with emphasis on Huntsville, AL; Mt. Pleasant, IA; Chicago, IL; Phoenix, AZ; Austin, Fort Worth, and Sequin, TX; and Fort Lauderdale and Boynton Beach, FL. No support for strictly sectarian or denominational religious organizations, national health organizations or their local chapters; secondary schools, trade schools, or state institutions (except through the employee matching gift program). No grants to individuals, or for university endowment funds, research, courtesy advertising, operating expenses of organizations receiving United Way funding, benefits or capital fund drives of colleges or universities; no loans.
Publications: Application guidelines.
Application information:
 Initial approach: Letter, telephone, or proposal
 Copies of proposal: 1
 Deadline(s): Nov.
 Board meeting date(s): Monthly and as required
 Final notification: 1 to 2 months
 Write: Mrs. Herta Betty Nikolai, Admin.
Officers: Robert W. Galvin,* Pres.; David W.L. Hickie,* V.P. and Exec. Dir.; Donald R. Jones,*

V.P.; Victor R. Kopidlansky, Secy.; Garth L. Milne, Treas.
Directors:* William J. Weisz.
Number of staff: 1 full-time professional; 1 full-time support.
Employer Identification Number: 366109323

835
Nalco Chemical Company Giving Program
One Nalco Ctr.
Naperville 60566-1024 (312) 961-9500

Financial data (yr. ended 12/31/87): Total giving, $382,324, including $220,657 for grants and $161,667 for 255 employee matching gifts.
Purpose and activities: The Nalco Foundation makes most charitable gifts for the company. Nalco Corporate Contributions--giving by headquarters, subsidiaries, and plants--includes employee matching gifts, United Way campaigns, and contributions to numerous organizations made locally by Nalco plants and offices. The educational matching gifts program matches the contributions of Nalco employees, directors, and retirees to accredited colleges and universities at a $2 to $1 ratio with a minimum donation of $25 and maximum of $2,000. In 1988 Nalco expanded the Matching Gift Program to include cultural organizations and nonprofit hospitals, matching donations on a dollar-for-dollar basis with a minimum donation of $25 and a maximum of $500.
Types of support: Employee matching gifts.
Limitations: Giving primarily in major operating locations.
Application information:
 Initial approach: Request guidelines to be sure organization meets giving criteria
 Write: Joanne C. Ford, Pres.

836
The Nalco Foundation
One Nalco Ctr.
Naperville 60566-1024 (312) 961-9500

Incorporated in 1953 in IL.
Donor(s): Nalco Chemical Co.
Financial data (yr. ended 12/31/88): Assets, $2,470,496 (M); gifts received, $1,000,000; expenditures, $1,596,068 for 232 grants (high: $50,000; low: $500; average: $2,000-$10,000).
Purpose and activities: Grants largely for private institutions of higher education, educational associations, hospitals, social service and youth agencies, and cultural activities.
Types of support: Operating budgets, continuing support, annual campaigns, seed money, building funds, equipment, land acquisition, capital campaigns, renovation projects, general purposes.
Limitations: Giving primarily in areas where company has manufacturing operations: the metropolitan Chicago area and DuPage County, IL, Carson, CA, Garryville, LA, Jonesboro, GA, Cleveland, OH, Jackson, MI, Paulsboro, NJ, and Sugar Land, TX. No support for state-supported colleges or universities, secondary or elementary schools, churches, or religious

education. No grants to individuals, or for endowments, research, scholarships, fellowships, purchase of tickets for fund-raising banquets, or matching gifts; no loans.
Publications: Annual report (including application guidelines), application guidelines.
Application information:
 Initial approach: Request guidelines
 Copies of proposal: 1
 Deadline(s): Submit proposal preferably in Jan., Apr., July, or Sept.; deadline Oct. 1
 Board meeting date(s): Mar., June, Sept., and Nov.
 Final notification: 3 to 6 months
 Write: Joanne C. Ford, Pres.
Officers: Joanne C. Ford,* Pres.; Clifford J. Carpenter, V.P. and Treas.; Theresa A. Slaboszewski, Secy.
Directors:* David R. Bertran, James F. Lambe.
Number of staff: 1 full-time professional; 1 full-time support.
Employer Identification Number: 366065864

837
New Horizon Foundation
2302 Orrington Ave.
Evanston 60201
Additional address: 7348 Vista del Mar, La Jolla, CA 92037

Established in 1985 in IL.
Donor(s): Roger R. Revelle, Ellen C. Revelle, William R. Revelle, Eleanor M. Revelle, Piero F. Paci, Mary Paci, and others.
Financial data (yr. ended 8/31/88): Assets, $3,235,615 (M); expenditures, $290,451, including $94,190 for 83 grants (high: $10,000; low: $50; average: $100-$1,000) and $165,000 for 1 foundation-administered program.
Purpose and activities: A private operating foundation; giving primarily for higher and other education, social service and youth agencies, public interest groups, and cultural programs.
Types of support: Annual campaigns, building funds, capital campaigns, continuing support, endowment funds, matching funds, operating budgets, research, scholarship funds, seed money.
Limitations: Giving primarily in San Diego, CA.
Application information: Contributes only to pre-selected organizations. Applications not accepted.
 Write: Carolyn Greenslate, Secy.-Treas.
Officers: William R. Revelle,* Pres.; Carolyn Hufbauer,* V.P.; Mary Paci,* V.P.; Carolyn Greenslate, Secy.-Treas.
Directors:* Gary Hufbauer, Piero F. Paci, Eleanor M. Revelle, Ellen C. Revelle, Roger R. Revelle.
Number of staff: 1 part-time professional.
Employer Identification Number: 363406294

838
Northern Illinois Gas Corporate Giving Program
P.O. Box 190
Aurora 60507-0190 (312) 983-8888

Purpose and activities: Support for social services, health care, cultural activities,

economic development, youth activities, and education.
Types of support: Building funds.
Limitations: Giving primarily in company's service area, the northern third of IL except for Chicago and a few North Shore suburbs. No grants for organizations funded by United Ways and the Crusade of Mercy, except for approved building funds.
Application information: Division offices handle small, local contributions; major giving and building fund requests must be approved by a committee. Application form required.
 Initial approach: Telephone inquiry or written proposal directed to Office of Community Affairs; invitations for on-site visits or follow-up phone calls are not necessary unless requested
 Write: Julian E. Brown, Dir., Community Affairs

839
The Northern Trust Company Charitable Trust
c/o Northern Trust Company
50 South LaSalle St.
Chicago 60675 (312) 444-3538

Trust established in 1966 in IL.
Donor(s): The Northern Trust Co.
Financial data (yr. ended 12/31/87): Assets, $200,929 (M); gifts received, $1,009,000; expenditures, $996,111, including $778,369 for 143 grants (high: $221,775; low: $500; average: $2,000-$5,000) and $216,978 for employee matching gifts.
Purpose and activities: Support for community development, education, hospitals and health services, civic and cultural programs, and social service and youth agencies, including a community fund.
Types of support: Operating budgets, continuing support, annual campaigns, seed money, emergency funds, equipment, land acquisition, employee matching gifts, consulting services, technical assistance, special projects, renovation projects, scholarship funds, matching funds, capital campaigns, general purposes.
Limitations: Giving limited to the metropolitan Chicago, IL, area. No support for national organizations, health organizations concentrating efforts in one area of human disease (except through matching gift program), hospital or college capital campaigns, religious organizations whose services are limited to any one sectarian group, fraternal or political groups, or operating support for United Way agencies. No grants to individuals, or for endowment funds, fellowships, advertising for fundraising benefits, or research; no loans.
Publications: Corporate giving report (including application guidelines), grants list.
Application information:
 Initial approach: Telephone or brief proposal
 Copies of proposal: 1
 Deadline(s): Community Revitalization - Dec. 1 and Aug. 1; Health - Feb. 1; Social Welfare - Feb. 1 and Oct. 1; Arts & Culture - Apr. 1; Education - June 1
 Board meeting date(s): Bimonthly
 Final notification: 2 months

Write: Marjorie W. Lundy, 2nd V.P., The Northern Trust Co.

Contributions Committee: William N. Setterstrom, Chair.; William F. Bahl, Jacqueline J. Beal, Niels C. Jensen, William E. McClintic, Sheila A. Penrose, Perry R. Pero, Lorraine M. Reepmeyer.

Trustee: The Northern Trust Co.

Number of staff: 2 part-time professional; 2 part-time support.

Employer Identification Number: 366147253

840

Oakley-Lindsay Foundation of Quincy Newspapers and Quincy Broadcasting Company, Inc.

130 South Fifth St.
Quincy 62301-3916 (217) 223-5100

Donor(s): Quincy Broadcasting Co., New Jersey Herald, WVVA Television, Inc., WSJV Television, Inc., Quincy Newspapers, Inc., KTTC Television, Inc.

Financial data (yr. ended 12/31/87): Assets, $464,512 (M); gifts received, $80,249; expenditures, $39,900, including $38,700 for 16 grants (high: $10,000; low: $600).

Purpose and activities: Support for civic affairs, social services, historic preservation, community funds, and the arts.

Limitations: Giving primarily in Quincy, IL.

Application information:
Initial approach: Letter
Deadline(s): None
Write: Thomas A. Oakley

Officers: Thomas A. Oakley, Pres.; Joseph Bonansinga, V.P.; F.M. Lindsay, Jr., V.P.; Peter A. Oakley, Secy.

Directors: James W. Collins, Joseph I. Conover, Don E. Fuller, Richard P. Herbst, Arthur O. Lindsay, Donald Lindsay, Allen M. Oakley, David Oakley, Gregory J. Ptacin, Charles E. Webb, Clark L. Widerman.

Employer Identification Number: 237025198

841

The Offield Family Foundation

410 North Michigan Ave., Rm. 942
Chicago 60611

Incorporated in 1940 in IL.

Donor(s): Dorothy Wrigley Offield.

Financial data (yr. ended 6/30/87): Assets, $22,850,677 (M); expenditures, $754,298, including $676,778 for 42 grants (high: $99,000; low: $500; average: $1,500-$40,000).

Purpose and activities: Emphasis on hospitals, a population control agency, education, and cultural programs.

Limitations: Giving primarily in the Chicago, IL area and MI. No grants to individuals.

Application information: Contributes only to pre-selected organizations. Applications not accepted.

Officers and Directors: Wrigley Offield, Pres.; Edna Jean Offield, V.P.; Marie Larson, Secy.; James E. Elworth, Treas.; James S. Offield, Paxson H. Offield.

Employer Identification Number: 366066240

842

OMC Foundation

(Formerly The Ole Evinrude Foundation)
100 Sea Horse Dr.
Waukegan 60085 (312) 689-5235

Incorporated in 1945 in WI.

Donor(s): Outboard Marine Corp.

Financial data (yr. ended 6/30/88): Assets, $798,795 (M); gifts received, $175,000; expenditures, $114,295, including $70,830 for 18 grants (high: $20,000; low: $800) and $37,500 for 39 grants to individuals.

Purpose and activities: Support of private higher education, especially business and engineering, in states in which the company operates, scholarship aid to children of company employees, and capital grants to hospital and cultural building projects in company locations; support also for recreation and environmental programs.

Types of support: Continuing support, annual campaigns, seed money, building funds, equipment, fellowships, special projects, research, scholarship funds, employee-related scholarships, matching funds, capital campaigns, employee matching gifts, renovation projects, general purposes.

Limitations: Giving limited to areas of company operations in GA, IL, MS, NC, NE, TN, and WI. No support for organizations participating in local combined appeals. No grants to individuals (except for employee-related scholarships), or for endowment funds or operating expenses; no loans.

Publications: Program policy statement, application guidelines, annual report.

Application information:
Initial approach: Letter
Copies of proposal: 1
Deadline(s): Submit proposal preferably in Oct.; deadline Oct. 31
Board meeting date(s): Dec.
Final notification: 30 days after annual meeting
Write: Laurin M. Baker, Dir., Public Affairs

Officers and Directors: James C. Chapman, Pres.; F. James Short, V.P.; Michael S. Duffy, Secy.; Norman Jacobs, Treas.

Number of staff: None.

Employer Identification Number: 396037139

843

Frank E. Payne and Seba B. Payne Foundation

c/o Continental Illinois National Bank & Trust Co. of Chicago
30 North LaSalle St.
Chicago 60693 (312) 828-1785

Trust established in 1962 in IL.

Donor(s): Seba B. Payne.†

Financial data (yr. ended 6/30/87): Assets, $61,817,065 (M); expenditures, $2,667,785, including $2,443,353 for 39 grants (high: $900,000; low: $2,500; average: $5,000-$50,000).

Purpose and activities: Support for education, hospitals, and cultural programs; support also for child and animal welfare.

Types of support: Equipment, operating budgets, building funds, general purposes.

Limitations: Giving primarily in the metropolitan Chicago, IL, area and PA. No grants to individuals, or for endowment funds, or fellowships; no loans.

Publications: Application guidelines.

Application information:
Initial approach: Proposal
Copies of proposal: 1
Deadline(s): None
Board meeting date(s): May and Nov., and as required
Final notification: 4 months
Write: M.C. Ryan, 2nd V.P., Continental Illinois National Bank & Trust Co. of Chicago

Trustees: Susan Hurd Cummings, George A. Hurd, Sr., Priscilla Payne Hurd, Charles M. Nisen, Continental Illinois National Bank & Trust Co. of Chicago.

Number of staff: None.

Employer Identification Number: 237435471

844

Peoples Energy Corporate Giving Program

122 South Michigan Avenue
Chicago 60603 (312) 431-4393

Financial data (yr. ended 9/30/88): $763,362 for grants (high: $200,000).

Purpose and activities: Supports health and welfare, civic and community affairs, education and arts and culture. Types of support include employee matching gifts for pre-collegiate and higher education, in-kind services of donations of materials and printing and technical assistance through design services and printing.

Types of support: Building funds, capital campaigns, employee matching gifts, general purposes, operating budgets, renovation projects, special projects, technical assistance, in-kind gifts.

Limitations: Giving primarily in headquarters city and service areas in northeast IL. No support for political or lobbying organizations; discriminatory organizations; government agencies; or religious groups for sectarian purposes. No grants to individuals, or for trips or tours, or advertising.

Publications: Informational brochure.

Application information: Include: organization history and purpose; type of support requested; project description; geographic area served; donor list; recently audited financial statement; current budget and list of programs; board list; number of staff members; and 501 (c)(3).
Initial approach: Letter and proposal
Deadline(s): None
Final notification: 8 weeks
Write: George E. Charles, Mgr., Corp. Contribs.

Number of staff: 1 full-time professional; 1 full-time support.

845

Pesch Family Foundation

c/o Richman, Grossman & Friedman
55 East Jackson, Suite 2000
Chicago 60604

Established in 1985 in IL.

Donor(s): Leroy A. Pesch.

Financial data (yr. ended 03/31/88): Assets, $1,988,493 (M); expenditures, $1,136,774, including $1,049,032 for 21 grants (high: $733,432; low: $25).
Purpose and activities: First year of operation, 1985-86; grants to a church, a child abuse prevention organization, and cultural programs.
Limitations: No grants to individuals.
Application information: Contributes only to pre-selected organizations. Applications not accepted.
Officers and Directors: Leroy A. Pesch, Pres. and Treas.; Brian Pesch, Secy.; Erika G. Eddy, Exec. Dir.; Christopher Kniefel, Linda Kniefel, Alida Pesch, Christopher Pesch, Daniel Pesch, Ellen Pesch, Gerri Pesch.
Employer Identification Number: 363348055

846
The Albert Pick, Jr. Fund
30 North Michigan Ave., Suite 819
Chicago 60602 (312) 236-1192

Incorporated in 1947 in IL.
Donor(s): Albert Pick, Jr.†
Financial data (yr. ended 12/31/87): Assets, $12,163,431 (M); gifts received, $27,500; expenditures, $789,268, including $586,180 for 188 grants.
Purpose and activities: Giving for cultural programs, education, health and social services, community organizations, and civic affairs.
Types of support: Operating budgets, special projects, continuing support, general purposes, renovation projects, technical assistance.
Limitations: Giving primarily in Chicago, IL. No support for religious purposes. No grants to individuals, or for building or endowment funds, deficit financing, long-term projects, or advertising.
Publications: Program policy statement, application guidelines.
Application information:
 Initial approach: Brief proposal
 Copies of proposal: 1
 Deadline(s): Feb. 1, Apr. 1, July 1, Oct. 1
 Board meeting date(s): Mar. or Apr., June, Sept., Dec., and as required
 Write: Nadine Van Sant, V.P.
Officers and Directors: Alan J. Altheimer, Pres.; Nadine Van Sant, V.P. and Secy.; Albert Pick III, V.P.; Ralph Lewy, Treas.; Arthur W. Brown, Jr., Burton B. Kaplan, Edward Neisser.
Number of staff: 1 full-time professional; 1 part-time professional.
Employer Identification Number: 366071402

847
Virginia G. Piper Foundation
Three First National Plaza, Suite 1950
Chicago 60603

Established in 1972 in IL.
Financial data (yr. ended 12/31/87): Assets, $1,812,363 (M); gifts received, $365,000; expenditures, $140,123, including $135,200 for 28 grants (high: $15,700; low: $500).
Purpose and activities: Support primarily for social services, the arts, higher education, and hospitals; support also for Catholic churches and religious orders.

Application information: Contributes only to pre-selected organizations. Applications not accepted.
Officers and Directors: Virginia G. Piper, Pres.; Carol Critchfield, Raymond Harkrider.
Employer Identification Number: 237230872

848
Pittway Corporation Charitable Foundation
333 Skokie Blvd.
P.O. Box 3012
Northbrook 60065-3012 (312) 498-1260

Established in 1966 in IL.
Donor(s): Pittway Corp.
Financial data (yr. ended 2/29/88): Assets, $4,192,630 (M); gifts received, $1,000,000; expenditures, $1,317,966, including $1,125,461 for 138 grants (high: $225,034; low: $100; average: $500-$25,000) and $183,037 for employee matching gifts.
Purpose and activities: Support for higher education, health associations, community funds, and social service agencies, including child welfare organizations; support also for an early childhood education institute and for cultural organizations, including public radio and television; also gives to primary and secondary schools and supports an employee matching gifts program.
Types of support: Employee matching gifts.
Limitations: Giving primarily in IL. No grants to individuals.
Application information:
 Deadline(s): None
 Board meeting date(s): Varies
 Write: Joseph J. Sclafani, Secy.
Officers: Nelson Harris,* Pres.; King Harris,* V.P.; Joseph J. Sclafani, Secy.; Paul R. Gauvreau, Treas.
Directors:* Irving B. Harris, Chair.; Sidney Barrows, Maurice Fulton, William W. Harris.
Number of staff: None.
Employer Identification Number: 366149938

849
The Playboy Foundation
919 North Michigan Ave.
Chicago 60611 (312) 751-8000

Financial data (yr. ended 6/30/88): Total giving, $157,514, including $50,000 for 31 grants (high: $7,500; low: $250; average: $3,500), $15,000 for 7 grants to individuals, $10,000 for loans and $82,514 for in-kind gifts.
Purpose and activities: The Playboy Foundation has two main areas of support: 1)innovative advocacy projects and organizations that are working in one of its priority categories. Current interests are in funding projects concerned with First Amendment freedoms; civil liberties and civil rights, including the rights of women, lesbians and gays; AIDS and reproductive rights. Support is earmarked for lobbying and litigating purposes for projects of national impact and scope. Grants are generally made for special projects or particular events, rather than for general operating support; most grants are under $10,000. In evaluating grants, the Foundation will take into consideration the

extent to which organizations provide equality of opportunity with respect to staff employment and promotion, selection of board members, and service to clients. The Foundation also funds social change documentary film or videos in the distribution and/or post-production phase. Grants range from $500-$1,000. The Hugh M. Hefner First Amendment Awards range from $1,000 to $3,000 and honor individuals who have made significant contributions in protecting and enhancing First Amendment rights. 2)The aim of the Neighborhood Relations Program is to enhance the quality of life in Chicago, Los Angeles, and New York (areas where employees reside). The Board is interested in innovative, community-based organizations that emerge from neighborhood residents' identification of needs that are inadequately addressed or recognized by conventional institutions. Support is for programs addressing the needs of traditionally disadvantaged people, including the poor, senior citizens, homeless, disabled, women, minorities, and children. Grants may be for advocacy/issue organizing around community reinvestment, municipal services, housing, education, the environment, race relations, or crime prevention; or social services concerned with employment/job training, day care, youth recreation, legal aid, food and shelter, or immigrant resettlement, or arts organizations and groups that are catalysts for positive social change. Grants do not exceed $1,000, and preference is given to community-based organizations serving a particular neighborhood. Grants are for general operating support and specific projects. Grants for both programs are made on a year to year basis, and in special circumstances are renewable. The Foundation also provides printing services for grassroots organizations.
Types of support: Equipment, general purposes, loans, publications, seed money, special projects, technical assistance, operating budgets, in-kind gifts.
Limitations: Giving limited to Chicago, IL, New York, NY, and Los Angeles, CA, for the Neighborhood Relations Program; civil liberties program operates on a national basis; no support for organizations concerned with issues outside the U.S. No support for religious purposes. No grants to individuals, except for First Amendment Awards, research/writing projects or individual scholarships, capital campaigns, endowments, or deficit financing; generally no support for conferences/symposia.
Publications: Application guidelines.
Application information: Letter of inquiry; First Amendment awards by nomination.
 Copies of proposal: 1
 Deadline(s): Proposals accepted on an on-going basis
 Board meeting date(s): 3 times per year: spring, fall, and winter
 Write: Cleo Wilson, Exec. Dir.
Directors: Burton Joseph, Chair.; Christie Hefner, James Petersen, Robyn Radomski, Richard Rosenzweig, Howard Shapiro, Bruce Williamson.
Number of staff: 2 full-time professional.

850
Prince Charitable Trusts

Ten South Wacker Dr., Suite 2575
Chicago 60606 (312) 454-9130

Established in 1947 in IL.

Financial data (yr. ended 12/31/87): Assets, $95,631,025 (M); expenditures, $6,269,470, including $5,217,936 for 223 grants (high: $557,562; low: $500; average: $5,000-$25,000).

Purpose and activities: Support for cultural programs, higher and secondary education, medical research, youth organizations, social services, and hospitals.

Types of support: Capital campaigns, continuing support, general purposes, seed money, special projects, technical assistance.

Limitations: Giving limited to Chicago, IL and RI.

Application information:
 Initial approach: Letter or proposal
 Copies of proposal: 1
 Deadline(s): None
 Board meeting date(s): Bimonthly

Trustees: William Wood Prince, William Norman Wood Prince, Frederick Henry Prince.

Number of staff: 2 full-time professional.

Employer Identification Number: 362411865

851
Prince Foundation

c/o F.H. Prince & Co.
Ten South Wacker Dr., No. 2575
Chicago 60606-7401 (312) 726-2232

Incorporated in 1955 in IL.

Donor(s): Central Manufacturing Distributors, Produce Terminal Corp., Union Stock Fund & Transit Co.

Financial data (yr. ended 12/31/86): Assets, $1,073,993 (M); expenditures, $73,107, including $68,500 for 3 grants (high: $54,000; low: $4,500).

Purpose and activities: Support primarily for the arts, a chamber of commerce, and a community fund.

Types of support: General purposes.

Application information:
 Initial approach: Proposal
 Deadline(s): None
 Write: Trustee

Officers: William Wood Prince,* Pres.; William Norman Wood Prince,* V.P.; Frederick Henry Prince,* V. P.; Thomas S. Tyler,* Secy.; Randall M. Highley, Treas.

Trustees:* Charles S. Potter.

Employer Identification Number: 366116507

852
Pritzker Foundation

c/o Jay Parker
200 West Madison, 38th Fl.
Chicago 60606 (312) 621-4200

Incorporated in 1944 in IL.

Donor(s): Members of the Pritzker family.

Financial data (yr. ended 12/31/86): Assets, $5,693,979 (M); gifts received, $4,645,374; expenditures, $1,821,774, including $1,802,352 for 255 grants (high: $474,500; low: $25; average: $100-$25,000).

Purpose and activities: Grants largely for higher education, including medical education, and religious welfare funds; giving also for hospitals, temple support, and cultural programs.

Limitations: No grants to individuals.

Application information: Contributes only to pre-selected organizations. Applications not accepted.
 Board meeting date(s): Dec. and as required
 Write: Simon Zunamon, Asst. Treas.

Officers: Robert A. Pritzker, Chair.; Jay A. Pritzker, Pres.; Nicholas J. Pritzker, V.P. and Secy.; Thomas J. Pritzker, V.P. and Treas.; James N. Pritzker, V.P.

Number of staff: None.

Employer Identification Number: 366058062

853
The Quaker Oats Foundation

Quaker Tower
321 North Clark St.
Chicago 60610 (312) 222-7033

Incorporated in 1947 in IL.

Donor(s): The Quaker Oats Co.

Financial data (yr. ended 6/30/88): Assets, $6,944,335 (M); gifts received, $7,196,702; expenditures, $2,997,287, including $1,593,225 for 456 grants (high: $80,470; low: $100; average: $2,000-$4,000) and $1,033,653 for employee matching gifts.

Purpose and activities: Emphasis on higher education, including scholarships and employee matching gifts programs, and guaranteeing of loans through United Student Aid Funds (USAF); civic affairs, social services, community funds, youth agencies, arts and culture, hospitals, and public policy.

Types of support: General purposes, building funds, equipment, land acquisition, internships, scholarship funds, employee-related scholarships, fellowships, employee matching gifts, operating budgets, special projects, matching funds, annual campaigns, publications, conferences and seminars, continuing support, renovation projects.

Limitations: Giving primarily in areas of company operations, particularly IL. No support for religious organizations. No grants to individuals (except employee-related scholarships), or for advertising; no loans, except for USAF program.

Publications: Annual report (including application guidelines), program policy statement.

Application information:
 Initial approach: Proposal
 Copies of proposal: 1
 Deadline(s): None
 Board meeting date(s): Sept., Dec., Mar., and June
 Final notification: 6 to 8 weeks
 Write: W. Thomas Phillips, Secy.

Officers: William D. Smithburg,* Chair.; Frank J. Morgan,* Pres.; Luther C. McKinney,* V.P.; W. Thomas Phillips, Secy.; Richard D. Jaquith, Treas.

Directors:* Weston R. Christopherson, William J. Kennedy III, Donald E. Meads, Gertrude G. Michelson, William L. Weiss.

Number of staff: 2 full-time professional; 3 full-time support; 1 part-time support.

Employer Identification Number: 366084548

Recent arts and culture grants:

Art Institute of Chicago, Chicago, IL, $5,000. 1987.

Boy Scouts of America, National Museum, Murray, KY, $8,000. 1987.

Buffalo Philharmonic Orchestra Society, Buffalo, NY, $35,000. 1987.

John G. Shedd Aquarium, Chicago, IL, $5,000. 1987.

Ravinia Festival Association, Highland Park, IL, $9,000. 1987.

Theater of Youth, Buffalo, NY, $5,000. 1987.

854
The Regenstein Foundation

8600 West Bryn Mawr Ave., Suite 705N
Chicago 60631 (312) 693-6464

Incorporated in 1950 in IL.

Donor(s): Joseph Regenstein,† Helen Regenstein.†

Financial data (yr. ended 12/31/88): Assets, $78,500,000 (M); expenditures, $3,900,000, including $3,561,000 for 40 grants.

Purpose and activities: Giving primarily for music, art, higher education, and medical research.

Types of support: Building funds, equipment, research, endowment funds, special projects, renovation projects.

Limitations: Giving primarily in the Chicago, IL, metropolitan area. No grants to individuals, or for scholarships, fellowships, annual campaigns, seed money, emergency funds, deficit financing, land acquisition, publications, conferences, matching gifts, or operating support; no loans.

Publications: Program policy statement, application guidelines.

Application information: Most grants made on the initiative of the trustees.
 Initial approach: Letter
 Copies of proposal: 1
 Deadline(s): None
 Board meeting date(s): May and as required
 Final notification: 30 days
 Write: Joseph Regenstein, Jr., Pres.

Officers and Directors: Joseph Regenstein, Jr., Pres.; Betty R. Hartman, V.P.; Robert A. Mecca, V.P.; John Eggum, Secy.-Treas.

Number of staff: 2 full-time professional; 1 full-time support.

Employer Identification Number: 363152531

855
The Retirement Research Foundation

1300 West Higgins Rd., Suite 214
Park Ridge 60068 (312) 823-4133

Incorporated in 1950 in MI.

Donor(s): John D. MacArthur.†

Financial data (yr. ended 12/31/88): Assets, $102,776,000 (M); expenditures, $5,438,255, including $4,089,985 for 105 grants (high: $194,471; low: $1,000; average: $24,000-$25,000) and $33,500 for 15 grants to individuals.

Purpose and activities: Support principally to improve the quality of life of older persons in the U.S. Priority interests are innovative model projects and research designed to: (1) increase

the availability and effectiveness of community programs to maintain older persons in independent living environments; (2) improve the quality of nursing home care; (3) provide volunteer and employment opportunities for the elderly; and (4) seek causes and solutions to significant problems of the aged.

Types of support: Seed money, matching funds, research, special projects, employee matching gifts.

Limitations: Giving limited to the Midwest-IL, IN, IA, KY, MI, MO, WI-and FL for service projects not having the potential of national impact. No grants to individuals (except through National Media Awards Program), or for construction, general operating expenses of established organizations, endowment or developmental campaigns, emergency funds, deficit financing, land acquisition, publications, conferences, scholarships, media productions, dissertation research, annual campaigns, or renovation projects; no loans.

Publications: Biennial report, program policy statement, application guidelines, occasional report.

Application information:
Initial approach: Letter or proposal
Copies of proposal: 3
Deadline(s): Submit proposal preferably in Jan., Apr., or July; deadlines Feb. 1, May 1, and Aug. 1
Board meeting date(s): Jan., Apr., July, and Oct.
Final notification: 3 to 6 months
Write: Marilyn Hennessy, Sr. V.P.

Officers: Edward J. Kelly, Chair.; Joe L. Parkin, Pres.; Marilyn Hennessy, Sr. V.P.; Brian F. Hofland, V.P.; Robert P. Ewing, Secy.; Floyd Caldini, Treas.

Trustees:* Duane Chapman, William T. Kirby, Thomas P. Rogers, John F. Santos, Sister Stella Louise, C.S.F.N., George E. Weaver.

Number of staff: 3 full-time professional; 1 part-time professional; 3 full-time support; 1 part-time support.

Employer Identification Number: 362429540

Recent arts and culture grants:
Lincoln Opera, Chicago, IL, $5,000. To support performances for seniors. 1987.

856
Hulda B. & Maurice L. Rothschild Foundation
c/o First National Bank of Chicago
One First National Plaza
Chicago 60670-0111

Established in 1981 in IL.
Donor(s): Hulda B. Rothschild.†
Financial data (yr. ended 12/31/87): Assets, $6,658,863 (M); expenditures, $661,942, including $587,434 for 15 grants (high: $152,469; low: $1,050).
Purpose and activities: Giving for Jewish welfare funds, hospitals, higher education, and the arts.
Trustee: Beatrice Mayer, Robert N. Mayer, First National Bank of Chicago.
Employer Identification Number: 366752787

857
A. Frank and Dorothy B. Rothschild Fund
135 South LaSalle St., Rm. 2011
Chicago 60603-4499

Established in 1952 in IL.
Financial data (yr. ended 12/31/87): Assets, $1,446,986 (M); expenditures, $96,671, including $70,980 for 107 grants (high: $10,000; low: $10).
Purpose and activities: Support primarily for health associations and hospitals, cultural programs, education, Jewish giving, social services, and wildlife and environmental organizations.
Limitations: Giving primarily in IL/NY/MI.
Application information:
Initial approach: Letter
Deadline(s): None
Write: A. Frank Rothschild, Pres., or Dorothy B. Rothschild, Secy.
Officers and Directors: A. Frank Rothschild, Pres.; Dorothy B. Rothschild, Secy.-Treas.; A. Frank Rothschild, Jr.
Employer Identification Number: 366049231

858
Patrick G. & Shirley W. Ryan Foundation
123 North Wacker Dr., Suite 1190
Chicago 60606

Established in 1984 in IL.
Donor(s): Ryan Holding Corp. of Illinois, Ryan Enterprises Corp.
Financial data (yr. ended 11/30/87): Assets, $338,457 (M); gifts received, $700,100; expenditures, $719,908, including $719,575 for 66 grants (high: $100,000; low: $50).
Purpose and activities: Support primarily for education, culture, social services, and health.
Limitations: Giving primarily in IL.
Application information: Contributes only to pre-selected organizations. Applications not accepted.
Officers and Directors: Shirley W. Ryan, Pres.; Patrick G. Ryan, V.P.; Glen E. Hess, Secy.
Employer Identification Number: 363305162

859
Salwil Foundation
400 Skokie Blvd., Suite 675
Northbrook 60062

Established in 1985 in IL.
Donor(s): William L. Searle.
Financial data (yr. ended 12/31/87): Assets, $2,057,882 (L); expenditures, $98,691, including $96,125 for 19 grants (high: $19,000; low: $1,000).
Purpose and activities: Support primarily for education, wildlife and the environment, health associations and hospitals, and cultural programs.
Application information: Contributes only to pre-selected organizations. Applications not accepted.
Write: William L. Searle, Pres.
Officers: William L. Searle, Pres.; Sally B. Searle, V.P. and Secy.-Treas.
Director: Marianne L. Pohle.
Employer Identification Number: 363377945

860
Santa Fe Southern Pacific Foundation
224 South Michigan Ave.
Chicago 60604-2401 (312) 786-6203

Incorporated in 1953 in IL.
Donor(s): Sante Fe Southern Pacific Corp., and subsidiary companies.
Financial data (yr. ended 12/31/87): Assets, $1,664,993 (M); gifts received, $3,500,000; expenditures, $3,528,663, including $3,171,933 for grants (high: $220,000; average: $1,000-$10,000) and $354,213 for employee matching gifts.
Purpose and activities: Emphasis on higher education, civic affairs, health and human services focusing on the homeless, hungry, and elderly, and cultural programs.
Types of support: Scholarship funds, employee matching gifts, employee-related scholarships, annual campaigns, capital campaigns, continuing support, operating budgets.
Limitations: Giving limited to areas of company operations in midwestern, southwestern, and western U.S. No support for religious organizations for sectarian purposes; public educational institutions, preschool, primary, and secondary educational institutions; operating funds for organizations already receiving United Way support; political, fraternal, or veterans' organizations; hospitals; national health or cultural organizations; or community and other grantmaking foundations. No grants to individuals, or for conferences, seminars, travel expenses, testimonial dinners, or endowment funds.
Publications: Annual report, informational brochure (including application guidelines).
Application information: Proposals are accepted and reviewed continuously, except for major requests (over $20,000) which are reviewed annually in the fall.
Initial approach: Proposal
Deadline(s): Sept. 1
Board meeting date(s): Feb. and in the fall
Final notification: Varies
Write: Ronald L. Holden, Exec. Dir.
Officers: Robert E. Gehrt,* Pres.; J.F. Kever, V.P. and Treas.; Ronald L. Holden,* V.P. and Exec. Dir.; Sharon M. Gavril, Secy.
Directors:* J.P. Des Barres, O.G. Linde, J.L. Payne, W.J. Swartz, R.T. Zitting.
Number of staff: 2 full-time professional.
Employer Identification Number: 366051896

861
Sara Lee Corporate Giving Program
Three First National Plaza
Chicago 60602-4260 (312) 726-2600

Financial data (yr. ended 7/02/88): Total giving, $9,487,043, including $3,438,004 for grants and $6,049,039 for in-kind gifts.
Purpose and activities: "At Sara Lee Corporation, we set high goals for ourselves. Our corporate mission is to be the leading brand name food and consumer products company. And in order to achieve our mission, we believe we must be recognized as a corporation with an especially high sense of responsibility to our employees and public constituencies." One of the ways in which

Sara Lee Corporation strives to demonstrate this sense of responsibility is through the corporate-wide contributions programs. The Sara Lee Foundation administers a major portion of these programs concentrating on the Chicago metropolitan area and focusing on programs serving the disadvantaged and on arts institutions. In addition to the Foundation's programs, the operating companies and divisions administer giving programs based on their assessment of needs in the communities where they operate. They contribute cash and product donations to local and national organizations. Divisions and their employees also participate in community-based projects. Individual divisions set their own guidelines, geographic limitations, and application procedures and are not bound by the foundation's priorities and practices.

Types of support: Annual campaigns, continuing support, operating budgets, special projects, employee matching gifts, equipment, scholarship funds, in-kind gifts.

Limitations: Giving primarily in operating areas.

Publications: Application guidelines.

Application information: Include 501(c)(3).

Initial approach: Contact management of local divison for corporate support

Write: Gretchen Miller Reimel, Exec. Dir.

862
Sara Lee Foundation
Three First National Plaza
Chicago 60602-4260 (312) 558-8448

Incorporated in 1981 in IL.

Donor(s): Sara Lee Corp.

Financial data (yr. ended 7/02/88): Assets, $2,334,796 (M); gifts received, $5,381,000; expenditures, $3,395,526, including $2,204,435 for 199 grants (high: $325,000; low: $1,000; average: $1,000-$5,000) and $898,839 for 2,116 employee matching gifts.

Purpose and activities: Primary focus is on organizations assisting the disadvantaged, and arts and cultural organizations.

Types of support: Employee-related scholarships, employee matching gifts, special projects, operating budgets, annual campaigns, seed money, matching funds, continuing support.

Limitations: Giving primarily in the Chicago, IL, area. No support for elementary or secondary schools, religious organizations, disease-specific health organizations, fraternal, political, or veterans' organizations, or national or international organizations with limited relationships to local company operations. No grants to individuals, or for fundraising events, goodwill advertising, endowments, or capital campaigns.

Publications: Corporate giving report, informational brochure (including application guidelines), annual report (including application guidelines).

Application information: Application form required.

Initial approach: Letter or telephone

Copies of proposal: 1

Deadline(s): 1st working day of Mar., June, Sept., or Dec.

Board meeting date(s): 4 to 6 weeks following deadline

Final notification: 1 to 2 weeks after Management Donations Committee meetings

Write: Gretchen Miller Reimel, Exec. Dir.

Officers: Robert L. Lauer,* Pres.; Gordon H. Newman, V.P. and Secy.; Mary Ellen Johnson, Treas.

Directors:* John H. Bryan, Jr., Paul Fulton, Michael E. Murphy.

Staff: Gretchen Miller Reimel, Exec. Dir.; Renee M. Aten, Administrative Coord.

Number of staff: 2 part-time professional; 3 part-time support.

Employer Identification Number: 363150460

Recent arts and culture grants:

Art Institute of Chicago, Chicago, IL, $100,000. For local underwriting of A Day in the Country; fourth payment on pledge to Institute's Campaign for Chicago's Masterpiece; and for operating support. 1987.

Auditorium Theater Council, Chicago, IL, $5,000. For operating support for Council's programs and theatrical performances. 1987.

Ballet Folklorico Ibero-Hispano, Chicago, IL, $5,000. For start-up funds for programs to train Hispanic youth in dance, music and other performing arts. 1987.

Business Committee for the Arts, NYC, NY, $5,000. For support of efforts to increase business community's funding of the arts. 1987.

Chicago Historical Society, Chicago, IL, $15,000. For second installment of pledge for Society's Modernization Program and operating funds for Historical Alliance. 1987.

Chicago International Theater Festival, Chicago, IL, $100,000. For first payment on grant as Founding Sponsor of 1988 Chicago International Theater Festival. 1987.

Chicago Symphony Orchestra, Chicago, IL, $70,000. For first payment on pledge supporting Orchestra's East Coast tour and operating support for Orchestra's 96th season. 1987.

De Paul University, The Theater School, Chicago, IL, $5,000. For Playworks Program, children's theater, and to underwrite costs of student transportation to Playworks performances. 1987.

DuSable Museum of African American History, Chicago, IL, $10,000. For final installment on capital campaign pledge. 1987.

Field Museum of Natural History, Chicago, IL, $50,000. To underwrite Treasures of the Field Museum fund-raising benefit. 1987.

Goodman Theater, Chicago, IL, $185,000. For underwriting Goodman's production of Sunday in the Park with George, final play of theater's 1986/87 season. 1987.

Hubbard Street Dance Company, Chicago, IL, $32,500. To underwrite major new dance for HSDC, choreographed by Lynne Taylor-Corbett. 1987.

John F. Kennedy Center for the Performing Arts, DC, $5,000. For operating support for 1987 performance season. 1987.

Kuumba Theater, Chicago, IL, $5,000. For 1986/87 performance season and general operating support. 1987.

Lincoln Park Zoological Society, Chicago, IL, $7,500. For second installment on pledge to Landmark Campaign. 1987.

Lyric Opera of Chicago, Chicago, IL, $20,000. For general operating support for Opera's 1986/87 performance year. 1987.

Mexican Fine Arts Center Museum, Chicago, IL, $7,500. To underwrite Museum's exhibit, Latina Art: Showcase '87. 1987.

Museum of Contemporary Art, Chicago, IL, $5,000. For general operating support. 1987.

Museum of Science and Industry, Chicago, IL, $10,000. For fourth installment on pledge to Museum's 50th anniversary capital campaign. 1987.

National Museum of Women in the Arts, DC, $5,000. For support as founding member of only museum devoted to work of women artists. 1987.

Newberry Library, Chicago, IL, $5,000. For final installment on pledge to Library's capital campaign. 1987.

Urban Gateways, Chicago, IL, $5,000. For programs which bring arts to more than 900,000 students, teachers and parents in 750 schools in Chicago area. 1987.

863
Sargent & Lundy Corporate Giving Program
55 E. Monroe St.
Chicago 60603 (312) 269-2000

Purpose and activities: Supports education and private colleges, engineering, fine arts institutes, economic development and environmental issues; also in-kind giving.

Types of support: Annual campaigns, building funds, capital campaigns, conferences and seminars, equipment, grants to individuals, lectureships.

Application information:

Write: W.A. Chittenden, Sr. Partner

864
Dr. Scholl Foundation
11 South LaSalle St., Suite 2100
Chicago 60603 (312) 782-5210

Incorporated in 1947 in IL.

Donor(s): William M. Scholl, M.D.†

Financial data (yr. ended 12/31/87): Assets, $101,072,753 (M); expenditures, $7,708,172, including $6,982,175 for 297 grants (high: $200,000; low: $1,000; average: $5,000-$50,000) and $346,500 for 77 grants to individuals.

Purpose and activities: Support for private education at all levels, including elementary, secondary, and post-secondary schools, colleges and universities, and medical and nursing institutions; medical and scientific research; and general charitable programs, including grants to hospitals, and programs for children, the developmentally disabled, and senior citizens; and civic, cultural, social welfare, economic, and religious activities.

Types of support: Equipment, research, conferences and seminars, special projects, endowment funds.

Limitations: No support for public education. No grants to individuals, or for building funds, general support, continuing support, operating budgets, deficit financing, or unrestricted purposes.

Publications: Program policy statement, application guidelines.
Application information: The scholarship program for the children of company employees, except for renewals, has been discontinued.

Initial approach: Ask for application form
Copies of proposal: 1
Deadline(s): May 15
Board meeting date(s): Jan., Apr., July, and Oct.
Final notification: Nov.
Write: Jack E. Scholl, Exec. Dir.

Officers: William H. Scholl,* Pres.; Jack E. Scholl,* V.P., Secy., and Exec. Dir.; Leonard J. Knirko, Treas.
Trustees:* William T. Branham, Paul Eiseman, Neil Flanagin, William B. Jordan, Charles F. Scholl.
Number of staff: 2 full-time professional; 2 part-time professional; 3 full-time support.
Employer Identification Number: 366068724
Recent arts and culture grants:
American Choral Foundation, Wilmette, IL, $35,000. To provide scholarships to singers of identified talent. 1987.
Black Spectrum Theater Company, Jamaica, NY, $5,000. To partially fund children's and youth repertory training and mobile theater program. 1987.
Chicago Educational Television Association, Chicago, IL, $50,000. To produce and broadcast television program about Field Museum of Natural History. 1987.
Chicago Horticultural Society, Glencoe, IL, $50,000. For visitor center. 1987.
Chicago String Ensemble, Chicago, IL, $5,000. To fund concerts in prisons, hospitals, nursing homes and retirement centers. 1987.
Elder Craftsmen, NYC, NY, $7,500. For controlled production unit program. 1987.
Family Theater, Hollywood, CA, $15,000. For production costs of program to offer family prayer. 1987.
Field Museum of Natural History, Chicago, IL, $50,000. Toward research programs. 1987.
Goodman Theater, Chicago Theater Group, Chicago, IL, $15,000. For general operating support. 1987.
Grant Park Concerts Society, Chicago, IL, $10,000. To help support presentation of music. 1987.
Hubbard Street Dance Company, Chicago, IL, $5,000. To help fund performances for outreach program. 1987.
Imagination Theater, Chicago, IL, $5,000. To assist in introducing creative drama as tool for greater learning. 1987.
John G. Shedd Aquarium, Chicago, IL, $50,000. To help construct and equip oceanarium. 1987.
Lincoln Park Zoological Society, Chicago, IL, $40,000. For educational program and lecture series. 1987.
Loyola Academy, Wilmette, IL, $20,000. To help renovate theater program. 1987.
Lyric Opera of Chicago, Chicago, IL, $69,000. For student matinee performance. 1987.
Museum of Science and Industry, Chicago, IL, $75,000. For assistance in fabrication of permanent exhibit on drugs and alcohol abuse. 1987.

Music Center of the North Shore, Winnetka, IL, $25,000. To provide scholarships for both music students and therapy clients. 1987.
Northlight Theater, Evanston, IL, $5,000. To provide support for senior citizen access program. 1987.
Old Town School of Folk Music, Chicago, IL, $50,000. To staff newly created museum/resource center. 1987.
Orchestral Association, Chicago, IL, $50,000. To support ensemble program. 1987.
Phoenix Symphony, Phoenix, AZ, $20,000. To support symphony's community outreach program. 1987.
Queen of All Saints Parish, Michigan City, IN, $7,000. For furthering of music and arts program. 1987.
Tucson Botanical Gardens, Tucson, AZ, $26,500. For continued services of Eduvan. 1987.
Vermont State Craft Center at Frog Hollow, Middlebury, VT, $10,000. For continuation of programs. 1987.
W B E Z, Chicago, IL, $5,000. To support production of AIRPLAY. 1987.

865
The Seabury Foundation
c/o Northern Trust Company
50 South LaSalle St.
Chicago 60675 (312) 630-6000

Trust established in 1947 in IL.
Donor(s): Charles Ward Seabury,† Louise Lovett Seabury.†
Financial data (yr. ended 12/31/86): Assets, $15,195,896 (M); expenditures, $632,977, including $590,800 for 129 grants (high: $35,000; low: $500).
Purpose and activities: Emphasis on hospitals, cultural programs, including music, higher and secondary education, aid to the handicapped, youth agencies, and child welfare.
Limitations: Giving primarily in the greater Chicago, IL, area. No grants to individuals; no loans.
Application information: Contributes only to pre-selected organizations. Applications not accepted.
Officers and Trustees: Clara Seabury Boone, Exec. Secy.; John Ward Seabury, Exec. Dir.; Daniel J. Boone, Charles B. Fisk, Elizabeth Seabury Mitchell, Louis Fisk Morris, Charlene B. Seabury, Northern Trust Company.
Employer Identification Number: 366027398

866
Sears, Roebuck and Co. Corporate Contributions
Sears, Roebuck and Co.
Dept. 903 BSC 51-02, Sears Tower
Chicago 60684 (312) 875-8337

Financial data (yr. ended 12/31/88): $26,335,901 for grants.
Purpose and activities: "Through the decades, Sears has conscientiously demonstrated its good corporate citizenship through an active program of contributions and community relations." There are essentially three tiers of funding at Sears. The Sears-Roebuck Foundation is the philanthropic umbrella for the

entire corporation and funds specific national programs related to the National Focus Priorities. Sears, Roebuck and Co. corporate contributions are allocated in response to major grant requests from national organizations or for activities in Chicago, Sears' headquarters city. Community programs are supported by local units of Sears' four business groups: Sears Merchandise Group, Allstate Insurance Group (gives through the Allstate Foundation), Dean Witter Financial Services Group and Coldwell Banker Real Estate Group. Giving is for 1) Health and Human Services with National Focus Priorities being older adults, the disabled, and health care cost containment; 2) Education-National Focus Priorities are literacy, early childhood education and day care teacher excellence, and job training; 3) Arts and Culture-the National Focus Priority is arts education; and 4) Civic and Community-the National Focus Priority in neighborhood economic development. To be considered national, a program or organization must serve constituents in multiple states, not limited to a specific geographic region. The figure above represents combined giving from the foundation, the headquarters, and the business groups. The amount of $4,916,723 was directed to both national and greater Chicago area organizations as grants and/or for programs under the authority of the office of the Corporate Contributions Director.
Limitations: Giving primarily in major operating locations in the continental U.S.A. and PR. No grants for non tax-exempt organizations.
Publications: Corporate giving report (including application guidelines).
Application information:
Initial approach: Letter or phone call
Board meeting date(s): Jan., and at four other times during the year in Apr., June, Sept., and Nov.
Write: Paula A. Banks, Dir., Corp. Contribs.
Number of staff: 5 full-time professional; 4 full-time support.

867
Soretta & Henry Shapiro Family Foundation, Inc.
1540 North Lake Shore Dr.
Chicago 60610

Established in 1970 in IL.
Donor(s): Isaac and Fannie Shapiro Memorial Foundation.
Financial data (yr. ended 12/31/87): Assets, $676,295 (M); gifts received, $50,000; expenditures, $157,619, including $156,319 for 111 grants (high: $50,000; low: $25).
Purpose and activities: Support for cultural programs and organizations and for Jewish organizations and schools.
Limitations: Giving primarily in Chicago, IL.
Application information:
Initial approach: Letter or proposal
Deadline(s): None
Write: Henry Shapiro, Trustee
Trustee: Henry Shapiro.
Employer Identification Number: 237063846

868
Arch W. Shaw Foundation
135 South LaSalle St.
Chicago 60603 (312) 726-7155

Trust established in 1949 in IL.
Financial data (yr. ended 12/31/87): Assets,
$6,795,612 (M); expenditures, $406,183,
including $400,000 for 64 grants (high:
$20,000; low: $1,000).
Purpose and activities: Grants for higher
education, hospitals, and cultural programs.
Limitations: Giving primarily in IL. No grants
to individuals.
Application information:
 Initial approach: Letter
 Deadline(s): None
 Write: John I. Shaw, Trustee
Trustees: William W. Shaw, Arch W. Shaw II,
John I. Shaw, Roger D. Shaw.
Employer Identification Number: 366055262

869
The Shifting Foundation
8000 Sears Tower
Chicago 60606

Established in 1982 in IL.
Financial data (yr. ended 1/31/88): Assets,
$1,542,038 (M); gifts received, $21,314;
expenditures, $87,449, including $37,000 for
21 grants (high: $5,000; low: $1,000) and
$36,000 for 4 grants to individuals.
Purpose and activities: Support for grants to
individual artists; support also for hunger relief,
social services, health organizations, human
and civil rights, environmental and anti-nuclear
interests.
Types of support: General purposes, grants to
individuals.
Limitations: No support for work in dance, the
behavioral sciences, or for musicians who are
mainly performers of traditional, classical or
pop music.
Publications: Application guidelines.
Application information: Application form
required.
 Copies of proposal: 1
 Deadline(s): None
 Final notification: within 4 months
Employer Identification Number: 366108560

870
Silver Spring Foundation
410 North Michigan Ave., Rm. 590
Chicago 60611

Established in 1953 in PA.
Donor(s): Charles Deering McCormick.
Financial data (yr. ended 12/31/86): Assets,
$4,685,205 (M); gifts received, $10,000;
expenditures, $242,617, including $240,500
for 25 grants (high: $25,000; low: $1,000).
Purpose and activities: Emphasis on cultural
programs, hospitals, social services, and higher
education.
Types of support: General purposes.
Application information: Contributes only to
pre-selected organizations. Applications not
accepted.
Trustees: Brooks McCormick, Charles
Deering McCormick, Charles E. Schroeder.
Employer Identification Number: 236254662

871
The Siragusa Foundation
840 North Michigan Ave., Suite 411
Chicago 60611 (312) 280-0833

Trust established in 1950 in IL; incorporated in
1980.
Donor(s): Ross D. Siragusa.
Financial data (yr. ended 12/31/88): Assets,
$9,177,753 (M); expenditures, $562,438,
including $399,000 for 75 grants (high:
$30,000; low: $500; average: $5,320).
Purpose and activities: Emphasis on higher
education and medical research; support also
for cultural activities, child development
programs, education of the handicapped, and
care of the elderly.
Types of support: Operating budgets,
equipment, matching funds, research, special
projects, general purposes, scholarship funds.
Limitations: Giving primarily in in the Midwest,
with preference to the Chicago, IL,
metropolitan area. No grants to individuals, or
for endowment funds; no loans.
Publications: Program policy statement,
application guidelines.
Application information: Submit proposal
only when invited.
 Initial approach: Letter
 Copies of proposal: 1
 Board meeting date(s): Mar., June, Sept., and
 Dec.
 Final notification: 2 to 3 months
 Write: John R. Siragusa, V.P.
Officers and Directors: Ross D. Siragusa,
Pres.; John R. Siragusa, V.P. and Secy.-Treas.;
Roy M. Adams, George E. Driscoll, Irene S.
Phelps, Melvyn H. Schneider, Martha P.
Siragusa, Richard D. Siragusa, Ross D. Siragusa,
Jr., Theodore M. Siragusa, James B. Wilson.
Number of staff: 1 full-time professional; 1 full-
time support.
Employer Identification Number: 363100492

872
Skidmore, Owings & Merrill Foundation
1365 North Astor St.
Chicago 60610 (312) 951-8006

Established in 1978.
Donor(s): Skidmore, Owings & Merrill.
Financial data (yr. ended 8/31/88): Assets,
$2,961,846 (M); gifts received, $359,042;
expenditures, $386,770, including $43,400 for
9 grants to individuals.
Purpose and activities: Grants "for the
purpose of education, research, or publications
in or directly related to the fields of
architecture or architectural engineering."
Types of support: Fellowships.
Publications: Financial statement.
Application information:
 Initial approach: Proposal
 Deadline(s): None
 Write: Sonia Cooke, Administrative Dir.
Officers and Directors: Bruce J. Graham,
Chair.; Marc E. Goldstein, Vice-Chair.; Diane
Legge Lohan, Secy.-Treas.; and 13 additional
directors.
Employer Identification Number: 362969068

873
Smith Charitable Trust
c/o Gordon Smith
P.O. Box 38
Rockford 61105

Trust established in 1956 in IL.
Donor(s): Smith Oil Corp., Carl A. Smith,†
Byron C. Marlowe.
Financial data (yr. ended 12/31/87): Assets,
$2,635,291 (M); expenditures, $129,000,
including $126,000 for grants.
Purpose and activities: Emphasis on hospitals,
higher education, and youth and child welfare;
grants also for cultural activities and civic affairs.
Types of support: Annual campaigns, building
funds, capital campaigns, equipment,
scholarship funds, seed money, special projects.
Limitations: Giving limited to IL. No support
for churches and schools. No grants to
individuals.
Application information:
 Copies of proposal: 3
 Deadline(s): Dec. 1
 Board meeting date(s): Dec. 15
Trustees: Howard Bell, David S. Paddock, C.
Gordon Smith.
Number of staff: None.
Employer Identification Number: 366078557

874
Soft Sheen Foundation
1000 East 87th St.
Chicago 60619-6391

Established in 1981 in IL.
Financial data (yr. ended 2/28/87): Assets,
$1,881,800 (M); gifts received, $747,295;
expenditures, $142,439, including $63,361 for
6 grants (high: $33,784; low: $400).
Purpose and activities: Support primarily for
African-American educational and cultural
organizations; support also for a cosmetology
association.
Application information:
 Deadline(s): None
Directors: Betty A. Gardner, Edward G.
Gardner, Robert Martin, Richard McGuire.
Employer Identification Number: 363211525

875
State Bank Foundation
50 West Douglas St.
Freeport 61032

Financial data (yr. ended 12/31/87): Assets,
$128,436 (M); qualifying distributions,
$11,517, including $12,476 for 3 grants (high:
$5,976; low: $2,500).
Purpose and activities: Support for arts and
culture, education, and the United Way.
Limitations: Giving primarily in IL.
Manager: State Bank of Freeport.
Employer Identification Number: 363139758

876
Donna Wolf Steigerwaldt Foundation, Inc.
200 North LaSalle St., Suite 2100
Chicago 60601-1095
Application address: 2300 60th St., Kenosha,
WI 53140; Tel.: (414) 658-8111, ext. 288

Established in 1980 in IL.
Donor(s): Donna Wolf Steigierwaldt, Jockey International, Inc.
Financial data (yr. ended 10/31/87): Assets, $1,424,204 (M); gifts received, $210,000; expenditures, $75,376, including $71,954 for 52 grants (high: $10,000; low: $15).
Purpose and activities: Giving primarily for higher education; support also for musical organizations.
Types of support: Annual campaigns, building funds, continuing support, scholarship funds.
Limitations: Giving primarily in WI and IL.
Application information: Contributes only to pre-selected organizations. Applications not accepted.
Initial approach: Letter
Deadline(s): None
Write: Noreen A. Wilkinson, Secy.
Officers and Directors: Donna Wolf Steigerwaldt, Pres. and Treas.; Debra Steigerwaldt Bender, V.P.; William Steigerwaldt, V.P.; Noreen A. Wilkinson, Secy.; Linda Steigerwaldt Davis, Michael R. Shelist.
Employer Identification Number: 363104409

877
Steinfeld Foundation
P.O. Box 3442
Chicago 60654

Established in 1967 in IL.
Donor(s): Manfred Steinfeld, Fern F. Steinfeld.
Financial data (yr. ended 9/30/88): Assets, $6,815 (M); gifts received, $2,000; expenditures, $276,581, including $276,268 for 36 grants (high: $149,375; low: $10).
Purpose and activities: Support primarily for Jewish giving and welfare, education, cultural programs, and hospitals and health associations.
Types of support: Annual campaigns, building funds, scholarship funds.
Limitations: Giving primarily in Chicago, IL.
Application information: Contributes only to pre-selected organizations. Applications not accepted.
Officers and Directors: Fern F. Steinfeld, Pres. and Secy.; Manfred Steinfeld, V.P. and Treas.; Herbert Roth, Walter Roth.
Employer Identification Number: 366166697

878
Jerome H. Stone Family Foundation
150 North Michigan Ave.
Chicago 60601

Established in 1963 in IL.
Donor(s): Jerome H. Stone, Cynthia Raskin.
Financial data (yr. ended 12/31/87): Assets, $3,202,546 (M); gifts received, $87,588; expenditures, $130,434, including $128,297 for 89 grants (high: $16,150; low: $25).
Purpose and activities: Support for Jewish organizations, culture, education, health, and social services.
Application information: Contributes only to pre-selected organizations. Applications not accepted.
Officers: Jerome H. Stone, Pres.; James H. Stone, V.P.; Cynthia Raskin, Secy.
Director: Ellen Stone Belic.
Employer Identification Number: 366061300

879
Marvin Stone Family Foundation
c/o Marvin Stone
150 North Michigan Ave.
Chicago 60601

Donor(s): Marvin N. Stone.
Financial data (yr. ended 12/31/87): Assets, $2,040,816 (M); expenditures, $70,323, including $69,680 for 78 grants (high: $10,000; low: $25).
Purpose and activities: Grants primarily for cultural programs, health services, Jewish welfare, and other Jewish giving.
Limitations: Giving primarily in IL, especially Chicago.
Application information: Contributes only to pre-selected organizations. Applications not accepted.
Officers: Marvin N. Stone, Pres.; Carol Stone, Secy.; Roger W. Stone, Treas.
Director: Avery J. Stone.
Employer Identification Number: 366061303

880
Roger and Susan Stone Family Foundation
150 North Michigan Ave.
Chicago 60601-7508

Established in 1969 in IL.
Donor(s): Susan Stone, Roger Stone.
Financial data (yr. ended 12/31/87): Assets, $169,124 (M); gifts received, $168,261; expenditures, $198,519, including $196,670 for 65 grants (high: $57,300; low: $50).
Purpose and activities: Support for higher education and cultural programs.
Limitations: Giving primarily in Chicago, IL.
Application information: Contributes only to pre-selected organizations. Applications not accepted.
Directors: Roger Stone, Susan Stone.
Employer Identification Number: 237026711

881
Stone Foundation, Inc.
150 North Michigan Ave.
Chicago 60601

Incorporated in 1944 in IL.
Donor(s): Stone Container Corp.
Financial data (yr. ended 12/31/86): Assets, $785,665 (M); expenditures, $254,053, including $230,500 for 33 grants (high: $185,000; low: $200) and $23,000 for 15 grants to individuals.
Purpose and activities: Emphasis on Jewish welfare funds, higher education, hospitals, and cultural activities; scholarships limited to children of employees with two or more years of service.
Types of support: Employee-related scholarships.
Application information: Application form required.
Deadline(s): Apr. 1 for scholarships
Write: Arnold Brookstone, Admin.
Directors: Jerome H. Stone, Marvin N. Stone, Roger W. Stone.
Employer Identification Number: 366063761

882
Sundstrand Corporation Foundation
4949 Harrison Ave.
P.O. Box 7003
Rockford 61125 (815) 226-6000

Incorporated in 1952 in IL.
Donor(s): Sundstrand Corp.
Financial data (yr. ended 10/31/88): Assets, $1,486,374 (M); expenditures, $1,001,695, including $845,850 for 112 grants (high: $122,000; low: $450) and $144,509 for employee matching gifts.
Purpose and activities: Grants for community funds, education, particularly higher education, hospitals, and youth agencies; support also for the handicapped, social service and health agencies, an employee-related scholarship program and cultural programs.
Types of support: Building funds, equipment, scholarship funds, employee-related scholarships, employee matching gifts, capital campaigns.
Limitations: Giving primarily in areas of company operations. No support for projects of a religious or political nature. No grants to individuals (except for employee-related scholarships), or for operating funds.
Application information:
Initial approach: Letter
Copies of proposal: 1
Deadline(s): None
Board meeting date(s): Mar., June, Sept., and Dec.
Final notification: 2 months
Write: John A. Thayer, Secy.
Officers: Don R. O'Hare,* Pres.; Philip W. Polgreen,* V.P.; John A. Thayer, Secy.; Ted Grenberg, Treas.
Directors:* Richard Schilling.
Employer Identification Number: 366072477

883
Mr. & Mrs. George W. Taylor Foundation
c/o Robert W. Baird & Co.
1700 North Alpine, Suite 302
Rockford 61107

Established in 1984 in IL.
Financial data (yr. ended 12/31/87): Assets, $182,615 (M); gifts received, $272,319; expenditures, $223,830, including $217,118 for 90 grants (high: $139,753; low: $10).
Purpose and activities: Giving primarily to museums and general charities; also grants scholarships for students at University of Minnesota Institute of Technology.
Application information:
Initial approach: Letter
Deadline(s): None
Write: James Thiede, Trustee
Trustees: Stephen R. Hill, James Thiede.
Employer Identification Number: 363321315

884
Curt Teich Foundation
One First National Plaza, Suite 3148
Chicago 60603-2279

Established in 1951 in IL.

Financial data (yr. ended 8/31/87): Assets, $504,650 (M); expenditures, $141,629, including $132,028 for 1 grant.
Purpose and activities: Support primarily for a museum.
Types of support: Special projects.
Application information: Funds are presently committed. Applications not accepted.
Officers and Directors: Roger P. Eklund, Pres. and Treas.; Sally S. Eklund, Secy.; Kathryn P. Eklund.
Employer Identification Number: 366033824

885
The Thorson Foundation
399 Fullerton Pkwy.
Chicago 60614 (312) 327-2687

Established in 1954 in IL.
Donor(s): Robert D. Thorson,† Reuben Thorson,† Dorothy W. Thorson.
Financial data (yr. ended 12/31/86): Assets, $1,814,296 (M); expenditures, $83,566, including $71,600 for 57 grants (high: $25,000; low: $50).
Purpose and activities: Grants primarily for higher and other education, cultural programs, health services, hospitals, and medical research; support also for religion and civic affairs.
Types of support: Annual campaigns, capital campaigns, continuing support, fellowships, scholarship funds.
Limitations: No grants to individuals.
Application information:
 Write: Dorothy W. Thorson, Pres.
Officers and Directors: Dorothy W. Thorson, Pres.; Virginia T. Goodall, V.P. and Treas.; John C. Goodall III, Secy.
Employer Identification Number: 366051916

886
Tyndale House Foundation
336 Gundersen Dr., Box 80
Wheaton 60187 (312) 668-8300

Established in 1964 in IL.
Donor(s): Kenneth N. Taylor, Howard A. Elkind, ENB Charitable Trust.
Financial data (yr. ended 12/31/87): Assets, $199,910 (M); gifts received, $761,697; expenditures, $798,816, including $776,750 for grants (high: $400,000).
Purpose and activities: To promote the gospel through Christian literature projects, Bible translations, and Christian services and activities in the U.S. and abroad.
Types of support: General purposes, special projects, publications, matching funds.
Limitations: No support for libraries. No grants to individuals, or for building or endowment funds, scholarships, fellowships, or personnel support.
Publications: Financial statement, informational brochure (including application guidelines).
Application information: New grants awarded on a limited basis.
 Initial approach: Letter or telephone
 Copies of proposal: 10
 Deadline(s): Middle of Aug.
 Board meeting date(s): Early Sept. for grantmaking and as required

Write: Mrs. Mary Kleine Yehling, Exec. Dir.
Officers and Managers: Edwin L. Frizen, Jr., Pres.; Sam F. Wolgemuth, Sr., V.P.; Margaret W. Taylor, Secy.-Treas.; Mary Gieser, Peter Gunther, Wendell C. Hawley, Elizabeth Knighton, Paul Mathews, Kenneth N. Taylor, Mark D. Taylor.
Number of staff: 1 part-time professional.
Employer Identification Number: 362555516

887
United Airlines Foundation
(Formerly UAL Foundation)
P.O. Box 66100
Chicago 60666 (312) 952-5714

Incorporated in 1951 in IL.
Donor(s): United Air Lines, Inc.
Financial data (yr. ended 12/31/87): Assets, $4,383,974 (M); gifts received, $500,000; expenditures, $1,585,881, including $1,574,464 for 194 grants (high: $206,900; low: $100; average: $2,000-$15,000).
Purpose and activities: Emphasis on programs encompassing education and educational reform, arts and culture, the United Way, and the Friendly Skies program which airlifts terminally and critically ill children to hospitals for treatment.
Types of support: Annual campaigns, operating budgets, research, employee-related scholarships, employee matching gifts.
Limitations: Giving limited to areas of company operations. No support for organizations established to influence legislation, labor unions, fraternal or veterans' organizations, political activities, or propaganda, or for sectarian religious organizations. No grants to individuals, or for endowments, advertising campaigns, purchase of tickets or tables for fundraising dinners or similar events, club memberships, conferences, or travel; no loans.
Publications: Application guidelines.
Application information:
 Initial approach: Proposal
 Copies of proposal: 1
 Deadline(s): 60 days prior to board meetings
 Board meeting date(s): Mar., June, Sept., and Dec.
 Final notification: 1 month
 Write: Eileen M. Younglove, Secy.
Officers: Stephen M. Wolf,* Pres.; Paul G. George,* V.P.; Eileen M. Younglove,* Secy. and Contribs. Mgr.
Directors:* James M. Guyette, Edward Hoenicke, John C. Pope, John R. Zeeman.
Number of staff: 2
Employer Identification Number: 366109873

888
Frederick S. Upton Foundation
c/o First National Bank of Chicago
One First National Plaza, Suite 0103
Chicago 60670 (312) 732-4260

Trust established in 1954 in IL.
Donor(s): Frederick S. Upton.†
Financial data (yr. ended 12/31/87): Assets, $12,000,000 (M); expenditures, $552,000, including $507,000 for 70 grants (high: $80,000; low: $1,000).

Purpose and activities: Emphasis on higher education; grants also for cultural programs, youth agencies, and church support.
Types of support: Annual campaigns, building funds, capital campaigns, general purposes, operating budgets, renovation projects, special projects.
Limitations: Giving primarily in MI.
Application information: Foundation notifies only those applicants who will receive grants.
 Copies of proposal: 1
 Deadline(s): None
 Board meeting date(s): Varies
 Write: Ward Farnsworth
Trustees: Priscilla Upton Byrns, David F. Upton, Stephen E. Upton, Sylvia Upton Wood, First National Bank of Chicago.
Number of staff: 1 part-time support.
Employer Identification Number: 366013317

889
USG Foundation, Inc.
101 South Wacker Dr.
Chicago 60606 (312) 606-4594

Incorporated in 1978 in IL.
Donor(s): United States Gypsum Co.
Financial data (yr. ended 12/31/88): Assets, $1,362,967 (M); expenditures, $740,620 for 99 grants (high: $139,599; low: $30; average: $500-$5,000) and $269,073 for employee matching gifts.
Purpose and activities: Emphasis on higher education and community funds; support also for arts and cultural organizations, hospitals and health, welfare, youth agencies, and public interest organizations. Preference given to supporting appropriate programs in which USG employees actively participate.
Types of support: Continuing support, annual campaigns, building funds, equipment, research, matching funds, employee matching gifts, technical assistance, general purposes, capital campaigns, employee-related scholarships, scholarship funds, renovation projects.
Limitations: Giving primarily in areas of company operations. No support for sectarian organizations that are exclusively religious, or for political parties, offices, or candidates; fraternal or veterans' organizations; primary or secondary schools, or generally organizations receiving funds from united campaigns. No grants to individuals, or for courtesy advertising; no loans.
Publications: Informational brochure, program policy statement, application guidelines.
Application information:
 Initial approach: Proposal
 Copies of proposal: 1
 Deadline(s): None
 Board meeting date(s): Quarterly
 Final notification: 2 months
 Write: Eugene Miller, Pres.
Officers and Directors:* Eugene Miller,* Pres.; Ralph C. Joynes,* V.P.; H.E. Pendexter,* V.P.; Arthur Leisten, Secy.; William K. Hogan, Treas.
Number of staff: 1 full-time professional.
Employer Identification Number: 362984045

890
Walgreen Benefit Fund
200 Wilmot Rd.
Deerfield 60015 (312) 940-2931

Incorporated in 1939 in IL.
Donor(s): Walgreen Co.
Financial data (yr. ended 4/30/87): Assets, $9,740,451 (M); expenditures, $584,358, including $347,069 for 282 grants and $214,982 for grants to individuals.
Purpose and activities: Emphasis on a welfare fund for present and former Walgreen employees and their families; balance of income distributed for community organizations, hospitals, minority, women's, and handicapped groups, and social, cultural and youth agencies.
Types of support: Annual campaigns, continuing support, emergency funds, general purposes, grants to individuals, building funds, capital campaigns, equipment, operating budgets, special projects.
Limitations: Giving primarily in areas of Walgreen markets, with emphasis on IL. No support for religious organizations. No grants to individuals (except employees of the company), or for capital or endowment funds, research-related programs, or matching gifts; no loans.
Application information:
 Initial approach: Letter or proposal
 Copies of proposal: 1
 Deadline(s): None
 Board meeting date(s): Monthly and as required
 Final notification: 30 to 60 days
 Write: Edward H. King, V.P.
Officers: Kenneth Weigand,* Pres.; Edward H. King,* V.P.; William G. Thien, V.P.; Nancy Godfrey,* Secy.-Treas.
Directors:* R.E. Engler, Charles D. Hunter, J.A. Rubino, Charles R. Walgreen III.
Number of staff: 1 part-time professional; 1 part-time support.
Employer Identification Number: 366051130

891
Walgreen Corporate Giving Program
200 Wilmot Rd.
Deerfield 60015 (312) 940-2500

Financial data (yr. ended 8/31/88): $2,848,123 for grants.
Purpose and activities: Supports a variety of programs, including: social services, with giving to the United Way and programs for crime rehabilitation, underprivileged children and emotionally disturbed children, youth service, race relations and rehabilitation programs; and arts and culture, including theater and symphonies. Individuals and national organizations are considered for funding.
Types of support: Building funds, general purposes, equipment, capital campaigns, operating budgets, annual campaigns, special projects.
Limitations: Giving primarily in headquarters city and major operating areas. No support for international organizations.
Application information:
 Initial approach: Letter or proposal
 Deadline(s): None

Board meeting date(s): Monthly and as needed
Final notification: 1-2 months
Write: Henry Cade, Dir., Public Affairs and Professional Relations
Number of staff: 2 full-time professional; 1 full-time support; 1 part-time support.

892
Mary Ann & Charles R. Walgreen, Jr. Fund
200 Wilmot Rd.
Deerfield 60015
Application address: P.O. Box 138, Deerfield, IL 60015; Tel.: (312) 940-3030

Established in 1952 in IL.
Financial data (yr. ended 12/31/87): Assets, $1,404,962 (M); expenditures, $175,950, including $168,561 for 35 grants (high: $161,981; low: $30).
Purpose and activities: Support for education, hospitals and health services, youth and child welfare, and cultural programs.
Limitations: Giving primarily in IL. No support for elementary or secondary schools. No grants to individuals.
Application information:
 Initial approach: Proposal
 Deadline(s): Sept. 30
 Write: Charles R. Walgreen, Jr., Pres.
Officers and Directors: Charles R. Walgreen, Jr., Pres. and Treas.; Emily Koulogeorge, V.P. and Secy.; Jean B. Walgreen.
Employer Identification Number: 366051129

893
The A. Montgomery Ward Foundation
c/o Continental Illinois National Bank & Trust Co. of Chicago, Attn.: M.C. Ryan, 2nd V.P.
30 North LaSalle St.
Chicago 60697 (312) 828-1785

Trust established in 1959 in IL.
Donor(s): Marjorie Montgomery Ward Baker.†
Financial data (yr. ended 6/30/86): Assets, $8,400,325 (M); expenditures, $438,773, including $366,000 for 16 grants (high: $100,000; low: $5,000).
Purpose and activities: Emphasis on hospitals; support also for higher education, youth agencies, cultural activities, and social agencies.
Limitations: Giving primarily in IL. No grants to individuals.
Publications: Application guidelines.
Application information:
 Initial approach: Letter
 Copies of proposal: 2
 Board meeting date(s): May and Nov.
 Write: A.W. Murray, Secy.
Officer: A.W. Murray, Secy.
Trustees: Richard A. Beck, John A. Hutchings, Continental Illinois National Bank & Trust Co. of Chicago.
Employer Identification Number: 362417437

894
Warner Electric Foundation
449 Gardner St.
South Beloit 61080

Trust established in 1964 in IL.
Donor(s): Warner Electric Brake & Clutch Co.
Financial data (yr. ended 12/31/87): Assets, $413,212 (M); expenditures, $170,977, including $169,000 for 26 grants (high: $50,000; low: $100).
Purpose and activities: Giving for higher education, cultural programs, youth agencies, and social services.
Limitations: Giving primarily in Beloit, IL.
Application information:
 Initial approach: Letter
 Deadline(s): None
 Write: Frank E. Bauchiero, Trustee
Trustees: Frank E. Bauchiero, James A. Hartman.
Employer Identification Number: 366142884

895
Washington National Corporate Giving Program
1630 Chicago Ave.
Evanston 60201 (312) 570-5723

Purpose and activities: The company primarily supports economic development through education/training that enables self-sufficiency, especially among minorities and the economically disadvantaged, with emphasis on education, vocational training and employment, and health through organizations that promote wellness and disease prevention. Also supports programs for civic and community affairs, youth, education, culture, and social services. Types of support include employee volunteer programs and donations of in-kind services, materials, and equipment.
Types of support: General purposes, employee matching gifts, equipment, in-kind gifts.
Limitations: Giving primarily in communities where offices and agencies are located in AL, AZ, CA, CO, DC, IL, IN, MA, MO, NJ, NM, NY, PA, TX, and WI. No support for religious organizations whose programs are strictly religious; political organizations or causes; or discriminatory organizations. No grants for the same organization for more than three consecutive years (such organizations will not be considered again for two full budget years); courtesy advertising; fundraising events for organizations that have not received program funds from the company; health-related policy development or research projects; or non-tax-exempt organizations.
Publications: Application guidelines, grants list, program policy statement.
Application information: Include a written request, completed application form, and all required supplementary information. Application form required.
 Initial approach: The home office serves national organizations and Chicago-area organizations; field agents and employees serve organizations located in communities where company has field offices
 Write: Carolyn B. Laughlin, Public Affairs Mgr.

896

Howard L. Willett Foundation, Inc.
111 West Washington St., Rm. 2000
Chicago 60602 (312) 236-4787

Incorporated in 1973 in IL.
Donor(s): Howard L. Willett,† Howard L. Willett, Jr.†
Financial data (yr. ended 12/31/86): Assets, $3,872,738 (M); expenditures, $398,224, including $385,110 for 87 grants (high: $36,700; low: $200).
Purpose and activities: Emphasis on higher education, health agencies, support for the aged, secondary education and cultural organizations.
Limitations: Giving primarily in Chicago, IL.
Application information:
Initial approach: Letter
Deadline(s): None
Write: John R. Covington, Secy.
Officers and Directors: Frank C. Rathje, Pres.; Irwin W. Hart, V.P. and Treas.; Mrs. Gerald A. Spore, V.P.; Mrs. Howard L. Willett, Jr., V.P.; John R. Covington, Secy.; Arthur J. Bruen, Jr.
Employer Identification Number: 237311429

897

Winona Corporation
c/o Thomas A. Kelly
70 East Cedar St., Apt. 10-W
Chicago 60611

Established in 1965 in IL.
Donor(s): Marjorie M. Kelly.†
Financial data (yr. ended 12/31/87): Assets, $4,687,294 (M); expenditures, $394,462, including $340,100 for 58 grants (high: $20,000; low: $1,000).
Purpose and activities: Giving for cultural programs, and higher and pre-college education; some support for hospitals and social services.
Limitations: Giving primarily in IL.
Application information:
Initial approach: Proposal
Deadline(s): None
Write: Thomas A. Kelly, Secy.
Officers and Directors: Patricia K. Healy, Pres.; Marjorie K. Webster, V.P. and Treas.; Thomas A. Kelly, Secy.
Employer Identification Number: 366132949

898

Woods Charitable Fund, Inc.
Three First National Plaza, Suite 2010
Chicago 60602 (312) 782-2698
For applications from Nebraska: Pam Baker, P.O. Box 81309, Lincoln, NE 68501; Tel.: (402) 474-0707

Incorporated in 1941 in NE.
Donor(s): Frank H. Woods,† Nelle C. Woods,† Sahara Coal Co., Inc.
Financial data (yr. ended 12/31/88): Assets, $38,644,486 (M); expenditures, $2,920,722, including $2,473,799 for 167 grants (high: $100,000; low: $500; average: $10,000-$20,000).
Purpose and activities: Giving primarily to enhance life in Chicago and Lincoln, particularly for the most disadvantaged residents, and largely through citizens' community-based organizations and public interest groups. Interests in both cities include public policy, culture, and education; in Chicago emphasis on community organizing, public school reform, government accountability, and public policy as it affects families; giving in Lincoln for the arts and humanities, the family, historic preservation, and community improvement and leadership.
Types of support: Operating budgets, seed money, matching funds, special projects, research, renovation projects, consulting services, continuing support, technical assistance, general purposes.
Limitations: Giving primarily in the metropolitan Chicago, IL, and Lincoln, NE, areas. No support for medical or scientific research, religious activities, national health, welfare, educational, or cultural organizations or their state or local affiliates, or college or university programs that do not involve students and/or faculty in projects of benefit to the Chicago or Lincoln areas. In Lincoln, no support for capital projects in health care institutions or for government agencies or projects; in Chicago, no support for residential care, treatment programs, clinics, recreation programs, social services, or health care institutions. No grants to individuals, or for endowments, scholarships, fellowships, fundraising benefits, or program advertising; low priority is given to capital campaigns and capital projects.
Publications: Annual report, program policy statement, application guidelines.
Application information: Capital campaigns and projects considered only at Dec. meeting; Chicago arts proposals considered only at June meeting.
Initial approach: Telephone or letter
Copies of proposal: 1
Deadline(s): Apr. 15, July 15, Oct. 15 (Chicago)
Board meeting date(s): Mar. (Lincoln proposals only), June, Sept., and Dec.
Final notification: 1 week after board meeting
Write: Jean Rudd, Exec. Dir., or Ken Rolling (Chicago area); Pam Baker (Lincoln)
Officers: Thomas C. Woods, Jr.,* Pres.; George Kelm,* V.P.; Thomas C. Woods III,* V.P.; Charles N. Wheatley, Jr., Secy.-Treas.; Jean Rudd, Exec. Dir.
Trustees:* Sheila Griffin, Sokoni Karanja, Lucia Woods Lindley.
Number of staff: 4 full-time professional; 1 full-time support.
Employer Identification Number: 476032847
Recent arts and culture grants:
Chicago Office of Fine Arts, CityArts I, Chicago, IL, $50,000. For CityArts I grant payments to new and emerging arts organizations in Chicago. 6/21/88.
Lincoln Community Playhouse, Lincoln, NE, $7,500. For Childrens Theater seating and riser replacement. 12/16/87.
Lincoln Fine Arts Radio, Lincoln, NE, $15,000. For relocation of KUCV broadcast facilities to NETC. 9/14/88.
MoMing Dance and Arts Center, Chicago, IL, $10,000. For general operating support for 15-year-old dance and arts center. 6/21/88.
Museum of Contemporary Art, Chicago, IL, $15,000. Toward public awareness campaign to increase museum attendance, memberships and member participation. 6/21/88.
Nebraska Committee for the Humanities, Lincoln, NE, $16,000. For second year support for Humanities Resource Center operations. 12/16/87.
Northlight Theater, Evanston, IL, $15,000. For general operating support for performing arts theater. 6/21/88.
Omaha Magic Theater, Omaha, NE, $7,500. For development and performance of original play, Headlights, for audiences in Lincoln and Omaha. 9/14/88.
Pegasus Players, Chicago, IL, $30,000. For theater group active in community outreach in Uptown area. 6/21/88.
Remains Theater, Chicago, IL, $20,000. For multi-year support intended to provide stabilization funding for mid-sized performing arts group. 6/21/88.
Steppenwolf Theater Company, Chicago, IL, $30,000. For operating support. 6/21/88.
University of Mississippi, Center for the Study of Southern Culture, University, MS, $10,000. Toward production costs of Goin' to Chicago, documentary video about economic, social and cultural implications of 20th Century migration of three million black Americans from Mississippi Delta to Chicago. 9/14/88.
Whirlwind Performance Company, Chicago, IL, $5,000. For WHIRLWIND ALL-STARS, project to bring together talented grade school artists from Whirlwind's performing arts sessions in disadvantaged schools to prepare and produce city-wide performance. 6/21/88.
Wisdom Bridge Theater, Chicago, IL, $20,000. For continued support to provide some predictable funding for mid-sized theater. 6/21/88.

899

The Farny R. Wurlitzer Foundation
P.O. Box 387
Sycamore 60178 (815) 895-2923

Established about 1948; incorporated in 1962 in NY.
Donor(s): Farny R. Wurlitzer,† Grace K. Wurlitzer.†
Financial data (yr. ended 12/31/87): Assets, $2,891,063 (M); expenditures, $135,234, including $107,100 for 35 grants (high: $10,000; low: $600; average: $2,000-$5,000) and $2,500 for grants to individuals.
Purpose and activities: Support for music education and organizations, and higher education.
Types of support: Operating budgets, continuing support, annual campaigns, emergency funds, deficit financing, building funds, equipment, land acquisition, endowment funds, special projects, research, capital campaigns, general purposes.
Limitations: Giving primarily in IL and the Midwest. No grants to individuals, or for scholarship funds, fellowships, seed money, publications, or conferences; no loans.
Application information: No new scholarships to Wurlitzer Co. employees' children.
Initial approach: Proposal

Copies of proposal: 1
Deadline(s): Submit proposal preferably between Jan. and Mar. or between July and Sept.
Board meeting date(s): May and Nov.
Final notification: 90 days
Write: William A. Rolfing, Pres.
Officers and Directors: William A. Rolfing, Pres.; W.S. Turner, V.P. and Treas.; J.D. Ovitz, Secy.; H.L. Evans, H.L. Hollingsworth.
Number of staff: None.
Employer Identification Number: 166023172

INDIANA

900
Ameribank Charitable Foundation, Inc.
10434 Covington Rd.
Fort Wayne 46804

Financial data (yr. ended 12/31/88): Assets, $2,968 (M); gifts received, $300; expenditures, $2,335, including $2,325 for 4 grants (high: $2,000; low: $100).
Purpose and activities: Support for religious giving, and arts and culture.
Officers and Directors: Louis Gallucci, Pres.; Rita M. Gallucci, Secy.; Frank L. Gallucci, Frank L. Gallucci, Jr., Peter Gallucci, Sandra Gallucci.
Employer Identification Number: 351661379

901
American United Life Insurance Company Giving Program
One American Square
P.O. Box 368
Indianapolis 46206 (317) 263-1877

Financial data (yr. ended 12/31/87): Total giving, $516,000, including $495,000 for grants and $21,000 for employee matching gifts.
Purpose and activities: The company has three avenues of giving: American United Life Insurance Charitable Trust which terminates in 1991; AUL Foundation, and a direct giving program; interests include education, community development, culture, and civic and community affairs.
Types of support: Employee matching gifts.
Limitations: Giving primarily in headquarters city.
Application information: Include list of directors, IRS letter, and budget.
Initial approach: Letter
Write: Ron Fritz, Chair., Corp. Contribs. Comm.

902
The Arvin Foundation, Inc.
1531 East 13th St.
Columbus 47201 (812) 379-3000

Incorporated in 1951 in IN.
Donor(s): Arvin Industries, Inc.
Financial data (yr. ended 12/31/88): Assets, $1,815,796 (M); gifts received, $734,030; expenditures, $545,924, including $535,600 for 275 grants (high: $70,532; low: $50) and $6,500 for 5 grants to individuals.
Purpose and activities: Giving primarily for education and technical training; United Way agencies; youth organizations and youth affiliations; hospitals, medical centers, and organizations for disease research and control; police and fire departments and service organizations; and arts and sciences.
Types of support: General purposes, building funds, operating budgets, continuing support, equipment, special projects.
Limitations: Giving primarily in communities where the company is located. No grants to individuals, or for endowment funds, scholarships, fellowships, or matching gifts; no loans.
Publications: Annual report.
Application information:
Initial approach: 1- or 2-page letter
Copies of proposal: 1
Deadline(s): None
Board meeting date(s): May and Oct.; Contributions Committee meets approximately every 6 weeks
Write: W. Fred Meyer, V.P., Public Affairs
Officers and Directors: James K. Baker, Chair. and Pres.; W. Fred Meyer, V.P., Public Affairs; Martha J. Schrader, Secy.; Stanley R. Wheeler, Treas.; Clyde R. Davis, Loren K. Evans, Richard L. Hendricks, V. William Hunt, J. William Kendall, Charles H. Watson.
Number of staff: None.
Employer Identification Number: 356020798

903
Ayres Foundation, Inc.
Two West Washington St., Suite 807
Indianapolis 46204 (317) 633-1635

Incorporated in 1944 in IN.
Donor(s): L.S. Ayres and Co., Theodore B. Griffith,† Mrs. Theodore B. Griffith.†
Financial data (yr. ended 12/31/86): Assets, $1,476,971 (M); expenditures, $91,069, including $88,050 for 26 grants (high: $30,000; low: $100; average: $250-$1,000).
Purpose and activities: Giving for community funds, cultural activities, and higher education; also provides relief to needy company employees, ex-employees, and their dependents.
Types of support: Operating budgets, building funds, grants to individuals.
Limitations: Giving primarily in IN, with emphasis on Indianapolis. No grants to individuals (except for employee-related welfare).
Application information:
Initial approach: Brief proposal including proof of IRS tax-exempt status, financial data, and nature of request
Deadline(s): None

Write: John E.D. Peacock, Pres.
Officers and Directors: John E.D. Peacock, Pres.; Alvin C. Fernandes, Jr., V.P. and Secy.; Daniel F. Evans, V.P. and Treas.; Lyman S. Ayres, William J. Stout, David P. Williams III.
Number of staff: None.
Employer Identification Number: 356018437

904
Ball Brothers Foundation
222 South Mulberry St.
P.O. Box 1408
Muncie 47308 (317) 741-5500

Incorporated in 1926 in IN.
Donor(s): Edmund B. Ball,† Frank C. Ball,† George A. Ball,† Lucius L. Ball, M.D.,† William A. Ball.†
Financial data (yr. ended 12/31/87): Assets, $78,185,723 (M); gifts received, $1,520; expenditures, $3,396,630, including $2,499,228 for 58 grants (high: $1,500,000; low: $1,000; average: $1,000-$50,000).
Purpose and activities: Support for cultural programs, higher education, and social services.
Types of support: Matching funds, professorships, research, publications, conferences and seminars, special projects, annual campaigns, fellowships, internships, operating budgets, renovation projects, seed money, technical assistance.
Limitations: Giving limited to IN. No grants to individuals.
Publications: 990-PF, application guidelines.
Application information:
Initial approach: Letter or proposal
Copies of proposal: 1
Deadline(s): Submit proposal preferably before June; no set deadline
Board meeting date(s): Quarterly and as necessary
Final notification: Varies
Write: Douglas A. Bakken, Exec. Dir.
Officers: Edmund F. Ball,* Pres.; John W. Fisher,* V.P.; Reed D. Voran,* Secy.; Douglas J. Foy,* Treas.; Douglas A. Bakken, Exec. Dir.
Directors:* Frank E. Ball, Frank A. Bracken, Lucina B. Moxley, John J. Pruis, Richard M. Ringoen.
Number of staff: 1 full-time professional; 1 part-time professional; 1 full-time support; 1 part-time support.
Employer Identification Number: 350882856

905
Ball Corporate Giving Program
345 South High St.
Muncie 47305 (317) 747-6100

Purpose and activities: Supports education, including business, research and higher education, culture, public policy, literacy, engineering, the disadvantaged, minorities, United Way, and civic and community affairs.
Types of support: General purposes, matching funds, annual campaigns, employee matching gifts, internships, publications.
Limitations: Giving primarily in headquarters and major operating locations.
Publications: Newsletter.
Application information:
Write: Dr. Ann Swedeen, Mgr. Publ. Affairs
Number of staff: 1 part-time professional.

906
The Beardsley Foundation
302 East Beardsley Ave.
Elkhart 46514 (219) 264-0330

Trust established in 1955 in IN.
Donor(s): Walter R. Beardsley.†
Financial data (yr. ended 12/31/87): Assets, $4,000,000 (M); expenditures, $261,400, including $36,150 for 10 grants and $198,000 for 1 foundation-administered program.
Purpose and activities: A private operating foundation; giving primarily for a museum, cultural programs and social services.
Limitations: Giving primarily in IN.
Application information:
 Write: Richard C. Spaulding, Treas.
Officers and Directors: Robert B. Beardsley, Pres.; John F. Dille, Jr., V.P.; John R. Harman, Secy.; Richard C. Spaulding, Treas.; Dean A. Porter.
Number of staff: 1 full-time professional; 2 full-time support; 10 part-time support.
Employer Identification Number: 351170807

907
Joseph Cantor Foundation
11 South Meridian St., Suite 711
Indianapolis 46204

Established in 1952 in IN.
Donor(s): Joseph Cantor.†
Financial data (yr. ended 9/30/88): Assets, $164,699 (M); expenditures, $690,875, including $672,170 for 23 grants (high: $250,000; low: $100).
Purpose and activities: Support for cultural activities, Jewish welfare, and education; substantial grant to a business association.
Limitations: Giving primarily in Indianapolis, IN.
Application information: Applications not accepted.
 Deadline(s): None
 Write: Daniel Cantor, Trustee
Trustee: Daniel Cantor.
Employer Identification Number: 356041729

908
The Clowes Fund, Inc.
250 East 38th St.
Indianapolis 46205 (317) 923-3264

Incorporated in 1952 in IN.
Donor(s): Edith W. Clowes,† George H.A. Clowes,† Allen W. Clowes.
Financial data (yr. ended 12/31/87): Assets, $29,821,678 (M); expenditures, $1,334,659, including $1,207,000 for 35 grants (high: $250,000; low: $2,500; average: $5,000-$50,000).
Purpose and activities: Giving largely for higher and secondary education; the fine and performing arts, including maintenance of the Clowes Collection of Old Master Paintings in Clowes Pavillion; Indianapolis Museum of Art; music; and marine biology; support also for social services.
Types of support: Operating budgets, continuing support, building funds, endowment funds, scholarship funds, special projects, research.

Limitations: Giving primarily in Indianapolis, IN, and Boston, MA. No grants to individuals, or for publications or conferences; no loans.
Application information:
 Initial approach: Letter or proposal
 Copies of proposal: 2
 Deadline(s): Submit proposal between Sept. and Jan.; proposal must be received by the last business day of Jan. of each year
 Board meeting date(s): Annually, between Feb. 1 and June 1
 Final notification: 1 month after board meeting
 Write: Allen W. Clowes, Pres.
Officers and Directors: Allen W. Clowes, Pres. and Treas.; Margaret J. Clowes, V.P.; Thomas M. Lofton, Secy.; Margaret C. Bowles, Alexander W. Clowes, Byron P. Hollett, William H. Marshall.
Number of staff: 2 full-time professional; 1 part-time support.
Employer Identification Number: 351079679

909
Olive B. Cole Foundation, Inc.
3242 Mallard Cove Ln.
Fort Wayne 46804 (219) 436-2182

Incorporated in 1954 in IN.
Donor(s): Richard R. Cole,† Olive B. Cole.
Financial data (yr. ended 3/31/87): Assets, $17,097,669 (M); expenditures, $731,942, including $404,405 for 28 grants (high: $100,000; low: $250; average: $10,400) and $113,931 for 197 grants to individuals.
Purpose and activities: Grants largely for education, including student aid for graduates of Noble County high schools, hospitals, civic affairs, youth agencies, and cultural programs.
Types of support: Seed money, building funds, equipment, land acquisition, student aid, matching funds, program-related investments, general purposes, continuing support.
Limitations: Giving limited to the Kendallville, Noble County, area, and to LaGrange, Steuben, and DeKalb counties, IN. No grants for endowment funds or research; no loans.
Publications: Application guidelines, program policy statement.
Application information: Application form required.
 Initial approach: Letter
 Copies of proposal: 7
 Deadline(s): None
 Board meeting date(s): Feb., May, Aug., and Nov.
 Final notification: 4 months
 Write: John E. Hogan, Jr., Exec. V.P.
Officers and Directors: John N. Pichon, Jr., Pres.; John E. Hogan, Jr., Exec. V.P. and Treas.; Maclyn T. Parker, Secy.; Thomas Alberts, Robert Borger, Matt Dalton, Paul Schirmeyer.
Scholarship Administrator: Gwendlyn I. Tipton.
Number of staff: 1 full-time professional; 1 full-time support.
Employer Identification Number: 356040491

910
Cummins Engine Foundation
500 Jackson St.
Columbus 47201 (812) 377-3114
Mailing address: Box 3005, MC 60814, Columbus, IN 47202-3005

Incorporated in 1954 in IN.
Donor(s): Cummins Engine Co., Inc.
Financial data (yr. ended 12/31/88): Assets, $2,452,000 (M); expenditures, $3,379,806, including $2,686,774 for grants (high: $315,300), $80,650 for grants to individuals and $296,032 for employee matching gifts.
Purpose and activities: Giving focused primarily on local community needs, youth, civil rights and justice, education, the arts, and public policy, including an employee matching gift program and a company employee scholarship program; selected grants also for national and international needs which combine equal opportunity and excellence and reinforce local programs.
Types of support: Annual campaigns, conferences and seminars, continuing support, emergency funds, endowment funds, matching funds, operating budgets, publications, seed money, technical assistance, employee-related scholarships, special projects, employee matching gifts, general purposes.
Limitations: Giving primarily in areas of company operations, particularly the Columbus, IN, area. No support for denominational religious purposes. No grants to individuals (except scholarships for children of company employees).
Publications: Corporate giving report (including application guidelines).
Application information:
 Initial approach: Proposal or letter
 Copies of proposal: 1
 Deadline(s): None
 Board meeting date(s): Feb., July, Sept., and Dec.
 Final notification: 1 to 3 months
 Write: Adele J. Vincent, Assoc. Dir.
Officers and Directors: Ted L. Marston, Chair.; James A. Henderson, Vice-Chair.; Henry B. Schacht, Vice-Chair.; Richard B. Stoner, Vice-Chair.; Martha D. Lamkin, Pres.; George Fauerbach, Hanna H. Gray, Peter B. Hamilton, James A. Joseph, J. Irwin Miller, Kevin E. Sheehan, Theodore M. Solso, B. Joseph White, Philip E. Wilson.
Number of staff: 2 full-time professional; 1 part-time professional; 1 full-time support; 1 part-time support.
Employer Identification Number: 356042373
Recent arts and culture grants:
American Academy in Rome, NYC, NY, $15,000. To help institution complete its national membership campaign. 1987.
Cookeville, City of, Cookeville, TN, $5,000. For general support for Cookeville Arts Council. 1987.
Driftwood Valley Arts Council, Columbus, IN, $41,250. For general support for agency serving 31 local arts and cultural organizations and for artist-in-residence program. 1987.
Indiana University, Bloomington, IN, $57,781. For final year of project to strengthen teaching of writing in nine selected school districts in southeastern Indiana. Project is

directed by Indiana University professors but involves teachers and administrators in its planning and implementation. Each school district sent teachers to intensive summer institute, then received two years of follow-up guidance and support from Indiana University faculty. 1987.

Indiana University, Bloomington, IN, $13,000. For two programs in conjunction with major exhibition, William Wordsworth and the Age of Romanticism, at Indiana University Art Museum; summer workshop for area high school teachers; and international symposium at Indiana University to complement exhibition. 1987.

West Dallas Community Centers, Dallas, TX, $6,100. For expanding dance program for Black and Hispanic youngsters. 1987.

911
Arthur J. Decio Foundation
c/o Skyline Corp.
2520 By-Pass Rd.
Elkhart 46514

Established in 1970 in IN.
Donor(s): Arthur J. Decio.
Financial data (yr. ended 9/30/87): Assets, $2,539,333 (M); gifts received, $470,469; expenditures, $216,453, including $213,900 for 22 grants (high: $39,200; low: $100).
Purpose and activities: Emphasis on education, cultural programs, and health and social services.
Limitations: Giving primarily in IN.
Application information:
 Write: Ronald F. Kloska, Fdn. Mgr.
Trustees: Arthur J. Decio, Patricia C. Decio, Ronald F. Kloska, Andrew McKenna, Richard M. Treckelo.
Employer Identification Number: 237083597

912
English-Bonter-Mitchell Foundation
900 Fort Wayne National Bank Bldg.
Fort Wayne 46802

Established in 1972 in IN.
Donor(s): Mary Tower English, Louise Bonter, and others.
Financial data (yr. ended 12/31/87): Assets, $37,416,157 (M); gifts received, $1,756,816; expenditures, $2,163,965, including $2,009,500 for 56 grants (high: $155,000; low: $1,000).
Purpose and activities: Giving primarily for cultural programs and programs for youth; support also for higher education, hospitals, churches and religious organizations, social services, health, and community development.
Limitations: Giving primarily in Fort Wayne, IN.
Officer: Mary E. Mitchell, Board member.
Trustee: Fort Wayne National Bank.
Number of staff: None.
Employer Identification Number: 356247168

913
Enterprise Foundation, Inc.
c/o Lyall Electric, Inc.
P.O. Box 2000
Kendallville 46755-8000 (219) 547-0700

Donor(s): Lyall Electric, Inc., Custom Component Sales, Inc.
Financial data (yr. ended 12/31/87): Assets, $1,472,739 (M); gifts received, $500,000; expenditures, $62,910, including $58,600 for 6 grants (low: $100).
Purpose and activities: Giving primarily for fine arts, higher education, and child welfare projects.
Limitations: Giving primarily in northeast IN.
Application information:
 Deadline(s): None
 Write: Chester E. Dekko, Pres.
Officers: Chester E. Dekko, Pres.; Paul E. Shaffer, V.P.
Employer Identification Number: 351534381

914
Foellinger Foundation, Inc.
1125 Lincoln Bank Tower
116 East Berry St., Suite 1125
Fort Wayne 46802 (219) 422-2900

Incorporated in 1958 in IN.
Donor(s): Esther A. Foellinger,† Helene R. Foellinger,† News Publishing Co.
Financial data (yr. ended 8/31/88): Assets, $81,693,896 (M); gifts received, $57,820,669; expenditures, $1,659,110, including $1,097,518 for 82 grants (high: $100,000; low: $150; average: $10,000-$25,000).
Purpose and activities: Giving primarily for cultural organizations, higher education, parks and recreation, social services, and a community fund.
Types of support: Operating budgets, building funds, special projects, capital campaigns, conferences and seminars, consulting services, equipment, general purposes, land acquisition, matching funds, renovation projects, seed money.
Limitations: Giving primarily in the Fort Wayne, IN, area. Generally, no grants for religious groups or pre-college education. No grants to individuals, or generally, for endowments.
Publications: Annual report, program policy statement, application guidelines.
Application information:
 Initial approach: Letter or proposal
 Copies of proposal: 1
 Deadline(s): 90 days before funds needed
 Board meeting date(s): 3rd Thursday of each month
 Final notification: Varies, depending on request
 Write: Carl D. Rolfsen, Pres.
Officers and Directors: Ernest E. Williams, Chair.; Carl D. Rolfsen, Pres.; Walter P. Helmke, V.P.; Harry V. Owen, Treas.; Barbara Burt.
Number of staff: 2 full-time professional; 1 part-time professional.
Employer Identification Number: 356027059

915
Fort Wayne Community Foundation, Inc.
116 East Wayne St.
Fort Wayne 46802 (219) 426-4083

Community foundation incorporated in 1956 in IN.
Financial data (yr. ended 12/31/87): Assets, $3,426,709 (M); gifts received, $122,737; expenditures, $253,811, including $225,517 for 45 grants (high: $26,066; low: $100; average: $4,000-$5,000).
Purpose and activities: Discretionary grant-making preference given to "projects expected to generate substantial benefits for the greater Fort Wayne area," including capital projects, demonstration projects, and projects promoting effective management, efficient use of community resources or volunteer participation.
Types of support: Seed money, emergency funds, building funds, equipment, land acquisition, matching funds, consulting services, conferences and seminars, special projects, renovation projects.
Limitations: Giving primarily in Allen County, IN. No support for religious purposes, hospitals or medical research, or private schools;. No grants to individuals, or for operating budgets, continuing support, annual campaigns, deficit financing, endowment funds, technical assistance, fellowships, research, or publications; no loans.
Publications: Application guidelines, grants list, occasional report.
Application information:
 Initial approach: Proposal, letter, or telephone
 Copies of proposal: 1
 Deadline(s): None
 Board meeting date(s): Feb., May, Aug., and Nov.
 Final notification: 3 months
 Write: Mrs. Barbara Burt, Exec. Dir.
Staff: Barbara Burt, Exec. Dir.; Paul Clarke, Dir.-Special Projects; Joyce Schlatter, Dir.-Grants.
Number of staff: 1 full-time professional; 1 part-time professional.
Employer Identification Number: 351119450

916
The W. C. Griffith Foundation
c/o Merchants National Bank & Trust Co.
P.O. Box 5031
Indianapolis 46255 (317) 267-7281

Trust established in 1959 in IN.
Donor(s): William C. Griffith,† Ruth Perry Griffith.
Financial data (yr. ended 11/30/86): Assets, $5,171,803 (M); expenditures, $227,985, including $204,450 for 54 grants (high: $40,000; low: $250; average: $1,000).
Purpose and activities: Emphasis on hospitals, the arts, community funds, and higher and secondary education.
Limitations: Giving primarily in Indianapolis, IN. No grants to individuals, or for scholarships and fellowships.
Publications: 990-PF.
Application information:
 Initial approach: Letter
 Copies of proposal: 1

Deadline(s): None
Write: Mike Miner, V.P. and Trust Officer
Trustee: Merchants National Bank & Trust Co.
Advisors: Charles P. Griffith, Jr., W.C. Griffith, Jr., Walter Stuhr Griffith, William C. Griffith III.
Number of staff: None.
Employer Identification Number: 356007742

917
The Habig Foundation, Inc.
1600 Royal St.
Jasper 47546
Application address: P.O. Box 460, Jasper, IN 47546; Tel.: (812) 482-1600

Incorporated in 1951 in IN.
Donor(s): Kimball International, Inc.
Financial data (yr. ended 6/30/87): Assets, $512,929 (M); gifts received, $222,000; expenditures, $361,736, including $300,636 for 151 grants (high: $60,000; low: $25) and $59,480 for 33 grants to individuals.
Purpose and activities: Emphasis on higher education, including scholarships for children of company employees, civic affairs, church support, and cultural programs.
Types of support: Employee-related scholarships.
Limitations: Giving primarily in IN.
Application information: Application form required for scholarships.
Deadline(s): Apr. 1 for scholarships; none for grants
Write: Douglas A. Habig, Treas.
Officers and Directors: Arnold F. Habig, Chair.; Thomas L. Habig, Pres.; Maurice R. Kuper, V.P.; H.E. Thyen, Secy.; Douglas A. Habig, Treas.; Anthony P. Habig, John B. Habig, Leonard B. Marshall, Jr., Patricia H. Snyder, James C. Thyen, Ronald J. Thyen, Jack R. Wentworth.
Employer Identification Number: 356022535

918
Stanley W. Hayes Research Foundation, Inc.
P.O. Box 1404
801 Elks Rd.
Richmond 47374 (317) 962-4894

Incorporated in 1959 in IN.
Donor(s): Stanley W. Hayes.†
Financial data (yr. ended 6/30/87): Assets, $4,900,000 (M); expenditures, $303,920, including $4,750 for 14 grants.
Purpose and activities: Educational purposes; a private operating foundation which maintains the Hayes Regional Arboretum as a laboratory for ecological research by educational institutions, a source of regional flora for civic improvement, and a teaching center for biological sciences; some limited support for local cultural organizations, youth agencies, and other organizations interested in education about and preservation of Indiana plants.
Limitations: Giving limited to IN, particularly the Richmond area. No grants to individuals.
Publications: Program policy statement, application guidelines.
Application information: No grants over $500 considered. Application form required.
Initial approach: Letter

Copies of proposal: 2
Deadline(s): Between June 1 and Sept. 1
Board meeting date(s): Sept.
Final notification: Nov. 15
Write: Stephen H. Hayes, Pres.
Officers and Directors: Stephen H. Hayes, Pres. and Treas.; Edmund B. Hayes, V.P.; Robert E. McClure, Secy.; James B. Cope, Donald R. Hendricks, Patricia A. Mayer, William H. Reller.
Employer Identification Number: 351061111

919
Hayner Foundation
c/o Lincoln National Bank and Trust Co.
P.O. Box 9340
Fort Wayne 46899 (219) 461-6451

Established in 1966 in IN.
Donor(s): John F. Hayner.†
Financial data (yr. ended 12/31/87): Assets, $1,465,435 (M); expenditures, $87,268, including $76,520 for 12 grants (high: $38,325; low: $500).
Purpose and activities: Support for education, including health education services, and cultural activities.
Types of support: Operating budgets, continuing support, seed money, equipment, matching funds, general purposes, capital campaigns, renovation projects, scholarship funds.
Limitations: Giving limited to Allen County, IN. No grants to individuals, religious organizations, or endowment funds, deficit financing, land acquisition, fellowships, research, publications, or conferences; no loans.
Publications: 990-PF.
Application information:
Initial approach: Letter
Deadline(s): None
Board meeting date(s): Monthly
Final notification: 6 weeks
Write: Alice Kopfer, V.P.
Trustee: Lincoln National Bank and Trust Co. of Fort Wayne.
Number of staff: None.
Employer Identification Number: 356064431

920
Heritage Fund of Bartholomew County, Inc.
646 Franklin St.
Columbus 47201 (812) 376-7772
Application address: P.O. Box 1547, Columbus, IN 47202-1547

Community foundation established in 1977 in IN.
Financial data (yr. ended 12/31/87): Assets, $3,561,951 (M); gifts received, $102,935; expenditures, $217,219, including $129,105 for 16 grants (high: $48,000; low: $88; average: $4,000).
Purpose and activities: Giving for education, social services, health, hospitals, cultural programs, and civic affairs.
Types of support: Operating budgets, continuing support, seed money, emergency funds, deficit financing, building funds, equipment, land acquisition, matching funds, consulting services, technical assistance,

scholarship funds, program-related investments, special projects, research, publications, conferences and seminars, loans, capital campaigns, renovation projects.
Limitations: Giving primarily in Bartholomew County, IN. No grants to individuals, or for annual campaigns or endowment funds.
Publications: Annual report, newsletter, program policy statement, application guidelines.
Application information:
Initial approach: Letter of inquiry
Write: Edward F. Sullivan, Exec. Dir.
Officers and Directors: James E. Shipp, Chair. and Pres.; Joanne L. Sprouse, V.P.; J. Howard Beam, Secy.; David M. Kirr, Treas.; W. Calvert Brand, Robert N. Brown, Donald R. Buckman, George Doup, V. William Hunt, Nancy K. King, Bobbi Kroot, Mrs. Dean F. O'Connor, Henry B. Schacht.
Number of staff: 1 full-time professional; 2 part-time support.
Employer Identification Number: 351343903

921
Hook Drugs Foundation
2800 Enterprise St.
Indianapolis 46226

Established in 1969 in IN.
Donor(s): Hook Drugs, Inc.
Financial data (yr. ended 12/31/87): Assets, $1,022,088 (M); gifts received, $273,001; expenditures, $114,581, including $110,094 for 114 grants (high: $20,000; low: $25).
Purpose and activities: Giving to organizations involved in education, community, cultural, civic and health issues.
Application information:
Initial approach: Varies with nature of request; information available
Deadline(s): None
Write: Newell J. Hall
Officers and Directors: Newell J. Hall, Pres.; Kenneth Gaskins, V.P.; John J. Kelly, Treas.; Thomas Dingledy, Secy.; Thomas Cunningham, Gayl W. Doster, James Richter.
Employer Identification Number: 237046664

922
Indiana National Corporate Giving Program
One Indiana Square
Indianapolis 46266 (317) 266-6000

Financial data (yr. ended 12/31/86): $740,000 for grants (high: $5,000; low: $500; average: $0-$500).
Purpose and activities: Support for arts and culture, civic affairs, urban development, education, including business and minority education, health, and services involving homelessness and hunger. Donations include equipment, furniture, and use of company's goods or services.
Types of support: Annual campaigns, capital campaigns, emergency funds, employee matching gifts, equipment, general purposes, operating budgets, renovation projects, seed money, matching funds, endowment funds, building funds, special projects, publications, in-kind gifts.

Limitations: Giving primarily in headquarters city and major operating locations in central IN. No support for national organizations, political parties and candidates, religious organizations and primary or secondary educational institutions.
Publications: Informational brochure.
Application information: Proposal including descriptions of organization and project, project goals and budget, 501(c)(3), lists of board members and major donors, and organization's past and future budget .
 Initial approach: Letter and proposal
 Copies of proposal: 1
 Board meeting date(s): Quarterly
 Write: Jean M. Smith, 1st. V.P., Public Relations
Number of staff: 1 part-time professional; 1 part-time support.

923
The Indianapolis Foundation
615 North Alabama St., Rm. 119
Indianapolis 46204 (317) 634-7497

Community foundation established in 1916 in IN by resolution of trust.
Donor(s): James Proctor,† James E. Roberts,† Delavan Smith,† Charles N. Thompson,† Georgeanna Zumpfe.†
Financial data (yr. ended 12/31/88): Assets, $54,381,934 (M); gifts received, $4,862,058; expenditures, $2,589,205, including $2,406,427 for 72 grants (high: $335,500; low: $150; average: $4,000-$50,000).
Purpose and activities: Support for the areas of health, welfare, education, character building, and culture through grants for services to youth and children; health, hospitals, and the handicapped; family and neighborhood services; civic and cultural programs; research and community planning; and general education.
Types of support: Matching funds, program-related investments, seed money, general purposes, equipment, special projects, conferences and seminars, annual campaigns, emergency funds, renovation projects, capital campaigns.
Limitations: Giving limited to Indianapolis and Marion County, IN. No support for religious or sectarian purposes, elementary or secondary private schools, or sectarian pre-school or day care centers. No grants to individuals, or for endowment funds; no loans.
Publications: Annual report (including application guidelines), newsletter.
Application information:
 Initial approach: Telephone or letter
 Copies of proposal: 7
 Deadline(s): Submit proposal by last day of Jan., Mar., May, July, Sept., or Nov.
 Board meeting date(s): Feb., Apr., June, Aug., Oct., and Dec.
 Final notification: Immediately following meetings
 Write: Kenneth I. Chapman, Exec. Dir.
Officers and Trustees: Charles A. Pechette, Chair.; Matthew E. Welsh, Vice-Chair.; Howard S. Wilcox, Secy.; Rexford C. Early, Daniel R. Efroymson, Louis S. Hensley, Jr.
Trustee Banks: Ameritrust National Bank, Bank One, Indianapolis, N.A., First of America Bank,

The Huntington National Bank of Indiana, Indiana National Bank, Merchants National Bank & Trust Co., Peoples Bank & Trust Co.
Staff: Kenneth I. Chapman, Exec. Dir.
Number of staff: 2 full-time professional; 2 full-time support.
Employer Identification Number: 350868115
Recent arts and culture grants:
Indiana Opera Theater, Indianapolis, IN, $12,000. To support programming costs. 2/19/88.
Indiana Repertory Theater, Indianapolis, IN, $25,000. To support efforts to achieve long-term financial stability. 5/10/88.
Indiana State Museum Society, Indianapolis, IN, $10,000. For acquisition of Pottinger Collection of historic Indiana Amish quilts. 10/8/87.
Indiana Transportation Museum, Steam Division, Noblesville, IN, $10,470. To complete restoration of former Nickel Plate Road steam locomotive No. 587 for historical and educational reuse. 5/10/88.
Indianapolis Art League, Indianapolis, IN, $45,000. To develop and better utilize property at League site in Broad Ripple. 5/10/88.
Indianapolis Ballet Theater, Indianapolis, IN, $20,000. To update production components for its annual Nutcracker production. 5/10/88.
Indianapolis Opera Company, Indianapolis, IN, $12,000. To support programming costs. 2/19/88.
Indianapolis Project, Indianapolis, IN, $75,000. Toward costs of new City Center in Pan Am Plaza. 10/8/87.
Indianapolis Symphony Orchestra, Indianapolis, IN, $25,000. For concerts for grade school and high school students. 2/19/88.
Indianapolis Zoological Society, Indianapolis, IN, $150,000. To support campaign for New Zoo in White River Park. 2/19/88.
Phoenix Theater, Indianapolis, IN, $25,000. To carry out renovation project. 5/10/88.

924
Inland Container Corporation Foundation, Inc.
151 North Delaware St.
P.O. Box 925
Indianapolis 46206 (317) 262-0308

Incorporated in 1951 in IN.
Donor(s): Inland Container Corp., Temple-Inland, Inc.
Financial data (yr. ended 12/31/87): Assets, $7,315,000 (M); gifts received, $650,000; expenditures, $593,900, including $375,307 for 321 grants (high: $34,000; low: $100; average: $500) and $93,000 for grants to individuals.
Purpose and activities: Emphasis on community funds and education; grants also for cultural programs and youth agencies.
Types of support: Employee-related scholarships, annual campaigns, continuing support, general purposes, operating budgets, special projects.
Limitations: Giving primarily in areas of plant locations. No support for religious organizations for sectarian purposes. No grants for building or endowment funds; individual

scholarship grants are only for the children of company employees.
Publications: Application guidelines.
Application information: Scholarships are only for the children of Inland Container Corp. employees; only eligible applicants should apply.
 Initial approach: Letter
 Copies of proposal: 1
 Deadline(s): Submit proposal in Sept. or Oct.; deadline Oct. 15
 Board meeting date(s): June and Dec.
 Write: Frank F. Hirschman, Pres.
Officers and Directors: Frank F. Hirschman, Pres.; J.M. Areddy, V.P.; D.J. Harrison, V.P.; Ben J. Lancashire, V.P.; P.A. Foley, Secy.-Treas.
Employer Identification Number: 356014640

925
Irwin-Sweeney-Miller Foundation
420 Third St.
P.O. Box 808
Columbus 47202 (812) 372-0251

Incorporated in 1952 in IN.
Donor(s): Members of the Irwin, Sweeney, and Miller families.
Financial data (yr. ended 12/31/88): Assets, $578,329 (L); expenditures, $855,063, including $703,200 for 60 grants (high: $286,014; low: $90; average: $500-$10,000).
Purpose and activities: Support for creative programs in social justice, education, religion, the arts, and improving family stability; giving for the disadvantaged, child welfare, social services, and community development.
Types of support: Annual campaigns, building funds, capital campaigns, conferences and seminars, consulting services, continuing support, emergency funds, endowment funds, exchange programs, general purposes, land acquisition, matching funds, operating budgets, program-related investments, renovation projects, seed money, special projects, technical assistance.
Limitations: Giving primarily in the Columbus, IN, area for new funding. No grants to individuals, or for deficit financing, research, scholarships, or fellowships; no loans.
Publications: Biennial report.
Application information:
 Initial approach: Letter with proposal
 Copies of proposal: 1
 Deadline(s): Mar. 1 and Sept. 1
 Board meeting date(s): Apr. and Oct.
 Final notification: 1 month
 Write: Sarla Kalsi, Exec. Dir.
Officers and Directors: Clementine M. Tangeman, Chair.; Richard B. Stoner, Pres.; Sarla Kalsi, V.P., Treas., and Exec. Dir.; Susan Ingmire, Secy.; John F. Dorenbusch, Lynne M. Maguire, Katherine T. McLeod, Robert Alan Melting, Catherine G. Miller, Elizabeth G. Miller, Hugh Thomas Miller, J. Irwin Miller, Margaret I. Miller, William I. Miller, Xenia S. Miller, George W. Newlin, Jonathan D. Schiller, Carolyn S. Tangeman, John Tangeman.
Number of staff: 1 full-time professional; 1 full-time support.
Employer Identification Number: 356014513
Recent arts and culture grants:
Commons, The, Columbus, IN, $532,261. For operating expenses of community cultural

and activities center located in downtown area. 1987.

Commons, The, Columbus, IN, $6,240. For major repairs and maintenance. 1987.

Driftwood Valley Arts Council, Columbus, IN, $36,500. For general support. 1987.

Indiana University Foundation, School of Music, Bloomington, IN, $60,000. For Campaign for Indiana. 1987.

926
Arthur Jordan Foundation
1230 North Delaware St.
Indianapolis 46202 (317) 635-1378

Trust established in 1928 in IN.
Donor(s): Arthur Jordan.†
Financial data (yr. ended 12/31/86): Assets, $9,111,020 (M); expenditures, $550,377, including $435,200 for 44 grants (high: $125,000; low: $250; average: $5,000-$10,000).
Purpose and activities: Giving primarily for private colleges and universities and fine arts.
Types of support: Operating budgets, general purposes, continuing support, annual campaigns, building funds, matching funds, capital campaigns.
Limitations: Giving limited to Marion County, IN. No support for medical research. No grants to individuals, or for endowment funds, research, scholarships, or fellowships; no loans.
Publications: Application guidelines.
Application information:
 Initial approach: Letter
 Copies of proposal: 3
 Deadline(s): Submit proposal preferably in Apr. or Oct.; deadlines May 1 and Nov. 1
 Board meeting date(s): May and Nov.
 Final notification: 30 days
 Write: Margaret F. Sallee, Admin. Asst.
Officers: Richard A. Steele,* Chair.; Eugene M. Busche,* Vice-Chair.; Fred C. Tucker, Jr., Secy.; Andrew J. Paine, Treas.; Margaret F. Sallee, Admin. Asst.
Trustees:* Richard B. DeMars, Boris E. Meditch.
Number of staff: 1 part-time professional.
Employer Identification Number: 350428850

927
Journal Gazette Foundation, Inc.
701 South Clinton
Fort Wayne 46802 (219) 461-8202

Established in 1985 in IN.
Donor(s): Journal-Gazette Co., Richard G. Inskeep.
Financial data (yr. ended 12/31/87): Assets, $1,195,296 (M); gifts received, $708,150; expenditures, $236,550, including $236,508 for 80 grants (high: $200,000; low: $100).
Purpose and activities: Support for social services, youth, cultural organizations, and health services.
Types of support: Operating budgets.
Limitations: Giving primarily in northeastern IN.
Application information: Application form required.
 Deadline(s): None
 Write: Richard G. Inskeep, Pres.

Officers and Directors: Richard G. Inskeep, Pres.; Jerry D. Fox, Secy.-Treas.; Marian Abromson, Harriet J. Inskeep, Julia Inskeep Walda.
Employer Identification Number: 311134237

928
E. H. Kilbourne Residuary Charitable Trust
c/o Lincoln National Bank Trust Dept.
P.O. Box 9340
Fort Wayne 46899 (219) 461-6451

Trust established in IN.
Donor(s): Edgar Kilbourne.†
Financial data (yr. ended 1/31/88): Assets, $6,036,494 (M); expenditures, $526,863, including $242,681 for 30 grants (high: $19,488; low: $500) and $211,575 for 120 grants to individuals.
Purpose and activities: Giving for higher education, including scholarships for graduating high school seniors, youth agencies, health and social services, and the arts.
Types of support: Student aid, capital campaigns, equipment, general purposes.
Limitations: Giving limited to Allen County, IN. No grants to individuals (except for scholarships to local, graduating high school seniors), or for endowment funds, research, publications, or conferences; no loans.
Publications: 990-PF, application guidelines.
Application information: Application form required.
 Initial approach: Letter
 Deadline(s): Apr. 15 for scholarships
 Board meeting date(s): May for scholarships; monthly for other grants
 Final notification: 6 weeks
 Write: Alice Kopfer, V.P.
Trustee: Lincoln National Bank and Trust Co. of Fort Wayne.
Number of staff: None.
Employer Identification Number: 356332820

929
George Koch Sons Foundation, Inc.
10 South 11th Ave.
Evansville 47744

Incorporated in 1945 in IN.
Donor(s): Gibbs Die Casting Aluminum Corp., George Koch Sons, Inc.
Financial data (yr. ended 12/31/87): Assets, $4,556,527 (M); gifts received, $220,000; expenditures, $282,447, including $266,596 for 46 grants (high: $150,328; low: $100).
Purpose and activities: Emphasis on relief for needy families designated by charitable institutions; grants also to cultural and educational institutions, museums, churches, and youth camps, with particular emphasis on underprivileged children.
Limitations: Giving limited to IN, with emphasis on the Evansville-Vanderburgh County area.
Application information:
 Write: Robert L. Koch, II, Secy.
Officers and Directors: Robert L. Koch, Pres. and Treas.; Robert L. Koch II, V.P. and Secy.; James H. Muehlbauer, V.P.
Number of staff: None.
Employer Identification Number: 356023372

930
Kuehn Foundation
P.O. Box 207
Evansville 47702

Established in 1968 in IN.
Financial data (yr. ended 12/31/87): Assets, $2,658,448 (M); gifts received, $6,500; expenditures, $167,881, including $159,570 for 38 grants (high: $70,000; low: $200).
Purpose and activities: Giving largely for higher and secondary education, museums, cultural affairs, and youth activities.
Limitations: Giving primarily in IN.
Trustees: Mary Catherine Powell, Chair.; George E. Powell, Jr., Vice-Chair.; Nicholas K. Powell, Secy.; Peter E. Powell, Richardson K. Powell.
Employer Identification Number: 237021199

931
Lassus Brothers Oil, Inc. Foundation
4600 West Jefferson St.
Fort Wayne 46804

Financial data (yr. ended 9/30/88): Assets, $23,090 (M); gifts received, $12,000; expenditures, $6,700, including $6,700 for 22 grants (high: $1,250; low: $25).
Purpose and activities: Support for social services, community funds, arts, youth, and education.
Limitations: Giving primarily in Fort Wayne, IN.
Trustee: Jon F. Lassus.
Employer Identification Number: 311190500

932
Leighton-Oare Foundation, Inc.
112 West Jefferson Blvd., Suite 603
South Bend 46601

Incorporated in 1955 in IN.
Donor(s): Mary Morris Leighton.
Financial data (yr. ended 12/31/86): Assets, $10,451,121 (M); expenditures, $269,096, including $259,036 for 43 grants (high: $60,000; low: $25).
Purpose and activities: Emphasis on higher education and health; grants also for the arts and community funds.
Types of support: Continuing support.
Limitations: Giving primarily in IN. No grants to individuals, or for capital, endowment or emergency funds, operating budgets, annual campaigns, seed money, deficit financing, matching gifts, scholarships, or fellowships; no loans.
Publications: 990-PF.
Application information:
 Initial approach: Letter
 Deadline(s): None
 Board meeting date(s): Feb., May, Aug., and Nov.
 Final notification: 90 to 120 days
 Write: Judd C. Leighton, Secy.-Treas.
Officers and Directors: Mary Morris Leighton, Pres.; James F. Thornburg, V.P.; Judd C. Leighton, Secy.-Treas.
Number of staff: None.
Employer Identification Number: 356034243

933
Eli Lilly and Company Foundation
Lilly Corporate Ctr.
Indianapolis 46285 (317) 276-5342

Incorporated in 1968 in IN.
Donor(s): Eli Lilly and Co.
Financial data (yr. ended 12/31/88): Assets,
$9,278,926 (M); gifts received, $14,000,000;
expenditures, $5,741,253, including
$4,665,114 for 192 grants (high: $1,272,712;
low: $220; average: $1,000-$100,000) and
$1,055,381 for 2,150 employee matching gifts.
Purpose and activities: Giving primarily for
health, civic and cultural activities, and
education, including higher education.
Types of support: General purposes, operating
budgets, building funds, land acquisition,
fellowships, annual campaigns, capital
campaigns, employee matching gifts, matching
funds.
Limitations: Giving primarily in Indianapolis,
IN, and other areas of company operations.
No grants to individuals, or for endowment
funds, special projects, research, publications,
or conferences; no loans.
Application information:
Initial approach: Proposal
Copies of proposal: 1
Deadline(s): None
Board meeting date(s): Quarterly
Final notification: 3 weeks to 3 months
Write: Carol Edgar, Secy.
Officers: Vaughn D. Bryson,* Pres.; Michael S.
Hunt, V.P. and Treas.; Carol Edgar, Secy.
Directors:* James M. Cornelius, Earl B. Herr,
Jr., Mel Perelman, Eugene L. Step, Richard D.
Wood.
Number of staff: 1 full-time professional; 2 full-
time support.
Employer Identification Number: 356202479

934
Lilly Endowment Inc.
2801 North Meridian St.
P.O. Box 88068
Indianapolis 46208 (317) 924-5471

Incorporated in 1937 in IN.
Donor(s): J.K. Lilly, Sr.,† Eli Lilly,† J.K. Lilly, Jr.†
Financial data (yr. ended 12/31/88): Assets,
$2,141,490,142 (M); expenditures,
$87,273,570, including $78,849,207 for grants
(high: $9,100,000; low: $1,500; average:
$10,000-$250,000), $539,043 for 85 grants to
individuals and $262,785 for 224 employee
matching gifts.
Purpose and activities: Support for religion,
education, and community development, with
special concentration on programs that benefit
youth, develop leadership, and help develop
state of the art fundraising to make nonprofit
organizations become more self-sustaining.
Giving emphasizes charitable organizations that
depend on private support, with a limited
number of grants to government institutions
and tax-supported programs. Also supports
limited grant program in economic education
and public policy research.
Types of support: Seed money, research,
fellowships, matching funds, special projects,
conferences and seminars, employee matching
gifts, scholarship funds, student aid.

Limitations: Giving limited to IN, especially
Indianapolis, for community development
projects (including the arts, capital building
funds, community leadership, social services),
elementary and secondary education,
undergraduate scholarship funds, and social
services; national giving in religion, youth,
leadership, and fund-raising research; higher
education programs geographically targeted on
a regional or invitational basis; no international
projects except for a small number of
developmental and informational projects
mostly in central America. Generally, no
support for health care and biological science
projects, or mass media projects. No grants to
individuals, except for fellowships awarded
under a few fellowship or grant programs
associated with specific groups of academic
institutions. Undergraduate scholarship
assistance limited to IN residents attending IN
institutions.
Publications: Annual report, informational
brochure (including application guidelines),
program policy statement, application
guidelines, occasional report.
Application information: Religion, higher
education and philanthropy grants primarily
national. Elementary and secondary
education/youth grants generally confined to
Indiana. Trusteeship/leadership education -
research at the national level, education
programs primarily limited to Indiana.
Community development concentrated chiefly
in Indianapolis, then in Indiana. Public policy
and economics research generally national in
scope.
Initial approach: 1- or 2-page letter
Copies of proposal: 1
Deadline(s): None
Board meeting date(s): Feb., Apr., June,
Sept., and Nov.; executive committee
meets in Mar., May, July, Oct., and Dec.
Final notification: 3 to 6 months
Write: John M. Mutz, Pres.
Officers: John M. Mutz, Pres.; Craig R.
Dykstra, Sr. V.P., Religion; William C. Bonifield,
V.P., Education; Michael A. Carroll, V.P.,
Community Development; Charles A. Johnson,
V.P., Development; William M. Goodwin,
Secy.-Treas.
Directors: Thomas H. Lake, Chair.; Otis R.
Bowen, M.D., Rev. William G. Enright, Byron
P. Hollett, Eli Lilly II, Eugene F. Ratliff, Margaret
Chase Smith, Herman B. Wells, Richard D.
Wood.
Number of staff: 18 full-time professional; 2
part-time professional; 21 full-time support.
Employer Identification Number: 350868122
Recent arts and culture grants:
Arts Indiana, Indianapolis, IN, $46,500. For
support for publishing capacity. 12/10/87.
Beethoven Foundation, Indianapolis, IN,
$50,000. For national public relations
campaign. 3/17/88.
Bethune Museum and Archives, DC, $25,000.
To plan history of black church women.
12/10/87.
Booth Tarkington Civic Theater of Indianapolis,
Indianapolis, IN, $50,000. For general
support and marketing program. 5/19/88.
Childrens Museum of Indianapolis, Indianapolis,
IN, $369,777. For continuation of Lilly
Endowment Leadership Education Program.
2/18/88.

Circus City Festival, Peru, IN, $20,000. For
organizational creativity and renewal awards
for youth serving agencies. 4/21/88.
Duke University, Durham, NC, $77,200. For
study of black sacred music. 10/15/87.
Eiteljorg Museum of the American Indian and
Western Art, Indianapolis, IN, $1,500,000.
For general operating support. 4/21/88.
Firefighters Museum and Survive Alive,
Indianapolis, IN, $100,000. For restoration of
historic fire station for use in children's fire
safety education program. 12/10/87.
Historic New Harmony, New Harmony, IN,
$150,000. For general support. 4/21/88.
Indiana Black Expo, Indianapolis, IN, $150,000.
For general support and strategic plan
implementation. 2/18/88.
Indiana Opera Society, Indianapolis, IN,
$150,000. For program support. 9/17/87.
Indiana Repertory Theater, Indianapolis, IN,
$450,000. For general support. 11/19/87.
Indiana University Foundation, Bloomington,
IN, $10,000. For National Childrens Theater
Playwriting Competition and Symposium.
5/19/88.
Indianapolis Art League Foundation,
Indianapolis, IN, $50,000. For improvement
of financial management. 12/10/87.
Indianapolis Childrens Choir, Indianapolis, IN,
$38,000. For general program support.
3/17/88.
Indianapolis Museum of Art, Indianapolis, IN,
$3,500,000. For capital expansion program.
9/17/87.
Indianapolis Museum of Art, Indianapolis, IN,
$1,000,000. For challenge grant for current
budget. 9/17/87.
Madame Walker Building Urban Life Center,
Indianapolis, IN, $20,000. For Youth in Arts
program. 7/21/88.
Midtown Economic Development and
Industrial Corporation, Indianapolis, IN,
$20,000. For sculpture in renovated
neighborhood. 12/10/87.
Minnesota Orchestral Association, Minneapolis,
MN, $52,500. For planned giving research
project. 10/15/87.
Museum of Indian Heritage, Indianapolis, IN,
$102,486. For program support. 11/19/87.
National Federation of State Humanities
Councils, DC, $49,937. For fundraising
training and implementation for state
humanities councils. 3/17/88.
Phoenix Theater, Indianapolis, IN, $30,000. For
support of marketing program. 3/17/88.

935
Merlin J. Loew Charitable Trust
300 West Third St., P.O. Box 899
Marion 46925 (317) 664-9041

Established in 1981 in IN.
Financial data (yr. ended 8/31/88): Assets,
$1,451,876 (M); expenditures, $167,641,
including $119,631 for 12 grants (high:
$58,579; low: $500; average: $500-$58,579).
Purpose and activities: Support for a world
gospel mission, educational institutions, youth
and social service agencies, and the performing
arts.
Types of support: Emergency funds, general
purposes, operating budgets.

Limitations: Giving limited to charitable organizations in Grant County, IN.
Publications: Annual report.
Application information:
Initial approach: Letter
Copies of proposal: 2
Deadline(s): None
Board meeting date(s): July 1
Final notification: Sept.
Write: George P. Osborn, Trustee
Trustees: George P. Osborn, Bank One.
Employer Identification Number: 566223270

936
The Martin Foundation, Inc.
500 Simpson Ave.
Elkhart 46515 (219) 295-3343

Incorporated in 1953 in IN.
Donor(s): Ross Martin, Esther Martin,† Lee Martin, Geraldine F. Martin, NIBCO, INC.
Financial data (yr. ended 6/30/88): Assets, $23,989,585 (M); expenditures, $1,461,121, including $1,086,279 for 87 grants (high: $310,000; low: $250; average: $500-$25,000).
Purpose and activities: Emphasis on education, particularly higher education, and social services, including programs for women, youth, and problems of drug abuse; support also for environmental and conservation organizations, cultural programs, hospitals and hospices, and international development.
Types of support: Capital campaigns, seed money, continuing support, special projects, emergency funds, equipment, general purposes, matching funds, operating budgets, publications, renovation projects.
Limitations: Giving limited to Elkhart and South Bend, IN. No grants to individuals.
Application information:
Deadline(s): None
Board meeting date(s): As required
Final notification: 3 to 6 weeks
Write: Geraldine F. Martin, Pres.
Officers and Directors: Geraldine F. Martin, Pres.; Elizabeth Martin, Secy.; Jennifer Martin, Treas.; Casper Martin, Lee Martin.
Number of staff: None.
Employer Identification Number: 351070929

937
Mead Johnson & Company Foundation, Inc.
2404 West Pennsylvania St.
Evansville 47721 (812) 429-6400

Incorporated in 1955 in IN.
Donor(s): Mead Johnson & Co.
Financial data (yr. ended 12/31/87): Assets, $2,590,708 (M); gifts received, $1,420,834; expenditures, $658,605, including $528,416 for 95 grants (high: $100,000; low: $300), $24,000 for 8 grants to individuals and $103,851 for employee matching gifts.
Purpose and activities: Giving largely for higher education, including scholarships (for children of employees or administered by university only) and employee matching gifts, and for community funds, cultural activities, health services, and youth agencies.
Types of support: Employee-related scholarships, employee matching gifts,

scholarship funds, annual campaigns, seed money, emergency funds, deficit financing, building funds, equipment, land acquisition, renovation projects, continuing support.
Limitations: Giving primarily in Evansville, IN. No grants to individuals (except scholarships to children of employees), or for endowment funds or research; no loans.
Application information:
Initial approach: Letter
Copies of proposal: 1
Deadline(s): Submit proposal preferably in July and Aug.
Board meeting date(s): Apr. and as required
Final notification: 2 months
Write: Rolland M. Eckels, Pres.
Officers: Rolland M. Eckels, Pres.; W.A. Davidson, Exec. V.P.; Edward F. Hassee, V.P. and Treas.; Raymond C. Egan, V.P.; Joel M. Lasker, Secy.
Number of staff: 1 part-time professional; 1 part-time support.
Employer Identification Number: 356017067

938
Newman Charitable Foundation, Inc.
c/o National City Bank, Trust Dept.
P.O. Box 868
Evansville 47705-0868

Financial data (yr. ended 12/31/87): Assets, $1,153,552 (M); expenditures, $44,758, including $38,450 for 9 grants (high: $10,000; low: $250).
Purpose and activities: Primarily supports health care facilities and programs, an orchestra, and a home for neglected children.
Trustee: National City Bank.
Employer Identification Number: 311018001

939
Northern Indiana Public Service Company Giving Program
5265 Hohman Ave.
Hammond 46320 (219) 853-5200

Financial data (yr. ended 12/31/88): $567,000 for grants (high: $10,000; low: $5,000).
Purpose and activities: Supports energy assistance funds, education, health, hospitals, hospital building funds, mental health, cultural programs, social welfare, arts and sciences, and civic and community affairs including youth programs.
Types of support: Building funds, capital campaigns, general purposes, matching funds, renovation projects, research, grants to individuals, special projects.
Limitations: Giving primarily in operating areas. No support for religious organizations, religious purposes, or agencies not serving company operating locations. No grants to individuals or political candidates.
Publications: Corporate report.
Application information: Include description and goal of organization and project; 501(c)(3) status letter.
Initial approach: Proposal
Deadline(s): None
Write: Jack W. Stine, Exec. V.P. and C.O.O.
Number of staff: None.

940
Nicholas H. Noyes, Jr. Memorial Foundation, Inc.
Lilly Corporate Ctr.
Indianapolis 46285 (317) 276-3171

Incorporated in 1951 in IN.
Donor(s): Nicholas H. Noyes,† Marguerite Lilly Noyes.†
Financial data (yr. ended 12/31/87): Assets, $14,257,854 (M); expenditures, $625,573, including $586,000 for 51 grants (high: $50,000; low: $500).
Purpose and activities: Giving for higher and secondary education, museums and cultural programs, a community fund, church support, hospitals, and youth agencies.
Types of support: Operating budgets, endowment funds, scholarship funds, matching funds.
Limitations: Giving primarily in IN. No grants to individuals, or for building funds; no loans.
Application information:
Initial approach: Proposal
Copies of proposal: 1
Deadline(s): None
Board meeting date(s): Semiannually
Write: James M. Cornelius, Asst. Treas.
Officers: A. Malcolm McVie,* Pres.; Frederic D. Anderson,* V.P.; Evan L. Noyes, Jr., Secy.-Treas.; David L. Chambers, Jr.
Directors:* Janet Noyes Adams, Frederic M. Ayres, Janet A. Carrington, Nicholas S. Noyes, Robert H. Reynolds.
Employer Identification Number: 351003699

941
Cornelius O'Brien Foundation, Inc.
One Indiana Sq., No. 733
Indianapolis 46266 (317) 266-6247

Established around 1969 in IN.
Financial data (yr. ended 11/30/87): Assets, $1,726,938 (M); expenditures, $114,657, including $79,500 for 9 grants (high: $20,000; low: $500).
Purpose and activities: Grants primarily for historical societies, historic preservation, and higher education.
Limitations: Giving primarily in southeast IN and Washington, DC.
Application information:
Initial approach: Proposal
Deadline(s): None
Board meeting date(s): Oct.
Write: Robert H. Everitt
Officers: Mary O'Brien Gibson, Pres. and Treas.; John Timberlake Gibson, V.P. and Secy.
Employer Identification Number: 237025303

942
Old National Bank Charitable Trust
c/o Old National Bank in Evansville
P.O. Box 207
Evansville 47702 (812) 464-1397

Established in 1957 in IN.
Donor(s): Old National Bank in Evansville.
Financial data (yr. ended 12/31/87): Assets, $804,879 (M); gifts received, $129,413; expenditures, $134,438, including $133,629 for 19 grants (high: $45,939; low: $500).

Purpose and activities: Giving for cultural programs, higher and other education, social services, health associations, and hospitals.
Types of support: Capital campaigns.
Limitations: Giving primarily in Evansville, IN.
Application information:
Initial approach: Letter
Copies of proposal: 1
Deadline(s): None
Board meeting date(s): Mar.
Write: M. H. Sunderman
Trustees: Daniel W. Mitchell, Richard A. Schlottman, Old National Bank in Evansville.
Employer Identification Number: 356015583

943
The Plumsock Fund
9292 North Meridian St., Suite 312
Indianapolis 46260

Incorporated in 1959 in IN.
Donor(s): Evelyn L. Lutz,† Herbert B. Lutz, Sarah L. Lutz.
Financial data (yr. ended 12/31/87): Assets, $2,996,608 (M); gifts received, $367,000; expenditures, $542,596, including $389,550 for 80 grants (high: $127,500; low: $50).
Purpose and activities: Giving for cultural programs, higher and secondary education, anthropology, youth agencies, and welfare and health agencies, with some emphasis on Central America.
Limitations: No grants to individuals, or for scholarships or fellowships; no loans.
Application information:
Initial approach: Letter
Copies of proposal: 3
Deadline(s): None
Board meeting date(s): Annually and as required
Write: John G. Rauch, Jr., Secy.-Treas.
Officers and Directors: Edwin Fancher, Pres.; Daniel A. Wolf, V.P.; John G. Rauch, Jr., Secy.-Treas.; Christopher H. Lutz.
Employer Identification Number: 356014719

944
Rock Island Refining Foundation
5000 West 86th St.
P.O. Box 68007
Indianapolis 46268 (317) 872-3200

Established in 1973.
Financial data (yr. ended 11/30/88): Assets, $1,686,675 (M); expenditures, $117,905, including $114,883 for 60 grants (high: $45,200; low: $200).
Purpose and activities: Emphasis on community funds, health and hospitals, higher education, culture and the arts, and youth agencies.
Limitations: Giving primarily in IN.
Application information:
Initial approach: Letter
Deadline(s): None
Write: Jerry Davis
Trustees: John D. Cochran, F.W. Grube, William E. Huff.
Employer Identification Number: 356264479

945
Byron H. Somers Foundation
5814 Reed Rd.
Fort Wayne 46835

Established in 1977.
Financial data (yr. ended 11/30/86): Assets, $4,161,189 (M); expenditures, $222,489, including $210,425 for 8 grants (high: $105,900; low: $2,900).
Purpose and activities: Emphasis on youth agencies, education, and cultural programs.
Limitations: Giving limited to IN.
Trustees: Norman S. Baker, Druscilla S. Doehrman, Robert W. Gibson.
Employer Identification Number: 351410969

946
Thirty Five Twenty, Inc.
7440 North Shadeland
Indianapolis 46250 (317) 842-0880

Incorporated in 1965 in IN.
Donor(s): Enid Goodrich.
Financial data (yr. ended 4/30/88): Assets, $1,659,673 (M); expenditures, $85,085, including $57,000 for 7 grants (high: $20,000; low: $3,500).
Purpose and activities: "To further educational activities which concern themselves with human liberty and individual freedom within a free society"; grants largely for higher education and cultural programs.
Types of support: Operating budgets, continuing support, special projects.
Limitations: No grants to individuals, or for annual campaigns, seed money, emergency funds, deficit financing, capital or endowment funds, scholarships, fellowships, matching gifts, research, demonstration projects, publications, or conferences; no loans.
Application information:
Initial approach: Letter
Copies of proposal: 1
Deadline(s): Submit proposal preferably in Mar.; deadline Apr. 1
Board meeting date(s): Apr. and Sept.
Final notification: 1 to 2 weeks if denied; after April meeting if favorable
Write: W.W. Hill, Chair. and C.E.O.
Officers and Directors: W.W. Hill, Pres. and Treas.; Enid Goodrich, Vice-Chair.; Helen W. Garlotte, Secy.; Ruth E. Connolly, Ralph W. Husted, Chris L. Talley.
Number of staff: 2 part-time professional.
Employer Identification Number: 356056960

947
Thrush-Thompson Foundation, Inc.
(Formerly H. A. Thrush Foundation, Inc.)
P.O. Box 185
Peru 46970

Incorporated in 1936 in DE.
Donor(s): Homer A. Thrush.†
Financial data (yr. ended 7/31/87): Assets, $3,199,361 (M); expenditures, $150,904, including $123,235 for 48 grants.
Purpose and activities: Emphasis on higher education, youth agencies, Protestant church support, health agencies, and cultural programs.
Limitations: Giving primarily in IN.

Officers and Directors: Paul F. Thompson, Pres. and Treas.; Pauline Thrush Thompson, V.P.; Robert L. Thompson, Secy.; Dean A. Thompson, Jerry T. Thompson.
Employer Identification Number: 356018476

948
The Winchester Foundation
100 South Meridian St.
Winchester 47394 (317) 584-3501

Established in 1946 in IN.
Financial data (yr. ended 12/31/86): Assets, $1,258,846 (M); gifts received, $10,000; expenditures, $60,892, including $42,000 for 10 grants (high: $12,000; low: $1,500) and $7,720 for 4 grants to individuals.
Purpose and activities: Grants primarily for higher education, educational associations, scholarships, and cultural programs.
Types of support: General purposes, student aid.
Limitations: Giving primarily in IN.
Application information: Candidates for scholarships are pre-selected by a scholarship committee from Winchester Community High School; applications are not accepted by the foundation.
Write: Don Welch, Chair.
Officers and Trustees: Don E. Welch, Chair.; Enid Goodrich, Vice-Chair.; Chris L. Talley, Secy.; Helen Garlotte, Robert G. Jones, Terry I. Matchett.
Employer Identification Number: 237422941

IOWA

949
Philip D. & Henrietta B. Adler Foundation Trust
c/o Davenport Bank & Trust Co.
203 West Third St.
Davenport 52801-1977

Established in 1981 in IA.
Financial data (yr. ended 12/31/87): Assets, $5,780,772 (M); expenditures, $164,460, including $155,034 for 3 grants (high: $75,034; low: $30,000).
Purpose and activities: Support primarily for a theatre and social service agencies.
Application information: Contributes only to pre-selected organizations. Applications not accepted.
Trustees: Henrietta B. Adler, Davenport Bank & Trust Co.
Employer Identification Number: 426262655

950
Aegon, U.S.A. Corporate Giving Program
4333 Edgewood Road N.E.
Cedar Rapids 52499 (319) 398-8511

Financial data (yr. ended 12/31/88):
$286,962 for grants (high: $5,000; low:
$1,000).

Purpose and activities: Supports arts and
culture, education, programs to help minorities,
public broadcasting and private higher
education; support for conservation and
wildlife, and recreation; types of support
include equipment and short term projects.
Types of support: Equipment, annual
campaigns, building funds, capital campaigns,
continuing support, endowment funds, general
purposes.
Limitations: Giving primarily in headquarters
city and major operating locations in IA, NM,
SC, NC, TX, ND, SD, MN, KS, NE, WI, IL, MO,
and TN. No support for schools, churches,
towns, or sport teams.
Application information: Applications not
accepted.
 Write: Theron Thomsen, Sr. V.P.
Number of staff: None.

951
The Myron and Jacqueline Blank Charity Fund
414 Insurance Exchange Bldg.
505 Fifth Ave.
Des Moines 50309

Incorporated in 1948 in IA.
Donor(s): A.H. Blank, Myron N. Blank, and
others.
Financial data (yr. ended 12/31/86): Assets,
$5,747,175 (M); expenditures, $228,198,
including $215,496 for 58 grants (high:
$105,000; low: $25).

Purpose and activities: Emphasis on Jewish
welfare funds, higher education, and cultural
programs.
Limitations: Giving primarily in IA.
Application information: Contributions only
to pre-selected organizations. Applications not
accepted.
Officers and Directors: Myron N. Blank, Pres.
and Treas.; Jacqueline N. Blank, V.P. and
Secy.; Steven N. Blank.
Employer Identification Number: 237423791

952
The Bohen Foundation
1716 Locust St.
Des Moines 50336 (515) 284-2556

Incorporated in 1958 in IA.
Donor(s): Mildred M. Bohen Charitable Trust,
Edna E. Meredith Charitable Trust.
Financial data (yr. ended 6/30/87): Assets,
$7,922,137 (M); gifts received, $1,242,675;
expenditures, $1,368,132, including
$1,218,600 for 37 grants (high: $420,000; low:
$250; average: $1,000-$20,000).
Purpose and activities: Emphasis on higher
and secondary education, conservation, and
the performing arts.

Types of support: Operating budgets, building
funds, annual campaigns, special projects.
Limitations: No grants to individuals.
Application information:
 Initial approach: Letter
 Copies of proposal: 1
 Deadline(s): None
 Board meeting date(s): As required
 Write: Marilyn J. Dillivan, Treas.
Officers and Directors:* Frederick B. Henry,*
Pres.; Linda Cucchiara, Secy.; Marilyn J.
Dillivan, Treas.
Number of staff: None.
Employer Identification Number: 426054774

953
Gardner and Florence Call Cowles Foundation, Inc.
715 Locust St.
Des Moines 50309 (515) 284-8116

Incorporated in 1934 in IA.
Donor(s): Gardner Cowles, Sr.,† Florence C.
Cowles.†
Financial data (yr. ended 12/31/87): Assets,
$12,976,428 (M); gifts received, $3,500;
expenditures, $1,797,541, including
$1,642,000 for 20 grants (high: $508,000; low:
$5,000; average: $5,000-$250,000).
Purpose and activities: Grants largely for
higher education, with emphasis on 4-year
private colleges in IA, including buildings and
equipment, arts programs, and a civic center.
Types of support: Operating budgets,
continuing support, seed money, building
funds, endowment funds, matching funds,
equipment.
Limitations: Giving limited to IA, with
emphasis on Des Moines. No grants to
individuals, or for scholarships or fellowships;
no loans.
Publications: 990-PF.
Application information:
 Initial approach: Proposal or letter
 Copies of proposal: 1
 Deadline(s): None
 Board meeting date(s): Annually and as
 required
 Write: David Kruidenier, Pres.
Officers and Trustees: David Kruidenier,
Pres.; Kenneth MacDonald, V.P.; Luther L. Hill,
Jr., Secy.; Elizabeth S. Kruidenier, Treas.;
Morley Cowles Ballantine, Charles C. Edwards,
Jr.
Number of staff: None.
Employer Identification Number: 426054609

954
Employers Mutual Casualty Company Corporate Giving Program
717 Mulberry St.
P.O. Box 212
Des Moines 50303 (515) 280-2587

Financial data (yr. ended 12/31/88):
$350,000 for grants.
Purpose and activities: Support for the arts,
including museums and the performing arts,
insurance education, community development,
hospitals, and the United Way.

Types of support: Annual campaigns, building
funds, capital campaigns, continuing support,
endowment funds, equipment, professorships.
Limitations: Giving primarily in the Des
Moines, IA, area.
Application information:
 Initial approach: Short letter
 Deadline(s): None
 Write: Robb B. Kelley, Chair. and C.E.O.
Number of staff: None.

955
Gramma Fisher Foundation
112 West Church St.
Marshalltown 50158
Application address: c/o The Jaspar Corp., The
Bullitt House, Easton, MD 21601; Tel.: (301)
822-8450

Incorporated in 1957 in IA.
Donor(s): J. William Fisher.
Financial data (yr. ended 12/31/87): Assets,
$8,319,290 (M); expenditures, $886,001,
including $828,500 for 7 grants (high:
$500,000; low: $1,500).

Purpose and activities: Grants mainly for
support and sponsorship of opera; some
support for other areas of the performing arts.
Limitations: No grants to individuals.
Application information:
 Deadline(s): None
 Board meeting date(s): As necessary
 Write: Christine F. Hunter, Vice-Chair.
Officers and Trustees: J. William Fisher,
Chair.; Christine F. Hunter, Vice-Chair.; William
T. Hunter, Secy.-Treas.
Number of staff: None.
Employer Identification Number: 426068755

956
Gazette Foundation
500 Third Ave., S.E.
Cedar Rapids 52406 (319) 398-8207

Established in 1960 in IA.
Donor(s): The Gazette Co.
Financial data (yr. ended 12/31/87): Assets,
$296,069 (M); gifts received, $115,000;
expenditures, $100,663, including $99,914 for
60 grants (high: $24,700; low: $25).

Purpose and activities: Support for higher
education, including programs designed to
strengthen the skills of future newspaper and
broadcasting professionals, youth agencies,
cultural programs, health services, and a
community fund; support also for
environmental protection.
Limitations: Giving primarily in Cedar Rapids,
IA. No grants to individuals.
Publications: Program policy statement.
Application information: Application form
required.
 Deadline(s): None
 Final notification: 3 months
 Write: J.F. Hladky III, Pres.
Officers and Directors: J.F. Hladky III, Pres.;
Ken Slaughter, V.P.; John L. Donnelly, Treas.;
Elizabeth T. Barry, J.F. Hladky, Jr.
Employer Identification Number: 426075177

957
Madelyn L. Glazer Foundation
312 Hubbell Bldg.
Des Moines 50309

Established in 1957.
Financial data (yr. ended 12/31/86): Assets, $3,944,315 (M); expenditures, $82,502, including $75,076 for 38 grants (high: $22,000; low: $36).
Purpose and activities: Giving for higher education, cultural programs, welfare, and Jewish welfare funds.
Limitations: Giving primarily in Des Moines, IA.
Application information: Contributes only to pre-selected organizations. Applications not accepted.
Officers: Madelyn L. Glazer, Pres.; Edward Glazer, V.P.; Richard Toran, Secy.; William Toran, Treas.
Employer Identification Number: 426052426

958
The Ralph & Sylvia Green Charitable Foundation
Two Ruan Ctr., Suite 200G
Des Moines 50309 (515) 244-3000

Established in 1983 in IA.
Donor(s): Ralph Green.
Financial data (yr. ended 12/31/87): Assets, $1,223,759 (M); gifts received, $100,000; expenditures, $84,967, including $74,875 for 32 grants (high: $25,000; low: $100).
Purpose and activities: support for higher education, the arts and general charitable giving.
Types of support: Operating budgets, endowment funds, program-related investments, seed money.
Limitations: Giving primarily in Des Moines, IA.
Application information:
 Write: Ann G. Anderson, Pres.
Officers and Directors: Ralph Green, Chair.; Ann G. Anderson, Pres. and Secy.; Sigurd Anderson, V.P. and Treas.
Employer Identification Number: 421208959

959
The Hall Foundation, Inc.
803 Merchants National Bank Bldg.
Cedar Rapids 52401 (319) 362-9079

Incorporated in 1953 in IA.
Donor(s): Members of the Hall family.
Financial data (yr. ended 12/31/88): Assets, $39,214,495 (M); expenditures, $3,507,608, including $3,380,930 for 37 grants (high: $680,000; low: $500; average: $5,000-$100,000).
Purpose and activities: Support for cultural programs, including fine and performing arts groups, higher education, social service and youth agencies, a community fund, and hospitals and health services.
Types of support: Continuing support, annual campaigns, seed money, emergency funds, building funds, equipment, land acquisition, special projects, research, capital campaigns, scholarship funds.
Limitations: Giving limited to Cedar Rapids, IA, and the immediate trade area. No grants to

individuals, or for deficit financing, endowment funds, scholarships, or fellowships; no loans.
Publications: Informational brochure (including application guidelines), 990-PF.
Application information:
 Initial approach: Letter
 Copies of proposal: 1
 Deadline(s): None
 Board meeting date(s): 3rd Tuesday in June, and as required
 Final notification: 3 months
 Write: John G. Lidvall, Exec. Dir.
Officers and Directors: William P. Whipple, Pres.; George C. Foerstner, V.P.; Darrel A. Morf, Secy.; Joseph R. Loufek, Treas.; John G. Lidvall, V.P. and Exec. Dir.; E.J. Buresh, James E. Coquillette, Jack B. Evans, Carleen Grandon, Alex Meyer, Irene H. Perrine.
Number of staff: 2 part-time professional.
Employer Identification Number: 426057097

960
Hon Industries Charitable Foundation
414 East Third St.
Muscatine 52761-4182 (319) 264-7400

Established in 1985 in IA.
Financial data (yr. ended 06/30/88): Assets, $989,597 (M); expenditures, $196,815, including $195,645 for 44 grants (high: $32,500; low: $25).
Purpose and activities: Support for higher and other education, social services, youth, science and technology, business, recreation, arts and culture, conservation, and the United Way; scholarships awarded for higher education.
Types of support: Scholarship funds.
Limitations: Giving primarily in areas of company operations in IA, IL, TN, TX, and VA.
Application information:
 Deadline(s): None
 Write: Raymond E. Lasell, Secy.
Officers: Stanley M. Howe, Pres.; R. Michael Derry, V.P.; Russell D. Woodyard, V.P.; Raymond E. Lasell, Secy.-Treas.
Employer Identification Number: 421246787

961
James W. Hubbell, Jr. & Helen H. Hubbell Foundation
c/o Bankers Trust Co., Trust Dept.
P.O. Box 897
Des Moines 50304-0897

Established in 1976 in IA.
Donor(s): James W. Hubbell, Jr.
Financial data (yr. ended 12/31/87): Assets, $94,659 (M); gifts received, $3,815; expenditures, $133,278, including $129,925 for 35 grants (high: $52,600; low: $100).
Purpose and activities: Giving primarily for Christian churches and programs, higher and secondary education, and cultural programs.
Application information:
 Deadline(s): None
 Write: James W. Hubbell, Jr., Trustee
Trustees: James W. Hubbell, Jr., Bankers Trust Co.
Employer Identification Number: 426259130

962
Iowa and Illinois Gas and Electric Company Giving Program
206 E. 2nd St.
Davenport 52802 (319) 326-7038

Financial data (yr. ended 12/31/87): $537,065 for 186 grants (high: $106,375; low: $10).
Purpose and activities: Supports community arts, fine arts, cultural institutes, humanities, libraries, music, theater, economic development, environmental issues, education, health care, child welfare, civic affairs, community development, family services, the handicapped, and mental health programs. Special uses for funding include equipment and short term projects.
Types of support: Program-related investments, building funds, annual campaigns, capital campaigns, continuing support, general purposes, program-related investments.
Limitations: Giving primarily in Davenport, Bettendorf, Cedar Rapids, Iowa City and Fort Dodge, IA; Rock Island and Moline, IL; and OH.
Application information: Include project description, budget, financial report, 501(c)(3) status letter, board member list and major donor list. Must show record of other existing support.
 Initial approach: Letter
 Copies of proposal: 1
 Board meeting date(s): Jan., Apr., July, and Oct.
 Final notification: If rejected, applicant will receive notification
 Write: J.C. Decker, Secy.-Treas.
Administrator: John C. Decker, Secy.-Tres.
Number of staff: 1

963
Jensen Foundation
5550 North East 22nd St.
P.O. Box 3345
Des Moines 50316 (515) 266-5173

Financial data (yr. ended 2/28/88): Assets, $19,517 (M); expenditures, $11,119, including $11,100 for 2 grants (high: $10,000; low: $1,100).
Purpose and activities: Funding provided for the Danish Immigrant Museum and the Life Lutheran Church.
Application information: Applications not accepted.
Managers: Erling V. Jensen, Rose Jensen.
Employer Identification Number: 426060693

964
W. P. Johnson Company Foundation
1st & New York Ave.
Des Moines 50313

Financial data (yr. ended 12/31/87): Assets, $58,414 (M); gifts received, $125; expenditures, $14,261, including $13,000 for 12 grants (high: $2,500; low: $500).
Purpose and activities: Support for the United Way, education, the arts, the sciences, the needy, and the handicapped.
Limitations: Giving primarily in Des Moines, IA.

Application information:
Deadline(s): None
Write: Alvin H. Kirsner, Pres.
Officers: Alvin H. Kirsner, Pres.; Paul B.
Nurczyk, V.P.; Lawrence Kirsner, Secy.
Employer Identification Number: 421257120

965
Kent-Stein Foundation
c/o Grain Processing Corp.
1600 Oregon St.
Muscatine 52761

Established in 1945 in IA.
Donor(s): Grain Processing Corp.
Financial data (yr. ended 12/31/87): Assets,
$2,198,885 (M); gifts received, $500,000;
expenditures, $105,453, including $100,000
for 1 grant.
Purpose and activities: Emphasis on higher
education, museums and the arts, conservation,
libraries, and community funds.
Application information: Contributes only to
pre-selected organizations. Applications not
accepted.
Trustees: J.H. Kent, J.L. Lamb, S.G. Stein IV.
Employer Identification Number: 426058939

966
Kinney-Lindstrom Foundation, Inc.
P.O. Box 520
Mason City 50401 (515) 896-3888

Incorporated in 1957 in IA.
Donor(s): Ida Lindstrom Kinney.†
Financial data (yr. ended 12/31/87): Assets,
$5,832,035 (M); expenditures, $1,187,183,
including $890,570 for 46 grants (high:
$200,000; low: $100).
Purpose and activities: Grants primarily for
building funds for libraries in IA towns; support
also for education, cultural programs, social
services, youth agencies, health, religious
giving, and civic programs.
Types of support: Building funds.
Limitations: Giving primarily in IA. No grants
to individuals, or for endowment funds,
operating budgets, or research; no loans.
Application information:
Initial approach: Letter
Copies of proposal: 1
Deadline(s): Mar. 1
Board meeting date(s): 10 times a year
Final notification: 2 weeks after interview
Write: Lowell K. Hall, Secy.
Officer: Lowell K. Hall, Secy.
Trustees: Thor Jenson, Ira Stinson.
Number of staff: 1 full-time professional.
Employer Identification Number: 426037351

967
Lee Foundation
130 East Second St.
Davenport 52801

Incorporated in 1962 in IA.
Donor(s): Lee Enterprises.
Financial data (yr. ended 9/30/88): Assets,
$4,051,743 (M); gifts received, $1,000,000;
expenditures, $407,514, including $403,098
for 44 grants (high: $250,000; low: $125).

Purpose and activities: Grants largely for
higher education, hospitals, youth agencies,
cultural programs, and journalism.
Types of support: Endowment funds, building
funds.
Limitations: Giving primarily in areas of
company operations in IA, IL, WI, MT, ND,
OR, CA, and NE. No support for individuals.
Officers and Directors: Lloyd G. Schermer,
Pres.; Richard B. Belkin, V.P.; Richard D.
Gottlieb, V.P.; Ronald L. Rickman, V.P.;
Richard P. Galligan, Secy.; Michael J. Riley,
Treas.
Employer Identification Number: 426057173

968
The Maytag Company Foundation, Inc.
c/o Maytag Corp.
403 West 9th St., N.
Newton 50208 (515) 791-8216

Incorporated in 1952 in IA.
Donor(s): Maytag Corp.
Financial data (yr. ended 12/31/87): Assets,
$1,622,419 (M); gifts received, $900,000;
expenditures, $566,513, including $355,577
for 82 grants (high: $50,000; low: $10),
$160,063 for 164 grants to individuals and
$41,442 for 90 employee matching gifts.
Purpose and activities: Contributes to
worthwhile undertakings to help fulfil the
company's role as a responsible corporate
citizen. Principal interest in scholarships and
career education awards for students in
Newton High School and children of company
employees, with cost-of-education supplements
to colleges attended by scholarship winners;
matches company employees' gifts to approved
colleges up to $1,000 annually per employee;
makes other grants to Iowa College Fund,
United Negro College Fund and selected
national educational organizations. Supports
community betterment, including United Way
and cultural organizations in Newton/Central
IA area and other localities where company has
plants or offices.
Types of support: Student aid, employee
matching gifts, employee-related scholarships,
scholarship funds, operating budgets, building
funds, annual campaigns, capital campaigns,
continuing support, matching funds.
Limitations: Giving for community projects
limited to areas of company operations,
particularly Newton/Central IA area. No
support for health agencies, churches, religious
causes, or international relations. No grants to
individuals (except for Maytag Award
recipients), benefit dinners, or complimentary
advertising.
Publications: Financial statement, informational
brochure.
Application information: Application required
for scholarship program and career education
awards program.
Initial approach: Letter or telephone inquiry
Copies of proposal: 1
Deadline(s): Feb. 1 for grants to
organizations; varies annually for
scholarship and career education awards
programs
Board meeting date(s): Mar. and as required
Final notification: Varies

Write: Ms. Janis Cooper, V.P. of Corporate
Public Affairs
Officers: Daniel J. Krumm,* Pres.; Francis C.
Miller,* V.P.; Donald C. Byers, Secy.-Treas.;
Betty J. Dickinson, Exec. Dir.
Trustees:* J.C. Enyart, Karl F. Langrock, Jack
D. Levin, Donald R. Runger, Jerry A. Schiller,
Sterling O. Swanger.
Number of staff: 1 full-time professional; 1 full-
time support.
Employer Identification Number: 426055722
Recent arts and culture grants:
Des Moines Ballet Association, Des Moines, IA,
$15,000. 1987.
Des Moines Metro Opera, Indianola, IA,
$35,000. 1987.
Des Moines Symphony, Des Moines, IA,
$35,000. 1987.
Iowa Historical Museum Foundation, Des
Moines, IA, $20,000. 1987.
Iowa Natural Heritage Foundation, Des Moines,
IA, $5,000. 1987.
Iowa Public Television, Des Moines, IA,
$21,500. 1987.
Living History Farms Foundation, Des Moines,
IA, $20,000. 1987.
Newton Community Theater, Newton, IA,
$5,000. 1987.

969
The Fred Maytag Family Foundation
200 First St. South
P.O. Box 426
Newton 50208 (515) 792-1800

Trust established in 1945 in IA.
Donor(s): Fred Maytag II,† Members of the
Maytag family.
Financial data (yr. ended 12/31/87): Assets,
$25,698,595 (M); expenditures, $1,082,805,
including $1,082,805 for 87 grants (high:
$150,000; low: $50; average: $1,000-$50,000).
Purpose and activities: Giving for higher
education, arts and culture, public affairs,
health, and social services.
Types of support: Operating budgets,
continuing support, annual campaigns, seed
money, building funds, equipment, land
acquisition, matching funds, research, special
projects, renovation projects.
Limitations: Giving primarily in Des Moines
and Newton, IA. No grants to individuals, or
for emergency funds, deficit financing,
endowment funds, scholarships, fellowships,
demonstration projects, publications, or
conferences; no loans.
Application information:
Initial approach: Letter
Copies of proposal: 4
Deadline(s): Submit proposal preferably in
Apr. or May; deadline May 31
Board meeting date(s): June or July
Final notification: 30 days after meeting
Write: Francis C. Miller, Secy.
Trustees: Ellen Pray Maytag Madsen, Frederick
L. Maytag III, Kenneth P. Maytag.
Officer: Francis C. Miller, Secy.
Number of staff: 2 part-time support.
Employer Identification Number: 426055654

970
A. Y. McDonald Manufacturing Company Charitable Foundation
c/o A.Y. McDonald Manufacturing
P.O. Box 508
Dubuque 52001 (319) 583-7811

Financial data (yr. ended 12/31/87): Assets, $658,785 (M); gifts received, $30,000; expenditures, $86,777, including $85,929 for 31 grants (high: $13,589; low: $100).
Purpose and activities: Support for social services, health services, including cancer research, the arts, education, and youth.
Limitations: Giving primarily in eastern IA, with emphasis on Dubuque.
Application information:
 Initial approach: Letter
 Deadline(s): None
 Write: R.D. McDonald, Pres.
Officers: R.D. McDonald, Pres.; W.A. Knapp, V.P.; J.B. McDonald, V.P.; J.M. McDonald III, V.P.; L.J. Sherman, Secy.
Employer Identification Number: 426119514

971
Meredith Corporate Contributions Program
1716 Locust St.
Des Moines 50336 (515) 284-2656

Purpose and activities: Support for general charitable giving, including child welfare, education, family services, fine arts and culture.
Types of support: Continuing support, employee matching gifts, matching funds, special projects.
Limitations: Giving primarily in central IA, with emphasis on Des Moines. No grants to individuals.
Publications: Informational brochure (including application guidelines).
Application information:
 Board meeting date(s): Quarterly
 Write: Gail Stilwill, Mgr., Community Relations
Number of staff: 1 full-time professional; 1 full-time support.

972
Edwin T. Meredith Foundation
1716 Locust St.
Des Moines 50336 (515) 284-2545

Incorporated in 1946 in IA.
Donor(s): Meredith Publishing Co.
Financial data (yr. ended 12/31/87): Assets, $6,606,846 (M); gifts received, $407,200; expenditures, $299,003, including $222,085 for 23 grants (high: $50,000; low: $500).
Purpose and activities: Grants largely for youth agencies, higher education, cultural programs and a historic preservation area; some support for hospitals and health agencies, and conservation.
Limitations: No grants to individuals.
Application information: Contributes only to pre-selected organizations. Applications not accepted.
 Board meeting date(s): June
 Write: E.T. Meredith III, Pres.

Officers: E.T. Meredith III, Pres. and Dir.; Katherine C. Meredith, V.P.; Gerald Thornton, Secy.; Marilyn J. Dillivan, Treas.
Number of staff: None.
Employer Identification Number: 426059818

973
National Travelers Life Company Charitable Trust
820 Keosauqua Way
Des Moines 50309 (515) 283-0101

Donor(s): National Travelers Life Co.
Financial data (yr. ended 12/31/87): Assets, $437,586 (M); gifts received, $299,906; expenditures, $52,520, including $51,763 for 77 grants (high: $22,700; low: $25).
Purpose and activities: Support for health, cultural programs, community and social services, and higher education.
Types of support: General purposes.
Application information:
 Initial approach: Proposal
 Deadline(s): None
Trustees: Gerald Blake, Nancy Luckow, Edward Murphy, Melvin Rambo.
Employer Identification Number: 421288170

974
Pella Rolscreen Foundation
c/o Rolscreen Company
102 Main St.
Pella 50219 (515) 628-1000

Trust established in 1952 in IA.
Donor(s): Rolscreen Co.
Financial data (yr. ended 12/31/87): Assets, $9,186,572 (M); gifts received, $1,947,000; expenditures, $877,173, including $609,787 for 95 grants (high: $144,160; low: $100; average: $500-$10,000), $24,727 for grants to individuals and $215,193 for 295 employee matching gifts.
Purpose and activities: Emphasis on higher education, cultural programs, and social service agencies; employee gifts matched on one-to-one basis for education, United Way chapters, and tax-exempt organizations.
Types of support: Annual campaigns, building funds, scholarship funds, employee-related scholarships, employee matching gifts.
Limitations: Giving primarily in areas of company operations, with emphasis on Marion, Mahaska, and Carroll counties, IA. No grants to individuals (except for employee-related scholarships), or for endowment funds, research, or matching gifts; no loans.
Publications: Informational brochure, application guidelines.
Application information:
 Initial approach: Proposal
 Deadline(s): None
 Board meeting date(s): Quarterly
 Final notification: 1 month
 Write: William J. Anderson, Admin.
Officers and Directors: Mary Joan Farver, Pres.; J. Wayne Bevis, Secy.-Treas.
Number of staff: 1 part-time support.
Employer Identification Number: 237043881

975
Peoples Bank Charitable Trust
101 3rd Ave. S.W.
Cedar Rapids 52406
Application address: c/o Peoples Bank and Trust Co., Box 1887, Cedar Rapids, IA 52406

Donor(s): Peoples Bank & Trust Co.
Financial data (yr. ended 12/31/87): Assets, $358,580 (L); gifts received, $25,000; expenditures, $67,986, including $64,625 for 24 grants (high: $12,000; low: $100).
Purpose and activities: Support for United Way, higher education, child welfare, and culture.
Application information:
 Initial approach: Letter or brochure
 Deadline(s): None
 Write: John M. Sagers
Trustees: John D. Ellis, John M. Sagers, Ted J. Welch.
Employer Identification Number: 426052250

976
Pioneer Hi-Bred International Corporate Giving Program
400 Locust St., Suite 700
Des Moines 50309 (515) 245-3593

Financial data (yr. ended 8/31/88): Total giving, $2,846,219, including $2,111,747 for 658 grants (high: $175,000; low: $50; average: $3,209), $61,684 for 161 employee matching gifts, $611,656 for 2 company-administered programs and $61,132 for 29 in-kind gifts.
Purpose and activities: Supports children's welfare, civic affairs, economic development, environmental programs, fine arts, general arts, education, health care, handicapped, disabled, minority, science, senior citizens, vocational education, welfare and youth service programs. Also supports international groups, private and public colleges, as well as projects concerned with rural issues. Types of support include employee matching gifts for education, and in-kind donations.
Types of support: Building funds, capital campaigns, employee matching gifts, employee matching gifts, endowment funds, fellowships, general purposes, matching funds, operating budgets, scholarship funds, research, in-kind gifts.
Limitations: Giving primarily in headquarters city and major operating areas. No support for religious, political, or lobbying organizations. No support for health associations unless they provide direct services; athletic activities; or for touring or co-curricular activities. No grants to individuals, or for ticket sales or emergency funding.
Publications: Informational brochure.
Application information: Include project description, budget, financial report, and IRS 501(c)(3) status letter.
 Initial approach: Query letter
 Copies of proposal: 1
 Deadline(s): None
 Board meeting date(s): Requests reviewed quarterly
 Write: Lu Jean Cole, Dir., Community Relations
Number of staff: 1 full-time professional; 1 part-time professional; 2 full-time support.

977
The Principal Foundation, Inc.
711 High St.
Des Moines 50309 (515) 247-5209

Established in 1987 in IA.
Financial data (yr. ended 12/31/87): Assets, $19,764,350 (M); gifts received, $20,000,000; expenditures, $0.
Purpose and activities: Support for social services, arts and culture, health, education, civic and community affairs, and the United Way.
Types of support: Annual campaigns, building funds, capital campaigns, continuing support, employee matching gifts, operating budgets, special projects.
Limitations: Giving primarily in IA with emphasis on the Des Moines, IA, area. No support for athletic organizations, fraternal organizations, organizations redistributing funds, private foundations, sectarian, religious, and denominational organizations, social organizations; trade, industrial or professional associations, or veteran's groups. No grants to individuals, conference or seminar attendance, goodwill ads, endowments, festival participation, and hospital or health care capital fund drives.
Publications: Annual report, informational brochure (including application guidelines).
Application information: Include budget, audited financial statement, project goals, contributions received to date, names and business affiliations of officers and board, and background and 501(c)(3) designation.
 Initial approach: Proposal
 Copies of proposal: 1
 Deadline(s): 14 days prior to contributions committee meeting
 Board meeting date(s): Approximately once a month
 Final notification: 4 to 6 weeks
 Write: Walter J. Walsh, Chair.
Officer: Walter J. Walsh, Chair. and V.P., Corporate Relations.
Employer Identification Number: 421312301

978
John Ruan Foundation Trust
3200 Ruan Center
Des Moines 50304 (515) 245-2555

Trust established in 1955 in IA.
Donor(s): John Ruan.
Financial data (yr. ended 6/30/88): Assets, $4,068,141 (M); gifts received, $199,842; expenditures, $149,439, including $147,902 for 103 grants (high: $31,250; low: $25).
Purpose and activities: Emphasis on higher education, cultural programs, youth agencies, child welfare, and health agencies.
Limitations: Giving primarily in Des Moines, IA.
Application information:
 Deadline(s): None
 Write: John Ruan, Trustee
Trustees: Elizabeth J. Ruan, John Ruan.
Employer Identification Number: 426059463

979
Vermeer Charitable Foundation, Inc.
c/o Vermeer Manufacturing Co.
P.O. Box 200
Pella 50219 (515) 628-3141

Established in 1977 in IA.
Donor(s): Vermeer Manufacturing Co., Vermeer Sales and Service of Iowa, Vermeer Farms, Inc.
Financial data (yr. ended 12/31/87): Assets, $2,543,310 (M); gifts received, $4,729; expenditures, $302,093, including $293,997 for 19 grants (high: $60,000; low: $25; average: $10,000).
Purpose and activities: Giving primarily for Christian religious organizations, higher education, care of the elderly, and for a historical museum.
Types of support: General purposes, seed money, building funds.
Limitations: Giving primarily in the Pella, IA, area. No grants to individuals, or for endowment funds, scholarships, fellowships, or matching gifts; no loans.
Application information: Application form required.
 Initial approach: Letter
 Board meeting date(s): Dec. and as required
 Write: Mary Andringa, Dir.
Directors: Dale Andringa, Mary Andringa, Gary J. Vermeer, Lois J. Vermeer, Matilda Vermeer, Robert L. Vermeer.
Number of staff: 4 part-time professional.
Employer Identification Number: 421087640

980
Vogel Charities, Inc.
Country Road P South
Orange City 51041 (712) 737-4993

Established in 1973 in IA.
Donor(s): Vogel Paint & Wax, Marwin Paints.
Financial data (yr. ended 12/31/87): Assets, $1,101,075 (M); gifts received, $209,000; expenditures, $149,672, including $144,957 for 59 grants (high: $73,500; low: $25).
Purpose and activities: Giving primarily for higher and secondary education, cultural programs, and hospitals and health services.
Types of support: Scholarship funds, building funds.
Application information:
 Write: Franklin P. Vogel, Pres.
Officer: Franklin P. Vogel, Pres.
Employer Identification Number: 237169167

981
Wahlert Foundation
Sixteenth and Sycamore Sts.
Dubuque 52001 (319) 588-5400
Grant application office: c/o FDL Foods, Inc., P.O. Box 898, Dubuque, IA 52001

Incorporated in 1948 in IA.
Donor(s): Dubuque Packing Co., FDL Foods, Inc., H.W. Wahlert,† and officers of the foundation.
Financial data (yr. ended 11/30/88): Assets, $3,835,135 (M); gifts received, $2,675; expenditures, $226,044, including $215,250

for 19 grants (high: $111,250; low: $500; average: $1,000-$3,000).
Purpose and activities: Support primarily for education; grants also for hospitals, social agencies, and cultural activities.
Types of support: Continuing support, annual campaigns, seed money, emergency funds, building funds, equipment, capital campaigns, scholarship funds, special projects.
Limitations: Giving primarily in the Dubuque, IA, metropolitan area. No grants to individuals, or for endowment funds, operating budgets, deficit financing, research, publications, conferences, or matching gifts; no loans.
Application information:
 Initial approach: Proposal
 Copies of proposal: 1
 Deadline(s): Nov. 30
 Board meeting date(s): Dec.
 Final notification: Jan. 30
 Write: R.H. Wahlert, Pres. and Treas.
Officers and Trustees: R.H. Wahlert, Pres. and Treas.; Al E. Hughes, Secy.; A.J. Kisting, Donald Strausse, David Wahlert, Donna Wahlert, Jim Wahlert, R.C. Wahlert, R.C. Wahlert III.
Number of staff: None.
Employer Identification Number: 426051124

982
Younkers Foundation, Inc.
c/o Younker Brothers
Seventh and Walnut Sts., Box 1495
Des Moines 50306 (515) 244-1112

Incorporated in 1968 in IA.
Donor(s): Younkers, Inc.
Financial data (yr. ended 12/31/87): Assets, $1,438 (M); gifts received, $302,943; expenditures, $301,859, including $301,859 for 48 grants (high: $83,766; low: $25).
Purpose and activities: Grants mainly to community funds; some support also for higher education and cultural activities.
Limitations: Giving limited to areas of company operations in IA. No grants to individuals.
Application information: Applications not accepted.
Officers: William Thomas Gould, Pres.; Jack Prouty, V.P.; Gerry Roth, V.P.; Donald Thomas, V.P.; Carl Ziltz, V.P.; Richard Luse, Secy.-Treas.
Employer Identification Number: 420937873

KANSAS

983
Bank IV Charitable Trust
(Formerly Fourth National Bank of Wichita Charitable Trust)
c/o Bank IV Wichita, N.A.
P.O. Box 1122
Wichita 67201 (316) 261-4361

Trust established in 1952 in KS.
Donor(s): The Fourth National Bank and Trust Co.
Financial data (yr. ended 11/30/88): Assets, $1,382,810 (M); expenditures, $495,493, including $490,677 for 101 grants (high: $132,500; low: $120).
Purpose and activities: Emphasis on community funds, youth agencies, higher education, hospitals, health services, including aid to the handicapped, cultural programs, child development, and religious organizations.
Types of support: Building funds, equipment, endowment funds, scholarship funds, capital campaigns, research.
Limitations: Giving primarily in KS, with emphasis on Wichita. No support for political or religious organizations, fraternal groups, or organizations which receive a major portion of their support from government funds. No grants to individuals, or for general support, operating budgets, dinners, travel, annual campaigns, seed money, emergency funds, deficit financing, publications, conferences, or matching gifts; no loans.
Publications: Application guidelines.
Application information:
Initial approach: Letter
Copies of proposal: 1
Deadline(s): None
Board meeting date(s): Mar., June, Sept., and Dec.
Final notification: Up to 3 months
Write: Michael R. Ritchey, Exec. V.P., Bank IV Wichita, N.A.
Trustees: Fred F. Berry, Jr., Wilson K. Cadman, Jordan L. Haines, Mary L. Oliver, Nestor R. Weigand, Bank IV Wichita, N.A.
Number of staff: None.
Employer Identification Number: 486103519

984
Beech Aircraft Foundation
9709 East Central Ave.
Wichita 67201 (316) 681-8177

Incorporated in 1966 in KS.
Donor(s): Beech Aircraft Corp.
Financial data (yr. ended 12/31/88): Assets, $5,524,033 (M); expenditures, $438,870, including $359,994 for 113 grants, $22,000 for 34 grants to individuals and $25,075 for employee matching gifts.
Purpose and activities: Grants for higher education, community funds, youth agencies, and hospitals; some support for cultural activities, conservation, the handicapped, and the aged.
Types of support: Exchange programs, program-related investments, publications, seed money, employee-related scholarships, employee matching gifts, annual campaigns, capital campaigns, continuing support, matching funds, renovation projects, special projects.
Limitations: Giving primarily in communities with company facilities, with an emphasis on KS. No grants to individuals (except for employee-related scholarships), or for endowment funds, research, or matching gifts; no loans.
Application information:
Initial approach: Letter or telephone

Board meeting date(s): Jan., Apr., July, and Oct.
Write: Larry E. Lawrence, Secy.-Treas.
Officers: O.A. Beech,* Chair. and Pres.; Wey D. Kenny,* V.P.; Larry E. Lawrence, Secy.-Treas.
Directors:* Max E. Bleck, J.A. Elliot, Lucille Winters.
Employer Identification Number: 486125881

985
Willard J. and Mary G. Breidenthal Foundation
c/o Commercial National Bank, Trust Div.
P.O. Box 1400
Kansas City 66117 (913) 371-0035

Trust established in 1962 in KS.
Donor(s): Willard J. Breidenthal,† Mary G. Breidenthal,† and members of the Breidenthal family.
Financial data (yr. ended 12/31/87): Assets, $2,288,231 (M); expenditures, $175,550, including $145,500 for 38 grants (high: $10,000; low: $250; average: $3,725).
Purpose and activities: Emphasis on higher education and hospitals; support also for agriculture, child welfare, youth agencies, and cultural programs.
Limitations: Giving primarily in the Kansas City, KS, and Kansas City, MO, area.
Application information:
Initial approach: Letter
Deadline(s): Submit proposal preferably in Sept. or Oct.; deadline Nov. 1
Board meeting date(s): Nov.
Write: Ruth B. Snyder, Trustee
Trustees: George Gray Breidenthal, Mary Ruth Breidenthal, Ruth B. Snyder, Commercial National Bank.
Number of staff: None.
Employer Identification Number: 486103376

986
Samuel M. and Laura H. Brown Charitable Trust
c/o First National Bank in Wichita
P.O. Box One
Wichita 67201 (316) 268-1236

Trust established in 1974 in KS.
Donor(s): S.M. Brown.†
Financial data (yr. ended 11/30/88): Assets, $1,488,887 (M); expenditures, $129,511, including $116,293 for 25 grants (high: $10,000; low: $500).
Purpose and activities: Emphasis on cultural programs, especially music, higher education, and church support.
Limitations: Giving primarily in Wichita and Sedgwick counties, KS.
Application information:
Deadline(s): None
Write: Steve Woods, V.P. and Trust Officer, First National Bank
Trustees: Robert G. Braden, First National Bank in Wichita.
Employer Identification Number: 486193416

987
Cessna Foundation, Inc.
P.O. Box 7704
Wichita 67277 (316) 946-6000

Incorporated in 1952 in KS.
Donor(s): The Cessna Aircraft Co.
Financial data (yr. ended 12/31/87): Assets, $6,564,676 (M); expenditures, $500,476, including $446,462 for 73 grants (high: $20,000; low: $150; average: $500-$1,000) and $14,035 for 22 employee matching gifts.
Purpose and activities: Grants largely for the United Way, higher education, and youth agencies; support also for hospitals and cultural programs, including museums.
Types of support: Employee matching gifts, building funds, annual campaigns, capital campaigns, emergency funds, employee-related scholarships, special projects.
Limitations: Giving primarily in areas of company operations, particularly KS. No grants to individuals.
Application information:
Initial approach: Letter
Copies of proposal: 1
Deadline(s): Submit proposals preferably in Nov.
Board meeting date(s): Feb. and Dec.
Write: H.D. Humphrey, Secy.
Officers and Trustees: Russell W. Meyer, Jr., Pres.; John E. Moore, V.P.; H.D. Humphrey, Secy.-Treas.; Bruce E. Peterman.
Employer Identification Number: 486108801

988
Edith and Harry Darby Foundation
333 North Sixth St.
Kansas City 66101 (913) 281-0080

Incorporated in 1961 in KS.
Donor(s): Harry Darby Foundation, and others.
Financial data (yr. ended 9/30/87): Assets, $1,216,748 (M); expenditures, $98,004, including $84,031 for 35 grants (high: $13,150; low: $50).
Purpose and activities: Emphasis on higher education, hospitals, church support, community development, and cultural programs.
Limitations: Giving primarily in KS and MO.
Application information:
Deadline(s): None
Write: J.K. Meador, V.P.
Officers and Directors: Jay Dillingham, Pres.; J.K. Meador, V.P. and Secy.; L.A. Randall, Treas.
Employer Identification Number: 486103395

989
James A. and Juliet L. Davis Foundation, Inc.
802 First National Center
P.O. Box 2027
Hutchinson 67504-2027 (316) 663-5021

Incorporated in 1954 in KS.
Financial data (yr. ended 12/31/87): Assets, $2,244,686 (M); expenditures, $117,147, including $27,350 for 32 grants (high: $4,000; low: $250) and $46,000 for 29 grants to individuals.

Purpose and activities: Support for higher education, including scholarships and awards to educators, cultural programs, and child welfare.

Types of support: Student aid, general purposes, scholarship funds.

Limitations: Giving limited to the Hutchinson, KS, area.

Application information: Scholarships limited to students graduating from Hutchinson High School who will attend college in KS or MO.

 Deadline(s): Mar. 15

 Board meeting date(s): Third Monday of each month

 Final notification: Scholarship awards announced at High School Awards Assembly

 Write: William Y. Chalfant, Secy.

Officers and Trustees: Peter M. Macdonald, Pres.; William Y. Chalfant, Secy.; Kent Longenecker, Merl F. Sellers, Carol Shaft.

Number of staff: None.

Employer Identification Number: 486105748

990
Leo J. Dreiling & Albina Dreiling Charitable Trust

P.O. Box 1000

Victoria 67671 (913) 735-2204

Established in 1980 in KS.

Donor(s): Leo J. Dreiling.†

Financial data (yr. ended 9/30/87): Assets, $370,373 (M); gifts received, $50,482; expenditures, $426,472, including $420,621 for 9 grants (high: $100,578; low: $5,200).

Purpose and activities: Support primarily for education and culture; support also for a rest home.

Types of support: Scholarship funds, building funds, renovation projects.

Limitations: Giving primarily in Ellis County, KS. No grants to individuals.

Application information:

 Initial approach: Letter

 Deadline(s): None

 Write: Joseph A. Hess, Trustee

Trustees: Dennis L. Bieker, John G. Dreiling, Norbert R. Dreiling, Joseph A. Hess.

Employer Identification Number: 480916752

991
Hesston Foundation, Inc.

420 West Lincoln Blvd.

Hesston 67062-2094

Incorporated in 1965 in KS.

Donor(s): Hesston Corp., and others.

Financial data (yr. ended 12/31/87): Assets, $1,185,135 (L); expenditures, $61,599, including $49,150 for 18 grants (high: $18,500; low: $200; average: $1,000) and $3,672 for 22 employee matching gifts.

Purpose and activities: Grants are primarily made to causes within the "community of responsibility," with emphasis on higher education, church-supported activities, hospitals, nursing homes and health services, youth agencies, public music and fine arts agencies; and community and general welfare assistance agencies.

Types of support: Operating budgets, continuing support, annual campaigns, seed money, building funds, equipment, matching funds, special projects, research, employee matching gifts.

Limitations: Giving primarily in areas of company operations within KS. No grants to individuals, or for emergency funds, deficit financing, land acquisition, scholarships, or fellowships; no loans.

Application information:

 Initial approach: Proposal

 Copies of proposal: 1

 Deadline(s): Feb. 28, May 31, Aug. 31, and Nov. 30

 Board meeting date(s): Mar., June, Sept., and Dec.

 Final notification: 2 to 3 weeks after board meetings

 Write: Raymond C. Schlichting, Pres.

Officers: Raymond C. Schlichting,* Chair. and Pres.; Harold P. Dyck,* V.P.; Lyle E. Yost,* V.P.; Roberta M. Oliver, Secy.-Treas.

Directors:* Howard L. Brenneman, William L. Friesen, John Siemens, Jr., Kenneth G. Speir.

Number of staff: 1 part-time support.

Employer Identification Number: 480698307

992
Jordaan Foundation, Inc.

111 East 8th St., P.O. Box 360

Larned 67550 (316) 285-3157

Trust established in 1970 in KS.

Donor(s): J.D. Jordaan.†

Financial data (yr. ended 12/31/87): Assets, $1,682,784 (M); expenditures, $158,161, including $70,000 for grants and $30,000 for 20 grants to individuals.

Purpose and activities: Support for educational and civic development, with emphasis on community programs, museums, an historical society, and scholarships to graduates of a local high school only.

Types of support: General purposes, operating budgets, building funds, equipment, land acquisition, matching funds, consulting services, scholarship funds, special projects, research, publications, conferences and seminars, student aid.

Limitations: Giving limited to organizations and individuals in Pawnee County, KS. No grants for endowment funds; no loans.

Publications: Application guidelines.

Application information:

 Initial approach: Telephone or letter

 Copies of proposal: 5

 Deadline(s): 1st Tuesday of every month

 Board meeting date(s): Monthly

 Final notification: 2 days

 Write: Glee S. Smith, Chair.

Advisory Board: Glee S. Smith, Chair.; Edward B. Boyd, Ned M. Brown, Walter M. Crawford, Reed Peters.

Trustee Bank: First State Bank and Trust Co. of Larned.

Number of staff: None.

Employer Identification Number: 486155003

993
David H. Koch Charitable Trust

4111 East 37th St., North

Wichita 67220 (316) 832-5227

Application address: P.O. Box 2256, Wichita, KS 67201

Established in 1982 in KS.

Donor(s): David H. Koch, Fred C. Koch Trusts for Charity.

Financial data (yr. ended 12/31/86): Assets, $8,345,028 (M); gifts received, $1,346,181; expenditures, $1,973,705, including $1,948,182 for 37 grants (high: $500,000; low: $1,000; average: $10,000-$30,000).

Purpose and activities: Giving for arts, culture, education, public interest, and economics concerns.

Types of support: Annual campaigns, building funds, capital campaigns, conferences and seminars, emergency funds, conferences and seminars, emergency funds, endowment funds, equipment, fellowships, general purposes, internships, lectureships, matching funds, operating budgets, program-related investments, publications, renovation projects, scholarship funds, seed money, special projects, continuing support.

Limitations: No grants to individuals, or for deficit financing, exchange programs, land acquisition, or professorships; no loans.

Application information:

 Initial approach: Proposal

 Deadline(s): None

 Board meeting date(s): As necessary

 Final notification: Varies

 Write: George Pearson, Admin.

Officers: David H. Koch, Pres.; George H. Pearson, Admin.

Number of staff: None.

Employer Identification Number: 480926946

994
The Fred C. Koch Foundation, Inc.

P.O. Box 2256

Wichita 67201 (316) 832-5404

Incorporated in 1955 in KS.

Donor(s): Fred C. Koch,† Mary R. Koch, Koch Industries, Inc.

Financial data (yr. ended 12/31/86): Assets, $8,795,595 (M); gifts received, $20,000; expenditures, $155,182, including $128,439 for 21 grants (high: $30,000; low: $100) and $20,000 for 20 grants to individuals.

Purpose and activities: Grants primarily for cultural programs and for services for the mentally and physically handicapped; also supports a scholarship program for dependents of employees of Koch Industries.

Types of support: Employee-related scholarships.

Limitations: Giving primarily in KS. No grants to individuals, except for dependents of Koch Industries employees.

Application information:

 Initial approach: Letter

 Copies of proposal: 1

 Deadline(s): Submit proposal preferably in Feb.

 Board meeting date(s): Mar.

 Write: George H. Pearson, Pres.

Officers: George H. Pearson, Pres.; Mary R. Koch,* V.P.; Donald L. Cordes,* Secy.; Vonda Halliman, Treas.
Directors:* David H. Koch, Robert Martin, Samuel Polk.
Employer Identification Number: 486113560

995
Claude R. Lambe Charitable Foundation
411 East 37 St., North
Wichita 67220 (316) 837-5227
Application address: P.O. Box 2256, Wichita, KS 67201

Established in 1982 in KS.
Donor(s): Claude R. Lambe.†
Financial data (yr. ended 12/31/87): Assets, $23,218,864 (M); expenditures, $2,328,028, including $2,135,825 for 13 grants (high: $500,000; low: $4,345).
Purpose and activities: Giving primarily for education; some support also for the arts.
Limitations: Giving primarily in KS. No grants to individuals.
Application information:
 Initial approach: Proposal
 Write: George H. Pearson, Secy.
Officers: George H. Pearson, Secy.; Venda Holliman, Treas.
Trustee: Charles Koch.
Number of staff: None.
Employer Identification Number: 480935563

996
The Julia J. Mingenback Foundation, Inc.
One Main Plaza
McPherson 67460
Application address: 112 North Lakeside, McPherson, KS 67460; Tel.: (316) 241-1439

Incorporated in 1959 in KS.
Donor(s): E.C. Mingenback.†
Financial data (yr. ended 12/31/86): Assets, $3,150,528 (M); expenditures, $243,152, including $200,200 for 9 grants (high: $60,000; low: $500).
Purpose and activities: Emphasis on higher education and cultural programs.
Limitations: Giving primarily in McPherson County, KS.
Application information:
 Initial approach: Letter
 Deadline(s): None
 Write: Willda Coughenour, Pres.
Officers: Willda Coughenour, Pres.; Ruth Lancaster, Treas.
Directors: Edwin T. Pyle, L.H. Ruppenthal, Don C. Steffes.
Trustee: McPherson Bank and Trust Co.
Employer Identification Number: 486109567

997
Muchnic Foundation
107 North Sixth St., Suite 2
P.O. Box 329
Atchison 66002 (913) 367-4164

Trust established in 1946 in KS.
Donor(s): Valley Co., Inc., Helen Q. Muchnic,† H.E. Muchnic.

Financial data (yr. ended 11/30/88): Assets, $3,765,698 (M); expenditures, $234,553, including $219,758 for 46 grants (high: $53,758; low: $100).
Purpose and activities: Giving for higher education, health, cultural programs, including museums, and civic affairs.
Limitations: Giving primarily in KS. No grants to individuals.
Application information:
 Initial approach: Proposal
 Deadline(s): Oct. 31
 Board meeting date(s): As required
 Write: Roger L. Dennison
Officer and Trustees: E.M. Elicker, William H. Muchnic.
Employer Identification Number: 486102818

998
O'Connor Company-Piller Foundation
P.O. Box 2253
Wichita 67201 (316) 263-3187

Financial data (yr. ended 12/31/87): Assets, $18,495 (M); expenditures, $5,419, including $5,385 for 19 grants (high: $1,000; low: $25).
Purpose and activities: Support for medical research, youth, the arts, and wildlife.
Limitations: Giving primarily in KS.
Trustees: Eileen O. Piller, Lynn J. Piller, Robert J. Piller.
Employer Identification Number: 480932998

999
The Powell Family Foundation
10990 Roe Ave.
P.O. Box 7270
Shawnee Mission 66207 (913) 345-3000

Established in 1969 in MO.
Donor(s): George E. Powell, Sr.†
Financial data (yr. ended 12/31/87): Assets, $51,030,703 (M); expenditures, $1,824,939, including $1,824,939 for 116 grants (high: $139,500; low: $100).
Purpose and activities: Grants for education, religion, civic affairs, and social service and youth agencies; some support also for cultural programs.
Types of support: Operating budgets, annual campaigns, seed money, emergency funds, equipment, program-related investments, scholarship funds, matching funds, general purposes, renovation projects, special projects, continuing support, conferences and seminars.
Limitations: Giving primarily in Kansas City and for projects benefiting residents of the area. No grants to individuals, or for endowment or building funds.
Publications: Annual report (including application guidelines).
Application information:
 Initial approach: Letter
 Copies of proposal: 2
 Deadline(s): 30 days preceding board meeting
 Board meeting date(s): Usually in Jan., Apr., July, and Oct.
 Final notification: 60 days
 Write: Marjorie P. Allen, Pres.
Officers and Trustees: George E. Powell, Jr., Chair.; Marjorie P. Allen, Pres.; Marilyn P.

McLeod, V.P. and Secy.; George E. Powell III, Treas.; Nicholas K. Powell.
Number of staff: 1 full-time professional; 2 full-time support.
Employer Identification Number: 237023968

1000
Ross Foundation
105 South Broadway
Wichita 67202-2009

Established in 1961 in KS.
Financial data (yr. ended 12/31/87): Assets, $2,389,207 (M); expenditures, $124,048, including $100,113 for 10 grants (high: $60,866; low: $250).
Purpose and activities: Support primarily for cultural organizations, including the fine arts and an historical organization.
Limitations: Giving primarily in KS.
Application information:
 Deadline(s): None
 Write: Hal Ross, V.P.
Officers: Norman Jeter, Pres.; Hal Ross, V.P.; Susan Ross Sheets, Secy.-Treas.
Employer Identification Number: 486125814

1001
Security Benefit Life Insurance Company Charitable Trust
700 Harrison St.
Topeka 66636 (913) 295-3000
Additional address: c/o Bank IV, P.O. Box 88, Topeka, KS 66601

Established in 1976 in KS.
Financial data (yr. ended 12/31/87): Assets, $907,638 (M); expenditures, $153,390, including $146,549 for employee matching gifts.
Purpose and activities: Giving through employee matching funds for the arts, social services, health, and education.
Types of support: Employee matching gifts.
Application information:
 Write: Howard R. Fricke
Trustees: John H. Abrahams, Howard R. Fricke, James F. Haake, Bank IV Topeka.
Employer Identification Number: 486211612

1002
Security State Bank Charitable Trust
1 Security Plaza
Kansas City 66101 (913) 281-3165

Financial data (yr. ended 12/31/87): Assets, $76,567 (M); expenditures, $16,793, including $16,659 for 39 grants (high: $5,200; low: $30; average: $100-$300).
Purpose and activities: Support for religious giving, social services, health, conservation, women's issues, education, civic affairs, arts and culture, and community funds.
Limitations: Giving limited to Barton County, MO.
Application information:
 Deadline(s): Dec. 31
Trustee: United Missouri Bank of Kansas City.
Employer Identification Number: 486109832

1003
The Sosland Foundation
P.O. Box 29155
Shawnee Mission 66201 (913) 236-7300

Incorporated in 1955 in MO.
Donor(s): Members of the Sosland family.
Financial data (yr. ended 11/30/87): Assets, $17,717,260 (M); expenditures, $1,588,892, including $1,428,532 for 102 grants (high: $566,000; low: $250; average: $1,000-$20,000).
Purpose and activities: Giving to Jewish and social welfare funds, higher and secondary education, the arts, civic causes, and health organizations.
Types of support: General purposes, operating budgets, continuing support, annual campaigns, seed money, emergency funds, deficit financing, building funds, equipment, land acquisition, endowment funds, matching funds, consulting services, technical assistance, scholarship funds, special projects, research, capital campaigns, renovation projects, program-related investments.
Limitations: Giving primarily in MO and KS. No grants to individuals, or for publications, or conferences; no loans.
Application information:
 Initial approach: Letter
 Deadline(s): None
 Board meeting date(s): Mar., June, Sept., and Dec.
 Final notification: 3 months
 Write: Debbie Sosland-Edelman
Officers and Directors:* H.J. Sosland, Pres.; Neil Sosland,* V.P.; Morton I. Sosland,* Secy.-Treas.
Number of staff: 1 part-time professional.
Employer Identification Number: 446007129

1004
Stauffer Communications Foundation
P.O. Box 88
Topeka 66601
Application address: 616 Jefferson, Topeka, KS 66607; Tel.: (913) 295-1111

Financial data (yr. ended 12/31/87): Assets, $868,400 (M); gifts received, $200,000; expenditures, $123,667, including $120,627 for 78 grants (high: $8,500; low: $25).
Purpose and activities: Support primarily for cultural programs, community development, education, and youth organizations.
Types of support: Building funds, capital campaigns, renovation projects, operating budgets.
Application information:
 Deadline(s): None
 Write: Stanley H. Stauffer, Chair.
Officers: Stanley H. Stauffer, Chair.; William D. Duckworth, Secy.
Trustee: Bank IV Topeka.
Employer Identification Number: 486212412

1005
United Telecommunications Corporate Giving Program
2330 Shawnee Mission Pkwy.
Westwood 66205 (913) 676-3312
Mailing Address: P.O. Box 11315, Kansas City, MO 64112

Financial data (yr. ended 12/31/88):
$1,000,000 for grants.
Purpose and activities: Support for education, through private colleges and universities, minority education, business and economic education, engineering and science/technology education, continuing education and education associations; the arts, primarily the performing arts, arts institutes, museums and galleries, and public broadcasting; urban and community affairs; health organizations; social services, including United Funds, youth organizations and community service organizations. Types of support include employee matching gifts for education and the donation of in-kind services and loaned employees.
Types of support: Capital campaigns, fellowships, employee matching gifts, in-kind gifts.
Limitations: Giving primarily in headquarters city and subsidiary locations.
Application information: Include organization description, amount requested, purpose for funds, recently audited financial statement, and 501(c)(3).
 Initial approach: Brief letter or proposal
 Deadline(s): None
 Board meeting date(s): As needed
 Write: D.G. Forsythe, V.P.
Number of staff: 1 part-time professional; 1 part-time support.

1006
K. T. Wiedemann Foundation, Inc.
300 Page Court
Wichita 67202 (316) 265-9311

Incorporated in 1959 in KS.
Donor(s): K.T. Wiedemann Trust.
Financial data (yr. ended 2/28/87): Assets, $163 (M); expenditures, $181,426, including $150,495 for 7 grants (high: $50,000; low: $1,000; average: $100-$10,000).
Purpose and activities: Emphasis on higher education, youth agencies, social service organizations, hospitals, cultural programs, and Protestant church support; giving also for health-related associations.
Types of support: Annual campaigns, seed money, emergency funds, equipment, endowment funds, research, scholarship funds, matching funds, general purposes, continuing support, building funds.
Limitations: Giving primarily in south-central KS, with emphasis on Wichita. No grants to individuals.
Application information:
 Initial approach: Letter
 Copies of proposal: 1
 Deadline(s): None
 Board meeting date(s): Weekly
 Final notification: 10 days
 Write: Kenneth Pringle, Secy.
Officers and Trustees: Gladys H.G. Wiedemann, Pres. and Treas.; Kenneth Pringle, Secy.; Douglas S. Pringle.
Number of staff: None.
Employer Identification Number: 486117541

1007
Yellow Freight System Foundation
10990 Roe Ave.
Overland Park 66207 (913) 345-3000

Donor(s): Yellow Freight System, Inc.
Financial data (yr. ended 12/31/87): Assets, $3,170,782 (M); gifts received, $418,886; expenditures, $872,923, including $836,550 for grants and $250,000 for loans.
Purpose and activities: Emphasis on cultural programs, social services, education, health, and civic affairs.
Types of support: Annual campaigns, capital campaigns, continuing support, general purposes, loans, operating budgets, program-related investments, renovation projects.
Limitations: Giving primarily in the Kansas City, MO, metropolitan area. No grants to individuals.
Application information:
 Deadline(s): None
 Board meeting date(s): As necessary
 Final notification: 45 to 60 days
 Write: D.A. Wolfram, V.P.
Officers and Directors:* George E. Powell, Jr.,* Pres.; George E. Powell III,* V.P.; P.A. Spangler, Treas.
Number of staff: 1 part-time professional; 1 part-time support.
Employer Identification Number: 237004674

KENTUCKY

1008
Greater Ashland Area Cultural and Economic Development Foundation, Inc.
1212 Bath Ave.
Ashland 41105 (606) 324-3888
Mailing address: P.O. Box 2096, Ashland, KY 41105-2096

Community foundation incorporated in 1972 in KY.
Financial data (yr. ended 12/31/85): Assets, $3,048,571 (M); gifts received, $311,829; expenditures, $327,318, including $21,637 for grants and $104,911 for foundation-administered programs.
Purpose and activities: Giving for charitable, cultural, educational, and scientific purposes.
Types of support: General purposes, special projects, seed money, consulting services, technical assistance.
Limitations: Giving limited to the tri-state area of Ashland, KY, Ironton, OH, and Huntington, WV. No grants to individuals, or for annual campaigns, deficit financing, building or endowment funds.
Publications: Annual report, newsletter, application guidelines.
Application information: Application form required.
 Initial approach: Letter
 Copies of proposal: 1

Board meeting date(s): June
Write: Linda L. Ball, Exec. Dir.
Officers and Trustees:* C. Ronald Christmas,*
Pres.; Frank P. Justice,* V.P.; Linda L. Ball,
Secy. and Exec. Dir.; William Stinnett,* Treas.
Number of staff: 1 full-time professional; 1 full-
time support.
Employer Identification Number: 610729266

1009
Bank of Louisville Charities, Inc.
P.O. Box 1101
Louisville 40201
Application address: 500 West Broadway,
Louisville, KY 40202; Tel.: (502) 589-3351

Established in 1973.
Donor(s): Bank of Louisville.
Financial data (yr. ended 12/31/87): Assets,
$3,468,901 (M); expenditures, $255,664,
including $246,627 for 88 grants (high:
$30,000; low: $10).
Purpose and activities: Emphasis on cultural
programs, especially in the arts; support also
for education, health, civic affairs, and a
community fund.
Types of support: Annual campaigns, building
funds, continuing support, emergency funds,
program-related investments, special projects.
Limitations: Giving primarily in Jefferson
County, KY.
Application information:
Initial approach: Letter
Write: Bertram W. Klein, Chair.
Officer: Mary Pfeiffer, Secy.
Directors: Bertram W. Klein, Chair.; Orson
Oliver, Thomas L. Weber.
Employer Identification Number: 237423454

1010
BATUS Corporate Giving Program
2000 Citizens Plaza
Louisville 40202 (502) 581-8000

Purpose and activities: Supports education,
the arts, health and welfare, help for youth, the
disadvantaged, community development,
minorities, and civic affairs.
Types of support: Building funds, capital
campaigns, employee matching gifts, general
purposes, special projects.
Limitations: Giving primarily in Louisville, KY
for BATUS, the holding company; operating
companies contribute to charities in their
areas. No support for political organizations.
Publications: Corporate report.
Application information: Include description
of organization and project, budget for the
amount awarded, financial statement, list of
contributors, and evidence of tax-exemption.
Initial approach: Letter; contact different
operating companies directly for their
giving programs
Deadline(s): Applications accepted
throughout the year
Write: Robert Baker, Mgr., Public Affairs
Number of staff: 1

1011
James Graham Brown Foundation, Inc.
132 East Gray St.
Louisville 40202 (502) 583-4085

Trust established in 1943 in KY; incorporated in
1954.
Donor(s): J. Graham Brown,† Agnes B.
Duggan.†
Financial data (yr. ended 12/31/87): Assets,
$170,801,428 (M); expenditures, $10,776,197,
including $8,332,448 for 63 grants (high:
$2,000,000; low: $100; average: $5,000-
$250,000).
Purpose and activities: Support for higher
education, civic organizations, community
development, museums, and social service,
youth, and health agencies.
Types of support: Annual campaigns, building
funds, capital campaigns, conferences and
seminars, emergency funds, endowment funds,
equipment, matching funds, professorships,
renovation projects, research, scholarship
funds, special projects.
Limitations: Giving primarily in KY, with
emphasis on Louisville. No support for private
foundations or the performing arts; no funding
for elementary or secondary education. No
grants to individuals.
Publications: Grants list, 990-PF.
Application information: Application form
required only for larger or more complex
requests.
Initial approach: Letter
Copies of proposal: 12
Deadline(s): None
Board meeting date(s): Monthly
Final notification: Grants paid Dec. 31
Write: Michelle Quinn, Grants Coord.
Officers: Joe M. Rodes,* Pres.; Graham B.
Loper,* V.P.; Arthur H. Keeney, M.D.,* Secy.;
Harold E. Hawkins, Treas.
Trustees:* H. Curtis Craig, Chair.; Stanley S.
Dickson, Frank B. Hower, Jr., Stanley F.
Hugenberg, Jr., Ray E. Loper, Robert L. Royer.
Number of staff: 2 full-time professional; 1
part-time professional; 1 full-time support; 1
part-time support.
Employer Identification Number: 610724060

1012
W. L. Lyons Brown Foundation
850 Dixie Hwy.
Louisville 40210

Incorporated in 1962 in KY.
Donor(s): W.L. Lyons Brown.†
Financial data (yr. ended 12/31/86): Assets,
$5,967,901 (M); expenditures, $188,293,
including $182,618 for 32 grants (high:
$25,000; low: $250).
Purpose and activities: Emphasis on
education, conservation, cultural activities, and
the arts.
Limitations: Giving primarily in KY.
Application information:
Initial approach: Proposal
Deadline(s): None
Write: Ina B. Johnson, Pres.
Officers and Trustees: Ina B. Johnson, Pres.;
Mrs. W.L. Lyons Brown, Secy.; Owsley Brown
II, Treas.; Martin S. Brown, W.L. Lyons Brown,
Jr., Earl A. Dorsey, David L. McDonald,
Benjamin H. Morris.

Employer Identification Number: 610598511

1013
Capital Holding Corporate Giving Program
P.O. Box 32830
Louisville 40232 (502) 560-2536

Financial data (yr. ended 12/31/88): Total
giving, $860,000, including $815,000 for
grants (high: $50,000; low: $100; average:
$100-$50,000) and $45,000 for employee
matching gifts.
Purpose and activities: Primarily focuses on
education including scholarships; support also
for civic and community affairs, health and
human services, culture and the arts, and
subsidiary contributions. The program also
matches employee gifts.
Types of support: Employee matching gifts,
internships, matching funds, general purposes,
special projects, scholarship funds.
Limitations: Giving primarily in the Louisville,
KY area. No support for religious or political
organizations. No grants to individuals.
Application information: Include statement of
purpose and "exact need", complete budget,
current audited financial statement and
evidence of tax exemption. Application form
required.
Initial approach: Letter of inquiry
Copies of proposal: 1
Deadline(s): Applications accepted
throughout the year
Final notification: Aug. and Sept.
Write: Christy Callahan, Dir., Community
Relations and Corp. Giving

1014
Citizens Fidelity Foundation, Inc.
P.O. Box 33000
Louisville 40296 (502) 581-2016
Application address: Citizens Fidelity Bank and
Trust Co., Louisville, KY 40296

Incorporated in 1980 in KY.
Donor(s): Citizens Fidelity Bank and Trust Co.
Financial data (yr. ended 12/31/87): Assets,
$1,709,870 (M); gifts received, $55,875;
expenditures, $1,011,474, including
$1,008,035 for 70 grants (high: $200,000; low:
$500; average: $1,000-$10,000).
Purpose and activities: Emphasis on cultural
programs, education, including higher
education, and social services.
Types of support: Building funds, capital
campaigns, emergency funds, general purposes,
program-related investments, seed money,
special projects.
Limitations: Giving primarily in Louisville, KY.
No grants to individuals.
Publications: Application guidelines.
Application information: Application form
required.
Deadline(s): Mar. 1, June 1, Sept. 1, and
Dec. 1
Board meeting date(s): Last Tues. in Jan.,
Apr., July, and Oct.
Final notification: 2 weeks after board meets
Write: Traci Orman
Officers and Directors: E. Frederick Zopp,
Secy.; Mary R. Bush, Treas.; James H. Davis,

Warner L. Jones, Jr., Harry LaViers, Jr., Rose L. Rubel, Lawrence L. Smith, Douglas D. Stegner, James Thompson.
Employer Identification Number: 310999030

1015
Courier-Journal and Louisville Times Corporate Giving Program
525 W. Broadway
Louisville 40202 (502) 582-4552

Financial data (yr. ended 12/31/88): $610,000 for 41 grants (high: $158,000; low: $500; average: $4,000-$5,000).
Purpose and activities: Supports programs for drug abuse, health, rehabilitation, mental health, child abuse, homelessness, housing, hunger, family services, higher and minority education, community and rural development, recreation, literacy, leadership development, legal services, speech pathology, performing arts, journalism, and media and communications.
Types of support: Capital campaigns, consulting services, continuing support, emergency funds, employee matching gifts, equipment, seed money, special projects.
Limitations: Giving primarily in KY and southern IN.
Application information: The company decides on the grant recipients and then reports to the Gannett Foundation, which makes the actual gifts. Application form required.
 Deadline(s): Jan. 1, May 1, and Sept.1
 Final notification: 60 days after application
 Write: Donald Towles, V.P., Public Affairs
Number of staff: None.

1016
The Cralle Foundation
c/o Liberty National Bank
P.O. Box 32500
Louisville 40232 (502) 566-1702

Established in 1984 in KY.
Financial data (yr. ended 12/31/87): Assets, $4,661,275 (M); gifts received, $4,587,815; expenditures, $323,489, including $313,933 for 15 grants (high: $75,000; low: $3,000).
Purpose and activities: Support primarily for youth groups, higher education, health services, museums and community development.
Types of support: General purposes.
Limitations: Giving primarily in KY, with emphasis on Louisville.
Application information: Application form required.
 Write: Institutional Trust Dept.
Trustee: Liberty National Bank & Trust Co. of Louisville.
Employer Identification Number: 311070853

1017
First Kentucky National Charitable Foundation, Inc.
101 South Fifth St.
Louisville 40202 (502) 581-7870

Established in 1981 in KY.
Donor(s): First National Bank of Louisville.

Financial data (yr. ended 12/31/88): Assets, $1,200,000 (M); gifts received, $595,829; expenditures, $1,108,320, including $1,105,820 for 81 grants (high: $150,000; low: $1,000; average: $1,000-$10,000).
Purpose and activities: Giving primarily for education; support also for cultural activities and social services.
Limitations: Giving primarily in KY, with emphasis on Louisville. No grants to individuals.
Application information:
 Initial approach: Letter
 Deadline(s): None
 Board meeting date(s): Mar., June, Sept. and Dec.
 Final notification: Quarterly, after meetings
 Write: Sharon M. Gentner, Secy.
Officers: Mary Griffith,* Chair.; A. Stevens Miles,* Pres.; William F. Chandler, V.P.; Sharon M. Gentner, Secy.
Directors:* Morton Boyd, W.L. Lyons Brown, Jr., S. Gordon Dabney, Henry F. Frigon, Thomas R. Fuller, Jacob H. Graves, III, William H. Harrison, Jr., John B. Holland, David A. Jones, George N. King, Sr., Richard P. Mayer, Richard D. Sanborn, Franklin F. Starks, Jr., James W. Stites, Jr.
Employer Identification Number: 311033629

1018
The Gheens Foundation, Inc.
746 Starks Bldg.
Louisville 40202 (502) 584-4650

Incorporated in 1957 in KY.
Donor(s): C. Edwin Gheens,† Mary Jo Gheens Hill.†
Financial data (yr. ended 10/31/87): Assets, $38,388,579 (M); expenditures, $2,346,150, including $1,471,943 for grants (high: $597,904; low: $550; average: $5,000-$50,000).
Purpose and activities: Emphasis on higher and secondary education, ongoing teacher education, social service agencies, health associations, programs for the physically and mentally handicapped, and cultural programs.
Types of support: Special projects, building funds, scholarship funds, renovation projects, equipment.
Limitations: Giving primarily in KY, with emphasis on Louisville.
Publications: Application guidelines.
Application information: Application form required.
 Initial approach: Letter with 1-to-2 page outline
 Deadline(s): None
 Board meeting date(s): Quarterly
 Final notification: Within 90 days
 Write: James N. Davis, Exec. Dir.
Officers: Joseph E. Stopher,* Pres.; Laramie L. Leatherman,* V.P.; Oscar S. Bryant, Jr.,* Secy.; James N. Davis, Treas. and Exec. Dir.
Trustees:* Donald W. Doyle, John M. Smith.
Number of staff: 2 full-time professional; 2 full-time support.
Employer Identification Number: 616031406

1019
Glenmore Distilleries Corporate Giving Program
1700 Citizens Plaza
Louisville 40202 (502) 589-0130

Purpose and activities: Support for local community activities; major giving is through Glenmore Foundation.
Types of support: Annual campaigns, capital campaigns, endowment funds, general purposes, internships, operating budgets, research, special projects.
Limitations: Giving primarily in KY.
Application information:
 Initial approach: Narrative letter describing project and proposal with budget
 Final notification: 4 weeks
 Write: Donna-Ann P. Hayden

1020
Glenmore Foundation, Inc.
1700 Citizens Plaza
Louisville 40202-2874 (502) 589-0130

Financial data (yr. ended 6/30/87): Assets, $318,066 (M); gifts received, $2,600; expenditures, $3,284.
Purpose and activities: Support for the arts, medical education and medical research; gives to national organizations.
Trustee: James Thompson.
Employer Identification Number: 311018779

1021
The Humana Foundation, Inc.
The Humana Bldg., 500 West Main St.
P.O. Box 1438
Louisville 40201 (502) 580-3920

Incorporated in 1981 in KY.
Donor(s): Humana, Inc.
Financial data (yr. ended 8/31/88): Assets, $15,870,080 (M); gifts received, $6,317,059; expenditures, $8,226,538, including $8,162,032 for grants (high: $1,024,000; low: $100; average: $5,000-$25,000).
Purpose and activities: Support for the performing arts, health organizations, higher and secondary education, community and economic development, and a community center.
Limitations: Giving primarily in KY.
Application information:
 Deadline(s): None
 Board meeting date(s): Every 2 months
 Final notification: Generally, 6 weeks to 2 months
 Write: Jay L. Foley, Contribution Mgr.
Officers and Directors:* David A. Jones,* Chair. and C.O.O.; Wendell Cherry,* Pres. and C.O.O.; William C. Ballard, Jr., Exec. V.P., Finance and Administration; Carl F. Pollard,* Exec. V.P.; Thomas J. Flynn, Sr. V.P.; Alice F. Newton, Secy.
Number of staff: None.
Employer Identification Number: 611004763

1022
Kentucky Foundation for Women, Inc.

The Heyburn Bldg., Suite 1215
Louisville 40202 (502) 562-0045

Established in 1985 in KY.
Donor(s): Sallie Bingham.
Financial data (yr. ended 6/30/88): Assets, $8,047,262 (M); expenditures, $1,039,337, including $213,110 for 14 grants (high: $75,000; low: $25) and $462,740 for 70 grants to individuals.
Purpose and activities: Support primarily for women artists and arts-related organizations, with the goal of improving the status of women in the arts and bringing about social change through the arts; support also for projects relating to the humanities, science, and mathematics, particularly in fields traditionally closed to women.
Types of support: Conferences and seminars, continuing support, fellowships, grants to individuals, research, scholarship funds.
Limitations: Giving primarily in KY and contiguous areas.
Publications: Annual report, application guidelines, informational brochure.
Application information: Application form required for grants to individuals.
Initial approach: Letter
Copies of proposal: 2
Deadline(s): Oct. 1
Board meeting date(s): Oct. 1
Final notification: Jan.
Write: Sallie Bingham, Pres.
Officers and Directors: Sallie Bingham, Pres.; Frederick Smock, Secy.; Tim Peters, Treas.; Ann Stewart Anderson, Barry Ellsworth.
Number of staff: 2
Employer Identification Number: 611070429

1023
Kentucky Fried Chicken Corporate Giving Program

P.O. Box 32070
Louisville 40232 (502) 456-8300

Purpose and activities: Support for arts, health services, drug rehabilitation, education, community development and funds, social services, welfare, child welfare, and minority issues; also in-kind giving.
Types of support: Annual campaigns, capital campaigns, employee matching gifts, special projects, in-kind gifts.
Application information:
Write: Gregg M. Reynolds, V.P., Public Affairs
Number of staff: 5 part-time support.

1024
The Louisville Community Foundation, Inc.

Meidinger Tower, Suite 101
Louisville 40202 (502) 585-4649

Established in 1916 in KY; reorganized in 1984.
Financial data (yr. ended 6/30/88): Assets, $7,028,140 (M); gifts received, $1,925,140; expenditures, $460,715, including $233,079 for 80 grants (high: $25,000; low: $50; average: $4,000-$8,000) and $72,751 for 69 grants to individuals.
Purpose and activities: Giving for social services, arts and humanities, education, and environment; support also for scholarships, student loans, and a teacher awards program.
Types of support: Consulting services, technical assistance, seed money, special projects, emergency funds, student aid, student loans, equipment.
Limitations: Giving limited to the greater Louisville, KY, area. No grants for operating budgets, continuing support, annual campaigns, deficit financing, capital funds, research, publications, or conferences and seminars.
Publications: Annual report, program policy statement, application guidelines.
Application information: Application form required.
Initial approach: Letter
Copies of proposal: 10
Deadline(s): Submit proposal preferably in Mar. or Sept.; deadlines Apr. 1 and Oct. 1
Board meeting date(s): Sept., Dec., Mar., and June
Final notification: Within 2 weeks after June and Dec. meetings
Write: Darrell L. Murphy, Exec. Dir.
Administrator: Darrell L. Murphy, Exec. Dir.
Directors: Wilson W. Wyatt, Sr., Chair.; Baylor Landrum, Pres.; Ina B. Johnson, Secy.; John E. Brown, Treas.; and 31 additional directors.
Number of staff: 3 full-time professional; 3 full-time support; 1 part-time support.
Employer Identification Number: 310997017

1025
The George W. Norton Foundation, Inc.

1212 Citizens Plaza, 500 West Jefferson St.
Louisville 40202 (502) 589-1248

Incorporated in 1958 in KY.
Donor(s): Mrs. George W. Norton.
Financial data (yr. ended 12/31/87): Assets, $5,796,503 (M); gifts received, $10,000; expenditures, $301,968, including $258,700 for 23 grants (high: $44,000; low: $1,000).
Purpose and activities: Emphasis on education, health, cultural programs, youth agencies, and social services.
Types of support: Operating budgets.
Limitations: Giving primarily in KY. No support for private foundations. No grants to individuals, or for endowment funds.
Application information:
Initial approach: Proposal
Deadline(s): None
Board meeting date(s): Quarterly
Final notification: 90 days
Write: Miss Willodyne Miller, Exec. Dir.
Officers and Directors: Jane Morton Norton, Pres.; Rucker Todd, V.P.; Willodyne Miller, Secy.-Treas. and Exec. Dir.; Jane Norton Barrett, Robert W. Dulaney.
Employer Identification Number: 616024040

1026
H. J. Scheirich Company Foundation

P.O. Box 37120
Louisville 40233

Financial data (yr. ended 11/30/88): Assets, $31,680 (M); expenditures, $32,531, including $30,425 for 7 grants (high: $24,750; low: $100; average: $100-$700).
Purpose and activities: Support for the arts, United Way, Junior Achievement, social services, including Boy Scouts, the Salvation Army, and YMCAs.
Application information: Contributes only to preselected organizations. Applications not accepted.
Officers and Trustees: H.J. Scheirich III, Chair.; Judy F. Noble, Mgr.; Catherine G. Hines, Charles A. Mays.
Employer Identification Number: 616031045

1027
Al J. Schneider Foundation Corporation

3720 Seventh St. Rd.
Louisville 40216

Incorporated in 1957 in KY.
Donor(s): Al J. Schneider.
Financial data (yr. ended 2/28/87): Assets, $989,758 (M); gifts received, $322,500; expenditures, $264,415, including $263,608 for 110 grants (high: $30,637; low: $25).
Purpose and activities: Emphasis on church support, health, cultural programs, youth agencies, and education, particularly higher education.
Limitations: Giving primarily in KY.
Trustee: Al J. Schneider.
Employer Identification Number: 610621591

1028
The Thomas Foundation

(Formerly Thomas Industries Foundation)
4360 Brownsboro Rd., Suite 300
Louisville 40207 (502) 893-4600

Donor(s): Thomas Industries, Inc.
Financial data (yr. ended 12/31/87): Assets, $13,584 (M); gifts received, $50,000; expenditures, $40,866, including $40,826 for 30 grants (high: $10,000; low: $200).
Purpose and activities: Support for health associations, business and other education, community development, arts and culture, and youth.
Types of support: Annual campaigns, building funds, general purposes, scholarship funds.
Application information:
Initial approach: Written request
Write: Phillip Stuecker
Officers: Lee B. Thomas, Pres.; Thomas R. Fuller, V.P.; Gerald W. O'Pool, V.P.; C. Barr Schuler, V.P.; Phillip J. Stuecker, Secy.-Treas.
Number of staff: None.
Employer Identification Number: 396075230

LOUISIANA

1029
Baton Rouge Area Foundation
One American Place, Suite 1601
Baton Rouge 70825 (504) 387-6126

Community foundation incorporated in 1964 in LA.
Financial data (yr. ended 12/31/88): Assets, $5,942,493 (M); gifts received, $34,812; expenditures, $411,204, including $263,743 for grants.
Purpose and activities: Preference given to those projects which promise to affect a broad segment of the population or which tend to help a segment of the citizenry who are not being adequately served by the community's resources.
Types of support: Seed money, emergency funds, research, equipment, matching funds, special projects, renovation projects.
Limitations: Giving limited to the Baton Rouge, LA, area, including East Baton Rouge, West Baton Rouge, Livingston, Ascension, Iberville, Pointe Coupee, East Feliciana, and West Feliciana parishes. No grants to individuals, or for endowment funds, continuing support, annual campaigns, deficit financing, land acquisition, conferences, scholarships, fellowships, or operating budgets; no loans.
Publications: Annual report, application guidelines, newsletter, informational brochure.
Application information: Application form required.
 Initial approach: Telephone, letter, or proposal
 Copies of proposal: 1
 Deadline(s): Feb. 15, May 15, Aug. 15, and Nov. 15
 Board meeting date(s): Mar., June, Sept., and Dec.
 Final notification: 1 week after board meeting
 Write: John G. Davies, Exec. Dir.
Officers and Directors: John B. Noland, Pres.; Robert S. Greer, Sr., V.P.; Robert E. Wales, Secy.; Charles E. Schwing, Treas.; John G. Davies, Exec. Dir.; and 17 additional directors.
Trustee Banks: Premier Bank, Hibernia National Bank.
Number of staff: 2 full-time professional; 1 part-time support.
Employer Identification Number: 726030391
Recent arts and culture grants:
Community Fund for the Arts, Baton Rouge, LA, $10,000. 1987.

1030
The Ella West Freeman Foundation
P.O. Box 51299
New Orleans 70151-1299 (504) 568-0378
Additional tel.: (504) 796-9095

Trust established about 1940 in LA.
Donor(s): Richard W. Freeman,† Alfred B. Freeman.†
Financial data (yr. ended 12/31/87): Assets, $12,548,500 (M); gifts received, $122,772; expenditures, $308,562, including $174,600 for 6 grants (high: $164,000; low: $200).
Purpose and activities: Emphasis on higher education and civic affairs; also supports a museum.
Types of support: Annual campaigns, capital campaigns, endowment funds.
Limitations: Giving primarily in the greater New Orleans, LA, area. No grants to individuals.
Application information:
 Initial approach: Proposal
 Copies of proposal: 5
 Deadline(s): None
 Board meeting date(s): Approximately every 4 months beginning in spring
 Write: Richard W. Freeman, Jr., Chair.
Trustees: Richard W. Freeman, Jr., Chair.; Louis M. Freeman, Mrs. Montine McD. Freeman, Tina F. Woollam.
Number of staff: None.
Employer Identification Number: 726018322

1031
Freeport-McMoran Inc. Corporate Giving Program
1615 Poydras St.
New Orleans 70112 (504) 582-4000

Financial data (yr. ended 12/03/88): Total giving, $3,500,000, including $2,800,000 for 200 grants (high: $50,000; low: $1,000; average: $2,500-$7,500) and $700,000 for employee matching gifts.
Purpose and activities: Areas of special funding interest include education, health and welfare and social services, the arts, civic and community affairs and environmental concerns. Also support for agriculture, engineering, and business education.
Types of support: Matching funds, general purposes, research, scholarship funds, annual campaigns, building funds, capital campaigns, special projects, employee matching gifts.
Limitations: Giving primarily in operating areas in northern CA; FL; Baton Rouge, Belle Chase, Donaldsonville, Metairie, New Orleans, Uncle Sam, LA; Elko, NV; and the Southeast. No support for distributing foundations, national disease agencies or religious, political, fraternal, veterans', national, or tax-supported organizations. No grants to individuals.
Application information: Include description of project and organization, list of other sources of support, financial statements, and proof of tax-exemption.
 Initial approach: Initial contact by phone or letter; follow with full proposal
 Copies of proposal: 1
 Deadline(s): Applications accepted throughout the year.
 Board meeting date(s): Feb., Apr., June, Aug., Oct., and Dec.
 Write: Jay Handelman, Dir. Public Relations
Number of staff: 1

1032
The Matilda Geddings Gray Foundation
714 Esplanade Ave.
New Orleans 70116 (504) 581-5396

Established in 1969 in LA.
Donor(s): Matilda Geddings Gray,† Matilda Gray Stream.
Financial data (yr. ended 10/31/87): Assets, $6,547,774 (M); expenditures, $132,364, including $14,500 for 2 grants (high: $9,500; low: $5,000) and $105,658 for foundation-administered programs.
Purpose and activities: A private operating foundation that works with local universities to promote art exhibits and the study of art and art history at educational institutions throughout LA, especially in the fields of graphic, literary, and plastic arts; also supports agricultural education.
Types of support: Professorships.
Limitations: Giving primarily in LA.
Application information:
 Initial approach: Letter
 Deadline(s): None
 Write: Steven Carter
Officers and Trustees: Matilda Gray Stream, Pres.; Harold H. Stream II, V.P.; Harold H. Stream III, Secy.; Edward M. Carmouche, Nolan Miller, Sandra Stream Miller.
Employer Identification Number: 237072892

1033
The Helis Foundation
912 Whitney Bldg.
New Orleans 70130 (504) 523-1831

Incorporated in 1955 in LA.
Donor(s): Members of the William G. Helis family.
Financial data (yr. ended 12/31/87): Assets, $10,479,036 (M); gifts received, $400,000; expenditures, $495,828, including $477,825 for 32 grants (high: $125,000; low: $500).
Purpose and activities: Giving for music and the arts, community funds, religious associations, civic agencies, youth agencies and higher education.
Limitations: Giving primarily in LA.
Application information:
 Initial approach: Letter
 Deadline(s): None
 Write: A.E. Armbruster, V.P. and Treas.
Officers and Trustees: William G. Helis, Jr.,* Pres.; A.E. Armbruster, V.P. and Treas.; Bettie Conley Hanemann, Virginia Helis, Esther Helis Henry, David A. Kerstein, Nathan Wallfisch.
Members:* Cassandra Marie Helis.
Employer Identification Number: 726020536

1034
Mr. and Mrs. Jimmy Heymann Special Account
1201 Canal St.
New Orleans 70112

Incorporated in 1958 in LA.
Donor(s): Jimmy Heymann, Mrs. May H. Wolf.
Financial data (yr. ended 12/31/86): Assets, $3,103,772 (M); expenditures, $111,662, including $103,766 for 58 grants (high: $70,130; low: $10).

Purpose and activities: Giving for education, a community fund, health services, religious activities, youth activities, and cultural programs.
Limitations: Giving primarily in LA.
Application information: Contributes only to pre-selected organizations. Applications not accepted.
Officers: Janice Heymann, Pres.; Jerry Heymann, V.P. and Secy.-Treas.
Directors: Marion Levy Sontheimer, Maurice Sontheimer.
Employer Identification Number: 726019367

1035
Heymann-Wolf Foundation
1201 Canal St.
New Orleans 70112

Incorporated in 1947 in LA.
Donor(s): Leon Heymann,† Mrs. Leon Heymann,† Leon M. Wolf,† Mrs. May H. Wolf, Jimmy Heymann, Mrs. Jimmy Heymann, Krauss Co., Ltd.
Financial data (yr. ended 12/31/86): Assets, $3,037,756 (M); expenditures, $474,104, including $451,500 for 10 grants (high: $35,000; low: $500).
Purpose and activities: Giving for a university, a community fund, hospitals, and cultural programs.
Limitations: Giving primarily in LA.
Application information: Contributes only to pre-selected organizations. Applications not accepted.
Officers: Jerry Heymann, Pres.; Marjorie Heymann, V.P.; Mrs. Jimmy Heymann, Treas.
Employer Identification Number: 726019363

1036
D. H. Holmes Foundation
819 Canal St.
New Orleans 70112 (504) 561-6123

Established in 1965.
Donor(s): D.H. Holmes Co., Ltd.
Financial data (yr. ended 7/31/88): Assets, $5,390 (M); gifts received, $102,500; expenditures, $102,767, including $102,767 for 16 grants (high: $40,000; low: $1,100).
Purpose and activities: Emphasis on community funds, music, education, and nature centers and parks.
Types of support: Building funds.
Limitations: Giving limited to areas of company trading, including southern LA, Jackson, MS, Mobile, AL and Pensacola, FL.
Application information:
 Initial approach: Letter
 Deadline(s): None
 Write: James E. Ammon, Exec. V.P. - Finance
Officers and Directors: Donald W. Johnston, Chair. and Pres.; James E. Ammon, Exec. V.P. - Finance and Secy.; John F. Bricker, Robert R. Broadbent, Thomas H. Hicks, Alden J. LaBorde, Harry McCall, Jr., Donald J. Nalty, Frank E. Schmidt, Robert G. Sutherland.
Employer Identification Number: 726028216

1037
Keller Family Foundation
909 International Bldg.
611 Gravier St.
New Orleans 70130

Trust established in 1949 in LA.
Donor(s): Charles Keller, Jr., Rosa F. Keller.
Financial data (yr. ended 12/31/86): Assets, $1,586,473 (M); expenditures, $94,827, including $89,210 for 29 grants (high: $16,000; low: $100).
Purpose and activities: Giving for public policy organizations and higher education; support also for cultural programs, community development, a community fund, and a secondary school.
Limitations: Giving primarily in LA.
Trustees: Charles Keller, Jr., Chair.; Julie F. Breitmeyer, Rosa F. Keller, Caroline K. Loughlin, Mary K. Zervigon.
Employer Identification Number: 726027426

1038
La Nasa-Greco Foundation
3201 Ridgelake Dr.
Metairie 70002-4992 (504) 834-4226

Established in 1961 in LA.
Financial data (yr. ended 12/31/87): Assets, $1,718,555 (M); expenditures, $163,195, including $145,000 for 6 grants (high: $107,500; low: $7,500).
Purpose and activities: Support for higher education, scholarship funds; contributions also for music and health.
Types of support: Scholarship funds.
Limitations: Giving primarily in New Orleans, LA.
Application information:
 Deadline(s): None
 Write: Sarah La Nasa, Pres.
Officers: Sarah La Nasa, Pres.; C. Ellis Henican, V.P.; Sidney M. Rihner, Secy.-Treas.
Employer Identification Number: 726028040

1039
The Lupin Foundation
3715 Prytania St., Suite 403
New Orleans 70115 (504) 897-6125

Incorporated in 1981 in LA.
Financial data (yr. ended 12/31/87): Assets, $18,351,174 (M); expenditures, $1,333,253, including $834,512 for 60 grants (high: $100,000; low: $250).
Purpose and activities: Giving for education, civic affairs, community funds, religious associations, medical research, and cultural programs.
Types of support: Equipment, research, scholarship funds, special projects, matching funds, continuing support, general purposes, program-related investments, seed money.
Limitations: Giving primarily in LA. No grants to individuals; no loans.
Publications: Application guidelines.
Application information: Application form required.
 Initial approach: Brief proposal
 Copies of proposal: 9
 Deadline(s): None

Board meeting date(s): Monthly
Final notification: 4 to 6 weeks
Write: Arnold M. Lupin, Pres.
Officers and Directors: Arnold M. Lupin, M.D., Pres.; Louis Levy II, V.P.; Charles C. Mary, Jr., M.D., Secy.; E. Ralph Lupin, M.D., Treas.; Jay S. Lupin, M.D., Louis Lupin, Samuel Lupin, M.D., Suzanne Stokar.
Number of staff: 1 full-time support.
Employer Identification Number: 720940770

1040
The Magale Foundation, Inc.
c/o First National Bank of Shreveport
P.O. Box 21116
Shreveport 71154 (318) 226-2382

Incorporated in 1957 in LA.
Donor(s): John F. Magale.
Financial data (yr. ended 11/30/87): Assets, $1,454,194 (M); expenditures, $130,076, including $85,000 for 18 grants (high: $15,000; low: $1,000), $16,150 for 20 grants to individuals and $10,875 for 13 loans to individuals.
Purpose and activities: Grants for higher education, social services, and the performing arts, principally in LA and AR; loans are also made to students who reside in AR, LA, and TX.
Types of support: Student loans.
Limitations: Giving limited to residents of LA, TX and AR.
Application information: Application form required.
 Initial approach: Letter
 Deadline(s): Apr. 1
 Write: Mary J. Fain, Secy.
Officers and Directors: Joanna Magale, Pres.; T.A. Monroe, V.P.; Mary J. Fain, Secy.; First National Bank of Shreveport, Treas.; Homer Green, Hugh Lorsino.
Employer Identification Number: 726025096

1041
The Greater New Orleans Foundation
(Formerly The Greater New Orleans Regional Foundation)
2515 Canal St., Suite 401
New Orleans 70119 (504) 822-4906

Established in 1924 in LA, as the Community Chest; became a community foundation in 1983.
Financial data (yr. ended 12/31/88): Assets, $6,936,136 (M); gifts received, $1,335,621; expenditures, $627,018, including $438,519 for grants.
Purpose and activities: Giving for health, social services, cultural programs, and education.
Types of support: Emergency funds, technical assistance, seed money, special projects, matching funds, equipment.
Limitations: Giving limited to southeast LA, including the greater New Orleans area. No support for religion. No grants to individuals, or for operating budgets, annual fund campaigns, continuing support, endowment funds, building funds, or deficit financing.
Publications: Annual report, application guidelines, program policy statement, newsletter, informational brochure.

Application information: Application form required.

Initial approach: Proposal
Copies of proposal: 2
Deadline(s): None
Board meeting date(s): Quarterly
Write: Patricia C. Mason, Exec. Dir.

Officers: W. Boatner Reily III, Chair.; Harry J. Blumenthal, Jr., Vice-Chair.; Mrs. Morris E. Burka, Secy.; William F. Finegan, Treas.; Patricia C. Mason, Exec. Dir.

Trustees: Ian Arnof, Emmett W. Bashful, M.D., Philip Claverie, David Conroy, D. Blair Favrot, R. Thomas Fetters, Norman Francis, M.D., Tina Freeman, Mrs. Ronald French, Mrs. Robert Haspel, Thomas J. Egan, Charles Keller, Jr., Mrs. Francis E. Lauricella, Mrs. J. Thomas Lewis, Mrs. P. Roussel Norman, G. Frank Purvis, A. Louis Read, Mrs. Roger T. Stone, Charles C. Teamer, Sr., Robert Young.

Number of staff: 1 part-time professional; 1 full-time support; 1 part-time support.

Employer Identification Number: 720408921

1042
Parkside Foundation
1424 Whitney Bldg.
New Orleans 70130

Established in 1961 in LA.

Donor(s): Thomas B. Lemann, Stephen B. Lemann.

Financial data (yr. ended 12/31/86): Assets, $1,393,271 (M); gifts received, $220,895; expenditures, $126,190, including $123,017 for 57 grants.

Purpose and activities: Giving primarily for higher education, cultural programs, and Jewish welfare.

Limitations: Giving primarily in LA, with emphasis on New Orleans.

Application information: Applications not accepted.

Officers: Thomas B. Lemann, Pres.; Stephen B. Lemann, V.P.; Juanita T. Herndon, Secy.-Treas.

Employer Identification Number: 726019058

1043
Premier Foundation, Inc.
(Formerly First National Bank Foundation)
c/o Premier Bank
P.O. Box 21116
Shreveport 71154-0001

Incorporated in 1955 in LA.

Donor(s): Premier Bank.

Financial data (yr. ended 6/30/88): Assets, $664,410 (M); gifts received, $75,000; expenditures, $204,620, including $193,014 for 66 grants (high: $40,624; low: $25).

Purpose and activities: Giving for community development, cultural programs, and a community fund; support also for higher and secondary education, public policy organizations, and health agencies.

Limitations: Giving primarily in Shreveport, LA.

Application information:

Deadline(s): None
Write: Carol Fandefur, Secy.

Officers and Directors: Hugh J. Watson, Pres.; Jerry D. Boughton, V.P.; Don Updegraff, V.P.; Carol Fandefur, Secy.; Joseph M. Cantanese, Treas.

Employer Identification Number: 726022876

1044
Edward G. Schlieder Educational Foundation
431 Gravier St., Suite 400
New Orleans 70130 (504) 581-6179

Incorporated in 1945 in LA.

Donor(s): Edward G. Schlieder.†

Financial data (yr. ended 12/31/87): Assets, $12,792,265 (M); expenditures, $968,680, including $796,132 for 19 grants (high: $120,000; low: $11,109; average: $12,000-$30,000).

Purpose and activities: To aid schools, colleges, and universities; grants largely to universities for medical research.

Types of support: Research, equipment, capital campaigns.

Limitations: Giving limited to educational institutions in LA. No grants to individuals, or for general purposes, building or endowment funds, scholarships, fellowships, or operating budgets; no loans.

Publications: Annual report.

Application information:

Initial approach: Letter
Copies of proposal: 3
Deadline(s): Submit proposal preferably in Feb.; no set deadline
Board meeting date(s): As required
Final notification: 30 to 45 days
Write: Blanc A. Parker, Exec. Consultant

Officers: Donald J. Nalty,* Pres.; Louis G. Lemle,* V.P.; George G. Westfeldt, Jr.,* Secy.-Treas.; Blanc A. Parker, Exec. Consultant.

Directors:* Morgan L. Shaw, Thomas D. Westfeldt.

Number of staff: 1 part-time professional; 1 part-time support.

Employer Identification Number: 720408974

Recent arts and culture grants:

Loyola University, New Orleans, LA, $75,000. For equipment for Writing Across the Curriculum Center. 1987.

1045
The Community Foundation of Shreveport-Bossier
401 Edwards St., Suite 1520
Shreveport 71101 (318) 221-0582

Community foundation incorporated in 1961 in LA.

Financial data (yr. ended 12/31/88): Assets, $8,499,139 (M); gifts received, $606,241; expenditures, $860,744, including $691,920 for 41 grants (high: $100,000; low: $169).

Purpose and activities: Grants largely to health services, welfare, youth agencies, higher education, and cultural programs.

Types of support: Special projects, equipment, building funds, matching funds, scholarship funds, seed money, conferences and seminars, operating budgets, publications, renovation projects, research.

Limitations: Giving limited to the Caddo and Bossier parishes, LA. No grants to individuals.

Publications: Annual report, application guidelines.

Application information: Application form required.

Initial approach: Letter
Copies of proposal: 8
Deadline(s): Mar. 15, June 15, and Sept. 15
Board meeting date(s): Mar., Apr., July, and Oct.
Final notification: Immediately after board meetings
Write: Carol Emanuel, Exec. Dir.

Officers: Joseph L. Hargrove, Secy.; Charles Ellis Brown,* Treas.

Directors: Louis C. Pendleton, Chair.; Margaret W. Kinsey, Vice-Chair.; Joseph L. Hargrove, William C. Peatross, W.C. Raspberry, Jr., Donald P. Weiss.

Trustee Banks: Bossier Bank & Trust Co., Commercial National Bank in Shreveport, First National Bank of Bossier, First National Bank of Shreveport, Louisiana Bank & Trust Co., Pioneer Bank & Trust Co.

Number of staff: 1 full-time professional; 1 part-time support.

Employer Identification Number: 726022365

1046
Albert & Miriam Sklar Foundation
2925 Mansfield Rd.
Shreveport 71103-3613

Established in 1957 in LA.

Financial data (yr. ended 9/30/88): Assets, $1,031,645 (M); expenditures, $54,867, including $52,564 for 21 grants (high: $25,000; low: $200).

Purpose and activities: Giving for Jewish organizations, higher education, and the arts.

Officers: Albert Sklar, Pres.; Howard F. Sklar, V.P.; Miriam M. Sklar, Secy.-Treas.

Employer Identification Number: 726017597

1047
Virlane Foundation
1055 St. Charles Ave.
New Orleans 70130

Incorporated in 1958 in LA.

Financial data (yr. ended 9/30/88): Assets, $5,222,994 (M); expenditures, $103,716, including $95,900 for 15 grants (high: $25,000; low: $400).

Purpose and activities: A private operating foundation; emphasis on maintaining a sculpture plaza to encourage and foster the creation of art and sculpture; grants also for welfare funds, cultural programs, and community funds.

Limitations: Giving primarily in LA. No grants to individuals.

Application information: Contributes only to pre-selected organizations. Applications not accepted.

Officers and Directors: Jac Stich, Pres.; Virginia F. Bestoff, Secy.-Treas.

Number of staff: None.

Employer Identification Number: 726019440

1048
Kemper and Leila Williams Foundation
P.O. Box 50580
New Orleans 70150 (504) 523-4162

Incorporated in 1974 in LA.
Donor(s): L. Kemper Williams,† Leila M.
Williams,† and others.
Financial data (yr. ended 3/31/88): Assets,
$61,053,181 (M); gifts received, $48,084;
expenditures, $2,635,397, including
$2,236,574 for 2 grants.
Purpose and activities: Giving limited to the
Historic New Orleans Collection, a museum
and research Center, and to Kemper Williams
Park.
Limitations: Giving limited to New Orleans, LA.
Application information: Applications not
accepted.
Officers and Directors: Benjamin W. Yancey,
Pres.; Mary Lou M. Christovich, V.P.; Fred M.
Smith, Secy.-Treas.; Francis C. Doyle, G. Henry
Person, Jr.
Number of staff: 1 full-time professional; 1
part-time support.
Employer Identification Number: 237336090

1049
Zemurray Foundation
436 Whitney National Bank Bldg.
New Orleans 70130 (504) 525-0091

Incorporated in 1951 in LA.
Donor(s): Sarah W. Zemurray.
Financial data (yr. ended 12/31/87): Assets,
$32,754,245 (M); gifts received, $333,347;
expenditures, $1,147,339, including $871,990
for 30 grants (high: $330,500; low: $150).
Purpose and activities: Grants primarily for
education, particularly higher education,
cultural programs, civic affairs, hospitals, and
medical research.
Limitations: Giving primarily in New Orleans,
LA and Cambridge, MA.
Application information: Contributes only to
pre-selected organizations.
Board meeting date(s): Usually in Nov.
Write: Walter J. Belsom, Jr., Treas.
Officers and Directors: Doris Z. Stone, Pres.;
Samuel Z. Stone, V.P.; Thomas B. Lemann,
Secy.; Walter J. Belsom, Jr., Treas.
Employer Identification Number: 720539603

MAINE

1050
Casco Northern Bank Corporate
Contributions
c/o Marketing Communications
One Monument Sq., P.O. Box 678
Portland 04101 (207) 774-8221

Financial data (yr. ended 12/31/87): Total
giving, $367,671, including $345,611 for
grants and $22,060 for in-kind gifts.

Purpose and activities: Support for United
Ways, education, employment, and training,
higher education, health and human services,
culture and the arts, social services, civic and
community affairs, memberships, benefits, and
program ads; also provides in-kind services and
products.
Limitations: Giving limited to ME.
Application information:
Initial approach: Letter
Write: Caron Zand, Public Relations Officer

1051
Mabel S. Daveis Trust
Two Canal Plaza
Portland 04112 (207) 774-4000

Financial data (yr. ended 12/31/87): Assets,
$1,482,000 (M); expenditures, $104,000,
including $89,750 for 19 grants.
Purpose and activities: Giving to the United
Way; support also for social services, the arts,
and youth.
Limitations: Giving primarily in the Portland,
ME, area. No grants to individuals.
Application information:
Initial approach: Proposal
Deadline(s): Dec.
Final notification: Dec.
Write: Edward F. Dana, Trustee
Trustees: Edward F. Dana, George M. Lord,
Alden H. Sawyer, Jr.
Employer Identification Number: 016009342

1052
Guy Gannett Foundation
390 Congress St.
Portland 04101

Established in 1968 in ME.
Donor(s): Guy Gannett Publishing Co., and
subsidiaries.
Financial data (yr. ended 12/31/87): Assets,
$1,529,304 (M); gifts received, $206,000;
expenditures, $222,355, including $205,900
for 62 grants (high: $55,500; low: $50).
Purpose and activities: Giving for community
funds, cultural programs, especially a museum
and a library, education, and health and social
service agencies.
Limitations: Giving primarily in ME.
Officers and Directors: Jean Gannett Hawley,
Pres.; James E. Baker, Treas.; John R. DiMatteo,
John H. Gannett, Amory H. Houghton III,
George F. Marshall, Jr.
Employer Identification Number: 016003797

1053
The Maine Community Foundation, Inc.
210 Main St.
P.O. Box 148
Ellsworth 04605 (207) 667-9735

Community foundation incorporated in 1983 in
ME.
Financial data (yr. ended 12/31/88): Assets,
$3,024,561 (M); gifts received, $1,317,629;
expenditures, $650,032, including $489,583
for 191 grants (high: $47,500; low: $50;
average: $500-$5,000), $6,875 for 6 grants to
individuals and $127,000 for 3 loans.

Purpose and activities: Giving primarily for
youth and the elderly, the environment, arts,
education, and health.
Types of support: Seed money, matching
funds, conferences and seminars, general
purposes, publications, scholarship funds,
special projects, technical assistance, student
aid, emergency funds.
Limitations: Giving limited to ME. No support
for religious organizations for religious
purposes. No grants to individuals (except
from donor-designated funds), or for
endowment funds, equipment, or annual
campaigns for regular operations; grants rarely
made for capital campaigns.
Publications: Annual report (including
application guidelines), informational brochure.
Application information: Application form
required.
Initial approach: Letter
Copies of proposal: 1
Deadline(s): Feb. 1, Apr. 1, Aug. 1, Oct. 1,
and Dec. 1
Board meeting date(s): 5 times a year
Write: Marion Kane, Assoc. Dir.
Directors: H. King Cummings, Chair.; Edward
G. Kaelber, Exec. Dir.; and 17 additional
directors.
Number of staff: 2 full-time professional; 1
part-time professional; 1 part-time support.
Employer Identification Number: 010391479

1054
Market Trust
c/o Maine National Bank
P.O. Box 3555
Portland 04104 (207) 775-1000

Trust established in 1959 in ME.
Donor(s): Brockton Public Market, Inc.,
George C. Shaw Co., and subsidiaries.
Financial data (yr. ended 12/31/87): Assets,
$2,396,616 (M); gifts received, $150,000;
expenditures, $285,677, including $249,343
for 26 grants (high: $37,970; low: $650).
Purpose and activities: Giving for community
funds, hospitals, youth agencies, and arts and
cultural programs.
Types of support: Annual campaigns, building
funds, capital campaigns, emergency funds.
Limitations: Giving primarily in New England.
No grants to individuals.
Application information: Applications not
accepted.
Write: David MacNichol
Trustee: Maine National Bank.
Employer Identification Number: 016008389

1055
UNUM Charitable Foundation
2211 Congress St.
Portland 04122 (207) 770-2211

Established in 1969 in ME.
Donor(s): UNUM Life Insurance Co. of
America.
Financial data (yr. ended 12/31/87): Assets,
$1,629,333 (M); expenditures, $860,758,
including $829,151 for 54 grants (high:
$80,000; low: $100; average: $15,000) and
$25,602 for 192 employee matching gifts.

Purpose and activities: The foundation commits seventy-five percent of annual funds to corporate community grants for health and welfare agencies, arts and cultural programs, education (including employee matching gifts), and civic organizations. The remaining twenty-five percent is targeted for programs in AIDS and aging.

Types of support: Employee matching gifts, capital campaigns, special projects, matching funds, seed money.

Limitations: Giving primarily in ME; capital grants limited to the greater Portland area. No support for religious organizations, fundraising or athletic events, goodwill advertising, or United Way member agencies. No grants to individuals, or for endowments or funds for operating purposes.

Publications: Annual report (including application guidelines), informational brochure (including application guidelines).

Application information: Completion of formal application may be required after review of initial submission.

Initial approach: Letter
Copies of proposal: 1
Deadline(s): For capital grants, June 1; no deadline for other grants
Board meeting date(s): Trustees meet semiannually; grants under $25,000 reviewed by staff on an ongoing basis
Write: Judith Nedeau Harrison, Dir., Corp. Public Involvement

Officers: James F. Orr III,* Pres.; Donna T. Mundy,* V.P.; Judith Nedeau Harrison,* Secy.; Timothy Ludden, Treas.

Trustees:* William Bouman, Terry Cohen, James F. Keenan, James B. Moir, Wendolyn C. Clarke, James S. Orser, Cheryl Stewart, Barry W. Larman, Janet Whitehouse.

Number of staff: 1 full-time professional; 1 part-time professional; 1 part-time support.

Employer Identification Number: 237026979

Recent arts and culture grants:

Maine Acting Company, Lewiston, ME, $5,000. For school touring program. 1987.

New England Foundation for the Arts, Cambridge, MA, $17,500. 1987.

Portland Museum of Art, Portland, ME, $27,961. For Thursday night free admission. 1987.

Portland Stage Company, Portland, ME, $8,000. For educational outreach program. 1987.

Portland Symphony Orchestra, Portland, ME, $16,000. For youth concerts and Kinderkonzerts. 1987.

W C B B--Colby-Bates-Bowdoin Educational Telecasting Corporation, Lewiston, ME, $24,000. For McNeil-Lehrer program. 1987.

W C B B--Colby-Bates-Bowdoin Educational Telecasting Corporation, Lewiston, ME, $20,000. For capital campaign. 1987.

1056
Warren Memorial Foundation
645 Hearthside Rd.
North Windham 04062 (207) 892-8832

Incorporated in 1929 in ME.
Donor(s): Susan C. Warren.†
Financial data (yr. ended 12/31/87): Assets, $2,204,507 (M); gifts received, $245;

expenditures, $125,236, including $42,430 for 11 grants (high: $18,000; low: $700; average: $250-$1,600).

Purpose and activities: A private operating foundation; giving restricted to programs in education and the arts. Giving primarily for cultural and children's programs and secondary education; operates a local public library.

Types of support: Renovation projects, scholarship funds, operating budgets.

Limitations: Giving limited to Westbrook, ME. No grants to individuals, or for endowment funds.

Application information:

Initial approach: Letter
Copies of proposal: 1
Board meeting date(s): Usually monthly
Write: Lawrence B. Abbiati, Treas.

Officers and Directors: Howard C. Reiche, Jr., Pres.; Lawrence B. Abbiati, Treas.; Joseph T. Hakanson, Clerk; Rudolph T. Greep.

Employer Identification Number: 010220759

1057
Webber Oil Foundation
700 Main St.
Bangor 04401-6810

Financial data (yr. ended 8/31/88): Gifts received, $20,000; expenditures, $89,931, including $86,401 for 19 grants (high: $2,500; low: $250) and $3,000 for 8 grants to individuals.

Purpose and activities: Support for social services, community funds, education, health services, culture and the arts, including scholarships at Bangor high schools; recipient of scholarship must be a student of the high school awarding the scholarships.

Types of support: Student aid.

Limitations: Giving primarily in Bangor, ME.

Application information: Applications for scholarships should be addressed to the guidance counselors or principals of Bangor, ME, area high schools.

Trustees: Linda F. Harnum, Larry K. Mahaney, Louise F. Witham.

Employer Identification Number: 237046575

MARYLAND

1058
The Abell Foundation, Inc.
1116 Fidelity Bldg.
210 North Charles St.
Baltimore 21201-4013 (301) 547-1300

Incorporated in 1953 in MD.
Donor(s): A.S. Abell Co., Harry C. Black,† Gary Black, Sr.†
Financial data (yr. ended 12/31/88): Assets, $115,937,929 (M); expenditures, $5,541,540, including $4,565,299 for 145 grants (high: $550,000; low: $225; average: $5,000-$25,000), $14,950 for 12 grants to individuals,

$62,040 for 34 employee matching gifts and $197,000 for 1 loan.

Purpose and activities: Supports education with emphasis on public education; economic development; human services; arts and culture; conservation; and arts preservation.

Types of support: Endowment funds, capital campaigns, equipment, land acquisition, matching funds, renovation projects, conferences and seminars, general purposes, scholarship funds, seed money, special projects.

Limitations: Giving limited to MD, with a focus on Baltimore. Generally no support for housing or medical facilities. No grants to individuals, or for operating budgets, sponsorships, memberships, sustaining funds, or deficit financing.

Publications: Occasional report, application guidelines, annual report, newsletter, program policy statement.

Application information: Detailed information about what to submit with proposal should be requested. Employee-related scholarships have been phased out; previous commitments are being honored. Application form required.

Initial approach: Letter
Copies of proposal: 1
Deadline(s): Jan. 1, Mar. 1, May 1, July 1, Sept. 1, and Nov. 1
Board meeting date(s): Bimonthly
Final notification: Within 1 week of board meetings
Write: Robert C. Embry, Jr., Pres.

Officers: Robert C. Embry, Jr.,* Pres.; Anne La Farge Culman, V.P.; Faye V. Auchenpaugh, Secy.; Frances M. Keenan, Treas.

Trustees:* Gary Black, Jr., Chair.; W. Shepherdson Abell, Jr., George L. Bunting, Jr., Robert Garrett, William Jews, Donald H. Patterson, Walter Sondheim, Jr.

Number of staff: 4 full-time professional; 2 part-time professional; 2 full-time support; 2 part-time support.

Employer Identification Number: 526036106

1059
Abramson Foundation, Inc.
11501 Huff Court
North Bethesda 20895

Established in 1959 in MD.
Financial data (yr. ended 12/31/87): Assets, $3,390,485 (M); gifts received, $400,000; expenditures, $140,637, including $137,600 for 14 grants (high: $25,000; low: $100).

Purpose and activities: Support primarily for performing and fine arts, science and technology and education.

Types of support: General purposes.

Limitations: Giving primarily in the greater Washington, DC, area.

Application information: Contributes only to pre-selected organizations. Applications not accepted.

Officers: Albert Abramson, Pres.; Gary Abramson, Secy.; Ronald Abramson, Treas.

Employer Identification Number: 526039192

1060
The William G. Baker, Jr. Memorial Fund

c/o Mercantile-Safe Deposit & Trust Co.
P.O. Box 2257, Two Hopkins Plaza
Baltimore 21203 (301) 332-4171
Application address: c/o Baltimore Community Foundation, Six East Hamilton St., Baltimore, MD 21202

Established in 1964 in MD.
Financial data (yr. ended 8/31/87): Assets, $14,868,612 (M); expenditures, $632,689, including $556,686 for 61 grants (high: $50,000; low: $1,500; average: $10,000).
Purpose and activities: Giving primarily for education and community funds.
Types of support: Operating budgets, seed money, emergency funds, building funds, equipment, land acquisition, endowment funds, capital campaigns, renovation projects, scholarship funds.
Limitations: Giving limited to the Baltimore, MD, metropolitan area. No grants to individuals, or for annual campaigns or deficit financing; no loans.
Publications: Application guidelines.
Application information:
Initial approach: Proposal
Copies of proposal: 7
Deadline(s): Submit proposal 2 months before board meetings
Board meeting date(s): Generally Jan., Mar., Sept., and Dec.
Final notification: 3 months
Write: Martha K. Johnston, Prog. Officer
Officer and Governors: Douglas Dodge, Exec. Dir.; Mary Ellen Imboden, John T. King III, Walter Sondheim, Jr., Semmes G. Walsh.
Corp. Trustee Mercantile-Safe Deposit & Trust Co.
Number of staff: None.
Employer Identification Number: 526057178

1061
The Baltimore Community Foundation

(Formerly The Community Foundation of the Greater Baltimore Area, Inc.)
Six East Hamilton St.
Baltimore 21202 (301) 332-4171

Community foundation incorporated in 1972 in MD.
Financial data (yr. ended 12/31/86): Assets, $10,163,786 (M); gifts received, $2,341,098; expenditures, $1,241,959, including $949,563 for 98 grants (high: $179,466; low: $1,000; average: $1,000-$10,000), $130,313 for 84 grants to individuals and $12,000 for loans.
Purpose and activities: Giving primarily for educational, civic, cultural, health, welfare, environmental, and other community needs. Grants primarily for pilot projects and to increase organizational effectiveness and self-sufficiency.
Types of support: Building funds, general purposes, endowment funds, scholarship funds, matching funds, consulting services, technical assistance, grants to individuals.
Limitations: Giving primarily in the Baltimore, MD, area.
Publications: Annual report, informational brochure (including application guidelines).

Application information:
Initial approach: Letter
Deadline(s): 60 days before meetings
Board meeting date(s): 3 times a year
Final notification: Within 2 weeks after meetings
Write: Eugene C. Struckhoff, Exec. Dir.
Officers and Trustees:* H.J. Bremermann, Jr.,* Chair.; Herbert M. Katzenberg,* Vice-Chair.; Eugene C. Struckhoff, Pres. and Exec. Dir.; W. Wallace Lanahan, Jr.,* V.P. and Treas.; Timothy D. Armbruster, Secy.; and 20 additional trustees.
Number of staff: 2
Employer Identification Number: 237180620

1062
Baltimore Gas and Electric Foundation, Inc.

Box 1475
Baltimore 21203

Established in 1986 in MD.
Donor(s): Baltimore Gas and Electric Co.
Financial data (yr. ended 12/31/87): Assets, $4,216,494 (M); gifts received, $3,735,000; expenditures, $1,811,537, including $1,808,750 for 121 grants (high: $541,700; low: $1,100; average: $2,500-$75,000).
Purpose and activities: Support for arts and culture, higher and other education, community development, civic and public affairs, health and hospitals, the United Way, and Jewish giving.
Types of support: General purposes, annual campaigns, capital campaigns.
Limitations: Giving primarily in MD, with emphasis on Baltimore.
Application information: Contributes only to preselected organizations. Applications not accepted.
Officers: George V. McGowan,* Pres.; J.M. Files, V.P.; E.A. Crooke, Secy.; C.W. Shivery, Treas.
Directors:* B.C. Trueschler, Chair.; J. Owen Cole, L.B. Disharoon, K. Feeley, Jerome W. Geckle, W. Hackerman, P.G. Miller, G.G. Radcliffe, J.B. Slaughter, H.K. Wells.
Employer Identification Number: 521452037

1063
The Louis and Henrietta Blaustein Foundation, Inc.

Blaustein Bldg.
P.O. Box 238
Baltimore 21203

Incorporated in 1938 in MD.
Donor(s): Louis Blaustein,† Henrietta Blaustein,† American Trading and Production Corp., and members of the Blaustein family.
Financial data (yr. ended 12/31/87): Assets, $8,841,569 (M); gifts received, $435,000; expenditures, $815,039, including $750,950 for grants.
Purpose and activities: Giving mainly to recipients already known to the trustees; emphasis on higher and secondary education, Jewish welfare funds, museums, music and the arts, hospitals and health services, and a community fund.

Limitations: Giving primarily in the greater Baltimore, MD, metropolitan area.
Application information:
Initial approach: Letter
Deadline(s): None
Write: Morton K. Blaustein, Pres.
Officers and Trustees:* Ruth B. Rosenberg,* Chair.; Morton K. Blaustein,* Pres.; David Hirschhorn,* V.P.; Henry A. Rosenberg, Jr.,* V.P.; Louis B. Thalheimer,* V.P.; J. Warren Weiss, Secy.-Treas.
Employer Identification Number: 526038381

1064
Lois and Irving Blum Foundation

100 Garrett Bldg.
Baltimore 21202

Established about 1965 in MD.
Donor(s): Lois Blum-Feinblatt, Irving Blum.†
Financial data (yr. ended 3/31/86): Assets, $2,228,145 (M); gifts received, $20,513; expenditures, $65,276, including $48,386 for 25 grants (high: $10,000; low: $100).
Purpose and activities: Support for Jewish welfare, education, cultural programs, and social and health services.
Limitations: Giving primarily in MD.
Application information:
Initial approach: Proposal
Deadline(s): None
Write: Lois Blum-Feinblatt, Pres.
Officers: Lois Blum-Feinblatt, Pres.; Jerold C. Hoffberger, V.P.; Lawrence A. Blum, Secy.-Treas.
Number of staff: None.
Employer Identification Number: 526057035

1065
Alex Brown and Sons Charitable Foundation, Inc.

c/o Alex Brown and Sons Inc.
135 East Baltimore St.
Baltimore 21202 (301) 727-1700

Established in 1954 in MD.
Donor(s): Alex Brown and Sons, Inc., Alex Brown Partners, Alex Brown Investment Management, Alex Brown Management Services, Inc.
Financial data (yr. ended 12/31/87): Assets, $3,608,028 (M); gifts received, $988,375; expenditures, $623,193, including $596,065 for 62 grants.
Purpose and activities: Support for cultural programs, higher education, social services, and nature conservation.
Types of support: Annual campaigns, building funds, capital campaigns, continuing support, endowment funds, general purposes, operating budgets, scholarship funds, employee-related scholarships.
Limitations: Giving primarily in MD. No grants to individuals.
Publications: Annual report, 990-PF.
Application information:
Copies of proposal: 1
Deadline(s): Fall of year for next year's budget
Board meeting date(s): Feb. of each year
Write: Clinton P. Stephens, Sr., Secy. and Mgr.

Officers: Jack S. Griswold, Pres.; Truman T. Semans, V.P.; Clinton P. Stephens, Secy.; Alvin B. Krongard, Treas.
Trustees: F. Barton Harvey, Jr., Donald B. Webb, Jr.
Employer Identification Number: 526054236

1066
Bruce Ford Brown Charitable Trust
Two Hopkins Plaza
Baltimore 21201 (301) 237-5653

Established in 1965 in MD.
Donor(s): Donaldson Brown.†
Financial data (yr. ended 12/31/87): Assets, $1,495,615 (M); expenditures, $70,515, including $61,500 for 22 grants (high: $6,000; low: $750).
Purpose and activities: Grants primarily for higher and secondary education; support also for historic preservation.
Application information:
 Initial approach: Letter or proposal
 Deadline(s): None
 Write: J. Michael Miller, V.P., Mercantile-Safe Deposit & Trust Co.
Trustee: Mercantile-Safe Deposit & Trust Co.
Employer Identification Number: 526063085

1067
H. Barksdale Brown Charitable Trust
c/o Mercantile-Safe Deposit & Trust Co.
Two Hopkins Plaza
Baltimore 21201 (301) 237-5653

Established in 1965 in MD.
Financial data (yr. ended 10/31/87): Assets, $1,083,955 (M); expenditures, $40,494, including $33,000 for 9 grants (high: $15,000; low: $1,000).
Purpose and activities: Support primarily for a hospital; grants also for education and culture.
Application information:
 Initial approach: Letter
 Deadline(s): None
 Write: J. Michael Miller III, V.P., Mercantile-Safe Deposit & Trust Co.
Trustee: Mercantile-Safe Deposit & Trust Co.
Employer Identification Number: 526063083

1068
Frank D. Brown, Jr. Charitable Trust
c/o Mercantile-Safe Deposit & Trust Co.
Two Hopkins Plaza
Baltimore 21201

Established in 1965 in MD.
Financial data (yr. ended 12/31/87): Assets, $1,500,726 (M); expenditures, $78,614, including $70,000 for 19 grants (high: $10,000; low: $1,000).
Purpose and activities: Support primarily for education, hospitals, and museums.
Application information:
 Initial approach: Letter
 Deadline(s): None
 Write: J. Michael Miller III, V.P., Mercantile-Safe Deposit & Trust Co.
Trustee: Mercantile-Safe Deposit & Trust Co.
Employer Identification Number: 526063084

1069
Buckingham School of Frederick County, Maryland
1012 Cloverlea Rd.
Baltimore 21204 (301) 828-6557

Established in 1898 in MD.
Financial data (yr. ended 12/31/87): Assets, $1,009,557 (M); expenditures, $72,326, including $60,984 for 58 grants (high: $17,000; low: $25).
Purpose and activities: Support primarily for higher and secondary education, art museums, and hospitals.
Limitations: Giving limited to MD.
Application information:
 Initial approach: Letter
 Deadline(s): Apr.
 Write: Daniel Baker, Treas.
Officers and Directors: Mrs. Joseph D. Baker, Jr., Pres.; Mrs. A. McGhee Harvey, Secy.; Daniel Baker, Treas.; William F. Fritz.
Employer Identification Number: 526034781

1070
Campbell Foundation, Inc.
100 West Pennsylvania Ave.
Baltimore 21204

Donor(s): R. McLean Campbell.
Financial data (yr. ended 12/31/86): Assets, $1,637,205 (M); expenditures, $78,437, including $58,500 for 39 grants (high: $7,500; low: $500).
Purpose and activities: Grants primarily for culture and education; support also for child welfare and health and social services.
Types of support: Building funds, endowment funds.
Limitations: Giving primarily in the greater Baltimore, MD, area. No grants to individuals.
Application information:
 Initial approach: Proposal
 Deadline(s): None
 Write: Bruce S. Campbell, III, Secy.
Officers and Trustees: Harry G. Campbell, Jr., Pres.; R. McLean Campbell, V.P.; Bruce S. Campbell, Jr., V.P.; S. James Campbell, V.P. and Treas.; Bruce S. Campbell III, Secy.; William B. Campbell, Margaret C. Worthington.
Employer Identification Number: 520794348

1071
Eugene B. Casey Foundation
One West Deer Park Dr., Suite 401
Gaithersburg 20877-1701 (301) 948-6505

Established in 1981 in MD.
Financial data (yr. ended 8/31/87): Assets, $57,268,849 (M); gifts received, $50,329,927; expenditures, $675,615, including $119,280 for 16 grants (high: $63,340; low: $100).
Purpose and activities: Support primarily for higher education and medical research; support also for fine arts and community development.
Types of support: General purposes.
Limitations: Giving primarily in the greater Washington, DC, area.
Application information:
 Initial approach: Proposal
 Write: Betty Brown Casey, Chair.

Officers and Trustees: Betty Brown Casey, Chair. and Pres.; Stephen N. Jones, 1st V.P.; Nancy Casey Kelly, 2nd V.P.; Joseph M. McManns, Secy.; W. James Price.
Employer Identification Number: 526220316

1072
Clark-Winchcole Foundation
Air Rights Bldg.
4550 Montgomery Ave., Suite 345N
Bethesda 20814 (301) 654-3607

Established in 1964 in DC.
Donor(s): Dorothy C. Winchcole,† Elizabeth G. Clark.†
Financial data (yr. ended 12/31/86): Assets, $33,733,500 (M); gifts received, $223,072; expenditures, $1,671,234, including $1,403,995 for 82 grants (high: $30,000; low: $1,000; average: $10,000-$30,000).
Purpose and activities: Emphasis on higher education, hospitals, health agencies, cultural programs, social service and youth agencies, aid to the handicapped, and Protestant church support.
Types of support: Operating budgets, building funds, general purposes.
Limitations: Giving primarily in the Washington, DC, area.
Application information:
 Initial approach: Letter
 Deadline(s): Generally, during first 6 months of calendar year
 Write: Laura E. Phillips, Pres.
Officers and Trustees:* Laura E. Phillips, Pres.; Vincent E. Burke, Jr.,* V.P.; Joseph H. Riley, V.P.; Thomas C. Thompson, Jr.,* V.P.; E. Marie Lund, Secy.-Treas.
Employer Identification Number: 526058340

1073
The Columbia Foundation
9861 Broken Land Pkwy., Suite 300
Columbia 21046 (301) 381-0985

Incorporated in 1969 in MD.
Financial data (yr. ended 12/31/88): Assets, $905,931 (M); gifts received, $562,309; expenditures, $294,087, including $224,500 for 35 grants.
Purpose and activities: Grants for human services, cultural and educational programs that enhance the quality of life.
Types of support: Seed money, operating budgets, emergency funds, continuing support, equipment, building funds, matching funds, technical assistance, conferences and seminars, consulting services, general purposes, lectureships, special projects.
Limitations: Giving limited to Howard County, MD. No support for medical research, or for projects of a sectarian religious nature. No grants to individuals, or for annual campaigns, deficit financing, land acquisition, renovation projects, or general or special endowments.
Publications: Financial statement, application guidelines, grants list, newsletter, informational brochure (including application guidelines).
Application information: For information on emergency funding, contact the foundation. Project grants are reviewed in Mar. and

operational grants in Nov. Application form required.

Initial approach: Telephone
Copies of proposal: 9
Deadline(s): Jan. for project support; Sept. for operating support
Board meeting date(s): 3rd Tuesday of each month
Final notification: 3 months
Write: Barbara K. Lawson, Exec. Dir.

Officers: Richard G. McCauley, Pres.; Jean Moon, V.P.; Dwight Burrill, Secy.; Harvey Steinman, Treas.; Barbara K. Lawson, Exec. Dir.
Number of staff: 1 full-time professional; 1 full-time support.
Employer Identification Number: 520937644

1074
Commercial Credit Companies Foundation, Inc.
300 St. Paul Place
Baltimore 21202 (301) 332-2927

Incorporated in 1951 in DE.
Donor(s): Commercial Credit Co., and subsidiaries.
Financial data (yr. ended 12/31/87): Assets, $477,643 (M); expenditures, $96,928, including $94,350 for 14 grants (high: $30,000; low: $25) and $905 for 12 employee matching gifts.
Purpose and activities: Giving for the arts and cultural programs, higher education, and economic development with emphasis on jobs and training for disadvantaged youth and a community fund. In 1990, Commercial Credit Companies Foundation is merging with its parent company foundation, Primerica Foundation.
Types of support: Employee matching gifts.
Limitations: Giving primarily in the metropolitan Baltimore, MD, area.
Application information: Applications not accepted.
Board meeting date(s): As required
Write: F. Gregory Fitz-Gerald, V.P.
Officers and Trustees: Sanford I. Weill, Pres.; F. Gregory Fitz-Gerald, V.P. and Treas.; Charles O. Prince III, Secy.; Robert I. Lipp.
Employer Identification Number: 526043604

1075
Crown Central Petroleum Foundation, Inc.
One North Charles St.
Baltimore 21201 (301) 539-7400

Established in 1981 in MD.
Donor(s): Crown Central Petroleum Corp.
Financial data (yr. ended 12/31/87): Assets, $31,575 (M); gifts received, $220,000; expenditures, $202,359, including $196,548 for 54 grants (high: $98,199; low: $50) and $5,775 for employee matching gifts.
Purpose and activities: Support primarily for higher education, community funds, community development, and cultural organizations.
Types of support: General purposes, scholarship funds, special projects, employee matching gifts.
Limitations: Giving primarily in MD and TX.

Application information:
Write: W.R. Snyder, Pres.
Officers: W.R. Snyder, Pres.; Ted M. Jackson, V.P. and Treas.; J.G. Yawman, Secy.
Number of staff: 1 part-time support.
Employer Identification Number: 521203348

1076
Joel Dean Foundation, Inc.
c/o Jurrien Dean
7422 Hampden Ln.
Bethesda 20814

Established in 1957 in NY.
Donor(s): Joel Dean, Joel Dean Associates Corp.
Financial data (yr. ended 12/31/86): Assets, $2,347,837 (M); expenditures, $109,168, including $77,550 for 33 grants (high: $1,250; low: $150).
Purpose and activities: Grants primarily for higher education and cultural programs.
Types of support: General purposes.
Officers and Directors: Jurrien Dean, Pres.; Gretchen Dean, V.P.; Gillian Dean, Joel Dean, Jr.
Employer Identification Number: 136097306

1077
The Equitable Bank Foundation, Inc.
100 South Charles St.
Baltimore 21201 (301) 547-4274

Incorporated in 1964 in MD.
Donor(s): The Equitable Bank.
Financial data (yr. ended 12/31/87): Assets, $574,607 (M); gifts received, $468,000; expenditures, $599,161, including $598,282 for 71 grants (high: $175,000; low: $500).
Purpose and activities: Emphasis on community funds, higher education, youth agencies, hospitals, and arts and culture.
Limitations: Giving primarily in the greater Baltimore, MD, area. No grants to individuals.
Application information:
Write: Louis P. Mathews, Secy.
Officers: H. Grant Hathaway, Pres.; Joseph Keelty, V.P.; Louis P. Mathews, Secy.; Laura J. Bortle, Treas.
Employer Identification Number: 526060268

1078
Feinberg Foundation, Inc.
c/o Harab, Kamerow & Assoc., P.C.
11820 Parklawn Dr., Suite 400
Rockville 20852

Established in 1960 in MD.
Financial data (yr. ended 12/31/87): Assets, $1,144,766 (M); expenditures, $30,789, including $28,830 for 30 grants (high: $7,305; low: $25).
Purpose and activities: Support primarily for Jewish welfare organizations, support also for cultural programs.
Officer: Harry Feinberg, Pres.
Employer Identification Number: 237000380

1079
First Maryland Foundation, Inc.
25 South Charles St.
Baltimore 21201 (301) 244-4907

Incorporated in 1967 in MD.
Donor(s): First National Bank of Maryland.
Financial data (yr. ended 12/31/87): Assets, $1,422,929 (M); gifts received, $600,000; expenditures, $646,072, including $618,959 for 193 grants (high: $110,000; low: $10; average: $3,207) and $25,421 for 72 employee matching gifts.
Purpose and activities: Emphasis on community funds; support also for higher education, music, youth agencies, and hospitals.
Types of support: Annual campaigns, general purposes, scholarship funds, employee matching gifts.
Limitations: Giving primarily in the Baltimore, MD, area. No grants to individuals, or for endowment funds, scholarships, or fellowships; no loans.
Application information:
Initial approach: Letter
Copies of proposal: 1
Deadline(s): Mar. 31
Board meeting date(s): Mar., June, Sept., and Dec.
Write: Robert W. Schaefer, Secy.
Officers and Trustees: J. Owen Cole, Pres.; Charles W. Cole, Jr., V.P.; Robert W. Schaefer, Secy.-Treas.
Employer Identification Number: 526077253

1080
The Jacob and Annita France Foundation, Inc.
Charles at Woodbrook, Suite 7
6301 North Charles St.
Baltimore 21212 (301) 377-5251

Incorporated in 1959 in MD.
Donor(s): Jacob France,† Annita A. France.†
Financial data (yr. ended 5/31/88): Assets, $48,956,051 (M); expenditures, $2,520,251, including $2,080,550 for 81 grants (high: $380,000; low: $50; average: $500-$55,000).
Purpose and activities: Giving within five program areas: higher education, social services and health, historic preservation, arts and culture, conservation and civic projects.
Types of support: General purposes.
Limitations: Giving limited to MD, with emphasis on Baltimore. No grants to individuals.
Publications: Application guidelines.
Application information:
Initial approach: Letter
Copies of proposal: 1
Deadline(s): None
Board meeting date(s): Quarterly
Write: Frederick W. Lafferty, Exec. Dir.
Officers and Directors: Anne M. Pinkard, Pres.; Robert G. Merrick, Jr., V.P.; Frederick W. Lafferty, Exec. Dir.; Vernon T. Pittinger, Donna Silbersack.
Number of staff: 1 full-time professional; 2 full-time support; 1 part-time support.
Employer Identification Number: 520794585

1081
Carl M. Freeman Foundation, Inc.
11325 Seven Locks Rd.
Potomac 20854

Established in 1962.
Donor(s): Carl M. Freeman.
Financial data (yr. ended 12/31/87): Assets, $1,445,303 (M); expenditures, $103,113, including $77,500 for 8 grants (high: $20,000; low: $500).
Purpose and activities: Emphasis on cultural programs and Jewish welfare agencies.
Types of support: Operating budgets.
Limitations: Giving primarily in MD and DC.
Application information: Contributes only to pre-selected organizations. Applications not accepted.
Officers and Trustees: Carl M. Freeman, Pres.; Albert E. Arent, V.P.; Virginia A. Freeman, Secy.
Employer Identification Number: 526047536

1082
Giant Food Foundation, Inc.
6300 Sheriff Rd.
Landover 20785 (301) 341-4100
Mailing address: P.O. Box 1804, Washington, DC 20013

Incorporated in 1950 in DC.
Donor(s): Giant Food, Inc.
Financial data (yr. ended 1/31/87): Assets, $297,778 (M); gifts received, $200,000; expenditures, $682,706, including $679,022 for 229 grants (high: $300,000; low: $100).
Purpose and activities: Funds largely committed for continuing support in fields of Jewish welfare, community service, community funds, education, culture, and health, including mental health.
Types of support: General purposes, continuing support.
Limitations: Giving primarily in the Baltimore, MD, and Washington, DC, metropolitan areas; normally no grants to programs of national or international scope. No grants to individuals, or for scholarships, fellowships, or matching gifts; no loans.
Application information:
 Initial approach: Proposal
 Copies of proposal: 1
 Deadline(s): None
 Board meeting date(s): Monthly
 Final notification: 1 month
 Write: David Rutstein, Secy.
Officers: Israel Cohen,* Pres.; Samuel Lehrman,* V.P.; David W. Rutstein, Secy.; David B. Sykes,* Treas.
Directors:* John W. Mason, Richard Waxenburg, Millard F. West, Jr., Morton H. Wilner.
Number of staff: None.
Employer Identification Number: 526045041

1083
Peggy & Yale Gordon Charitable Trust
Three Church Ln.
Baltimore 21208 (301) 484-6410

Established in 1980 in MD.
Donor(s): Yale Gordon.†

Financial data (yr. ended 12/31/87): Assets, $7,184,965 (M); gifts received, $1,318; expenditures, $699,439, including $528,548 for 29 grants (high: $253,689; low: $20).
Purpose and activities: Support for Jewish organizations, cultural programs, and higher education.
Limitations: Giving primarily in Baltimore, MD.
Application information:
 Deadline(s): None
 Write: Sidney S. Sherr, Trustee
Trustees: Kenneth Battye, Loraine Bernstein, Sherry B. Gill, Ann Goldberg, Raymond J. Gordon, Sidney S. Sherr, Robert A. Steinberg.
Employer Identification Number: 521174287

1084
Hechinger Foundation
(also known as Sidney L. Hechinger Foundation)
3500 Pennsy Dr.
Landover 20785 (301) 341-0999

Incorporated in 1955 in DC.
Donor(s): Hechinger Co., members of the Hechinger family.
Financial data (yr. ended 6/30/88): Assets, $3,615,587 (M); gifts received, $1,823,322; expenditures, $1,187,684, including $1,181,297 for 600 grants (high: $188,334).
Purpose and activities: Emphasis on music and other cultural programs, Jewish welfare funds, higher education, United Way, and youth and social service agencies, including aid to the handicapped.
Types of support: General purposes.
Limitations: Giving limited to areas of company operations. No grants to individuals.
Publications: Application guidelines.
Application information:
 Initial approach: Proposal
 Copies of proposal: 1
 Deadline(s): None
 Board meeting date(s): Continuously
 Final notification: 8 to 10 weeks if approved
 Write: Richard England, Pres.
Managers and Trustees: Richard England,* Pres.; Lois H. England, John W. Hechinger, Jr., June R. Hechinger.
Number of staff: 1 full-time professional; 1 full-time support; 1 part-time support.
Employer Identification Number: 526054428
Recent arts and culture grants:
Arena Stage, DC, $9,000. For capital fund drive pledge. 1987.
Arena Stage, DC, $5,000. For annual gift. 1987.
Capital Childrens Museum, National Learning Center, DC, $15,000. 1987.
Corcoran Gallery of Art, DC, $10,000. For annual contribution. 1987.
John F. Kennedy Center for the Performing Arts, DC, $30,000. 1987.
National Gallery of Art, DC, $6,600. 1987.
National Symphony Orchestra, DC, $100,000. For endowment fund. 1987.
National Symphony Orchestra, DC, $20,000. For annual gift. 1987.
Studio Theater, DC, $5,000. For capital fund drive. 1987.
Studio Theater, DC, $5,000. For capital fund drive. 1987.
W E T A Greater Washington Educational Television Association, DC, $5,000. For

corporate gift in name of Hechinger Company. 1987.
Washington Ballet, DC, $25,000. For annual gift. 1987.
Washington Ballet, DC, $13,000. For additional annual gift. 1987.
Wolf Trap Farm Park for the Performing Arts, Vienna, VA, $5,000. For annual gift. 1987.

1085
The Hecht-Levi Foundation, Inc.
c/o Mercantile Safe Deposit & Trust Co.
Two Hopkins Plaza
Baltimore 21201 (301) 237-5521

Incorporated in 1958 in MD.
Donor(s): Alexander Hecht,† Selma H. Hecht,† Robert H. Levi, Ryda H. Levi.
Financial data (yr. ended 12/31/88): Assets, $6,768,931 (M); expenditures, $327,033 for 60 grants (high: $50,000; low: $250; average: $250-$50,000).
Purpose and activities: Grants primarily for Jewish welfare funds, cultural programs, including music, and higher education.
Limitations: Giving primarily in the Baltimore, MD, metropolitan area. No grants to individuals.
Application information:
 Initial approach: Proposal
 Copies of proposal: 1
 Deadline(s): Submit proposal preferably in Mar. or Sept.
 Board meeting date(s): June and Dec.
 Write: Patricia Bentz
Officers and Directors: Robert H. Levi, Pres.; Ryda H. Levi, V.P.; Wilbert H. Sirota, Secy.; Sandra L. Gerstung, Frank A. Kaufman, Alexander H. Levi, Richard H. Levi.
Employer Identification Number: 526035023

1086
Himmelrich Fund, Inc.
900 South Eutaw St.
Baltimore 21230-2496

Established in 1968 in MD.
Financial data (yr. ended 12/31/87): Assets, $3,251 (M); gifts received, $113,167; expenditures, $111,209, including $111,158 for 30 grants (high: $79,318; low: $50).
Purpose and activities: Support primarily for education, Jewish organizations, and the arts.
Limitations: Giving primarily in Baltimore, MD.
Application information:
 Deadline(s): None
Officers: Samuel K. Himmelrich, Pres.; Alfred R. Himmelrich, V.P.
Employer Identification Number: 526081812

1087
The Emmert Hobbs Foundation, Inc.
c/o Friedman & Friedman
409 Washington Ave., Suite 900
Towson 21204 (301) 494-0100

Incorporated in 1983 in MD.
Donor(s): Emmert Hobbs.†
Financial data (yr. ended 7/31/87): Assets, $2,396,526 (M); expenditures, $122,825,

including $95,700 for 20 grants (high: $15,000; low: $1,000; average: $3,000).
Purpose and activities: Support for health, social services, education, and limited cultural programs.
Types of support: General purposes, scholarship funds, building funds.
Limitations: Giving primarily in the Baltimore, MD, metropolitan area. No support for research. No grants to individuals.
Application information:
 Initial approach: Letter
 Deadline(s): None
 Write: Louis F. Friedman, Dir.
Directors: D. Sylvan Friedman, Louis F. Friedman.
Employer Identification Number: 521285106

1088
Harley W. Howell Charitable Foundation
c/o Signet Bank of Maryland
Seven Paul St., P.O. Box 17034
Baltimore 21203 (301) 332-5555

Established in 1961 in MD.
Donor(s): Harley W. Howell.
Financial data (yr. ended 12/31/87): Assets, $1,229,840 (M); expenditures, $115,502, including $105,850 for grants.
Purpose and activities: Support primarily for cultural programs, health services, and medical research.
Types of support: Endowment funds, research, general purposes.
Application information:
 Deadline(s): None
 Write: Robert C. Rice
Trustee: Signet Bank of Maryland.
Distribution Committee: Geneva E. Howell, H. Thomas Howell, Diane Howell Stewart.
Employer Identification Number: 526033554

1089
Ensign C. Markland Kelly, Jr. Memorial Foundation, Inc.
1406 Fidelity Bldg.
Baltimore 21201 (301) 837-8822

Incorporated in 1946 in MD.
Donor(s): C. Markland Kelly,† Kelly Buick Sales Corp.
Financial data (yr. ended 12/31/87): Assets, $3,673,378 (M); expenditures, $284,438, including $185,543 for 28 grants (high: $29,492; low: $100).
Purpose and activities: Giving primarily to support elementary and secondary education, youth activities, and civic and cultural organizations.
Types of support: Annual campaigns, building funds, equipment, endowment funds, special projects, scholarship funds, matching funds, capital campaigns.
Limitations: Giving limited to the greater Baltimore, MD, metropolitan area. No grants to individuals, or for operating budgets, research, fellowships, or travel; no loans.
Publications: Informational brochure, program policy statement, application guidelines, occasional report.
Application information:

Initial approach: Proposal
Copies of proposal: 3
Deadline(s): None
Board meeting date(s): Monthly
Final notification: 6 months
Write: Herbert E. Witz, Pres.
Officers and Directors: Herbert E. Witz, Pres.; Bowen P. Weisheit, V.P.; Carol A. Witz, Secy.; Bowen P. Weisheit, Jr., Treas.
Number of staff: 1 part-time professional; 1 part-time support.
Employer Identification Number: 526033330

1090
The Krieger Fund, Inc.
c/o Wolpoff & Co.
1111 North Charles St.
Baltimore 21201
Application address: P.O. Box 10493, Baltimore, MD 21209

Incorporated in 1944 in MD.
Donor(s): Abraham Krieger.
Financial data (yr. ended 12/31/86): Assets, $1,767,693 (M); expenditures, $71,081, including $67,000 for 9 grants (high: $50,000; low: $500).
Purpose and activities: Emphasis on Jewish welfare funds; support also for secondary education and cultural programs.
Limitations: Giving primarily in Baltimore, MD.
Application information:
 Initial approach: Letter
 Deadline(s): None
 Board meeting date(s): As required
 Write: Jane K. Schapiro, Pres.
Officer: Jane K. Schapiro, Pres.; Joann C. Fruchtman, V.P. and Secy.; Howard K. Cohen, V.P. and Treas.
Employer Identification Number: 526035537

1091
Greta Brown Layton Charitable Trust
c/o Mercantile-Safe Deposit & Trust Co.
Two Hopkins Plaza
Baltimore 21201 (301) 237-5653

Established in 1965 in MD.
Financial data (yr. ended 12/31/87): Assets, $1,373,632 (M); expenditures, $84,439, including $75,700 for 35 grants (high: $10,000; low: $200).
Purpose and activities: Grants for education, hospitals, social services, and cultural programs.
Limitations: Giving primarily in DE.
Application information:
 Initial approach: Letter
 Deadline(s): None
 Write: J. Michael Miller, V.P.
Trustee: Mercantile-Safe Deposit & Trust Co.
Employer Identification Number: 526063086

1092
Richard S. Levitt Foundation
6001 Montrose Rd., Suite 600
Rockville 20852

Established in 1957.
Donor(s): Members of the Levitt Family.
Financial data (yr. ended 12/31/87): Assets, $3,237,393 (M); gifts received, $30,000;

expenditures, $276,948, including $268,193 for 54 grants (high: $55,000; low: $5).
Purpose and activities: Giving for higher education, cultural programs, Jewish religious and welfare organizations, and social services.
Limitations: Giving primarily in Des Moines, IA.
Application information: Contributes only to pre-selected organizations. Applications not accepted.
Officers: Richard Levitt, Pres. and Treas.; Mark Levitt, V.P.; Randall Levitt, V.P.; Jeanne Levitt, Secy.
Employer Identification Number: 426052427

1093
Morton and Sophia Macht Foundation
ll East Fayette St.
Baltimore 21202 (301) 539-2370

Established in 1956 in MD.
Donor(s): Sophia Macht,† Westland Gardens Co., and others.
Financial data (yr. ended 4/30/87): Assets, $1,419,771 (M); gifts received, $102,600; expenditures, $171,081, including $155,655 for grants (high: $10,000; low: $15; average: $750).
Purpose and activities: Grants for Jewish giving, higher education, community funds, social services, and cultural programs.
Types of support: Annual campaigns, building funds, capital campaigns, consulting services, continuing support, deficit financing, emergency funds, endowment funds, equipment, exchange programs, general purposes, land acquisition, operating budgets, professorships, publications, renovation projects, research, scholarship funds, seed money, special projects, conferences and seminars.
Limitations: Giving primarily in MD. No grants to individuals.
Application information:
 Initial approach: Proposal
 Deadline(s): None
 Write: Bette Cohen, V.P.
Officers and Trustees:* Amy Macht,* Pres.; Bette Cohen, V.P.; H. William Cohen,* V.P.; Jill Gansler, V.P. and Treas.; Robert Gonzales, V.P. and Secy.; Alan Goodhardt,* V.P.; Lee Kaufman,* V.P.; Philip Macht,* V.P.
Number of staff: 1 part-time professional; 1 part-time support.
Employer Identification Number: 526035753

1094
Martin Marietta Corporation Foundation
6801 Rockledge Dr.
Bethesda 20817 (301) 897-6863

Trust established in 1955 in MD.
Donor(s): Martin Marietta Corp.
Financial data (yr. ended 12/31/87): Assets, $4,827,291 (M); gifts received, $9,100,000; expenditures, $4,651,475, including $2,782,695 for 1,186 grants (high: $313,410; low: $25; average: $500-$10,000), $554,325 for grants to individuals and $1,310,000 for employee matching gifts.
Purpose and activities: Primary interest in higher education, particularly through support

of scholarships for children of corporation employees; support also for health, cultural, and civic programs.
Types of support: Employee-related scholarships, employee matching gifts, general purposes.
Limitations: Giving primarily in areas of company operations. No support for political or religious groups, or current United Way recipients. No grants to individuals (except for employee-related scholarships).
Publications: Application guidelines.
Application information:
 Initial approach: Proposal
 Deadline(s): Applications accepted throughout the year, with majority of commitments made in the fall
 Board meeting date(s): As needed
 Final notification: 2 to 3 months
 Write: Donna Price, Contribs. Rep.
Trustees: Caleb B. Hurtt, Wayne A. Shaner, Peter F. Warren, Jr.
Number of staff: 1
Employer Identification Number: 136161566

1095
The Maryland National Foundation, Inc.
P.O. Box 987, MS020330
Baltimore 21203

Incorporated in 1965 in MD.
Donor(s): Maryland National Bank.
Financial data (yr. ended 12/31/88): Assets, $2,700,000 (M); gifts received, $3,000,000; expenditures, $2,323,469 for 186 grants (high: $287,000; low: $500) and $61,779 for employee matching gifts.
Purpose and activities: To enhance health and welfare in all the communities the foundation serves, and to support those institutions that make communities desirable places to live and work. Emphasis on community funds, education, arts and culture, environmental issues, health and hospitals, and human and community services.
Limitations: Giving limited to recipient organizations whose activities are principally conducted within the geographic areas in which MNC Financial and its subsidiaries are active.
Publications: Application guidelines.
Application information:
 Deadline(s): None
Officers: Alan P. Hoblitzell, Jr., Pres.; George B.P. Ward, Jr., Secy.-Treas.
Number of staff: 1 full-time professional.
Employer Identification Number: 526062721

1096
Morris A. Mechanic Foundation
P.O. Box 1623
Baltimore 21203

Established in 1942 in MD.
Financial data (yr. ended 12/31/87): Assets, $2,410,077 (M); gifts received, $88,172; expenditures, $100,804, including $40,950 for 23 grants (high: $6,000; low: $250).
Purpose and activities: Support primarily for higher education, hospitals, and music related organizations.
Application information:

Initial approach: Letter
Deadline(s): None
Write: Clarisse B. Mechanic, Pres.
Officers: Clarisse B. Mechanic, Pres.; Blue Barron, Secy.
Employer Identification Number: 526034753

1097
Thomas Meloy Foundation
c/o William W. Wolf
13001 Crookston Lane no. 38
Rockville 20851

Financial data (yr. ended 3/30/87): Assets, $1,119,714 (M); expenditures, $97,508, including $81,500 for 12 grants (high: $50,000; low: $2,000).
Purpose and activities: Support primarily for education, cultural programs, and health and social services.
Types of support: General purposes.
Application information:
 Deadline(s): None
Officers: Consuelo Nussbaum,* Pres.; William W. Wolf, Secy.-Treas.
Directors:* Thomas Stuart Meloy, John S. Nussbaum, Lise L. Nussbaum O'Haire.
Employer Identification Number: 521116472

1098
Robert G. and Anne M. Merrick Foundation, Inc.
c/o Wolpoff & Co.
1111 North Charles St.
Baltimore 21201
Application address: 6301 North Charles St., Baltimore, MD 21212; Tel.: (301) 377-5251

Established in 1962.
Donor(s): Robert G. Merrick, Sr.,† Anne M. Merrick,† Homewood Holding Co.
Financial data (yr. ended 10/31/86): Assets, $2,247,749 (M); gifts received, $124,292; expenditures, $303,424, including $297,750 for 8 grants (high: $150,000; low: $250).
Purpose and activities: Emphasis on cultural programs and higher education.
Limitations: Giving primarily in Baltimore, MD.
Application information:
 Initial approach: Letter
 Deadline(s): None
 Board meeting date(s): As needed
Officers: Robert G. Merrick, Jr., V.P.; Mary Balladarsch, Secy.-Treas.
Employer Identification Number: 526072964

1099
Robert & Jane Meyerhoff Foundation, Inc.
1025 Cranbrook Rd.
Cockeysville 21030

Established in 1980 in MD.
Donor(s): Robert E. Meyerhoff.
Financial data (yr. ended 12/31/87): Assets, $274,314 (M); gifts received, $200,000; expenditures, $729,071, including $724,450 for 12 grants (high: $572,500; low: $750).
Purpose and activities: Giving primarily for museums, culture, and higher education.

Application information: Contributes only to pre-selected organizations. Applications not accepted.
Directors: David P. Gordon, Rose Ellen Greene, Diana F. Jaquoti, Jane B. Meyerhoff, Neil A. Meyerhoff, Robert E. Meyerhoff.
Employer Identification Number: 521176421

1100
The Joseph Meyerhoff Fund, Inc.
25 South Charles St.
Baltimore 21201 (301) 727-3200

Incorporated in 1953 in MD.
Donor(s): Joseph Meyerhoff,† Mrs. Joseph Meyerhoff.
Financial data (yr. ended 12/31/87): Assets, $18,673,291 (M); expenditures, $432,355, including $102,505 for grants (high: $7,500).
Purpose and activities: Giving primarily to support and encourage cultural and higher educational programs and institutions and to facilitate immigration and absorption of new immigrants into Israel.
Types of support: Annual campaigns, seed money, emergency funds, deficit financing, building funds, land acquisition, endowment funds, research, publications, professorships, scholarship funds, matching funds, continuing support.
Limitations: Giving primarily in Baltimore, MD, New York, NY, and to organizations in Israel. No grants to individuals.
Application information: Funds are committed for a 2- or 3-year period beginning in 1986; contributes only to pre-selected organizations. Applications not accepted.
 Board meeting date(s): May and Oct. and as required
 Write: Louis L. Kaplan, Exec. V.P.
Officers: Harvey M. Meyerhoff, Pres.; Louis L. Kaplan, Exec. V.P.; Lenore P. Meyerhoff, V.P.; Joseph Meyerhoff II, Treas.
Number of staff: 1 part-time professional; 1 part-time support.
Employer Identification Number: 526035997

1101
Middendorf Foundation, Inc.
803 Cathedral St.
Baltimore 21201

Incorporated in 1953 in MD.
Donor(s): J. William Middendorf, Jr.,† Mrs. Alice C. Middendorf.†
Financial data (yr. ended 3/31/87): Assets, $14,319,048 (M); expenditures, $740,053, including $628,700 for 69 grants (high: $90,000; low: $1,000; average: $6,000).
Purpose and activities: Giving primarily for cultural programs, including historic preservation and museums, higher and secondary education, Protestant church support, and conservation; support also for hospitals and the handicapped.
Types of support: Matching funds, endowment funds, professorships.
Limitations: Giving primarily in MD. No grants to individuals.
Application information:
 Initial approach: Letter
 Deadline(s): None

Write: E. Phillips Hathaway, Pres.
Officers and Trustees: Forrest F. Bramble, Jr.,
Phillips Hathaway, E. Phillips Hathaway, Pres.;
Roger B. Hopkins, Jr., V.P.; Theresa N. Knell,
Secy.; Craig Lewis, Treas.; Peter B. Middendorf,
Robert B. Russell II.
Number of staff: 2 full-time professional.
Employer Identification Number: 526048944

1102
Vincent Mulford Foundation
c/o Mercantile Safe Deposit & Trust Co.
Two Hopkins Plaza
Baltimore 21201 (301) 237-5416

Trust established in 1951 in NJ.
Donor(s): Vincent S. Mulford,† Edith Mulford.†
Financial data (yr. ended 12/31/86): Assets,
$2,024,011 (M); expenditures, $152,481,
including $142,000 for 80 grants (high:
$10,000; low: $250).
Purpose and activities: Emphasis on the arts,
higher and secondary education, Protestant
church support, and social service agencies.
Limitations: Giving primarily in NY, NJ, and CT.
Application information:
 Initial approach: Letter or proposal
 Deadline(s): None
 Write: Lloyd Batzler
Trustees: Walter E. Moor, Donald L. Mulford,
Vincent S. Mulford, Jr., Thomas L. Pulling,
Christian R. Sonne.
Employer Identification Number: 226043594

1103
The Noxell Foundation, Inc.
11050 York Rd.
Hunt Valley 21031-2098 (301) 785-4313

Incorporated in 1951 in MD.
Donor(s): Noxell Corp.
Financial data (yr. ended 12/31/87): Assets,
$3,844,694 (M); gifts received, $2,000,000;
expenditures, $1,079,969, including
$1,065,875 for 117 grants (high: $200,000;
low: $250; average: $1,000-$10,000) and
$6,370 for 46 employee matching gifts.
Purpose and activities: Emphasis on higher
education, social services, hospitals and cultural
programs.
Types of support: Annual campaigns, seed
money, emergency funds, building funds,
equipment, land acquisition, employee
matching gifts, internships, capital campaigns,
endowment funds, matching funds, research,
scholarship funds.
Limitations: Giving primarily in MD. No
grants to individuals, or for operating budgets
or deficit financing; no loans.
Application information:
 Initial approach: Proposal
 Copies of proposal: 1
 Deadline(s): None
 Board meeting date(s): Quarterly
 Final notification: 3 months
 Write: William R. McCartin, Treas.
Officers: George L. Bunting, Jr., Pres.; Robert
W. Pierce, V.P.; Carroll A. Bodie, Secy.;
William R. McCartin, Treas.
Number of staff: None.
Employer Identification Number: 526041435

1104
The Peggy Meyerhoff Pearlstone Foundation, Inc.
Village of Cross Keys, Suite 212
Village Square II
Baltimore 21210 (301) 532-2263

Established in 1975 in MD.
Donor(s): Peggy Meyerhoff Pearlstone,†
Monumental Corp.
Financial data (yr. ended 2/28/87): Assets,
$3,758,146 (M); expenditures, $240,953,
including $195,300 for 22 grants (high:
$75,000; low: $500).
Purpose and activities: Support mainly for
Jewish welfare funds, youth, and the arts, with
emphasis on the performing arts.
Types of support: Operating budgets,
continuing support, annual campaigns, seed
money, emergency funds, deficit financing,
building funds, endowment funds, matching
funds, publications, special projects, capital
campaigns, general purposes, lectureships,
renovation projects, scholarship funds.
Limitations: Giving primarily in Baltimore,
MD. No grants to individuals; no loans.
Publications: 990-PF.
Application information:
 Initial approach: Letter
 Copies of proposal: 3
 Deadline(s): None
 Board meeting date(s): Aug.
 Final notification: 60 days
 Write: Richard L. Pearlstone, V.P.
Officers: Esther S. Pearlstone, Pres.; Richard L.
Pearlstone, V.P. and Secy.-Treas.
Number of staff: None.
Employer Identification Number: 521035731

1105
PHH Group Foundation, Inc.
P.O. Box 2174
Baltimore 21203
Principal office: 11333 McCormick Rd., Hunt
Valley, MD 21031

Established in 1962 in MD.
Donor(s): PHH Group, Inc.
Financial data (yr. ended 4/30/88): Assets,
$521,557 (M); gifts received, $501,000;
expenditures, $200,158, including $178,063
for 176 grants (high: $25,000; low: $25) and
$21,132 for 106 employee matching gifts.
Purpose and activities: Grants mainly for arts
and cultural programs, community funds,
higher education, and health.
Types of support: Operating budgets,
continuing support, annual campaigns, seed
money, emergency funds, building funds,
equipment, land acquisition, employee
matching gifts, scholarship funds.
Limitations: No support for governmental or
religious organizations. No grants to
individuals, or for deficit financing, endowment
funds, matching or challenge grants, research,
special projects, publications, or conferences;
no loans.
Publications: Program policy statement,
application guidelines.
Application information: Application form
required.
 Initial approach: Letter
 Copies of proposal: 1

Deadline(s): None
Board meeting date(s): June, Sept., Dec.,
 and Mar.
Final notification: 3 months
Write: Jerome W. Geckle, Pres.
Officers: Jerome W. Geckle, Pres.; John T.
Connor, Jr., Secy.; Marion Holmes, Treas.
Number of staff: 12 full-time professional; 1
full-time support.
Employer Identification Number: 526040911

1106
Howard and Geraldine Polinger Foundation, Inc.
5530 Wisconsin Ave., Suite 1000
Chevy Chase 20815 (301) 657-3600

Incorporated in 1968 in MD.
Donor(s): Howard Polinger, Geraldine Polinger.
Financial data (yr. ended 6/30/87): Assets,
$1,758,161 (M); expenditures, $78,247,
including $68,500 for 25 grants (high: $10,000;
low: $500).
Purpose and activities: Giving for Jewish
welfare funds and cultural programs.
Limitations: Giving primarily in the
Washington, DC, area. No grants to individuals.
Application information:
 Deadline(s): None
 Write: Howard Polinger
Officers and Directors: Howard Polinger,
Pres.; Jan Polinger Forsgren, V.P.; Arnold
Polinger, V.P.; Lorre Beth Polinger, V.P.;
Geraldine Polinger, Secy.; David Polinger, Treas.
Number of staff: None.
Employer Identification Number: 526078041

1107
T. Rowe Price Associates Foundation
100 East Pratt St.
Baltimore 21202 (301) 547-2000

Established in 1982.
Donor(s): T. Rowe Price Associates, Inc.
Financial data (yr. ended 12/31/87): Assets,
$1,449,808 (M); gifts received, $520,000;
expenditures, $438,541, including $430,901
for 215 grants (high: $13,036; low: $25).
Purpose and activities: Giving for higher and
secondary education, cultural programs, and
social services.
Types of support: General purposes,
employee matching gifts.
Limitations: Giving primarily in MD. No
grants to individuals.
Publications: Application guidelines.
Application information:
 Initial approach: Proposal
 Copies of proposal: 1
 Deadline(s): None
 Write: Albert C. Hubbard, Jr., Chair.
Officers: Albert C. Hubbard, Jr., Chair. and
Pres.; Thomas R. Broadus, Jr., V.P.; Patricia O.
Goodyear, V.P.; M. Jenkins Cromwell, Jr., V.P.
and Secy.; Carter O. Hoffman, V.P. and Treas.
Employer Identification Number: 521231953

1108
The Rall Foundation, Inc.
One Village Sq., Suite 115
Baltimore 21210

Established in 1952 in MD.
Financial data (yr. ended 12/31/87): Assets,
$132,065 (M); gifts received, $200;
expenditures, $342,449, including $332,500
for 7 grants (high: $200,000; low: $100).
Purpose and activities: Support primarily for
higher education, cultural programs, and for
medical education.
Application information:
Deadline(s): None
Officers and Directors:* Leonard L. Greif,
Jr.,* Pres.; Alice F. Greif,* V.P.; Amy F. Greif,*
V.P.; Ann B. Greif,* V.P.; Roger L. Greif,* V.P.;
Dorothy L. Booze, Secy.-Treas.; Steven M.
Gevarter.
Employer Identification Number: 526054603

1109
Rogers-Wilbur Foundation
Broadwater Way
P.O. Box 46
Gibson Island 21056-0046

Established in 1947 in MD.
Financial data (yr. ended 12/31/87): Assets,
$1,297,354 (M); expenditures, $65,137,
including $48,450 for 33 grants (high: $10,000;
low: $100).
Purpose and activities: Giving primarily for
museums and cultural societies, hospitals and
health organizations, and higher education.
Limitations: Giving primarily in MD.
Application information:
Initial approach: Letter
Deadline(s): None
Write: Leroy A. Wilbur, Jr., Pres.
Officers and Directors: Leroy A. Wilbur, Jr.,
Pres.; Lawrence A. Wilbur, V.P.; Anne R.
Wilbur, Secy.; Scott E. Wilbur, Treas.
Employer Identification Number: 136103945

1110
**The Rollins-Luetkemeyer Charitable
Foundation, Inc.**
P.O. Box 10147
17 West Pennsylvania Ave.
Baltimore 21285 (301) 644-5781

Established in 1961 in MD.
Financial data (yr. ended 12/31/87): Assets,
$3,836,633 (M); gifts received, $1,300,000;
expenditures, $16,227, including $7,580 for 63
grants (high: $500; low: $30).
Purpose and activities: Support primarily for
the arts, cultural programs, education, social
services, health, and historic preservation.
Types of support: General purposes.
Limitations: Giving primarily in the Baltimore,
MD, area.
Application information:
Initial approach: Letter
Deadline(s): None
Write: Priscilla D. Garner

Officers: John A. Luetkemeyer,* Pres.; Priscilla
D. Garner, V.P. and Treas.; Anne A.
Luetkemeyer,* Secy.
Directors:* John A. Luetkemeyer, Jr., Mary E.
Rollins, Anne L. Stone.
Employer Identification Number: 526041536

1111
**The Henry and Ruth Blaustein
Rosenberg Foundation, Inc.**
Blaustein Bldg.
P.O. Box 238
Baltimore 21203

Incorporated in 1959 in MD.
Donor(s): Ruth Blaustein Rosenberg, Henry A.
Rosenberg, Jr.
Financial data (yr. ended 12/31/87): Assets,
$7,529,604 (M); gifts received, $217,500;
expenditures, $857,908, including $783,300
for 72 grants (high: $290,000; low: $150).
Purpose and activities: Emphasis on
secondary and higher education, music and
other performing arts, Jewish welfare funds,
and health agencies.
Limitations: Giving primarily in the greater
Baltimore, MD, area.
Application information:
Initial approach: Letter
Deadline(s): None
Write: Henry A. Rosenberg, Jr., Pres.
Officers: Henry A. Rosenberg, Jr.,* Pres.;
Frank A. Strzelczyk, Secy.-Treas.
Trustees:* Ruth Blaustein Rosenberg, Chair.;
Judith R. Hoffberger, Ruth R. Marder.
Employer Identification Number: 526038384

1112
**Ben & Esther Rosenbloom Foundation,
Inc.**
3407 Fielding Rd.
Baltimore 21218-1804

Established in 1982 in MD.
Financial data (yr. ended 12/31/87): Assets,
$1,671,453 (M); expenditures, $53,229,
including $47,805 for grants.
Purpose and activities: Support primarily for
Jewish welfare; grants also for social services
and the arts.
Limitations: Giving primarily in Baltimore, MD.
Application information:
Initial approach: Proposal
Deadline(s): None
Officers: Ben Rosenbloom, Pres.; Esther
Rosenbloom, V.P.; Howard Rosenbloom, Secy.-
Treas.
Employer Identification Number: 521258672

1113
Albert Shapiro Fund, Inc.
Nine West Mulberry St.
Baltimore 21201 (301) 752-1230

Established in 1983 in MD.
Financial data (yr. ended 5/31/87): Assets,
$3,350,692 (M); expenditures, $166,671,
including $148,780 for 28 grants (high:
$90,000; low: $100).
Purpose and activities: Grants primarily for
Jewish giving and cultural programs.

Application information:
Initial approach: Letter
Deadline(s): None
Write: Irving Cohn, Secy.-Treas.
Officers: Albert Shapiro, Pres.; Eileen Shapiro,
V.P.; Irving Cohn, Secy.-Treas.
Employer Identification Number: 521300277

1114
**The Thomas B. and Elizabeth M.
Sheridan Foundation, Inc.**
Executive Plaza II, Suite 604
11350 McCormick Rd.
Hunt Valley 21031 (301) 771-0475

Incorporated in 1962 in MD.
Donor(s): Thomas B. Sheridan,† Elizabeth M.
Sheridan.†
Financial data (yr. ended 12/31/87): Assets,
$5,162,629 (M); expenditures, $413,720,
including $337,604 for 18 grants (high:
$150,000; low: $500).
Purpose and activities: Emphasis on private
secondary schools and cultural organizations.
Types of support: Continuing support, annual
campaigns, building funds, equipment,
endowment funds, scholarship funds, capital
campaigns, emergency funds, general purposes,
matching funds, operating budgets, program-
related investments, seed money, special
projects.
Limitations: Giving primarily in the greater
Baltimore, MD, area. No grants to individuals,
or for matching gifts; no loans.
Publications: Application guidelines, program
policy statement.
Application information: Application form
required.
Initial approach: Letter
Copies of proposal: 1
Deadline(s): None
Board meeting date(s): Mar., June, Sept., and
Dec.
Write: James L. Sinclair, Pres.
Officers and Trustees: James L. Sinclair, Pres.;
John B. Sinclair, Secy.; J. Robert Kenealy,
Treas.; L. Patrick Deering.
Number of staff: 1 full-time professional; 1
part-time support.
Employer Identification Number: 526075270

1115
Signet Bank/Maryland Giving Program
Marketing-TU307
P.O. Box 1077
Baltimore 21203 (301) 332-5000

Financial data (yr. ended 12/31/88):
$633,000 for grants.
Purpose and activities: Support for arts and
culture, civic affairs, education, and health.
Types of support: Annual campaigns, building
funds, continuing support, general purposes,
publications, research, special projects.
Limitations: Giving primarily in the Baltimore
metropolitan area and eastern shore of MD.
Application information:
Write: Corp. Contribs. Comm.
Administrator: Mrs. Fran Minakowski, V.P.

1116
The Alvin and Fanny Blaustein Thalheimer Foundation, Inc.
Blaustein Bldg.
P.O. Box 238
Baltimore 21203 (301) 685-4230

Incorporated in 1958 in MD.
Donor(s): American Trading and Production Corp.
Financial data (yr. ended 2/28/87): Assets, $9,180,859 (M); gifts received, $220,000; expenditures, $409,857, including $334,525 for 9 grants (high: $221,025; low: $5,000).
Purpose and activities: Giving for Jewish welfare funds, art education, and the arts.
Types of support: General purposes.
Limitations: Giving primarily in Baltimore, MD. No grants to individuals.
Application information:
 Initial approach: Letter
 Deadline(s): None
 Board meeting date(s): 6 times a year
 Write: Louis B. Thalheimer, Pres.
Officers: Louis B. Thalheimer,* Pres.; Morton K. Blaustein, V.P.; Henry A. Rosenberg, Jr., V.P.; J. Warren Weiss, Secy.-Treas.
Trustees: Marjorie Thalheimer Coleman, Ruth B. Rosenberg, Elizabeth T. Wachs.
Number of staff: None.
Employer Identification Number: 526038383

1117
Town Creek Foundation, Inc.
P.O. Box 159
Oxford 21654

Established in 1981 in MD.
Donor(s): Edmund A. Stanley, Jr.
Financial data (yr. ended 12/31/88): Assets, $19,127,625 (M); expenditures, $1,163,063, including $1,007,000 for 46 grants (high: $150,000; low: $1,000; average: $5,000-$25,000).
Purpose and activities: Giving nationally for environmental protection, public radio and television, and arms control and nuclear disarmament; grants also to help the disadvantaged in Talbot County, MD.
Types of support: Operating budgets, continuing support, seed money, special projects.
Limitations: Giving nationally for major programs; support limited to Talbot County, MD, for social services. No support for primary or secondary schools, colleges, hospitals, or religious organizations. No grants to individuals, or for capital campaigns.
Publications: Informational brochure (including application guidelines).
Application information:
 Initial approach: Proposal
 Deadline(s): Feb. 15, June 15, and Oct. 15
 Board meeting date(s): Mar., July, and Nov.
 Final notification: 15 days after board meetings
 Write: Edmund A. Stanley, Jr., Pres.
Officers and Trustees: Edmund A. Stanley, Jr., Pres. and Exec. Dir.; Jennifer Stanley, V.P.; Philip E.L. Dietz, Jr., Secy.-Treas.; Lisa A. Stanley, Gerald L. Stokes.
Number of staff: None.
Employer Identification Number: 521227030

1118
The Aber D. Unger Foundation, Inc.
c/o Gordon, et al.
233 East Redwood St.
Baltimore 21202 (301) 576-4211

Incorporated in 1960 in MD.
Financial data (yr. ended 2/28/88): Assets, $1,639,001 (M); expenditures, $182,841, including $154,900 for 34 grants (high: $50,000; low: $250).
Purpose and activities: Emphasis on handicapped children, Jewish welfare funds, music, and theatre.
Application information:
 Initial approach: Proposal
 Deadline(s): None
 Write: Eugene M. Feinblatt, Pres.
Officer: Eugene M. Feinblatt, Pres. and Treas.
Directors: John Feinblatt, Marjorie W. Feinblatt, Paul L. Wolman III.
Employer Identification Number: 526034758

1119
USF&G Corporate Giving Program
100 Light St.
Baltimore 21202 (301) 547-3000

Financial data (yr. ended 12/31/87): Total giving, $626,784, including $209,993 for 416 grants (high: $7,500; low: $5) and $416,791 for 885 employee matching gifts.
Purpose and activities: Most support is through the foundation, but the company will support programs unable to be funded by its foundation. Supports health through hospitals, welfare, education, including private colleges, culture and the arts, museums, theater, civic and community programs, minority programs, youth welfare, federated campaigns, United Way, conservation and safety. Types of support include employee gift matching for education, use of company facilities, employee volunteer programs and donations of company's facilities and primary goods or services.
Types of support: In-kind gifts, capital campaigns, renovation projects, employee matching gifts, scholarship funds, continuing support.
Limitations: Giving primarily in headquarters city and major operating locations. Giving concentrated in greater Baltimore area. No support for projects/organizations for business reasons alone; trade and industry associations; primary or secondary schools; except for College of Insurance, no funding for educational institutions outside of MD; non-tax-exempt organizations; political organizations or candidates, religious organizations, veterans' organizations; or propaganda institutions.
Application information:
 Initial approach: Letter and proposal
 Copies of proposal: 1
 Final notification: 3 to 4 weeks
 Write: Paul J. Scheel, Exec. V.P.

1120
The USF&G Foundation, Inc.
100 Light St.
Baltimore 21202 (301) 547-3000

Foundation established in 1980 in MD.
Donor(s): United States Fidelity and Guaranty Co.
Financial data (yr. ended 12/31/87): Assets, $9,056,031 (M); gifts received, $8,087,000; expenditures, $1,495,141, including $1,488,060 for 34 grants (high: $400,000; low: $500; average: $1,000-$50,000).
Purpose and activities: Support largely for a community fund, arts and cultural programs, and higher education.
Types of support: Operating budgets, continuing support, annual campaigns, building funds, equipment, scholarship funds, special projects, endowment funds, capital campaigns, renovation projects.
Limitations: Giving primarily in MD, particularly the Baltimore area. No support for trade and industry associations, political or veterans' organizations, or religious organizations for religious purposes; generally, no grants to primary or secondary schools. No grants to individuals, or for seed money, emergency funds, deficit financing, land acquisition, matching gifts, research, publications, or conferences; no loans.
Publications: Program policy statement, application guidelines.
Application information: Application form required.
 Initial approach: Proposal
 Copies of proposal: 1
 Deadline(s): None
 Board meeting date(s): As required
 Final notification: 3 to 4 weeks
 Write: Jack Moseley, Pres.
Officers and Trustees:* Jack Moseley,* Pres.; Paul J. Scheel,* V.P.; William F. Spliedt, Secy.-Treas.
Number of staff: None.
Employer Identification Number: 521197155

1121
Jack Wilen Foundation, Inc.
c/o Sidney M. Friedman
1700 Reisterstown Rd., Suite 222
Baltimore 21208-3815

Financial data (yr. ended 11/30/87): Assets, $1,073,000 (M); expenditures, $50,981, including $48,311 for 71 grants (high: $11,000; low: $10).
Purpose and activities: Emphasis on Jewish giving; support also for cultural institutions.
Officer: Ruth E. Wilen Cooper, Pres.
Employer Identification Number: 520794415

1122
Wye Institute, Inc.
Cheston-on-Wye
P.O. Box 50
Queenstown 21658 (301) 827-7401

Incorporated in 1963 in MD.
Donor(s): Arthur A. Houghton, Jr.
Financial data (yr. ended 12/31/88): Assets, $1,082,086 (M); expenditures, $310,773,

including $189,352 for 22 grants (high: $40,000; low: $100).

Purpose and activities: A private operating foundation to assist in the advancement of local education, culture, and the economy of the eastern shore of MD.

Types of support: Conferences and seminars, consulting services, publications, seed money, special projects.

Limitations: Giving limited to the eastern shore of MD. No grants to individuals.

Application information:
Initial approach: Letter
Deadline(s): None
Board meeting date(s): Semiannually
Write: James G. Nelson, Pres.

Officers: James G. Nelson, Pres. and Mgr.; Rowland Stebbins III, V.P. and Treas.; Richard Garrett, Secy.

Trustees:* Arthur A. Houghton, Jr., Chair.; Sylvia H. Garrett, Nina R. Houghton, James A. Houston, John R. Kimberly.

Number of staff: None.

Employer Identification Number: 520799244

1123
The Zamoiski Foundation, Inc.
3000 Waterview Ave.
Baltimore 21230

Incorporated in 1948 in MD.
Donor(s): The Zamoiski Co.
Financial data (yr. ended 11/30/87): Assets, $658,764 (M); gifts received, $1,000; expenditures, $75,768, including $73,550 for 25 grants (high: $41,819; low: $25).

Purpose and activities: Emphasis on social services, higher education, medical research, and music.

Application information: Contributes only to preselected organizations. Applications not accepted.

Officer: Calman J. Zamoiski, Jr., Pres.

Employer Identification Number: 526043231

MASSACHUSETTS

1124
Frank W. and Carl S. Adams Memorial Fund
(also known as Charles E. & Caroline J. Adams Trust)
c/o First National Bank of Boston
P.O. Box 1890
Boston 02105 (617) 434-5669

Trust established in 1955 in MA.
Donor(s): Charles E. Adams,† Caroline J. Adams.†
Financial data (yr. ended 5/31/87): Assets, $8,639,700 (M); expenditures, $398,255, including $324,150 for 20 grants (high: $28,348; low: $4,000; average: $1,000-$7,500).

Purpose and activities: One half of the net income is distributed for general purposes, in the fields of health, welfare, the humanities, and education; the balance of income is designated to assist needy and deserving students selected by Massachusetts Institute of Technology and the Harvard Medical School.

Types of support: General purposes, building funds, operating budgets, capital campaigns, seed money.

Limitations: Giving limited to the city of Boston, MA. No support for national organizations. No grants for conferences, film production, scholarships, travel, research projects, or publications; no loans.

Application information:
Initial approach: Proposal
Copies of proposal: 1
Deadline(s): First day of month prior to board meetings
Board meeting date(s): Mar., June, Sept., and Dec.
Write: Miss Sharon M. Driscoll, Trust Officer, First National Bank of Boston

Trustee: First National Bank of Boston.

Employer Identification Number: 046011995

1125
Alcan Aluminum Corporate Giving Program
124 Mount Auburn St.
Cambridge 02138 (617) 576-2233

Purpose and activities: Supports civic programs, urban problems, education, arts and minority programs.

Types of support: Annual campaigns, building funds, employee matching gifts, internships, renovation projects.

Limitations: Giving primarily in major operating locations.

Application information:
Write: Stanford H. Lampe, Mgr., Public Relations

Number of staff: 1 full-time professional; 1 full-time support.

1126
George I. Alden Trust
370 Main St., Suite 1250
Worcester 01608 (617) 757-9243

Trust established in 1912 in MA.
Donor(s): George I. Alden.†
Financial data (yr. ended 12/31/87): Assets, $64,542,796 (M); expenditures, $2,785,083, including $2,513,200 for 156 grants (high: $200,000; low: $1,000; average: $5,000-$50,000).

Purpose and activities: For the promotion of education in schools, colleges, or other educational institutions, with a preference for industrial, vocational, or professional education; for the promotion of the work carried on by the Young Men's Christian Association, or its successors, either in this country or abroad; and for the benefit of the Worcester Trade Schools and the Worcester Polytechnic Institute; some support also for cultural and historic programs.

Types of support: Annual campaigns, seed money, emergency funds, building funds, equipment, land acquisition, research, publications, conferences and seminars, scholarship funds, internships, professorships, matching funds, general purposes, renovation projects, continuing support, endowment funds.

Limitations: Giving primarily in the Northeast, with emphasis on Worcester, MA. No grants to individuals; no loans.

Publications: Annual report, informational brochure (including application guidelines).

Application information:
Initial approach: Proposal
Copies of proposal: 1
Deadline(s): None
Board meeting date(s): Bimonthly beginning in Feb.
Final notification: 2 months
Write: Paris Fletcher, Chair.

Trustees: Paris Fletcher, Chair.; Robert G. Hess, Vice-Chair.; George W. Hazzard, Secy.; Francis H. Dewey III, Treas.

Number of staff: None.

Employer Identification Number: 046023784

Recent arts and culture grants:
Albright College, Reading, PA, $20,000. Toward Center for the Arts. 1987.
American Antiquarian Society, Worcester, MA, $50,000. Toward Alden P. Johnson Publications Fund. 1987.
Anna Maria College for Men and Women, Paxton, MA, $25,000. Toward Center for the Performing Arts. 1987.
Bay Path Junior College, Longmeadow, MA, $10,000. Toward new arts building. 1987.
International Artist Series, Worcester, MA, $5,000. For operating support. 1987.
Museum of Fine Arts, School of, Boston, MA, $5,000. For building construction. 1987.
New England Science Center, Worcester, MA, $27,500. For renovation of its Omnisphere. 1987.
Old Sturbridge Village, Sturbridge, MA, $32,000. For teacher training institute. 1987.
Performing Arts School of Worcester, Worcester, MA, $35,000. For matching grant for Center for the Performing Arts. 1987.
Performing Arts School of Worcester, Worcester, MA, $5,000. For annual fund. 1987.
Plimoth Plantation, Plymouth, MA, $20,000. For electronic communication equipment. 1987.
W G B H Educational Foundation, Boston, MA, $25,000. For programming in humanities. 1987.
W I C N Public Radio, Worcester, MA, $7,500. For operating support. 1987.
Worcester Art Museum, Worcester, MA, $200,000. Toward educational program. 1987.
Worcester Craft Center, Worcester, MA, $20,000. For scholarship aid. 1987.
Worcester Foothills Theater Company, Worcester, MA, $50,000. Toward new construction. 1987.
Worcester Historical Museum, Worcester, MA, $50,000. Toward purchase of Horticultural Hall. 1987.

1127
Amdur Leather Associates Foundation
226 Salem St.
Woburn 01801-2029

Financial data (yr. ended 9/30/88): Assets,
$44,854 (M); gifts received, $2,676;
expenditures, $1,749, including $1,645 for 12
grants (high: $500; low: $25).
Purpose and activities: Support for Jewish
giving, community funds, health services,
hunger, and public television.
Application information:
 Initial approach: Letter
 Write: R.L. Gitter
Trustees: Allan E. Gitter, Richard L. Gitter.
Employer Identification Number: 046142547

1128
Mary Alice Arakelian Foundation
c/o Institute for Savings
P.O. Box 510
Newburyport 01950
Additional address: P.O. Box 510,
Newburyport, MA 01950

Established in 1966 in MA.
Financial data (yr. ended 12/31/87): Assets,
$3,424,454 (M); expenditures, $268,274,
including $209,000 for 11 grants (high:
$70,000; low: $5,000).
Purpose and activities: Support primarily for
higher education, cultural programs, and
religious giving.
Application information:
 Deadline(s): None
 Board meeting date(s): Grants are decided in
 Oct.
 Write: John H. Pramberg, Jr., Pres.
Officer and Directors: John H. Pramberg, Jr.,
Pres.; Rose M. Marshall, Donald D. Mitchell,
Charles P. Richmond, Bank of New England,
N.A.
Employer Identification Number: 046155695

1129
Bank of Boston Corporate Giving
Program
c/o Public Affairs Dept., 01-23-01
P.O. Box 2016
Boston 02106-2016 (508) 434-2171
Bank of Boston contacts: Cape Cod region,
contact branch office in Yarmouth Port; Central
region: Worcester; Northern region: Burlington;
Southeastern region: New Bedford; Southern
region: Wellesley; Western region: Springfield

Financial data (yr. ended 12/31/87): Total
giving, $2,072,795, including $844,620 for
grants, $403,318 for employee matching gifts
and $824,857 for in-kind gifts.
Purpose and activities: "Since its founding in
1784, Bank of Boston has considered it an
essential part of its role to recognize
community needs and channel its resources to
most productively meet them." Bank of Boston
seeks to help meet the financial needs of its
communities, enhance the health and welfare
of all the communities the Bank serves,
improve educational programs and
opportunities for all members of these
communities, help those who require special

assistance to assume a full role in society, and
participate in major public policy issues that
affect the well-being of the community.
Because the communities it serves are so
diverse, the subject areas of interest to Bank of
Boston are broadly defined. Support for civic
and community organizations, culture and the
arts, education, including higher education,
health and hospitals, social services, in-kind
services, and United Way. The Bank also
administers an employee matching gifts
program, and in 1988 started an employee
community service program. Three
international business units also contribute
employee time, resources, facilities, and cash,
and three affiliate banks in CT, ME, and RI
operate their own contributions programs.
Types of support: In-kind gifts, operating
budgets, program-related investments, capital
campaigns, endowment funds.
Limitations: Giving primarily in the Greater
Boston region, and six other regions in MA:
Cape Cod, Central, Northern, Southeastern,
Southern, and Western; affiliate banks in CT,
ME, and RI have contributions programs in
their own communities. No support for
religious programs for religious purposes, or for
national health organizations, including state
and local chapters. No grants to individuals, or
for research projects, conferences, forums,
benefits, and similar events.
Application information:
 Initial approach: Proposal; write to nearest
 branch
 Copies of proposal: 1
 Deadline(s): 6 weeks prior to Committee
 meeting
 Board meeting date(s): the Corporate
 Contributions Committee considers
 requests in Mar., June, Sept., and Dec.
 Write: Judith H. Kidd, Mgr., Corp. Contribs.

1130
Bank of Boston Corporation Charitable
Foundation
c/o Bank of Boston
100 Federal St., Govt. & Community Affairs
Dept.
Boston 02106 (617) 434-2171

Trust established in 1961 in MA for First
National Bank of Boston Charitable Foundation;
absorbed into First National Boston Corporation
Foundation in 1983; present name adopted in
1983.
Donor(s): Bank of Boston Corp.
Financial data (yr. ended 12/31/87): Assets,
$11,538,293 (M); gifts received, $5,281,115;
expenditures, $3,735,186, including
$3,562,398 for 383 grants (high: $100,000;
low: $1,000; average: $2,500-$7,500).
Purpose and activities: Giving limited to
community organizations with programs in
education, health and hospitals, social services,
arts and culture, and the civic community.
Types of support: Annual campaigns, building
funds, general purposes, matching funds,
operating budgets, special projects, continuing
support, capital campaigns, endowment funds,
equipment, scholarship funds, renovation
projects.
Limitations: Giving primarily in MA. No
support for religious or partisan causes,

fundraising events, conferences, forums, or
nationally organized health programs. No
grants to individuals, or for research or
fellowships; no loans.
Publications: Annual report, corporate giving
report (including application guidelines), grants
list, informational brochure.
Application information:
 Initial approach: Proposal or letter
 Copies of proposal: 1
 Deadline(s): At least 6 weeks before meetings
 Board meeting date(s): 3rd week of Mar.,
 June, Sept., and Dec.
 Final notification: 2 months
 Write: Judith Kidd, Mgr., Corp. Contribs.
Trustees: William L. Brown, Ira Stepanian, Eliot
N. Vestner.
Number of staff: 2 full-time professional; 1 full-
time support.
Employer Identification Number: 042748070

1131
Bank of New England Corporation
Foundation
c/o Karen Hurst, Exec. Dir., Public Affairs
28 State St.
Boston 02109 (617) 573-2524

Established in MA in 1987.
Financial data (yr. ended 12/31/88):
Expenditures, $4,429,174 for 86 grants (high:
$60,000; low: $100; average: $2,500) and
$211,451 for 1,367 employee matching gifts.
Purpose and activities: Focus is on areas most
directly affecting the Bank and its employees,
with priority given to programs that specifically
encourage economic independence. Funding
categories include education, human and social
services, community service, culture, and
hospitals and health care, with primary
emphasis given to public education and human
and social services. While the Bank prefers to
fund established programs with proven track
records, in some instances it will support pilot
programs.
Types of support: Capital campaigns,
employee matching gifts, endowment funds,
operating budgets, special projects.
Limitations: No support for religious, fraternal,
governmental, veteran, labor, single-disease,
information, and research organizations, or
primarily grantmaking foundations. No grants
to individuals, or for trips, tours, transportation,
or deficit spending.
Publications: Newsletter, informational
brochure (including application guidelines).
Application information: Include project
budget, goals, directors, annual report, board
and contributors list, 501(c)(3) status proof, and
financial statement.
 Initial approach: Proposal with cover page;
 body of proposal no more than 10 pages
 Copies of proposal: 1
 Deadline(s): None
 Board meeting date(s): Quarterly for
 Contributions Committee
 Final notification: 3 months
 Write: Edward Lane-Reticker, Chair., BNE
 Corporate Foundation
Employer Identification Number: 222859802

1132
Frank M. Barnard Foundation, Inc.
Three Center Plaza, Suite 800
Boston 02108 (617) 227-9610

Established in 1982 in MA.
Financial data (yr. ended 12/31/87): Assets, $1,018,121 (M); expenditures, $94,447, including $54,625 for 18 grants (high: $15,000; low: $100).
Purpose and activities: Support for libraries, with emphasis on university collections, higher education, and cultural programs.
Limitations: Giving primarily in New England.
Application information: Application form required.
 Deadline(s): None
 Write: Dudley A. Weiss, Pres.
Officer: Dudley A. Weiss, Pres. and Treas.
Employer Identification Number: 042767462

1133
The Barrington Foundation, Inc.
P.O. Box 270
Great Barrington 01230

Established in 1978.
Donor(s): Samuel A. Strassler,† Gary M. Strassler, R.C.M. Corp., Weston Associates.
Financial data (yr. ended 12/31/87): Assets, $1,707,129 (M); gifts received, $447,871; expenditures, $258,267, including $256,596 for 108 grants (high: $100,000; low: $15).
Purpose and activities: Giving primarily for Jewish welfare funds, higher education, and cultural programs.
Application information:
 Write: David H. Strassler, Pres.
Officers: David H. Strassler, Pres.; Robert B. Strassler, Secy.-Treas.
Employer Identification Number: 132930849

1134
Barry Wright Corporate Giving Program
680 Pleasant St.
Watertown 02172 (617) 923-1150

Financial data (yr. ended 12/31/86): Total giving, $179,000, including $110,000 for grants (high: $10,000), $49,000 for employee matching gifts and $20,000 for in-kind gifts.
Purpose and activities: Supports education, arts, culture, social services, and health and welfare programs. Donations include in-kind giving, such as company products and services.
Types of support: In-kind gifts, general purposes, employee matching gifts.
Limitations: Giving primarily in major operating areas.
Application information: Applications not accepted.
 Initial approach: Letter
 Write: Eustis Walcott, Jr., V.P., Corp. Relations

1135
BayBanks Corporate Giving Program
175 Federal St.
Boston 02110 (617) 482-1040

Financial data (yr. ended 12/31/88): Total giving, $825,480, including $797,220 for

grants (high: $100,000; low: $500) and $28,260 for employee matching gifts.
Purpose and activities: Support for health and welfare, hospitals and hospital building funds, education, culture and the arts, museums, and civic activities.
Types of support: General purposes, capital campaigns, endowment funds, employee matching gifts.
Limitations: Giving primarily in state of MA, and parts of CT. No support for political, religious, fraternal or social, veteran, labor or directly tax-supported organizations.
Application information: Include complete budget, proof of 501(c)(3) status, board and contributors list, and audited statement.
 Initial approach: Letter and proposal; phone call
 Copies of proposal: 1
 Deadline(s): None
 Board meeting date(s): Annually, beginning in Dec.
 Final notification: 1-6 months
 Write: Pamela S. Henrikson, Sr. V.P. or Sonia K. DiBetta, Asst.
Administrators: Pamela S. Henrikson, Sr. V.P.; Sonia K. DiBetta, Asst.
Number of staff: 1 full-time professional; 1 part-time support.

1136
Adelaide Breed Bayrd Foundation
c/o John A. Plummer
Eight Wilson Rd.
Stoneham 02180 (617) 438-6619

Incorporated in 1927 in MA.
Donor(s): Frank A. Bayrd,† Blanche S. Bayrd.†
Financial data (yr. ended 12/31/88): Assets, $1,298,409 (M); gifts received, $227,000; expenditures, $282,339, including $244,900 for 61 grants (high: $30,000; low: $150; average: $5,000) and $1,600 for 8 grants to individuals.
Purpose and activities: To aid those causes in which the donor's mother was interested; primarily supports cultural activities.
Types of support: Operating budgets, annual campaigns, emergency funds, building funds, equipment, endowment funds, research, special projects, student aid.
Limitations: Giving primarily in the metropolitan Boston, MA, area, with emphasis on Malden. No support for national or out-of-state organizations. No grants to individuals (except for scholarships supplementary to the will of Blanche Bayrd), or for matching or challenge grants, demonstration projects, conferences, or publications; no loans.
Publications: Annual report (including application guidelines).
Application information:
 Initial approach: Proposal
 Deadline(s): Submit proposal preferably in Dec. or Jan.; deadline Feb. 15
 Board meeting date(s): 1st Tuesday in Feb.; special meetings usually held in Mar. or Apr. to consider grant requests
 Final notification: Generally in Apr. or May
 Write: John A. Plummer, Pres.
Officers and Trustees: John A. Plummer, Pres.; Russell E. Watts, Treas.; Florence C. Burns, C. Henry Kezer, Susan C. Mansur,

William H. Marshall, Gaynor K. Rutherford, Jean H. Stearns, H. Allen Stevens.
Number of staff: 1 part-time professional; 1 part-time support.
Employer Identification Number: 046051258

1137
Bird Companies Charitable Foundation, Inc.
One Dedham Pl.
P.O. Box 35
Westwood 02090 (617) 461-1414

Incorporated in 1967 in MA.
Donor(s): Bird & Son, Inc., Bird Machine Co., Inc.
Financial data (yr. ended 12/31/86): Assets, $55,928 (M); expenditures, $59,084, including $49,850 for 22 grants (high: $15,150; low: $500; average: $500-$1,000).
Purpose and activities: Grant emphasis on community development, education, cultural programs, and natural resources. Additional consideration to projects related to corporate locations as determined by local committees. Emphasis on seed monies.
Types of support: Seed money.
Limitations: Giving primarily in MA. No grants to individuals.
Publications: Program policy statement, application guidelines.
Application information:
 Initial approach: Letter, telephone, or proposal
 Copies of proposal: 1
 Board meeting date(s): Feb., May, Aug., and Oct.
 Final notification: 1 to 6 months
Officers: George J. Haufler,* Pres.; Frank S. Antony, Secy.; William A. Krivsky, Treas.
Directors:* Robert P. Bass, Jr., Charles S. Bird, David Bird, Robert Cooper, Francis J. Dunleavy, John T. Dunlop, Guy W. Fiske, Mary Bird Phillips.
Employer Identification Number: 237067725

1138
Curtis Blake Foundation
c/o Friendly Ice Cream Corp.
33 Mill Rd.
Longmeadow 01106 (413) 567-1574

Established in 1972 in MA.
Donor(s): Curtis L. Blake.
Financial data (yr. ended 12/31/86): Assets, $1,955,328 (M); gifts received, $50,000; expenditures, $70,362, including $67,600 for 24 grants (high: $3,600; low: $100).
Purpose and activities: Emphasis on higher education, culture, and programs for the learning disabled.
Limitations: Giving primarily in MA. No grants to individuals.
Application information: Contributes only to pre-selected organizations. Applications not accepted.
 Write: Curtis L. Blake, Trustee
Trustees: Curtis L. Blake, Alfred W. Fuller.
Employer Identification Number: 237204498

1139
S. P. Blake Foundation
666 Bliss Rd.
Longmeadow 01106 (413) 567-9483

Established in 1972 in MA.
Donor(s): S. Prestley Blake.
Financial data (yr. ended 12/31/87): Assets, $3,276,320 (M); expenditures, $201,405, including $169,102 for 25 grants (high: $125,000; low: $25).
Purpose and activities: Educational purposes with emphasis on higher education and historic preservation, including a museum.
Limitations: Giving primarily in the western MA area. No grants to individuals.
Application information:
Initial approach: Letter
Copies of proposal: 1
Deadline(s): None
Board meeting date(s): Monthly
Final notification: 2 months
Write: S. Prestley Blake, Trustee
Trustees: Benson P. Blake, S. Prestley Blake.
Employer Identification Number: 237185871

1140
Arthur F. Blanchard Trust
c/o Boston Safe Deposit and Trust Co.
One Boston Place
Boston 02108 (617) 722-7340

Trust established in 1943 in MA.
Donor(s): Arthur F. Blanchard.†
Financial data (yr. ended 12/31/87): Assets, $8,251,718 (M); expenditures, $528,111, including $311,143 for grants (high: $100,000; low: $5,000).
Purpose and activities: Grants principally in the areas of community development, human services, education, and culture.
Types of support: General purposes, seed money, emergency funds, equipment, land acquisition, research, special projects, matching funds, capital campaigns, renovation projects.
Limitations: Giving limited to MA, with emphasis on the Boston metropolitan area. No grants to individuals, or for endowment funds, scholarships, or fellowships; no loans.
Publications: Program policy statement, application guidelines.
Application information:
Initial approach: Proposal
Copies of proposal: 1
Deadline(s): Jan. 1, Apr. 1, July 1, and Sept. 1
Board meeting date(s): Mar., June, Sept., and Dec.
Final notification: 3 months
Write: Sylvia Salas, Trust Officer, Boston Safe Deposit and Trust Co.
Trustee: Boston Safe Deposit and Trust Co.
Number of staff: None.
Employer Identification Number: 046093374

1141
Boston Edison Foundation
800 Boylston St., P359
Boston 02199 (617) 424-2235

Established in 1981 in MA.
Donor(s): Boston Edison Co.

Financial data (yr. ended 12/31/88): Assets, $1,731,000 (M); gifts received, $400,000; expenditures, $1,120,240, including $1,073,240 for 97 grants (high: $375,000; low: $500; average: $500-$50,000), $47,000 for employee matching gifts and $100 for 1 in-kind gift.
Purpose and activities: Support for higher education, health and welfare organizations, including hospitals and community funds; museums, performing arts groups, and other cultural programs; civic affairs, and community development groups.
Types of support: Employee matching gifts, annual campaigns, building funds, capital campaigns, continuing support, emergency funds, endowment funds, general purposes, renovation projects, research, operating budgets, scholarship funds.
Limitations: Giving primarily in areas of company operations, with emphasis on Boston and eastern MA.
Publications: Application guidelines.
Application information:
Initial approach: Proposal, including proof of 501(c)3 status, annual report, contributors list, organization and project budget
Deadline(s): Nov. 1
Board meeting date(s): Dec.
Final notification: Within 10 days
Write: Neil F. Doherty, Dir.
Officers: Neil F. Doherty, Dir.; Craig D. Peffer,* Exec. Advisor; Catherine J. Keuthen, Counsel; Basil G. Pallone, Treas.; C.S. Daisy Jao, Tax Advisor; Ann L. Cardello.
Trustees:* Stephen J. Sweeney, Chair.; Douglas C. Bauer, Theodora S. Convisser, Eleanor T. Daly, William D. Harrington, Thomas J. May, Bernard W. Reznicek.
Number of staff: None.
Employer Identification Number: 042754285

1142
The Boston Foundation, Inc.
60 State St., 6th Fl.
Boston 02109 (617) 723-7415

Community foundation established in 1915 in MA by agreement and declaration of trust; incorporated in 1917.
Financial data (yr. ended 6/30/88): Assets, $197,964,481 (M); gifts received, $8,707,823; expenditures, $14,772,088, including $12,094,964 for 1,218 grants (high: $156,095; low: $650; average: $5,000-$75,000).
Purpose and activities: To support local health, welfare, educational, cultural, environmental and housing programs and institutions; grants for start-up expenses of new or experimental programs of both established and new institutions, as well as for capital needs and for coordination and planning projects.
Types of support: Building funds, emergency funds, equipment, land acquisition, matching funds, seed money, special projects, renovation projects.
Limitations: Giving limited to the Boston, MA, metropolitan area. No support for religious purposes, small arts groups, public or private schools, municipalities, or national or international programs. No grants to individuals, or for general operating funds,

medical, scientific, or academic research; books or articles; films, radio, or television programs; audio and/or video equipment; travel; scholarships, fellowships, conferences, or multi-million dollar capital campaigns with a national focus; no loans.
Publications: Annual report, application guidelines, newsletter, occasional report.
Application information:
Initial approach: Letter or proposal
Copies of proposal: 1
Deadline(s): 10 weeks prior to board meetings
Board meeting date(s): Mar., June, Sept., and Dec.
Final notification: Within 1 or 2 weeks of board meeting
Write: Anna Faith Jones, Pres.
Officers: Dwight L. Allison, Jr.,* Chair.; Lawrence T. Perera,* Vice-Chair.; Anna Faith Jones, Pres. and C.E.O.
Distribution Committee:* Peter J. Gomes, Daniel A. Hart, Charles Ray Johnson, Martin S. Kaplan, Gael Mahony, David R. Pokross, Sr., David Rockefeller, Jr., Muriel S. Snowden, John Larkin Thompson.
Trustee Banks: Bank of New England, N.A., Bank of Boston, Boston Safe Deposit and Trust Co., Shawmut Bank, N.A., State Street Bank & Trust Co.
Number of staff: 11 full-time professional; 6 full-time support.
Employer Identification Number: 042104021
Recent arts and culture grants:
Arts/Boston, Boston, MA, $25,000. Toward salary of full-time professional coordinator for Midtown Cultural District Task Force. 10/88.
Lexington Public Schools, Lexington, MA, $12,500. To hire drama specialist and program coordinator to work with Watertown and Somerville middle schools. 10/16/87.
W G B H Educational Foundation, Boston, MA, $20,000. For Violence Prevention Television Project. 3/18/88.

1143
Boston Gas Company Giving Program
One Beacon St.
Boston 02108 (617) 742-8400

Financial data (yr. ended 12/31/88): Total giving, $391,000, including $186,000 for 100 grants (high: $1,500; low: $100; average: $250) and $205,000 for employee matching gifts.
Purpose and activities: Supports business and minority education; child welfare; programs for the disadvantaged, the handicapped, and the homeless; civic affairs, including housing and safety; intercultural relations; legal services; and performing arts.
Types of support: Employee matching gifts, renovation projects, general purposes.
Limitations: Giving primarily in company territory of eastern MA.
Publications: Application guidelines, newsletter, informational brochure (including application guidelines).
Application information: Application form required.
Copies of proposal: 1

Deadline(s): Apr. 15
Board meeting date(s): Late Apr.
Write: S.T. Horwitz, V.P., Public Relations
Administrator: S.T. Horwitz, V.P., Public Relations and Advertising.

1144
The Boston Globe Foundation, Inc.
c/o The Boston Globe
135 William T. Morrissey Blvd.
Boston 02107 (617) 929-2895
Additional tel.: (617) 929-3194

Incorporated in 1981 in MA.
Donor(s): Affiliated Publications, Inc.
Financial data (yr. ended 6/30/88): Assets, $1,855,553 (M); gifts received, $1,071,323; expenditures, $1,277,482, including $1,139,456 for grants (high: $340,000; low: $25; average: $1,000-$10,000), $15,927 for 14 grants to individuals and $43,041 for employee matching gifts.
Purpose and activities: The Boston Globe Foundation, Inc., a public charity, oversees the operation of the Globe Santa Fund, and administers the employee matching gifts program, and the several scholarship funds. The Globe Santa Fund is a collaboration with Globe Newspaper readers to provide gifts for needy children during the holiday season. The Fund solicits contributions in the form of money or merchandise from the general public. Three scholarship funds provide assistance to the children of employees of the Boston Globe; the fourth fund assists athletes attending colleges in the Greater Boston area and New England.
Types of support: Employee matching gifts, operating budgets, special projects, building funds, scholarship funds, employee-related scholarships, research, renovation projects, emergency funds, endowment funds, internships, publications.
Limitations: Giving primarily in the Boston, MA, metropolitan area. No grants to individuals, or for the purchase of advertisements or tables.
Publications: Annual report (including application guidelines).
Application information: Very detailed proposal requirements are provided in the guidelines brochure. Application form required.
Initial approach: Proposal
Copies of proposal: 1
Deadline(s): None
Board meeting date(s): Feb., Mar., June, Sept., and Nov.
Final notification: 4 months after submitting proposal
Write: Suzanne T. Watkin, Exec. Dir.
Number of staff: 3 full-time professional; 1 part-time professional.
Employer Identification Number: 042731195
Recent arts and culture grants:
American Antiquarian Society, Worcester, MA, $6,000. For newspaper archival preservation program. 1988.
Arnold Arboretum of Harvard University, Jamaica Plain, MA, $5,000. For production of brochure announcing Endowment Campaign. Grant made through Boston Natural Areas Fund. 1988.

Art Institute of Boston, Boston, MA, $5,470. Toward printing of Boston Public School Christmas card prize paintings with all public sales profits going to Boston Public Schools art department for student materials. 1988.
Artists Foundation, Boston, MA, $12,500. For final payment of pledge. 1988.
Artists Foundation, Boston, MA, $12,500. For City Place project to create, define and develop cultural performing and exhibit space in State Transportation Building. 1988.
Arts in Progress, Jamaica Plain, MA, $7,000. For general operating expenses for therapeutic, social programming in Boston Public Schools serving population of low income, culturally and ethnically mixed youth and elderly. 1988.
Arts/Boston, Boston, MA, $15,000. For Boston Space Chase symposium for local artists to obtain information on developing rehearsal and performance space through working in partnership with developers and City. 1988.
Boston Ballet, Boston, MA, $20,000. For capital renovations and development of new center for dance in Boston. 1988.
Boston Ballet, Boston, MA, $15,000. To support free public Esplanade performances of Ballet II for summer '87. 1988.
Boston Ballet, Boston, MA, $15,000. To support talented students in Boston Ballet II and their free performances in Esplanade for summer '88. 1988.
Boston Film Video Foundation, Boston, MA, $5,000. For general operating expenses. 1988.
Boston Lyric Opera Company, Boston, MA, $5,000. For final payment of pledge for operating expenses and for continued expansion of productions. 1988.
Boston Lyric Opera Company, Boston, MA, $5,000. To underwrite general production and operating costs. 1988.
Boston Preservation Alliance, Boston, MA, $5,000. Toward general operating expenses in continuing public education of historic research of landmark architecture in Boston. 1988.
Boston Preservation Alliance, Boston, MA, $5,000. Toward general operating expenses. 1988.
Boston Symphony Orchestra, Boston, MA, $15,000. For annual corporate support and membership including President's night. 1988.
Boston Symphony Orchestra, Boston, MA, $15,000. For annual corporate support and membership including President's night. 1988.
Boston Youth Theater, Cambridge, MA, $7,500. For general operating expenses. 1988.
Calliope Film Resources, Somerville, MA, $5,000. For completion and distribution of film, Yonder Come the Blues. 1988.
Center for Creative Art Therapies, Boston, MA, $5,000. To support music, painting and dance programming in public schools for children with behavioral disabilities and in battered women's shelters for both children and their mothers. 1988.
Childrens Literature Foundation, Watertown, MA, $35,000. For Children and Books Program. 1988.
Chinese Culture Institute, Boston, MA, $5,000. For operating expenses. 1988.

Chinese Culture Institute, Boston, MA, $5,000. To support expansion of Institute and its anti-racism efforts. 1988.
Chinese Culture Institute, Boston, MA, $5,000. For unrestricted grant for operating expenses. 1988.
Chinese Culture Institute, Boston, MA, $5,000. For first payment of grant with accompanying challenge grant in support of outreach program. 1988.
Community Art Center, Cambridge, MA, $5,000. Toward rehabilitation of courthouse facility. 1988.
Concert Dance Company of Boston, Watertown, MA, $6,000. Toward operating expenses of CDC tours of schools as well as for developing workshops. 1988.
Copley Square Centennial Committee, Boston, MA, $25,000. For final payment of pledge. 1988.
Copley Square Centennial Committee, Boston, MA, $25,000. For renovation of Copley Square. 1988.
Creative Arts at Park, Brookline, MA, $5,000. For camperships for children of low income familes of South End of Boston to attend summertime multi-arts program. 1988.
Creative Arts at Park, Brookline, MA, $5,000. For scholarship aid to children from Boston's South End neighborhood for summer arts camp. 1988.
Cultural Education Collaborative, Boston, MA, $7,500. To support Boston Program. 1988.
Cultural Education Collaborative, Boston, MA, $7,500. For Boston Program providing critical link between Boston Public Schools and area cultural institutions. 1988.
Dance Umbrella, Cambridge, MA, $10,000. For emergency funding to relocate spring performance series after unforeseen loss of performance space. 1988.
Dance Umbrella, Cambridge, MA, $8,000. For sponsorship of Boston Jazz-Tap Festival to focus on this indigenous American art form. 1988.
Dorchester Allied Veterans Council, Dorchester, MA, $5,000. Toward completion of Dorchester Vietnam Veterans Memorial. 1988.
Ecumenical Social Action Committee, ESAC Media Arts Camp, Jamaica Plain, MA, $5,000. 1988.
First Night, Boston, MA, $5,500. For operating expenses to support First Night 1988 Arts Celebration. 1988.
Fort Point Arts Community, Boston, MA, $7,500. To encourage initiatives in stabilizing art community in Fort Point Channel area. 1988.
Handel and Haydn Society, Boston, MA, $7,500. For unrestricted operating expenses. 1988.
Huntington Theater Company, Back Bay, MA, $8,000. For unrestricted support of professional company producing classic plays with emphasis on programs at low prices for public school students. 1988.
Huntington Theater Company, Back Bay, MA, $7,500. To underwrite attendance by Boston Public School students. 1988.
Jamaica Plain Arts Council, Jamaica Plain, MA, $7,500. For operating support for new Firehouse Arts Center providing local,

cultural programs for Jamaica Plain residents. 1988.

Jefferson Park Writing Center, Cambridge, MA, $10,000. For maintenance of core programming and development of new initiatives for alternative community school serving residents of public housing. 1988.

Jefferson Park Writing Center, Cambridge, MA, $7,500. For general operating expenses for community-based educational program with emphasis on arts and humanities. 1988.

John F. Kennedy Library Foundation, Cambridge, MA, $10,000. For final payment of pledge. 1988.

John F. Kennedy Library Foundation, Cambridge, MA, $10,000. For program expansion. 1988.

Kodaly Center of America, West Newton, MA, $5,000. For support of unique music education program in Boston Public Schools. 1988.

Loon and Heron Theater, Brookline, MA, $5,000. For productions utilizing handicapped and disabled high school performers and dealing with themes from rape to interracial harmony. 1988.

Massachusetts Cultural Alliance, Boston, MA, $25,000. For Phase II of Mass Cultural Agenda which looks to combine business, education, cultural and government representatives to influence and support future of culture in Massachusetts. 1988.

Massachusetts Cultural Alliance, Boston, MA, $10,000. For research of needs of cultural community of Massachusetts as first step towards developing statewide agenda for next decade. 1988.

Massachusetts Cultural Alliance, Boston, MA, $10,000. For general operating support. 1988.

Massachusetts Cultural Alliance, Boston, MA, $8,000. For challenge grant toward development of new publication focused on advocacy for arts programming. 1988.

McCormack Center for the Arts, Strand Theater, Dorchester, MA, $10,000. Toward expansion and selection of professional staff and to expand service to community. 1988.

Museum of Fine Arts, Boston, MA, $12,500. For annual corporate support and membership. 1988.

Museum of Fine Arts, Boston, MA, $12,500. For corporate membership. 1988.

Museum of Science, Boston, MA, $15,000. For Master Teacher Program, and Elementary Science Outreach Program/Science Kit Program providing major educational resources and teacher training programs. 1988.

Museum of Science, Boston, MA, $15,000. For second payment toward pledge. 1988.

Museum of Science, Boston, MA, $7,500. For corporate membership. 1988.

Museum of Science, Boston, MA, $7,500. For annual corporate membership and support. 1988.

Neighborhood Arts Center, Boston, MA, $7,500. For arts programs benefiting young and old residents of Boston's neighborhoods. 1988.

Neighborhood Arts Center, Boston, MA, $7,500. Toward year round arts programming for intergenerational range of students. 1988.

New England Aquarium, Boston, MA, $10,000. For final payment of pledge for development of Boston Harbor exhibit. 1988.

New England Aquarium, Boston, MA, $7,500. For annual corporate support and membership. 1988.

New England Aquarium, Boston, MA, $5,000. For corporate membership. 1988.

New England Foundation for the Arts, Cambridge, MA, $7,500. For operating support for touring programs for New England artists. 1988.

New England Foundation for the Arts, Cambridge, MA, $5,000. For general operating expenses. 1988.

New England Foundation for the Humanities, Boston, MA, $15,000. For start-up expenses for six state collaborative effort to address need for additional humanities programming in New England states. 1988.

New England Sports Museum, Boston, MA, $7,500. For final payment of challenge toward new facilities. 1988.

North Atlantic Ballet Company, Cambridge, MA, $5,000. Toward general operating expenses. 1988.

Opera Company of Boston, Boston, MA, $25,000. For challenge grant for unrestricted general operating expenses. 1988.

Performers Ensemble, South End, MA, $5,000. For presentation of workshops on racism for residents and staff of public housing residencies at South Boston, Dorchester and South End. 1988.

Photographic Resource Center, Boston, MA, $5,000. For Assimilation/Isolation project which provides exhibitions of minority artists work. 1988.

Plimoth Plantation, Plymouth, MA, $10,000. For second payment toward capital pledge. 1988.

Plimoth Plantation, Plymouth, MA, $10,000. For capital program for construction of Educational Center. 1988.

Revels, Cambridge, MA, $5,000. For Sea Revels, musical/theatrical presentation of our maritime heritage which is integrated into educational programs by Boston teachers and students in Boston Voyages in Learning. 1988.

Revels, Cambridge, MA, $5,000. For Sea Revels and thematic education experience. 1988.

Schooner Bowdoin Association, Rockland, ME, $10,000. For Boston school education programming involving Arctic ship Bowdoin. 1988.

Science Discovery Museum, Acton, MA, $15,000. To build new science museum facility and creative hands-on exhibits for young people. 1988.

Somerville Historical Museum/Somerville Historical Society, Somerville, MA, $20,000. For final payment of capital pledge for development of museum and programs. 1988.

South Boston High School, South Boston, MA, $5,000. For MOSAIC program that provides unique writing and artistic experience for betterment of interracial understanding. 1988.

South Shore Art Center, Cohasset, MA, $5,000. Toward construction of facilities. 1988.

U.S.S. Constitution Museum, Charlestown, MA, $20,000. For creation of development office. 1988.

U.S.S. Constitution Museum, Charlestown, MA, $12,500. For Constitution Bicentennial Forum Series. 1988.

Very Special Arts Massachusetts, Boston, MA, $15,000. To sponsor elementary grades art festival for disabled children held at Children's Museum. 1988.

Very Special Arts Massachusetts, Boston, MA, $10,000. To support Springfest art program for thousands of disabled children. 1988.

W G B H Educational Foundation, Boston, MA, $20,000. For development of programming in humanities as part of NEH challenge grant. 1988.

Wang Center for the Performing Arts, Boston, MA, $12,500. To support Project Discovery in public and special needs schools. 1988.

1145
The Boston Globe Foundation II, Inc.
135 Morrissey Blvd.
Boston 02107 (617) 929-3194

Financial data (yr. ended 6/30/88): Assets, $112,220 (M); gifts received, $4,312,866; expenditures, $4,353,567, including $4,284,715 for 499 grants (high: $340,000; low: $25).

Purpose and activities: Giving primarily for community services, with emphasis on multiservice agencies, handicapped accessibility, housing development, and race relations; support also for culture and the arts, education, science and the environment, hospitals and health care, summer camps, and media business.

Types of support: Employee matching gifts, operating budgets, special projects, building funds, scholarship funds, employee-related scholarships, employee matching gifts, research, renovation projects, emergency funds, endowment funds, internships, publications.

Limitations: Giving primarily in the Greater Boston, MA, area.

Application information: Detailed proposal requirements are provided in the guidelines brochure.

Initial approach: Proposal
Deadline(s): None
Board meeting date(s): Feb., Mar., June, Sept., and Nov.
Final notification: 4 months after submitting proposal
Write: Suzanne Watkin, Exec. Dir.

Officers and Directors: William O. Taylor, Pres.; John P. Guiggio, Treas.; Suzanne Watkin, Exec. Dir.; Dexter Eure, Sr., Catherine E.C. Henn, Benjamin Taylor, William D. Taylor.

Employer Identification Number: 222821421

1146
The Braitmayer Foundation
c/o North American Management Corp.
28 State St., Suite 3854
Boston 02109

Trust established in 1964 in MA.
Donor(s): Marian S. Braitmayer.

Financial data (yr. ended 12/31/87): Assets, $2,284,771 (M); expenditures, $178,245, including $157,500 for 22 grants (high: $10,000; low: $2,500).
Purpose and activities: Support primarily for the advancement of higher education, particularly in developing techniques of instruction in the humanities and liberal arts.
Limitations: Giving primarily in New England states. No grants to individuals or for building or endowment funds, scholarships, fellowships, or matching gifts; no loans.
Application information: Contributes only to pre-selected organizations. Applications not accepted.
 Board meeting date(s): Annually and as required
Trustees: John W. Braitmayer, Karen L. Braitmayer, Anne B. Webb, R. Davis Webb, Jr.
Employer Identification Number: 046112131

1147
Julia B. Buxton Trust
c/o Shawmut First Bank & Trust Co. of Hampden County
127 State St.
Springfield 01103

Financial data (yr. ended 12/31/87): Assets, $1,178,853 (M); expenditures, $59,434, including $38,000 for 18 grants (high: $5,000; low: $500).
Purpose and activities: Support primarily for social services, the arts, museums and public television.
Types of support: General purposes.
Application information:
 Initial approach: Proposal
 Deadline(s): Aug.
Trustee: Shawmut First Bank & Trust Co. of Hampden County.
Employer Identification Number: 046263415

1148
Cabot Corporation Foundation, Inc.
950 Winter St.
P.O. Box 9073
Waltham 02254-9073 (617) 890-0200

Incorporated in 1953 in MA.
Donor(s): Cabot Corp.
Financial data (yr. ended 9/30/87): Assets, $1,731,405 (M); gifts received, $1,300,000; expenditures, $1,219,465, including $786,455 for 116 grants (high: $62,500; low: $725; average: $1,000-$10,000) and $433,010 for 372 employee matching gifts.
Purpose and activities: Emphasis on science and technology, higher education, including employee matching gifts, community improvement, and public policy. Support also for community funds and cultural programs; particular interest in strengthening the future scientific and technological capabilities of the nation. As a result, projects, organizations, and activities with a science and technology focus that cut across all program areas receive special attention.
Types of support: Annual campaigns, seed money, building funds, equipment, scholarship funds, fellowships, special projects, matching

funds, general purposes, employee matching gifts, capital campaigns.
Limitations: Giving primarily in communities near Cabot corporate installations in TX; Douglas County, IL; St. Mary Parish and Evangeline Parish, LA; Boyertown, PA; Kanawha County, WV; and Waltham, MA. No support for political organizations, religious institutions for religious purposes, or fraternal organizations. No grants to individuals, or for advertising or dinner table sponsorship.
Publications: Annual report (including application guidelines), occasional report.
Application information:
 Initial approach: Proposal
 Copies of proposal: 1
 Deadline(s): 1 month prior to meetings
 Board meeting date(s): Mar., June, Sept., and Dec.
 Final notification: 3 months
 Write: Ruth C. Scheer, Exec. Dir.
Officers: Louis W. Cabot,* Pres.; Ruth C. Scheer, V.P. and Exec. Dir.; Robert A. Charpie,* V.P.; Althea M. Burpos, Secy.; Frederick A. Conti, Treas.
Directors:* Maryellen Cabot, Thomas D. Cabot, Michael J. Widmer.
Number of staff: 1 full-time professional; 1 full-time support.
Employer Identification Number: 046035227
Recent arts and culture grants:
Boston Museum of Science, Boston, MA, $20,000. For Omnimax Theater Campaign. 1987.
Charles River Museum of Industry, Waltham, MA, $5,000. For curriculum development workshops. 1987.
Cultural Education Collaborative, Boston, MA, $5,000. 1987.
Indiana Repertory Theater, Indianapolis, IN, $5,000. For signers and materials for hearing-impaired audiences. 1987.
W F Y I-Metropolitan Indianapolis Television Association, Indianapolis, IN, $8,580. For science television programming. 1987.
W G B H Educational Foundation, Boston, MA, $10,000. For scientists training in broadcast journalism. 1987.
Wang Center for the Performing Arts, Boston, MA, $15,000. 1987.

1149
Cabot Family Charitable Trust
950 Winter St.
P.O. Box 9073
Boston 02254-9073 (617) 890-0200

Trust established in 1942 in MA.
Donor(s): Godfrey L. Cabot.†
Financial data (yr. ended 12/31/86): Assets, $10,311,000 (M); expenditures, $325,831, including $316,250 for 38 grants (high: $50,000; low: $250; average: $2,000-$10,000).
Purpose and activities: Program interests include urban programs, youth and family services, higher and other education, cultural programs, conservation, hospitals, population-related projects, and nuclear accord.
Types of support: Annual campaigns, seed money, building funds, equipment, land acquisition, endowment funds, general purposes, continuing support, capital campaigns, research.

Limitations: Giving limited to the Boston, MA, area. No support for computer-related projects. No grants to individuals, or for medical or scientific research, scholarships, fellowships, or matching gifts; no loans.
Publications: Annual report.
Application information:
 Initial approach: Proposal
 Copies of proposal: 1
 Deadline(s): May, Aug., and Nov.
 Board meeting date(s): June, Sept., and Dec.
 Final notification: 3 to 5 months
 Write: Ruth C. Scheer, Mgr.
Trustees: Jane C. Bradley, John Cabot, Louis W. Cabot.
Number of staff: 1 full-time professional.
Employer Identification Number: 046036446

1150
Ella Lyman Cabot Trust, Inc.
109 Rockland St.
Holliston 01746 (508) 429-8997

Incorporated in 1939 in MA.
Donor(s): Richard Cabot.†
Financial data (yr. ended 12/31/88): Assets, $1,374,384 (M); expenditures, $80,239, including $70,211 for 9 grants to individuals (high: $21,000; low: $1,680; average: $4,000-$8,000).
Purpose and activities: Grants for projects involving a departure from one's usual vocation or a creative extension of it, with a promise of good to others. Awards are usually made on a one-year basis and are not renewed.
Types of support: Grants to individuals.
Limitations: No grants for scholarships, fellowships, or research pursued as a regular part of a profession; no grants to organizations.
Publications: Informational brochure, application guidelines.
Application information: Proposals screened before application is issued. Application form required.
 Initial approach: Letter and proposal
 Copies of proposal: 1
 Deadline(s): Feb. 15 and Sept. 15
 Board meeting date(s): Nov. and May
 Final notification: Usually by May 15 and Nov. 15
 Write: Mary Jane Gibson, Exec. Secy.
Officers: Allan L. Friedlich, Chair.; Jeffrey Swope, Treas.; Mary Jane Gibson, Exec. Secy.
Number of staff: 1 part-time professional.
Employer Identification Number: 042111393

1151
Calvert Trust
c/o D.H. Bigelow
79 Milk St.
Boston 02109

Established in 1965 in MA.
Financial data (yr. ended 12/31/87): Assets, $1,346,131 (M); expenditures, $102,518, including $80,000 for 10 grants.
Purpose and activities: Emphasis on hospitals, cultural programs, and aid for the handicapped.
Limitations: Giving primarily in Boston, MA.

Application information: Contributes only to pre-selected organizations. Applications not accepted.
Trustee: D.H. Bigelow.
Employer Identification Number: 046121842

1152
Clark Charitable Trust
P.O. Box 251
Lincoln 01773

Established in 1937 in MA.
Financial data (yr. ended 12/31/87): Assets, $1,741,937 (M); expenditures, $80,372, including $66,933 for 41 grants (high: $5,000; low: $250; average: $1,500).
Purpose and activities: Support for basic human needs, preservation of environment, animal welfare, music, and higher education.
Types of support: Annual campaigns, building funds, capital campaigns, endowment funds, equipment, land acquisition, operating budgets, scholarship funds.
Publications: 990-PF, financial statement.
Application information:
Write: Timothy A. Taylor, Trustee
Trustees: Russel T. Kopp, Timothy A. Taylor.
Employer Identification Number: 046037650

1153
Jessie B. Cox Charitable Trust
c/o Grants Management Associates, Inc.
230 Congress St., 3rd Fl.
Boston 02110 (617) 357-1516
Additional tel.: (617) 357-1500

Charitable lead trust established in 1982 in Boston, MA.
Donor(s): Jessie B. Cox.†
Financial data (yr. ended 12/31/87): Assets, $50,000,000 (M); expenditures, $3,059,230 for 69 grants (high: $125,000; low: $10,000; average: $20,000-$100,000).
Purpose and activities: Grants for education, health, the protection of the environment, and the development of philanthropy. The trustees tend to favor organizations which have not received prior grants, and new approaches over those similar to previously funded projects; fixed amount of approximately $3 million to be paid out annually through the life of the trust.
Types of support: Seed money, special projects.
Limitations: Giving primarily in New England. No support for sectarian religious activities, or efforts usually supported by the general public. No grants to individuals, or for capital or building funds, equipment and materials, land acquisition, renovation projects, deficit financing, operating budgets, continuing support, annual campaigns, or general endowments; no loans.
Publications: Annual report, informational brochure (including application guidelines).
Application information:
Initial approach: Brief concept paper
Copies of proposal: 3
Deadline(s): Jan. 15, Apr. 15, July 15, and Oct. 15
Board meeting date(s): Mar., June, Sept., and Dec.

Final notification: Within 3 months of deadline
Write: Administrators
Administrators: Susan Britt, Newell Flather, Ala H. Reid, Ann Fowler Wallace.
Trustees: William C. Cox, Jr., Roy A. Hammer, Jane Cox MacElree, George T. Shaw.
Number of staff: 4 part-time professional; 1 full-time support.
Employer Identification Number: 046478024
Recent arts and culture grants:
Academy of Natural Sciences of Philadelphia, Philadelphia, PA, $30,000. For project: Natural differences between adults and juveniles in populations of oyster, Crassostrea virginica. 1987.
Artists Foundation, Boston, MA, $10,000. To support state-wide Artists' Health Education Program that will provide artists with information about hazardous substances and procedures associated with their work. 1987.
Childrens Museum, Boston, MA, $100,000. For Museum's new multi-cultural program to promote greater cultural literacy and understanding in Greater Boston. 1987.
Community Music Center of Boston, Boston, MA, $45,000. For Advanced Study Project to prepare Boston youths for advanced instrument training and participation in new, all-city youth orchestra. 1987.
Manomet Bird Observatory, Manomet, MA, $68,000. To assist with transition of Manomet's intern program into Field Biology Training Program with academic credit for undergraduate students. 1987.
New England Foundation for the Arts, Boston, MA, $53,715. To reorganize, expand and revitalize Foundation's programs throughout New England. 1987.
Peabody Museum of Salem, Salem, MA, $10,000. To develop and implement new and expanded educational outreach programs, especially in Boston's Asian community. 1987.
StageWest, Springfield, MA, $55,000. To expand Professional Theatre Intern Education Program. 1987.
Thames Science Center, New London, CT, $50,000. For Sounds Conservancy Marine Conservation Education and Research Program which supports students and non-profit groups investigating coastal issues. 1987.
Thames Science Center, New London, CT, $7,806. For Project Porifera, through which museum scientists and educators will train and assist teachers in integrating newly developed aquatic biology research program into life sciences curriculum at 20 junior high schools in Thames River watershed. 1987.

1154
Cox Foundation, Inc.
c/o Gaston & Snow
One Federal St.
Boston 02110 (617) 426-4600

Established in 1970.
Donor(s): William C. Cox, Jr.
Financial data (yr. ended 12/31/87): Assets, $4,358,620 (M); gifts received, $750,000; expenditures, $227,923, including $225,965 for 30 grants (high: $75,000; low: $500).

Purpose and activities: Emphasis on private schools, hospitals and medical research; support also for conservation and the environment, and cultural programs, including museums.
Types of support: Annual campaigns, continuing support, general purposes, land acquisition, operating budgets, research, special projects, capital campaigns.
Limitations: Giving primarily in MA and FL.
Application information: Applications not accepted.
Officers: William C. Cox, Jr., Pres.; David E. Place, Secy.; Martha W. Cox, Treas.
Employer Identification Number: 237068786

1155
Crane & Company Fund
South St.
Dalton 01226

Established in 1953 in MA.
Donor(s): Crane & Co., Inc., Byron-Weston Co.
Financial data (yr. ended 12/31/87): Assets, $55,093 (M); gifts received, $79,746; expenditures, $161,181, including $161,025 for 51 grants (high: $25,000; low: $100).
Purpose and activities: Giving for civic affairs, social services, health, community funding, education and culture.
Application information:
Deadline(s): None
Trustees: Benjamin J. Sullivan, Stephen H. Wismer.
Employer Identification Number: 046057388

1156
Henry H. Crapo Charitable Foundation
c/o Davis C. Howes, Treas.
13 North Sixth St.
New Bedford 02740 (617) 999-1351

Established in 1952 in MA.
Financial data (yr. ended 12/31/87): Assets, $1,649,288 (M); expenditures, $97,873, including $90,000 for 7 grants (high: $20,000; low: $500).
Purpose and activities: Support for a community fund, cultural programs, social services and community development.
Limitations: Giving primarily in New Bedford, MA.
Officers: John C. Bullard, Pres.; W. Julian Underwood, V.P.; Davis C. Howes, Treas.
Employer Identification Number: 042270340

1157
Douglas & Isabelle Crocker Foundation
c/o S. F. Chittick
111 Ross St.
Fitchburg 01420 (617) 342-2016

Established in 1954 in MA.
Financial data (yr. ended 11/30/88): Assets, $1,130,803 (M); expenditures, $73,533, including $56,000 for 3 grants (high: $26,000; low: $10,000).
Purpose and activities: Support primarily for a church and for a youth organization; support also for an art museum.
Limitations: Giving primarily in MA.

Application information:
Deadline(s): None
Write: Stanley F. Chittick, Treas.
Officers: Bartow Kelly, Pres.; Stanley F. Chittick, Treas.; Donald Crocker.
Employer Identification Number: 046044767

1158
Cullinane Charitable Foundation
c/o Cullinet Software, Inc.
400 Blue Hill Dr.
Westwood 02090

Established in 1982 in MA.
Donor(s): Cullinet Software, Inc.
Financial data (yr. ended 6/30/88): Assets, $50,738 (M); expenditures, $48,354, including $48,063 for 47 grants (high: $14,535; low: $50).
Purpose and activities: Support for social services, including aid for the handicapped, higher and other education, including educational associations, and cultural programs.
Limitations: Giving primarily in the metropolitan Boston, MA, area. No grants to individuals.
Application information:
Initial approach: Proposal
Deadline(s): None
Trustees: David L. Chapman, John J. Cullinane, Gerard F. Doherty, Jeffrey P. Papows, James A. Pitts, Edward B. Stead, George Tamke.
Employer Identification Number: 042760159

1159
The Fred Harris Daniels Foundation, Inc.
c/o The Mechanics Bank, Trust Dept.
P.O. Box 987
Worcester 01613 (617) 798-6443
Application address: c/o The Mechanics Bank, Trust Dept., 2000 Mechanics Tower, Worcester, MA 01608

Incorporated in 1949 in MA.
Donor(s): Fred H. Daniels,† Riley Stoker Co.
Financial data (yr. ended 10/31/88): Assets, $7,448,478 (M); expenditures, $429,101, including $378,000 for 58 grants (high: $45,000; low: $350; average: $1,000-$20,000).
Purpose and activities: Grants for the advancement of the sciences, and medicine; support for higher education, hospitals, community funds and services, museums, and cultural programs.
Types of support: Operating budgets, continuing support, annual campaigns, emergency funds, building funds, equipment, land acquisition, endowment funds, matching funds, professorships, internships, scholarship funds, fellowships, special projects, capital campaigns, general purposes, renovation projects.
Limitations: Giving primarily in the Worcester, MA, area. No grants to individuals, or for seed money or deficit financing; no loans.
Application information:
Initial approach: Letter
Copies of proposal: 1
Deadline(s): Mar. 1, June 1, Sept. 1 and Dec. 1

Board meeting date(s): Mar., June, Sept., and Dec.
Final notification: 1 to 2 1/2 months
Write: Bruce G. Daniels, Pres.
Officers and Directors: Bruce G. Daniels, Pres.; F. Turner Blake, Jr., Secy.; William O. Pettit, Jr., Treas.; Johnathan D. Blake, Fred H. Daniels II, Janet B. Daniels, Eleanor D. Hodge, Sarah D. Morse, William S. Nicholson, Meridith D. Wesby.
Number of staff: None.
Employer Identification Number: 046014333

1160
Data General Corporate Giving Program
4400 Computer Dr.
Westborough 01580 (617) 366-8911

Financial data (yr. ended 9/24/88): Total giving, $427,762, including $178,215 for 120 grants (high: $25,000; low: $50; average: $500-$1,000) and $249,547 for 14 in-kind gifts.
Purpose and activities: Supports education, civic affairs, health, welfare, culture and the arts; in-kind support.
Types of support: General purposes, research, in-kind gifts.
Limitations: Giving primarily in company-operating areas. No support for fund-raising or religious organizations. No grants to individuals.
Application information:
Initial approach: Letter and proposal
Deadline(s): None
Write: David L. Dimmick, Donations Admin.
Number of staff: 1

1161
Devonshire Associates
50 Federal St.
Boston 02110

Incorporated in 1949 in MA.
Donor(s): Melita S. Howland, Weston Howland III, Thomas Power, Weston Howland, Jr.
Financial data (yr. ended 12/31/86): Assets, $1,746,748 (M); gifts received, $286,250; expenditures, $113,172, including $97,750 for 11 grants (high: $25,000; low: $500).
Purpose and activities: Emphasis on a college and an aquarium; support also for cultural programs, higher education, and youth agencies.
Limitations: Giving primarily in MA.
Application information: Contributes only to pre-selected organizations. Applications not accepted.
Officers and Trustees: Weston Howland, Jr., Pres.; William H. MacCrellish, Jr., Secy.; Donald M. DeHart, Treas.; Lewis H. Parks.
Employer Identification Number: 046004808

1162
Eugene A. Dexter Charitable Fund
c/o BayBank Valley Trust Co.
1500 Main St.
Springfield 01115 (413) 781-7575
Grant application address: Robert J. Van Wart, Secy., Community Funds Advisory Comm., 1365 Main St., Springfield, MA 01103

Trust established in 1946 in MA.

Donor(s): Henrietta F. Dexter.†
Financial data (yr. ended 12/31/86): Assets, $7,214,019 (M); expenditures, $389,805, including $313,162 for grants (high: $60,750; average: $24,700).
Purpose and activities: Grants for public charitable purposes, including health, welfare, the humanities, and education; emphasis on the physically and mentally handicapped, minorities, youth and child welfare agencies, and health services.
Types of support: Building funds, equipment, land acquisition, conferences and seminars, publications, matching funds, special projects, capital campaigns, seed money, renovation projects.
Limitations: Giving limited to the city of Springfield, MA. No grants to individuals, or for endowment funds, operating budgets, scholarships, fellowships, or general purposes; no loans.
Publications: Informational brochure (including application guidelines).
Application information:
Initial approach: Telephone, letter, or proposal
Copies of proposal: 12
Deadline(s): Submit proposals preferably in Dec., Apr., or Aug.; deadline 1st Monday in Jan. and May and 1st Tuesday in Sept.
Board meeting date(s): 4th Tuesday of Mar., July, and Nov.
Final notification: 4 months
Write: Peter Weston, V.P., BayBank Valley Trust Co.
Trustee: BayBank Valley Trust Co.
Number of staff: 1 part-time professional; 1 part-time support.
Employer Identification Number: 046018698

1163
Digital Equipment Corporate Giving Program
111 Powdermill Road, B14
Maynard 01754 (508) 493-9210

Financial data (yr. ended 6/30/88): Total giving, $27,600,000, including $24,643,000 for grants, $457,000 for 413 grants to individuals (high: $8,000; low: $1,000) and $2,500,000 for 30,000 employee matching gifts.
Purpose and activities: Support for education, both national and international, arts and humanities, health and social services, civic and public affairs, and the handicapped and cultural programs.
Types of support: Research, scholarship funds, matching funds, employee matching gifts, employee-related scholarships.
Limitations: Giving primarily in Digital operating areas worldwide. No support for political activities, religious and veterans' organizations. No grants to individuals, or for endowments, or capital campaigns.
Publications: Informational brochure (including application guidelines).
Application information: Include project description and budget, proof of 501(c)(3) status, board member and contributors list.
Initial approach: Letter and proposal
Copies of proposal: 1
Deadline(s): None

Final notification: 120 days
Write: Jane Hamel, Corp. Contrib. Mgr.
Number of staff: 4 full-time professional; 1 full-time support.

1164
The Ellison Foundation
129 South St.
Boston 02111 (617) 542-0690

Trust established in 1952 in MA.
Donor(s): Eben H. Ellison.†
Financial data (yr. ended 12/31/87): Assets, $592,081 (M); gifts received, $88,800; expenditures, $149,756, including $148,174 for 31 grants (high: $32,973; low: $100).
Purpose and activities: Emphasis on higher education, hospitals and medical research, a community fund, church support, and cultural programs.
Limitations: Giving primarily in MA.
Application information: Contributes only to pre-selected organizations. Applications not accepted.
Write: Wendell R. Freeman, Trustee
Trustees: William P. Ellison, Wendell R. Freeman, Harriet E. Rogers.
Employer Identification Number: 046050704

1165
Endowment for Biblical Research, Boston
P.O. Box 993
Boston 02123 (617) 734-5600

Established in 1920 in MA.
Donor(s): Mary Beecher Longyear.†
Financial data (yr. ended 6/30/88): Assets, $1,648,532 (L); expenditures, $108,751, including $70,000 for 7 grants (low: $2,000).
Purpose and activities: To facilitate and advance research in the Bible and the history of the Christian church, including archaeological digs, publications, and lecture tours; and maintains the Zion Research Library; prefers seed grants to long-term support.
Types of support: Publications, research, conferences and seminars, seed money, special projects.
Limitations: No support for denominational and non-biblical education.
Publications: Informational brochure (including application guidelines).
Application information: Funds largely committed, but proposals invited.
Board meeting date(s): Apr. and Oct.
Final notification: May and Nov.
Trustees: Merelice K. England, Richard M. Harley, Stephen R. Howard, Elizabeth L. Jacobs, Virginia B. Stopfel.
Number of staff: 1 part-time professional.
Employer Identification Number: 042104439

1166
Fidelity Foundation
82 Devonshire St.
Boston 02109 (617) 570-6806

Trust established in 1965 in MA.
Donor(s): Fidelity Management & Research Co. (FMR).

Financial data (yr. ended 12/31/87): Assets, $18,037,644 (M); gifts received, $3,958,280; expenditures, $7,558,766, including $7,088,450 for 157 grants (high: $5,705,172; low: $30; average: $5,000-$50,000) and $168,422 for employee matching gifts.
Purpose and activities: Giving largely to organizations working in the fields of community development, cultural affairs, education, and health.
Types of support: Building funds, operating budgets, special projects, endowment funds, employee matching gifts.
Limitations: Giving primarily in MA, and in other communities where Fidelity employees live and work. No grants to individuals.
Application information:
Initial approach: Proposal
Copies of proposal: 1
Deadline(s): Mar. 30 and Oct. 30
Board meeting date(s): June and Dec.
Final notification: Immediately following board meeting
Write: Anne-Marie Soulliere, Fdn. Dir.
Trustees: Edward C. Johnson III, Caleb Loring, Jr., Ross E. Sherbrooke.
Number of staff: 1 full-time professional; 1 part-time professional; 1 full-time support; 1 part-time support.
Employer Identification Number: 046131201

1167
Lincoln and Therese Filene Foundation, Inc.
c/o Nutter, McClennen & Fish
One International Pl.
Boston 02110-2699 (617) 439-2000

Incorporated in 1937 in MA.
Donor(s): Lincoln Filene.†
Financial data (yr. ended 1/31/88): Assets, $11,007,188 (M); gifts received, $33,353; expenditures, $614,238, including $543,345 for 18 grants (high: $120,000; low: $100; average: $5,000-$100,000).
Purpose and activities: General purposes, including particularly the scientific investigation of the causes of economic distress; grants largely for higher education, music, the performing arts, and public policy issues. Funds largely committed to long-term support of existing projects.
Types of support: Continuing support, emergency funds, equipment, matching funds, operating budgets, special projects.
Limitations: No grants to individuals, or for endowment funds, scholarships, or fellowships; no loans.
Application information: Funds largely committed.
Initial approach: Letter
Copies of proposal: 1
Deadline(s): Apr. 15 and Oct. 15
Board meeting date(s): May and Nov.
Final notification: After next semiannual meeting
Write: John K.P. Stone III, Secy.
Officers and Directors: Lincoln F. Ladd, Pres.; George E. Ladd III, V.P.; John K.P. Stone III, Secy.-Treas.; G. Michael Ladd, Robert M. Ladd, David A. Robertson, Jr., John J. Robertson, Catherine F. Shouse, Joan D. Tolley, Benjamin A. Trustman.
Number of staff: None.

Employer Identification Number: 237423946

1168
First Mutual Foundation
800 Boylston St.
Boston 02199 (617) 247-6500

Established in 1982 in MA.
Donor(s): Mutual Bank.
Financial data (yr. ended 12/31/87): Assets, $5,727 (M); gifts received, $100,000; expenditures, $100,520, including $100,516 for 42 grants (high: $18,000; low: $500).
Purpose and activities: Support primarily to cultural institutions and social service programs.
Limitations: Giving primarily in areas where bank has branches.
Application information: Contributes to organizations serving communities where bank has branches or investments.
Initial approach: Proposal
Deadline(s): 4-6 weeks prior to meeting
Write: Nancy Hamton, Asst. Secy.
Officer: Joan M. Diver,* Chair.
Trustees:* Cecil W. Cadwell, and nine others.
Employer Identification Number: 042755093

1169
Fisher Foundation
c/o Boston Safe Deposit and Trust Co.
One Boston Place
Boston 02106

Established in 1969 in MA.
Financial data (yr. ended 8/31/87): Assets, $1,744,475 (M); expenditures, $60,642, including $43,570 for 6 grants (high: $15,000; low: $3,870).
Purpose and activities: Giving primarily for cultural programs; support also for social services.
Types of support: Equipment, seed money, general purposes.
Limitations: Giving primarily in upstate NY. No grants to individuals.
Application information:
Initial approach: Letter
Board meeting date(s): Nov.
Write: Sylvia Salas, Trust Officer
Trustee Bank: Boston Safe Deposit and Trust Co.
Employer Identification Number: 046198798

1170
Orville W. Forte Charitable Foundation, Inc.
311 Sumner St.
Boston 02210 (617) 482-8434

Established in 1952 in MA.
Financial data (yr. ended 12/31/87): Assets, $1,360,508 (M); gifts received, $37,830; expenditures, $73,033, including $56,000 for 29 grants (high: $15,000; low: $500).
Purpose and activities: Support primarily for community funds, hospitals, cultural programs, youth organizations, and education.
Types of support: Scholarship funds.
Limitations: Giving primarily in New England, with emphasis on the Greater Boston, MA, area.
Application information:

Deadline(s): Jul. 31
Final notification: Dec.
Write: Cheryl Forte, Exec. Dir.
Officers: Donald Forte,* Pres.; Donald Forte, Jr.,* Secy.; John H. Forte,* Treas.
Directors:* Cheryl Forte, William R. Forte, Orville W. Forte, Jr., David E. Place.
Employer Identification Number: 046017836

1171
Joseph C. and Esther Foster Foundation, Inc.

122 Buckskin Dr.
Weston 02193 (617) 891-1192

Established in 1961 in MA.
Donor(s): Esther Foster, Joseph C. Foster.†
Financial data (yr. ended 12/31/87): Assets, $2,124,969 (M); gifts received, $20,000; expenditures, $294,348, including $274,946 for 34 grants (high: $217,385; low: $100).
Purpose and activities: Grants for higher education, Jewish welfare funds, cultural programs and medical research.
Types of support: Annual campaigns, building funds, matching funds.
Application information:
 Initial approach: Letter
 Deadline(s): None
 Write: Marcia J. Scheinbart, Secy.
Officers and Directors: Leo Scheinbart, Pres.; Marcia J. Scheinbart, Secy.; Esther J. Foster, Treas.; Jacob Chatkis, Samuel Rappaporte, Jr.
Number of staff: None.
Employer Identification Number: 046114436

1172
The French Foundation

c/o Boston Safe Deposit and Trust Co.
One Boston Place
Boston 02106

Established in 1947 in MA.
Financial data (yr. ended 12/31/87): Assets, $1,898,584 (M); expenditures, $142,370, including $117,550 for 46 grants (high: $10,000; low: $50).
Purpose and activities: Giving primarily for conservation and the environment, support also for the arts and social services.
Limitations: No grants to individuals.
Application information:
 Initial approach: Letter
 Deadline(s): Feb., May, Aug., and Nov.
 Board meeting date(s): Mar., June, Sept., and Dec.
 Write: Sylvia Salas
Trustees: Catherine L. French, Robert L.V. French, Edward F. Williams, Boston Safe Deposit and Trust Co.
Employer Identification Number: 046053426

1173
George F. and Sybil H. Fuller Foundation

105 Madison St.
Worcester 01610 (617) 756-5111

Trust established in 1955 in MA.
Donor(s): George Freeman Fuller.†

Financial data (yr. ended 12/31/87): Assets, $53,744,357 (M); expenditures, $4,237,454, including $4,020,850 for 110 grants (high: $300,000; low: $1,000; average: $2,000-$30,000).
Purpose and activities: Emphasis on higher education, cultural institutions, historic preservation, hospitals, community funds, and youth organizations; support also for social service agencies and schools.
Types of support: Annual campaigns, seed money, emergency funds, general purposes, building funds, endowment funds, research, continuing support, renovation projects.
Limitations: Giving primarily in MA, with emphasis on Worcester. No grants to individuals, or for scholarships, fellowships, or matching gifts; no loans.
Application information:
 Initial approach: Proposal
 Copies of proposal: 1
 Deadline(s): None
 Board meeting date(s): Jan.-Mar., June-Aug., and Oct.-Dec.
 Final notification: Varies
 Write: Russell E. Fuller, Chair.
Officers and Trustees: Russell E. Fuller, Chair. and Treas.; Robert Hallock, Jr., Vice-Chair.; Paris Fletcher, Secy.; Ernest M. Fuller, Mark Fuller, David Hallock.
Number of staff: 1
Employer Identification Number: 046125606

1174
General Cinema Corporate Giving Program

27 Boylston St.
Chestnut Hill 02167 (617) 232-8200
One copy of proposal to: Grant Management Associates, Proposal Secy., Review Staff for General Cinema, 100 Franklin St., Boston, MA 02110

Purpose and activities: Supports education, health, social services, and the arts, through two principal programs: the Corporate Charitable Program and the Divisional Program. The Corporate Charitable Program focuses on the charitable needs of General Cinema's corporate headquarters location, Greater Boston, while making occasional, highly selective grants on the national level, and features: a Major Grants Program, with an emphasis on the special needs of children and youth, for organizations in the Greater Boston area. Grants are made on a one-time basis, though payment may be scheduled over several years; an Institutional Impact Program, to provide transitional support during times of major innovation, expansion of services, or dynamic change for organizations in the Greater Boston area, providing designated project support or transitional support for a 3-7 year period; and a National Impact Program for a one-time, unsolicited grant to a leading national organization in health and education. The Divisional Charitable Fund contributes to organizations working to improve the quality of life in communities across the U.S., generally where General Cinema employees reside, and to organizations in which company employees and retirees are involved; it features a Community Emphasis Program, with support

for civic affairs and community development, and an employee matching gifts program.
Types of support: Research, capital campaigns, employee matching gifts, general purposes, matching funds.
Limitations: Giving primarily in headquarters city and major operating areas. No support for sectarian religious activities; political and lobbying activities; projects usually supported by the general public; recent grantees; organizations whose applications have been denied within the past year; where General Cinema may become the predominant source of an organization's support. No grants to individuals, or for film, operating budgets, or deficits.
Publications: Application guidelines.
Application information: Cover letter not exceeding 3 pages which requests a grant amount for a defined purpose, including project's objectives, time frame, and relation to the priorities of both the applicant and General Cinema; a detailed proposal with a present operating budget, audited financial statements for the past two years, list of major donors and board members, plans for an evaluation of the project and for its maintenance after the grant period; brief description of applicant organization; 501(c)(3).
 Initial approach: Letter and proposal; one copy of proposal must be sent to proposal review staff at Grant Management Assocs.
 Copies of proposal: 2
 Deadline(s): Jan. 2, Apr. 1, July 1, and Oct. 1
 Board meeting date(s): Feb., May, Aug., and Nov.
 Final notification: After meeting
 Write: Kay M. Kilpatrick, Contribs. Secy.
Corporate Contributions Committee: Richard A. Smith, Chair; Samuel Frankenheim, J. Atwood Ives, Robert A. Smith, Robert J. Tarr, Jr.

1175
GenRad Foundation

300 Baker Ave.
Concord 01742 (617) 369-4400

Trust established in 1934 in MA.
Donor(s): GenRad, Inc., Henry Shaw.†
Financial data (yr. ended 12/31/87): Assets, $3,626,696 (M); expenditures, $423,434, including $351,003 for 279 grants and $33,000 for 22 grants to individuals.
Purpose and activities: Giving primarily for social services, hospitals, cultural programs, higher and secondary education, and public broadcasting.
Types of support: Employee matching gifts, annual campaigns, building funds, capital campaigns, continuing support, endowment funds, general purposes, operating budgets, renovation projects, seed money, special projects.
Limitations: Giving primarily in MA. No grants to individuals.
Publications: Application guidelines.
Application information:
 Initial approach: Telephone for guidelines; proposal limited to 5 pages
 Copies of proposal: 1
 Deadline(s): None
 Board meeting date(s): Bimonthly

Final notification: Within 3 months of receipt of proposal
Write: Linda B. Smoker, Admin.
Officers and Trustees: Constantine J. Lahanas, V.P.; Raymond F. McNulty, Dir.
Number of staff: 1 full-time professional; 1 part-time support.
Employer Identification Number: 046043570

1176
The Nehemias Gorin Foundation
c/o William Gorin
1330 Beacon St.
Brookline 02146 (617) 738-4319

Established in 1964 in MA.
Donor(s): Nehemias Gorin.†
Financial data (yr. ended 11/30/88): Assets, $2,661,000 (M); expenditures, $285,000, including $265,000 for 60 grants (high: $60,000; low: $1,000).
Purpose and activities: Support for hospitals, Jewish welfare funds, Israel, higher education, the handicapped, cultural programs, community funds, and health agencies.
Types of support: Annual campaigns.
Limitations: Giving primarily in MA.
Application information: Applications not accepted.
Board meeting date(s): Nov.
Trustees: Bertha G. Fritz, Stephen Goldenberg, William Gorin, Ida G. Leckart.
Employer Identification Number: 046119939

1177
Guild of Boston Artists, Inc.
162 Newbury St.
Boston 02116-2889

Established in 1914 in MA.
Financial data (yr. ended 3/31/87): Assets, $1,181,492 (M); gifts received, $969; expenditures, $51,009, including $2,850 for 7 grants (high: $2,000; low: $100) and $400 for 3 grants to individuals.
Purpose and activities: Support primarily for the arts.
Limitations: Giving primarily in MA.
Application information: Contributes only to pre-selected organizations. Applications not accepted.
Officers: Robert Cormier, Pres.; Marian Williams Steele, Secy.; Roger W. Curtis, Treas.
Employer Identification Number: 042104266

1178
Joseph M. Hamilburg Foundation
c/o Plymouth Rubber Co.
Revere St.
Canton 02021

Established in 1963.
Donor(s): Daniel M. Hamilburg.
Financial data (yr. ended 12/31/87): Assets, $1,357,059 (M); expenditures, $66,190, including $43,535 for 82 grants (high: $10,000; low: $25).
Purpose and activities: Giving for health agencies, hospitals, and the performing arts; support also for higher education.

Limitations: Giving primarily in MA. No grants to individuals.
Application information: Contributes only to pre-selected organizations. Applications not accepted.
Trustee: Daniel M. Hamilburg.
Employer Identification Number: 046128210

1179
Harvard Musical Association
c/o Chair., Awards Comm.
57A Chestnut St.
Boston 02109-2881 (617) 523-2897

Established in 1837; incorporated in 1845 in MA.
Financial data (yr. ended 6/30/88): Assets, $3,173,288 (M); expenditures, $80,228, including $21,500 for 20 grants.
Purpose and activities: Supporting grants to musical organizations and commissions to composers for new works; maintains a library of musicology and scores, and practice and concert facilities.
Types of support: Scholarship funds, operating budgets, grants to individuals.
Limitations: Giving limited to the greater Boston, MA, area.
Application information:
 Initial approach: Letter
 Deadline(s): Apr. 1
Board of Directors: John L. Thorndike, Pres.; Kilmer McCully, V.P.; Ronald G. Sampson, V.P.; George W. Butterworth III, Secy.; Sherwood E. Bain, Treas.; Leo L. Beranek, Jean T. Bok, Hugh H. Sharpe III.
Number of staff: 1 full-time professional; 1 full-time support.
Employer Identification Number: 042104284

1180
The George B. Henderson Foundation
c/o Palmer & Dodge
One Beacon St.
Boston 02108 (617) 227-4400

Established in 1964 in MA.
Donor(s): George B. Henderson.†
Financial data (yr. ended 12/31/87): Assets, $4,329,593 (M); expenditures, $154,408, including $95,505 for 6 grants (high: $37,745; low: $700).
Purpose and activities: Grants for enhancement of the physical appearance of the city of Boston.
Types of support: Renovation projects, special projects.
Limitations: Giving limited to Boston, MA. No grants to individuals, or for endowment funds, maintenance, operating budgets, research, scholarships, fellowships, or general purposes; no loans.
Application information: Application form required.
 Initial approach: Letter or proposal
 Copies of proposal: 1
 Deadline(s): None
 Board meeting date(s): As required
 Final notification: One to three months

Write: John T. Galvin, Secy., Board of Designators
Trustees: Henry B. Guild, Jr., Ernest Henderson III, Gerard C. Henderson.
Employer Identification Number: 046089310

1181
Nan and Matilda Heydt Fund
c/o BayBank Valley Trust Co.
1500 Main St.
Springfield 01115 (413) 781-7575
Grant application address: c/o BayBank Valley Trust Co., P.O. Box 422, Burlington, MA 01803; Tel.: (413) 617-2294

Trust established in 1966 in MA.
Donor(s): Matilda L. Heydt.†
Financial data (yr. ended 12/31/87): Assets, $3,246,138 (M); expenditures, $174,660, including $135,938 for 22 grants (high: $25,000; low: $1,307).
Purpose and activities: Grants for public charitable purposes including health, welfare, the humanities, and education; emphasis on child welfare and youth agencies, community funds, and aid to the handicapped.
Types of support: Capital campaigns, equipment, land acquisition, matching funds, publications, renovation projects, seed money, special projects.
Limitations: Giving limited to Hampden County, MA. No grants to individuals, or for endowment funds, scholarships, fellowships, or operating budgets; no loans.
Publications: Informational brochure (including application guidelines).
Application information:
 Initial approach: Telephone, letter, or proposal
 Copies of proposal: 12
 Deadline(s): Submit proposal preferably in Dec., Apr., or Aug.; deadline 1st Monday in Jan. and May, and 1st Tuesday in Sept.
 Board meeting date(s): Mar., July, and Nov.
 Final notification: 4 months
 Write: Peter Weston, V.P., BayBank Valley Trust Co.
Trustee: Baybank Valley Trust Co.
Number of staff: 1 part-time professional; 1 part-time support.
Employer Identification Number: 046136421

1182
Jacob and Frances Hiatt Foundation, Inc.
P.O. Box 1657, Station C
Worcester 01607

Incorporated in 1951 in MA.
Donor(s): Jacob Hiatt, Estey Charitable Income Trust, Rand-Whitney Packaging Corp., Frances L. Hiatt.
Financial data (yr. ended 8/31/87): Assets, $6,730,838 (M); gifts received, $2,121,292; expenditures, $1,205,056, including $1,164,091 for grants.
Purpose and activities: Giving primarily for higher education, cultural programs, and Jewish organizations.
Limitations: Giving primarily in Worcester, MA.
Officers and Directors: Jacob Hiatt, Pres. and Treas.; Myra H. Kraft, Robert K. Kraft.
Employer Identification Number: 046050716

1183
Aldus C. Higgins Foundation

c/o Fiduciary Trust Co.
175 Federal St.
Boston 02110

Trust established in 1946 in MA.
Donor(s): Higgins Trust No. 13, Mary S. Higgins Trust No. 2, and others.
Financial data (yr. ended 9/30/87): Assets, $2,850,960 (M); expenditures, $123,386, including $109,000 for 18 grants (high: $20,000; low: $250).
Purpose and activities: Giving for higher and secondary education and cultural programs.
Limitations: Giving primarily in Worcester, MA.
Application information:
　Initial approach: Letter
　Deadline(s): None
　Write: Edmund H. Kendrick, Trustee
Trustees: Richard Chapin, Milton P. Higgins, Edmund H. Kendrick.
Employer Identification Number: 046049262

1184
John W. & Clara C. Higgins Foundation

370 West Main St., Suite 1250
Worcester 01608

Established in 1956 in MA.
Financial data (yr. ended 12/31/86): Assets, $1,488,170 (M); expenditures, $67,096, including $48,650 for 19 grants (high: $26,000; low: $50).
Purpose and activities: Giving for the arts, a museum, and education.
Limitations: No grants to individuals.
Application information:
　Initial approach: Letter
　Deadline(s): None
Trustees: Richard Higgins, Mary Louise Wilding-White, Philip O. Wilding-White.
Employer Identification Number: 046026914

1185
High Meadow Foundation, Inc.

c/o Country Curtains, Inc.
Main St.
Stockbridge 01262　　　(413) 298-5565

Established in 1984 in MA.
Donor(s): John H. Fitzpatrick, Jane P. Fitzpatrick, Country Curtains, Inc., Housatonic Curtain Co.
Financial data (yr. ended 09/30/86): Assets, $389,965 (M); gifts received, $360,479; expenditures, $306,418, including $305,853 for 142 grants (high: $65,770; low: $25).
Purpose and activities: Support primarily for the performing arts, especially theatre and music, and other cultural organizations.
Limitations: Giving primarily in MA.
Application information:
　Initial approach: Letter
　Deadline(s): None
Officers and Directors: Jane P. Fitzpatrick, Chair. and Treas.; John H. Fitzpatrick, Pres.; JoAnn Fitzpatrick, Nancy J. Fitzpatrick, Stephen R. Lett, Robert B. Trask.
Employer Identification Number: 222527419

1186
The Hoche-Scofield Foundation

c/o Shawmut Worcester County Bank, N.A.
446 Main St.
Worcester 01608　　　(617) 793-4552

Established in 1983 in MA.
Financial data (yr. ended 6/30/88): Assets, $9,591,916 (M); expenditures, $643,378, including $541,755 for 80 grants (high: $54,379; low: $500).
Purpose and activities: Grants primarily for community improvement, higher education, cultural organizations, and health organizations.
Limitations: Giving primarily in the city and county of Worcester, MA.
Application information: Application form required.
　Write: Norman J. Richardson, Sr. Trust Officer
Trustees: Henry B. Dewey, Alice C. Higgins, Paul S. Morgan, Shawmut Bank, N.A.
Employer Identification Number: 222519554

1187
Henry Hornblower Fund, Inc.

P.O. Box 2365
Boston 02107　　　(617) 589-3286

Incorporated in 1945 in MA.
Donor(s): Hornblower & Weeks - Hemphill, Noyes.
Financial data (yr. ended 12/31/87): Assets, $2,113,844 (M); expenditures, $105,984, including $91,525 for 28 grants (high: $5,525; low: $1,000).
Purpose and activities: Emphasis on higher and secondary education, hospitals, and cultural programs; support also for needy individuals presently or formerly employed by Hornblower & Weeks.
Types of support: Grants to individuals.
Limitations: Giving primarily in Boston, MA.
Application information:
　Write: Nathan N. Withington, Pres.
Officers and Directors: Nathan N. Withington, Pres.; Karl Grace, Treas.; Jack Beaty, Dudley Bradlee II, Martin J. Carew, George Larson.
Employer Identification Number: 237425285

1188
Hurdle Hill Foundation

c/o Woodstock Service Corp.
18 Tremont St.
Boston 02108

Established in 1960 in MA.
Donor(s): Edith M. Adams, Members of the Phippen family.
Financial data (yr. ended 12/31/87): Assets, $106,146 (M); gifts received, $217,173; expenditures, $211,478, including $206,200 for 62 grants (high: $20,000; low: $100).
Purpose and activities: Support for higher and secondary education, cultural programs, and health services.
Limitations: Giving primarily in MA.
Application information: Contributes only to pre-selected organizations. Applications not accepted.

Trustees: Nelson J. Darling, Jr., Peter D. Phippen, Richard D. Phippen, Susanne LaCroix Phippen, William LaCroix Phippen.
Employer Identification Number: 046012782

1189
Godfrey M. Hyams Trust

One Boston Place, 32nd Fl.
Boston 02108　　　(617) 720-2238

Trust established in 1921 in MA.
Donor(s): Godfrey M. Hyams.†
Financial data (yr. ended 12/31/87): Assets, $54,656,606 (M); expenditures, $3,404,457, including $2,578,939 for 177 grants (high: $85,000; low: $1,412; average: $5,000-$20,000) and $556,561 for 2 loans.
Purpose and activities: Giving for the benefit of low income residents through support primarily of urban youth agencies and neighborhood centers; support also for other social service and community development purposes, including mental health counseling, services to the handicapped, and health services. Priority program areas initiated since 1984 include housing, refugee services, adolescent pregnancy, and women in prisons.
Types of support: Operating budgets, continuing support, seed money, building funds, equipment, land acquisition, matching funds, special projects.
Limitations: Giving limited to the Boston, MA, metropolitan area. No support for municipal, state, or federal agencies; to institutions of higher learning for standard educational programs; to religious organizations for religious purposes; or to national or regional health organizations; support for medical research is being phased out. No grants to individuals, or for endowment funds, hospitals for capital campaigns, fellowships, publications, or conferences.
Publications: Biennial report (including application guidelines).
Application information:
　Initial approach: Proposal
　Copies of proposal: 6
　Deadline(s): None
　Board meeting date(s): 6 times a year regularly from Sept. through June
　Final notification: 1 to 6 months
　Write: Joan M. Diver, Exec. Dir.
Officer: Joan M. Diver, Exec. Dir.
Trustees: William N. Swift, Chair.; John H. Clymer, Theresa J. Morse, Lewis H. Spence, Roslyn M. Watson, Boston Safe Deposit and Trust Co.
Number of staff: 2 full-time professional; 1 part-time professional; 2 full-time support; 1 part-time support.
Employer Identification Number: 042214849

1190
Marion Gardner Jackson Charitable Trust

c/o The First National Bank of Boston
P.O. Box 1861
Boston 02105　　　(617) 434-5669

Financial data (yr. ended 12/31/87): Assets, $5,644,964 (M); expenditures, $312,525,

including $261,000 for 27 grants (high: $25,000; low: $1,000).
Purpose and activities: Giving largely in capital funds for youth, social services, health agencies, higher education, and arts and cultural programs.
Types of support: Building funds.
Limitations: Giving primarily in Adams County, IL.
Application information:
Initial approach: Proposal
Deadline(s): Sept. 1
Write: Sharon M. Driscoll, Trust Officer, First National Bank of Boston
Trustee: Bank of Boston.
Employer Identification Number: 046010559

1191
John Hancock Mutual Life Insurance Company Giving Program
John Hancock Place
P.O. Box 111
Boston 02117 (617) 572-6607

Financial data (yr. ended 12/31/88): Total giving, $2,800,000, including $2,150,000 for grants (high: $100,000; low: $1,000; average: $5,000-$10,000) and $650,000 for 4,700 employee matching gifts.
Purpose and activities: Supports United Way, civic and community affairs, education, health, culture, AIDS programs, the disadvantaged, housing, and minorities.
Types of support: Capital campaigns, endowment funds, general purposes, matching funds, research, special projects, employee matching gifts.
Limitations: Giving primarily in Boston, MA, except for employee matching gifts and support for the United Way. No grants to individuals.
Application information: Include goals and description of organization, board list, and 501(c)(3) status proof.
Initial approach: Letter and proposal
Deadline(s): Sept. 1
Final notification: One month
Write: James H. Young, Gen. Dir. and Asst. Secy.
Number of staff: 1

1192
The Howard Johnson Foundation
P.O. Box 235
541 Main St.
South Weymouth 02190 (617) 337-2201
Application address: c/o Howard B. Johnson, 720 Fifth Ave., Suite 1304, New York, NY 10019

Trust established in 1961 in MA.
Donor(s): Howard D. Johnson.†
Financial data (yr. ended 12/31/88): Assets, $2,957,121 (M); expenditures, $219,974, including $165,000 for 80 grants (high: $25,000; low: $1,000).
Purpose and activities: Giving primarily for higher and secondary education and hospitals; support also for museums, churches, and religious welfare agencies.
Limitations: Giving nationally, except to organizations in AK, ID, LA, MT, OR, and WV. No grants to individuals.

Application information:
Initial approach: Letter
Copies of proposal: 1
Deadline(s): Submit proposal early in calendar year
Board meeting date(s): Quarterly
Final notification: 2 months
Write: Eugene J. Durgin, Secy.
Officer: Eugene J. Durgin, Secy.
Trustees: Marissa J. Brock, Howard Bates Johnson, Patricia Bates Johnson, Joshua J. Weeks, William H. Weeks.
Number of staff: 1 part-time support.
Employer Identification Number: 046060965

1193
Edward C. Johnson Fund
82 Devonshire St.
Boston 02109 (617) 570-6806

Trust established in 1964 in MA.
Donor(s): Edward C. Johnson, 2nd,† Edward C. Johnson, 3rd.
Financial data (yr. ended 12/31/86): Assets, $12,285,398 (M); gifts received, $2,551,121; expenditures, $829,919, including $729,151 for 49 grants (high: $267,000; low: $50; average: $500-$40,000).
Purpose and activities: Emphasis on museums, historical societies, institutions of higher education, medical institutions, and some youth programs. Support also for the visual arts, historic preservation, elementary and secondary schools, and environmental organizations.
Limitations: Giving limited to the greater Boston, MA, area.
Publications: Application guidelines.
Application information:
Initial approach: Proposal
Deadline(s): Apr. 1 and Nov. 1
Board meeting date(s): June and Dec.
Write: Anne-Marie Soulliere, Foundation Dir.
Officer: Anne-Marie Soulliere, Foundation Dir.
Trustees: Edward C. Johnson, 3rd, Caleb Loring, Jr.
Number of staff: 2
Employer Identification Number: 046108344

1194
The Henry P. Kendall Foundation
176 Federal St.
Boston 02110 (617) 951-2525

Trust established in 1957 in MA.
Donor(s): Members of the Henry P. Kendell family.
Financial data (yr. ended 12/31/87): Assets, $48,291,617 (M); gifts received, $1,000; expenditures, $1,301,284, including $842,921 for 7 grants (high: $443,706; low: $5,000).
Purpose and activities: Emphasis on arms control and peace, and matters concerning the natural environment and natural resources; some funding for museums.
Types of support: Operating budgets, seed money, emergency funds, research, special projects, publications, conferences and seminars, loans, continuing support.
Limitations: No grants to individuals, or for capital or endowment funds, scholarships, fellowships, or matching gifts.

Application information:
Initial approach: Brief proposal
Copies of proposal: 1
Deadline(s): Feb. 15, May 15, Aug. 15, and Nov. 15
Board meeting date(s): Mar., June, Sept., and Dec.
Final notification: 2 months
Write: Salvatore F. Battinelli
Officer and Trustees: John P. Kendall, Pres.; Henry W. Kendall, Ann W. Plimpton.
Number of staff: 1 full-time professional.
Employer Identification Number: 046029103

1195
Kraft Foundation
One Boston Pl.
Boston 02108 (617) 723-3455

Established in 1973 in MA.
Donor(s): Robert K. Kraft.
Financial data (yr. ended 11/30/87): Assets, $1,780,006 (M); gifts received, $422,175; expenditures, $132,238, including $126,955 for 71 grants (high: $10,716; low: $50).
Purpose and activities: Support primarily for cultural programs, education, and Jewish giving.
Application information:
Deadline(s): None
Write: Robert K. Kraft, Trustee
Trustees: Richard A. Karelitz, Myra H. Kraft, Robert K. Kraft.
Employer Identification Number: 237326249

1196
Lechmere Corporate Giving Program
275 Wildwood Street
Woburn 01801 (617) 935-8320

Financial data (yr. ended 1/31/89): $237,250 for grants.
Purpose and activities: Social service programs account for 80 percent of giving, with substance abuse prevention being a major focus; support also for the arts and community development.
Types of support: General purposes, special projects.
Limitations: Giving primarily in major operating locations in NY, MA, NH, CT, and RI, where most stores are located; stores also in GA, AL, FL, NC, and SC; national projects funded through the Dayton Hudson Foundation.
Publications: Corporate giving report.
Application information: Include project budget, audited financial statement, board list, and 501(c)(3) status proof.
Initial approach: Telephone inquiry and proposal
Copies of proposal: 1
Deadline(s): None
Write: Christine Johnson, External Relations Specialist
Number of staff: 2 full-time professional; 1 full-time support.

1197
June Rockwell Levy Foundation, Inc.
One Federal St., 15th Fl.
Boston 02110 (617) 426-4600

Incorporated in 1947 in CT.
Donor(s): Austin T. Levy.†
Financial data (yr. ended 12/31/86): Assets, $11,100,000 (M); expenditures, $633,988, including $533,800 for 56 grants (high: $45,000; low: $1,000).
Purpose and activities: Grants largely for hospitals, medical research, and higher and secondary education; support also for youth agencies, cultural programs, and the handicapped.
Limitations: Giving primarily in RI. No support for religious purposes.
Application information:
 Initial approach: Letter
 Deadline(s): None
 Write: James W. Noonan, Secy.
Officers: Edward H. Osgood,* Chair. and Pres.; Robert S. Swain,* V.P.; James W. Noonan,* Secy.; Jonathan B. Loring, Treas.
Trustees:* George T. Helm, Winifred H. Thompson.
Employer Identification Number: 046074284

1198
Trustee of the Lowell Institute
45 School St.
Boston 02108 (617) 523-1635

Established in 1837.
Donor(s): John Lowell.†
Financial data (yr. ended 7/31/87): Assets, $17,200 (M); expenditures, $678,974, including $575,129 for 21 grants (high: $175,000; low: $1,000; average: $5,000-$25,000).
Purpose and activities: Grants largely for higher education and cultural programs.
Types of support: Conferences and seminars, lectureships.
Limitations: Giving primarily in MA. No grants to individuals, or for operating budgets, building or endowment funds, scholarships, fellowships, or matching gifts; no loans.
Application information: Contributes only to pre-selected organizations. Applications not accepted.
 Copies of proposal: 1
 Write: Mary L. O'Toole, Admin.
Manager and Trustee: John Lowell.
Number of staff: 1 part-time support.
Employer Identification Number: 042105771

1199
Nancy Lurie Marks Charitable Foundation
c/o Goulston & Stopps
400 Atlantic Ave.
Boston 02210-2206 (617) 482-1776

Established in 1976 in MA.
Financial data (yr. ended 10/31/87): Assets, $844,970 (M); gifts received, $335,400; expenditures, $332,076, including $314,649 for 35 grants (high: $60,000; low: $24).

Purpose and activities: Support for educational and cultural institutions, and medical research.
Limitations: No grants to individuals.
Application information:
 Initial approach: Letter or proposal
 Write: Jay E. Orlin, Trustee
Trustee: Cathy J. Lurie, Jeffrey R. Lurie, Harry L. Marks, Jay E. Orlin.
Employer Identification Number: 042607232

1200
Massachusetts Mutual Life Insurance Company Contribution Plan
1295 State St.
Springfield 01111 (413) 788-8411

Purpose and activities: Support for health, social services, education, community and civic affairs, arts and culture, and the United Way.
Limitations: Giving primarily in areas of home office in MA; some contributions to national and state agencies if contribution will benefit the home office area.
Application information:
 Deadline(s): Mid-July
 Write: Annette Holmes, Community Relations Asst.

1201
Mildred H. McEvoy Foundation
370 Main St.
Worcester 01608 (617) 798-8621

Trust established in 1963 in MA.
Donor(s): Mildred H. McEvoy.†
Financial data (yr. ended 12/31/87): Assets, $20,194,068 (M); expenditures, $1,100,229, including $1,001,625 for 58 grants (high: $100,000; low: $250).
Purpose and activities: Grants largely for higher education, museums and historic preservation, scientific and medical research, and hospitals.
Limitations: Giving primarily in Worcester, MA, and Boothbay Harbor, ME. No grants to individuals, or for endowment funds.
Application information:
 Initial approach: Letter with I.R.S. determination letter
 Copies of proposal: 1
 Deadline(s): Submit proposal in Apr.; no set deadline
 Board meeting date(s): Dec.
 Final notification: Dec. 31
 Write: Sumner B. Tilton, Jr., Trustee
Trustees: George H. McEvoy, Sumner B. Tilton, Jr.
Number of staff: None.
Employer Identification Number: 046069958

1202
Merlin Foundation
c/o Loring, Wolcott & Coolidge Office
230 Congress St.
Boston 02110 (617) 523-6531

Financial data (yr. ended 12/31/87): Assets, $1,102,491 (M); gifts received, $50,000; expenditures, $144,204, including $120,000 for 4 grants (high: $70,000; low: $10,000).

Purpose and activities: Support primarily for museums.
Application information:
 Write: Peter B. Loring, Trustee
Trustees: Caleb Loring, Jr., Caleb Loring III, Peter B. Loring.
Employer Identification Number: 222765555

1203
Arthur G. B. Metcalf Foundation
265 Winter St.
Waltham 02154
Application address: 45 Arlington St., Winchester, MA 01890; Tel.: (617) 466-8000

Established in 1960 in MA.
Donor(s): Arthur G.B. Metcalf.
Financial data (yr. ended 12/31/87): Assets, $1,237,720 (M); gifts received, $11,650; expenditures, $11,901, including $11,770 for 7 grants (high: $5,000; low: $20).
Purpose and activities: Grants largely for a national strategic defense institute and the U.S. Air Force; support also for local higher education, church support, and cultural and other charitable organizations.
Limitations: No grants to individuals.
Application information:
 Initial approach: Letter or proposal
 Deadline(s): None
 Write: Richard R. Glendon
Trustee: Arthur G.B. Metcalf.
Employer Identification Number: 046130186

1204
Microwave Associates Charitable Foundation
c/o M/A-COM, Inc.
Seven New England Executive Park
Burlington 01803-5003 (617) 272-9600

Donor(s): M/A-COM, Inc.
Financial data (yr. ended 9/30/88): Assets, $320,944 (M); gifts received, $75,000; expenditures, $109,142, including $108,750 for grants (high: $21,750; low: $100).
Purpose and activities: Scholarships for employees' children, and giving for United Way, youth, and culture.
Application information:
 Deadline(s): Mar. 1 for scholarships; no set deadline for grants
 Write: Vessario Chigas, Trustee
Trustees: Vessario Chigas, Howard Hall, Robert Galudel.
Manager: Kevin Kietnen.
Employer Identification Number: 046169568

1205
Middlecott Foundation
27 State St., 8th Fl.
Boston 02109

Established in 1967 in MA.
Donor(s): Members of the Saltonstall family.
Financial data (yr. ended 12/31/87): Assets, $610,973 (M); gifts received, $255,243; expenditures, $261,048, including $255,114 for 257 grants (high: $60,000; low: $15; average: $100-$1,000).

Purpose and activities: Support primarily for education, social services, health associations and hospitals, cultural programs, and child and youth agencies.
Application information:
 Deadline(s): None
 Write: William L. Saltonstall, Trustee
Trustees: Robert A. Lawrence, George Lewis, William L. Saltonstall.
Employer Identification Number: 046155699

1206
The Millipore Foundation
80 Ashby Rd.
Bedford 01730-2271 (617) 275-9200

Established in 1985 in MA.
Donor(s): Millipore Corp.
Financial data (yr. ended 9/30/88): Assets, $406,742 (M); gifts received, $585,000; expenditures, $508,777, including $395,875 for 95 grants (high: $100,000; low: $100) and $105,645 for 821 employee matching gifts.
Purpose and activities: Giving primarily through grants and employee matching gifts program to organizations involved in culture, health, education, educational research, biochemistry research, and social services.
Types of support: Research, general purposes, employee matching gifts.
Limitations: No support for religious programs.
Publications: Annual report, informational brochure (including application guidelines).
Application information: Application form required.
 Initial approach: Letter
 Copies of proposal: 1
 Deadline(s): None
 Board meeting date(s): Quarterly
 Write: Charleen L. Johnson, Exec. Dir.
Officers: Geoffrey Nunes,* Chair.; Charleen Johnson, Exec. Dir.
Trustees:* John A. Gilmartin, Wayne J. Kennedy.
Number of staff: None.
Employer Identification Number: 222583952

1207
Monarch Capital Corporate Giving Program
One Monarch Place
Springfield 01144 (413) 781-3000

Financial data (yr. ended 12/31/88): $300,000 for grants.
Purpose and activities: Supports education; health, including AIDS programs; arts and culture; and civic affairs; employee matching gifts for higher education.
Types of support: Capital campaigns, operating budgets, employee matching gifts.
Limitations: Giving primarily in the Springfield, MA, area.
Publications: Annual report, informational brochure (including application guidelines).
Application information: Application form required.
 Deadline(s): Quarterly
 Board meeting date(s): Quarterly
 Write: Mark L. Conners, V.P., Personnel

1208
Morgan-Worcester, Inc.
15 Belmont St.
Worcester 01605 (508) 755-6111

Incorporated in 1953 in MA.
Donor(s): Morgan Construction Co.
Financial data (yr. ended 9/30/88): Assets, $977,538 (M); gifts received, $50,000; expenditures, $145,279, including $101,449 for 21 grants (high: $40,000; low: $20) and $30,445 for 185 employee matching gifts.
Purpose and activities: Giving with emphasis on civic affairs, cultural programs, education, health, and community funds.
Types of support: Employee matching gifts, operating budgets, continuing support, annual campaigns, seed money, emergency funds, building funds, equipment, land acquisition.
Limitations: Giving primarily in the greater Worcester, MA, area. No support for religious purposes. No grants to individuals, or for endowment funds, special projects, research, publications, conferences, scholarships, or fellowships; no loans.
Application information:
 Initial approach: Letter
 Copies of proposal: 1
 Deadline(s): None
 Board meeting date(s): Quarterly
 Final notification: Only in the case of acceptance
 Write: Peter S. Morgan, Pres.
Officers and Directors: Peter S. Morgan, Pres. and Treas.; Daniel M. Morgan, Paul B. Morgan, Jr., Paul S. Morgan, Philip R. Morgan, Gavin D. Robertson.
Number of staff: 1 part-time professional.
Employer Identification Number: 046111693

1209
The David G. Mugar Foundation, Inc.
One Bulfinch Place
Boston 02114

Financial data (yr. ended 9/30/87): Assets, $874,328 (M); gifts received, $1,283,769; expenditures, $727,102, including $577,722 for 4 grants (high: $550,000; low: $1,500).
Purpose and activities: Support primarily for a museum of science.
Types of support: General purposes.
Limitations: Giving primarily in MA.
Application information: Contributes only to pre-selected organizations. Applications not accepted.
Officers and Directors: David Mugar, Pres.; Lawrence K. Goodier, Treas.; Robert D. Carey, C. Peter Jorgenson, Nancy R. Randall, George W. Tuttle.
Employer Identification Number: 042587530

1210
NEBS Foundation, Inc.
c/o New England Business Services
500 Main St.
Groton 01450 (508) 448-6111

Established in 1983 in MA.
Donor(s): New England Business Services, Inc.
Financial data (yr. ended 8/31/88): Assets, $190,613 (M); gifts received, $125,000;

qualifying distributions, $197,213, including $192,000 for 19 grants (high: $21,000; low: $5,000) and $84,000 for 659 employee matching gifts.
Purpose and activities: Support primarily for education, culture, hospitals, social services, and civic affairs.
Types of support: Annual campaigns, capital campaigns, employee matching gifts, equipment, scholarship funds, special projects.
Limitations: Giving primarily in areas where company facilities are located, in AZ, CA, MA, MO, NH, and WI.
Application information:
 Copies of proposal: 1
 Deadline(s): Mar. 31 and Sept. 30
 Board meeting date(s): Apr. and Oct.
 Write: Benjamin H. Lacy, Treas.
Officers and Directors: Jay R. Rhoads, Jr., Pres.; Benjamin H. Lacy, Treas.; Peter A. Brooke.
Number of staff: None.
Employer Identification Number: 042772172

1211
New England Electric System Giving Program
25 Research Dr.
Westborough 01582 (617) 366-9011

Purpose and activities: Supports education, the arts, community affairs, general health care, the environment, economics, and youth.
Types of support: Matching funds, building funds, general purposes.
Limitations: Giving primarily in headquarters city and major operating locations.
Application information: 501(c)(3) status proof with application.
 Initial approach: Letter
 Write: Don F. Goodwin, Corp. Contribs. Coord.
Number of staff: None.

1212
New England Telephone & Telegraph Company Giving Program
185 Franklin St., Room 1602
Boston 02107 (617) 743-4846

Financial data (yr. ended 12/31/87): $4,000,000 for grants.
Purpose and activities: Supports health, human services, education, community services, the arts and humanities. Employee matching gift program for education and the arts; recent emphasis has been on hunger, homelessness, and job training. Types of support includes employee volunteerism.
Types of support: Capital campaigns, employee matching gifts, special projects.
Limitations: Giving primarily in the northeast. No support for religious organizations when sectarian in purpose, political causes or organizations, elementary or secondary schools, national health organizations, or hospital building funds. No grants to individuals, or for general operating expenses, endowments, special occasion or good will advertising.
Publications: Corporate giving report, application guidelines.

Application information: Include description and budget of organization and project, time frame for project, board and contributors list, financial statement, and 501(c)(3) status proof.
Initial approach: Letter or phone
Deadline(s): None
Final notification: Two weeks
Write: Susan M. Flaherty, Contribs. Mgr.

1213
Norton Company Foundation
120 Front St.
Worcester 01608-1446 (508) 795-5334

Trust established in 1953 in MA; incorporated in 1975.
Donor(s): Norton Co.
Financial data (yr. ended 12/31/87): Assets, $1,101,772 (M); gifts received, $2,146,000; expenditures, $1,092,897, including $809,028 for 376 grants (high: $210,000; low: $80; average: $5,000-$10,000) and $262,691 for 461 employee matching gifts.
Purpose and activities: Giving primarily for education, youth, cultural programs, and social service agencies.
Types of support: Program-related investments, operating budgets, annual campaigns, seed money, emergency funds, building funds, matching funds, employee matching gifts, continuing support, capital campaigns, general purposes, renovation projects, special projects.
Limitations: Giving primarily in Gainesville, GA; Worcester and Northboro, MA; Milford and Littleton, NH; Wayne, NJ; Akron and Stowe, OH; and Brownsville and Stephenville, TX. Generally no support for national organizations, including national health agencies, religious, veterans', or fraternal organizations, or hospitals for operating support. No grants to individuals, or for endowment funds, scholarships, or fellowships; no loans.
Publications: Informational brochure (including application guidelines).
Application information: Application form required.
Initial approach: Phone call or proposal
Copies of proposal: 1
Deadline(s): None
Board meeting date(s): Mar., June, Sept., and Dec.
Final notification: Within 3 weeks
Write: Francis J. Doherty, Jr., Exec. Dir.
Officers: John M. Nelson,* Pres.; Janice Lindsay, Secy.; Gilbert A. Fuller, Treas.; Francis J. Doherty, Jr., Exec. Dir.
Directors:* Thomas J. Hourihan, Bernard F. Meyer.
Number of staff: 1 part-time professional; 1 part-time support.
Employer Identification Number: 237423043

1214
Bessie Pappas Charitable Foundation, Inc.
P.O. Box 318
Belmont 02178 (617) 862-2851

Established in 1984 in MA as successor to the Pappas Family Foundation.

Donor(s): Thomas Anthony Pappas Charitable Foundation.
Financial data (yr. ended 12/31/87): Assets, $2,710,221 (M); expenditures, $150,659, including $100,800 for 30 grants (high: $15,000; low: $500).
Purpose and activities: Support for the arts, health, education, family and social services, and religious welfare organizations.
Limitations: Giving primarily in MA. No grants to individuals.
Application information:
Deadline(s): Oct. 1
Write: Betsy Pappas, Dir. of Development
Officer and Directors: Charles A. Pappas, Pres. and Treas.; Helen K. Pappas, V.P.; Betsy Z. Pappas, Clerk and Dir. of Development; Sophia Pappas.
Number of staff: 2 full-time professional.
Employer Identification Number: 222540702

1215
Thomas Anthony Pappas Charitable Foundation, Inc.
P.O. Box 463
Belmont 02178 (617) 862-2802

Incorporated in 1975 in MA.
Donor(s): Thomas A. Pappas.†
Financial data (yr. ended 12/31/86): Assets, $15,740,830 (M); expenditures, $782,191, including $556,500 for 41 grants (high: $200,000; low: $1,000; average: $1,000-$100,000).
Purpose and activities: Emphasis on higher education, hospitals, cultural programs, Greek Orthodox church support, religious associations, and youth and social service agencies.
Types of support: Annual campaigns, building funds, endowment funds, research, professorships, scholarship funds, fellowships, continuing support, building funds.
Limitations: Giving primarily in MA. No grants to individuals.
Publications: Program policy statement, application guidelines.
Application information:
Initial approach: Letter or proposal
Deadline(s): Submit proposal preferably in Mar. or Sept.; deadline Sept. 30
Board meeting date(s): Mar., June, Sept., and Dec., and as required
Final notification: Dec. 31
Officers and Directors: Charles A. Pappas, Pres. and Treas.; Helen K. Pappas, V.P.; Betsy Z. Pappas, Clerk and Dir. of Development; Sophia Pappas.
Number of staff: 3
Employer Identification Number: 510153284

1216
The Theodore Edson Parker Foundation
c/o Grants Management Associates, Inc.
230 Congress St., 3rd Fl.
Boston 02110 (617) 426-7172

Incorporated in 1944 in MA.
Donor(s): Theodore Edson Parker.†
Financial data (yr. ended 12/31/88): Assets, $10,000,000 (M); expenditures, $485,000,

including $405,200 for 26 grants (high: $50,000).
Purpose and activities: Giving largely in Lowell, MA, for social services, arts, housing, community development, and the urban environment; with a particular interest in aiding underserved populations, particularly minorities; in Boston, MA, giving for social services and the urban environment.
Types of support: Seed money, building funds, equipment, special projects, renovation projects.
Limitations: Giving limited to the greater Boston and Lowell, MA, area. No grants to individuals, or for operating budgets, continuing support, annual campaigns, emergency funds, deficit financing, matching gifts, scholarships, or fellowships; no loans.
Publications: Program policy statement, application guidelines, grants list.
Application information:
Initial approach: Telephone, proposal, or letter
Copies of proposal: 1
Deadline(s): None
Board meeting date(s): Spring and fall
Final notification: 4 to 5 months
Write: Lauress Wilkins or Ala H. Reid, Admins.
Officers and Trustees: Newell Flather, Pres.; Andrew C. Bailey, Secy.-Treas.; Karen H. Carpenter, Edward L. Emerson, Thomas E. Leggat.
Number of staff: 2 part-time professional; 1 part-time support.
Employer Identification Number: 046036092

1217
Amelia Peabody Charitable Fund
201 Devonshire St.
Boston 02109 (617) 451-6178

Established in 1974.
Donor(s): Amelia Peabody,† Eaton Foundation.
Financial data (yr. ended 12/31/88): Assets, $87,000,000 (M); expenditures, $4,428,000 for 105 grants (high: $1,000,000; low: $500).
Purpose and activities: Grants primarily for higher education, hospitals, medical research, and health services, and culture, including museums and historic preservation.
Types of support: Building funds, endowment funds, capital campaigns, renovation projects, equipment.
Limitations: Giving primarily in New England. No support for tax supported organizations or religious groups. No grants to individuals.
Application information:
Initial approach: Letter
Copies of proposal: 1
Deadline(s): None
Board meeting date(s): Quarterly
Write: Harry F. Rice, Trustee
Trustees: Richard A. Leahy, Harry F. Rice, Patricia E. Rice.
Number of staff: 1 part-time professional.
Employer Identification Number: 237364949

1218
Amelia Peabody Foundation
c/o Hale and Dore
60 State St.
Boston 02109 (617) 742-9100

Trust established in 1942 in MA; absorbed a share of the assets of The Eaton Foundation, MA, in l985.
Donor(s): Amelia Peabody.†
Financial data (yr. ended 12/31/87): Assets, $81,354,625 (M); expenditures, $4,569,671, including $4,004,633 for 50 grants (high: $1,193,000; low: $5,000; average: $10,000-$150,000).
Purpose and activities: To assist local charitable and educational organizations, with emphasis on education, hospitals, youth agencies, cultural programs, and conservation.
Limitations: Giving limited to MA. No grants to individuals, or for endowment funds, scholarships, or fellowships; no loans.
Application information:
 Initial approach: Letter
 Copies of proposal: 1
 Deadline(s): None
 Board meeting date(s): Quarterly
 Final notification: As required
 Write: James D. St. Clair, Trustee
Trustees: Bayard D. Waring, G. Dana Bill, James D. St. Clair, Margaret N. St. Clair, Lloyd B. Waring.
Number of staff: 3
Employer Identification Number: 046036558

1219
Joseph Pellegrino Family Foundation
50 Milk St., Suite 1500
Andover 02109

Financial data (yr. ended 12/31/87): Assets, $1,499,751 (M); expenditures, $34,868, including $26,950 for 6 grants (high: $20,000; low: $150).
Purpose and activities: Support primarily for secondary education; support also for hospitals, health organizations and an Italian-American culture club.
Application information: Contributes only to pre-selected organizations. Applications not accepted.
Trustees: Joseph Pellegrino, Joseph P. Pellegrino, Lena Pellegrino.
Employer Identification Number: 046112616

1220
Pellegrino-Realmuto Charitable
Foundation, Inc.
50 Milk St., Suite 1500
Boston 02109

Established in 1960 in MA.
Financial data (yr. ended 12/31/87): Assets, $1,931,805 (M); expenditures, $40,651, including $38,800 for 13 grants (high: $25,000; low: $100).
Purpose and activities: Support primarily for the National Italian-American Fund; support also for a children's camp, churches and a clinic.

Application information: Contributes only to pre-selected organizations. Applications not accepted.
Officers and Directors: Mae Realmuto, Pres.; Joseph P. Pellegrino, Secy.; Joseph Pellegrino, Treas.
Employer Identification Number: 046112614

1221
Harold Whitworth Pierce Charitable
Trust
c/o Nichols and Pratt
28 State St.
Boston 02109
Application address: One Beacon St., Boston, MA 02108

Trust established in 1960 in MA.
Donor(s): Harold Whitworth Pierce.†
Financial data (yr. ended 11/30/87): Assets, $8,880,369 (M); expenditures, $576,295, including $510,287 for 35 grants (high: $134,286; low: $1,000).
Purpose and activities: Emphasis on hospitals, higher and secondary education, youth agencies, cultural activities, and conservation.
Limitations: Giving primarily in MA.
Application information:
 Initial approach: Letter
 Deadline(s): None
 Write: Robert U. Ingalls, Trustee
Trustees: Robert U. Ingalls, Richard M. Nichols.
Employer Identification Number: 046019896

1222
Pittsfield Anti-Tuberculosis Association
69 Taconic St.
Pittsfield 01201-5150 (413) 499-1611

Established in 1907 in MA.
Financial data (yr. ended 12/31/87): Assets, $1,162,333 (M); expenditures, $83,645, including $71,987 for 4 grants (high: $43,000; low: $987).
Purpose and activities: Support primarily for tuberculosis research; limited support for the arts.
Types of support: General purposes.
Limitations: Giving primarily in NY and Pittsfield, MA.
Application information:
 Initial approach: Letter
 Deadline(s): None
 Write: Richard Power, Pres.
Officers: Richard Power, Pres.; Irving Rubin, V.P.; Patricia Curd, Secy.; Joseph J. Barry, Jr., Treas.
Directors: Louis Bolduc, Clement Curd, George Douglas, Thomas Edwards, Daniel Fox, Phyllis Lord, Anthony J. Ruberto, Jr., Shirley Rubin.
Employer Identification Number: 042104839

1223
Polaroid Foundation, Inc.
28 Osborn St., 4th Fl.
Cambridge 02139 (617) 577-4035

Incorporated in 1971 in MA.
Donor(s): Polaroid Corp.

Financial data (yr. ended 12/31/87): Assets, $20,548 (M); gifts received, $2,166,848; expenditures, $2,133,159, including $1,720,799 for 416 grants (high: $361,000; low: $100; average: $2,000-$10,000), $44,052 for grants to individuals, $326,413 for employee matching gifts and $20,000 for loans.
Purpose and activities: Support for community funds and social service agencies, including programs for the urban poor, and higher education, including matching gifts; grants also to cultural programs, youth agencies, and health services.
Types of support: Matching funds, employee matching gifts, employee-related scholarships, seed money, emergency funds, scholarship funds, exchange programs, fellowships, general purposes, annual campaigns, capital campaigns, continuing support, equipment, loans, operating budgets, publications, renovation projects, special projects.
Limitations: Giving primarily in MA, particularly greater Boston and Cambridge. No grants to individuals (except for employee-related scholarships), or for endowment funds.
Publications: Annual report, application guidelines, program policy statement.
Application information: Application form required.
 Initial approach: Proposal
 Copies of proposal: 2
 Deadline(s): None
 Board meeting date(s): Monthly
 Final notification: 2 to 3 months after board meeting
 Write: Marcia Schiff, Exec. Dir.
Officers: Robert Delahunt, Pres.; Marcia Schiff, Secy. and Exec. Dir.; Ralph Norwood, Treas.
Trustees: I. MacAllister Booth, Sheldon A. Buckler, Richard F. deLima, Milton S. Dietz, Owen J. Gaffney, Peter O. Kliem, Joseph Oldfield, William J. O'Neill, Jr.
Number of staff: 2 full-time professional; 1 part-time professional; 2 full-time support; 1 part-time support.
Employer Identification Number: 237152261

1224
Olive Higgins Prouty Foundation, Inc.
c/o Bank of New England
28 State St.
Boston 02109 (617) 973-1793

Incorporated in 1952 in MA.
Donor(s): Olive Higgins Prouty.†
Financial data (yr. ended 12/31/87): Assets, $1,551,285 (M); expenditures, $110,530, including $89,000 for 31 grants (high: $17,000; low: $1,000; average: $1,000-$5,000).
Purpose and activities: Giving for hospitals, higher and secondary education, music, and museums.
Types of support: Annual campaigns, building funds, capital campaigns, general purposes, operating budgets, renovation projects, continuing support.
Limitations: Giving primarily in the Greater Worcester, MA, area. No grants to individuals.
Publications: Application guidelines.
Application information: Application form required.
 Initial approach: Telephone
 Copies of proposal: 1

Deadline(s): Oct. 1
Board meeting date(s): Oct. 31
Final notification: Dec. 31
Write: John M. Dolan, V.P.
Officers and Trustees: Richard Prouty, Pres.;
Jane Prouty Smith, V.P.; Lewis I. Prouty, V.P.;
Kenneth L. Grinnell, Treas.
Employer Identification Number: 046046475

1225
Quabaug Corporation Charitable Foundation

17 School St.
North Brookfield 01535-1926

Financial data (yr. ended 12/31/87): Assets,
$662,083 (M); expenditures, $49,417,
including $47,400 for 61 grants (high: $2,000;
low: $150; average: $200-$500).
Purpose and activities: Support for health and
welfare, education, including scholarships for
North Brookfield High School students, arts and
culture, civic affairs, and social services.
Types of support: Student aid.
Limitations: Giving primarily in MA.
Application information: Contributes only to
preselected organizations; scholarship
applicants contact the guidance office.
Deadline(s): Apr. 15 for scholarships
Trustees: John E. Hodgson, Herbert M.
Varnum, Jean S. Varnum.
Employer Identification Number: 510179366

1226
George A. Ramlose Foundation, Inc.

c/o Adams and Blinn
43 Thorndike St.
Cambridge 02141 (617) 577-9700

Established in 1956 in NY.
Donor(s): George Ramlose.†
Financial data (yr. ended 04/30/87): Assets,
$1,553,103 (M); expenditures, $58,662,
including $40,250 for 19 grants (high: $5,000;
low: $250).
Purpose and activities: Giving primarily for
higher and medical education, social services,
health agencies, and cultural programs.
Types of support: General purposes, operating
budgets, research, special projects.
Application information:
Initial approach: Proposal
Copies of proposal: 7
Deadline(s): May 15 and Oct. 15
Board meeting date(s): June and Nov.; dates
vary from year to year
Write: David L. Taylor, Secy.
Officers and Directors: Lloyd W. Moseley,
Pres.; James P. Fisher, V.P.; John A. Logan,
V.P.; Kenneth Wilson, V.P.; David L. Taylor,
Secy.; A. Leavitt Taylor, Treas.; Ernest F. Boyce.
Number of staff: None.
Employer Identification Number: 046048231

1227
A. C. Ratshesky Foundation

40 Webster Place
Brookline 02146 (617) 277-7426

Incorporated in 1916 in MA.
Donor(s): A.C. Ratshesky,† and family.

Financial data (yr. ended 12/31/88): Assets,
$3,070,577 (M); gifts received, $696,884;
expenditures, $203,260, including $164,800
for 83 grants (high: $5,000; low: $1,000;
average: $1,000-$5,000).
Purpose and activities: Giving for education,
cultural programs, and social service agencies;
some support for hospitals and youth agencies.
Types of support: Operating budgets,
emergency funds, building funds, equipment,
matching funds, technical assistance,
scholarship funds, general purposes, renovation
projects, special projects.
Limitations: Giving primarily in the greater
Boston, MA, area. No support for scientific
research. No grants to individuals, or for
continuing support, annual campaigns, general
endowments, seed money, deficit financing,
land acquisition, research, publications, or
conferences; no loans.
Publications: Annual report, application
guidelines.
Application information: Application form
required.
Initial approach: Proposal
Copies of proposal: 1
Deadline(s): 3 months prior to board meeting
Board meeting date(s): Apr., June, Sept., and
Dec.
Final notification: 4 months
Write: Theresa J. Morse, Pres., or Ninon
Landaverry Freeman, Exec. Dir.
Officers and Trustees: Theresa J. Morse, Pres.;
John Morse, Jr., V.P.; Eric Robert Morse, Secy.;
Alan R. Morse, Jr., Treas.; Roberta Morse Levy,
Edith Morse Milender, Timothy Morse.
Number of staff: 1 part-time professional.
Employer Identification Number: 046017426

1228
Raytheon Company Corporate Giving Program

141 Spring St.
Lexington 02173 (617) 862-6600

Financial data (yr. ended 12/31/88): Total
giving, $5,300,000, including $4,975,000 for
1,000 grants (high: $100,000; low: $100;
average: $5,000) and $325,000 for 3,300
employee matching gifts.
Purpose and activities: Program focus:
1)Quality of education: to encourage minorities
and women to pursue careers in science and
math; to assist leading engineering schools in
maintaining their technological and innovative
edge; to develop linkages between public
schools and colleges in the areas of curriculum
development, teacher training, and preparation
of students for higher education and industry;
to promote public understanding of science and
math concepts through museum and library
programs; 2)Quality of opportunity: to assure
that minorities and women receive training and
education that will offer equal access to
employment opportunities; to encourage
initiatives that enable people with physical
disabilities to lead independent lives; to support
programs for young people that develop
leadership, promote positive values, and build
self-esteem; 3)Quality of care: to encourage
health care decision makers to examine
medical practices and service delivery methods
in order to address access to care, the quality

of care and the costs of health care; to support
collaborative approaches to the issues of
availability, cost and quality of child care; to
foster support systems for elders and their
families that offer alternatives to
institutionalized care; 4)Quality of life: to
maintain and improve the ecosystems that
affect water and air quality; to encourage
regional planning and growth management; to
support local United Ways and well-established
social service and cultural institutions in their
efforts to respond to community needs.
Emphasis also on improving the quality of
nonprofit management and the quality of
nonprofit service delivery. Grant size varies,
depending on the scope of the project and
Raytheon Company's relationship to it. Multiple
year grants will be considered for capital
purposes. The range of one-year grants is $500
to $20,000; typical size is $5,000. Multi-year
commitments paid over 3-5 years range from
$10,000 to $250,000. Requests for product
donations of kitchen and laundry appliances
and marine electronics will be considered in
lieu of, or as a supplement to, cash grants.
Types of support: Building funds, capital
campaigns, employee matching gifts, operating
budgets, special projects, equipment,
renovation projects, technical assistance, in-
kind gifts.
Limitations: Giving limited to local
organizations in plant communities and to
regional organizations benefiting plant
communities. No support for religious,
fraternal, or veterans' groups, disease-specific
organizations, independent elementary and
secondary schools, organizations with primarily
international activities, productions for public
broadcasting, or private foundations. No grants
to individuals, or for basic research, operating
support for United Way affiliates, or
organizations whose applications have been
denied within the past 12 months.
Publications: Corporate giving report,
application guidelines.
Application information: Include brief history
of organization, budget for project, other
sources of support, list of board of directors,
(501)(c)(3), and geographic area and population
to be served by project.
Initial approach: Write to the Manager of
Human Resources at the local Raytheon
facility or send to headquarters; telephone
inquiries discouraged
Deadline(s): Mar. 15, June 30, and Oct. 1
Final notification: May, Sept., and Dec.
Write: Janet Taylor, Mgr., Corp. Contribs.
Number of staff: 1 full-time professional; 1 full-
time support.

1229
Reebok Foundation

150 Royall St.
Canton 02021 (617) 821-2800

Established in 1985 in MA.
Donor(s): Reebok International, Ltd.
Financial data (yr. ended 12/31/87): Assets,
$1,916,547 (M); expenditures, $292,664,
including $286,120 for 33 grants (high:
$125,000; low: $100).
Purpose and activities: Support for human
and social services; support also for arts and

culture, health and medicine, education and religion.
Limitations: No grants to individuals.
Application information:
 Deadline(s): None
 Write: Jean Mahoney
Trustees: Paul Fireman, William M. Marcus, R. Stephen Rubin.
Employer Identification Number: 222709235

1230
The Albert W. Rice Charitable Foundation
c/o Shawmut Worcester County Bank, N.A., Trust Dept.
P.O. Box 2032
Worcester 01613-2032 (617) 793-4205

Established in 1959.
Donor(s): Albert W. Rice.†
Financial data (yr. ended 12/31/86): Assets, $3,515,038 (M); expenditures, $218,045, including $190,000 for 12 grants (high: $25,000; low: $5,000).
Purpose and activities: Giving for historic preservation, higher education, social services, and a community foundation.
Limitations: Giving primarily in Worcester, MA.
Application information:
 Initial approach: Letter
 Deadline(s): Apr. and Oct.
 Write: Stephen Fritch, V.P., Shawmut Worcester County Bank, N.A.
Trustee: Shawmut Worcester County Bank, N.A.
Employer Identification Number: 046028085

1231
The Riley Foundation
230 Congress St., 3rd Fl.
Boston 02110 (617) 426-7172

Foundation established in 1971 in MA as the Mabel Louise Riley Charitable Trust.
Donor(s): Mabel Louise Riley.†
Financial data (yr. ended 5/31/88): Assets, $28,495,252 (M); expenditures, $1,585,468, including $1,512,468 for 44 grants (high: $105,000; low: $2,700; average: $30,000-$100,000).
Purpose and activities: Interest in new approaches to important problems, with an emphasis on improved social services and race relations; special interest in programs for children and youth; selective support for schools, community and neighborhood development, and for cultural, employment, and housing programs.
Types of support: Seed money, building funds, equipment, land acquisition, special projects, renovation projects, technical assistance, capital campaigns, loans.
Limitations: Giving limited to the greater Boston, MA, area, with emphasis on the city. No grants to individuals, or for operating budgets, continuing support, annual campaigns, emergency funds, deficit financing, research, publications, conferences, professorships, internships, exchange programs, fellowships, or matching gifts; no loans.
Publications: Annual report, application guidelines.

Application information:
 Initial approach: Proposal or telephone
 Copies of proposal: 1
 Deadline(s): Submit proposal preferably in early Feb. or early Aug.; deadlines Feb. 15 and Aug. 15
 Board meeting date(s): Apr.-May and Oct.-Nov.
 Final notification: 1 month after board meetings
 Write: Newell Flather or Naomi Tuchmann, Admin.
Administrators: Newell Flather, Naomi Tuchmann.
Trustees: Josephus Long, Andrew C. Bailey, Douglas Danner, Robert W. Holmes, Jr., Boston Safe Deposit and Trust Co.
Number of staff: 2 part-time professional; 1 part-time support.
Employer Identification Number: 046278857

1232
Rowland Foundation, Inc.
P.O. Box 13
Cambridge 02238

Incorporated in 1960 in DE.
Donor(s): Edwin H. Land, Helen M. Land.
Financial data (yr. ended 11/30/88): Assets, $32,673,124 (M); expenditures, $2,580,880, including $1,702,049 for grants (high: $318,000; average: $5,000-$50,000).
Purpose and activities: Grants primarily for education, health, conservation, cultural programs, and social services.
Types of support: General purposes, professorships, research.
Limitations: Giving primarily in the Boston-Cambridge, MA, area. No grants to individuals, or for capital or endowment funds, or matching gifts; no loans.
Publications: Annual report.
Application information:
 Initial approach: Letter
 Copies of proposal: 1
 Deadline(s): None
 Board meeting date(s): As required
 Final notification: Varies
 Write: Philip DuBois, V.P.
Officers: Edwin H. Land,* Pres.; Helen M. Land,* V.P. and Treas.; Philip DuBois,* V.P.; Julius Silver, Secy.
Trustees:* Jennifer Land DuBois.
Number of staff: None.
Employer Identification Number: 046046756

1233
Lawrence J. and Anne Rubenstein Charitable Foundation
50 Longwood Ave., Suite 816
Brookline 02146

Trust established in 1963 in MA.
Donor(s): Lawrence J. Rubenstein,† Anne C. Rubenstein.
Financial data (yr. ended 5/31/87): Assets, $7,700,000 (M); expenditures, $500,000, including $500,000 for grants (high: $350,000; low: $10,000).
Purpose and activities: Giving for hospitals, higher education, and medical research and

education, with emphasis on medical care and research relating to children's illnesses.
Types of support: Annual campaigns, building funds, capital campaigns, emergency funds, endowment funds, equipment, general purposes, professorships, special projects.
Limitations: Giving primarily in MA.
Application information:
 Initial approach: Letter
 Copies of proposal: 1
 Deadline(s): Prior to May 1 of year grant requested
 Board meeting date(s): Quarterly
 Write: Richard I. Kaner, Trustee
Trustees: Richard I. Kaner, Frank Kopelman, Anne C. Rubenstein.
Number of staff: 1 part-time professional.
Employer Identification Number: 046087371

1234
Sagamore Foundation
c/o Woodstock Service Corp.
18 Tremont St.
Boston 02108

Trust established in 1947 in MA.
Donor(s): Nelson J. Darling, Jr., Members of the LaCroix family.
Financial data (yr. ended 12/31/87): Assets, $609,700 (M); expenditures, $119,275, including $109,000 for 15 grants (high: $10,000; low: $1,000).
Purpose and activities: Emphasis on higher education, hospitals, arts and cultural programs, particularly museums, and a community fund.
Limitations: Giving primarily in MA.
Application information: Contributes only to pre-selected organizations. Applications not accepted.
Trustees: Bigelow Crocker, Jr., Jeanne LaCroix Crocker, Edith LaCroix Dabney, Nelson J. Darling, Jr., Ruth LaCroix Darling, Richard D. Phippen, Susanne LaCroix Phippen.
Employer Identification Number: 046027799

1235
Richard Saltonstall Charitable Foundation
27 State St., 8th Fl.
Boston 02109

Established in 1964 in MA.
Financial data (yr. ended 12/31/87): Assets, $8,508,297 (M); expenditures, $458,202, including $416,000 for 30 grants (high: $50,000; low: $500).
Purpose and activities: Giving primarily for cultural programs, hospitals and medical research, and youth organizations.
Limitations: Giving primarily in MA.
Application information:
 Initial approach: Letter
 Deadline(s): None
Trustees: Robert A. Lawrence, Dudley H. Willis.
Employer Identification Number: 046078934

1236
William E. Schrafft and Bertha E. Schrafft Charitable Trust

One Financial Center
Boston 02111 (617) 350-6100

Trust established in 1946 in MA.
Donor(s): William E. Schrafft,† Bertha E. Schrafft.†
Financial data (yr. ended 12/31/87): Assets, $12,681,640 (M); expenditures, $802,811, including $709,000 for 71 grants (high: $100,000; low: $1,000; average: $1,500-$60,000).
Purpose and activities: Grants primarily for hospitals, higher and secondary education, community funds, cultural programs, and youth agencies.
Types of support: General purposes, operating budgets, continuing support, annual campaigns, endowment funds, scholarship funds.
Limitations: Giving limited to MA, with emphasis on the Boston metropolitan area. No grants to individuals, or for matching gifts, seed money, emergency funds, or deficit financing; no loans.
Publications: Annual report, application guidelines.
Application information:
 Initial approach: Proposal
 Copies of proposal: 4
 Deadline(s): Submit proposal preferably from Jan. through July; no set deadline
 Board meeting date(s): About 6 times a year
 Final notification: 2 months
 Write: John M. Wood, Jr., Trustee
Trustees: Hazen H. Ayer, Robert H. Jewell, Arthur Parker, John M. Wood, Jr.
Number of staff: None.
Employer Identification Number: 046065605

1237
SCOA Foundation, Inc.

15 Dan Rd.
Canton 02021 (617) 821-1000

Established in 1969 in OH.
Donor(s): SCOA Industries, Inc.
Financial data (yr. ended 06/30/87): Assets, $6,300,759 (M); expenditures, $776,719, including $707,475 for 154 grants (high: $100,000; low: $350).
Purpose and activities: Grants primarily for Jewish welfare, child welfare, and community funds. Support also for higher education, hospitals, and cultural activities.
Limitations: Giving primarily in communities where Hills Department Stores are located; in 13 states in the Midwest.
Application information: Contributes only to preselected organizations. Applications not accepted.
 Write: William K. Friend, Secy.
Officers: William K. Friend, Secy.
Trustees:* Herbert H. Schiff,* Chair.; George R. Friese, Stephen A. Goldberger, Harvey Kruger, Thomas H. Lee, Neil Papiano.
Employer Identification Number: 237002220

1238
The Shawmut Charitable Foundation

c/o Shawmut Bank, N.A.
One Federal St., 35th Fl.
Boston 02211

Trust established in 1961 in MA.
Donor(s): Shawmut Bank.
Financial data (yr. ended 12/31/87): Assets, $80,641 (M); gifts received, $1,355,290; expenditures, $1,349,886, including $1,284,746 for 534 grants (high: $277,000; low: $44; average: $2,500) and $63,494 for 36 employee matching gifts.
Purpose and activities: Support for the United Way, community services, education, health, cultural organizations, and urban development projects.
Types of support: Operating budgets, employee matching gifts, capital campaigns.
Limitations: Giving limited to MA. No support for national or local medical foundations. No grants to individuals, or for research.
Publications: Program policy statement, application guidelines.
Application information:
 Initial approach: Telephone or letter
 Copies of proposal: 1
 Deadline(s): 6 weeks prior to meeting
 Board meeting date(s): 3 times a year
 Write: Dinah Waldsmith, Admin.
Agent: Shawmut Bank.
Number of staff: 1 full-time professional; 1 part-time support.
Employer Identification Number: 046023794

1239
Shawmut Worcester County Bank Charitable Foundation, Inc.

c/o Shawmut Central Tax Unit
P.O. Box 15032
Worcester 01613-0032
Application address: 446 Main St., Worcester, MA 01608; Tel.: (617) 793-4401

Incorporated in 1982 in MA.
Donor(s): Shawmut Worcester County Bank, N.A.
Financial data (yr. ended 12/31/87): Assets, $191,762 (M); gifts received, $225,000; expenditures, $220,609, including $220,058 for 59 grants (high: $68,000; low: $300).
Purpose and activities: Giving for community funds and for higher education; support also for cultural programs, health and social services, and youth agencies.
Types of support: Annual campaigns, capital campaigns.
Limitations: Giving limited to agencies within the Shawmut Worcester County Bank market area.
Application information:
 Initial approach: Letter
 Deadline(s): None
 Write: Harry I. Spencer, Jr., Treas.
Officers and Directors:* F. William Marshall, Jr.,* Pres.; John D. Hunt,* V.P; John M. Lydon, Secy.; Harry I. Spencer, Jr.,* Treas.
Employer Identification Number: 042746775

1240
Richard and Susan Smith Foundation

27 Boylston St., Box 1000
Chestnut Hill 02167 (617) 232-8200
To contact only when further clarification of the guidelines is needed: c/o Grants Management Assocs., 100 Franklin St., Boston, MA 02110; Tel.: (617) 357-1514

Trust established in 1970 in MA.
Donor(s): Marian Smith,† Richard A. Smith.
Financial data (yr. ended 4/30/87): Assets, $1,274,361 (M); gifts received, $112,304; expenditures, $149,063, including $124,175 for 30 grants (high: $50,000; low: $100).
Purpose and activities: Grants for health, education, and Jewish organizations serving a worldwide community; arts a secondary field of interest. Particularly interested in organizations providing opportunities for economically disadvantaged populations, especially children and youth, and cancer research.
Types of support: General purposes, building funds, capital campaigns, special projects, annual campaigns, fellowships, research.
Limitations: Giving primarily in the greater Boston, MA, area. No support for sectarian religious activities or political causes. No grants to individuals, or for deficit financing, endowment funds, operating budgets, efforts supported by the general public, or efforts in which the foundation may become the sole source of funding.
Publications: 990-PF, application guidelines.
Application information:
 Initial approach: Letter
 Copies of proposal: 1
 Deadline(s): None
 Board meeting date(s): Fall and spring
 Write: Richard A. Smith, Trustee
Trustees: Amy S. Berylson, John Berylson, Brian Knez, Debra S. Knez, Richard A. Smith, Susan F. Smith.
Employer Identification Number: 237090011

1241
Sonesta Charitable Foundation, Inc.

200 Clarendon St.
Boston 02116-5021 (617) 421-5414

Established in 1967 in MA.
Financial data (yr. ended 12/31/87): Assets, $0 (M); gifts received, $10,100; expenditures, $10,100, including $10,100 for 11 grants (high: $3,300; low: $150).
Purpose and activities: Support for culture and the arts, youth, business education, health, and community services.
Types of support: Continuing support.
Limitations: Giving primarily in Boston, MA.
Application information:
 Deadline(s): None
 Board meeting date(s): May
 Write: Maureen Sullivan
Officers: Roger P. Sonnabend, Pres.; Paul Sonnabend,* V.P.; Brian T. Owen, V.P. and Treas.; Peter T. Sonnabend, Clerk.
Directors:* Joseph L. Bower, William J. Poorvu.
Number of staff: None.
Employer Identification Number: 046169167

1242
Phineas W. Sprague Memorial Foundation
c/o Tucker Anthony Management Corp.
P.O. Box 1250
Boston 02104

Established in 1956 in MA.
Financial data (yr. ended 12/31/87): Assets, $1,041,859 (M); expenditures, $95,024, including $75,000 for 16 grants (high: $30,000; low: $500).
Purpose and activities: Support primarily for a camp and for private secondary schools; support also for land and historic preservation.
Application information: Contributes only to pre-selected organizations. Applications not accepted.
Officers and Trustees: Henderson Inches, Treas.; Julie Talmadge.
Employer Identification Number: 046043554

1243
The Stare Fund
c/o Ropes and Gray
225 Franklin St., Rm. 2400
Boston 02110 (617) 423-6100

Established in 1959 in MA.
Financial data (yr. ended 11/30/87): Assets, $1,519,504 (M); gifts received, $22,600; expenditures, $62,449, including $41,000 for 28 grants (high: $7,500; low: $250).
Purpose and activities: Support for health and nutrition, cultural programs, and higher education.
Application information:
 Initial approach: Letter or proposal
 Deadline(s): None
Trustees: Harry K. Mansfield, David S. Stare, Fredrick J. Stare, Irene M. Stare, Mary S. Wilkinson.
Employer Identification Number: 046026648

1244
State Street Foundation
c/o State Street Bank and Trust Co.
P.O. Box 351
Boston 02101 (617) 654-3381

Trust established in 1963 in MA.
Donor(s): State Street Bank and Trust Co.
Financial data (yr. ended 12/31/87): Assets, $2,987,615 (M); gifts received, $1,378,000; expenditures, $1,115,668, including $1,064,101 for 111 grants (high: $81,250; low: $1,000) and $42,622 for 318 employee matching gifts.
Purpose and activities: Grants to organizations helping to improve the quality of life for residents of the greater Boston area, with emphasis on community funds, neighborhood development, health and human services, public and secondary education, job training, and cultural programs.
Types of support: Annual campaigns, building funds, capital campaigns, conferences and seminars, continuing support, emergency funds, employee matching gifts, endowment funds, equipment, general purposes, land acquisition, lectureships, loans, matching funds, operating budgets, program-related investments,

publications, renovation projects, seed money, special projects, technical assistance.
Limitations: Giving primarily in MA. No grants to individuals, or for scholarships.
Publications: Annual report (including application guidelines), 990-PF.
Application information:
 Initial approach: Proposal
 Copies of proposal: 1
 Deadline(s): None
 Board meeting date(s): Quarterly
 Final notification: 2 weeks after meeting
 Write: James J. Darr, V.P., State Street Bank and Trust Co.
Trustee: State Street Bank and Trust Co.
Number of staff: 2 full-time professional; 2 full-time support.
Employer Identification Number: 046401847
Recent arts and culture grants:
Artists Foundation, Boston, MA, $5,000. For national model urban renewal/arts project to showcase quality, contemporary professional artwork and to create free lively cultural resource. 1987.
Arts/Boston, Boston, MA, $10,000. To provide sponsorship for minority arts groups to appear on Around Town cable television network. 1987.
Boston Symphony Orchestra, Boston, MA, $6,000. For continued annual support targeted toward Boston Pops' open-air concerts performed on Esplanade. 1987.
Childrens Museum, Boston, MA, $20,000. For planning grant to launch pilot project enabling Boston elementary and middle school teachers to develop curricula sensitive to changing demographics of their classes. 1987.
Cultural Education Collaborative, Boston, MA, $10,000. To provide program support in conjunction with Superintendent's Boston Education Plan. 1987.
Handel and Haydn Society, Boston, MA, $5,000. To continue educational outreach opportunities in Quincy Public Schools (expanding into Roxbury & Cambridge); and to underwrite rush tickets for high school students. 1987.
Hull Lifesaving Museum, Hull, MA, $5,000. To support specialized boating experiences for at-risk students from Boston Public Schools, and to provide confidence building and skills training for disadvantaged youth. 1987.
Inquilinos Boricuas en Accion, Boston, MA, $5,000. To support community outreach and programming activities for Jorge Hernandez Cultural Center, multi-purpose facility serving Hispanic community of Villa Victoria. 1987.
Library of the Boston Athenaeum, Boston, MA, $6,000. To support exhibition of 19th century photographers to be shown at State Street's Concourse Gallery and to support monograph of exhibition. 1987.
Museum of Afro American History, Boston, MA, $7,500. To provide program support for Youth Education Project to develop curricula related to social history of New England's Afro-American communities for Boston Public School students. 1987.
Museum of Fine Arts, Boston, MA, $5,000. To provide general operating support. 1987.
Museum of Science, Boston, MA, $12,000. To support Museum's OMNI Campaign to

broaden reach of science education to inner-city and minority children. 1987.
National Dance Institute/New England, Boston, MA, $7,500. For program support to expand accessibility of program in Boston Public Schools. 1987.
Photographic Resource Center, Boston, MA, $6,000. To support pilot outreach program which will bring photographic arts to Boston-area schools. 1987.
Plimoth Plantation, Plymouth, MA, $10,000. To provide capital support for new Visitor Center, as well as program support for educational outreach activities enabling Boston public school students to visit Museum. 1987.
Society for the Preservation of New England Antiquities, Boston, MA, $7,500. To provide outreach support extending Two Boston Federalists Program to Boston area middle schools. 1987.
W G B H Educational Foundation, Boston, MA, $6,000. For radio component and Fund for the 80's which will provide programming and capital equipment for state of the art public broadcasting. 1987.

1245
Stearns Charitable Trust
66 Commonwealth Ave.
Concord 01742

Trust established in 1947 in MA.
Donor(s): Russell B. Stearns.†
Financial data (yr. ended 12/31/87): Assets, $2,605,000 (M); expenditures, $147,049, including $119,000 for 28 grants (high: $10,000; low: $1,000).
Purpose and activities: Emphasis on cultural programs, including a science museum; support also for hospitals, education, community funds, an aquarium corporation, and social services.
Types of support: Annual campaigns, general purposes, endowment funds.
Limitations: Giving primarily in MA. No grants to individuals.
Application information: Contributes only to pre-selected organizations. Applications not accepted.
 Board meeting date(s): As required
 Write: Russell S. Beede, Trustee
Trustees: Russell S. Beede, Andree B. Stearns.
Employer Identification Number: 046036697

1246
Albert Steiger Memorial Fund, Inc.
1477 Main St.
Springfield 01101 (413) 781-4211

Incorporated in 1953 in MA.
Donor(s): Ralph A. Steiger, Chauncey A. Steiger, Albert Steiger, Inc.
Financial data (yr. ended 12/31/86): Assets, $1,809,815 (M); expenditures, $119,917, including $103,950 for 18 grants.
Purpose and activities: Grants recommended by the Community Funds Advisory Committee of the Community Council, primarily for community funds, social service agencies, cultural programs, and higher education.
Types of support: Special projects, building funds, capital campaigns.

Limitations: Giving primarily in Hampden County, MA. No grants to individuals, or for endowment funds or operating budgets.
Application information: Submit proposal between May and Nov.
Initial approach: Letter
Copies of proposal: 1
Board meeting date(s): As required
Write: Albert A. Steiger, Jr., Pres.
Officers and Trustees: Albert A. Steiger, Jr., Pres.; Ralph A. Steiger II, V.P.; Allen Steiger, Treas.; Richard Milstein, Clerk; Philip C. Steiger, Jr., Robert Steiger.
Employer Identification Number: 046051750

1247
The Abbot and Dorothy H. Stevens Foundation
P.O. Box 111
North Andover 01845 (508) 688-7211

Trust established in 1953 in MA.
Donor(s): Abbot Stevens.†
Financial data (yr. ended 12/31/88): Assets, $10,422,711 (M); expenditures, $649,879, including $528,872 for 84 grants (high: $65,000; low: $100; average: $2,000-$5,000).
Purpose and activities: Giving for education, health, welfare, youth organizations, arts and humanities, conservation, and historic preservation.
Types of support: Building funds, capital campaigns, continuing support, endowment funds, equipment, matching funds, operating budgets, renovation projects, seed money, technical assistance.
Limitations: Giving limited to MA, with emphasis on the greater Lawrence area. No support for national organizations, or for state or federal agencies. No grants to individuals, or for annual or capital campaigns, deficit financing, exchange programs, internships, professorships, scholarships, or fellowships; no loans.
Publications: Program policy statement, application guidelines.
Application information:
Initial approach: Proposal
Copies of proposal: 1
Board meeting date(s): Monthly except July and Aug.
Write: Elizabeth A. Beland, Admin.
Trustees: Phebe S. Miner, Christopher W. Rogers, Samuel S. Rogers.
Number of staff: 1
Employer Identification Number: 046107991

1248
The Nathaniel and Elizabeth P. Stevens Foundation
P.O. Box 111
North Andover 01845 (508) 688-7211

Trust established in 1943 in MA.
Donor(s): Nathaniel Stevens.†
Financial data (yr. ended 12/31/88): Assets, $8,655,238 (M); expenditures, $561,353, including $487,983 for 75 grants (high: $50,000; low: $1,000; average: $2,000-$10,000).

Purpose and activities: Giving for education, historic preservation, the arts, social services, health and conservation.
Types of support: General purposes, seed money, emergency funds, building funds, equipment, land acquisition, endowment funds, special projects, matching funds, capital campaigns, conferences and seminars, consulting services, continuing support, operating budgets, renovation projects, technical assistance.
Limitations: Giving limited to MA, with emphasis on the greater Lawrence area. No support for national organizations, or for state or federal agencies. No grants to individuals, or for deficit financing, exchange programs, internships, lectureships, research, professorships, scholarships, fellowships, or annual campaigns; no loans.
Publications: Application guidelines, program policy statement.
Application information:
Initial approach: Proposal
Copies of proposal: 1
Deadline(s): None
Board meeting date(s): Monthly except in July and Aug.
Final notification: 2 months
Write: Elizabeth A. Beland, Admin.
Trustees: Joshua L. Miner IV, Phebe S. Miner, Samuel S. Rogers.
Number of staff: 1
Employer Identification Number: 042236996

1249
The Stoddard Charitable Trust
370 Main St., Suite 1250
Worcester 01608 (617) 798-8621

Trust established in 1939 in MA.
Donor(s): Harry G. Stoddard.†
Financial data (yr. ended 12/31/87): Assets, $46,975,788 (M); gifts received, $25,000; expenditures, $3,024,789, including $2,873,208 for 83 grants (high: $500,000; low: $1,000; average: $3,000-$50,000).
Purpose and activities: Emphasis on education, cultural programs, historical associations, youth agencies, and a community fund; support also for social service agencies, the environment, and health associations.
Types of support: Annual campaigns, seed money, emergency funds, building funds, equipment, land acquisition, research, scholarship funds, fellowships, professorships, internships, matching funds, general purposes, continuing support, renovation projects.
Limitations: Giving primarily in Worcester, MA. No grants to individuals.
Application information:
Initial approach: Proposal
Copies of proposal: 5
Deadline(s): Submit proposal between Jan. and Nov.; no set deadlines
Board meeting date(s): As required
Final notification: 3 months
Write: Paris Fletcher, Chair.
Officers and Trustees: Paris Fletcher, Chair.; Helen E. Stoddard, Vice-Chair.; Warner S. Fletcher, Secy.-Treas.; Allen W. Fletcher, Marion S. Fletcher, Judith S. King, Valerie S. Loring.
Number of staff: None.
Employer Identification Number: 046023791

1250
The Stone Charitable Foundation, Inc.
P.O. Box 728
Wareham 02571

Incorporated in 1948 in MA.
Donor(s): Dewey D. Stone,† Stephen A. Stone, Anne A. Stone, Thelma Finn, Jack Finn, Harry K. Stone.†
Financial data (yr. ended 11/30/86): Assets, $5,399,204 (M); gifts received, $25,000; expenditures, $407,729, including $362,356 for 58 grants (high: $106,000; low: $36).
Purpose and activities: Giving largely for Jewish welfare funds; grants also for hospitals, higher education, and cultural programs.
Types of support: General purposes, research, endowment funds, scholarship funds, building funds, annual campaigns, equipment, capital campaigns.
Limitations: Giving primarily in MA. No grants to individuals.
Application information:
Deadline(s): None
Board meeting date(s): As required
Write: Stephen Stone, Pres.
Officers and Trustees: Stephen A. Stone, Pres.; Theodore Teplow, Secy.; Alfred P. Rudnick, Treas.
Number of staff: None.
Employer Identification Number: 046114683

1251
The Stride Rite Charitable Foundation, Inc.
c/o The Stride Rite Corp.
Five Cambridge Center
Cambridge 02142 (617) 491-8800

Incorporated in 1953 in MA as J.A. and Bessie Slosberg Charitable Foundation, Inc.
Donor(s): Stride Rite Corp.
Financial data (yr. ended 9/30/88): Assets, $2,640,769 (M); gifts received, $1,600,163; expenditures, $494,829, including $491,628 for 156 grants (high: $175,000; low: $25; average: $1,000-$5,000).
Purpose and activities: Giving primarily for child welfare; support also for cultural programs and community funds.
Types of support: Annual campaigns, continuing support, operating budgets, employee-related scholarships, scholarship funds.
Limitations: Giving limited to MA, with emphasis on the greater Boston area.
Application information:
Deadline(s): None
Write: Vicki Mann
Officer and Director: Arnold Hiatt, Pres.
Employer Identification Number: 046059887

1252
Waters Foundation
1153 Grove St.
Framingham 01701 (617) 877-3791

Trust established in 1958 in MA.
Donor(s): James L. Waters.
Financial data (yr. ended 12/31/87): Assets, $1,066,891 (M); gifts received, $1,000;

expenditures, $444,560, including $382,600 for 21 grants (high: $100,000; low: $500).
Purpose and activities: Grants primarily for higher education; support also for cultural programs.
Application information: Seldom contributes to unsolicited applicants.
 Initial approach: Letter
 Deadline(s): None
 Write: James L. Waters, Trustee
Trustees: Faith P. Waters, James L. Waters, Richard C. Waters.
Employer Identification Number: 046115211

1253
Edwin S. Webster Foundation

c/o Grants Management Associates, Inc.
230 Congress St., 3rd Fl.
Boston 02110 (617) 426-7172

Trust established in 1948 in MA.
Donor(s): Edwin S. Webster.†
Financial data (yr. ended 12/31/87): Assets, $14,331,277 (M); expenditures, $726,338, including $621,000 for 46 grants (high: $105,000; low: $1,000).
Purpose and activities: Emphasis on cultural activities, hospitals, medical research, higher and secondary education, youth agencies, community funds, and programs relating to alcoholism, the handicapped, and minorities.
Types of support: Operating budgets, continuing support, annual campaigns, building funds, equipment, land acquisition, endowment funds, matching funds, scholarship funds, professorships, internships, fellowships, special projects, research.
Limitations: Giving primarily in the Northeast, especially MA, NH, and NY. No grants to individuals, or for seed money, emergency funds, deficit financing, publications, or conferences; no loans.
Publications: Grants list, application guidelines.
Application information:
 Initial approach: Proposal
 Copies of proposal: 1
 Deadline(s): Submit proposal preferably in Mar. or Sept.; no set deadline
 Board meeting date(s): May or June and Nov. or Dec.
 Final notification: 10 days after meetings on grant proposals
 Write: Susan Brit, Admin.
Officer and Trustees: Richard Harte, Jr., Secy.; Henry U. Harris, Jr., Henry U. Harris III, Edwin W. Hiam.
Number of staff: 2
Employer Identification Number: 046000647
Recent arts and culture grants:
Boston Symphony Orchestra, Boston, MA, $10,000. For general purposes. 1987.
Museum of Science, Boston, MA, $10,000. For annual fund. 1987.
New England Aquarium, Boston, MA, $10,000. For general purposes. 1987.
New York Botanical Garden, Bronx, NY, $10,000. For general purposes. 1987.
Science Center of New Hampshire, Holderness, NH, $10,000. For general purposes. 1987.
W G B H Educational Foundation, Boston, MA, $10,000. For general purposes. 1987.

1254
Arthur Ashley Williams Foundation

345 Union Ave.
P.O. Box 665
Framingham 01701 (617) 429-1149

Incorporated in 1951 in MA.
Donor(s): Arthur A. Williams.†
Financial data (yr. ended 12/31/87): Assets, $2,935,965 (M); expenditures, $224,287, including $116,480 for 26 grants (high: $30,000; low: $1,000; average: $5,000-$10,000) and $40,080 for 32 grants to individuals.
Purpose and activities: Grants primarily for churches and social welfare and youth agencies. Financial aid for higher education to students in need.
Types of support: Student aid.
Publications: Application guidelines.
Application information: Application form required.
 Initial approach: Letter
 Copies of proposal: 1
 Deadline(s): Submit proposal preferably in Dec.; deadline 1 week prior to board meetings
 Board meeting date(s): Jan., Apr., July, and Oct.
 Write: Frederick Cole, Chair.
Officers and Trustees: Frederick Cole, Chair.; Elbert F. Tuttle, Secy.; Clement T. Lambert, Treas.; David S. Williams, William Williams, Hayden R. Wood.
Employer Identification Number: 046044714

1255
Greater Worcester Community Foundation, Inc.

44 Front St., Suite 530
Worcester 01608 (508) 755-0980

Community foundation incorporated in 1975 in MA.
Financial data (yr. ended 12/31/88): Assets, $20,963,916 (M); gifts received, $10,913,177; expenditures, $1,192,012, including $892,593 for grants (high: $100,000; low: $100; average: $1,000-$4,000) and $66,796 for 35 grants to individuals.
Purpose and activities: "To help meet the health, educational, social welfare, cultural and civic needs of the people of Greater Worcester, including, but not limited to, assisting charitable and educational institutions; for the needy, sick, aged or helpless; for the care of children; for the betterment of living and working conditions; for recreation for all classes, and for such other public and/or charitable uses and purposes as will best make for mental, moral and physical improvement, or contribute to the public welfare."
Types of support: Seed money, emergency funds, equipment, matching funds, internships, scholarship funds, employee-related scholarships, special projects, technical assistance, student aid.
Limitations: Giving limited to the greater Worcester, MA, area.
Publications: Annual report, program policy statement, application guidelines, newsletter.
Application information: Submit 8 copies of Foundation summary sheet plus 2 copies of

proposal. Scholarships are for residents of Worcester County, MA or for children of employees of Bank of New England-Worcester or Rotman's Furniture. Application form required.
 Initial approach: Telephone or letter
 Copies of proposal: 2
 Deadline(s): Educational grants, Apr. 1; women and children, June 1; discretionary awards, Dec. 1; and scholarships, Mar. 15
 Board meeting date(s): Mar., June, Sept., Nov., and as required
 Final notification: 3 1/2 months
 Write: Ms. Kay M. Seivard, Exec. Dir.
Officers and Directors: Michael P. Angelini, Pres.; Martha A. Cowan, V.P.; F. William Marshall, V.P.; David R. Grenon, Treas.; Joan E. Arnold, Helen A. Bowditch, Michael D. Brockelman, Richard B. Collins, Harold N. Cotton, Bayard T. DeMallie, William P. Densmore, Barry L. Krock, Michael D. Leavitt, Stephen B. Loring, John O. Mirick, Margery Morgan, Evangelina Tierney, Polly Traina, J. Robert Seder, Edward D. Simsarian, Robert H. Wetzel, David Woodbury.
Distribution Committee: Michael Brockernan, Barbara Greenberg, Abraham Haddad, Joseph Hagan, Vincent O'Rourke, Sara J. Robertson, David Stephens, Corinne Turner, Meridith Wesby.
Trustee Banks: Bank of New England-Worcester, Mechanics Bank, Shawmut Worcester County Bank, N.A.
Number of staff: 3 full-time professional; 1 part-time professional; 2 part-time support.
Employer Identification Number: 042572276
Recent arts and culture grants:
Worcester Art Museum, Art Unlimited, Worcester, MA, $7,500. For scholarships for low-income children to attend art classes. 1987.

1256
Wyman-Gordon Foundation

105 Madison St., Box 789
Worcester 01613-0789 (508) 756-5111

Established in 1966 in DE.
Donor(s): Wyman-Gordon Co.
Financial data (yr. ended 12/31/88): Assets, $4,784,180 (M); expenditures, $354,225 for 52 grants (high: $194,500; low: $100) and $9,087 for 76 employee matching gifts.
Purpose and activities: Giving primarily for community funds, cultural programs, higher education, hospitals, and youth agencies.
Types of support: General purposes, operating budgets, continuing support, annual campaigns, seed money, emergency funds, deficit financing, building funds, equipment, land acquisition, employee matching gifts, scholarship funds, employee-related scholarships, fellowships.
Limitations: Giving primarily in MA, with emphasis on the Worcester area, and in plant communities in Danville, IL, Jackson, MI, and South Gate, CA. No grants to individuals, or for endowment funds, special projects, research, publications, or conferences; no loans.
Application information:
 Initial approach: Letter or proposal
 Copies of proposal: 1
 Deadline(s): None

Board meeting date(s): Feb., Apr., June, Aug., Oct., and Dec.

Write: Richard L. Stevens, Secy.-Treas.

Officers and Directors: Joseph R. Carter, Pres.; Henry Dormitzer, V.P.; William S. Hurley, V.P.; James S. Walsh, V.P.; Richard L. Stevens, Secy.-Treas.

Number of staff: 1 part-time professional; 1 part-time support.

Employer Identification Number: 046142600

MICHIGAN

1257
ANR Foundation, Inc.

One Woodward Ave.
Detroit 48226 (313) 965-1200

Incorporated in 1985 in MI.

Donor(s): American Natural Resources Co., and subsidiaries.

Financial data (yr. ended 12/31/87): Assets, $1,406,764 (M); qualifying distributions, $1,220,746, including $1,220,232 for 216 grants (high: $91,000; low: $25) and $29,312 for 81 employee matching gifts.

Purpose and activities: Support for health and welfare, culture, education, and community responsibility.

Types of support: Employee matching gifts, operating budgets, general purposes, scholarship funds.

Limitations: No support for organizations supported by the United Way, or for exclusively denominational or sectarian purposes. No grants to individuals, or for fundraising events, conventions, or goodwill advertising.

Application information:
Initial approach: Letter or proposal with annual report
Deadline(s): None
Write: James F. Cordes, Pres.

Officers: James R. Paul,* Chair.; James F. Cordes,* Pres.; Austin M. O'Toole, Secy.; David A. Arledge, Treas.

Directors:* Lawrence P. Doss.

Employer Identification Number: 382602116

1258
Baldwin Foundation

Old Kent Bank Bldg.
300 Old Kent
Grand Rapids 49503

Trust established in 1964 in MI.

Donor(s): Members of the Baldwin family.

Financial data (yr. ended 11/30/88): Assets, $2,330,134 (M); expenditures, $153,137, including $135,350 for 45 grants (high: $20,000; low: $250).

Purpose and activities: Giving for arts and cultural programs, higher education, and social service agencies.

Limitations: Giving primarily in western MI.

Application information:
Deadline(s): None
Write: James R. Dice, Secy.

Officers: John R. Davies,* Pres.; Ralph B. Baldwin,* V.P.; James R. Dice, Secy.-Treas.

Trustees:* Melvin Dana Baldwin II, Mrs. Ralph B. Baldwin, Carol Curlin, Lemuel Curlin, Dan Heyns, Mrs. Dan Heyns, L.V. Mulnix, Jr., Frances Mulnix, Peter Wolf.

Manager: Old Kent Bank & Trust Co.

Employer Identification Number: 386085641

1259
Bank of Alma Charitable Trust

c/o Tom Plaxton
311 Woodworth Ave.
Alma 48801-1826

Financial data (yr. ended 12/31/87): Assets, $3,274 (M); expenditures, $10,045, including $10,045 for 12 grants (high: $4,000; low: $200).

Purpose and activities: Support for higher education, United Way, hospitals, culture, youth, and civic affairs.

Officer: Keith Bever, Chair.

Trustees: Richard Walton, Charles Van Atten.

Employer Identification Number: 386065630

1260
Barton-Malow Company Foundation

P.O. Box 5200
Oak Park 48237-3276 (313) 873-4081

Established in 1954 in MI.

Donor(s): Barton Malow Co., Cloverdale Equipment Co.

Financial data (yr. ended 3/31/88): Assets, $7,971 (M); gifts received, $100,000; expenditures, $101,766, including $101,633 for 52 grants (high: $19,550; low: $100).

Purpose and activities: Giving to community, hospital, educational, cultural, social and welfare programs.

Types of support: General purposes.

Trustees: Mark A. Bahr, Ben C. Maibach III.

Employer Identification Number: 386088176

1261
Battle Creek Community Foundation

(Formerly Greater Battle Creek Foundation)
512 Michigan National Bank Bldg.
Battle Creek 49017-3653 (616) 962-2181

Community foundation established in 1974 in MI.

Financial data (yr. ended 4/30/88): Assets, $4,070,882 (M); gifts received, $2,405,331; expenditures, $891,191, including $445,798 for 45 grants (high: $30,000; low: $100; average: $3,000).

Purpose and activities: Support for charitable, scientific, literary, and educational programs of all kinds that will foster improvement of the physical environment and the living, working, and social conditions.

Types of support: Seed money, emergency funds, building funds, equipment, land acquisition, scholarship funds, special projects, publications, conferences and seminars, matching funds.

Limitations: Giving limited to the greater Battle Creek, MI, area. No grants for operating budgets, deficit financing, endowments, or research; no loans.

Publications: Annual report, grants list, newsletter, application guidelines.

Application information: Application form required.
Initial approach: Letter or phone call
Copies of proposal: 1
Deadline(s): Quarterly
Board meeting date(s): Quarterly
Write: James M. Richmond, Pres.

Officers: James M. Richmond, Pres.; Lawrence Crandall, V.P.; Susan E. Ordway, Secy.; Dale G. Griffin, Treas.

Trustees: C. Dennis Barr, Elizabeth H. Binda, Robert de S. Couch, William E. LaMothe, Robert B. Miller, Sr., Sadie Penn, Theodore E. Sovern.

Number of staff: 2 full-time professional; 1 full-time support.

Employer Identification Number: 382045459

1262
Charles M. Bauervic Foundation, Inc.

Box 2938
Southfield 48037 (313) 356-7890
Additional address: 25154 Acacia Rd., Southfield, MI 48034

Incorporated in 1967 in MI.

Donor(s): Charles M. Bauervic.†

Financial data (yr. ended 12/31/87): Assets, $3,011,833 (M); expenditures, $116,501, including $74,500 for 18 grants (high: $10,000; low: $500; average: $1,000-$10,000).

Purpose and activities: Giving primarily for private higher, secondary, and elementary education; limited support for hospitals, churches, child welfare and youth development organizations, and cultural organizations.

Limitations: Giving primarily in MI. No grants to individuals.

Application information: Application form required.
Initial approach: Letter
Deadline(s): May 30
Write: Patricia A. Leonard, Pres.

Officers: Patricia A. Leonard, Pres. and Secy.; James P. Leonard, V.P.; Theodore J. Leonard, Treas.

Director: Timothy J. Leonard.

Employer Identification Number: 386146352

1263
Bauervic-Paisley Foundation

2855 Coolidge Hwy., Suite 103
Troy 48084

Established in 1984 in MI.

Financial data (yr. ended 12/31/87): Assets, $2,709,491 (M); expenditures, $177,307, including $128,760 for 14 grants (high: $40,000; low: $260).

Purpose and activities: Grants primarily for education and social services; support also for cultural programs and religion.

Types of support: Renovation projects, operating budgets, matching funds.

Application information: Application form required.

Deadline(s): Oct. 1
Officers and Directors: Beverly Paisley, Pres. and Secy.; Peter W. Paisley, Treas.; Rose Bauervic-Wright.
Employer Identification Number: 382494390

1264
A. G. Bishop Charitable Trust
c/o NBD Genesee Merchants Bank & Trust Co.
One East First St.
Flint 48502 (313) 766-8307

Trust established in 1944 in MI.
Donor(s): Arthur Giles Bishop.†
Financial data (yr. ended 12/31/88): Assets, $4,838,572 (M); expenditures, $249,640, including $227,837 for 49 grants (high: $33,334; low: $750).
Purpose and activities: Emphasis on health agencies and a hospital, a community fund, cultural programs, higher education, and social service and youth agencies.
Types of support: Operating budgets, continuing support, annual campaigns, seed money, emergency funds, deficit financing, building funds, equipment, land acquisition, research.
Limitations: Giving limited to the Flint-Genesee County, MI, community. No grants to individuals, or for endowment funds, scholarships, fellowships, or matching gifts; no loans.
Application information:
 Initial approach: Letter
 Copies of proposal: 1
 Deadline(s): None
 Board meeting date(s): Annually in the fall
 Final notification: 2 weeks
 Write: C. Ann Barton, Asst. V.P. and Trust Officer
Trustees: Carrie Jane Bellairs, Elizabeth B. Wentworth, NBD Genesee Merchants Bank & Trust Co.
Number of staff: 1 part-time professional.
Employer Identification Number: 386040693

1265
The Borman's, Inc. Fund
18718 Borman Ave.
Detroit 48228 (313) 270-1155
Additional address: P.O. Box 33446, Detroit, MI 48232-5446

Donor(s): Borman's, Inc.
Financial data (yr. ended 12/31/87): Assets, $865,884 (M); gifts received, $295,000; expenditures, $429,005, including $427,990 for 82 grants (high: $100,600; low: $100).
Purpose and activities: Giving primarily for Jewish welfare and social services; support also for the arts.
Types of support: Annual campaigns.
Limitations: Giving primarily in southeastern MI.
Publications: Application guidelines.
Application information:
 Initial approach: Letter
 Copies of proposal: 1
 Write: Gilbert Borman, Secy.-Treas.
Officers and Directors: Gilbert Borman, Secy.-Treas.
Number of staff: 1 part-time support.
Employer Identification Number: 386069267

1266
Arnold and Gertrude Boutell Memorial Fund
c/o Second National Bank of Saginaw
101 North Washington Ave.
Saginaw 48607 (517) 776-7582

Trust established in 1961 in MI.
Donor(s): Arnold Boutell,† Gertrude Boutell.†
Financial data (yr. ended 3/31/86): Assets, $6,283,735 (M); expenditures, $567,406, including $487,300 for 24 grants.
Purpose and activities: Support largely for a community fund, education, cultural programs, community development, and hospitals.
Limitations: Giving limited to Saginaw County, MI. No grants to individuals, or for endowment funds.
Application information: Application form required.
 Initial approach: Letter
 Copies of proposal: 1
 Board meeting date(s): Bimonthly
 Write: Denice McGlaughlin, Trust Admin.
Trustee: Second National Bank of Saginaw.
Employer Identification Number: 386040492

1267
Viola E. Bray Charitable Trust
c/o NBD Genesee Bank
One East First St.
Flint 48502 (313) 766-8307

Trust established in 1961 in MI.
Donor(s): Viola E. Bray.
Financial data (yr. ended 9/30/88): Assets, $2,534,859 (M); expenditures, $130,594, including $104,231 for 29 grants (high: $23,157; low: $650).
Purpose and activities: Giving for the fine arts.
Types of support: Continuing support, annual campaigns, seed money, emergency funds, building funds, equipment, matching funds.
Limitations: Giving limited to the Flint, MI, area. No grants to individuals, or for research, scholarships, or fellowships; no loans.
Publications: 990-PF, program policy statement, application guidelines.
Application information:
 Initial approach: 1-page proposal
 Copies of proposal: 3
 Deadline(s): None
 Board meeting date(s): As required
 Final notification: 2 months
 Write: C. Ann Barton, Trust Officer, NBD Genesee Bank
Trustees: Bertha Bray Richards, Sally Richards Ricker, NBD Genesee Bank.
Employer Identification Number: 386039741

1268
The Bundy Foundation
12345 E. Nine Mile Rd.
Warren 48090 (313) 758-4511

Incorporated in 1952 in MI.
Donor(s): Bundy Corp.
Financial data (yr. ended 12/31/87): Assets, $5,637,285 (M); gifts received, $547,750; expenditures, $681,043, including $572,090 for 110 grants (high: $126,000; low: $20).

Purpose and activities: Emphasis on community funds, education, hospitals, and cultural programs.
Types of support: Employee matching gifts, operating budgets.
Limitations: Giving primarily in areas of company operations. No support for organizations currently receiving funds from other organizations which the foundation supports. No grants to individuals.
Application information: One request per calendar year.
 Initial approach: Letter
 Copies of proposal: 1
 Deadline(s): Sept. 1
 Board meeting date(s): As required
Officers and Trustees: Wendell W. Anderson, Jr., Pres.; John W. Anderson II, V.P.; Robert E. Barton, Secy.-Treas.
Employer Identification Number: 386053694

1269
Samuel Higby Camp Foundation
145 South Jackson
Jackson 49201 (517) 787-4100

Established in 1951 in MI.
Donor(s): Donna Ruth Camp.†
Financial data (yr. ended 12/31/87): Assets, $1,016,744 (M); expenditures, $60,426, including $48,465 for 18 grants (high: $5,000; low: $1,000; average: $1,000-$5,000).
Purpose and activities: Support for educational institutions, youth services and organizations, community development, animal welfare, hospices, and cultural programs.
Types of support: Annual campaigns, capital campaigns, deficit financing, lectureships, operating budgets.
Limitations: Giving primarily in Jackson County, MI.
Application information:
 Initial approach: Letter or proposal
 Copies of proposal: 1
 Deadline(s): Aug. 15
 Board meeting date(s): As needed
 Final notification: Oct. or Nov.
 Write: Walter R. Boris, Chair.
Officers: Walter R. Boris, Pres. and Chair.; D.H. Calkins, Secy.; H. E. Spieler, Treas.
Trustees: I.R. Bauer, Nancy J. Ordway.
Employer Identification Number: 381643281

1270
Gerald W. Chamberlin Foundation, Inc.
500 Stephenson Hwy., Suite 405
Troy 48083

Incorporated in 1955 in MI.
Donor(s): Gerald W. Chamberlin,† Myrtle F. Chamberlin,† Donald F. Chamberlin, Joanne M. Chamberlin, Chamberlin Products.
Financial data (yr. ended 12/31/86): Assets, $2,314,804 (M); gifts received, $7,130; expenditures, $193,430, including $124,950 for 76 grants (high: $10,500; low: $100).
Purpose and activities: Giving for Protestant church support, youth agencies, higher and secondary education, and cultural programs.
Limitations: Giving primarily in MI.

Application information: Contributes only to pre-selected organizations. Applications not accepted.

Officers: Donald F. Chamberlin, Pres.; John W. Butler, V.P.; Joy C. Robbins, Secy.-Treas.

Employer Identification Number: 386055730

1271
Chrysler Corporation Fund
12000 Chrysler Dr.
Highland Park 48288-1919 (313) 956-5194

Incorporated in 1953 in MI.

Donor(s): Chrysler Corp.

Financial data (yr. ended 12/31/87): Assets, $27,296,789 (M); gifts received, $9,658,474; expenditures, $7,601,412, including $6,927,486 for 340 grants (high: $626,700; low: $100; average: $1,000-$25,000) and $576,983 for employee matching gifts.

Purpose and activities: Support for community funds, health and human services, higher education, civic affairs, and cultural programs.

Types of support: Continuing support, annual campaigns, emergency funds, special projects, employee matching gifts, building funds, employee-related scholarships, scholarship funds, operating budgets.

Limitations: Giving primarily in areas where the company has a substantial number of employees. No support for primary or secondary schools, religious organizations for religious purposes, conferences, seminars, veterans' and labor organizations, fraternal associations, athletic groups, social clubs, political organizations or campaigns, or national health organizations, except through the United Way. No grants to individuals (except for scholarships to children of company employees), or for endowment funds, fellowships, deficit financing, equipment and materials, or research; no grants for operating expenses of organizations supported through the United Ways; no loans.

Publications: Program policy statement, application guidelines.

Application information:
 Initial approach: Letter
 Copies of proposal: 1
 Deadline(s): None
 Board meeting date(s): As required, usually quarterly; educational grants approved at fall meeting
 Final notification: 3 months
 Write: Ms. Lynn A. Feldhouse, Mgr.

Officers: T.G. Denomme,* Pres.; Robert S. Miller, Jr.,* V.P. and Treas.; Lynn A. Feldhouse, Secy. and Mgr.

Trustees: B.E. Bidwell, R.E. Dauch, M.M. Glusac, W.J. O'Brien III, G.E. White.

Number of staff: 2 full-time professional; 1 full-time support; 3 part-time support.

Employer Identification Number: 386087371

1272
Citizens Commercial and Savings Bank Corporate Giving Program
One Citizens Banking Center
Flint 48502 (313) 766-7500

Financial data (yr. ended 12/31/88): Total giving, $235,350, including $120,350 for 42 grants (high: $51,500; low: $400; average: $1,000-$3,000), $55,000 for loans and $60,000 for 40 in-kind gifts.

Purpose and activities: Supports the arts, music, education, including higher education, civic affairs, community development, housing, and urban affairs; supports welfare through United Way.

Types of support: Annual campaigns, building funds, capital campaigns, conferences and seminars, continuing support, emergency funds, employee matching gifts, endowment funds, general purposes, matching funds, operating budgets, renovation projects, research, scholarship funds.

Limitations: Giving primarily in the Genesee County area of Flint, MI; Lapper and Shiawassee counties on a limited basis.

Publications: Grants list.

Application information:
 Copies of proposal: 1
 Deadline(s): Reviewed as received
 Board meeting date(s): Monthly for approval of requests of over $5,000; Contributions Committee meets quarterly
 Write: John L. Asselin, V.P.

Number of staff: 1 part-time support.

1273
Consumers Power Corporate Giving Program
212 West Michigan Ave.
Jackson 49201 (517) 788-0550

Financial data (yr. ended 12/31/88): Total giving, $700,000, including $670,000 for 312 grants (high: $50,000; low: $50) and $30,000 for 180 employee matching gifts.

Purpose and activities: Supports culture and the arts, economic, business, minority, engineering and science/technology education, and higher education, civic and social services, public affairs programs that include local trade and professional organizations, public policy, community development, health, volunteerism, welfare, women, wilderness, and youth. Also supports religious and social service organizations and United Way. Types of support include printing, donation of meeting space, and loaned employees.

Types of support: Capital campaigns, general purposes, seed money, equipment, building funds, annual campaigns, conferences and seminars, employee matching gifts, endowment funds, matching funds, publications, renovation projects, special projects, in-kind gifts.

Limitations: Giving primarily in headquarters location and service area. No support for fraternal organizations or churches. No grants to individuals.

Application information: Include organization description, amount requested, purpose for funding, recently audited financial statement, 501(c)(3), and major donor list. Application form required.
 Initial approach: Letter; proposal
 Copies of proposal: 1
 Deadline(s): Best time to apply is in first quarter
 Board meeting date(s): As needed

Final notification: 8-10 weeks
 Write: Herbert E. Spieler, Mgr., Public Affairs, Progs., and Services

Number of staff: 1 part-time professional.

1274
Cross and Trecker Foundation
505 North Woodward Ave., Suite 2000
Bloomfield Hills 48013 (313) 644-4343

Established about 1980 in MI.

Financial data (yr. ended 9/30/87): Assets, $264,137 (M); expenditures, $200,422, including $187,127 for 82 grants (high: $24,500; low: $100) and $12,591 for 82 employee matching gifts.

Purpose and activities: Giving primarily for the United Way, the arts, youth, and education; support also for a matching gift program.

Types of support: Employee matching gifts.

Limitations: No grants to individuals.

Application information:
 Initial approach: Proposal
 Deadline(s): None
 Write: D.E. Porter, Secy.

Officers: Russell A. Hedden, Chair.; Richard T. Lindgren, Pres.; D.E. Porter, Secy.; L.C. Helber, Treas.

Trustee: J.A. Buiteweg.

Employer Identification Number: 382325539

1275
Dorothy U. Dalton Foundation, Inc.
c/o Old Kent Bank of Kalamazoo
151 East Michigan Ave.
Kalamazoo 49007 (616) 383-6958

Incorporated in 1978 in MI as successor to Dorothy U. Dalton Foundation Trust.

Donor(s): Dorothy U. Dalton.†

Financial data (yr. ended 12/31/87): Assets, $20,934,992 (M); expenditures, $982,998, including $818,010 for 50 grants (high: $100,000; low: $150).

Purpose and activities: Emphasis on higher education, mental health, social service and youth agencies, and cultural programs.

Types of support: Operating budgets, continuing support, seed money, emergency funds, deficit financing, building funds, equipment, land acquisition, matching funds, research, special projects, general purposes, capital campaigns, renovation projects.

Limitations: Giving primarily in Kalamazoo County, MI. No grants to individuals, or for religious organizations, annual campaigns, scholarships, fellowships, publications, or conferences; no loans.

Publications: 990-PF.

Application information:
 Initial approach: Proposal
 Copies of proposal: 5
 Deadline(s): Submit proposal preferably in Apr. and Oct.
 Board meeting date(s): May and Nov.
 Final notification: 30 days after board meetings
 Write: Ronald N. Kilgore, Secy.-Treas.

Officers and Trustees: Suzanne D. Parish, Pres.; Howard Kalleward, V.P.; Ronald N. Kilgore, Secy.-Treas.; Thompson Bennett, Arthur F. Homer.

Number of staff: None.
Employer Identification Number: 382240062

1276
Dearborn Cable Communications Fund
922 South Military
Dearborn 48124 (313) 563-8877
Application address: c/o Cablevision of
Dearborn, 15200 Mercantile Dr., Dearborn, MI
48124

Established in 1984 in MI.
Donor(s): Group W Cable, Inc.
Financial data (yr. ended 12/31/87): Assets,
$1,076,549 (M); expenditures, $29,582,
including $19,407 for 5 grants (high: $7,593;
low: $405).
Purpose and activities: Support for cable
television programming of interest to the
general community.
Types of support: Equipment.
Limitations: Giving primarily in the Dearborn,
MI, area.
Application information:
 Initial approach: Proposal
 Deadline(s): None
 Final notification: 60 days from receipt of
 proposal
 Write: Dr. Robert T. Pendergrass, Pres.
Officers: Frank Caddy, Pres.; Patricia A. Davis,
V.P.; Carole Lennis, Secy.; Robert T.
Pendergrass, Treas.
Directors: Margaret I. Campbell, Gerald
Degrazia, Russ Gibb, Sam Hallick, Jackie
Kaiser, Carole Lennis, Leveto K. Squalls, Paul
Streffon.
Employer Identification Number: 382571195

1277
DeRoy Testamentary Foundation
3274 Penobscot Bldg.
Detroit 48226 (313) 961-3814

Established in 1979 in MI.
Donor(s): Helen L. DeRoy.†
Financial data (yr. ended 12/31/87): Assets,
$13,669,782 (M); expenditures, $664,910,
including $523,750 for 57 grants (high:
$95,000; low: $1,000).
Purpose and activities: Emphasis on higher
education; support also for arts and culture,
Jewish welfare funds, hospitals, and social
service and youth agencies.
Types of support: Special projects.
Limitations: Giving primarily in MI. No grants
to individuals.
Application information:
 Deadline(s): None
 Write: Leonard H. Weiner, Pres., or Arthur
 Rodecker, V.P.
Officers and Trustees: Leonard H. Weiner,
Pres.; Arthur Rodecker, V.P.; Bernice Michel,
Secy.
Employer Identification Number: 382208833

1278
Detroit Edison Foundation
2000 Second Ave., Rm. 1132 WCB
Detroit 48226 (313) 237-8781

Established in 1986 in MI.
Donor(s): Detroit Edison Co.
Financial data (yr. ended 12/31/87): Assets,
$14,086,065 (M); gifts received, $5,000,000;
expenditures, $1,651,562, including
$1,637,533 for 257 grants (high: $470,000;
low: $25; average: $500-$20,000).
Purpose and activities: Giving primarily for a
community fund and a symphony orchestra.
Support also for higher and other education,
and civic, social service, and cultural
organizations.
Types of support: Operating budgets, capital
campaigns.
Limitations: Giving primarily in MI.
Application information:
 Initial approach: Letter
 Deadline(s): None
 Write: Katharine W. Hunt, Secy.
Officers and Directors: Malcolm G. Dade, Jr.,
Pres.; Katherine W. Hunt, Secy.; Leslie L.
Loomans, Treas.; John E. Lobbia, Claybourne
Mitchell, Jr., James B. Oliver, Burkhard H.
Schneider, Harry Tauber, Saul J. Waldman,
Kathryn L. Westman.
Employer Identification Number: 382708636

1279
The Richard and Helen DeVos
Foundation
7575 East Fulton
Ada 49355 (616) 676-6753

Incorporated in 1969 in MI.
Donor(s): Richard M. DeVos, Helen J. DeVos.
Financial data (yr. ended 12/31/86): Assets,
$11,945,149 (M); gifts received, $1,550,000;
expenditures, $1,581,145, including
$1,557,808 for 88 grants (high: $408,500; low:
$31; average: $1,000-$25,000).
Purpose and activities: Giving largely for
religious programs and associations, church
support, music, and the performing arts, higher
education, and social welfare.
Types of support: General purposes.
Application information:
 Write: Richard M. DeVos, Pres.
Officers: Richard M. DeVos, Pres.; Helen J.
DeVos, V.P.; Otto Stolz, Secy.; James
Rosloniec, Treas.
Employer Identification Number: 237066873

1280
Edward & Ruth Diehl Foundation
30285 Hickory Ln.
Franklin 48025

Established in 1948 in MI.
Financial data (yr. ended 12/31/87): Assets,
$1,249,621 (M); expenditures, $67,348,
including $51,500 for 10 grants (high: $20,000;
low: $1,000).
Purpose and activities: Support primarily for
health organizations and the arts.
Application information:
 Initial approach: Letter
 Deadline(s): None

Write: Gerald W. Diehl, Pres.
Officers: Gerald W. Diehl, Pres.; Charles E.
Diehl, V.P.; Gregg A. Diehl, V.P.; Robert W.
Wilson, Secy.
Employer Identification Number: 386089393

1281
The Herbert & Junia Doan Foundation
3801 Valley Dr.
Midland 48640-2626

Donor(s): Herbert D. Doan.
Financial data (yr. ended 12/31/87): Assets,
$1,887,152 (M); expenditures, $66,393,
including $54,740 for 44 grants (high: $12,000;
low: $25).
Purpose and activities: Support primarily for
community funds, science and the arts.
Officers: Herbert D. Doan, Pres.; Junia Doan,
Exec. V.P.; Jeffrey W. Doan, V.P.
Employer Identification Number: 386078714

1282
Dow Corning Corporate Contributions
Program
P.O. Box 0994
Midland 48686-0994 (517) 496-6290

Financial data (yr. ended 12/31/88): Total
giving, $1,899,000, including $1,596,545 for
grants, $30,000 for 15 grants to individuals
(high: $3,000; low: $1,000; average: $1,000-
$3,000) and $272,455 for 1,234 employee
matching gifts.
Purpose and activities: Support for performing
arts, libraries, museums, and public
broadcasting in communitites where employees
work and live. Also supports general,
economic, and science education, public and
private colleges, the United Way, business and
civic affairs, youth organizations, hospitals, and
engineering programs.
Types of support: Capital campaigns,
employee matching gifts, matching funds, seed
money, general purposes, employee-related
scholarships.
Limitations: Giving primarily in Midland and
Hemlock, MI; Carollton and Elizabethtown, KY;
Greensboro, NC; and Springfield, OR. No
support for political, veterans' or religious
organizations, or athletic activities at the
college/university level. Generally, no
contributions of company products, materials,
or equipment.
Publications: Informational brochure (including
application guidelines).
Application information: Include
organization's history, board list, donor list,
sources of income and their percentage of the
budget, percentage of yearly income expended
in fundraising, administrative and general
program services, 501(c)(3), purpose, impact,
and amount requested.
 Initial approach: Letter
 Copies of proposal: 1
 Deadline(s): None
 Board meeting date(s): Monthly
 Write: Anne M. DeBoer, Mgr., Corp.
 Contribs. Comm.

1283
Herbert H. and Barbara C. Dow Foundation
2301 West Sugnet Rd.
Midland 48642

Incorporated in 1957 in MI.
Donor(s): Herbert H. Dow.
Financial data (yr. ended 12/31/87): Assets, $9,597,361 (M); expenditures, $335,816, including $316,000 for 24 grants (high: $50,031; low: $200).
Purpose and activities: Emphasis on higher education, cultural programs, and community funds.
Types of support: Equipment, continuing support, general purposes.
Limitations: Giving primarily in MI.
Application information:
 Initial approach: Letter
 Board meeting date(s): Annually
 Write: Herbert H. Dow, Pres.
Officers and Trustees: Herbert H. Dow, Pres.; Barbara C. Dow, Secy.-Treas.; Willard H. Dow II.
Employer Identification Number: 386058513

1284
The Herbert H. and Grace A. Dow Foundation
P.O. Box 2184
Midland 48641-2184 (517) 636-2482

Trust established in 1936 in MI.
Donor(s): Grace A. Dow.†
Financial data (yr. ended 12/31/87): Assets, $263,538,518 (M); gifts received, $6,891; expenditures, $11,111,260, including $9,195,045 for 144 grants (high: $499,983; low: $26; average: $23,000-$255,000).
Purpose and activities: "Support of the arts, and especially of the symbiotic relationship between the arts and sciences." Grants largely for education, particularly higher education, community and social services, civic improvement, conservation, scientific research, church support, and cultural programs; maintains a public horticultural garden.
Types of support: General purposes, building funds, equipment, operating budgets, annual campaigns, endowment funds, research, special projects, renovation projects.
Limitations: Giving limited to MI, primarily Midland County. No grants to individuals, or for scholarships, travel, or conferences; no loans.
Publications: Annual report, application guidelines, program policy statement.
Application information:
 Initial approach: Proposal
 Copies of proposal: 1
 Deadline(s): None
 Board meeting date(s): Bimonthly
 Final notification: 2 months
 Write: Herbert H. Dow, Pres.
Officers and Trustees: Herbert H. Dow, Pres. and Treas.; Dorothy D. Arbury, V.P.; Herbert D. Doan, Secy.; Julie Carol Arbury, Michael L. Dow, I. Frank Harlow, Margaret Ann Riecker.
Number of staff: None.
Employer Identification Number: 381437485
Recent arts and culture grants:

Dow Gardens, Midland, MI, $1,250,400. For annual operating costs. 1987.
Midland Center for the Arts, Midland, MI, $825,000. To support Center, its groups, their programs, and Hall of Ideas. 1987.
Midland County Historical Society, Midland, MI, $250,000. For initial payment on pledge for reconstruction of original Herbert H. Dow laboratory complex. 1987.
Saginaw Valley State College, University Center, MI, $500,000. For payment on pledge for new Fine Arts Center. 1987.

1285
Earl-Beth Foundation
131 Kercheval Ctr., 3rd Level
Grosse Pointe Farms 48236 (313) 882-1577

Incorporated in 1944 in MI.
Donor(s): Earl Holley, Mrs. Earl Holley, Holley Carburetor Co.
Financial data (yr. ended 12/31/87): Assets, $7,096,762 (M); expenditures, $506,911, including $280,920 for 130 grants.
Purpose and activities: Giving for higher and secondary education, hospitals, child welfare, cultural programs, including music, and health.
Limitations: Giving primarily in MI. No grants to individuals, or for endowment funds.
Application information:
 Initial approach: Letter or telephone
 Copies of proposal: 1
 Board meeting date(s): May and Nov.
 Write: Danforth Holley, Pres.
Officers: Danforth Holley, Pres. and Treas.; Lisa Holley,* V.P.; Theodore Oldham, Secy.
Trustees: Danforth Earl Holley, Deborah Holley.
Employer Identification Number: 386055542

1286
C. K. Eddy Family Memorial Fund
c/o Second National Bank of Saginaw
101 North Washington Ave.
Saginaw 48607

Trust established in 1925 in MI.
Donor(s): Arthur D. Eddy.†
Financial data (yr. ended 6/30/87): Assets, $8,740,075 (M); expenditures, $574,526, including $367,721 for 21 grants (high: $60,290; low: $500) and $196,372 for loans to individuals.
Purpose and activities: Giving for hospitals, a community fund, musical and cultural activities, and aid to Saginaw public schools.
Types of support: Student loans, special projects, equipment.
Limitations: Giving limited to Saginaw County, MI.
Publications: Application guidelines.
Application information: Application form required.
 Deadline(s): For student loans, May 1; for grants under $5,000, the Monday before the weekly Thursday meeting; for grants over $5,000, 2 weeks prior to the bimonthly meeting on the 3rd Wednesday of the month
 Write: Denice McGlaughlin (Grants); Marsha Sieggreen (Student Loans)
Trustee: Second National Bank of Saginaw.
Employer Identification Number: 386040506

1287
Federal Screw Works Foundation, Inc.
2400 Buhl Bldg.
Detroit 48214-1229 (313) 963-2323

Financial data (yr. ended 06/30/88): Assets, $100,710 (M); expenditures, $8,590, including $8,116 for 13 grants (high: $2,250; low: $50).
Purpose and activities: Giving primarily for cultural activities, higher education, and community funds.
Types of support: General purposes, annual campaigns, capital campaigns.
Limitations: Giving primarily in MI.
Application information:
 Initial approach: Letter or proposal
 Copies of proposal: 1
 Deadline(s): None
 Write: D.L. Davis, Secy.-Treas.
Officer: D.L. Davis, Secy.-Treas.
Trustees: H.G. Harness, W.T. Zurschmiede, Jr., W.T. Zurschmiede III.
Employer Identification Number: 386088208

1288
Federal-Mogul Corporate Giving Program
P.O. Box 1966
Detroit 48235 (313) 354-9934

Purpose and activities: Supports arts and culture, higher and vocational education; also supports general health care, civic affairs, youth, and the United Way.
Limitations: Giving primarily in headquarters city and major operating locations.
Publications: Application guidelines.
Application information:
 Initial approach: Letter
 Deadline(s): None
 Write: Lonnie Ross, Secy., Corp. Contribs. Comm.

1289
Federal-Mogul Corporation Charitable Trust Fund
Federal-Mogul Corporation
P.O. Box 1966
Detroit 48235 (313) 354-9934

Established in 1952 in MI.
Donor(s): Federal-Mogul Corp.
Financial data (yr. ended 10/31/87): Assets, $624,317 (M); gifts received, $420,000; expenditures, $414,635, including $407,754 for 260 grants (high: $65,000; low: $25).
Purpose and activities: Support largely for educational and cultural projects, including employee matching gifts programs.
Types of support: Employee matching gifts, building funds, continuing support, annual campaigns, research, matching funds, general purposes.
Limitations: Giving primarily in Detroit, MI, and other areas where the foundation maintains major manufacturing or distribution facilities. No grants to individuals, or for endowments, scholarships, or fellowships; no loans.
Publications: Application guidelines.
Application information:
 Initial approach: Letter
 Copies of proposal: 1

Deadline(s): None
Board meeting date(s): May and Nov.
Write: Lonnie Ross, Secy., Corp. Contribs. Comm.
Board of Control: Leonard Gay, C.B. Grant, R.W. Hague, J.J. Zamoyski.
Trustee: National Bank of Detroit.
Employer Identification Number: 386046512

1290
Community Foundation of Greater Flint

North Bank Ctr., Suite 410
432 North Saginaw St.
Flint 48502-2013 (313) 767-8270

Established in MI in 1978.
Financial data (yr. ended 12/31/88): Assets, $13,721,111 (M); gifts received, $1,384,011; expenditures, $993,890, including $776,059 for 60 grants (high: $53,100; low: $500).
Purpose and activities: "To respond to current or emerging needs in the Genesee County, MI, area in conservation and environment, culture and the arts, education, health and human services."
Types of support: Annual campaigns, continuing support, general purposes, program-related investments, special projects.
Limitations: Giving limited to Genesee County, MI. No grants to individuals.
Publications: Annual report, informational brochure (including application guidelines).
Application information: Application form required.
Write: David K. Swenson, Exec. V.P.
Officers: Helen Philpott, Chair.; Webb F. Martin, Vice-Chair.; Arthur L. Tuuri, M.D., Pres.; David K. Swenson, Exec. V.P., Admin.; H. Halladay Flynn, Exec. V.P., Devel.; Laura B. Froats, Secy.-Treas.
Number of staff: 3 full-time professional; 1 full-time support.
Employer Identification Number: 382190667

1291
Benson and Edith Ford Fund

100 Renaissance Center, 34th Fl.
Detroit 48243 (313) 259-7777

Incorporated in 1943 in MI as the Hotchkiss Fund.
Donor(s): Benson Ford.†
Financial data (yr. ended 12/31/86): Assets, $7,293,703 (M); gifts received, $534,401; expenditures, $641,793, including $628,000 for 40 grants (high: $102,000; low: $1,000).
Purpose and activities: Giving for education, hospitals, community funds, and the arts; grants also for church support, child welfare, and youth agencies.
Limitations: No grants to individuals.
Application information: Awards generally limited to charities already favorably known to substantial contributors of the foundation.
Initial approach: Letter
Deadline(s): None
Write: P.V. Heftler, Secy.
Officers and Trustees:* Lynn F. Alandt,* Pres.; Pierre V. Heftler,* Secy.; Richard M. Cundiff, Treas.
Employer Identification Number: 386066333

1292
Eleanor and Edsel Ford Fund

100 Renaissance Center, 34th Fl.
Detroit 48243

Incorporated in 1944 in MI.
Donor(s): Eleanor Clay Ford.†
Financial data (yr. ended 12/31/86): Assets, $11,936,047 (M); expenditures, $57,719, including $40,000 for 1 grant.
Purpose and activities: Giving for higher and secondary education, the arts, including museums and an orchestra, a hospital, and a church.
Types of support: Building funds, scholarship funds, general purposes.
Limitations: Giving primarily in MI, with emphasis on Detroit. No grants to individuals.
Application information: Funds presently committed. Applications not accepted.
Board meeting date(s): Oct. or Nov.
Write: Pierre V. Heftler, Secy.
Officers: William Clay Ford,* Pres.; Pierre V. Heftler,* Secy.; Richard M. Cundiff, Treas.
Trustees:* Josephine F. Ford.
Number of staff: None.
Employer Identification Number: 386066331

1293
Walter and Josephine Ford Fund

100 Renaissance Ctr., 34th Fl.
Detroit 48243 (313) 259-7777

Incorporated in 1951 in MI.
Donor(s): Josephine F. Ford.
Financial data (yr. ended 12/31/86): Assets, $4,628,058 (M); gifts received, $1,786,366; expenditures, $362,417, including $347,964 for 114 grants (high: $51,500; low: $50).
Purpose and activities: Giving for education, community funds, the arts, including museums, and hospitals; grants also for Protestant church support, medical research, and youth and social agencies.
Limitations: Giving primarily in MI. No grants to individuals.
Application information: Awards generally limited to charities already favorably known to substantial contributors of the foundation.
Initial approach: Letter
Deadline(s): None
Write: Pierre V. Heftler, Secy.
Officers and Trustees:* Walter B. Ford II,* Pres.; Josephine F. Ford,* V.P.; Pierre V. Heftler,* Secy.; Richard M. Cundiff, Treas.
Employer Identification Number: 386066334

1294
William and Martha Ford Fund

100 Renaissance Center, 34th Fl.
Detroit 48243 (313) 259-7777

Incorporated in 1953 in MI.
Donor(s): William Clay Ford, Martha Firestone Ford.
Financial data (yr. ended 12/31/87): Assets, $2,324,320 (M); gifts received, $307,754; expenditures, $645,193, including $640,162 for 59 grants (high: $151,000; low: $50).
Purpose and activities: Giving primarily for higher and other education, and hospitals and medical research; support also for community

funds, child welfare, church support, the arts, and youth and social service agencies.
Limitations: No grants to individuals.
Application information: Awards generally limited to organizations known to the donors.
Initial approach: Letter
Deadline(s): None
Write: Pierre V. Heftler, Secy.
Officers: William Clay Ford,* Pres.; Pierre V. Heftler,* Secy.; Richard M. Cundiff, Treas.
Trustees:* Martha F. Ford.
Employer Identification Number: 386066335

1295
The Henry Ford II Fund

100 Renaissance Ctr., 34th Fl.
Detroit 48243 (313) 259-7777

Incorporated in 1953 in MI.
Donor(s): Henry Ford II.†
Financial data (yr. ended 12/31/86): Assets, $7,353,375 (M); gifts received, $772,857; expenditures, $1,004,019, including $992,557 for 44 grants (high: $120,000; low: $500; average: $500-$25,000).
Purpose and activities: Grants to cultural programs, education, a community fund, youth and social services, a Jewish welfare fund, civic and public affairs, and hospitals.
Limitations: No grants to individuals.
Application information: Funds presently committed. Applications not accepted.
Board meeting date(s): As needed
Write: Pierre V. Heftler, Secy.
Officers and Trustees: Pierre V. Heftler, Secy.; Richard M. Cundiff, Treas.
Number of staff: None.
Employer Identification Number: 386066332

1296
Ford Motor Company Fund

The American Rd.
Dearborn 48121 (313) 845-8711

Incorporated in 1949 in MI.
Donor(s): Ford Motor Co.
Financial data (yr. ended 12/31/88): Assets, $97,210,678 (L); gifts received, $85,671; expenditures, $20,033,056, including $17,749,689 for 1,424 grants (high: $1,300,000; low: $50; average: $12,500) and $2,080,727 for 11,977 employee matching gifts.
Purpose and activities: Support for education, including matching gifts for colleges and universities and basic research grants; community funds and urban affairs; hospitals; and civic and cultural programs.
Types of support: Matching funds, research, annual campaigns, equipment, general purposes, publications, conferences and seminars, employee matching gifts, continuing support, employee-related scholarships.
Limitations: Giving primarily in areas of company operations nation-wide, with special emphasis on Detroit and the rest of MI. No grants to individuals, or for building or endowment funds, scholarships, or fellowships.
Publications: Annual report, application guidelines, informational brochure.
Application information:
Initial approach: Letter

Copies of proposal: 1
Deadline(s): None
Board meeting date(s): Jan., Apr., June, and Oct.
Final notification: 6 months
Write: Leo J. Brennan, Jr., Exec. Dir.
Officers: Donald E. Petersen,* Pres.; S.A. Seneker, Treas.
Trustees:* William Clay Ford, Allan D. Gilmour, David N. McCammon, Henry R. Nolte, Jr., Peter J. Pestillo, Harold Poling, David Scott.
Number of staff: 4 full-time professional; 1 part-time professional.
Employer Identification Number: 381459376
Recent arts and culture grants:
American Architectural Foundation, DC, $50,000. 1988.
American Council for the Arts, NYC, NY, $5,000. 1988.
American Stage Company, Teaneck, NJ, $5,000. 1988.
American Symphony Orchestra League, DC, $25,000. 1988.
American Theater Company, Tulsa, OK, $5,000. 1988.
Art in the Stations, Detroit, MI, $50,000. 1988.
Art Institute of Chicago, Chicago, IL, $400,000. 1988.
Artrain, Detroit, MI, $7,500. 1988.
Artrain, Detroit, MI, $5,000. 1988.
Asia Society, NYC, NY, $5,000. 1988.
Asia Society, NYC, NY, $5,000. 1988.
Atlanta Arts Alliance, Atlanta, GA, $5,000. 1988.
Automotive Hall of Fame, Midland, MI, $25,000. 1988.
Birmingham-Bloomfield Symphony Orchestra, Birmingham, MI, $5,000. 1988.
Blair House Endowment Fund, DC, $100,000. 1988.
Boarshead Theater, Lansing, MI, $5,000. 1988.
Brooklyn Museum Fund, Brooklyn, NY, $5,000. 1988.
Buffalo Fine Arts Academy, Albright-Knox Art Gallery, Buffalo, NY, $5,000. 1988.
Business Committee for the Arts, NYC, NY, $5,000. 1988.
California Vehicle Foundation, Sacramento, CA, $50,000. 1988.
Center for Creative Studies: College of Art and Design, Detroit, MI, $10,000. 1988.
Chicago, City of, Chicago, IL, $20,000. For museum award. 1988.
Cincinnati Institute of Fine Arts, Cincinnati, OH, $5,000. 1988.
Cleveland Restoration Society, Cleveland, OH, $42,935. 1988.
Colonial Williamsburg Foundation, Williamsburg, VA, $5,000. 1988.
Colorado Springs Fine Arts Center, Colorado Springs, CO, $15,000. 1988.
Colorado Springs Symphony Orchestra Association, Colorado Springs, CO, $25,000. 1988.
Corcoran Gallery of Art, DC, $40,000. 1988.
Corcoran Gallery of Art, DC, $36,300. 1988.
Corporate Design Foundation, Boston, MA, $10,000. 1988.
Dallas Opera, Dallas, TX, $5,000. 1988.
Dallas Theater Center, Dallas, TX, $10,000. 1988.
Dearborn Orchestral Society, Dearborn, MI, $10,000. 1988.

Detroit Concert Band, Grosse Pointe Woods, MI, $11,200. 1988.
Detroit Focus, Detroit, MI, $7,500. For arts award. 1988.
Detroit Historical Society, Detroit, MI, $7,500. 1988.
Detroit Institute of Arts, Founders Society, Detroit, MI, $35,000. 1988.
Detroit Symphony Orchestra, Detroit, MI, $100,000. 1988.
Detroit Zoological Society, Detroit, MI, $80,000. 1988.
Edison Institute, Dearborn, MI, $100,000. 1988.
Field Museum of Natural History, Chicago, IL, $10,000. 1988.
Fords Theater Society, DC, $7,500. 1988.
Greater Washington Educational Telecommunications Association, DC, $16,000. 1988.
Harmonie Park Playhouse, Detroit, MI, $6,000. 1988.
Historic Connersville, Connersville, IN, $5,000. 1988.
Indiana State Symphony Society, Indianapolis, IN, $5,000. 1988.
Inter-American Music Friends, Silver Spring, MD, $5,000. 1988.
Interlochen Center for the Arts, Interlochen, MI, $25,000. 1988.
International Center of Photography, NYC, NY, $25,000. 1988.
International Center of Photography, NYC, NY, $5,000. 1988.
International Museum of Photography at George Eastman House, Rochester, NY, $50,000. 1988.
International Museum of Photography at George Eastman House, Rochester, NY, $25,700. 1988.
International Museum of Photography at George Eastman House, Rochester, NY, $10,000. 1988.
Japan Society, NYC, NY, $50,000. 1988.
John F. Kennedy Center for the Performing Arts, DC, $30,000. 1988.
Kansas City Ballet Association, Kansas City, MO, $25,000. 1988.
Kansas City Symphony, Kansas City, MO, $7,000. 1988.
Kentucky Center for the Arts Corporation, Louisville, KY, $5,000. 1988.
Kentucky Dance Council, Louisville, KY, $22,000. 1988.
Kentucky Dance Council, Louisville, KY, $7,500. 1988.
Lincoln Center for the Performing Arts, NYC, NY, $5,000. 1988.
Lorain Civic Center Committee, Lorain, OH, $15,000. 1988.
Los Angeles County Museum of Natural History Foundation, Los Angeles, CA, $5,000. 1988.
Louisville Orchestra, Louisville, KY, $15,000. 1988.
Louisville Zoo Foundation, Louisville, KY, $5,000. 1988.
Lyric Chamber Ensemble, Southfield, MI, $5,000. 1988.
Marcel Marceau World Center for Mime, Ann Arbor, MI, $5,000. 1988.
Metropolitan Museum of Art, NYC, NY, $1,300,000. 1988.
Michigan Opera Theater, Detroit, MI, $50,000. 1988.

Missouri Botanical Garden, Saint Louis, MO, $5,000. 1988.
Museum of African American History, Detroit, MI, $25,000. 1988.
Museum of Modern Art, NYC, NY, $10,000. 1988.
Music Hall Center for the Performing Arts, Detroit, MI, $20,000. 1988.
Nashville Symphony Association, Nashville, TN, $5,000. 1988.
National Black Arts Festival, Atlanta, GA, $5,000. 1988.
National Gallery of Art, DC, $550,000. 1988.
National Tennis Foundation and Hall of Fame, Newport, RI, $5,000. 1988.
New Playwrights Theater of Washington, DC, $5,000. 1988.
New York Historical Society, NYC, NY, $5,000. 1988.
Oakland University, Rochester, MI, $22,500. For support as part of Foundation's Performing Arts Program. 1988.
Orange County Performing Arts Center, Costa Mesa, CA, $25,000. 1988.
Park Forest Orchestra Association, Park Forest, IL, $5,000. 1988.
Performing Arts Council of the Music Center, Los Angeles, CA, $35,000. 1988.
Performing Arts Foundation of Kansas City, Kansas City, MO, $8,000. 1988.
Philadelphia Museum of Art, Philadelphia, PA, $50,000. 1988.
Pierpont Morgan Library, NYC, NY, $175,000. 1988.
Playhouse Square Foundation, Cleveland, OH, $25,000. 1988.
Plimoth Plantation, Plymouth, MA, $10,000. 1988.
Plymouth Historical Society, Plymouth, MI, $15,000. 1988.
Princeton University, Princeton, NJ, $30,515. For museum award. 1988.
Renaissance Concerts, West Bloomfield, MI, $7,500. 1988.
Saint Louis Symphony Society, Saint Louis, MO, $15,000. 1988.
San Jose Symphony Association, San Jose, CA, $10,000. 1988.
Spoleto Festival USA, Charleston, SC, $75,000. 1988.
Studio Museum in Harlem, NYC, NY, $10,000. 1988.
Supreme Court Historical Society, DC, $10,000. 1988.
Toledo Zoological Society, Toledo, OH, $5,000. 1988.
Trust for Museum Exhibitions, DC, $45,000. 1988.
Tulsa Opera, Tulsa, OK, $5,000. 1988.
Tulsa Philharmonic Society, Tulsa, OK, $5,000. 1988.
University Cultural Center Association, Detroit, MI, $10,000. 1988.
University Musical Society, Ann Arbor, MI, $20,000. 1988.
University of Colorado, Boulder, CO, $7,500. For performing arts award. 1988.
W Q E D Metropolitan Pittsburgh Public Broadcasting, Pittsburgh, PA, $25,000. 1988.
W T V S Detroit Educational Television Foundation, Detroit, MI, $25,000. 1988.
Washington Drama Society, DC, $75,000. 1988.

Washington Project for the Arts (WPA), DC, $30,000. 1988.

Whitney Museum of American Art, NYC, NY, $5,000. 1988.

Zoological Society of Middle Tennessee, Nashville, TN, $5,000. 1988.

1297
The Fremont Area Foundation
108 South Stewart
Fremont 49412 (616) 924-5350

Community foundation incorporated in 1951 in MI.

Financial data (yr. ended 12/31/87): Assets, $22,507,751 (M); gifts received, $290,654; expenditures, $1,308,124, including $1,030,207 for 209 grants (high: $297,500; low: $400; average: $1,000-$20,000) and $69,220 for 113 grants to individuals.

Purpose and activities: Support for health, education, social welfare, civic responsibilities, arts and culture, character building, and rehabilitation.

Types of support: Operating budgets, seed money, emergency funds, student aid, matching funds, consulting services, equipment, general purposes, renovation projects, special projects.

Limitations: Giving primarily in Newaygo County, MI. No grants to individuals (except for scholarships from specified funds of the foundation), or for endowments, contingencies, reserves, or deficit financing; no loans.

Publications: Annual report, application guidelines, informational brochure, newsletter.

Application information:
Initial approach: Letter or telephone to arrange interview
Copies of proposal: 8
Deadline(s): Oct. 1
Board meeting date(s): Usually in Feb., Apr., July, and Nov.
Final notification: 3 months
Write: Bertram W. Vermeulen, Exec. Dir.

Officers: Kenneth B. Peirce,* Pres.; Maynard DeKryger,* V.P.; Bertram W. Vermeulen, Secy. and Exec. Dir.; Virginia Gerber,* Treas.

Trustees:* Gay G. Cummings, Sally DeShetler, Richard Hogancamp, Douglas M. Jeannero, L. Max Lee, Gerald E. Martin, Dean H. Morehouse, Dennis C. Nelson, William A. Rottman, Eric W. Ruder, Ross G. Scott, Philip T. Smith.

Number of staff: 3 full-time professional; 1 full-time support; 1 part-time support.

Employer Identification Number: 381443367

1298
Frey Foundation
200 Ottowa Ave.
Grand Rapids 49503 (616) 451-7212

Established in 1974 in MI.

Donor(s): Edward J. Frey, Sr.

Financial data (yr. ended 12/31/86): Assets, $236,899 (M); gifts received, $405,013; expenditures, $261,227, including $260,600 for 50 grants (high: $50,000; low: $25).

Purpose and activities: Giving primarily for the arts, Protestant religion, and social services.

Types of support: General purposes.

Application information:
Deadline(s): None
Write: Edward J. Frey, Sr., Pres.

Officers and Directors: Edward J. Frey, Sr., Pres.; Frances T. Frey, V.P.; David G. Frey, Secy.-Treas.; Edward J. Frey, Jr., John M. Frey, Mary Frey Rottschafer.

Employer Identification Number: 237094777

1299
Fruehauf Corporate Giving Program
c/o Robert D. Rowan
10900 Harper Ave.
Detroit 48213 (313) 267-1034

Financial data (yr. ended 12/31/87): Total giving, $278,000, including $247,500 for grants (high: $5,000; low: $500; average: $1,000-$5,000) and $30,500 for 73 employee matching gifts.

Purpose and activities: Supports community and civic affairs, fine and performing arts, general and economic education, and public and private colleges. Community funding includes economic development, youth service, and the United Way. Types of support include donations of company's primary goods or services, use of company facilities, volunteer recruitment, and employee volunteer programs.

Types of support: In-kind gifts, building funds, general purposes, special projects, employee matching gifts.

Limitations: Giving primarily in headquarters city and operating locations.

Publications: Corporate report.

Application information: Include project description and 501(c)(3) status.
Initial approach: Proposal
Copies of proposal: 1
Deadline(s): None
Write: Howard O. Emorey, V.P. and Treas.

1300
The Fruehauf Foundation
100 Maple Park Blvd., Suite 106
St. Clair Shores 48081-2254 (313) 774-5130

Incorporated in 1968 in MI.

Donor(s): Angela Fruehauf, and others.

Financial data (yr. ended 12/31/86): Assets, $2,373,229 (M); gifts received, $19,299; expenditures, $197,013, including $186,950 for 95 grants (high: $20,000; low: $100).

Purpose and activities: Grants primarily for educational institutions, cultural programs, hospitals, health agencies, welfare, including youth agencies, economic research, and churches and religious programs.

Limitations: Giving primarily in MI.

Application information:
Initial approach: Letter
Deadline(s): None; applications reviewed monthly
Board meeting date(s): As required
Write: Elizabeth J. Woods, Asst. Secy.

Officers and Trustees: Harvey C. Fruehauf, Jr., Pres.; Ann F. Bowman, V.P. and Treas.; Barbara F. Bristol, V.P.; Frederick R. Keydel, Secy.

Employer Identification Number: 237015744

1301
General Motors Corporate Giving Program
3044 West Grand Blvd.
Detroit 48202 (313) 556-4260

Financial data (yr. ended 12/31/87): $35,712,279 for grants (average: $500-$10,000).

Purpose and activities: Support for higher education, with special emphasis on graduate business and undergraduate engineering programs at nationally recognized universities where GM traditionally seeks new hires. With regard to contributions to health and welfare organizations, the company actively supports the concept of "United Giving" rather than contributing to organizations on an individual basis; accordingly, sizeable contributions made to the United Way in various communities throughout the U.S. GM also supports culture and arts, and public policy and economic education organizations that are located in GM communities or have a positive impact upon GM business.

Types of support: Building funds, equipment, general purposes, operating budgets, renovation projects, special projects.

Limitations: Giving primarily in headquarters city and operating locations nationwide. No support for special interest groups or projects, or for elementary and secondary schools, medical and nursing schools, medical or other research not related to marketing or business, religious organizations when denominational or sectarian in purpose, or industrial affiliate programs. No grants to individuals, or for conferences, workshops, or seminars, endowment funds, journal or "goodwill" advertisements. Further, General Motors does not contribute its products for on-highway use.

Publications: Application guidelines, informational brochure.

Application information: Include project description and budget, financial report, and 501(c)(3) status.
Initial approach: Universities: contact GM Exec. Liaison. If no GM executive is assigned, contact the public affairs officer at the nearest GM facility; local organizations, contact nearest plant; national organizations, contact Detroit address
Deadline(s): None
Final notification: 5 to 6 weeks after letter is received
Write: John J. Nowicki, Dir., Corp. Contribs. and Special Projects

1302
General Motors Foundation, Inc.
13-145 General Motors Bldg.
3044 West Grand Blvd.
Detroit 48202 (313) 556-4260

Incorporated in 1976 in MI.

Donor(s): General Motors Corp.

Financial data (yr. ended 12/31/88): Assets, $172,221,509 (M); expenditures, $23,325,367 for 577 grants (high: $2,000,000; low: $110; average: $10,000-$100,000).

Purpose and activities: Grants largely for higher education, community funds, social

services, hospitals, health, cancer research, cultural programs, and urban and civic affairs.

Types of support: Operating budgets, continuing support, annual campaigns, seed money, emergency funds, building funds, equipment, land acquisition, research, publications, special projects, capital campaigns, renovation projects, technical assistance.

Limitations: Giving primarily in plant cities where company has significant operations. No support for special interest groups. No grants to individuals, or for deficit financing, endowment funds, or matching gifts; no loans.

Publications: Application guidelines.

Application information:

Initial approach: Letter

Copies of proposal: 1

Deadline(s): None

Board meeting date(s): Contributions committee meets annually

Final notification: 2 months

Write: J.J. Nowicki, Mgr.

Officers: J.E. Mischi, Pres.; L.J. Krain, Treas.

Trustees: R.T. O'Connell, Chair.; W.E. Hoglund, L.E. Reuss, F. Alan Smith, J.F. Smith, Robert B. Smith, Robert C. Stempel.

Number of staff: None.

Employer Identification Number: 382132136

Recent arts and culture grants:

Army Aviation Museum Foundation, Fort Rucker, AL, $16,667. For capital support. 1987.

Art Center College of Design, Pasadena, CA, $200,000. For development of computer graphics lab. 1987.

Art Center College of Design, Pasadena, CA, $50,000. For design staff scholarship. 1987.

Art in the Stations, Detroit, MI, $50,000. For Cobo Hall Mural Station. 1987.

Arts Council of Greater Lansing, Lansing, MI, $17,500. For operating support. 1987.

Automotive Hall of Fame, Midland, MI, $20,000. For capital support. 1987.

Center for Creative Studies: College of Art and Design, Detroit, MI, $30,000. For operating support. 1987.

Cleveland Institute of Art, Cleveland, OH, $10,000. For operating support. 1987.

Colonial Williamsburg Foundation, Williamsburg, VA, $5,000. For operating support. 1987.

Dayton Art Institute, Dayton, OH, $6,000. For operating support. 1987.

Dayton Performing Arts Fund, Dayton, OH, $15,000. For operating support. 1987.

Detroit Historical Society, Detroit, MI, $10,000. For operating support. 1987.

Detroit Institute of Arts, Founders Society, Detroit, MI, $25,000. For operating support. 1987.

Detroit Renaissance Foundation, Detroit, MI, $15,000. For International Freedom Festival. 1987.

Detroit Symphony Orchestra, Detroit, MI, $135,000. For operating support. 1987.

Flint Institute of Arts, Flint, MI, $7,500. For operating support. 1987.

Flint Institute of Music, Flint, MI, $7,500. For operating support. 1987.

Fords Theater, DC, $5,000. For operating support. 1987.

Greater Dayton Public Television, Dayton, OH, $10,000. For operating support. 1987.

Henry Ford Museum and Greenfield Village, Dearborn, MI, $25,000. For Auto in American Life exhibit. 1987.

Interlochen Center for the Arts, Interlochen, MI, $5,000. For scholarships for disadvantaged students. 1987.

International Museum of Photography at George Eastman House, Rochester, NY, $10,000. For capital support. 1987.

Japan Society, NYC, NY, $50,000. For special projects fund. 1987.

John F. Kennedy Center for the Performing Arts, DC, $100,000. For support designated for underwriting special programs. 1987.

John F. Kennedy Center for the Performing Arts, DC, $25,000. For operating support. 1987.

Lincoln Center for the Performing Arts, NYC, NY, $25,000. For operating support. 1987.

Metropolitan Museum of Art, NYC, NY, $5,000. For operating support. 1987.

Metropolitan Opera Centennial Fund Endowment Trust, NYC, NY, $20,000. For Endowment Trust--Centennial Fund. 1987.

Michigan Opera Theater, Detroit, MI, $22,500. For operating support. 1987.

Music Hall Center for the Performing Arts, Detroit, MI, $15,000. For operating support. 1987.

National Corporate Fund for Dance, NYC, NY, $10,000. For operating support. 1987.

National Symphony Orchestra, DC, $6,000. For operating support. 1987.

Niagara County Historical Society, Lockport, NY, $15,000. For operating support. 1987.

Oakland University, Meadow Brook Music Festival, Rochester, MI, $20,000. For operating support. 1987.

R.E. Olds Transportation Museum Association, Lansing, MI, $20,000. For Merry Oldsmobile exhibit. 1987.

Renaissance Theater, Mansfield, OH, $10,000. For operating support. 1987.

Rochester Museum and Science Center, Rochester, NY, $10,000. For contribution for renovation and expansion. 1987.

Tuskegee University, School of Engineering and Architecture, Tuskegee, AL, $20,000. 1987.

University Cultural Center Association, Detroit, MI, $10,000. For operating support of Detroit Festival. 1987.

W T V S Detroit Educational Television, Detroit, MI, $5,200. For operating support. 1987.

W T V S Detroit Educational Television Foundation, Detroit, MI, $16,000. For operating support. 1987.

W T V S Detroit Educational Television Foundation, Detroit, MI, $16,000. For operating support. 1987.

Woodruff Arts Center, Atlanta, GA, $10,000. For operating support. 1987.

1303

The Rollin M. Gerstacker Foundation

P.O. Box 1945

Midland 48640 (517) 631-6097

Incorporated in 1957 in MI.

Donor(s): Eda U. Gerstacker,† Carl A. Gerstacker.

Financial data (yr. ended 12/25/88): Assets, $75,641,488 (M); expenditures, $1,643,215,

including $1,491,233 for 98 grants (high: $120,000; low: $1,000; average: $5,000-$25,000).

Purpose and activities: To assist community projects, with emphasis on the aged and youth; grants also for higher education (including seminaries), health care, a medical research institute, and a hospital.

Types of support: Annual campaigns, seed money, emergency funds, building funds, equipment, endowment funds, research, matching funds, general purposes, continuing support, land acquisition, capital campaigns.

Limitations: Giving primarily in MI and OH. No grants to individuals, or for scholarships or fellowships; no loans.

Publications: Annual report.

Application information:

Initial approach: Letter

Copies of proposal: 1

Deadline(s): May 15 and Nov. 15

Board meeting date(s): June and Dec.

Final notification: 1 month

Write: E.N. Brandt, V.P.

Officers and Trustees: Gail E. Allen, Pres.; E.N. Brandt, V.P. and Secy.; Carl A. Gerstacker, V.P. and Treas.; Gilbert A. Currie, Esther S. Gerstacker, Lisa J. Gerstacker, Julius Grosberg, Paul F. Oreffice, Alan W. Ott, William D. Schuette.

Number of staff: None.

Employer Identification Number: 386060276

Recent arts and culture grants:

Chippewa Nature Center, Midland, MI, $13,000. 1987.

Historical Society of Michigan, Ann Arbor, MI, $5,000. 1987.

Midland Center for the Arts, Midland, MI, $10,500. 1987.

Midland County Historical Society, Midland, MI, $7,250. 1987.

Midland Music Society, Midland, MI, $9,750. 1987.

1304

Gordy Foundation, Inc.

2648 West Grand Blvd.

Detroit 48208 (313) 867-0991

Established in 1967 in MI.

Donor(s): Jobete Music Co., Inc.

Financial data (yr. ended 6/30/88): Assets, $1,177,596 (M); gifts received, $25,022; expenditures, $71,692, including $59,050 for 25 grants (high: $20,000; low: $50).

Purpose and activities: Giving primarily for education and community activities; some support for religious and cultural activities.

Types of support: Building funds, scholarship funds, general purposes.

Limitations: Giving primarily in MI and CA. No grants to individuals.

Application information:

Deadline(s): None

Write: Esther Edwards, V.P.

Officers and Directors: Berry Gordy, Pres.; Esther Edwards, V.P. and Secy.; Gwen Fuqua, Treas.

Employer Identification Number: 386149511

1305
Gossett Fund
505 North Woodward Ave., Suite 3000
Bloomfield Hills 48013-7166

Established in 1955 in MI.
Donor(s): William T. Gossett.
Financial data (yr. ended 9/30/87): Assets,
$1,229,244 (M); expenditures, $65,512,
including $62,700 for 24 grants (high: $10,000;
low: $100).
Purpose and activities: Giving primarily for
higher education; support also for cultural and
historical organizations.
Application information: Contributes only to
pre-selected organizations. Applications not
accepted.
Officers and Trustees: William T. Gossett,
Pres. and Treas.; William T. Gossett, Jr., V.P.;
Kathryn M. Gossett, Joyce S. Korson.
Employer Identification Number: 386061739

1306
Grand Haven Area Community
Foundation, Inc.
One South Harbor, Suite 3
Grand Haven 49417 (616) 842-6378

Incorporated in 1971 in MI.
Financial data (yr. ended 4/30/88): Assets,
$3,618,556 (M); gifts received, $338,601;
expenditures, $287,500, including $198,031
for 47 grants (high: $16,200; low: $65;
average: $2,000-$5,000), $13,500 for 67
grants to individuals and $13,160 for 45 loans
to individuals.
Purpose and activities: Support for education,
recreation, culture, social services, civic affairs,
community development, and youth.
Types of support: Seed money, matching
funds, student loans, capital campaigns,
equipment, general purposes, special projects.
Limitations: Giving primarily in the Tri-City
and northwest Ottawa County, MI, areas. No
grants to individuals (other than scholarships
and student loans), or for annual campaigns,
emergency or deficit financing, operating costs
or ongoing operating support, or endowments.
Publications: Annual report, informational
brochure (including application guidelines),
program policy statement, application
guidelines.
Application information: For student loans,
request application form. Application form
required.
 Initial approach: Proposal, letter, or
 telephone call
 Copies of proposal: 10
 Deadline(s): Quarterly
 Board meeting date(s): Quarterly
 Final notification: 1 week after board meeting
 Write: Linda B. Strevy, Dir.
Officers and Trustees: Gary L. Verplank,
Pres.; Nancy Riekse, V.P. and Chair.,
Distribution Comm.; Bob Swart, Secy.; Mary
Jacobson, Treas.; Kenneth Harestad, George
Jackoboice, Marion Sherwood, Doris Van Dam.
Number of staff: 1 full-time professional.
Employer Identification Number: 237108776

1307
Grand Rapids Foundation
209-C Waters Bldg.
161 Ottawa, N.W.
Grand Rapids 49503 (616) 454-1751

Community foundation established in 1922 in
MI by resolution and declaration of trust.
Financial data (yr. ended 6/30/88): Assets,
$36,847,797 (M); gifts received, $340,680;
expenditures, $2,084,025, including
$1,764,824 for 74 grants (high: $240,000; low:
$288; average: $288-$240,000), $67,083 for
91 grants to individuals, $14,000 for 6 loans to
individuals and $41,660 for in-kind gifts.
Purpose and activities: To provide support for
projects or causes designed to benefit the
people and the quality of life in the Grand
Rapids community and its environs, through
grants for social welfare, youth agencies,
cultural programs, health, recreation,
neighborhood development, the environment,
and education, including scholarships for Kent
County residents to attend selected colleges.
Types of support: Seed money, emergency
funds, building funds, equipment, land
acquisition, matching funds, scholarship funds,
capital campaigns, consulting services, loans,
renovation projects, special projects, technical
assistance, student aid, employee-related
scholarships.
Limitations: Giving limited to Kent County,
MI. No grants to individuals (except for
scholarships), or for continued operating
support, annual campaigns, deficit financing, or
endowment funds; no student loans.
Publications: Annual report, informational
brochure (including application guidelines),
newsletter.
Application information: The student loan
program has been discontinued; new loans will
not be made. Application form required.
 Initial approach: Letter or telephone
 Copies of proposal: 12
 Deadline(s): Submit scholarship applications
 between Jan. 1 and Apr. 1; deadline for all
 other applications is 8 weeks preceding
 board meeting
 Board meeting date(s): Bimonthly beginning
 in Aug.
 Final notification: June 15 for scholarships; 1
 month for other requests
 Write: Diana R. Sieger, Exec. Dir.
Officer: Diana R. Sieger, Exec. Dir.
Trustees: Norman B. DeGraaf, Chair.; Herbert
L. Vander Mey, Vice-Chair.; David G. Frey,
Benjamin F. Gibson, Jane H. Idema, David B.
LaClaire, Ernest A. Mika, Robert L. Sadler, C.
Christopher Worfel.
Trustee Banks: Michigan National Bank, NBD
Grand Rapids, N.A., Old Kent Bank & Trust Co.
Number of staff: 3 full-time professional.
Employer Identification Number: 386032912
Recent arts and culture grants:
Chamber Choir of Grand Rapids, Grand
 Rapids, MI, $5,000. For computerization.
 1987.
Combined Arts Campaign, Grand Rapids, MI,
 $110,000. 1987.
Council of Performing Arts for Children, Grand
 Rapids, MI, $5,000. For touring
 performances. 1987.

Grand Rapids Art Museum, Grand Rapids, MI,
 $15,000. For auditorium improvements.
 1987.
Grand Rapids Art Museum, Grand Rapids, MI,
 $5,000. For computerization update. 1987.
Grand Rapids Civic Ballet, Grand Rapids, MI,
 $7,000. For costumes and sets. 1987.
Ladies Literary Club of Greater Grand Rapids
 Michigan, Grand Rapids, MI, $20,000. For
 building restoration. 1987.
Opera Grand Rapids, Grand Rapids, MI,
 $7,500. For market study. 1987.
Saint Cecilia Music Society, Grand Rapids, MI,
 $20,000. For restoration campaign. 1987.
Wyoming Community Television, Wyoming,
 MI, $13,000. For remote broadcast vehicle.
 1987.

1308
Great Lakes Bancorp Corporate Giving
Program
401 East Liberty
P.O. Box 8600
Ann Arbor 48107 (313) 769-8300

Financial data (yr. ended 12/31/88):
$120,000 for grants.
Purpose and activities: Supports health,
welfare, the arts and culture, civic affairs,
education, and community programs, and
United Way.
Types of support: Capital campaigns, special
projects, operating budgets.
Limitations: Giving primarily in headquarters
city and branch office locations.
Publications: Application guidelines.
Application information: Include project
description and budget, list of board members
and donors and 501(c)(3).
 Initial approach: Letter
 Deadline(s): None
 Final notification: 8 weeks
 Write: James S. Patterson, Mgr., Corp.
 Communications

1309
Herrick Foundation
2500 Comerica Bldg.
Detroit 48226 (313) 963-6420

Incorporated in 1949 in MI.
Donor(s): Ray W. Herrick,† Hazel M. Herrick.†
Financial data (yr. ended 9/30/87): Assets,
$213,693,392 (M); expenditures, $8,677,641,
including $8,446,600 for 192 grants (high:
$1,000,000; low: $500; average: $5,000-
$100,000).
Purpose and activities: Emphasis on higher
and secondary education, including scholarship
and capital funds, Protestant church support,
cultural programs, youth agencies, hospitals,
and health and welfare agencies.
Types of support: Building funds, equipment,
land acquisition, research, scholarship funds,
special projects, general purposes.
Limitations: Giving primarily in MI. No grants
to individuals.
Application information:
 Initial approach: Letter
 Deadline(s): None
 Board meeting date(s): Every 2 to 3 months
 Write: Kenneth G. Herrick, Pres.

Officers: Kenneth G. Herrick,* Chair., Pres., and Treas.; John W. Gelder, V.P. and Secy.; Todd W. Herrick, V.P.
Trustees:* Catherine R. Cobb, Richard B. Gushee,* V.P.
Number of staff: None.
Employer Identification Number: 386041517
Recent arts and culture grants:
Bruce Museum Associates, Greenwich, CT, $25,000. 1987.
Detroit Zoological Society, Detroit, MI, $100,000. Toward establishing proposed chimpanzee exhibit, Chimp House. 1987.
Detroit Zoological Society, Detroit, MI, $5,000. For general support. 1987.
Edison Institute, Dearborn, MI, $1,000,000. Toward costs and expenses in developing completely new, permanent exhibition of its internationally renowned transportation collection. 1987.
Ella Sharp Museum Association, Jackson, MI, $40,000. For general support. 1987.
Grace English Evangelical Lutheran Church, Tecumseh, MI, $5,000. For general support, including defraying, in part, cost of choir robes and to be added to Organ Fund. 1987.
Greater Palm Beach Symphony Association, Palm Beach, FL, $25,000. For general support. 1987.
Jonesville Heritage Association, Jonesville, MI, $10,000. For general support. 1987.
Lenawee Community Chorus, Adrian, MI, $5,000. For general support. 1987.
Michigan State University, East Lansing, MI, $100,000. To continue Catherine Herrick Cobb Scholarship Program established, and sponsored by, its Wharton Center for the Performing Arts. 1987.
Public Broadcasting Foundation of Northwest Ohio, Toledo, OH, $50,000. For general support. 1987.
Sculptors Guild, NYC, NY, $5,000. For general support. 1987.
South Michigan Railroad Society, Clinton, MI, $25,000. For general support. 1987.
Spanish Institute, NYC, NY, $50,000. For general support. 1987.
Toledo Museum of Art, Toledo, OH, $100,000. For general support. 1987.
Toledo Orchestra Association, Toledo, OH, $50,000. For general support. 1987.

1310
The Clarence and Jack Himmel Foundation
3000 Town Center, Suite 2550
Southfield 48075

Established in 1975 in MI.
Donor(s): Clarence Himmel.†
Financial data (yr. ended 10/31/86): Assets, $1,542,455 (M); expenditures, $100,974, including $65,750 for 60 grants (high: $5,000; low: $250).
Purpose and activities: Emphasis on family and child welfare services and youth agencies; grants also for hospitals, Jewish welfare funds, health agencies, cultural programs, and the handicapped.
Limitations: Giving primarily in MI.
Officers and Directors: Robert A. Karbel, Pres. and Secy.; Sidney J. Karbel, V.P.; Ronald A. Rothstein, Treas.
Employer Identification Number: 510140773

1311
James and Lynelle Holden Fund
1026 Buhl Bldg.
Detroit 48226 (313) 962-4757

Incorporated in 1941 in MI.
Donor(s): James S. Holden,† Lynelle A. Holden.†
Financial data (yr. ended 12/31/87): Assets, $7,826,927 (M); expenditures, $925,573, including $833,871 for 49 grants (high: $150,000; low: $1,000; average: $2,500-$35,000).
Purpose and activities: Support for medical research, including medical schools and hospitals; aid to youth agencies, minority and underprivileged children, education, and care of the aged; grants also for cultural programs.
Types of support: Annual campaigns, general purposes, building funds, equipment, research, scholarship funds, fellowships, matching funds, continuing support, operating budgets.
Limitations: Giving primarily in MI, with emphasis on Detroit. No grants to individuals, or for endowment funds; no loans.
Application information:
 Initial approach: Letter or proposal
 Copies of proposal: 1
 Deadline(s): None
 Board meeting date(s): Jan., Apr., July, and Oct.
 Final notification: Several weeks
 Write: Joseph Freedman, Pres.
Officers and Trustees: Joseph Freedman, Pres. and Secy.; Louis F. Dahling, V.P.; Herbert J. Wilson, Treas.
Number of staff: 1 full-time professional; 1 part-time professional.
Employer Identification Number: 386052154

1312
The Holley Foundation
c/o Manufacturers National Bank Detroit
100 Renaissance Center, 7th Fl.
Detroit 48243

Established in 1944 in MI.
Financial data (yr. ended 12/31/87): Assets, $1,753,393 (M); expenditures, $138,067, including $96,500 for 20 grants (high: $10,000; low: $500).
Purpose and activities: Support for hospitals and health associations, including a rehabilitation center, and for education and cultural programs.
Officers: Margery H. Uihlein, Pres.; Douglas Rasmussen, Secy.
Directors and Trustees:* Walker L. Cisler,* A.J. Fisher,* Barbara K. Frank,* David C. Holley,* George M. Holley III,* John C. Holley, Sr.,* John C. Holley, Jr.,* Margaret Holley, Philipp Gregg Kuehn, Jr., Edmund R. Sutherland.*
Employer Identification Number: 386055168

1313
Hudson-Webber Foundation
333 West Fort St., Suite 1310
Detroit 48226 (313) 963-7777

Incorporated in 1943 in MI; on Jan. 1, 1984 absorbed The Richard H. and Eloise Jenks Webber Charitable Fund, Inc., and the Eloise and Richard Webber Foundation.
Donor(s): Eloise Webber,† Richard Webber,† The J.L. Hudson Co., The Richard H. and Eloise Jenks Webber Charitable Fund, The Eloise and Richard Webber Foundation, and members of the Webber family.
Financial data (yr. ended 12/31/87): Assets, $69,299,282 (M); gifts received, $5,000; expenditures, $3,249,369, including $2,372,676 for 82 grants (high: $250,000; low: $2,000; average: $10,000-$40,000) and $95,480 for 119 grants to individuals.
Purpose and activities: Concentrates efforts and resources in support of projects within six program missions, which impact upon the vitality and quality of life of the community: 1) growth and development of the Detroit Medical Center, 2) economic development of southeastern MI, with emphasis on the creation of additional employment opportunities, 3) physical revitalization of downtown Detroit, 4) enhancement of major art and cultural resources in Detroit, 5) reduction of crime in Detroit, and 6) charitable assistance of J. L. Hudson Company employees or ex-employees needing help to overcome personal crises and misfortunes.
Types of support: Operating budgets, continuing support, annual campaigns, seed money, building funds, matching funds, special projects, grants to individuals, equipment, consulting services, renovation projects, fellowships.
Limitations: Giving primarily in the Wayne, Oakland, and Macomb tri-county area of southeastern MI, particularly the Detroit metropolitan area. No support for educational institutions or neighborhood organizations, except for projects that fall within current program missions. No grants to individuals (except for J.L. Hudson Company employees and ex-employees), or for emergency funds, deficit financing, endowment funds, scholarships, fellowships, publications, conferences, fundraising social events, or exhibits; no loans.
Publications: Biennial report (including application guidelines).
Application information:
 Initial approach: Proposal
 Copies of proposal: 1
 Deadline(s): Apr. 15, Aug. 15 (for July and Dec. meetings), and Dec. 15 (for meeting in Apr. of following year)
 Board meeting date(s): July, Dec., and Apr.
 Final notification: 1 week after board decision
 Write: Gilbert Hudson, Pres.
Officers and Trustees: Joseph L. Hudson, Jr., Chair.; Gilbert Hudson, Pres. and C.E.O.; Hudson Holland, Jr., Secy.; Frank M. Hennessey, Treas.; Lawrence P. Doss, David Lawrence, Jr., Philip J. Meathe, Theodore H. Mecke, Jr., Mrs. Alan E. Schwartz.
Number of staff: 1 full-time professional; 1 full-time support; 1 part-time support.
Employer Identification Number: 386052131
Recent arts and culture grants:
Concerned Citizens for the Arts in Michigan, Detroit, MI, $30,000. For implementation of marketing and fundraising components of strategic plan. 4/7/88.

Detroit Center for the Performing Arts, Detroit, MI, $10,000. For general program needs. 7/14/88.

Detroit Institute of Arts, Founders Society, Detroit, MI, $75,000. For comprehensive strategic planning. 4/7/88.

Detroit Symphony Orchestra, Detroit, MI, $75,000. For general program needs. 7/14/88.

Edison Institute, Dearborn, MI, $150,000. For building and display improvements at Henry Ford Museum. 12/1/87.

Lyric Chamber Ensemble, Detroit, MI, $15,000. For audience development plan. 12/1/87.

Michigan Opera Theater, Detroit, MI, $30,000. For marketing plan. 12/1/87.

Millan Theater Company, Detroit, MI, $5,000. For general program needs of Detroit Repertory Theater. 7/14/88.

Roadside Attractions, Detroit, MI, $40,000. For Attic Theater's marketing plan. 12/1/87.

University Cultural Center Association, Detroit, MI, $25,000. For Cultural Center Planning Project. 4/7/88.

University Cultural Center Association, Detroit, MI, $15,000. For Detroit Arts Festival. 4/7/88.

1314
The Jackson Foundation
505 Wildwood Ave.
Jackson 49201 (517) 787-1321

Community foundation incorporated in 1948 in MI.

Financial data (yr. ended 12/31/88): Assets, $2,391,855 (M); gifts received, $172,307; expenditures, $124,121, including $84,691 for 20 grants (high: $18,100; low: $510; average: $500-$18,000).

Purpose and activities: Support for community improvement and other programs for the benefit of the residents of Jackson County.

Types of support: Seed money, building funds, equipment, land acquisition, matching funds, consulting services, technical assistance, loans, special projects, research, capital campaigns.

Limitations: Giving limited to Jackson County, MI. No support for religious purposes. No grants to individuals, or for endowment funds, scholarships, fellowships, publications, or conferences.

Publications: Annual report (including application guidelines).

Application information: Application form required.

 Initial approach: Letter or telephone
 Copies of proposal: 1
 Deadline(s): Submit proposal preferably in Jan., Apr., July, or Oct.; deadlines Feb. 1, May 1, Aug. 1, and Nov. 1
 Board meeting date(s): Mar., June, Sept., and Dec.
 Final notification: 6 weeks
 Write: Mrs. Jody Bacon, Exec. Dir.

Officers: Carl F. Spaeth, Jr., Pres.; Douglas L. Burdick,* V.P.; Marc Rosenfeld,* Secy.-Treas.; Jody Bacon, Exec. Dir.

Trustees:* Charles H. Aymond, Robert W. Ballantine, Jerry B. Booth, Richard Firestone,

Donna Hardy, Clara D. Noble, William Sigmund, James Winter, Susan Wrzesinski.

Number of staff: 1 part-time professional; 1 part-time support.

Employer Identification Number: 386070739

1315
JSJ Foundation
P.O. Box 687
Grand Haven 49417 (616) 842-6350

Established in 1983 in MI.

Donor(s): JSJ Corp.

Financial data (yr. ended 12/31/87): Assets, $349,336 (M); gifts received, $150,000; expenditures, $173,872, including $170,500 for grants (high: $30,000; low: $200).

Purpose and activities: Giving primarily to community funds; some support also for the arts, humanities, and cultural organizations, civic affairs, education, social service and youth organizations, and health associations.

Limitations: Giving primarily in locations where the corporation has facilities. No grants to individuals, or for exchange programs, fellowships, internships, lectureships, or professorships; no loans.

Application information:

 Deadline(s): None
 Write: Donald A. Johnson, Chair.

Officers: Donald A. Johnson,* Chair. and Secy.; Michael D. Metzger, Treas.

Trustees:* Alvin E. Jacobson, Martin Johnson, Paul A. Johnson, Lynne Sherwood.

Employer Identification Number: 382421508

1316
K Mart Corporate Giving Program
3100 West Big Beaver Rd.
Troy 48084 (313) 643-1000

Purpose and activities: Supports higher education and educational associations, arts, business education, public affairs, health, welfare, minority programs, national disease associations, community funding and United Way. Types of support include volunteer programs with retired company employees, in-kind donations, and employee gift matching for education and the arts.

Types of support: Employee matching gifts, general purposes, employee-related scholarships, in-kind gifts.

Limitations: Giving primarily in headquarters state and operating locations, including CA, CO, DE, FL, GA, IL, IN, IA, KY, NJ, NY, OH, PA, and PR. No support for religious organizations for religious purposes, charities supported by united funds, or secondary education. No grants to individuals, or for endowments or research.

Application information: Include organization's history, description of project's need, budget, involvement with K Mart clientele or employees, list of major donors, and 501(c)(3).

 Initial approach: Letter
 Deadline(s): None
 Board meeting date(s): Committee meets quarterly

Write: A. Robert Stevenson, V.P., Public and Government Affairs

Administrator: Linda M. Holsen, Contribs. Coord. and Secy., Contribs. Comm.

Number of staff: 1 full-time professional.

1317
Kalamazoo Foundation
151 South Rose St., Suite 332
Kalamazoo 49007 (616) 381-4416

Community foundation established in 1925; incorporated in 1930 in MI.

Financial data (yr. ended 12/31/88): Assets, $59,981,895 (M); gifts received, $4,965,772; expenditures, $7,135,239, including $6,455,977 for grants.

Purpose and activities: Grants largely for capital purposes, for education, primarily higher education, child welfare, youth agencies, music and the arts, a civic auditorium, and hospitals; support also for housing, care of the aged, aid to the handicapped, recreation, public health, and community development.

Types of support: Seed money, building funds, general purposes, emergency funds, research, publications, matching funds.

Limitations: Giving limited to Kalamazoo County, MI. No grants to individuals, or for endowment funds, scholarships, or fellowships.

Publications: Annual report, informational brochure, application guidelines.

Application information: Application form required.

 Initial approach: Telephone or letter
 Copies of proposal: 9
 Deadline(s): Apr. 1, Aug. 1, or Dec. 1
 Board meeting date(s): May, Sept, and Jan.
 Final notification: 2 months
 Write: John E. Hopkins, Exec. Dir.

Officers: William J. Lawrence, Jr.,* Pres.; Martha G. Parfet,* V.P.; John E. Hopkins, Exec. Dir.

Trustees and Distribution Committee:* Joseph J. Dunnigan, Judson A. Knapper, Elizabeth S. Upjohn.

Trustee Banks: Comerica Bank-Kalamazoo, First of America Bank-Michigan, Old Kent Bank of Kalamazoo.

Number of staff: 2 full-time professional; 2 full-time support.

Employer Identification Number: 386048002

1318
The Kantzler Foundation
900 Center Ave.
Bay City 48708 (517) 892-0591

Incorporated in 1974 in MI.

Donor(s): Leopold J. Kantzler.†

Financial data (yr. ended 12/31/87): Assets, $3,606,770 (M); expenditures, $165,115, including $138,910 for grants (high: $80,000; low: $566; average: $10,000).

Purpose and activities: To support projects and capital improvements of charitable, artistic, educational, and cultural organizations.

Types of support: Seed money, building funds, equipment, land acquisition, matching funds, capital campaigns.

Limitations: Giving limited to the greater Bay City, MI area. No grants to individuals, or for

endowment funds, operating budgets, continuing support, annual campaigns, special projects, publications, conferences, emergency funds, deficit financing, research, scholarships, or fellowships; no loans.

Publications: Program policy statement (including application guidelines), financial statement.

Application information:

Initial approach: Proposal

Copies of proposal: 1

Deadline(s): None

Board meeting date(s): Approximately 10 times a year

Final notification: 2 months

Write: Robert D. Sarow, Secy.

Officers: Dominic Monagtiere, Pres.; Clifford C. Van Dyke, V.P.; Robert D. Sarow, Secy.; Arthur E. Hagen, Jr.,* Treas.

Trustees:* Robbie L. Baker, Ruth Jaffe.

Number of staff: None.

Employer Identification Number: 237422733

Recent arts and culture grants:

Saginaw Valley State College, University Center, MI, $22,500. For capital campaign for fine arts facility, development of engineering curriculum and other projects. 11/7/85.

1319
Kaufman Foundation

716 Nims St.
Muskegon 49443

Established in 1959 in MI.

Financial data (yr. ended 10/31/87): Assets, $1,251,894 (M); gifts received, $100,000; expenditures, $22,103, including $19,850 for 11 grants (high: $5,000; low: $50).

Purpose and activities: Support for higher education, Jewish institutions, and museums.

Trustees: R.F. Kaufman, Sylvia C. Kaufman.

Employer Identification Number: 386091556

1320
The Miner S. & Mary Ann Keeler Fund

220 Monroe, N.W., Suite 440
Grand Rapids 49503

Incorporated in 1985 in MI as successor to the First Keeler Fund established in 1953, which transferred its assets to the new Keeler Fund in 1986.

Donor(s): The Keeler Fund.

Financial data (yr. ended 7/31/88): Assets, $1,858,767 (M); expenditures, $129,256, including $107,337 for 52 grants (high: $20,000; low: $50).

Purpose and activities: Support for education, and arts and culture.

Application information:

Initial approach: Letter

Deadline(s): None

Trustees: Isaac S. Keeler II, Mary Ann Keeler, Miner S. Keeler II.

Employer Identification Number: 382625402

1321
Kellogg Corporate Giving Program

One Kellogg Square
Battle Creek 49016-3599 (616) 961-2235

Purpose and activities: Support for areas where the company has a plant, subsidiary, or other important operation. Emphasis on 1)Education--in addition to colleges and universities receiving support through the company's matching gift program, consideration may be given to such organizations as the United Negro College Fund, independent state college foundations, and other similar organizations; 2)Research-- nutrition and/or certain programs conducted by universities related to research within the company's realm of interests; 3)Minority- oriented organizations--organizations designed to improve economic opportunities for members of minority groups; 4)Hospital building funds--funds for capital improvements to institutions (normally no funds contributed to support maintenance or operating funds); 5)Civic and Cultural--programs which are devoted to improving the quality of life and which have wide community and employee acceptance; 6)Health--organizations such as the American Dental Association for research related to the company's realm of interests. Occasional support is given to organizations such as Y Centers, Salvation Army, Boy Scouts, Girl Scouts, or similar programs which are popular in the community and do not receive funds from United Way in areas where the company has a significant operation; support also for disasters or emergencies and gifts of real or personal property.

Types of support: Equipment, employee matching gifts, in-kind gifts.

Limitations: Giving primarily in headquarters city and major operating locations in CA, MI, NE, PA, and TN; national programs also considered. No support for sectarian organizations. No grants to individuals, or for building or capital funds, operating budgets, or for United Way recipients.

Publications: Application guidelines.

Application information: Include organization's history, project description, budget, major donor list, and 501(c)(3). Interviews or on-site visits are arranged for large requests. Plant locations have their own budgets and decide on smaller local grants; larger and national requests are handled by headquarters.

Initial approach: Letter and proposal; local requests can be addressed to plants

Deadline(s): Aug. 31

Board meeting date(s): Committee meets in Apr. and Oct.

Final notification: Within 4 months

Write: Debra Price, Exec. Services Coord.

1322
W. K. Kellogg Foundation

400 North Ave.
Battle Creek 49017-3398 (616) 968-1611

Incorporated in 1930 in MI.

Donor(s): W.K. Kellogg,† W.K. Kellogg Foundation Trust.

Financial data (yr. ended 8/31/88): Assets, $3,162,546,321 (M); gifts received, $0; expenditures, $122,041,398, including $100,498,318 for 781 grants (high: $5,125,000; low: $50), $4,322,855 for 208 grants to individuals and $237,650 for 408 employee matching gifts.

Purpose and activities: "To receive and administer funds for educational and charitable purposes." Aid limited to programs concerned with application of existing knowledge rather than research. Supports pilot projects which, if successful, can be continued by initiating organization and emulated by other communities or organizations with similar problems. Current funding priorities include projects designed to improve human well-being through: adult continuing education; problem- focused community-based health services; a wholesome food supply; and broadening leadership capacity of individuals. In MI only, projects are supported for economic development and opportunities for youth. The following areas, which will receive limited funding, may become major interests in the future: the development of rural America, water resources, information management systems, philanthropy and voluntarism in America, and science education.

Types of support: Seed money, fellowships.

Limitations: Giving primarily in the U.S., Latin America, the Caribbean and southern African countries; support also for international fellowship programs in other countries. No support for religious purposes. No grants to individuals, or for building or endowment funds, research, development campaigns, films, equipment, publications, conferences, or radio and television programs unless they are an integral part of a project already being funded; no grants for operating budgets, annual campaigns, emergency funds, deficit financing, land acquisition, or renovation projects; no loans.

Publications: Annual report (including application guidelines), informational brochure (including application guidelines), newsletter.

Application information: Proposals must conform to specified program priorities.

Initial approach: Letter

Copies of proposal: 1

Deadline(s): None

Board meeting date(s): Monthly

Final notification: 3 months to 2 years

Write: Nancy A. Sims, Exec. Asst.- Programming

Officers: Russell G. Mawby,* Chair. and C.E.O.; Norman A. Brown,* Pres.; Laura A. Davis, V.P.-Corp. Affairs and Corp. Secy.; William W. Fritz, V.P.-Finance and Treas.; Karen R. Hollenbeck, V.P.-Admin.

Trustees:* Shirley Dunlap Bowser, Chris T. Christ, William N. Hubbard, Jr., Dorothy A. Johnson, Wenda W. Moore, Robert L. Raun, Fred Sherriff, Howard R. Sims, Jonathan T. Walton.

Number of staff: 46 full-time professional; 2 part-time professional; 73 full-time support; 2 part-time support.

Employer Identification Number: 381359264

Recent arts and culture grants:

Battle Creek Civic Art Center, Battle Creek, MI, $8,250. For 40th anniversary art show and to develop promotional brochure and slide

presentation. Grant made because of Foundation's response to special programming opportunities, and it is unlikely to make such a grant otherwise. 8/9/88.

Battle Creek Community United Arts Council, Battle Creek, MI, $20,000. To provide annual program subsidiaries. This grant was made because of Foundation's responsibility as corporate member of Greater Battle Creek Area. Foundation would not make such grant in any other community. 6/7/88.

Battle Creek Community United Arts Council, Battle Creek, MI, $20,000. To provide greater variety of programs by establishing special grants fund. This grant was made because of Foundation's responsibility as corporate member of Greater Battle Creek Area. Foundation would not make such grant in any other community. 6/30/88.

Battle Creek Community United Arts Council, Battle Creek, MI, $14,175. To increase art appreciation in Battle Creek by helping support traveling neighborhood Family Theater. Grant made because of Foundation's responsibility as corporate entity of Michigan, and it is unlikely to make such a grant in any other state. 7/28/88.

Battle Creek, City of, Battle Creek, MI, $19,926. To underwrite ticket costs for low-income youth attending Sesame Street production at Kellogg Center in Battle Creek. This grant was made because of Foundation's responsibility as corporate member of Greater Battle Creek Area. Foundation would not make such a grant in any other community. This grant bring total of Foundation assistance for project to $38,196. 2/10/88.

Battle Creek, City of, Battle Creek, MI, $12,000. To encourage pride of ownership and renovation of historical structures through survey of historical buildings in Battle Creek. Grant made because of Foundation's responsibility as corporate member of Greater Battle Creek Area. It would not make such a grant in any other community. 7/12/88.

Detroit Institute of Arts, Founders Society, Detroit, MI, $172,500. To promote understanding of various art forms and provide quality art experiences among Michigan youth. This grant brings total of Foundation assistance for this project to $322,500. This grant was made because of Foundation's responsibility as corporate entity of Michigan. It is unlikely Foundation would make such a grant in any other state. 10/15/87.

Historical Society of Battle Creek, Battle Creek, MI, $5,000. To share Battle Creek's rich heritage with citizens of Michigan through series of historical events to be held as part of state's sesquicentennial celebration. This grant was made because of Foundation's responsibility as corporate member of Greater Battle Creek Area. Foundation would not make such a grant in any other community. 9/29/87.

Jackson Community College, Jackson, MI, $64,400. To enable Rosier Players to continue bringing theatrical performances to rural Michigan residents by restoring Players' transport trucks. 11/25/87.

Junior League of Battle Creek, Battle Creek, MI, $10,000. To help youth develop their artistic, creative, and scientific abilities by conducting arts and science exhibit for students of Greater Battle Creek area. This grant brings total of Foundation assistance for project to $16,728. This grant was made because of Foundation's responsibility as corporate entity of Michigan. It is unlikely Foundation would make such a grant in any other state. 2/17/88.

Muskegon Public Schools, Muskegon, MI, $150,000. To provide understanding of various art forms and provide quality art experiences among Michigan youth. Grant made because of Foundation's responsibility as corporate entity of Michigan. It is unlikely Foundation would make such a grant in any other state. 3/24/88.

National Council of La Raza, DC, $40,000. To produce music video to promote educational alternatives for black and Hispanic school dropouts. Grant made because of Foundation's response to special programming opportunities, and it is unlikely to make such a grant otherwise. 8/30/88.

Northern Michigan University, Marquette, MI, $11,696. To motivate Upper Peninsula area school students' interest in math and science through dramatic presentation, A Dialogue with Einstein. This grant was because of Foundation's response to special programming opportunities. It is unlikely Foundation would make such grant otherwise. 6/30/88.

Saint Philips Lutheran Church and School, Detroit, MI, $5,074. For summer programs for Detroit youth focusing on neighborhood beautification and creative writing. Grant made because of Foundation's response to special programming opportunities, and it is unlikely to make such a grant otherwise. 7/29/88.

1323
Elizabeth E. Kennedy Fund

c/o John S. Dobson, Secy.
500 City Center Bldg.
Ann Arbor 48104 (313) 761-3780
Application address: c/o James N. Gamble, 301 East Colorado Blvd., Suite 402, Pasadena, CA 91101; Tel.: (818) 795-7583

Incorporated in 1954 in MI.
Donor(s): Elizabeth E. Kennedy.
Financial data (yr. ended 12/31/87): Assets, $2,042,753 (M); expenditures, $89,099, including $76,320 for 12 grants (high: $15,000; low: $1,000; average: $1,000–$10,000) and $6,000 for 2 foundation-administered programs.
Purpose and activities: Emphasis on higher education, the arts, conservation, health and family planning; preference is to provide seed money.
Types of support: Seed money, operating budgets, renovation projects, capital campaigns, equipment.
Limitations: Giving primarily in MI, with emphasis on less populated areas of the state.
Publications: Annual report (including application guidelines), 990-PF.
Application information:
Initial approach: Letter

Deadline(s): None
Board meeting date(s): Mar. and Sept.
Officers and Trustees: Elizabeth E. Kennedy, Pres.; John S. Dobson, Secy.; Ann K. Irish, Joan K. Slocum, William W. Slocum.
Number of staff: None.
Employer Identification Number: 386063463

1324
Kowalski Sausage Company Charitable Trust, Inc.

c/o Theresa Thorn, National Bank of Detroit
611 Woodward Ave.
Detroit 48232 (313) 225-3124

Financial data (yr. ended 12/31/87): Assets, $532,773 (M); expenditures, $71,977, including $65,750 for 97 grants (high: $3,000; low: $100).
Purpose and activities: Support for charitable purposes, religious organizations, cultural associations, medical research, and education programs.
Limitations: Giving primarily in MI.
Application information:
Deadline(s): None
Officers: Stephen Kowalski, Chair.; Donald Kowalski, Pres.
Trustees: Agnes Kowalski, Kenneth Kowalski, National Bank of Detroit.
Employer Identification Number: 386046508

1325
The Kresge Foundation

P.O. Box 3151
3215 West Big Beaver Rd.
Troy 48007-3151 (313) 643-9630

Incorporated in 1924 in MI.
Donor(s): Sebastian S. Kresge.†
Financial data (yr. ended 12/31/88): Assets, $1,097,329,727 (M); expenditures, $57,405,765, including $53,080,000 for 172 grants (high: $2,250,000; low: $25,000).
Purpose and activities: Challenge grants only for building construction or renovation projects, major capital equipment or an integrated system at a cost of at least $75,000 and purchase of real estate; grants generally to tax-exempt institutions involved in higher education (awarding baccalaureate and/or graduate degrees), health and long-term care, social services, science and environment, arts and humanities, and public affairs. Full accreditation is required for higher education and hospital applicants. The foundation does not grant initial funds or total project costs; grants are for a portion of the costs remaining at the time of grant approval. Special Program: The Kresge Foundation will accept applications for a challenge grant program to upgrade and endow scientific equipment and laboratories in colleges and universities, teaching hospitals, medical schools, and research institutions. Applications may be submitted from Apr. 1, 1988 through Mar. 31, 1990 whether or not a traditional bricks and mortar application has been submitted. For details, request a pamphlet entitled "The Kresge Foundation Science Initiative."

Types of support: Building funds, equipment, land acquisition, matching funds, renovation projects.

Limitations: No support for elementary or secondary schools. No grants to individuals, operating or special project budgets, furnishings, conferences, seminars, church building projects, endowment funds, student aid, scholarships, fellowships, research, debt retirement, completed projects, or general purposes; no loans.

Publications: Annual report, informational brochure (including application guidelines).

Application information: Application form required.

Initial approach: Letter or telephone
Copies of proposal: 1
Deadline(s): None
Board meeting date(s): Monthly
Final notification: Generally within 5 months; grants announced Feb. through June, and Sept. through Dec. for approvals, throughout the year for rejections
Write: Alfred H. Taylor, Jr., Chair.

Officers: Alfred H. Taylor, Jr.,* Chair.; John E. Marshall III, Pres. and Secy.; Thomas W. Herbert, V.P. and Treas.

Trustees:* George E. Cartmill, Jill K. Conway, Bruce A. Kresge, M.D., George D. Langdon, Jr., Edward H. Lerchen, Margaret T. Smith, Richard C. Van Dusen.

Number of staff: 8 full-time professional; 10 full-time support.

Employer Identification Number: 381359217

Recent arts and culture grants:

Agnes Scott College, Decatur, GA, $300,000. Toward renovation of Dana Fine Arts Building and Presser Hall. 3/88.

Albright College, Reading, PA, $250,000. Toward construction of center for arts. 9/88.

Ballet Hispanico of New York, NYC, NY, $200,000. Toward purchase and renovation of studio and administrative space. 6/88.

Brooklyn Historical Society, Brooklyn, NY, $75,000. Toward renovation of facility for Shellens Gallery. 6/88.

Buffalo Fine Arts Academy, Buffalo, NY, $350,000. Toward Phase I-III renovation and construction of facilities for Albright-Knox Art Gallery. 9/88.

Chicago Zoological Society, Brookfield, IL, $700,000. Toward renovation of Lion House for World of Carnivores exhibits. 6/88.

Childrens Museum, Indianapolis, IN, $450,000. Toward construction of facilities. 2/88.

Circus World Museum, Baraboo, WI, $50,000. Toward construction of exhibit hall/visitor center. 3/88.

Colonial Williamsburg Foundation, Williamsburg, VA, $750,000. Toward renovation and expansion of Abby Aldrich Rockefeller Folk Art Center. 2/88.

Colorado Historical Foundation, Denver, CO, $150,000. Toward renovation and restoration of Byers-Evans House. 9/88.

Coyote Point Museum for Environmental Education, San Mateo, CA, $250,000. Toward construction of Wildlife Center. 9/88.

Crocker Art Museum, Sacramento, CA, $100,000. Toward Phase II renovation of facilities. 6/88.

Cumberland Science Museum, Nashville, TN, $250,000. Toward construction of

Interpretive Center Museum at Grassmere Nature Center and Animal Forest. 9/88.

Dayton Museum of Natural History, Dayton, OH, $300,000. Toward construction of visitor center at SunWatch. 9/88.

Denver Museum of Natural History, Denver, CO, $500,000. Toward construction of exhibits in Hall of Life. 6/88.

Detroit Institute of Arts, Founders Society, Detroit, MI, $200,000. Toward renovation of auditorium and replacement of Rivera Courtyard skylight. 11/87.

East Asian History of Science, NYC, NY, $250,000. Toward Stage I-III construction of facilities. 2/88.

Flynn Theater for Performing Arts, Burlington, VT, $100,000. Toward renovation of Flynn Theater. 4/88.

Helena Film Society, Helena, MT, $150,000. Toward renovation of facility for use as cultural center. 6/88.

High Desert Museum, Bend, OR, $100,000. Toward expansion of museum. 5/88.

Historic Trinity, Detroit, MI, $100,000. Toward renovation of Parish Hall. 2/88.

Hyde Collection Trust, Glens Falls, NY, $300,000. Toward renovation and expansion of facilities. 5/88.

K T C A Twin Cities Public Television, Saint Paul, MN, $250,000. Toward construction of new telecommunications center. 9/88.

Laudholm Trust, Kennebunkport, ME, $250,000. Toward renovation of main house for use as Visitor's Center. 4/88.

Lawrence University, Appleton, WI, $500,000. Toward construction of visual arts facility. 2/88.

Metropolitan Museum of Art, NYC, NY, $500,000. Toward construction of European Sculpture and Decorative Arts Wing. 2/88.

Milwaukee Repertory Theater, Milwaukee, WI, $200,000. Toward renovation of space for new theater facilities. 10/87.

Missouri Botanical Garden, Saint Louis, MO, $650,000. Toward renovation of Climatron Exhibit. 4/88.

Montshire Museum of Science, Hanover, NH, $300,000. Toward construction of new museum facility in Norwich, Vermont. 2/88.

Morris Museum, Morristown, NJ, $300,000. Toward renovation and expansion of facilities. 4/88.

Mount Vernon Nazarene College, Mount Vernon, OH, $350,000. Toward construction of building for use as chapel, auditorium, and fine arts facility. 11/87.

Museum of Science, Boston, MA, $750,000. Toward construction of new wing. 3/88.

National Aquarium in Baltimore, Baltimore, MD, $500,000. Toward construction of marine mammal complex. 3/88.

Old Sewickley Post Office Corporation, Sewickley, PA, $50,000. Toward purchase and renovation of Sewickley Post Office building. 2/88.

Peabody Museum of Salem, Salem, MA, $500,000. Toward construction of Asian Export Art Wing and renovation of facilities. 4/88.

Phillips Collection, DC, $750,000. Toward Phase II renovation and expansion of museum wing. 2/88.

Robert W. Woodruff Arts Center, Atlanta, GA, $400,000. Toward replacement of roof. 12/87.

Royal Winnipeg Ballet, Winnipeg, Canada, $250,000. Toward construction of facility. 4/88.

Saint Louis Zoological Park, Saint Louis, MO, $450,000. Toward construction of Education and Discovery Center. 4/88.

Seattle Art Museum, Seattle, WA, $500,000. Toward construction of museum. 3/88.

Skowhegan School of Painting and Sculpture, NYC, NY, $50,000. Toward construction of painting studio II. 12/87.

Southeastern Center for Contemporary Art, Winston-Salem, NC, $250,000. Toward construction of addition. 4/88.

Spirit Square Arts Center, Charlotte, NC, $100,000. Toward construction of addition and renovation of existing space. 2/88.

Studio Museum in Harlem, NYC, NY, $150,000. Toward Phase I construction of sculpture garden. 11/87.

Thomasville Cultural Center, Thomasville, GA, $150,000. Toward renovation of school building for use as cultural center. 11/87.

Trinity Repertory Company, Providence, RI, $225,000. Toward renovation of Lederer Theater and purchase and installation of computer equipment. 10/87.

University of Pennsylvania, Philadelphia, PA, $300,000. For renovation of facilities for Institute of Contemporary Art. 4/88.

W H Y Y-TV, Philadelphia, PA, $70,000. Toward construction and equipping of new facility in Wilmington, Delaware. 10/88.

Washington and Lee University, Lexington, VA, $600,000. Toward construction of performing arts facility. 2/88.

Washington Project for the Arts (WPA), DC, $100,000. Toward leasehold improvements. 10/88.

1326
Kysor Industrial Corporation Foundation

One Madison Ave.
Cadillac 49601 (616) 775-4645

Established in 1972 in MI.

Donor(s): Kysor Industrial Corp.

Financial data (yr. ended 5/31/87): Assets, $1,027,385 (M); expenditures, $81,675, including $80,185 for 150 grants (high: $7,500; low: $25).

Purpose and activities: Support for higher education, health and social welfare, including community funds, civic and community activities, including youth groups, arts and culture, and conservation.

Types of support: Building funds, capital campaigns, continuing support, general purposes, publications, research.

Limitations: Giving primarily in areas of company operations in MI, GA, FL, TX, and IL. No support for political organizations or political campaigns, religious organizations (when exclusively denominational or sectarian in purpose), or national or international organizations not directly serving the foundation's interests. No grants to individuals.

Publications: Application guidelines.

Application information:

Initial approach: Letter no more than 2
pages long
Deadline(s): None
Write: Mary C. Janik, Mgr.
Officers and Trustees: George R. Kempton,
Pres.; Richard G. DeBoer, V.P.; Clayton C.
Jesweak, V.P.; Mary C. Janik, Mgr.
Employer Identification Number: 237199469

1327
The Loutit Foundation
P.O. Box 491
Grand Haven 49417

Incorporated in 1957 in MI.
Donor(s): William R. Loutit.†
Financial data (yr. ended 12/31/87): Assets,
$1,793,000 (M); expenditures, $257,438,
including $208,500 for 25 grants (high:
$35,000; low: $500).
Purpose and activities: Support for hospitals,
public schools and higher education, including
buildings and equipment, youth agencies, aid to
the handicapped, cultural programs, and
community funds.
Types of support: Capital campaigns, annual
campaigns, seed money, emergency funds,
endowment funds, building funds, equipment,
general purposes, land acquisition, matching
funds, special projects.
Limitations: Giving limited to MI, with
emphasis on the western area of the state. No
grants to individuals or for research; no loans.
Publications: Biennial report.
Application information:
Initial approach: Letter or full proposal
Copies of proposal: 6
Deadline(s): 1 week prior to board meeting
Board meeting date(s): Feb., May, Aug., and
Nov.
Final notification: 2 weeks after meeting
Write: Paul A. Johnson, Pres.
Officers and Trustees: Paul A. Johnson, Pres.;
Harvey L. Scholten, V.P.; C. Christopher
Worfel, Secy.-Treas.; Jon W. Eshleman, Eugene
O. Harbeck, Jr.
Number of staff: None.
Employer Identification Number: 386053445

1328
Lyon Foundation, Inc.
1592 Redding
Birmingham 48009

Incorporated in 1951 in MI.
Donor(s): G. Albert Lyon, Sr.
Financial data (yr. ended 12/31/86): Assets,
$1,386,949 (M); expenditures, $75,413,
including $65,970 for 36 grants (high: $11,000;
low: $200).
Purpose and activities: Giving for cultural
activities, higher and secondary education,
hospitals, health associations, and youth
agencies.
Types of support: Research, operating budgets.
Limitations: Giving primarily in MI.
Officers: Alberta L. Judd, V.P.; T. Terrill Judd,
Secy.; A. Randolph Judd, Treas.
Agent: National Bank of Detroit.
Employer Identification Number: 386121075

1329
J. Harvey Mallery Trust
(also known as Mallery Charitable Trust)
c/o Michigan National Bank
519 South Saginaw St.
Flint 48502 (313) 762-5563

Trust established in 1970 in MI.
Donor(s): Harvey J. Mallery.
Financial data (yr. ended 6/30/87): Assets,
$773,564 (M); expenditures, $170,025,
including $161,336 for 10 grants (high:
$35,000; low: $2,000).
Purpose and activities: Support for education,
cultural programs, and recreation, including a
youth agency.
Limitations: Giving limited to Genessee
County, MI. No grants to individuals, or for
endowment funds, scholarships, or fellowships;
no loans.
Application information:
Initial approach: Proposal, letter, or
telephone
Copies of proposal: 2
Board meeting date(s): Quarterly
Write: Susan K. Piper, Admin.
Officer: Susan K. Piper, Admin.
Trustees: Mary Davis, J. Joseph England,
Michigan National Bank.
Employer Identification Number: 386039907

1330
Alex and Marie Manoogian Foundation
21001 Van Born Rd.
Taylor 48180 (313) 274-7400

Incorporated in 1942 in MI.
Donor(s): Alex Manoogian, Marie Manoogian.
Financial data (yr. ended 12/31/86): Assets,
$44,796,643 (M); gifts received, $2,937,500;
expenditures, $1,772,080, including
$1,714,501 for 86 grants (high: $622,045; low:
$50; average: $500-$25,000).
Purpose and activities: Support primarily for
Armenian welfare funds and religious
institutions, and higher and secondary
education; support also for cultural programs.
Types of support: Building funds, equipment,
operating budgets, seed money, emergency
funds, matching funds, endowment funds,
scholarship funds, fellowships, research,
continuing support.
Limitations: No grants for annual campaigns,
deficit financing, land acquisition, publications,
or conferences and seminars.
Application information: Contributes only to
pre-selected organizations. Applications not
accepted.
Board meeting date(s): Twice a year
Write: Alex Manoogian, Pres.
Officers and Directors: Alex Manoogian,
Pres.; Richard A. Manoogian, V.P. and Treas.;
Eugene H. Gargaro, Jr., Secy.; Louise M.
Simone.
Number of staff: None.
Employer Identification Number: 386089952

1331
Masco Corporation Charitable Trust
(Formerly Masco Screw Products Company
Charitable Trust)
c/o Comerica Bank-Detroit, Tr. Tax Dept.
Detroit 48275-1022

Trust established in 1952 in MI.
Donor(s): Masco Corp.
Financial data (yr. ended 12/31/87): Assets,
$491,968 (M); gifts received, $500,000;
expenditures, $289,087, including $285,800
for 29 grants (high: $36,200; low: $2,000).
Purpose and activities: Emphasis on the arts,
higher education, museums, social services,
and church support.
Limitations: Giving primarily in MI.
Trustee: Comerica Bank-Detroit.
Employer Identification Number: 386043605

1332
The McColl-Batts Foundation
151 E. Michigan Ave.
Kalamazoo 49007 (616) 383-6831

Financial data (yr. ended 12/31/87): Assets,
$1,042,491 (M); expenditures, $72,204,
including $5,000 for grants.
Purpose and activities: Giving primarily for
environmental conservation, hospitals, and
museums.
Application information:
Initial approach: Letter
Deadline(s): None
Write: William Lee
Officers: H. Lewis Batts, Jr., Pres.; Jean M.
Batts, V.P.; Edward P. Thompson, Secy.; Floyd
L. Parks, Treas.
Employer Identification Number: 386052870

1333
McGregor Fund
333 West Fort Bldg., Suite 2090
Detroit 48226 (313) 963-3495

Incorporated in 1925 in MI.
Donor(s): Tracy W. McGregor,† Mrs. Tracy
W. McGregor.†
Financial data (yr. ended 6/30/87): Assets,
$76,472,852 (M); expenditures, $3,272,155,
including $2,551,060 for 79 grants (high:
$100,000; low: $1,000; average: $10,000-
$50,000).
Purpose and activities: A general purpose
foundation supporting education, welfare,
including health and youth agencies,
humanities, and sciences, with emphasis on
higher education; grants also to private colleges
and universities in MI, OH, and IN.
Types of support: Operating budgets, annual
campaigns, building funds, equipment, special
projects, capital campaigns, continuing support,
general purposes, renovation projects.
Limitations: Giving primarily in Detroit, MI;
grants to private colleges and universities
limited to IN, MI, and OH. No grants to
individuals, or for deficit financing, land
acquisition, endowment funds, scholarships,
fellowships, research, travel, workshops,
publications, or conferences; no loans.
Publications: Annual report (including
application guidelines).

Application information:
Initial approach: Proposal
Copies of proposal: 1
Deadline(s): None
Board meeting date(s): Feb., Apr., June, Sept., and Nov.
Final notification: 60 days
Write: W. Calvin Patterson III, Exec. Dir.
Officers: Elliot H. Phillips,* Pres.; Lem W. Bowen,* V.P.; Peter P. Thurber, Secy.; Robert M. Surdam,* Treas.; W. Calvin Patterson III, Exec. Dir.
Trustees:* Carlton M. Higbie, Jr., Eugene Miller, W. Warren Sheldon, Bruce W. Steinhauer, M.D., Peter W. Stroh.
Number of staff: 1 part-time professional; 2 full-time support.
Employer Identification Number: 380808800
Recent arts and culture grants:
Artrain, Detroit, MI, $10,000. For operational support. 1988.
Attic Theater, Detroit, MI, $15,000. For renovation of facilities. 1988.
Detroit Center for the Performing Arts, Detroit, MI, $10,000. For volunteer workshop program. 1988.
Detroit Institute of Arts, Founders Society, Detroit, MI, $50,000. To renovate auditorium. 1988.
Detroit Repertory Theater, Detroit, MI, $10,000. For new sound system. 1988.
Detroit Science Center, Detroit, MI, $15,000. For summer day camp program. 1988.
Detroit Symphony Orchestra, Detroit, MI, $75,000. For regular support. 1988.
Detroit Symphony Orchestra, Detroit, MI, $75,000. For special support. 1988.
Detroit Zoological Society, Detroit, MI, $100,000. For chimpanzee exhibit. 1988.
Edison Institute, Dearborn, MI, $50,000. For unrestricted support. 1988.
Interlochen Center for the Arts, Interlochen, MI, $50,000. To modify waste treatment system. 1988.
Michigan Opera Theater, Detroit, MI, $25,000. For marketing program. 1988.
Michigan Technological University, Houghton, MI, $25,000. To construct Arts and Humanities Center. 1988.
Renaissance Concerts, West Bloomfield, MI, $10,000. For operational support. 1988.
University Cultural Center Association, Detroit, MI, $10,000. For operational support. 1988.
University of Michigan, Ann Arbor, MI, $62,500. For preservation of valuable works. 1988.
Wayne State University, Detroit, MI, $50,000. For capital improvements to McGregor Memorial. 1988.
Wayne State University, Detroit, MI, $50,000. For extra maintenance at McGregor Memorial. 1988.

1334
Meadowdale Foods Corporate Giving Program
8711 Meadowdale St.
Detroit 48228 (313) 943-3300

Financial data (yr. ended 12/31/88): $18,723 for grants.
Purpose and activities: Supports the United Way, Jewish giving, hospitals, delinquency

programs, labor, recreation, and the performing arts, including music and theater.
Application information: Applications not accepted.

1335
The Mendel Foundation
777 Riverview Dr.
Benton Harbor 49022

Established in 1964 in MI.
Donor(s): Herbert D. Mendel.
Financial data (yr. ended 4/30/87): Assets, $2,556,701 (M); expenditures, $153,678, including $148,975 for 20 grants (high: $100,000; low: $25).
Purpose and activities: Emphasis on Jewish welfare funds, religious associations, and temple support; grants also for the arts and education.
Limitations: Giving primarily in MI.
Application information:
Write: Edwin J. Mendel, V.P.
Officers: Herbert D. Mendel, Pres.; Edwin J. Mendel, V.P.
Employer Identification Number: 386099787

1336
MichCon Foundation
500 Griswold St.
Detroit 48226 (313) 256-5077

Established in 1984 in MI.
Donor(s): MichCon.
Financial data (yr. ended 12/31/87): Assets, $9,866,979 (M); expenditures, $902,575, including $872,679 for 216 grants (high: $108,000; low: $25).
Purpose and activities: To enhance the economic vitality and quality of life through support in five areas: economic development, including business development, job training, and neighborhood revitalization; education, including employee matching gifts; United Foundations/United Ways; community services with emphasis on youth, community leadership; and culture and the arts.
Types of support: Employee matching gifts, scholarship funds.
Limitations: Giving primarily in areas of company operations in MI.
Publications: Corporate giving report.
Application information:
Initial approach: Proposal
Deadline(s): Nov. 30
Write: Mary E. Bradish, Secy.
Officers and Directors:* Richard W. Zemmin,* Pres.; Leon H. Atchison,* V.P.; Mary E. Bradish,* Secy.; Peter L. Verardi, Treas.
Employer Identification Number: 382570358

1337
Michigan Wheel Foundation
c/o Trust Dept.
200 Ottawa, N.W.
Grand Rapids 49503-2468

Financial data (yr. ended 11/30/87): Assets, $117,306 (M); expenditures, $10,155, including $8,100 for 11 grants (high: $1,000; low: $100).

Purpose and activities: Support for religion, culture and the arts, and social services.
Limitations: Giving primarily in Grand Rapids, MI.
Agent: NBD Grand Rapids, N.A.
Trustees: Charles R. Glenson, Delmar M. Seitz, Herbert L. Vander May.
Employer Identification Number: 382108172

1338
Frances Goll Mills Fund
101 N. Washington Ave.
Saginaw 48607 (517) 776-7582

Established in 1982 in MI.
Donor(s): Frances Goll Mills.†
Financial data (yr. ended 9/30/88): Assets, $3,084,295 (M); expenditures, $207,258, including $155,455 for 14 grants (high: $35,000; low: $800).
Purpose and activities: Giving primarily for hospitals, social services, civic organizations, historic preservation, and a church.
Types of support: Operating budgets, continuing support, seed money, emergency funds, building funds, equipment, land acquisition, matching funds, consulting services.
Limitations: Giving primarily in Saginaw County, MI. No grants to individuals, or for annual campaigns, deficit financing, endowments, special programs, scholarships, fellowships, professorships, or internships; no loans.
Publications: Application guidelines.
Application information:
Initial approach: Letter or proposal
Copies of proposal: 1
Deadline(s): None
Board meeting date(s): Bimonthly, beginning in Feb.
Final notification: 1 week after meeting
Write: Denice McGlaughlin
Trustee: Second National Bank of Saginaw.
Number of staff: None.
Employer Identification Number: 382434002

1339
Monroe Auto Equipment Company Foundation
c/o Comerica Bank
Detroit 48275-1022
Application address: c/o Kay Osgood, Monroe Auto Equipment Co./One International Dr., Monroe, MI 48161; Tel.: (313) 243-8000

Trust established in 1958 in MI; currently registered in OH.
Donor(s): Monroe Auto Equipment Co., C.S. McIntyre,† and others.
Financial data (yr. ended 12/31/87): Assets, $963,796 (M); expenditures, $89,233, including $83,865 for 39 grants (high: $21,000; low: $30).
Purpose and activities: Grants for youth agencies, community funds, social services, and cultural programs; also supports an educational employee matching gift program.
Types of support: Employee matching gifts, continuing support, research.
Limitations: Giving primarily in areas where company plants are located: Hartwell, GA, Cozad, NE, and Paragould, AR.

Application information: Application form required for employee matching gift program.
Initial approach: Proposal
Copies of proposal: 1
Deadline(s): None
Board meeting date(s): Quarterly
Write: Kay Osgood, Trustee
Trustees: James K. Ashford, R.G. Foster, G. Paul Hill, Kay M. Osgood, W.N. White, Comerica Bank.
Number of staff: 5
Employer Identification Number: 346518867

1340
Morley Brothers Foundation
5895 West Michigan Ave., Suite 2B
Saginaw 48603-5917 (517) 792-1427

Incorporated in 1948 in MI.
Donor(s): Ralph Chase Morley, Sr.,† Mrs. Ralph Chase Morley, Sr.†
Financial data (yr. ended 12/31/87): Assets, $3,263,753 (M); expenditures, $216,134, including $191,166 for 35 grants (high: $45,000; low: $100; average: $100-$12,000).
Purpose and activities: Emphasis on higher and secondary education, community funds, the arts, youth agencies, and hospitals.
Types of support: Operating budgets, continuing support, annual campaigns, seed money, emergency funds, building funds, equipment, scholarship funds, exchange programs, special projects, research, matching funds, employee matching gifts.
Limitations: Giving primarily in the greater Saginaw, MI, area. No grants to individuals, or for endowment funds, deficit financing, land acquisition, renovation projects, publications, or conferences; no loans.
Application information:
Initial approach: Letter
Copies of proposal: 1
Deadline(s): None
Board meeting date(s): Apr., July, Oct., and Dec.
Final notification: 3 months
Write: Edward B. Morley, Jr., Pres.
Officers: Edward B. Morley, Jr.,* Pres.; Lucy M. Thompson,* V.P.; Lois K. Guttowsky, Secy.; Peter B. Morley,* Treas.
Trustees:* Burrows Morley, Burrows Morley, Jr., George B. Morley, Robert S. Morley.
Number of staff: 1 part-time professional.
Employer Identification Number: 386055569

1341
Charles Stewart Mott Foundation
1200 Mott Foundation Bldg.
Flint 48502-1851 (313) 238-5651

Incorporated in 1926 in MI.
Donor(s): Charles Stewart Mott,† and family.
Financial data (yr. ended 12/31/88): Assets, $838,815,760 (M); expenditures, $27,389,114, including $23,823,458 for 333 grants (high: $1,719,549; low: $1,430; average: $10,000-$100,000).
Purpose and activities: Supports community improvement through grants for expressing individuality; expanding personal horizons; citizenship; volunteer action; counteracting root causes of alienation; community identity and stability; community renewal; environmental management; fostering institutional openness; better delivery of services; and training in and improving practices of leadership. Pioneer in community education concept.
Types of support: Annual campaigns, conferences and seminars, continuing support, deficit financing, emergency funds, loans, matching funds, operating budgets, program-related investments, publications, seed money, special projects, technical assistance, general purposes.
Limitations: No grants to individuals, or generally for building or endowment funds, research, scholarships, or fellowships.
Publications: Annual report (including application guidelines), newsletter, financial statement, informational brochure, program policy statement.
Application information:
Initial approach: Letter
Copies of proposal: 1
Deadline(s): None
Board meeting date(s): Mar., June, Sept., and Dec.
Final notification: 60 to 90 days
Write: Judy Samelson, Dir. of Communications
Officers: William S. White,* Chair., Pres. and C.E.O.; Richard K. Rappleye, V.P. and Secy.-Treas.; Frank Gilsdorf, V.P. for Prog. Administration; Willard J. Hertz, V.P. for Prog. Planning and Dissemination; Robert E. Swaney, Jr., V.P. for Investments.
Trustees:* Marjorie Powell Allen, Alonzo A. Crim, Charles B. Cumings, C.S. Harding Mott II, Maryanne Mott, William H. Piper, Willa B. Player, John W. Porter, Harold P. Rodes, George L. Whyel.
Number of staff: 24 full-time professional; 2 part-time professional; 18 full-time support.
Employer Identification Number: 381211227
Recent arts and culture grants:
Buckham Alley Theater, Flint, MI, $25,000. To continue support for Buckham Alley Theater, new community center for performing arts in downtown Flint. 1988.
Flint Institute of Music, Flint, MI, $40,000. To provide quality educational and training experiences in music and dance in variety of class, ensemble and performance formats. 1988.
Genesee County Parks and Recreation Commission, Flint, MI, $215,000. To construct permanent enclosure to protect Historical Crossroads Village carousel. 1988.
Greater Flint Arts Council, Flint, MI, $20,000. To develop and coordinate services for local artists and arts organizations and to expand community appreciation for the arts. 1988.
National Public Radio, DC, $40,000. To encourage production of news reports focusing on Great Lakes environmental issues for public radio broadcast and for dissemination, in cassette form, for educational uses. 1988.
Nature Conservancy, Arlington, VA, $225,000. To purchase private properties in Flint College and Cultural Center area in effort to protect Center from undesirable development and allow for possible future expansion. 1988.
Star Theater of Flint, Flint, MI, $175,000. To pay Theater's debt obligations remaining from 1987 season. 1988.
Star Theater of Flint, Flint, MI, $35,000. To continue general support. 1988.

1342
Ruth Mott Fund
1726 Genesee Towers
Flint 48502 (313) 232-3180

Incorporated in 1979 in MI.
Donor(s): Ruth R. Mott.
Financial data (yr. ended 11/30/86): Assets, $554,454 (M); gifts received, $1,553,849; expenditures, $1,525,689, including $1,282,186 for 119 grants (high: $60,000; low: $50; average: $10,000-$25,000).
Purpose and activities: Support for programs that focus on topics of emerging significance, exemplify originality, and offer the potential for application on a broader scale within four broad areas: 1) arts and special interests, including arts as a means to a greater educational, humanistic, or social goal, and for arts and beautification in Flint and Genesee County, MI; 2) environment programs focusing on global deforestation, alternative (sustainable) agriculture, the total burden of toxic substances in the Great Lakes ecosystem, and alternatives to their proliferation; 3) health promotion, with emphasis on preventive programs for low income sectors of the population that emphasize one or more of the following: improved nutrition, stress control, exercise and fitness, smoking cessation, and reduced alcohol and drug use (proposals encouraged from new or small organizations with budgets of less than $150,000 per year); and 4) national and international security programs which foster public review and discussion of factors that contribute to the security of a nation, and the science and technology of the intentional or accidental use of nuclear or space weapons.
Types of support: Operating budgets, continuing support, seed money, matching funds, special projects, research, publications, conferences and seminars.
Limitations: No grants to individuals, or for capital or endowment funds, annual campaigns, emergency funds, deficit financing, scholarships, or fellowships; no loans.
Publications: Application guidelines, multi-year report.
Application information:
Initial approach: Proposal (up to 12 pages)
Copies of proposal: 1
Deadline(s): None
Board meeting date(s): Feb., June, and Oct.
Final notification: 3 to 4 months
Write: Deborah E. Tuck, Exec. Dir.
Officers: Sandra Butler,* Chair.; Maryanne Mott,* Pres.; Stewart Dansby,* Secy.-Treas.; Deborah E. Tuck, Exec. Dir.
Trustees:* John Hatch, Susan Kleinpell, Donna Metcalf, Ruth R. Mott, Ralph Rinzler, Joe Robinson, Herman E. Warsh, George Woodwell.
Number of staff: 2 full-time professional; 1 full-time support; 1 part-time support.
Employer Identification Number: 382284264

1343
Muskegon County Community Foundation, Inc.
Frauenthal Center, Suite 304
425 West Western Ave.
Muskegon 49440 (616) 722-4538

Community foundation incorporated in 1961 in MI.

Donor(s): Harold Frauenthal,† Charles Goodnow.†

Financial data (yr. ended 3/31/88): Assets, $15,214,626 (M); expenditures, $1,250,148, including $704,826 for 71 grants (high: $100,000; low: $200) and $153,482 for 230 grants to individuals.

Purpose and activities: To assist worthwhile projects, with emphasis on health and human services, the arts and culture, education, and community development and urban affairs. Priority support for pilot projects, seed money, and challenge gifts.

Types of support: Seed money, special projects, matching funds, building funds, equipment, land acquisition, scholarship funds, loans, research, publications, conferences and seminars, endowment funds, student aid, annual campaigns.

Limitations: Giving limited to Muskegon County, MI. No grants to individuals (except for scholarships), or for operating budgets, continuing support, emergency funds, or deficit financing.

Publications: Annual report (including application guidelines).

Application information: Application form required.
 Initial approach: Letter or telephone
 Copies of proposal: 12
 Deadline(s): None
 Board meeting date(s): Feb., May, Aug., and Nov.
 Final notification: 2 to 3 weeks
 Write: Patricia B. Johnson, Exec. Dir.

Officers: Robert D. Tuttle, Pres.; Robert Jewell,* V.P.; Patricia B. Johnson, Secy.-Treas. and Exec. Dir.

Distribution Committee:* Robert Hilleary, Chair.; Josephine F. Anacker, Marilyn V. Andersen, George Arwady, Douglas Bard, George W. Bartlett, Robert W. Christie, Bettye Clark-Cannon, Fred C. Culver, Jr., Eugene Fisher, John Halmond, John L. Hilt, Richard G. Johnson, Robert Kersman, John H. Martin, Theodore Operhall, Sherman R. Poppen, Donald F. Seyferth, Daniel Thill.

Trustee Banks: Comerica Bank, First of America Bank, FMB Lumberman's Bank, Old Kent Bank of Grand Haven.

Number of staff: 1 full-time professional; 1 full-time support; 2 part-time support.

Employer Identification Number: 386114135

Recent arts and culture grants:
Boarshead Theater, Lansing, MI, $14,600. For support of summer theater. 1987.
Frauenthal Center for the Performing Arts, Muskegon, MI, $10,000. For presentation of A Christmas Carol for all sixth graders in Muskegon County. 1987.
Hackley Heritage Association, Muskegon, MI, $5,000. For purchase of furnishings. 1987.
Muskegon Civic Theater, Muskegon, MI, $10,000. For general operational support. 1987.

Muskegon Community College, Muskegon, MI, $15,000. For 1986 Muskegon Summer residency of Boarshead: Michigan Theater. 1987.
Muskegon Museum of Art, Muskegon, MI, $68,932. For general operational support. 1987.
Muskegon Museum of Art, Muskegon, MI, $20,800. For acquisition of sculptures. 1987.
Muskegon Museum of Art, Muskegon, MI, $20,800. For purchase of humidification system. 1987.
West Shore Symphony Orchestra, Muskegon, MI, $5,000. For performance in conjunction with Jewish Centennial Celebration. 1987.

1344
National Bank of Detroit Charitable Trust
c/o National Bank of Detroit
611 Woodward Ave.
Detroit 48232 (313) 225-3124

Trust established in 1963 in MI.
Donor(s): National Bank of Detroit.
Financial data (yr. ended 12/31/87): Assets, $1,481,783 (M); gifts received, $1,808,537; expenditures, $1,687,102, including $1,572,659 for 117 grants (high: $543,000; low: $25; average: $500-$15,000) and $97,701 for 116 employee matching gifts.
Purpose and activities: Emphasis on higher education (including employee matching gifts), cultural programs, and community development; support also for community funds and social services.
Types of support: Employee matching gifts, general purposes.
Limitations: Giving primarily in MI, with emphasis on the Detroit area.
Application information:
 Initial approach: Proposal
 Deadline(s): None
 Board meeting date(s): Every 2 weeks, except July and Aug.
 Write: Therese Thorn, Mgr.
Officers: Gerald E. Warren, Chair.; Dennis Kembel, Secy.
Board of Control: Bernard Butcher, Charles T. Fischer III, Vern Istock, Thomas Jeffs II, Richard A. Manoogian, James McNeal, Irving Rose.
Trustee: Therese Thorn, Mgr.; National Bank of Detroit.
Number of staff: 2 full-time professional; 1 part-time professional.
Employer Identification Number: 386059088

1345
NBD Genesee Bank Charitable Trust
One East First Street
Flint 48502 (313) 766-8292

Established in 1978 in MI.
Financial data (yr. ended 12/31/88): Expenditures, $86,500 for 6 grants (high: $61,000; low: $500).
Purpose and activities: Supports arts and culture, educational associations, intercultural relations, community development, single-disease associations and youth organizations.
Types of support: Annual campaigns, building funds, capital campaigns, endowment funds,

operating budgets, renovation projects, seed money, special projects.
Limitations: Giving primarily in Flint, MI and portions of Genesee, Lapeer, Shiawassee, and Oakland counties, MI. No grants to individuals.
Publications: Program policy statement.
Application information:
 Initial approach: Letter and proposal
 Copies of proposal: 1
 Deadline(s): None
 Write: Ronald J. Butler, Jr., Asst. V.P.
Number of staff: 1 full-time professional; 1 full-time support.
Employer Identification Number: 386391170

1346
Gust K. Newberg Construction Company Scholarship Foundation
(Formerly Gust A. Newberg Scholarship Trust)
500 South Stephenson Ave.
Iron Mountain 49801-3456

Financial data (yr. ended 6/30/88): Assets, $814,475 (M); expenditures, $57,887, including $49,650 for 21 grants to individuals (high: $4,400; low: $2,200).
Purpose and activities: Scholarships to public school graduates of the City of Iron Mountain, Breitung Township, Norway-Vulcan, and North Dickerson school districts who wish to pursue a course of college study in construction-related fields of architecture and/or engineering.
Types of support: Student aid.
Application information:
 Deadline(s): None
Trustee: Commercial National Bank & Trust Co.
Employer Identification Number: 386372554

1347
Old Kent Charitable Trust
300 Old Kent Bldg.
Grand Rapids 49503

Financial data (yr. ended 6/30/88): Assets, $1,103,681 (M); expenditures, $76,913, including $69,250 for 15 grants (high: $20,000; low: $500).
Purpose and activities: Funds for education, the arts, YMCA, and social services.
Limitations: Giving primarily in Grand Rapids, MI.
Trustee: Old Kent Bank & Trust Co.
Employer Identification Number: 386400384

1348
Perry Drug Stores Charitable Foundation
5400 Perry Dr.
Pontiac 48056 (313) 334-1300

Established in 1981 in MI.
Financial data (yr. ended 10/31/87): Assets, $9,067 (M); gifts received, $76,000; expenditures, $90,080, including $85,852 for 279 grants (high: $5,182; low: $25) and $4,050 for employee matching gifts.
Purpose and activities: Giving for community funds, health agencies, Jewish welfare funds, civic and community affairs, and cultural programs.

Types of support: Operating budgets, employee matching gifts, scholarship funds.
Limitations: Giving primarily in MI and IL.
Application information:
Initial approach: Letter
Deadline(s): None
Write: Jack A. Robinson, Trustee
Trustees: Patricia Ambrose, Berl Falbaum, Jack A. Robinson, M. David Schwartz.
Employer Identification Number: 382386022

1349
Plym Foundation
Star Bldg.
Niles 49120 (616) 683-8300

Incorporated in 1952 in MI.
Donor(s): Mrs. Francis J. Plym.
Financial data (yr. ended 9/30/88): Assets, $3,474,172 (M); expenditures, $343,612, including $318,491 for grants (high: $240,000).
Purpose and activities: Emphasis on education, including a community education center, the arts, and scholarships.
Types of support: Scholarship funds.
Limitations: Giving primarily in MI.
Application information:
Initial approach: Letter
Copies of proposal: 1
Deadline(s): None
Write: Murray C. Campbell, Secy.
Officers: Lawrence J. Plym,* Pres.; J. Eric Plym, V.P.; Rosemary Donnelly, Secy.
Directors:* Sally P. Campbell, Andrew J. Plym.
Employer Identification Number: 386069680

1350
Ralph L. and Winifred E. Polk
Foundation
431 Howard St.
Detroit 48231 (313) 961-9470

Incorporated in 1962 in MI.
Donor(s): Ralph L. Polk.
Financial data (yr. ended 12/31/87): Assets, $2,125,856 (M); expenditures, $84,300, including $82,000 for 27 grants (high: $10,000; low: $500).
Purpose and activities: Emphasis on welfare funds, Protestant giving, culture, particularly music, hospitals, and youth.
Types of support: General purposes, building funds, capital campaigns.
Application information: Contributes only to pre-selected organizations. Applications not accepted.
Officers: Winifred E. Polk,* Pres.; Stephen R. Polk,* V.P. and Treas.; John M. O'Hara, Secy.
Trustees:* Janet P. Read.
Employer Identification Number: 386080075

1351
The Meyer and Anna Prentis Family
Foundation, Inc.
c/o Frenkel
26323 Hendrie Blvd.
Huntington Woods 48070 (313) 540-4340

Incorporated in 1955 in MI.
Donor(s): Members of the Prentis family.

Financial data (yr. ended 12/31/88): Assets, $5,000,000 (M); expenditures, $4,946,000, including $4,936,000 for 24 grants (high: $300,000; low: $500).
Purpose and activities: Giving primarily for medical research and cultural programs; support also for Jewish giving, including Jewish welfare funds.
Limitations: Giving primarily in MI. No grants to individuals, or for endowment funds, scholarships, fellowships, or matching gifts; no loans.
Application information:
Initial approach: Letter
Copies of proposal: 1
Board meeting date(s): July and Dec.
Write: Lester J. Morris, Secy.-Treas.
Officers and Trustees: Beverly J. Prentis, Pres.; Barbara P. Frenkel, V.P.; Lester J. Morris, Secy.-Treas.; Denise L. Farber-Brown, Dale P. Frenkel, Marvin A. Frenkel, Jewell P. Morris, Robert P. Morris, Patrice M. Phillips.
Employer Identification Number: 386090332

1352
Ransom Fidelity Company
702 Michigan National Tower
Lansing 48933 (517) 482-1538

Incorporated in 1915 in MI.
Donor(s): Ransom E. Olds.†
Financial data (yr. ended 12/31/86): Assets, $9,825,504 (M); expenditures, $603,275, including $473,877 for 76 grants (high: $90,000; low: $100).
Purpose and activities: Emphasis on higher and secondary education, hospitals, youth agencies, cultural programs, Protestant church support, a conservation organization, and the handicapped.
Limitations: Giving primarily in MI. No grants to individuals.
Application information: Application form required.
Deadline(s): None
Write: R.E. Olds Anderson, V.P.
Officers and Directors: J. Woodward Roe, Pres. and Treas.; R.E. Olds Anderson, V.P. and Secy.
Employer Identification Number: 381485403

1353
Sage Foundation
2500 Comerica Bldg.
Detroit 48226 (313) 963-6420

Incorporated in 1954 in MI.
Donor(s): Charles F. Sage,† Effa L. Sage.†
Financial data (yr. ended 12/31/87): Assets, $46,638,810 (M); expenditures, $2,319,932, including $2,213,675 for 305 grants (high: $50,000; low: $1,000).
Purpose and activities: Emphasis on higher and secondary education and hospitals; grants also for aid to the handicapped, Roman Catholic religious and charitable organizations, youth agencies, child welfare, church support, and cultural programs.
Types of support: General purposes, scholarship funds, renovation projects, building funds, operating budgets, research, special projects.

Limitations: Giving primarily in MI.
Application information:
Initial approach: Letter
Deadline(s): None
Write: Robert F. Sage, Pres., or Emmett E. Eagan, Sr., Secy.
Officers: Robert F. Sage,* Chair., Pres., and Treas.; Emmett E. Eagan, Sr.,* V.P. and Secy.; Melissa Sage Booth,* V.P.; John W. Gelder, V.P.
Trustees:* Emmett E. Eagan, Jr., Donato F. Sarapo.
Number of staff: None.
Employer Identification Number: 386041518

1354
Sebastian Foundation
2000 Robinson Rd., S.E.
Grand Rapids 49506 (616) 454-7661
Application address: 82 Ionia, N.W., Suite 360, Grand Rapids, MI 49503

Established in 1980.
Donor(s): Audrey M. Sebastian, James R. Sebastian.
Financial data (yr. ended 8/31/88): Assets, $5,664,850 (M); expenditures, $301,275, including $223,350 for 43 grants (high: $50,000; low: $250).
Purpose and activities: Giving to higher education, community funds, cultural programs, and social services.
Limitations: Giving primarily in the Grand Rapids and Kent County areas, MI. No grants to individuals.
Application information:
Initial approach: Proposal
Deadline(s): None
Write: James R. Sebastian, Trustee
Trustees: Audrey M. Sebastian, David S. Sebastian, James R. Sebastian, John O. Sebastian.
Employer Identification Number: 382340219

1355
The Thomas Erler Seidman Foundation
800 Campau Square Bldg.
Grand Rapids 49503 (616) 774-7000

Trust established in 1950 in MI.
Donor(s): Frank E. Seidman,† Esther L. Seidman.†
Financial data (yr. ended 12/31/87): Assets, $2,318,103 (M); expenditures, $126,729, including $110,753 for 24 grants (high: $25,000; low: $53).
Purpose and activities: Emphasis on cultural programs and higher education; support also for social service agencies, and medical research.
Types of support: General purposes, building funds, endowment funds, annual campaigns, equipment.
Limitations: Giving primarily in MI. No grants to individuals.
Application information:
Deadline(s): None
Write: J.R. Doud
Trustees: Augusta Eppinga, B. Thomas Seidman, L. William Seidman, Sarah B. Seidman.
Employer Identification Number: 136098204

1356
The Nate S. and Ruth B. Shapero Foundation

1927 Rosa Parks Blvd.
Detroit 48216

Established in 1949 in MI.
Donor(s): Nate S. Shapero, Ray A. Shapero.
Financial data (yr. ended 4/30/87): Assets,
$2,368,549 (M); expenditures, $166,239,
including $146,420 for 55 grants (high:
$80,000; low: $25).
Purpose and activities: Emphasis on Jewish
welfare funds, higher education, and the arts,
including music.
Types of support: General purposes.
Limitations: Giving primarily in MI.
Application information: Contributes only to
pre-selected organizations. Applications not
accepted.
Officers and Trustees: Ray A. Shapero, Chair.;
Ruth B. Shapero, Vice-Chair.; Gloria Stalla,
Secy.; J.E. Shapero, Treas.; Alan E. Schwartz,
Marianne S. Schwartz.
Employer Identification Number: 386041567

1357
Elizabeth, Allan and Warren Shelden Fund

333 West Fort Bldg., Suite 1870
Detroit 48226 (313) 963-2356

Incorporated in 1937 in MI.
Donor(s): Elizabeth Warren Shelden,† Allan
Shelden III,† W. Warren Shelden.
Financial data (yr. ended 12/31/88): Assets,
$2,971,261 (M); expenditures, $147,180,
including $142,000 for 18 grants (high:
$50,500; low: $500; average: $2,500-$15,000).
Purpose and activities: Support for hospitals,
community funds, higher and secondary
education, youth agencies, and cultural
organizations.
Types of support: Continuing support, annual
campaigns, building funds, equipment,
endowment funds, research, general purposes,
capital campaigns.
Limitations: Giving primarily in MI. No grants
to individuals, or for scholarships, fellowships,
or matching gifts; no loans.
Publications: 990-PF.
Application information:
　Initial approach: Proposal
　Copies of proposal: 1
　Deadline(s): Submit proposal preferably in
　　Nov.; no set deadline
　Board meeting date(s): Dec. or Jan.
　Write: W. Warren Shelden, Pres.
Officers: W. Warren Shelden,* Pres.; Virginia
D. Shelden,* V.P.; Robert W. Emke, Jr., Secy.;
William W. Shelden, Jr.,* Treas.
Trustees:* William G. Butler, Robert M.
Surdam.
Number of staff: 1 part-time professional; 1
part-time support.
Employer Identification Number: 386052198

1358
Simone Foundation

21001 Van Born Rd.
Taylor 48180

Established in 1962 in MI.
Donor(s): Alex Manoogian, Masco Corp.
Financial data (yr. ended 10/31/88): Assets,
$2,537,444 (M); gifts received, $1,121,875;
expenditures, $359,082, including $357,725
for 15 grants (high: $171,500; low: $100).
Purpose and activities: Giving for Armenian
organizations, including Armenian churches
and cultural organizations, and education.
Application information: Contributes only to
pre-selected organizations. Applications not
accepted.
Officers: Louise Simone, Pres.; Christine
Simone, V.P.; David Simone, Secy.-Treas.
Director: Mark Simone.
Employer Identification Number: 381799107

1359
Simpson Industries Fund

32100 Telegraph Rd., Suite 120
Birmingham 48010

Established in 1977 in MI as successor to
Simpson Fund.
Donor(s): Simpson Industries, Inc.
Financial data (yr. ended 3/31/87): Assets,
$428,605 (M); gifts received, $50,000;
expenditures, $86,152, including $67,152 for
43 grants (high: $8,650; low: $250), $10,125
for grants to individuals and $4,264 for
employee matching gifts.
Purpose and activities: Support for religious,
educational, cultural, recreational, civic, and
health organizations in counties where
company plants are located; also an employee
matching gift program for education, and
college scholarships for employees' children.
Types of support: General purposes,
employee-related scholarships, employee
matching gifts.
Limitations: Giving primarily in MI.
Application information:
　Initial approach: Letter
　Deadline(s): Apr. 15
　Write: Deborah Baluch
Officer: Robert W. Navarre, Chair.; Robert E.
Carlson,* V.P.; Charles K. Winter.
Trustee: K.E. Berman, City Bank & Trust Co.
Employer Identification Number: 382157102

1360
The Skillman Foundation

333 West Fort St., Suite 1350
Detroit 48226 (313) 961-8850

Incorporated in 1960 in MI.
Donor(s): Rose P. Skillman.†
Financial data (yr. ended 12/31/88): Assets,
$249,699,373 (M); gifts received, $499,000;
expenditures, $13,761,627, including
$10,938,639 for 142 grants (high: $1,000,000;
low: $1,000; average: $20,000-$200,000) and
$37,122 for employee matching gifts.
Purpose and activities: Giving primarily for
children, youth and young persons; education;
basic human needs; community-wide
collaborative efforts; and culture and arts.

Types of support: Seed money, general
purposes, employee matching gifts, special
projects.
Limitations: Giving primarily in southeastern
MI, with emphasis on metropolitan Detroit,
including Wayne, Macomb, and Oakland
counties. No support for long-term projects
not being aided by other sources, sectarian
religious activities, or political lobbying or
legislative activities. No grants to individuals,
or for endowment funds, annual campaigns, or
deficit financing; no loans.
Publications: Annual report, informational
brochure (including application guidelines),
newsletter.
Application information:
　Initial approach: Proposal (original and 5
　　copies)
　Deadline(s): Dec. 1, Apr. 1, and Aug. 1
　Board meeting date(s): Middle of Feb., June,
　　and Oct.
　Final notification: 2 weeks after board
　　meeting
　Write: Kari Schlachtenhaufen, Prog. Officer
Officers: Mandell L. Berman,* Chair.; Leonard
W. Smith,* Pres. and Secy.; William E.
Hoglund,* V.P.; Jane R. Thomas,* V.P.; Jean E.
Gregory, Treas.
Trustees:* James A. Aliber, William M.
Brodhead, Bernadine N. Denning.
Number of staff: 7 full-time professional; 2 full-
time support.
Employer Identification Number: 381675780
Recent arts and culture grants:
Attic Theater, Detroit, MI, $20,000. For general
　operating support. 6/17/88.
Center for Creative Studies: College of Art and
　Design, Detroit, MI, $30,000. For
　scholarships for graduates of Detroit Public
　Schools. 11/23/87.
Center for Creative Studies: College of Art and
　Design, Institute of Music and Dance,
　Detroit, MI, $45,000. For scholarships for
　elementary school age minority children in
　Detroit. 11/23/87.
Central Business District Foundation, Detroit,
　MI, $100,000. To improve lighting of
　downtown Detroit landmarks and historic
　buildings. 11/23/87.
Cranbrook Educational Community, Cranbrook
　Institute of Science, Bloomfield Hills, MI,
　$8,000. For educational outreach program
　for Pontiac and Detroit public school
　students. 6/17/88.
Croswell Opera House and Fine Arts
　Association, Adrian, MI, $33,000. For
　intergenerational arts program with Adrian
　Training School. 6/17/88.
Detroit Historical Society, Detroit, MI,
　$20,000. For general operating support.
　6/17/88.
Detroit Institute of Arts, Founders Society,
　Detroit, MI, $50,000. For general operating
　support. 6/17/88.
Detroit Repertory Theater, Detroit, MI,
　$12,000. For computerized sound system.
　6/17/88.
Detroit Science Center, Detroit, MI, $20,000.
　For general operating support. 6/17/88.
Detroit Symphony Orchestra, Detroit, MI,
　$50,000. For general operating support.
　6/17/88.

Michigan Opera Theater, Detroit, MI, $40,000. For general operating support and educational outreach programs. 6/17/88.

Michigans Thanksgiving Parade Foundation, Detroit, MI, $30,000. For relocation costs associated with new headquarters. 3/11/88.

Music Hall Center for the Performing Arts, Detroit, MI, $20,000. For general operating support. 6/17/88.

Pewabic Society, Detroit, MI, $10,000. For general operating support. 6/17/88.

Save Orchestra Hall, Detroit, MI, $500,000. For restoration and construction campaign. 11/23/87.

Save Orchestra Hall, Detroit, MI, $20,000. For general operating support. 6/17/88.

W T V S Detroit Educational Television Foundation, Channel 56, Detroit, MI, $50,000. For general operating support. 6/17/88.

Wayne State University, Hilberry Theater, Detroit, MI, $30,000. For general operating support. 6/17/88.

1361
William E. Slaughter, Jr. Foundation, Inc.

32949 Bingham Ln.
Birmingham 48010 (313) 666-9300

Incorporated in 1959 in MI.
Donor(s): William E. Slaughter, Jr.
Financial data (yr. ended 12/31/87): Assets, $1,442,694 (M); expenditures, $170,579, including $156,010 for 55 grants (high: $38,100; low: $10).
Purpose and activities: Grants primarily for youth agencies, higher education, Protestant church support, cultural programs, disease research, and social agencies.
Application information: Applications not accepted.
Officers: William E. Slaughter, Jr.,* Pres. and Treas.; William E. Slaughter IV,* V.P.; Miles Jaffe, Secy.
Directors:* Herbert E. Everett, Gloria Slaughter, Kent C. Slaughter.
Employer Identification Number: 386065616

1362
Community Foundation for Southeastern Michigan

333 West Fort St.
Detroit 48226 (313) 961-6675

Established in 1984 in MI.
Financial data (yr. ended 12/31/88): Assets, $17,366,382 (M); gifts received, $3,100,273; expenditures, $2,120,749, including $1,411,516 for 343 grants (high: $200,000; low: $250; average: $10,000), $32,300 for 24 grants to individuals and $110,211 for 1 foundation-administered program.
Purpose and activities: Supports projects in areas of civic affairs, social services, culture, health, and education.
Types of support: Seed money, special projects, employee-related scholarships.
Limitations: Giving limited to southeastern MI. No support for sectarian, religious programs. No grants to individuals, or for capital projects,

endowments, annual campaigns, or operating budgets (except in initial years of new ventures).
Publications: Annual report (including application guidelines), application guidelines, 990-PF.
Application information:
Initial approach: Proposal
Copies of proposal: 1
Deadline(s): Mar., 1, June 1, Sept. 1, and Dec. 1
Board meeting date(s): Quarterly
Final notification: Following board meetings
Write: C. David Campbell, Prog. Off.
Officers: Joseph L. Hudson, Jr., Chair.; Wendell W. Anderson, Jr., Vice-Chair.; Max M. Fisher, Vice-Chair.; Frank D. Stella, Vice-Chair.; Mrs. R. Alexander Wrigley, Secy.; Richard H. Austin, Treas.
Number of staff: 3 full-time professional; 2 full-time support.
Employer Identification Number: 382530980
Recent arts and culture grants:

Art in the Stations, Detroit, MI, $10,000. Toward installation of Allie McGhee's work of art in Michigan Avenue station of Detroit People Mover. 1987.

Detroit Historical Society, Detroit, MI, $10,000. To support study for adaptive reuse of structures at Historic Fort Wayne. 1987.

Detroit Institute of Arts, Founders Society, Detroit, MI, $9,250. 1987.

Detroit Symphony Orchestra, Detroit, MI, $5,750. 1987.

Edison Institute, Dearborn, MI, $10,000. To support The Constitution in a Changing America living history exhibit. 1987.

Edison Institute, Dearborn, MI, $6,000. 1987.

University Cultural Center Association, Detroit, MI, $5,000. To support first Detroit Festival of the Arts. 1987.

Your Heritage House, Detroit, MI, $5,000. To support planning and self-study process. 1987.

1363
SPX Corporation Foundation
(Formerly Sealed Power Foundation)
100 Terrace Plaza
Muskegon 49443 (616) 724-5816

Established in 1984 in MI.
Donor(s): Sealed Power Corp.
Financial data (yr. ended 12/31/87): Assets, $36,481 (M); expenditures, $377,334, including $101,174 for 144 grants (high: $47,520; low: $25) and $23,032 for 171 employee matching gifts.
Purpose and activities: Emphasis on education, community funds, culture and the arts; some support for employment development.
Types of support: Employee matching gifts, general purposes.
Limitations: Giving primarily in plant communities.
Officers: J.M. Sheridan,* Pres.; S.A. Lison,* V.P.; J.D. Tyson, V.P.
Trustees:* C.E. Johnson III, D.H. Johnson, Robert D. Tuttle, R. Budd Werner.
Employer Identification Number: 386058308

1364
Steelcase Foundation

P.O. Box 1967
Grand Rapids 49507 (616) 246-4695

Trust established in 1951 in MI.
Donor(s): Steelcase, Inc.
Financial data (yr. ended 11/30/88): Assets, $34,462,334 (M); gifts received, $6,001,133; expenditures, $3,524,804, including $3,393,759 for 114 grants (high: $1,000,000; low: $1,000; average: $2,000-$25,000).
Purpose and activities: Support for human services, including a community fund, health, education, arts, and the environment; particular concerns include helping the disadvantaged, disabled, young, and elderly to improve the quality of their lives.
Types of support: Building funds, general purposes, capital campaigns, special projects, employee-related scholarships.
Limitations: Giving limited to areas of company operations, including Grand Rapids, MI; Orange County, CA; Ashville, NC; Athens, AL; and Toronto, Canada. No support for churches, or programs with substantial religious overtones of a sectarian nature. No grants to individuals, or for endowment funds.
Publications: Annual report (including application guidelines), application guidelines.
Application information: Application form required.
Initial approach: Letter
Copies of proposal: 1
Deadline(s): None
Board meeting date(s): Quarterly and as required
Final notification: At least 90 days
Write: Kate Pew Wolters, Exec. Dir.
Trustees: David D. Hunting, Jr., Roger L. Martin, Frank H. Merlotti, Robert C. Pew, Peter M. Wege, Old Kent Bank & Trust Co.
Number of staff: 1 full-time professional; 1 part-time support.
Employer Identification Number: 386050470
Recent arts and culture grants:

Arts Council of Greater Grand Rapids, Grand Rapids, MI, $55,000. 1987.

Grand Rapids Area Council for the Humanities, Grand Rapids, MI, $60,000. 1987.

Grand Rapids Art Museum, Grand Rapids, MI, $33,000. 1987.

Grand Rapids Civic Ballet, Grand Rapids, MI, $10,000. 1987.

Grand Rapids Summerfest, Grand Rapids, MI, $10,000. 1987.

Grand Rapids Symphony Orchestra, Grand Rapids, MI, $50,000. 1987.

Grand Valley State College, Allendale, MI, $33,000. For TV 35/52. 1987.

Kendall School of Design, Grand Rapids, MI, $5,000. 1987.

Ladies Literary Club of Greater Grand Rapids Michigan, Grand Rapids, MI, $10,000. 1987.

Opera Grand Rapids, Grand Rapids, MI, $12,500. 1987.

Pack Place Education, Arts and Science Center, Asheville, NC, $100,000. 1987.

University of Michigan, Institute for the Humanities, Ann Arbor, MI, $100,000. 1987.

1365
Stroh Brewery Corporate Giving Program
100 River Place
Detroit 48207 (313) 446-2179

Financial data (yr. ended 03/31/87): Total giving, $1,000,000, including $995,000 for grants (high: $50,000; low: $500; average: $10,000) and $5,000 for in-kind gifts.
Purpose and activities: Bulk of support is through the corporate giving program. While foundation giving is almost exclusively in southeast MI, the direct giving program concentrates on areas where there are facilities. National organizations are also considered. Giving interests include environmental issues, public administration, race relations, education, hospitals, medical research, community funds, and the arts.
Types of support: General purposes, operating budgets, employee-related scholarships, scholarship funds, in-kind gifts.
Limitations: Giving primarily in headquarters city and major operating locations. No support for organizations dealing primarily with clients under 21. No grants to individuals, or for endowments.
Application information: Proposal.
Initial approach: Letter
Copies of proposal: 1
Deadline(s): None
Write: William V. Weatherston, V.P., Corp. Affairs
Number of staff: 3 full-time professional.

1366
The Stroh Foundation
100 River Place
Detroit 48207

Established in 1965 in MI.
Donor(s): Stroh Brewery Co.
Financial data (yr. ended 3/31/88): Assets, $46,072 (M); gifts received, $300,000; expenditures, $306,440, including $306,250 for 73 grants (high: $35,000; low: $500).
Purpose and activities: Support for arts and cultural institutions, education (including higher education), social services, health care and research, community development, and conservation and ecology.
Limitations: Giving primarily in MI. No support for religious organizations. No grants to individuals, or for fund raising events.
Officers and Trustees: David V. Van Howe, Pres.; Gari M. Stroh, Jr., Secy.; John W. Stroh, Jr., Treas.; Peter W. Stroh.
Employer Identification Number: 386108732

1367
The Charles J. Strosacker Foundation
P.O. Box 2164
Midland 48641-2164

Incorporated in 1957 in MI.
Donor(s): Charles J. Strosacker.†
Financial data (yr. ended 12/31/88): Assets, $29,236,525 (M); expenditures, $1,181,797, including $1,124,520 for 48 grants (high: $494,000; low: $50; average: $1,000-$10,000).

Purpose and activities: To assist and benefit political subdivisions of the state of MI and religious, charitable, artistic, or educational organizations.
Types of support: General purposes, fellowships, building funds, operating budgets, special projects, continuing support.
Limitations: Giving primarily in MI, with emphasis on the city of Midland. No grants to individuals, or for matching gifts; no loans.
Publications: Annual report (including application guidelines).
Application information:
Initial approach: Letter
Copies of proposal: 1
Deadline(s): Submit proposal in Oct. of the year preceding the time payment is desired
Board meeting date(s): Mar., July, and Nov.
Write: Patricia E. McKelvey, Secy.
Officers: Eugene C. Yehle,* Chair.; Martha G. Arnold,* Pres.; Ralph A. Cole,* V.P. and Treas.; Patricia E. McKelvey, Secy.
Trustees:* Lawrence E. Burks, Donna T. Morris, John S. Ludington, Charles J. Thrune.
Number of staff: 1 part-time professional.
Employer Identification Number: 386062787
Recent arts and culture grants:
Midland Center for the Arts, Midland, MI, $22,200. 1987.

1368
Taubman Endowment for the Arts
200 East Long Lake Rd.
Bloomfield Hills 48303-0200

Established in 1985 in MI.
Donor(s): A. Alfred Taubman.
Financial data (yr. ended 12/31/87): Assets, $391 (M); gifts received, $140,370; expenditures, $141,446, including $140,329 for 9 grants (high: $34,996; low: $1,000).
Purpose and activities: Giving primarily for the arts.
Officers and Trustees: A. Alfred Taubman, Chair., Pres. and Treas.; Jeffrey H. Miro, Secy.
Employer Identification Number: 382590370

1369
Thorn Apple Foundation
150 West Court St.
Hastings 49058
Special address for applications: 538 West Green St., Hastings, MI 49058; Tel.: (616) 945-5122

Financial data (yr. ended 1/31/88): Assets, $200,806 (M); expenditures, $25,519, including $25,171 for 3 grants (high: $14,671; low: $500).
Purpose and activities: Support for YMCA, a public library, and an arts council.
Limitations: Giving limited to the Barry County, MI, area.
Application information:
Initial approach: Letter
Deadline(s): None
Write: Thomas Stebbins, Treas.
Officers: Richard Gross, Chair.; Thomas F. Stebbins, Treas.
Directors: Richard M. Cook, Stephen I. Johnson, Paul Siegel.
Employer Identification Number: 386095412

1370
A. M. Todd Company Foundation
c/o Old Kent Bank of Kalamazoo
Kalamazoo 49007

Financial data (yr. ended 12/31/87): Assets, $98,918 (M); gifts received, $20,000; expenditures, $24,284, including $21,750 for 21 grants (high: $5,800; low: $50).
Purpose and activities: Support for the United Way, the arts, and social services.
Limitations: Giving primarily in Kalamazoo, MI.
Application information: Contributes only to preselected organizations. Applications not accepted.
Trustees: Ian D. Blair, A.J. Todd III.
Employer Identification Number: 386055829

1371
The Harry A. and Margaret D. Towsley Foundation
670 City Center Bldg.
220 East Huron St.
Ann Arbor 48104 (313) 662-6777

Incorporated in 1959 in MI.
Donor(s): Margaret D. Towsley.
Financial data (yr. ended 12/31/88): Assets, $38,771,730 (M); expenditures, $1,328,124, including $1,257,963 for 36 grants (high: $150,000; low: $1,000; average: $5,000-$25,000).

Purpose and activities: Support for medical and preschool education, social services, and continuing education and research in the health sciences.
Types of support: Continuing support, annual campaigns, building funds, endowment funds, matching funds, special projects.
Limitations: Giving limited to MI, with emphasis on Ann Arbor and Washtenaw County. No grants to individuals, or for travel, scholarships, fellowships, or conferences; no loans.
Publications: Annual report, application guidelines.
Application information:
Initial approach: Letter and proposal
Copies of proposal: 2
Deadline(s): Submit proposal between Jan. and Mar.; deadline Mar. 31
Board meeting date(s): Apr., July, Sept., and Dec.
Final notification: 60 to 90 days
Write: Margaret Ann Riecker, Pres.
Officers: Harry A. Towsley, M.D.,* Chair.; Margaret Ann Riecker,* Pres.; Margaret D. Towsley,* V.P.; John E. Riecker, Secy.; C. Wendell Dunbar,* Treas.
Trustees:* Judith T. Alexander, Robert L. Bring, Lynn T. Hamblin, Janis T. Poteat, Susan T. Wyland.
Number of staff: None.
Employer Identification Number: 386091798
Recent arts and culture grants:
Ann Arbor Symphony Orchestra, Ann Arbor, MI, $5,000. 1987.
Cobblestone Farm, Ann Arbor, MI, $10,000. 1987.
Michigan Theater Foundation, Ann Arbor, MI, $35,000. 1987.

Northwestern Michigan College, Community Art Museum/Gallery, Traverse City, MI, $10,575. 1987.

University of Michigan, School of Music, Vocal Arts, Ann Arbor, MI, $100,000. 1987.

University of Michigan, University Musical Society, Ann Arbor, MI, $5,000. 1987.

1372
Katherine Tuck Fund
2500 Comerica Bldg.
Detroit 48226 (313) 963-6420

Incorporated in 1935 in MI.
Donor(s): Katherine Tuck.†
Financial data (yr. ended 12/31/88): Assets, $18,977,069 (M); expenditures, $3,981,620, including $3,735,500 for 38 grants (high: $1,000,000; low: $1,000; average: $1,000-$35,000).
Purpose and activities: Support for Michigan-based cultural and educational institutions and programs for youth and social and human services.
Types of support: General purposes, building funds, operating budgets, scholarship funds, annual campaigns, capital campaigns, continuing support, endowment funds.
Limitations: Giving primarily in MI. No grants to individuals.
Application information:
 Initial approach: Letter
 Copies of proposal: 1
 Deadline(s): 2 weeks before board meetings
 Board meeting date(s): Monthly
 Final notification: Within 30 days after board meetings
 Write: Peter P. Thurber, Pres.
Officers and Trustees: Peter P. Thurber, Pres.; George E. Parker III, V.P. and Secy.; Richard B. Gushee, V.P. and Treas.
Number of staff: None.
Employer Identification Number: 386040079

1373
Jay and Betty VanAndel Foundation
7186 Windy Hill Rd., S.E.
Grand Rapids 49506

Established in 1963.
Donor(s): Jay VanAndel, Betty VanAndel.
Financial data (yr. ended 12/31/87): Assets, $8,540,753 (M); gifts received, $400,000; expenditures, $610,758, including $610,410 for 77 grants (high: $125,000; low: $100).
Purpose and activities: Emphasis on Christian religious activities, including higher and secondary education; giving also for hospitals and cultural programs.
Limitations: Giving primarily in MI.
Officers and Trustees: Jay VanAndel, Pres.; Betty VanAndel, V.P.; Otto Stolz, Secy.; James Roslonic, Treas.
Employer Identification Number: 237066716

1374
Vlasic Foundation
200 Town Ctr., Suite 900
Southfield 48075

Established in 1958 in MI.
Donor(s): Robert J. Vlasic, Joseph Vlasic.
Financial data (yr. ended 5/31/87): Assets, $1,656,198 (M); expenditures, $53,362, including $52,350 for 35 grants (high: $20,000; low: $100).
Purpose and activities: Grants primarily for cultural programs, and health agencies and hospitals; some support for social services and Roman Catholic organizations.
Types of support: General purposes.
Application information: Applications not accepted.
Officers and Trustees: Robert J. Vlasic, Pres.; Richard R. Vlasic, V.P.; William J. Vlasic, V.P.; James J. Vlasic, Secy.-Treas.; Michael A. Vlasic.
Employer Identification Number: 386077329

1375
Wege Foundation
P.O. Box 6388
Grand Rapids 49506 (616) 957-0480

Established about 1967 in MI.
Donor(s): Peter M. Wege.
Financial data (yr. ended 12/31/87): Assets, $4,039,000 (M); gifts received, $223,843; expenditures, $216,875, including $216,875 for 44 grants (high: $45,000; low: $150).
Purpose and activities: Support primarily for youth, social services, and culture; some support for education and community development.
Limitations: Giving primarily in MI, with emphasis on the Grand Rapids area.
Application information:
 Initial approach: Proposal
Officers: Peter M. Wege, Pres.; Peter M. Wege II, V.P.; Charles Lundstrom, Secy.; Robert A. Risselade, Treas.
Employer Identification Number: 386124363

1376
Henry E. and Consuelo S. Wenger Foundation, Inc.
P.O. Box 43098
Detroit 48243

Incorporated in 1959 in MI.
Donor(s): Consuelo S. Wenger.
Financial data (yr. ended 12/31/86): Assets, $6,000,303 (M); expenditures, $332,079, including $318,330 for 80 grants (high: $125,000; low: $100).
Purpose and activities: Support for secondary and higher education, hospitals, and cultural programs.
Limitations: No grants to individuals.
Application information: Applications not accepted.
Officers and Directors: Henry Penn Wenger, Pres.; Diane Wenger Wilson, V.P.; Miles Jaffe, Secy.; William E. Slaughter, Jr., Treas.
Employer Identification Number: 386077419

1377
Samuel L. Westerman Foundation
1700 North Woodward, Suite A
Bloomfield Hills 48013 (313) 642-5770

Established in 1971 in MI.
Financial data (yr. ended 1/31/87): Assets, $6,982,122 (M); gifts received, $4,569,451; expenditures, $366,986, including $300,000 for grants.
Purpose and activities: Giving primarily for hospitals and health agencies, social service and youth agencies, religious organizations, including churches, higher education, and cultural programs.
Limitations: No grants to individuals.
Application information:
 Initial approach: Letter
 Deadline(s): None
 Write: James H. LoPrete, Pres.
Officers: James H. LoPrete, Pres.; Ruth H. Cooke, V.P. and Secy.; Keith H. Muir, Treas.
Employer Identification Number: 237108795

1378
Whirlpool Foundation
2000 U.S. 33, N.
Benton Harbor 49022 (616) 926-3461

Incorporated in 1951 in MI.
Donor(s): Whirlpool Corp.
Financial data (yr. ended 12/31/86): Assets, $11,540,957 (L); gifts received, $2,800,000; expenditures, $3,304,639, including $2,736,682 for 364 grants (high: $119,684; low: $80; average: $250-$65,000), $257,000 for 116 grants to individuals and $156,927 for employee matching gifts.
Purpose and activities: Giving primarily to community funds, youth and social welfare agencies, cultural programs, and higher education, including scholarships for children of corporation employees and employee matching gifts.
Types of support: Matching funds, operating budgets, annual campaigns, emergency funds, building funds, equipment, research, employee-related scholarships, continuing support, employee matching gifts.
Limitations: Giving limited to communities where major company units are located. No grants to individuals (except employee-related scholarships), or for endowment funds; no loans.
Application information:
 Initial approach: Letter or telephone
 Copies of proposal: 1
 Deadline(s): Dec. 31
 Board meeting date(s): As required
 Final notification: 30 to 60 days
 Write: Patricia O'Day, Secy.
Officers: Stephen E. Upton,* Pres.; Patricia O'Day, Secy.; William B. Naylor, Treas.
Trustees:* William K. Emery, William D. Marohn.
Number of staff: 1 full-time professional.
Employer Identification Number: 386077342

1379
David M. Whitney Fund
2500 Comerica Bldg.
Detroit 48226

Established in 1949 in MI.
Financial data (yr. ended 12/31/87): Assets,
$1,464,700 (M); gifts received, $56,550;
expenditures, $112,275, including $62,750 for
28 grants (high: $7,000; low: $500).
Purpose and activities: Support for social
services, educational institutions, cultural
organizations and child welfare.
Limitations: No grants to individuals.
Application information:
 Initial approach: Letter
 Deadline(s): None
 Write: Peter P. Thurber, Pres.
Officers: Peter P. Thurber, Pres.; George E.
Parker III, V.P. and Secy.; Richard B. Gushee,
V.P. and Treas.
Employer Identification Number: 386040080

1380
Harvey Randall Wickes Foundation
Plaza North, Suite 472
4800 Fashion Square Blvd.
Saginaw 48604 (517) 799-1850

Incorporated in 1945 in MI.
Donor(s): Harvey Randall Wickes,† members
of the Wickes family and others.
Financial data (yr. ended 12/31/87): Assets,
$20,164,406 (M); expenditures, $1,099,301,
including $973,955 for 34 grants (high:
$250,000; low: $200; average: $5,000-
$60,000).
Purpose and activities: Giving for education,
including higher education, social service and
youth agencies, a community fund, civic affairs
groups, hospitals, and cultural activities.
Types of support: Building funds, equipment.
Limitations: Giving limited to the Saginaw, MI,
area. No grants to individuals.
Application information:
 Initial approach: Letter followed by proposal
 Copies of proposal: 1
 Deadline(s): Submit proposal preferably 1
 month prior to meeting
 Board meeting date(s): Jan., Apr., June, and
 Oct.
 Final notification: After meeting
 Write: James V. Finkbeiner, Pres.
Officers and Trustees: Melvin J. Zahnow,
Chair.; James V. Finkbeiner, Pres.; H.E. Braun,
Jr., V.P. and Secy.; Lloyd J. Yeo, Treas.; F.N.
Andersen, R.G. App, G.A. Barber, F.M.
Johnson, William Kessel, D.F. Wallace.
Number of staff: 1 full-time professional; 1
part-time support.
Employer Identification Number: 386061470

1381
Wickson-Link Memorial Foundation
P.O. Box 3275
3023 Davenport St.
Saginaw 48605 (519) 793-9830

Financial data (yr. ended 12/31/88): Assets,
$310,600 (M); gifts received, $53,000;
expenditures, $205,089, including $174,855
for 31 grants (high: $32,000; low: $250).

Purpose and activities: Support for
community funds, youth and cultural
organizations and higher education.
Limitations: Giving primarily in Saginaw, MI.
Application information:
 Initial approach: Letter
 Copies of proposal: 3
 Deadline(s): None
 Write: Lloyd J. Yeo, Pres.
Officers and Director: Lloyd J. Yeo, Pres. and
Treas.; B.J. Humphreys, V.P. and Secy.; C.
Ward Lauderbach.
Number of staff: None.
Employer Identification Number: 386083931

1382
Wilkinson Foundation
c/o Comerica Bank
Detroit 48275-1022
Application address: Two Woodland Pl.,
Grosse Pointe, MI 48230

Established in 1986 in MI.
Financial data (yr. ended 1/31/88): Assets,
$1,536,072 (M); expenditures, $84,845,
including $39,740 for 44 grants (high: $11,000;
low: $15).
Purpose and activities: Giving primarily for
historic preservation; grants also for higher and
secondary education, churches, and
environmental causes.
Limitations: giving limited to southeast MI.
Application information:
 Write: Warren S. Wilkinson
Trustees: Guerin Wilkinson, Todd Wilkinson,
Comerica Bank.
Number of staff: None.
Employer Identification Number: 382683326

1383
Matilda R. Wilson Fund
100 Renaissance Center, Suite 3377
Detroit 48243 (313) 259-7777

Incorporated in 1944 in MI.
Donor(s): Matilda R. Wilson,† Alfred G.
Wilson.†
Financial data (yr. ended 12/31/87): Assets,
$27,505,032 (M); expenditures, $1,592,995,
including $1,372,856 for 41 grants (high:
$350,000; low: $500; average: $1,000-
$150,000).
Purpose and activities: Support for culture
and art, youth agencies, higher education,
hospitals, and social services.
Types of support: Operating budgets, general
purposes, building funds, equipment,
endowment funds, research, special projects,
scholarship funds, matching funds.
Limitations: Giving primarily in southeast MI.
No grants to individuals; no loans.
Application information:
 Initial approach: Proposal or letter
 Copies of proposal: 1
 Deadline(s): None
 Board meeting date(s): Jan., Apr., July, and
 Oct.
 Write: Frederick C. Nash, Pres.
Officers and Trustees: Frederick C. Nash,
Pres.; Pierre V. Heftler, V.P.; Henry T.
Bodman, Treas.
Employer Identification Number: 386087665

1384
Lula C. Wilson Trust
1116 West Long Lake Rd.
Bloomfield Hills 48013 (313) 645-6600

Trust established in 1963 in MI.
Donor(s): Lula C. Wilson.†
Financial data (yr. ended 12/31/88): Assets,
$1,711,117 (M); expenditures, $103,956,
including $97,592 for 20 grants (high: $15,000;
low: $1,892; average: $2,000-$5,000).
Purpose and activities: Grants primarily for
higher and secondary education, performing
arts groups and other cultural programs, youth
agencies and family services, and community
service agencies.
Types of support: Operating budgets,
continuing support, annual campaigns, seed
money, emergency funds, building funds,
equipment, renovation projects.
Limitations: Giving limited to Pontiac and
Oakland County, MI. No grants to individuals,
or for endowment funds, research, deficit
financing, land acquisition, special projects,
publications, conferences, scholarships,
fellowships, or matching gifts; no loans.
Publications: 990-PF.
Application information:
 Initial approach: Letter
 Copies of proposal: 1
 Deadline(s): None
 Board meeting date(s): As required
 Final notification: 1 month
 Write: Frederick H. Gravelle, V.P., National
 Bank of Detroit
Trustee: National Bank of Detroit.
Number of staff: None.
Employer Identification Number: 386058895

1385
Wolverine World Wide Foundation
9341 Courtland Dr.
Rockford 49351 (616) 866-5521

Trust established in 1959 in MI.
Donor(s): Wolverine World Wide, Inc.
Financial data (yr. ended 12/31/88): Assets,
$188,209 (M); expenditures, $73,600,
including $69,345 for 88 grants (average: $10-
$16,500) and $4,255 for 43 employee
matching gifts.
Purpose and activities: Giving for education,
health, community funds, cultural programs,
youth agencies, and social services.
Types of support: Employee matching gifts.
Application information: Application form
required.
 Initial approach: Phone or letter
 Deadline(s): None
 Write: Robert S. Wolff
Manager: Robert S. Wolff.
Trustee: NBD Grand Rapids, N.A.
Employer Identification Number: 386056939

MINNESOTA

1386
Adams-Mastrovich Family Foundation
c/o Norwest Bank-Minneapolis, N.A.
Eighth & Marquette
Minneapolis 55479-0063

Established in 1957 in MN.
Donor(s): Mary Adams Balmat.
Financial data (yr. ended 12/31/87): Assets, $1,317,499 (M); gifts received, $25,833; expenditures, $26,516, including $3,950 for 8 grants (high: $1,000; low: $100).
Purpose and activities: Support primarily for Catholic churches and welfare-related activities; giving also for the performing arts.
Limitations: No grants to individuals.
Application information: Contributes only to pre-selected organizations. Applications not accepted.
Trustee: Northwest Bank-Minneapolis, N.A.
Employer Identification Number: 416014092

1387
AHS Foundation
c/o First Trust Company
W-555, First National Bank Bldg.
St. Paul 55101 (612) 291-5128

Established in 1968 in MN.
Donor(s): Arthur H. Schubert,† Helen D. Schubert.
Financial data (yr. ended 6/30/87): Assets, $1,764,223 (M); expenditures, $79,706, including $69,985 for 24 grants (high: $10,000; low: $500; average: $1,000-$5,000).
Purpose and activities: Giving primarily for education, the arts, social services, conservation, health programs and other services for the handicapped, and community programs.
Types of support: General purposes, building funds, capital campaigns, operating budgets.
Limitations: No grants to individuals; no loans.
Application information:
 Initial approach: Letter
 Copies of proposal: 2
 Deadline(s): None
 Board meeting date(s): July
 Final notification: 1 to 3 months
 Write: Leland W. Schubert, Jr., Pres.
Officers and Directors: Leland W. Schubert, Jr.,* Pres.; John D. Schubert,* 1st V.P.; Gage A. Schubert, 2nd V.P.; John L. Jerry,* Secy.-Treas.; William Frels.
Members:* Terence N. Doyle, Helen D. Schubert, Leland Schubert.
Number of staff: 1 part-time support.
Employer Identification Number: 410944654

1388
American Hoist and Derrick Foundation
345 St. Peter St., Suite 1800
St. Paul 55102 (612) 293-4909

Incorporated in 1958 in MN.
Donor(s): American Hoist & Derrick Co.
Financial data (yr. ended 12/31/88): Assets, $5,000 (L); gifts received, $65,000; expenditures, $65,000, including $65,000 for 15 grants (high: $25,000; low: $100).
Purpose and activities: Giving largely to community funds and higher education; additional support for culture and the arts, environment, rehabilitation, community development, the homeless, and civic and social agencies.
Types of support: Annual campaigns, general purposes, operating budgets, renovation projects, employee-related scholarships.
Limitations: Giving primarily in cities with operating locations. No grants for matching gifts; no loans.
Publications: Application guidelines, program policy statement.
Application information:
 Initial approach: Proposal
 Copies of proposal: 1
 Deadline(s): None
 Board meeting date(s): As required
 Final notification: 60 days
 Write: D. Scott Ross, Pres.
Officers: Robert H. Nassau, Chair.; D. Scott Ross, Pres.
Employer Identification Number: 416080179

1389
Andersen Foundation
c/o Andersen Corporation
Bayport 55003 (612) 439-5150

Incorporated in 1959 in MN.
Donor(s): Fred C. Andersen.†
Financial data (yr. ended 12/31/87): Assets, $192,007,671 (M); expenditures, $6,057,185, including $5,396,350 for 88 grants (high: $1,662,000; low: $500).
Purpose and activities: Grants largely for higher education; grants also for cultural programs, medical research, hospitals, and civic affairs.
Limitations: No support for state or federally funded colleges or universities. No grants to individuals.
Application information:
 Deadline(s): None
 Board meeting date(s): 3 or 4 times a year, as required
 Final notification: Varies
 Write: Lisa Carlstrom, Asst. Secy.
Officers and Directors: Katherine B. Andersen, Pres.; Earl C. Swanson, V.P. and Secy.; Keith R. Clements, Treas.; W.R. Foster.
Number of staff: 1 part-time professional.
Employer Identification Number: 416020920

1390
Hugh J. Andersen Foundation
c/o Baywood Corp.
287 Central Ave.
Bayport 55003 (612) 439-1557

Established in 1962.
Donor(s): Hugh J. Andersen,† Jane K. Andersen,† Katherine B. Andersen.
Financial data (yr. ended 2/28/88): Assets, $26,070,000 (M); expenditures, $1,573,076, including $1,531,852 for 110 grants (high: $115,020; low: $350; average: $1,500-$20,000).
Purpose and activities: Emphasis on social service and youth agencies, health issues, education, arts and cultural programs, and civic affairs.
Types of support: Research, operating budgets, seed money, special projects, capital campaigns, equipment, general purposes, annual campaigns, renovation projects.
Limitations: Giving primarily in MN, especially the Bayport area, St. Paul, and western WI. No grants to individuals, or for scholarships or fellowships; no loans.
Publications: Annual report (including application guidelines).
Application information: Application form required.
 Initial approach: Letter or proposal
 Copies of proposal: 1
 Deadline(s): Apr. 1, July 1, Oct. 1, and Dec. 1
 Board meeting date(s): May, Aug., Nov., and Jan.
 Final notification: Approximately 3 months
 Write: Carol F. Andersen, Pres. or Peggie Scott, Grants Consultant
Officers and Trustees: Carol F. Andersen, Pres.; Sarah J. Andersen, V.P.; Christine E. Andersen, Treas.
Number of staff: 2
Employer Identification Number: 416020914
Recent arts and culture grants:
Actors Theater of Saint Paul, Saint Paul, MN, $11,000. 1987.
Community Programs in the Arts and Sciences (COMPAS), Saint Paul, MN, $5,000. 1987.
Great North American History Theater, Saint Paul, MN, $35,000. 1987.
K T C A Twin Cities Public Television, Minneapolis, MN, $42,842. 1987.
Minnesota Museum of Art, Saint Paul, MN, $10,000. 1987.
Minnesota Public Radio, Saint Paul, MN, $15,000. 1987.
Northern Minnesota Public Television, Bemidji, MN, $20,000. 1987.
Phipps Center for the Arts, Hudson, WI, $7,000. 1987.
Saint Paul Chamber Orchestra, Saint Paul, MN, $20,000. 1987.
Washington County Historic Courthouse, Stillwater, MN, $5,000. 1987.
World Theater Corporation, Saint Paul, MN, $10,000. 1987.